Property of FAMILY OF FAITH LIBRARY

CULTURE AND VALUES

A Survey of the Humanities

Volume I 🐘 Fifth Edition

Harcourt College Publishers

Where Learning Comes to Life

TECHNOLOGY

Technology is changing the learning experience, by increasing the power of your textbook and other learning materials; by allowing you to access more information, more quickly; and by bringing a wider array of choices in your course and content information sources.

Harcourt College Publishers has developed the most comprehensive Web sites, e-books, and electronic learning materials on the market to help you use technology to achieve your goals.

PARTNERS IN LEARNING

Harcourt partners with other companies to make technology work for you and to supply the learning resources you want and need. More importantly, Harcourt and its partners provide avenues to help you reduce your research time of numerous information sources.

Harcourt College Publishers and its partners offer increased opportunities to enhance your learning resources and address your learning style. With quick access to chapter-specific Web sites and e-books . . . from interactive study materials to quizzing, testing, and career advice . . . Harcourt and its partners bring learning to life.

Harcourt's partnership with Digital:Convergence[™] brings :CRQ[™] technology and the :CueCat[™] reader to you and allows Harcourt to provide you with a complete and dynamic list of resources designed to help you achieve your learning goals. You can download the free :CRQ software from www.crq.com. Visit any of the 7,100 RadioShack stores nationwide to obtain a free :CueCat reader. Just swipe the cue with the :CueCat reader to view a list of Harcourt's partners and Harcourt's print and electronic learning solutions.

http://www.harcourtcollege.com/partners

Family of Family

CULTURE AND VALUES

A Survey of the Humanities

LAWRENCE S. CUNNINGHAM

John A. O'Brien Professor of Theology University of Notre Dame

JOHN J. REICH

Syracuse University Florence, Italy

Volume I 🔹 Fifth Edition

HARCOURT COLLEGE PUBLISHERS

Fort Worth Philadelphia San Diego New York Austin Orlando San Antonio Toronto Montreal London Sydney Tokyo PublisherChristopher P. KleinAcquisitions EditorJohn SwansonMarket StrategistSteve DrummondDevelopmental EditorStacey SimsProject EditorRebecca DodsonArt DirectorBrian SalisburyProduction ManagerSerena Sipho

Cover image: Limbourg Brothers. May page from the *Trés Riches du Duc de Berry*, 1413–1416. Musée Condé, Chantilly, France.

ISBN: 0-15-506527-0 Library of Congress Catalog Card Number: 2001091450

Copyright © 2002, 1998, 1994, 1990, 1982 by Harcourt, Inc.

All rights reserved. No part of this publication may be reproduced or transmitted in any form or by any means, electronic or mechanical, including photocopy, recording, or any information storage and retrieval system, without permission in writing from the publisher.

Requests for permission to make copies of any part of the work should be mailed to the following address: Permissions Department, Harcourt, Inc., 6277 Sea Harbor Drive, Orlando, FL 32887-6777.

Copyrights and Acknowledgments appear on page 467, which constitutes a continuation of the copyright page.

Address for Domestic Orders Harcourt College Publishers, 6277 Sea Harbor Drive, Orlando, FL 32887-6777 800-782-4479

Address for International Orders International Customer Service Harcourt, Inc., 6277 Sea Harbor Drive, Orlando, FL 32887-6777 407-345-3800 (fax) 407-345-4060 (e-mail) hbintl@harcourt.com

Address for Editorial Correspondence Harcourt College Publishers, 301 Commerce Street, Suite 3700, Forth Worth, TX 76102

Web Site Address http://www.harcourtcollege.com

Printed in the United States of America

1 2 3 4 5 6 7 8 9 0 048 9 8 7 6 5 4 3 2 1

Harcourt College Publishers

IT is now over twenty years since we finished the manuscript which would become this textbook. In the various additions, updatings, and rewriting that constitutes the various editions of *Culture and Values*, we have not repented of our earliest convictions about what this book should represent. We repeat here what we said in the first edition, namely, that our desire is to present, in a chronological fashion, the most crucial landmarks of Western culture with clarity and, in such a way, that students might react to this tradition and its major accomplishments with the same enthusiasm as we experienced when we first encountered them and began to teach about them.

We believe that our own backgrounds have enhanced our appreciation for what we discuss in these pages. Lawrence Cunningham has degrees in philosophy, theology, literature, and humanities, while John Reich is a trained classicist, musician, and field archaeologist. Both of us have lived and lectured for extended periods in Europe. There is very little Western art or architecture discussed in this book which we have not seen firsthand.

In developing the new editions of *Culture and Values*, we have been the beneficiaries of the suggestions and criticisms of classroom teachers who have used the book. We have also consulted closely with the editorial team in meetings at Harcourt's Fort Worth office. Our own experiences as teachers both here and abroad have also made us sensitive to new needs and refinements as we rework this book.

In this new edition we have made a number of changes: updated and pruned the suggested readings; brought the final chapter up-to-date; and made additions to the Glossary. Furthermore, we have expanded some of the discussions, art representations, and readings to reflect the ever growing retrieval of women's voices in the history of Western culture. We are also very pleased that the editorial team has obtained some newer art reproductions, redrawn the timelines, and generally used the latest in technology to make the book so attractive. The biggest improvements to this edition are several new chapters which take into account the Islamic, African, and Asian cultures, which more than ever impinge on the ideas of the West. We have added these chapters in response to the many teachers who have noted the increasingly multicultural character of the world in which we live.

While it is true that the newer and ever expanding information technologies as well as the emergence of a global socio-political economy may render the notion of a purely occidental culture somewhat skewed (think, for example, of the globalization of popular music), we have generally stayed within the traditional parameters of the West, although we now feel it necessary to put that Western context into a larger, more global, framework. This fifth edition, which comes in the beginning of the new millenium, seems the appropriate time to start such an expanded vision.

One of the more vexatious issues with which we have had to deal is what to leave out. Our aim is to provide some representative examples from each period, hoping that instructors would use their own predilections to fill out where we have been negligent. In that sense, to borrow the Zen concept, we are fingers pointing the way attend to the direction and not to the finger. We refine that direction using input from instructors making those decisions and would like to acknowledge the reviewers of the fifth edition:

Debra Barrett-Graves, College of Santa Fe; Margaret Brill, Corning Community College; Michael Call, Brigham Young University; Rich Campbell, Riverland College; Ransom P. Cross, The University of Texas–El Paso; Kimberly Felos, St. Petersburg Junior College; Jenette Flow, Pasco–Hernando Community College; Bruce W. Hozeski, Ball State University; David Hutto, Georgia Perimeter College; Steven P. Johnson, Brigham Young University; Terrence Lewis, Calencia Community College; Fay C. McMillan, Northeast State Technical Community College; Sarah C. Neitzel, University of Texas–Pan American; Carol Nicklaus, Amarillo College; Lilian Taylor, College of Santa Fe; Elizabeth D. Van Loo, Troy State University–Dothan; Michael Walensky, Diablo Valley College; Gary Zacharias, Palomar College.

Finally, we would like to express our gratitude to those who have helped us in preparing this fifth edition. We would especially like to acknowledge the work of Scott Douglass of Chattanooga State Technical Community College, who served as our technology consultant on the new edition, providing assistance on the Web sites and captions for the cues, in development of the *Culture and Values* Web site, and in creation of online course materials for the book. Special thanks also go to John R. Swanson, acquisitions editor; Stacey Sims, developmental editor; Rebecca Dodson, project editor; Serena Manning, production manager; Brian Salisbury, art director; and Shirley Webster, picture and rights editor.

LSC JJR

FEATURES

The fifth edition of *Culture and Values* maintains many of the features that have made the book so successful.

Enhanced Illustrations. As in prior editions, the text is beautifully illustrated with over five hundred images, most of them in color. This new edition includes over ninety new images, including a photo of King Tutankhamen's golden death mask and another of the restored *Last Supper* with its unfamiliarly bright color. Many of the images previously reproduced in the book have been replaced with higher quality photos that provide either a better view of the original artwork or a truer match to the original's color and overall appearance. A number of the line drawings have also been redrawn for better accuracy of representation and better consistency with similar drawings found in the book.

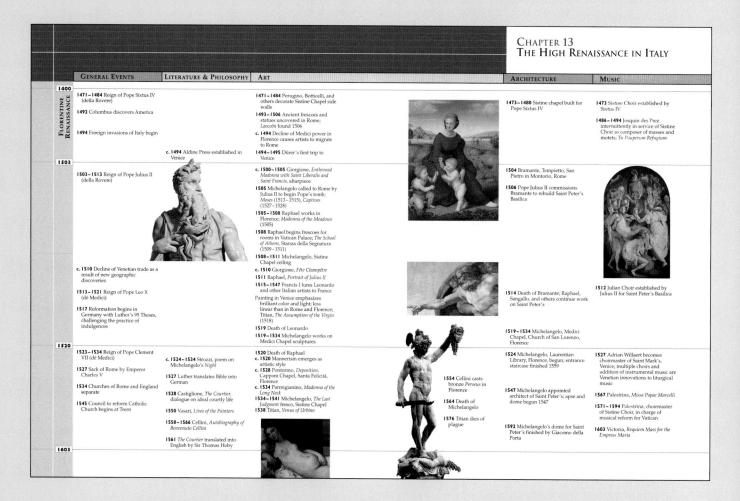

Timelines. Each chapter begins with an illustrated, two-page timeline that organizes the major events and works for each era and, where appropriate, for each major category of works discussed in the chapter (i.e., general events, literature

and philosophy, art, architecture, and music). The timelines provide an instant visual reference that allows students to see the development of each type of art over the time period presented.

47 CHAPTER 17 The Romantic Era

VALUES Nationalism

One of the consequences of the rise of the cities and growing political consciousness was the development of nationalism: the identification of individuals with a nation-state, with its own culture and history. In the past, the units of which people felt a part were either smaller—a local region—or larger—a religious orga-nization or a social class. In many cases, the nations with which people began to identify were either bro-ken up into separate small states, as in the case of the future Germany and Italy, or formed part of a larger state: Hungary, Austria, and Serbia were all under the rule of the Hapsburg Empire, with Austria dominating the rest.

the rest. The period from 1848 to 1914 was one in which the struggle for national independence marked political and social life and left a strong impact on European cul-ture. The arts, in fact, became one of the chief ways in ture. The arts, in fact, became one of the chief ways in which nationalists sought to stimulate a sense of peo-ples' awareness of their national roots. One of the basic factors that distinguished the Hungarians or the Czechis from their Austrian rulers was their language, and pa-triotic leaders fought for the right to use their own lan-guage in schools, government, and legal proceedings. In Hungary, the result was the creation by Austria of the Dual Monarchy in 1867, which allowed Hungarian peakers to have their own systems of education and the Dual Monarchy in 1867, which allowed Hungarian speakers to have their own systems of education and public life. A year later, the Hapaburgs granted a simi-lar independence to minorities. Iving there: Poles, Czeche, Slovaks, Romanians, and others. In Germany and laby, the verses process operated. Although most Italians spoke a dialect of the same lan-

and rugos own natio Basques of are just tw arts contin

re laid by Thomas Cole (1801–1848), born in England, whose later paintings combine grandeur of effect with accurate observation of details. His Genesee Scenery [17.30] is particularly successful in capturing a sense of atmosphere and presence.

nineteer By mid-century, a new approach to landscape paint by indecently, a new approach to indicate praint ing had developed. Generally called luminism, it aimed to provide the sense of artistic anonymity Emerson and other Transcendentalists demanded. In a way this is the approach vidual st early pai exact antithesis of Romanticism. Instead of sharing with the viewer their own reactions, the luminists tried by rework as Civil Wa became alism to eliminate their own presence and let nothing stand between the viewer and the scenes. Yet the results, painting Head [17. far from achieving only a photographic realism, have an utterly characteristic and haunting beauty that has no piction o in which real parallel in European art of the time. The painting

Boxes. Two types of boxes run throughout the book. "Contemporary Voices" boxes, taken from letters, journals, and narratives of the time period under discussion, provide students with insight into the concerns of individuals responding to the major events and ideas of the era firsthand. "Values" boxes make

guage, they had been ruled for centuries by a bewilder

guage, they had been ruled for centuries by a bewilder-ing array of outside powers. In Sicily alone, Araba, French, Spaniards, and English were only some of the occupiers who had succeeded one another. The archi-tects of Italian unity used the existence of a common language, which went back to the poet Dante, to forge a sense of national identity. The arts also played their part. Nationalist com-posers used folktunes, sometimes rela and sometimes monthed, to underscore a sense of national conscious-ess. In the visual arts, painters illustrated historical events and sculptors portrayed patriotic leaders. While the newly formed nations aimed to craste an indepen-dent national culture, the great powers reinforced their oven identities. Russian composers turned away from Western models to underline their Slavic roots, while in Britain the artists and writers of the Victorian Age de-pieted the glories (and, in some cases, the horroors) of their ratio.

The consequences of the rise of national conscious ness dominus today.

competiti the twent of many

Among th and Yugos

Lake Ge

of the lea

Surrealist

The

CHAPTER 10 High Middle Ages: The Search for Synthesis

CONTEMPORARY VOICES

A Medieval Parent and a Student

We occupy a good and comely dwelling, next door but one from the schools and marketplace, so that we can go to school each day without wetting our feet. We

By our standards, student life in the thirteenth cenclericnor clerical orders of the church) in his Prologue to the Canterbury Tales:

By our standards, student life in the furthernin cen-tury was harsh. Food and lodging were primitive, heat-ing scarce, artificial lighting nonexistent, and income sporadic. The daily schedule was rigorous, made more so by the shortage of books and writing material. An "ideal" student's day, as sketched out in a late medieval who have the day are more more there are medieval pamphlet for student use, now seems rather grim:

4:00 A.M.	Rise
5:00-6:00	Arts lectures
6:00	Mass and breakfast
8:00-10:00	Lectures
11:00-12:00	Disputations before the noon meal
1:00-3:00 p.m.	"Repetitions"—study of morning lec- tures with tutors
3:00-5:00	Cursory lectures (generalized lec- tures on special topics) or disputa- tions
6:00	Supper
7:00-9:00	Study and repetitions
9:00	Bed

The masters' lectures consisted of detailed commen taries on certain books the master intended to cover in a given term. Since books were expensive, emphasis was piter in term: Jinte tooks in the spectra it of piters in the piter on note taking and copying so that the student might build up his own collection of books. Examinations were oral, before a panel of masters. Students were also ex-pected to participate in formal debates (called disputa-

tions) as part of their training. Geoffrey Chaucer provides us an unforgettable, albeit idealized, portrait of the medieval student (the clerk or

I have recently discovered that you live dissolutely and slothfully, preferring license to restraint and play to work and strumming a guitar while the others are at buers studies, whence it happens that you have read but "ane volume of law while more industrious companions". Wherefore, lest production should cease for lack of ma-have read several. I have decided to exhort you here-with to repent utterly of your dissolute and careless ways that your may no longer be called a waster and tay curstame may be turned to good repute. Tement to a son at the university in Orleans, fourteenth entury! More compute a good and comealy dwelling, next door that the compute a good and comealy dwelling next door that the compute a good means of the sons and the other things which we need, in sufficient amount that we may suffer no want on your account (God for-bid!) but finish our studies and return home with hookings which you will son tak entarge of the shoes and tookings which you will send us, and any news at all.

-many of the students were members of the mi

[Scholar to his father, Orleans, fourteenth century]

A clerk from Oxford was with us also Who'd turned to getting knowledge, As meagre was his horse as is a rake, Nor he himself too fat, I'll undertake, But he looked hollow and went sober in undertake, But he looked hollow and went soberly. Right threadbare was his overcoat; for he Had got him yet no churchly benefice, Nor was so worldly as to gain office. For he would rather have at his bed's head For he would rather have at his bed's head Some twenty books, all bound in black and red, Of Aristotie and his philosophy Than rich roless, fiddle, or gay psaltery. Yet, and for all he was philosopher. He had but little gold within his offer: But all that he might borrow from a firend On books and karning he would swiftly spend, And then he'd pray right busily for the souls Of those who gave him wherewihal for schools. Of study took we durned see and head. Of study took he utmost care and need. Not one word spoke he more than was his need; And that was said in fullest reverence And short and quick and full of high good sense Pregnant of moral virtue was his speech; And gladly would he learn and gladly teach.

poor. zealou Chaucer's portrait of the lean, pious student was highly idealized to create a type. We proba bly get a far more realistic picture of what students were actually doing and thinking about from the considerable amount of popular poetry that comes from the student culture of the medieval period. This poetry depicts a stu dent life we are all familiar with: a poetry of wine, en, song, sharp satires at the expense of pompous

explicit the underlying issues or concerns unifying the works of a given era, examining their root causes and their ultimate impact on the type of art produced. *New Global Coverage.* Many instructors using *Culture and Values* have expressed an interest in seeing more global coverage of the humanities. Under their guidance and review, three new chapters covering Asian and African cultures have been added to the book, and the treatment of Islamic culture has been expanded to a full chapter. In each case, the presentation focuses on the unique achievements and traditions of these cultures and their place within the broader human story.

Fully Integrated Technology. The fifth edition of *Culture and Values* integrates technology as never before. In this :Cue Cat edition, student learning is fully Web-enhanced via captioned cues that appear throughout the book. With the swipe of the cue cat reader, students can access additional online resources directly relevant to the material presented, including the online chapter resources provided on the text-specific Web site—for

example, links, Web activities, review questions, and self-tests. The reader is available FREE at <u>www.har-courtcat.com</u>, or at the nearest Radio Shack store. An annotated list of related online links is also provided at the end of each chapter.

Culture and Values Web Site

SUPPLEMENTS*

Culture and Values *Listening CD.* This all-new CD features selections and excerpts from some of the major musical works discussed in the text. An icon of a lyre appears throughout the textbook to indicate the musical works represented on the CD. A full listing of the contents of the CD is provided on the textbook Web site. The Listening CD can be value-added to *Culture and Values* at a substantial discount to the student.

Culture and Values Online. Completely revised for the fifth edition and fully integrated with the textbook, the Web site for *Culture and Values* includes links to sites on major artists, writers, thinkers, and composers, and other resources related to the introduction to the humanities course. Included are chapter-by-chapter links to the sites referenced in the textbook's cues and end-of-chapter Web resources and to other sites directly related to the material in the text. The site also provides the timelines and the Glossary from the textbook, an audio pronunciation guide, and a selection of self-assessment tools. A variety of instructor's resources is also available, including a syllabus generator, online course management tools, and an electronic instructor's manual.

Course Management Tools (WebCT and Blackboard). For the first time ever, a text-specific online course prepared by Scott Douglass is also available for adoption with *Culture and Values.* Among the many features are chapter-by-chapter learning modules, assignments, discussion questions, Web links and activities, and self-tests. Also available for Blackboard.

Humanities Hits on the Web. This brief guide by Scott Douglass of Chattanooga State Technical Community College provides an overview on accessing and exploring the wealth of resources available to students of the humanities on the World Wide Web. It includes information on major search engines, e-mail, list serves and newsgroups, information on documenting Internet resources, as well as an annotated list of Web sites specifically for the humanities.

Great Artists CD-ROM. This CD-ROM focuses on the works of eight major

artists—William Blake, El Greco, Leonardo da Vinci, Pablo Picasso, Rembrandt, Vincent van Gogh, J.H.M. W. Turner, and Jean-Antoine Watteau. Students explore forty famous paintings and discover the influences that inspired the artists. They examine each painting by date, type, and content, and find out exactly how they were created. The CD-ROM includes one thousand full-color images, twenty minutes of running video, biographies of the artists, five hundred thousand words of descriptive text, and one hundred music excerpts and video clips. It also provides an examination of the artists' materials and methods, the ability to compare and contrast sections of different paintings, and insight into composition and techniques through video sequences and timelines. *Great Artists*

can be value-added to Culture and Values at a substantial discount to the student.

Harcourt Humanities Video and CD-ROM Library. This extensive library of videos and CD-ROMs contains selections covering every era, a significant number of major artists, and a variety of media including architecture and photography. Videos and CD-ROMs are available featuring civilizations from around the globe including the Americas, Africa, and Asia.

World Cultures Resources Database [http://www.harbrace.com/hist/world]. The World Cultures Resources Series, compiled by Lynn H. Nelson and Steven K. Drummond, is a database of classic primary and secondary readings appropriate for courses within the integrated humanities curriculum. The Series places the creation of the text in your hands, allowing you to create learning materials that match your course and your teaching style. You choose the readings that you want to teach and build the text to present them in the order in which you choose.

Instructor's Manual and Test Bank

The Instructor's Manual, prepared by Roberta Vandermast, contains a variety of features for each chapter including suggestions for classroom discussion, assignments for students, and audiovisual resources. The Test Bank provides fill-in-theblank, matching, short-answer, essay, and multiple-choice questions for each chapter. A computerized version of the Test Bank is available on CD for both Windows and Mac users.

Study Guide

For the first time a study guide, prepared by Ira Holmes, is available for purchase with Culture and Values. It provides a section of self-review activities and a self-quiz for each chapter of the book. Additional resources at the end of the book include information on researching and writing about the humanities, suggestions for a museum visit, and a set of study cards that can be used for preparing exams.

Slide Package I: 100 Artworks

Each of the one hundred slides in this all-new package has been carefully selected to provide the highest quality and closest match available to the view of the image provided in the textbook. So that previous adopters of the textbook may enjoy even more comprehensive slide coverage, the fifth edition slide set is composed of all-new images and does not reproduce images provided in the previous edition set.

Slide Package II: Maps and Diagrams

This smaller slide set contains twenty-five slides of maps and diagrams taken directly from the textbook.

Digital Images from Saskia

Enter the digital age with a set of high quality digital images from the leading provider of fine art images, Saskia, Ltd. The entire one hundred-slide collection is delivered on CD-ROM for your department's use. Build classroom presentations, use on your Web site, or build study collections for your students.

TABLE OF CONTENTS—SPECIAL FEATURES VOLUME I

Maps

- 1 The Ancient World 5
- 2 36 Ancient Greece
- The Hellenistic World 93 3
- The Roman World 128 4
- 5 The Spread of Buddhism 179 183 Shang Control of Ancient China
- Israel at the Time of Jesus 6 208 Christian Communities 208
- 7 The Byzantine World 242 Justinian's Empire 250
- 8 269 The Islamic World
- 9 The Carolingian World 294
- The Île of France 10 347
- The Black Death 398 11

Values Boxes

- Mortality 14 1
- 2 Destiny 39
- 3 **Civic Pride** 74
- 4 Empire 135
- Revelation 206 6
- 7 Autocracy 243
- 8 277 Values
- 9 Feudalism 309
- 10 Dialectics 356
- Natural Disaster and Human Response 399 11

Contemporary Voices Boxes

- Love, Marriage, and Divorce in Ancient 1 Egypt 18
- 41 2 Daily Life in the World of Homer
- 3 Kerdo the Cobbler 94
- 4 A Dinner Party in Imperial Rome 135
- 5 War and Religion in the Age of Ashoka 178 209
- 6 Vibia Perpetua
- 237 7 Procopius of Caesarea
- 276 8 **Contemporary Voices**
- 9 An Abbot, an Irish Scholar, and Charlemagne's Biographer 297
- 10 A Medieval Parent and a Student 358
- 11 John Ball 403

VOLUME I

CHAPTER 1 THE BEGINNINGS OF CIVILIZATION 1

CHAPTER 2 EARLY GREECE 33

CHAPTER 3 Classical Greece and the Hellenistic Period 69

CHAPTER 4 The Roman Legacy 125

Chapter 5 Ancient Civilizations of India and China 173

CHAPTER 6 JERUSALEM AND EARLY CHRISTIANITY 201 CHAPTER 7 Byzantium 233

CHAPTER 8 Islam 265

CHAPTER 9

CHARLEMAGNE AND THE RISE OF MEDIEVAL CULTURE 291

CHAPTER 10 High Middle Ages: The Search for Synthesis 341

CHAPTER 11 The Fourteenth Centu

THE FOURTEENTH CENTURY: A TIME OF TRANSITION 395

GLOSSARY 441 INDEX 451 Photo credits 467 literary credits 469

CONTENTS

VOLUME I

CHAPTER 1 The Beginnings of Civilization 1

The Earliest People and Their ArtThe Cultures of Mesopotamia6Ancient Egypt10

VALUES: Mortality 14

CULTURE AND VALUES: Love, Marriage, and Divorce in Ancient Egypt 18

3

Aegean Culture in the Bronze Age18Cycladic Art20The Excavation of Knossos21Schliemann and the Discovery of Mycenae24

Summary27Pronunciation Guide28Exercises29Further Reading29Additional Web References29Reading Selections30

CHAPTER 2 EARLY GREECE

Homer and the Heroic Age 35 VALUES: Destiny 39 Art and Society in Early Greece 39 Geometric Art 39 CONTEMPORARY VOICES: Daily Life in the World of Homer 41 The Age of Colonization 41 42 The Visual Arts at Corinth and Athens The Beginnings of Greek Sculpture 43 Sculpture and Painting in the Archaic Period 43 Architecture: The Doric and Ionic Orders 46 Music and Dance in Early Greece 49 Early Greek Literature and Philosophy 51 Lyric Poetry 51 The First Philosophers: The Presocratics 52 Herodotus: The First Greek Historian 53 Summary 54 **Pronunciation Guide** 54 **Exercises** 55 **Further Reading** 55

33

55 **Online Chapter Links Reading Selections** Homer: The Iliad, Book XV 56 Homer: The Iliad, Book XXIII 60 Homer: The Iliad, Book XXIV 61 Sappho: Selected Poems 64 Heraclitus of Ephesus: Presocratics 64 Herodotus: History of the Persian Wars, Book VIII 65

CHAPTER 3

CLASSICAL GREECE AND THE Hellenistic Period 69

The Classical Ideal 71 74 VALUES: Civic Pride Drama and Philosophy in Classical Greece 74 74 The Drama Festivals of Dionysus The Athenian Tragic Dramatists 76 78 Aristophanes and Greek Comedy 79 Philosophy in the Late Classical Period Greek Music in the Classical Period 81 82 The Visual Arts in Classical Greece Sculpture and Vase Painting in the Fifth Century B.C. 82 83 Architecture in the Fifth Century B.C. 90 The Visual Arts in the Fourth Century B.C. The Hellenistic Period 92 **CONTEMPORARY VOICES:** Kerdo the Cobbler 94 97 Summary **Pronunciation Guide** 98 98 Exercises 98 **Further Reading Online Chapter Links** 99 **Reading Selections** 99 Sophocles: Oedipus the King Plato: Apology 112 Plato: Phaedo 114 Plato: The Republic, Book VII 117 118 Aristotle: The Nicomachean Ethics, Book I Aristotle: The Politics, Book V 121

CHAPTER 4 THE ROMAN LEGACY 125 The Importance of Rome 127 The Etruscans and Their Art 129

Republican Rome (509–31 B.C.) 130 Literary Developments During the Republic 133 Roman Philosophy and Law 134 **CONTEMPORARY VOICES:** A Dinner Party in Imperial Rome 135 Republican Art and Architecture 136 Imperial Rome (31 B.C.-A.D. 476) 137 Augustan Literature: Vergil 138 VALUES: Empire 139 Augustan Sculpture 140 The Evidence of Pompeii 143 Roman Imperial Architecture 147 Rome as the Object of Satire 150 The End of the Roman Empire 151 Late Roman Art and Architecture 153 Summary 154 **Pronunciation Guide** 155 Exercises 156 **Further Reading** 156 **Online Chapter Links** 156 **Reading Selections** Catullus: Selected Poems 157 Vergil: Aeneid, Book I 157 Vergil: Aeneid, Book IV 161 Vergil: Aeneid, Book VI 162 Vergil: Aeneid, Book VI 165 Horace: Selected Odes 167 Juvenal: Third Satire 168 Marcus Aurelius Antoninus: The Meditations: Book II 169

CHAPTER 5

ANCIENT CIVILIZATIONS OF INDIA AND CHINA 173

Indian Civilization175The Indus Valley Civilization175

The Aryans175Buddha177The Emperor Ashoka178

CONTEMPORARY VOICES: War and Religion in the Age of Ashoka 178

Hindu and Buddhist Art 179

The Gupta Empire and Its Aftermath180Gupta Literature and Science181The Collapse of Gupta Rule182

The Origins of Civilization in China183The Chou Dynasty183Confucianism and Taoism184

The Unification of China: The Ch'in, Han, andT'ang Dynasties185The Arts in Classical China186

Summary 188 **Pronunciation Guide** 190 **Exercises** 190 **Further Reading** 191 **Online Chapter Links** 191 **Reading Selections** The Rig Veda 192 Brihad-Aranyaka Upanishad 194 Christmas Humphries: The Wisdom of Buddha 197 Li Po: Selected Poems 198

CHAPTER 6

JERUSALEM AND EARLY Christianity 201

Judaism and Early Christianity 203 The Hebrew Bible and Its Message 204 **VALUES:** Revelation 206 The Beginnings of Christianity 207 **CONTEMPORARY VOICES:** Vibia Perpetua 209 Constantine and Early Christian Architecture 212 Early Christian Music 214 Summary 215 **Pronunciation Guide** 216 Exercises 216 **Further Reading** 216 **Online Chapter Links** 216 **Reading Selections** Genesis 1-2 217 Job 37-40 218 Exodus 19-20 220 221 Amos 3-6Matthew 5-7 223 Acts 17:14-34 224 I Corinthians 13 225 II Corinthians 11–12 225 Justin's First Apology 226 The Passion of Perpetua and Felicity 228

CHAPTER 7

BYZANTIUM 233

The Decline of Rome 235 Literature and Philosophy 235 CONTEMPORARY VOICES: Procopius of Caesarea 237 The Ascendancy of Byzantium 237 Church of Hagia Sophia: Monument and Symbol 238 Ravenna 240 Art and Architecture 240 VALUES: Autocracy 243

Saint Catherine's Monastery at Mount Sinai 249

The Persistence of Byzantine Culture 252

Summary254Pronunciation Guide254Exercises254Further Reading254Online Chapter Links255Reading Selections255Saint Augustine: Confessions255Saint Augustine: The City of God257

CHAPTER 8

ISLAM 265

Muhammad and the Birth of Islam267The Qu'ran268Calligraphy269Islamic Architecture270Sufism275

CONTEMPORARY VOICES 276

The Culture of Islam and the West 276

VALUES 277

Summary 278**Pronunciation Guide** 278 Exercises 279 279 **Further Reading** 279 **Online Chapter Links Reading Selections** Selections from the Qur'an 279 Memories of Rabia 287 288 Rumi: Poems and Meditations

CHAPTER 9

CHARLEMAGNE AND THE RISE OF MEDIEVAL CULTURE 291
Charlemagne as Ruler and Diplomat 293
Learning in the Time of Charlemagne 295
Benedictine Monasticism296The Rule of Saint Benedict296
CONTEMPORARY VOICES: An Abbot, an Irish Scholar,and Charlemagne's Biographer297Women and the Monastic Life298
Monasticism and Gregorian Chant 298
Liturgical Music and the Rise of Drama300The Liturgical Trope300The Quem Quæritis Trope300
The Morality Play: Everyman301Nonliturgical Drama301
The Legend of Charlemagne: <i>Song of</i> <i>Roland</i> 302
The Visual Arts303The Illuminated Book303

305 Charlemagne's Palace at Aachen The Carolingian Monastery 308 The Romanesque Style 308 **VALUES:** Feudalism 309 Summary 312 313 **Pronunciation Guide** Exercises 313 **Further Reading** 313 **Online Chapter Links** 313 **Reading Selections** 314 Hildegard of Bingen: Causae et Curae Everyman 317 Hroswitha: The Conversion of the 325 Harlot Thaïs Bertilla, Abbess of Chelles 330 The Song of Roland 333 CHAPTER 10 HIGH MIDDLE AGES: THE 341 SEARCH FOR SYNTHESIS The Significance of Paris 343 The Gothic Style 343 Suger's Building Program for Saint Denis 343 The Mysticism of Light 347 348 The Many Meanings of the Gothic Cathedral Music: The School of Notre Dame 354 Scholasticism 355 The Rise of the Universities 355 **VALUES:** *Dialectics* 356 **CONTEMPORARY VOICES:** A Medieval Parent and a Student 358 359 Francis of Assisi 360 Thomas Aquinas 363 Dante's Divine Comedy Summary 366 **Pronunciation Guide** 366 Exercises 366 **Further Reading** 367 **Online Chapter Links** 367 **Reading Selections** Saint Francis of Assisi: The Canticle of Brother Sun 368 Saint Thomas Aquinas: Summa Theologiae 368 Dante Alighieri: Divine Comedy 370 CHAPTER 11 THE FOURTEENTH CENTURY: A TIME OF TRANSITION 395 Calamity, Decay, and Violence 397 The Black Death 397 397 The Great Schism VALUES: Natural Disaster and Human 399 Response

XVI Contents

The Hundred Years' War 399

Literature in Italy, England, and France 399 Petrarch 400 Petrarch's Sonnet 15 401 Chaucer 401 Christine de Pisan 402 CONTEMPORARY VOICES: John Ball 403 Art in Italy 403 The Italo-Byzantine Background 404 Giotto's Break with the Past 407 Painting in Siena 410

Art in Northern Europe410Late Gothic Architecture414Music: Ars Nova416Summary420Pronunciation Guide420

Exercises 420 Further Reading 421 Online Chapter Links 421 Reading Selections Giovanni Boccaccio: Decameron 422 Geoffrey Chaucer: The Canterbury Tales 424 Christine de Pisan: The Book of the City of Ladies 437

GLOSSARY 441

INDEX 451

PHOTO CREDITS 467

LITERARY CREDITS 469

ONE way to see the arts as a whole is to consider a widespread mutual experience: a church or synagogue service or the worship in a Buddhist monastery. Such a gathering is a celebration of written literature done, at least in part, in music in an architectural setting decorated to reflect the religious sensibilities of the community. A church service makes use of visual arts, literature, and music. While the service acts as an integrator of the arts, considered separately, each art has its own peculiar characteristics that give it shape. The same integration may be seen, of course, in an opera or in a music video.

Music is primarily a temporal art, which is to say that there is music when there is someone to play the instruments and sing the songs. When the performance is over, the music stops.

The visual *arts* and *architecture* are spatial arts that have permanence. When a religious service is over, people may still come into the building to admire its architecture or marvel at its paintings or sculptures or look at the decorative details of the building.

Literature has a permanent quality in that it is recorded in books, although some literature is meant not to be read but to be heard. Shakespeare did not write plays for people to read, but for audiences to see and hear performed. Books nonetheless have permanence in the sense that they can be read not only in a specific context, but also at one's pleasure. Thus, to continue the religious-service example, one can read the psalms for their poetry or for devotion apart from their communal use in worship.

What we have said about the religious service applies equally to anything from a rock concert to grand opera: artworks can be seen as an integrated whole. Likewise, we can consider these arts separately. After all, people paint paintings, compose music, or write poetry to be enjoyed as discrete experiences. At other times, of course, two arts may be joined when there was no original intention to do so, as when a composer sets a poem to music or an artist finds inspiration in a literary text or, to use a more complex example, when a ballet is inspired by a literary text and is danced against the background or sets created by an artist to enhance both the dance and the text that inspired it.

However we view the arts, either separately or as integrated, one thing is clear: they are the product of human invention and human genius. When we speak of *culture*, we are not talking about something strange or "highbrow"; we are talking about something that derives from human invention. A jungle is a product of nature, but a garden is a product of culture: human ingenuity has modified the vegetative world. In this book we discuss some of the works of human culture that have endured over the centuries. We often refer to these works as *masterpieces*, but what does the term mean? The issue is complicated because tastes and attitudes change over the centuries. Two hundred years ago the medieval cathedral was not appreciated; it was called Gothic because it was considered barbarian. Today we call such a building a masterpiece. Very roughly we can say that a masterpiece of art is any work that carries with it a surplus of meaning.

Having "surplus of meaning" means that a certain work not only reflects technical and imaginative skill, but also that its very existence sums up the best of a certain age, which spills over as a source of inspiration for further ages. As one reads through the history of the Western humanistic achievement it is clear that certain products of human genius are looked to by subsequent generations as a source of inspiration; they have a surplus of meaning. Thus the Roman achievement in architecture with the dome of the Pantheon both symbolized their skill in architecture and became a reference point for every major dome built in the West since. The dome of the Pantheon finds echoes in 6th-century Constantinople (Hagia Sophia); in 15th-century Florence (the Duomo); in 16th-century Rome (St. Peter's); and in 18thcentury Washington D.C. (the Capitol building).

The notion of surplus of meaning provides us with a clue as to how to study the humanistc tradition and its achievements. Admittedly simplifying, we can say that such a study has two steps that we have tried to synthesize into a whole in this book:

The Work in Itself. At this level we are asking the question of fact and raising the issue of observation: What is the work and how is it achieved? This question includes not only the basic information about, say, what kind of visual art this is (sculpture, painting, mosaic) or what its formal elements are (Is it geometric in style? bright in color? very linear? and so on), but also questions of its function: Is this work an homage to politics? for a private patron? for a church? We look at artworks, then, to ask questions about both their form and their function.

This is an important point. We may look at a painting or sculpture in a museum with great pleasure, but that pleasure would be all the more enhanced were we to see that work in its proper setting rather than as an object on display. To ask about form and function, in short, is to ask equally about context. When reading certain literary works (such as the *lliad* or the *Song of Roland*) we should read them aloud since, in their original form, they were written to be recited, not read silently on a page. The Work in Relation to History. The human achievements of our common past tell us much about earlier cultures both in their differences and in their similarities. A study of the tragic plays that have survived from ancient Athens gives us a glimpse into Athenians' problems, preoccupations, and aspirations as filtered through the words of Sophocles or Euripides. From such a study we learn both about the culture of Athens and something about how the human spirit has faced the perennial issues of justice, loyalty, and duty. In that sense we are in dialogue with our ancestors across the ages. In the study of ancient culture we see the roots of our own.

To carry out such a project requires willingness really to look at art and closely read literature with an eye equally to the aspect of form/function and to the past and the present. Music, however, requires a special treatment because it is the most abstract of arts (How do we speak about that which is meant not to be seen but to be heard?) and the most temporal. For that reason a somewhat more extended guide to music follows.

How to Look at Art

Anyone who thumbs through a standard history of art can be overwhelmed by the complexity of what is discussed. We find everything from paintings on the walls of caves and huge sculptures carved into the faces of mountains to tiny pieces of jewelry or miniature paintings. All of these are art because they were made by the human hand in an attempt to express human ideas and/or emotions. Our response to such objects depends a good deal on our own education and cultural biases. We may find some modern art ugly or stupid or bewildering. We may think of all art as highbrow or elitist despite the fact that we like certain movies (film is an art) enough to see them over and over. At first glance, art from the East may seem odd simply because we do not have the reference points with which we can judge the art good or bad.

Our lives are so bound up with art that we often fail to recognize how much we are shaped by it. We are bombarded with examples of graphic art (television commercials, magazine ads, CD jackets, displays in stores) every day; we use art to make statements about who we are and what we value in the way we decorate our rooms and in the style of our clothing. In all of these ways we manipulate artistic symbols to make statements about what we believe in, what we stand for, and how we want others to see us. The many sites on the Web bombard us with visual clues which attempt to make us stop and find out what is being offered or argued.

The history of art is nothing more than the record of how people have used their minds and imaginations to symbolize who they are and what they value. If a certain age spends enormous amounts of money to build and decorate churches (as in 12th-century France) and another spends the same kind of money on palaces (like 18th-century France), we learn about what each age values the most.

The very complexity of human art makes it difficult to interpret. That difficulty increases when we are looking at art from a much different culture and/or a far different age. We may admire the massiveness of Egyptian architecture, but find it hard to appreciate why such energies were used for the cult of the dead. When confronted with the art of another age (or even our own art, for that matter), a number of questions we can ask of ourselves and of the art may lead us to greater understanding.

For What Was This Piece of Art Made? This is essentially a question of *context*. Most of the religious paintings in our museums were originally meant to be seen in churches in very specific settings. To imagine them in their original setting helps us to understand that they had a devotional purpose that is lost when they are seen on a museum wall. To ask about the original setting, then, helps us to ask further whether the painting is in fact devotional or meant as a teaching tool or to serve some other purpose.

Setting is crucial. A frescoed wall on a public building is meant to be seen by many people, while a fresco on the wall of an aristocratic home is meant for a much smaller, more elite class of viewer. The calligraphy decorating an Islamic mosque tells us much about the importance of the sacred writings of Islam. A sculpture designed for a wall niche is going to have a shape different from one designed to be seen by walking around it. Similarly, art made under official sponsorship of an authoritarian government must be read in a far different manner than art produced by underground artists who have no standing with the government. Finally, art may be purely decorative or it may have a didactic purpose, but (and here is a paradox) purely decorative art may teach us while didactic art may end up being purely decorative.

What, If Anything, Does This Piece of Art Hope to Communicate? This question is one of *intellectual* or *emotional* context. Funeral sculpture may reflect the grief of the survivors, or a desire to commemorate the achievements of the deceased, or to affirm what the survivors believe about life after death, or a combination of these purposes. If we think of art as a variety of speech we can then inquire of any artwork: What is it saying?

An artist may strive for an ideal ("I want to paint the most beautiful woman in the world," or "I wish my painting to be taken for reality itself," or "I wish to move people to love or hate or sorrow by my sculpture") or to illustrate the power of an idea or (as in the case with most primitive art) to "capture" the power of the spirit world for religious and/or magical purposes.

An artist may well produce a work simply to demonstrate inventiveness or to expand the boundaries of what art means. The story is told of Pablo Picasso's reply to a woman who said that her ten-year-old child could paint better than he. Picasso replied, "Congratulations, Madame. Your child is a genius." We know that before he was a teenager Picasso could draw and paint with photographic accuracy. He said that during his long life he tried to learn how to paint with the fresh eye and spontaneous simplicity of a child.

How Was This Piece of Art Made? This question inquires into both the materials and the skills the artist employs to turn materials into art. Throughout this book we will speak of different artistic techniques, like bronze casting or etching or panel painting; here we make a more general point. To learn to appreciate the craft of the artist is a first step toward enjoying art for its worth as art-to developing an "eye" for art. This requires looking at the object as a crafted object. Thus, for example, a close examination of Michelangelo's Pietà shows the pure smooth beauty of marble, while his Slaves demonstrates the roughness of stone and the sculptor's effort to carve meaning from hard material. We might stand back to admire a painting as a whole, but then to look closely at one portion of it teaches us the subtle manipulation of color and line that creates the overall effect.

What Is the Composition of This Artwork? This question addresses how the artist "composes" the work. Much Renaissance painting uses a pyramidal construction so that the most important figure is at the apex of the pyramid and lesser figures form the base. Some paintings presume something happening outside the picture itself (such as an unseen source of light); a cubist painting tries to render simultaneous views of an object. At other times, an artist may enhance the composition by the manipulation of color with a movement from light to dark or a stark contrast between dark and light, as in the chiaroscuro of Baroque painting. In all of these cases the artists intend to do something more than merely "depict" a scene; they appeal to our imaginative and intellectual powers as we enter into the picture or engage the sculpture or look at their film.

Composition, obviously, is not restricted to painting. Filmmakers compose with close-ups or tracking shots just as sculptors carve for frontal or side views of an object. Since all of these techniques are designed to make us see in a particular manner, only by thinking about composition do we begin to reflect on what the artist has done. If we do not think about composition, we tend to take an artwork at "face value" and, as a consequence, are not training our "eye." Much contemporary imaging is done by the power of mixing done on the computer.

What Elements Should We Notice about a Work of *Art*? The answer to this question is a summary of what we have stated above. Without pretending to exclusivity, we should judge art on the basis of the following three aspects:

Formal elements. What kind of artwork is it? What materials are employed? What is its composition in terms of

structure? In terms of pure form, how does this particular work look when compared to a similar work of the same or another artist?

Symbolic elements. What is this artwork attempting to "say"? Is its purpose didactic, propagandistic, to give pleasure, or what? How well do the formal elements contribute to the symbolic statement being attempted in the work of art?

Social elements. What is the context of this work of art? Who is paying for it and why? Whose purposes does it serve? At this level, many different philosophies come into play. A Marxist critic might judge a work in terms of its sense of class or economic aspects, while a feminist might inquire whether it affirms women or acts as an agent of subjugation and/or exploitation.

It is possible to restrict oneself to formal criticism of an artwork (Is this well done in terms of craft and composition?), but such an approach does not do full justice to what the artist is trying to do. Conversely, to judge every work purely in terms of social theory excludes the notion of an artistic work and, as a consequence, reduces art to politics or philosophy. For a fuller appreciation of art, then, all of the elements mentioned above need to come into play.

How to Listen to Music

The sections of this book devoted to music are designed for readers who have no special training in musical theory and practice. Response to significant works of music, after all, should require no more specialized knowledge than the ability to respond to *Oedipus Rex*, say, or a Byzantine mosaic. Indeed, many millions of people buy recorded music in one form or another, or enjoy listening to it on the radio without the slightest knowledge of how the music is constructed or performed.

The gap between the simple pleasure of the listener and the complex skills of composer and performer often prevents the development of a more serious grasp of music history and its relation to the other arts. The aim of this section is to help bridge that gap without trying to provide too much technical information. After a brief survey of music's role in Western culture, we shall look at the "language" used to discuss musical works—both specific terminology, such as *sharp* and *flat*, and more general concepts, such as line and color.

Music in Western Culture

The origins of music are unknown, and neither the excavations of ancient instruments and depictions of performers nor the evidence from modern primitive societies gives any impression of its early stages. Presumably, like the early cave paintings, music served some kind of magical or ritual purpose. This is borne out by the fact that music still forms a vital part of most religious ceremonies today, from the hymns sung in Christian churches or the solo singing of the cantor in an Orthodox Jewish synagogue to the elaborate musical rituals performed in Buddhist or Shinto temples in Japan. The Old Testament makes many references to the power of music, most notably in the famous story of the battle of Jericho, and it is clear that by historical times music played an important role in Jewish life, both sacred and secular.

By the time of the Greeks, the first major Western culture to develop, music had become as much a science as an art. It retained its importance for religious rituals; in fact, according to Greek mythology the gods themselves invented it. At the same time the theoretical relationships between the various musical pitches attracted the attention of philosophers such as Pythagoras (c. 550 B.C.), who described the underlying unity of the universe as the "harmony of the spheres." Later 4th-century-B.C. thinkers like Plato and Aristotle emphasized music's power to affect human feeling and behavior. Thus for the Greeks, music represented a religious, intellectual, and moral force. Once again, music is still used in our own world to affect people's feelings, whether it be the stirring sound of a march, a solemn funeral dirge, or the eroticism of much modern "pop" music (of which Plato would thoroughly have disapproved).

Virtually all of the music—and art, for that matter to have survived from the Middle Ages is religious. Popular secular music certainly existed, but since no real system of notation was invented before the 11th century, it has disappeared without a trace. The ceremonies of both the Western and the Eastern (Byzantine) church centered around the chanting of a single musical line, a kind of music that is called monophonic (from the Greek "single voice"). Around the time musical notation was devised, composers began to become interested in the possibilities of notes sounding simultaneously-what we would think of as harmony. Music involving several separate lines sounding together (as in a modern string quartet or a jazz group) became popular only in the 14th century. This gradual introduction of *polyphony* ("many voices") is perhaps the single most important development in the history of music, since composers began to think not only horizontally (that is, melodically), but also vertically, or harmonically. In the process the possibilities of musical expression were immeasurably enriched.

The Experience of Listening

"What music expresses is eternal, infinite, and ideal. It does *not* express the passion, love, or longing of this or that individual in this or that situation, but passion, love, or longing in itself; and this it presents in that unlimited variety of motivations which is the exclusive and particular characteristic of music, foreign and inexpressible in any other language" (Richard Wagner). With these words, one of the greatest of all composers described the power of music to express universal emotions. Yet for those unaccustomed to serious listening, it is precisely this breadth of experience with which it is difficult to identify. We can understand a joyful or tragic situation. Joy and tragedy themselves, though, are more difficult to comprehend.

There are a number of ways by which the experience of listening can become more rewarding and more enjoyable. Not all of them will work for everyone, but over the course of time they have proved helpful for many newcomers to the satisfactions of music.

1. *Before listening* to the piece you have selected, ask yourself some questions:

What is the historical context of the music? For whom was it composed—for a general or for an elite audience?

Did the composer have a specific assignment? If the work was intended for performance in church, for example, it should sound very different from a set of dances. Sometimes the location of the performance affected the sound of the music: composers of masses to be sung in Gothic cathedrals used the buildings' acoustical properties to emphasize the resonant qualities of their works.

With what forces was the music to be performed? Do they correspond to those intended by the composer? Performers of medieval music, in particular, often have to reconstruct much that is missing or uncertain. Even in the case of later traditions, the original sounds can sometimes be only approximated. The superstars of the 18thcentury world of opera were the castrati, male singers who had been castrated in their youth and whose soprano voices had therefore never broken; contemporaries described the sounds they produced as incomparably brilliant and flexible. The custom, which seems to us so barbaric, was abandoned in the 19th century, and even the most fanatic musicologist must settle for a substitute today. The case is an extreme one, but it points to the moral that even with the best of intentions, modern performers cannot always reproduce the original sounds.

Does the work have a text? If so, read it through before you listen to the music; it is easiest to concentrate on one thing at a time. In the case of a translation, does the version you are using capture the spirit of the original? Translators sometimes take a simple, popular lyric and make it sound archaic and obscure in order to convey the sense of "old" music. If the words do not make much sense to you, they would probably seem equally incomprehensible to the composer. Music, of all the arts, is concerned with direct communication.

Is the piece divided into sections? If so, why? Is their relationship determined by purely musical considerations—the structure of the piece—or by external factors, the words of a song, for example, or the parts of a Mass? Finally, given all the above, what do you expect the music to sound like? Your preliminary thinking should have prepared you for the kind of musical experience in store for you. If it has not, go back and reconsider some of the points above.

2. While you are listening to the music:

Concentrate as completely as you can. It is virtually impossible to gain much from music written in an unfamiliar idiom unless you give it your full attention. Read written information before you begin to listen, as you ask yourself the questions above, not *while* the music is playing. If there is a text, keep an eye on it but do not let it distract you from the music.

Concentrating is not always easy, particularly if you are mainly used to listening to music as a background, but there are some ways in which you can help your own concentration. To avoid visual distraction, fix your eyes on some detail near you—a mark on the wall, a design in someone's dress, the cover of a book. At first this will seem artificial, but after a while your attention should be taken by the music. If you feel your concentration fading, do *not* pick up a magazine or gaze around; consciously force your attention back to the music and try to analyze what you are hearing. Does it correspond to your expectations? How is the composer trying to achieve an effect? By variety of instrumental color? Are any of the ideas, or tunes, repeated?

Unlike literature or the visual arts, music occurs in the dimension of time. When you are reading, you can turn backward to check a reference or remind yourself of a character's identity. In looking at a painting, you can move from a detail to an overall view as often as you want. In music, the speed of your attention is controlled by the composer. Once you lose the thread of the discourse, you cannot regain it by going back; you must try to pick up again and follow the music as it continues— and that requires your renewed attention.

On the other hand, in these times of easy access to recordings, the same pieces can be listened to repeatedly. Even the most experienced musicians cannot grasp some works fully without several hearings. Indeed, one of the features that distinguishes "art" music from more "popular" works is its capacity to yield increasing rewards. On a first hearing, therefore, try to grasp the general mood and structure and note features to listen for the next time you hear the piece. Do not be discouraged if the idiom seems strange or remote, and be prepared to become familiar with a few works from each period you are studying.

As you become accustomed to serious listening, you will notice certain patterns used by composers to give form to their works. They vary according to the styles of the day, and throughout this book there are descriptions of each period's musical characteristics. In responding to the general feeling the music expresses, therefore, you should try to note the specific features that identify the time of its composition. 3. *After you have heard the piece,* ask yourself these questions:

Which characteristics of the music indicated the period of its composition? Were they due to the forces employed (voices and/or instruments)?

How was the piece constructed? Did the composer make use of repetition? Was there a change of mood and, if so, did the original mood return at the end?

What kind of melody was used? Was it continuous or did it divide into a series of shorter phrases?

If a text was involved, how did the music relate to the words? Were they audible? Did the composer intend them to be? If not, why not?

Were there aspects of the music that reminded you of the literature and visual arts of the same period? In what kind of buildings can you imagine it being performed? What does the music tell you about the society for which it was written?

Finally, ask yourself the most difficult question of all: What did the music express? Richard Wagner described the meaning of music as "foreign and inexpressible in any other language." There is no dictionary of musical meaning, and listeners must interpret for themselves what they hear. We all understand the general significance of words like *contentment* or *despair*, but music can distinguish between a million shades of each.

Concepts in Music

There is a natural tendency in talking about the arts to use terms from one art form in describing another. Thus most people would know what to expect from a "colorful" story or a painting in "quiet" shades of blue. This metaphorical use of language helps describe characteristics that are otherwise often very difficult to isolate, but some care is required to remain within the general bounds of comprehension.

Line. In music, *line* generally means the progression in time of a series of notes: the melody. A melody in music is a succession of tones related to one another to form a complete musical thought. Melodies vary in length and in shape and may be made up of several smaller parts. They may move quickly or slowly, smoothly or with strongly accented (stressed) notes. Some melodies are carefully balanced and proportional, others are irregular and asymmetrical. A melodic line dictates the basic character of a piece of music, just as lines do in a painting or the plot line does for a story or play.

Texture. The degree to which a piece of music has a thick or thin *texture* depends on the number of voices and/or instruments involved. Thus the monophonic music of the Middle Ages, with its single voice, has the thinnest texture possible. At the opposite extreme is a 19th-century opera, where half a dozen soloists, chorus, and a large orchestra were sometimes combined. Needless to say, thickness and thinness of texture are neither

good nor bad in themselves, merely simple terms of description.

Composers control the shifting texture of their works in several ways. The number of lines heard simultaneously can be increased or reduced — a full orchestral climax followed by a single flute, for example. The most important factor in the texture of the sound, however, is the number of combined independent melodic lines; this playing (or singing) together of two or more separate melodies is called *counterpoint*. Another factor influencing musical texture is the vertical arrangement of the notes: six notes played close together low in the scale will sound thicker than six notes more widely distributed.

Color. The color, or *timbre*, of a piece of music is determined by the instruments or voices employed. Gregorian chant is monochrome, having only one line. The modern symphony orchestra has a vast range to draw upon, from the bright sound of the oboe or the trumpet to the dark, mellow sound of the cello or French horn. Different instruments used in Japanese or Chinese music will result in a quite distinct but very different timbre. Some composers have been more interested than others in exploiting the range of color instrumental combinations can produce; not surprisingly, Romantic music provides some of the most colorful examples.

Medium. The *medium* is the method of performance. Pieces can be written for solo piano, string quartet, symphony orchestra, or any other combination the composer chooses. A prime factor will be the importance of color in the work. Another is the length and seriousness of the musical material. It is difficult, although not impossible, for a piece written for solo violin to sustain the listener's interest for half an hour. Still another is the practicality of performance. Pieces using large or unusual combinations of instruments stand less chance of being frequently programmed. In the 19th century composers often chose a medium that allowed performance in the home, thus creating a vast piano literature.

Form. Form is the outward, visible (or hearable) shape of a work as opposed to its substance (medium) or color. This structure can be created in a number of ways. Baroque composers worked according to the principle of unity in variety. In most Baroque movements the principal melodic idea continually recurs in the music, and the general texture remains consistent. The formal basis of much classical music is contrast, where two or more melodies of differing character (hard and soft, or brilliant and sentimental) are first laid out separately, then developed and combined, then separated again. The Romantics often pushed the notion of contrasts to extremes, although retaining the basic motions of classical form. Certain types of work dictate their own form. A composer writing a requiem mass is clearly less free to experiment with formal variation than one writing a piece for symphony orchestra. The words of a song strongly suggest the structure of the music, even if they do not impose it. Indeed, so pronounced was the Baroque sense of unity that the sung arias in Baroque operas inevitably conclude with a repetition of the words and music of the beginning, even if the character's mood or emotion has changed.

Thus music, like the other arts, involves the general concepts described above. A firm grasp of them is essential to an understanding of how the various arts have changed and developed over the centuries and how the changes are reflected in similarities—or differences—between art forms. The concept of the humanities implies that the arts did not grow and change in isolation from one another or from around the world. As this book shows, they are integrated both among themselves and with the general developments of Western thought and history.

How to Read Literature

"Reading literature" conjures up visions of someone sitting in an armchair with glasses on and nose buried in a thick volume—say, Tolstoy's *War and Peace*. The plain truth is that a fair amount of the literature found in this book was never meant to be read that way at all. Once that fact is recognized, reading becomes an exercise in which different methods can serve as a great aid for both pleasure and understanding. That becomes clear when we consider various literary forms and ask ourselves how their authors originally meant them to be encountered. Let us consider some of the forms that will be studied in this volume to make the point more specifically:

Dramatic Literature. This is the most obvious genre of literature that calls for something more than reading the text quietly. Plays—ancient, medieval, Elizabethean, or modern—are meant to be acted, with living voices interpreting what the playwright wrote in the script. What seems to be strange and stilted language as we first encounter Shakespeare becomes powerful and beautiful when we hear his words spoken by someone who knows and loves language.

A further point: Until relatively recent times most dramas were played on stages nearly bare of scenery and, obviously, extremely limited in terms of lighting, theatrical devices, and the like. As a consequence, earlier texts contain a great deal of description that in the modern theater (and, even more, in a film) can be supplied by current technology. Where Shakespeare has a character say "But look, the morn in russet mangle clad/Walks o'er the dew of yon high eastward hill," a modern writer might simply instruct the lighting manager to make the sun come up.

Dramatic literature must be approached with a sense of its oral aspect as well as an awareness that the language reflects the intention of the author to have the words acted out. Dramatic language is meant to be *heard* and *seen*.

Epic. Like drama, epics have a strong oral background. It is commonplace to note that before Homer's *lliad* took its present form, it was memorized and recited by a professional class of bards. Similarly, the *Song of Roland* was probably heard by many people and read by relatively few in the formative decades of its composition. Even epics that are more consciously literary echo the oral background of the epic; Vergil begins his elegant *Aeneid* with the words "Arms and the man I sing" not "Of Arms and the man I write." The Islamic scriptures the Koran—is most effectively recited.

The practical conclusion to be drawn from this is that these long poetic tales take on a greater power when they are read aloud with sensitivity to their cadence.

Poetry. Under this general heading we have a very complicated subject. To approach poetry with intelligence, we need to inquire about the kind of poetry with which we are dealing. The lyrics of songs are poems, but they are better heard sung than read in a book. On the other hand, certain kinds of poems are so arranged on a page that not to see them in print is to miss a good deal of their power or charm. Furthermore, some poems are meant for the individual reader, while others are public pieces meant for the group. There is, for example, a vast difference between a love sonnet and a biblical psalm. Both are examples of poetry, but the former expresses a private emotion while the latter most likely gets its full energy from use in worship: we can imagine a congregation singing a psalm, but not the same congregation reciting one of Petrarch's sonnets to Laura.

In poetry, then, context is all. Our appreciation of a poem is enhanced once we have discovered where the poem belongs: with music? on a page? with an aristocratic circle of intellectuals? as part of a national or ethnic or religious heritage? as propaganda or protest or to express deep emotions?

At base, however, poetry is the refined use of language. The poet is the maker of words. Our greatest appreciation of a poem comes when we say to ourselves that this could not be said better. An authentic poem cannot be edited or paraphrased or glossed. Poetic language, even in long poems, is economical. One can understand that by simple experiment: take one of Dante's portraits in the *Divine Comedy* and try to do a better job of description in fewer words. The genius of Dante (or Chaucer in the *Prologue* to *The Canterbury Tales*) is his ability to sketch out a fully formed person in a few stanzas.

Prose. God created humans, the writer Elie Wiesel once remarked, because he loves a good story. Narrative is as old as human history. The stories that stand behind the *Decameron* and *The Canterbury Tales* have been shown to have existed not only for centuries, but in widely different cultural milieus. Stories are told to draw out moral examples or to instruct or warn, but, by and large, stories are told because we enjoy hearing them. We read novels in order to enter into a new world and suspend the workaday world we live in, just as we watch films for the same purpose. The difference between a story and a film is that one can linger over a story, but in a film there is no "second look."

Some prose obviously is not fictional. It can be autobiographical like Augustine's *Confessions* or it may be a philosophical essay like Jean-Paul Sartre's attempt to explain what he means by existentialism. How do we approach that kind of writing? First, with a willingness to listen to what is being said. Second, with a readiness to judge: Does this passage ring true? What objections might I make to it? and so on. Third, with an openness that says, in effect, there is something to be learned here.

A final point has to do with attitude. We live in an age in which much of what we know comes to us in very brief "sound bites" via television, and much of what we read comes to us in the disposable form of newspapers and magazines and inexpensive paperbacks. To readreally to read-requires that we discipline ourselves to cultivate a more leisurely approach to that art. There is merit in speed-reading the morning sports page; there is no merit in doing the same with a poem or a short story. It may take time to learn to slow down and read at a leisurely pace (leisure is the basis of culture, says Aristotle), but if we learn to do so we have taught ourselves a skill that will enrich us throughout our lives. A good thought exercise is to ask whether reading from a computer screen is a different exercise than reading from a book.

	DREWICTORY		MECORORINA
	Prehistory		Mesopotamia
2,000,000 B.C.		8000 B.C.	
	c. 100,000 First ritual burying of dead	NEOLITHIC PERIOD	3500–2350 Sumerian Period: Development of pictographic writing; construction of first ziggurats; cult of mother goddess
PALEOLITHIC PERIOD (OLD STONE AGE)	Control of the second secon	BRONZE AGE	 c. 3000 Lady of Warka c. 2700 Reign of Gilgamesh c. 2600-2400 Ram in a Thicket, from Royal Cemetery at Ur 2350-2150 Akkadian Period: Rule of Sargon and descendants; ended by invasion of Gutians from Iran c. 2200 Head of an Akkadian Ruler, probably Sargon; Victory Stele of Naram-Sin 2150-1900 Neo-Sumerian Period 2100-2000 Construction of ziggurat at Ur c. 2100 Gudea, governor of Lagash c. 2000 Earliest version of The Epic of Gilgamesh 1900-1600 Babylonian Period 1792-1750 The Law Code of Hammurabi
NEOLITHIC PERIOD (LATE STONE AGE) (LATE STONE AGE)	Stone weapons Domestication of animals; cultivation of food Villages formed First wars c. 5000 Beginnings of civilization; pottery invented First large-scale architecture; bronze tools	IRON AGE 000	 c. 1780 Stele of Hammurabi I600–1150 Kassite Period 1150–612 Assyrian Period 883–859 Reign of Assurnasirpal II; palace at Nimrud 668–626 Reign of Assurbanipal; palace at Nineveh 612 Fall of Nineveh
	Most dates are approximate	600	559–529 Reign of Cyrus the Great; expansion of Persian Empire

CHAPTER 1 The Beginnings of Civilization

c. 6000 Introduction of new agricultural

AEGEAN WORLD

techniques from the East

3200-2700 Predynastic Period

EGYPT

- c. 3100 Development of hieroglyphic writing
- **2700–2250** Old Kingdom: Development of mummification ritual; art reflects confidence and certainty
- **c. 2650** Imhotep constructs first pyramid for King Zoser at Saqqara
- 2650-2514 Great Pyramids and Sphinx built at Giza

c. 2470 *Seated Scribe,* from Saqqara

2250–1990 First Intermediate Period

- **1990–1790 Middle Kingdom:** art reflects new uncertainty
- c. 1900 "Song of the Harper"
- c. 1878–1841 Reign of Sesostris III; Portrait: Sesostris III

1790–1570 Second Intermediate Period

1570-1185 New Kingdom

1364–1347 Reign of Amenhotep IV (Akhenaton); religious and political reform; worship of single god Aton; capital moved from Thebes to Tel el-Amarna; naturalism in art

- c. 1370 Portrait: Nefertiti; Akhenaton, "Hymn to Aton"
- 1361–1352 Reign of Tutankhamen; return to conservatism

1298–1232 Reign of Ramses II; colossal buildings constructed at Luxor, Karnak, Abu Simbel

I185-500 Late Period: Egypt's power declines; artists revert to Old Kingdom styles

671–663 Assyrian occupation of Egypt

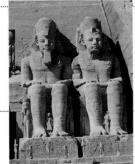

- 2800–2000 Early Minoan Period on
- Crete; growth of Cycladic culture
- c. 2500 Cycladic idol

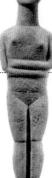

- **2000 1600** Middle Minoan Period on Crete; construction of palace complexes; development of linear writing
- c. 1700 Knossos Palace destroyed by earthquake and rebuilt on grander scale; *Wasp Pendant*, from Mallia
- 1600-1400 Late Minoan Period on Crete
- c. 1600 First Mycenaean palace constructed; Royal Grave Circle at Mycenae
- c. 1600 Snake Goddess, from Knossos
- **c. 1550** Gold death mask, from Mycenae
- 1500 Frescoes from House Delta, Thera
- **1400** Fall of Knossos and decline of Minoan civilization
- **1400–1200** Mycenaean empire flourishes
- **1250** Mycenaean war against Troy
- **I 100** Final collapse of Mycenaean power
- 1100-1000 Dark Age

1000-750 Heroic Age

c. 900-700 Evolution of Homeric epics Iliad and Odyssey

750-600 Age of Colonization

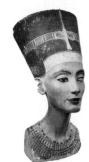

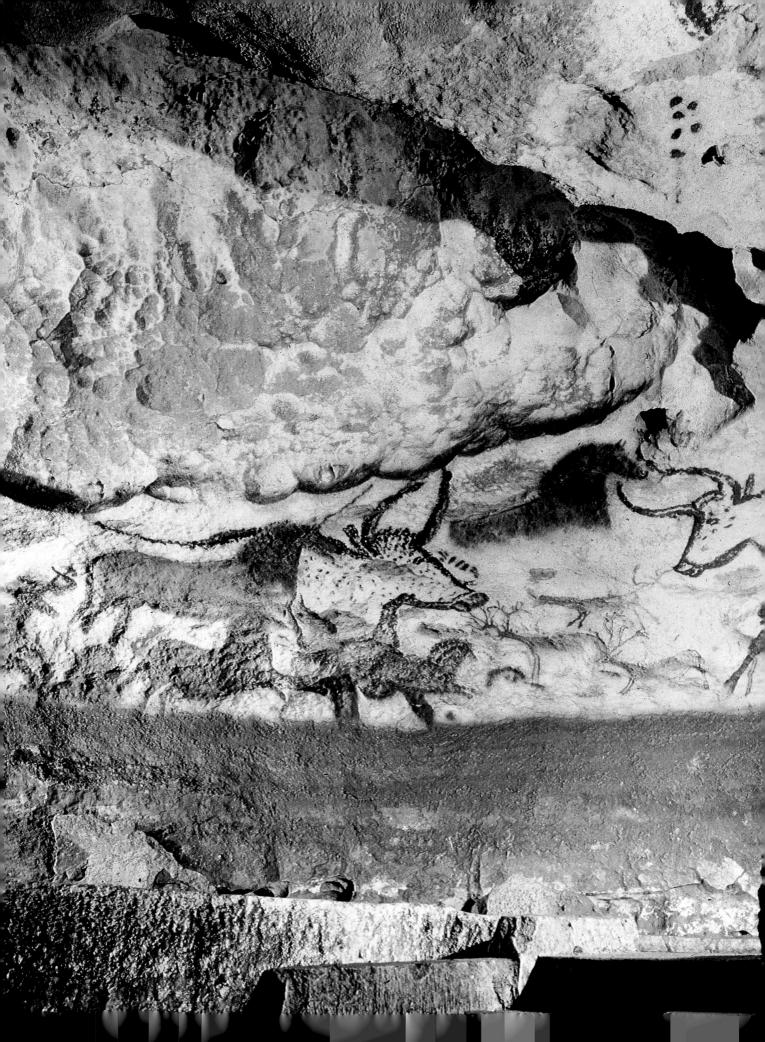

CHAPTER 1

THE BEGINNINGS OF CIVILIZATION

round 5000 B.C. humans began to lay the bases for the growth of civilization. After millennia of hunting and gathering, the development of agriculture made possible for the first time the formation of settled communities. Civilization is so broad a term that it is not easy to define simply. Nonetheless, societies which qualify for the label "civilized" generally possess at least the majority, if not all, of the following characteristics:

- some form of urban life involving the construction of permanent settlements—cities, in short;
- a system of government which regulates political relations;
- the development of distinct social classes, distinguished from one another by two related factors, wealth and occupation;
- tools and specialized skills for the production of goods, leading to the rise of manufacturing and trade;
- 5. some form of written communication, making it possible to share and preserve information; and
- 6. a shared system of religious belief, whose officials or priests often play a significant role in community affairs.

It is important to realize, at the beginning of our survey of Western civilization, that the term "civilized," when used in this anthropological sense, implies no value judgment as to the merits of a particular society. So-called "primitive" peoples are capable of producing valuable and lasting works of art, and of living full and satisfying lives, while, as the twentieth century demonstrated, some of the most "civilized" societies in history can be responsible for causing indescribable human suffering. Furthermore, at that century's end, advanced industrial civilization seemed increasingly in danger of destroying the environment, and making the world uninhabitable for any form of life, human or animal. The pages that follow chronicle the high achievements of Western civilization, but the grim background against which many of these appeared should never be forgotten. As the eighteenth-century philosopher Giambattista Vico observed, "advanced" civilizations can be barbaric in ways far more terrible than preliterate peoples.

The basic advances that made possible the growth of Western civilization were first achieved by the earlier civilizations of the ancient Middle East. These ancient peoples were the first who systematically produced food, mined and processed metals, organized themselves into cities, and devised legal and moral codes of behavior, together with systems of government and religion. In all these areas they had a profound influence on later peoples. At the same time they produced a major artistic tradition which, quite apart from its high intrinsic interest, was to have a number of effects on the development of Western art.

To discover the origins of Western civilization, we must therefore look at cultures that at first seem remote in both time and place. Yet these peoples produced the achievements described in this chapter—achievements that form the background to the history of our own culture.

THE EARLIEST PEOPLE AND THEIR ART

Even the earliest civilizations appeared relatively late in human history, at the beginning of the period known as the Neolithic or Late Stone Age (c. 8000 B.C.). The process of human evolution is long and confusing, and many aspects of it remain uncertain. The earliest form of hominid, Ramapithecus, is known from fossil fragments dating from eight to eleven million years ago, but our first direct ancestors, homo erectus, probably appeared between a million and half a million years ago in the Paleolithic period or Old Stone Age. For most of the succeeding millennia, people were dominated by the physical forces of geography and climate, able to keep themselves alive only by a persistent search for food and shelter. Those who chose the wrong places or the wrong methods did not survive, whereas others were preserved by their instincts or good fortune.

Primitive conditions hardly encouraged the growth of civilization, yet there is some evidence of a kind of intellectual development. Archaeological evidence has shown that about one hundred thousand years ago the ancestors of Homo sapiens belonging to the type known as Neanderthal people were the first to bury their dead carefully and place funerary offerings in the graves—the earliest indication of the existence of religious beliefs.

Toward the end of the Paleolithic period, around 15,000 B.C., there was a major breakthrough. The human desire for self-expression resulted in the invention of visual art. The cave paintings of Lascaux and Altamira and statuettes like the Venus of Willendorf are among the earliest products of the human creative urge. Although the art of this remote age would be valuable for its historical significance alone, many of the paintings and statues stand as masterpieces in their own right.

The lines are concentrated but immensely expressive. In some cases, artists used the surface on which they were painting to create an added sense of realism: a bulge on a cave wall suggested the hump of a bull [1.1]. The combination of naturalistic observation and abstraction can only be described as sophisticated, and since their discovery in the twentieth century the paintings have served as a powerful inspiration to modern eyes.

The choice of subjects tells us something about the worldview of Paleolithic people. The earliest cave paintings show animals and hunting, which played a vital part in providing food and clothing. More significant, perhaps, is the fact that all the oldest known statuettes of human figures represent women, who are shown with their sexual characteristics emphasized or enlarged [1.2]. The Paleolithic world perhaps viewed woman's practical role—the source of birth and life—as symbolic of a more profound feminine force that underlay the masculine world of the hunt. Worship of female creative power was also to play an important part in the religion of the ancient Middle East and of Bronze Age Greece. Even though the Greeks of a later period emphasized other aspects of human power, reverence for a mother goddess or Earth Mother—was to live on.

The Neolithic period (c. 8000 B.C.) represents in all aspects a major break with the past. After a million years of hunting, ways to domesticate animals and cultivate food were discovered. People began to gather together in villages where they could lead a settled existence. The development of improved farming techniques made it possible for a community to accumulate stores of grain and thereby become less dependent for their survival on a good harvest each year. But these stores provided a motive for raids by neighboring communities. Thus war, for the first time in human history, became profitable.

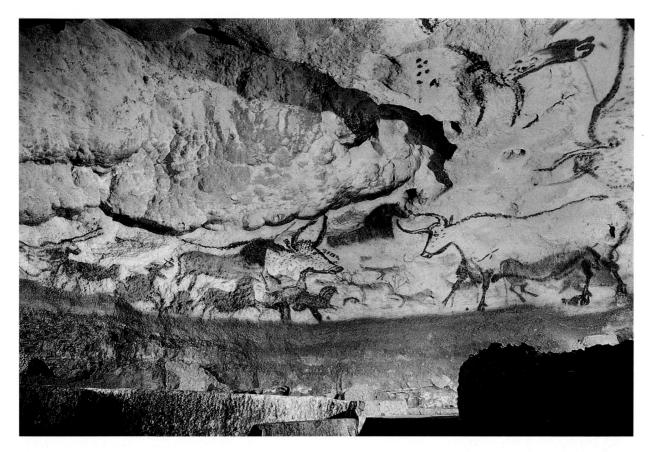

1.1 Hall of the Bulls (left wall), Lascaux (Dordogne), France, c. 15,000–13,000 B.C. Largest bull approx. 11'6" long. Paintings like these were not intended to be decorations, since they are not in the inhabited parts of the caves, but in the dark inner recesses. They probably had magical significance for their creators, who may have believed that gaining control of an animal in a painting would help to defeat it in the hunt.

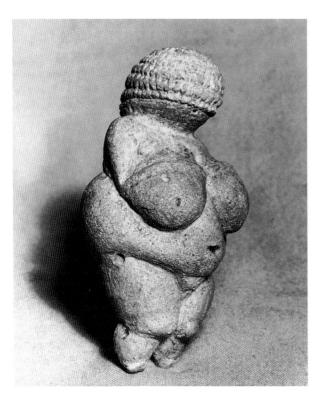

1.2 Venus of Willendorf (Austria), c. 28,000–23,000 B.C. Limestone, approx. $4^{1}/_{4}^{"}$ (11 cm) high. Naturhistorisches Museum, Vienna. This tiny statuette is one of a series of female figurines from the Upper Paleolithic period that are known as Venus figures. The statuette, which has no facial features, is evidently a fertility symbol.

Other more constructive changes followed at a rapid pace. Pottery was invented around 5000 B.C. and not long afterward metal began to replace stone as the principal material for tools and weapons. The first metal used was copper, but it was soon discovered that an alloy of copper and tin would produce a far stronger metal: bronze. The use of bronze became widespread, giving its name to the Bronze Age, which lasted from around 3000 B.C. to the introduction of iron around 1000 B.C.

At the beginning of the Bronze Age, large-scale architecture began to appear. The fortified settlements that had been established in Egypt and Mesopotamia were now able to develop those aspects of existence that entitle them to be called the first true civilizations.

Search this site. . .

Egypt and Mesopotamia have much in common. Their climates are similar and both are dominated by great rivers, Egypt by the Nile and Mesopotamia by the Tigris and Euphrates (see map). Yet each was to develop its own distinct culture and make its own contribution to the history of civilization. Mesopotamia is discussed first in the following account, but both areas developed over the same general time span.

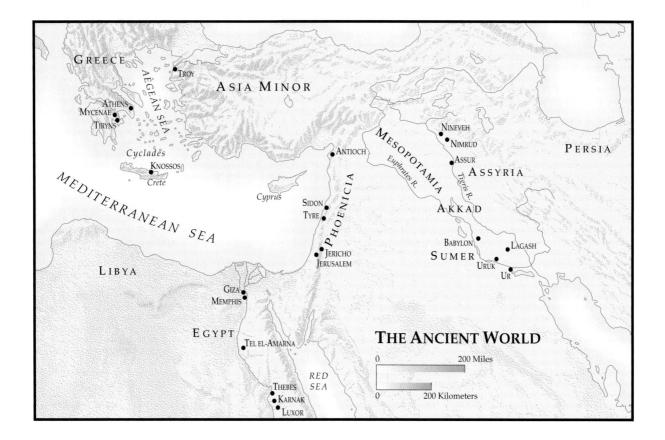

The Cultures of Mesopotamia

The unity so characteristic of ancient Egyptian culture has no parallel in the history of ancient Mesopotamia. A succession of different peoples, each with their own language, religion, and customs, produced a wide variety of achievements. This makes it far more difficult to generalize about Mesopotamian culture than about ancient Egyptian. The picture is further complicated by the presence of a series of related peoples on the periphery of the Mesopotamian territory. The Hittites, the Syrians, and the peoples of early Iran all had periods of prosperity and artistic greatness, although in general they were overshadowed by the more powerful nations of Mesopotamia and Egypt. A description of their achievements would be beyond the scope of this book.

Sumer

The history of Mesopotamia can be divided into two major periods: the Sumerian (c. 3500–2350 B.C.) and the Semitic (c. 2350–612 B.C., when Nineveh fell). The Sumerians and Semitic peoples differed in their racial origins and languages; the term "Semitic" is derived from the name of Shem, one of the sons of Noah, and is generally used to refer to people speaking a Semitic language. In the ancient world, these included the Akkadians, Babylonians, Assyrians, and Phoenicians. The most common association of *Semitic* is with the Jewish people, whose traditional language, Hebrew, falls into the same group; they also originated in the region of Mesopotamia (for a discussion of the early history of the Jews, see Chapter 6). Arabic and certain other Mediterranean languages—including Maltese—are also Semitic.

The earliest Sumerian communities were agricultural settlements on the land between the Tigris and Euphrates rivers, an area known as the Fertile Crescent. Unlike Upper Egypt, the land here is flat; dikes and canals were therefore needed to prevent flooding during the rainy season and to provide water during the rest of the year. When the early settlers found that they had to undertake these large-scale construction projects in order to improve their agriculture, they began to merge their small villages to form towns.

By far the most important event of this stage in the development of Sumerian culture was the invention of the first system of writing, known as cuneiform [1.3]. The earliest form of writing was developed at Uruk (now Warka), one of the first Mesopotamian settlements, around the middle of the fourth millennium B.C. It consisted of a series of simplified picture signs (pictographs) that represented the objects they described and, in addition, related ideas. Thus a leg could mean either a leg itself or the concept of walking. The signs were drawn on soft clay tablets which were then baked hard. These pictorial signs evolved into a series of wedge-shaped marks that were pressed in clay with a split reed. The cunei-

form system (*cuneus* is the Latin word for "wedge") had the advantage of being quick and economical, and the inscribed clay tablets were easy to store. The ability to write made it possible to trade and to keep records on a wider scale, and with the increasing economic strength this more highly organized society brought, a number of powerful cities began to develop.

The central focus of life in these larger communities was the temple, the dwelling place of the particular god who watched over the town. Religion, in fact, played a central part in all aspects of Sumerian culture. The gods themselves were manifest in natural phenomena, sky and earth, sun and moon, lightning and storm. The chief religious holidays were closely linked to the passage of the seasons. The most important annual event was the New Year, the crucial moment when the blazing heat of the previous summer and the cold of winter gave way to the possibility of a fertile spring. The fertility of the earth was symbolized by the Great Mother and the sterility of the winter by the death of her partner, Tammuz. Each year his disappearance was mourned at the beginning of the New Year festival. When his resurrection was celebrated at the end of the festival, hope for the season to come was expressed by the renewal of the sacred marriage of god and goddess.

As in the Paleolithic period, the importance of female creative power is reflected in Sumerian art. Among its finest achievements is the so-called *Lady of Warka* [1.4], a female head from the city of Uruk. It is not clear whether the head is of a divine or mortal figure. The face shows an altogether exceptional nobility and sensitivity.

The governing power in cities like Uruk was in the hands of the priests, who controlled and administered both religious and economic affairs. The ruler himself served as the representative on Earth of the god of the city but, unlike the pharaoh, was never thought of as divine and never became the center of a cult. His purpose was to watch over his people's interests by building better temples and digging more canals rather than acquiring personal wealth or power. Over the centuries, rulers began to detach themselves increasingly from the control of the priests, but the immense prestige of the temples assured the religious leaders a lasting power.

The most famous of all Sumerian rulers was Gilgamesh, who ruled at Uruk about 2700 B.C. Around his name grew up a series of legends that developed into one of the first great masterpieces of poetic expression. *The Epic of Gilgamesh* begins with the adventures of Gilgamesh and his warrior friend Enkidu. Gilgamesh himself is courted by the queen of heaven, the goddess Ishtar. He rejects her advances and later kills a bull sent against him as a punishment. In revenge, the gods kill Enkidu; his death marks the turning point of the poem's mood. With the awareness of death's reality even for the bravest, Gilgamesh now sets out to seek the meaning of life. Toward the end of his journey he meets Utnapishtim,

1.3 Top: Picture writing: Copy of a limestone tablet from Kish. c. 3200 B.C. Ashmolean Museum, Oxford; original in Baghdad Museum. Center: Hieroglyphics: detail of a pillar of a festival building of Sesostris I, Karnak. c. 1940 B.C. Egyptian Museum, Cairo. Bottom: Cuneiform: detail of the Stele of Hammurabi (see Figure 1.9), c. 1760 B.C. The limestone tablet is the oldest known example of picture writing. Among the signs are several representing parts of the human body, including a head, hand, and foot. This writing system later developed into cuneiform. The Egyptians, however, continued to use hieroglyphics throughout their history.

the only person to whom the gods have given everlasting life; from him Gilgamesh seeks the secrets of immortality. Utnapishtim, in the course of their conversation, tells him the story of the flood as it was known in Babylonia. By the end of the epic, Gilgamesh fails to achieve immortality and returns home to die.

Originally composed in Sumerian (c. 2000 B.C.), the epic was eventually written down on clay tablets in their own languages by Babylonians, Hittites, and others. The poem was widely known. The story of the flood, re-

corded in tablet eleven, bears a striking resemblance to that of the biblical story in Genesis; both accounts have parallel accounts of the building of boats, the coming of torrential rain, and the sending out of birds. The tone is very different, however. The God of the Hebrews acts out of moral disapproval, while the divinities in the epic were disturbed in their sleep by noisy mortals. The Epic of Gilgamesh is a profoundly pessimistic work. Unlike the ancient Egyptians, the Mesopotamians saw life as a continual struggle whose only alternative was the bleak

1.4 *Female head* (Inanna?), from Uruk, c. 3500-3000 B.C. Marble, height $7^{7}/_{8}$ " (20 cm). Iraq Museum, Baghdad. Originally, the hair was probably gold leaf and the eyes and eyebrows were colored inlays.

darkness of death. Dying Egyptians, if they were righteous, could expect a happy existence in the next life, but for the Mesopotamian there was only the dim prospect of eternal gloom. The story of Gilgamesh rises to a supreme level in the section that describes the last stages of his journey. Then the epic touches on universal questions: Is all human achievement futile in the face of death? Is there a purpose to human existence? If so, how can it be discovered? The quest of Gilgamesh is the basic human search. Only at the end of Gilgamesh's journey do we sense that the purpose of the journey may have been the journey itself and that what was important was to have asked the questions. Weary as he was on his return he was wiser than when he left, and in leaving us an account of his experiences, "engraved on a stone," he communicates them to us, a dramatic and moving illustration of the power of the written word.

Akkadian and Babylonian Culture

In the years from 2350 to 2150 B.C. the whole of Mesopotamia fell under the control of the Semitic king Sargon and his descendants. The art of this Akkadian period (named for Sargon's capital city, Akkad) shows a contin-

1.5 Head of an Akkadian ruler (King Sargon?), from Nineveh, c. 2200 B.C. Bronze, height $14^{1}/_{4}^{''}$ (37 cm). Iraq Museum, Baghdad. Originally, the eyes were probably precious stones.

uation of the trends of the Sumerian Age, although total submission to the gods is replaced by a more positive attitude to human achievement. A bronze head from Nineveh [1.5], perhaps a portrait of Sargon himself, expresses a pride and self-confidence that recur in other works of the period like the famous Stele of Naram-Sin (stele: stone slab), showing a later Akkadian king standing on the bodies of his enemies [1.6].

When Akkadian rule was brought to an abrupt and violent end by the invasion of the Gutians from Iran, the cities of Mesopotamia reverted to earlier ways. As in the early Sumerian period, the chief buildings constructed were large brick platforms with superimposed terraces, known as *ziggurats*. These clearly had religious significance; the one built at Ur around 2100 B.C. [1.7] had huge staircases that led to a shrine at the top. The same return

1.6 *Victory Stele of Naram-Sin,* from Susa, Iran, Akkadian c. 2200 B.C. Pink sandstone, approx. 6'7" high. Musée du Louvre, Paris. The king, wearing a horned crown, stands beneath symbols of the gods. The diagonal composition is well suited to the triangular shape of the stele.

to traditional beliefs is illustrated by the religious inscriptions on the bases of the many surviving statues of Gudea, the governor of the city of Lagash around 2100 B.C., as well as by his humble attitude [1.8].

Ziggurat at Ur

The Earliest People and Their Art

9

most famous king, Hammurabi, was the author of a law code that was one of the earliest attempts to achieve social justice by legislation—a major development in the growth of civilization. The laws were carved on a stele, with Hammurabi himself shown at the top in the presence of the sun god Shamash [1.9]. Many of the law code's provisions deal with the relationship between husbands, wives, and other family members, as the following shows.

from The Law Code of Hammurabi

131. If a man accuse his wife and she have not been taken in lying with another man, she shall take an oath in the name of god and she shall return to her house.

142. If a woman hate her husband and say, "Thou shalt not have me," her past shall be inquired into for any deficiency of hers; and if she have been careful and be without past sin and her husband have been going out and greatly belittling her, that woman has no blame. She shall take her dowry and go to her father's house.

145. If a man take a wife and she do not present him with children, and he set his face to take a concubine, that man may take a concubine and bring her into his house. That concubine shall not take precedence of his wife.

162. If a man take a wife and she bear him children and that woman die, her father may not lay claim to her dowry. Her dowry belongs to her children.

The Assyrians

By 1550 B.C. Babylon had been taken over by the Kassites, a formerly nomadic people who had occupied Babylonia and settled there, but they too would fall in turn under the domination of the Assyrians, who evolved the last great culture of ancient Mesopotamia. The peak of Assyrian power was between 1000 and 612 B.C., the time when Greek civilization was developing, as described in Chapter 2. But Assyrian achievements are the culmination of the culture of ancient Mesopotamia.

A huge palace constructed at Nimrud during the reign of Assurnasirpal II (883–859 B.C.) was decorated with an elaborately carved series of relief slabs. The subjects are often religious, but a number of slabs that show the king on hunting expeditions have a vigor and freedom that are unusual in Mesopotamian art. The palaces of later Assyrian kings were decorated with similar reliefs. At Nineveh, the palace of Assurbanipal (668–626 B.C.) was filled with scenes of war appropriate to an age of increasing turmoil. The representations of dead and dying soldiers on the battlefields are generally conventional, if highly elaborate. But again the hunting scenes are different—they show a genuine and moving identification with the suffering animals [1.10].

With the fall of Nineveh in 612 B.C. Assyrian domination ended. The Assyrian Empire fell into the hands of two tribes, first the Medes and then the Persians; the great age of Mesopotamia was over. The Persians, like

By around 1800 B.C., Mesopotamia had once again been unified, this time under the Babylonians. Their

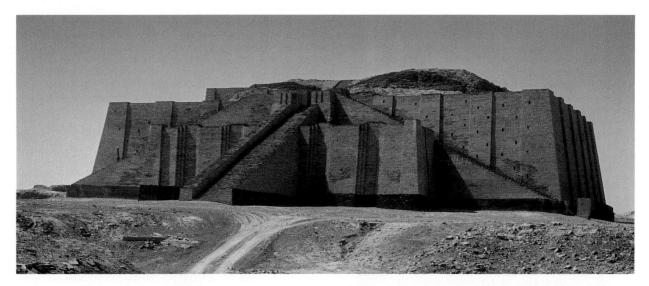

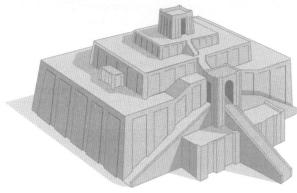

the Medes whom they subsequently conquered and absorbed, were originally a nomadic warrior people. In the century following their victory over the Assyrians, they continued to expand; by the death of the Persian ruler Cyrus the Great (c. 590–529 B.C.), their empire stretched from the Mediterranean to the Indus River. After an unsuccessful attempt to conquer Greece (see Chapter 2), the Persians were finally themselves conquered by Alexander the Great around 330 B.C.

Lacking the unifying elements provided in Egypt by the pharaoh and a national religion, the peoples of Mesopotamia perhaps never equaled Egyptian achievements in the arts. However, they formed ordered societies within independent city–states that anticipated the city– states of the Greeks. They also evolved a comparatively enlightened view of human relationships, as shown by *The Law Code of Hammurabi*.

Ancient Egypt

One major determinant in the development of ancient Egyptian culture was geography. In total area, ancient Egypt was only a little larger than the state of Maryland. At the delta of the Nile was Lower Egypt, broad and flat, within easy reach of neighboring parts of the Mediterranean. Upper Egypt, more isolated from foreign **1.7** Ziggurat at Ur, Neo-Sumerian, c. 2100–2000 B.C. Mudbrick faced with baked brick laid in bitumen. This drawing shows the probable original appearance. The photograph shows the *ziggurat* now, partially restored. The Akkadian word *ziggurat* means "pinnacle" or "mountaintop"—a place where the gods were thought to reveal themselves. These plains dwellers made artificial mountains surrounded by shrines.

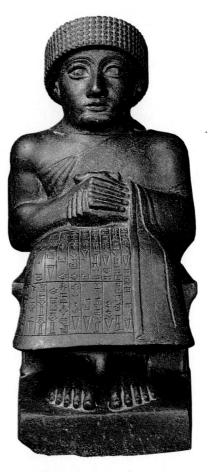

1.8 Seated Statue of Gudea, from Telloh, c. 2100 B.C. Diorite, approx. $17^{1}/_{4}^{"}$ high. The Metropolitan Museum of Art, Harris Brisbane Dick Fund, 1959.

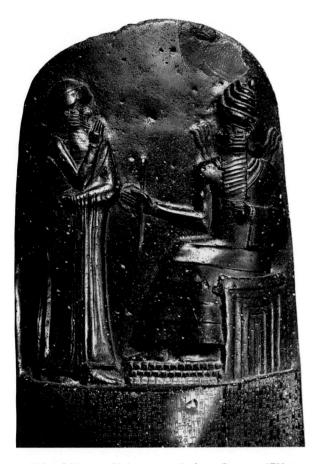

1.9 *Stele of Hammurabi* (upper part), from Susa, c. 1780 B.C. Basalt, entire stele height $7'3^{3}/_{4}''$ (2.25 m) high. Musée du Louvre, Paris. The sun god is dictating the law to the king, who is listening reverently. They are shown on a mountain, indicated by the irregular ridges beneath the god's feet. Below is *The Law Code of Hammurabi*, carved in cuneiform.

contacts, consisted of a long narrow strip of fertile soil, hemmed in by high cliffs and desert, running on either side of the Nile for most of its 1250 miles (2000 kilometers).

Since rainfall was very sparse along the Nile, agriculture depended on the yearly flooding of the river. The immensely long span of Egyptian history was divided into thirty-one dynasties by an Egyptian priest, Manetho, who wrote a *History of Egyptian Greek* around 280 B.C. Modern scholars still follow his system, putting the dynasties into four groups and calling the period that preceded them the Predynastic. The four main divisions, with their approximate dates, are: the Old Kingdom, c. 2700 B.C.; the Middle Kingdom, c. 1990 B.C.; the New Kingdom, c. 1570 B.C.; and the Late Period, c. 1185 B.C. until Egypt was absorbed into the Persian Empire around 500 B.C. The periods were separated from one another by intermediate times of disturbances and confusion.

During the final centuries of the Late Period, Egypt was invaded by the Nubians of the upper Nile, a black people whom the Egyptians called Cush. Overrunning first Upper Egypt in 750 B.C. and then Lower Egypt around 720 B.C., they and their successors, the Nobatae, helped to preserve Egyptian culture through the periods of foreign rule. The role played by these black peoples in the formation of the Western cultural tradition, in particular their influence on the Greeks, has recently become the focus of much scholarly discussion.

Despite its long history, the most striking feature of Egyptian culture is its unity and consistency. Nothing is in stronger contrast to the process of dynamic change

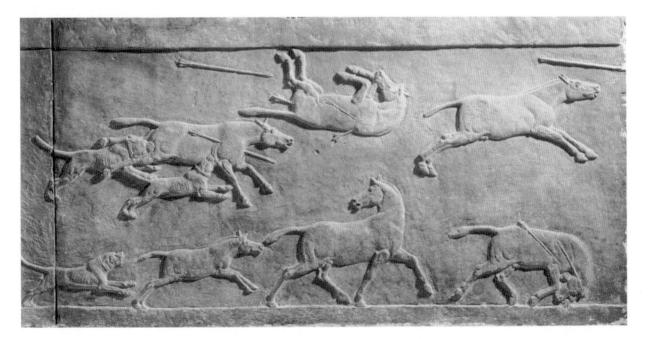

1.10 Detail, relief from the Palace of Assurbanipal at Nineveh, 668–626 B.C. Gypsum slab carved in low relief, height 19" (50 cm). British Museum, London (reproduced by courtesy of the Trustees). Wild asses are being hunted by mastiffs. The mare below turns in her flight to look back for her foal.

initiated by the Greeks and still characteristic of our own culture than the relative absence of change of Egyptian art, religion, language, and political structure over thousands of years. Naturally, even the Egyptians were subject to outside influences, and events at home and abroad affected their worldview. It is possible to trace a mood of increasing pessimism from the vital, life-affirming spirit of the Old Kingdom to the New Kingdom vision of death as an escape from the grim realities of life. Nevertheless, the Egyptians maintained a strong resistance to change. Their art, in particular, remained conservative and rooted in the past.

In a land where regional independence already existed in the natural separation of Upper from Lower Egypt, national unity was maintained by a strong central government firmly controlled by a single ruler, the pharaoh. He was regarded as a living god, the equal of any other deity. He had absolute power, although the execution of his orders depended on a large official bureaucracy whose influence tended to increase in time.

Beneath the pharaoh were the priests, who saw as their responsibility the preservation of traditional religious beliefs. One of the most fundamental of these was the concept of divine kingship involving the pharaoh himself, a belief that reflected the Egyptian view of creation. The first great god of Egyptian religion, the sun god Aton-Ra, had created the world by imposing order on the primeval chaos of the universe; in the same way, the pharaoh ordered and controlled the visible world.

The most striking aspect of Egyptian religious thought, however, is its obsession with immortality and the possibilities of life after death. All Egyptians, not only the ruling class, were offered the hope of survival in the next world as a reward for a good life in a form that was thought of in literal, physical terms. Elaborate funeral rituals at which the dead would be judged and passed as worthy to move on to the afterlife began to develop. The funeral rites, together with their meaning, were described in a series of sacred texts known collectively as the Book of the Dead. The god who presided over these ceremonies was Osiris [1.11]. The worship of Osiris, his wife Isis, and their son, the falcon god Horus, which came in time to symbolize a sense of spiritual afterlife, as opposed to simple material survival, represented the mystical side of Egyptian religion. Osiris himself, according to the myth, had been killed and then reborn; he owed his resurrection to the intervention of Isis, the dominant mother goddess of Egyptian religion, protectress of the living and dead. The worship of Isis became one of the most important and durable of Egyptian cults-a temple to her was found among the ruins of Roman Pompeii-while the return to life of Osiris provided a divine parallel to the annual rebirth of the land caused by the flooding Nile.

At the same time the Egyptians worshiped a host of other deities, subdeities, and nature spirits whose names

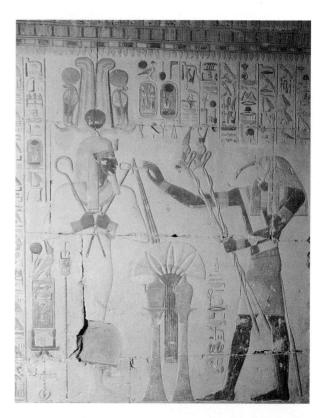

1.11 Painted relief from the funerary temple of Sethos I at Abydos. c. 1300 B.C. Sethos in the guise of the god Osiris, standing at left, is conversing with Thoth, the ibis-headed god of writing.

were often confused and sometimes interchangeable. These gods, responsible for all aspects of existence, inspired mythology and ritual that affected the daily life of every Egyptian. They included Hathor, the goddess of beauty and love, often represented as a cow; Bes, the god of war; and Hapi, the god of the Nile. A number of animals, like the jackal and the cat, also had special sacred significance (Table 1.1).

Traditional Egyptian religion involved, then, a bewildering confusion of figures whose rights and privileges were jealously guarded by their priests. One of the ways to worship them was to give them visible form in works of art—a principal function of Egyptian artists. In addition to producing images of deities, artists were required to provide temples and shrines where they could be honored. Even the buildings that commemorated the names and deeds of real people served religious purposes.

Thus the same central authority that controlled religion affected the development of the arts. The pharaoh's court laid down the standards applied throughout Egypt. Individual artists had little opportunity to exercise their own ingenuity by deviating from them.

The Old and Middle Kingdoms

The huge scale of many Egyptian works of art is at least in part the result of the easy availability of stone, the

:C.	C 62 00 00 00 00 00 06 45	
-----	---------------------------	--

The Great Pyramids at Giza

The construction of the pyramids was an elaborate and complex affair. Stone quarried on the spot formed the core of each structure, but the fine limestone blocks originally used for facing, now eroded away, came from across the Nile. These were quarried in the dry season; then when the floods came they were ferried across the river, cut into shape, and dragged into place. At the center of each pyramid was a chamber in which was placed the mummified body of the pharaoh, surrounded by the treasures that were to follow him into the next life. The pharaohs planned these massive constructions as their resting places for eternity and as monuments that would perpetuate their names. Their success was partial. Four and a half thousand years later, their names are remembered-their pyramids, still dominating the flat landscape, symbolize the enduring character of ancient Egypt. As shelters for their occupants and their treasures, however, the pyramids were vulnerable. The very size of the pyramids drew attention to the riches hidden within them, and robbers were quick to tunnel through and plunder them, sometimes only shortly after the burial chamber had been sealed.

Chefren, who commissioned the second of the three pyramids at Giza, was also responsible for perhaps the most famous of all Egyptian images, the colossal Sphinx [1.12], a guardian for his tomb. The aloof tranquility of the human face, perhaps a portrait of the pharaoh, set on a lion's body, made an especially strong impression fifteen hundred years later on the Classical Greeks, who saw it as a divine symbol of the mysterious and enigmatic. Greek art makes frequent use of the sphinx as a motif, and it also appears in Greek mythology, most typically in the story of how Oedipus solved its riddle and thereby saved the Greek city of Thebes from disaster.

The Sphinx at Giza

The appearance of Chefren himself is preserved for us in a number of statues that are typical of Old Kingdom art [1.13]. The sculptor's approach to anatomy and drapery is realistic, and details are shown with great precision. But the features of the pharaoh are idealized; it is a portrait not of an individual but of the concept of divine power, power symbolized by the falcon god Horus perched behind the pharaoh's head. The calmness, even indifference, of the expression is particularly striking.

The art of the Old Kingdom reflects a mood of confidence and certainty that was brought to an abrupt end around 2200 B.C. by a period of violent disturbance.

TABLE 1.1 Principal Egyptian Deities		
Aton-Ra	Sun God	Creator of Heaven and Earth
Osiris	King of the	Judge of the Dead
	Underworld	
Isis	Sister and Wife	Mourner of the Dea
	of Osiris	
Horus	Son of Isis and Osiris	God of the Mornin
		Sun
Chensu	Moon God	Human-headed wi
		crescent moon

ne Dead orning ed with crescent moon Ptah Father of the Gods Created humans Thoth Ibis (bird) God The Scribe of the Gods Personification of Set Brother of Osiris Evil Anubis Jackal God God of the Dead Hapi God of the Nile Fertility God Cow Goddess Sky Goddess Hathor Hawk God God of the Night Sun Seker

most frequently used material from the early Old Kingdom to the Late Period. In Dynasty III, the architect Imhotep used stone to construct the earliest pyramid as a tomb for his master, the pharaoh Zoser. This began the tradition of building massive funerary monuments that would serve to guarantee immortality for their occupants. At the same time, the practice of mummification developed. The body was embalmed to maintain its physical form, since Egyptian religious belief held that preservation of the body was necessary for the survival of the soul. Imhotep himself, the first architect known to history, was in later ages regarded as the epitome of wisdom and was deified.

The great age of the pyramid came in Dynasty IV with the construction of the three colossal pyramids at Giza for the pharaohs Cheops, Chefren, and Mycerinus. In size and abstract simplicity, these structures show Egyptian skill in design and engineering on a massive scale—an achievement probably made possible by slave labor, although some scholars believe that the building of the great monuments was essentially the work of farmers during the off season. In any case, the pyramids and almost all other Egyptian works of art perpetuate the memories of members of the upper classes, and bear witness to a lifestyle which would not have been possible without slaves. We still know little about the slaves or the poor Egyptians who were farm laborers. Many of the slaves were captured prisoners, who were forced to labor in the government quarries and on the estates of the temples. Over time, the descendants of slaves could enlist in the army; as professional soldiers they could take their place in Egyptian society.

VALUES

Mortality

The first humans to preserve the bodies of their dead were the Neanderthal people. They buried them in shallow graves, and left offerings with them, suggesting that they envisioned a future life, in which the dead person would use the objects placed with them. Virtually all subsequent cultures either inhumed (buried intact) the bodies of the dead, or cremated them, placing the ashes in a container.

The notion of a life beyond the grave became central to the development of religious systems, although it took a wide variety of different forms. For the Egyptians, death brought judgment, and for those who passed the test survival in the next world. The burial ritual sought to provide the dead person with the means to continue a life which was similar to that of this world. The body was preserved by the process of mummification, and food, servants (in the form of small statuettes known as shawabtis), and other necessities were placed in the tomb.

Mummification

Divisions between the regions began to strengthen the power of local governors. By the time of the Middle Kingdom, it was no longer possible for pharaoh, priests, or nobles to face the future with complete trust in divine providence. Middle Kingdom art reflects this new uncertainty in two ways: On the one hand, the Old Kingdom came to represent a kind of Golden Age; artists tried to recapture its lofty serenity in their own works. At the same time, the more troubled spirit of the new period is reflected in the massive weight and somber expressions of some of the official portraits. The furrowed brow and grim look of Sesostris III convey the impression that to be a Middle Kingdom pharaoh was hardly a very relaxing occupation [1.14].

The New Kingdom

Despite increasing contacts with foreign cultures, New Kingdom artists continued basically to work within ageold traditions. Like virtually all artists in the ancient world they depicted the idea of what they wanted to show rather than its actual appearance; an eye in a profile carving, for example, would be depicted as if seen from the front. This approach is often called "concepThe Mesopotamian view of the world of the dead was far less comforting: a place of gloom and shadows. Nonetheless, the tombs of the illustrious dead contained treasures and, in the Royal Cemetery at Ur, the bodies of scores of human attendants sacrificed to accompany their dead rulers.

For many cultures, the treatment of a corpse was a major factor in the future life of the dead person. To leave a body unburied was regarded by the Greeks as the most terrible of punishments, since the victim could not complete the journey to the next world. In Sophocles' play *Antigone*, the heroine buries the body of her brother even though Creon, the king of Thebes, has decreed that he should be left unburied as punishment for his betrayal of his city.

The range of funeral practices over the past ten thousand years or so is vast, but most at least imply a belief in some form of survival—physical or spiritual after death.

tual," as opposed to the "descriptive" style the Greeks were to develop. In Dynasty XVIII, however, there was a remarkable change. The pharaoh Amenhotep IV, who ruled from 1379 to 1362 B.C., single-handedly attempted a total reform of Egyptian religious and political life. He replaced the numberless deities of traditional religion with a single one, the sun god Aton, and changed his own name to Akhenaton, or "the servant of Aton." The most complete expression of his devotion to Aton survives in the form of a hymn to the god, which movingly expresses his sincerity: "Thou appearest beautifully on the horizon of Heaven, thou living Aton, the beginning of life! When thou art risen on the eastern horizon, thou hast filled every land with thy beauty. . . ." In order to make these revolutionary moves more effective and to escape the influence of the priests at the royal court of Thebes, he transferred the capital to a new location, known today as Tel el-Amarna.

Here a new kind of art developed. The weight and idealism of the traditional conceptual style gave way to a new lightness and naturalism. For the first time physical characteristics are depicted in detail, and scenes are relaxed and even humorous. A stone relief showing the royal couple and three of their children sitting quietly

1.12 Great Sphinx (with Pyramid of Chefren in the background at left), Gizeh, Dynasty IV, c. 2575–2525 B.C. Sandstone, approx. 65' (19.83 m) high, 240' (73.2 m) long. The lion's body symbolizes immortality. The pharaohs were often buried in lion skins.

under the rays of the sun disc is an astonishing departure from the dignified style of the preceding thousand years [1.15]. Queen Nefertiti herself is the subject of perhaps the most famous of all Egyptian portraits [1.16], a sculpture that shows none of the exaggeration to which Amarna art is sometimes prone, but a grace and elegance very different from earlier official portraits.

All these artistic changes were, of course, the result of Akhenaton's sweeping and revolutionary religious reforms. They did not last long. Akhenaton's belief in a single god who ruled the universe was threatening to the priests, who had a vested interest in preserving the old polytheistic traditions. Not surprisingly, Akhenaton's successors branded him a heretic and fanatic and cut out his name from all the monuments that survived him.

The reaction against Akhenaton's religious policy and the Amarna style was almost immediate. His successor, Tutankhamen, however, is remembered not for leading

the opposition-or indeed for any event in his short life. He owes his fame to the treasures found intact in his undisturbed tomb. These sumptuous gold objects, enriched with ivory and precious stones, still show something of the liveliness of Amarna art, but a return to conservatism is beginning; in fact by Dynasty XIX and XX, Akhenaton had been completely forgotten. In any case, it is not so much for what they reveal about the trends in art that the treasures of Tutankhamen are significant. The discovery of the tomb is important for a different reason. Our knowledge of the cultures of the ancient world is constantly being revised by the work of archaeologists; many of their finds are minor, but some are major and spectacular. In the case of excavations such as the tomb of Tutankhamen the process of uncovering the past sometimes becomes as exciting and significant as what is discovered. The long search conducted by Howard Carter in the Valley of the Kings that

1.13 *Chefren* (right side and front), from Gizeh, Dynasty IV, c. 2575–2525 B.C. Dark green diorite, approx. 5'6" high. Egyptian Museum, Cairo.

Tutankhamen

Valley of the Kings

culminated in the opening of the inner chamber of the sealed tomb of Tutankhamen on February 17, 1923, and the discovery of the intact sarcophagus of the king has become part of history [1.17, 1.18].

The excavations of Knossos and Mycenae, discussed later in this chapter, and the discovery of Pompeii (Chapter 4) are also major turning points in the growth of our knowledge of the past. But sensational finds like these are exceptions. Understanding the cultural achievements of past civilizations involves a slow and painstaking series of minor discoveries, each of which adds to the knowledge that thus must be constantly revised and reinterpreted.

By the close of the New Kingdom the taste for monumental building had returned. The temples constructed during the reign of Ramses II (1298–1232 B.C.) at Luxor,

1.14 Sesostris III, c. 1878–1841 B.C. Black granite, height $4'10'/_2''$ (1.5 m). Egyptian Museum, Cairo.

Karnak, and Abu Simbel are probably the most colossal of all Egyptian constructions [1.19]. Within a century, however, internal dissensions and foreign events had produced a sharp decline in Egypt's power. Throughout the Late Period, artists reverted again to the styles of earlier periods. Tombs were once again constructed in the shape of pyramids, as they had been in the Old Kingdom, and sculptors tried to recapture the realism and sense of volume of Old and Middle Kingdom art. Even direct contacts with the Assyrians, Persians, and Greeks—during the period between the Assyrian occupation of 671–633 B.C. and Alexander's conquest of

1.15 Akhenaton, Nefertiti, and Three of Their Children, Amarna, c. 1370–1350 B.C. Limestone relief, height 17" (43 cm). Egyptian Museum, State Museums, Berlin. The naturalism of this relief, verging on sentimentality, is typical of late-Amarna art.

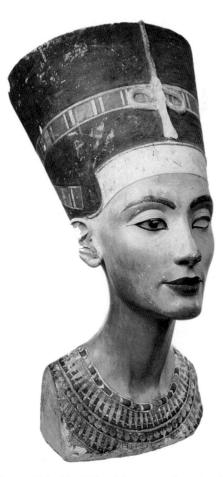

1.16 *Queen Nefertiti*, Tell el-Amarna, Dynasty XVIII, c. 1355–1335 B.C. Painted limestone, approx. 20" high. Ägyptisches Museum, Berlin. Though the portrait is not exaggerated, it is idealized.

CONTEMPORARY VOICES

Love, Marriage, and Divorce in Ancient Egypt

A Young Man's Love Song:

Seven days from yesterday I have not seen my beloved, And sickness has crept over me, And I am become heavy in my limbs And am unmindful of mine own body. If the master-physicians come to me, My heart has no comfort of their remedies, And the magicians, no resource is in them, My malady is not diagnosed. Better for me is my beloved than any remedies, More important is she for me than the entire compendium of medicine. My salutation is when she enters from without. When I see her, then am I well; Opens she her eye, my limbs are young again; Speaks she, and I am strong; And when I embrace her, she banishes evil, And it passes from me for seven days.

Quoted in Leonard Cottrell, Life Under the Pharaohs (New York: Holt, Rinehart and Winston, 1960), p. 84.

A Young Girl's Song to Her Beloved:

Oh, flower of henna!

My heart stands still in thy presence. I have made mine eyes brilliant for thee with kohl. When I behold thee, I fly to thee, oh my Beloved! Oh, Lord of my heart, sweet is this hour. An hour

passed with thee is worth an hour of eternity! Oh, flower of marjoram!

Fain would I be to thee as the garden in which I have planted flowers and sweet-smelling shrubs! the garden watered by pleasant runlets, and refreshed by the north breeze! Here let us walk, oh my Beloved, hand in hand, our hearts filled with joy! Better than food, better than drink, is it to behold thee. To behold thee, and to behold thee again! 10

Quoted in Amelia B. Edwards, Pharaohs, Fellahs, and Explorers (New York: Harper, 1891), p. 225.

A Father's Advice to His Son:

10

Double the food which thou givest thy mother, carry her as she carried thee. She had a heavy load in thee, but she did not leave it to me. After thou wert borne she was still burdened with thee; her breast was in thy mouth for three years, and though thy filth was disgusting, her heart was not disgusted. When thou takest a wife, remember how thy mother gave birth to thee, and her raising thee as well; do not let thy wife blame thee, nor cause that she raise her hands to the god.

Quoted in Barbara Mertz, Temples, Tombs and Hieroglyphics (New York: Coward-McCann, 1964), p. 333.

How a Wife Can Obtain a Divorce:

If she shall stand up in the congregation and shall say, "I divorce my husband," the price of divorce shall be on her head; she shall return to the scales and weigh for the husband five shekels, and all which I have delivered into her hand she shall give back, and she shall go away whithersoever she will.

Quoted in Leonard Cottrell, Life Under the Pharaohs (New York: Holt, Rinehart and Winston, 1960), p. 94.

Egypt in 331 B.C. — produced little effect on late Egyptian art. To the end of their history, the Egyptians remained faithful to their three-thousand-year-old tradition. Probably no other culture in human history has ever demonstrated so strong a conservatism and determination to preserve its separate traditions.

AEGEAN CULTURE IN THE BRONZE AGE

Neither the Egyptians of the Old Kingdom nor the Sumerians appear to have demonstrated any interest in

their contemporaries living to the west of them, and with good reason. In Greece and the islands of the Aegean Sea, although the arrival of immigrants from farther east in the early Neolithic period (c. 6000 B.C.) had brought new agricultural techniques, life in general continued there for the next three thousand years almost completely untouched by the rise of organized cultures elsewhere.

Yet, beginning in the early Bronze Age, there developed in the area around the Aegean Sea a level of civilization as brilliant and sophisticated as any other in Europe or western Asia. (The same period saw the appearance of a similarly urban culture in the Indus Valley

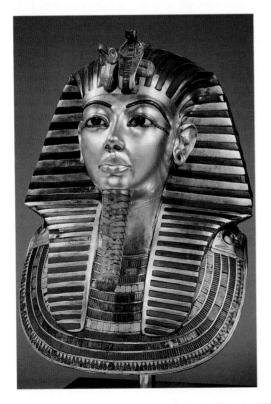

1.18 Death Mask of Tutanhkamen, Thebes, Egypt. Dynasty XVIII, ca. 1323 B.C. Gold with inlay of semiprecious stones, $1'9'_{4}''$ high. Egyptian Museum, Cairo.

1.17 The first view of the treasures of Tutankhamen. Egyptian, Dynasty XVIII. Thebes: Valley of the Kings. Antechamber: west side. This is what Howard Carter saw when he opened the doorway of the antechamber of the tomb of Tutankhamen on November 26, 1922. The objects include three gilt couches in the form of animals and, at the right in back, the pharaoh's golden throne. The tomb itself was opened three months later.

on the Indian subcontinent.) Then around 1100 B.C., after almost two thousand years of existence, this Bronze Age Aegean civilization disappeared as dramatically as it had arisen. The rediscovery in the twentieth century of these peoples—the Minoans of Crete and the Mycenaeans of mainland Greece—is perhaps the most splendid achievement in the history of archaeology in the Mediterranean—and one that has opened up vast new perspectives in the study of the later Greeks.

What connection is there between Greek culture and the magnificent civilization of the Bronze Age? Did much of later Greek religion, thought, and art have its origins in this earlier period, even though the Greeks themselves seemed to know nothing about it? Or was the culture of the Minoans and Mycenaeans an isolated phenomenon, destroyed utterly near the end of the Bronze Age, lost until it was found again in the twentieth century? The Aegean culture is important not only for the possible light it throws on later times. Its existence also shows

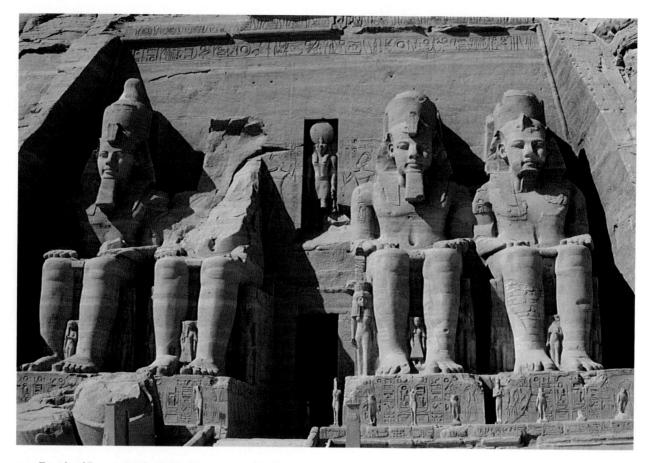

1.19 Temple of Ramses II, Abu Simbel (now relocated), Dynasty XIX, c. 1275–1225 B.C. Colossi approx. 65' high. These four huge statues, erected in commemoration of Ramses' military victories, are all of the pharaoh himself. Between and near the feet are small statues of Ramses' mother, wife, and children. Below are statues of the pharaoh as the god Osiris and the falcon god Horus, to whom the temple was dedicated.

that the ancient world could reach beyond the monumentality and earnestness of the Egyptians and Mesopotamians, that it could attain a way of life that valued grace, beauty, and comfort—a life that could truly be called civilized.

Cycladic Art

During most of the Bronze Age the major centers of Aegean culture were on Crete or the mainland, but in the early phase there were settlements on a group of islands of the central Aegean, the Cyclades. Little is known about these Cycladic people. They used bronze tools. They also produced pottery which, though less finely made than that produced elsewhere in the Aegean at the time, sometimes shows remarkable imagination and even humor [1.20]. The chief claim to fame of Cycladic art—a considerable one—lies in the marble statues, or idols, that were produced in large quantities and in many cases buried with the dead. The statues range in height from a few inches to almost life-size; the average is about a foot (30.5 centimeters) high. Most of the figures are female; the most common type shows a naked woman standing or, more probably, lying, with her arms folded and head tilted back [1.21]. The face is indicated only by a central ridge for the nose. The simplicity of the form and the fine working of the marble—stone of superb quality—often produce an effect of great beauty.

The purpose of the Cycladic idols remains uncertain. The fact that most of them have been found in graves suggests that they had a religious function in the funeral ritual. The overwhelming preponderance of female figures seems to indicate that they were in some way connected with the cult of the mother goddess, which was common in Mesopotamia and which dominated Aegean Bronze Age religion. Whether the figures actually represent goddesses remains uncertain.

We now know that the period of the production of the Cycladic idols was one of increasing development on Crete. Yet for the classical Greeks of the fifth century B.C. Crete was chiefly famous as the home of the legendary King Minos, who ruled at Knossos. Here, according to myth, was a Labyrinth that housed the Minotaur, a monstrous creature, half man and half bull, the product of the union of Minos' wife Pasiphae with a bull. Minos exacted from Athens a regular tribute of seven boys and seven girls who were sent to be devoured by the Mino-

1.20 Cycladic vase in the shape of a hedgehog drinking from a bowl. Syros, c. 2500-2200 B.C. Painted clay, height $4^{1}/_{4}^{"}$ (11 cm). National Archaeological Museum, Athens.

taur. According to the myths, after this had been going on for some time, the Athenian hero Theseus volunteered to stop the grisly tribute. He went to Knossos with the new group of intended victims and, with the help of the king's daughter Ariadne (who had fallen in love with him) killed the Minotaur in its lair in the middle of the Labyrinth. He then escaped with Ariadne and the Athenian boys and girls. Theseus later abandoned Ariadne on the island of Naxos, but the god Dionysus discovered her there and comforted her. The story had many more details, and other myths describe other events. The important point is that the later Greeks had a mythological picture of Knossos as a prosperous and thriving community ruled by a powerful and ruthless king from his palace. Knossos was not the only center mentioned in Greek stories of Crete. In the Odyssey Homer even refers to "Crete of a hundred cities."

These were, however, legends. By the time of Classical Greece no evidence whatsoever for the existence of the Palace of Minos or the other cities could be seen. It is not surprising that the Greeks themselves showed no inclination to try to find any hidden traces. Archaeology, after all, is a relatively modern pursuit, and there is little indication of any serious enthusiasm in classical antiquity for the material remains of the past. Later ages continued to accept the Greeks' own judgment. For many centuries the story of Minos and the Labyrinth was thought to be a good tale with no foundation in fact.

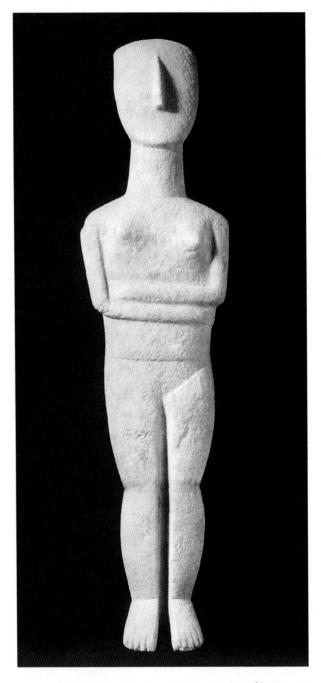

1.21 Cycladic idol, c. 2500 B.C. Marble, height $19^{1}/_{4}^{\prime\prime\prime}$ (50 cm). British Museum, London (reproduced by courtesy of the Trustees).

The Excavation of Knossos

By the end of the nineteenth century, however, things had changed. Heinrich Schliemann had proven that the stories of the war against Troy and the Mycenaeans who had waged it were far from mere legends. Was it possible that the mythical palace of King Minos at Knossos also really existed? In 1894 the English archaeologist Arthur Evans first went to Crete to see if he could discover

something of its history in the Bronze Age. At Knossos he found evidence of ancient remains, some of them already uncovered by amateur enthusiasts. He returned in 1899 and again in 1900, this time with a permit to excavate. On March 23, 1900, serious work began at Knossos, and within days it became apparent that the finds represented a civilization even older than that of the Mycenaeans. The quantity was staggering: pottery, frescoes, inscribed tablets, and, on April 13, a room with elaborate paintings and a raised seat with high back-the throne room of King Minos. Evans' discoveries at Knossos (and finds later made elsewhere on Crete by other archaeologists) did much to confirm legendary accounts of Cretan prosperity and power. Yet these discoveries did far more than merely give a true historical background to the myth of the Minotaur. Evans had in fact found an entire civilization, which he called Minoan after the legendary king. Evans himself is said to have once remarked modestly, "Any success as an archaeologist I owe to two things: very short sight, so I look at everything closely, and being slow on the uptake, so I never leap to conclusions." Actually, the magnitude of his achievement can scarcely be exaggerated. All study of the Minoans has been strongly influenced by his initial classification of the finds, especially the pottery. Evans divided the history of the Bronze Age in Crete into three main periods—Early Minoan, Middle Minoan, and Late Minoan-and further subdivided each of these into three. The precise dates of each period can be disputed, but all the excavations of the years following Evans have confirmed his initial description of the main sequence of events.

Life and Art in the Minoan Palaces

The Early Minoan period was one of increasing growth. Small towns began to appear in the south and east of Crete, and the first contacts were established with Egypt and Mesopotamia. Around 2000 B.C., however, came the first major development in Minoan civilization, marking the beginning of the Middle Minoan period. The earlier scattered towns were abandoned and large urban centers evolved. These are generally called palaces, although their function was far more than just to provide homes for ruling families.

The best known of these centers is Knossos (other important ones have been excavated at Phaistos, Mallia, and Zakro) [1.22]. The main palace building, constructed around an open rectangular courtyard, contained rooms for banquets, public receptions, religious ceremonies, and administrative work. In addition, there were living quarters for the royal family and working areas for slaves and craftsmen [1.23, 1.24]. Around the palace were the private houses of the aristocrats and chief religious leaders. The technical sophistication of these great centers was remarkable. There were elaborate drainage systems, and the palaces were designed and constructed to remain cool in summer and be heated easily in winter.

Few aspects of the Minoan achievement are more impressive than the development of an architectural style appropriate for these great structures. Unlike the carefully, almost obsessively planned Egyptian building complexes, Minoan palaces seem at first disorganized in plan. In practice, however, the division between the various functions of a palace-official, residential, religious—was achieved by a careful division of space. In the construction of the buildings themselves, rough stonework was hidden behind plaster and frescoes. Minoan columns tapered downward; their narrowest point was at their base, unlike Greek columns, which widen to their base, or Egyptian columns, most of which retain the same width from top to bottom. Minoan architects used these columns to provide impressive entrances, and to construct "light-wells" (vertical shafts running down through the buildings to carry light to the lower stories).

Middle Minoan art shows great liveliness and color. The brilliantly painted pottery, superb jewelry such as the famous Wasp Pendant from Mallia [1.25], and the many exquisitely carved seal stones all attest to the Minoans' love of beauty and artistic skill. Unlike their contemporaries in Egypt and Mesopotamia, the Minoans showed little interest in monumental art. Their greatest works are on a small, even miniature, scale. At the same time, they invented a writing system of hieroglyphic signs that was used in the archives of the palace for administrative purposes.

Hieroglyphics

Toward the end of the Middle Minoan period (c. 1700 B.C.) the palaces were destroyed, probably by an earthquake, then rebuilt on an even grander scale. There was further reconstruction about a century later, perhaps because of another earthquake. These palaces of the Late Minoan period represent the high point of Minoan culture. The wall paintings of this period are among the greatest treasures of all. Their spontaneity and freedom create a mood very different from Egyptian and Mesopotamian art, and they show a love of nature expressed with brilliant colors and vivid observation. Most of the best examples of these later paintings are from Knossos, but some particularly enchanting scenes have been found in the recent excavation of a Minoan colony on the island of Thera [1.26].

Although the rulers of the palaces seem to have been male, the central figure of Minoan religion was a mother goddess who was connected with fertility. She seems to have taken on different forms, or rather the function of female divinity was divided among several separate deities. Sometimes when she is shown flanked by animals, as the Mistress of the Beasts, she seems to be the ancestor of the Greek goddess Artemis. Other depictions show goddesses of vegetation. The most famous Minoan figurine is the so-called *Snake Goddess* [1.27].

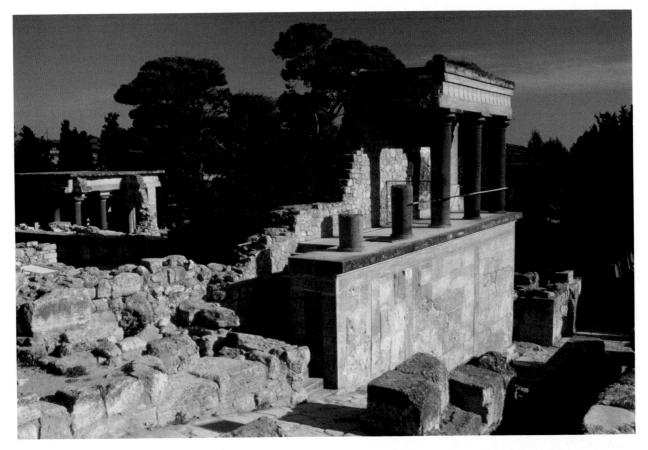

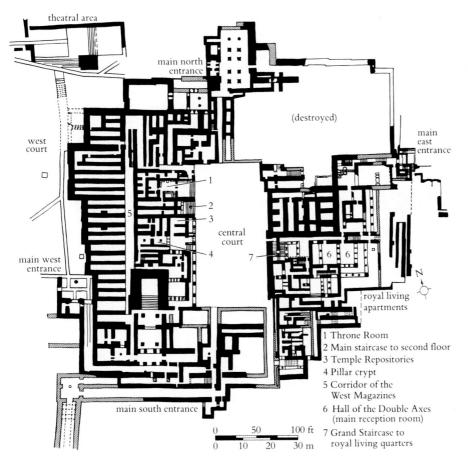

1.22 Palace of Minos at Knossos, c. 1600–1400 B.C. Exterior view.

1.23 Plan of the Palace of Minos at Knossos. c. 1600–1400 B.C. Each Cretan palace had a central court oriented north–south, state apartments to the west, and royal living apartments to the east.

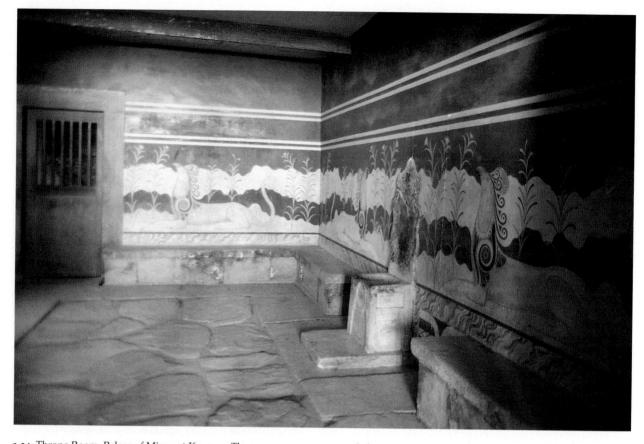

1.24 Throne Room, Palace of Minos at Knossos. The room was reconstructed about 1450 B.C., shortly before the final destruction of the palace. The frescoes around the throne show sacred flowers and griffins—mythological beasts with lion bodies and bird heads.

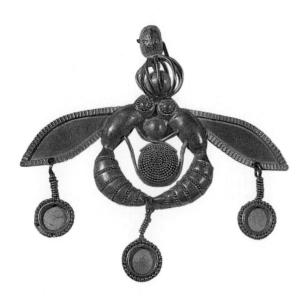

1.25 *Wasp Pendant,* from Mallia, c. 1700 B.C. Gold, width 17/8'' (5 cm). Archaeological Museum, Heraklion. This enlarged view shows the exquisite craftsmanship, using the techniques of granulation and wire-working. Two wasps (or perhaps hornets) are curved around a honeycomb.

Throughout the last great age of the palaces, the influence of Minoan artistic styles began to spread to the mainland. But Minoan political and military power was on the wane, and Knossos seems to have been invaded and occupied by mainlanders around 1450 B.C. Shortly afterward, both at Knossos and elsewhere, there is evidence of widespread destruction.

By 1400 B.C., Minoan culture had come to an abrupt end. The causes are mysterious and have been much argued; we shall probably never know exactly what happened. The eruption of a volcano on Thera a century earlier, about 1500 B.C., may have played some part in changing the balance of power in the Aegean. In any case, there is no doubt that throughout the last period of the palaces a new power was growing, the Mycenaeans. These people may well have played a part in the destruction of Knossos.

Schliemann and the Discovery of Mycenae

The Mycenaeans, the people of mainland Greece in the Bronze Age, are named after the largest of their settlements, Mycenae. Most of the Mycenaean centers were in the southern part of Greece known as the Peloponnesus,

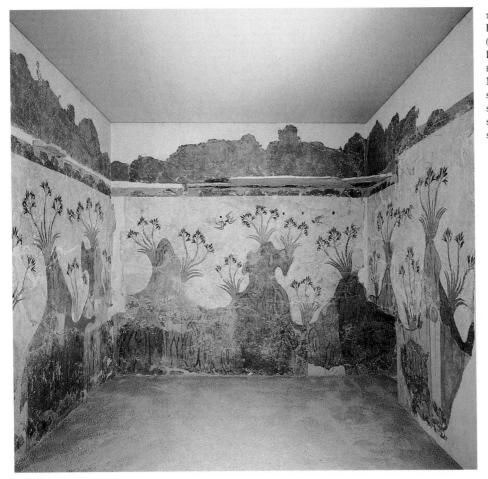

1.26 Room with frescoes: Landscape with swallows (*Spring Fresco*), from Room Delta 2, Akrotiri, Thera, c. 1650 B.C. Fresco, approx. 7'6" high. National Archaeological Museum, Athens. A springtime scene—bright flowers and soaring birds—covers three sides of a small room.

although there were also some settlements farther north, of which the two most important were Athens and Thebes. Like the Minoans, the Mycenaeans were familiar from Greek myths long before their material remains were excavated. They were famous in legend mainly for launching an expedition against Troy, across the Aegean Sea. The Trojan War (c. 1250 B.C.) and its aftermath provided the material for many later Greek works, most notably the *lliad* and the *Odyssey*, the two great epic poems of Homer, but for a long time it was believed that the war and even the very existence of Troy were myths.

Heinrich Schliemann dedicated his life and work to proving that the legends were founded on reality. Born in Germany in 1822, Schliemann was introduced to the Homeric poems as a child by his father and was overwhelmed by their incomparable vividness. He became determined to discover Homer's Troy and prove the poet right. Excavation has always been expensive, and Schliemann therefore decided to make his fortune in business, retire early, and devote his profits to the pursuit of his goal. By 1863, this remarkable man had accumulated a considerable amount of money from trading in, among other things, tea and was ready to devote himself to his second career. After a period of study and travel, in 1870 he finally began excavations on the site where he had decided the remains of Homer's Troy lay buried beneath the Roman city of Ilium. By 1873 he had found not only walls and the gate of the city but quantities of gold, silver, and bronze objects.

Inspired by the success of his Trojan campaign, Schliemann moved on to the second part of his task: to discover the Mycenaeans who had made war on Troy. In 1876 he began to excavate within the walls of Mycenae itself, and there he almost immediately came upon the Royal Grave Circle with its stupendous quantities of gold treasures [1.28]. Homer had described Mycenae as "rich in gold," and Schliemann was always convinced that the royal family whose graves he had unearthed was that of Agamemnon, leader of the Mycenaean expedition against Troy. We now know that the finds date to an even earlier period, and later excavations both at Mycenae and at other mainland sites have provided a much more exact picture of Mycenaean history. This does not diminish Schliemann's achievement. However unscientific his methods, he had proved the existence of a civilization in Bronze Age Greece that surpassed in splendor even the legends; he had opened a new era in the study of the past.

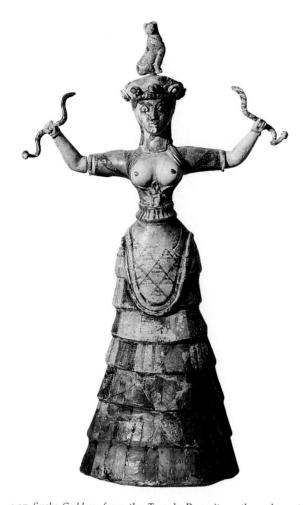

1.28 *Funerary mask,* from Grave Circle A, Shaft Grave V, Mycenae, c. 1600–1500 B.C. Beaten gold, height $10^{1/8''}$ (26 cm). National Archaeological Museum, Athens. This death mask is actually a portrait of a Mycenaean ruler of three centuries earlier than Agamemnon.

1.27 *Snake Goddess,* from the Temple Repository, the palace at Knossos, c. 1600 B.C. Faïence, approx. $13^{1/2''}$ high. Archaeological Museum, Heraklion. The bare breasts are typical for Minoan court ladies, but the apron indicates a religious function. The figure probably represents a priestess serving the goddess, not the goddess herself.

Mycenaean Art and Architecture

Like the Minoans, the Mycenaeans centered their life around great palace complexes. In Mycenae itself, the palace probably was first built around 1600 B.C., and the graves found by Schliemann date to shortly thereafter. Until the fall of Knossos in 1400 B.C., the Mycenaeans were strongly under the influence of Minoan culture, but with the end of Minoan power they became the natural leaders in the Aegean area. From 1400 to 1200 B.C., Mycenaean traders traveled throughout the Mediterranean, from Egypt and the Near East as far west as Italy. The Mycenaean empire grew in power and prosperity.

Toward the end of this period (around 1250 B.C.), the successful expedition was launched against Troy, perhaps for reasons of trade rivalry. A short time later (around 1200 B.C.), the Mycenaean empire itself fell, its major centers destroyed and most of them abandoned. Invasion by enemies, internal strife, and natural causes have all been suggested, but the fall of the Mycenaeans still remains mysterious. Their collapse is made even more incomprehensible by the massive fortifications that protocted most of the

by the massive fortifications that protected most of the palaces. At Mycenae itself, the walls are 15 feet (4.6 meters) thick and probably were 50 feet (15.3 meters) high. As in the case of other Mycenaean centers, the actual location was chosen for its defensibility [1.29]. The somber character of these fortress–palaces is reflected in the general tone of Mycenaean civilization.

Unlike the relaxed culture of the Minoans, Mycenaean culture as reflected in its art was preoccupied with death and war. It is no coincidence that many of the richest finds have come from tombs. Like the Minoans, the Mycenaeans decorated their palaces with frescoes, although the Mycenaean paintings are more solemn and dignified than their Minoan counterparts.

The disaster of 1200 B.C. brought a violent end to the Mycenaeans' political and economic domination of the Mediterranean, but their culture lingered on for another one hundred years. A few of the palaces were inhabited again, and some Mycenaeans fled eastward, where they settled on the islands of Rhodes and Cyprus. By 1100 B.C., however, renewed violence had extinguished the last traces of Bronze Age culture in Greece. A century later, after a period our lack of information forces us to call the Dark Age, the story of Western culture truly begins with the dawning of the Iron Age.

Before leaving the rich achievements of the Bronze Age world, both in Greece and farther afield, it is worth

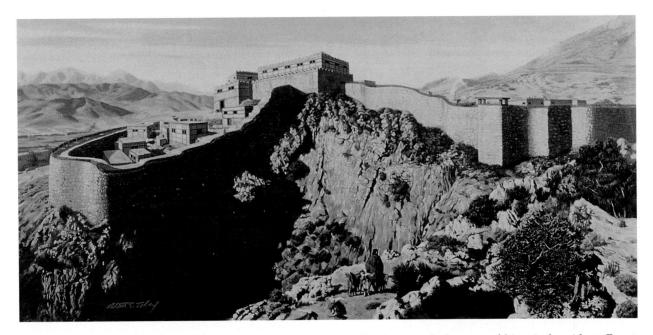

1.29 Reconstruction of the Citadel of Mycenae as it would have looked around 1300 B.C. The very thick walls are visible. The palace has a commanding position at the summit.

asking how much survived to be handed down to our own civilization. For the Greeks themselves, the Iron Age brought a new beginning in most material respects. At the same time, however, there are links with the earlier era in less tangible areas. In particular, although Greek religion never placed as strong an emphasis on worship of the mother goddess as did the Bronze Age, she remained a potent force in traditional beliefs. Behind the official reverence for Zeus, father of the gods and mortals, there lay a profound respect for goddesses like Hera, patroness of the family; Artemis, Mistress of the Beasts and goddess of childbirth; and Demeter, the goddess of fertility and agriculture. The continued worship of these goddesses, which was to last under different guises for centuries, represents a reverence for female creative power that is one of the oldest legacies from the period before our culture began-we saw it as far back as the Paleolithic period-and perhaps one of the most significant.

Regarding Egypt and Mesopotamia, their impact on later culture remains the subject of debate. In the course of their growth and development, the Greeks were brought into contact with the black Cushite culture of Egypt, and Greek art and architecture were decisively influenced by it. Although the Greeks retained their artistic independence, the style they developed under the inspiration of Eastern models, including those of Mesopotamia, has conditioned the entire history of Western art. The cultures of ancient Egypt and the Middle East had very little firsthand influence on the formation of our civilization, partly because Greek culture had a vitality that was by this time lacking in the older peoples and at least partly because of historical accident. Egypt and Assyria, powerful though they were, fell to the Persians, while Greece managed not only to survive but even to inflict an ignominious defeat on its Persian invaders. Yet even if ancient Egypt and Mesopotamia lie outside the mainstream of our cultural tradition, they continue to exert a powerful influence on the Western imagination, as the Tutankhamen exhibitions and their accompanying "Tut mania" showed in the 1970s. In part, their fascination lies in their exoticism and in the excitement of their rediscovery in our own day. The pharaoh who can curse his excavator from beyond the grave is certainly a dramatic, if fictional, representative of his age. At the same time, the artistic achievements of those distant times need no historical justification. Created in a world very remote from our own, they serve as a reminder of the innate human urge to give expression to the eternal problems of existence.

SUMMARY

The Beginnings of Civilization The early civilizations of the ancient Middle East laid the basis for the development of Western culture. In Egypt and Mesopotamia, in the period around 3000 B.C., the simple farming communities of the earlier Neolithic (New Stone) Age were replaced by cities, the product of agricultural discoveries that provided the food supply for relatively large numbers of people to live together.

Many of the characteristics of urban life developed during the following centuries: large-scale buildings, trade and commerce, systems of government and religion. The people of the Mesopotamian city of Uruk invented the earliest known writing system in the world.

Ancient Egypt Egyptian society was dominated by a strong central monarchy, with the pharaoh (the Egyptian

king) presiding over a large bureaucracy that administered the affairs of state. Egyptian religious life was controlled by the priests, who sought to maintain old traditions, and Egyptian art generally reflected the policy of state control. Periods of political uncertainty were reflected in contemporary art. The confidence and stability of Old Kingdom sculpture, for example, disappeared in the unsettled conditions of the Middle Kingdom.

In the reign of the New Kingdom pharaoh Amenhotep IV, better known as Akhenaton (1379–1362 B.C.), there was a change: The numberless deities of Egyptian religion were replaced by a single sun god, and Egyptian art became naturalistic for the first time in its history. Akhenaton's successors, however, restored the traditional system of deities and the artistic conventions of former times.

The chief characteristic of Egyptian religious thought was the belief in survival after death for those who had led a good life. Elaborate funeral rituals were devised, in which the god Osiris, Judge of the Dead, was invoked. From early in Egyptian history monumental tombs were constructed for the ruling classes, the most famous of which are the Great Pyramids at Giza.

The People of Mesopotamia Mesopotamian culture lacked the unity of Egyptian life: A series of different peoples had their own languages, religions, and customs. The Sumerians, the earliest, lived in cities dominated by great temples built on artificial platforms. The temple priests administered both religious and economic affairs, sharing their duties with local civic rulers. Unlike the Egyptian pharaohs who were thought of as gods, Sumerian rulers never became the focus of a cult. They represented their city's god and served the interests of their people by overseeing government projects. Among the earliest of Sumerian kings was Gilgamesh, whose legendary deeds are described in the epic poem that bears his name. Mesopotamia was ruled by the Akkadians, a Semitic people, from 2350 to 2150 B.C. Their kingdom was invaded and destroyed, and in a brief period of Neo-Sumerian revival the principal religious monument at Ur, the Ziggurat, was built. Around 1800 B.C. Mesopotamia was reunified by the Babylonians, whose most famous king, Hammurabi, was the author of an important law code.

The last people to rule Mesopotamia were the Assyrians, the peak of whose power occurred between 1000 B.C. and 612 B.C., the year in which their capital Nineveh was sacked by the Persians. Successive royal palaces, first at Nimrud and then at Nineveh, were decorated with massive stone relief carvings that showed aspects of life at court (royal processions, hunting scenes) with considerable realism.

The Cultures of Bronze Age Greece The first urban culture in the West, known as Minoan, developed on the Mediterranean island of Crete. Around 2000 B.C. large towns were constructed; these served as centers for the

ruling families and the chief religious leaders. The largest Minoan community, Knossos, was destroyed several times by earthquakes and each time was rebuilt on a grander scale. Like the other Minoan palaces, Knossos was decorated with vivid wall paintings depicting religious ceremonies and scenes from daily life. Many examples have been found of the elaborate jewelry worn by figures in the paintings; one of the richest is the gold Wasp Pendant from Mallia.

Around 1400 B.C., Knossos was abandoned for reasons that remain mysterious, and power passed to mainland Greece, where a people called the Mycenaeans had appeared by 1600 B.C. Most of our information about the Mycenaeans comes from their tombs. The earliest ones, at Mycenae itself, were dug into the ground within a circular enclosure; vast quantities of gold treasure—including death masks, jewelry, and weapons—were buried with the bodies of the dead. The Mycenaeans traded widely in the Mediterranean area, and around 1250 B.C. they sacked the city of Troy, an economic rival. Shortly after, however, their own cities were destroyed. Within a century Mycenaean culture had vanished, although it was to exert important influence upon later Greek civilization.

PRONUNCIATION GUIDE

Akhenaton: Ak-en-AH-tun Akkadian: Ak-AY-di-un Amarna: Am-AR-nuh Assurbanipal: As-er-BAN-i-pal Assurnasirpal: A-ser-na-SEER-pal Chefren: KEF-ren Cheops: **KEE-ops Cuneiform:** CUE-ni-form **Cyclades:** SIK-la-dees **Euphrates:** You-FRAY-tees Gilgamesh: GIL-gum-esh Hammurabi: Ham-oo-RA-bee **Hieroglyph:** HIGH-ro-glif **Knossos:** KNO-sos Lascaux: Lasc-OWE Mallia: MAH-lia Mesopotamia: Mes-o-pot-AIM-i-a Minos: MY-nos Mycenae: My-SEEN-ee Nefertiti: Nef-er-TEE-TEE Phaistos: FES-tos Pharaoh: FARE-owe Schliemann: SHLEE-man Stele: STAY-lay Sumerian: Soo-MEE-ri-an **Tutankhamen:** Tu-tan-KA-mun Uruk: **Oo-ROOK**

Willendorf:	VIL-en-dorf
Zakro:	ZAK-roe
Ziggurat:	ZIG-oo-rat

EXERCISES

- 1. Compare the religious beliefs of the Egyptians and the Mesopotamians. What do their differences tell us about the cultures involved?
- 2. How did the development of Egyptian society affect their art? What were the principal subjects depicted by Egyptian artists?
- 3. What evidence is there for the role of women in the cultures discussed in this chapter?
- 4. What information do the excavations at the Palace of Knossos provide about Minoan daily life?
- 5. If you could return in time to visit one of the peoples described in the chapter, which would you choose?

FURTHER READING

- Aldred, C. (1987). *The Egyptians*. London: Thames and Hudson. A short but comprehensive account of Egyptian culture by one of the leading Egyptologists of the century.
- Binford, L. R. (1988). In pursuit of the past. New York: Thames and Hudson. An absorbing introduction to prehistoric archaeology; written for general readers.
- Frankfort, H. (1996). The art and architecture of the ancient Orient (5th ed.). New Haven: Yale University Press. The best single-volume guide to its subject. Technical in places but written with immense breadth of knowledge; fully illustrated.
- Hood, S. (1978). *The arts in prehistoric Greece*. Baltimore: Penguin. An introduction to Minoan and Mycenaean art. The author, who has himself dug both in Crete and at Mycenae, includes evidence from the excavations new at the time of its publication.
- Lerner, G. (1986). *The creation of patriarchy*. New York: Oxford University Press. A study of gender and politics in the ancient world.
- Malek, Jaromir. (1999). *Egyptian art*. London: Phaidon. Well illustrated and current.
- Nissen, H. J. (1988). *The early history of the ancient Near East* 9000–2000 B.C. Chicago: University of Chicago Press. A survey of Mesopotamian history and culture that takes into account excavations up to its publication date.
- Roux, G. (1980). *Ancient Iraq* (2nd ed.). Baltimore: Penguin. A history of the ancient Near East from the Paleolithic period to Roman times.
- Smith, W. S. (1981). The art and architecture of ancient Egypt (2nd ed., revised by W. K. Simpson). Baltimore: Penguin. A thorough survey of all aspects of Egyptian art, with numerous photographs and diagrams.
- Trigger, B. B. G., et al. (1983). Ancient Egypt: A social history. Cambridge: Cambridge University Press. A collection of essays on various aspects of ancient Egyptian life.
- Warren, P. (1989). *The Aegean civilizations* (2nd ed.). Oxford: Elsevier-Phaidon. A good general account of Bronze Age Aegean culture, especially well illustrated. The author includes an interesting account of his own excavations in Crete.

Willetts, R. F. (1977). *The civilization of ancient Crete*. London: Methuen. Deals with the Minoans and their successors on Crete and concludes with a section on Crete in the twentieth century.

Online Chapter Links

Convert any English word to hieroglyphics at http://www.tourism.egnet.net/cafe/tor_trn.htm

An extensive listing of Egyptian rulers is available at

http://www.touregypt.net/kings.htm

To investigate recent excavations at the Great Pyramids and the Sphinz at Giza, visit the *Pyramids: The Inside Story* at

http://www.pbs.org/wgbh/nova/pyramid/

Links to a large number of Internet resources related to the pyramids are available at http://guardians.net/egypt/pyramids.htm

Links to a large number of Internet resources related to the Sphinx are available at

http://www.guardians.net/egypt/sphinx/

Links to a large number of Internet resources related to Egyptian mummies are available at http://guardians.net/egypt/mummies.htm

Links to a large number of Internet resources related to the hieroglyphs are available at http://guardians.net/egypt/hiero.htm

The Ancient Vine at

http://ancient.thevines.com/

provides an extensive annotated list of links to Internet sites related to Egyptian studies.

Visit these Web sites for extensive information about the mummification process, plus a key to hieroglyphs, a timeline, and links to other related Web sites.

Mummies of the World at

http://www.pbs.org/wgbh/nova/peru/mummies/ index.html

Visit Mummies of Ancient Egypt at www.si.umich.edu/CHICO/mummy

Funerary Beliefs Connected with Mummification at http://touregypt.net/historicalessays/mummyessay.htm

Online Chapter Resources

READING SELECTIONS

from The Epic of Gilgamesh

The following extracts are from The Epic of Gilgamesh, which describes the exploits of the Sumerian ruler Gilgamesh and his friend Enkidu. In the course of the poem, Enkidu dies of an illness sent by the gods and Gilgamesh goes on a journey in search of the meaning of existence. Toward the end he meets Utnapishtim, the only mortal to whom the gods have given eternal life, and tries to learn from him the secret of immortality. The futility of his quest is expressed by his inability even to stay awake.

At the end of the epic, like all mortals he dies, and the poet points out the lesson: "O Gilgamesh, you were given the kingship, such was your destiny, everlasting life was not your destiny."

The Flood

With the first light of dawn a black cloud came from the horizon; it thundered within where Adad, lord of the storm, was riding. In front over hill and plain Shullat and Hanish, heralds of the storm, led on. Then the gods of the abyss rose up; Nergal pulled out the dams of the nether waters, Ninurta the warlord threw down the dykes, and the seven judges of hell, the Annunaki, raised their torches, lighting the land with their livid flame. A stupor of despair went up to heaven when the god of the storm turned daylight to darkness, when he smashed the land like a cup. One whole day the tempest raged gathering fury as it went, it poured over the people like the tides of battle; a man could not see his brother nor the people be seen from heaven. Even the gods were terrified at the flood, they fled to the highest heaven, the firmament of Anu; they crouched against the walls, cowering like curs. Then Ishtar the sweet-voiced Queen of Heaven cried out like a woman in travail:

"Alas the days of old are turned to dust because I commanded evil; why did I command this evil in the council of all the gods? I commanded wars to destroy the people, but are they not my people, for I brought them forth? Now like the spawn of fish they float in the ocean." The great gods of heaven and of hell wept, they covered their mouths.

The Afterlife

Enkidu slept alone in his sickness and he poured out his heart to Gilgamesh, "Last night I dreamed again, my friend. The heavens moaned and the earth replied; I stood alone before an awful being; his face was somber like the black bird of the storm. He fell upon me with the talons of an eagle and he held me fast, pinioned with his claw, till I smothered; then he transformed me so that my arms became wings covered with feathers. He turned his stare towards me, and he led me away to the palace of Irkalla, the Queen of Darkness, to the house from which none who enters ever returns, down the road from which there is no coming back.

"There is the house whose people sit in darkness; dust is their food and clay their meat. They are clothed like birds with wings for covering, they see no light, they sit in darkness. I entered the house of dust and I saw the kings of the earth, their crowns put away for ever; rulers and princes, all those who once wore kingly crowns and ruled the world in the days of old. They who had stood in the place of the gods, like Anu and Enlil, stood now like servants to fetch baked meats in the house of dust, to carry cooked meat and cold water from the water-skin. In the house of dust which I entered were high-priests and acolytes, priests of the incantation and of ecstasy; there were servers of the temple, and there was Etana, that king of Kish whom the eagle carried to heaven in the days of old. I saw also Samuqan, god of cattle, and there was Ereshkigal the Queen of the Underworld; and Belit-Sheri squatted in front of her, she who is recorder of the gods and keeps the book of death.

She held a tablet from which she read. She raised her head, she saw me and spoke: 'Who has brought this one here?' Then I awoke like a man drained of blood who wanders alone in a waste of rushes; like one whom the bailiff has seized and his heart pounds with terror. O my brother, let some great prince, some other, come when I am dead, or let some god stand at your gate, let him obliterate my name and write his own instead."

The Return of Gilgamesh

Utnapishtim said, "As for you, Gilgamesh, who will assemble the gods for your sake, so that you may find that life for which you are searching? But if you wish, come and put it to the test: only prevail against sleep for six days and seven nights." But while Gilgamesh sat there resting on his haunches, a mist of sleep like soft wool teased from the fleece drifted over him, and Utnapishtim said to his wife, "Look at him now, the strong man who would have everlasting life, even now the mists of sleep are drifting over him." His wife replied, "Touch the man to wake him, so that he may return to his own land in peace, going back through the gate by which he came." Utnapishtim said to his wife, "All men are deceivers, even you he will attempt to deceive; therefore bake loaves of bread, each day one loaf, and put it beside his head; and make a mark on the wall to number the days he has slept."

So she baked loaves of bread, each day one loaf, and put it beside his head, and she marked on the wall the days that he slept; and there came a day when the first loaf was hard, the second loaf was like leather, the third loaf was soggy, the crust of the fourth had mould, the fifth was mildewed, the sixth was fresh, and the seventh was still on the embers. Then Utnapishtim touched him and he woke. Gilgamesh said to Utnapishtim the Faraway, "I hardly slept when you touched and roused me." But Utnapishtim said, "Count these loaves and learn how many days you slept, for your first is hard, your second is like leather, your third is soggy, the crust of your fourth has mould, your fifth is mildewed, your sixth is fresh, and your seventh was still over the glowing embers when I touched and woke you." Gilgamesh said, "What shall I do, O Utnapishtim, where shall I go? Already the thief in the night has hold of my limbs, death inhabits my room; wherever my foot rests, there I find death."

Then Utnapishtim spoke to Urshanabi the ferryman: "Woe to you Urshanabi, now and for ever more you have become hateful to this harborage; it is not for you, nor for you are the crossings of this sea. Go now, banished from the shore. But this man before whom you walked, bringing him here, whose body is covered with foulness and the grace of whose limbs has been spoiled by wild skins, take him to the washing-place. There he shall wash his long hair clean as snow in the water, he shall throw off his skins and let the sea carry them away, and the beauty of his body shall be shown, the fillet on his forehead shall be renewed, and he shall be given clothes to cover his nakedness. Till he reaches his own city and his journey is accomplished, these clothes will show no sign of age, they will wear like a new garment." So Urshanabi took Gilgamesh and led him to the washing-place, he washed his long hair as clean as snow in the water, he

threw off his skins, which the sea carried away, and showed the beauty of his body. He renewed the fillet on his forehead, and to cover his nakedness gave him clothes which would show no sign of age, but would wear like a new garment till he reached his own city, and his journey was accomplished. Then Gilgamesh and Urshanabi launched the boat on to the water and boarded it, and they made ready to sail away; but the wife of Utnapishtim the Faraway said to him, "Gilgamesh came here wearied out, he is worn out; what will you give him to carry him back to his own country?" So Utnapishtim spoke, and Gilgamesh took a pole and brought the boat in to the bank. "Gilgamesh, you came here, a man wearied out, you have worn yourself out; what shall I give you to carry you back to your own country? Gilgamesh, I shall reveal a secret thing, it is a mystery of the gods that I am telling you. There is a plant that grows under the water, it has a prickle like a thorn, like a rose; it will wound your hands, but if you succeed in taking it, then your hands will hold that which restores his lost youth to a man."

When Gilgamesh heard this he opened the sluices so that a sweet-water current might carry him out to the deepest channel; he tied heavy stones to his feet and they dragged him down to the water-bed. There he saw the plant growing; although it pricked him he took it in his hands; then he cut the heavy stones from his feet, and the sea carried him and threw him on to the shore. Gilgamesh said to Urshanabi the ferryman, "Come here, and see this marvelous plant. By its virtue a man may win back all his former strength. I will take it to Uruk of the strong walls; there I will give it to the old men to eat. Its name shall be 'The Old Men Are Young Again'; and at last I shall eat it myself and have back all my lost youth." So Gilgamesh returned by the gate through which he had come, Gilgamesh and Urshanabi went together. They traveled their twenty leagues and then they broke their fast; after thirty leagues they stopped for the night.

Gilgamesh saw a well of cool water and he went down and bathed; but deep in the pool there was lying a serpent, and the serpent sensed the sweetness of the flower. It rose out of the water and snatched it away, and immediately it sloughed its skin and returned to the well. Then Gilgamesh sat down and wept, the tears ran down his face, and he took the hand of Urshanabi; "O Urshanabi, was it for this that I toiled with my hands, is it for this I have wrung out my heart's blood? For myself I have gained nothing; not I, but the beast of the earth has joy of it now.

Already the stream has carried it twenty leagues back to the channels where I found it. I found a sign and now I have lost it. Let us leave the boat on the bank and go." After twenty leagues they broke their fast, after thirty leagues they stopped for the night; in three days they had walked as much as a journey of a month and fifteen days. When the journey was accomplished they arrived at Uruk, the strongwalled city.

Gilgamesh spoke to him, to Urshanabi the ferryman, "Urshanabi, climb up on to the wall of Uruk, inspect its foundation terrace, and examine well the brickwork; see if it is not of burnt bricks; and did not the seven wise men lay these foundations? One third of the whole is city, one third is garden, and one third is field, with the precinct of the goddess Ishtar. These parts and the precinct are all Uruk."

This too was the work of Gilgamesh, the king, who knew the countries of the world. He was wise, he saw mysteries and knew secret things, he brought us a tale of the days before the flood. He went a long journey, was weary, worn out with labor, and returning engraved on a stone the whole story.

The Death of Gilgamesh

The destiny was fulfilled which the father of the gods, Enlil of the mountain, had decreed for Gilgamesh: "In netherearth the darkness will show him a light; of mankind, all that are known, none will leave a monument for generations to come to compare with his. The heroes, the wise men, like the new moon have their waxing and waning. Men will say, 'Who has ever ruled with might and with power like him?' As in the dark month, the month of shadows, so without him there is no light. O Gilgamesh, this was the meaning of your dream. You were given the kingship, such was your destiny, everlasting life was not your destiny. Because of this do not be sad at heart, do not be grieved or oppressed; he has given you power to bind and to loose, to be the darkness and the light of mankind. He has given unexampled supremacy over the people, victory in battle from which no fugitive returns, in forays and assaults from which there is no going back. But do not abuse this power, deal justly with your servants in the palace, deal justly before the face of the Sun."

The king has laid himself down and will not rise again The Lord of Kullab will not rise again; He overcame evil, he will not come again; Though he was strong of arm he will not rise again; He had wisdom and a comely face, he will not come again; He is gone into the mountain, he will not come again;

On the bed of fate he lies, he will not rise again, From the couch of many colors he will not come again.

The people of the city, great and small, are not silent; they lift up the lament, all men of flesh and blood lift up the lament. Fate has spoken; like a hooked fish he lies stretched on the bed, like a gazelle that is caught in a noose. Inhuman Namtar is heavy upon him, Namtar that has neither hand nor foot, that drinks no water and eats no meat. For Gilgamesh, son of Ninsun, they weighed out their offerings; his dear wife, his son, his concubine, his musicians, his jester, and all his household; his servants, his stewards, all who lived in the palace weighed out their offerings for Gilgamesh the son of Ninsun, the heart of Uruk. They weighed out their offerings to Ereshkigal, the Queen of Death, and to all the gods of the dead. To Namtar, who is fate, they weighed out the offering. Bread for Neti the Keeper of the Gate, bread for Ningizzida the god of the serpent, the lord of the Tree of Life; for Dumuzi also, the young shepherd, for Enki and Ninki, for Endukugga and Nindukugga, for Enmul and Ninmul, all the ancestral gods, forbears of Enlil. A feast for Shulpae, the god of feasting. For Samuqan, god of the herds, for the mother Ninhursag, and the gods of creation in the place of creation, for the host of heaven, priest and priestess weighed out the offering of the dead. Gilgamesh, the son of Ninsun, lies in the tomb. At the place of offerings he weighed the bread-offering, at the place of libation he poured out the wine. In those days the lord Gilgamesh departed, the son of Ninsun, the king, peerless, without an equal among men, who did not neglect Enlil his master. O Gilgamesh, lord of Kullab, great is thy praise.

		GENERAL EVENTS	LITERATURE & PHILOSOPHY	Art
	3000			
1	MYCENAEAN PERIOD	c. 1184 Fall of Troy		
BRONZE AGI	DARK AGE	1100 Collapse of Mycenaean Empire		
	Heroic AGE	 1000 Development of Iron Age culture at Athens 800–700 Greeks begin colonizing in East and Italy 776 First Olympic Games c. 775 First Greek colony in Italy founded at Pithekoussai 	 c. 900–700 Evolution of Homeric epics <i>Iliad</i> and <i>Odyssey</i> 8th cent. Hesiod, <i>Works and Days</i> and <i>Theogony</i> 	 1000–900 Protogeometric pottery decoration: bold circular shapes similar to Mycenaean motifs 900–700 Geometric pottery decoration: linear designs of zigzags, triangles, diamonds, meanders
	AGE OF COLONIZATION	750–600 Greeks found colonies throughout Mediterranean, from Egypt to Black Sea	 c. 700 Greeks adapt Phoenician alphabet for their own language c. 650 Archilochus, earliest Greek lyric poet, active 	 8th cent. Geometric pottery incorporates stylized human figure in painted design; Dipylon amphora c. 650 Large freestanding sculpture evolves late 7th cent. Orientalizing styles in vase painting; Corinthian aryballos c. 600 New York Kouros; Athenians develop narrative style in black- figure vase painting; increased
	600	c. 590 Solon reforms Athenian	h. Lab Compton Dogue	naturalism in Greek art
IRON AGE	ARCHAIC PERIOD	 constitution 546 Rule of Pisistratus begins growth of Athenian power; Persian Empire expands to take over Greek colonies in Asia Minor 510 Restoration of democracy at Athens 490 Start of the Persian Wars; forces 	 early 6th cent. Sappho, Poems 6th cent. Development of Presocratic schools of philosophy: Materialists, Pythagoreans, Dualists, Atomists c. 540–480 Heraclitus of Ephesus teaches his theory of "impermanence" late 6th cent. Playwriting competition begins 	 c. 550 Calf-Bearer c. 530 Anavysos Kouros; Peplos Kore c. 525 Exekias, The Suicide of Ajax, amphora late 6th cent. Red-figure style of vase painting introduced; Euphronios Vase, krater
	480	of King Darius defeated at Marathon	after 525 First official version of Homeric epics written	c. 490 <i>Kritios Boy;</i> turning point between Archaic and Classical periods
	CLASSICAL PERIOD	 480 Xerxes leads a second expedition against Greece; wins battle of Thermopylae and sacks Athens; Greeks defeat Persians decisively at Salamis 479 Greek victories at Plataea and Mycale end Persian Wars 	 c. 475 Parmenides writes on his theory of knowledge c. 440 Herodotus begins <i>History of the Persian Wars</i> 	
	323	Most dates are approximate		

CHAPTER 2 Early Greece

ARCHITECTURE

MUSIC

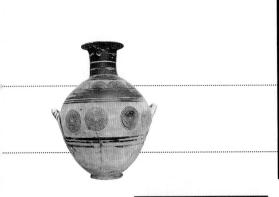

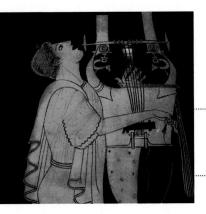

Early music primarily vocal with instrumental accompaniment; use of flute and simple lyre popular

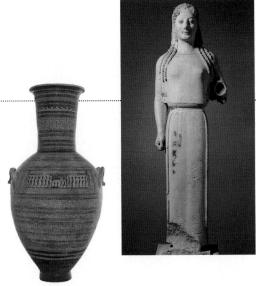

c. 600 Form of Doric temple fully established, derived from early wooden structures; Temple of Hera at Olympia

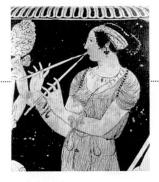

7th cent. Development of aulos (double flute), used to accompany songs

c. 675 Terpander of Lesbos introduces cithara

586 Sacadas of Argos composes first known purely instrumental work for performance on aulos at Pythian Games in Delphi

c. 550 Pythagoras discovers numerical relationship of music harmonies and our modern musical scale

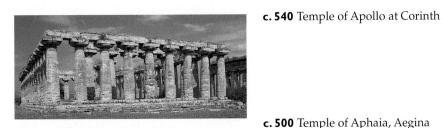

c. 500 Temple of Aphaia, Aegina

c. 550 Basilica at Paestum

5th cent. First widespread use of Ionic order

late 5th cent. Earliest surviving fragment of Greek music

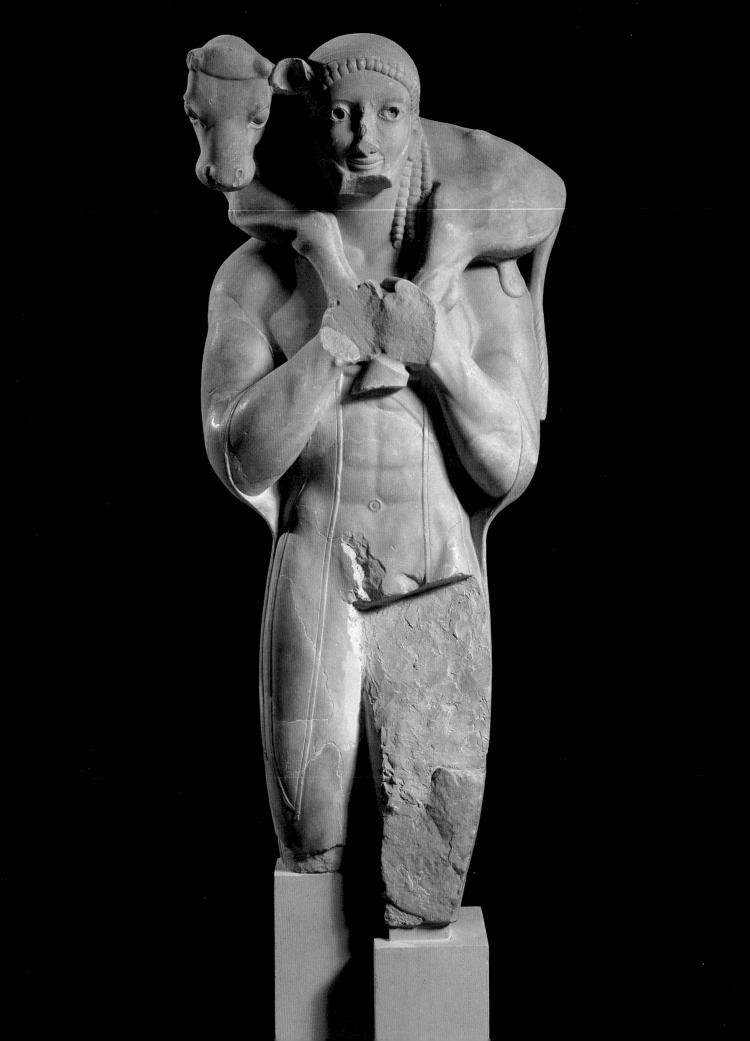

CHAPTER 2 EARLY GREECE

ne of the major turning points of history is the period around 1000 B.C., the change from the Bronze Age to the Iron Age throughout the Mediterranean area. In the following centuries a culture developed in a small corner of southeastern Europe— Greece—which was to form the foundation of Western civilization. By the fifth century B.C. this culture had produced one of the greatest eras of human achievement.

In certain basic ways, of course, there was some continuity between the Bronze Age and the Iron Age. For example, Athens, which in the fifth century B.C. became the intellectual center of Classical Greece, had been a Mycenaean city long before the Iron Age began. In most significant respects, however, the Iron Age Greeks had to discover for themselves almost all the cultural skills associated with civilization-the visual arts, architecture, literature, philosophy, even the art of writing. The Mycenaeans had known how to write and build and create art. However, their abrupt and violent end around 1100 B.C. was followed by a century of disturbance and confusion that cut off the Bronze Age from the new world of the Iron Age. To follow the first attempts of these Iron Age people to develop an artistic style, organize their societies, and question the nature of the universe is to witness the birth of Western culture.

The history of early Greece falls naturally into three periods, each marked by its own distinctive artistic achievement. During the first three hundred years or so of the Iron Age, development was slow and the Greeks had only limited contact with other Mediterranean peoples. During this period the first great works of literature were created: the epic poems known as the *Iliad* and the *Odyssey*. Because these works treat heroic themes, the early Iron Age in Greece is sometimes known as the Heroic Age. The visual art of the period used a style known as Geometric.

Homer's Greece

By the beginning of the eighth century B.C. Greek travelers and merchants had already begun to explore the lands to the east and west. In the next one hundred fifty years (c. 750–600 B.C.), called the Age of Colonization, many new ideas and artistic styles were brought to Greece. These foreign influences were finally absorbed in the third era of early Greece known as the Archaic period (c. 600–480 B.C.). This period, the culmination of the first five hundred years of Greek history, paved the way for the Classical period (discussed in Chapter 3). The Greeks' relationship to the world around them took a decisive turn at the very end of the Archaic period with their victory over the Persians in the wars that lasted from 490 to 479 B.C. The events of the Persian Wars thus end this chapter.

Homer and the Heroic Age

During the Mycenaean period most of Greece had been united under a single influence. When the Mycenaeans fell, however, Greece split up into a series of independent regions that corresponded to the geographically separated areas created by the mountain ranges and high hills that crisscross the terrain. Within each of these geographically discrete areas there developed an urban center that controlled the surrounding countryside. Thus Athens became the dominating force in the geographical region known as Attica; Thebes controlled Boeotia; Sparta controlled Laconia; and so on (see map, "Ancient Greece"). A central urban community of this kind was called by the Greeks of a later period a *polis*, a term generally translated as "city-state."

The polis served as focal point for all political, religious, social, and artistic activities within its region. Its citizens felt toward their own individual city a loyalty that was far stronger than any generalized sense of community with their fellow Greeks over the mountains. Each of the leading cities developed its own artistic style, which led to fierce competition and in time to bitter and destructive rivalries. The polis was therefore both the glory and the ruin of Greek civilization, producing on the one hand an unequaled concentration of intellectual and cultural development, and on the other a tendency to internal squabbling at the least provocation.

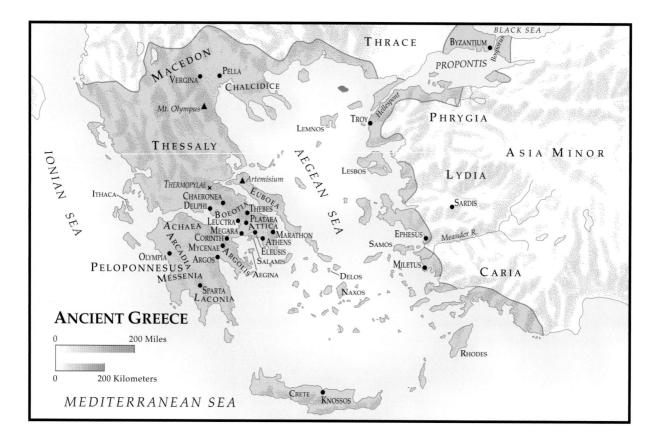

The fragmentation of social and cultural life had a marked effect on the development of Greek mythology and religion. Religion played an important part in Greek life, as Greek art and literature demonstrate, but it was highly different in nature from the other systems of belief that influenced our culture, Judaism and Christianity. For one thing, Greek mythology offers no central body of information or teaching corresponding to the Old Testament or New Testament. Often there are varying versions of the same basic story; even when these versions do not actually contradict one another, they are difficult to reconcile. For another thing, the very characters of the Greek gods and goddesses often seem confused and selfcontradictory. For example, Zeus, president of the Immortals and father of gods and humans, generally represented the concept of an objective moral code to which both gods and mortals were expected to conform; Zeus imposed justice and supervised the punishment of wrongdoers [2.1]. Yet this same majestic ruler was also involved in many love affairs and seductions, in the course of which his behavior was often undignified and even comical. How could the Greeks have believed in a champion of morality whose own moral standards were so lax?

The answer lies in the fact that Greek myth and religion of later times consist of a mass of folktales, primitive customs, and traditional rituals that grew up during the Heroic Age and were never developed into a single unified system. Individual cities had their own mythological traditions, some of them going back to the Bronze Age, others gradually developing under the influence of neighboring peoples. Poets and artists felt free to choose the versions that appealed to their own tastes or helped them to express their ideas. Later Greeks, it is true, tried to organize all these conflicting beliefs into something resembling order. Father Zeus ruled from Mount Olympus, where he was surrounded by the other principal Olympian deities. His wife Hera was the goddess of marriage and the protectress of the family. His daughter Athena symbolized intelligence and understanding. Aphrodite was the goddess of love, Ares, her lover, the god of war, and so on. But the range and variety of the Greek imagination defied this kind of categorization. The Greeks loved a good story, and so tales that did not fit the ordered scheme continued to circulate.

Shrine to Athena

These contradictions were, of course, perfectly apparent to the Greeks themselves, but they used their religion to illuminate their own lives, rather than to give them divine guidance. One of the clearest examples is the contrast that Greek poets drew between the powers of Apollo and Dionysus, two of the most important of their gods. Apollo represented logic and order, the power of

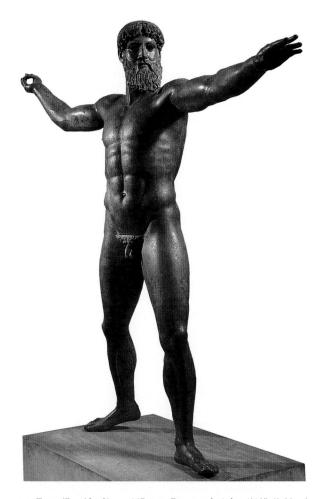

2.1 Zeus (Poseidon?), c. 465 B.C. Bronze, height 6'10" (2.08 m). National Archaeological Museum, Athens. Whether this striding god is Zeus or Poseidon, god of the sea, the combination of majestic dignity and physical strength reflects the Greeks' view of their gods as superior beings with definitely human attributes. This statue, found in the sea off Cape Artemisium, comes from the end of the period covered in this chapter; it may have been intended to commemorate the Greek victory over the Persians.

the mind; Dionysus was the god of the emotions, whose influence, if excessive, could lead to violence and disorder. By worshiping both these forces, the Greeks were acknowledging an obvious dual existence in human nature and trying to strike a prudent balance.

The Greek deities served many purposes, therefore, but these purposes were very different from those of the other Western religions. No Greek god, not even Zeus, represents supreme good. At the other end of the moral scale, there is no Greek figure of supreme evil corresponding to the Christian concept of Satan. The Greeks turned to their deities for explanations of both natural phenomena and psychological characteristics they recognized in themselves. At the same time they used their gods and goddesses as yet another way of enhancing the glory of their individual city–states, as in the case of the cult of Athena at Athens. Problems of human morality required human, rather than divine, solutions. The Greeks turned to art and literature, rather than prayer, as a means of trying to discover them (Table 2.1).

At the beginning of Greek history stand two epic poems, which even the quarrelsome Greeks themselves saw as national—indeed universal—in their significance. The *lliad* and the *Odyssey* have, from that early time, been held in the highest esteem. Homer, their accepted author, is generally regarded as not only the first figure in the Western literary tradition but also one of the greatest. Yet even though Homer's genius is beyond doubt, little else about him is clear. In fact, the many problems and theories connected with the Homeric epics and their creator are generally summed up under the label "the Homeric Question."

The ancient Greeks themselves were not sure who had composed the *lliad* and the *Odyssey*, when and where the author had lived, or even if one person was responsible for both of them. In general, tradition ascribed the epics to a blind poet called Homer; almost every city worthy of the name claimed to be his birthplace. Theories about when he had lived ranged from the time of the Trojan War, around 1250 B.C., to 500 years later.

The problem of who Homer was, and even whether he existed at all, continues to vex scholars to this day. In any case, most experts would probably now agree that the creation of the *Iliad* and the *Odyssey* was a highly complex affair. Each of the epics consists basically of a number of shorter folktales that were combined, gradually evolving over a century or more into the works as we now know them.

These epic poems were almost certainly composed and preserved at a time before the introduction of writing in Greece by individuals who passed them down by word of mouth. Professional bards—storytellers probably learned a host of ready-made components: traditional tales, stock incidents, and a whole catalog of repeated phrases and descriptions. In the absence of any written text the works remained fluid, and individual

TABLE 2.1 Principal Greek Deities

Zeus Hera	Father of Gods and Men Wife of Zeus, Oueen of Heaven
Poseidon	Brother of Zeus, God of the Sea
Hephaestus	Son of Zeus and Hera, God of Fire
Ares	God of War
Apollo	God of Prophecy, Intellect, Music, and
	Medicine
Artemis	Goddess of Chastity and the Moon
Demeter	Earth Mother, Goddess of Fertility
Aphrodite	Goddess of Beauty, Love, and Marriage
Athena	Goddess of Wisdom
Hermes	Messenger of the Gods, God of
	Cleverness
Dionysus	God of Wine and the Emotions

reciters would bring their own contributions. On the other hand, both the Homeric epics show a marked unity of style and structure.

The first crystallization of these popular stories had probably occurred by around 800 B.C., but the poems were still not in their final form for more than a century. The first written official version of each epic was probably not made before the late sixth century B.C. The edition of the poems used by modern scholars was made by a scribe working at Alexandria in the second century B.C.

Where, then, in this long development must we place Homer? He may perhaps have been the man who first began to combine the separate tales into a single whole; or perhaps he was the man who, sometime after 800 B.C., imposed an artistic unity on the mass of remembered folk stories he had inherited. The differences between the Iliad and the Odyssey have suggested to a number of commentators that a different "Homer" may have been responsible for the creation or development of each work, but here we enter the realm of speculation. Perhaps after all it would be best to follow the ancient Greeks themselves, contenting ourselves with the belief that at some stage in the evolution of the poems they were filtered through the imagination of the first great genius of the Western literary tradition, without being too specific about which stage it was.

Both works show evidence of their long evolution by word of mouth. All the chief characters are given standardized descriptive adjectives as "epithets" that are repeated whenever they appear: Achilles is "swift-footed" and Odysseus "cunning." Phrases, lines, and entire sections are often repeated. There are also minor inconsistencies in the plots.

Further, the heroic world of warfare is made more accessible to the poem's audience by the use of elaborate similes that compare aspects of the story to everyday life in the early Iron Age—the massing of the Greek forces, for example, is likened to a swarm of flies buzzing around pails of milk.

Although the two poems are clearly of a single tradition, they are very different in spirit. The *lliad* is somber, taut, direct. The concentration of its theme makes it easier to understand, and certainly easier to explain, than the more digressive and lighthearted *Odyssey*. But the *Odyssey* is certainly not a lesser work; if anything, its range and breadth of humanity are even greater, and its design more elaborate.

The action of the *lliad* takes place during the final year of the Greeks' siege of Troy, or Ilium. Its subject is only indirectly concerned with the Trojan War, however, and the poem ends before the episode of the wooden horse and the fall of the city. Its principal theme is stated in the opening lines of Book I, which establish the tragic mood of the work. Here the poet invokes the goddess of poetic inspiration: "Sing, goddess, of the anger of Peleus' son Achilles, which disastrously inflicted countless sufferings on the Greeks, sending the strong souls of many heroes to Hades and leaving their bodies to be devoured by dogs and all birds. . . ."

The subject of the Iliad, then, is the anger of Achilles and its consequences. Its message is a direct one: We must be prepared to answer for the results of our own actions and realize that when we act wrongly we will cause suffering both for ourselves and, perhaps more important, for those we love. Although the setting of the Iliad is heroic, even mythic, the theme of human responsibility is universal. This relevance to our own experience is underlined by the realism in the scenes of battles and death, which are characteristic of epic literature's interest in heroic warfare. The story of Achilles' disastrous mistake is told in a basically simple and direct narrative. It begins with a quarrel between Agamemnon, commander-inchief of the Greek forces; and Achilles, his powerful ally, who resents Agamemnon's overbearing assertion of authority. After a public argument, Achilles decides to punish Agamemnon by withdrawing his military support and retiring to his tent, in the hope that without his aid the Greeks will be unable to overcome the Trojans. In the battles that follow he is proved correct; the Trojans inflict a series of defeats on the Greeks, killing many of their leading warriors.

Agamemnon eventually (Book IX) admits that he behaved too highhandedly and offers Achilles, through intermediaries, not only a handsome apology but a generous financial inducement to return to the fighting and save the Greek cause. Achilles, however, rejects this attempt to make amends and stubbornly nurses his anger as the fighting resumes and Greek casualties mount. Then his dearest friend Patroclus is killed by the Trojan leader Hector, son of their king (Book XVI). Only now does Achilles return to battle, his former anger against Agamemnon now turned against the Trojans in general and Hector in particular.

After killing Hector in single combat (Book XXII), Achilles abuses Hector's corpse in order to relieve his own sense of guilt at having permitted Patroclus' death. Finally, Priam, the old king of Troy, steals into the Greek camp by night to beg for the return of his son's body (Book XXIV). In this encounter with Priam, Achilles at last recognizes and accepts the tragic nature of life and the inevitability of death. His anger melts and he hands over the body of his dead enemy. The *Iliad* ends with the funeral rites of Hector, "tamer of horses."

As is clear even from this brief summary, there is a direct relationship between human actions and their consequences. The gods appear in the *lliad* and frequently play a part in the action, but at no time can divine intervention save Achilles from paying the price for his unreasonable anger. Furthermore, Achilles' crime is committed not against a divine code of ethics but against human standards of behavior. All his companions, including Patroclus, realize that he is behaving unreasonably.

VALUES

Destiny

Like most peoples since them, the Greeks had conflicting ideas on how much of human life was preordained by some force in the universe, which they called Fate, or Destiny. In one passage, Homer speaks of the three Fates, or Moirai, goddesses who govern the thread of life for each individual person. Lachesis assigns each person's lot at birth, Clotho spins the thread of life, and Atropos—her name means "she who cannot be turned—cuts the thread at the moment of death.

Neither Homer himself or later Greeks seemed very clear on how the Fates related to the other gods. One author, Hesiod, describes them as the daughters of Zeus and Themis (Righteousness), while Plato calls them the daughters of Ananke (Necessity). Sometimes Fate is a force with unlimited power over all humans and deities, and Zeus performs its commands; on other occasions Zeus can change the course of Destiny, and even humans sometimes succeed in reversing their fate.

The Greeks also acknowledged another force operating in their lives, that of pure random chance, which

From its earliest beginnings, therefore, the Greek view of morality is in strong contrast to the Judeo-Christian tradition. At the center of the Homeric universe is not God but human beings, who are at least partly in control of their own destiny. If they cannot choose the time when they die, they can at least choose how they live. The standards by which human life will be judged are those established by one's fellow humans. In the Iliad the gods serve as divine "umpires." They watch the action and comment on it and at times enforce the rules, but they do not affect the course of history. Humans do not always, however, fully realize the consequences of their behavior. In fact, they often prefer to believe that things happen "according to the will of the gods" rather than because of their own actions. Yet the gods themselves claim no such power. In a remarkable passage at the beginning of Book I of the Odyssey we see the world for a moment through the eyes of Zeus as he sits at dinner on Mount Olympus: "How foolish men are! How unjustly they blame the gods! It is their lot to suffer, but because of their own folly they bring upon themselves sufferings over and above what is fated for them. And then they blame the gods." These are hardly words we can imagine coming from the God of the Old Testament.

The principal theme of the *Odyssey* is the return home of the Greek hero Odysseus from the war against Troy. Odysseus' journey, which takes ten years, is filled with adventures involving one-eyed giants, monsters of various kinds, a seductive enchantress, a romantic young girl, a floating island, a trip to the underworld, and many they symbolized by the goddess Tyche, or Fortune. Tyche can award lavish benefits, but she does so at random. Her symbols—wings, a wheel, a revolving ball—convey her variability. With the general decline of traditional religious beliefs in later Greek history, Tyche became revered as one of the most powerful forces in the universe.

Although the Romans adopted the Greek Moirai in the form of the Parcae, they paid far more attention to the notion of luck, worshiped as Fortuna. In art, Fortuna was represented like Tyche, but the Roman goddess appeared in a wide variety of forms: Fortuna liberum (of children), Fortuna redux (assuring a safe return from a journey), Fortuna privata (of family life), and many more. In the early second century A.D., the Roman emperor Trajan founded a special temple in honor of Fortuna as the all-pervading power of the world.

other fairytale elements. Into this main narrative is woven a description of the wanderings of Odysseus' son, Telemachus, who, searching for his missing father, visits many of the other Greek leaders who have returned safely from Troy.

In the last half of the poem Odysseus finally returns home in disguise. Without revealing his identity to his ever-faithful wife Penelope, he kills the suitors who have been pestering her for ten years to declare her husband dead and remarry. Homer keeps us waiting almost to the very end for the grand recognition scene between husband and wife. All ends happily, with Penelope, Odysseus, and his aged father Laertes peacefully reunited.

It is worth examining the Homeric world at some length, because the *lliad* and the *Odyssey* formed the basis of education and culture throughout the Greek and Roman world; children learned the two poems by heart at school. Ideas changed and developed, but reverence for Homer remained constant.

Art and Society in Early Greece

Geometric Art

Our impressions of the first three hundred years of Greek art (1000–700 B.C.) are based largely on painted pottery, hardly a major art form even in later times, for

little else has survived. Of architecture there is almost no trace. Although small bronze and ivory statuettes and relief plaques were being made from the ninth century B.C. on, the earliest surviving large stone sculptures date to the mid-seventh century B.C.

Painted vases are therefore our major source of information about artistic developments. It comes as something of a surprise to find that Homer's contemporaries decorated their pots with abstract geometric designs, with no attempt at the qualities most typical of their literature: vividness and realism. This style has given its name to the two subdivisions of the period, the Protogeometric (1000–900 B.C.) and the Geometric (900– 700 B.C.).

For the first hundred years, artists decorated their vases with simple, bold designs consisting mainly of concentric circles and semicircles [2.2]. In some ways this period represents a transition from the end of the Mycenaean age, but the memory of Mycenaean motifs soon gave way to a new style. If Protogeometric pottery seems a long way from Greek art of later centuries, it does show qualities of clarity and order that reappear later, although in a very different context.

2.2 Protogeometric amphora, c. 950 B.C. Height 21^{3}_{4} " (56 cm). Kerameikos Museum, Athens. Photo DAI Athens, Ker 7750. The circles and semicircles typical of this style were drawn with a compass.

In the Geometric pottery of the following two centuries (900–700 в.С.) the use of abstract design continued, but the emphasis changed. Circles and semicircles were replaced by linear designs, zigzags, triangles, diamonds, and above all the *meander* (a maze pattern). There is something strangely obsessive about many of these vessels—a sense of artists searching for a subject, meanwhile working out over and over the implications of mathematical formulas. Once again we seem a long way from the achievements of later Greek artists, with their emphasis on realism, yet precise mathematical relationships lie behind the design of much of the greatest Greek art.

By the eighth century B.C., artists had begun to find their way toward the principal subject of later Greek art: the human form. Thus human and animal figures begin to appear among the meanders and zigzags. This is a moment of such importance in the history of Western art that we should not take it for granted. We have been so conditioned by the art of the ancient Greeks that from the late Geometric period until our own time Western art has been primarily concerned with the depiction of human beings. Landscapes are a popular subject, it is true, and in contemporary times, art has again become abstract. Yet most paintings and sculptures deal with the human form, treated in a more or less realistic way. This realism may seem so obvious as to be hardly worth stating, but it must be remembered that the art of peoples who were not influenced by the Greeks is very different. Islamic art, for example, deals almost exclusively in abstract design. Indian sculptors depicted their gods and heroes in human form, but they certainly did not treat them realistically. The Hindu god Shiva, for example, is often shown with many arms. It is a tribute to the Greeks' overwhelming influence on our culture that, from the Roman period to the beginning of the twenty-first century, artists have accepted the Greeks' decision to make the realistic treatment of the human form the central focus of art, whether the forms were those of mortal people or divine gods and goddesses.

The Greeks themselves did not achieve this naturalism overnight. The first depictions of human beings, which appear on Geometric vases shortly after 800 B.C., are highly stylized. They are painted in silhouette, and a single figure often combines front and side views, the head and legs being shown in profile while the upper half of the body is seen from the front. A number of the vases decorated with stick figures of this kind are of immense size. One of them, the *Dipylon Amphora*, is almost 5 feet (1.24 meters) tall [2.3]. These vases were set up over tombs to serve as grave markers; they had holes in their bases so that offerings poured into them could seep down to the dead below. The scenes on them frequently show the funeral ceremony. Others show processions of warriors, both on foot and in chariots.

CONTEMPORARY VOICES

Daily Life in the World of Homer

From the description of scenes on the shield of Achilles:

Next he showed two beautiful cities full of people. In one of them weddings and banquets were afoot. They were bringing the brides through the streets from their homes, to the loud music of the wedding-hymn and the light of blazing torches. Youths accompanied by flute and lyre were whirling in the dance, and the women had come to the doors of their houses to enjoy the show. But the men had flocked to the meeting-place, where a case had come up between two litigants, about the payment of compensation for a man who had been killed. The defendant claimed the right to pay in full and was announcing his intention to the people; but the other contested his claim and refused all compensation. Both parties insisted that the issue should be settled by a referee; and both were cheered by their supporters in the crowd, whom the heralds were attempting to silence. The Elders sat on the sacred bench, a semicircle of polished stone; and each, as he received the speaker's rod from the clear-voiced heralds, came forward in his turn to give his judgment, staff in hand. Two talents of gold were displayed in the center: They were the fee for the Elder whose exposition of the law should prove the best.

Homer, Iliad, trans. E. V. Rieu (Baltimore: Penguin, 1950), Book XVII, p. 349.

The Age of Colonization

Throughout the period of Homer and Geometric art, individual city-states were ruled by small groups of aristocrats who concentrated wealth and power in their own hands. Presumably, it is their graves that were marked with great amphoras like the *Dipylon* vase. By the eighth century B.C., however, two centuries of peace had allowed the individual city-states to become quite prosperous. The ruling classes became increasingly concerned with the image of their city-states. They began to function as patrons of the arts as well as military leaders. Great international festivals began to develop at Olympia, Delphi, and other sacred sites, at which athletes and poets—representing their city—would compete against one another.

During the seventh century, as trade with both fellow Greeks and other Near Eastern peoples increased, economic success became a crucial factor in the growth of a *polis;* individual cities began to mint their own coins shortly before 600 B.C. Yet political power remained in the hands of a small hereditary aristocracy, leaving a growing urban population increasingly frustrated. Both the accumulation of wealth and the problem of overpopulation produced a single result: colonization.

Throughout the eighth and seventh centuries B.C., enterprising Greeks went abroad either to make their fortunes or to increase them. To the west, Italy and Sicily were colonized and Greek cities established there. Some of these, like Syracuse in Sicily or Sybaris in southern Italy, became even richer and more powerful than the mother cities from which the colonizers had come. Unfortunately if inevitably, the settlers took with them not only the culture of their polis but also their intercity

2.3 *Dipylon Amphora*, c. 750 B.C. Height 4'11" (1.24 m). National Archaeological Museum, Athens. This immense vase originally was a grave marker. The main band, between the handles, shows the lying-in-state of the dead man on whose grave the vase stood; on both sides of the bier are mourners tearing their hair in grief. Note the two bands of animals, deer and running goats, in the upper part of the vase.

rivalries, often with disastrous results. To the south and east, cities were also established in Egypt and on the Black Sea.

The most significant wave of colonization was that which moved eastward to the coast of Asia Minor, in some cases back to territory that had been inhabited by the Mycenaeans centuries earlier. From here the colonizers established trade contacts with peoples in the ancient Near East, including the Phoenicians and the Persians. Within Greece itself the effect on art and life of this expansion to the east was immense. After almost three hundred years of cultural isolation, in a land cut off from its neighbors by mountains and sea, the Greeks were brought face to face with the immensely rich and sophisticated cultures of the ancient Near East. Oriental ideas and artistic styles were seen by the colonizers and carried home by the traders. A growing quantity of Eastern artifacts, ivories, jewelry, and metalwork was sent back to the mother cities and even to the Greek cities of Italy. So great was the impact of Near Eastern art on the Greeks from the late eighth century to around 600 B.C. that this period and its style are generally known by the name Orientalizing.

THE VISUAL ARTS AT CORINTH AND ATHENS

Different Greek cities reacted to Oriental influences in different ways, although all were strongly influenced. In particular, the growing hostility between the two richest city-states—Athens and Corinth—which two centuries later led to the Peloponnesian War and the fall of Athens, seems already symbolized in the strong differences between their Orientalizing pottery. The Corinthian artists developed a miniature style that made use of a wide variety of Eastern motifs—sphinxes, winged human figures, floral designs—all of which were arranged in bands covering almost the entire surface of the vase. White, yellow, and purple were often used to highlight details, producing a bold and striking effect. After the monotony of Geometric pottery the variety of subject and range of color come as a welcome change.

The small size of the pots made them ideal for export. Corinthian vases have in fact been discovered not only throughout Greece but also in Italy, Egypt, and the Near East. Clearly, any self-respecting woman of the seventh century B.C. wanted an elegant little Corinthian flask [2.4] for her perfume, oil, or makeup. The vases are well made, the figures lively, and the style instantly recognizable as Corinthian—an important factor for commercial success. Corinth's notable political and economic strength throughout the seventh and early sixth centuries B.C. was, in fact, built on the sale of these little pots and their contents.

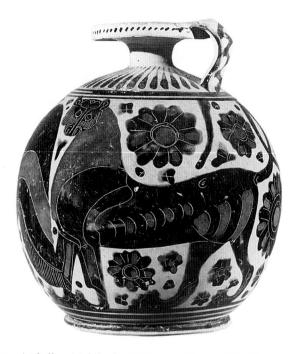

2.4 Aryballos, Middle Corinthian, c. 625 B.C. State Museums, Berlin. The black-figure techniques and the very Eastern-looking panther are characteristic of the Orientalizing style. Also characteristic are the flowerlike decorations, which are blobs of paint scored with lines. The musculature and features of the panther are also the result of scoring.

In Athens, potters were slower to discard the effects of the Geometric period and less able to develop an all-purpose style like the Corinthian. The vases remain large and the attempts to depict humans and animals are often clumsy. The achievements of later Athenian art are

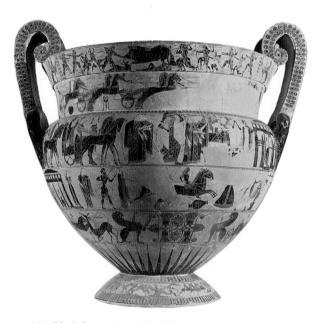

2.5 Attic Black-figure krater (the "François Vase") by Clitias and Ergotimos, c. 575 B.C. Archaeological Museum, Florence.

nonetheless clearly foreshadowed in the vitality of the figures and the constant desire of the artists to illustrate events from mythology [2.5] or daily life rather than simply to decorate a surface in the Corinthian manner.

By 600 B.C., the narrative style had become established at Athens. As the Athenians began to take over an increasing share of the market for painted vases and their contents, Corinth's position declined, and the trade rivalry that later had devastating results began to develop.

THE BEGINNINGS OF GREEK SCULPTURE

The influence of Near Eastern and Egyptian models on Greek sculpture and architecture is more consistent and easier to trace than that of pottery. The first Greek settlers in Egypt were given land around the mid-seventh century B.C. by the Egyptian pharaoh Psammetichos I. It is surely no coincidence that the earliest Greek stone sculptures, which date from about the same period, markedly resemble Egyptian cult statues and were placed in similarly grandiose temples. (The earliest surviving temple, that of Hera at Olympia, dates at least in part to this period.) These stone figures consist of a small number of subjects repeated over and over. The most popular were the standing female, or kore, clad in drapery [2.6]; and the standing male, or kouros, always shown nude [2.7]. This nudity already marks a break with the Egyptian tradition in which figures wore loincloths and foreshadows the heroic male nudity of Classical Greek art. The stance of the kouros figures, however, was firmly based on Egyptian models. One foot (usually the left) is forward, the arms are by the sides, and the hands are clenched. The elaborate wiglike hair is also Egyptian in inspiration.

By 600 B.C., only a few years after the first appearance of these statues, Greek art had reached a critical stage. After the slow and cautious progress of the Geometric period, the entire character of painting and sculpture had changed and, within the century following 700 B.C., Greek artists had abandoned abstract design for increasing realism. At this point in their development the Greek spirit of independence and inquiry asserted itself. Instead of following their Eastern counterparts and repeating the same models and conventions for centuries, Greek painters and sculptors allowed their curiosity to lead them in a new direction, one that changed the history of art. The early stone figures and painted silhouettes had represented human beings, but only in a schematic, stylized form. Beginning in the Archaic period artists used their work to try to answer such questions as: What do human beings really look like? How do perspective and foreshortening work? What in fact is the true nature of appearance? For the first time in history

2.6 *Kore* from Delos, dedicated by Nikandre, c. 650 B.C. Marble, National Archaeological Museum, Athens. Photo DAI Athens, Hege 1100. Unlike the kouros, the figure is completely clothed, although both have the same rigid stance, arms by sides, and wiglike hair.

artists began to reproduce the human form in a way true to nature rather than merely to echo the achievements of their predecessors.

Sculpture and Painting in the Archaic Period

It is tempting to view the works of art and literature of the Archaic period (600–480 B.C.) as steps on the road that leads to the artistic and intellectual achievement in

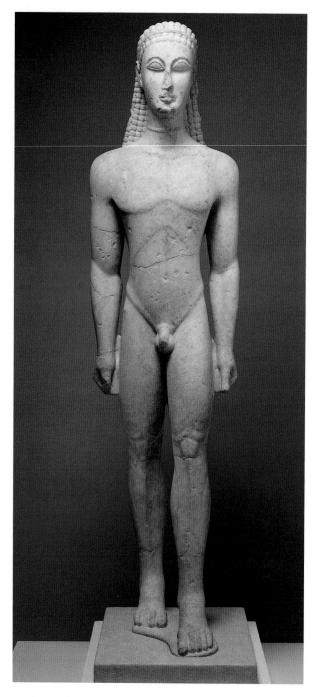

2.7 *Kouros,* from Attica, c. 600 B.C. Marble, height $6'1^{1}/_{2}''$ (1.87 m). The Metropolitan Museum of Art, Fletcher Fund, 1932.

the Classical Age of the fifth and fourth centuries B.C. rather than to appreciate them for their own qualities. This would be to underestimate seriously the vitality of one of the most creative periods in the development of our culture. In some ways, in fact, the spirit of adventure, of striving toward new forms and new ideas, makes the Archaic achievement more exciting, if less perfected, than that of the Classical period. It is better to travel hopefully than to arrive, as Robert Louis Stevenson put it.

The change in Archaic art is a reflection of similar social developments. The hereditary aristocrats were beginning to lose their commanding status. At Athens, Solon (c. 639–559 B.C.), the legislator and poet, reformed the legal system in 594 B.C., and divided the citizens into four classes; members of all four could take part in the debates of the Assembly and sit in the law courts. In place of the old aristocratic clans, a new class of rich merchant traders, who had made their fortunes in the economic expansion, began to dominate, winning power by playing on the discontent of the oppressed lower classes. These new rulers were called "tyrants," although the word had none of the unfavorable implications it now has. Many of them were in fact patrons of the arts. The most famous of them all was Pisistratus, who ruled Athens from 546 until 528 B.C. Clearly, revolutions like those that brought him and his fellow tyrants to power were likely to produce revolutionary changes in the arts.

In sculpture there was an astounding progress from the formalized *kouroi* of the early Archaic period, with their flat planes and rigid stances, to the fully rounded figures of the late sixth century, toward the end of the period. Statues like the *Anavysos Kouros* [2.8] show a careful study of the human anatomy. The conventions remain the same, but the statues have a new life and vigor.

Although most of the male figures are shown in the traditional stance, there are a few important exceptions. The finest is perhaps the famous *Calf-Bearer* [2.9] from the Athenian Acropolis (the hill that dominated the center of ancient Athens). The essential unity between man and beast is conveyed simply but with great feeling by the diagonals formed by the man's hands and the calf's legs and by the alignment of the two heads.

The finest female figures of the period also come from the Acropolis. The Persians broke them when they sacked Athens in 480 B.C., and then the Athenians buried them when they returned to their city the next year after defeating the Persians. Rediscovered by modern excavators, the statues are among the most impressive of Archaic masterpieces. They show a gradual but sure development from the earliest *korai* (the plural form of *kore*) to the richness and variety of the work of the late sixth century B.C. [2.10].

In addition to these freestanding figures, two other kinds of sculpture now appeared: large-scale statues made to decorate temples and carved stone slabs. In both cases sculptors used the technique of *relief* carving: Figures do not stand freely, visible from all angles, but are carved into a block of stone, part of which is left as background. In *high relief* the figures project from the background so much as to seem almost three-dimensional. In *low relief* the carving preserves the flat surface of the stone. Temple sculpture or, as it is often called, architectural sculpture, was frequently in high relief, as in the depiction of the decapitation of Medusa from Selinus [2.11]. Individual carved stone slabs are generally in low relief. Most that have survived were used as grave mark-

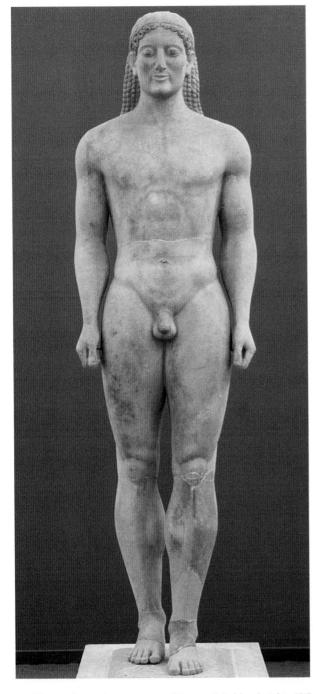

2.8 *Kouros* from Anavysos, c. 530 B.C. Marble, height 6'4" (1.93 m) high. National Archaeological Museum, Athens. Note the realism of the muscles and the new sense of power. According to the inscription on the base, this was the funerary monument to a young man, Kroisos, who had died heroically in battle.

ers. The workmanship is often of a remarkable subtlety, as on the grave stele, or gravestone, of Aristion [2.12].

The range of Archaic sculpture is great, and the best pieces communicate something of the excitement of their makers in solving new problems. Almost all of them, however, have in common one feature that often disturbs the modern viewer: the famous "archaic smile." This facial expression, which to our eyes may seem more like a

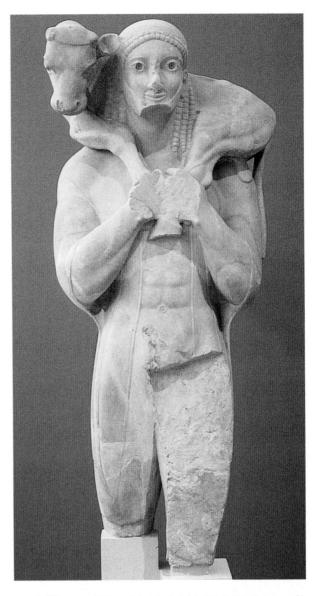

2.9 *Calf-Bearer*, c. 550 B.C. Marble, height 5'6" (1.65 m). Acropolis Museum, Athens. The archaic smile is softened in this figure. Realism appears in the displacement of the man's hair by the animal's legs and in the expression of the calf.

grimace, has been explained in a number of ways. Some believe that it is merely the result of technical inexperience on the part of the sculptors. Others see it as a reflection of the Archaic Greeks' sense of certainty and optimism in facing a world that they seemed increasingly able to control. Whatever its cause, by the end of the sixth century B.C., and with the increasing threat posed by the Persians, the archaic smile had begun to fade. It was replaced by the more somber expression of works like the Kritios Boy [2.13]. This statue marks a literal "turning point" between the late Archaic world and the early Classical period. For the first time in ancient art the figure is no longer looking or walking straight ahead. The head and the upper part of the body turn slightly; as they do so, the weight shifts from one leg to the other and the hips move. Having solved the problem of

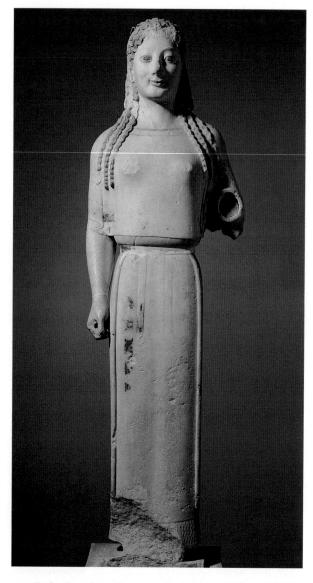

2.10 *Peplos Kore,* from the Acropolis, Athens, c. 530 B.C. Marble, approx. 4' (1.21 m) high. Acropolis Museum, Athens. The statue is identified by the woolen *peplos* (mantle) the woman is wearing over her dress. The missing left arm was extended. The Greeks painted important parts of their stone statues; traces of paint show here.

representing a standing figure in a realistic way, the sculptor has tackled a new and even more complex problem—showing a figure in motion. The consequences of this accomplishment were explored to the full in the Classical period.

By the mid-sixth century B.C. the art of vase painting had also made great progress. Works like those of Exekias, perhaps the greatest of black-figure painters, combine superb draftsmanship and immense power of expression [2.14]. For so restricted a medium, vase painting shows a surprising range. If Exekias' style is serious, somber, sometimes even grim, the style of his contemporary, the Amasis painter, is relaxed, humorous, and charming.

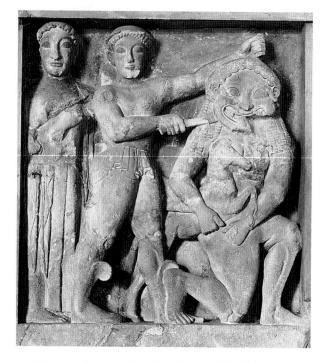

2.11 Metope showing the decapitation of Medusa, Selinus, c. 540 B.C. Archaeological Museum, Palermo. Medusa was a gorgon whose look turned anyone to stone. Perseus is cutting off Medusa's head with the encouragement of Athena, who stands at left. The gorgon's son Pegasus, the winged horse, leaps up at her side. Medusa is shown in the conventional pose indicating rapid motion.

The end of the sixth century B.C. marks a major development in vase painting with the introduction of the new *red-figure style*. This showed the figures in the red color of the clay, with details filled in using a brush. The increased subtlety made possible by this style was used to develop new techniques of foreshortening, perspective, and three-dimensionality.

Although some artists continued to produce blackfigure works, by the end of the Archaic period, around 525 B.C., almost all had turned to the new style. The last Archaic vase painters are among the greatest red-figure artists. Works like the *Euphronios Vase* [2.15] have a solidity and monumentality that altogether transcend the usual limitations of the medium.

Architecture: The Doric and Ionic Orders

Orders of Architecture

In architecture, the Archaic period was marked by the construction of a number of major temples in the Doric

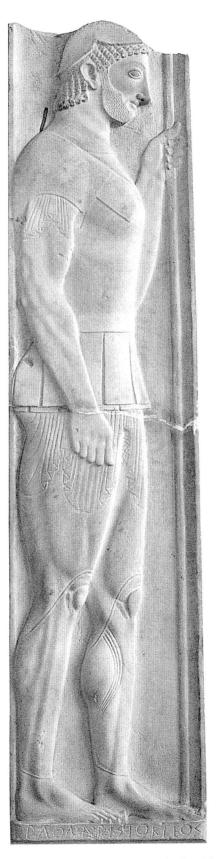

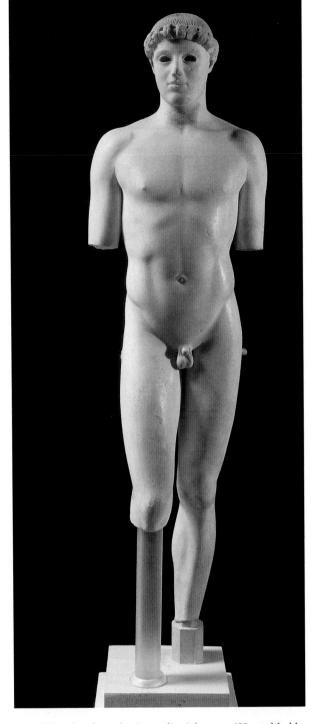

2.13 *Kritios Boy,* from the Acropolis, Athens, c. 490 B.C. Marble, height 34" (86 cm). Acropolis Museum, Athens. The archaic smile has been superseded by a more natural expression.

style or order. As in the case of sculpture, Egyptian models played an important part in the early development of the Greek style. The first architect in history whose name has come down to us was the Egyptian Imhotep. The earliest Egyptian buildings made use of bundles of

2.12 Aristokles, *Stele of Aristion*, c. 510 B.C. Height without base 8' (2.44 m). National Archaeological Museum, Athens. The leather jacket contrasts with the soft folds of the undershirt.

2.14 Exekias, *The Suicide of Ajax*, c. 525 B.C. Black-figure vase, height $21^{1}/_{4}^{"}$ (54 cm). Musée des Beaux-Arts, Boulogne. Ajax buries his sword in the ground so that he can throw himself on to it. The pathos of the warrior's last moments is emphasized by the empty space around him, the weeping tree, and his now useless shield and helmet.

papyrus to form posts; from these there soon developed the stone post-and-lintel constructions characteristic of Egyptian architecture. Buildings in this style probably inspired the first Greek temples.

2.15 Euphronios, painter, Euxitheos, potter, red-figure calyx krater, side A, Sarpedon carried by Thanatos and Hypnos, c. 515 B.C. Terra cotta, height of vase 18" (46 cm), diameter 21³/₄" (55 cm). Metropolitan Museum of Art, bequest of Joseph H. Durkee, gift of Darius Ogden Mills, and gift of C. Ruxton Love, by exchange, 1972 (1972.11.10). This masterpiece of red-figure vase painting, generally known as the *Euphronios Vase*, shows the moment when Sarpedon falls in battle during the Trojan War. As his body stiffens in agony, his wounds streaming blood, the twin gods Death (on the right) and Sleep come to his aid. The god Hermes, who leads the souls of the dead to Hades, stands sympathetically behind.

The Doric order seems to have been firmly established by 600 B.C., although none of the earlier examples of the evolving style have survived. Important Doric temples include the Temple of Hera at Olympia, the Temple of Apollo at Corinth, and the earliest of the three Doric temples at Paestum, often called the Basilica (meeting hall), but now known to have been dedicated to the goddess Hera [2.16]. The Ionic style of temple architecture, which was widely used in Classical Greece, did not become fully established until later. In the Archaic period, Ionic buildings were constructed at such sites as Samos and Ephesus, but most Ionic temples date to the fifth century B.C. and later. For the sake of convenience, both the Doric and Ionic orders [2.17] are described here. A later order, the Corinthian, is principally of interest for its popularity with Roman architects and is discussed in that context in Chapter 4.

The Doric order is the simpler and the grander of the two. Some of its characteristics seem directly derived from construction methods used in earlier wooden buildings, and its dignity is perhaps in part related to the length of its history. Doric columns have no base but rise directly from the floor of a building. They taper toward the top and have twenty flutes, or vertical grooves. The capital, which forms the head of each column, consists of two sections, a spreading convex disc (the echinus) and, above, a square block (the *abacus*). The upper part of the temple, or entablature, is divided into three sections. The lowest, the architrave, is a plain band of rectangular blocks, above which is the *frieze*, consisting of alternating triglyphs and metopes. The triglyphs are divided by grooves into three vertical bands. The metope panels are sometimes plain, sometimes decorated with sculpture or painting. The building is crowned by a cornice, or projecting upper part, consisting of a horizontal section and two slanting sections meeting at a peak. The long extended triangle thus formed is the *pediment*, often filled with sculptural decoration.

In contrast, the Ionic order is more graceful and more elaborate in architectural details. Ionic columns rise from a tiered base and have twenty-four flutes. These flutes do not meet at a sharp angle as Doric flutes do but are separated by narrow vertical bands. The capitals consist of a pair of spirals, or *volutes*. The architrave is not flat as in the Doric order but composed of three projecting bands. In place of the Doric triglyphs and metopes is a continuous band often decorated with a running frieze of sculpture.

The two orders produced different effects. The Doric order suggested simple dignity; the absence of decorative detail drew attention to the weight and massiveness of the Doric temple itself. Ionic temples, on the other hand, conveyed a sense of lightness and delicacy by means of ornate decorations and fanciful carving. The surface of an Ionic temple is as important as its structural design.

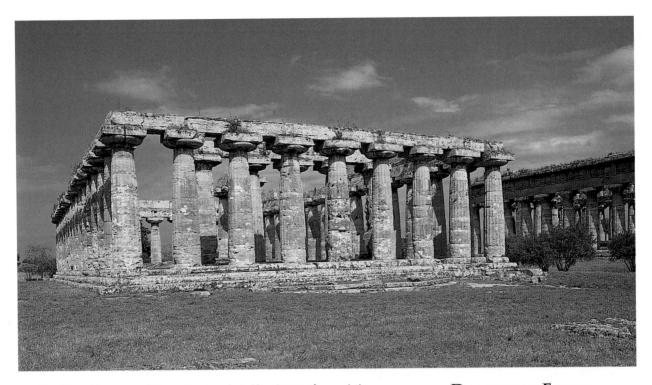

2.16 Basilica at Paestum, c. 550 B.C. This temple to Hera is one of the earliest surviving Greek temples. The bulging columns and spreading capitals are typical of Doric architecture in the period. To the right is the Temple of Neptune.

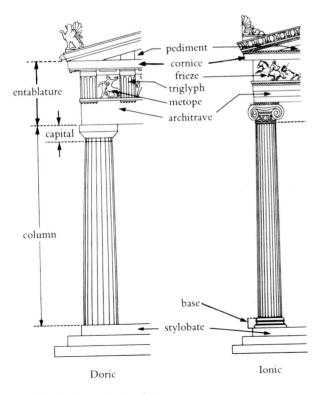

2.17 The Doric and Ionic orders.

Music and Dance in Early Greece

In comparison to the visual arts, the history of Greek music is highly problematic. The very small quantity of evidence is as confusing as it is helpful. Although the frequent references to musical performance make it clear that music played a vital role in all aspects of Greek life, less than a dozen fragments of actual Greek music have survived; the earliest of these dates from the late fifth century B.C. Unfortunately, the problem of understanding the system of notation makes authentic performance of these fragments impossible.

Our inability to recreate even the examples we have is particularly frustrating because from the earliest times music was renowned for its emotional and spiritual power. For the Greeks, music was of divine origin; the gods themselves had invented musical instruments: Hermes or Apollo the lyre, Athena the flute, and so on. Many of the earliest myths told of the powerful effect of music. Orpheus could move trees and rocks and tame wild beasts by his song; the lyre playing of Amphion brought stones to life. Nor was music making reserved for professional performers or women, as so often in later centuries. When, in Book IX of the Iliad, Agamemnon's ambassadors arrive at the tent of Achilles they find the great hero playing a lyre, "clear-sounding, splendid and carefully wrought," and entertaining himself by singing "of men's fame." How one would like to have heard that song!

The Greek belief that music could profoundly affect human behavior meant that it played an important part

2.18 Berlin painter, detail of red-figure amphora, Nola, c. 490 B.C. Terra cotta, height of vase $16\frac{3}{8}''$ (42 cm). Metropolitan Museum of Art, New York (Fletcher Fund, 1956). This vase gives a good idea of the Greeks' enthusiasm for music in general and the cithara in particular. The young musician is singing to his own accompaniment.

in both public and private life and was especially important in a religious context. Greek musical theory was later summarized by the two great philosophers of the fourth century B.C., Plato and Aristotle, both of whom discuss the doctrine of *ethos* and give music an important place in their writings. An understanding of doctrines of musical theory was also considered fundamental to a good general education.

Greek music was composed using a series of distinct modes, or scale types, each of which had its own name (see Chap. 3, "Greek Music in the Classical Period"). According to the doctrine of ethos, the characteristic of each mode was so powerful that it gave music written in it the ability to affect human behavior in a specific way. Thus, the *Dorian* mode expressed firm, powerful, even warlike feelings; whereas the *Phrygian* mode produced passionate, sensual emotions. This identification of specific note patterns with individual human reactions seems to reach back to the dawn of Greek music history. The legendary founder of Greek music was Olympus, who was believed by the Greeks to have come from Asia Minor; it is surely no coincidence that two of the modes—the Phrygian and the Lydian—bear names of places in Asia Minor.

The first figure in music about whose existence we can be relatively certain was Terpander, who came from the island of Lesbos. Around 675 B.C., he used the *cithara*, an elaborate seven-string lyre, to accompany vocal music on ceremonial occasions. The simple lyre, relatively small and easy to hold, had a sounding box made of a whole tortoise shell and sides formed of goat horns or curved pieces of wood. On the other hand, the cithara had a much larger sounding box made of wood, metal, or even ivory, and broad, hollow sides, to give greater resonance to the sound. The player had to stand while performing on it; the instrument had straps to support it, leaving the player's hands free [2.18].

Another musical instrument developed about this time was the *aulos*, a double-reed instrument [2.19] similar to the modern oboe, which according to the traditional account had first been brought into Greece by Olympus. Like the cithara and lyre, the aulos was generally used by singers to accompany their songs.

The little evidence we have suggests that early Greek music was primarily vocal—the instruments were used

2.19 Karneia painter, detail of red-figure krater, Ceglie del Campo, c. 410 B.C. Terra cotta. Museo Nazionale, Taranto. A young woman plays the aulos for the god Dionysus. The flowing lines of the dress accentuate her figure. The necklace and bracelets are in low relief.

mainly to accompany the singers. The breakthrough into purely instrumental music seems to have come at the beginning of the Archaic period. We know that in 586 B.C. Sacadas of Argos composed a work to be played on the aulos for the Pythian Games at Delphi—a piece that remained well known and popular for centuries. Also, its character confirms the Greek love of narrative, for it described in music Apollo's fight with the dragon that the Pythian Games commemorated. The information is tantalizing indeed, since this first piece of "program music," the remote ancestor of Richard Strauss' *Till Eulenspiegel* and *Don Quixote*, must have been highly effective for its appeal to have lasted so long.

We know little more of the music of the Archaic period than these odd facts. The lyrics of some of the songs have survived, including some of the choral odes performed in honor of various gods. Apollo and his sister Artemis were thanked for delivery from misfortune by the singing of a paean, or solemn invocation to the gods; whereas the dithyramb, or choral hymn to Dionysus, was sung in his honor at public ceremonies. Also closely tied to music was dance, which played a significant part as well in the development of drama. Our knowledge of Greek dance is limited to visual evidence. For example, we have from as early as the late Geometric period actual depictions of dances in progress [2.20]. On the other hand, in the Classical period the function of dance remained religious and social, and was rarely described in writing, whereas a vast literature on music theory developed, with philosophical implications that became explicit in the writings of Plato and Aristotle; through this literature some information on early music has been preserved.

What we do know about dancing and individual dances suggests that here, as in music and visual arts, telling a story was important. One famous dance was

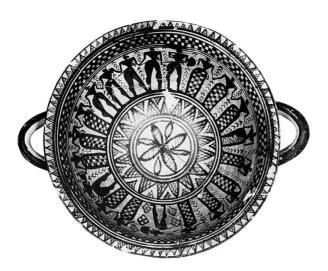

2.20 Geometric bowl showing dancing, c. 740 B.C. Diameter $6^{1}_{4}^{\prime\prime}$ (16 cm). National Archaeological Museum, Athens. The dancers include both women and men, three playing lyres.

called the *geranos*, from the word for "crane." The dancers apparently made movements like those of the bird, but the steps of the dance had a more specific meaning. According to tradition, it was first performed by Theseus outside the Labyrinth with the boys and girls he had saved by killing the Minotaur. The intricate patterns of the dance were supposed to represent the Labyrinth itself. Having accomplished two dangerous feats—killing the Minotaur and finding his way out of the Labyrinth—Theseus stayed around long enough to lead a complicated performance. Dancing was obviously of great importance to the Greeks.

EARLY GREEK LITERATURE AND Philosophy

Our knowledge of literary developments between the time of Homer and the Archaic period is very limited. An exception is Hesiod, who probably lived shortly before 700 B.C. He is the author of a poetic account of the origins of the world called the *Theogony* and a rather more down-to-earth long poem, the *Works and Days*, which mainly concerned the disadvantages in being a poor, oppressed (and depressed) farmer in Boeotia, where the climate is "severe in winter, stuffy in summer, good at no time of year." In the Archaic period, however, the same burst of creative energy that revolutionized the visual arts produced a wave of new poets. The medium they chose was lyric verse.

Lyric Poetry

The emergence of lyric poetry was, like developments in the other arts, a sign of the times. The heroic verse of Homer was intended for the ruling class of an aristocratic society, which had the leisure and the inclination to hear of the great and not so great deeds of great men and who were interested in the problems of mighty leaders like Agamemnon and Achilles. Lyric verse is concerned above all else with the poet's own feelings, emotions, and opinions. The writers of the sixth century B.C. do not hesitate to tell us how they themselves feel about life, death, love, drinking too much wine, or anything else that crosses their minds. Heroes and the glories of battle are no longer the ideal.

Above all other Greek lyric poets, Sappho has captured the hearts and minds of the following ages. She is the first woman to leave a literary record that reflects her own personal experiences. Her poems have survived only in fragmentary form, and the details of her life remain confused and much disputed. We must be grateful, then, for what we have and not try to overinterpret it.

Sappho was born around 612 B.C. on the island of Lesbos, where she spent most of her life. She seems to have

been able to combine the roles of wife and mother with those of poet and teacher; within her own lifetime she was widely respected for her works and surrounded by a group of younger women who presumably came to Lesbos to finish their education, in much the same way that Americans used to go to Paris for a final cultural polish.

The affection between Sappho and her pupils was deep and sincere and is constantly reflected in her poems. The nature of this affection has been debated for centuries. The plain fact is that apart from her poetry we know almost nothing about Sappho herself. Even her appearance is debatable; she is described by one ancient authority as "beautiful day" and by another as short, dark, and ugly. Her fellow poet Alcaeus calls her "violethaired, pure, and honey-smiling." Thus, those who read Sappho must decide for themselves what the passion of the poems expresses, for passionate they certainly are. Perhaps Sappho's greatest quality lies in her ability to probe the depths of her own responses and by describing them to understand them. Just as contemporary sculptors and painters sought to understand the workings of their own bodies by depicting them, so Sappho revealed both to herself and to us the workings of her emotions.

The First Philosophers: The Presocratics

The century that saw the expression of the intimate self-revelations of lyric poetry was marked by the development of rational philosophy, which challenged the traditional religious ideas of Homer and Hesiod and scoffed at gods who took human form. If horses and cows had hands and could draw, they would draw gods looking like horses and cows, wrote Xenophanes of Colophon in the second half of the sixth century B.C.

The word *philosophy* literally means "love of wisdom," but in the Western tradition it usually refers to inquiries into the nature and ultimate significance of the human experience. Ever since the Archaic period philosophers have spent some two and a half millennia debating the question: "What is philosophy?" Some of its branches are logic (the study of the structure of valid arguments); metaphysics (investigation into the nature of ultimate reality); epistemology (theory of knowledge); ethics (moral philosophy); aesthetics (the philosophy of the arts and, more generally, taste); and political philosophy.

For the first time in history, the philosophers of the Archaic period turned away from religious teachings; they used the power of human reason to try to discover how the world came into being and how it works, and to understand the place of humans in it. A wide variety of schools of thought developed, which is collectively described by the somewhat confusing label *Presocratics*. The label is accurate in that they all lived and died before the time of Socrates (469–399 B.C.), who, together with his pupil Plato (c. 427–347 B.C.), are the greatest names in Greek philosophy. On the other hand, these sixth-century

philosophers had little in common with one another except the time in which they lived. Thus it is important to remember that the term Presocratic does not describe any single philosophical system. Indeed, many of the socalled Presocratic philosophers, with their studies into the origins of the world and the workings of nature, were examining questions that we would consider scientific rather than philosophical. The various schools were united principally by their use of logic and theoretical reasoning to solve practical questions about the world and human existence.

The earliest school to develop was that of the *Materialists*, who sought to explain all phenomena in terms of one or more elements. Thales of Miletus (c. 585 B.C.), for example, thought that water alone underlay the changing world of nature. However absurd Thales' theory was, his notion that the world had evolved naturally, rather than as a result of divine creation, was revolutionary. He also began the Greek tradition of free discussion of ideas in the marketplace and other public areas. Intellectual exchange was no longer limited to an educated elite or a priestly class. In this way, as with his rejection of traditional religion, Thales and his successors created a fundamental breakaway from the traditional values of Homeric society.

Later, Empedocles of Acragas (c. 495 B.C.) introduced four elements—fire, earth, air, water. The varying combinations (through love) and separations (through strife and war) of these elements in a cyclical pattern explained how creatures as well as nations were born, grew, decayed, and died. Anaxagoras of Clazomenae (c. 500 B.C.) postulated an infinite number of small particles, which, however small they might be, always contained not only a dominant substance (for example, bone or water) but also stray bits of other substances in lesser quantities. Unity in nature, he claimed, came from the force of Reason.

The Presocratic philosopher who had the greatest influence on later times was Pythagoras of Samos (c. 550 B.C.). He left his home city for political reasons and settled in southern Italy, where he founded a school of his own. He required his followers to lead pure and devout lives, uniting together to uphold morals and chastity, as well as order and harmony, for the common good. These apparently noble principles did nothing to win him favor from the people among whom he had settled; according to one account he and three hundred of his followers were murdered.

Pythagoras

It is difficult to know which of the principles of *Pythagoreanism* can be directly attributed to Pythagoras himself and which were later added by his disciples. His

chief religious doctrines seem to have been belief in the transmigration of souls and the kinship of all living things; teachings that led to the development of a religious cult that bore his name. In science, his chief contribution was in mathematics. He discovered the numerical relationship of musical harmonies. Our modern musical scale, consisting of an *octave* (a span of eight tones) divided into its constituent parts, derives ultimately from his researches. Inspired by this discovery, Pythagoras went on to claim that mathematical relationships represented the underlying principle of the universe and of morality, the so-called harmony of the spheres. He is chiefly remembered today for a much less cosmic discovery, the geometrical theorem that bears his name.

In contrast to Pythagoras' belief in universal harmony, the *Dualists* claimed that there existed two separate universes: the world around us, subject to constant change; and another ideal world, perfect and unchanging, which could be realized only through the intellect. The chief proponent of this school was Heraclitus of Ephesus (c. 500 B.C.) whose cryptic pronouncements won him the label "the Obscure." He summed up the unpredictable, and therefore unknowable, quality of Nature in the wellknown saying, "It is not possible to step twice into the same river." Unlike his predecessors who had tried to understand the fundamental nature of matter, Heraclitus thus drew attention instead to the process whereby matter changed.

Parmenides of Elea (c. 510 B.C.), on the other hand, went so far as to claim that true reality can only be apprehended by reason and is all-perfect and unchanging, without time or motion. Our mistaken impressions come from our senses, which are flawed and subject to error. As a result, the world which we perceive through them, including the processes of time and change, is a sham and a delusion. His younger pupil, Zeno (c. 490 B.C.), presented a number of difficult paradoxes in support of their doctrines. These paradoxes were later discussed by Plato and Aristotle.

The last and perhaps the greatest school of Presocratic philosophy was that of the *Atomists*, led by Leucippus and Democritus (c. 460 B.C.), who believed that the ultimate, unchangeable reality consisted of atoms (small "indivisible" particles not obvious to the naked eye) and the void (nothingness). Atomism survived into Roman times in the later philosophy of Epicureanism and into the nineteenth century in the early Atomic Theory of John Dalton. Even in the recent past, the great physicist Werner Heisenberg (1901–1976), who astonished the world of science with his discoveries in quantum mechanics, derived his initial inspiration from the Greek Atomists.

The various schools of Presocratic philosophers are often complex and difficult to understand. This is due to the kinds of questions they addressed, but also to the fragmentary nature of the texts in which their ideas have survived. Further, unlike all subsequent philosophers, they had no predecessors on whom to base their ideas or methods. Yet, through the cryptic phrases and often mysterious arguments, there shines a love of knowledge and a passionate search for answers to questions that still perplex humanity. And in their emphasis on the human rather than the divine they prefigure many of the most important stages in the development of the Western tradition, from Classical Athens to the Renaissance to the eighteenth-century Age of Reason. In the words of Protagoras (c. 485–415 B.C.), "Man is the measure of all things, of the existence of those that exist, and of the nonexistence of those that do not."

Herodotus: The First Greek Historian

At the beginning of the fifth century B.C. the Greeks had to face the greatest threat in their history. Their success in meeting the challenge precipitated a decisive break with the world of Archaic culture.

In 499 B.C., the Greek cities of Asia Minor, with Athenian support, rebelled against their Persian rulers. The Persian king Darius, succeeded in checking this revolt; he then resolved to lead a punitive expedition against the mainland Greek cities that had sent help to the eastern cities. In 490 B.C. he led a massive army to Greece; to everyone's surprise, the Persians were defeated by the Athenians at the Battle of Marathon. After Darius' death in 486 B.C., his son Xerxes launched an even more grandiose expedition in 480 B.C. Xerxes defeated the Spartans at Thermopylae and then attacked and sacked Athens itself. While the city was falling, the Athenians took to their ships, obeying an oracle that enjoined them to "trust to their wooden walls." Eventually they inflicted a crushing defeat on the Persian navy at nearby Salamis. In 479 B.C., after being conquered on land and sea, at Plataea and Mycale, the Persians returned home, completely beaten.

Battle of Marathon

The great historian Herodotus (484–420 B.C.) has left us, in his nine books of *History of the Persian Wars*, a detailed account of the closing years of the Archaic period. He also, however, has two other claims on our attention. He is the first writer in the Western tradition to devote himself to historical writing rather than epic or lyric poetry, a fact that has earned him the title Father of History. At the same time, he is one of the greatest storytellers, always sustaining the reader's interest in both the mainline of his narrative and the frequent and entertaining digressions. One of these, the tale of Rhampsinitus and the thief, has been described as the first detective story in Western literature. Herodotus was not a scientific historian in our terms—he had definite weaknesses. He never really understood the finer points of military strategy. He almost always interpreted events in terms of personalities, showing little interest in underlying political or economic causes. His strengths, however, were many. Although his subject involved conflict between Greeks and foreigners, he remained remarkably impartial and free from national prejudice. His natural curiosity about the world around him and about his fellow human beings was buttressed by acute powers of observation. Above all, he recorded as much information as possible, even when versions conflicted. He also tried to provide a reasonable evaluation of the reliability of his sources so later readers could form their own opinions.

Herodotus' analysis of the Greek victory was based on a serious philosophical, indeed theological, belief that the Persians were defeated because they were morally in the wrong. Their moral fault was *hubris* (excessive ambition); thus the Greeks' victory was at the same time an example of right over might and a demonstration that the gods themselves would guarantee the triumph of justice. In Book VII, Xerxes' uncle, Artabanus, warns him in 480 B.C. not to invade Greece: "You know, my lord, that amongst living creatures it is the great ones that Zeus smites with his thunder, out of envy of their pride. It is God's way to bring the lofty low. For He tolerates pride in none but Himself."

Modern readers, however, less influenced by Herodotus' religious beliefs, will be more inclined to draw a political message from the Persian defeat. The Greeks were successful at least partly because for once they had managed to unite in the face of a common enemy. Their victories inaugurated the greatest period in Greek history, the Classical Age.

SUMMARY

The Dawn of Greek Culture Shortly after 1000 B.C., Greek civilization began to develop. From the beginning, the Greek world was divided into separate city-states among which fierce rivalries would grow. For the first two centuries the Greeks had little contact with other peoples but, around 800 B.C., Greek travelers and merchants began to explore throughout the Mediterranean. The visual arts during these early centuries are principally represented by pottery decorated with geometric designs. The period also saw the creation of two of the greatest masterpieces of Western literature: the *lliad* and the *Odyssey*.

The Age of Colonization During the Age of Colonization (c. 750–600 B.C.) the Greeks came in contact with a wide range of foreign peoples. The ancient Near East, in particular, played a large part in influencing the development of Greek art and architecture. The decoration of pottery became Orientalizing in style, while large free-

standing sculpture based on Egyptian models began to evolve. Important Greek colonies began to develop in southern Italy and Sicily.

The Archaic Period The period from 600 B.C. to 480 B.C., known as the Archaic Age, was marked by political and cultural change. A new literary form, lyric poetry, became popular; one of its leading practitioners was the poetess Sappho. The so-called Presocratics began to develop a wide range of philosophical schools. Sculpture and vase painting both became increasingly naturalistic. The aristocratic rulers of earlier times were supplanted by "tyrants," rich merchant traders who depended on the support of the lower classes. In Athens, Solon's reform of the constitution introduced a form of democracy, which was overthrown by the tyrant Pisistratus in 546 B.C.

The Persian Wars Democratic government was restored at Athens in 510 B.C., and shortly thereafter the Greeks became embroiled with the mighty Persian empire to their east. In 499 B.C., the Greek cities of western Asia, established more than a century earlier, rebelled against their Persian rulers; the Athenians sent help. The Persians crushed the revolt and, in 490 B.C., the Persian king Darius led an expedition against the Greeks to punish them for their interference. Against all odds, the Persians were defeated at the Battle of Marathon. Darius, humiliated, was forced to withdraw, but ten years later Xerxes, his son, mounted an even more grandiose campaign to restore Persian honor. In 480 B.C. he invaded Greece, defeated Spartan troops at Thermopylae, and sacked Athens. The Athenians took to their ships, however, and destroyed the Persian navy at the Battle of Salamis.

The following year combined Greek forces defeated Xerxes' army on land, and the Persians returned home in defeat. Faced by the greatest threat in their history, the Greeks had managed to present a united front. Their victories set the scene for the Classical Age of Greek culture. A detailed account of the Greeks' success can be found in the *History of the Persian Wars* written by Herodotus, the first Greek historian and the earliest significant prose writer in Western literature.

Pronunciation Guide

Achilles:	A-KILL-ees
Agamemnon:	A-ga-MEM-non
Amphora:	AM-fo-ra
Aphrodite:	Af-ro-DIE-tee
Boeotia:	Bee-OWE-sha
Darius:	Dar-I-us
Dionysus:	Di-on-EES-us
Dithyramb:	DITH-ee-ram
Euphronius:	You-FRO-ni-us
Hera:	HERE-a
Herodotus:	Her-ODD-ot-us

Kore:	KO-ray
Laconia:	La-CONE-ee-a
Metope:	MET-owe-pe
Paestum:	PES-tum
Peloponnesian:	Pel-op-on-EASE-i-an
Phoenician:	Fun-EESH-i-an
Priam:	PRY-am
Sappho:	SAF-owe
Thales:	THAY-lees
Thermopylae:	Ther-MOP-u-lee
Triglyph:	TRIG-lif
Xerxes:	ZER-ksees

EXERCISES

- 1. What are the main features of the Homeric worldview? What effect do they have on the style of the Homeric epics?
- 2. Describe the development of Greek sculpture from the mid-seventh century to the end of the Archaic period.
- 3. What evidence has survived as to the nature of Greek music? What does it tell us about the Greeks' attitude to music?
- Discuss the principal schools of Presocratic philosophy.
- 5. What are the chief differences between the Doric and Ionic orders of architecture?

FURTHER READING

- Biers, William. (1996). The archaeology of Greece: An introduction (2nd ed.). Ithaca, NY: Cornell University Press. A good overall picture of the present state of our knowledge of the material remains of ancient Greece.
- Boardman, J. (1982). *The Greek overseas*. New York: Penguin Books. A vivid and informative account of the development and effects of Greek colonization.
- Bury, J. B., & R. Meiggs. (1975). *A history of Greece to the death of Alexander the Great* (4th ed.). New York: St. Martin's. The best single-volume history of ancient Greece.
- Cook, R. M. (1976). *Greek art*. Baltimore: Penguin. The best single-volume survey of all the visual arts in Greece, this book places them in their historical context.
- Fullerton, Mark D. (2000). *Greek art.* New York: Cambridge University Press. Perhaps the best recent survey of the range of Greek art.
- Hooker, J. T. (1980). *The ancient Spartans*. London: Methuen. A detailed study of a still relatively neglected subject; collects and interprets discoveries up to the time of its publication.
- Luce, J. V. (1975). *Homer and the heroic age*. New York: Harper & Row. A masterful account of the historical background of the Homeric epics, although the author's view that Homer's world reflects chiefly that of the Mycenaeans is by no means universally shared.
- Schups, K. (1979). Economic rights of women in ancient Greece. Edinburgh: Edinburgh University Press. By using modern research techniques to analyze a wide range of material, this book significantly enlarges our view of Greek society.
- Snodgrass, A. (1980). Archaic Greece. Berkeley: University of California Press. An important survey of the historical and archaeological evidence for a rich and complex period.

- Stansbury-O'Donnell. (1999). *Pictorial narratives in ancient Greek art.* New York: Cambridge University Press. This book examines one of the most characteristic and revolutionary aspects of Greek art, its ability to tell a story.
- Stewart, A. (1997). Art, desire and the body in ancient Greece. New York: Cambridge University Press. A fascinating study of Greek attitudes toward life, and their transformation into art.
- Vermeule, E. (1981). Aspects of death in early Greek art and poetry. Berkeley: University of California Press. In a sensitively written study, the author uses the visual arts and poetry to deal with themes that are, by their nature, difficult to pin down.

Online Chapter Links

The Ancient Vine at

http://ancient.thevines.com/

provides an extensive annotated list of links to Internet sites related to Greek studies.

The Shrine of the Goddess Athena at

www.goddess-athena.org

provides extensive information about the patroness of Athens, including a museum with countless exhibits, an atlas, a timeline, and numerous links to related Internet resources.

The Ancient Olympic Games are examined at http://www.perseus.tufts.edu/Olympics which features a tour of ancient Olympia as well as interesting stories about the athletes.

Biographical information about Sappho is available at

http://www.sappho.com/poetry/historical/sappho.html which also provides excerpts from her works as well as a bibliography.

Euesperides: An Ancient Greek Colony in North Africa at

http://www.ashmol.ox.ac.uk/ash/departments/ antiguities/euesperides/

reports about the archaeological research sponsored by Oxford University's Ashmolean Museum.

View the Cast Gallery at Oxford University's Ashmolean Museum at

http://www.ashmol.ox.ac.uk/ash/departments/ cast-gallery/

where Greek works are represented among this outstanding collection of casts derived from sculptures found in museums around the world.

Online Chapter Resources

Reading Selections

HOMER

from the Iliad, Book XV

The following long extract contains the crucial battle around the Greek ships, in which the Trojan prince Hector (Hektor) plays a decisive part. With Achilles still refusing to fight, despite Agamemnon's attempt to patch up their quarrel, the Trojans seem on the point of finally gaining the upper hand. Time after time, Hector leads his men within reach of the Greek ships, ready to set them on fire, and only mighty Greek counterattacks block his way. As casualties mount, the epic reaches its pivotal point. In the passage's last lines, only the stubborn courage of "great-hearted" Aias (Ajax) holds back the destruction of the entire Greek fleet. At the beginning of the next Book, Achilles' dearest friend Patroclus rushes to Achilles' tent in a desperate attempt to persuade him to reenter the fighting. Achilles' only concession is to lend Patroclus his own armor, and to send him into battle to give the impression that Achilles himself has returned. When Patroclus is in turn slain by Hector, Achilles-driven by rage and grief-hurls himself into the fighting and defeats Hector in single combat.

- The Achaians stood steady against the Trojan attack, but they could not
- beat the enemy, fewer as they were, away from their vessels,
- nor again had the Trojans strength to break the battalions of the Danaans, and force their way into the ships and the shelters.

410

420

430

But as a chalkline straightens the cutting of a ship's timber

in the hands of an expert carpenter, who by Athene's inspiration is well versed in all his craft's subtlety, so the battles fought by both sides were pulled fast and even.

Now by the ships others fought in their various places but Hektor made straight for glorious Aias. These two were fighting hard for a single ship, and neither was able, Hektor to drive Aias off the ship, and set fire to it, nor Aias to beat Hektor back, since the divinity drove him. Shining Aias struck with the spear Kaletor, Klytios' son, in the chest as he brought re to the vessel He fell, thunderously, and the torch dropped from his hand. Then

Hektor, when his eyes were aware of his cousin fallen in the dust in front of the black ship, uplifting his voice in a great cry called to the Trojans and Lykians: "Trojans, Lykians, Dardanians who fight at close quarters, do not anywhere in this narrow place give way from the fighting

but stand by the son of Klytios, do not let the Achaians strip the armor from him, fallen where the ships are assembled."

So he spoke, and made a cast at Aias with the shining spear, but missed him and struck the son of Mastor, Lykophron,

henchman of Aias from Kythera who had been living with him; for he had killed a man in sacred Kythera. Hektor struck him in the head above the ear with the sharp bronze

as he stood next to Aias, so that Lykophron sprawling dropped from the ship's stern to the ground, and his strength was broken.

- And Aias shuddered at the sight, and spoke to his brother:
- "See, dear Teukros, our true companion, the son of Mastor,
- is killed, who came to us from Kythera and in our household
- was one we honored as we honored our beloved parents.
- Now great-hearted Hektor has killed him. Where are your arrows
- of sudden death, and the bow that Phoibos Apollo gave you?"
- He spoke, and Teukros heard and came running to stand beside him
- holding in his hand the backstrung bow and the quiver to hold arrows, and let go his hard shots against the Trojans.

First he struck down Kleitos, the glorious son of Peisenor and companion of Poulydamas, proud son of Panthoös. Now Kleitos held the reins, and gave all his care to the

- horses,
- driving them into that place where the most battalions were shaken,
- for the favor of Hektor and the Trojans, but the sudden evil
- came to him, and none for all their desire could defend him,

for the painful arrow was driven into his neck from behind him.

He fell out of the chariot, and the fast-footed horses shied away, rattling the empty car; but Poulydamas

their master saw it at once, and ran first to the heads of the horses.

He gave them into the hands of Astynoös, Protiaon's

son, with many orders to be watchful and hold the horses

close; then himself went back into the ranks of the champions.

But Teukros picked up another arrow for bronze-helmed

- Hektor, and would have stopped his fighting by the ships of the Achaians
- had he hit him during his bravery and torn the life from him;
- but he was not hidden from the close purpose of Zeus, who was guarding

Hektor, and denied that glory to Telamonian Teukros;

who broke in the unfaulted bow the close-twisted sinew

as Teukros drew it against him, so the bronzeweighted arrow

- went, as the bow dropped out of his hands, driven crazily sidewise.
- And Teukros shuddered at the sight, and spoke to his brother:

"See now, how hard the divinity cuts across the intention in all our battle, who struck the bow out of my hand, who has broken

the fresh-twisted sinew of the bowstring I bound on this morning, so it would stand the succession of

springing arrows." Then in turn huge Telamonian Aias answered him:

- "Dear brother, then let your bow and your showering arrows
- lie, now that the god begrudging the Danaans wrecked them.
- But take a long spear in your hands, a shield on your shoulder,
- and close with the Trojans, and drive on the rest of your people.

460

450

440

540

550

Let them not, though they have beaten us, easily capture our strong-benched ships. We must remember the frenzy of fighting."

He spoke, and Teukros put away the bow in his shelter and threw across his shoulders the shield of the fourfold ox-hide.

- Over his mighty head he set the well-fashioned helmet
- with the horse-hair crest, and the plumes nodded terribly above it.
- Then he caught up a powerful spear, edged with sharp bronze,
- and went on his way, running fast, and stood beside Aias. But Hektor, when he saw how the arrows of Teukros were baffled,
- lifted his voice in a great cry to the Trojans and Lykians: "Trojans, Lykians, Dardanians who fight at close quarters, be men now, dear friends, remember your furious valor along the hollow ships, since I have seen with my

own eyes

- how by the hand of Zeus their bravest man's arrows were baffled.
- Easily seen is the strength that is given from Zeus to mortals
- either in those into whose hands he gives the surpassing glory, or those he diminishes and will not defend them as now he diminishes the strength of the Argives, and helps us.
- Fight on then by the ships together. He who among you finds by spear thrown or spear thrust his death and
- destiny, let him die. He has no dishonor when he dies defending
- his country, for then his wife shall be saved and his
- children afterwards, and his house and property shall not be damaged, if the Achaians
- must go away with their ships to the beloved land of their fathers."
- So he spoke, and stirred the spirit and strength in each man.
- But Aias on the other side called to his companions:
- "Shame, you Argives; here is the time of decision, whether
- we die, or live on still and beat back ruin from our vessels.
- Do you expect, if our ships fall to helm-shining Hektor,

you will walk each of you back dryshod to the land of your fathers?

Do you not hear how Hektor is stirring up all his people, how he is raging to set fire to our ships? He is not inviting you to come to a dance. He invites you to battle. For us there can be no design, no purpose, better than this one,

- to close in and fight with the strength of our hands at close quarters.
- Better to take in a single time our chances of dying or living, than go on being squeezed in the stark
 - encounter
- right up against our ships, as now, by men worse than we are."
- So he spoke, and stirred the spirit and strength in each man.
- There Hektor killed the son of Perimedes, Schedios, lord of the men of Phokis; but Aias killed Laodamas, leader of the foot-soldiers, and shining son of Antenor. Then Poulydamas stripped Otos of Kyllene, companion

- to Meges, Phyleus' son, and a lord among the greathearted
- Epeians. Meges seeing it lunged at him, but Poulydamas 520 bent down and away, so that Meges missed him. Apollo would not let Panthoös' son go down among the front fighters,
- but Meges stabbed with the spear the middle of the chest of Kroismos.
- He fell, thunderously, and Meges was stripping the armor
- from his shoulders, but meanwhile Dolops lunged at him, Lampos'
- son, a man crafty with the spear and strongest of the sons born
- to Lampos, Laomedon's son, one skilled in furious fighting.
- He from close up stabbed with his spear at the shield of Phyleides
- in the middle, but the corselet he wore defended him, solid
- and built with curving plates of metal, which in days past Phyleus
- had taken home from Ephyra and the river Seleëis.

A guest and friend had given him it, lord of men, Euphetes,

to carry into the fighting and beat off the attack of the enemy,

and now it guarded the body of his son from destruction. But Meges stabbed with the sharp spear at the uttermost summit

of the brazen helmet thick with horse-hair, and tore off the mane of horse-hair from the helmet, so that it toppled groundward and lay in the dust in all its new shining of purple.

- Yet Dolops stood his ground and fought on, in hope still of winning,
- but meanwhile warlike Menelaos came to stand beside Meges,
- and came from the side and unobserved with his spear, and from behind
- threw at his shoulder, so the spear tore through his chest in its fury
- to drive on, so that Dolops reeled and went down, face forward.
- The two of them swept in to strip away from his shoulders

the bronze armor, but Hektor called aloud to his brothers, the whole lot, but first scolded the son of Hiketaon,

- strong Melanippos. He in Perkote had tended his lumbering
- cattle, in the days before when the enemy were still far off;

but when the oarswept ships of the Danaans came, then he returned to Ilion, and was a great man among the Trojans,

- and lived with Priam, who honored him as he honored his children.
- Now Hektor spoke a word and called him by name and scolded him:
- "Shall we give way so, Melanippos? Does it mean nothing
- even to you in the inward heart that your cousin is fallen?
- Do you not see how they are busied over the armor of Dolops?
- Come on, then; no longer can we stand far off and fight with

510

500

480

ior

- He spoke, and led the way, and the other followed, a mortal
- godlike. But huge Telamonian Aias stirred on the Argives:
- "Dear friends, be men; let shame be in your hearts, and discipline,

570

580

590

- and have consideration for each other in the strong encounters,
- since more come through alive when men consider each other,
- and there is no glory when they give way, nor warcraft either."
- He spoke, and they likewise grew furious in their defense,
- and put his word away in their hearts, and fenced in their vessels
- in a circle of bronze, but Zeus against them wakened the Trojans.
- Then Menelaos of the great war cry stirred on Antilochos:

"Antilochos, no other Achaian is younger than you are, nor faster on his feet, nor strong as you are in

fighting.

- You could make an outrush and strike down some man of the Trojans."
- So speaking, he hastened back but stirred Antilochos onward,
- and he sprang forth from the champions and hefted the shining javelin,
- glaring round about him, and the Trojans gave way in the face
- of the man throwing with the spear. And he made no vain cast
- but struck Hiketaon's son, Melanippos the high-hearted, in the chest next to the nipple as he swept into the

fighting.

- He fell, thunderously, and darkness closed over both eves.
- Antilochos sprang forth against him, as a hound rushes against a stricken fawn that as he broke from his covert
- a hunter has shot at, and hit, and broken his limbs' strength.
- So Antilochos stubborn in battle sprang, Melanippos,
- at you, to strip your armor, but did not escape brilliant Hektor's
- notice, who came on the run through the fighting against him.
- Antilochus did not hold his ground, although a swift fighter,
- but fled away like a wild beast who has done some bad thing,
- one who has killed a hound or an ox-herd tending his cattle
- and escapes, before a gang of men has assembled against him;
- so Nestor's son ran away, and after him the Trojans and Hektor
- with unearthly clamor showered their groaning weapons against him.
- He turned and stood when he got into the swarm of his own companions.
- But the Trojans in the likeness of ravening lions swept on against the ships, and were bringing to accomplishment Zeus' orders,

who wakened always the huge strength in them, dazed the courage of the Argives, and denied their glory, and stirred on the others. Zeus' desire was to give glory to the son of Priam,

Hektor, that he might throw on the curved ships the inhuman

- weariless strength of fire, and so make completely accomplished
- the prayer of Thetis. Therefore Zeus of the counsels waited
- the sight before his eyes of the are, when a single ship burned.
- From thereon he would make the attack of the Trojans surge back again from the ships, and give the Danaans glory.
- With this in mind he drove on against the hollow ships Hektor,

Priam's son, though Hektor without the god was in fury and raged, as when destructive fire or spear-shaking Ares

- rages among the mountains and dense places of the deep forest.
- A slaver came out around his mouth, and under the lowering
- brows his eyes were glittering, the helm on his temples was shaken and thundered horribly to the fighting of
- Hektor.
- Out of the bright sky Zeus himself was working to help him
- and among men so numerous he honored this one man and glorified him, since Hektor was to have only a short life
- and already the day of his death was being driven upon him
- by Pallas Athene through the strength of Achilleus. And now
- he was probing the ranks of men, and trying to smash them,
- and made for where there were most men together, and the best armor.
- But even so he could not break them, for all his fury,
- for they closed into a wall and held him, like some towering

huge sea-cliff that lies close along the grey salt water and stands up against the screaming winds and their

- sudden directions
- and against the waves that grow to bigness and burst up against it.
- So the Danaans stood steady against the Trojans, nor gave way.
- But he, lit about with flame on all sides, charged on their numbers
- and descended upon them as descends on a fast ship the battering
- wave storm-bred from beneath the clouds, and the ship goes utterly
- hidden under the foam, and the dangerous blast of the hurricane
- thunders against the sail, and the hearts of the seamen are shaken
- with fear, as they are carried only a little way out of death's reach.
- So the heart in the breast of each Achaian was troubled.
- Hektor came on against them, as a murderous lion on cattle
- who in the low-lying meadow of a great marsh pasture

610

620

690

700

710

by hundreds, and among them a herdsman who does not quite know

how to fight a wild beast off from killing a horn-curved ox, and keeps pace with the first and the last of the cattle always, but the lion making his spring at the middle eats an ox as the rest stampede; so now the Achaians fled in unearthly terror before father Zeus and Hektor, all, but he got one only, Periphetes of Mykenai, beloved son of Kopreus, who for the lord Eurystheus had gone often with messages to powerful Herakles.

To him, a meaner father, was born a son who was better for all talents, in the speed of his feet and in battle and for intelligence counted among the first in Mykenai. Thereby now higher was the glory he granted to Hektor.

For as he whirled about to get back, he fell over the out-rim

- of the shield he carried, which reached to his feet to keep the spears from him.
- Stumbling on this he went over on his back, and the helmet
- that circled his temples clashed horribly as he went down.
- Hektor saw it sharply, and ran up and stood beside him,
- and stuck the spear into his chest and killed him before
- the eyes of his dear friends, who for all their sorrowing could do nothing
- to help their companion, being themselves afraid of great Hektor.
- Now they had got among the ships, and the ends were about them
- of the ships hauled up in the first line, but the Trojans swarmed
- on them. The Argives under force gave back from the first line
- of their ships, but along the actual shelters they rallied
- in a group, and did not scatter along the encampment.
- Shame held them and fear. They kept up a continuous call to each other, and beyond others Gerenian Nestor, the Achaians'
- watcher, supplicated each man by the knees for the sake of his
- parents. "Dear friends, be men; let shame be in your hearts and discipline

in the sight of other men, and each one of you remember his children and his wife, his property and his parents, whether a man's father and mother live or have died. Here now

- I supplicate your knees for the sake of those who are absent
- to stand strongly and not be turned to the terror of panic."

So he spoke, and stirred the spirit and heart in each man, and from their eyes Athene pushed the darkness

immortal

- of mist, and the light came out hard against them on both sides
- whether they looked from the ships or from the closing of battle. 670

They knew Hektor of the great war cry, they knew his companions

- whether they stood away behind and out of the fighting or whether alongside the fast ships they fought in the battle.
- Nor did it still please great-hearted Aias to stand back

where the other sons of the Achaians had taken position; but he went in huge strides up and down the decks of the vessels.

- He wielded in his hands a great pike for sea fighting, twenty-two cubits long and joined together by clinchers. And as a man who is an expert rider of horses who when he has chosen and coupled four horses out of many
- makes his way over the plain galloping toward a great city

640

650

660

- along the travelled road, and many turn to admire him, men or women, while he steadily and never slipping jumps and shifts his stance from one to another as they
- gallop; so Aias ranged crossing from deck to deck of the fast ships
- taking huge strides, and his voice went always up to the bright sky
- as he kept up a terrible bellow and urged on the Danaans to defend their ships and their shelters, while on the other side Hektor
- would not stay back among the mass of close-armored Trojans,
- but as a flashing eagle makes his plunge upon other flying birds as these feed in a swarm by a river,
- whether these be geese or cranes or swans long-throated, so Hektor steered the course of his outrush straight for a vessel
- with dark prows, and from behind Zeus was pushing him onward
- hard with his big hand, and stirred on his people beside him.
- Now once again a grim battle was fought by the vessels; you would say that they faced each other unbruised, unwearied
- in the fighting, from the speed in which they went for each other.
- This was the thought in each as they struggled on: the Achaians
- thought they could not get clear of the evil, but must perish,
- while the heart inside each one of the Trojans was hopeful
- to set Fire to the ships and kill the fighting men of Achaia. With such thoughts in mind they stood up to fight with each other.
- Hektor caught hold of the stern of a grand, fast-running, seafaring ship, that once had carried Protesilaos
- to Troy, and did not take him back to the land of his fathers.
- It was around his ship that now Achaians and Trojans cut each other down at close quarters, nor any longer had patience for the volleys exchanged from bows and javelins
- but stood up close against each other, matching their fury,
- and fought their battle with sharp hatchets and axes, with great swords

and with leaf-headed pikes, and many magnificent

swords were scattered along the ground, black-thonged, heavy-hilted,

- sometimes dropping from the hands, some glancing from shoulders
- of men as they fought, so the ground ran black with blood. Hektor
- would not let go of the stern of a ship where he had caught hold of it

but gripped the sternpost in his hands and called to the Trojans:

"Bring Fire, and give single voice to the clamor of battle. Now Zeus has given us a day worth all the rest of them: the ships' capture, the ships that came here in spite of the gods' will

and have visited much pain on us, by our counsellors' cowardice

- who would not let me fight by the grounded ships, though I wanted to,
- but held me back in restraint, and curbed in our fighters. But Zeus of the wide brows, though then he fouled our intentions,
- comes now himself to urge us on and give us encouragement."
- He spoke, and they thereby came on harder against the Argives.
- Their volleys were too much for Aias, who could hold no longer
- his place, but had to give back a little, expecting to die there,
- back to the seven-foot midship, and gave up the high deck of the balanced
- ship. There he stood and waited for them, and with his pike always
- beat off any Trojan who carried persistent fire from the vessels.
- He kept up a terrible bellowing, and urged on the Danaans:

"Friends and fighting men of the Danaans, henchmen of Ares,

be men now, dear friends, remember your furious valor.

Do we think there are others who stand behind us to help us?

- Have we some stronger wall that can rescue men from perdition?
- We have no city built strong with towers lying near us, within which
- we could defend ourselves and hold off this host that matches us.
- We hold position in this plain of the close-armored Trojans,

bent back against the sea, and far from the land of our fathers.

Salvation's light is in our hands' work, not the mercy of battle."

He spoke, and came forward with his sharp spear, raging for battle.

And whenever some Trojan crashed against the hollow ships

with burning fire, who sought to wake the favor of Hektor,

Aias would wait for him and then stab with the long pike and so from close up wounded twelve in front of the vessels.

from the Iliad, Book XXIII

Book XXIII describes the funeral of Patroclus, and the games held to commemorate the event. In the following passage, the "painful" boxing and wrestling contests give Homer a chance to use vivid similes to describe the action. In lines 692–693, he compares one of the boxers to a fish jumping in the water; note the extra touch of atmosphere provided by the description of the water as "roughened by the north wind." The two wrestlers, with their arms interlocked, are likened to the rafters of a high house. Peleides went back among the great numbers

- of Achaians assembled, when he had listened to all the praise spoken
- by Neleus' son, and set forth the prizes for the painful boxing.
- He led out into the field and tethered there a hardworking
- six-year-old unbroken jenny, the kind that is hardest
- to break; and for the loser set out a two-handled goblet. He stood upright and spoke his word out among the Argives:
- "Son of Atreus, and all you other strong-greaved Achaians,
- we invite two men, the best among you, to contend for these prizes
- with their hands up for the blows of boxing. He whom Apollo

grants to outlast the other, and all the Achaians witness it, let him lead away the hard-working jenny to his own

shelter.

- The beaten man shall take away the two-handled goblet." He spoke, and a man huge and powerful, well skilled in boxing,
- rose up among them; the son of Panopeus, Epeios.
- He laid his hand on the hard-working jenny, and spoke out:
- "Let the man come up who will carry off the two-handled goblet.

I say no other of the Achaians will beat me at boxing and lead off the jenny. I claim I am the champion. Is it not enough that I fall short in battle? Since it could

not be

- ever, that a man could be a master in every endeavor. For I tell you this straight out, and it will be a thing
- accomplished.
- I will smash his skin apart and break his bones on each other.
- Let those who care for him wait nearby in a huddle about him
- to carry him out, after my fists have beaten him under." So he spoke, and all of them stayed stricken to silence.

Alone Euryalos stood up to face him, a godlike man, son of lord Mekisteus of the seed of Talaos;

- of him who came once to Thebes and the tomb of Oidipous after
- his downfall, and there in boxing defeated all the Kadmeians.
- The spear-famed son of Tydeus was his second, and talked to him

in encouragement, and much desired the victory for him. First he pulled on the boxing belt about his waist,

- and then gave him the thongs carefully cut from the hide of a ranging
- ox. The two men, girt up, strode into the midst of the circle
- and faced each other, and put up their ponderous hands at the same time
- and closed, so that their heavy arms were crossing each other,
- and there was a fierce grinding of teeth, the sweat began to run
- everywhere from their bodies. Great Epeios came in, and hit him

as he peered out from his guard, on the cheek, and he could no longer

keep his feet, but where he stood the glorious limbs gave.

680

690

660

720

730

- As in the water roughened by the north wind a fish jumps in the weeds of the beach-break, then the dark water closes above him,
- so Euryalos left the ground from the blow, but greathearted Epeios
- took him in his arms and set him upright, and his true companions
- stood about him, and led him out of the circle, feet dragging
- as he spat up the thick blood and rolled his head over on one side.
- He was dizzy when they brought him back and set him among them.
- But they themselves went and carried off the twohandled goblet.

Now Peleides set forth the prizes for the third contest,

- for the painful wrestling, at once, and displayed them before the Danaans.
- There was a great tripod, to set over fire, for the winner. The Achaians among themselves valued it at the worth of twelve oxen.
- But for the beaten man he set in their midst a woman skilled in much work of her hands, and they rated her at four oxen.
- He stood upright and spoke his word out among the Argives:
- "Rise up, two who would endeavor this prize." So he spoke

and presently there rose up huge Telamonian Aias,

and resourceful Odysseus rose, who was versed in every advantage.

- The two men, girt up, strode out into the midst of the circle.
- and grappled each other in the hook of their heavy arms, as when
- rafters lock, when a renowned architect has fitted them
- in the roof of a high house to keep out the force of the winds' spite.
- Their backs creaked under stress of violent hands that tugged them
- stubbornly, and the running sweat broke out, and raw places

frequent all along their ribs and their shoulders broke out bright red with blood, as both of them kept up their hard

- efforts
- for success and the prize of the wrought tripod. Neither Odysseus
- was able to bring Aias down or throw him to the ground, nor
- could Āias, but the great strength of Odysseus held out against him.
- But now as they made the strong-greaved Achaians begin to be restless,
- at last great Telamonian Aias said to the other:
- "Son of Laertes and seed of Zeus, resourceful Odysseus: lift me, or I will lift you. All success shall be as Zeus gives it."
- He spoke, and heaved; but not forgetting his craft Odysseus
- caught him with a stroke behind the hollow of the knee, and unnerved
- the tendons, and threw him over backward, so that Odysseus
- fell on his chest as the people gazed upon them and wondered.
- Next, brilliant much-enduring Odysseus endeavored to lift him

- and budged him a little from the ground, but still could not raise him
- clear, then hooked a knee behind, so that both of them went down
- together to the ground, and lay close, and were soiled in the dust. Then
- they would have sprung to their feet once more and wrestled a third fall,
- had not Achilleus himself stood up and spoken to stop them:
- "Wrestle no more now; do not wear yourselves out and get hurt.
- You have both won. Therefore take the prizes in equal division
- and retire, so the rest of the Achaians can have their contests."

from the Iliad, Book XXIV

700

710

720

This extract from Book XXIV of the Iliad comprises the last great episode in the work, the confrontation between Priam, king of Troy, and the Greek hero Achilles over the body of Priam's son Hector. Throughout the long scene, Homer maintains the heroic dignity of his characters while allowing us to identify with them as human beings. After the pathos of Priam's appeal, Achilles' immediate reaction is as perfectly appropriate as it is unexpected. His own changing moods, veering from philosophical resignation to sudden anger to tenderness, seem to run the gamut of emotional response. How typical it is, too, of a Homeric hero to be practical enough after such an intense encounter to think of dinner and supervise its serving.

- [Priam] made straight for the dwelling
 - where Achilleus the beloved of Zeus was sitting. He found him
 - inside, and his companions were sitting apart, as two only,
 - Automedon the hero and Alkimos, scion of Ares,
 - were busy beside him. He had just now got through with his dinner,
 - with eating and drinking, and the table still stood by. Tall Priam
 - came in unseen by the other men and stood close beside him
 - and caught the knees of Achilleus in his arms, and kissed the hands
 - that were dangerous and manslaughtering and had killed so many
 - of his sons. As when dense disaster closes on one who has murdered
 - a man in his own land, and he comes to the country of others,
 - to a man of substance, and wonder seizes on those who behold him,
 - so Achilleus wondered as he looked on Priam, a godlike man, and the rest of them wondered also, and looked at each other.
 - But now Priam spoke to him in the words of a suppliant:
 - "Achilleus like the gods, remember your father, one who
 - is of years like mine, and on the door-sill of sorrowful old age.
 - And they who dwell nearby encompass him and afflict him,
 - nor is there any to defend him against the wrath, the destruction.
 - Yet surely he, when he hears of you and that you are still living,

490

is gladdened within his heart and all his days he is hopeful that he will see his beloved son come home from the Troad But for me, my destiny was evil. I have had the noblest of sons in Troy, but I say not one of them is left to me. Fifty were my sons, when the sons of the Achaians came here. Nineteen were born to me from the womb of a single mother, and other women bore the rest in my palace; and of these violent Ares broke the strength in the knees of most of them, but one was left me who guarded my city and people, that one you killed a few days since as he fought in defense of his country 500 Hektor; for whose sake I come now to the ships of the Achaians to win him back from you, and I bring you gifts beyond number. Honor then the gods, Achilleus, and take pity upon me remembering your father, yet I am still more pitiful; I have gone through what no other mortal on earth has gone through; I put my lips to the hands of the man who has killed my children." So he spoke, and stirred in the other a passion of grieving for his own father. He took the old man's hand and pushed him gently away, and the two remembered, as Priam sat huddled at the feet of Achilleus and wept close for manslaughtering Hektor 510 and Achilleus wept now for his own father, now again for Patroklos. The sound of their mourning moved in the house. Then when great Achilleus had taken full satisfaction in sorrow and the passion for it had gone from his mind and body, thereafter he rose from his chair, and took the old man by the hand, and set him on his feet again, in pity for the grey head and the grey beard, and spoke to him and addressed him in winged words: "Ah, unlucky, surely you have had much evil to endure in your spirit. How could you dare to come alone to the ships of the Achaians and before my eyes, when I am one who have killed in such numbers 520 such brave sons of yours? The heart in you is iron. Come, then, and sit down upon this chair, and you and I will even let our sorrows lie still in the heart for all our grieving. There is not any advantage to be won from grim lamentation. Such is the way the gods spun life for unfortunate mortals, that we live in unhappiness, but the gods themselves have no sorrows There are two urns that stand on the door-sill of Zeus. They are unlike

for the gifts they bestow: an urn of evils, an urn of blessings.

If Zeus who delights in thunder mingles these and bestows them on man, he shifts, and moves now in evil, again in good fortune. But when Zeus bestows from the urn of sorrows, he makes a failure of man, and the evil hunger drives him over the shining earth, and he wanders respected neither of gods nor mortals. Such were the shining gifts given by the gods to Peleus and pride of possession, and was lord over the Myrmidons. Thereto the gods bestowed an immortal wife on him, who was mortal. But even on him the god piled evil also. There was not any generation of strong sons born to him in his great house but a single all-untimely child he had, and I give him no care as he grows old, since far from the land of my fathers I sit here in Troy, and bring nothing but sorrow to you and your children. And you, old sir, we are told you prospered once; for as much as Lesbos, Makar's hold, confines to the north above it and Phrygia from the north confines, and enormous Hellespont, of these, old sir, you were lord once in your wealth and your children. But now the Uranian gods brought us, an affliction upon vou, forever there is fighting about your city, and men killed. But bear up, nor mourn endlessly in your heart, for there is not anything to be gained from grief for your son; you will never bring him back; sooner you must go through yet another sorrow." In answer to him again spoke aged Priam the godlike: "Do not, beloved of Zeus, make me sit on a chair while Hektor lies yet forlorn among the shelters; rather with all speed give him back, so my eyes may behold him, and accept the ransom we bring you, which is great. You may have joy of it, and go back to the land of your own fathers, since once you have permitted me to go on living myself and continue to look on the sunlight." Then looking darkly at him spoke swift-footed Achilleus: "No longer stir me up, old sir. I myself am minded to give Hektor back to you. A messenger came to me from Zeus, my mother, she who bore me, the daughter of the sea's ancient. I know you, Priam, in my heart, and it does not escape me

- that some god led you to the running ships of the Achaians.
- For no mortal would dare come to our encampment, not even
- one strong in youth. He could not get by the pickets, he could not

lightly unbar the bolt that secures our gateway. Therefore

530

540

from his birth, who outshone all men beside for his riches

560

you must not further make my spirit move in my sorrows,

for fear, old sir, I might not let you alone in my shelter, suppliant as you are; and be guilty before the god's

orders."

570

580

590

600

He spoke, and the old man was frightened and did as he told him.

The son of Peleus bounded to the door of the house like a lion,

nor went alone, but the two henchmen followed attending,

the hero Automedon and Alkimos, those whom Achilleus

honored beyond all companions after Patroklos dead. These two

now set free from under the yoke the mules and the horses,

and led inside the herald, the old king's crier, and gave him

a chair to sit in, then from the smooth-polished mule wagon

lifted out the innumerable spoils for the head of Hektor

but left inside it two great cloaks and a finespun tunic to shroud the corpse in when they carried him home. Then Achilleus

called out to his serving-maids to wash the body and anoint it

all over; but take it first aside, since otherwise Priam might see his son and in the heart's sorrow not hold in his anger

at the sight, and the deep heart in Achilleus be shaken to anger;

that he might not kill Priam and be guilty before the god's orders.

Then when the serving-maids had washed the corpse and anointed it

with olive oil, they threw a fair great cloak and a tunic

about him, and Achilleus himself lifted him and laid him on a litter, and his friends helped him lift it to the smooth-

polished

mule wagon. He groaned then, and called by name on his beloved companion:

"Be not angry with me, Patroklos, if you discover,

though you be in the house of Hades, that I gave back great Hektor

to his loved father, for the ransom he gave me was not unworthy.

I will give you your share of the spoils, as much as is fitting."

So spoke great Achilleus and went back into the shelter

and sat down on the elaborate couch from which he had risen,

against the inward wall, and now spoke his word to Priam:

"Your son is given back to you, aged sir, as you asked it.

He lies on a bier. When dawn shows you yourself shall see him

as you take him away. Now you and I must remember our supper.

For even Niobe, she of the lovely tresses, remembered to eat, whose twelve children were destroyed in her

palace,

six daughters, and six sons in the pride of their youth, whom Apollo

killed with arrows from his silver bow, being angered with Niobe, and shaft-showering Artemis killed the daughters;

because Niobe likened herself to Leto of the fair coloring

and said Leto had borne only two, she herself had borne many;

but the two, though they were only two, destroyed all those others.

Nine days long they lay in their blood, nor was there anyone

to bury them, for the son of Kronos made stones out of the people; but on the tenth day the Uranian gods buried them.

But she remembered to eat when she was worn out with weeping.

- And now somewhere among the rocks, in the lonely mountains,
- in Sipylos, where they say is the resting place of the goddesses
- who are nymphs, and dance beside the waters of Acheloios,
- there, stone still, she broods on the sorrows that the gods gave her.
- Come then, we also, aged magnificent sir, must remember

to eat, and afterwards you may take your beloved son back

- to Ilion, and mourn for him; and he will be much lamented."
- So spoke fleet Achilleus and sprang to his feet and slaughtered
- a gleaming sheep, and his friends skinned it and butchered it fairly,
- and cut up the meat expertly into small pieces, and spitted them,
- and roasted all carefully and took off the pieces.
- Automedon took the bread and set it out on the table
- in fair baskets, while Achilleus served the meats. And thereon
- they put their hands to the good things that lay ready before them.
- But when they had put aside their desire for eating and drinking,
- Priam, son of Dardanos, gazed upon Achilleus, wondering
- at his size and beauty, for he seemed like an outright vision
- of gods. Achilleus in turn gazed on Dardanian Priam
- and wondered, as he saw his brave looks and listened to him talking.
- But when they had taken their fill of gazing one on the other,
- first of the two to speak was the aged man, Priam the godlike:
- "Give me, beloved of Zeus, a place to sleep presently, so that
- we may even go to bed and take the pleasure of sweet sleep.
- For my eyes have not closed underneath my lids since that time
- when my son lost his life beneath your hands, but always
- I have been grieving and brooding over my numberless sorrows
- and wallowed in the muck about my courtyard's enclosure.

to make a bed in the porch's shelter and to lay upon it

630

640

Now I have tasted food again and have let the gleaming wine go down my throat. Before, I had tasted nothing." He spoke, and Achilleus ordered his serving-maids and companions

fine underbedding of purple, and spread blankets above it

- and fleecy robes to be an over-all covering. The maidservants
- went forth from the main house, and in their hands held torches
- and set to work, and presently had two beds made. Achilleus
- of the swift feet now looked at Priam and said, sarcastic:
- "Sleep outside, aged sire and good friend, for fear some Achaian
- might come in here on a matter of counsel, since they keep coming
- and sitting by me and making plans; as they are supposed to.
- But if one of these come through the fleeting black night should notice you,
- he would go straight and tell Agamemnon, shepherd of the people,

and there would be delay in the ransoming of the body. But come, tell me this and count off for me exactly

how many days you intend for the burial of great Hektor. Tell me, so I myself shall stay still and hold back the people."

- In answer to him again spoke aged Priam the godlike:
- "If you are willing that we accomplish a complete funeral
- for great Hektor, this, Achilleus, is what you could do and give
- me pleasure. For you know surely how we are penned in our city,
- and wood is far to bring in from the hills, and the Trojans are frightened
- badly. Nine days we would keep him in our palace and mourn him,
- and bury him on the tenth day, and the people feast by him,
- and on the eleventh day we would make the gravebarrow for him,
- and on the twelfth day fight again; if so we must do."

Then in turn swift-footed brilliant Achilleus answered him:

"Then all this, aged Priam, shall be done as you ask it.

I will hold off our attack for as much time as you bid me."

So he spoke, and took the aged king by the right hand at the wrist, so that his heart might have no fear. Then these two,

Priam and the herald who were both men of close counsel,

slept in the place outside the house, in the porch's shelter; but Achilleus slept in the inward corner of the strongbuilt shelter,

and at his side lay Briseis of the fair coloring.

SAPPHO

Selected Poems

The chief subject of Sappho's poetry is love, but her work also gives voice to the contrasting but equally painful agonies of loneliness and of passionate commitment. Perhaps her greatest quality is her ability to probe the depths of her own responses and by describing them to understand them. Poems such as these reveal a reluctant resignation that comes only from profound self-understanding.

Alone

The moon and Pleiades are set. Midnight, and time spins away. I lie in bed, alone.

Seizure

650

To me he seems like a god as he sits facing you and hears you near as you speak softly and laugh in a sweet echo that jolts the heart in my ribs. For now as I look at you my voice is empty and can say nothing as my tongue cracks and slender fire is quick under my skin. My eyes are dead to light, my ears pound, and sweat pours over me. I convulse, paler than grass, and feel my mind slip as I go close to death.

To Eros

660

670

From all the offspring of the earth and heaven love is the most precious.

The Virgin

Like a sweet apple reddening on the high tip of the topmost branch and forgotten by the pickers—no, beyond their reach. Like a hyacinth crushed in the mountains by shepherds; lying trampled on the earth yet blooming purple.

Age and Light

Here are fine gifts, children, O friend, singer on the clear tortoise lyre, all my flesh is wrinkled with age, my black hair has faded to white, my legs can no longer carry me, once nimble as a fawn's, but what can I do? It cannot be undone, No more than can pink-armed Dawn not end in darkness on earth, or keep her love for Tithonos, who must waste away; yet I love refinement, and beauty and light are for me the same as desire for the sun.

THE PRESOCRATICS: HERACLITUS OF EPHESUS

The following fragments consist of observations and teachings of Heraclitus, many of which must have been passed down orally by his pupils.

This world . . . was created by no god or man; it was, it is, and it always will be an undying fire which kindles and extinguishes itself in a regular pattern. All things change place with fire and fire with all things, as money does with goods and goods with money.

Heraclitus says that everything is in motion, nothing stands fast. Comparing things to the flow of a river, he says that you cannot step twice into the same stream . . . for new water is always flowing down. By the violence and swiftness of its change, it tears itself away, yet renews itself again. It has no past and no future; it is in advance and in retreat at the same time. . . . The way up and the way down are the same. [Both have the same beginning and end.]

Know that conflict is universal, that justice is strife; through strife all things arise and disappear. Men do not realize that a thing which thrusts out in opposite directions is at unity with itself; harmony is a matter of opposing tensions, like those in a bow or a lyre. . . . Conflict is the father and ruler of all.

THE PRESOCRATICS: PARMENIDES OF ELEA

Parmenides set out his ideas in a poem divided into three parts: the Prologue, the Way of Truth, and the Way of Opinion. A collection of lines from this work has survived, and some of them are reproduced below. The second extract is one of the longest of all Presocratic fragments in existence.

Now I shall show you—do you listen well and mark my words—the only roads of inquiry which lead to knowledge. The first is that of him who says, "That which exists is real; that it should not exist is impossible." This is the reasonable road, for Truth herself makes it straight. The other road is his who says, "There are, of necessity, things which do not exist,"—and this, I tell you, is a fantastic and impossible path. For how could you know about something which does not exist? a sheer impossibility. You could not even talk about it, for thought and existence are the same.

There remains only to tell of the way of him who maintains that Being does exist; and on this road there are many signs that Being is without beginning or end. It is the only thing that is; it is all-inclusive and immoveable, without an end. It has no past and no future; its only time is now, for it is one continuous whole. What sort of creation could you find for it? From what could it have grown, and how? I cannot let you say or think that it came from nothing, for we cannot say or think that something which does not exist actually does so [i.e., if we say that Being comes from Not-being, we imply that Not-being exists, which is selfcontradictory]. What necessity could have roused up existence from nothingness? And, if it had done so, why at one time rather than at another? No; we must either admit that Being exists completely, or that it does not exist at all. Moreover, the force of my argument makes us grant that nothing can arise from Being except Being. Thus iron Law does not relax to allow creation and destruction, but holds all things firm in her grasp.

HERODOTUS

from History of the Persian Wars, Book VIII

In Book VIII of his History Herodotus describes Xerxes' invasion of Greece in 480 B.C. In the course of their journey southward toward Athens, the Persian troops arrive at the narrow mountain pass of Thermopylae in central Greece. There a small band of Greek soldiers blocks the road and threatens to hold up the entire Persian army. In his justly famous account of the battle Herodotus summons up a world of meaning by carefully chosen details the Spartan soldiers preparing for battle by combing their hair, for example. As the fighting intensifies, so does the tension of the account. With simplicity and dignity Herodotus leads us to the final desperate struggle over the body of the dead Greek commander, one of the first great prose passages in Western literature.

The Persian army was now close to the pass, and the Greeks, suddenly doubting their power to resist, held a conference to consider the advisability of retreat. It was proposed by the Peloponnesians generally that the army should fall back upon the Peloponnese and hold the Isthmus; but when the Phocians and Locrians expressed their indignation at this suggestion, Leonidas gave his voice for staying where they were and sending, at the same time, an appeal for reinforcements to the various states of the confederacy, as their numbers were inadequate to cope with the Persians.

During the conference Xerxes sent a man on horseback to ascertain the strength of the Greek force and to observe what the troops were doing. He had heard before he left Thessaly that a small force was concentrated here, led by the Lacedaemonians under Leonidas of the house of Heracles. The Persian rider approached the camp and took a thorough survey of all he could see-which was not, however, the whole Greek army; for the men on the further side of the wall which, after its reconstruction, was now guarded, were out of sight. He did, nonetheless, carefully observe the troops who were stationed on the outside of the wall. At that moment these happened to be the Spartans, and some of them were stripped for exercise, while others were combing their hair. The Persian spy watched them in astonishment; nevertheless he made sure of their numbers, and of everything else he needed to know, as accurately as he could, and then rode quietly off. No one attempted to catch him, or took the least notice of him.

Back in his own camp he told Xerxes what he had seen. Xerxes was bewildered; the truth, namely that the Spartans were preparing themselves to kill and to be killed according to their strength, was beyond his comprehension, and what they were doing seemed to him merely absurd. Accordingly he sent for Demaratus, the son of Ariston, who had come with the army, and questioned him about the spy's report, in the hope of finding out what the unaccountable behavior of the Spartans might mean. "Once before," Demaratus said, "when we began our march against Greece, you heard me speak of these men. I told you then how I saw this enterprise would turn out, and you laughed at me. I strive for nothing, my lord, more earnestly than to observe the truth in your presence; so hear me once more. These men have come to fight us for possession of the pass, and for that struggle they are preparing. It is the common practice of the Spartans to pay careful attention to their hair when they are about to risk their lives. But I assure you that if you can defeat these men and the rest of the Spartans who are still at home, there is no other people in the world who will dare to stand firm or lift a hand against you. You have now to deal with the finest kingdom in Greece, and with the bravest men."

Xerxes, unable to believe what Demaratus said, asked further how it was possible that so small a force could fight with his army. "My lord," Demaratus replied, "treat me as a liar, if what I have foretold does not take place." But still Xerxes was unconvinced.

For four days Xerxes waited, in constant expectation that the Greeks would make good their escape; then, on the fifth, when still they had made no move and their continued presence seemed mere impudent and reckless folly, he was seized with rage and sent forward the Medes and Cissians with orders to take them alive and bring them into his presence. The Medes charged, and in the struggle which ensued many fell; but others took their places, and in spite of terrible losses refused to be beaten off. They made it plain enough to anyone, and not least to the king himself, that he had in his army many men, indeed, but few soldiers. All day the battle continued; the Medes, after their rough handling, were at length withdrawn and their place was taken by Hydarnes and his picked Persian troops—the King's— Immortals who advanced to the attack in full confidence of bringing the business to a quick and easy end. But, once engaged, they were no more successful than the Medes had been; all went as before, the two armies fighting in a confined space, the Persians using shorter spears than the Greeks and having no advantage from their numbers.

On the Spartan side it was a memorable fight; they were men who understood war pitted against an inexperienced enemy, and amongst the feints they employed was to turn their backs in a body and pretend to be retreating in confusion, whereupon the enemy would come on with a great clatter and roar, supposing the battle won; but the Spartans, just as the Persians were on them, would wheel and face them and inflict in the new struggle innumerable casualties. The Spartans had their losses too, but not many. At last the Persians, finding that their assaults upon the pass, whether by divisions or by any other way they could think of, were all useless, broke off the engagement and withdrew. Xerxes was watching the battle from where he sat; and it is said that in the course of the attacks three times, in terror for his army, he leapt to his feet.

Next day the fighting began again, but with no better success for the Persians, who renewed their onslaught in the hope that the Greeks, being so few in number, might be badly enough disabled by wounds to prevent further resistance. But the Greeks never slackened; their troops were ordered in divisions corresponding to the states from which they came, and each division took its turn in the line except the Phocian, which had been posted to guard the track over the mountains. So when the Persians found that things were no better for them than on the previous day, they once more withdrew.

How to deal with the situation Xerxes had no idea; but while he was still wondering what his next move should be, a man from Malis got himself admitted to his presence. This was Ephialtes, the son of Eurydemus, and he had come, in hope of a rich reward, to tell the king about the track which led over the hills to Thermopylae—and the information he gave was to prove the death of the Greeks who held the pass.

Later on, Ephialtes, in fear of the Spartans, fled to Thessaly, and during his exile there a price was put upon his head at an assembly of the Amphictyons at Pylae. Some time afterwards he returned to Anticyra, where he was killed by Athenades of Trachis. In point of fact, Athenades killed him not for his treachery but for another reason, which I will explain further on; but the Spartans honored him nonetheless on that account. According to another story, which I do not at all believe, it was Onetes, the son of Phanagoras, a native of Carystus, and Corydallus of Anticyra who spoke to Xerxes and showed the Persians the way round by the mountain track; but one may judge which account is the true one, first by the fact that the Amphictyons, who must surely have known everything about it, set a price not upon Onetes and Corydallus but upon Ephialtes of Trachis, and, secondly, by the fact that there is no doubt that the accusation of treachery was the reason for Ephialtes' flight. Certainly Onetes, even though he was not a native of Malis, might have known about the track, if he had spent much time in the neighborhood - but it was Ephialtes, and no one

else, who showed the Persians the way, and I leave his name on record as the guilty one.

Xerxes found Ephialtes' offer most satisfactory. He was delighted with it, and promptly gave orders to Hydarnes to carry out the movement with the troops under his command. They left camp about the time the lamps are lit.

The track was originally discovered by the Malians of the neighborhood; they afterwards used it to help the Thessalians, taking them over it to attack Phocis at the time when the Phocians were protected from invasion by the wall which they had built across the pass. That was a long time ago, and no good ever came of it since. The track begins at the Asopus, the stream which flows through the narrow gorge, and, running along the ridge of the mountain which, like the track itself, is called Anopaea—ends at Alpenus, the first Locrian settlement as one comes from Malis, near the rock known as Black-Buttocks' Stone and the seats of the Cercopes. Just here is the narrowest part of the pass.

This then, was the mountain track which the Persians took, after crossing the Asopus. They marched throughout the night, with the mountains of Oeta on their right hand and those of Trachis on their left. By early dawn they were at the summit of the ridge, near the spot where the Phocians, as I mentioned before, stood on guard with a thousand men, to watch the track and protect their country. The Phocians were ready enough to undertake this service, and had, indeed, volunteered for it to Leonidas, knowing that the pass at Thermopylae was held as I have already described.

The ascent of the Persians had been concealed by the oak-woods which cover this part of the mountain range, and it was only when they reached the top that the Phocians became aware of their approach; for there was not a breath of wind, and the marching feet made a loud swishing and rustling in the fallen leaves. Leaping to their feet, the Phocians were in the act of arming themselves when the enemy was upon them. The Persians were surprised at the sight of troops preparing to resist; they had not expected any opposition-yet here was a body of men barring their way. Hydarnes asked Ephialtes who they were, for his first uncomfortable thought was that they might be Spartans; but on learning the truth he prepared to engage them. The Persian arrows flew thick and fast, and the Phocians, supposing themselves to be the main object of the attack, hurriedly withdrew to the highest point of the mountain, where they made ready to face destruction. The Persians, however, with Ephialtes and Hydarnes paid no further attention to them, but passed on along the descending track with all possible speed.

The Greeks at Thermopylae had their first warning of the death that was coming with the dawn from the seer Megistias, who read their doom in the victims of sacrifice; deserters, too, had begun to come in during the night with news of the Persian movement to take them in the rear, and, just as day was breaking, the look-out men had come running from the hills. At once a conference was held, and opinions were divided, some urging that they must on no account abandon their post, others taking the opposite view. The result was that the army split; some dispersed, the men returning to their various homes, and others made ready to stand by Leonidas.

There is another account which says that Leonidas himself dismissed a part of his force, to spare their lives, but thought it unbecoming for the Spartans under his command to desert the post which they had originally come to guard. I myself am inclined to think that he dismissed them when he realized that they had no heart for the fight and were unwilling to take their share of the danger; at the same time honor forbade that he himself should go. And indeed by remaining at his post he left a great name behind him, and Sparta did not lose her prosperity, as might otherwise have happened; for right at the outset of the war the Spartans had been told by the oracle, when they asked for advice, that either their city must be laid waste by the foreigner or one of their kings be killed. The prophecy was in hexameter verse and ran as follows:

Hear your fate, O dwellers in Sparta of the wide spaces; Either your famed, great town must be sacked by

Perseus' sons.

Or, if that be not, the whole land of Lacedaemon Shall mourn the death of a king of the house of Heracles, For not the strength of lions or of bulls shall hold him, Strength against strength; for he has the power of Zeus, And will not be checked till one of these two he has consumed.

I believe it was the thought of this oracle, combined with his wish to lay up for the Spartans a treasure of fame in which no other city should share, that made Leonidas dismiss those troops; I do not think that they deserted, or went off without orders, because of a difference of opinion. Moreover, I am strongly supported in this view by the case of Megistias, the seer from Acarnania who foretold the coming doom by his inspection of the sacrificial victims: this man he was said to be descended from Melampus—was with the army, and quite plainly received orders from Leonidas to quit Thermopylae, to save him from sharing the army's fate. But he refused to go, sending away instead an only son of his, who was serving with the forces.

Thus it was that the confederate troops, by Leonidas' orders, abandoned their posts and left the pass, all except the Thespians and the Thebans who remained with the Spartans. The Thebans were detained by Leonidas as hostages very much against their will—unlike the loyal Thespians, who refused to desert Leonidas and his men, but stayed, and died with them. They were under the command of Demophilus the son of Diadromes.

In the morning Xerxes poured a libation to the rising sun, and then waited till about the time of the filling of the marketplace, when he began to move forward. This was according to Ephialtes' instructions, for the way down from the ridge is much shorter and more direct than the long and circuitous ascent. As the Persian army advanced to the assault, the Greeks under Leonidas, knowing that the fight would be their last, pressed forward into the wider part of the pass much farther than they had done before; in the previous days' fighting they had been holding the wall and making sorties from behind it into the narrow neck, but now they left the confined space and battle was joined on more open ground. Many of the invaders fell; behind them the company commanders plied their whips, driving the men remorselessly on. Many fell into the sea and were drowned, and still more were trampled to death by their friends. No one could count the number of the dead. The Greeks, who knew that the enemy were on their way round by the mountain track and that death was inevitable, fought with reckless desperation, exerting every ounce of strength that was in them against the invader. By this time most of their spears were broken, and they were killing Persians with their swords.

In the course of that fight Leonidas fell, having fought like a man indeed. Many distinguished Spartans were killed at his side—their names, like the names of all the three hundred, I have made myself acquainted with, because they deserve to be remembered. Amongst the Persian dead, too, were many men of high distinction—for instance, two brothers of Xerxes, Habrocomes and Hyperanthes, both of them sons of Darius by Artanes' daughter Phratagune.

There was a bitter struggle over the body of Leonidas; four times the Greeks drove the enemy off, and at last by their valor succeeded in dragging it away. So it went on, until the fresh troops with Ephialtes were close at hand; and then, when the Greeks knew that they had come, the character of the fighting changed. They withdrew again into the narrow neck of the pass, behind the walls, and took up a position in a single compact body—all except the Thebans on the little hill at the entrance to the pass, where the stone lion in memory of Leonidas stands today. Here they resisted to the last, with their swords, if they had them, and, if not, with their hands and teeth, until the Persians, coming on from the front over the ruins of the wall and closing in from behind, finally overwhelmed them.

Of all the Spartans and Thespians who fought so valiantly on that day, the most signal proof of courage was given by the Spartan Dieneces. It is said that before the battle he was told by a native of Trachis that, when the Persians shot their arrows, there were so many of them that they hid the sun. Dieneces, however, quite unmoved by the thought of the terrible strength of the Persian army, merely remarked: "This is pleasant news that the stranger from Trachis brings us: for if the Persians hide the sun, we shall have our battle in the shade." He is said to have left on record other sayings, too, of a similar kind, by which he will be remembered. After Dieneces the greatest distinction was won by the two Spartan brothers, Alpheus and Maron, the sons of Orsiphantus; and of the Thespians the man to gain the highest glory was a certain Dithyrambus, the son of Harmatides.

The dead were buried where they fell, and with them the men who had been killed before those dismissed by Leonidas left the pass. Over them is this inscription, in honor of the whole force:

Four thousand here from Pelops' land Against three million once did stand.

The Spartans have a special epitaph; it runs:

Go tell the Spartans, you who read: We took their orders, and are dead.

For the seer Megistias there is the following:

I was Megistias once, who died When the Mede passed Spercheius' tide. I knew death near, yet would not save Myself, but share the Spartans' grave. **GENERAL EVENTS**

LITERATURE & PHILOSOPHY ART

	500			
	в.с. 480			c. 490 <i>Kritios Boy;</i> turning point between Archaic and Classical Periods
	480	478 Formation of Delian League; beginning of Athenian empire		480–323 First naturalistic sculpture and painting appear
		461 Pericles comes to prominence at Athens		c. 460 Sculptures at Temple of Zeus, Olympia
	450	454 Treasury of Delian League moved to Athens	458 Aeschylus, <i>Oresteia</i> trilogy wins first prize in drama festival of Dionysus	
	430	443–429 Pericles in full control of Athens	440 Sophocles, Antigone	c. 450 Myron, Discus Thrower
DD		431 Peloponnesian War begins	c. 429 Sophocles, <i>Oedipus the King</i>c. 421 Euripides, <i>The Suppliant</i>	c. 440 Polykleitos, Doryphoros,
RIC	AGE	429 Pericles dies of plague that devastates Athens	Women	treatise The Canon
PE	OLDEN	421 Peace of Nicias	c. 420–c. 399 Thucydides, <i>History of</i> <i>Peloponnesian War</i>	432 Phidias completes Parthenon sculptures
AL	Goi	413 Renewed outbreak of Peloponnesian War	414 Aristophanes, <i>The Birds</i>411 Aristophanes, <i>Lysistrata</i>	late 5th cent. Funerary
CLASSICAL PERIO	404		The Ansiophanes, Eysistratia	relief sculpture and white-ground vase painting; lekythos, Warrior Seated at His Tomb
CLA	404	404 Fall of Athens and victory of Sparta	399 Trial and execution of Socrates	
0	IOD	404–403 Rule of Thirty Tyrants	before 387 Plato, Republic	c. 350 Scopas, Pothos
	CLASSICAL PERIOD	387 King's Peace signed	387 Plato founds Academy	c. 350 Frescoes, Royal Cemetery at Vergina
	ICAL	371–362 Ascendancy of Thebes	c. 385 Xenophon chronicles teachings of Socrates	c. 340 Praxiteles, <i>Hermes with</i>
	ASSI	359–336 Philip II, king of Macedon		Infant Dionysus
	U	338 Macedonians defeat Greeks at Battle of Chaeronaea	c. 347–c. 399 Aristotle, Politics, Metaphysics	
	LATE	336–323 Alexander the Great, king of Macedon	335 Aristotle founds Lyceum	
	323	331 City of Alexandria founded		c. 330 Lysippus, Apoxyomenos
TIC		323–281 Wars of Alexander's successors		
ENIST	RIOI	262 Pergamum becomes independent kingdom		323–146 Development of realistic portraiture
LLE	PEF	197–156 Eumenes II, king of Pergamum	ST BAR	
HE	146	146 Romans sack Corinth; Greece becomes Roman province	NO AND	c. 150 <i>Laocoön;</i> mosaic, House of Masks, Delos

CHAPTER 3 Classical Greece and the Hellenistic Period

ARCHITECTURE

MUSIC

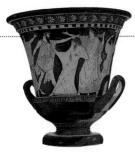

470–456 Libon of Elis, Temple of Zeus at Olympia

c. 500–425 Music serves as accompaniment in dramatic performances

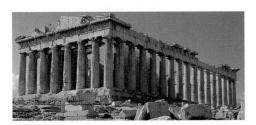

- **449** Pericles commissions work on Acropolis
- **447–438** Ictinus and Callicrates, Parthenon
- 437-431 Mnesikles, Propylaea
- **c. 427–424** Callicrates, Temple of Athena Nike

421–406 Erechtheum

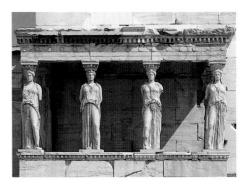

c. 400 Music dominates dramatic performances

4th cent. Instrumental music becomes popular

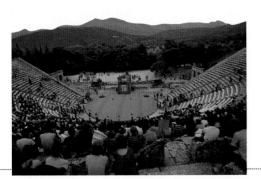

- **356** Temple of Artemis at Ephesus destroyed by fire and rebuilt
- c. 350 Theater at Epidaurus

323–146 *Tholos* and other new building forms appear

- 279 Lighthouse at Alexandria
- **c. 180** Eumenes II, Pergamum Altar of Zeus

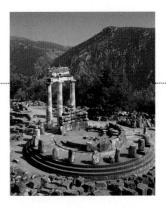

late 2nd cent. Earliest surviving Greek music

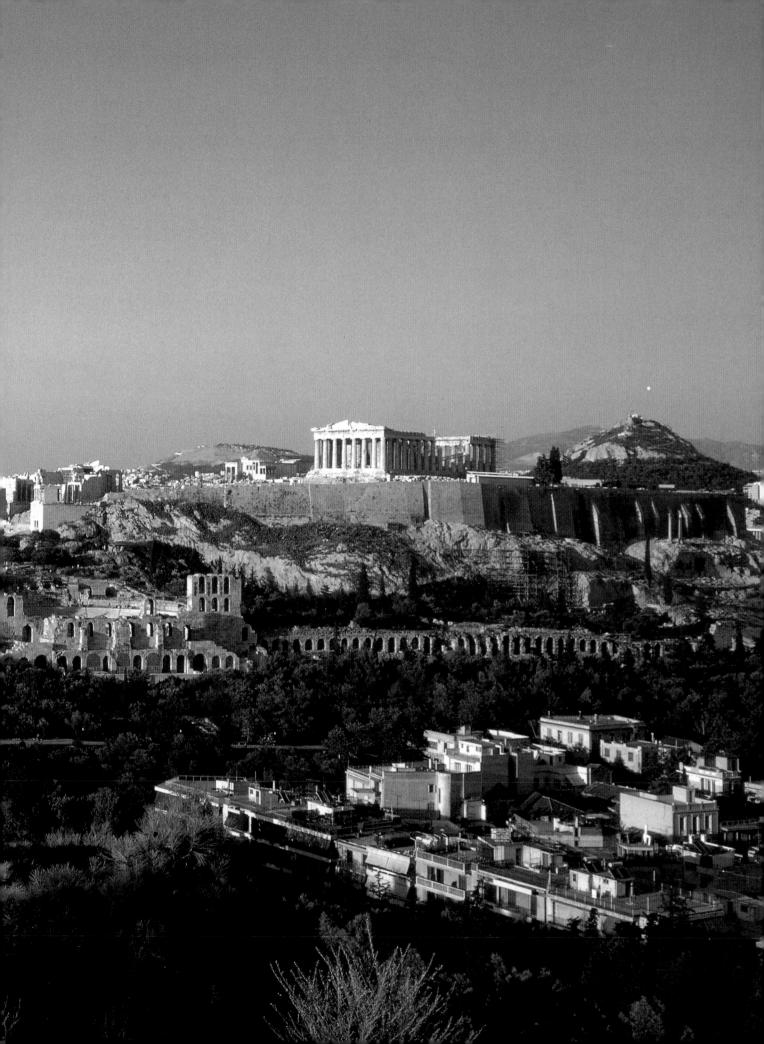

CHAPTER 3

CLASSICAL GREECE AND THE Hellenistic Period

he victories in the Persian Wars produced a new spirit of optimism and unity in Greece. Divine forces, it appeared, had guaranteed the triumph of right over wrong. There seemed to be no limit to the possibilities of human development. The achievements of the Classical period, which lasted from 479 B.C. to the death of Alexander the Great in 323 B.C., do much to justify the Greeks' proud self-confidence. They certainly represent a level of civilization that has rarely, if ever, been reached since—a level that has been a continuing inspiration to our culture.

Alexander the Great

Classical civilization reached its high point in Athens during the last half of the fifth century B.C., a time of unparalleled richness in artistic and intellectual achievement that is often called the Golden Age of Greece. To some extent, the importance of the great figures who dominated this period lies in the fact that they were the first in their fields. There are, in fact, few areas of human thought in which the fifth-century Greeks were not pioneers. In subjects as diverse as drama and historiography, town planning and medicine, painting and sculpture, mathematics and government, they laid the foundations for later achievements. Even more astonishing, often they were not merely the first in their fields but also among the greatest of all time. Greek tragedies, for example, are still read and performed today because they give experiences that are as intense emotionally and intellectually as anything in the Western dramatic tradition.

In the Late Classical period (404 to 323 B.C.), artists and writers continued to explore ideas and styles first outlined in the century before, though in different ways. Greek cultural life was no longer dominated by Athens; a single center no longer governed artistic developments. This fourth-century period was therefore one of greater variety, with individual artists following their own personal visions. The greatest of all Late Classical contributions to modern cultural tradition was in the field of philosophy. The works of Plato and Aristotle became the basis of Western thought for the next two thousand years.

Aristotle

Even after the death of Alexander the Great and the end of the Classical Age, the Hellenistic period that followed was characterized by an artistic vitality that ultimately drew its inspiration from Classical achievements. Only when Greece was conquered by the Romans in the late second century B.C. did Greek culture cease to have an independent existence.

THE CLASSICAL IDEAL

Although the Roman conquest of Greece ended the glories of the Classical Age, in a way it also perpetuated them by contributing to the melding of Greek culture into the Western humanistic tradition. It was not the Greeks themselves but their conquerors who spread Greek ideas throughout the ancient world and thus down in time to the present. These conquerors were first the Macedonians and then, above all, the Romans, possessors of practical skills that they used to construct a world sufficiently at peace for ideas to have a place in it. The Greeks did not live in such tranquility; we must always remember that the Athenians of the Golden Age existed not in an environment of calm contemplation but in a world of tension and violence

Their tragic inability to put into practice their own noble ideals and live in peace with other Greeks—the darker side of their genius-proved fatal to their independence; it led to war with the rest of Greece in 431 B.C. and to the fall of Athens in 404 B.C. In this context, the Greek search for order takes on an added significance. It was the belief that the quest for reason and order could succeed that gave a unifying ideal to the immense and varied output of the Classical Age. The central principle of this Classical Ideal was that existence can be ordered and controlled, that human ability can triumph over the apparent chaos of the natural world and create a balanced society. In order to achieve this equilibrium, individual human beings should try to stay within what seem to be reasonable limits, for those who do not are guilty of hubris-the same hubris of which the Persian leader Xerxes was guilty and for which he paid the price. The aim of life should be a perfect balance: everything in due proportion and nothing in excess. "Nothing too much" was one of the most famous Greek proverbs.

The emphasis that the Classical Greeks placed on order affected their spiritual attitudes. Individuals can achieve order, they believed, by understanding why people act as they do and, above all, by understanding the motives for their own actions. Thus confidence in the power of both human reason and human self-knowledge was as important as belief in the gods. The greatest of all Greek temples of the Classical Age, the Parthenon, which crowned the Athenian Acropolis [3.1], was planned not so much to honor the goddess Athena as to glorify Athens and thus human achievement. Even in their darkest days, the Classical Greeks never lost sight of the

3.1 The Acropolis, Athens, from the northwest. The Parthenon, temple to Athena, is at the highest point. Below it spreads the monumental gateway, the Propylaea. At far left is the Erechtheum.

magnitude of human capability and, perhaps even more important, human potential—a vision that has returned over the centuries to inspire later generations and has certainly not lost its relevance in our own times.

The political and cultural center of Greece during the first half of the Classical period was Athens. Here, by the end of the Persian Wars in 479 B.C., the Athenians had emerged as the most powerful people in the Greek world. For one thing, their role in the defeat of the Persians had been a decisive one. For another, their democratic system of government, first established in the late sixth century B.C., was proving to be both effective and stable. All male Athenian citizens were not only entitled but were required to participate in the running of the state, either as members of the General Assembly, the *ecclesia*, with its directing council, the *boulé*, or by holding individual magistracies. They were also eligible to serve on juries.

Under Athenian leadership in the years following the wars, a defensive organization of Greek city-states was formed to guard against any future outside attack. The money collected from the participating members was kept in a treasury on the island of Delos, sacred to Apollo and politically neutral. This organization became known as the Delian League.

Within a short time a number of other important city-states, including Thebes, Sparta, and Athens' old trade rival Corinth, began to suspect that the league was serving not so much to protect all of Greece as to strengthen Athenian power. They believed the Athenians were turning an association of free and independent states into an empire of subject peoples. Their suspicions were confirmed when (in 454 B.C.) the funds of the league were transferred from Delos to Athens and some of the money was used to pay for Athenian building projects, including the Parthenon. The spirit of Greek unity was starting to dissolve; the Greek world was

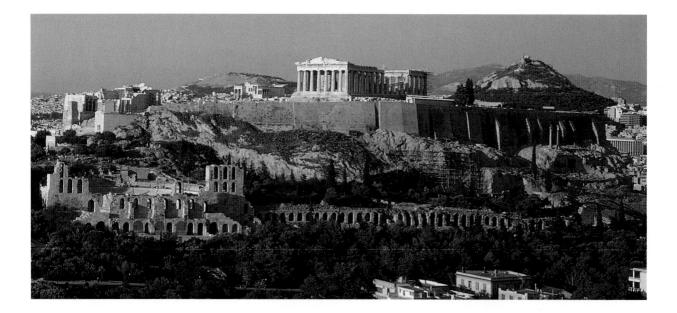

beginning to divide into two opposing sides: on the one hand, Athens and her allies (the cities that remained in the league) and on the other, the rest of Greece. Conflict was inevitable. The Spartans were finally persuaded to lead an alliance against Athens to check her "imperialistic designs." This war, called the Peloponnesian War after the homeland of the Spartans and their supporters, began in 431 B.C. and dragged on until 404 B.C.

Our understanding of the Peloponnesian War and its significance owes much to the account by the great historian Thucydides, who himself lived through its calamitous events. Born around 460 B.C., Thucydides played an active part in Athenian politics in the years before the war. In 424 B.C., he was elected general and put in charge of defending the city of Amphipolis in northern Greece. When the city fell to Spartan troops, Thucydides was condemned in his absence and sentenced to exile. He did not return to Athens until 404 B.C.

Thucydides

Thucydides intended his History of the Peloponnesian War to describe the entire course of the war up to 404 B.C., but he died before completing it; the narrative breaks off at the end of 411 B.C. The work is extremely valuable for its detailed description of events, for, although its author was an Athenian, he managed to be both accurate and impartial. At the same time, however, Thucydides tried to write more than simply an account of a local war. The history was an attempt to analyze human motives and reactions so that future generations would understand how and why the conflict occurred and, in turn, understand themselves. The work was not meant to entertain by providing digressions and anecdotes but to search out the truth and use it to demonstrate universal principles of human behavior. This emphasis on reason makes Thucydides' work typical of the Classical period.

The hero of Thucydides' account of the years immediately preceding the war is Pericles, the leader whose name symbolizes the achievements of the Athenian Golden Age [3.2]. An aristocrat by birth, Pericles began his political career in the aftermath of the transfer of the Delian League's funds to Athens. By 443 B.C., he had unofficially assumed the leadership of the Athenian democracy, although he continued democratically to run for reelection every year. Under his guidance the few remaining years of peace were devoted to making visible the glory of Athens by constructing on the Acropolis the majestic buildings that still, though in ruins, evoke the grandeur of Periclean Athens (Table 3.1).

Had Pericles continued to lead Athens during the war itself, the final outcome might have been different, but in

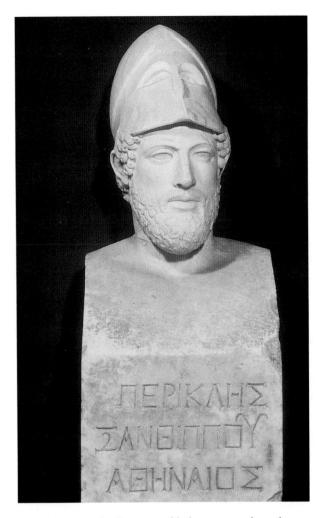

3.2 Kresilas, *Pericles.* Roman marble herm copy after a bronze original of c. 429 B.C. Approx. 72" high. Vatican Museums, Rome. Pericles is wearing a helmet, pushed up over his forehead because his official rank, while leader of Athens, was that of general.

TABLE 3.1 Athens in the Age of Pericles (ruled 443–429 B.C.)

Indee our rinnene no me	-30 0) - 010000 (10000
Area of the city Population of the city Population of the	7 square miles 100,000–125,000 200,000–250,000
region (Attica)	200,000 200,000
Political institution	General Assembly, Council of
	500, Ten Generals
Economy	Maritime trade; Crafts (textiles,
	pottery); Farming (olives,
	grapes, wheat)
Cultural life	History (Thucydides); Drama
	(Aeschylus, Sophocles, Euripi-
	des, Aristophanes); Philosophy
	(Socrates); Architecture (Ictinus,
	Callicrates, Mnesicles); Sculp-
8 TH 8 TH	ture (Phidias)
Principal buildings	Parthenon, Propylea (the
	Erechtheum, the other major
	building on the Athenian Acrop-
	olis, was not begun in Pericles'
	lifetime)

VALUES

Civic Pride

Aristotle's comment that "Man is a creature who lives in a city," sometimes translated as "Man is a political animal," summarizes the Greeks' attitude to their *polis* (city). The focus of political, religious, and cultural life, and most other aspects as well—sport, entertainment, justice—the *polis* came to represent the central force in the life of each individual citizen.

The Greeks saw the importance of their city-states as the fundamental difference between their culture and that of the "barbarians," since it enabled them to participate in their community's affairs as responsible individuals. This participation was limited to adult male citizens; female citizens played little significant role in public life, and slaves and resident foreigners were completely excluded.

If the *polis* was responsible for many of the highest achievements of Greek culture, the notion of civic pride produced in the end a series of destructive rivalries that ended Greek independence. The unity forged in the threat of the Persian invasions soon collapsed in the build-up to the Peloponnesian War. Even in the face of the campaigns of Philip of Macedon, the Greek cities continued to feud among themselves, unable to form a common front in the face of the danger of conquest.

The notion of the individual city as the focus of political and cultural life returned in the Italian Renaissance. Renaissance Florence and Siena, Milan, Venice and Verona, saw themselves as separate city-states, with their own styles of art and society. Even a small community such as Urbino became an independent political and artistic unit, modeled consciously on the city-states of Classical Greece. As in Greek times, civic pride led to strife between rivals, and left the Italians helpless in the face of invasions by French forces, or those of the Holy Roman Emperor.

430 B.C. the city was ravaged by disease, perhaps bubonic plague, and in 429 B.C. Pericles died. No successor could be found who was capable of winning the respect and support of the majority of his fellow citizens. The war continued indecisively until 421 B.C., when an uneasy peace was signed. Shortly thereafter the Athenians made an ill-advised attempt to replenish their treasury by organizing an unprovoked attack on the wealthy Greek cities of Sicily. The expedition proved a total disaster; thousands of Athenians were killed or taken prisoner. When the war began again (411 B.C.), the Athenian forces were fatally weakened.

The end came in 404 B.C. After a siege that left many people dying in the streets, Athens surrendered unconditionally to the Spartans and their allies.

DRAMA AND PHILOSOPHY IN CLASSICAL GREECE

The Drama Festivals of Dionysus

The tumultuous years of the fifth century B.C., passing from the spirit of euphoria that followed the ending of the Persian Wars to the mood of doubt and selfquestioning of 404 B.C., may seem unlikely to have produced the kind of intellectual concentration characteristic of Classical Greek drama. Yet it was, in fact, in the plays written specifically for performance in the theater of Dionysus at Athens in these years that Classical literature reached its most elevated heights. The tragedies of the three great masters—Aeschylus, Sophocles, and Euripides—not only illustrate the development of contemporary thought but also contain some of the most memorable scenes in the history of the theater.

Aeschylus

Tragic drama was not itself an invention of the fifth century B.C. It had evolved over the preceding century from choral hymns sung in honor of the god Dionysus, and the religious character of its origins was still present in its fully developed form. The plays that have survived from the Classical period at Athens were all written for performance at one of the two annual festivals sacred to Dionysus before an audience consisting of the entire population of the city. (Like the Egyptian god, Osiris, Dionysus died and was reborn, and the festivals held in his honor may be related to earlier ceremonies developed in Egypt.) To go to the theater was to take part in a religious ritual; the theaters themselves were regarded as sacred ground [3.3].

Each of the authors of the works given annually normally submitted four plays to be performed consecutively on a single day—three tragedies, or a "trilogy," and a more lighthearted play called a *satyr* play (a satyr

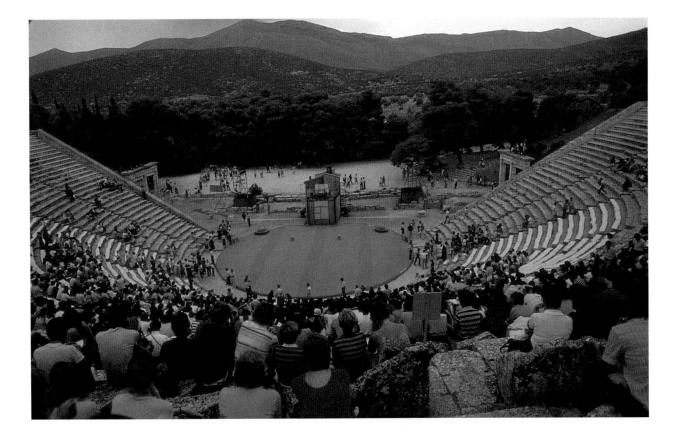

3.3 Polykleitos, Theater, Epidaurus, c. 350 B.C. Diameter 373' (113.69 m), orchestra 66' (20.12 m) across.

was a mythological figure: a man with an animal's ears and tail). The trilogies sometimes narrated parts of a single story, although often the three works were based on different stories with a common theme. At the end of each festival the plays were judged and a prize awarded to the winning author.

The dramas were religious not only in time and place but also in nature. The plots, generally drawn from mythology, often dealt with the relationship between the human and the divine. To achieve an appropriate seriousness, the style of performance was lofty and dignified. The actors, who in a sense served as priests of Dionysus, wore masks, elaborate costumes, and raised shoes.

The chorus, whose sacred dithyrambic hymn had been the original starting point in the development of tragedy, retained an important function throughout the fifth century B.C. In some plays (generally the earlier ones) the chorus forms a group centrally involved in the action, as in Aeschylus' *Suppliants* and *Eumenides*. More often, as in Sophocles' *Oedipus the King* or *Antigone*, the chorus represents the point of view of the spectator, rather than that of the characters participating directly in the events on stage; in these plays the chorus reduces to more human terms the intense emotions of the principals and comments on them. Even in the time of Euripides, when dramatic confrontation became more important than extended poetic or philosophical expression, the chorus still retained one important function: that of punctuating the action and dividing it into separate episodes by singing lyric odes the subject of which was sometimes only indirectly related to the action of the play.

These aspects of Classical tragedy are a reminder that the surviving texts of the plays represent only a small part of the total experience of the original performances. The words—or at least some of them—have survived; but the music to which the words were sung and which accompanied much of the action, the elaborate choreography to which the chorus moved, indeed the whole grandiose spectacle performed out-of-doors in theaters located in sites of extreme natural beauty before an audience of thousands-all of this can only be recaptured in the imagination. It is perhaps relevant to remember that when, almost two thousand years later, around A.D. 1600, a small group of Florentine intellectuals decided to revive the art of Classical drama, they succeeded instead in inventing opera. Similarly, in the nineteenth century, the German composer Richard Wagner was inspired by Greek tragedy to devise his concept of a Gesamtkunstwerk (literally "total work of art"), a work of art that combined all the arts into one; he illustrated this concept by writing his dramatic operas.

The Athenian Tragic Dramatists

Even if some elements of the surviving Greek dramas are lost, we do have the words. The differing worldviews of the authors of these works vividly illustrate the changing fate of fifth-century-B.C. Athens. The earliest of the playwrights, Aeschylus (525–456 B.C.), died before the lofty aspirations of the early years of the Classical period could be shaken by contemporary events. His work shows a deep awareness of human weakness and the dangers of power (he had himself fought at the Battle of Marathon in 490 B.C.), but he retains an enduring belief that in the end right will triumph. In Aeschylus' plays, the process of being able to recognize what is right is painful. One must suffer to learn one's errors; yet the process is inevitable, controlled by a divine force of justice personified under the name of Zeus.

The essential optimism of Aeschylus' philosophy must be kept in mind because the actual course of the events he describes is often violent and bloody. Perhaps his most impressive plays are the three that form the *Oresteia* trilogy. This trilogy, the only complete one that has survived, won first prize in the festival of 458 B.C. at Athens. The subject of the trilogy is nothing less than the growth of civilization, represented by the gradual transition from a primitive law of *vendetta* ("blood for blood") to the rational society of civilized human beings.

The first of the three plays, the *Agamemnon*, presents the first of these systems in operation. King Agamemnon returns to his homeland, Argos, after leading the Greeks to victory at Troy. Ten years earlier, on the way to Troy, he had been forced to choose either to abandon the campaign because of unfavorable tides or to obtain an easy passage by sacrificing his daughter Iphigenia. (The situation may seem contrived, but it clearly symbolizes a conflict between public and personal responsibilities.) After considerable hesitation and self-doubt he had chosen to sacrifice his daughter. On his return home at the end of the Trojan War, he pays the price for her death by being murdered by his wife Clytemnestra and her lover Aegisthus [3.4]. Her ostensible motive is vengeance for Iphigenia's death, but an equally powerful, if less noble, one is her desire to replace Agamemnon both as husband and king by her lover Aegisthus. Thus, Aeschylus shows us that even the "law of the jungle" is not always as simple as it may seem, while at the same time the punishment of one crime creates in its turn another crime to be punished. If Agamemnon's murder of his daughter merits vengeance, then so does Clytemnestra's sacrifice of her husband. Violence breeds violence.

The second play, *The Libation Bearers*, shows us the effects of the operation of this principle on Agamemnon and Clytemnestra's son, Orestes. After spending years in exile, Orestes returns to Argos to avenge his father's death by killing his mother. Although a further murder can accomplish nothing except the transfer of blood guilt

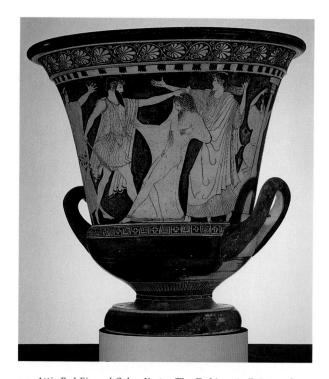

3.4 Attic Red Figured Calyx Krater, The Dokimasia Painter, about 460 B.C. Side A: *The Murder of Agamemnon by Aegisthus*. Clay, height: 0.51 m, diam: 0.51 m. Museum of Fine Arts, Boston. Aegisthus strikes the blow in this version of the story, with Clytemnestra standing behind him grasping an axe. Agamemnon, murdered as he was about to take a bath, is wearing only a light robe.

to Orestes himself, the primitive law of vendetta requires him to act. With the encouragement of his sister Electra, he kills Clytemnestra. His punishment follows immediately. He is driven mad by the Furies, the implacable goddesses of vengeance, who hound him from his home.

The Furies themselves give their name to the third play, in which they are tactfully called The Eumenides ("the kindly ones"). In his resolution of the tragedy of Orestes and his family, Aeschylus makes it clear that violence can only be brought to an end by the power of reason and persuasion. After a period of tormented wandering, Orestes comes finally to Athens where he stands trial for the murder of his mother before a jury of Athenians, presided over by Athena herself. The Furies insist on his condemnation on the principle of blood for blood, but Orestes is defended by Apollo, the god of reason, and finally acquitted by his fellow human beings. Thus, the long series of murders is brought to an end, and the apparently inevitable violence and despair of the earlier plays is finally dispelled by the power of persuasion and human reason, which-admittedly with the help of Athena and Apollo-have managed to bring civilization and order out of primeval chaos.

Despite all the horror of the earlier plays, therefore, the *Oresteia* ends on a positive note. Aeschylus affirms

his belief that progress can be achieved by reason and order. This gradual transition from darkness to light is handled throughout the three plays with unfailing skill. Aeschylus matches the grandeur of his conception with majestic language. His rugged style makes him sometimes difficult to understand, but all the verbal effects are used to dramatic purpose. The piling up of images and complexity of expression produce an emotional tension that has never been surpassed.

The life of Sophocles (496–406 в.С.) spanned both the glories and the disasters of the fifth century в.С. Of the three great tragic poets, Sophocles was the most prosperous and successful; he was a personal friend of Pericles. He is said to have written 123 plays, but only seven have survived, all of which date from the end of his career. They all express a much less positive vision of life than that of Aeschylus. His philosophy is not easy to extract from his work, since he is more concerned with exploring and developing the individual characters in his dramas than with expounding a point of view; in general, Sophocles seems to combine an awareness of the tragic consequences of individual mistakes with a belief in the collective ability and dignity of the human race.

The consequences of human error are vividly depicted in his play *Antigone*, first performed around 440 B.C. Thebes has been attacked by forces under the leader-

3.5 The ancient theater at Delphi, 1951. The columns in the background are the ruins of the Temple of Apollo.

ship of Polynices; the attack is beaten off and Polynices killed. In the aftermath Creon, king of Thebes, declares the dead warrior a traitor and forbids anyone to bury him on pain of death. Antigone, Polynices' sister, disobeys, claiming that her religious and family obligations override those to the state. Creon angrily condemns her to death. He subsequently relents, but too late: Antigone, his son (betrothed to Antigone), and his wife have all committed suicide. Creon's stubbornness and bad judgment thus result in tragedy for him as well as for Antigone.

Paradoxically, however, the choice between good and evil is never clear or easy and is sometimes impossible. More than any of his contemporaries, Sophocles emphasizes how much lies outside our own control, in the hands of destiny or the gods. His insistence that we respect and revere the forces that we cannot see or understand makes him the most traditionally religious of the tragedians. These ambiguities appear in his best-known play, Oedipus the King, which has stood ever since Classical times as a symbol of Greek tragic drama [3.5]. A century after it was first performed (c. 429 B.C.), Aristotle used it as his model when, in the Poetics, he discussed the nature of tragedy. Its unities of time, place, and action, the inexorable drive of the story with its inevitable yet profoundly tragic conclusion, the beauty of its poetryall have made *Oedipus the King* a true classic, in all senses. Its impact has lasted down to the present; it had a notable effect on the ideas of Sigmund Freud. Yet in spite of the

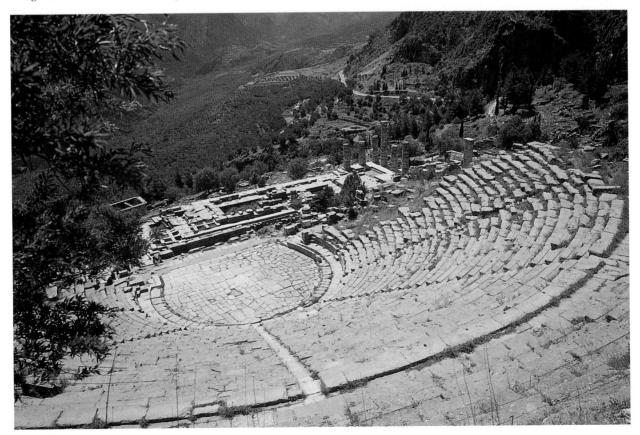

universal admiration the play has excited, its message is far from clear.

The story concerns Oedipus, doomed even before his birth to kill his father and marry his mother, his attempts to avoid fate, and his final discovery that he has failed. If the play seems, in part, to be saying that we cannot avoid our destiny, it leaves unanswered the question of whether or not we deserve that destiny. Certainly Oedipus does not choose deliberately to kill his father and marry his mother, even though unknowingly everything he does leads to this end. Then why does he deserve to suffer for his actions?

One of the traditional answers to this question can be found in Aristotle's analysis of tragedy in the Poetics. Referring particularly to Oedipus, Aristotle makes the point that the downfall of a tragic figure is generally the result of a flaw (the Greek word is hamartia) in his character. Thus Oedipus' pride and stubbornness in insisting on discovering who he is and the anger he shows in the process bring about the final disastrous revelation. In this way the flaws, or weaknesses, in his character overcome his good points and destroy him. As a description of Oedipus' behavior, this explanation is convincing enough, but it fails to provide a satisfactory account of the original causes of his condition. Perhaps the message of the play is, in fact, that there are some aspects of existence beyond our understanding, aspects that operate by principles outside our range of experience. If this is so, and many literary critics would deny it, Sophocles seems to be describing the final helplessness of humanity in the face of forces that we cannot control and warning against too great a belief in self-reliance.

The significance for the Athenians themselves of Oedipus' fall from greatness emerges in full force in the work of Euripides (c. 484–406 B.C.). Although only slightly younger than Sophocles, Euripides expresses all the weariness and disillusion of the war-torn years at the end of the fifth century B.C. Of all the tragedians, Euripides is perhaps the closest to our own time, with his concern for realism and his determination to expose social, political, and religious injustices.

Although Euripides admits the existence of irrational forces in the universe that can be personified in the forms of gods and goddesses, he certainly does not regard them as worthy of respect and worship. This skepticism won him the charge of impiety. His plays show characters frequently pushed to the limits of endurance; their reactions show a new concern for psychological truth. In particular, Euripides exhibits a profound sympathy and understanding for the problems of women who live in a society dominated by men. Characters like Medea and Phaedra challenged many of the basic premises of contemporary Athenian society.

Euripides' deepest hatred is reserved for war and its senseless misery. Like the other dramatists he draws the subject matter of his plays from traditional myths, but the lines delivered by the actors must have sounded in their hearers' ears with a terrible relevance. *The Suppliant Women* was probably written in 421 B.C., when ten years of indecisive fighting had produced nothing but an uneasy truce. Its subject is the recovery by Theseus, ruler of Athens, of the bodies of seven chiefs killed fighting at Thebes in order to return them to their families for burial. He yields to their mothers—the women of the title—who beg him to recover the corpses. The audience would have little need to be reminded of the grief of wives and mothers or of the kind of political processes that produced years of futile fighting.

If Aeschylus' belief in human progress is more noble, Euripides is certainly more realistic. Although unpopular in his own time, he later became the most widely read of the three tragedians. As a result, more of his plays have been preserved (nineteen in all), works with a wide range of emotional expression. They extend from romantic comedies like *Helen* and *Iphigenia in Taurus* to the profoundly disturbing *Bacchae*, his last completed play, in which Euripides the rationalist explores the inadequacy of reason as the sole approach to life. In this acknowledgment of the power of emotion to overwhelm the order and balance so typical of the Classical ideal, he is most clearly speaking for his time.

Aristophanes and Greek Comedy

Euripides was not, of course, the only Athenian to realize the futility of war. The plays of Aristophanes (c. 450–385 B.C.), the greatest comic poet of fifth-century-B.C. Athens, deal with the same theme. His work combines political satire with a strong vein of fantasy.

In *The Birds*, produced in 414 B.C., two Athenians decide to leave home and find a better place to live. They join forces with the birds and build a new city in midair called Cloudcuckooland, which cuts off contact between gods and humans by blocking the path of the smoke rising from sacrifices. The gods are forced to come to terms with the new city and Zeus hands over his scepter of authority to the birds.

This is simple escapism, but *Lysistrata*, written a few years later (411 B.C.), deals with the problem of how to prevent war in a more practical fashion. In the course of the play, the main protagonist, Lysistrata, persuades her fellow women of Athens to refuse to make love with their husbands until peace is negotiated. At the same time her followers seize the Acropolis. The men, teased and frustrated, finally give in and envoys are summoned from Sparta. The play ends with the Athenians and Spartans dancing together for joy at the new peace.

With the end of the Peloponnesian War (404 B.C.) and the fall of Athenian democracy, both art and political life were to be affected by an atmosphere of considerable confusion. Though Athens had been removed as the dominating force in Greece, there was no successor among her rivals. The vacuum was not filled until the mid-fourth century with the appearance on the scene of Philip of Macedon. Earlier, a disastrous series of skirmishes between Sparta, Thebes, Athens, Corinth, and Argos had been temporarily suspended by the intervention of the great King of the Persians himself, and the socalled King's Peace was signed in 387 B.C. But after a brief respite, the Thebans decisively defeated the Spartan forces at Leuctra in 371 B.C. and remained for a few years the leading force in Greek political life.

With the accession of Philip in Macedon (359 B.C.), however, the balance of power in Greece began to change. The hitherto backward northern kingdom of Macedon began to exert a new unifying influence, despite opposition in Thebes and in Athens, where the great Athenian orator Demosthenes led the resistance. In 338 B.C., at the Battle of Chaeronaea (see map, "Ancient Greece," Chap. 2), Philip defeated Athenian and Theban forces and unified all the cities of Greece, with the exception of Sparta, in an alliance known as the League of Corinth.

Even before his assassination in 336 B.C., Philip had developed schemes for enlarging his empire by attacking Persia. His son and successor, Alexander, carried them out. He spent the ten years from 333 B.C. until his own death in 323 B.C. in an amazing series of campaigns across Asia, destroying the Persian Empire and reaching as far as India. The effects of the breakup of this new Macedonian empire after the death of Alexander were to be felt throughout the Hellenistic period that followed.

Philosophy in the Late Classical Period

The intellectual and cultural spirit of the new century was foreshadowed in its very first year in an event at Athens. In 399 B.C., the philosopher Socrates was charged with impiety and corruption of the young, found guilty, and executed. Yet the ideas that Socrates represented concern with the fate of the individual and the questioning of traditional values—could not be killed so easily. They had already begun to spread at the end of the fifth century B.C. and came to dominate the culture of the fourth century B.C.

Socrates is one of the most important figures in Greek history. He is also one of the most difficult to understand clearly. Much of the philosophy of the Greeks and of later ages and cultures has been inspired by his life and teachings. Yet Socrates himself wrote nothing; most of what we know of him comes from the works of his disciple, Plato. Socrates was born around 469 B.C., the son of a sculptor and a midwife; in later life he claimed to have followed his mother's profession in being a "midwife to ideas." He seems first to have been interested in natural science, but soon turned to the problems of human behavior and morality. Unlike the sophists (the professional philosophers of the day), he neither took money for teaching, nor did he ever found a school. Instead he went around Athens, to both public places like the markets and the gymnasia and private gatherings, talking and arguing, testing traditional ideas by subjecting them to a barrage of questions—as he put it, "following the argument wherever it led."

Socrates gradually gained a circle of enthusiastic followers, drawn mainly from the young. At the same time he acquired many enemies, disturbed by both his challenge to established morality and the uncompromising persistence with which he interrogated those who upheld it. Socrates was no respecter of the pride or dignity of others, and his search for the truth inevitably exposed the ignorance of his opponents. Among Socrates' supporters were a number who had taken part in an unpopular and tyrannical political coup at Athens immediately following the Peloponnesian War. The rule of the socalled Thirty Tyrants lasted only from 404 to 403 B.C.; it ended with the death or expulsion of its leading figures. The return of democracy gave Socrates' enemies a chance to take advantage of the hostility felt toward those who had "collaborated" with the tyrants; thus, in 399 B.C., he was put on trial. It seems probable that to some degree the proceedings were intended for show and that those who voted for the death sentence never seriously thought it would be carried out. Socrates was urged by his friends to escape from prison, and the authorities themselves offered him every opportunity. However, the strength of his own morality and his reverence for the laws of his city prohibited him from doing so. After a final discussion with his friends, he was put to death by the administration of a draught of hemlock.

Many of Socrates' disciples tried to preserve his memory by writing accounts of his life and teachings. The works of only two have survived. One of these is the Greek historian Xenophon, whose *Apology, Symposium*, and *Memorabilia* are interesting, if superficial. The other is Plato, who, together with his pupil Aristotle, stands at the forefront of the whole intellectual tradition of Western civilization.

The Dialogues of Plato claim to record the teachings of Socrates. Indeed, in almost all of them Socrates himself appears, arguing with his opponents and presenting his own ideas. How much of Plato's picture of Socrates is historical truth and how much is Plato's invention, however, is debatable. The Socratic problem has been almost as much discussed as the identity of Homer. In general, modern opinion supports the view that in the early Dialogues Plato tried to preserve something of his master's views and methods, while in the later ones he used Socrates as the spokesman for his own ideas. There can certainly be no doubt that Plato was deeply impressed by Socrates' life and death. Born in 428 B.C., he was drawn by other members of his aristocratic family into the Socratic circle. Plato was present at the trial of Socrates, whose speech in his own defense Plato records in the Apology, one of three works that describe Socrates' last days. In the Crito, set in prison, Socrates explains why he refuses to escape. The Phaedo gives an account of his last day spent discussing with his friends the immortality of the soul and his death.

After Socrates' death, Plato left Athens, horrified at the society that had sanctioned the execution, and spent a number of years traveling. He returned in 387 B.C. and founded the Academy, the first permanent institution in Western civilization devoted to education and research, and thus the forerunner of all our universities. Its curriculum concentrated on mathematics, law, and political theory. Its purpose was to produce experts for the service of the state. Some twenty years later, in 368 B.C., Plato was invited to Sicily to put his political theories into practice by turning Syracuse into a model kingdom and its young ruler, Dionysius II, into a philosopher king. Predictably, the attempt was a dismal failure and, by 366 B.C., he was back in Athens. Apart from a second visit to Syracuse in 362 B.C., equally unsuccessful, Plato seems to have spent the rest of his life in Athens, teaching and writing. He died there in 347 B.C.

Much of Plato's work deals with political theory and the construction of an ideal society. The belief in an ideal is, in fact, characteristic of most of his thinking. It is most clearly expressed in his Theory of Forms, according to which in a higher dimension of existence there are perfect forms of which all the phenomena we perceive in the world around us represent pale reflections. There can be no doubt that Plato's vision of an ideal society is far too authoritarian for most tastes, involving among other restrictions the careful breeding of children, the censorship of music and poetry, and the abolition of private property. In fairness to Plato, however, it must be remembered that his works are intended not as a set of instructions to be followed literally but as a challenge to think seriously about how our lives should be organized. Furthermore, the disadvantages of democratic government had become all too clear during the last years of the fifth century B.C. If Plato's attempt to redress the balance seems to veer excessively in the other direction, it may in part have been inspired by the continuing chaos of fourthcentury Greek politics.

Plato's most gifted pupil, Aristotle (384–322 B.C.), continued to develop his master's doctrines, at first wholeheartedly and later critically, for at least twenty years. In 335 B.C., Aristotle founded a school in competition with Plato's Academy, the Lyceum, severing fundamental ties with Plato from then on. Aristotle in effect introduced a rival philosophy—one that has attracted thinking minds ever since. Indeed, in the nineteenth century, the English poet Samuel Taylor Coleridge was to comment, with much truth, that one was born either a "Platonist" or an "Aristotelian."

The Lyceum seems to have been organized with typical Aristotelian efficiency. In the morning Aristotle himself lectured to the full-time students, many of whom came from other parts of Greece to attend his courses and work on the projects he was directing. In the afternoon the students pursued their research in the library, museum, and map collection attached to the Lyceum, while Aristotle gave more general lectures to the public. His custom of strolling along the Lyceum's circular walkways, immersed in profound contemplation or discourse, gained his school the name *Peripatetic* (the "walking" school).

As a philosopher Aristotle was the greatest systematizer. He wrote on every topic of serious study of the time. Many of his classifications have remained valid to this day, although some of the disciplines, such as psychology and physics, have severed their ties with philosophy and have become important sciences in their own right. The most complex of Aristotle's works is probably the *Metaphysics*, in which he deals with his chief dispute with Plato, which concerned the Theory of Forms. Plato had postulated a higher dimension of existence for the ideal forms and thereby created a split between the apparent reality that we perceive and the genuine reality that we can only know by philosophical contemplation. Moreover, knowledge of these forms depended on a theory of "remembering" them from previous existences.

Aristotle, on the other hand, claimed that the forms were actually present in the objects we see around us, thereby eliminating the split between the two realities. Elsewhere in the *Metaphysics* Aristotle discusses the nature of God, whom he describes as "thought thinking of itself" and "the Unmoved Mover." The nature of the physical world ruled over by this supreme being is further explored in the *Physics*, which is concerned with the elements that compose the universe and the laws by which they operate.

Other important works by Aristotle include the Rhetoric, which prescribes the ideal model of oratory; and the Poetics, which does the same for poetry and includes the famous definition of *tragedy* mentioned earlier. Briefly, Aristotle's formula for tragedy is as follows: The tragic hero, who must be noble, through some undetected "tragic flaw" in character meets with a bad end involving the reversal of fortune and sometimes death. The audience, through various emotional and intellectual relations with this tragic figure, undergoes a "cleansing" or "purgation" of the soul, called *catharsis*. Critics of this analysis sometimes complain that Aristotle was trying to read his own very subjective formulas into the Greek tragedies of the time. This is not entirely justified, since Aristotle was probably writing for future tragedians, prescribing what ought to be rather than what was.

Aristotle's influence on later ages was vast, although not continuous. Philip of Macedon employed him to tutor young Alexander, but the effect on the young conqueror was probably minimal. Thereafter his works were lost and not recovered until the first century B.C., when they were used by the Roman statesman and thinker Cicero (106–43 B.C.). During the Middle Ages, they were translated into Latin and Arabic and became a philosophical basis for Christian theology. Saint Thomas Aquinas' synthesis of Aristotelian philosophy and Christian doctrine still remains the official philosophical position of the Roman Catholic Church. In philosophy, theology, and scientific and intellectual thought as a whole, many of the distinctions first applied by Aristotle were rediscovered in the early Renaissance and are still valid today. Indeed, no survey such as this can begin to do justice to one described by Dante as "the master of those who know." In the more than two thousand years since his death only Leonardo da Vinci has come near to equaling his creative range.

GREEK MUSIC IN THE CLASSICAL PERIOD

Both Plato and Aristotle found a place for music in their ideal states; their comments on it provide some information on the status of Greek music in the Classical period. Throughout the fifth century B.C., music played an important part in dramatic performances but was generally subordinated to the poetry. By the end of the Peloponnesian War, however, the musical aspect of tragedy had begun to predominate. It is interesting to note that Euripides was criticized by his contemporaries for the lack of form and symmetry and the overemotionalism of his music, not of his verse. With its release from the function of mere accompaniment, instrumental music became especially popular in the fourth century B.C.

The belief in the doctrine of ethos whereby music had the power to influence human behavior, meant that the study of music played a vital part in the education and lifestyle of Classical Greeks. In Plato's view, participation in musical activities molded the character for better or worse-thus the ban on certain kinds of music, those with the "wrong" ethos, in his ideal Republic. At the same time, the musical scale-with its various ratios of pitches-reflected the proportions of the cosmos; music thereby provided a link between the real world and the abstract world of forms. For Aristotle, music held a more practical, less mystical, value in the attainment of virtue. As a mathematician he believed that the numerical relationships, which linked the various pitches, could be used by a musician to compose works which imitated the highest state of reason, and thus virtue. Further, just as individuals could create works with a virtuous, moral ethos, so too the state would be served by "ethical" music.

For all its importance in Greek life and thought, however, the actual sound of Greek music and the principles whereby it was composed are not easy to reconstruct or understand. The numerical relationship of notes to one another established by Pythagoras was used to divide the basic unit of an octave (series of eight notes) into smaller intervals named after their positions in relation to the lowest note in the octave. The interval known as a *fourth*, for example, represents the space between the lowest note and the fourth note up the octave. The intervals were then combined to form a series of scales, or *modes*. Each was given a name and was associated with a particular emotional range. Thus the Dorian mode was serious and warlike, the Phrygian exciting and emotional, and the Mixolydian plaintive and pathetic.

The unit with which Greek music was constructed was the *tetrachord*, a group of four notes of which the two outer ones are a perfect fourth apart and the inner ones variably spaced. The combination of two tetrachords formed a mode. The Dorian mode, for example, consisted of the following two tetrachords:

The Lydian mode was composed of two different tetrachords:

The origin of the modes and their relationship to one another is uncertain; it was disputed even in ancient times. The situation has not been made easier by the fact that medieval church music adopted the same system of mathematical construction and even some of the same names, but applied them to different modes. The word harmony is Greek in origin; literally it means a "joining together," and in a musical context the Greeks used it to describe various kinds of scales. There is nevertheless no evidence that Greek music contained any element of harmony in a more modern sense-that is, of groups of notes (chords) sounded simultaneously. Throughout the fifth century B.C., musical rhythm was tied to that of the words or dance steps the music accompanied. Special instruments such as cymbals and tambourines were used to mark the rhythmical patterns, and Greek writers on music often discussed specific problems presented to composers in terms of the Greek language and its accent system.

Although few traces have survived, a system of musical notation was used to write down compositions; the Greeks probably borrowed it, like their alphabet, from the Phoenicians. Originally used for lyre music, it used symbols to mark the position of fingers on the lyre strings, rather like modern guitar notation (tablature). The system was then adapted for vocal music and for nonstringed instruments such as the *aulos*. The oldest of the few examples to survive dates to around 250 B.C.

THE VISUAL ARTS IN CLASSICAL GREECE

Sculpture and Vase Painting in the Fifth Century B.C.

Like the writers and thinkers of their time, artists of the mid-fifth century B.C. were concerned with ideas of balance and order. Very early Classical works like the *Kritios Boy* [2.13] revealed a new interest in realism, and the sculptors who came later began to explore the exciting possibilities of representing the human body in motion. Among the most famous fifth-century sculptors working at Athens was Myron. Although none of his sculptures have survived, there are a number of later copies of one of his most famous pieces, the *Discus Thrower* [3.6]. The original, made around 450 B.C., is typical of its age in combining realistic treatment of an action with an idealized portrayal of the athlete himself.

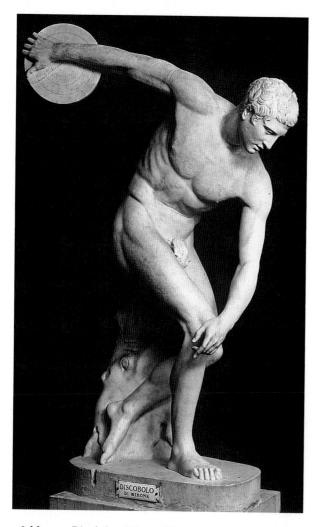

3.6 Myron, *Discobolos* (*Discus Thrower*), Roman copy after bronze original of c. 450 B.C. Marble, life-size. Museo Nationale Romano, Rome, Italy.

While striving for naturalism, artists like Myron tried also to create a new standard of human beauty by controlling the human form according to principles of proportion, symmetry, and balance. Among the finest examples of mid-fifth-century-B.C. sculpture are two bronze statues found off the coast of southeast Italy in the 1980s [3.7]. Known as the Riace Bronzes, they were probably the work of a master sculptor on the Greek mainland. They represent warriors, although their precise subject, together with the reason for their presence in Italian waters, remains a mystery. Around 440 B.C., one of the greatest of Classical sculptors, Polykleitos of Argos, devised a mathematical formula for representing the perfect male body, an ideal canon of proportion, and wrote a book about it. The idea behind The Canon was that ideal beauty consisted of a precise relationship between the various parts of the body. Polykleitos' book must have set forth the details of his system of proportion. To illustrate his theory, he also produced a bronze statue of a young man holding a spear, the Doryphoros. Both book and original statue are lost; only later copies of the Doryphoros survive [3.8].

We do not therefore know exactly what Polykleitos' system was. Nevertheless, we have some indication in the writings of a later philosopher, Chrysippus (c. 280– 207 B.C.), who wrote that "beauty consists of the proportion of the parts; of finger to finger; of all the fingers to the palm and the wrist; of those to the forearm; of the forearm to the upper arm; and of all these parts to one another, as set forth in *The Canon* of Polykleitos." Even if the exact relationships are lost, what was important about Polykleitos' ideal—and what made it so characteristic of the Classical vision as a whole—was that it depended on precisely ordered and balanced interrelationships of the various parts of the human body. Furthermore, the ideal beauty this created was not produced by nature, but by the power of the human intellect.

In the late fifth century B.C., as the Greeks became embroiled in the Peloponnesian War, sculpture and vase painting were characterized by a growing concern with the individual rather than a generalized ideal. Artists began to depict the emotional responses of ordinary people to life and death instead of approaching these responses indirectly through the use of myths.

Thus death and mourning became increasingly common subjects. Among the most touching works to survive from the period are a number of oil flasks used for funerary offerings [3.9]. They are painted with mourning or graveside scenes on a white rather than red background. The figures are depicted with quiet and calm dignity but with considerable feeling. This personal rather than public response to death is also found on the gravemarkers of the very end of the fifth century B.C., which show a grief that is perhaps resigned but still intense [3.10].

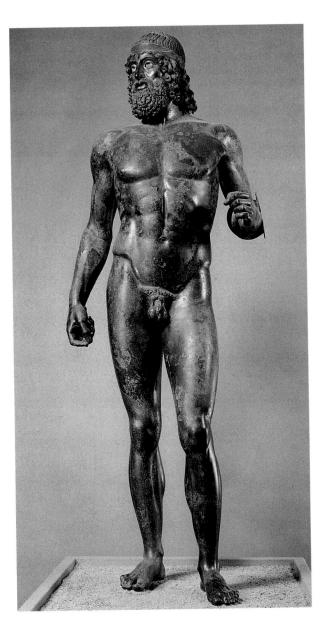

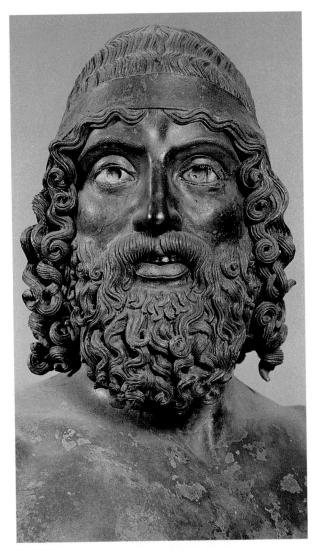

3.7 Warrior (front and detail of head), from the sea off Riace (Italy), c. 460–450 B.C. Bronze with glass, bone, silver, and copper inlay, height 6'6" (2 m). Archaeological Museum, Reggio Calabria, Italy.

Architecture in the Fifth Century B.C.

In architecture, as in sculpture, designers were concerned with proportion and the interrelationship of the various parts that constitute a complete structure. Nowhere is this more apparent than in the Temple of Zeus at Olympia [3.11], the first great artistic achievement of the years following the Persian Wars, begun in 470 B.C. and finished by 456 B.C. By the time of its completion it was also the largest Doric temple on mainland Greece; it was clearly intended to illustrate the new Classical preoccupation with proportion. The distance from the center of one column to the center of the next was the unit of measurement for the whole temple. Thus the height of each column is equal to two units, and the combined length of a triglyph and a metope equals half a unit. The theme of order, implicit in the architecture of the temple, became explicit in the sculpture that decorated it. At the center of the west pediment, standing calmly amidst a fight raging between Lapiths and Centaurs, was the figure of Apollo, the god of reason, exerting his authority by a single confident gesture [3.12].

The Statue of Zeus at Olympia

Like the works of Aeschylus, the sculptures from Olympia express a conviction that justice will triumph and that the gods will enforce it. The art of the second half of the fifth century B.C., however, is more concerned with human achievement than with divine will.

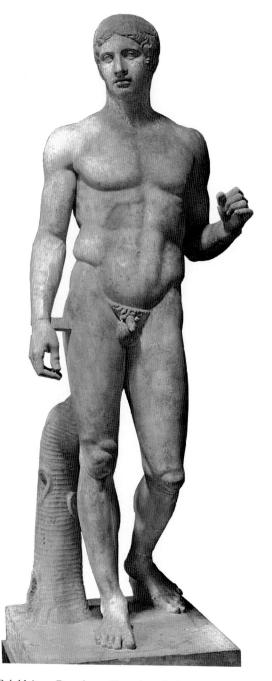

3.8 Polykleitos, *Doryphoros* (*Spear-bearer*). Roman marble copy after a bronze original of c. 450–440 B.C. Marble, height: 6'11". Museo Nazionale, Naples, Italy.

Pericles' building program for the Acropolis, or citadel of Athens, represents the supreme expression in visual terms of Classical ideals [3.13]. This greatest of all Classical artistic achievements has a special grandeur and poignancy. The splendor of its conception and execution has survived the vicissitudes of time; the great temple to Athena, the Parthenon, remains to this day an incomparable symbol of the Golden Age of Greece. Yet it was built during years of growing division and hostility

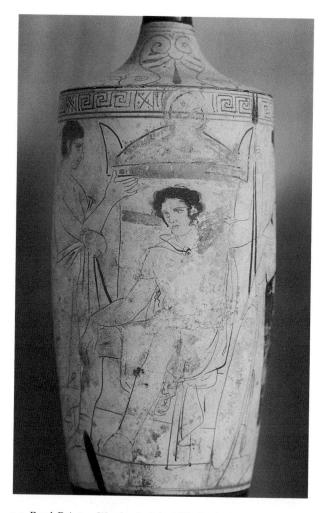

3.9 Reed Painter, *Warrior Seated at His Tomb*, late fifth century B.C. White-ground lekythos, height $187/_8$ " (48 cm). National Archaeological Museum, Athens. A youth is at one side. On the other side is a young woman who holds the warrior's shield and helmet.

in the Greek world—the last sculpture was barely in place before the outbreak of the Peloponnesian War in 431 B.C. Pericles died in 429 B.C., but fighting and building both dragged on. The Erechtheum, the final temple to be completed, was not finished until 406 B.C., two years before the end of the war and the fall of Athens. Pericles had intended the entire program to perpetuate the memory of Athens' glorious achievements, but instead it is a reminder of the gulf between Classical high ideals and the realities of political existence in fifthcentury-B.C. Greece.

The Acropolis

Even the funding of the Parthenon symbolizes this gap, since it was paid for at least in part from the trea-

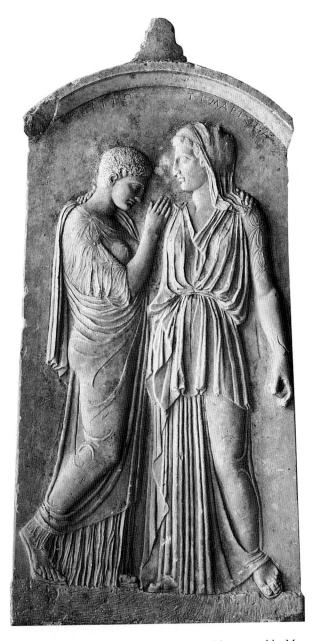

3.10 Grave stele of Crito and Timarista, c. 420 B.C., marble, Museum, Rhodes.

sury of the Delian League. The transfer of the League's funds to Athens in 454 B.C. clearly indicated Pericles' imperialist intentions, as did the use to which he put them. In this way the supreme monument of Periclean Athens was built with money originally intended for a pan–Hellenic League. It is even more ironic that Athens' further high-handed behavior created a spirit of ill feeling and distrust throughout the Greek world that led inevitably to the outbreak of the Peloponnesian War—a war that effectively destroyed the Athenian glory the Parthenon had been intended to symbolize.

The great outcrop of rock that forms the Acropolis was an obvious choice by Pericles for the Parthenon and

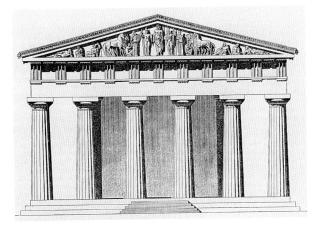

3.11 Reconstruction drawing of east facade, Temple of Zeus, Olympia, c. 470–456 B.C. The pediment shows Zeus between two contestants prior to a chariot race.

the other buildings planned with it. The site, which towers above the rest of the city, had served as a center for Athenian life from Mycenaean times, when a fortress was built on it. Throughout the Archaic period a series of temples had been constructed there, the last of which was destroyed by the Persians in 480 B.C. Work on the Acropolis was begun in 449 B.C. under the direction of Phidias, the greatest sculptor of his day and a personal friend of Pericles. The Parthenon [3.14] was the first building to be constructed (the name of the temple comes from the Greek parthenos ["virgin"]; that is, the goddess Athena). It was built between 447 and 438 B.C.; its sculptural decoration was complete by 432 B.C. Even larger than the Temple of Zeus at Olympia, the building combines the Doric order of its columns (seventeen on the sides and eight on the ends) with some Ionic features, including a continuous running frieze inside the outer colonnade, at the top of the temple wall and inner colonnades. The design incorporates a number of refinements intended to prevent any sense of monotony or heaviness and gives the building an air of richness and grace. Like earlier Doric columns, those of the Parthenon are thickest at the point one-third from the base and then taper to the top, a device called entasis. In addition, all the columns tilt slightly toward each other (it has been calculated that they would all meet if extended upward for two miles, or 3.2 kilometers). The columns at the corners are thicker and closer together than the others and the entablature leans outwards. The seemingly flat floor is not flat at all but convex. All these refinements are, of course, extremely subtle and barely visible to the naked eye. The perfection of their execution, requiring incredible precision of mathematical calculation, is the highest possible tribute to the Classical search for order.

The sculptural decoration of the Parthenon occupied three parts of the building and made use of three

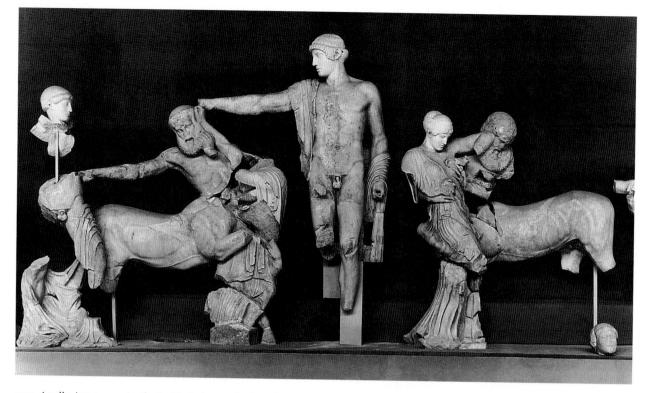

3.12 Apollo intervenes in the battle between the Lapiths and Centaurs, from the west pediment of the Temple of Zeus, Olympia, c. 470–456 B.C., Museum, Olympia.

3.13 Model reconstruction of the Acropolis. Royal Ontario Museum, Toronto. Most of the smaller buildings no longer exist, leaving an unobstructed view of the Parthenon that was not possible in ancient times.

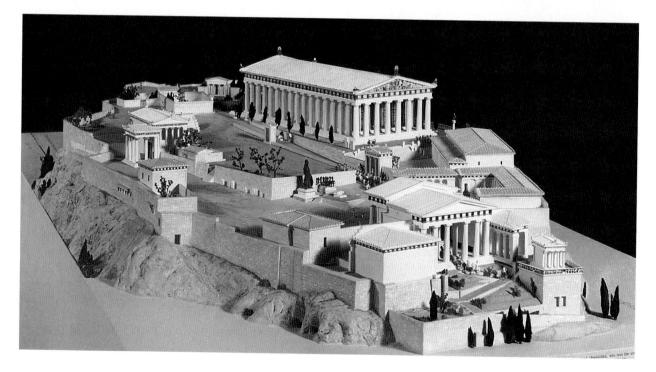

different techniques of carving. The figures in the pediments are freestanding; the frieze is carved in low relief; the metopes are in high relief (see next page). The Ionic frieze, 520 feet (158.6 meters) long, is carved in low relief;

it depicts a procession that took place every four years on the occasion of the Great Panathenaic Festival. It shows Athenians walking and riding to the Acropolis in a ceremony during which an ancient wooden statue of Athena

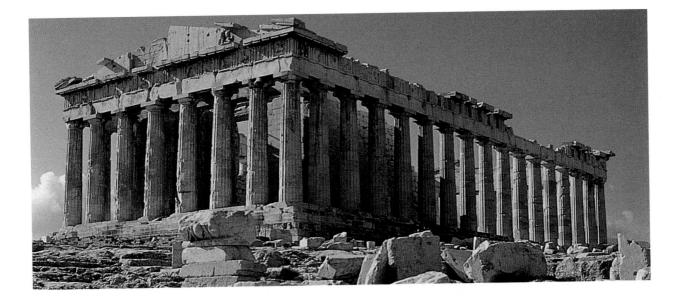

was presented with a new robe. The variety of movement, gesture, and rhythm achieved in the relatively limited technique of low relief makes the frieze among the greatest treasures of Greek art [3.15]. At the beginning of the nineteenth century, most of the frieze, together with other Parthenon sculptures, was removed from the building by the British ambassador to Constantinople, Lord Elgin; these are now in the British Museum. (All the sculptures from the Parthenon that are in the British Museum are generally known as the Elgin Marbles.)

Equally impressive are the surviving figures from the east and west pediments, which are freestanding. They show, respectively, the birth of Athena and her contest with Poseidon, god of the sea, to decide which of them should be patron deity of the city. They are badly damaged; even so, statues like the group of three goddesses [3.16], from the east pediment, show a combination of idealism and naturalism that has never been surpassed. The anatomy of the figures and the drapery, which in some cases covers them, are both treated realistically, even in places where the details of the workmanship would have been barely visible to the spectator below. The realism is combined, however, with a characteristically Classical preoccupation with proportion and balance; the result is sculptures that achieve an almost perfect blend of the two elements of the Classical style: ideal beauty represented in realistic terms. In contrast to the frieze, the technique employed on the metopes is high relief, so high, in fact, that some of the figures seem almost completely detached from their background. These metopes, which illustrate a number of mythological battles, represent a lower level of achievement, although some are more successful than others at reconciling scenes of violence and Classical idealism. The most impressive ones show episodes from the battle between Lapiths and Centaurs [3.17], the same story we saw on the west pediment at Olympia.

3.14 Ictinus and Callicrates, the Parthenon, Athens. 447–432 B.C. Height of columns 34' (10.36 m). Below is a plan of the temple.

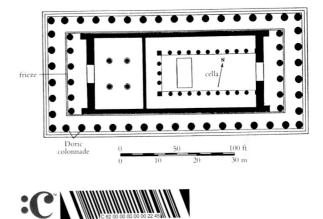

The Elgin Marbles

The monumental entrance to the Acropolis, the Propylaea [3.18], was begun in 437 B.C. and finished on the eve of the outbreak of war, although probably only by a modification of the architect Mnesikles' original plan. An unusual feature of its design is that both Doric and Ionic columns are used, the Doric ones visible from the front and the back and the Ionic ones lining the passageway through the outer porch.

The other major building on the Acropolis is the Erechtheum, an Ionic temple of complex design, which was begun in 421 B.C. but not completed until 406 B.C. The chief technical problem facing the architect, whose identity is unknown, was the uneven ground level of the site. The problem was solved by creating a building with entrances on different levels. The nature of the building itself produced other design problems. The Erechtheum had to commemorate a whole series of elaborate religious events and honor a number of different deities.

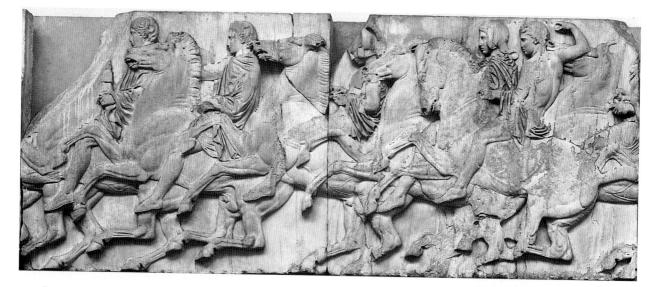

3.15 Equestrian group, detail of Parthenon frieze (north face), c. 442–432 B.C. Pentelic marble, height $41^{3}/_{8}$ " (106 cm). British Museum, London (reproduced by courtesy of the Trustees). The composition is elaborate but clear. The riders, with their calm, typically Classical expressions, are shown in various positions. Note especially the last figure on the right.

One of its four chambers housed the ancient wooden statue of Athena that was at the center of the Great Panathenaic Festival shown on the Parthenon frieze. Elsewhere in the temple were altars to Poseidon and Erechtheus, an early Athenian king; to the legendary Athenian hero Butes; and to Hephaistos, the god of the forge. Furthermore, the design had to incorporate the marks in the ground made by Poseidon's trident during the competition with Athena, as shown on the west pediment of the Parthenon, and the site of the grave of another early and probably legendary Athenian king, Cecrops. The result of all this was a building whose com-

plex plan is still not fully understood. In fact, the exact identification of the inner chambers remains in doubt.

The decoration of the temple is both elaborate and delicate, almost fragile. Its best-known feature is the South Porch, where the roof rests not on columns but on the famous *caryatids*, statues of young women [3.19]. These graceful figures, which stand gravely upright with one knee slightly bent as if to sustain the weight of the roof, represent the most complete attempt until then to conceal the structural functions of a column behind its form. In many respects innovations such as these make the Erechtheum as representative of the mood of the late

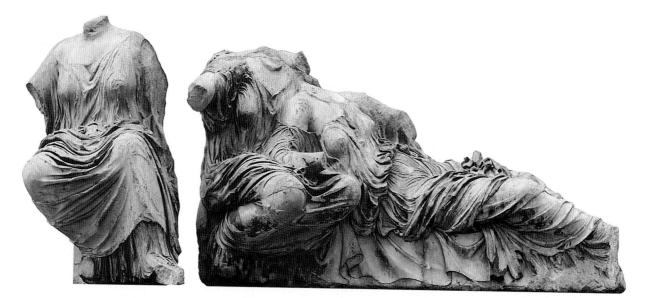

3.16 *Three Goddesses* from Parthenon east pediment, c. 438–432 B.C. Marble, over life-size. British Museum, London (reproduced by courtesy of the Trustees). The robes show the sculptor's technical virtuosity in carving drapery.

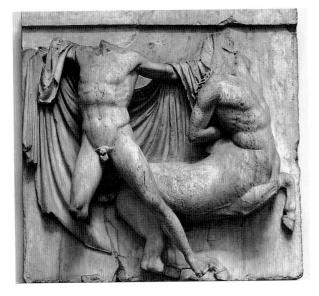

3.17 *Lapith and Centaur,* metope from Parthenon (south face) c. 448–442 B.C. Pentelic marble, height $4'4^{1}/_{4}''$ (1.34 m). British Museum, London (reproduced by courtesy of the Trustees). The assailed Lapith has dropped to one knee.

3.18 Mnesikles, Propylaea, Athens (west front) 437–431 B.C. This is the view from the Temple of Athena Nike. Note the contrast between the simple Doric columns of the facade and the Ionic columns that line the central passageway.

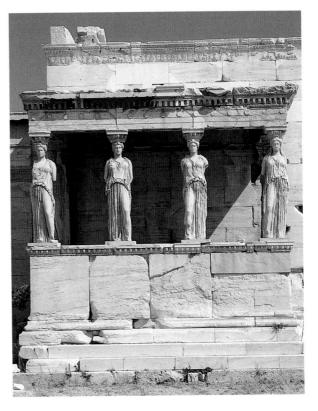

3.19 *Porch of the Maidens,* Erechtheum, Athens, 421–406 B.C. Height of the caryatids 7'9" (2.36 m).

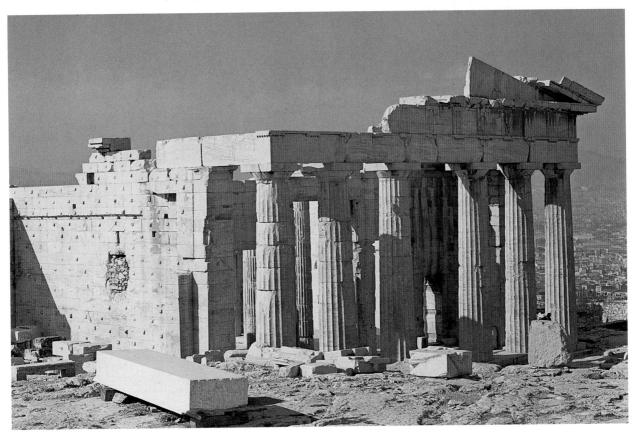

fifth century B.C. as the confident Parthenon is of the mood of a generation earlier. The apparent lack of a coherent overall plan and the blurring of traditional distinctions between architecture and sculpture, structure and decoration, seem to question traditional architectural values in a way that parallels the doubts of Euripides and his contemporaries.

THE VISUAL ARTS IN THE FOURTH CENTURY B.C.

As in the case of literature and philosophy, the confusion of Greek political life in the years following the defeat of Athens (404 B.C.) affected the development of the visual arts. In general, the idealism and heroic characters of High Classical art were replaced with a growing interest in realism and emotion. Our knowledge of the visual arts in the fourth century B.C. is, however, far from complete. Greek fresco painting of the period has been entirely lost, although recent discoveries in northern Greece at the Royal Cemetery of Vergina suggest that some of it may yet be found again [3.20]. In sculpture, fortunately, Roman copies of lost original statues enable us to form a

3.20 *Pluto Seizing Persephone*, detail of wall painting from Royal Tomb I, Vergina, mid-fourth century B.C. This unique example of Late Classical monumental painting was discovered by the Greek archaeologist Manolis Andronikos in 1977. It shows a remarkable fluency and freedom of technique.

fairly good estimation of the main developments. It is clear that Plato's interest in the fate of the individual soul finds its parallel in the sculptural treatment of the human form. Facial expressions become more emotional, often characterized by a mood of dreamy tenderness. Technical skill in depicting drapery and the anatomy beneath are put to the service of a new virtuosity. The three sculptors who dominated the art of the fourth century B.C. are Praxiteles, Scopas, and Lysippus.

The influence of Praxiteles on his contemporaries was immense. His particular brand of gentle melancholy is

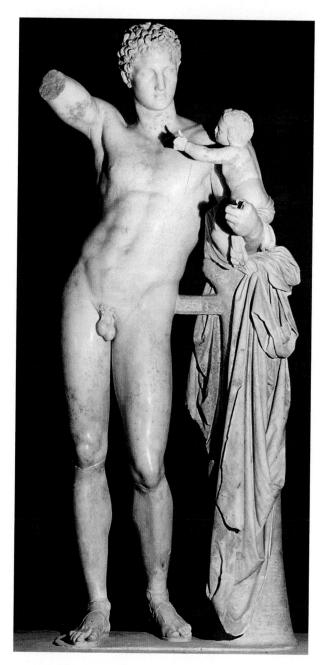

3.21 Praxiteles. *Hermes with Infant Dionysus*, c. 340 B.C. Marble, height 7'1" (2.16 m). Museum, Olympia. Hermes' missing right arm held a bunch of grapes just out of the baby's reach.

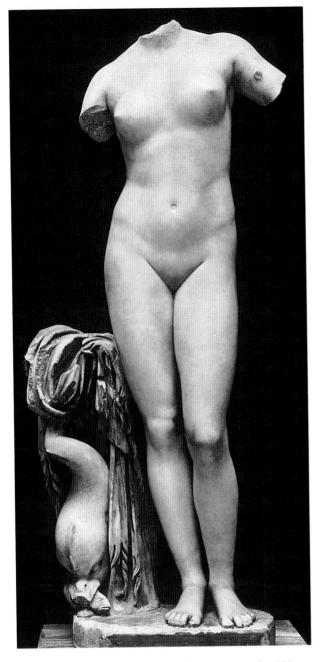

3.22 Praxiteles, *Aphrodite of Cyrene*. Roman copy of c. 100 B.C. Marble, height 5' (1.52 m). National Museum, Rome. This copy was found by chance in the Roman baths at Cyrene, North Africa. The status is also called *Venus Anadyomene*, the Roman name for Aphrodite and a Greek word meaning "rising up from the sea," often used in referring to Aphrodite because she was supposed to have arisen from the sea at her birth. The porpoise is a reminder of the goddess' marine associations.

well illustrated by the *Hermes* at Olympia [3.21] that is generally attributed to him. Equally important is his famous statue of Aphrodite nude [3.22], of which some fifty copies have survived. This represents the discovery of the female body as an object of beauty in itself; it was also one of the first attempts in Western art to introduce the element of sensuality into the portrayal of the female form. The art of Scopas was more dramatic, with an emphasis on emotion and intensity. Roman copies of his statue of *Pothos* (or *Desire*) [3.23], allow comparison of this yearning figure with Praxiteles' more relaxed *Hermes*. The impact of Lysippus was as much on succeeding periods as on his own time. One of his chief claims to fame was as the official portraitist of Alexander the Great. Lysippus' very individual characteristics—a new, more attenuated system of proportion, greater concern for realism, and the large scale of many of his work had a profound effect later on Hellenistic art [3.24].

In architecture, as in the arts generally, the Late Classical period was one of innovation. The great sanctuaries at Olympia and Delphi were expanded and new cities were laid out at Rhodes, Cnidus, and Priene, using Classical principles of town planning. The fourth century B.C.

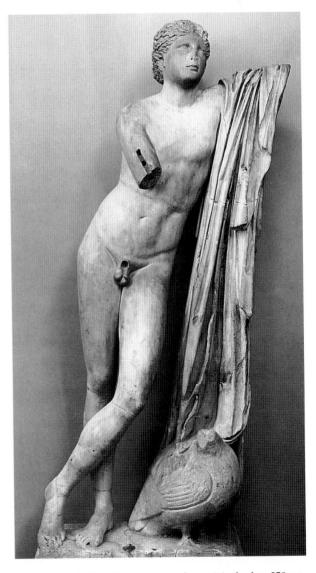

3.23 Scopas, *Pothos.* Roman copy after original of c. 350 B.C. Marble. Palazzo dei Conservatori, Rome.

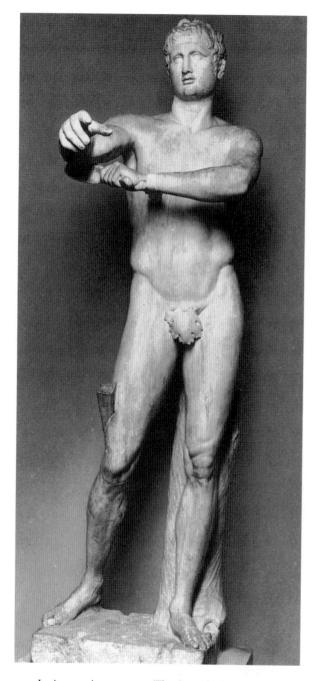

3.24 Lysippus, *Apoxyomenos* (*The Scraper*). Roman copy after bronze original of c. 330 B.C. Marble, height 6'9" (2.06 m). Vatican Museums, Rome. The young athlete is cleaning off sweat and dirt with a tool called a *strigil*.

was also notable for the invention of building forms new to Greek architecture, including the *tholos*, ("circular building") [3.25]. The most grandiose work of the century was probably the Temple of Artemis at Ephesus, destroyed by fire in 356 B.C. and rebuilt on the same massive scale as before. Although the Greeks of the fourth century B.C. lacked the certainty and self-confidence of their predecessors, their culture shows no lack of ideas

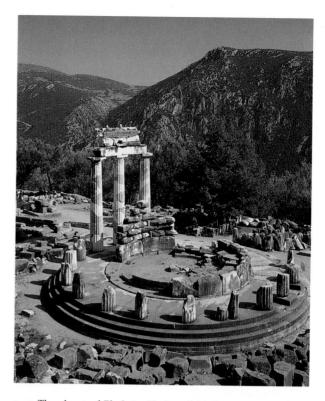

3.25 Theodoros of Phokaia, Tholos of the Sanctuary of Athena Pronaia, Delphi, c. 390 B.C. Marble and limestone; diameter of cella $28'2^{5}/_{8}''$ (8.6 m). This is one of the first circular designs in Greek architecture. Originally, twenty Doric columns encircled the temple and ten Corinthian columns were set against the wall of the cella within.

or inspiration. Furthermore, even before Alexander's death the Macedonian Empire had spread Greek culture throughout the Mediterranean world. If Athens itself had lost any real political or commercial importance, the ideas of its great innovators began to affect an ever-growing number of people.

When Alexander died in the summer of 323 B.C., the division of his empire into separate independent kingdoms spread Greek culture even more widely. The kingdoms of the Seleucids in Syria and the Ptolemies in Egypt are the true successors to Periclean Athens. Even as far away as India sculptors and town planners were influenced by ideas developed by Athenians of the fifth and fourth centuries B.C. In due course, the cultural achievement of Classical Greece was absorbed and reborn in Rome, as Chapter 4 will show. Meanwhile, in the period known as the Hellenistic Age, which lasted from the death of Alexander to the Roman conquest of Greece in 146 B.C., that achievement took a new turn.

The Hellenistic Period

Alexander's generals' inability to agree on a single successor after his death made the division of the Macedon-

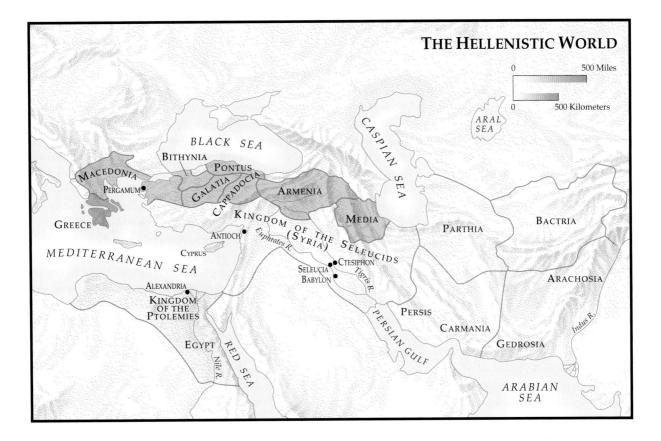

ian Empire inevitable. The four most important kingdoms that split off, Syria (the kingdom of the Seleucids), Egypt, Pergamum, and Macedonia itself (see map, above), were soon at loggerheads and remained so until they were finally conquered by Rome. Each of these, however, in its own way continued the spread of Greek culture, as the name of the period implies (it is derived from the verb "to Hellenize," or to spread Greek influence).

The greatest of all centers of Greek learning was in the Egyptian city of Alexandria, where King Ptolemy, Alexander's former personal staff officer and bodyguard, planned a large institute for scholarship known as the Temple of the Muses, or the Museum. The Library at the Museum contained everything of importance ever written in Greek, up to seven hundred thousand separate works, according to contemporary authorities. Its destruction by fire when Julius Caesar besieged the city in 47 B.C. must surely be one of the great intellectual disasters in the history of Western culture.

In Asia Minor and farther east in Syria the Hellenistic rulers of the new kingdoms fostered Greek art and literature as one means of holding foreign influences at bay. Libraries were built at Pergamum and the Syrian capital of Antioch, and philosophers from Greece were encouraged to visit the new centers of learning and lecture there. In this way Greek ideas not only retained their hold but began to make an impression on more remote peoples even farther east. The first Buddhist monumental sculpture, called *Gandharan* after the Indian province of Gandhara where it developed, made use of Greek styles and techniques. There is even a classic Buddhist religious work called *The Questions of King Milinda* in which a local Greek ruler, probably called Menandros, is described exchanging ideas with a Buddhist sage, ending with the ruler's conversion to Buddhism—one example of the failure of Greek ideas to convince those exposed to them.

Yet, however much literature and philosophy could do to maintain the importance of Greek culture, it was primarily to the visual arts that Hellenistic rulers turned. In so doing they inaugurated the last great period of Greek art. The most powerful influence on the period immediately following Alexander's death was the memory of his life. The daring and immensity of his conquests, his own heroic personality, the new world he had sought to create-all these conspired to produce a spirit of adventure and experiment. Artists of the Hellenistic period sought not so much to equal or surpass their Classical predecessors in the familiar forms as to discover new subjects and invent new techniques. The development of realistic portraiture dates to this period [3.26], as does the construction of buildings like the Lighthouse at Alexandria [3.27], in its day the tallest tower ever built and one of the Seven Wonders of the World.

CONTEMPORARY VOICES

Kerdo the Cobbler

Step lively: open that drawer of sandals.

Look first at this, Metro; this sole, is it not adjusted like the most perfect of soles? Look, you also, women, at the heel-piece; see how it is held down and how well it is joined to the straps; yet, no part is better than another: all are perfect. And the color! - may the Goddess give you every joy of life!-you could find nothing to equal it. The color! neither saffron nor wax glow like this! Three minæ, for the leather, went to Kandas from Kerdo, who made these. And this other color! it was no cheaper. I swear, by all that is sacred and venerable, women, in truth held and maintained, with no more falsehood than a pair of scales - and, if not, may Kerdo know life and pleasure no more!-this almost drove me bankrupt! For enormous gains no longer satisfy the leathersellers. They do the least of the work, but our works of art depend on them and the cobbler suffers the most terrible misery and distress, night and day. I am glued to my stool even at night, worn out with work, sleepless until the noises of the dawn. And I have not told all: I support thirteen workmen, women, because my own children will not work. Even if Zeus begged them in tears, they would only chant: "What do you bring? What do you bring?" They sit around in comfort somewhere else, warming their legs, like little birds. But, as the saying goes, it is not talk, but money, which pays the bills. If this pair does not please you, Metro, you can see more and still more, until you are sure that Kerdo has not been talking nonsense.

Lighthouse at Pharos

The all-pervading spirit of the Classical Age had been order. Now artists began to discover the delights of freedom. Classical art was calm and restrained, but Hellenistic art was emotional and expressive. Classical artists sought clarity and balance even in showing scenes of violence, but Hellenistic artists allowed themselves to depict riotous confusion involving strong contrasts of light and shade and the appearance of perpetual motion. It is not surprising that the term baroque, originally used to describe the extravagant European art of the seventeenth century A.D., is often applied to the art of the Hellenistic period. The artists responsible for these innovations created their works for a new kind of patron. Most of the great works of the Classical period had been produced for the state, with the result that the principal themes and inspirations were religious and political.

Pistos, bring all those shoes from the shelves.

You must go back satisfied to your houses, women. Here are novelties of every sort: of Sykione and Ambrakia, laced slippers, hemp sandals, Ionian sandals, night slippers, high heels, Argian sandals, red ones: name the ones you like best. (How dogs—and women—devour the substance of the cobbler!)

A WOMAN: And how much do you ask for that pair you have been parading so well? But do not thunder too loud and frighten us away!

KERDO: Value them yourself, and fix their price, if you like; one who leaves it to you will not deceive you. If you wish, woman, a good cobbler's work, you will set a price—yes, by these gray temples where the fox has made his lair which will provide bread for those who handle the tools. (O Hermes! if nothing comes into our net now, I don't know when our saucepan will get another chance as good!)

Herondas, trans. George Howe and Gustave Adolphus Harrer, *Greek literature in translation* (New York: Harper, 1924), p. 542. Herondas was a Greek poet of the third century B.C. whose mimes, from one of which this passage comes, were probably written for public performance.

With the disintegration of the Macedonian Empire and the establishment of prosperous kingdoms at Pergamum, Antioch, and elsewhere, there developed a group of powerful rulers and wealthy businessmen who commissioned works either to provide lavish decoration for their cities or to adorn their private palaces and villas. Artists were no longer responsible to humanity and to the gods, but to whoever paid for the work. Their patrons encouraged them to develop new techniques and surpass the achievements of rivals. At the same time, the change in the artist's social role produced a change in the function of the work. Whereas in the Classical period architects had devoted themselves to the construction of temples and religious sanctuaries, the Hellenistic Age is notable for its marketplaces and theaters, as well as for scientific and technical buildings like the Tower of the Winds at Athens and the Lighthouse at Alexandria [3.27]. Among the rich cities of Hellenistic Asia, none was wealthier than Pergamum, ruled by a dynasty of kings known as the Attalids. Pergamum was founded in the early third century B.C. and reached the high point of its

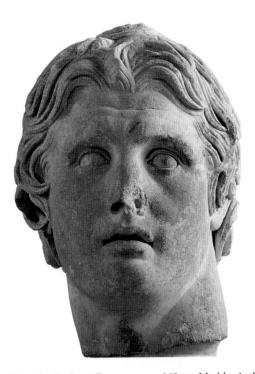

3.26 Alexander the Great, Pergamum, c. 160 B.C. Marble. Archaeological Museum, Istanbul. Note the emotional fire of the eyes and mouth, emphasized by the set of the head.

greatness in the reign of Eumenes II (197–159 B.C.). The layout of the chief buildings in the city represents a rejection of the Classical concepts of order and balance. Unlike the Periclean buildings on the Athenian Acropolis, the buildings in Pergamum were placed independently of one another with a new and dramatic use of space. The theater itself, set on a steep slope, seemed to be falling headlong down the hillside [3.28].

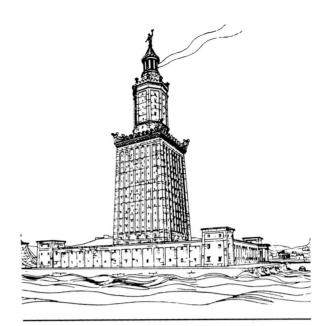

3.27 Reconstruction of the Lighthouse on Pharos, north of Alexandria harbor, 279 B.C. Original height 440' (134.2 m). The beam of light from the lantern atop was intensified by a system of reflectors. The name of the island, Pharos, became, and still is, another word for *lighthouse* or *beacon*.

The chief religious shrine of Pergamum was the immense Altar of Zeus erected by Eumenes II (c. 180 B.C.) to commemorate the victories of his father, Attalus I, over the Gauls. Its base is decorated with a colossal frieze

3.28 Reconstruction model of Upper City, State Museums, Berlin, Germany. The steeply sloping theater is at left; the Altar to Zeus is in the center foreground.

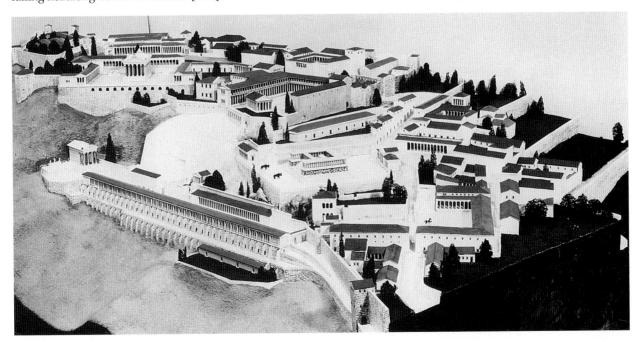

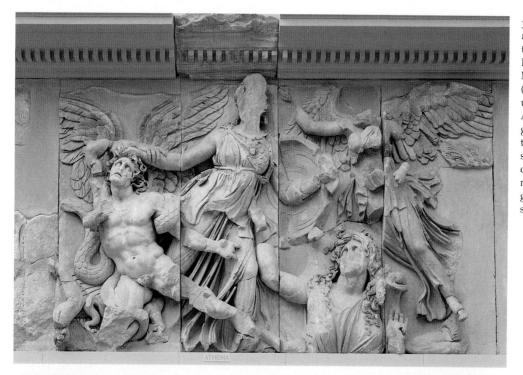

3.29 Athena Slaying the Giant. Detail of Altar to Zeus frieze, Pergamum, c. 180 B.C. Marble, height 7'6" (2.29 m). State Museums, Berlin, Germany. Athena is grasping the giant Alcyoneus by the hair, source of his strength, to lift him off the ground. His mother, Ge, the earth goddess, looks on despairingly from below.

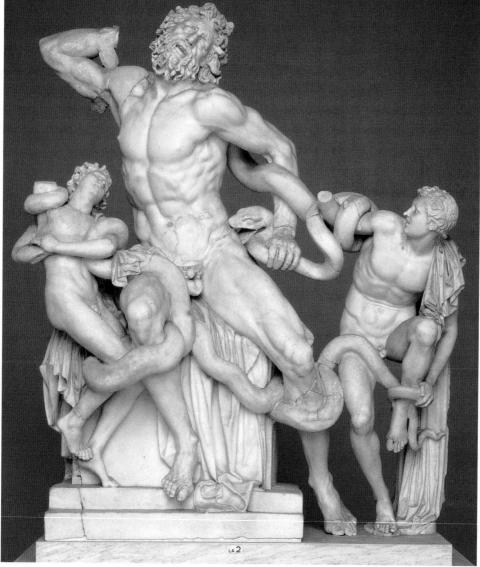

3.30 Agesander, Athenodorus, and Polydorus of Rhodes, *Laccoön Group*, early first century A.D. Marble, height 7'10¹/₂" (2.44 m). Vatican Museums, Rome. This statue was unearthed in 1506 in the ruins of Nero's Golden House. Note the similarity between Laocoön's head and the head of the giant Alcyoneus on the Pergamum frieze. depicting the battle of the gods and giants. The triumphant figure of Zeus stands presumably as a symbol for the victorious king of Pergamum. The drama and violence of the battle find perfect expression in the tangled, writhing bodies, which leap out of the frieze in high relief, and in the intensity of the gestures and facial expressions [3.29]. The immense emotional impact of the scenes may prevent us from appreciating the remarkable skill of the artists, some of whom were brought from Athens to work on the project. However, the movement of the figures is far from random and the surface of the stone has been carefully worked to reproduce the texture of hair, skin, fabric, metal, and so on.

The Altar of Zeus represents the most complete illustration of the principles and practice of Hellenistic art. It is, of course, a work on a grand, even grandiose, scale, intended to impress a wide public. But many of its characteristics occur in freestanding pieces of sculpture like the *Laocoön* [3.30]. This famous work shows the Trojan priest Laocoön, punished by the gods for his attempt to warn his people against bringing into their city the wooden horse left by the Greeks. To silence the priest, Apollo sends two sea serpents to strangle him and his sons. The large piece is superbly composed, with the three figures bound together by the sinuous curves of the serpents; they pull away from one another under the agony of the creature's coils.

By the end of the Hellenistic period both artists and public seemed a little weary of so much richness and elaboration, and returned to some of the principles of Classical art. Simultaneously, the gradual conquest of the Hellenistic kingdoms by Rome and their absorption into the Roman Empire produced a new synthesis in which the achievements of Classical and Hellenistic Greece fused with the native Italian culture and passed on to later ages.

SUMMARY

The Classical Age The period covered in this chapter falls into three parts. The first, the years from 479 B.C. to 404 B.C., saw the growth of Athenian power and the consequent mistrust on the part of the rest of the Greek world of Athens' intentions. The same period was marked by major cultural developments at Athens. Sculptors such as Myron and Phidias created the High Classical blend of realism and idealism. Tragic drama, in which music played an important role, reached its highest achievement in the works of Aeschylus, Sophocles, and Euripides. In 449 B.C., work was begun on the buildings on the Athenian Acropolis planned by Pericles, Athens' ambitious leader. The Parthenon and the Propylaea were completed in an atmosphere made increasingly tense by the deteriorating relations between Athens and the other leading Greek states, particularly Corinth and Sparta.

The Peloponnesian War In 431 B.C., the Peloponnesian War erupted, with Athens and her few remaining allies on one side, and the remaining Greek world on the other. In 429 B.C. Pericles died from a plague that ravaged the city. In the absence of firm leadership the war dragged on and, during a period of truce, the Athenians launched a disastrous campaign against the Greek cities of Sicily. When hostilities resumed, the Athenians were fatally weakened and, in 404 B.C., they surrendered to the Spartans and their allies.

Classical Art and Literature The years of fighting profoundly affected cultural developments at Athens. Both the sculpture and the vase painting of the late fifth century B.C. show a new and somber interest in funerary subjects. In the theater, the later plays of Euripides depicted the horrors of war, while the comedies of Aristophanes mocked the political leaders responsible for the turmoil. Thucydides wrote his *History of the Peloponnesian War* to try to analyze the motives and reactions of the participants. Socrates began to question his fellow Athenians about their moral and religious beliefs in a similar spirit of inquiry.

The Late Classical Period The second period, from 404 B.C. to 323 B.C., was marked by considerable upheaval. Athens was no longer the dominating force in the Greek world, but there was no successor among her rivals. First Sparta and then Thebes achieved an uneasy control of Greek political life. With the collapse of the optimism of the High Classical period the Late Classical Age was marked by a new concern with the individual. The dreamy melancholy of Praxiteles' statues is in strong contrast to the idealism of a century earlier, while his figure of Aphrodite naked was one of the first examples in the Western tradition of sensuous female nudity. The most complete demonstration of the new interest in the fate of the individual can be found in the works of Plato, Socrates' disciple, who spent much of his life studying the relationship between individuals and the state. Aristotle, Plato's younger contemporary, also wrote on political theory as well as on a host of other topics.

The Rise of Macedon In 359 B.C., the northern kingdom of Macedon passed under the rule of Philip II and began to play an increasing part in Greek affairs. Despite Athenian resistance, led by the orator Demosthenes, Philip succeeded in uniting the cities of Greece in an alliance known as the League of Corinth; the only important city to remain independent was Sparta.

When Philip was assassinated in 336 B.C., he was succeeded by his son Alexander, who set out to expand the Macedonian Empire. After defeating the Persians, he set out in an amazing series of campaigns across Asia that brought him to the borders of India. Only the revolt of his weary troops prevented him from going farther. In 323 B.C., in the course of the long journey home, Alexander died of fever.

The Hellenistic World The period from 323 to 146 B.C., marked by the spread of Greek culture throughout

the parts of Asia conquered by Alexander, is known as the Hellenistic Age. In the confusion following his death, four kingdoms emerged: Syria, Egypt, Pergamum, and Macedon itself. Prosperous and aggressive and frequently at war with one another, they combined Greek intellectual ideas and artistic styles with native Eastern ones.

The chief characteristics of Hellenistic art were virtuosity and drama. Works such as the Altar of Zeus at Pergamum were commissioned by Hellenistic rulers to glorify their reigns. Artists were encouraged to develop elaborate new techniques and employ them in complex and dramatic ways. The principal buildings of the age were public works like markets and theaters or scientific constructions such as the Lighthouse at Alexandria.

The Roman Conquest of Greece The inability of the Hellenistic kingdoms to present a united front caused them to fall—one by one—victim to a new force in the eastern Mediterranean: Rome. By the end of the third century B.C., the Romans had secured their position in the western Mediterranean and begun an expansion into Asia that was to bring all the Hellenistic kingdoms under their control.

In 146 B.C., Roman troops captured the city of Corinth, center of the League of Corinth founded by Philip and symbol of Greek independence. Greece was made into a Roman province, and its subsequent history followed that of the Roman Empire. If Greece was under Roman political control, however, Greek art and culture dominated much of Roman cultural life and were passed on by the Romans into the Western tradition.

PRONUNCIATION GUIDE

Aegisthus:	Ee-GISTH-us
Aeschylus:	ESK-ill-us
Antigone:	Ant-IG-owe-nee
Aristophanes:	A-rist-OFF-an-ease
Caryatid:	Ca-ree-AT-id
Catharsis:	Cath-ARE-sis
Chaeronaea:	Kai-ron-EE-a
Clytemnestra:	Klit-em-NESS-tra
Demosthenes:	Dem-OSTH-en-ease
Doryphoros:	Dor-IF-or-us
Elgin:	EL-ghin
Elgin: Entasis:	EL-ghin ENT-ass-iss
0	0
Entasis:	ENT-ass-iss
Entasis: Erechtheum:	ENT-ass-iss Er-EK-thee-um
Entasis: Erechtheum: Eumenides:	ENT-ass-iss Er-EK-thee-um You-MEN-id-ease
Entasis: Erechtheum: Eumenides: Euripides:	ENT-ass-iss Er-EK-thee-um You-MEN-id-ease You-RIP-id-ease
Entasis: Erechtheum: Eumenides: Euripides: Ictinus:	ENT-ass-iss Er-EK-thee-um You-MEN-id-ease You-RIP-id-ease Ic-TINE-us
Entasis: Erechtheum: Eumenides: Euripides: Ictinus: Laocoön:	ENT-ass-iss Er-EK-thee-um You-MEN-id-ease You-RIP-id-ease Ic-TINE-us La-OK-owe-on

PARTH-en-on
PE-rik-lees
FEE-doe
FID-i-ass
Po-lic-LIE-tus
Pro-pie-LEE-a
PTOL-em-ee
SAY-tr
SKOWE-pass
Sell-YOU-sids
Thyou-SID-id-ease

EXERCISES

- Explain the chief differences between the three principal Greek tragic dramatists. Illustrate with episodes in particular plays.
- 2. Discuss the contributions of Plato and Aristotle to the development of philosophy.
- 3. Describe Greek musical theory in the fifth and fourth centuries B.C.
- 4. How was sculpture used to decorate the buildings on the Athenian Acropolis? What is the significance of the myths it illustrates?
- 5. What are the features of a work of art that indicate it is Hellenistic? How does the Hellenistic style contrast with that of the Classical period?

Further Reading

- Barnes, J. (1982). Aristotle. Oxford: Oxford University Press. In a mere eighty pages this remarkable book provides an excellent general introduction to Aristotle's vast range of works.
- Boardman, J. (1987). *Greek sculpture: The classical period*. New York: Thames and Hudson.
- Boardman, J. (1995). *Greek sculpture: The late classical period and sculpture in colonies and overseas.* New York: Thames and Hudson. This and the above-listed book provide authoritative guides to the Greek sculpture produced during the period covered by this chapter.
- Boardman, J., J. Griffin, & O. Murray. (1988). Greece and the Hellenistic world. New York: Oxford University Press. An excellent collection of essays on aspects of Greek history and culture.
- Bosworth, A. B. (1988). *Conquest and empire*. New York: Cambridge University Press. The rise of Macedon, and the careers of Philip and Alexander.
- Finley, M. I. (Ed.). (1981). *The legacy of Greece: A new appraisal*. Oxford: Oxford University Press. A collection of essays by authors who discuss Greek achievements in various fields—philosophy, art, literature, among others—and evaluate their relevance to the late twentieth century.
- Garlan, Y. (1988). Slavery in ancient Greece. Ithaca, NY: Cornell University Press. An account of slavery in the Greek world.
- Hammond, N. G. L. (1981). Alexander the Great: King, commander, and statesman. London: Methuen. Alexander is still a controversial figure. The author of this scholarly study, clearly an admirer, provides a vivid account of Alexander's life.

- Keuls, E. C. (1985). *The reign of the phallus: Sexual politics in ancient Athens*. New York: Harper & Row. A thought-provoking discussion of the role of gender in Athenian life.
- Lesky, A. (1983). *Greek tragic poetry* (3rd ed.; trans. M. Dillon). New Haven: Yale University Press. The latest version of one of the standard works on Greek tragedy, analyzing it as literature rather than as theater.
- Morford, M. P. O., & P. J. Lenardon. (1977). *Classical mythology*. New York: Longman. A useful reference source for the many myths found in Greek art and literature, this book also discusses Greek religion and the Greeks' views of the afterlife.
- Pollitt, J. J. (1986). *Art in the Hellenistic Age*. New York: Cambridge University Press. A thorough survey of Hellenistic art, with good illustrations.
- Walbank, F. W. (1982). *The Hellenistic world*. Cambridge: Harvard University Press. This book describes the various Hellenistic kingdoms and evaluates their cultural achievements; includes a good section on Hellenistic science and technology.
- Wycherley, R. E. (1978). The stones of Athens. Princeton, NJ: Princeton University Press. An authoritative description of the monuments of Classical Athens that includes an individual description as well as a bibliography for each important building.

Online Chapter Links

An extensive investigation of the Parthenon is available at

http://homer.reed.edu/Parthenon.html

In the Footsteps of Alexander the Great at

http://www.pbs.org/mpt/alexander/

a companion site to the PBS documentary, follows the journey of Alexander and his army as they swept across Africa.

The Ancient Vine at

http://ancient.thevines.com/

provides an extensive annotated list of links to Internet sites related to Greek studies.

View the Cast Gallery at Oxford University's Ashmolean Museum at

http://www.ashmol.ox.ac.uk/ash/departments/ cast-gallery/

where Greek works are represented among this outstanding collection of casts derived from sculptures found in museums around the world.

Online Chapter Resources

READING SELECTIONS

SOPHOCLES

OEDIPUS THE KING

Sophocles' famous play recounts the tragic downfall of Oedipus, king of Thebes, fated even before birth to kill his father and marry his mother. In the course of the action he is transformed from the confident ruler of the first scene to the self-blinded helpless beggar of the play's conclusion. The inexorable drive of the action is accomplished in a series of dramatic encounters: Oedipus with the Thebans; Oedipus and Teiresias; Oedipus and Creon; Oedipus and his wife Jocasta; the arrival of the first messenger with news that Jocasta understands only too well; the arrival of the second messenger, the old servant who finally opens Oedipus' eyes to the truth.

When at last all is clear, by a powerful stroke of Sophoclean irony Oedipus blinds himself. The entire play is, in fact, marked by the use of what is called dramatic irony. The term is used to describe situations or speeches that have one meaning for the characters in the play but a very different one for the audience. Thus when in the opening scene Oedipus tells the chorus "None there is among you as sick as I," unknown to him his statement has a terrible truth. Similarly, in the central scene of the play Jocasta pours scorn on the warnings of oracles and prophets; we know, although she does not, that her own words contradict themselves and that everything she claims to be false is in fact true.

The end of the play is a gradual unwinding of the tension. As the broken king prepares to go into exile, the chorus reminds us of the instability of success and happiness, leaving us to interpret for ourselves the moral of Oedipus' fate.

CHARACTERS

OEDIPUS, king of Thebes A PRIEST CREON, brother-in-law of Oedipus CHORUS of Theban elders TEIRESIAS, a prophet JOCASTA, sister of Creon, wife of Oedipus MESSENGER SERVANT of Laius, father of Oedipus SECOND MESSENGER (silent) ANTIGONE and ISMENE, daughters of Oedipus

SCENE. Before the palace of Oedipus at Thebes. In front of the large central doors, an altar; and an altar near each of the two side doors. On the altar steps are seated suppliants—old men, youths, and young boys—dressed in white tunics and cloaks, their hair bound with white fillets. They have laid on the altars olive branches wreathed with wool-fillets.

The old PRIEST OF ZEUS stands alone facing the central doors of the palace. The doors open, and OEDIPUS, followed by two attendants who stand at either door, enters and looks about.

OEDIPUS O children, last born stock of ancient Cadmus,

What petitions are these you bring to me With garlands on your suppliant olive branches? The whole city teems with incense fumes, Teems with prayers for healing and with groans. Thinking it best, children, to hear all this Not from some messenger, I came myself, The world renowned and glorious Oedipus.

But tell me, aged priest, since you are fit To speak before these men, how stand you here, In fear or want? Tell me, as I desire To do my all; hard hearted I would be To feel no sympathy for such a prayer. PRIEST O Oedipus, ruler of my land, you see How old we are who stand in supplication Before your altars here, some not yet strong For lengthy flight, some heavy with age, Priests, as I of Zeus, and choice young men. The rest of the tribe sits with wreathed branches, In market places, at Pallas' two temples, And at prophetic embers by the river. The city, as you see, now shakes too greatly And cannot raise her head out of the depths Above the gory swell. She wastes in blight, Blight on earth's fruitful blooms and grazing flocks, And on the barren birth pangs of the women. The fever god has fallen on the city, And drives it, a most hated pestilence Through whom the home of Cadmus is made empty. Black Hades is enriched with wails and groans. Not that we think you equal to the gods These boys and I sit suppliant at your hearth, But judging you first of men in the trials of life, And in the human intercourse with spirits:-You are the one who came to Cadmus' city And freed us from the tribute which we paid To the harsh-singing Sphinx. And that you did Knowing nothing else, unschooled by us. But people say and think it was some god That helped you to set our life upright. Now Oedipus, most powerful of all, We all are turned here toward you, we beseech you, Find us some strength, whether from one of the gods You hear an omen, or know one from a man. For the experienced I see will best Make good plans grow from evil circumstance. Come, best of mortal men, raise up the state. Come, prove your fame, since now this land of ours Calls you savior for your previous zeal. O never let our memory of your reign Be that we first stood straight and later fell, But to security raise up this state. With favoring omen once you gave us luck; Be now as good again; for if henceforth You rule as now, you will be this country's king, Better it is to rule men than a desert, Since nothing is either ship or fortress tower Bare of men who together dwell within. OEDIPUS O piteous children, I am not ignorant Of what you come desiring. Well I know

You are all sick, and in your sickness none There is among you as sick as I, For your pain comes to one man alone, To him and to none other, but my soul Groans for the state, for myself, and for you. You do not wake a man who is sunk in sleep; Know that already I have shed many tears, And travelled many wandering roads of thought. Well have I sought, and found one remedy; And this I did: the son of Menoeceus, Creon, my brother-in-law, I sent away Unto Apollo's Pythian halls to find What I might do or say to save the state. The days are measured out that he is gone; It troubles me how he fares. Longer than usual

He has been away, more than the fitting time. 10 But when he comes, then evil I shall be, If all the god reveals I fail to do. PRIEST You speak at the right time. These men just now Signal to me that Creon is approaching. OEDIPUS O Lord Apollo, grant that he may come In saving fortune shining as in eye. PRIEST Glad news he brings, it seems, or else his head Would not be crowned with leafy, berried bay. OEDIPUS We will soon know. He is close enough to hear.-Prince, my kinsman, son of Menoeceus, What oracle do you bring us from the god? CREON A good one. For I say that even burdens If they chance to turn out right, will all be well. OEDIPUS Yet what is the oracle? Your present word Makes me neither bold nor apprehensive. CREON If you wish to hear in front of this crowd I am ready to speak, or we can go within. OEDIPUS Speak forth to all. The sorrow that I bear Is greater for these men than for my life. CREON May I tell you what I heard from the god? Lord Phoebus clearly bids us to drive out, And not to leave uncured within this country, A pollution we have nourished in our land. OEDIPUS With what purgation? What kind of misfortune? CREON Banish the man, or quit slaughter with slaughter In cleansing, since this blood rains on the state. OEDIPUS Who is this man whose fate the god reveals? CREON Laius, my lord, was formerly the guide Of this our land before you steered this city. OEDIPUS I know him by hearsay, but I never saw him. CREON Since he was slain, the god now plainly bids us To punish his murderers, whoever they may be. OEDIPUS Where are they on the earth? How shall we find This indiscernible track of ancient guilt? CREON In this land, said Apollo. What is sought Can be apprehended; the unobserved escapes. OEDIPUS Did Laius fall at home on this bloody end? Or in the fields, or in some foreign land? CREON As a pilgrim, the god said, he left his tribe And once away from home, returned no more. OEDIPUS Was there no messenger, no fellow wayfarer Who saw, from whom an inquirer might get aid? CREON They are all dead, save one, who fled in fear And he knows only one thing sure to tell. OEDIPUS What is that? We may learn many facts from one If we might take for hope a short beginning. CREON Robbers, Apollo said, met there and killed him Not by the strength of one, but many hands. OEDIPUS How did the robber unless something from here Was at work with silver, reach this point of daring? CREON These facts are all conjecture. Laius dead, There rose in evils no avenger for him. OEDIPUS But when the king had fallen slain, what trouble Prevented you from finding all this out? CREON The subtle-singing Sphinx made us let go What was unclear to search at our own feet. OEDIPUS Well then, I will make this clear afresh From the start. Phoebus was right, you were right To take this present interest in the dead. Justly it is you see me as your ally Avenging alike this country and the god.

Not for the sake of some distant friends,

But for myself I will disperse this filth.

Whoever it was who killed that man

70

60

20

30

40

50

140

80

90

100

110

120

With the same hand may wish to do vengeance on me. And so assisting Laius I aid myself. But hurry quickly, children, stand up now From the altar steps, raising these suppliant boughs. Let someone gather Cadmus' people here To learn that I will do all, whether at last With Phoebus' help we are shown saved or fallen. PRIEST Come, children, let us stand. We came here

First for the sake of what this man proclaims. Phoebus it was who sent these prophecies And he will come to save us from the plague. CHORUS

Strophe A

O sweet-tongued voice of Zeus, in what spirit do you come From Pytho rich in gold

To glorious Thebes? I am torn on the rack, dread shakes my fearful mind,

Apollo of Delos, hail!

As I stand in awe of you, what need, either new

Do you bring to the full for me, or old in the turning times of the year?

Tell me, O child of golden Hope, undying Voice!

Antistrophe A

First on you do I call, daughter of Zeus, undying Athene 160And your sister who guards our land,Artemis, seated upon the throne renowned of our circled Place,And Phoebus who darts afar;

Shine forth to me, thrice warder-off of death;

If ever in time before when ruin rushed upon the state,

The flame of sorrow you drove beyond our bounds, come also now.

Strophe B

O woe! Unnumbered that I bear The sorrows are! My whole host is sick, nor is there a sword of thought To ward off pain. The growing fruits Of glorious earth wax not, nor women Withstand in childbirth shrieking pangs. Life on life you may see, which, like the wellwinged bird, Faster than stubborn fire, speed To the strand of the evening god.

Antistrophe B

Unnumbered of the city die. Unpitied babies bearing death lie unmoaned on the ground. Grey-haired mothers and young wives From all sides at the altar's edge Lift up a wail beseeching, for their mournful woes. The prayer for healing shines blent with a grieving cry; Wherefore, O golden daughter of Zeus, Send us your succor with its beaming face.

Strophe C

Grant that fiery Ares, who now with no brazen shield Flames round me in shouting attack May turn his back in running flight from our land, May be borne with fair wind To Amphitrite's great chamber Or to the hostile port Of the Thracian surge. For even if night leaves any ill undone It is brought to pass and comes to be in the day. O Zeus who bear the fire And rule the lightning's might, Strike him beneath your thunderbolt with death!

Antistrophe C

150

170

180

O lord Apollo, would that you might come and scatter forth Untamed darts from your twirling golden bow; Bring succor from the plague; may the flashing Beams come of Artemis, With which she glances through the Lycian hills. Also on him I call whose hair is held in gold, Who gives a name to this land, Bacchus of winy face, whom maidens hail! Draw near with your flaming Maenad band And the aid of your gladsome torch Against the plague, dishonored among the gods.

OEDIPUS You pray; if for what you pray you would be willing

To hear and take my words, to nurse the plague, You may get succor and relief from evils. A stranger to this tale I now speak forth, A stranger to the deed, for not alone Could I have tracked it far without some clue, But now that I am enrolled a citizen Latest among the citizens of Thebes To all you sons of Cadmus I proclaim Whoever of you knows at what man's hand Laius, the son of Labdacus, met his death, I order him to tell me all, and even If he fears, to clear the charge and he will suffer No injury, but leave the land unharmed. If someone knows the murderer to be an alien From foreign soil, let him not be silent; I will give him a reward, my thanks besides. But if you stay in silence and from fear For self or friend thrust aside my command, Hear now from me what I shall do for this; I charge that none who dwell within this land Whereof I hold the power and the throne Give this man shelter whoever he may be, Or speak to him, or share with him in prayer Or sacrifice, or serve him lustral rites, But drive him, all, out of your homes, for he Is this pollution on us, as Apollo Revealed to me just now in oracle. I am therefore the ally of the god And of the murdered man. And now I pray That the murderer, whether he hides alone Or with his partners, may, evil coward, Wear out in luckless ills his wretched life. I further pray, that, if at my own hearth He dwells known to me in my own home, I may suffer myself the curse I just now uttered. And you I charge to bring all this to pass For me, and for the god, and for our land Which now lies fruitless, godless, and corrupt. Even if Phoebus had not urged this affair, Not rightly did you let it go unpurged When one both noble and a king was murdered! You should have sought it out. Since now I reign Holding the power which he had held before me, 190

200

210

220

Having the selfsame wife and marriage bed — And if his seed had not met barren fortune We should be linked by offspring from one mother: But as it was, fate leapt upon his head. Therefore in this, as if for my own father I fight for him, and shall attempt all Searching to seize the hand which shed that blood, For Labdacus' son, before him Polydorus, And ancient Cadmus, and Agenor of old. And those who fail to do this, I pray the gods May give them neither harvest from their earth Nor children from their wives, but may they be Destroyed by a fate like this one, or a worse. You other Thebans, who cherish these commands, May Justice, the ally of a righteous cause, And all the gods be always on your side.

- CHORUS By the oath you laid on me, my king, I speak. I killed not Laius, nor can show who killed him. Phoebus it was who sent this question to us, And he should answer who has done the deed.
- OEDIPUS Your words are just, but to compel the gods In what they do not wish, no man can do.
- CHORUS I would tell what seems to me our second course.
- OEDIPUS If there is a third, fail not to tell it too.
- CHORUS Lord Teiresias I know, who sees this best Like lord Apollo; in surveying this,
- One might, my lord, find out from him most clearly. OEDIPUS Even this I did not neglect; I have done it already. At Creon's word I twice sent messengers.
- It is a wonder he has been gone so long. CHORUS And also there are rumors, faint and old.
- OEDIPUS What are they? I must search out every tale.
- CHORUS They say there were some travellers who killed him.
- OEDIPUS So I have heard, but no one sees a witness. CHORUS If his mind knows a particle of fear
- He will not long withstand such curse as yours.
- OEDIPUS He fears no speech who fears not such a deed. CHORUS But here is the man who will convict the guilty.
- Here are these men leading the divine prophet In whom alone of men the truth is born.
- OEDIPUS O you who ponder all, Teiresias, Both what is taught and what cannot be spoken, What is of heaven and what trod on the earth, Even if you are blind, you know what plague Clings to the state, and, master, you alone We find as her protector and her savior. Apollo, if the messengers have not told you, Answered our question, that release would come From this disease only if we make sure Of Laius' slayers and slay them in return Or drive them out as exiles from the land. But you now, grudge us neither voice of birds Nor any way you have of prophecy. Save yourself and the state; save me as well. Save everything polluted by the dead. We are in your hands; it is the noblest task To help a man with all your means and powers.
- TEIRESIAS Alas! Alas! How terrible to be wise, Where it does the seer no good. Too well I know And have forgot this, or would not have come here.
- OEDIPUS What is this? How fainthearted you have come! TEIRESIAS Let me go home; it is best for you to bear
- Your burden, and I mine, if you will heed me. OEDIPUS You speak what is lawless, and hateful to the state
- Which raised you, when you deprive her of your answer.

250 260	 TEIRESIAS And I see that your speech does not proceed In season; I shall not undergo the same. OEDIPUS Don't by the gods turn back when you are wise, When all we suppliants lie prostrate before you. TEIRESIAS And all unwise; I never shall reveal My evils, so that I may not tell yours. OEDIPUS What do you say? You know, but will not speak? Would you betray us and destroy the state? TEIRESIAS I will not hurt you or me. Why in vain Do you probe this? You will not find out from me. OEDIPUS Worst of evil men, you would enrage 	320
	A stone itself. Will you never speak, But stay so untouched and so inconclusive? TEIRESIAS You blame my anger and do not see that With which you live in common, but upbraid me. OEDIPUS Who would not be enraged to hear these words By which you now dishonor this our city? TEIRESIAS Of itself this will come, though I hide it in silence.	330
270	OEDIPUS Then you should tell me what it is will come. TEIRESIAS I shall speak no more. If further you desire,	
	Rage on in wildest anger of your soul. OEDIPUS I shall omit nothing I understand I am so angry. Know that you seem to me Creator of the deed and worker too In all short of the slaughter; if you were not blind,	
280	I would say this crime was your work alone. TEIRESIAS Really? Abide yourself by the decree You just proclaimed, I tell you! From this day Henceforth address neither these men nor me. You are the godless defiler of this land.	340
	OEDIPUS You push so bold and taunting in your speech; And how do you think to get away with this? TEIRESIAS I have got away. I nurse my strength in truth. OEDIPUS Who taught you this? Not from your art you got it.	
290	TEIRESIAS From you. You had me speak against my will. OEDIPUS What word? Say again, so I may better learn. TEIRESIAS Didn't you get it before? Or do you bait me? OEDIPUS I don't remember it. Speak forth again. TEIRESIAS You are the slayer whom you seek, I say. OEDIPUS Not twice you speak such bitter words	350
	unpunished. TEIRESIAS Shall I speak more to make you angrier still? OEDIPUS Do what you will, your words will be in vain. TEIRESIAS I say you have forgot that you are joined With those most dear to you in deepest shame And do not see where you are in sin. OEDIPUS Do you think you will always say such things in joy?	360
300	 TEIRESIAS Surely, if strength abides in what is true. OEDIPUS It does, for all but you, this not for you Because your ears and mind and eyes are blind. TEIRESIAS Wretched you are to make such taunts, for soon All men will cast the selfsame taunts on you. OEDIPUS You live in entire night, could do no harm To me or any man who sees the day. 	
310	TEIRESIAS Not at my hands will it be your fate to fall. Apollo suffices, whose concern it is to do this. OEDIPUS Are these devices yours, or are they Creon's? TEIRESIAS Creon is not your trouble; you are yourself. OEDIPUS O riches, empire, skill surpassing skill	370

OEDIPUS O riches, empire, skill surpassing skill In all the numerous rivalries of life, How great a grudge there is stored up against you If for this kingship, which the city gave, Their gift, not my request, into my hands-

For this, the trusted Creon, my friend from the start Desires to creep by stealth and cast me out Taking a seer like this, a weaver of wiles, A crooked swindler who has got his eyes On gain alone, but in his art is blind. Come, tell us, in what clearly are you a prophet? How is it, when the weave-songed bitch was here You uttered no salvation for these people? Surely the riddle then could not be solved By some chance comer; it needed prophecy. You did not clarify that with birds Or knowledge from a god; but when I came, The ignorant Oedipus, I silenced her, Not taught by birds, but winning by my wits, Whom you are now attempting to depose, Thinking to minister near Creon's throne. I think that to your woe you and that plotter Will purge the land, and if you were not old Punishment would teach you what you plot. CHORUS It seems to us, O Oedipus our king,

- Both this man's words and yours were said in anger. Such is not our need, but to find out How best we shall discharge Apollo's orders.
- TEIRESIAS Even if you are king, the right to answer Should be free to all; of that I too am king. I live not as your slave, but as Apollo's. And not with Creon's wards shall I be counted. I say, since you have taunted even my blindness, You have eyes, but see not where in evil you are Nor where you dwell, nor whom you are living with. Do you know from whom you spring? And you forget You are an enemy to your own kin Both those beneath and those above the earth. Your mother's and father's curse, with double goad And dreaded foot shall drive you from this land. You who now see straight shall then be blind, And there shall be no harbor for your cry With which all Mount Cithaeron soon shall ring, When you have learned the wedding where you sailed At home, into no port, by voyage fair. A throng of other ills you do not know Shall equal you to yourself and to your children. Throw mud on this, on Creon, on my voice-Yet there shall never be a mortal man Eradicated more wretchedly than you.

OEDIPUS Shall these unbearable words be heard from him? Go to perdition! Hurry! Off, away,

Turn back again and from this house depart. TEIRESIAS If you had not called me, I should not

- have come. OEDIPUS I did not know that you would speak such folly
- Or I would not soon have brought you to my house.
- TEIRESIAS And such a fool I am, as it seems to you. But to the parents who bore you I seem wise.
- OEDIPUS What parents? Wait! What mortals gave me birth?
- TEIRESIAS This day shall be your birth and your destruction.

OEDIPUS All things you say in riddles and unclear. TEIRESIAS Are you not he who best can search this out? OEDIPUS Mock, if you wish, the skill that made me great. TEIRESIAS This is the very fortune that destroyed you. OEDIPUS Well, if I saved the city, I do not care. TEIRESIAS I am going now. You, boy, be my guide.

OEDIPUS Yes, let him guide you. Here you are in the way. When you are gone you will give no more trouble.

TEIRESIAS I go when I have said what I came to say Without fear of your frown; you cannot destroy me. I say, the very man whom you long seek With threats and announcements about Laius' murder-380 This man is here. He seems an alien stranger, But soon he shall be revealed of Theban birth, Nor at this circumstance shall he be pleased. He shall be blind who sees, shall be a beggar Who now is rich, shall make his way abroad Feeling the ground before him with a staff. He shall be revealed at once as brother And father to his own children, husband and son To his mother, his father's kin and murderer. 390 Go in and ponder that. If I am wrong,

Say then that I know nothing of prophecy. CHORUS

Strophe A

400

410

420

430

Who is the man the Delphic rock said with oracular voice Unspeakable crimes performed with his gory hands? It is time for him now to speed His foot in flight, more strong Than horses swift as the storm. For girt in arms upon him springs With fire and lightning, Zeus' son And behind him, terrible, Come the unerring Fates.

Antistrophe A

From snowy Parnassus just now the word flashed clear To track the obscure man by every way, For he wanders under the wild Forest, and into caves And cliff rocks, like a bull, Reft on his way, with care on care Trying to shun the prophecy Come from the earth's mid-navel; But about him flutters the ever living doom.

Strophe B

Terrible, terrible things the wise bird-augur stirs. I neither approve nor deny, at a loss for what to say, I flutter in hopes and fears, see neither here nor ahead; For what strife has lain On Labdacus' sons or Polybus' that I have found ever before Or now, whereby I may run for the sons of Labdacus In sure proof against Oedipus' public fame As avenger for dark death?

Antistrophe B

Zeus and Apollo surely understand and know The affairs of mortal men, but that a mortal seer Knows more than I, there is no proof. Though a man May surpass a man in knowledge,

Never shall I agree, till I see the word true, when men blame Oedipus,

For there came upon him once clear the winged maiden And wise he was seen, by sure test sweet for the state. So never shall my mind judge him evil guilt.

CREON Men of our city, I have heard dread words That Oedipus our king accuses me. I am here indignant. If in the present troubles He thinks that he has suffered at my hands 450

440

460

480

One word or deed tending to injury CREON Am I with you two not an equal third? I do not crave the long-spanned age of life OEDIPUS In just that do you prove a treacherous friend. To bear this rumor, for it is no simple wrong CREON No, if, like me, you reason with yourself. The damage of this accusation brings me; Consider this fact first: would any man 560 It brings the greatest, if I am called a traitor Choose, do you think, to have his rule in fear To you and my friends, a traitor to the state. Rather than doze unharmed with the same power? CHORUS Come now, for this reproach perhaps was For my part I have never been desirous forced Of being king instead of acting king. By anger, rather than considered thought. Nor any other man has, wise and prudent. 500 CREON And was the idea voiced that my advice For now I obtain all from you without fear. Persuaded the prophet to give false accounts? If I were king, I would do much unwilling. CHORUS Such was said. I know not to what intent. How then could kingship sweeter be for me CREON Was this accusation laid against me Than rule and power devoid of any pain? From straightforward eyes and straightforward mind? I am not yet so much deceived to want 570 CHORUS I do not know. I see not what my masters do; Goods besides those I profitably enjoy. But here he is now, coming from the house. Now I am hailed and gladdened by all men. OEDIPUS How dare you come here? Do you own a face Now those who want from you speak out to me, So bold that you can come before my house Since all their chances' outcome dwells therein. When you are clearly the murderer of this man 510 How then would I relinquish what I have And manifestly pirate of my throne? To get those gains? My mind runs not so bad. I am prudent yet, no lover of such plots, Come, say before the gods, did you see in me A coward or a fool, that you plotted this? Nor would I ever endure others' treason. Or did you think I would not see your wiles And first as proof of this go on to Pytho; Creeping upon me, or knowing, would not ward off? See if I told you truly the oracle. 580 Surely your machination is absurd Next proof: see if I plotted with the seer; Without a crowd of friends to hunt a throne If you find so at all, put me to death Which is captured only by wealth and many men. With my vote for my guilt as well as yours. CREON Do you know what you do? Hear answer to your Do not convict me just on unclear conjecture. charges It is not right to think capriciously On the other side. Judge only what you know. 520 The good are bad, nor that the bad are good. OEDIPUS Your speech is clever, but I learn it ill It is the same to cast out a noble friend, Since I have found you harsh and grievous toward me. I say, as one's own life, which best he loves. CREON This very matter hear me first explain. The facts, though, you will safely know in time, OEDIPUS Tell me not this one thing: you are not false. Since time alone can show the just man just, 590 CREON If you think stubbornness a good possession But you can know a criminal in one day. Apart from judgment, you do not think right. CHORUS A cautious man would say he has spoken well. OEDIPUS If you think you can do a kinsman evil O king, the quick to think are never sure. Without the penalty, you have no sense. OEDIPUS When the plotter, swift, approaches me in CREON I agree with you. What you have said is just. stealth Tell me what you say you have suffered from me. 530 I too in counterplot must be as swift. OEDIPUS Did you, or did you not, advise my need If I wait in repose, the plotter's ends Was summoning that prophet person here? Are brought to pass and mine will then have erred. CREON And still is. I hold still the same opinion. CREON What do you want then? To cast me from the land? OEDIPUS How long a time now has it been since Laius— OEDIPUS Least of all that. My wish is you should die, CREON Performed what deed? I do not understand. Not flee to exemplify what envy is. 600 OEDIPUS — Disappeared to his ruin at deadly hands. CREON Do you say this? Will you neither trust nor yield? CREON Far in the past the count of years would run. OEDIPUS [No, for I think that you deserve no trust.] OEDIPUS Was this same seer at that time practicing? CREON You seem not wise to me. CREON As wise as now, and equally respected. OEDIPUS I am for me. CREON You should be for me too. OEDIPUS At that time did he ever mention me? 540 CREON Never when I stood near enough to hear. OEDIUPUS No, you are evil. OEDIPUS But did you not make inquiry of the murder? CREON Yes, if you understand nothing. CREON We did, of course, and got no information. OEDIPUS Yet I must rule. OEDIPUS How is it that this seer did not utter this then? CREON Not when you rule badly. CREON When I don't know, as now, I would keep still. OEDIPUS O city, city! 610 OEDIPUS This much you know full well, and so should CREON It is my city too, not yours alone. speak:-CHORUS Stop, princes. I see Jocasta coming CREON What is that? If I know, I will not refuse. Out of the house at the right time for you. OEDIPUS This: If he had not first conferred with you With her you must settle the dispute at hand. He never would have said that I killed Laius. JOCASTA O wretched men, what unconsidered feud CREON If he says this, you know yourself, I think; 550 Of tongues have you aroused? Are you not ashamed, I learn as much from you as you from me. The state so sick, to stir up private ills? OEDIPUS Learn then: I never shall be found a slayer. Are you not going home? And you as well?

Will you turn a small pain into a great? CREON My blood sister, Oedipus your husband Claims he will judge against me two dread ills: Thrust me from the fatherland or take and kill me.

620

CREON What then, are you the husband of my sister? OEDIPUS What you have asked is plain beyond denial. CREON Do you rule this land with her in equal sway? OEDIPUS All she desires she obtains from me.

OEDIPUS I will, my wife; I caught him in the act And I shall briefly show you proof of this: An oracle came once to Laius. I do not say Doing evil to my person with evil skill. From Phoebus himself, but from his ministers CREON Now may I not rejoice but die accursed That his fate would be at his son's hand to die-If ever I did any of what you accuse me. A child, who would be born from him and me. JOCASTA O, by the gods, believe him, Oedipus. And yet, as the rumor says, they were strangers, First, in reverence for his oath to the gods, Robbers who killed him where three highways meet. Next, for my sake and theirs who stand before you. But three days had not passed from the child's birth CHORUS Hear my entreaty, lord. Consider and consent. 630 When Laius pierced and tied together his ankles, OEDIPUS What wish should I then grant? And cast him by others' hands on a pathless mountain. CHORUS Respect the man, no fool before, who now in oath Therein Apollo did not bring to pass is strong. That the child murder his father, nor for Laius OEDIPUS You know what you desire? CHORUS I know. The dread he feared, to die at his son's hand. Such did prophetic oracles determine. OEDIPUS Say what you mean. Pay no attention to them. For the god CHORUS Your friend who has sworn do not dishonor Will easily make clear the need he seeks. By casting guilt for dark report. OEDIPUS Know well that when you ask this grant from me, OEDIPUS What wandering of soul, what stirring of mind You ask my death or exile from the land. Holds me, my wife, in what I have just heard! 640 JOCASTA What care has turned you back that you say this? CHORUS No, by the god foremost among the gods, OEDIPUS I thought I heard you mention this, that Laius The Sun, may I perish by the utmost doom Was slaughtered at the place where three highways meet. Godless and friendless, if I have this in mind. IOCASTA That was the talk. The rumor has not ceased. But ah, the withering earth wears down My wretched soul, if to these ills OEDIPUS Where is this place where such a sorrow was? Of old are added ills from both of you. JOCASTA The country's name is Phocis. A split road OEDIPUS Then let him go, though surely I must die Leads to one place from Delphi and Daulia. OEDIPUS And how much time has passed since these Or be thrust dishonored from this land by force. events? Your grievous voice I pity, not that man's; IOCASTA The news was heralded in the city scarcely Wherever he may be, he will be hated. A little while before you came to rule. CREON Sullen you are to yield, as you are heavy 650 OEDIPUS O Zeus, what have you planned to do to me? When you exceed in wrath. Natures like these JOCASTA What passion is this in you, Oedipus? Are justly sorest for themselves to bear. OEDIPUS Don't ask me that yet. Tell me about Laius. OEDIPUS Will you not go and leave me? What did he look like? How old was he when murdered? CREON I am on my way. JOCASTA A tall man, with his hair just brushed with white. You know me not, but these men see me just. CHORUS O queen, why do you delay to bring this man His shape and form differed not far from yours. OEDIPUS Alas! Alas! I think unwittingly indoors? I have just laid dread curses on my head. JOCASTA I want to learn what happened here. JOCASTA What are you saying? I shrink to behold you, lord. CHORUS Unknown suspicion rose from talk, and the unjust OEDIPUS I am terribly afraid the seer can see. devours. That will be clearer if you say one thing more. JOCASTA In both of them? CHORUS Just so. JOCASTA Though I shrink, if I know what you ask, I will 660 answer. JOCASTA What was the talk? CHORUS Enough, enough! When the land is pained OEDIPUS Did he set forth with few attendants then, Or many soldiers, since he was a king? It seems to me at this point we should stop. JOCASTA They were five altogether among them. One was OEDIPUS Do you see where you have come? a herald. One chariot bore Laius. Though your intent Is good, you slacken off and blunt my heart OEDIPUS Alas! All this is clear now. Tell me, my wife, Who was the man who told these stories to you? CHORUS O lord, I have said not once alone, JOCASTA One servant, who alone escaped, returned. Know that I clearly would be mad OEDIPUS Is he by chance now present in our house? And wandering in mind, to turn away JOCASTA Not now. Right from the time when he returned 670 You who steered along the right, To see you ruling and Laius dead, When she was torn with trouble, our beloved state. O may you now become in health her guide. Touching my hand in suppliance, he implored me To send him to fields and to pastures of sheep JOCASTA By the gods, lord, tell me on what account That he might be farthest from the sight of this city. You have set yourself in so great an anger. So I sent him away, since he was worthy OEDIPUS I shall tell you, wife; I respect you more than For a slave, to bear a greater grant than this. these men. OEDIPUS How then could he return to us with speed? Because of Creon, since he has plotted against me. JOCASTA It can be done. But why would you order this? JOCASTA Say clearly, if you can; how started the OEDIPUS O lady, I fear I have said too much. quarrel? On this account I now desire to see him. OEDIPUS He says that I stand as the murderer of Laius. JOCASTA Then he shall come. But I myself deserve JOCASTA He knows himself, or learned from someone else? To learn what it is that troubles you, my lord. 680 OEDIPUS No, but he sent a rascal prophet here. OEDIPUS And you shall not be prevented, since my fears He keeps his own mouth clean in what concerns him. Have come to such a point. For who is closer JOCASTA Now free yourself of what you said, and listen. That I may speak to in this fate than you? Learn from me, no mortal man exists Polybus of Corinth was my father, Who knows prophetic art for your affairs,

690

700

710

720

730

My mother, Dorian Merope. I was held there Chief citizen of all, till such a fate Befell me—as it is, worthy of wonder, But surely not deserving my excitement. A man at a banquet overdrunk with wine Said in drink I was a false son to my father. The weight I held that day I scarcely bore, But on the next day I went home and asked My father and mother of it. In bitter anger They took the reproach from him who had let it fly. I was pleased at their actions; nevertheless The rumor always rankled; and spread abroad. In secret from mother and father I set out Toward Delphi. Phoebus sent me away ungraced In what I came for, but other wretched things Terrible and grievous, he revealed in answer; That I must wed my mother and produce An unendurable race for men to see, That I should kill the father who begot me. When I heard this response, Corinth I fled Henceforth to measure her land by stars alone. I went where I should never see the disgrace Of my evil oracles be brought to pass, And on my journey to that place I came At which you say this king had met his death. My wife, I shall speak the truth to you. My way Led to a place close by the triple road. There a herald met me, and a man Seated on colt-drawn chariot, as you said. There both the guide and the old man himself Thrust me with driving force out of the path. And I in anger struck the one who pushed me, The driver. Then the old man, when he saw me, Watched when I passed, and from his chariot Struck me full on the head with double goad. I paid him back and more. From this very hand A swift blow of my staff rolled him right out Of the middle of his seat onto his back. I killed them all. But if relationship Existed between this stranger and Laius, What man now is wretcheder than I? What man is cursed by a more evil fate? No stranger or citizen could now receive me Within his home, or even speak to me, But thrust me out; and no one but myself Brought down these curses on my head. The bed of the slain man I now defile With hands that killed him. Am I evil by birth? Am I not utterly vile if I must flee And cannot see my family in my flight Nor tread my homeland soil, or else be joined In marriage to my mother, kill my father, Polybus, who sired me and brought me up? Would not a man judge right to say of me That this was sent on me by some cruel spirit? O never, holy reverence of the gods, May I behold that day, but may I go Away from mortal men, before I see Such a stain of circumstance come to me. CHORUS My lord, for us these facts are full of dread.

Until you hear the witness, stay in hope.

OEDIPUS And just so much is all I have of hope, Only to wait until the shepherd comes.

JOCASTA What, then, do you desire to hear him speak? OEDIPUS I will tell you, if his story is found to be

The same as yours, I would escape the sorrow.

JOCASTA What unusual word did you hear from me? OEDIPUS You said he said that they were highway robbers Who murdered him. Now, if he still says The selfsame number, I could not have killed him, Since one man does not equal many men. But if he speaks of a single lonely traveller, The scale of guilt now clearly falls to me. JOCASTA However, know the word was set forth thus

And it is not in him now to take it back; This tale the city heard, not I alone. But if he diverges from his previous story, Even then, my lord, he could not show Laius' murder To have been fulfilled properly. Apollo Said he would die at the hands of my own son. Surely that wretched child could not have killed him, But he himself met death some time before.

- Therefore, in any prophecy henceforth I would not look to this side or to that. OEDIPUS Your thoughts ring true, but still let someone go To summon the peasant. Do not neglect this.
- JOCASTA I shall send without delay. But let us enter. I would do nothing that did not please you.

CHORUS

760

780

790

800

Strophe A

May fate come on me as I bear Holy pureness in all word and deed, For which the lofty striding laws were set down, Born through the heavenly air Whereof the Olympian sky alone the father was; No mortal spawn of mankind gave them birth, Nor may oblivion ever lull them down; Mighty in them the god is, and he does not age.

Antistrophe A

Pride breeds the tyrant.

Pride, once overfilled with many things in vain, Neither in season nor fit for man, Scaling the sheerest height Hurls to a dire fate Where no foothold is found.

I pray the god may never stop the rivalry That works well for the state. The god as my protector I shall never cease to hold.

Strophe B

But if a man goes forth haughty in word or deed With no fear of the Right Nor pious to the spirits' shrines, May evil doom seize him For his ill-fated pride, If he does not fairly win his gain Or works unholy deeds, Or, in bold folly lays on the sacred profane hands. For when such acts occur, what man may boast Ever to ward off from his life darts of the gods? If practices like these are in respect, Why then must I dance the sacred dance?

810 Antistrophe B

Never again in worship shall I go To Delphi, holy navel of the earth, Nor to the temple at Abae, Nor to Olympia, 840

820

830

850

If these prophecies do not become Examples for all men. O Zeus, our king, if so you are rightly called, Ruler of all things, may they not escape You and your forever deathless power. Men now hold light the fading oracles Told about Laius long ago And nowhere is Apollo clearly honored; Things divine are going down to ruin. JOCASTA Lords of this land, the thought has come to me To visit the spirits' shrines, bearing in hand

870

880

890

930

- These suppliant boughs and offerings of incense. For Oedipus raises his soul too high With all distresses; nor, as a sane man should, Does he confirm the new by things of old, But stands at the speaker's will if he speaks terrors. And so, because my advice can do no more, To you, Lycian Apollo-for you are nearest-A suppliant, I have come here with these prayers, That you may find some pure deliverance for us: We all now shrink to see him struck in fear, That man who is the pilot of our ship.
- MESSENGER Strangers, could I learn from one of you Where is the house of Oedipus the king? Or best, if you know, say where he is himself.
- CHORUS This is his house, stranger; he dwells inside; This woman is the mother of his children.
- MESSENGER May she be always blessed among the blest, Since she is the fruitful wife of Oedipus.
- JOCASTA So may you, stranger, also be. You deserve As much for your graceful greeting. But tell me What you have come to search for or to show.
- MESSENGER Good news for your house and your husband, lady.
- JOCASTA What is it then? And from whom have you come? MESSENGER From Corinth. And the message I will tell
- Will surely gladden you and vex you, perhaps. JOCASTA What is it? What is this double force it holds?
- MESSENGER The men who dwell in the Isthmian country Have spoken to establish him their king.

JOCASTA What is that? Is not old Polybus still ruling?

- MESSENGER Not he. For death now holds him in the tomb.
- JOCASTA What do you say, old man? Is Polybus dead?

MESSENGER If I speak not the truth, I am ready to die.

JOCASTA O handmaid, go right away and tell your master The news. Where are you, prophecies of the gods? For this man Oedipus has trembled long, And shunned him lest he kill him. Now the man Is killed by fate and not by Oedipus.

- OEDIPUS O Jocasta, my most beloved wife, Why have you sent for me within the house?
- JOCASTA Listen to this man, and while you hear him, think 920 To what have come Apollo's holy prophecies.
- OEDIPUS Who is this man? Why would he speak to me?
- JOCASTA From Corinth he has come, to announce that your father

Polybus no longer lives, but is dead.

OEDIPUS What do you say, stranger? Tell me this yourself. MESSENGER If I must first announce my message clearly, Know surely that the man is dead and gone.

OEDIPUS Did he die by treachery or chance disease? MESSENGER A slight scale tilt can lull the old to rest. OEDIPUS The poor man, it seems, died by disease. MESSENGER And by the full measure of lengthy time.

OEDIPUS Alas, alas! Why then do any seek Pytho's prophetic art, my wife, or hear The shrieking birds on high, by whose report I was to slay my father? Now he lies Dead beneath the earth, and here am I Who have not touched the blade. Unless in longing For me he died, and in this sense was killed by me. Polybus has packed away these oracles In his rest in Hades. They are now worth nothing. JOCASTA Did I not tell you that some time ago? OEDIPUS You did, but I was led astray by fear. JOCASTA Henceforth put nothing of this on your heart. OEDIPUS Why must I not still shrink from my mother's bed? JOCASTA What should man fear, whose life is ruled by fate, For whom there is clear foreknowledge of nothing? It is best to live by chance, however you can. Be not afraid of marriage with your mother; Already many mortals in their dreams Have shared their mother's bed. But he who counts This dream as nothing, easiest bears his life. OEDIPUS All that you say would be indeed propitious, If my mother were not alive. But since she is, I still must shrink, however well you speak. JOCASTA And yet your father's tomb is a great eye. OEDIPUS A great eye indeed. But I fear her who lives. MESSENGER Who is this woman that you are afraid of? OEDIUPUS Merope, old man, with whom Polybus lived. MESSENGER What is it in her that moves you to fear? OEDIPUS A dread oracle, stranger, sent by the god. MESSENGER Can it be told, or must no other know? OEDIPUS It surely can. Apollo told me once 900 That I must join in intercourse with my mother And shed with my own hands my father's blood. Because of this, long since I have kept far Away from Corinth—and happily—but yet It would be most sweet to see my parents' faces. MESSENGER Was this your fear in shunning your own city? OEDIPUS I wished, too, old man, not to slay my father. MESSENGER Why then have I not freed you from this fear, 970 Since I have come with friendly mind, my lord? OEDIPUS Yes, and take thanks from me, which you deserve. MESSENGER And this is just the thing for which I came, That when you got back home I might fare well. 910 OEDIPUS Never shall I go where my parents are. MESSENGER My son, you clearly know not what you do. OEDIPUS How is that, old man? By the gods, let me know. MESSENGER If for these tales you shrink from going home. OEDIPUS I tremble lest what Phoebus said comes true.

MESSENGER Lest you incur pollution from your parents? 980 OEDIPUS That is the thing, old man, that always haunts me.

- MESSENGER Well, do you know that surely you fear nothing?
- OEDIPUS How so? If I am the son of those who bore me. MESSENGER Since Polybus was no relation to you. OEDIPUS What do you say? Was Polybus not my father? MESSENGER No more than this man here but just so much. OEDIPUS How does he who begot me equal nothing? MESSENGER That man was not your father, any more than I am.

OEDIPUS Well then, why was it he called me his son? MESSENGER Long ago he got you as a gift from me. OEDIPUS Though from another's hand, yet so much he loved me!

MESSENGER His previous childlessness led him to that.

940

950

960

OEDIPUS Had you bought or found me when you gave me to him? MESSENGER I found you in Cithaeron's folds and glens. OEDIPUS Why were you travelling in those regions? MESSENGER I guarded there a flock of mountain sheep. OEDIPUS Were you a shepherd, wandering for pay? MESSENGER Yes, and your savior too, child, at that time. OEDIPUS What pain gripped me, that you took me in your arms? MESSENGER The ankles of your feet will tell you that. OEDIPUS Alas, why do you mention that old trouble? MESSENGER I freed you when your ankles were pierced together. OEDIPUS A terrible shame from my swaddling clothes I got. MESSENGER Your very name you got from this misfortune. OEDIPUS By the gods, did my mother or father do it? Speak. MESSENGER I know not. He who gave you knows better than I. OEDIPUS You didn't find me, but took me from another? MESSENGER That's right. Another shepherd gave you to me. OEDIPUS Who was he? Can you tell me who he was? MESSENGER Surely. He belonged to the household of Laius. 1010 OEDIPUS The man who ruled this land once long ago? MESSENGER Just so. He was a herd in that man's service. OEDIPUS Is this man still alive, so I could see him? MESSENGER You dwellers in this country should know best. OEDIPUS Is there any one of you who stand before me Who knows the shepherd of whom this man speaks? If you have seen him in the fields or here, Speak forth; the time has come to find this out. CHORUS I think the man you seek is no one else Than the shepherd you were so eager to see before. 1020 Jocasta here might best inform us that. OEDIPUS My wife, do you know the man we just ordered To come here? Is it of him that this man speaks? JOCASTA Why ask of whom he spoke? Think nothing of it. Brood not in vain on what has just been said. OEDIPUS It could not be that when I have got such clues, I should not shed clear light upon my birth. JOCASTA Don't, by the gods, investigate this more If you care for your own life. I am sick enough. OEDIPUS Take courage. Even if I am found a slave For three generations, your birth will not be base. JOCASTA Still, I beseech you, hear me. Don't do this. OEDIPUS I will hear of nothing but finding out the truth. JOCASTA I know full well and tell you what is best. OEDIPUS Well, then, this best, for some time now, has given me pain. JOCASTA O ill-fated man, may you never know who vou are. OEDIPUS Will someone bring the shepherd to me here? And let this lady rejoice in her opulent birth. JOCASTA Alas, alas, hapless man. I have this alone To tell you, and nothing else forevermore. 1040 CHORUS O Oedipus, where has the woman gone In the rush of her wild grief? I am afraid Evil will break forth out of this silence. OEDIPUS Let whatever will break forth. I plan to see The seed of my descent, however small. My wife, perhaps, because a noblewoman Looks down with shame upon my lowly birth.

I would not be dishonored to call myself The son of Fortune, giver of the good. She is my mother. The years, her other children, Have marked me sometimes small and sometimes great. Such was I born! I shall prove no other man, Nor shall I cease to search out my descent.

CHORUS

1000 Strophe

If I am a prophet and can know in mind, Cithaeron, by tomorrow's full moon You shall not fail, by mount Olympus, To find that Oedipus, as a native of your land, Shall honor you for nurse and mother. And to you we dance in choral song because you bring Fair gifts to him our king. Hail, Phoebus, may all this please you.

Antistrophe

Who, child, who bore you in the lengthy span of years?
One close to Pan who roams the mountain woods,
One of Apollo's bedfellows?
For all wild pastures in mountain glens to him are dear.
Was Hermes your father, who Cyllene sways,
Or did Bacchus, dwelling on the mountain peaks,
Take you a foundling from some nymph
Of those by springs of Helicon, with whom he sports the most?

OEDIFUS II I may guess, although I never met him,
I think, elders, I see that shepherd coming
Whom we have long sought, as in the measure
Of lengthy age he accords with him we wait for.
Besides, the men who lead him I recognize
As servants of my house. You may perhaps

Know better than I if you have seen him before. CHORUS Be assured, I know him as a shepherd

As trusted as any other in Laius' service. OEDIPUS Stranger from Corinth, I will ask you first, Is this the man you said?

MESSENGER You are looking at him.

OEDIPUS You there, old man, look here and answer me What I shall ask you. Were you ever with Laius? SERVANT I was a slave, not bought but reared at home.

1030 OEDIPUS What work concerned you? What was your way of life?

SERVANT Most of my life I spent among the flocks.

- OEDIPUS In what place most of all was your usual pasture?
- SERVANT Sometimes Cithaeron, or the ground nearby.
- OEDIPUS Do you know this man before you here at all?

SERVANT Doing what? And of what man do you speak?

OEDIPUS The one before you. Have you ever had congress with him?

SERVANT Not to say so at once from memory.

- MESSENGER That is no wonder, master, but I shall remind him,
- Clearly, who knows me not; yet will I know That he knew once the region of Cithaeron. He with a double flock and I with one Dwelt there in company for three whole years During the six months' time from spring to fall. When winter came, I drove into my fold My flock, and he drove his to Laius' pens. Do I speak right, or did it not happen so?

1060

1070

1080

1090

SERVANT You speak the truth, though it was long ago. MESSENGER Come now, do you recall you gave me then A child for me to rear as my own son? SERVANT What is that? Why do you ask me this? MESSENGER This is the man, my friend, who then was young SERVANT Go to destruction! Will you not be quiet? OEDIPUS Come, scold him not, old man. These words of yours Deserve a scolding more than this man's do. 1110 SERVANT In what, most noble master, do I wrong? OEDIPUS Not to tell of the child he asks about. SERVANT He speaks in ignorance, he toils in vain. OEDIPUS If you will not speak freely, you will under torture. SERVANT Don't, by the gods, outrage an old man like me. OEDIPUS Will someone quickly twist back this fellow's arms? SERVANT Alas, what for? What do you want to know? OEDIPUS Did you give this man the child of whom he asks? SERVANT I did. Would I had perished on that day! OEDIPUS You will come to that unless you tell the truth. 1120 SERVANT I come to far greater ruin if I speak. OEDIPUS This man, it seems, is trying to delay. SERVANT Not I. I said before I gave it to him. OEDIPUS Where did you get it? At home or from someone else? SERVANT It was not mine. I got him from a man. OEDIPUS Which of these citizens? Where did he live? SERVANT O master, by the gods, ask me no more. OEDIPUS You are done for if I ask you this again. SERVANT Well then, he was born of the house of Laius. OEDIPUS One of his slaves, or born of his own race? 1130 SERVANT Alas, to speak I am on the brink of horror. OEDIPUS And I to hear. But still it must be heard. SERVANT Well, then, they say it was his child. Your wife Who dwells within could best say how this stands. OEDIPUS Was it she who gave him to you? SERVANT Yes, my lord. **OEDIPUS** For what intent? SERVANT So I could put it away. OEDIPUS When she bore him, the wretch. 1140 SERVANT She feared bad oracles. **OEDIPUS** What were they? SERVANT They said he should kill his father. OEDIPUS Why did you give him up to this old man? SERVANT I pitied him, master, and thought he would take him away To another land, the one from which he came. But he saved him for greatest woe. If you are he Whom this man speaks of, you were born curst by fate. OEDIPUS Alas, alas! All things are now come true. O light, for the last time now I look upon you; I am shown to be born from those I ought not to 1150 have been. I married the woman I should not have married, I killed the man whom I should not have killed. CHORUS Strophe A

Than just the seeming so, And then, like a waning sun, to fall away? When I know your example, Your guiding spirit, yours, wretched Oedipus, I call no mortal blest.

Antistrophe A

He is the one, O Zeus, Who peerless shot his bow and won well-fated bliss, Who destroyed the hook-clawed maiden, The oracle-singing Sphinx, And stood a tower for our land from death; For this you are called our king, Oedipus, are highest-honored here, And over great Thebes hold sway.

Strophe B

And now who is more wretched for men to hear, Who so lives in wild plagues, who dwells in pains, In utter change of life? Alas for glorious Oedipus! The selfsame port of rest Was gained by bridegroom father and his son, How, O how did your father's furrows ever bear you, suffering man? How have they endured silence for so long?

Antistrophe B

You are found out, unwilling, by all seeing Time. It judges your unmarried marriage where for long Begetter and begot have been the same. Alas, child of Laius, Would I had never seen you. As one who pours from his mouth a dirge I wail, To speak the truth, through you I breathed new life, And now through you I lulled my eye to sleep. SECOND MESSENGER O men most honored always of this land What deeds you shall hear, what shall you behold! What grief shall stir you up, if by your kinship You are still concerned for the house of Labdacus! I think neither Danube nor any other river Could wash this palace clean, so many ills Lie hidden there which now will come to light. They were done by will, not fate; and sorrows hurt The most when we ourselves appear to choose them. CHORUS What we heard before causes no little sorrow. What can you say which adds to that a burden? SECOND MESSENGER This is the fastest way to tell the tale: Hear it: Jocasta, your divine queen, is dead. CHORUS O sorrowful woman! From what cause did she die? SECOND MESSENGER By her own hand. The most painful of the action Occurred away, not for your eyes to see. But still, so far as I have memory You shall learn the sufferings of that wretched woman: How she passed on through the door enraged And rushed straight forward to her nuptial bed, Clutching her hair's ends with both her hands. Once inside the doors she shut herself in And called on Laius, who has long been dead,

1160

1170

1180

1190

1200

Alas, generations of mortal men! How equal to nothing do I number you in life! Who, O who, is the man

Who bears more of bliss

Having remembrance of their seed of old By which he died himself and left her a mother To bear an evil brood to his own son. She moaned the bed on which by double curse She bore husband to husband, children to child. How thereafter she perished I do not know, For Oedipus burst in on her with a shriek, And because of him we could not see her woe. We looked on him alone as he rushed around. Pacing about, he asked us to give him a sword, Asked where he might find the wife no wife, A mother whose plowfield bore him and his children. Some spirit was guiding him in his frenzy, For none of the men who are close at hand did so. With a horrible shout, as if led on by someone, He leapt on the double doors, from their sockets Broke hollow bolts aside, and dashed within. There we beheld his wife hung by her neck From twisted cords, swinging to and fro. When he saw her, wretched man, he terribly groaned And slackened the hanging noose. When the poor woman

Lay on the ground, what happened was dread to see. He tore the golden brooch pins from her clothes, And raised them up, and struck his own eyeballs, Shouting such words as these "No more shall you Behold the evils I have suffered and done. Be dark from now on, since you saw before What you should not, and knew not what you should." Moaning such cries, not once but many times He raised and struck his eyes. The bloody pupils Bedewed his beard. The gore oozed not in drops, But poured in a black shower, a hail of blood. From both of them these woes have broken out, Not for just one, but man and wife together. The bliss of old that formerly prevailed Was bliss indeed, but now upon this day Lamentation, madness, death, and shame-No evil that can be named is not at hand.

CHORUS Is the wretched man in any rest now from pain? SECOND MESSENGER He shouts for someone to open up the doors

And show to all Cadmeans his father's slayer, His mother's—I should not speak the unholy word. He says he will hurl himself from the land, no more To dwell cursed in the house by his own curse. Yet he needs strength and someone who will guide him. His sickness is too great to bear. He will show it to you For the fastenings of the doors are opening up, And such a spectacle you will soon behold

As would make even one who abhors it take pity. CHORUS O terrible suffering for men to see,

Most terrible of all that I Have ever come upon. O wretched man, What madness overcame you, what springing

daimon Greater than the greatest for men

Has caused your evil-daimoned fate?

Alas, alas, grievous one,

But I cannot bear to behold you, though I desire

To ask you much, much to find out,

Much to see, You make me shudder so!

OEDIPUS Alas, alas, I am grieved! Where on earth, so wretched, shall I go? Where does my voice fly through the air, O Fate, where have you bounded?

CHORUS To dreadful end, not to be heard or seen. 1210

Strophe A

OEDIPUS O cloud of dark

That shrouds me off, has come to pass, unspeakable, Invincible, that blows no favoring blast. Woe,

O woe again, the goad that pierces me,

Of the sting of evil now, and memory of before. CHORUS No wonder it is that among so many pains

You should both mourn and bear a double evil. 1220

Antistrophe A

OEDIPUS Ah, friend, You are my steadfast servant still, You still remain to care for me, blind. Alas! Alas!

You are not hid from me; I know you clearly.

And though in darkness, still I hear your voice.

CHORUS O dreadful doer, how did you so endure To quench your eyes? What daimon drove you on?

Strophe B

1230

1240	OEDIPUS Apollo it was, Apollo, friends Who brought to pass these evil, evil woes of mine. The hand of no one struck my eyes but wretched me. For why should I see, When nothing sweet there is to see with sight? CHORUS This is just as you say. OEDIPUS What more is there for me to see, My friends, what to love, What joy to hear a greeting? Lead me at once away from here, Lead me at once away from here, Chead me away, friends, wretched as I am, Accursed, and hated most Of mortals to the gods. CHORUS Wretched alike in mind and in your fortune,	
	CHORUS Wretched alike in mind and in your fortune,	
	How I wish that I had never known you.	

Antistrophe B

	OEDIPUS May he perish, whoever freed me	
1250	From fierce bonds on my feet,	
	Snatched me from death and saved me, doing me	
	no joy	
	For if then I had died, I should not be	
	So great a grief to friends and to myself.	
	CHORUS This also is my wish.	131
	OEDIPUS I would not have come to murder my father,	
	Nor have been called among men	
	The bridegroom of her from whom I was born.	
	But as it is I am godless, child of unholiness,	
1260	Wretched sire in common with my father.	
	And if there is any evil older than evil left,	
	It is the lot of Oedipus.	
	CHORUS I know not how I could give you good advice,	
	For you would be better dead than living blind.	
	OEDIPUS That how things are was not done for the best—	1320
	Teach me not this, or give me more advice.	
	If I had sight, I know not with what eyes	
	I could ever face my father among the dead,	
	Or my wretched mother. What I have done to them	
	Is too great for a noose to expiate.	
1270	Do you think the sight of my children would be a joy	

For me to see, born as they were to me? No, never for these eyes of mine to see.

1280

1290

1400

1410

1420

1430

Nor the city, nor the tower, nor the sacred Statues of gods; of these I deprive myself, Noblest among the Thebans, born and bred, Now suffering everything. I tell you all To exile me as impious, shown by the gods Untouchable and of the race of Laius. When I uncovered such a stain on me, Could I look with steady eyes upon the people? No, No! And if there were a way to block The spring of hearing, I would not forbear To lock up wholly this my wretched body. I should be blind and deaf. — For it is sweet When thought can dwell outside our evils. Alas, Cithaeron, why did you shelter me? Why did you not take and kill me at once, so I Might never reveal to men whence I was born? O Polybus, O Corinth, O my father's halls, Ancient in fable, what an outer fairness, A festering of evils, you raised in me. For now I am evil found, and born of evil. O the three paths! Alas the hidden glen, The grove of oak, the narrow triple roads That drank from my own hands my father's blood. Do you remember any of the deeds I did before you then on my way here And what I after did? O wedlock, wedlock! You gave me birth, and then spawned in return Issue from the selfsame seed; you revealed Father, brother, children, in blood relation, The bride both wife and mother, and whatever Actions are done most shameful among men. But it is wrong to speak what is not good to do. By the gods, hide me at once outside our land, Or murder me, or hurl me in the sea Where you shall never look on me again. Come, venture to lay your hands on this wretched man. Do it. Be not afraid. No mortal man There is, except myself, to bear my evils. CHORUS Here is Creon, just in time for what you ask To work and to advise, for he alone Is left in place of you to guard the land.

OEDIPUS Alas, what word, then, shall I tell this man? What righteous ground of trust is clear in me, As in the past in all I have done him evil?

CREON Oedipus, I have not come to laugh at you, Nor to reproach you for your former wrongs.

(TO THE ATTENDANTS)

If you defer no longer to mortal offspring, Respect at least the all-nourishing flame Of Apollo, lord of the sun. Fear to display So great a pestilence, which neither earth Nor holy rain nor light will well receive. But you, conduct him to the house at once. It is most pious for the kin alone To hear and to behold the family sins.

OEDIPUS By the gods, since you have plucked me from my fear,

Most noble, facing this most vile man,

Hear me one word—I will speak for you, not me. CREON What desire do you so persist to get?

OEDIPUS As soon as you can, hurl me from this land To where no mortal man will ever greet me.

CREON I would do all this, be sure. But I want first To find out from the god what must be done.

OEDIPUS His oracle, at least, is wholly clear; Leave me to ruin, an impious parricide.

	CREON Thus spake the oracle. Still, as we stand
1330	It is better to find out sure what we should do.
1000	OEDIPUS Will you inquire about so wretched a man?
	CREON Yes. You will surely put trust in the god.
	OEDIPUS I order you and beg you, give the woman
	Now in the house such burial as you yourself
	Now in the house such burlar as you yoursen
	Would want. Do last rites justly for your kin.
	But may this city never be condemned—
	My father's realm—because I live within.
	Let me live in the mountains where Cithaeron
	Yonder has fame of me, which father and mother
1340	When they were alive established as my tomb.
	There I may die by those who sought to kill me.
	And yet this much I know, neither a sickness
	Nor anything else can kill me. I would not
	Be saved from death, except for some dread evil.
	Well, let my fate go wherever it may.
	As for my sons, Creon, assume no trouble;
	They are men and will have no difficulty
	Of living wherever they may be.
	O my poor grievous daughters, who never knew
1250	Their dinner table set apart from me,
1350	But always shared in everything I touched—
	Take care of them for me, and first of all
	Allow me to touch them and bemoan our ills.
	Grant it, lord,
	Grant it, noble. If with my hand I touch them
	I would think I had them just as when I could see.
	(CREON'S ATTENDANTS BRING IN ANTIGONE AND ISMENE.)
1360	What's that?
	By the gods, can it be I hear my dear ones weeping?
	And have you taken pity on me, Creon?
	Have you had my darling children sent to me?
	Do I speak right?
	CREON You do. For it was I who brought them here,
	Knowing this present joy your joy of old.
	OEDIPUS May you fare well. For their coming may the
	spirit That watches over you be better than mine.
1270	My children, where are you? Come to me, come
1370	Into your brother's hands, that brought about
	Nour father's man and bright to see like this
	Your father's eyes, once bright, to see like this.
	Your father, children, who, seeing and knowing
	nothing,
	Became a father whence he was got himself.
	I weep also for you—I cannot see you—
	To think of the bitter life in days to come
	Which you will have to lead among mankind.
	What citizens' gatherings will you approach?
	What festivals attend, where you will not cry
1380	When you go home, instead of gay rejoicing?

1450

1440

1390

1330

1340

You must decay in barrenness, unwed. Son of Menoeceus—since you are alone Left as a father to them, for we who produced them Are both in ruin—see that you never let

And when you arrive at marriageable age,

Incurring such reproaches on his head,

Disgraceful to my children and to yours?

What evil will be absent, when your father

From whom he was born himself, and equally

Has fathered you whence he himself was born.

My children, there is no one for you. Clearly

What man, my daughters, will there be to chance you,

Killed his own father, sowed seed in her who bore him,

Such will be the reproaches. Who then will wed you?

These girls wander as beggars without husbands, Let them not fall into such woes as mine. But pity them, seeing how young they are To be bereft of all except your aid. Grant this, my noble friend, with a touch of your hand. My children, if your minds were now mature, I would give you much advice. But, pray this for me, To live as the time allows, to find a life Better than that your siring father had.

CREON You have wept enough here, come, and go inside the house.

OEDIPUS I must obey, though nothing sweet.

CREON All things are good in their time.

OEDIPUS Do you know in what way I go?

CREON Tell me, I'll know when I hear.

OEDIPUS Send me outside the land.

CREON You ask what the god will do.

OEDIPUS But to the gods I am hated.

CREON Still, it will soon be done.

OEDIPUS Then you agree?

CREON What I think not I would not say in vain.

OEDIPUS Now lead me away.

CREON Come then, but let the children go.

OEDIPUS Do not take them from me.

CREON Wish not to govern all,

For what you ruled will not follow you through life. CHORUS Dwellers in native Thebes, behold this Oedipus

Who solved the famous riddle, was your mighteest man. What citizen on his lot did not with envy gaze? See to how great a surge of dread fate he has come! So I would say a mortal man, while he is watching To see the final day, can have no happiness Till he pass the bound of life, nor be relieved of pain.

PLATO

from the Apology

Socrates, after ironical compliments to the cleverness of his accusers, begs to be allowed to use his customary plain style; he will merely tell the truth, first explaining the causes of his present predicament.

[Socrates is speaking.] First, then, I ought to reply to the earlier charges against me and my earlier accusers, and then to the later ones. For there have been many accusers for many years, though their charges have been false; and I am more afraid of them than of Anytus and his associates, though they, too, are formidable. But the earlier are still more formidable, since they began when most of you were children to persuade you by false accusations that there is one Socrates, a wise man, who speculates about the heavens above and investigates what is beneath the earth, and who makes the worse appear to be the better case. They who have broadcast this rumor are my really formidable accusers; for their hearers suppose that those who investigate these matters do not believe in the existence of the gods. Then, too, these accusers are many and have been at work for a long time during your most credulous years, when you were children or young men, and when there was no one to answer them. And what makes it hardest of all is that I do not know and cannot name any of them—unless perhaps it be some comic poet. All who by envy and malice persuaded you, some of them actually themselves persuaded, are most difficult to deal

with; for I cannot put any of them up here for crossexamination, but must engage in shadow-fighting in my defense, and must ask questions when there is no one to 1460 answer me. . . .

Well, then, I must defend myself, and I must try in a short time to clear away a slander that you have accepted for a long time. I hope I may succeed, if success is for your welfare as well as mine. But I think, indeed I know, it will be difficult. Yet God's will be done; and I must make my defense in obedience to the law.

Let us begin at the beginning. What is the accusation that lies behind the slander against me, relying on which Meletus has brought this charge against me? Well, what do the slanderers say? I may phrase their charge as follows: 1470 "Socrates is guilty of busying himself with inquiries about subterranean and celestial matters and of making the worse appear the better case and of teaching these matters to others." There, that's the sort of charge; and you yourselves have seen it embodied in the comedy of Aristophanes, in which "Socrates" is presented as suspended aloft and proclaiming that he is "treading on air" and talking a lot of other nonsense about which I understand nothing either great or small. Not that I disprize such knowledge on the part of any one who really knows about such matters; I hope 1480 I may not have to defend myself against Meletus on such a charge. But the fact is that I have nothing to do with such matters. I appeal to most of you as witnesses of this fact, and I beg you to speak up to one another, as many as have ever heard me discoursing; tell one another whether any of you have ever heard me talking about such matters in brief or at length. You see; and from their response to this question you will judge that the rest of the gossip about me is of the same cloth.

[And it is not true that Socrates, like the Sophists, undertakes formal instruction and charges fees.]

Perhaps, then, some one of you may ask: "Well, Socrates, what is this occupation of yours? How have these slanders against you arisen? Surely all this talk would not have sprung up if you had not been busying yourself with something out of the ordinary. Tell us then what it is, so that we may not judge you arbitrarily."

Fair enough; and I'll try to show you what has given me this reputation and this slander. Listen. Perhaps I shall seem to some of you to be speaking in jest; but I am going to tell you the whole truth. I got this reputation wholly because of a kind of wisdom. What sort of wisdom? Well, perhaps it is such wisdom as man can make his own; I rather think I have that kind of wisdom. The gentlemen whom I mentioned a moment ago may have a superhuman wisdom, or I don't know what to call it; I don't understand it, and any one who says I do speaks falsely in order to slander me. Now, gentlemen, don't make a disturbance even if I seem to say something extravagant; for the point that I am going to make is not mine, but I am going to refer you to a witness as to my wisdom and its nature who is deserving of your credence: the god of Delphi.

You must have known Chaerephon; he was a boyhood friend of mine, and as your friend he shared in the recent exile of the people and returned with you. And you know what manner of man he was—very impetuous in all his undertakings. Well, he went to Delphi and had the audacity to ask the oracle—now, as I was saying, please don't make a disturbance, gentlemen—he asked the oracle if there was any one wiser than I. And the Pythian priestess answered that there was no one wiser. Since Chaerephon is dead, his brother here will vouch for this statement.

Consider now why I tell you this; I am going to explain to you the source of the slander against me. When I had heard the answer of the oracle, I said to myself: "What in the world does the god mean, and what is this riddle? For I realize that I am wise in nothing, great or small; what then does he mean by saying that I am the wisest? Surely, he does not lie; that is not in keeping with his nature." For a long time I was perplexed; then I resorted to this method of inquiry. I went to one of those men who were reputed to be wise, with the idea of disproving the oracle and of showing it: "Here is one wiser than I; but you said that I was the wisest." Well, after observing and talking with him (I don't need to mention his name; but he was a politician), I had this experience: the man seemed in the opinions of many other men, and especially of himself, to be wise; but he really wasn't. And then I tried to show him that he thought he was wise, but really wasn't; so I found myself disliked by him and by many of those present. So I left him, and said to myself: "Well, I am wiser than this man. Probably neither of us knows anything noble; but he thinks he knows, whereas he doesn't, while I neither know nor think I know. So I seem to have this slight advantage over him, that I don't think I know what I don't know." Next I went to another man who was reputed to be even wiser, and in my opinion the result was the same; and I got myself disliked by him and by many others.

After that I went to other men in turn, aware of the dislike that I incurred, and regretting and fearing it; yet I felt that God's word must come first, so that I must go to all who had the reputation of knowing anything, as I inquired into the meaning of the oracle. And by the Dog! gentlemen, for I must tell you the truth, this is what happened to me in my quest: those who were in greatest repute were just about the most lacking, while others in less repute were better off in respect to wisdom. I really must expound to you my wanderings, my Herculean labors to test the oracle. After the politicians, I went to the poets, tragic, dithyrambic, and the rest, with the expectation that there I should be caught less wise than they. So picking up those of their poems which seemed to me to be particularly elaborated, I asked them what they meant, so that at the same time I might learn something from them. Now I am ashamed to tell you the truth, but it must be spoken; almost every one present could have talked better about the poems than their authors. So presently I came to know that the poets, too, like the seers and the soothsayers, do what they do not through wisdom but through a sort of genius and inspiration; for the poets, like them, say many fine things without understanding what they are saying. And I noticed also that they supposed because of their poetry that they were wisest of men in other matters in which they were not wise. So I left them, too, believing that I had the same advantage over them that I had over the politicians.

Finally I went to the craftsmen; for I knew that I knew hardly anything, but that I should find them knowing many fine things. And I was not deceived in this; they knew things that I did not know, and in this way they were wiser than I. But even good craftsmen seemed to me to have the same failing as the poets; because of his skill in his craft each one supposed that he excelled also in other matters of the greatest importance; and this lapse obscured their wisdom. So I asked myself whether I would prefer to be as I was, without their wisdom and without their ignorance, or to have both their wisdom and their ignorance; and I answered myself and the oracle that I was better off just as I was.

From this inquiry many enmities have arisen against me, both violent and grievous, as well as many slanders and my

reputation of being "wise." For those who are present on each occasion suppose that I have the wisdom that I find wanting in others; but the truth is that only God is wise, and that by that oracle he means to show that human wisdom is worth little or nothing. And by speaking of "Socrates" he appears to use me and my name merely as an example, just as if he were to say, "Mortals, he of you is wisest who, like Socrates, knows that in truth his wisdom is worth nothing." That is why I go about even now, questioning and examining in God's name any man, citizen or stranger, whom I suppose to be wise. And whenever I find that he is not wise, then in vindication of the divine oracle I show him that he is not wise. And by reason of this preoccupation I have no leisure to accomplish any public business worth mentioning or any private business, but I am in extreme poverty because of my service to the god.

Besides this, the young men who follow me about of their own accord, well-to-do and with plenty of leisure, take delight in hearing men put to the test, and often imitate me and put others to test; and then, I believe, they find no lack of men who suppose they know something but who know little or nothing. Then the people who are quizzed by them are angry with me, not with themselves, and say, "There is one Socrates who is a rascal and who corrupts the young." And when any one asks them what this Socrates does or teaches, they don't know and have nothing to say, but so as not to seem to be at a loss they repeat the ready-made charges made against all philosophers, about things celestial and things subterranean, and not believing in gods, and making the worse appear the better case. They wouldn't like to admit the truth, I suppose, which is that they have been shown up as pretenders to knowledge that they do not possess. Now since they are ambitious and energetic and numerous, and are well marshalled and persuasive, they have filled your ears with vehement and oft-repeated slander.

[Turning now to the immediate charges, Socrates has no difficulty in showing their shallowness and insincerity. But he has no illusions about the deep and dangerous prejudice that lies behind them, though he will not therefore abandon his divine and philosophic mission, even to save his life. "For I go about doing nothing but persuading you all, young and old, not to care for your bodies or for money more than for the excellence of your souls, saying that virtue does not come from money, but that it is from virtue that money comes and every other good of man, both private and public."]

Socrates the Gadfly

Now therefore, Athenians, I am far from arguing merely in self-defense, as one might suppose; I am arguing on your behalf, to prevent you from sinning against God by condemning me who am his gift to you. For if you put me to death you will not easily find another like me, one attached by God to the state, which (if I may use a rather ludicrous figure) is like a great and noble steed, but a sluggish one by reason of his bulk and in need of being roused by a gadfly. I am the gadfly, I think, which God has attached to the state; all day and in all places I always light on you, rousing you and persuading you and reproaching each one of you. Another like me you will not easily find, and if you will take my advice you will spare me. But perhaps you may be annoyed by me, like people who are roused from slumber, and may slap at me and kill me, as Anytus advises; and then you would doze through the rest of your lives-unless God in his mercy should send you another gadfly. . . .

Socrates Has Been Deterred by His Inner Voice from Entering Politics

It may seem strange that I go about busying myself with private advice but do not venture to enter public life and advise the state. Well, the reason for this is what you have often and in many places heard me mention: that divine warning, or voice, which has come to me from childhood, and which Meletus ridiculed in his indictment. When it speaks, it always diverts me from something that I am going to do, but never eggs me on; and it is this that opposes my entering politics. And quite rightly, I think; for rest assured, gentlemen, that if I had tried to engage in politics I should have perished long ago without benefiting either you or myself. Now don't be angry at me for telling you the truth; for the fact is that no man who honestly opposes you or any other crowd, trying to prevent the many unjust and lawless deeds that are done in the state, will save his life. He who fights effectively for what is just, if he wants to save his life for even a brief time, must remain a private citizen and not engage in public life.

[After a few further arguments, and a dignified refusal to indulge in emotional appeals to the jury (or judges), Socrates rests his case. He is condemned by a narrow margin; to the accuser's proposal of death as penalty he is tempted to propose as counter-penalty that he be honored by the support of the state, but is persuaded by friends to offer instead a fine of money, which they will guarantee. By a larger margin, he is condemned to death. The rest of his speech is addressed, first to the judges who voted against him, then to those who voted to acquit him.]

A Prophecy of Judgment

And now, you who have voted to condemn me, I wish to proclaim to you a prophecy; for I am now approaching death, and it is when men are about to die that they are most given to prophecy. I tell you who have brought about my death that immediately after my death there will come upon you a punishment far more grievous, by Zeus, than the punishment that you have inflicted on me. You have voted in the belief that you would rid yourselves of the need of giving an account of your lives; I tell you that the very opposite will befall you. Your accusers will be more numerous, men whom I restrained though you were not aware of them, fiercer because younger; and you will smart the more. If you think that by killing men you are going to prevent any one from reproaching you for not living well, you are not well advised; for that riddance is neither possible nor noble. The noblest and the easiest means of relief is not to cut short the lives of others but to reform your own lives. That, then, is the prophecy that I give to those who have condemned me, before I depart.

To those who voted to acquit me I would gladly talk about what has befallen, while the magistrates are busy and I am not yet on my way to the place where I must die. Do remain, gentlemen, just these few minutes, for nothing prevents our discoursing while it is permitted. For I should like to show you, friends as you are, the meaning of what has happened to me. Why, judges (you I may rightly call judges), something wonderful has befallen me. That customary divine warning of mine has frequently prevented me in time past from acting wrongly, even in trifling matters; but on this occasion, when what would generally be regarded as the worst of evils befell me, it did not oppose me when I was leaving my house in the morning, or when I was on my way hither, or at any point in my speech, though it has often checked me in the midst of other speeches. This time, it has opposed no deed or word of mine in the whole affair. What then am I to suppose to be the explanation? I will tell you: I am inclined to believe that what has happened is a good, and that they are mistaken who suppose death to be an evil. A great token of this has been given me; for my customary sign would have opposed me if I had not been going to fare well.

Let us consider another argument for there being great reason to hope that death is a good. There are two possibilities: either death is nothingness and utter lack of consciousness, or as men say it is a change and migration of the soul from this world to another place. Now if there be no consciousness, but something like a dreamless sleep, death would be a wondrous boon. For if one were to select that night during which he had thus slept without a dream, and were to compare with it all the other nights and days of his life, and were to tell us how many days and nights he has spent in the course of his life, better and more pleasantly than this one, I think that any private citizen, and even the great king, would not find many such days or nights. If then death be of such a nature, I say that it is a boon; for all eternity in this case appears to be only a single night.

But if death is a journey to another place, and if, as men say, it is true that all the dead abide there, what greater good could there be than this? [Socrates pictures his arrival there and his discourse with the great men of old.] Above all, it would be pleasant to spend my time examining the men there, as I have those here, and discovering who among them is wise and who thinks he is but is not. What would one not give to examine the leader of the great expedition against Troy, or Odysseus, or Sisyphus, or countless others, both men and women? It would be an indescribable delight to converse with them, and associate with them, and examine them. For surely they don't put men to death there for asking questions; those who dwell there, besides being happier than men here are in general, are immortal, if what is said is true.

So, my judges, you must be of good cheer about death and be assured of this one truth, that no evil can befall a good man, in life or in death, and his estate is not neglected by the gods; nor have my affairs been determined by chance, but it is clear to me that for me to die and to take my leave of troubles is now for the best. That is why my sign did not divert me, and why I am not really angry with those who condemned me or with my accusers. To be sure, they acted not with the intent of helping me, but thinking to hurt me; for this I have a right to find fault with them.

I have nevertheless this request to beg of them: when my sons are grown up, punish them, gentlemen, and trouble them just as I troubled you, if they seem to be more concerned about money or about anything else than virtue; and if they pretend to be something when they are really nothing, reproach them as I reproached you for wrong concerns and false pretensions. If you do this, my sons and I shall have received justice from you.

But now it is time to depart, for me to die, for you to live. Which of us goes to the better state, God only knows.

Plato

from the Phaedo

The Phaedo describes Socrates' last hours, spent discussing with his friends the immortality of the soul, and ends with his death. A number of ideas Plato developed further in later works appear in this section. Belief in the immortal nature of the soul is reinforced by a conviction that during life the soul is trapped in the body and thereby prevented from attaining its full powers. This emphasis on the superiority of spiritual to material values had a great appeal for later Christian philosophers.

[Socrates is speaking.] "Now then, I want to give the proof at once, to you as my judges, why I think it likely that one who has spent his life in philosophy should be confident when he is going to die, and have good hopes that he will win the greatest blessings in the next world when he has ended: so Simmias and Cebes my judges, I will try to show how this could be true.

"The fact is, those who tackle philosophy aright are simply and solely practicing dying, practicing death, all the time, but nobody sees it. If this is true, then it would surely be unreasonable that they should earnestly do this and nothing else all their lives, yet when death comes they should object to what they had been so long earnestly practicing."

Simmias laughed at this, and said, "I don't feel like laughing just now, Socrates, but you have made me laugh. I think the many if they heard that would say, 'That's a good one for the philosophers!' And other people in my city would heartily agree that philosophers are really suffering from a wish to die, and now they have found them out, that they richly deserve it!"

"That would be true, Simmias," said Socrates, "except the words 'found out.' For they have not found out in what sense the real philosophers wish to die and deserve to die, and what kind of death it is. Let us say good-bye to them," he went on, "and ask ourselves: Do we think there is such a thing as death?"

"Certainly," Simmias put in.

"Is it anything more than the separation of the soul from the body?" said Socrates. "Death is, that the body separates from the soul, and remains by itself apart from the soul, and the soul, separated from the body, exists by itself apart from the body. Is death anything but that?"

"No," he said, "that is what death is."

"Then consider, my good friend, if you agree with me here, for I think this is the best way to understand the question we are examining. Do you think it the part of a philosopher to be earnestly concerned with what are called pleasures, such as these—eating and drinking, for example?"

"Not at all," said Simmias.

"The pleasures of love, then?"

"Oh no."

"Well, do you suppose a man like that regards the other bodily indulgences as precious? Getting fine clothes and shoes and other bodily adornments—ought he to price them high or low, beyond whatever share of them it is absolutely necessary to have?"

"Low, I think," he said, "if he is a true philosopher."

"Then in general," he said, "do you think that such a man's concern is not for the body, but as far as he can he stands aloof from that and turns towards the soul?"

"I do."

"Then firstly, is it not clear that in such things the philosopher as much as possible sets free the soul from communion with the body, more than other men?"

"So it appears."

"And I suppose, Simmias, it must seem to most men that he who has no pleasure in such things and takes no share in them does not deserve to live, but he is getting pretty close to death if he does not care about pleasures which he has by means of the body."

"Quite true, indeed."

"Well then, what about the actual getting of wisdom? Is the body in the way or not, if a man takes it with him as companion in the search? I mean, for example, is there any truth for men in their sight and hearing? Or as poets are forever dinning into our ears, do we hear nothing and see nothing exactly? Yet if these of our bodily senses are not exact and clear, the others will hardly be, for they are all inferior to these, don't you think so?"

"Certainly," he said.

"Then," said he, "when does the soul get hold of the truth? For whenever the soul tries to examine anything in company with the body, it is plain that it is deceived by it."

"Ouite true."

"Then is it not clear that in reasoning, if anywhere, something of the realities becomes visible to it?"

"Yes."

"And I suppose it reasons best when none of these senses disturbs it, hearing or sight, or pain, or pleasure indeed, but when it is completely by itself and says good-bye to the body, and so far as possible has no dealings with it, when it reaches out and grasps that which really is."

"That is true.

"And is it not then that the philosopher's soul chiefly holds the body cheap and escapes from it, while it seeks to be by itself?"

"So it seems."

"Let us pass on, Simmias. Do we say there is such a thing as justice by itself, or not?"

"We do say so, certainly!"

"Such a thing as the good and beautiful?"

"Of course!"

"And did you ever see one of them with your eyes?"

"Never," said he.

"By any other sense of those the body has did you ever grasp them? I mean all such things, greatness, health, strength, in short everything that really is the nature of things whatever they are: Is it through the body that the real truth is perceived? Or is this better—whoever of us prepares himself most completely and most exactly to comprehend each thing which he examines would come nearest to knowing each one?"

"Certainly."

"And would he do that most purely who should approach each with his intelligence alone, not adding sight to intelligence, or dragging in any other sense along with reasoning, but using the intelligence uncontaminated alone by itself, while he tries to hunt out each essence uncontaminated, keeping clear of eyes and ears and, one might say, of the whole body, because he thinks the body disturbs him and hinders the soul from getting possession of truth and wisdom when body and soul are companions—is not this the man, Simmias, if anyone, who will hit reality?"

"Nothing could be more true, Socrates," said Simmias.

"Then from all this," said Socrates, "genuine philosophers must come to some such opinion as follows, so as to make to one another statements such as these: 'A sort of direct path, so to speak, seems to take us to the conclusion that so long as we have the body with us in our enquiry, and our soul is mixed up with so great an evil, we shall never attain sufficiently what we desire, and that, we say, is the truth. For the body provides thousands of busy distractions because of its necessary food; besides, if diseases fall upon us, they hinder us from the pursuit of the real. With loves and desires and fears and all kinds of fancies and much rubbish, it infects us, and really and truly makes us, as they say, unable to think one little bit about anything at any time. Indeed, wars and factions and battles all come from the body and its desires, and from nothing else. For the desire of getting wealth causes all wars, and we are compelled to desire wealth by

the body, being slaves to its culture; therefore we have no leisure for philosophy, from all these reasons. Chief of all is that if we do have some leisure, and turn away from the body to speculate on something, in our searches it is everywhere interfering, it causes confusion and disturbance, and dazzles us so that it will not let us see the truth; so in fact we see that if we are ever to know anything purely we must get rid of it, and examine the real things by the soul alone; and then, it seems, after we are dead, as the reasoning shows, not while we live, we shall possess that which we desire, lovers of which we say we are, namely wisdom. For if it is impossible in company with the body to know anything purely, one thing of two follows: either knowledge is possible nowhere, or only after death; for then alone the soul will be quite by itself apart from the body, but not before. And while we are alive, we shall be nearest to knowing, as it seems, if as far as possible we have no commerce or communion with the body which is not absolutely necessary, and if we are not infected with its nature, but keep ourselves pure from it, until God himself shall set us free. And so, pure and rid of the body's foolishness, we shall probably be in the company of those like ourselves, and shall know through our own selves complete incontamination, and that is perhaps the truth. But for the impure to grasp the pure is not, it seems, allowed.' So we must think, Simmias, and so we must say to one another, all who are rightly lovers of learning; don't you agree?'

"Assuredly, Socrates."

"Then," said Socrates, "if this is true, my comrade, there is great hope that when I arrive where I am travelling, there if anywhere I shall sufficiently possess that for which all our study has been pursued in this past life. So the journey which has been commanded for me is made with good hope, and the same for any other man who believes he has got his mind purified, as I may call it."

"Certainly," replied Simmias.

"And is not purification really that which has been mentioned so often in our discussion, to separate as far as possible the soul from the body, and to accustom it to collect itself together out of the body in every part, and to dwell alone by itself as far as it can, both at this present and in the future, being freed from the body as if from a prison?"

"By all means," said he.

"Then is not this called death—a freeing and separation of soul from body?"

"Not a doubt of that," said he.

"But to set it free, as we say, is the chief endeavor of those who rightly love wisdom, nay of those alone, and the very care and practice of the philosophers is nothing but the freeing and separation of soul from body, don't you think so?"

"It appears to be so."

"Then, as I said at first, it would be absurd for a man preparing himself in his life to be as near as possible to death, so to live, and then when death came, to object?"

"Of course."

"Then in fact, Simmias," he said, "those who rightly love wisdom are practicing dying, and death to them is the least terrible thing in the world. Look at it in this way: If they are everywhere at enmity with the body, and desire the soul to be alone by itself, and if, when this very thing happens, they shall fear and object—would not that be wholly unreasonable? Should they not willingly go to a place where there is good hope of finding what they were in love with all through life (and they loved wisdom), and of ridding themselves of the companion which they hated? When human favorites and wives and sons have died, many have been willing to go down to the grave, drawn by the hope of seeing there those they used to desire, and of being with them; but one who is really in love with wisdom and holds firm to this same hope, that he will find it in the grave, and nowhere else worth speaking of—will he then fret at dying and not go thither rejoicing? We must surely think, my comrade, that he will go rejoicing, if he is really a philosopher; he will surely believe that he will find wisdom in its purity there and there alone. If this is true, would it not be most unreasonable, as I said just now, if such a one feared death?"

"Unreasonable, I do declare," said he.

The Phaedo ends with one of the most famous of all passages in Greek literature, the description of Socrates' death. His last words have been interpreted in many different ways. Asclepius was the god of healing, and Socrates may perhaps be reminding his friends that death, by releasing the soul, is the final cure for bodily ills.

. . . [He] got up and retired into another room for the bath, and Criton went after him, telling us to wait. So we waited discussing and talking together about what had been said, or sometimes speaking of the great misfortune which had befallen us, for we felt really as if we had lost a father and had to spend the rest of our lives as orphans. When he had bathed, and his children had been brought to see him-for he had two little sons, and one big—and when the women of his family had come, he talked to them before Criton and gave what instructions he wished. Then he asked the women and children to go, and came back to us. It was now near sunset, for he had spent a long time within. He came and sat down after his bath, and he had not talked long after this when the servant of the Eleven came in, and standing by him said, "O Socrates! I have not to complain of you as I do of others, that they are angry with me, and curse me, because I bring them word to drink their potion, which my officers make me do! But I have always found you in this time most generous and gentle, and the best man who ever came here. And now too, I know well you are not angry with me, for you know who are responsible, and you keep it for them. Now you know what I came to tell you, so farewell, and try to bear as well as you can what can't be helped."

Then he turned and was going out, with tears running down his cheeks. And Socrates looked up at him and said, "Farewell to you also, I will do so." Then, at the same time turning to us, "What a nice fellow!" he said. "All the time he has been coming and talking to me, a real good sort, and now how generously he sheds tears for me! Come along, Criton, let's obey him. Someone bring the potion, if the stuff has been ground; if not, let the fellow grind it."

Then Criton said, "But, Socrates, I think the sun is still over the hills, it has not set yet. Yes, and I know of others who, having been told to drink the poison, have done it very late; they had dinner first and a good one, and some enjoyed the company of any they wanted. Please don't be in a hurry, there is time to spare."

But Socrates said, "Those you speak of have very good reason for doing that, for they think they will gain by doing it; and I have good reasons why I won't do it. For I think I shall gain nothing by drinking a little later, only that I shall think myself a fool for clinging to life and sparing when the cask's empty. Come along," he said, "do what I tell you, if you please."

And Criton, hearing this, nodded to the boy who stood near. The boy went out, and after spending a long time, came in with the man who was to give the poison carrying it ground ready in a cup. Socrates caught sight of the man and said, "Here, my good man, you know about these things; what must I do?" "Just drink it," he said, "and walk about till your legs get heavy, then lie down. In that way the drug will act of itself."

At the same time, he held out the cup to Socrates, and he took it quite cheerfully, Echecrates, not a tremble, not a change in color or looks; but looking full at the man under his brows, as he used to do, he asked him, "What do you say about this drink? What of a libation to someone? Is that allowed, or not?"

He said, "We only grind so much as we think enough for a moderate potion."

"I understand," he said, "but at least, I suppose, it is allowed to offer a prayer to the gods and that must be done, for good luck in the migration from here to there. Then that is my prayer, and so may it be!"

With these words he put the cup to his lips and, quite easy and contented, drank it up. So far most of us had been able to hold back our tears pretty well; but when we saw him begin drinking and end drinking, we could no longer. I burst into a flood of tears for all I could do, so I wrapped up my face and cried myself out; not for him indeed, but for my own misfortune in losing such a man and such a comrade. Criton had got up and gone out even before I did, for he could not hold the tears in. Apollodoros had never ceased weeping all this time, and now he burst out into loud sobs, and by his weeping and lamentations completely broke down every man there except Socrates himself. He only said, "What a scene! You amaze me. That's just why I sent the women away, to keep them from making a scene like this. I've heard that one ought to make an end in decent silence. Quiet yourselves and endure."

When we heard him we felt ashamed and restrained our tears. He walked about, and when he said that his legs were feeling heavy, he lay down on his back, as the man told him to do; at the same time the one who gave him the potion felt him, and after a while examined his feet and legs; then pinching a foot hard, he asked if he felt anything; he said no. After this, again, he pressed the shins; and, moving up like this, he showed us that he was growing cold and stiff. Again he felt him, and told us that when it came to his heart, he would be gone. Already the cold had come nearly as far as the abdomen, when Socrates threw off the covering from his face—for he had covered it over—and said, the last words he uttered, "Criton," he said, "we owe a cock to Asclepios; pay it without fail."

"That indeed shall be done," said Criton. "Have you anything more to say?"

When Criton had asked this, Socrates gave no further answer, but after a little time, he stirred, and the man uncovered him, and his eyes were still. Criton, seeing this, closed the mouth and eyelids.

This was the end of our comrade, Echecrates, a man, as we would say, of all then living we had ever met, the noblest and the wisest and most just.

PLATO

from The Republic, Book VII

The Allegory of the Cave

In The Republic Plato describes his version of the ideal society. The role of education and the function of the philosopher within this society are defined in an elaborate metaphor, the Allegory of the Cave. We are to imagine a group of people who live, as it were, chained to the ground in an underground cave in such a way that they can see only shadows of reality projected onto the inner wall of the cave by firelight behind them. Since they have been accustomed to seeing nothing but shadows all their lives they have no way of comprehending the real world outside the cave. It is therefore the task of the philosopher, who is already free from the chains of misconception, to liberate the others and educate them in such a way as to set them free from the imprisonment of the senses.

"Next, then," I said, "take the following parable of education and ignorance as a picture of the condition of our nature. Imagine mankind as dwelling in an underground cave with a long entrance open to the light across the whole width of the cave; in this they have been from childhood, with necks and legs fettered, so they have to stay where they are. They cannot move their heads round because of the fetters, and they can only look forward, but light comes to them from fire burning behind them higher up at a distance. Between the fire and the prisoners is a road above their level, and along it imagine a low wall has been built, as puppet showmen have screens in front of their people over which they work their puppets."

"I see," he said.

"See, then, bearers carrying along this wall all sorts of articles which they hold projecting above the wall, statues of men and other living things, made of stone or wood and all kinds of stuff, some of the bearers speaking and some silent, as you might expect."

"What a remarkable image," he said, "and what remarkable prisoners!"

"Just like ourselves," I said. "For, first of all, tell me this: What do you think such people would have seen of themselves and each other except their shadows, which the fire cast on the opposite wall of the cave?"

"I don't see how they could see anything else," said he, "if they were compelled to keep their heads unmoving all their lives!"

"Very well, what of the things being carried along? Would not this be the same?"

"Of course it would."

"Suppose the prisoners were able to talk together, don't you think that when they named the shadows which they saw passing they would believe they were naming things?" "Necessarily."

"Then if their prison had an echo from the opposite wall, whenever one of the passing bearers uttered a sound, would they not suppose that the passing shadow must be making the sound? Don't you think so?"

"Indeed I do," he said.

"If so," said I, "such persons would certainly believe that there were no realities except those shadows of handmade things."

"So it must be," said he.

"Now consider," said I, "what their release would be like, and their cure from these fetters and their folly; let us imagine whether it might naturally be something like this. One might be released, and compelled suddenly to stand up and turn his neck round, and to walk and look towards the firelight; all this would hurt him, and he would be too much dazzled to see distinctly those things whose shadows he had seen before. What do you think he would say, if someone told him that what he saw before was foolery, but now he saw more rightly, being a bit nearer reality and turned towards what was a little more real? What if he were shown each of the passing things, and compelled by questions to answer what each one was? Don't you think he would be puzzled, and believe what he saw before was more true than what was shown to him now?"

"Far more," he said.

"Then suppose he were compelled to look toward the real light, it would hurt his eyes, and he would escape by turning them away to the things which he was able to look at, and these he would believe to be clearer than what was being shown to him."

"Just so," said he.

"Suppose, now," said I, "that someone should drag him thence by force, up the rough ascent, the steep way up, and never stop until he could drag him out into the light of the sun, would he not be distressed and furious at being dragged; and when he came into the light, the brilliance would fill his eyes and he would not be able to see even one of the things now called real?"

"That he would not," said he, "all of a sudden."

"He would have to get used to it, surely, I think, if he is to see the things above. First he would most easily look at shadows, after that images of mankind and the rest in water, lastly the things themselves. After this he would find it easier to survey by night the heavens themselves and all that is in them, gazing at the light of the stars and moon, rather than by day the sun and the sun's light."

"Of course."

"Last of all, I suppose, the sun; he could look on the sun itself by itself in its own place, and see what it is like, not reflections of it in water or as it appears in some alien setting."

"Necessarily," said he.

"And only after all this he might reason about it, how this is he who provides seasons and years, and is set over all there is in the visible region, and he is in a manner the cause of all things which they saw."

"Yes, it is clear," said he, "that after all that, he would come to this last."

"Very good. Let him be reminded of his first habitation, and what was wisdom in that place, and of his fellowprisoners there; don't you think he would bless himself for the change, and pity them?"

"Yes, indeed."

"And if there were honors and praises among them and prizes for the one who saw the passing things most sharply and remembered best which of them used to come before and which after and which together, and from these was best able to prophesy accordingly what was going to come—do you believe he would set his desire on that, and envy those who were honored men or potentates among them? Would he not feel as Homer says, and heartily desire rather to be serf of some landless man on earth and to endure anything in the world, rather than to opine as they did and to live in that way?"

"Yes indeed," said he, "he would rather accept anything than live like that."

"Then again," I said, "just consider; if such a one should go down again and sit on his old seat, would he not get his eyes full of darkness coming in suddenly out of the sun?"

"Very much so," said he.

"And if he should have to compete with those who had been always prisoners, by laying down the law about those shadows while he was blinking before his eyes were settled down—and it would take a good long time to get used to things—wouldn't they all laugh at him and say he had spoiled his eyesight by going up there, and it was not worthwhile so much as to try to go up? And would they not kill anyone who tried to release them and take them up, if they could somehow lay hands on him and kill him?"

"That they would!" said he.

"Then we must apply this image, my dear Glaucon," said I, "to all we have been saying. The world of our sight is like the habitation in prison, the firelight there to the sunlight here, the ascent and the view of the upper world is the rising of the soul into the world of mind; put it so and you will not be far from my own surmise, since that is what you want to hear; but God knows if it is really true. At least, what appears to me is, that in the world of the known, last of all, is the idea of the good, and with what toil to be seen! And seen, this must be inferred to be the cause of all right and beautiful things for all, which gives birth to light and the king of light in the world of sight, and, in the world of mind, herself the queen produces truth and reason; and she must be seen by one who is to act with reason publicly or privately."

"I believe as you do," he said, "insofar as I am able."

"Then believe also, as I do," said I, "and do not be surprised, that those who come thither are not willing to have part in the affairs of men, but their souls ever strive to remain above; for that surely may be expected if our parable fits the case."

"Quite so," he said.

"Well then," said I, "do you think it surprising if one leaving divine contemplations and passing to the evils of men is awkward and appears to be a great fool, while he is still blinking—not yet accustomed to the darkness around him, but compelled to struggle in law courts or elsewhere about shadows of justice, or the images which make the shadows, and to quarrel about notions of justice in those who have never seen justice itself?"

"Not surprising at all," said he.

"But any man of sense," I said, "would remember that the eyes are doubly confused from two different causes, both in passing from light to darkness and from darkness to light; and believing that the same things happen with regard to the soul also, whenever he sees a soul confused and unable to discern anything he would not just laugh carelessly; he would examine whether it had come out of a more brilliant life, and if it were darkened by the strangeness; or whether it had come out of greater ignorance into a more brilliant light, and if it were dazzled with the brighter illumination. Then only would he congratulate the one soul upon its happy experience and way of life, and pity the other; but if he must laugh, his laugh would be a less downright laugh than his laughter at the soul which came out of the light above."

ARISTOTLE

from The Nicomachean Ethics, Book I

I. The End, or the Good, in Practical Activities

Every activity aims at some end.

¹Every art and every inquiry, and in the same way every action and choice, seem to aim at some good; so that people have well defined the good as that at which all things aim. ²But there appears to be a certain difference among ends; some are activities, and others certain products distinct from these; and in cases where there are ends aside from the actions, the products are better than the activities. ³Since there are many actions and arts and sciences, there are also many ends: of medicine, health; of ship-building, a ship; of military science, victory; of household management, wealth. ⁴But as many of these as come under some one faculty, as the art of bridle-making and the others concerned with the trappings of a horse come under horsemanship, and the latter as well as every other action concerned with war under military science, and other arts under different faculties in the same way—in all of them the ends of all the leading arts are more choiceworthy than those beneath them, for the latter are pursued for the sake of the former. ⁵And it makes no difference whether the activities themselves are the ends of action or something else aside from them, as in the sciences mentioned.

II. The Highest Good, That of Politics

The highest good, or end, is one chosen for its own sake. Its knowledge is of great practical value.

¹If then there is some end of action which we desire for its own sake, and other things for its sake, and if we do not choose everything for the sake of something else (for this would lead us into an infinite series, so that all desire would be ineffectual and vain), it is clear that this would be the good, and indeed the highest good. ²Now does the knowledge of this not have a great influence in the conduct of life, and if we knew it would we not, like archers who have a mark to shoot at, be more likely to attain what is required?

It belongs to the leading art of politics.

³If so, we must try to define in rough outline what it is and to which of the sciences or faculties it belongs. ⁴It would seem to belong to that which is most authoritative, most eminently a leading art, (5) and this seems to be that of politics. ⁶This art determines which of the sciences is to exist in each city and which each person is to learn, and to what extent. We perceive, too, that the most honored of the arts come under politics, such as military science, household management, and rhetoric. 7Since it uses the rest of the sciences and decrees what one must do and refrain from doing, its end would include those of the others, so that it would be the good for man. ⁸Even though the end be the same for an individual and a city, that of the city seems to be greater and more perfect, both to achieve and to preserve. It is worth while even for a single individual, but fairer and more divine for a people or a city. This is what our inquiry aims at, being political in nature.

III. Method in Politics and Ethics

The study of politics and ethics is not an exact science.

¹Our account will be adequate if it is worked out clearly as far as the subject matter at hand allows. The same degree of accuracy is not to be expected in every philosophical discussion, any more than in every product of handicraft. ²There is much difference and fluctuation of opinion about what is noble and what is just, which are the subject matter of politics, so that some believe they are so only by custom and not by nature. ³The same sort of fluctuation exists in the case of what is good, because harm has come to many persons through good things-some have been destroyed by wealth, others by courage. ⁴Now for us, since we are speaking on matters of this sort and with principles of this sort, it will be satisfactory to indicate the truth roughly and in outline, and since we are speaking about things which are generally true, it will suffice for our conclusions to be of the same nature. What we say should of course be received in the same spirit, for it is the part of an educated person to seek accuracy in each kind of subject matter to the extent which its nature admits. It seems equally absurd to accept probable arguments from a mathematician and to demand demonstration of an orator. ⁵Each man judges capably the things which he knows, and of them he is a good judge—in each particular field, the man who is educated in it, and in general, the man who is generally educated.

Since it depends on experience and on a disposition to follow reason, it is not a suitable study for the young.

This is why a young person is not a proper student of political science, for he is without experience in the activities of life, and theories are derived from these and concerned with them. ⁶Furthermore, since he is inclined to follow emotion, it will be vain and unprofitable for him to listen to instruction, because the end is not knowledge but action. ⁷It makes no difference whether one is young in age or merely youthful in character, for the defect lies not in age but in the fact of living and pursuing one's desires according to emotion. For such people knowledge is of no benefit, any more than for the incontinent. For those whose desires and actions are governed by reason, however, knowledge of these matters would be very useful.

⁸Let this be our prologue on the student, on how the discussion is to be understood, and on what we propose to discuss.

IV. Happiness, the End of Politics

All agree that the end which politics pursues is happiness, but what does this mean? There are several different ideas current.

¹Now resuming our argument, since every investigation and choice aims at some good, let us say what it is that we affirm politics aims at and what is the highest of all the goods of action. ²As far as the name is concerned there is almost universal agreement, for both the many and the refined call it happiness, and consider living well and doing well to be the same thing as being happy. But they disagree about the definition of happiness, and the many do not account for it in the same way as the wise. ³Some regard happiness as something manifest and obvious, like pleasure or wealth or honor, others as something different-and frequently the same person will contradict himself, in sickness calling it health, in poverty wealth. Realizing their own ignorance, people admire those who say something grand and above their comprehension. Again, some used to suppose that alongside these many good things there is something else independent which is the cause of their being good. ⁴It would doubtless be unprofitable to examine every opinion; it will be enough to consider those which are most prevalent or which seem to have some reason in them.

We must begin with the known facts and proceed from them to generalizations.

⁵Let us not forget that there is a difference between arguments from first principles and those to first principles. Plato did well in raising this difficulty and inquiring whether the path is from or toward the first principles, as in a race track it may be from the judges to the goal or the reverse. We must begin with the known, but this has two senses: to us, and absolutely. We at least must begin, it seems, with what is known to us. ⁶Therefore one who is to be a competent student of the noble and just, and of politics generally, must be trained in good habits. ⁷This is so because the starting point is in the facts, and if these are sufficiently established there

will be no difficulty about the cause. A person like this either possesses already or can easily grasp the principles. Let him to whom neither of these applies hear the words of Hesiod: "Best of all is he who knows all things, good also he who obeys good counsel. But he who neither knows nor, listening to another, takes his words to heart he is a worthless man."

VII. The Nature of Happiness

The highest good of action is an activity chosen always for its own sake.

¹Now let us return to the good we are seeking, and its nature. It seems to be different in different actions and arts; it is one thing in medicine, another in military science, and so on for the rest. Now what is the good of each art? That for whose sake everything else is done? In medicine this is health; in military science, victory; in household management, the household—in each art something different; but in every action and every exercise of choice it is the end, for it is on account of the end that people do everything. Thus, if some one thing is the end of all actions, it would be the good of action, or if there is more than one, they would be.

²By a gradual advance our argument has come round again to the same conclusion; but we must try to clarify this still further. ³Since ends are plural, and we choose some of them for the sake of something else, like wealth and flutes and instruments generally, it is clear that all of them are not perfect. But the highest good is obviously something perfect, so that if there is some one thing which alone is perfect, this would be what we are seeking, and if there is more than one, the most perfect of these. ⁴We call that which is sought for its own sake more perfect than what is sought for the sake of something else, and that which is never chosen for the sake of something else more perfect than things chosen both for its sake and for their own, and we call absolutely perfect that which is always chosen for its own sake and never because of anything else.

Happiness fits this definition; it is completely self-sufficient.

⁵Happiness certainly seems to be something of this nature, for we always choose it for itself and never for something else, whereas we choose honor and pleasure and intelligence both for their own sake (even if nothing further resulted from them we should choose them) and also for the sake of happiness, in the belief that through them we are going to live happily. But happiness no one chooses for the sake of these things, nor generally for the sake of anything but itself.

⁶The same result seems to follow also from consideration of its self-sufficiency. (The perfect good surely is something self-sufficient.) By self-sufficient we mean not only what suffices for a person himself, leading a solitary life, but also for his parents and children and wife and generally his friends and fellow citizens, since man is by nature a political being. ⁷But there must be some end to this list, for if we extend it to the ancestors and descendants and friends' friends we could go on to infinity. This matter may be taken up again later; at present we shall consider self-sufficient that which taken by itself alone makes a life desirable and lacking in nothing; and this is the sort of thing we commonly judge happiness to be. 8 Moreover, it is the most choiceworthy of all good things, not as though it were counted as one of them, for it is clear that if it were counted as one of them it would become more choiceworthy with the addition of even the least of

good things; for what is added is the measure of superiority among goods, and the greater good is always the more choiceworthy. Happiness, then, is perfect and self-sufficient, the end of action.

The nature of happiness is connected with the function of man.

⁹No doubt, however, to say that happiness is the greatest good seems merely obvious, and what is wanted is a still clearer statement of what it is. ¹⁰It may be possible to achieve this by considering the function of man. As with a flute player or sculptor or any artisan, or generally those who have a function and an activity, the good and good performance seem to lie in the performance of function, so it would appear to be with a man, if there is any function of man. ¹¹Are there actions and a function peculiar to a carpenter and a shoemaker, but not to man? Is he functionless? Or as there appears to be a function of the eye and the foot and generally of every part of him, could one also posit some function of man aside from all these? ¹²What would this be? Life he shares even with plants, so that we must leave out the life of nourishment and growth. The next in order would be a kind of sentient life, but this seems to be shared by horse and cow and all the animals. ¹³There remains an active life of a being with reason. This can be understood in two senses: as pertaining to obedience to reason and as pertaining to the possession of reason and the use of intelligence; and since the latter as well is spoken of in two senses, we must take the one which has to do with action, for this seems to be regarded as higher.

¹⁴If the function of man is an activity of the soul according to reason or not without reason, and we say that the function of a thing and of a good thing are generically the same, as of a lyre-player and a good lyre-player, and the same way with all other cases, the superiority of virtue being attributed to the function—that of a lyre-player being to play, that of a good one being to play well—⁽¹⁵⁾if this is so, the good for man becomes an activity of the soul in accordance with virtue, and if there are more virtues than one, in accordance with the best and most perfect. ¹⁶And further, in a complete life; for one swallow does not make it spring, nor one day, and so a single day or a short time does not make a man blessed and happy.

Ethics is not an exact science.

¹⁷Let this be our account of the good. It seems desirable to make a sketch first, and then later to fill it in. It would be easy for anyone to develop and work out in detail that which is well outlined, and time could be a discoverer and co-worker in such matters. This is the way the arts, too, make progress; for it is easy for anyone to add what is missing.

¹⁸We must remember also what was said before, and not ask for the same precision in everything, but only that which is proper to the material at hand and to an extent suitable to the type of investigation. ¹⁹Both a carpenter and a geometer aspire toward a straight line, but in different ways—the one to the extent to which it is useful in his work, the other endeavoring to discover what it is or what sort of thing, being an investigator of the truth. One should do the same in other fields as well, that subsidiary tasks may not crowd out the main ones. ²⁰Not even the cause is to be asked for in the same sense in all investigations, but in some it is good enough for the fact to be demonstrated, as with first principles: facts and first principles are primary. ²¹Of principles some are apprehended by induction, some by sense perception, some by a certain habituation, and others in other ways. ²²But we must try to investigate each in accordance with its nature and be zealous that each be defined well;⁽²³⁾ they give a great impetus towards discovery of the rest. For the principle—the beginning—seems to be more than half of the whole, and many objects of inquiry become obvious as soon as it is discovered. . . .

ARISTOTLE

from The Politics, Book V

I. General Causes of Revolution

¹We have dealt with about all the topics we previously proposed; our next task, after what has been said, is to consider what are the causes of revolution in constitutions, and how many they are and of what nature, and what kinds are likely to change into what other kinds, and further, what are the means of preserving them (both the means common to all and those peculiar to each single type), and also what are the particular means by which each of them is most likely to be preserved.

Recapitulation: strife arises because people wish to extend equally or inequality in one field to all others.

²First we must take as our starting point that there have come into existence many forms of government in spite of the fact that everyone agrees on the nature of justice [that is, proportionate equality], because they understand its meaning wrongly, as we said before. Democracy rose from the assumption that those who were equal in any respect were absolutely equal: since all alike are free they believe that all are equal absolutely. But oligarchy rose from the supposition that persons unequal [i.e., superior] in some one respect were generally unequal [superior]: being unequal in property they suppose they are absolutely unequal. ³Then the one group think that, being equal, they should share equally in every thing, and the others, since they are unequal, seek a greater share, since superiority means inequality. Each constitution has an element of justice, but each is, from an absolute point of view, faulty. And it is for this reason, when they do not have shares in the constitution corresponding to the beliefs which each group happens to hold, that they engage in party strife. The ones who would be most justified of all in entering the struggle, but who do it least, are those who excel in virtue. In their case alone is it reasonable to consider them absolutely unequal [superior]. There are some who, being superior in birth, think of themselves as worth more than equality because of this inequality, for they believe that to be well born is to have the wealth and virtue of one's ancestors. ⁴These are the beginnings and as it were the fountainheads of party strife.

Revolutions usually aim either to change the form of government or to transfer power from one group to another, within the same form.

Thus it is that revolutions are of two kinds: one kind is against the constitution, that they may set up another in place of the existing one, as an oligarchy instead of a democracy or a democracy instead of an oligarchy or a "polity" or aristocracy in place of either of these, or vice versa. Sometimes a revolution is not against the constitution, when people want the same constitutional arrangement but want it in their power, for example in an oligarchy or monarchy.

They may also aim at a general tightening or loosening of the existing type or at partial revision of some kind.

⁵Or a revolution may be concerned with the more or less, for example that an existing oligarchy may be more or less oligarchical, or that an existing democracy may be more or less democratic, and the same way with the other constitutions, that they may be either tightened or loosened. Again, it may be intended to change a certain part of the constitution, for example, to establish or remove a certain office, as some say Lysander tried to destroy the monarchy in Lacedaemon and King Pausanias the ephorate. ⁶In Epidamnus, too, the constitution suffered a partial change, for they set up a council in place of the conclave of tribe leaders, and of the citizens it is still compulsory for the magistrates alone to attend the meeting of the assembly when some office is being voted on; and another oligarchical feature is the election of a single archon.

People confuse arithmetical and proportionate equality.

Everywhere party strife is due to inequality, where the unequal are not treated according to proportion (a perpetual monarchy is unequal, if it exists among equals). Generally party conflict is a struggle for equality. 7Equality is of two kinds, the arithmetical and that according to merit. By arithmetical I mean that which is the same or equal in number or size, by "according to merit" that which is proportionate. For example, 3 exceeds 2 and 2 exceeds 1 by an equal amount, arithmetically, but according to proportion 4 exceeds 2 as 2 exceeds 1, since 2 is the same part of 4 as 1 is of 2, namely half. But while they agree that the absolutely just is in accordance with worth, people develop differences, as was said before, some because, if they are equal in one respect, they think they are generally equal, and others because if they are unequal in one respect they think themselves worthy of inequality [superiority] in everything.

Democracy and oligarchy are the most common forms of government, because there are always rich and poor.

⁸This is the reason why there are two principal forms of government, democracy and oligarchy; good birth and virtue are restricted to a few, but the qualifications of these governments exist in a larger number. Nowhere are there as many as a hundred well born and virtuous, but there are many rich and poor everywhere. It is wrong, though, for the government to be organized simply and in all respects according to either idea of equality. This is clear from the consequences, for no government of this kind is stable. The cause of this is that it is impossible, starting from an original error in principle, to avoid some evil in the outcome. Some matters, therefore, must be handled according to arithmetical equality and some according to the equality based on merit.

Democracy is more stable than oligarchy, and is closer to the "polity."

⁹All the same, however, democracy is safer and freer from party strife than oligarchy. In oligarchies there are two kinds of strife, that among members of the ruling class and that against the people, whereas in democracies there is only that against the oligarchs, and factional strife of the people against itself does not occur often enough to mention. Further, the "polity," based on the middle classes, comes closer to the people than to the few, and is the safest constitution of this type.

IV. Causes of Revolution in Democracies

The main cause is the reckless wickedness of popular leaders. This can be seen from many examples.

¹We must now consider what happens in each form of government, taking them one by one.

Democracies are overthrown mainly through the wanton license of popular leaders. Sometimes they cause the men of property to unite by their private persecutions (a common fear brings even the bitterest enemies together), and sometimes by publicly leading the populace against them. In many instances one can see that things have turned out in this way. ²For example, in Cos the democracy was overthrown when unscrupulous popular leaders arose and the nobles united against them; and in Rhodes, when the popular leaders introduced payment and prevented the trierarchs from being paid what was owing them, so that the latter were compelled, when suits were brought against them, to dissolve the democracy. The democracy in Heraclea was also dissolved, immediately after the foundation of the colony, because of the popular leaders; the nobles, being unjustly treated by them, went into exile, and then the exiles, joining together and coming back, destroyed the democracy. ³The democracy in Megara, too, was overthrown in a similar manner; the popular leaders, in order to have property to confiscate, banished many of the nobles, until they produced a large body of exiles, who returned, defeated the populace in battle, and established an oligarchy. The same thing also happened in Cyme to the democracy which Thrasymachus destroyed. And in practically every other case, if one looks closely, he can see that the revolution has had this cause. For sometimes in a quest for popular favor, popular leaders have driven the nobles to unite by treating them unjustly, either dividing up their property or crippling their revenues by the imposition of public burdens; sometimes they have done this by slandering them, in order to be able to confiscate the property of the rich.

Formerly democracies often changed into tyrannies, because the popular leaders were military men.

⁴In ancient times, when the same man used to be popular leader and general, they would change from democracy to tyranny, for most of the ancient tyrants developed out of popular leaders. The reason that this happened then but does not do so now, is that at that time popular leaders were chosen from the military leaders (people were not yet clever at public speaking). Now, on the other hand, since the art of oratory has burgeoned, those who are good at speaking become popular leaders, but because of their inexperience have no aspirations toward military leadership, though there may be some exceptions to this.

⁵Another reason why tyrannies were more common formerly than now is in the important offices which fell to some individuals, like that which developed out of the prytany (Presidents of the Assembly) in Miletus, where the prytany had charge of many important matters. Furthermore, since the cities were not then large, and the populace, living in the country, was busy with its work, the leaders of the populace, when they had military experience, had the opportunity to establish tyrannies. They all did this on the basis of popular confidence, and this confidence lay in hatred for the rich. In Athens, for example, Pisistratus became tyrant by leading a party struggle against the "party of the plain"; and Theagenes in Megara by slaughtering the herds of the wealthy when he found them grazing along the river; and Dionysius, having brought accusations against Daphnaeus and the wealthy, was thought worthy to be tyrant, establishing confidence, by his hatred, in his democratic sentiments.

Sometimes there is simply a change within the democratic form.

⁶Changes also take place from "ancestral" democracies to the latest type; for wherever the offices are elective, but not on the basis of a property qualification, and the populace does the electing, those who are eager for office, using the arts of demagoguery, bring things to a point where the populace even has power over the laws. A remedy which will do away with this defect, or at least render it less severe, is for the tribes to provide the magistrates, and not the whole populace.

These are the causes of practically all revolutions in democracies. . . .

VIII. Characteristics of Monarchy

Two types of monarchy distinguished: kingship (closer to aristocracy) and tyranny (closer to democracy).

¹It remains to consider monarchy, and the causes by which it is naturally destroyed and preserved. What has been said about other constitutional forms is practically the same as what happens with kingships and tyrannies; for kingship is like aristocracy, and tyranny is a compound of extreme oligarchy and democracy—this is why it is the most harmful to the subjects, being compounded of two bad forms and having the deviations and flaws of both these forms.

²The origins of the two monarchical forms are from directly opposite causes. Kingship arose to assist the better classes against the populace, and a king is established by the upper classes because of preeminence in virtue or the deeds which arise from virtue, or the preeminence of a family of this sort. The tyrant, on the other hand, is set up by the people and the multitude against the nobles, that the populace may not suffer injustice at their hands.

Origins of tyranny

³The majority of tyrants have developed out of popular leaders, so to speak, gaining credit by slander of the nobles. Some tyrannies came about in this way after the cities were already well grown; and others, earlier, from kings who violated ancestral customs and strove for a more absolute rule; a third group from those elected to authoritative positions (in former times democracies used to give officers and magistrates a long tenure); and still others from oligarchies when they chose one man with authority over the highest magistracies. ⁴In these ways it was easy for them to accomplish their purpose, if only they had the will, because they had power in advance—some that of the position of king, others that of higher office. Thus Pheidon of Argos and others became tyrants under a kingship, Phalaris and those of Ionia from other offices, while Panaetius of Leontini, Cypselus of Corinth, Pisistratus of Athens, Dionysius of Syracuse, and others, came to power in the same way after being popular leaders.

Origins of kingship

⁵Now as we said, kingship is classified with aristocracy, since it is based on worth, either the virtue of an individual or a family, or benefactions, or these along with ability. All who have attained this office have done so by conferring benefits, or being able to do so, upon cities or nations— some, by war, saving them from slavery, like Codrus, others setting them free, like Cyrus, or settling or acquiring territory, like the kings of the Lacedaemonians, Macedonians, and Molossians.

⁶It is the intention of a king to be a guardian, that those who have acquired property may suffer no injustice, and that the populace may suffer no violence; tyranny, however, as has been said many times, does not regard the public interest unless for the sake of private advantage. The criterion of goodness for a tyrant is the pleasant, for a king, the noble. Thus, too, of the kinds of greed, that for money is characteristic of a tyrant, that for honor of a king; and the guard of a king will be composed of citizens, that of a tyrant of foreigners.

Tyranny has the bad points of both democracy and oligarchy.

⁷It is clear that tyranny has the evils of both democracy and oligarchy. From oligarchy comes the fact that its end is wealth (for it is by this alone that the tyrant's guard and his luxury can be maintained), and the fact that it does not allow trust in the multitude. This is why tyrants take away the people's arms; and oligarchy and tyranny are alike in oppressing the common people, driving them from the city into the country, and dispersing them. From democracy it gets its habit of warring against the nobles, destroying them secretly and openly, and banishing them for being rivals and hindrances to its power. This is the cause of conspiracies, too, since some want to hold power themselves, others not to be slaves. And from this came the advice of Periander to Thrasybulus, to cut off the ears of grain which project above the rest-meaning always to remove the outstanding citizens.

		GENERAL EVENTS	LITERATURE & PHILOSOPHY	
	753			
	B.C.	753 B.C. Founding of Rome (traditional date)		
		c. 700 Development of Etruscan culture		
			A A A A A	
	509			
	CONQUEST OF ITALY AND MEDITERRANEAN	509 Expulsion of Etruscan kings and foundation of Roman Republic	ATTENT	
	CONQUEST OF ITALY ND MEDITERRANEAN	450 Promulgation of the <i>Twelve Tables</i> of laws		
	OF	c. 390 Sack of Rome by Gauls		
	EST	287 Hortensian Law reinforces plebeian power	c. 200–160 B.C. Ennius, Annals, epic poem; Plautus, Mostellaria,	
U	QUI	264–241 First Punic War: Roman conquest of Sicily, Sardinia, Corsica	Roman comedy; Terence, Roman	
ROMAN REPUBLI	NON	218–201 Second Punic War: Roman conquest of Spain	comedies	
	U NA 133	146 Destruction of Carthage: Africa becomes Roman province; sack of Corinth: Greece becomes Roman province	2nd cent. Epicureanism and Stoicism imported to Rome	
	S	90–88 Social War		
Z	CRISIS	82–81 Sulla dictator at Rome		
	ME	60 First Triumvirate: Pompey, Caesar, Crassus	c. 65–43 Lucretius, On the Nature of	
4	RO	58–56 Caesar conquers Gaul	<i>Things,</i> Epicurean poem; Cicero, orations and philosophical essays;	
W	POLITICAL CR AT ROME	48 Battle of Pharsalus: war of Caesar and Pompey ends in death of Pompey; Caesar meets Cleopatra in Egypt	Catullus, lyric poems; Caesar, Commentaries, on Gallic wars	
2		46–44 Caesar rules Rome as dictator until assassinated		
<u> </u>		43 Second Triumvirate: Antony, Lepidus, Octavian		
		31 Battle of Actium won by Octavian	27	
		30 Death of Antony and Cleopatra	c. 27 B.C.–A.D. 14 Horace, Odes and Ars Poetica; Vergil, Aeneid, Georgics,	
- B		27–14 Octavian under name of Augustus rules as first Roman emperor	<i>Eclogues;</i> Ovid, <i>Metamorphoses,</i> mythological tales; Livy, <i>Annals of</i>	
B.C		c. 6 Birth of Jesus; crucified c. A.D. 30	the Roman People	
A.0	~	A.D. 14–68 Julio-Claudian emperors: Tiberius, Caligula, Claudius, Nero	CAD 100 150 Tacitus Vistamu	
	TAF	69–96 Flavian emperors: Vespasian, Titus, Domitian	c. A.D. 100–150 Tacitus, <i>History;</i> Juvenal, <i>Satires;</i> Pliny the Younger,	
	S	70 Capture of Jerusalem by Titus; destruction of Solomon's Temple	<i>Letters;</i> Suetonius, <i>Lives of the</i> <i>Caesars;</i> Epictetus, <i>Enchiridion</i> , on	
Щ		79 Destruction of Pompeii and Herculaneum	Stoicism	
IR		96–138 Adoptive emperors: Nerva, Trajan, Hadrian, et al.	c. 166–179 Marcus Aurelius,	
4 P	180	138–192 Antonine emperors: Antoninus Pius, Marcus Aurelius, et al.	Meditations, on Stoicism	
E N	-HE-	193–235 Severan emperors: Septimius Severus, Caracalla, et al.		
	DISINTE- GRATION	212 Edict of Caracalla		
Z	and the second se			
M	284	284–305 Reign of Diocletian; return of civil order		
ROMAN EMPIRE	ION	301 Edict of Diocletian, fixing wages and prices		
K	RUC	307–337 Reign of Constantine; sole emperor after 324		
		330 Founding of Constantinople		
	ECONS AND	392 Paganism officially suppressed; Christianity made state religion		
	A	409–455 Vandals and Visigoths invade Italy, Spain, Gaul, Africa		
	A.D.	476 Romulus Augustulus forced to abdicate as last Western Roman emperor		
	476	1		

Chapter 4 The Roman Legacy

ARCHITECTURE

MUSIC

c. 650–500 B.C. Influence of Greek and Orientalizing styles on Etruscan art

late 6th cent. Etruscan Apollo of Veii

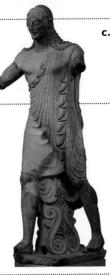

c. 616–509 B.C. Etruscans drain marshes, build temples, construct roads Extension of Greek trumpet into Roman tuba, used in games, processions, battles

c. 2nd cent. B.C. Greek music becomes popular at Rome

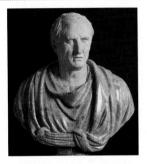

Ist cent. Realistic portraiture; *Portrait of Cicero*

c. 30 B.C.–A.D. 30 Villa of Mysteries frescoes, Pompeii Ist cent. Discovery of concrete

c. 82 Sulla commissions Sanctuary of Fortuna Primagenia, Praeneste

13–9 Ara pacis

c. A.D. 14 Augustus of Prima Porta

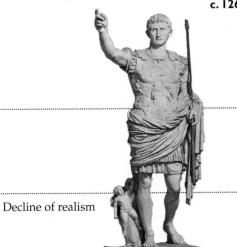

324–330 Colossal head from Basilica of Constantine, Rome

principles of

Use of arch, vault, dome,

stress/counterstress

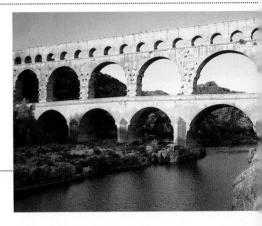

Ist cent. A.D. Pont du Gard, Nîmes; atrium-style houses at Pompeii

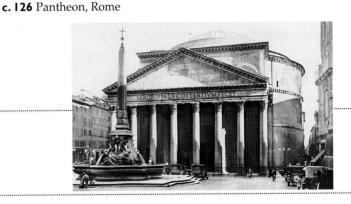

300–305 Diocletian's palace, Split

306–315 Basilica of Constantine, Rome

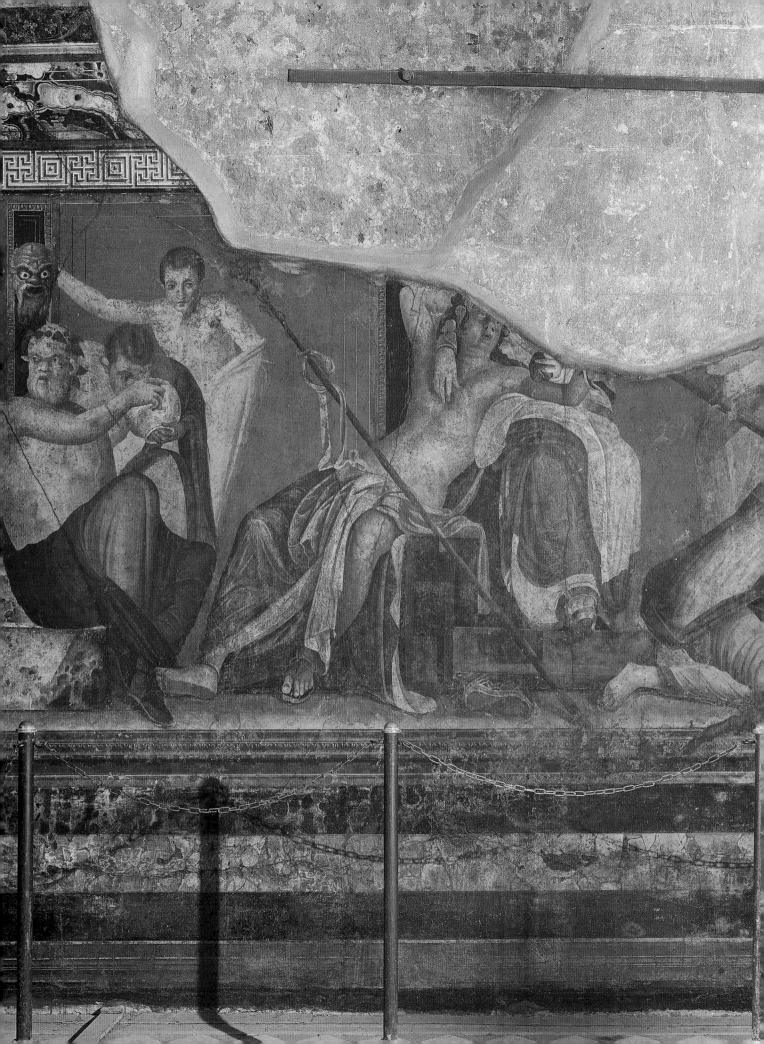

Chapter 4 The Roman Legacy

The Importance of Rome

I f the origins of our intellectual heritage go back to the Greeks and, less directly, to the peoples of Egypt and the Near East, the contribution of Rome to the wider spreading of Western civilization was tremendous. In fields like language, law, politics, religion, and art Roman culture continues to affect our lives. The road network of modern Europe is based on one planned and built by the Romans some two thousand years ago; the alphabet we use is the Roman alphabet; and the division of the year into twelve months of unequal length is a modified form of the calendar introduced by Julius Caesar in 45 B.C. Even after the fall of the Roman Empire the city of Rome stood for centuries as the symbol of civilization itself; later empires deliberately shaped themselves on the Roman model.

Julius Caesar

The enormous impact of Rome on our culture is partly the result of the industrious and determined character of the Romans themselves, who very early in their history saw themselves as the divinely appointed rulers of the world. In the course of fulfilling their mission they spread Roman culture from the north of England to Africa, from Spain to India (see map, "The Roman World"). This Romanization of the entire known world permitted the Romans to disseminate ideas drawn from other peoples. It was through the Romans that Greek art and literature were handed down and incorporated into the Western tradition, not from the Greeks themselves. The rapid spread of Christianity in the fourth century A.D. was a result of the decision by the Roman emperors to adopt it as the official religion of the Roman Empire. In these and in other respects, the legacy that Rome was to pass on to Western civilization had been inherited from its predecessors.

The Romans themselves were in fact surprisingly modest about their own cultural achievements, believing

that their strengths lay in good government and military prowess rather than in artistic and intellectual attainments. It was their view that Rome should get on with the job of ruling the world and leave luxuries like sculpture and astronomy to others.

It is easy but unfair to accept the Romans' estimate of themselves as uncreative without questioning it. True, in some fields the Roman contribution was not very impressive. What little we know about Roman music, for example, suggests that its loss is hardly a serious one. It was intended mainly for performance at religious events like weddings and funerals, and as a background for social occasions. Musicians were often brought into aristocratic homes to provide after-dinner entertainment at a party, and individual performers, frequently women, would play before small groups in a domestic setting. Small bands of traveling musicians, playing on pipes and such percussion instruments as cymbals and tabourines, provided background music for the acrobats and jugglers who performed in public squares and during gladiatorial contests [4.1].

Nonetheless, for the Romans music certainly had none of the intellectual and philosophical significance it bore for the Greeks, and when Roman writers mention musical performances it is often to complain about the noise. The only serious development in Roman music was the extension of the Greek trumpet into a longer and louder bronze instrument known as the *tuba*, which was used on public occasions like games and processions and in battle, when an especially powerful type some 4 feet (1.2 m) long gave the signals for attack and retreat. The sound was not pleasant.

In general, Roman music lovers contented themselves with Greek music played on Greek instruments. Although serious music began to grow in popularity with the spread of Greek culture, it always remained an aristocratic rather than a popular taste. Emperor Nero's love of music, coupled with his insistence on giving public concerts on the lyre, may have even hastened his downfall.

In areas other than music, the Roman achievement is considerable. There is no doubt that Roman art and literature rarely show the originality of their Greek

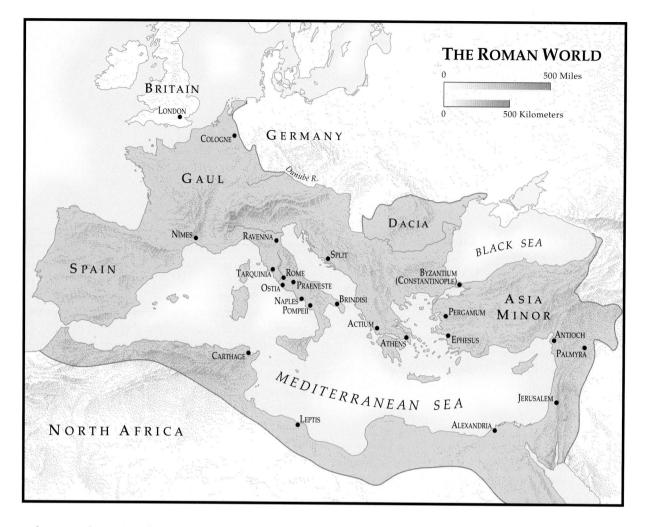

predecessors, but originality is neither the only artistic virtue, nor is its absence always a defect. The Roman genius, in fact, lay precisely in absorbing and assimilating influences from outside and going on to create from them something typically Roman. The lyric poetry of first-century-B.C. writers like Catullus was inspired by

the works of Sappho, Alcaeus, and other Greek poets of the sixth century B.C., but nothing could be more Roman

4.1 Mosaic, from villa near Zliten, North Africa, c. A.D. 70. Gladiatorial contest with orchestra of hydraulic organ, trumpet, and horn players. Museum of Antiquities, Tripoli.

in spirit than Catullus' poems. In architecture, the Romans achieved a style that is one of the most impressive of all our legacies from the ancient world.

It is useful to emphasize the very real value of Roman art and literature because there has been a tendency since the nineteenth century to exalt the Greek cultural achievement at the expense of the Roman. All agree on the superior quality of Roman roads, sewers, and aqueducts; Roman sculpture or drama has in general been less highly rated, mainly because of comparisons to that of the Greeks. Any study of Roman culture inevitably involves examining the influences that went to make it up, and it is always necessary to remember the Roman ability to absorb and combine outside ideas and create something fresh from them.

Rome's history was a long one, beginning with the foundation of the city in the eighth century B.C. For the first two and a half centuries of its existence it was ruled by kings. The rest of the vast span of Roman history is divided into two long periods: Republican Rome (509–31 B.C.), during which time democratic government was first developed and then allowed to collapse; and Imperial Rome (31 B.C.–A.D. 476), during when the Roman world was ruled, at least in theory, by one man—the emperor. The date A.D. 476 marks the deposition of the last Roman emperor in the West; it forms a convenient, if artificial, terminus to the Imperial period.

Shortly after the foundation of the Republic, the Romans began their conquest of neighboring peoples, first in Italy, then throughout Europe, Asia, and North Africa. As their territory grew, Roman civilization developed along with it, assimilating the cultures of the peoples who fell under Roman domination. But long before the Romans conquered Greece or anywhere else, they were themselves conquered by the Etruscans, and the story of Rome's rise to power truly begins with the impact on Roman life made by Etruscan rule there.

Etruscans

THE ETRUSCANS AND THEIR ART

The late eighth century B.C. was a time of great activity in Italy. The Greeks had reached the south coast and Sicily. In the valley of the Tiber, farmers and herdsmen of a group of tribes known as the Latins (origin of the name of the language spoken by the Romans) were establishing small village settlements, one of which was to become the future imperial city of Rome. The most flourishing area at the time, however, was to the north of Rome, where in central Italy a new culture—the Etruscan—was appearing.

The Etruscans are among the most intriguing of ancient peoples, and ever since early Roman times scholars have argued about who they were, where they came from, and what language they spoke. Even today, in spite of the discoveries of modern archaeologists, we still know little about the origins of the Etruscans and their language has yet to be deciphered. By 700 B.C., they had established themselves in the part of Italy named for them, Tuscany; but it is not clear whether they arrived from abroad or whether their culture was a more developed form of an earlier Italian one. The ancient Greeks and Romans believed that the Etruscans had come to Italy from the East, perhaps from Lydia, an ancient kingdom in Asia Minor. Indeed, many aspects of their life and much of their art have pronounced Eastern characteristics. In other ways, however, the Etruscans have much in common with their predecessors in central Italy. Even so, no other culture related to the Etruscans' has ever been found. Whatever their origins, they were to have a major effect on Italian life, and on the growth of Rome and its culture [4.2].

From the very beginning of their history the Etruscans showed an outstanding sophistication and technological ability. The sumptuous gold treasures buried in their tombs are evidence both of their material prosperity and of their superb craftsmanship. The commercial contacts of the Etruscans extended over most of the western Mediterranean and, in Italy itself, Etruscan cities like Cerveteri and Tarquinia developed rich artistic traditions. Etruscan art has its own special character, a kind of elemental force almost primitive in spirit, although the

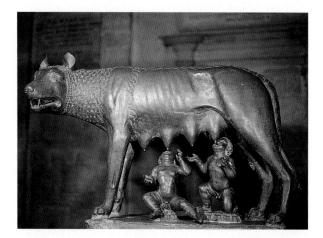

4.2 *Capitoline She-Wolf*, c. 500–480 B.C. Bronze, height 31", length 4'4" (1.32 m). Palazzo dei Conservatori, Rome. Although this statue or one very like it became the mascot of Rome, it was probably made by Etruscan craftsmen. The twins Romulus and Remus, legendary founders of the city, were added during the Renaissance.

craftsmanship and techniques are highly sophisticated. Unlike the Greeks, the Etruscans were less interested in intellectual problems of proportion or understanding how the human body works than in producing an immediate impact upon the viewer. The famous statue of Apollo found in 1916 at Veii [4.3] is unquestionably related to Greek models, but the tension of the god's pose and the sinister quality of his smile produce an effect of great power in a typically Etruscan way. Other Etruscan

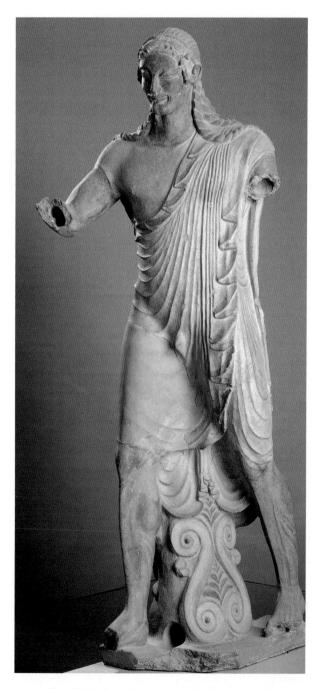

4.3 Apollo of Veii, from the roof of the Portonaccio Temple, Veii, Etruscan, c. 510–500 B.C. Painted terra cotta, height 5'11" (1.78 m). Museo Nazionale di Villa Giulia, Rome.

art is more relaxed, showing a love of nature rarely found in Greek art. The paintings in the Tomb of Hunting and Fishing at Tarquinia [4.4] convey a marvelous sense of light and air, the hazy blue background evoking the sensations of sea and spray.

This gifted people was bound to exert a strong influence on the development of civilization in Italy; Etruscan occupation of Rome (616–510 B.C.) marks a turning point in Roman history. According to later tradition, the city of Rome had been founded in 753 B.C. and was ruled in its earliest days by kings (in actual fact, Rome was probably not much more than a small country town for most of this period). The later Romans' own grandiose picture of the early days of their city was intended to glamorize its origins, but only with the arrival of the Etruscans did anything like an urban center begin to develop. Etruscan engineers drained a large marshy area, previously uninhabitable, which became the community's center, the future Roman forum. They built temples and shrines and constructed roads. Among other innovations, the Etruscans introduced a number of things we are accustomed to think of as typically Roman, including public games like chariot racing and even the toga, the most characteristic form of Roman dress.

Most important, however, was the fact that under Etruscan domination the Romans found themselves for the first time in contact with the larger world. Instead of being simple villagers living in a small community governed by tribal chiefs, they became part of a large cultural unit with links throughout Italy and abroad. Within a hundred years Rome had learned the lessons of Etruscan technology and culture, driven the Etruscans back to their own territory, and begun her unrelenting climb to power.

The rise of Rome signaled the decline of the Etruscans throughout Italy. In the centuries following their expulsion from Rome in 510 B.C., their cities were conquered and their territory taken over by the Romans. In the first century B.C., they automatically received the right of Roman citizenship and became absorbed into the Roman Empire. The gradual collapse of their world is mirrored in later Etruscan art. The wall paintings in the tombs become increasingly gloomy, suggesting that for an Etruscan of the third century B.C. the misfortunes of this life were followed by the tortures of the next. The old couple from Volterra whose anxious faces are so vividly depicted on the lid of their sarcophagus [4.5] give us some idea of the troubled spirit of the final days of Etruscan culture.

REPUBLICAN ROME (509-31 B.C.)

With the expulsion of the Etruscans the Romans began their climb to power, free now to rule themselves. Instead of choosing a new king, Rome constituted itself a

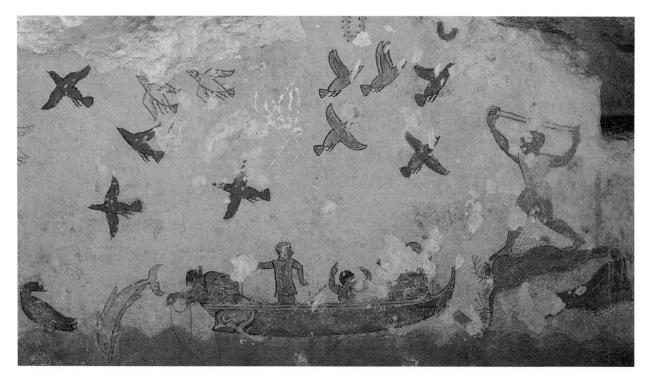

4.4 Wall painting from the Tomb of Hunting and Fishing, Tarquinia, c. 520 B.C., Fresco. Men, fish, and birds are all rendered naturalistically, with acute observation. Note the bird perched on the waves to the left of the diving fish and the hunter at right.

Republic, governed by the people somewhat along the lines of the Greek city-states, although less democratically. Two chief magistrates or consuls were elected for a one-year term by all the male citizens, but the principal assembly, the Senate, drew most of its members from Roman aristocratic families. From the very beginning, therefore, power was concentrated in the hands of the upper class (the *patricians*), although the lower class (the *plebeians*) was permitted to form its own assembly. The leaders elected by the plebeian assembly, the *tribunes*, represented the plebeians' interests and protected them against state officials who treated them unjustly. The meeting place for both the Senate and the assemblies of the people was the *forum*, the large open space at the foot of the Palatine and Capitoline hills that had been drained and made habitable by the Etruscans [4.6].

From the founding of the Roman Republic to its bloody end in the civil wars following the murder of

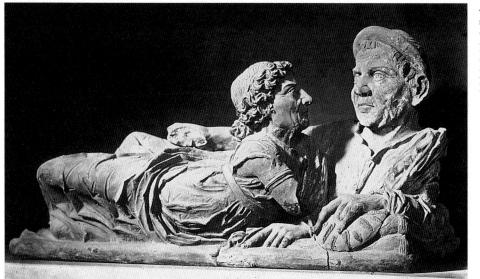

4.5 Lid of funerary urn showing the dead couple whose ashes it contains. Etruscan, first century B.C., terra cotta, length 18" (47 cm). Museo Guarnacci, Volterra, Italy. **4.6** The Roman forum — center of the political, economic, and religious life of the Roman world as it appears today.

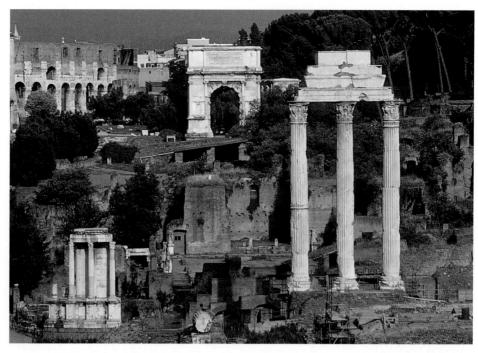

Julius Caesar (44 B.C.), its history was dominated by agitation for political equality. Yet the first major confrontation—the conflict between patricians and plebeians—never seriously endangered political stability in Rome or military campaigns abroad. Both sides showed a flexibility and spirit of compromise that produced a gradual growth in plebeian power while avoiding any split disastrous enough to interrupt Rome's growing domination of the Italian peninsula. The final plebeian victory came in 287 B.C. with the passage of the Hortensian Law, which made the decisions of the plebeian assembly binding on the entire Senate and Roman people. By then most of Italy had already fallen under Roman control.

Increasing power brought new problems. In the third and second centuries B.C., Rome began to build its empire abroad. The first major target of Roman aggression was the city of Carthage, founded by the Phoenicians around 800 B.C., and by the third century the independent ruler of territories in North Africa, Spain, and Sicily. In the Punic Wars (called after the Roman name for the Phoenicians, *Poeni*), the Romans decisively defeated the Carthaginians and confiscated their territories. By the first century B.C., the entire Hellenistic world had been conquered. From Spain to the Middle East stretched a vast territory consisting of subject provinces, protectorates, and nominally free kingdoms, all of which depended on Roman goodwill and administrative efficiency.

Unfortunately, the Romans had been too busy acquiring their empire to think very hard about how to rule it; the results were frequently chaotic. Provincial administration was incompetent and often corrupt. The long series of wars had hardened the Roman character, leading to insensitivity and, frequently, brutality in the treatment of conquered peoples. This situation was not helped by increasing political instability at home. The old balance of power struck between the patricians and plebeians was being increasingly disturbed by the rise of a middle class, the equites, many of whom were plebeians who had made their fortunes in the wars. Against this background were fought bitter struggles that eventually caused the collapse of the Republic.

By the first century B.C., it was apparent that the political system that had been devised for a thriving but small city five hundred years earlier was hopelessly inadequate for a vast empire. Discontent among Rome's Italian allies led to open revolt. Although the Romans were victorious in the Social War of 90-88 B.C., the cost in lives and economic stability was tremendous. The ineffectuality of the Senate and the frustration of the Roman people led to a series of struggles among the leading statesmen for supreme power. The popular leader Marius briefly held power but was replaced by his aristocratic rival, Roman general Sulla, who ruled as dictator for a brief and violent period beginning in 82 B.C., only suddenly to resign three years later, in 79 B.C. There followed a longdrawn-out series of political skirmishes between Pompey, the self-appointed defender of the Senate, and Julius Caesar, culminating in Caesar's withdrawal to Gaul and subsequent return to Rome in 49 B.C. After a short but bitter conflict, Caesar defeated Pompey in 48 B.C. at the

Battle of Pharsalus and returned to Rome as dictator, only to be assassinated himself in 44 B.C. The civil wars that followed brought the Republic to its unlamented end.

The years of almost uninterrupted violence had a profound effect upon the Roman character, and the relief felt when a new era dawned under the first emperor, Augustus, can only be fully appreciated in this light.

Literary Developments During the Republic

The Romans put most of their energy into political and military affairs, leaving little time for art or literature. By the third century B.C., when most of the Mediterranean was under their control and they could afford to relax, they were overwhelmed intellectually and artistically by the Greeks. Conquest of the Hellenistic kingdoms of the East and of Greece itself brought the Romans into contact with Hellenistic Greek culture (see pages Chap. 3, "The Hellenistic Period"). Thus, from the third century B.C., most Roman works of art followed Greek models in form and content. Roman plays were based on Greek originals, Roman temples imitated Greek buildings, and Roman sculpture and painting depicted episodes from Greek mythology.

Greek influence extends to the works of Ennius (239–169 B.C.), known to later Romans as the father of Roman poetry. Almost all of his works are lost, but from later accounts Ennius' tragedies appear to have been adapted from Greek models. His major work was the *Annals*, an epic chronicle of the history of Rome, in which for the first time a Greek metrical scheme was used to write Latin verse.

The two comic playwrights-Plautus (c. 254-184 B.C.) and Terence (c. 185-159 B.C.)—are the first Roman writers whose works have survived in quantity. Their plays are adaptations of Greek comedies; whereas the Greek originals are comic satires, the Roman versions turn human foibles into pure comedy. Plautus, the more boisterous of the two, is fond of comic songs and farcical intrigues. Terence's style is more refined and his characters show greater realism. It says something about the taste of the Roman public that Plautus was by far the more successful. In later times, however, Terence's sophisticated style was much admired. His plays were studied and imitated both during the Middle Ages and more recently. Both authors were fond of extremely elaborate plots involving mistaken identities, identical twins, and general confusion, with everything sorted out in the last scene.

In general, however, when educated Romans of the late Republic stopped to think about something other than politics, it was likely to be love. Roman lyric poetry, often on a romantic theme, is one of the most rewarding

genres of Latin literature. The first great Roman lyric poet, Catullus (c. 80-54 B.C.), is one of the best-loved of all Roman authors. Instead of philosophical or historical themes, he returned to a traditional subject from Sappho's time-personal experience-and charted the course of his own love affair with a woman whom he calls Lesbia. Among his works are twenty-five short poems describing the course of that relationship, which range from the ecstasy of its early stages to the disillusionment and despair of the final breakup. The clarity of his style is the perfect counterpart to the direct expression of his emotions. These poems, personal though they are, are not simply an outpouring of feelings. Catullus makes his own experiences universal. However trivial one man's unhappy love affair may seem in the context of the grim world of the late Republic, Lesbia's inconstancy has achieved a timelessness unequaled by many more serious events.

Two of the principal figures who dominated those events also made important contributions to Republican literature. Julius Caesar (100–44 B.C.) is perhaps the most famous Roman of them all. Brilliant politician, skilled general, expert administrator and organizer, he was also able to write the history of his own military campaigns in his *Commentaries*, in a simple but gripping style. In the four years during which he ruled Rome he did much to repair the damage of the previous decades. Caesar's assassination on March 15, 44 B.C., at the hands of a band of devoted republicans, served only to prolong Rome's agony for another thirteen years—as well as to provide Shakespeare with the plot for one of his best-known plays: *Julius Caesar*.

Perhaps the most endearing figure of the late Republic was Marcus Tullius Cicero (106-43 B.C.), who first made his reputation as a lawyer. He is certainly the figure of this period about whom we know the most, for he took part in a number of important legal cases and embarked on a political career. In 63 B.C., he served as consul. A few years later, the severity with which he had put down a plot against the government during his consulship earned him a short period in exile as the result of the scheming of a rival political faction. Cicero returned in triumph, however, and in the struggle between Pompey and Caesar supported Pompey. Although Caesar seems to have forgiven him, Cicero never really trusted Caesar, despite his admiration for the dictator's abilities. His mixed feelings are well expressed in a letter to his friend Atticus after he had invited Caesar, by then the ruler of the Roman world, to dinner:

Cicero

Quite a guest, although I have no regrets and everything went very well indeed. . . . He was taking medicine for his digestion, so he ate and drank without worrying and seemed perfectly at ease. It was a lavish dinner, excellently served and in addition well prepared and seasoned with good conversation, very agreeable, you know. What can I say? We were human beings together. But he's not the kind of guest to whom you'd say "it's been fun, come again on the way back." Once is enough! We talked about nothing serious, a lot about literature: he seemed to enjoy it and have a good time. So now you know about how I entertained him—or rather had him billeted on me. It was a nuisance, as I said, but not unpleasant.

From letters like these we can derive an incomparably vivid picture of Cicero and his world. Almost nine hundred were published, most of which after his death. If they often reveal Cicero's weaknesses—his vanity, his inability to make a decision, his stubbornness—they confirm his humanity and sensitivity. For his contemporaries and for later ages his chief fame was nevertheless as an orator. Although the cases and causes that prompted his speeches have ceased to have any but historical interest, the power of a Ciceronian oration can still thrill the responsive reader, especially when it is read aloud.

Roman Philosophy and Law

The Romans produced little in the way of original philosophical writing. Their practical nature made them suspicious of professional philosophers and unable to appreciate the rather subtle delights involved in arguing both sides of a complex moral or ethical question. In consequence most of the great Roman philosophical writers devoted their energies to expounding Greek philosophy to a Roman audience. The two principal schools of philosophy to make an impact at Rome—*Epicureanism* and *Stoicism*—were both imported from Greece.

Epicureanism never really gained many followers, in spite of the efforts of the poet Lucretius (99–55 B.C.), who described its doctrines in his brilliant poem *On the Nature of Things* (*De Rerum Natura*). A remarkable synthesis of poetry and philosophy, this work alone is probably responsible for whatever admiration the Romans could muster for a system of thought so different from their own traditional virtues of simplicity and seriousness. According to Epicurus (341–271 B.C.), the founder of the school (Epicureanism), the correct goal and principle of human actions is pleasure. Although Epicureanism stresses moderation and prudence in the pursuit of pleasure, the Romans insisted on thinking of the philosophy as a typically Greek enthusiasm for self-indulgence and debauchery.

Lucretius tried to correct this impression by emphasizing the profoundly intellectual and rational aspects of Epicureanism. Its principal teaching was that the gods, if they exist, play no part in human affairs or in the phenomena of nature; we can therefore live our lives free from superstitious fear of the unknown and the threat of divine retribution. The Epicurean theory of matter explains the world in purely physical terms. It describes the universe as made up of two elements: small particles of matter, or atoms, and empty space. The atoms are completely solid, possessing the qualities of size, shape, and mass, and can be neither split nor destroyed. Their joining together to form complex structures is entirely caused by their random swerving in space, without interference from the gods. As a result, human life can be lived in complete freedom; we can face the challenges of existence and even natural disasters like earthquakes or plagues with complete serenity, since their occurrence is random and outside our control. According to Epicurus, at death the atoms that make up our body separate and body, mind, and soul are lost. Since no part of us is in any way immortal, we should have no fear of death, which offers no threat of punishment in a future world but rather brings only the complete ending of any sensation.

Epicureanism's rejection of a divine force in the world and its campaign against superstition probably appealed to the Romans as little as its claim that the best life was one of pleasure and calm composure. The hardheaded practical moralizing of the Roman mentality found far more appeal in the other school of philosophy imported into Rome from Greece, Stoicism. The Stoics taught that the world was governed by Reason and that Divine Providence watched over the virtuous, never allowing them to suffer evil. The key to becoming virtuous lay in willing or desiring only that which was under one's own control. Thus riches, power, or even physical health—all subject to the whims of Fortune—were excluded as objects of desire. For the Stoic, all that counted was that which was subject to the individual's will.

Although Stoicism had already won a following at Rome by the first century B.C. and was discussed by Cicero in his philosophical writings, its chief literary exponents came slightly later. Seneca (8 B.C.-A.D. 65) wrote a number of essays on Stoic morality. He had an opportunity, and the necessity, to practice the moral fortitude about which he wrote when his former pupil, the emperor Nero, ordered him to commit suicide, since the taking of one's own life was fully sanctioned by Stoic philosophers. Perhaps the most impressive of all Stoic writers is Epictetus (c. A.D. 50-134), a former slave who established a school of philosophy in Rome and then in Greece. In his Enchiridion (Handbook) he recommends an absolute trust in Divine Providence to be maintained through every misfortune. For Epictetus, the philosopher represented the spokesman of Providence itself "taking the human race for his children."

Epictetus' teachings exerted a profound influence on the last great Stoic, emperor Marcus Aurelius (A.D.

CONTEMPORARY VOICES

A Dinner Party in Imperial Rome

At the end of this course Trimalchio left the table to relieve himself, and so finding ourselves free from the constraint of his overbearing presence, we began to indulge in a little friendly conversation. Accordingly Dama began first, after calling for a cup of wine. "A day! what is a day?" he exclaimed, "before you can turn round, it's night again! So really you can't do better than go straight from bed to board. Fine cold weather we've been having; why! even my bath has hardly warmed me. But truly hot liquor is a good clothier. I've been drinking bumpers, and I'm downright fuddled. The wine has got into my head."

Seleucus then struck into the talk: "I don't bathe every day," he said; "your systematic bather's a mere fuller. Water's got teeth, and melts the heart away, a little every day; but there! when I've fortified my belly with a cup of mulled wine, I say 'Go hang!' to the cold. Indeed I couldn't bathe today, for I've been to a funeral. A fine fellow he was too, good old Chrysanthus, but he's given up the ghost now. He was calling me just this moment, only just this moment; I could fancy myself talking to him now. Alas! alas! what are we but blown bladders on two legs? We're not worth as much as flies; they are some use, but we're no better than bubbles."

"He wasn't careful enough in his diet?"

"I tell you, for five whole days not one drop of water—or one crumb of bread—passed his lips. Nevertheless he has joined the majority. The doctors killed him, or rather his day was come; the very best of doctors is only a satisfaction to the mind.

Anyhow he was handsomely buried, on his own best bed, with good blankets. The wailing was first class—he did a trifle manumission before he died; though no doubt his wife's tears were a bit forced. A pity he always treated her so well. But woman! woman's of the kite kind. No man ought ever to do 'em a good turn; just as well pitch it in the well at once. Old love's an eating sore!"

From Petronius, The Satyricon, trans. attributed to Oscar Wilde (privately printed, 1928), p. 81.

121–180), who was constantly plagued with the dilemma of being a Stoic and an emperor at the same time. Delicate in health, sentimental, inclined to be disillusioned by the weaknesses of others, Marcus Aurelius struggled hard to maintain the balance between his public duty and his personal convictions. While on military duty he composed his *Meditations*, which are less a philosophical treatise than an account of his own attempt to live the life of a Stoic. As many of his observations make clear, this was no easy task: "Tell yourself every morning 'Today I shall meet the officious, the ungrateful, the bullying, the treacherous, the envious, the selfish. All of them behave like this because they do not know the difference between good and bad.'"

Yet, even though Stoicism continued to attract a number of Roman intellectuals, the great majority of Romans remained immune to the appeal of the philosophical life. In the first century B.C. and later, the very superstition both Stoicism and Epicureanism sought to combat remained deeply ingrained in the Roman character. Festivals in honor of traditional deities were celebrated until long after the advent of Christianity (Table 4.1). Rituals that tried to read the future by the traditional examination of animals' entrails and other time-honored methods continued to be popular. If the Romans had paused more often to meditate on the nature of existence, they would probably have had less time to civilize the world.

Among the most lasting achievements of Julius Caesar's dictatorship and of Roman culture in general was

the creation of a single unified code of civil law: the Ius Civile. The science of law is one of the few original creations of Roman literature. The earliest legal code of the Republic was the so-called Law of the Twelve Tables of 451–450 B.C. By the time of Caesar, however, most of this law had become either irrelevant or outdated and had been replaced by a mass of later legislation, much of it contradictory and confusing. Caesar's Ius Civile, produced with the help of eminent legal experts of the day, served as the model for later times, receiving its final form in A.D. 533, when it was collected, edited, and published by Byzantine Emperor Justinian (A.D. 527-565). Justinian's Corpus Iuris Civilis remained in use in many parts of Europe for centuries, and profoundly influenced the development of modern legal systems. Today, millions of people live in countries whose legal systems

TABLE 4.1	Principal Roman Deities a	and Their Greek
Equivalen	ts	

Roman	Greek	Roman	Greek
Jupiter	Zeus	Diana	Artemis
Juno	Hera	Ceres	Demeter
Neptune	Poseidon	Venus	Aphrodite
Vulcan	Hephaestus	Minerva	Athena
Mars	Ares	Mercury	Hermes
Apollo	Apollo	Bacchus	Dionysus

136 CHAPTER 4 The Roman Legacy

derive from that of ancient Rome; one eminent British judge has observed of Roman law that "there is not a problem of jurisprudence which it does not touch: there is scarcely a corner of political science on which its light has not fallen." According to the great Roman lawyer Ulpian (died A.D. 228), "Law is the art of the good and the fair." The Romans developed this art over the centuries during which they built up their empire of widely differing peoples. Roman law was international, adapting Roman notions of law and order to local conditions, and changing and developing in the process. Many of the jurists responsible for establishing legal principles had practical administrative experience from serving in the provinces. Legal experts were in great demand at Rome; the state encouraged public service, and problems of home and provincial government frequently occupied the best minds of the day. Many of these jurists acquired widespread reputations for wisdom and integrity. Emperor Augustus gave to some of them the right to issue "authoritative opinions," while a century or so later Emperor Hadrian formed a judicial council to guide him in matters of law. Their general aim was to equate human law with that of Nature by developing an objective system of natural justice. By using this, the emperor could fulfill his duty to serve his subjects as benefactor, and bring all peoples together under a single government.

lus Civile

Thus, over the centuries, the Romans built up a body of legal opinion that was comprehensive, concerned with absolute and eternal values, and valid for all times and places; at its heart lay the principle of "equity"—equality for all. By the time Justinian produced his codification, he was able to draw on a thousand years of practical wisdom.

Republican Art and Architecture

In the visual arts as in literature, the late Republic shows the translation of Greek styles into new Roman forms. The political scene was dominated by individuals like Cicero and Caesar; their individualism was captured in portrait busts that were both realistic and psychologically revealing. To some extent these realistic sculptures are based on such Etruscan models as the heads of the old couple on the Volterra sarcophagus (see Figure 4.5) rather than on Hellenistic portraits, which idealized their subjects. However, the subtlety and understanding shown in portraits like those of Cicero and Caesar represent a typical Roman combination and amplification of others' styles. In many respects, indeed, Roman portraiture represents Roman art at its most creative and sensitive. It certainly opened up new expressive possibilities,

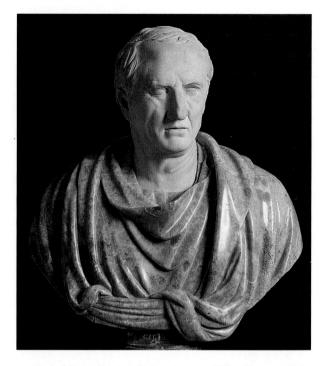

4.7 Bust of Cicero, Roman, first century B.C. Uffizi, Florence, Italy. This portrait of one of the leading figures of the late Republic suggests the ability of Roman sculptors of the period to capture both likeness and character. Cicero is portrayed as thoughtful and preoccupied.

4.8 Reconstruction drawing of the Sanctuary of Fortuna Primigenia, Palestrina. This vast complex, constructed by Sulla after his destruction of the city in 82 B.C., is a series of six immense terraces crowned by a semicircular structure in front of which stood an altar.

as artists discovered how to use physical appearance to convey something about character. Many of the best Roman portraits serve as revealing psychological documents, expressing, for example, Cicero's self-satisfaction as well as his humanity [4.7]. Realistic details like the lines at the corners of the eyes and mouth, the hollows in the cheeks, or the set of the lips are used to express both outer appearance and inner character. The new skill, as it developed, could of course be put to propaganda use, and statesmen and politicians soon learned that they could project their chosen self-image through their portraits.

The powerful political figures of the period also used the medium of architecture to express their authority. The huge sanctuary constructed by Sulla at Praeneste (modern Palestrina) around 82 B.C. [4.8] has all the qualities of symmetry and grandeur we associate with later Roman imperial architecture, although it took its inspiration from massive Hellenistic building programs such as that at Pergamum. Caesar himself cleared a large area in the center of Rome for the construction of a forum, to be named after him. In time, it was dwarfed by later monumental fora, but it had initiated the construction of public buildings for personal display and glory.

Imperial Rome (31 b.c.-a.d. 476)

With the assassination of Julius Caesar, a brief respite from civil war was followed by further turmoil. Caesar's lieutenant, Mark Antony, led the campaign to avenge his death and punish the conspirators. He was joined in this by Caesar's young great-nephew, Octavius, who had been named by Caesar as his heir and who had recently arrived in Rome from the provinces. It soon became apparent that Antony and Octavius (or Octavian, to use the name he then adopted) were unlikely to coexist very happily. After the final defeat of the conspirators (42 B.C.) a temporary peace was obtained by putting Octavian in charge of the western provinces and sending Antony to the East. A final confrontation could not be long delayed, and Antony's fatal involvement with Cleopatra alienated much of his support in Rome. The end came in 31 B.C. at the Battle of Actium. The forces of Antony, reinforced by those of Cleopatra, were routed, and the couple committed suicide. Octavian was left as sole ruler of the Roman world, a world that was now in ruins. His victory marked the end of the Roman Republic.

When Octavian took supreme control after the Battle of Actium, Rome had been continuously involved in both civil and external wars for the better part of a century. The political and cultural institutions of Roman life were beyond repair, the economy was wrecked, and large areas of Italy were in complete turmoil. By the time of Octavian's death (A.D. 14), Rome had achieved a peace and prosperity unequaled in its history—before or after. The art and literature created during his reign represents the peak of the Roman cultural achievement. To the Romans of his own time it seemed that a new Golden Age had dawned, and for centuries afterward his memory was revered. As the first Roman emperor, Octavian inaugurated the second great period in Roman history—the empire, which lasted technically from 27 B.C., when he assumed the title Augustus, until A.D. 476, when the last Roman emperor was overthrown. In many ways, however, the period began with the Battle of Actium and continued in the subsequent western and Byzantine empires (Table 4.2).

Caesar Augustus

Augustus' cultural achievement was stupendous, but it could only have been accomplished in a world at peace. In order to achieve this, it was necessary to build a new political order. A republican system of government suitable for a small state had long since proved woefully inadequate for a vast and multi-ethnic empire. Augustus tactfully, if misleadingly, claimed that he "replaced the State in the hands of the Senate and Roman people." He in fact did the reverse: While maintaining the appearance of a reborn republic, Augustus took all effective power into the hands of himself and his imperial staff.

From the time of Augustus, the emperor and his bureaucracy controlled virtually all decisions. A huge civil service developed, with various career paths. A typical

TABLE 4.2 The Principal Roman Emperors			
Augustus	27 в.с	1	
_	A.D. 14		
Tiberius	14 - 37	Julio-Claudians	
Gaius (Caligula)	37 - 41	,	
Claudius	41 - 54		
Nero	54 - 68		
Year of the			
Four Emperors	69		
Vespasian	69-79]	
Titus	79-81	Flavians	
Domitian	81-96		
Nerva	96-98		
Trajan	98 - 117	Adoptive Emperors	
Hadrian	117 - 138		
Antoninus Pius	138 - 161		
Marcus Aurelius	161 - 180	Antonines	
Commodus	180 - 193		
Septimius Severus	193-211		
Alexander Severus	222-235		
Decius	249-251		
Diocletian	284 - 305		
Constantine	306-337		

middle-class Roman might begin with a period of military service, move on to a post as fiscal agent in one of the provinces, then serve in a governmental department back in Rome, and end up as a senior official in the imperial postal service or the police.

Augustus also began the reform of the army, which the central government had been unable to control during the last chaotic decades of the Republic. Its principal function now became to guard the frontiers. It was made up of some 250,000 Roman citizens, and about the same number of local recruits. The commanders of these half a million soldiers looked directly to the emperor as their general-in-chief. The troops did far more than fight. They served as engineers, building roads and bridges. They sowed crops and harvested them. They surveyed the countryside and helped to police it. In the process, they won widespread respect and gratitude from Rome's provincial subjects.

Protected by the army, and administered by the civil service, the Empire expanded economically. With freedom of travel and trade, goods circulated with no tariffs or customs duties; traders only had to pay harbor dues. From the time of Augustus, the Roman road system carried increasing numbers of travelers—traders, officials, students, wandering philosophers, the couriers of banks and shipping agencies—between the great urban centers. Cities like Alexandria or Antioch were selfgoverning to some degree, with municipal charters giving them constitutions based on the Roman model.

Not all later emperors were as diligent or successful as Augustus. Caligula, Nero, and some others have become notorious as monsters of depravity. Yet the imperial system which Augustus founded was to last for almost five hundred years.

Augustan Literature: Vergil

Vergil

Augustus himself played an active part in supporting and encouraging the writers and artists of his day; many of their works echo the chief themes of Augustan politics: the return of peace, the importance of the land and agriculture, the putting aside of ostentation and luxury in favor of a simple life, and above all the belief in Rome's destiny as world ruler. Some of the greatest works of Roman sculpture commemorate Augustus and his deeds; Horace and Vergil sing his praises in their poems. It is sometimes said that much of this art was propaganda, organized by the emperor to present the most favorable picture possible of his reign. Even the greatest works of the time do relate in some way or other to the Augustan worldview, and it is difficult to imagine a poet whose philosophy differed radically from that of the emperor being able to give voice to it. But we have no reason to doubt the sincerity of the gratitude felt toward Augustus or the strength of what seems to have been an almost universal feeling that at last a new era had dawned. In any case, from the time of Augustus art at Rome became in large measure official. Most of Roman architecture and sculpture of the period was public, commissioned by the state, and served state purposes.

The greater the artist, the more subtle the response to the Augustan vision. Vergil, the greatest of all Roman poets, whose full name was Publius Vergilius Maro (70-19 B.C.), devoted the last ten years of his life to the composition of an epic poem intended to honor Rome and, by implication, Augustus. The result was the Aeneid, one of the great poems of the world, not completely finished at the poet's death. For much of the Middle Ages, Vergil himself was held in the highest reverence. A succession of great poets have regarded him as their master: Dante, Tasso, and Milton, among others. Probably no work of literature in the entire tradition of Western culture has been more loved and revered than the Aeneid-described by T. S. Eliot as the classic of Western society—yet its significance is complex and by no means universally agreed upon.

The Aeneid

The Aeneid was not Vergil's first poem. The earliest authentic works that have survived are ten short pastoral poems known as the Eclogues (sometimes called the Bucolics) which deal with the joys and sorrows of the country and the shepherds and herdsmen who live there. Vergil was the son of a farmer; his deep love of the land emerges also in his next work, the four books of the Georgics (29 B.C.). Their most obvious purpose is to serve as a practical guide to farming; they offer helpful advice on such subjects as cattle breeding and beekeeping as well as a deep conviction that the strength of Italy lies in its agricultural richness. In a great passage in Book II of the Georgics, Vergil hails the "ancient earth, great mother of crops and men." He does not disguise the hardships of the farmer's life, the poverty, hard work, and frequent disappointments, but still feels that only life in the country brings true peace and contentment [4.9].

The spirit of the *Georgics* clearly matched Augustus' plans for an agricultural revival. Indeed, it was probably the emperor himself who commissioned Vergil to write an epic poem that would be to Roman literature what the

VALUES

Empire

The Romans were certainly not the first people to extend their power by external conquests: from the time of ancient Egypt, ambitious rulers had sought control over weaker states. Neither was the Roman Empire the first multi-ethnic one. For the Greeks, Persian agression was the one threat sufficiently strong to drive them to unite, but for many of the peoples who formed part of the Persian Empire, their conquerors' rule was benign not least for the Jews.

Yet no power before Rome—or since, for that matter—succeeded in ruling so vast and varied an empire for so long. In order to maintain its unity, the Romans had to devise a system of provincial government that guaranteed central control, while allowing for local differences. In the process, they developed many aspects of daily life, which foreshadow the modern world: systems of highways, a postal service, efficient food and water distribution.

At the same time, the spread of Roman culture became an end in itself. Even in the remotest Roman cities in Europe, Asia and North Africa, Roman theaters for the performance of Roman plays, Roman baths, a Roman forum with a temple to Jupiter of the Capitoline at its north end, and Roman schools all reinforced the sense of a dominant imperial power, symbolized in the person of the emperor.

Many later peoples aimed to repeat the Romans' achievements. Constantine built his new capital, which became the center of the Byzantine Empire, as a "New Rome" in the East. The title which Augustus, the first emperor, assumed-Pater Patriae (Father of his native land)-was imitated by many rulers, among them Cosimo de Medici of Renaissance Florence. In ninteenthcentury England, the Victorian Age owes its name to the symbolic importance of Queen Victoria, whose crowning glory was to become "Empress of India," while the use of cultural unity to underpin political stability soon became a feature of the growth of the United States. Indeed, many of the political characteristics of the young Republic were borrowed by the Founding Fathers from Rome: The U.S. Senate and Congress are based on the Roman Senate and Assembly of the People, while the separation of federal and state government reflects the Romans' distinction between central and provincial rule.

Iliad and *Odyssey* were for Greek literature: a national epic. The task was immense. Vergil had to find a subject that would do appropriate honor to Rome and its past as well as commemorate the achievements of Augustus.

The *Aeneid* is not a perfect poem (on his deathbed Vergil ordered his friends to destroy it), but in some ways it surpasses even the high expectations Augustus must have had for it. Vergil succeeded in providing Rome with

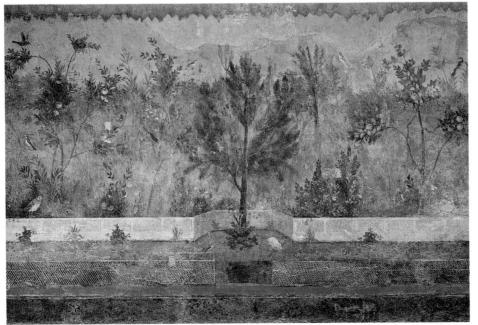

4.9 View of the garden from the villa of Livia and Augustus, at Prima Porta, c. 20 B.C. Fresco, detail, Museo di Palazzo Massimo, Rome. The peaceful scene, with its abundance of fruit and flowers, reflects the interest in country life expressed in Vergil's *Eclogues* and *Georgics*.

its national epic and stands as a worthy successor to Homer. At the same time, he created a profoundly moving study of the nature of human destiny and personal responsibility.

The Aeneid is divided into twelve books. Its hero is a Trojan prince, Aeneas, who flees from the ruins of burning Troy and sails west to Italy to found a new city, the predecessor of Rome. Vergil's choice was significant: Aeneas' Trojan birth establishes connections with the world of Homer; his arrival in Italy involves the origins of Rome; and the theme of a fresh beginning born, as it were, out of the ashes of the past corresponds perfectly to the Augustan mood of revival. We first meet Aeneas and his followers in the middle of his journey from Troy to Italy, caught in a storm that casts them upon the coast of North Africa. They make their way to the city of Carthage, where they are given shelter by the Carthaginian ruler, Queen Dido. At a dinner in his honor Aeneas describes the fall of Troy (Book II) and his wanderings from Troy to Carthage (Book III), in the course of which his father Anchises had died.

In Book IV, perhaps the best known, the action resumes where it had broken off at the end of Book I. The tragic love that develops between Dido and Aeneas tempts Aeneas to stay in Carthage and thereby abandon his mission to found a new home in Italy. Mercury, the divine messenger of the gods, is sent to remind Aeneas of his responsibilities. He leaves after an agonizing encounter with Dido, and the distraught queen kills herself.

Book V brings the Trojans to Italy. In Book VI, Aeneas journeys to the underworld to hear from the spirit of his father the destiny of Rome. This tremendous episode provides the turning point of the poem. Before it we see Aeneas, and he sees himself, as a man prone to human weaknesses and subject to personal feelings. After Anchises' revelations, Aeneas' humanity is replaced by a sense of mission and the weary, suffering Trojan exile becomes transformed into a "man of destiny."

In Books VII and VIII, the Trojans arrive at the river Tiber and Aeneas visits the future site of Rome while the Italian peoples prepare to resist the Trojan invaders. The last four books describe in detail the war between the Trojans and the Latins, in the course of which there are losses on both sides. The *Aeneid* ends with the death of the great Italian warrior Turnus and the final victory of Aeneas.

It is tempting to see Aeneas as the archetype of Augustus; certainly Vergil must have intended for us to draw some parallels. Other historical analogies can also be found: Dido and Cleopatra, for example, have much in common. The *Aeneid* is, however, far more than an allegorical retelling of the events leading up to the foundation of the Empire. Put briefly, Aeneas undertakes a responsibility for which initially he has no real enthusiasm and which costs him and others considerable suffering. It would have been much easier for him to have stayed in Carthage, or settled somewhere else along his way, rather than push forward under difficult circumstances into a foreign land where he and his followers were not welcome.

Once he has accepted his mission, however, Aeneas fulfills it conscientiously and in the process learns to sublimate his own personal desires to a common good. If this is indeed a portrait of Augustus, it represents a far more complex view of his character than we might expect. And Vergil goes further. If greatness can only be acquired by sacrificing human individuals, is it worth the price? Is the future glory of Rome a sufficient excuse for the cruel and unmanly treatment of Dido? Readers will provide their own answers. Vergil's might have been that the sacrifices were probably worth it, but barely. Much, of course, depends on individual views on the nature and purpose of existence, and for Vergil there is no doubt that life is essentially tragic. The prevailing mood of the poem is one of melancholy regret for the sadness of human lives and the inevitability of human suffering.

Augustan Sculpture

Many of the characteristics of Vergil's poetry can also be found in contemporary sculpture. In a relief from one of the most important works of the period, the Ara Pacis (Altar of Peace), Aeneas himself performs a sacrifice on his arrival in Italy before a small shrine that contains two sacred images brought from Troy [4.10]. More significantly, the Ara Pacis depicts the abundance of nature that could flourish again in the peace of the Augustan Age. The altar, begun on Augustus' return to Rome in 13 B.C. after a visit to the provinces, was dedicated on January 30, 9 B.C., at a ceremony that is shown in the surrounding reliefs [4.11]. The procession making its way to the sacrifice is divided into two parts. On the south side Augustus leads the way, accompanied by priests and followed by the members of his family; the north side shows senators and other dignitaries. The lower part of the walls is decorated with a rich band of fruit and floral motifs, luxuriantly intertwined, amid which swans are placed. The actual entrance to the altar is flanked by two reliefs-on the right, the one showing Aeneas; and on the left, Romulus and Remus.

The *Ara Pacis* is perhaps the single most comprehensive statement of how Augustus wanted his contemporaries and future generations to view his reign. The altar is dedicated neither to Jupiter or Mars nor to Augustus himself but to the spirit of Peace. Augustus is shown as the first among equals rather than supreme ruler; although he leads the procession, he is marked by no special richness of dress. The presence of Augustus' family indicates that he intends his successor to be drawn from

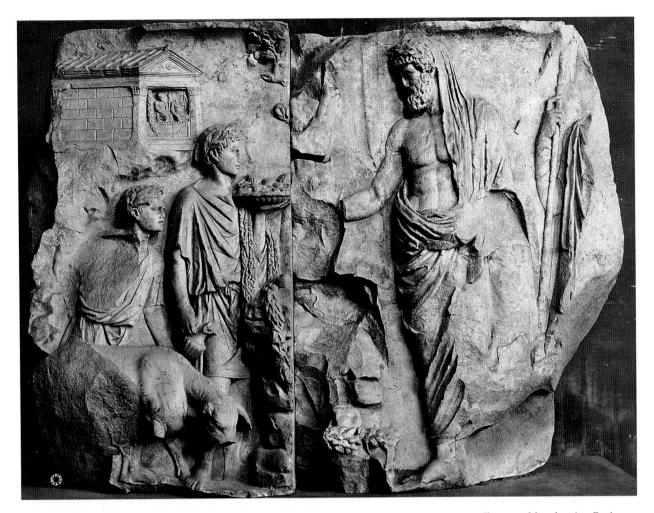

4.10 Aeneas sacrificing, from the *Ara Pacis*, Rome 13–9 B.C. Marble. Aeneas is depicted in the manner of a Classical Greek god; the landscape and elaborate relief detail are typical of late Hellenistic art.

among them, and that they have a special role to play in public affairs. The reliefs of Aeneas and of Romulus and Remus relate the entire ceremony to Rome's glorious past. Further scenes at the back showing the Earth Mother and the goddess of war emphasize the abundance of the land and the need for vigilance. The rich vegetation of the lower band is a constant reminder of the rewards of agriculture that can be enjoyed once more in the peace to which the whole altar is dedicated.

Amazingly enough, this detailed political and social message is expressed without pretentiousness and with superb workmanship. The style is deliberately and selfconsciously "classical," based on works like the Parthenon frieze. To depict the New Golden Age of Augustus, his artists have chosen the artistic language of the Golden Age of Athens, although with a Roman accent. The figures in the procession, for instance, are portrayed far more realistically than those in the sculpture of fifthcentury-B.C. Athens.

The elaborate message illustrated by the Ara Pacis can also be seen in the best-preserved statue of the emperor himself, the Augustus of Prima Porta, so-called after the spot where an imperial villa containing the sculpture was excavated [4.12]. The statue probably dates from about the time of the emperor's death; the face is in the full vigor of life, calm and determined. The stance is one of quiet authority. The ornately carved breastplate recalls one of the chief events of Augustus' reign. In 20 B.C., he defeated the Parthians, an eastern tribe, and recaptured from them the Roman standards that had been lost in battle in 53 B.C. On that former occasion Rome had suffered one of the greatest military defeats in its history, and Augustus' victory played an important part in restoring national pride. The breastplate shows a bearded Parthian handing back the eagle-crowned standard to a Roman soldier. The cupid on a dolphin at Augustus' feet serves two purposes. The symbol of the goddess Venus, it connects Augustus and his family with Aeneas (whose mother was Venus) and thereby with the origins of Rome. At the same time it looks to the future by representing Augustus' grandson Gaius, who was born the year of the victory over the Parthians and was at one time considered a possible successor to his grandfather.

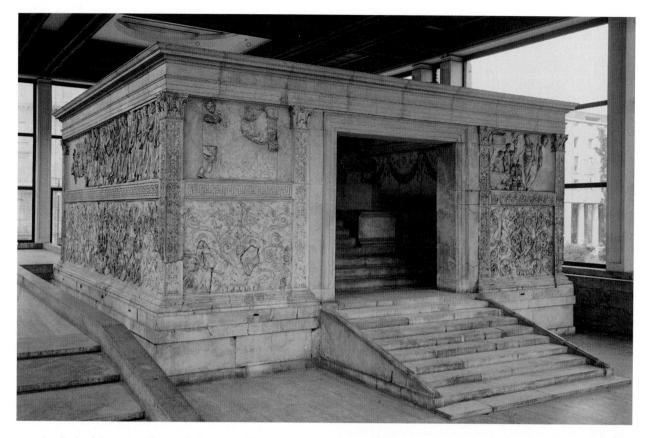

4.11 Ara Pacis of Augustus, Rome, 13-9 B.C. Marble, $36' \times 33'$ (11×10 m). The central doorway, through which the altar itself is just visible, is flanked by reliefs showing Romulus and Remus and Aeneas. On the right side is the procession led by Augustus. The altar originally stood on the ancient Via Flaminia. Fragments were discovered in the sixteenth century; the remaining pieces were located in 1937 and 1938, and the structure was reconstructed near the mausoleum of Augustus.

4.12 Augustus of Prima Porta, portrait of Augustus as general, from Prima Porta. Marble, height 6'8" (2.03 m). Vatican Museums, Rome.

The choice of his successor was the one problem that Augustus never managed to resolve to his own satisfaction. The death of other candidates forced him to fall back reluctantly on his unpopular stepson Tiberius—the succession was a problem that was to recur throughout the long history of the Empire, since no really effective mechanism was ever devised for guaranteeing a peaceful transfer of power. (As early as the reign of Claudius [A.D. 41–54], the right to choose a new emperor was seized by the army.) In every other respect the Augustan age was one of high attainment. In the visual arts, Augustan artists set the styles that dominated succeeding generations, while writers like the poets Vergil, Horace, Ovid, and Propertius, and the historian Livy established a Golden Age of Latin literature.

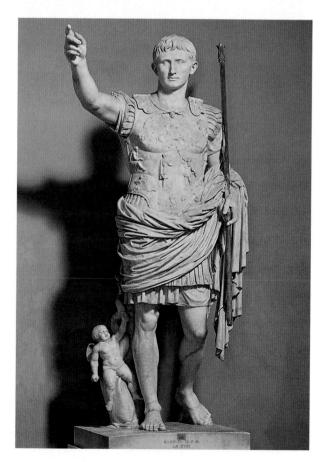

Curiously enough, perhaps the only person to have any real doubts about the Augustan achievement may have been Augustus himself. The Roman writer and gossip Suetonius (A.D. c. 69–c. 140) tells us that as the emperor lay dying he ordered a slave to bring a mirror so that he could comb his hair. He looked at himself, then turned to some friends standing by and asked, "Tell me, have I played my part in the comedy of life well enough?"

The Evidence of Pompeii

Pompeii

The first and second centuries A.D. are probably the bestdocumented times in the whole of classical antiquity. From the main literary sources and the wealth of art and architecture that has survived, it is possible to reconstruct a detailed picture of life in imperial Rome. Even more complete is our knowledge of a prosperous but unimportant little town some 150 miles (240 km) south of Rome that owes its worldwide fame to the circumstances of its destruction [4.13]. On August 24 in the year A.D. 79, the volcano Vesuvius above the Gulf of Naples erupted and a number of small towns were buried, the nearer ones under flowing lava and those some distance away under pumice and ash. By far the most famous is Pompeii, situated some ten miles (16 km) southeast of the erupting peak. Excavation first began there more than two hundred years ago. The finds preserved by the volcanic debris give us a rich and vivid impression of the way of life in a provincial town of the early Empire—from the temples in which the Pompeians worshiped and the baths in which they cleansed themselves to their food on the fatal day [4.14 a & b, 4.15].

An eyewitness report about the eruption comes from two letters written by the Roman politician and literary figure Pliny the Younger (A.D. 62–before 114)—so-called to distinguish him from his uncle, Pliny the Elder (A.D. 23–79). The two were in fact together at Misenum on the Bay of Naples on the day of the eruption. Pliny's uncle was much interested in natural phenomena (his chief work was a *Natural History* in thirty-seven volumes); to investigate for himself the nature of the explosion he made his way toward Vesuvius, where he was suffocated to death by the fumes. The younger Pliny stayed behind with his mother and in a letter to the historian Tacitus

4.13 Aerial view of excavated portion of Pompeii as it appears today. The long, open rectangular space in the lower center is the forum. The total area is 166 acres (67.23 ha). Although excavations at Pompeii have been in progress for more than two hundred years, some two-fifths of the city is still buried.

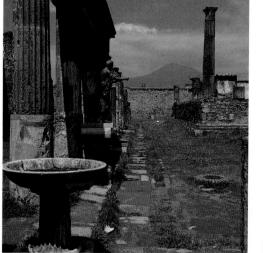

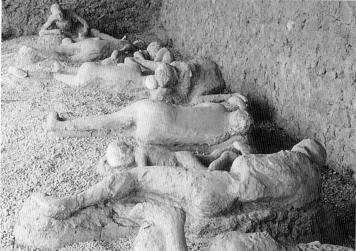

4.14a A view of the ruins of Pompeii. The Temple of Apollo.

4.14b Casts of people trapped in volcanic pumice during the eruption of Mount Vesuvius at Pompeii, A.D. 79.

a little while later described the events of the next few hours.

Pliny the Younger

Letter to Tacitus on the Eruption of Vesuvius

You say that the letter I wrote at your request about the death of my uncle makes you want to hear about the terrors, and dangers as well, which I endured, having been left behind at Misenum—I had started on that topic but broken off.

"Though my mind shudders to remember, I shall begin." After my uncle departed I spent the rest of the day on my studies; it was for that purpose I had stayed. Then I took a bath, ate dinner, and went to bed; but my sleep was restless and brief. For a number of days before this there had been a quivering of the ground, not so fearful because it was common in Campania. On that night, however, it became so violent that everything seemed not so much to move as to be overturned.

My mother came rushing into my bedroom; I was just getting up, intending in my turn to arouse her if she were asleep. We sat down in the rather narrow courtyard of the house lying between the sea and the buildings. I don't know whether I should call it iron nerves or folly— I was only seventeen: I called for a book of Titus Livy

4.15 Carbonized dates, walnuts, sunflower seeds, and bread from Pompeii, August 24, A.D. 79. Museo Nazionale, Naples, Italy.

and as if at ease I read it and even copied some passages, as I had been doing. Then one of my uncle's friends, who had recently come from Spain to visit him, when he saw my mother and me sitting there, and me actually reading a book, rebuked her apathy and my unconcern. But I was as intent on my book as ever.

It was now the first hour of day, but the light was still faint and doubtful. The adjacent buildings now began to collapse, and there was great, indeed inevitable, danger of being involved in the ruins; for though the place was open, it was narrow. Then at last we decided to leave the town. The dismayed crowd came after us; it preferred following someone else's decision rather than its own; in panic that is practically the same as wisdom. So as we went off we were crowded and shoved along by a huge mob of followers. When we got out beyond the buildings we halted. We saw many strange fearful sights there. For the carriages we had ordered brought for us, though on perfectly level ground, kept rolling back and forth; even when the wheels were checked with stones they would not stand still. Moreover the sea appeared to be sucked back and to be repelled by the vibration of the earth; the shoreline was much farther out than usual, and many specimens of marine life were caught on the dry sands. On the other side a black and frightful cloud, rent by twisting and quivering paths of fire, gaped open in huge patterns of flames; it was like sheet lightning, but far worse. Then indeed that friend from Spain whom I have mentioned spoke to us more sharply and insistently: "If your brother and uncle still lives, he wants you to be saved; if he has died, his wish was that you should survive him; so why do you delay to make your escape?" We replied that we would not allow ourselves to think of our own safety while still uncertain of his. Without waiting any longer he rushed off and left the danger behind at top speed.

Soon thereafter the cloud I have described began to descend to the earth and to cover the sea; it had encircled Capri and hidden it from view, and had blotted out the promontory of Misenum. Then my mother began to plead, urge, and order me to make my escape as best I could, for I could, being young; she, weighed down with years and weakness, would die happy if she had not been the cause of death to me. I replied that I would not find safety except in her company; then I took her hand and made her walk faster. She obeyed with difficulty and scolded herself for slowing me. Now ashes, though thin as yet, began to fall. I looked back; a dense fog was looming up behind us; it poured over the ground like a river as it followed. "Let us turn aside," said I, "lest, if we should fall on the road, we should be trampled in the darkness by the throng of those going our way." We barely had time to consider the thought, when night was upon us, not such a night as when there is no moon or there are clouds, but such as in a closed place with the lights put out. One could hear the wailing of women, the crying of children, the shouting of men; they called each other, some their parents, others their children, still others their mates, and sought to recognize each other by their voices. Some lamented their own fate, others the fate of their loved ones. There were even those who in fear of death prayed for death. Many raised their hands to the gods; more held that there were nowhere gods any more and that this was that eternal and final night of the universe. Nor were those lacking who exaggerated real dangers with feigned and lying terrors. Men appeared who reported that part of Misenum was buried in ruins, and part of it in flames; it was false, but found credulous listeners.

It lightened a little; this seemed to us not daylight but a sign of approaching fire. But the fire stopped some distance away; darkness came on again, again ashes, thick and heavy. We got up repeatedly to shake these off; otherwise we would have been buried and crushed by the weight. I might boast that not a groan, not a cowardly word, escaped from my lips in the midst of such dangers, were it not that I believed I was perishing along with everything else, and everything else along with me; a wretched and yet a real consolation for having to die. At last the fog dissipated into smoke or mist, and then vanished; soon there was real daylight; the sun even shone, though wanly, as when there is an eclipse. Our still trembling eyes found everything changed, buried in deep ashes as if in snow. We returned to Misenum and attended to our physical needs as best we could; then we spent a night in suspense between hope and fear. Fear was the stronger, for the trembling of the earth continued, and many, crazed by their sufferings, were mocking their own woes and others' by awful predictions. But as for us, though we had suffered dangers and anticipated others, we had not even then any thought of going away until we should have word of my uncle.

You will read this account, far from worthy of history, without any intention of incorporating it; and you must blame yourself, since you insisted on having it, if it shall seem not even worthy of a letter.

With a few exceptions, like the frescoes in the Villa of the Mysteries [4.16], the works of art unearthed at Pompeii are not masterpieces. Their importance lies precisely in the fact that they show us how the ordinary Pompeian lived, worked, and played [4.17]. The general picture is very impressive. Cool, comfortable houses were decorated with charming frescoes and mosaics and included quiet gardens, remote from the noise of busy streets and watered by fountains. The household silver and other domestic ornaments found in the ruins of houses were often of very high quality. Although the population of Pompeii was only twenty thousand, there were no fewer than three sets of public baths, a theater, a concert hall, an amphitheater large enough to seat the entire population, and a more-than-adequate number of brothels. The forum was closed to traffic, and the major public buildings ranged around it include a splendid basilica or large hall that served as both stock exchange and law courts. Life must have been extremely comfortable at Pompeii, even though it was by no means the most prosperous of the towns buried by Vesuvius. Although only a small

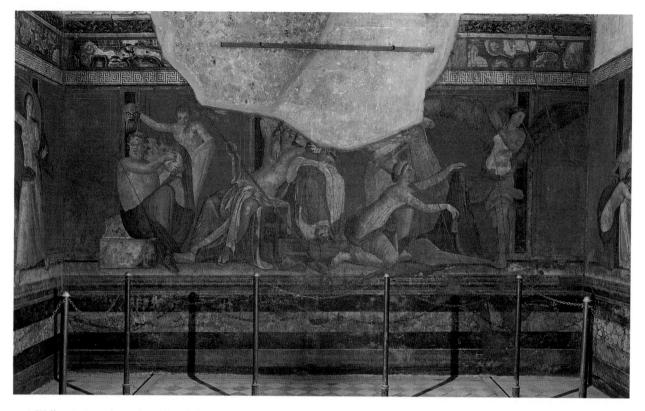

4.16 Wall paintings from the Villa of the Mysteries, Pompeii, c. 60 B.C. Frescoes. Probably no ancient work of art has been more argued about than these paintings. They seem to relate to the cult of the Greek god Dionysus and the importance of the cult for girls approaching marriage, but many of the details are difficult to interpret. There is no argument, however, about the high quality of the paintings.

4.17 Atrium of the House of the Silver Wedding, Pompeii, first century A.D. The open plan of substantial houses such as this helped keep the interior cool in summer; the adjoining rooms were closed off by folding doors in winter.

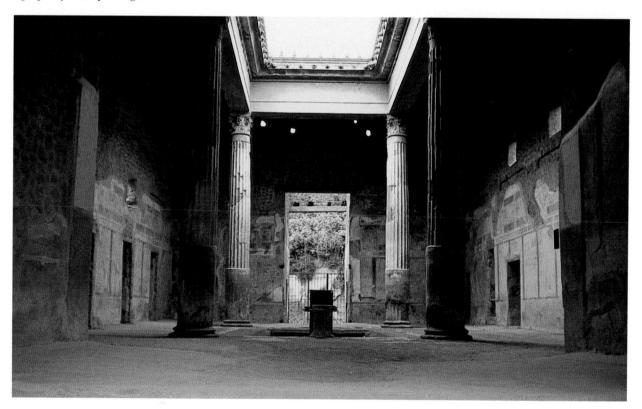

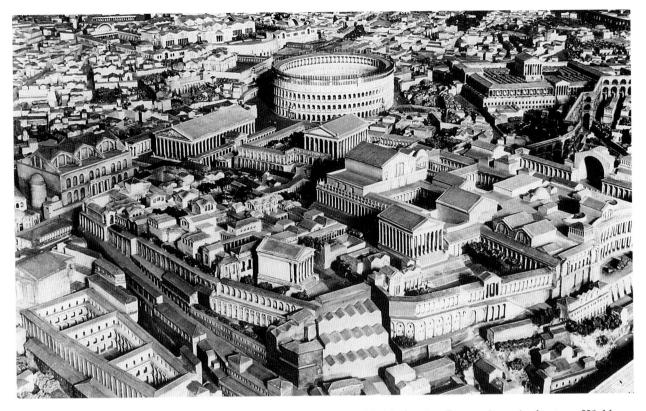

part of Herculaneum has been excavated, some mansions found there far surpass the houses of Pompeii. In the past few years work has begun at Oplontis, where a superbly decorated villa has already come to light.

Apart from its historic importance, the excavation of Pompeii in the eighteenth and nineteenth centuries had a profound effect on contemporary writers and artists. Johann Wolfgang von Goethe visited the site in 1787 and wrote of the buried city that "of all the disasters there have been in this world, few have provided so much delight to posterity." Johann Winckelmann (1717-1768), sometimes called the father of archaeology and art history, used material from the excavations in his History of Ancient Art. Artists like Ingres, David, and Canova were influenced by Pompeian paintings and sculptures; on a more popular level a style of Wedgwood china was based on Pompeian motifs. Countless poets and novelists of the nineteenth century either set episodes in the excavations at Pompeii or tried to imagine what life there was like in Roman times.

Roman Imperial Architecture

All the charm and comfort of Pompeii pale before the grandeur of imperial Rome itself, where both public buildings and private houses were constructed in numbers and on a scale that still remains impressive [4.18]. The Roman achievement in both architecture and engineering had a lasting effect on the development of later architectural styles. In particular their use of the arch, probably borrowed from the Etruscans, was widely

4.18 Model of ancient Rome as it was in about A.D. 320. Museo della Civiltà Romana, Rome. In the right center is the emperor's palace on the Palatine Hill, with the Colosseum above and the mammoth Basilica of Constantine at the upper left.

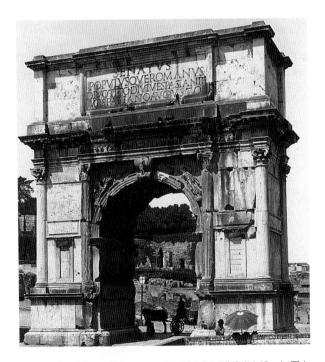

4.19 Arch of Titus, Rome, A.D. 81. Height 47'4" (14.43 m). This structure commemorates the Roman capture of Jerusalem in A.D. 70.

4.20 *Top:* Simple arch composed of wedge-shaped blocks (*voussoirs*) and keystone; the curve of the arch rises from the springers on either side. *Center:* Tunnel (barrel vault) composed of a series of arches. *Bottom:* Dome composed of a series of arches intersecting each other around a central axis.

4.21 Pantheon, Rome. c. A.D. 126. Height of portico 59' (17.98 m).

imitated, and pseudo-Roman triumphal arches have sprung up in such unlikely places as the Champs Elysées in Paris and Washington Square in New York. The original triumphal arches commemorated military victories [4.19]; each was a permanent version of the temporary wooden arch erected to celebrate the return to the capital of a victorious general.

Equally important was the use of internal arches and vaults [4.20] to provide roofs for structures of increasing size and complexity. Greek and Republican Roman temples had been relatively small, partly because of the difficulties involved in roofing over a large space without supports. With the invention of concrete in the first century B.C. and growing understanding of the principles of stress and counterstress, Roman architects were able to experiment with elaborate new forms, many of which—like the barrel vault and the dome—were to pass into the Western architectural tradition.

The Greeks rarely built arches, but the Etruscans used them as early as the fifth century B.C., and the Romans may well have borrowed the arch from them. From the second century B.C. on, stone arches were used regularly for bridges and aqueducts. Vaults of small size were often used for domestic buildings, and by the time of Augustus, architects had begun to construct larger-scale barrel vaults, semicylindrical in shape, two or more of

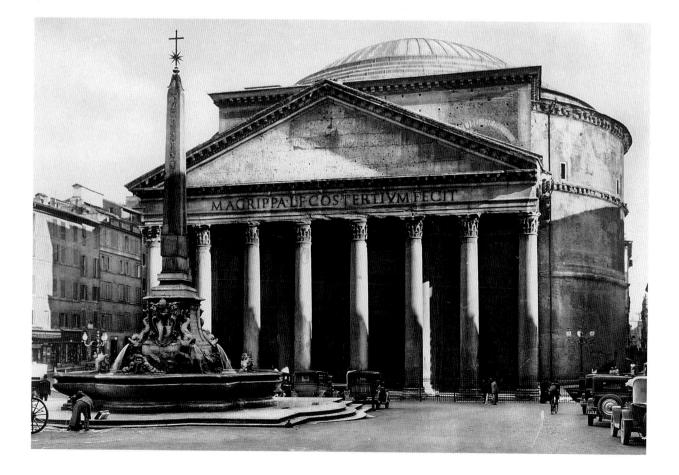

which could intersect to roof a large area. The dome, which is really a hemispherical vault, became increasingly popular with the building of the vast public baths of Imperial Rome. Using both bricks and concrete, architects could combine vaults, barrel vaults, and domes to construct very elaborate buildings capable of holding thousands of people at a time. The inside and outside surfaces of the buildings were then covered with a marble facing to conceal the elaborate internal support structures.

Much of the work of these architects was destroyed during the Barbarian invasions of the fifth and sixth centuries A.D. and more was wrecked in the Renaissance by builders removing bricks or marble. By great good fortune one of the most superb of all imperial structures has been preserved almost intact. The Pantheon [4.21] was built around A.D. 126, during the reign of Hadrian (117–138) to a design by the emperor himself. An austere and majestic exterior portico is supported on granite columns with Corinthian capitals [4.22]. It leads into the central rotunda, an astonishing construction approximately 142 feet (43.3 m) high and wide in which a huge concrete dome rests on a wall interrupted by a series of niches. The building's only light source is a huge *oculus* (*eye*) at the top of the dome, an opening 30' (9.2 m) across. The proportions of the building are very carefully calculated and contribute to its air of balance. The height of the dome from the ground, for example, is exactly equal to its width.

Pantheon

The Pantheon was dwarfed by the huge complex of buildings that made up the imperial fora. Completed by the beginning of the second century A.D., they formed a vast architectural design unsurpassed in antiquity and barely equaled since [4.23]. Elsewhere in the city, baths, theaters, temples, racetracks, and libraries catered to the

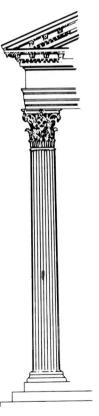

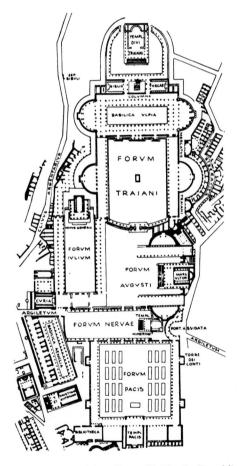

4.22 Corinthian capital. This elaborate bell-shaped design, decorated with acanthus leaves, first became commonly used in Hellenistic times. It was especially popular with Roman architects who generally preferred it to both the Doric and Ionic styles.

4.23 Plan of the imperial fora, Rome. Unlike the Republican forum, which served as a public meeting place, these huge complexes were constructed as monuments to the emperors who commissioned them.

needs and fancies of a huge urban population. In many of these structures builders continued to experiment with new techniques of construction, and architectural principles developed in Rome were applied throughout the Roman Empire. From Spain to the Middle East, theaters, amphitheaters, and other public buildings were erected according to the same basic designs, leaving a permanent record of construction methods for later generations.

Urban life on such a scale required a constant supply of one of the basic human necessities: water. Their system of aqueducts is one of the most impressive of the Romans' engineering achievements. A vast network of pipes brought millions of gallons of water a day into Rome, distributing it to public fountains and baths and to the private villas of the wealthy. At the same time, a system of covered street drains was built, eliminating the open sewers that had been usual before Roman times. These open drains were to return during the medieval period, when many of the Roman engineering skills were lost.

With the passage of time, most of the aqueducts that supplied ancient Rome have been demolished or have collapsed. Elsewhere in the Roman Empire, however, examples have survived that give some idea of Roman engineering skill. The famous Pont du Gard [4.24], which can still be seen in southern France, was probably first constructed during the reign of Augustus. It carried the aqueduct that supplied the Roman city of Nîmes with water—a hundred gallons (387.5 lit) a day—for each inhabitant and was made of uncemented stone. The largest blocks weigh two tons (1.8 MT).

Even with the provision of such facilities, Imperial Rome suffered from overcrowding. The average Roman lived in an apartment block, of which there were some 45,000. Most of these have long since disappeared, although their appearance can be reconstructed from examples excavated at Ostia, Rome's port [4.25]. The height of the apartment blocks was controlled by law to prevent the construction of unsafe buildings, but it was not unheard of for a building to collapse and fire was a constant danger. No doubt the grandeur of the public buildings in Rome was intended at least in part to distract the poorer Romans from thoughts of their humble private residences.

Rome as the Object of Satire

Life in this huge metropolis had many of the problems of big-city living today: noise, traffic jams, dirty streets, and overcrowding were all constant sources of complaint. A particularly bitter protest comes from the Roman satirist

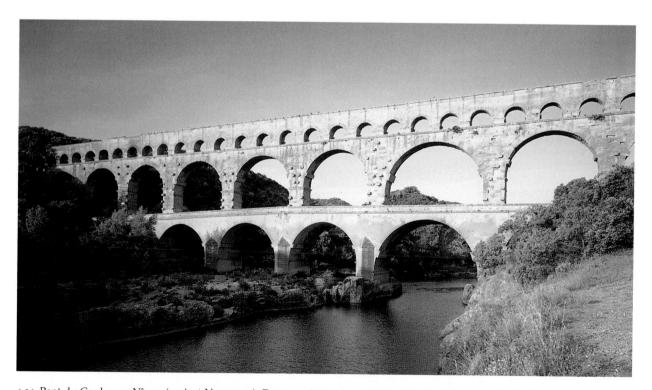

4.24 Pont du Gard, near Nîmes (ancient Nemausus), France, c. 16 B.C. Length 902' (274.93 m), height 161' (49.07 m). Note the careful positioning of the three rows of arches along the top of which ran the water channel. The whole aqueduct was 25 miles (40 km) long. This section carried the water over the river Gard.

4.25 Reconstruction drawing of the garden façade of the Insula dei Dipinti, an apartment block in Ostia, the seaport of ancient Rome.

Juvenal (A.D. c. 60–c. 130). Born in the provinces, he came to Rome, where he served as a magistrate and irritated the then current emperor, Domitian—not a difficult task. After a period of exile, probably in Egypt, he returned to Rome and lived in considerable poverty. Toward the end of his life, however, his circumstances improved. His sixteen *Satires* make it perfectly clear that Juvenal liked neither Rome nor Romans. He tells us that he writes out of fierce outrage at the corruption and decadence of his day, the depraved aristocracy, the general greed and meanness. "At such a time who could not write satire?" His fiercest loathing is reserved for foreigners, although in the sixth satire he launches a particularly virulent attack against women in one of the archetypal documents of misogyny.

Juvenal himself does not emerge as a very pleasant character and his obsessive hatred frequently verges on the psychopathic. As a satirical poet, though, he is among the greatest in Western literature, and strongly influenced many of his successors, including Jonathan Swift. Few other writers can make better or more powerful use of biting sarcasm, irony, and outright invective.

THE END OF THE ROMAN EMPIRE

Few historical subjects have been as much discussed as the fall of the Roman Empire. It is not even possible to agree on when it fell, let alone why. The traditional date—A.D. 476—marks the deposition of the last Roman emperor, Romulus Augustulus. By that time, however, the political unity of the empire had already disintegrated. Perhaps the beginning of the end was A.D. 330, when Emperor Constantine moved the capital from Rome to a new city on the Bosporus, Constantinople, although in another sense the transfer represented a new development as much as a conclusion. It might even be possible to argue that Constantine's successors in the East, the Byzantine emperors, were the successors of Augustus and that there is a continuous tradition from the beginning of the Empire in 31 B.C. to the fall of Constantinople in A.D. 1453.

Fascinating though the question may be, in a sense it is theoretical rather than practical. The Roman Empire did not fall overnight. Many of the causes for its long decline are obvious though not always easy to order in importance. One crucial factor was the growing power and changing character of the army. The larger it became, the more necessary it was to recruit troops from the more distant provinces—Germans, Illyrians, and others, the very people the army was supposed to be holding in check. Most of these soldiers had never been anywhere

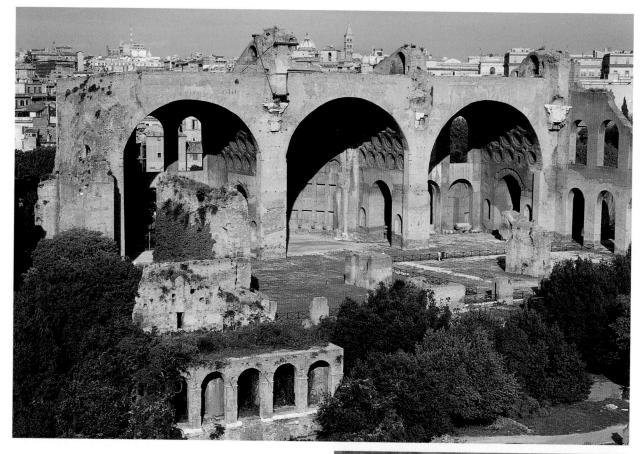

4.26 Basilica of Constantine, the last great imperial building in Rome. Begun in A.D. 306 by Maxentius, it was finished by Constantine after A.D. 315. Only the northern side is still standing; the central nave and south aisle collapsed during antiquity.

4.27 Head of the colossal statue of Constantine that stood in the Basilica of Constantine, Rome, A.D. 324–330. Marble, height 8'6" (2.59 m). Palazzo dei Conservatori, Rome. The massive and majestic simplicity of this portrait is very different from the detailed observation of earlier, much smaller Roman portraits like that of Cicero (Figure 4.7), illustrating the new belief in the emperor as God's regent on earth.

near Rome. They felt no loyalty to the empire, no reason to defend Roman interests. A succession of emperors had to buy their support by raising their pay and promising gifts of lands. At the same time, the army came to play an increasingly prominent part in the choice of a new emperor and, since the army itself was largely non-Roman, so were many of the emperors chosen. Rulers of the third and fourth centuries included Africans, Thracians, a Syrian, and an Arab—men unlikely to feel any strong reason to place the interests of Rome over those of themselves and their own men.

Throughout this late period the empire was increasingly threatened from outside. To the west, barbarian tribes like the Huns, the Goths, and the Alemanni began

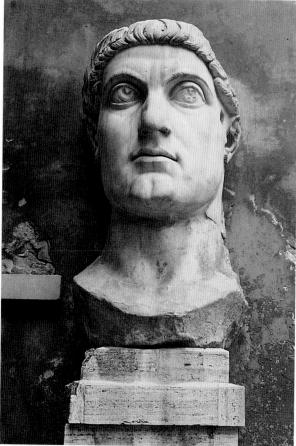

to penetrate farther and farther into its defenses and even to sack Rome itself. Meanwhile, in the east, Roman armies were continually involved in resisting the growing power of the Persians. In many parts of the empire it became clear that Rome could provide no help against invaders, and some of the provinces set themselves up as independent states with their own armies.

Problems like these inevitably had a devastating effect on the economy. Taxes increased and the value of money depreciated. The constant threat of invasion or civil war made trade impossible. What funds there were went for the support of the army, and the general standard of living suffered a steady decline. The eastern provinces, the old Hellenistic kingdoms, suffered rather less than the rest of the empire, since they were protected in part by the wealth accumulated over the centuries and by their long tradition of civilization. As a result, Italy sank to the level of a province rather than remaining the center of the imperial administration.

Total collapse was prevented by the efforts of two emperors: Diocletian, who ruled from A.D. 284 to 305; and Constantine, who ruled from 306 to 337. Both men were masterly organizers who realized that the only way to save the empire was to impose the most stringent controls on every aspect of life—social, administrative, and economic. In A.D. 301, the Edict of Diocletian was passed, establishing fixed maximums for the sale of goods and for wages. A vast bureaucracy was set up to collect taxes and administer the provinces. The emperor himself became once again the focal point of the empire, but to protect himself from the dangers of coups and assassinations, he never appeared in public. As a result, an elaborate court with complex rituals developed, and the emperor's claim to semidivine status invested him with a new religious authority.

Late Roman Art and Architecture

Even if the emperor did not show himself to his subjects, he could impress them in other ways, and the reigns of Diocletian and Constantine marked the last great age of Roman architecture. The immense Basilica of Constantine [4.26], with its central nave rising to a height of 100 feet (30.5 meters), is now in ruins, but in its day this assembly hall must have been a powerful reminder of the emperor's authority. It also contained a 30-foot (9.2 m) statue of the emperor himself [4.27]. The palace Diocletian had built for him at Split, on the Adriatic coast, is constructed on the plan of a military camp, with enormous central avenues dividing it into four quarters [4.28]. The decoration makes use of eastern motifs, and the entire design is far from the Classical style of earlier times.

Diocletian's Palace

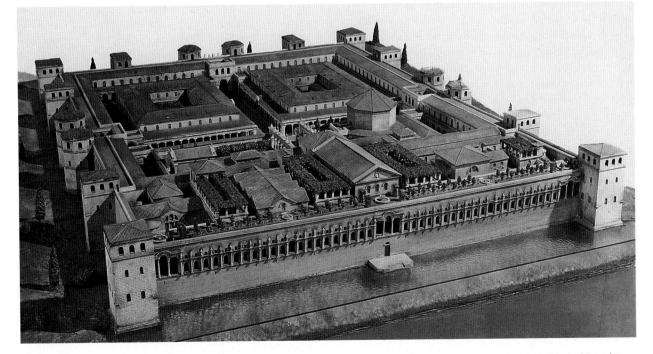

4.28 Reconstruction model of the Palace of Diocletian at Split, Croatia, A.D. 300–305. Museo della Civiltà Romana, Rome. Note the octagonal dome of the emperor's mausoleum.

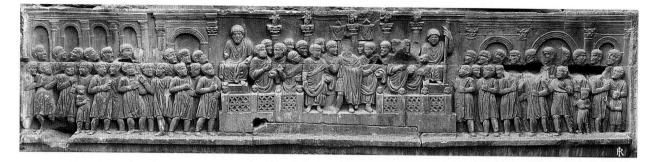

4.29 Constantine Receiving Homage from the Senate, frieze on the Arch of Constantine, Rome, A.D. 315. Marble relief, $3'4'' \times 17'6''$ (1.02 \times 5.33 m). On both sides of the emperor (seated in the center) his officials distribute money to the crowd below. The simplified style, in which most of the puppetlike figures are shown frontally, foreshadows Byzantine and medieval art and is certainly very different from the style of earlier reliefs (Figures 4.10, 4.11).

In sculpture, too, Classical forms and styles were increasingly abandoned. Realistic portraiture and naturalistic drapery were neglected, and sculptors no longer tried to express depth or reality in their relief carving. The lack of perspective and precision in their work foreshadows the art of the early Middle Ages [4.29]. The general abandonment of Classical ideas these artistic changes indicate went along with a waning of interest in Stoicism and Epicureanism and a new enthusiasm for Eastern religious cults. Traditional Roman religion had always been organized by the state, and from the time of the late Republic some Romans had sought a more personal religious satisfaction in the worship of Eastern deities. During the last stages of the empire, strong cults developed around the Phrygian goddess Cybele, the Egyptian Isis, and the sun god Mithras.

The appearance and eventual triumph of Christianity is outside the scope of this account, but its emergence as the official religion of the empire played a final and decisive part in bringing to an end the Classical era. Pagan art, pagan literature, and pagan culture as a whole represented forces and ideals Christianity strongly rejected, and the art of the early Christians is fundamentally different in its inspiration. Yet even the fathers of the early church, implacable opponents of paganism, could not fail to be moved by the end of so great a cultural tradition.

The memory of Rome's greatness lived on through the succeeding ages of turmoil and achievement and the Classical spirit survived, to be reborn triumphantly in the Renaissance.

SUMMARY

The Monarchy The vast extent of ancient Roman history—more than twelve hundred years—can be conveniently divided into three chief periods: the Monarchy

(753–510 B.C.); the Republic (509–31 B.C.); and the Empire (31 B.C.–A.D. 476). The city was founded in the mideighth century, around the time the Greeks were setting up colonies in southern Italy and Sicily. Rome's first inhabitants were Latins, an Italian people native to central Italy, after whom the Roman language is named. Traditional accounts of the city's origins claimed that its first rulers were a series of seven kings. The first four were Latin, but in 616 B.C. Rome fell under Etruscan control.

Rome Under the Etruscans The Etruscans had developed in the region of central Italy to the north of Rome, although their origins are uncertain; they may have migrated to Italy from western Asia. Etruscan art was strongly influenced by Greek and Orientalizing styles. Among the most striking works to survive are the tomb paintings at Tarquinia, one of the principal Etruscan cities, and the sculpture from the temple of Apollo at Veii. Although many Etruscan inscriptions can be deciphered, no Etruscan literature has been discovered. For the century during which they ruled Rome, the Etruscans expanded its trade contacts and introduced important technological innovations. In 510 B.C., the Romans drove out the last Etruscan king.

The Beginnings of the Roman Republic In 509 B.C., the Roman Republic was declared. The political system of the new state evolved from the need to achieve a balance of political power between the two classes of citizens: the aristocratics (patricians) and the people (plebeians). There gradually developed two political institutions, the Senate and the assembly of the people, while plebeians eventually won the right to run for election to virtually all offices of state. The growth of internal political stability was accompanied by the spread of Roman power throughout Italy. Among those to fall under Roman domination were the Etruscans, their former rulers. Little in the way of art or literature has survived from this early period, and most of what was produced seems to have been inspired by Etruscan or, more generally, Greek models.

Roman Expansion in the Mediterranean In 264 B.C. there began a series of wars (the Punic wars) between Rome and her chief rival in the western Mediterranean, Carthage. By 201 B.C., the Romans had proved victorious, and Roman colonies were established in Spain and North Africa. Throughout the following century Roman power spread eastward. In 146 B.C., Greece was absorbed into the Roman Empire, and the Hellenistic kingdom of Pergamum was bequeathed to Rome by its last king, Attalus III, on his death in 133 B.C. The second century B.C. also saw the beginnings of the development of an independent Roman culture, although Greek influence remained strong. The Roman poet Ennius composed his epic, the Annals, while Plautus and Terence wrote comedies based on Greek originals. Greek music became popular in Rome, and the two chief schools of Greek philosophy, Stoicism and Epicureanism, began to attract Roman adherents.

The Collapse of the Republic With such vast territorial expansion, strains began to appear in Roman political and social life. The growth of a middle class, the *equites*, disturbed the old equilibrium, and the last century of the Republic (133 B.C. to 31 B.C.) was beset by continual crisis. A succession of powerful figures—Marius, Sulla, Pompey, Caesar—struggled to assume control of the state. The last of these proved victorious in 48 B.C. only to be assassinated four years later. Amid bitter fighting between Mark Antony, Caesar's lieutenant, and Octavius, the late dictator's nephew and heir, the Republic collapsed.

The political confusion of the Republic's last century was accompanied by important cultural developments. Among the major literary figures of the age were the Epicurean poet Lucretius, the lyric poet Catullus, and the orator and politician Cicero. Caesar himself combined his political and military career with the writing of accounts of his campaigns. In the visual arts realistic portrait sculpture became common, while the invention of concrete was to have enormous consequences, both for Roman building and for the history of all later architecture in the West. Sulla's great Sanctuary at Praeneste inaugurated the tradition of large-scale public building projects that became common during the empire.

The Augustan Age In 31 B.C., Octavius defeated the combined forces of Antony and Cleopatra to emerge as sole ruler of the Roman world; in 27 B.C., under the name Augustus, he became its first emperor. The Augustan Age marked the high point of Roman art and literature, and many of its finest achievements were produced to celebrate the Augustan revolution. Vergil was commissioned to write a Roman national epic: The result was the *Aeneid*. Augustus himself was portrayed in numerous statues and portraits, including the *Augustus of Prima Porta*, and in the reliefs on the *Ara Pacis*. Important public works included the Pont du Gard near Nîmes, France.

Life, Art, and Literature in the Early Empire From the time of Augustus until A.D. 476, the empire was ruled by a series of emperors who were increasingly dependent on an elaborate state bureaucracy. Augustus and his first four successors were from a single family, but with time emperors either seized power for themselves or were imposed by the army. The empire continued to expand until the reign of Hadrian (A.D. 117-138), who fixed its borders to achieve stability abroad. Some idea of the character of provincial daily life in the Empire can be gained from the excavations at Pompeii and the other cities around the Bay of Naples, which were destroyed by an eruption of the volcano Vesuvius in A.D. 79. Writers of the early empire include the historian Tacitus and the satirist Juvenal. Among the most impressive works of architecture of the period is the Pantheon, designed by Hadrian himself, which makes bold use of concrete.

The Roman Empire in Decline The third century was marked by continual struggles for imperial power. Only Emperor Diocletian (A.D. 284–305) managed to restore order by massive administrative and economic reform. After Diocletian's retirement to his palace at Split, one of his successors, Constantine (A.D. 307–337), transferred the imperial capital from Rome to the new city of Constantinople in A.D. 330, and the western part of the empire began its final decline. During this last period, Roman art became less realistic as Classical forms and styles were abandoned in favor of simpler, more massive effects. Finally Rome itself was shaken by barbarian assaults, and the last western emperor was forced to abdicate in A.D. 476.

PRONUNCIATION GUIDE

Aeneid:	Ee-NEE-id
Anchises:	Ank-ICE-ease
Ara Pacis:	ARE-a-PAH-kiss
Ceres:	SEAR-ease
Cerveteri:	Cher-VET-er-ee
Cicero:	SISS-er-owe
Cybele:	KIB-e-lee
Dido:	DIE-doe
Diocletian:	Die-owe-KLEE-shan
Epictetus:	Ep-ic-TEE-tus
Epicureanism:	Ep-ik-you-REE-an-ism
Etruscans:	Et-RUSK-ans
Gaius:	GUY-us
Ius Civile:	YUS-kiv-EE-lay
Lydia:	LID-i-a
Pantheon:	PAN-thi-on
Plautus:	PLAW-tus
Plebeians:	Pleb-EE-ans
Pliny:	PLIN-ee
Praeneste:	Pry-NEST-ee

Stoicism:	STOW-i-sism
Tacitus:	TASS-it-us
Tarquinia:	Tar-QUIN-i-a
Veii:	VAY-ee
Winckelmann:	VIN-kel-man

EXERCISES

- 1. What are the chief features of Etruscan culture and religion? What light do they cast on the problem of the Etruscans' origins?
- 2. "Roman art and culture are late and debased forms of Hellenistic art." Discuss.
- 3. In what ways does the *Aeneid* fulfill its aim to provide the Romans with a national epic?
- 4. Compare the *Aeneid* in this respect to the Greek epics, the *Iliad* and *Odyssey*, discussed in Chapter 2.
- 5. Describe in detail Augustus' use of the visual arts as instruments of propaganda. Are there comparable examples of the arts used for political purposes in recent times?
- 6. What do the discoveries at Rome and Pompeii tell us about daily life in the Roman Empire? In what significant respects did it differ from life today?

FURTHER READING

- Anderson, James C. (1997). Roman architecture and society. Baltimore: Johns Hopkins University Press. An excellent introduction to the influence of social factors in the development of Roman architectural forms.
- Boardman, J., J. Griffin, & O. Murray. (1988). *The Roman world*. New York: Oxford University Press. An excellent collection of essays on a wide range of aspects of Roman history and culture.
- Brendel, O. J. (1995). *Etruscan art* (2nd ed.). New Haven: Yale University Press. The most up-to-date survey of Etruscan painting and sculpture; numerous illustrations.
- Claridge, Amanda. (1998). Rome: An Oxford archaeological guide. New York. The best recent archaeological guide to the Imperial capital.
- Crawford, M. (1982). *The Roman republic*. Cambridge: Harvard University Press. An excellent survey of Republican history and culture; particularly good on coinage.
- D'Ambra, Eve. (1998). *Roman art.* New York: Cambridge University Press. Perhaps the best recent single-volume survey of a vast body of material.
- Dixon, S. (1988). *The Roman mother*. Norman: University of Oklahoma Press. An absorbing study of the legal and social status of Roman mothers.
- Elsner, Jas. (1998). *Imperial Rome and Christian triumph*. New York: Oxford University Press. Very good on the later years of the empire and the transition to Christianity.
- Garnsey, P., & R. Saller. (1987). The Roman Empire: Economy, society, and culture. Berkeley: University of California Press. A wide-ranging examination of the many aspects of Roman civilization, with special attention paid to Roman influences on other Mediterranean cultures.
- Graves, Robert. (1977). *I, Claudius* and *Claudius the God.* Baltimore: Penguin. These two historical novels, originally published in 1934, are re-creations of the Roman world that are both scholarly and thoroughly absorbing. Highly recommended.

- Kleiner, Diana E. E., & Susan B. Matheson (eds.). (1996). I Claudia. Women in ancient Rome. New Haven: Yale University Art Gallery.
- Kleiner, Diana E. E. , & Susan B. Matheson (eds.). (2000). I Claudia II: Women in Roman art and society. New Haven: Yale University Art Gallery. These two well-illustrated catalogues reveal a wealth of new information on the role of women in Roman society and culture. Highly recommended.
- Pallottino, M. (1975). *The Etruscans*. Baltimore: Penguin. A revised version of the standard work by the most eminent Etruscologist of our time, covering all aspects of Etruscan culture. Especially good on the language.
- Richardson, Lawrence, Jr. (1988). Pompeii: An architectural history. Baltimore: Johns Hopkins University Press. A masterly introduction to the variety of Roman architectural forms represented at Pompeii.
- Spivey, Nigel. (1997). *Etruscan art*. New York: Thames and Hudson. An interesting and up-to-date analysis of all aspects of Etruscan art.
- West, D., & A. J. Woodman. (1984). *Poetry and politics in the age of Augustus*. New York: Cambridge University Press. A study of the effects of Augustus' cultural program.
- Zanker, Paul. (1998). *Pompeii: Public and private life.* Cambridge: Harvard University Press. This recent survey incorporates much new material.

Online Chapter Links

Etruscan artifacts are found at http://www.comune.bologna.it/bologna/Musei/ Archaeologico/etruschi/en/7_e.htm

An Annotated Guide to Internet Resources related to Julius Caesar is available at

http://virgil.org/caesar/

which provides links to primary sources, background information, a collection of images, and modern commentary.

An Annotated Guide to Internet Resources related to Caesar Augustus is available at

http://virgil.org/augustus/

which provides links to primary sources, background information, a collection of images, and modern commentary.

The Vergil Project at

http://vergil.classics.upenn.edu provides resources for students, teachers, and readers of Vergil.

The Cicero of Homepage at

http://www.utexas.edu/depts/classics/documents/ Cic.html offers a biography, a timeline, a bibliography, and links to texts.

The Pompeii Forum Project at

http://jefferson.village.virginia.edu/pompeii

offers an extensive archive of photographs that chronicle excavations among the ruins of ancient Pompeii.

Roman Law Resources at

http://iuscivile.com

provides links to a variety of Internet resources related to *Ius Civile*.

The Ancient Vine at

http://ancient.thevines.com

provides an extensive annotated list of links to Internet sites related to Roman studies.

View the Cast Gallery at Oxford University's Ashmolean Museum at

http://www.ashmol.ox.ac.uk/ash/departments/cast-gallery/

where Roman works are represented among this outstanding collection of casts derived from sculptures found in museums around the world.

Online Chapter Resources

READING SELECTIONS

CATULLUS Selected Poems

Many of Catullus' short poems trace the course of his relationship with a woman given the pseudonym of Lesbia; her real name was Clodia, and she was the sister of Cicero's archenemy Publius Clodius Pulcher. The poems written in the early days of their affair express Catullus' joy in language of almost musical beauty.

The contentment was not to last. Lesbia lost interest, even as Catullus continued to protest his love. Driven to desperation by the hopelessness of his cause, he described in later poems his vain attempts to cure himself of the "fever" of his passion, until finally he could take no more: The last of the Lesbia poems expresses bitterness and hatred.

This short sequence follows their affair from rapturous beginning to hostile breakup; the reader inclined to sympathize with Catullus' pain should, of course, remember that Lesbia's (that is Clodia's) side of the story remains untold.

V

My darling, let us live And love for ever. They with no love to give, Who feel no fever, Who have no tale to tell But one of warning— The pack of them might sell For half a farthing. The sunset's dying ray Has its returning, But fires of our brief day Shall end their burning In night where joy and pain Are past recalling— So kiss me, kiss again— The night is falling.

Kiss me and kiss again, Nor spare thy kisses. Let thousand kisses rain A thousand blisses. Then, when ten thousand more Their strength have wasted, Let's wipe out all the score Of what we've tasted: Lest we should count our bliss To our undoing, Or others grudge the kiss On kiss accruing.

LXXXVII

None could ever say that she, Lesbia! was so loved by me. Never all the world around Faith so true as mine was found: If no longer it endures (Would it did!) the fault is yours. I can never think again Well of you: I try in vain: But—be false—do what you will— Lesbia! I must love you still.

:

LXXV

The office of my heart is still to love When I would hate. Time and again your faithlessness I prove Proven too late. Your ways might mend, yet my contempt could never Be now undone. Yet crimes repeated cannot stop this fever From burning on.

:

LVIII

She that I loved, that face, Those hands, that hair, Dearer than all my race, As dear as fair— See her where throngs parade Th' imperial route, Plying her skill unpaid— Rome's prostitute. 10

20

VERGIL

from the Aeneid, Book I

The opening of the epic invokes the poem's central theme: the destiny that will bring Aeneas to Italy and lead to the foundation of Rome. Thereafter we first meet Aeneas and his men as they struggle through a storm blown up by Aeolus, god of the winds, at the request of Juno; the goddess's implacable hostility to the Trojans goes back to Paris' failure to award her the golden apple in the beauty contest between Juno, Minerva, and Venus. Aeneas emerges as resolute and determined, a good leader, although Vergil shows us his hidden anxiety—very much that of a modern rather than Homeric hero. When Venus, Aeneas' mother, appeals to Jupiter for mercy, the father of gods and men comforts her with a description of the future glories of Rome.

- I tell about war and the hero who first from Troy's frontier,
- Displaced by destiny, came to the Lavinian shores,
- To Italy—a man much travailed on sea and land
- By the powers above, because of the brooding anger of Juno
- Suffering much in war until he could found a city
- And march his gods into Latium, whence rose the Latin race,
- The royal line of Alba and the high walls of Rome. Where lay the cause of it all? How was her godhead
- injured? What grievance made the queen of heaven so harry a man
- Renowned for piety, through such toils, such a cycle of calamity?
- Can a divine being be so persevering in anger?
- There was a town of old men from Tyre colonized it —
- Over against Italy and Tiber mouth, but afar off,
- Carthage, rich in resources, fiercely efficient in warfare.

This town, they say, was Juno's favorite dwelling, preferred

- To all lands, even Samos: here were her arms, her chariot:
- And even from the long-ago time she cherished the aim that this

Should be, if fate allowed, the metropolis of all nations. Nevertheless, she had heard a future race was forming

Of Trojan blood, which one day would topple that Tyrian stronghold—

A people arrogant in war, born to be everywhere rulers And root up her Libyan empire—so the Destiny-Spinners planned.

Juno, afraid of this, and remembering well the old war Wherein she had championed the Greeks whom she loved against the Trojans—

- Besides, she has other reasons for rage, bitter affronts Unblotted as yet from her heart: deep in her mind rankle The judgment of Paris, the insult of having her beauty
- scorned,
- Her hate for Troy's origin, Ganymede taken and made a favorite—

Furious at these things too, she tossed all over the sea The Trojans, the few that the Greeks and relentless Achilles had left,

And rode them off from their goal, Latium. Many years

- They were wandering round the seven seas, moved on by destiny.
- So massive a task it was to found the Roman race.

- They were only just out of sight of Sicily, towards deep water
- Joyfully crowding on sail and driving the foam-flocks before them,
- When Juno, who under her heart nursed that inveterate wound,
- Soliloquized thus:-

Shall I give up? own myself beaten? Impotent now to foil the Trojan lord from Italy? Fate forbids me, indeed! Did not Athene burn The Argive fleet and drown the crews, because one man Had given offence? because of the criminal madness of Ajax?

Why, she herself flung down Jove's firebolt from the clouds,

Blasted that navy and capsized the sea with a storm; And Ajax, gasping flame out of his cloven breast, She whisked up in the whirlwind, impaled him on a crag. But I, who walk in majesty, queen of heaven, Jove's Sister and consort, I must feud with a single nation For all these years. Does anyone worship my divinity After this, or pay my altar a suppliant's homage? Such were the thoughts milling round in her angry heart as the goddess

Came to the storm-cloud country, the womb-land of brawling siroccos,

Aeolia. Here in a huge cavern King Aeolus

10

20

30

Keeps curbed and stalled, chained up in durance to his own will,

The heaving winds and far-reverberating tempests.

Behind the bars they bellow, mightily fretting: the mountain is

- One immense murmur, Aeolus, aloft on his throne of power,
- Scepter in hand, gentles and disciplines their fierce spirits.
- Otherwise, they'd be bolting off with the earth and the ocean
- And the deep sky—yes, brushing them all away into space.
- But to guard against this the Father of heaven put the winds
- In a dark cavern and laid a heap of mountains upon them,
- And gave them an overlord who was bound by a firm contract
- To rein them in or give them their head, as he was ordered.
- Him Juno now petitioned. Here are the words she used:—

Aeolus, the king of gods and men has granted You the rule of the winds, to lull the waves or lift them. A breed I have no love for now sails the Tyrrhene sea, Transporting Troy's defeated gods to Italy.

Lash fury into your winds! Whelm those ships and sink them!

- Flail the crews apart! Litter the sea with their fragments! Fourteen nymphs I have—their charms are quite out of the common—
- Of whom the fairest in form, Deiopea, I'll join

To you in lasting marriage and seal her yours for ever,

A reward for this great favor I ask, to live out all

The years with you, and make you the father of handsome children.

Aeolus answered thus: —

O queen, it is for you to

70

40

120

130

140

150

Be fully aware what you ask: my duty is but to obey.

Through you I hold this kingdom, for what it's worth, as Jove's

Viceroy; you grant the right to sit at the gods' table;

You are the one who makes me grand master of cloud and storm.

Thus he spoke, and pointing his spear at the hollow mountain,

80

90

110

Pushed at its flank: and the winds, as it were in a solid mass,

- Hurl themselves through the gates and sweep the land with tornadoes.
- They have fallen upon the sea, they are heaving it up from its deepest

Abysses, the whole sea—East wind, South, Sou'wester

Thick with squalls—and bowling great billows at the shore.

There follows a shouting of men, a shrilling of stays and halyards.

All of a sudden the storm-clouds are snatching the heavens, the daylight

From the eyes of the Trojans; night, black night is fallen on the sea.

The welkin explodes, the firmament flickers with thickand-fast lightning,

And everything is threatening the instant death of men.

At once a mortal chill went through Aeneas and sapped him;

He groaned, and stretching out his two hands toward the stars,

Uttered these words:-

Oh, thrice and four times blessed you

Whose luck it was to fall before your father's eyesUnder Troy's battlements! O Diomed, the bravestOf the Greek kind, why could not I have fallen to death100On Ilium's plains and shed my soul upon your sword?Fallen where Hector lies, whom Achilles slew, and tallSarpedon fell, and Simois our river rolls so manyHelmets and shields and heroes together down its

stream? Even as he cried out thus, a howling gust from the North

Hit the front of the sail, and a wave climbed the sky.

Oars snapped; then the ship yawed, wallowing broadside on

To the seas: and then, piled up there, a precipice of sea hung.

One vessel was poised on a wave crest; for another the waters, collapsing,

Showed sea-bottom in the trough: the tide-race boiled with sand.

Three times did the South wind spin them towards an ambush of rocks

- (Those sea-girt rocks which Italians call by the name of "The Altars"),
- Rocks like a giant spine on the sea: three times did the East wind

Drive them in to the Syrtes shoal, a piteous spectacle—

Hammering them on the shallows and hemming them round with sandbanks.

One ship, which carried in her the Lycians and faithful Orontes,

Before Aeneas' eyes is caught by an avalanche wave

And pooped: her helmsman is flicked from off the deck and headlong

Sent flying; but three times the vessel is twirled around

- By the wave ere the waters open and greedily gulp her down.
- A man or two can be seen swimming the huge maelstrom,
- With weapons and planks and Trojan treasure spilt on the sea.
- Now Ilioneus' strong ship, now the ship of valiant Achates,
- And the ships that carry Abás and aged Aletes go
- Down to the gale; the ships have all sprung leaks and are letting
- The enemy pour in through the loosened joints of their hulls, Meanwhile Neptune has felt how greatly the sea is in turmoil,
- Felt the unbridled storm disturbing the water even
- Down to the sea-bed, and sorely troubled has broken surface;

He gazes forth on the deep with a pacific mien. He sees the fleet of Aeneas all over the main, dismembered,

The Trojans crushed by waves and the sky in ribbons about them:

Juno's vindictive stratagems do not escape her brother. He summons the East and the West winds, and then

proceeds to say:—

Does family pride tempt you to such impertinence? Do you really dare, you Winds, without my divine assent To confound earth and sky, and raise this riot of water? You, whom I—! Well, you have made the storm, I must lay it.

Next time, I shall not let you so lightly redeem your sins. Now leave, and quickly leave, and tell your overlord

this— Not to him but to me was allotted the stern trident,

- Dominion over the seas. His domain is the mountain of rock,
- Your domicile, O East wind. Let Aeolus be king of

That castle and let him keep the winds locked up in its dungeon.

He spoke; and before he had finished, the insurgent sea was calmed,

The mob of cloud dispersed and the sun restored to power.

Nereid and Triton heaving together pushed the ships off From the sharp rock, while Neptune levered them up with his trident,

- And channelled a way through the sandbanks, and made the sea lie down—
- Then lightly charioted off over the face of the waters. Just as so often it happens, when a crowd collects, and violence
- Brews up, and the mass mind boils nastily over, and the next thing
- Firebrands and brickbats are flying (hysteria soon finds a missile),
- That then, if they see some man whose goodness of heart and conduct
- Have won their respect, they fall silent and stand still, ready to hear him;
- And he can change their temper and calm their thoughts with a speech:
- So now the crash of the seas died down, when Neptune gazed forth
- Over their face, and the sky cleared, and the Father of ocean,
- Turning his horses, wheeled away on an easy course. Aeneas' men, worn out, with a last effort, make for

The nearest landing place; somewhere on the coast of Libya.

A spot there is in a deep inlet, a natural harbor Formed by an island's flanks upon which the swell from the deep sea

Breaks and dividing runs into the land's recesses. At either end of the lofty cliffs a peak towers up Formidably to heaven, and under these twin summits The bay lies still and sheltered: a curtain of overhanging Woods with their shifting light and shadow forms the backdrop;

At the seaward foot of the cliffs there's a cave of stalactites

- Fresh water within, and seats which nature has hewn from the stone —
- A home of the nymphs. Here, then, tired ships could lie, and need

No cable nor the hooking teeth of an anchor to hold them. Here, with seven ships mustered, all that was left of his convoy,

Aeneas now put in: and the Trojans, aching for dry land, Tumbled out of their ships onto the sands they craved so, And laid their limbs, crusted with brine, upon the shore. Then first of all Achates struck a spark from flint,

Nursed the spark to a flame on tinder, gave it to feed on Dry fuel packed around it and made the flame blaze up there.

Sick of mischance, the men got ready the gifts and gear of 180 Ceres, setting themselves to roast on the fire and grind, Though tainted it was with the salt water, what grain

they had salvaged.

While this was going forward, Aeneas scaled a crag To get an extensive view of the sea, hoping to sight Some Trojan ship—Antheus perhaps, safe from the storm, Or Capys, or the tall ship displaying the shield of Caicus.

Ship there was none in view; but on the shore three stags Caught his eye as they wandered with a whole herd behind them,

- A straggling drove of deer which browsed along the valley.
- Aeneas, where he stood, snatched up the bow and arrows—
- The weapons he had borrowed just now from faithful Achates—
- And aiming first at the leaders of the herd, which carried their heads high

With branching antlers, he laid them low; then shot at the herd,

And his arrows sent it dodging all over the leafy woods. Nor would he stop shooting until triumphantly

- He had brought down seven beasts, one for each of his ships.
- Then he returned to the harbor and shared them among his comrades.
- And then he shared out the wine which good Acestes had casked

In Sicily and given them — a generous parting present,

And spoke these words of comfort to his sad-hearted friends:—

Comrades, we're well acquainted with evils, then and now.

Worse than this you have suffered. God will end all this too.

You, who have risked the mad bitch, Scylla, risked the cliffs

- So cavernously resounding, and the stony land of the Cyclops,
- Take heart again, oh, put your dismal fears away!
- One day—who knows?—even these will be grand things to look back on.

Through chance and change, through hosts of dangers, our road still

- Leads on to Latium: there, destiny offers a home
- And peace; there duty tells us to build the second Troy.
- Hold on, and find salvation in the hope of better things! 210 Thus spoke Aeneas; and though his heart was sick with anxiety,
- He wore a confident look and kept his troubles to himself.
- The Trojans set to work, preparing the game for a banquet;

170

190

200

- Hacked the chines apart from the ribs, and exposed the guts:
- Some sliced the meat into steaks which they spitted with trembling fingers,
- Some set down cooking pots on the beach, and fed the fires,
- Then they restored their strength with the food, and sprawling at ease
- On the grass they took their fill of the wine and the rich venison.
- Afterwards, hunger appeased and the meal cleared away, for a long time
- They talked of their missing friends, longing to have them back,
- Half-way between hope and fear, not knowing whether to deem them
- Alive or utterly perished and far beyond human call.

True-hearted Aeneas grieved especially for the fate of Ardent Orontes, and Amycus, and the cruel fate of Lvcus,

- Grieved for Gyas the brave and for the brave Cloanthus. At last they made an end. Jupiter from high heaven
- Looked down at the flights of sails on the sea, and the earth beneath him,
- Its shores and its far-flung peoples: so, at the top of the morning
- He stood, and presently focused his gaze on the Libyan realm.
- Now, as he deeply pondered the troubles there, came Venus,
- Sadder than is her wont, her eyes shining with tears, And spoke to him:—

Sir, you govern the affairs of gods and men By law unto eternity, you are terrible in the lightning: Tell me, what wrong could my Across on his Traine

Tell me, what wrong could my Aeneas or his Trojans Have done you, so unforgivable that, after all these

- deaths, To stop them reaching Italy they are locked out from the
- whole world? Verily you had promised that hence, as the years
- rolled on,
- Troy's renaissance would come, would spring the Roman people
- And rule as sovereigns absolute over earth and sea. You promised it. Oh, my father, why have you changed your mind?

That knowledge once consoled me for the sad fall of Troy: I could balance fate against fate, past ills with luck to come.

But still the same ill fortune dogs my disaster-ridden

230

240

300

10

Heroes. Oh when, great king, will you let their ordeal end?

Antenor, slipping away through the Greek army, could safely

Sail right up the Illyrian gulf, pass by the remote Liburnians, and pass the source of river Timavus Where tidal water, roaring aloud below rock, spouts up

Through nine mouths, and the fields are hemmed with a sound of the sea.

He was allowed to found Padua, make a home for Trojans there—could give his people a name, and nail up His arms, could settle down to enjoy peace and quiet. But we, your seed, for whom you sanction a place in

heaven—

Our ships damnably sunk—because of one being's anger

We are cheated, and fenced afar from Italy.

Is this the reward for being true? Is it thus you restore a king?

The begetter of gods and men inclined towards her the smiling

Countenance which calms the sky and makes fair weather,

Gently kissed his daughter's mouth, and began to speak:—

Fear no more, Cytherea. Take comfort, for your people's

Destiny is unaltered; you shall behold the promised City walls of Lavinium, and exalt great-hearted Aeneas Even to the starry skies. I have not changed my mind. I say it now—for I know these cares constantly

gnaw you—

And show you further into the secret book of fate: Aeneas, mightily warring in Italy, shall crush Proud tribes, to establish city walls and a way of life, Till a third summer has seen him reigning in Latium And winter thrice passed over his camp in the conquered land.

His son Ascanius, whose surname is now Iulus—... Ilus it was, before the realm of Ilium fell— Ascanius for his reign shall have full thirty years With all their wheeling mouths; shall move the king-

dom from Lavinium and make Long Alba his sure stronghold. Here for three hundred years shall rule the dynasty Of Hector, until a priestess and queen of Trojan blood, With child by Mars, shall presently give birth to

twin sons. Romulus, then, gay in the coat of the tawny she-wolf Which suckled him, shall succeed to power and found the city

Of Mars and with his own name endow the Roman nation.

To these I set no bounds, either in space or time;

Unlimited power I give them. Even the spiteful Juno,

Who in her fear now troubles the earth, the sea and the sky,

Shall think better of this and join me in fostering

The cause of the Romans, the lords of creation, the togaed people.

Thus it is written. An age shall come, as the years glide by,

When the children of Troy shall enslave the children of Agamemnon,

Of Diomed and Achilles, and rule in conquered Argos. From the fair seed of Troy there shall be born a Caesar— 290 Julius, his name derived from great Iulus—whose empire

- Shall reach to the ocean's limits, whose fame shall end in the stars.
- He shall hold the East in fee; one day, cares ended, you shall

Receive him into heaven; him also will mortals pray to. Then shall the age of violence be mellowing into peace: Venerable Faith, and the Home, with Romulus and

Remus, Shall make the laws; the grim, steel-welded gates of War Be locked; and within, on a heap of armaments, a hundred

Bronzen knots tying his hands behind him, shall sit Growling and bloody-mouthed the godless spirit of

So Jupiter spoke, and sent Mercury down from on high

To see that the land and the new-built towers of Carthage offered

Asylum to the Trojans, for otherwise might queen Dido, Blind to destiny, turn them away.

260 VERGIL

280

250

from the Aeneid, Book IV

Discord

The bitter confrontation between Dido and Aeneas in Book IV of the Aeneid forms the emotional heart of the epic's first half. The scene begins as Aeneas has received the divine message to leave Carthage and continue on his journey. He says nothing to Dido for the moment and makes his preparations for departure. The queen cannot be fooled so easily; in a frenzy of grief and rage, she accuses him of deserting her. Aeneas' response seems cold and indicates the sacrifice of personal feelings his mission requires. His appeal to common sense and the will of the gods only enrages Dido further; she dismisses him with words of furious contempt. Yet, at the end of the scene, Vergil leaves no doubt as to Aeneas' terrible

But who can ever hoodwink a woman in love? The queen, Apprehensive even when things went well, now sensed his deception,

Got wind of what was going to happen. That mischievous Rumor,

Whispering the fleet was preparing to sail, put her in a frenzy.

Distraught, she witlessly wandered about the city, raving Like some Bacchante driven wild, when the emblems of sanctity

- Stir, by the shouts of "Hail, Bacchus!" and drawn to Cithaeron
- At night by the din of revellers, at the triennial orgies.

Finding Aeneas at last, she cried, before he could speak:—

Unfaithful man, did you think you could do such a dreadful thing

- And keep it dark? yes, skulk from my land without one word?
- Our love, the vows you made me—do these not give you pause,

Nor even the thought of Dido meeting a painful death? Now, in the dead of winter, to be getting your ships ready

And hurrying to set sail when northerly gales are blowing,

²⁷⁰ the end of the scene, veryli leaves no doubt us to Aeneas terrible dilemma. Faced with the choice between love and duty he has chosen duty, but only at the price of personal anguish.

You heartless one! Suppose the fields were not foreign, the home was

- Not strange that you are bound for, suppose Troy stood as of old,
- Would you be sailing for Troy, now, in this stormy weather?
- Am I your reason for going? By these tears, by the hand you gave me—

20

30

- They are all I have left, to-day, in my misery—I implore you,
- And by our union of hearts, by our marriage hardly begun,
- If I have ever helped you at all, if anything
- About me pleased you, be sad for our broken home, forgo
- Your purpose, I beg you, unless it's too late for prayers of mine!
- Because of you, the Libyan tribes and the Nomad chieftains
- Hate me, the Tyrians are hostile: because of you I have lost
- My old reputation for faithfulness—the one thing that could have made me
- Immortal. Oh, I am dying! To what, my guest, are you leaving me?
- "Guest" that is all I may call you now, who have called you husband.
- Why do I linger here? Shall I wait till my brother, Pygmalion,
- Destroys this place, or Iarbas leads me away captive? If even I might have conceived a child by you before
- You went away, a little Aeneas to play in the palace
- And in crite of all this to remind me of your hy his la

And, in spite of all this, to remind me of you by his looks, oh then

I should not feel so utterly finished and desolate. She had spoken. Aeneas, mindful of Jove's words, kept his eves

- Unyielding, and with a great effort repressed his feeling for her.
- In the end he managed to answer: —

Dido, I'll never pretend

You have not been good to me, deserving of everything 40 You can claim. I shall not regret my memories of Elissa As long as I breathe, as long as I remember my own self. For my conduct—this, briefly: I did not look to make off from here

In secret—do not suppose it; nor did I offer you marriage At any time or consent to be bound by a marriage contract. If fate allowed me to be my own master, and gave me Free will to choose my way of life, to solve my problems, Old Troy would be my first choice: I would restore it, and honor

My people's relics—the high halls of Priam perpetuated, Troy given back to its conquered sons, a renaissant city Had been my task. But now Apollo and the Lycian Oracle have told me that Italy is our bourne.

There lies my heart, my homeland. You, a Phoenician, are held by

These Carthaginian towers, by the charm of your Libyan city:

So can you grudge us Trojans our vision of settling down In Italy? We too may seek a kingdom abroad. Often as night envelops the earth in dewy darkness, Often as star-rise, the troubled ghost of my father, Anchises, Comes to me in my dreams, warns me and frightens me. I am disturbed no less by the wrong I am doing Ascanius, 60 Defrauding him of his destined realm in Hesperia.

What's more, just now the courier of heaven, sent by Jupiter I swear it on your life and mine—conveyed to me, swiftly flying, His orders: I saw the god, as clear as day, with my own eyes, Entering the city, and these ears drank in the words he uttered. No more reproaches, then—they only torture us both. God's will, not mine, says "Italy." All the while he was speaking she gazed at him askance, Her glances flickering over him, eyes exploring the whole man In deadly silence. Now, furiously, she burst out:-Faithless and false! No goddess mothered you, no Dardanus Your ancestor! I believe harsh Caucasus begat you On a flint-hearted rock and Hyrcanian tigers suckled you. Why should I hide my feelings? What worse can there be to keep them for? Not one sigh from him when I wept! Not a softer glance! Did he yield an inch, or a tear, in pity for her who loves him? I don't know what to say first. It has come to this,not Iuno. Not Jove himself can view my plight with the eye of justice. Nowhere is it safe to be trustful. I took him, a castaway, A pauper, and shared my kingdom with him—I must have been mad-Rescued his lost fleet, rescued his friends from death. Oh, I'm on fire and drifting! And now Apollo's prophecies, Lycian oracles, couriers of heaven sent by Jupiter With stern commands—all these order you to betray me. Oh, of course this is just the sort of transaction that troubles the calm of The gods. I'll not keep you, nor probe the dishonesty of your words, Chase your Italy, then! Go, sail to your realm overseas! I only hope that, if the just spirits have any power, Marooned on some mid-sea rock you may drink the full cup of agony And often cry out for Dido. I'll dog you, from far, with the death-fires; And when cold death has parted my soul from my body, my specter Will be wherever you are. You shall pay for the evil vou've done me. The tale of your punishment will come to me down in the shades. With these words Dido suddenly ended, and sick at heart Turned from him, tore herself away from his eyes, ran indoors, While he hung back in dread of a still worse scene, although He had much to say. Her maids bore up the fainting queen

- Into her marble chamber and laid her down on the bed. But the god-fearing Aeneas, much as he longed to soothe
- Her anguish with consolation, with words that would end her troubles,

Heavily sighing, his heart melting from love of her, Nevertheless obeyed the gods and went off to his fleet. 100

70

80

40

60

70

VERGIL

from the Aeneid, Book VI

In Book VI of the Aeneid, Aeneas travels to the underworld led by his guide, the Sibyl of Cumae, to learn of the future destiny both of himself and of Rome. The opening lines of this passage evoke the melancholy gloom of the scene; as Aeneas comes to the river of the dead, the poet emphasizes by a string of pathetic images the sadness of those trying to cross it. Aeneas' journey is necessary because he has to confront his past and come to terms with it before he can move on to his future heroic destiny.

As the Sibyl leads him through the ranks of the dead he meets Palinurus, the helmsman of Aeneas' ship who had fallen overboard just before reaching Troy and drowned. The most emotional encounter, however, is the one that concludes this episode—Aeneas' meeting with Dido. Now it is Aeneas who weeps and pleads, while Dido neither looks at him nor speaks.

You gods who rule the kingdom of souls!

You soundless shades!

Chaos, and Phlegethon! O mute wide leagues of Nightland!—

Grant me to tell what I have heard! With your assent

May I reveal what lies deep in the gloom of the Underworld!

Dimly through the shadows and dark solitudes they wended,

10

20

30

Through the void domiciles of Dis, the bodiless regions:

Just as, through fitful moonbeams, under the moon's thin light,

A path lies in a forest, when Jove has palled the sky With gloom, and the night's blackness has bled the world of color.

See! At the very porch and entrance way to Orcus Grief and ever-haunting Anxiety make their bed: Here dwell pallid Diseases, here morose Old Age, With Fear, ill-prompting Hunger, and squalid Indigence, Shapes horrible to look at, Death and Agony; Sleep, too, which is the cousin of Death; and Guilty Joys, And there, against the threshold, War, the bringer of Death:

Here are the iron cells of the Furies, and lunatic Strife Whose viperine hair is caught up with a headband soaked in blood.

In the open a huge dark elm tree spreads wide its immemorial

Branches like arms, whereon, according to old wives' tales,

Roost the unsolid Dreams, clinging everywhere under its foliage.

Besides, many varieties of monsters can be found Stabled here at the doors—Centaurs and freakish Scyllas, Briareus with his hundred hands, the Lernaean Hydra That hisses terribly and the flame-throwing Chimaera, Gorgons and Harpies, and the ghost of three-bodied

Geryon.

Now did Aeneas shake with a spasm of fear, and drawing

His sword, offered its edge against the creatures' onset: Had not his learned guide assured him they were but

incorporeal Existences floating there, forms with no substance behind them,

He'd have attacked them, and wildly winnowed with steel mere shadows.

From here is the road that leads to the dismal waters of Acheron.

Here a whirlpool boils with mud and immense swirlings Of water, spouting up all the slimy sand of Cocytus. A dreadful ferryman looks after the river crossing, Charon: Appallingly filthy he is, with a bush of unkempt White beard upon his chin, with eyes like jets of fire; And a dirty cloak draggles down, knotted about his shoulders.

He poles the boat, he looks after the sails, he is all the crew

Of the rust-colored wherry which takes the dead across—

An ancient now, but a god's old age is green and sappy. This way came fast and streaming up to the bank the whole throng:

Matrons and men were there, and there were great-heart heroes

Finished with earthly life, boys and unmarried maidens, Young men laid on the pyre before their parents' eyes; Multitudinous as the leaves that fall in a forest

At the first frost of autumn, or the birds that out of the deep sea

Fly to land in migrant flocks, when the cold of the year Has sent them overseas in search of a warmer climate. 50 So they all stood, each begging to be ferried across first, Their hands stretched out in longing for the shore beyond

the river. But the surly ferryman embarks now this, now that group,

- While others he keeps away at a distance from the shingle.
- Aeneas, being astonished and moved by the great stir, said:—

Tell me, O Sibyl, what means this rendezvous at the river?

- What purpose have these souls? By what distinction are some
- Turned back, while other souls sweep over the wan water?
- To which the long-lived Sibyl uttered this brief reply:—
 - O son of Anchises' loins and true-born offspring of heaven,

What you see is the mere of Cocytus, the Stygian marsh

- By whose mystery even the gods, having sworn, are afraid to be forsworn.
- All this crowd you see are the helpless ones, the unburied:
- That ferryman is Charon: the ones he conveys have had burial.
- None may be taken across from bank to awesome bank of
- That harsh-voiced river until his bones are laid to rest.

Otherwise, he must haunt this place for a hundred years

Before he's allowed to revisit the longed-for stream at last.

The son of Anchises paused and stood stock still, in deep

- Meditation, pierced to the heart by pity for their hard fortune.
- He saw there, sorrowing because deprived of death's fulfilment,

Leucaspis and Orontes, the commodore of the Lycian Squadron, who had gone down, their ship being lost with all hands

In a squall, sailing with him the stormy seas from Troy. And look! yonder was roaming the helmsman, Palinurus,

Who, on their recent voyage, while watching the stars, had fallen

From the afterdeck, thrown off the ship there in midpassage.

A somber form in the deep shadows, Aeneas barely Recognized him; then accosted:—

Which of the gods, Palinurus,

Snatched you away from us and made you drown in the midsea?

80

90

Oh, tell me! For Apollo, whom never before had I found Untruthful, did delude my mind with this one answer, Foretelling that you would make your passage to Italy Unharmed by sea. Is it thus he fulfils a sacred promise?

Palinurus replied:—

The oracle of Phoebus has not tricked you, My captain, son of Anchises; nor was I drowned by a god. It was an accident: I slipped, and the violent shock Of my fall broke off the tiller to which I was holding

firmly As helmsman, and steering the ship. By the wild seas

I swear That not on my own account was I frightened nearly

so much as Lest your ship, thus crippled, its helmsman overboard,

- Lose steerage-way and founder amid the mountainous waves.
- Three stormy nights did the South wind furiously drive me along

Over the limitless waters: on the fourth day I just

Caught sight of Italy, being lifted high on a wave crest. Little by little I swam to the shore. I was all but safe,

When, as I clung to the rough-edged cliff top, my fingers

crooked

And my soaking garments weighing me down, some barbarous natives 100

Attacked me with swords, in their ignorance thinking that I was a rich prize.

Now the waves have me, the winds keep tossing me up on the shore again.

So now, by the sweet light and breath of heaven above I implore you, and by your father, by your hopes for growing Ascanius

Redeem me from this doom, unconquered one! Please sprinkle

Dust on my corpse—you can do it and quickly get back to port Velia:

Or else, if way there is, some way that your heavenly mother

Is showing you (not, for sure, without the assent of deity Would you be going to cross the swampy Stygian stream),

Give poor Palinurus your hand, take me with you across the water 110

So that at least I may rest in the quiet place, in death. Thus did the phantom speak, and the Sibyl began to speak thus:—

This longing of yours, Palinurus, has carried you quite away.

- Shall you, unburied, view the Styx, the austere river
- Of the Infernal gods, or come to its bank unbidden? Give up this hope that the course of fate can be swerved

by prayer. But hear and remember my words, to console you in your hard fortune.

- I say that the neighboring peoples, compelled by portents from heaven
- Occurring in every township, shall expiate your death,

Shall give you burial and offer the solemn dues to your grave, 120 And the place shall keep the name of Palinurus forever. Her sayings eased for a while the anguish of his sad heart. He forgot his cares in the joy of giving his name to a region. So they resumed their interrupted journey, and drew near The river. Now when the ferryman, from out on the Styx, espied them Threading the soundless wood and making fast for the bank, He hailed them, aggressively shouting at them before they could speak:-Whoever you are that approaches my river, carrying a weapon, Halt there! Keep your distance, and tell me why you are come! This is the land of ghosts, of sleep and somnolent night: 130 The living are not permitted to use the Stygian ferry. Not with impunity did I take Hercules, When he came, upon this water, nor Theseus, nor Pirithous, Though their stock was divine and their powers were irresistible. Hercules wished to drag off on a leash the watch-dog of Hades, Even from our monarch's throne, and dragged it away trembling: The others essayed to kidnap our queen from her lord's bedchamber. The priestess of Apollo answered him shortly, thus:-There is no such duplicity here, so set your mind at rest; These weapons offer no violence: the huge watch-dog in his kennel 140 May go on barking for ever and scaring the bloodless dead, Prosperpine keep her uncle's house, unthreatened in chastity. Trojan Aeneas, renowned for war and a duteous heart, Comes down to meet his father in the shades of the

- Underworld. If you are quite unmoved by the spectacle of such great
- If you are quite unmoved by the spectacle of such great faith,

This you must recognize—

And here she disclosed the golden

- Bough which was hid in her robe. His angry mood calms down.
- No more is said. Charon is struck with awe to see
- After so long that magic gift, the bough fate-given;

150

He turns his sombre boat and poles it towards the bank. Then, displacing the souls who were seated along its

- benches And clearing the gangways, to make room for the big frame of Aeneas,
- He takes him on board. The ramshackle craft creaked under his weight
- And let in through its seams great swashes of muddy water.

At last, getting the Sibyl and the hero safe across,

- He landed them amidst wan reeds on a dreary mud flat. Huge Cerberus, monstrously couched in a cave confronting them,
- Made the whole region echo with his three-throated barking.

The Sibyl, seeing the snakes bristling upon his neck now, 160 Threw him for bait a cake of honey and wheat infused with

Sedative drugs. The creature, crazy with hunger, opened

Its three mouths, gobbled the bait; then its huge body relaxed

And lay, sprawled out on the ground, the whole length of its cave kennel.

Aeneas, passing its entrance, the watch-dog neutralized, Strode rapidly from the bank of that river of no return.

At once were voices heard, a sound of mewling and wailing,

Ghosts of infants sobbing there at the threshold, infants From whom a dark day stole their share of delicious life,

Snatched them away from the breast, gave them sour death to drink.

Next to them were those condemned to death on a false charge.

Yet every place is duly allotted and judgment is given.

Minos, as president, summons a jury of the dead: he hears

Every charge, examines the record of each; he shakes the urn.

Next again are located the sorrowful ones who killed

- Themselves, throwing their lives away, not driven by guilt
- But because they loathed living: how they would like to be
- In the world above now, enduring poverty and hard trials!
- God's law forbids: that unlovely fen with its glooming water

Corrals them there, the nine rings of Styx corral them in. 180

Not far from here can be seen, extending in all directions,

- The vale of mourning—such is the name it bears: a region
- Where those consumed by the wasting torments of merciless love
- Haunt the sequestered alleys and myrtle groves that give them

Cover; death itself cannot cure them of love's disease.

Here Aeneas descried Phaedra and Procris, sad

Eriphyle displaying the wounds her heartless son once dealt her,

Evadne and Pasiphae; with them goes Laodamia;

Here too is Caeneus, once a young man, but next a woman

And now changed back by fate to his original sex. Amongst them, with her death-wound still bleeding, through the deep wood

- Was straying Phoenician Dido. Now when the Trojan leader
- Found himself near her and knew that the form he glimpsed through the shadows
- Was hers—as early in the month one sees, or imagines he sees,
- Through a wrack of cloud the new moon rising and glimmering—
- He shed some tears, and addressed her in tender, loving tones:—

Poor, unhappy Dido, so the message was true that came to me

Saying you'd put an end to your life with the sword and were dead?

Oh god! was it death I brought you, then? I swear by the stars,

By the powers above, by whatever is sacred in the Underworld, 200

It was not of my own will, Dido, I left your land.

Heaven's commands, which now force me to traverse the shades,

This sour and derelict region, this pit of darkness, drove me

Imperiously from your side. I did not, could not imagine My going would ever bring such terrible agony on you. Don't move away! Oh, let me see you a little longer!

- To fly from me, when this is the last word fate allows us! Thus did Aeneas speak, trying to soften the wild-eyed,
- Passionate-hearted ghost, and brought the tears to his own eves.
- She would not turn to him; she kept her gaze on the ground,

And her countenance remained as stubborn to his appeal

As if it were carved from recalcitrant flint or a crag of marble.

At last she flung away, hating him still, and vanished Into the shadowy wood where her first husband, Sychaeus,

- Understands her unhappiness and gives her an equal love.
- Nonetheless did Aeneas, hard hit by her piteous fate, Weep after her from afar, as she went, with tears of compassion.

VERGIL

170

190

from the Aeneid, Book VI

Toward the end of Book VI, Aeneas meets his father, Anchises. After an emotional greeting, Anchises describes many of the future heroes of Roman history, and in a famous passage, beginning at line 96, evokes Rome's destined rise to world ruler and peacemaker. Yet after Vergil's ringing description of the glorious future, he ends the episode ambiguously. There are two gates out of the underworld, one of horn for true dreams, and one of ivory — bright and shining — for false dreams. Anchises sends his son back into the world through the gate of ivory.

When Anchises had finished, he drew his son and the Sibyl

- Into the thick of the murmuring concourse assembled there
- And took his stand on an eminence from which he could scan the long files
- Over against him, and mark the features of those who passed

Listen, for I will show you your destiny, setting forth The fame that from now shall attend the seed of

Dardanus

The posterity that awaits you from an Italian marriage — Illustrious souls, one day to come in for our Trojan name. That young man there—do you see him? who leans on an untipped spear,

Has been allotted the next passage to life, and first of All these will ascend to earth, with Italian blood in his veins;

He is Silvius, an Alban name, and destined to be your last child,

10

The child of your late old age by a wife, Lavinia, who shall

Bear him in sylvan surroundings, a king and the father of kings

Through whom our lineage shall rule in Alba Longa. Next to him stands Procas, a glory to the Trojan line; Then Capys and Numitor, and one who'll revive your own name—

Silvius Aeneas, outstanding alike for moral rectitude And prowess in warfare, if ever he comes to the Alban throne.

What fine young men they are! Look at their stalwart bearing,

The oak leaves that shade their brows—decorations for saving life!

20

30

40

50

These shall found your Nomentum, Gabii and Fidenae, These shall rear on the hills Collatia's citadel,

Pometii, and the Fort of Inuus, Bola and Cora— All nameless sites at present, but then they shall have these names.

Further, a child of Mars shall go to join his grandsire— Romulus, born of the stock of Assarcus by his mother, Ilia. Look at the twin plumes upon his helmet's crest, Mars' cognizance, which marks him out for the world of earth!

His are the auguries, my son, whereby great Rome Shall rule to the ends of the earth, shall aspire to the highest achievement,

Shall ring the seven hills with a wall to make one city, Blessed in her breed of men: as Cybele, wearing her turreted

Crown, is charioted round the Phrygian cities, proud of Her brood of gods, embracing a hundred of her

children's children—

Heaven-dwellers all, tenants of the realm above. Now bend your gaze this way, look at that people there! They are your Romans. Caesar is there and all Ascanius'

Posterity, who shall pass beneath the arch of day. And here, here is the man, the promised one you know of —

Caesar Augustus, son of a god, destined to rule Where Saturn ruled of old in Latium, and there Bring back the age of gold: his empire shall expand Past Garamants and Indians to a land beyond the zodiac And the sun's yearly path, where Atlas the sky-bearer pivots

The wheeling heavens, embossed with fiery stars, on his shoulder.

Even now the Caspian realm, the Crimean country Tremble at oracles of the gods predicting his advent, And the seven mouths of the Nile are in a lather of fright.

Not even Hercules roved so far and wide over earth,

Although he shot the bronze-footed deer, brought peace to the woods of

Erymanthus, subdued Lerna with the terror of his bow; Nor Bacchus, triumphantly driving his team with vines

- for reins, His team of tigers down from Mount Nysa, travelled so far.
- Do we still hesitate, then, to enlarge our courage by action?

Shrink from occupying the territory of Ausonia? Who is that in the distance, bearing the hallows, crowned with

A wreath of olive? I recognize—grey hair and hoary chin-That Roman king who, called to high power from humble Cures, A town in a poor area, shall found our system of law And thus refound our city. The successor of Numa, destined To shake our land out of its indolence, stirring men up to fight Who have grown unadventurous and lost the habit of victory, Is Tullus. After him shall reign the too boastful Ancus, Already over-fond of the breath of popular favor. Would you see the Tarquin kings, and arrogant as they, Brutus The avenger, with the symbols of civic freedom he won back? He shall be first to receive consular rank and its power of Life and death: when his sons awake the dormant conflict, Their father, a tragic figure, shall call them to pay the extreme Penalty, for fair freedom's sake. However posterity Look on that deed, patriotism shall prevail and love of Honor. See over there the Decii, the Drusi, Torquatus With merciless axe, Camillus with the standards he recovered. See those twin souls, resplendent in duplicate armor: now They're of one mind, and shall be as long as the Underworld holds them; But oh, if ever they reach the world above, what warfare, What battles and what carnage will they create between them-Caesar descending from Alpine strongholds, the fort of Monoceus, His son-in-law Pompey lined up with an Eastern army against him. Lads, do not harden yourselves to face such terrible wars! Turn not your country's hand against your country's heart! You, be the first to renounce it, my son of heavenly lineage, You be the first to bury the hatchet! . That one shall ride in triumph to the lofty Capitol, The conqueror of Corinth, renowned for the Greeks he has slain. That one shall wipe out Argos and Agamemnon's Mycenae, Destroying an heir of Aeacus, the seed of warrior Achilles, Avenging his Trojan sires and the sacrilege done to Minerva. Who could leave unnoticed the glorious Cato, Cossus, The family of the Gracchi, the two Scipiosthunderbolts In war and death to Libya; Fabricius, who had plenty In poverty; Serranus, sowing his furrowed fields? Fabii, where do you lead my lagging steps? O Fabius, The greatest, you the preserver of Rome by delaying tactics! Yet others fashion from bronze more lifelike, breathing images

For so they shall—and evoke living faces from marble; Others excel as orators, others track with their instruments 60

70

80

- The planets circling in heaven and predict when stars will appear.
- But, Romans, never forget that government is your medium!

Be this your art: — to practice men in the habit of peace, Generosity to the conquered, and firmness against

aggressors.

They marvelled at Anchises' words, and he went on:—

Look how Marcellus comes all glorious with the highest

Of trophies, a victor over-topping all other men!

He shall buttress the Roman cause when a great war shakes it,

Shatter the Carthaginian and rebel Gaul with his cavalry,

Give to Quirinus the third set of arms won in single combat.

Aeneas interposed, seeing beside Marcellus A youth of fine appearance, in glittering accoutrements,

But his face was far from cheerful and downcast were his eyes:—

Father, who is he that walks with Marcellus there? His son? Or one of the noble line of his children's

children?

- How the retinue murmurs around him! How fine is the young man's presence!
- Yet is his head haloed by somber shade of night. Then father Anchises began, tears welling up in his eyes:—

My son, do not probe into the sorrows of your kin. Fate shall allow the earth one glimpse of this

young man— One glimpse, no more. Too puissant had been Rome's stock, ye gods,

What lamentations of men shall the Campus Martius echo To Mars' great city! O Tiber, what obsequies you shall see One day as you glide past the new-built mausoleum! No lad of the Trojan line shall with such hopeful

promise

Exalt his Latin forebears, nor shall the land of Romulus Ever again be so proud of one she has given birth to.

Alas for the sense of duty, the old-time honor! Alas for The hand unvanquished in war! Him would no foe have met

- In battle and not rued it, whether he charged on foot Or drove his lathering steed with spurs against the
- enemy.

Alas, poor youth! If only you could escape your harsh fate!

Marcellus you shall be. Give me armfuls of lilies

That I may scatter their shining blooms and shower these gifts

At least upon the dear soul, all to no purpose though Such kindness be.

So far and wide, surveying all,

They wandered through that region, those broad and hazy plains.

After Anchises had shown his son over the whole place And fired his heart with passion for the great things to come.

He told the hero of wars he would have to fight one day, 140 Told of the Laurentines and the city of Latinus, And how to evade, or endure, each crisis upon his way.

There are two gates of Sleep: the one is made of horn, They say, and affords the outlet for genuine apparitions: The other's gate of brightly-shining ivory; this way The Shades send up to earth false dreams that impose upon us.

- Talking, then, of such matters, Anchises escorted his son And the Sibyl as far as the ivory gate and sent them through it.
- Aeneas made his way back to the ships and his friends with all speed,

Then coasted along direct to the harbor of Caieta. The ships, anchored by the bows, line the shore with their sterns.

HORACE

100

110

130

SELECTED ODES

Horace's poetry addresses a wide range of subjects: love, friendship, the inevitable approach of old age, political issues of his times, famous episodes in Roman history. The selection below illustrates a number of these.

The first evokes various pleasures: the beauty of nature, companionable drinking, romantic assignations. The wistful note of the uncertainty of life and the all-too-certain coming of old age, is utterly characteristic of Horace's view of the world. The second invites Maecenas, his friend and patron, to dinner. Maecenas, who oversaw Augustus' cultural program, had just recovered from an illness. The opening line of the third expresses another familiar Horatian theme, while the next poem shows Horace at his most despondent. Yet, as the last reminds us, the poet may die but his poems will live on. Few have described art's ability to transcend death more gloriously.

Book I, ix

Look how the snow lies deeply on glittering Soracte. White woods groan and protestingly Let fall their branch-loads. Bitter frost has Paralyzed rivers: the ice is solid.

Unfreeze the cold! Pile plenty of logs in the Fireplace! And you, dear friend Thaliarchus, come, Bring out the Sabine wine-jar four years Old and be generous. Let the good gods

Take care of all else. Later, as soon as they've Calmed down this contestation of winds upon Churned seas, the old ash-trees can rest in Peace and the cypresses stand unshaken.

Try not to guess what lies in the future, but, As Fortune deals days, enter them into your Life's book as windfalls, credit items,

Gratefully. Now that you're young, and peevish

Grey hairs are still far distant, attend to the Dance-floor, the heart's sweet longings; for now is the Right time for midnight assignations, Whispers and murmurs in Rome's piazzas

And fields, and soft, low laughter that gives away The girl who plays love's games in a hiding-place— Off comes a ring coaxed down an arm or Pulled from a faintly resisting finger.

Book I, xx

My dear Maecenas, noble knight, You'll drink cheap Sabine here tonight From common cups. Yet I myself Sealed it and stored it on the shelf

20

10

In a Greek jar that day the applause Broke out in your recovery's cause, So that the compliment resounded Through the full theater and rebounded From your own Tiber's banks until The echo laughed on Vatican hill. At your house you enjoy the best— Caecuban or the grape that's pressed At Cales. But whoever hopes My cups will taste of Formian slopes Or of the true Falernian Must leave a disappointed man.

Book II, iii

Maintain an unmoved poise in adversity; Likewise in luck one free of extravagant Joy. Bear in mind my admonition, Dellius. Whether you pass a lifetime

Prostrate with gloom, or whether you celebrate Feast-days with choice old brands of Falernian Stretched out in some green, unfrequented Meadow, remember your death is certain.

For whom but us do silvery poplar and

Tall pine conspire such welcome with shadowy Laced boughs? Why else should eager water Bustle and fret in its zigzag channel?

Come, bid them bring wine, perfume and beautiful Rose-blooms that die too swiftly: be quick while the Dark threads the three grim Sisters weave still Hold and your years and the times allow it.

Soon farewell town house, country estate by the Brown Tiber washed, chain-acres of pasture-land, Farewell the sky-high piles of treasure Left with the rest for an heir's enjoyment.

Rich man or poor man, scion of Inachus Or beggar wretch lodged naked and suffering God's skies—it's all one. You and I are Victims of never-relenting Orcus,

Sheep driven deathward. Sooner or later Fate's Urn shakes, the lot comes leaping for each of us And books a one-way berth in Charon's Boat on the journey to endless exile.

Book II, xiv

Ah, how they glide by, Postumus, Postumus, The years, the swift years! Wrinkles and imminent Old age and death, whom no one conquers— Piety cannot delay their onward

March; no, my friend, not were you to sacrifice Three hundred bulls each day to inflexible Pluto, whose grim moat holds the triple Geryon jailed with his fellow Giants—

Death's lake that all we sons of mortality Who have the good earth's fruits for the picking are Foredoomed to cross, no matter whether Rulers of kingdoms or needy peasants.

In vain we stay unscratched by the bloody wars, In vain escape tumultuous Hadria's

Storm-waves, in vain each autumn dread the Southern sirocco, our health's destroyer.

We must at last set eyes on the scenery Of Hell: the ill-famed daughters of Danaus, Cocytus' dark, slow, winding river, Sisyphus damned to his endless labor.

Farewell to lands, home, dear and affectionate Wife then. Of all those trees that you tended well Not one, a true friend, save the hated Cypress shall follow its short-lived master.

An heir shall drain those cellars of Caecuban You treble-locked (indeed he deserves it more) And drench the stone-flagged floor with prouder Wine than is drunk at the pontiffs' banquet.

Book III, xxx

More durable than bronze, higher than Pharaoh's Pyramids is the monument I have made, A shape that angry wind or hungry rain Cannot demolish, nor the innumerable Ranks of the years that march in centuries. I shall not wholly die: some part of me Will cheat the goddess of death, for while High Priest And Vestal climb our Capitol in a hush, My reputation shall keep green and growing. Where Aufidus growls torrentially, where once, Lord of a dry kingdom, Daunus ruled His rustic people, I shall be renowned As one who, poor-born, rose and pioneered A way to fit Greek rhythms to our tongue. Be proud, Melpomene, for you deserve What praise I have, and unreluctantly Garland my forehead with Apollo's laurel.

20 JUVENAL

from the THIRD SATIRE

Juvenal tells us at the beginning of his First Satire that he turned to writing out of fierce outrage at the corruption and decadence of his day. In the Third Satire he takes on Rome itself and the inconveniences (to say the least) of urban life. An imaginary friend has decided that he no longer can stand life in the big city and, as he leaves for the country (symbolized in the first lines of this passage by small towns such as Praeneste and Gabii), he catalogues some of the reasons for his departure.

"Who, in Praeneste's cool, or the wooded Volsinian uplands,

Who, on Tivoli's heights, or a small town like Gabii, say, Fears the collapse of his house? But Rome is supported

on pipestems, Matchsticks; it's cheaper, so, for the landlord to shore up his ruins,

Patch up the old cracked walls, and notify all the tenants They can sleep secure, though the beams are in ruins above them.

No, the place to live is out there, where no cry of *Fire!* Sounds the alarm of the night, with a neighbor yelling for water,

- Moving his chattels and goods, and the whole third story is smoking.
- This you'll never know: for if the ground floor is scared first,
- You are the last to burn, up there where the eaves of the attic

10

10

10

10

Keep off the rain, and the doves are brooding their nest eggs. . . .

"Here in town the sick die from insomnia mostly. Undigested food, on a stomach burning with ulcers, Brings on listlessness, but who can sleep in a flophouse? Who but the rich can afford sleep and a garden

apartment?

That's the source of infection. The wheels creak by on the narrow

- Streets of the wards, the drivers squabble and brawl when they're stopped,
- More than enough to frustrate the drowsiest son of a sea cow.
- When his business calls, the crowd makes way, as the rich man,
- Carried high in his car, rides over them, reading or writing,
- Even taking a snooze, perhaps, for the motion's composing.
- Still, he gets where he wants before we do; for all of our hurry

Traffic gets in our way, in front, around and behind us.

- Somebody gives me a shove with an elbow, or two-byfour scantling.
- One clunks my head with a beam, another cracks down with a beer keg.
- Mud is thick on my shins, I am trampled by somebody's big feet.
- Now what?—a soldier grinds his hobnails into my toes. "Don't you see the mob rushing along to the handout?
- There are a hundred guests, each one with his kitchen servant.
- Even Samson himself could hardly carry those burdens,

Pots and pans some poor little slave tries to keep on his head, while he hurries

Hoping to keep the fire alive by the wind of his running. Tunics, new-darned, are ripped to shreds; there's the

- flash of a fir beam Huge on some great dray, and another carries a pine tree,
- Nodding above our heads and threatening death to the people.
- What will be left of the mob, if that cart of Ligurian marble

Breaks its axle down and dumps its load on these swarms?

Who will identify limbs or bones? The poor man's cadaver,

- Crushed, disappears like his breath. And meanwhile, at home, his household
- Washes the dishes, and puffs up the fire, with all kinds of clatter
- Over the smeared flesh-scrapers, the asks of oil, and the towels.

So the boys rush around, while their late master is sitting, Newly come to the bank of the Styx, afraid of the filthy Ferryman there, since he has no fare, not even a copper In his dead mouth to pay for the ride through that

muddy whirlpool.

"Look at other things, the various dangers of nighttime.

- How high it is to the cornice that breaks, and a chunk beats my brains out,
- Or some slob heaves a jar, broken or cracked, from a window.
- Bang! It comes down with a crash and proves its weight on the sidewalk.

- You are a thoughtless fool, unmindful of sudden disaster, If you don't make your will before you go out to have dinner.
- There are as many deaths in the night as there are open windows
- Where you pass by; if you're wise, you will pray, in your wretched devotions,
- People may be content with no more than emptying slop jars."

MARCUS AURELIUS ANTONINUS from The Meditations, Book II (COMPLETE)

20

30

40

50

The Meditations of Marcus Aurelius, written in Greek, consist of a philosophical journal or diary, in which the emperor recorded his reflections and observations. Some parts were carefully composed; elsewhere he jotted down a few words or a quotation. Ideas were recorded in no logical order and Marcus Aurelius contradicted himself in places—or at least changed his mind. The chief theme of the Meditations is that of self-examination and the search for spiritual happiness, inspired by the teachings of Stoicism.

The tone of the book is not a happy one, and in places the emperor seems to come close to despair. Yet it is inspiring to share the thoughts of a man of high responsibilities and even higher ideals. Furthermore, on page after page we find observations that transcend Marcus Aurelius' historical period and remind us of the universality of human experience by their relevance to our own lives.

1. Say to yourself in the morning: I shall meet people who are interfering, ungracious, insolent, full of guile, deceitful and antisocial; they have all become like that because they have no understanding of good and evil. But I who have contemplated the essential beauty of good and the essential ugliness of evil, who know that the nature of the wrongdoer is of one kin with mine-not indeed of the same blood or seed but sharing the same mind, the same portion of the divine—I cannot be harmed by any one of them, and no one can involve me in shame. I cannot feel anger against him who is of my kin, nor hate him. We were born to labor together, like the feet, the hands, the eyes, and the rows of upper and lower teeth. To work against one another is therefore contrary to nature, and to be angry against a man or turn one's back on him is to work against him.

2. Whatever it is which I am, it is flesh, breath of life, and directing mind. The flesh you should despise: blood, bones and a network woven of nerves, veins and arteries. Consider too the nature of the life-breath: wind, never the same, but disgorged and then again gulped in, continually. The third part is the directing mind. Throw away your books, be no longer anxious: that was not your given role. Rather reflect thus as if death were now before you: "You are an old man, let this third part be enslaved no longer, nor be a mere puppet on the strings of selfish desire; no longer let it be vexed by your past or present lot, or peer suspiciously into the future."

3. The works of the gods are full of Providence. The works of Chance are not divorced from Nature or from the spinning and weaving together of those things which are governed by Providence. Thence everything flows. There is also Necessity and what is beneficial to the whole ordered universe of which you are a part. That which is brought by the nature of the Whole, and preserves it, is good for every part. As do changes in the elements, so changes in their compounds preserve the ordered universe. That should be enough for you, these should ever be your beliefs. Cast out the thirst for books that you may not die growling, but with true graciousness, and grateful to the gods from the heart.

- 4. Remember how long you delayed, how often the gods have appointed the day of your redemption and you have let it pass. Now, if ever, you must realize of what kind of ordered universe you are a part, of what kind of governor of that universe you are an emanation, that a time limit has now been set for you and that if you do not use it to come out into the light, it will be lost, and you will be lost, and there will be no further opportunity.
- 5. Firmly, as a Roman and a man should, think at all times how you can perform the task at hand with precise and genuine dignity, sympathy, independence, and justice, making yourself free from all other preoccupations. This you will achieve if you perform every action as if it was the last of your life, if you rid yourself of all aimless thoughts, of all emotional opposition to the dictates of reason, of all pretense, selfishness and displeasure with your lot. You see how few are the things a man must overcome to enable him to live a smoothly flowing and godly life; for even the gods will require nothing further from the man who keeps to these beliefs.
- 6. You shame yourself, my soul, you shame yourself, and you will have no further opportunity to respect yourself; the life of every man is short and yours is almost finished while you do not respect yourself but allow your happiness to depend upon the souls of others.
- 7. Do external circumstances to some extent distract you? Give yourself leisure to acquire some further good knowledge and cease to wander aimlessly. Then one must guard against another kind of wandering, for those who are exhausted by life, and have no aim at which to direct every impulse and generally every impression, are foolish in their deeds as well as in their words.
- A man is not easily found to be unhappy because he takes no thought for what happens in the soul of another; it is those who do not attend to the disturbances of their own soul who are inevitably in a state of unhappiness.
- 9. Always keep this thought in mind: what is the essential nature of the universe and what is my own essential nature? How is the one related to the other, being so small a part of so great a Whole? And remember that no one can prevent your deeds and your words being in accord with nature.
- 10. Theophrastus speaks as a philosopher when, in comparing sins as a man commonly might, he states that offenses due to desire are worse than those due to anger, for the angry man appears to be in the grip of pain and hidden pangs when he discards Reason, whereas he who sins through desire, being overcome by pleasure, seems more licentious and more effeminate in his wrongdoing. So Theophrastus is right, and speaks in a manner worthy of philosophy, when he says that one who sins through pleasure deserves more blame than one who sins through pain. The latter is more like a man who was wronged first and compelled by pain to anger; the former starts on the path to sin of his own accord, driven to action by desire.
- It is possible to depart from life at this moment. Have this thought in mind whenever you act, speak, or think.

There is nothing terrible in leaving the company of men, if the gods exist, for they would not involve you in evil. If, on the other hand, they do not exist or do not concern themselves with human affairs, then what is life to me in a universe devoid of gods or of Providence? But they do exist and do care for humanity, and have put it altogether within a man's power not to fall into real evils. And if anything else were evil they would have seen to it that it be in every man's power not to fall into it. As for that which does not make a man worse, how could it make the life of man worse?

Neither through ignorance nor with knowledge could the nature of the Whole have neglected to guard against this or correct it; nor through lack of power or skill could it have committed so great a wrong, namely that good and evil should come to the good and the evil alike, and at random. True, death and life, good and ill repute, toil and pleasure, wealth and poverty, being neither good nor bad, come to the good and the bad equally. They are therefore neither blessings nor evils.

12. How swiftly all things vanish; in the universe the bodies themselves, and in time the memories of them. Of what kind are all the objects of sense, especially those which entice us by means of pleasure, frighten us by means of pain, or are shouted about in vainglory; how cheap they are, how contemptible, sordid, corruptible and dead — upon this our intellectual faculty should fix its attention. Who are these men whose voice and judgment make or break reputations? What is the nature of death? When a man examines it in itself, and with his share of intelligence dissolves the imaginings which cling to it, he conceives it to be no other than a function of nature, and to fear a natural function is to be only a child. Death is not only a function of nature but beneficial to it.

How does man reach god, with what part of himself, and in what condition must that part be?

- 13. Nothing is more wretched than the man who runs around in circles busying himself with all kinds of things—investigating things below the earth, as the saying goes—always looking for signs of what his neighbors are feeling and thinking. He does not realize that it is enough to be concerned with the spirit within oneself and genuinely to serve it. This service consists in keeping it free from passions, aimlessness, and discontent with its fate at the hands of gods and men. What comes from the gods must be revered because of their goodness; what comes from men must be welcomed because of our kinship, although sometimes these things are also pitiful in a sense, because of men's ignorance of good and evil, which is no less a disability than to be unable to distinguish between black and white.
- 14. Even if you were to live three thousand years or three times ten thousand, remember nevertheless that no one can shed another life than this which he is living, nor live another life than this which he is shedding, so that the longest and the shortest life come to the same thing. The present is equal for all, and that which is being lost is equal, and that which is being shed is thus shown to be but a moment. No one can shed that which is past, nor what is still to come; for how could he be deprived of what he does not possess?

Therefore remember these two things always: first, that all things as they come round again have been the same from eternity, and it makes no difference whether you see the same things for a hundred years, or for two hundred years, or for an infinite time; second, that the longest-lived or the shortest-lived sheds the same thing at death, for it is the present moment only of which he will be deprived, if indeed only the present moment is his, and no man can discard what he does not have.

- 15. "All is but thinking so." The retort to the saying of Monimus the Cynic is obvious, but the usefulness of the saying is also obvious, if one accepts the essential meaning of it insofar as it is true.
- 16. The human soul violates itself most of all when it becomes, as far as it can, a separate tumor or growth upon the universe; for to be discontented with anything that happens is to rebel against that Nature which embraces, in some part of itself, all other natures. The soul violates itself also whenever it turns away from a man and opposes him to do him harm, as do the souls of angry men; thirdly, whenever it is overcome by pleasure or pain; fourthly, whenever it acts a part and does or says anything falsely and hypocritically; fifthly, when it fails to direct any action or impulse to a goal, but acts at random, without purpose, whereas even the most trifling actions must be directed toward the end; and this end, for reasonable creatures, is to follow the reason and the

law of the most honored commonwealth and constitution.

17. In human life time is but a point, reality a flux, perception indistinct, the composition of the body subject to easy corruption, the soul a spinning top, fortune hard to make out, fame confused. To put it briefly: physical things are but a owing stream, things of the soul dreams and vanity; life is but a struggle and the visit to a strange land, posthumous fame but a forgetting.

What then can help us on our way? One thing only: philosophy. This consists in guarding our inner spirit inviolate and unharmed, stronger than pleasures and pains, never acting aimlessly, falsely or hypocritically, independent of the actions or inaction of others, accepting all that happens or is given as coming from whence one came oneself, and at all times awaiting death with contented mind as being only the release of the elements of which every creature is composed. If it is nothing fearful for the elements themselves that one should continually change into another, why should anyone look with suspicion upon the change and dissolution of all things? For this is in accord with nature, and nothing evil is in accord with nature.

	GENERAL EVENTS	LITERATURE & PHILOSOPHY	ART & ARCHITECTURE
		INDIA	
INDUS VALLEY CIVILIZATION	300–1700 в.с.е. Sites occupied at Harappa and Mohenjo-daro	Development of written language based on picture signs	Stone and ceramic remains Public buildings of fired brick Communal drainage system
00 B.C.E.	1700–500 B.C.E. Aryan Invasion	First evidence of the Sanskrit language Vedic tradition evolves	Bronze work
200 в.с.е.		1000 B.C.E. The <i>Vedas</i> committed to writing	
в.с.	 326 B.C.E. Invasion of Alexander the Great Life of Siddartha Gautama, who becomes known as the Buddha (c. 563–483) 261 B.C.E. Emperor Ashoka unifies India, making Buddhism the official state religion 	<i>Upanishads</i> develop <i>Mahabharata,</i> including the <i>Baghavad-Gita,</i> is written	Large scale sculpture and architecture begins to appear
A.D. 200 A.D.			
400 A.D.	 320-500 A.D. Founding of the Gupta Empire Indian development of "Arabic" numerals Use of decimal and zero developed 480-500 A.D. Invasion of the White 	Kalidasa, Sakuntala; Sudraka, The Little Clay Cart	Temples of Khajuraho
600 A.D.	Huns		

CHAPTER 5 Ancient Civilizations of India and China

GENERAL EVENTS

LITERATURE & PHILOSOPHY ART & ARCHITECTURE

C hina

Bronze works

1600-1100 B.C.E. Shang Dynasty

System of writing based on picture signs evolves

II00-22I B.C.E. Chou Dynasty

Lao-Tzu (c. 570 B.C.)

Life of Confucius (c. 551-479 B.C.)

403–221 B.C.E. Period of the Warring States

221–210 в.с.е. Ch'in Dynasty (c. 221 в.с.–210 в.с.)

Shih Huang-ti ("First Emperor") conquers all rivals in China

202 B.C.-A.D. 220 Han Dynasty

Kao-tsu, the first Han Emperor restores a degree of order after Shih Hung-ti's death **403–221 B.C.E.** *Tao te ching* written c. 3rd century B.C.

Five Classics and the Classic of Songs

circulate

Buddhist writings, *Mahayana* and *Hinayana*, circulate

The Great Wall; the First Emperor connects existing structures to create the Great Wall and prepares an elaborate tomb

618–906 A.D. T'ang Dynasty

Beginning of China's Golden Age

Li Po, best-known Chinese poet (701–762)

Monumental shrines to Buddha reflect the influence of similar Indian works

CHAPTER 5 ANCIENT CIVILIZATIONS OF INDIA AND CHINA

INDIAN CIVILIZATION

The Indus Valley Civilization

n what is present-day Pakistan there once existed, three thousand years before the common era (B.C.E.), a culture that had two large centers at Harappa and Mohenjo-daro. What we know of these people can be told only by a reading of the archaeological evidence and that evidence, is only imperfectly understood. They possessed a written language based on picture signs, but that language has yet to be deciphered. At Mohenjodaro, scholars have uncovered a vast assembly hall, a large bath, and other public buildings all made from fired brick. Despite such urban centers, the Indus Valley dwellers were an agriculture-based society. It is believed that they were the first people to cultivate cotton.

Harappa

Mohenjo-daro

From their seal stones and other art works recovered from excavations they seem to have had an intense interest (possibly religious) in the figure of the bull, but no direct link between their bull cult and that of the Minoans—who had a similar cult—has been established. Although there is much evidence of a highly developed religious life (based mainly on stone and ceramic remains) there is no clear evidence as to what that religion entailed [5.1]. Other archaeological evidence suggests that there was some centralization in their culture since they used standard weights and measures for trading purposes, and had communal drainage systems as well as ways of distributing goods (mainly pottery).

Around 1700 B.C. the Indus Valley culture, as this complex civilization is known, began to go into decline as the area was struck by series of floods and through the exhaustion of the soil as well as the overuse of the wood-lands. To these ecological disasters, apparent in the archaeological record, was added a new threat: a series of invasions from the Northwest by a people called the *Aryans*. The decline of the older Indus Valley culture was so complete that archaeologists have failed to find any significant art works from the period of decline until the later emergence of Buddhist culture.

THE ARYANS

The Aryan people settled in the Indus Valley by around 1500 B.C., but who they were and where they came from is not at all clear. Some scholars point to the Russian steppes, but the picture of their migration into the subcontinent of India is not completely understood. The material evidence mapping the spread of the Aryan peoples is at best spotty. What we do know (mainly by reading back into their history from texts written at a later time) is that they spoke the language we call *Sanskrit*. That language groups and as such is the ancestor of Latin and the other Romance languages. A few examples might help to see how words evolved as Sanskrit words developed in Latin and then were borrowed as English words.

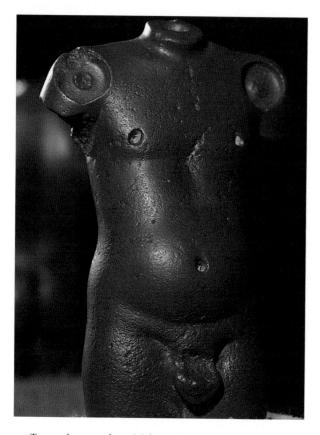

5.1 Torso of a man from Mohenjo-daro, third millennium B.C. Red stone. National Museum, New Delhi.

Sanskrit

yoga (yoke for an animal; later: discipline)—*jugum* (Latin: yoke)—*yoke* (English)

Agni (God of fire)—*ignis* (Latin: fire)—*ignition* (English)

The Aryans brought with them a culture that made a class distinction between the *nobility* and the commonality (common people). Over a long period of time, this distinction developed into a *caste system* which divided all of society into the castes of the priesthood, the warriors, the laborers, and the serfs. The development of the caste system in India underwent many changes over the millennia so that today the caste system recognizes the priests, warriors and rulers, merchants, and laborers with a subgroup simply known as *outcasts* (the unclean ones). Within the large groupings there are many subcastes. The caste system was one of the shaping social forces in India reinforced by many laws concerning marriage, table exclusion (who could eat with whom), laws of ritual purity, and so on.

Aryan culture mixed agricultural and pastoral culture with cattle, serving as a medium of trade, functioning almost like a currency. The horse was also known, but served mainly as an instrument of the warrior caste where the use of the chariot was common. Horses were so important for the warriors that some of the earliest hymns speak of rare but highly important horse rituals including horse sacrifices. While settled agriculture was common enough it was not considered as prestigious as cattle raising. The Aryan people also possessed high technical skills with evidence indicating that they had a keen sense of technology for bronze work. The early Aryans did not found great city centers; they were more tribal in their structure but aggressive in their growth. Over the centuries they would migrate from their strongholds in the Northwest of the subcontinent into the southern reaches of India. The great epic poems of India like the Ramayana and the Mahabharata, written centuries after the events they purport to describe, reflect the warring period when the Aryans subdued the Indus Valley dwellers. These epics—with their complex story lines of gods, heroes, and battles—are central to Indian culture; their dramatization on Indian television has proved to be one of the most popular shows among all classes of people in India.

Mahabharata

Most characteristic of Aryan culture was its elaborate religious system that placed enormous emphasis on ritual sacrifice to the pantheon of gods. The fact that the priests had the highest place in the caste system was due to their responsibility in the carrying out of the religious ceremonies in honor of the gods. Highly complex in its detail, the rituals had to be carried out exactly according to tradition in order for the ceremonies to attain their goal, for example, the fertility of the soil, the arrival of the rains, and so on. These ceremonies and their companions-hymns and gestures-were passed from one generation of hereditary priests to the next in a fixed oral form. It was only around the year 1000 B.C. that these texts were committed to writing in a slow compilation which is now know as the Vedas, with the best known of these compilations called the Rig Veda. The Vedas represent the oldest strain of Indian religious literature and are still chanted by Hindus at all important moments in Indian religious life: at birth, naming ceremonies, rites of

passage to adulthood, in sickness, and at death. They also form the core text of Hindu temple worship. The *Vedas*, in fact, represent one of the oldest bodies of religious writings known to humanity.

Rig Veda

Shortly after the composition of the *Rig Veda* a new kind of literature came into being. The sages of India were interested in the large questions of what we would call philosophical issues, for example: What caused the cosmos to be? How did human beings arise? Why is human life short? Why do people suffer? What is the deep meaning behind the priestly rituals and sacrifices? The responses to those and similar questions are treated in a series of classical Indian texts known as the *Upanishads* (meaning a "session"; i.e., from a learned person). We possess over one hundred upanishadic texts which vary in length and sophistication. Some deal with the allegorical meaning of ritual, while others are more philosophical in nature.

The fundamental worldview of the *Upanishads* may be stated briefly. The ultimate reality is an impersonal reality called *Brahman*. Everything else is a manifestation of this underlying reality. Each individual person has within the self *Brahman*, which, in a person, is called *Atman*. The secret of life is to come to the knowledge that *Brahman* is the ultimate reality (i.e., one's inner self is part of this fundamental reality) and everything else is, in a certain fashion, permeable and "unreal." This fundamental assertion is summed up in a classical Sanskrit expression *Tat tvam asi:* "you (the individual) are that (the eternal essence or Brahman)."

Indian religion, later called the Hindu religion (derived from an Arabic word meaning "those who live in the Indus Valley"), combined, then, a highly ritualized worship of the gods of the pantheon (many believe these gods are merely faces or names for the ultimate reality) with a strong speculative tradition that tries to grasp the ultimate meaning of the cosmos and those who live in it. Indian religion, in short, is both a religion of the priest and the temple as well as the religion of solitary meditation and study. Most Indian homes to this day will have a small altar for a god or goddess in order for the family to show respect and worship (called *puja*) in the home. The fundamental aim of Indian religion, however, is to find the path that leads one to the correct knowledge of ultimate reality which, when known, leads one to be liberated from the illusory world of empirical reality and be absorbed into the one true reality, Brahman.

Broadly speaking, three paths have been proposed for attaining such knowledge. These paths are: (1) The path

Hinduism

or discipline (i.e., yoga) of asceticism (fasting, nonpossession, bodily discipline, etc.) by which one lives so that the material world becomes accidental and that person becomes enlightened. This is the hardest path of all which, if at all undertaken, usually comes after one has had a normal life as a householder. (2) The path or discipline of *karma* in which one does one's duty according to one's caste obligations (e.g., priests should sacrifice; warriors fight, etc.) and not out of greed or ambition motives that cloud the mind. (3) The path of devotion in which all people refer all of their deeds as an act of devotion (*bhakti*) to the gods or to the one god to whom a person has a special devotion. By doing everything out of devotion one does not fall into the trap of greed or selfcenteredness.

Buddha

Buddha

It is into this highly complex world of the Indian subcontinent that the person who came to be called Buddha (meaning "the enlightened one"; it is a title not a personal name) was born. Because biographies of Buddha were written several centuries after his death, his story is somewhat clouded by myths. The main lines, however, seem to be reasonably clear. His given name was Siddhartha and his family name was Gautama. He was born around 563 B.C. into the family of a king who belonged to the warrior caste in the foothills of the Himalayas in what is present-day Nepal. Raised in luxury, he married young and fathered a son. When he was not yet thirty he traveled outside his palatial quarters and saw enough suffering (beggars, a corpse, a sick person and a wandering, begging ascetic) to wonder about the inescapability of suffering and death. Leaving his family, he took up a wandering life as an ascetic practitioner of meditation and self-denial. According to Buddhist tradition, he visited learned men, undertook meditation, and practiced fasting and self-deprivation. At age thirty-five, frustrated by his lack of insight, he decided to sit under the shade of a tree until he intuited the truth about existence. At the climax of this long vigil he received the illumination that caused him to be called the Enlightened One (Buddha). He left his spot and went to the Deer Park at Sarnath

CONTEMPORARY VOICES

War and Religion in the Age of Ashoka

Ashoka's intrinsic tolerance emerges in this extract from his Rock Edict XII:

His Sacred and Gracious Majesty does reverence to men of all sects, whether ascetics or householders, by gifts and various forms of reverence. His Sacred Majesty, however, cares not so much for gifts or external reverence as that there should be a growth of the essence of matter in all sects. The root of this is restraint of speech; to wit, a man must not do reverence to his own sect by disparaging that of another man without reason. Concord, therefore, is meritorious; to wit, hearkening, and hearkening willingly to the law of piety as accepted by other people. For it is the desire of his Sacred Majesty that adherents of all sects should hear much teaching and hold sound doctrine.

In his Rock Edict XIII, the king describes his attitude to war:

This pious edict has been written in order that my sons and grandsons, who may be, should not regard it as their duty to conquer a new conquest. If, perchance, they become engaged in a new conquest by arms, they should take pleasure in patience and gentleness, and regard the only true conquest the conquest won by piety. That avails for both this world and the next.

near what is present-day Benares (Varanasi) to teach his new doctrine. It was there that he preached his famous first sermon outlining the "Middle Way" between extreme asceticism and self-indulgence. Buddha's doctrine has been called the "Fourfold Noble Path":

Fourfold Noble Path

- 1. existence itself is suffering;
- 2. suffering comes from craving and attachment;
- 3. there exists a cessation of suffering, which is called *nirvana;* and
- 4. there is a path to nirvana, which is eightfold.

The eightfold path can be summarized as a "way of life," which derives from the following: right views, right resolve, right speech, right action, right livelihood, right effort, right mindfulness, and right concentration. When these eight basic dispositions are lived correctly, one then might escape the never-ending cycle of rebirth and find nirvana. The specific character of this eightfold disposition would emphasize ethical living, awareness of who one is and what one does; nonviolence (*ahimsa*); temperance in dealing with material realities; erasure of impulses to greed, acquisition, sensual living, and so on. This kind of life leads a person to understand the passing reality in which people are enmeshed and thus find liberation.

Eightfold Path

Like its parent religion, Buddhism preaches liberation through knowledge. The typical figures that represent Buddha makes the point forcefully: Buddha sits in a meditative position with eyes half closed and a half smile on his face because he has discovered within himself the ultimate truth, which has enlightened him. Buddha does not look up to the heavens to a god or kneel in worship. Truth comes from within.

The Emperor Ashoka

When Buddha died in 483 B.C., his religious tradition was just one of many that circulated within India even though it had its own growth and the accumulation of a religious tradition based on Buddha's teaching. That situation was to change through the efforts of perhaps the greatest emperor of ancient India: Ashoka. He was a superb and ruthless ruler who unified all of India (including such faraway places as Afghanistan and Baluchistan) around 261 B.C. However, Ashoka was appalled by the suffering and bloodshed he had caused in this enterprise. Out of remorse, he converted from traditional Brahmanism to Buddhism and, out of his Buddhist conviction, began to preach the doctrine of nonviolence in his empire. Although tolerant of all religious traditions, he established Buddhism as the religion of the state. He mitigated the harsh laws of the empire, regulated the slaughter of animals, founded and sustained Buddhist

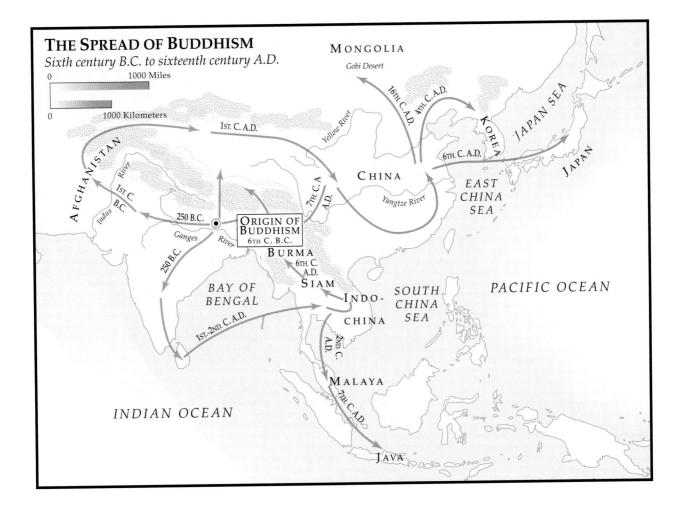

monasteries (called *sanghas*) and erected many *stupas* those characteristic towers which one finds in Buddhists lands. They may serve as reliquaries for Buddha or a repository of Buddhists texts but symbolically they represent the enlightenment of the Buddha. In addition, Ashoka erected pillars and towers with his decrees carved on them, some of which exist to this day. Finally, Ashoka is credited with calling a vast Buddhist convocation to fix the canon of sacred books for Buddhism; that is, the authoritative list of writings that are the measure (canon) of Buddhist belief and practice.

Perhaps the most important thing that Ashoka did was to send Buddhist monks as missionaries to all parts of India and to other countries to share Buddhist wisdom. There is evidence that his missionaries went as far as Syria, Egypt, and Greece. One of his most important missions was the sending of a blood relative (perhaps a son or a brother) to Ceylon (present-day Sri Lanka) where the Buddhist doctrine took root and then spread to other parts of Southeast Asia (see map). Although Buddhism—like all of the major religions of the world has a variety of forms and quite different cultural expressions, at its core is the code enshrined in the Buddha's "Four Noble Truths." It is one of the small ironies of history that Ashoka, the emperor of all of India, spread Buddhism all over the East, while in his native India, Buddhism would shrink in time to a small minority which is the situation at present.

HINDU AND BUDDHIST ART

There is little evidence for artistic production in the period following the disappearance of the Indus Valley people. Only with the reign of Ashoka does a tradition of large-scale sculpture and architecture begin to appear, probably influenced by developments to the west, in Persia. Thus, the earliest monumental Indian sculpture, a column crowned with lions [5.2], which comes from one of his palaces, resembles similar column decorations found at Persepolis, the capital of Persia.

Both Hindu and Buddhist art are overwhelmingly religious in spirit. The great statues and sculptural reliefs that decorate the temples are narrative, telling the stories of the Hindu deities and the life of Buddha to their worshipers. The difference between the two styles of art

5.2 Lion capital, from a column erected by King Ashoka, 242–232 B.C. Height 7' (2.1 m).

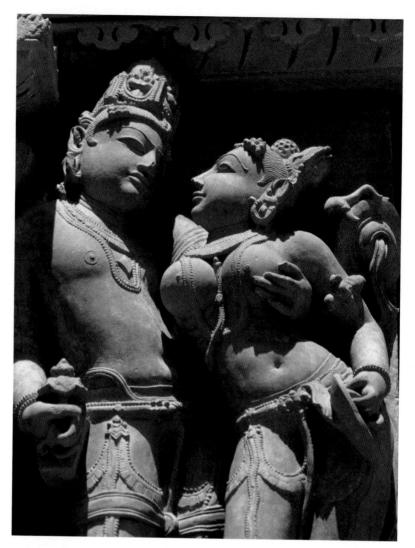

5.3 Detail from sculptured frieze showing erotic scene on a temple at Khajuraho, northern India.

reflects the differing characteristics of the two faiths. Much of Hindu art is openly erotic, reflecting the belief of pious Hindus that sexual union represents union with their gods [5.3]. Other works illustrate the Hindu sense of the unity of all forms of life. Thus, Vishnu—the supreme Hindu spirit—appears in a series of *avataras*, or incarnations, which include that of a boar, a fish, or a dwarf [5.4]. Over time, scenes from the *Mahabharata* and other great Hindu epics combined the elements of eroticism and naturalism. Figure 5.5 shows Krishna, the hero of the *Mahabharata*'s central section, the *Baghavad-Gita*, in a pleasant landscape where the birds in the trees are painted in detail [5.5].

By contrast, Buddhist art emphasizes the spiritual, even austere nature of Buddhist doctrines. Buddha and his many saints, the *Bodhisattvas*, are shown as calm, often transcendent images, inviting prayer and meditation [5.6]. Sometimes the Buddhist command to renounce all worldly pleasures becomes even more powerfully expressed, as in the image of the Fasting Buddha [5.7].

The Gupta Empire and Its Aftermath

In the years following the death of Ashoka, his empire began to fall apart, and a series of invaders from the north established small kingdoms in the Indus and Ganges valleys. These northerners never penetrated the southern regions, where numbers of small independent states flourished economically by trading with Southeast Asia and, to the west, with the expanding commercial power of the Roman Empire.

Only in A.D. 320 did Chandra Gupta I lay the foundations of a new large-scale kingdom, known as the *Gupta Empire*, which reached its zenith under his grandson, Chandra Gupta II (ruled A.D. c. 380–c. 415). Known as "The Sun of Power," Chandra Gupta's reign was famous for its cultural achievements, economic stability, and religious tolerance. As a Buddhist monk noted, "The people vie with each other in the practice of benevolence and

5.4 Wooden figure representing the *avatar* (incarnation) of the god Vishnu as the boar Varaha. Other incarnations include the fish (Matsya) and the dwarf (Vamena).

righteousness." In spite of this general tolerance, however, the Gupta period saw the rapid decline of Buddhism in India and a return to the traditions of Hinduism.

Gupta Empire

Gupta Literature and Science

Literary skills assumed vast importance at the Gupta court, where poets competed with one another to win fame. The language they used was ancient Sanskrit, that of the old Hindu Vedas, which served as the literary language of the period; it was no longer spoken by the general population. The most famous of all Indian Classical writers was Kalidasa (active c. 400), who wrote plays,

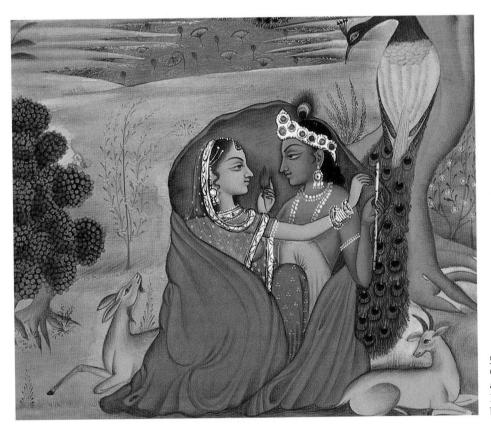

5.5 *Krishna and the Maiden in a Garden.* Painted illustration of a scene from the *Mahabharata.* Krishna is easily recognizable by the blue color of his skin.

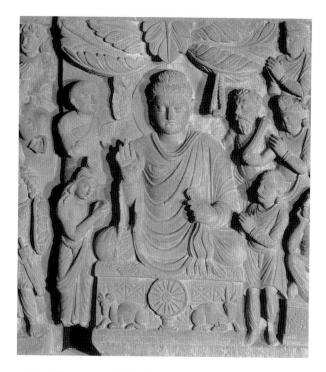

5.6 Buddha surrounded by devotees, second century A.D. Stone. Smithsonian Institution, Freer Gallery of Art, Washington, D.C.

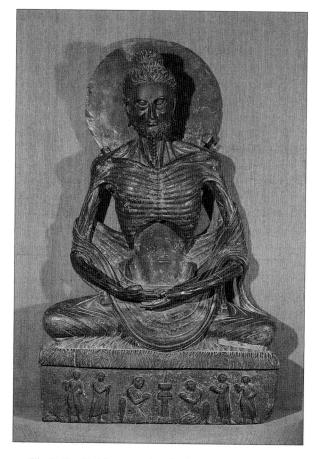

5.7 *The Fasting Buddha*, second or third century A.D. Stone. Central Museum, Lahore, Pakistan.

epics, and lyric poetry. His best-known work was the play *Sakuntala*, which describes the happy marriage of the beautiful Sakuntala to King Dusyanta, its collapse as a result of a curse pronounced by an irascible holy man, and the couple's eventual triumphant reunion. By contrast to the Classical dramas of the Greek tradition, with their analysis of profound moral dilemmas, Kalidasa's play has the spirit of a fairytale with a happy ending.

Sakuntala

The work of another author of the same period, Sudraka, is more realistic. Among the characters in his play *The Little Clay Cart* are a nobleman, a penniless Brahmin, a prostitute, and a thief, who at one point offers a vivid description of his technique of housebreaking.

Under the Guptas, many important scientific discoveries were made possible by the foundation of large universities. The most important, at Nalanda, had some five thousand students who came from various parts of Asia. Among the subjects taught were mechanics, medicine, and mathematics. In this latter field, Indian scholars continued to make important advances. The system of socalled Arabic numerals, which only became widespread in Western Europe in the Renaissance (A.D. fifteenth and sixteenth centuries), had first been invented in India in the late third century B.C. By the time of the Gupta Empire, Indian mathematicians were using a form of decimal, and it may have been at this time that the concept of the zero was first employed. Among their work in algebra were quadratic equations and the use of the square root of two.

The Collapse of Gupta Rule

The decline of the Gupta Empire, which began with the death of Chandra Gupta II, became headlong with a series of invasions around A.D. 480–500 by the White Huns, a people related to the Huns and other Central Asian tribes. Around the same time, other related tribes moved westward from Central Asia and sacked Rome in A.D. 476, thereby effectively ending the Roman Empire. The White Huns never managed to establish a secure power base in India, however, and over the following centuries innumerable local princely states fought both among themselves and against foreign invaders. In part, the difficulty in constructing a central government and a lasting peace was due to the powerful Hindu priestly

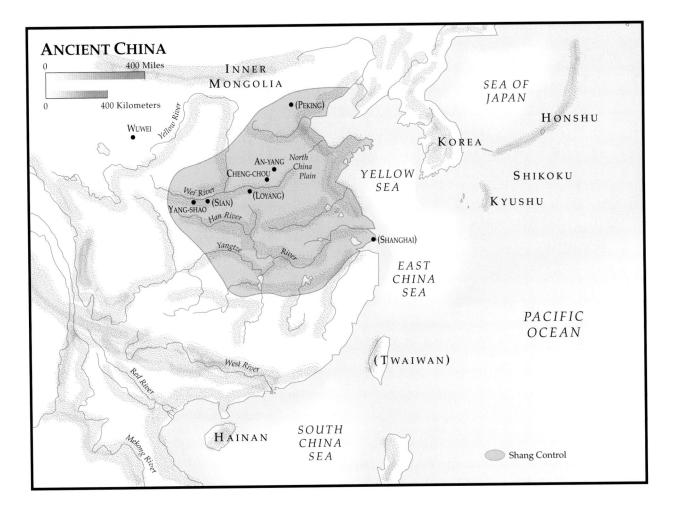

class, who were unwilling to surrender conflicting religious interests to an overall secular, political settlement. When a new united Indian Empire did begin to develop in the fifteenth and sixteenth centuries, its rulers were Muslim, not Hindu.

White Huns

THE ORIGINS OF CIVILIZATION IN CHINA

Although some of the earliest traces in history of human habitation settlements come from Northern China, urban life seems to have developed in China somewhat later than in Mesopotamia or Egypt. The earliest period for which we have secure evidence is that of the *Shang Dynasty* (c. 1600–1100 B.C.) (see map). Under Shang rulers, the Chinese began to work bronze, and many magnificent bronze sacrificial vessels—in a wide variety of shapes—demonstrate their creators' technical skill and artistic imagination [5.8]. Trade and commerce began to develop and, at the same time, the Chinese devised a system of writing, based—like the Egyptian hieroglyphs— on picture signs representing sounds or ideas.

The Chou Dynasty

Around 1100 B.C., a new dynasty replaced the Shang, known as the *Chou Dynasty* (c. 1100–c. 221 B.C.). The Chou rulers did not provide strong central government, but served as the coordinators of a series of separate kingdoms, each with its own local lord. The relationship of these local rulers with the Chou emperors was often unstable. In times of trouble they could supply the Chou with military aid, but frequently feuded with both the central authority and each other. Over time, Chou influence began to diminish, and the last period of their dynasty is known as the Period of the Warring States (403–221 B.C.). It was during these centuries of increasing crisis that the foundations of Chinese thought and culture were laid.

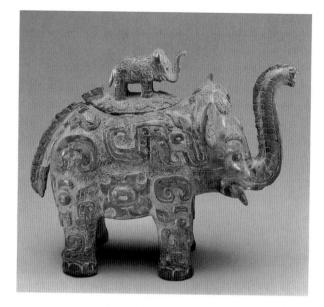

5.8 Ceremonial vessel in the form of an elephant, c. 1200 B.C. Bronze. Smithsonian Institution, Freer Gallery of Art, Washington D.C.

Confucianism and Taoism

The two chief schools of Chinese philosophy were founded by *Confucius* (c. 551–479 B.C.) and Lao-tzu (active c. 570 B.C.). Born in humble circumstances in central China at a time when local wars were raging, Confucius' chief aim was to restore the peace of earlier times by en-

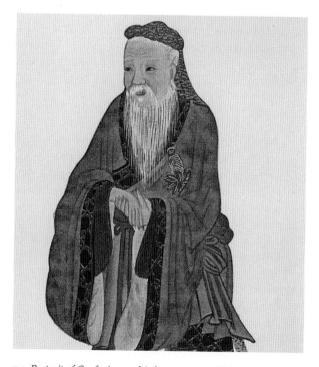

5.9 *Portrait of Confucius.* c. third century B.C. This image of Confucius is stylized rather than realistic.

couraging the wise and virtuous to enter government service. A state run by a wise ruling class, he believed, would produce similar characteristics in its people. To achieve this he traveled throughout China in search of pupils [5.9].

Confucius

According to the central dogma of Confucianism, the morally superior person should possess five inner virtues, and acquire another two external ones. The five with which each virtuous person is born are righteousness, inner integrity, love of humanity, altruism, and loyalty. Those with these natural gifts should also acquire culture (education) and a sense of decorum, or ritual. If individuals with these qualities served their rulers in government, they would be loyal and unconcerned with material rewards, yet fearlessly critical of their masters.

Traditional religion played no part in Confucius' teachings. He refused to speculate about the gods, or the possibility of life after death; he is said to have commented "Not yet understanding life, how can we understand death?" Confucius was a revolutionary figure in that he defended the rights of the people and believed that the state existed for the benefit of the people, rather than the reverse. At the same time, however, he strongly endorsed strict authority and discipline, both within the state and the individual family-devotion to parents, worship of ancestors, respect for elders, and loyalty to rulers were all crucial to the Confucian system. In the centuries following his death, many totalitarian regimes in China abused the innate conservatism of Confucius' teaching, using it to justify their assaults on the freedom of individuals.

If the central principle of Confucianism is the possibility of creating a new, virtuous social order, Taoism emphasized the limitations of human perceptions, and encouraged withdrawal and passivity. Its central concept is that of "the Way" (*tao*). According to this, one should follow one's own nature, not distinguishing between good and bad, but accepting both as part of "the Way." The traditional founder of this school of philosophy, *Laotzu*, an obscure, even legendary figure, is said to have lived around the time of Confucius. Many modern scholars, however, believe that the book that sets out Lao-tzu's teachings, *The Classic of the Way and Its Power (Tao te ching)* was written two or more centuries after the death of Confucius, at some point in the third century B.C.

Taoism

The followers of Taoism often expressed their ideas in obscure and frequently contradictory language. Their overriding concept is perhaps best illustrated by one of the central images of Taoist art: water. As it flows, water gives way to the rocks in its path, yet over time "the soft yield of water cleaves the obstinate stone." Humans should, in the same way, avoid participating in society or culture or seeking actively to change them. Far from sharing Confucius' mission to reform the world, the Taoists preached passivity and resignation. Worst of all was war, for "every victory celebration is a funeral rite."

Both Confucianism and Taoism can be seen as reactions—albeit opposing ones—to the increasingly chaotic struggles of the later Chou period. They were to remain powerful sources of inspiration over the succeeding centuries, and the tension between them played a large part in the evolution of Chinese civilization.

THE UNIFICATION OF CHINA: THE CH'IN, HAN, AND T'ANG Dynasties

In the struggle for power in the last years of the Chou period, one state emerged victorious. In 221 B.C., the king of

the state of Ch'in succeeded in conquering all his rivals and ruling them by means of a centralized government, thereby establishing the *Ch'in Dynasty*. He took the name of Shih Huang-ti ("First Emperor") and was remembered by later generations for the brutality of his conquests as much as for the brilliant organizational skill with which he organized his new empire.

He ordered the building of a magnificent capital city, Hsien-yang (near modern Sian), and instructed the leading noble families from the former independent kingdoms to move there, where they would be under his direct control, and thus unable to lead revolts. No private citizen was allowed to possess weapons, and it was left to the imperial army to maintain order. The emperor divided his territory into thirty-six provinces, imposed a single writing system, and unified weights and measures throughout them. In order to check criticism, he ordered the destruction of all philosophical writings, the socalled "Burning of the Books"—including, of course, the works of Confucius—an action that his successors bitterly condemned.

To defend his empire from outside invaders, Shih Huang-ti connected a series of preexisting defensive walls to make the *Great Wall*, some fourteen hundred miles long (about two thousand two hundred km) [5.10]. Peasants and prisoners of war were forced into construction gangs.

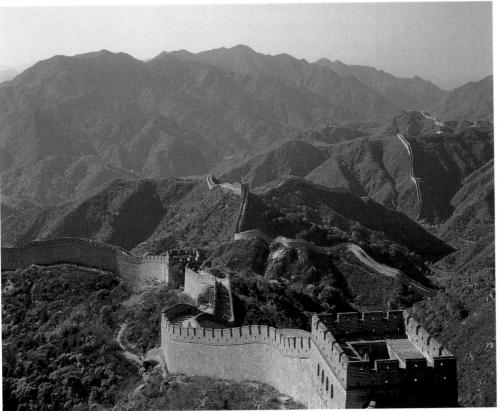

5.10 The Great Wall of China. Height 15-30' (4.3–8.6 m), width 12-20' (3.5–6.2 m). The Wall runs for 1400 miles (approx. 2200 km), and has been repaired and rebuilt many times since its first construction in the late third century B.C.

In the extreme climates of north and south, it was said that each single stone cost the life of one of the workers. The Great Wall has remained continuously visible to this day; indeed, it is one of the few human constructions on earth which can be seen from the moon. The emperor's other great building project, the massive tomb he designed for himself, barely survived his death, and was only rediscovered in 1974. Ever since, archaeologists have been exploring its riches [5.11].

Great Wall

Shih Huang-ti believed that he was creating an empire to last forever, but his ruthless methods ensured that his rule barely survived his death. One contemporary described him as "a monster who had the heart of a tiger and a wolf. He killed men as though he thought he could never finish, he punished men as though he were afraid he would never get round to them all." When Shih Huang-ti died in 210 B.C., the empire plunged into chaos as nobles and peasants alike ran riot.

By 202 B.C., a new dynasty had established itself the *Han Dynasty*—which was to rule China for the next four centuries. The first Han emperor, Kao-tsu (256–195 B.C.), returned a degree of power to the local rulers, but maintained the Ch'in system of provinces, with governors appointed by the central authority. In order to strengthen the imperial administration, Kao-tsu and his successors created an elaborate central bureaucracy. To reinforce their authority, the early Han emperors lifted the ban on philosophical works, and encouraged scholars to reconstruct the writings of Confucius and others either from the few surviving texts or from memory. With the emperor's encouragement, many of these reconstructions emphasized the need for loyalty to the emperor and a central bureaucracy, and omitted Confucius' emphasis on constructive criticism by virtuous observers.

By the second century A.D., the central government gradually lost its control over the provinces. The great aristocratic families began to take control, as successive emperors became paralyzed by internal feuding and plotting. In the ensuing civil war, the last Han emperor finally abdicated in A.D. 220, only to plunge China into another extended period of confusion. Finally, in the early seventh century, the *T'ang Dynasty* (A.D. 618–906) managed to reunite China. The political and economic stability they created made possible a period of cultural achievement known as China's "Golden Age."

The Arts in Classical China

With the notable exception of the period of Ch'in rule, literature played an important part in Chinese culture. As early as the Chou period, standard texts, known as the *Five Classics*, circulated widely—Confucius may have been partly responsible for editing them. They included history, political documents such as speeches, and descriptions of ceremonies. The *Classic of Songs* contained

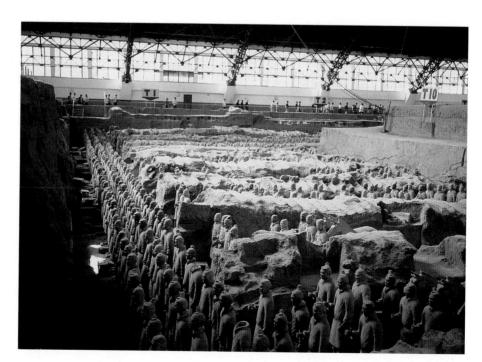

5.11 Excavation of the life-size pottery figures of soldiers and horses found near the tomb of Shih Huang-ti. Sian, China. The tomb dates to the late third century B.C.

more than three hundred poems dealing with private life (love, the family) and public affairs. Because the Chinese language makes use of pitch and stress (inflections; the meanings of words and/or phrases change according to the way they are pronounced), poetry became especially popular, and any educated Chinese person was expected to memorize and recite Classical verse.

Later generations drew inspiration from these Classical texts, developing their themes and expressing new ideas based on familiar concepts. The introduction of Buddhism into China during the Han Dynasty provided a new subject for philosophical writing; during the years of chaos following the fall of the Han rulers, Buddhist texts provided consolation for the suffering by offering eventual release from pain. The two main strains of Buddhism were Mahayana, the "Great Vehicle"; and Hinayana, the "Lesser Vehicle." The first of these was less ascetic and more worldly than the second, and thus appealed more to those influenced by Confucianism. It also met with more favor in the eyes of the ruling class although, when the Buddhist monasteries began to grow in wealth and influence, the central authorities started to limit the number of monasteries permitted and set limits on the ordination of monks and priests. For this reason, Buddhist writings never acquired the status that religious texts have in the Christian world.

During the T'ang Dynasty a new literary form developed: the short story. Unlike the works inspired by Classical models, these tales often provide a vivid picture of contemporary life. The best known of all Chinese poets, Li Po (A.D. 701–762), lived in the early years of T'ang rule. Appointed court poet in 742, after a couple of years his unruly temperament and wild behavior (many of his poems describe his addiction to wine) drove him to a life of wandering. Inspired by Taoism, Li Po preferred simple

5.12 Perforated pendant in the form of a dragon. Green jade, $5 \times 2^{1/2''}$ (18.5 × 9 cm). China, Late Chou (Warring States) period (403–221). Musee des Arts Asiatiques-Guimet, Paris.

5.13 Prancing Horse, Han Dynasty, second century A.D. Ceramic.

language and ignored the rules of the Classical style. Impressing his contemporaries as much by his charisma and personal appearance as by his writings, he could produce poems of all kinds and lengths, and his unconventional lifestyle provided him with unlimited subject matter. Many of his best-loved poems describe scenes from nature, often involving rivers or waterfalls images central to Taoist thought.

Li Po

The visual arts continued to use traditional styles while introducing new ones. A jade pendant from the end of the Chou Dynasty [5.12] depicting a dragon is reminiscent of the Shang bronzes of centuries earlier, while a bronze horse from a little later shows much greater realism [5.13]. Other works offer a more direct impression of daily life, whether in the form of a pottery tile illustrating hunters and peasants [5.14] or a painting of T'ang ladies playing a board game [5.15]. With the coming of Buddhism, Chinese devotees began to construct shrines and decorate them with monumental carvings. Many of these show the influence of similar relief sculptures in India, particularly in the treatment of drapery [5.16].

In all the art of the Classical period great emphasis went into craftsmanship. From the smallest carved jade or ivory to the huge stone statues, precision and clarity of design were the mark of the supreme artist. One of the effects of this emphasis on beauty of line was that writing itself became an art; examples of fine handwriting calligraphy—were as prized as a work made of precious material [5.17].

5.14 Scene of Hunting and Threshing, rubbing from a tomb tile from Cha'ang-tu, Szechuan, China. Han Dynasty, second century A.D.

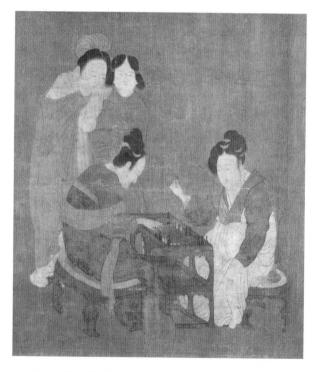

5.15 T'ang Court Ladies Playing a Board Game. Attributed to Chou Fang (c. A.D. 800). Smithsonian Institution, Freer Gallery of Art, Washington, D.C.

SUMMARY

The Indus Valley People The earliest culture to develop in the subcontinent of India appeared in the Indus Valley around 3000 B.C. Its people supported themselves by farming, growing grain and rice, and cotton. The two main centers were Harappa and Mohenjo-daro, which became large urban settlements with imposing public buildings and elaborate drainage systems. They massproduced pottery and invented a hieroglyphic script (still undeciphered) which they carved on seal-stones. Around 1700 B.C., their civilization went into decline, in part as the result of the arrival of a new people, the Aryans.

The Aryans The founders of the culture we think of as Indian were the Aryans, a people whose origin is uncertain, and who brought to India two of its most vital aspects: religion-Hinduism, and language-Sanskrit. The Hindu religion, as it developed, acquired a mass of deities and legends, but its basis remained, and remains to this day, the sacred texts of the Vedas, which were first written down around 1000 B.C. Over time, Hinduism evolved into a complex philosophical vision of life. which aims to distinguish between the illusions of everyday life and the ultimate reality. One way to achieve this reality is by yoga, a renunciation of worldly pleasures. Another is by fulfilling the requirements of one's caste, or destiny, and living according to one's duty (karma). Aryan society was divided into castes (social classes) of which the priestly caste was the highest.

Buddha At the end of the sixth century B.C., the figure known to posterity as Buddha inspired a new approach to life that emphasized the more austere aspects of Hinduism. Buddhism claimed that human suffering came from indulgence in superficial pleasures. Whereas Hinduism taught that life consisted of an endless series of deaths and reincarnations, according to the Buddha this cycle could be broken by renouncing all worldly ambitions and satisfactions. In this way it was possible to achieve nirvana, the ultimate freedom and release from the ego. The truth came not from external ritual or ceremony, but as a result of personal internal meditation. Thus, while Hinduism encouraged its followers to enjoy the pleasures of life permitted to them by their caste, Buddhism viewed life pessimistically and emphasized the rejection of the world in favor of spiritual redemption.

King Ashoka The spread of Buddhism owed much to Ashoka, the third-century-B.C. Indian ruler, who abandoned his early military campaigns, supposedly horrified at the human suffering they caused, gave up traditional Hindu beliefs, and converted to Buddhism. Under his rule, Buddhism became the predominant religion in India, although, like Buddha himself, Ashoka encouraged religious tolerance.

Ashoka's reign strengthened the influence of Buddhism in two important ways: He established a standard edition of Buddhist texts—the *Canon*—and encouraged Buddhist missionaries to spread the master's teachings outside India. As a result, Buddhism became widespread throughout southeast Asia, most notably in China.

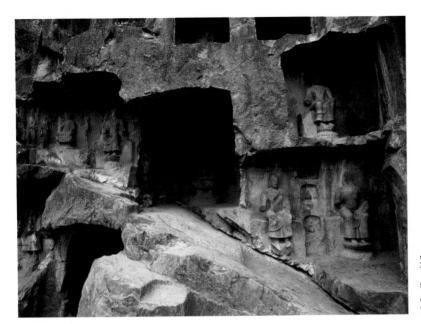

5.16 Lung-men Caves, Loyang, China. The Buddhist rock carvings were begun in the sixth century A.D., and greatly extended around 690, when Loyang became the new T'ang capital.

Hindu and Buddhist Art Most Indian art of the period of Ashoka and his successors was religious in inspiration. Hindu artists depicted their gods, in their various incarnations, as representative of all aspects of life, and Hindu myths often stressed sensual elements: Sexual union served as a symbol of union with the divine. By contrast, Buddhist art aimed to inspire spiritual meditation and a rejection of worldly values.

The Gupta Empire After the collapse of Ashoka's empire, India split into a series of local states, until it became united again in A.D. 320 under the rule of Gupta emperors. Hinduism regained its position as the dominating religion in India, and art, literature, and science flourished. The Gupta court became a center of learning and culture, and commerce developed with China and other parts of southeast Asia. Shortly before A.D. 500, the invasion of the White Huns from Central Asia caused the collapse of Gupta power, however, and India once again fragmented into separate local kingdoms. Only with the arrival of Muslim rule—almost a thousand years later—did India reunite under a central authority.

Early China: The Shang Dynasty The first organized urban society in China came under the rule of the Shang Dynasty (c. 1600–1100 B.C.). Trade and commerce began to develop, a system of writing was invented, and crafts-

men achieved a high standard of workmanship in bronze.

The Chou Dynasty (c. 1100–221 B.C.) The Chou rulers, who replaced the Shang Dynasty around 1100 B.C., served as the coordinators of a series of regional kingdoms rather than as a central governing authority. In a system that somewhat resembles the feudal system of Medieval Europe, the Chou ruler relied on the support and military resources of the nobles who ruled the local kingdoms. Over time this support fluctuated eventually collapsed: the end of Chou rule is known as the "Period of the Warring States" (403–221 B.C.).

Confucianism and Taoism The two schools of philosophy that have influenced Chinese culture for much of the past two thousand five hundred years developed around 500 B.C., toward the end of the Chou Dynasty. Confucianism, an essentially optimistic system of belief, argued that those who were naturally virtuous should, while behaving with loyalty and respect, help to govern their country by maintaining their independence and criticizing their rulers if necessary: The government served its citizens, rather than the reverse. Taoism, by contrast, taught that humans should withdraw from culture and society, devoting themselves to meditation and, like water, adapt themselves to natural forces.

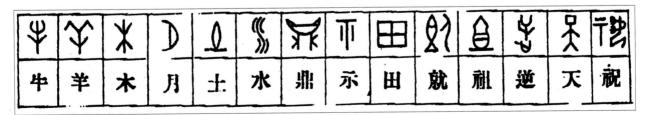

5.17 Rubbing from a stone inscription of the Han Dynasty. The carving of each character separately, rather than continuously, is known as the "Official Style."

The Ch'in, Han, and T'ang Dynasties The disorder of the latter part of Chou rule led finally to the brief Ch'in Dynasty (221–202 B.C.). Shih Huang-ti, the Ch'in leader, forcibly united the warring kingdoms, removed from power the regional noble rulers, and created a centralized state with an imperial army, unified a writing system, and standardized weights and measures. By a policy known as "the Burning of the Books" he eliminated philosophical writings he viewed as dangerous (including Confucian texts). So cruel was his reign that it barely survived his own death in 210 B.C.

The succeeding dynasty, that of the Han emperors (202 B.C.-A.D. 221), sought to establish a compromise between central government and local independence. During the first two centuries of their reign, China prospered, the arts flourished, and the philosophical teachings banned under the Ch'in returned to circulation. As their authority began to wane, however, under challenge by the regional states, China once again fell into chaos. Order was only restored under the T'ang Dynasty (A.D. 618–906), which saw an artistic and cultural revival often known as China's Golden Age.

The Arts in Classical China Under the Han and T'ang dynasties China enjoyed a cultural revival. A standard body of literature, the *Five Classics*, circulated widely. Among the new subjects to inspire writers, painters, and sculptors was Buddhism, which spread throughout China following its introduction in the first century A.D. The most important poet of the T'ang Dynasty—and one of the best-loved of all China's writers—was Li Po.

PRONUNCIATION GUIDE

Aryans:	AIR-i-ans	
Ashoka:	A-SHOW-ka	
Avatar:	AV-a-TAR	
Baghavad-Gita:	BAG-a-vad-GEE-ta	
Bodhisattvas:	BODY-SAT-vas	
Chou:	Ch-owe	
Confucius:	Con-FEW-shus	
Gautama:	GORE-ta-ma	
Harappa:	Har-AP-a	
Hinayana:	Hin-a-YA-na	
Li Po:	LEE POE	
Mahabharata:	MA-hab-HAR-a-ta	
Mahayana:	MA-ha-YA-na	
Mohenjo-daro:	Mo-HENJ-owe-DAR-owe	
Persepolis:	Per-SEP-o-lis	
Ramayana:	RAM-a-YA-na	
Sakuntala:	Sak-UN-ta-la	
Taoism:	TOW-ism	
Upanishad:	Up-AN-i-shad	
Vedas:	VAY-das	

EXERCISES

- 1. The early civilization of the Indus Valley had many of the marks of a sophisticated culture, including a writing system. This is still, however, undeciphered. If scholars one day decipher it, what new information about the Indus Valley people could they hope to learn? Are there any other ancient cultures whose writing we have but cannot understand?
- 2. What are the chief features of Buddhism? How do they differ from traditional Hindu beliefs, and why did they induce many Indians to convert?
- 3. Both Buddhism and Hinduism have many followers today. What gives these religions their continuing appeal? More particularly, why does Buddhism continue to attract increasing numbers in the United States and other Western countries?
- 4. Indian art and literature was based in large measure on the great epic poems, the *Mahabharata* and the *Ramayana*. What are the characteristics of their heroes? Illustrate them by describing two or three episodes.
- 5. Buddhism never acquired the same importance in China that Hinduism has always had in India. What effect has this had on the history of the two countries, both in ancient times and today?
- 6. What light do Chinese painting and sculpture of the Han and T'ang dynasties cast on daily life in those times?

Further Reading

- Allchin, Bridget, & Raymond Allchin. (1968). *The birth of Indian civilization*. Harmondsworth, UK: Penguin. This survey includes material on the Indus Valley people, and the first centuries of Aryan development.
- Basham, A. L. (1967). *The wonder that was India*. New York: Sidgwick and Jackson. One of the standard introductions to ancient India, a little dated by more recent discoveries, but still very readable.
- Buchanan, K., et al. (1981). China: The land and people. New York: Crown. A useful collection of essays on various aspects of Chinese life and culture.
- Hook, B. (Ed.). (1982). *The Cambridge encyclopedia of China*. Cambridge: Cambridge University Press. A massive work, invaluable for its entries on the whole range of Chinese studies.
- Humfries, Christmas. (1987). *The wisdom of Buddhism*. Atlantic Heights, NJ: Humanities Press. An excellent reader, which includes Buddhist texts and writings about Buddhism from the earliest times to the present.
- Ling, Trevor. (1973). *The Buddha*. New York: Scribner's. A lucid account of Buddhism and the physical, economic and social conditions under which it developed, with a good chapter on "The Ashokan Buddhist State."
- Mandelbaum, David G. (1970). *Society in India*. Berkeley: University of California Press. A two-volume examination of life in India during the Classical period.
- O'Flaherty, Wendy D. (1975). *Hindu myths*. Harmondsworth, UK: Penguin. A useful brief guide to a highly complex subject.
- Rawson, Jessica. (1980). *Ancient China*. London: British Museum Publications. A handy guide to Chinese art and archaeology, which takes the story from the earliest period to the end of the Han Dynasty.

- Sen, K. M. (1961). *Hinduism.* Harmondsworth, UK: Penguin. One of the best standard introductions to the many aspects of Hinduism, including its role in the modern world.
- Wolpert, Stanley. (1989). *A new history of India* (3rd ed.). New York, Oxford: Oxford University Press. This third edition of the best single-volume book on Indian history begins with an introductory section on "The Ecological Setting," and then takes the story from the Indus Valley period to modern India.

Online Chapter Links

A virtual tour of Harappa is available at http://www.harappa.com/walk/index.html

This Mohenjo-daro site at http://www.wnn.or.jp/wnn-asia/moenjo_e/ moenjo_e.html

provides a virtual tour, a photo gallery, and insights about life at Mohenjo-daro, plus background information about Indus Valley civilization.

Information concerning the rise and fall of the Indus civilization is found at

http://www.harappa.com/har/har3.html

For extensive information about Sanskrit documents, visit

http://www.hscc.net/sanskrit/doc_1_title.html where links to many additional related Internet resources—including Sanskrit dictionaries—are available.

Extensive information about Gotama (Buddha), his teachings, and historical places related to him is found at

http://www.vri.dhamma.org/publications/buddha.html

Among the sites providing valuable information related to Buddhism are

http://www.fundamentalbuddhism.com/ http://www.easternreligions.com/bframe.html http://www.internets.com/buddha.htm

Hindu Resources Online at

http://www.hindu.org/

http://www.hindunet.org

provide numerous links to a wide variety of information—including art, music, and culture; dharma and philosophy; travel and pilgrimage; and ancient sciences (e.g., yoga).

Links to Hindu art are available at http://www.hindunet.org/hindu_pictures/

For information about *Ramayana*, one of the great epics of India, visit this site

http://www.askasia.org/frclasrm/lessplan/

and click on lesson plan 1000054.htm, where links provide an English translation of the text accompanied by illustrations.

Among the sites providing valuable information related to Confucius are

http://www.confucius.org/main01.htm#e

http://www.easternreligions.com/cframe.html which offer links to biographies, translations in several languages, and graphics representing several writings in their original characters.

Among the sites providing valuable information related to Taoism are

http://www.easternreligions.com/tframe.html http://www.taorestore.org/intro.html http://www.tao.org/

http://www.dmoz.org/Society/

Religion_and_Spirituality/Taoism/ http://www.chebucto.ns.ca/Philosophy/Taichi/ other.html#taoist

Walk along the Great Wall of China at this intriguing site

http://www.walkthewall.com/greatwall/

Read about the construction of the Great Wall at http://www.crystalinks.com/chinawall.html

View radar images of the Great Wall as seen from space at

http://www.discovery.com/stories/history/greatwall/ satphoto.html

Online Chapter Resources

READING SELECTIONS

from The Rig Veda

The hymns below represent a small selection of prayers used in various rituals. Three of them discuss the god Agni who is the god of fire; the third of these hymns represent Agni under the god's representation as water. The fourth hymn is connected to death rituals.

10.18 Burial Hymn

This evocative hymn contains several references to symbolic gestures that may well have been accompanied by rituals similar to those know to us from later Vedic literature. But the human concerns of the hymn are vividly accessible to us, whatever the ritual may have been.

- Go away, death, by another path that is your own, different from the road of the gods. I say to you who have eyes, who have ears: do not injure our children or our men.
- 2. When you have gone, wiping away the footprint of death, stretching farther your own lengthening span of life, become pure and clean and worthy of sacrifice, swollen with offspring and wealth.
- 3. These who are alive have now parted from those who are dead. Our invitation to the gods has become auspicious today. We have gone forward to dance and laugh, stretching farther our own lengthening span of life.
- 4. I set up this wall for the living, so that no one else among them will reach this point. Let them live a hundred full autumns and bury death in this hill.
- 5. As days follow days in regular succession, as seasons come after seasons in proper order, in the same way order their life-spans, O Arranger, so that the young do not abandon the old.
- 6. Climb on to old age, choosing a long life-span, and follow in regular succession, as many as you are. May Tvastr who presides over births be persuaded to give you a long life-span to live.
- 7. These women who are not widows, who have good husbands—let them take their places, using butter to anoint their eyes. Without tears, without sickness, well dressed let them first climb into the marriage bed.
- 8. Rise up, woman, into the world of the living. Come here; you are lying beside a man whose life's breath has gone. You were the wife of this man who took your hand and desired to have you.
- 9. I take the bow from the hand of the dead man, to be our supremacy and glory and power, and I say, 'You are there; we are here. Let us as great heroes conquer all envious attacks.'
- Creep away to this broad, vast earth, the mother that is kind and gentle. She is a young girl, soft as wool to anyone who makes offerings; let her guard you from the lap of Destruction.
- Open up, earth; do not crush him. Be easy for him to enter and to burrow in. Earth, wrap him up as a mother wraps a son in the edge of her skirt.
- 12. Let the earth as she opens up stay firm, for a thousand pillars must be set up. Let them be houses dripping with butter for him, and let them be a refuge for him here for all his days.
- 13. I shore up the earth all around you; let me not injure you as I lay down this clod of earth. Let the fathers hold up this pillar for you; let Yama build a house for you here.
- 14. On a day that will come, they will lay me in the earth, like the feather of an arrow. I hold back speech that goes against the grain, as one would restrain a horse with a bridle.

1.1 I Pray to Agni

Appropriately placed at the very beginning of the *Rig Veda*, this hymn invites Agni, the divine priest to come to the sacrifice.

- 1. I pray to Agni, the household priest who is the god of the sacrifice, the one who changes and invokes and brings most treasure.
- 2. Agni earned the prayers of the ancient sages, and of those of the present, too; he will bring the gods here.

- 3. Through Agni one may win wealth, and growth from day to day, glorious and most abounding in heroic sons.
- 4. Agni, the sacrificial ritual that you encompass on all sides—only that one goes to the gods.
- 5. Agni, the priest with the sharp sight of a poet, the true and most brilliant, the god will come with the gods.
- 6. Whatever good you wish to do for the one who worships you, Agni, through you, O Angiras [the Angirases were an ancient family of priests, often identified with Vedic gods such as Agni and Indra], that comes true.
- 7. To you Agni, who shine upon darkness, we come day after day, bringing our thoughts and homage.
- 8. To you, the kind over sacrifices, the shining guarding of the Order, growing in your own house.
- 9. Be easy for us to reach, like a father to his son. Abide with us, Agni, for our happiness.

1.26 Agni and the Gods

This hymn emphasizes the close symbiosis between the sacrificer and Agni, on the one hand, and the sacrificer and the gods on the other.

- 1. Now get dressed in your robes,¹ lord of powers and master of the sacrificial food, and offer this sacrifice for us.
- 2. Young Agni, take your place as our favorite priest with inspirations and shining speech.
- 3. The father sacrifices for his son, the comrade for his comrade, the favorite friend for his friend.²
- 4. May Varuna, Mitra and Aryaman, proud of their powers, sit upon our sacred grass, as upon Manu's.³
- You who were the first to invoke, rejoice in our friendship and hear only these songs.
- 6. When we offer sacrifice to this god or that god, in the full line of order, it is to you alone that the oblation is offered.
- Let him be a beloved lord of tribes for us, a favorite, kindly invoker; let us have a good fire and be beloved.
- 8. For when the gods have a good fire, they bring us what we wish for. Let us pray with a good fire.
- 9. So let praises flow back and forth between the two, between us who are mortals and you, the immortal.⁴
- 10. Agni, young spawn of strength, with all the fires take pleasure in this sacrifice and in this speech.

2.35 The Child of the Waters (Apām Napāt)

The Child of the Waters is often identified with Agni, as the form of fire that appears as the lightning born of the clouds. But he is a deity in his own right, who appears in the Avesta as a spirit who lives deep in the waters, surrounded by females, driving swift horses. As the embodiment of the di-

- ² Many gods are asked to behave like friends or fathers; here, it is also suggested that one person might sacrifice on behalf of another, and Agni is asked to do this on behalf of the worshipper.
- ³ A reference to the primeval sacrifice offered by Manu, ancestor of mankind.
- ⁴ The verse, which is elliptic, implies both that Agni and the worshipper should enjoy a mutuality of praise and that, through that link, the other gods and the worshippers should enjoy such a mutuality.

¹ When Agni becomes the priest, his robes are both the flames and the prayers.

alectic conjunction of fire and water, the child of the waters is a symbol central to Vedic and later Hindu cosmology. This hymn, the only one dedicated entirely to him, plays upon the simultaneous unity and nonunity of the eartly and celestial forms of Agni and the Child of the Waters.

- Striving for the victory prize, I have set free my eloquence; let the god of the rivers gladly accept my songs. Surely the child of the waters, urging on his swift horses, will adorn my songs,¹ for he enjoys them.
- We would sing to him this prayer well-fashioned from the heart; surely he will recognize it. With his divine² energy, the child of the waters has created all noble creatures.
- 3. Some flow together, while others flow toward the sea, but the rivers fill the same hollow cavern.³ The pure waters surrounded this pure, radiant child of the waters.
- 4. The young women, the waters, flow around the young god, making him shine and gazing solemnly upon him. With his clear, strong flames he shines riches upon us, wearing his farment of butter, blazing without fuel in the waters.
- 5. Three women, goddesses,⁴ wish to give food⁵ to the god so that he will not weaken. He has stretched forth in the waters; he sucks the new milk of those who have given birth for the first time.⁶
- 6. The firth of the horse is here⁷ and in the sun. Guard our patrons from falling prey to malice or injury. When far away in fortresses of unbaked bricks,⁸ hatred and false-hoods shall not reach him.
- 7. In his own house he keeps the cow who yields good milk; he makes his vital force swell as he eats the nourishing food. Fathering strength in the waters, the child of the waters shines forth to give riches to his worshipper.
- 8. True and inexhaustible, he shines forth in the waters with pure divinity.⁹ Other creatures and plants, his branches, are reborn with their progeny.¹⁰
- 9. Clothed in lightning, the upright child of the waters has climbed into the lap of the waters as they lie down. The golden-hued young women¹¹ flow around him, bearing with them his supreme energy.

- ⁷ Agni is often depicted as a horse, who is in turn identified with the sun; the micro-macrocosmic parallel is enriched by Agni's simultaneous terrestrial and celestial forms, and those of the waters ("here"). Moreover, the sun, like the child of the waters, is born in the waters.
- ⁸ The sacrificer asks to be protected by Agni, who is safe even when among enemies who do not control fire and so do not fire their pricks, or who (as the sun) is safe from his enemies when he is in his own "natural" citadels not make of baked bricks, i.e., the clouds.

¹¹ The waters of heaven or earth.

- 10. Golden is his form, like gold to look upon; and gold in color is this child of the waters. Seated away from his golden womb,¹² the givers of gold give him food.
- 11. His face and the lovely secret name of the child of the waters grow when the young women¹³ kindle him thus. Golden-hued butter is his food.
- 12. To him, the closest friend among many,¹⁴ we would offer worship with sacrifices, obeisance, and oblations. I rub his back;¹⁵ I bring him shavings; I give him food; I praise him with verses.
- 13. Being a bull, he engendered that embryo in the females,¹⁶ being a child, he sucks them, and they lick him. The child of the waters, whose color never fades, seems to enter the body of another here.¹⁷
- 14. He shines forever, with undarkened flames, remaining in this highest place. The young waters, bringing butter as food to their child, themselves enfold him with robes.
- 15. O Agni, I have given a good dwelling place to the people; I have given a good hymn to the generous patron. All this is blessed, that the gods love. Let us speak great words as men of power in the sacrificial gathering.

from Brihad-Aranyaka Upanishad

This selection is called the "Supreme Teaching" because it captures some of the most fundamental truths taught by all of the literature found in the Upanishads.

The Supreme Teaching—Prologue

To Janaka King of Videha came once Yajñavalkya meaning to keep in silence the supreme secret wisdom. But once, when Janaka and Yajñavalkya had been holding a discussion at the offering of the sacred fire, Yajñavalkya promised to grant the kind any wish and the king chose to ask questions according to his desire. Therefore Janaka, king of Videha, began and asked this question:

Yajñavalkya, what is the light of man?

The sun is his light, O king, he answered. It is by the light of the sun that a man rests, goes forth, does his work, and returns.

This is so in truth, Yajñavalkya. And when the sun is set, what is then the light of man?

The moon then becomes his light, he replied. It is by the light of the moon that a man rests, goes forth, does his work, and returns.

This is so in truth, Yajñavalkya. And when the sun and the moon are set, what is then the light of man?

- ¹² The construction is loose, and may imply either that it is Agni who is seated away from his gold womb or that the sacrificers are seated around him.
- ¹³ Here the young women are the ten fingers, not the waters. The fingers kindle the earthly fire, that grows in the waters (the clouds) secretly and then is fed with butter at the sacrifice.
- ¹⁴ Literally, the lowest, that is the most intimate friend of men among the many gods, and therefore enjoying intimate services as described in the rest of this verse.
- ¹⁵ That is, the fire-altar.
- ¹⁶ The child of the waters engenders himself. He is father and son, pervading a body that belongs to someone who merely *seems* to be other.
- ¹⁷ That is, on earth. This is an explicit statement of the identity of the Child of the Waters with Agni as the sacrificial fire: the former enters the body of the latter.

¹ Either he will make them beautiful, or he will reward them.

 $^{^{2}}$ As a form of Agni, the child of the waters is an Asura, a high divinity.

³ That is, the ocean.

⁴ The three mothers of Agni, the waters of the three worlds.

⁵ Soma or butter.

⁶ The waters are *primaparas* or *primagravitas*, as the child of the waters is their first child.

⁹ Here the Child of the Waters is a god (*deva*).

¹⁰ Other fires on earth are regarded as branches of Agni, who also appears in plants; on another level, Agni causes all creatures and plants to be reborn.

Fire then becomes his light. It is by the light of fire that a man rests, goes forth, does his work, and returns.

And when the sun and the moon are set, Yajñavalkya, and the fire has sunk down, what is then the light of man?

Voice then becomes his light; and by the voice as his light he rests, goes forth, does his work and returns. Therefore in truth, O king, when a man cannot see even his own hand, if he hears a voice after that he wends his way.

This is so in truth, Yajñavalkya. And when the sun is set, Yajñavalkya, and the moon is also set, and the fire has sunk down, and the voice is silent, what is then the light of man?

The Soul then becomes his light; and by the light of the Soul he rests, goes forth, does his work, and returns.

What is the Soul? asked the kind of Videha.

Waking and Dreaming

Yajñavalkya spoke:

It is the consciousness of life. It is the light of the heart. Forever remaining the same, the Spirit of man wanders in the world of waking life and also in the world of dreams. He seems to wander in thought. He seems to wander in joy.

But in the rest of deep sleep he goes beyond this world and beyond its fleeting forms.

For in truth when the Spirit of man comes to life and takes a body, then he is joined with moral evils; but when at death he goes beyond, then he leaves evil behind.

The Spirit of man has two dwellings: this world and the world beyond. There is also a third dwelling place: the land of sleep and dreams. Resting in this borderland the Spirit of man can behold his dwelling in this world and in the other world afar, and wandering in this borderland he beholds behind him the sorrows of this world and in front of him he seeks the joys of the beyond.

Dreams

When the Spirit of man retires to rest, he takes with him materials from this all-containing world, and he creates and destroys in his own glory and radiance. Then the Spirit of man shines in his own light.

In that land there are no chariots, no teams of horses, nor roads; but he creates his own chariots, his teams of horses, and roads. There are no joys in that region, and no pleasures nor delights; but he creates his own joys, his own pleasures and delights. In that land there are no lakes, no lotus ponds, nor streams; but he creates his own lakes, his lotus ponds, and streams. For the Spirit of man is Creator.

It was said in these verses:

Abandoning his body by the gate of dreams, the Spirit beholds in awaking his senses sleeping. Then he takes his own light and returns to his home, this Spirit of golden radiance, the wandering swan everlasting.

Leaving his next below in charge of the breath of life, the immortal Spirit soars afar from his nest. He moves in all regions wherever he loves, this Spirit of golden radiance, the wandering swan everlasting.

And in the region of dreams, wandering above and below, the Spirit makes for himself innumerable subtle creations. Sometimes he seems to rejoice in the love of fairy beauties, sometimes he laughs or beholds awe-inspiring terrible visions.

People see his field of pleasure; but he can never be seen.

So they say that one should not wake up a person suddenly, for hard to heal would he be if the Spirit did not return. They say also that dreams are like the waking state, for what is seen when awake is seen again in a dream. What is true is that the Spirit shines in his own light.

"I give you a thousand gifts," said then the king of Videha, "but tell me of the higher wisdom that leads to liberation."

When the Spirit of man has had his joy in the land of dreams, and his wanderings there has beholden good and evil, he then returns to this world of waking. But whatever he has seen does not return with him, for the Spirit of man is free.

And when he has had his joy in this world of waking and in his wanderings here has beholden good and evil, he returns by the same path again to the land of dreams.

Even as a great fish swims along the two banks of a river, first along the eastern bank and then the western bank, in the same way the Spirit of man moves along beside his two dwellings: this waking world and the land of sleep and dreams.

Deep Sleep

Even as a falcon or an eagle, after soaring in the sky, folds his wings for he is weary, and flies down to his nest, even so the Spirit of man hastens to that place of rest where the soul has no desires and the Spirit sees no dreams.

What was seen in a dream, all the fears of waking, such as being slain or oppressed, pursued by an elephant or falling into an abyss, is seen to be a delusion. But when like a king or a god of the Spirit feels "I am all," then he is in the highest world. It is the world of the Spirit, where there are no desires, all evil has vanished, and there is no fear.

As a man in the arms of the woman beloved feels only peace all around, even so the Soul in the embrace of Atman, the Spirit of vision, feels only peace all around. All desires are attained, since the Spirit that is all has been attained, no desires are there, and there is no sorrow.

There a father is a father no more, nor is a mother there a mother; the worlds are no longer worlds, nor the gods are gods any longer. There the *Vedas* disappear; and a thief is not a thief, nor is a slayer a slayer; the outcast is not an outcast, nor the base-born a base-born; the pilgrim is not a pilgrim and the hermit is not a hermit; because the Spirit of man has crossed the lands of good and evil, and has passed beyond the sorrows of the heart.

There the Spirit sees not, but though seeing not he sees. How could the Spirit not see if he is the All? But there is no duality there, nothing apart for him to see.

There the Spirit feels no perfumes, yet feeling no perfumes he feels them. How could the Spirit feel no perfumes if he is the All? But there is no duality there, no perfumes, apart for him to feel.

There the Spirit tastes not, yet tasting not he tastes. How could the Spirit not taste if he is the All? But there is no duality there, nothing apart for him to taste.

There the Spirit speaks not, yet speaking not he speaks. How could the Spirit not speak if he is the All? But there is no duality there, nothing apart for him to speak to.

There the Spirit hears not, yet hearing not he hears. How could the Spirit not hear if he is the All? But there is no duality there, nothing apart for him to hear.

There the Spirit thinks not, yet thinking not he thinks. How could the Spirit not think if he is the All? But there is no duality there, nothing apart for him to think.

There the Spirit touches not, yet touching not he touches. How could the Spirit not touch if he is the All? But there is no duality there, nothing apart for him to touch. There the Spirit knows not, yet knowing not he knows. How could the Spirit not know if he is the All? But there is no duality there, nothing apart for him to know.

For only where there seems to be a duality, there one sees another, one feels another's perfume, one tastes another, one speaks to another, one listens to another, one touches another and one knows another.

But in the ocean of Spirit the seer is alone beholding his own immensity.

This is the world of Brahman, O king. This is the path supreme. This is the supreme treasure. This is the world supreme. This is the supreme joy. On a portion of that joy all other beings live.

He who in this world attains success and wealth, who is Lord of men and enjoys all human pleasures, has reached the supreme human joy.

But a hundred times greater than the human joy is the joy of those who have attained the heaven of the ancestors.

A hundred times greater than the joy of the heaven of the ancestors is the joy of the heaven of the celestial beings.

A hundred times greater than the joy of the heaven of the celestial beings is the joy of the gods who have attained divinity through holy works.

A hundred times greater than the joy of the gods who have attained divinity through holy works is the joy of the gods who were born divine, and of him who has sacred wisdom, who is pure and free from desire.

A hundred times greater than the joy of the gods who were born divine is the joy of the world of the Lord of Creation, and of him who has sacred wisdom, who is pure and free from desire.

And a hundred times greater than the joy of the Lord of Creation is the joy of the world of Brahman, and of him who has sacred wisdom, who is pure and free from desire.

This is the joy supreme, this is the world of the Spirit, O king.

"I give you a thousand gifts," said then the kind of Videha: "but tell me of the higher wisdom that leads to liberation."

And Yajñavalkya was afraid and thought: Intelligent is the kind. He has cut me off from all retreat.

When the Spirit of man has had his joy in the land of dreams, and in his wanderings there has beholden good and evil, he returns once again to this the world of waking.

Death

Even as a heavy-laden cart moves on groaning, even so the cart of the human body, wherein lives the Spirit, moves on groaning when a man is giving up the breath of life.

When the body falls into weakness on account of old age or disease, even as a mango-fruit, or the fruit of the holy fig tree, is loosened from its stem, so the Spirit of man is loosened from the human body and returns by the same way to Life, wherefrom he came.

As when a king is coming, the nobles and officers, the charioteers and heads of the village prepare for him food and drink and royal lodgings, saying "The king is coming, the king is approaching," in the same way all the powers of life wait for him who knows this and say: "The Spirit is coming, the Spirit is approaching."

And as when a king is going to depart, the nobles and officers, the charioteers and the heads of the village assemble around him, even so all the powers of life gather about the soul when a man is giving up the breath of life. When the human soul falls into weakness and into seeming unconsciousness all the powers of life assemble around. The soul gathers these elements of life-fire and enters into the heart. And when the Spirit that lives in the eye has returned to his own source, then the soul knows no more forms.

Then a person's power of life become one and people say: "he sees no more." His powers of life become one and people say: "he feels perfumes no more." His powers of life become one and people say: "he tastes no more." His powers of life become one and people say: "he speaks no more." His powers of life become one and people say: "he hears no more." His powers of life become one and people say: "he thinks no more." His powers of life become one and people say: "he touches no more." His powers of life become one and people say: "he touches no more." His powers of life become one and people say: "he knows no more."

Then at the point of the heart a light shines, and this light illumines the soul on its way afar. When departing, by the head, or by the eye or other parts of the body, life arises and follows the soul, and the powers of life follow life. The soul becomes conscious and enters into Consciousness. His wisdom and works take him by the hand, and the knowledge known of old.

Even as a caterpillar, when coming to the end of a blade of grass, reaches out to another blade of grass and draws itself over to it, in the same way the Soul, leaving the body and unwisdom behind, reaches out to another body and draws itself over to it.

And even as a worker in gold, taking an old ornament, molds it into a form newer and fairer, even so the Soul, leaving the body and unwisdom behind, goes into a form newer and fairer: a form like that of the ancestors in heaven, or of the celestial beings, or of the gods of light, or of the Lord of Creation, or of Brahma the Creator supreme, or a form of other beings.

The Soul is Brahman, the Eternal.

It is made of consciousness and mind: it is made of life and vision. It is made of the earth and the waters: it is made of air and space. It is made of light and darkness: it is made of desire and peace. It is made of anger and love: it is made of virtue and vice. It is made of all that is near: it is made of all that is afar. It is made of all.

Karma

According as a man acts and walks in the path of life, so he becomes. He that does good becomes good; he that does evil becomes evil. By pure actions he becomes pure; by evil actions he becomes evil.

And they say in truth that a man is made of desire. As his desire is, so is his faith. As his faith is, so are his works. As his works are, so he becomes. It was said in this verse:

A man comes with his actions to the end of his determination.

Reaching the end of the journey begun by his works on earth, from that world a man returns to this world of human action.

Thus far for the man who lives under desire.

Liberation

Now as to the man who is free from desire.

He who is free from desire, whose desire finds fulfillment, since the Spirit is his desire, the powrs of life leave him not. He becomes one with Brahman, the Spirit, and enters into the Spirit. there is a verse that says:

When all desires that cling to the heart disappear, then a mortal becomes immortal, and even in this life attains liberation.

As the slough of a snake lies dead upon an ant-hill, even so the mortal body; but the incorporeal immortal Spirit is life and light and Eternity.

Concerning this are these verses:

I have found the small path known of old that stretches far away. By it the sages who know the Spirit arise to the regions of heaven and thence beyond to liberation.

It is adorned with white and blue, yellow and green and red. this is the path of the seers of Brahman, of those whose actions are pure and who have inner fire and light.

Into deep darkness fall those who follow action. Into deeper darkness fall those who follow knowledge.

There are worlds of no joy, regions of utter darkness. to those worlds go after death those who in their unwisdom have not wakened up to light.

When awake to the vision of the Atman, our own Self, when a man in truth can say: "I am He," what desires could lead him to grieve in fever for the body?

He who in the mystery of life has found the Atman, the Spirit, and has awakened to his light, to him as creator belongs the world of the Spirit, for he is this world.

While we are here in this life we may reach the light of wisdom; and if we reach it not, how deep is the darkness. Those who see the light enter life eternal: those who live in darkness enter into sorrow.

When a man sees the Atman, the Self in him, God himself, the Lord of what was and of what shall be, he fears no more.

Before whom the years roll and all the days of the years, him the gods adore as the Light of all lights, as Life immortal;

In whom the five hosts of beings rest and the vastness of space, him I know as Atman immortal, him I know as eternal Brahman.

Those who know him who is the eye of the eye, the ear of the ear, the mind of the mind and the life of life, they know Brahman from the beginning of time.

Even by the mind this truth must be seen: there are not many but only One. Who sees variety and not the Unity wanders on from death to death.

Behold then as One the infinite and eternal One who is in radiance beyond space, the everlasting Soul never born.

Knowing this, let the lover of Brahman follow wisdom. Let him not ponder on many words, for many words are weariness.

Yajñavalkya went on:

This is the great Atman, the Spirit never born, the consciousness of life. He dwells in our own hearts as ruler of all, master of all, lord of all. His greatness becomes no greater by good actions no less great by evil actions. He is the Lord supreme, sovereign and protector of all beings, the bridge that keeps the worlds apart that they fall not into confusion.

The lovers of Brahman seeks him through the sacred *Vedas*, through holy sacrifices, charity, penance and abstinence. He who knows him becomes a Muni, a sage. Pilgrims follow their life of wandering in their longing for his kingdom.

Knowing this, the sages of old desired not offspring. "What shall we do with offspring," said they, "we who possess the Spirit, the wold world?" Rising above the desire of sons, wealth, and the world they followed the life of the pilgrim. For the desire of sons and wealth is the desire of the world. And this desire is vanity.

But the Spirit is not this, is not this. He is incomprehensible, for he cannot be comprehended. He is imperishable, for he cannot pass away. He has no bonds of attachment, for he is free; and free from all bonds he is beyond suffering and fear.

A man who knows this is not moved by grief or exultation on account of the evil or good he has done. He goes beyond both. What is done or left undone grieves him not.

This was said in this sacred verse:

The everlasting greatness of the seer of Brahman is not greater or less great by actions. Let man find the path of the Spirit: who has found this path becomes free from the bonds of evil.

Who knows this and has found peace, he is the lord of himself, his is a calm endurance, and calm concentration. In himself he sees the Spirit, and he sees the Spirit as all.

He is not moved by evil: he removes evil. He is not burned by sin: he burns all sin. And he goes beyond evil, beyond passion, and beyond doubts, for he sees the Eternal.

This is the world of the Spirit, O king. Thus spoke Yajñavalkya.

O Master. Yours is my kingdom and I am yours, said then the king of Vedeha.

Epilogue

This is the great never-born Spirit of man, enjoyer of the food of life, and giver of treasure. He finds this treasure who knows this.

This is the great never-born Spirit of man, never old and immortal. This is the Spirit of the universe, a refuge from all fear.

CHRISTMAS HUMPHRIES

from The Wisdom of Buddha

The following three selections are ancient Buddhist texts. The first is the famous sermon given by Buddha at Sarnath outside of Benares; it is considered his most famous sermon on the "Middle Way." The second is the well-known "Fire Sermon." The final selection comes from an early hymn of praise for Buddha and his significance.

Buddha's Pity

My children,

The Enlightened One, because he saw Mankind drowning in the Great Sea of Birth, Death and Sorrow, and longed to save them,

For this he was moved to pity.

Because he saw the men of the world straying in false paths, and none to guide them,

For this he was moved to pity.

Because he say that they lay wallowing in the mire of the Five Lusts, in dissolute abandonment,

For this he was moved to pity.

Because he saw them still fettered to their wealth, their wives and their children, knowing not to how to cast them aside,

For this he was moved to pity.

Because he saw them doing evil with hand, heart and tongue, and many times receiving the bitter fruits of sin, yet ever yielding to their desires,

For this he was moved to pity.

Because he saw that they slaked the thirst of the Five Lusts as it were with brackish water,

For this he was moved to pity.

Because he saw that though they longed for happiness, they made for themselves no karma of happiness; and though they hated pain, yet willingly made for themselves a karma of pain: a though they coveted the joys of Heaven, would not follow his commandments on earth,

For this he was moved to pity.

Because he saw them afraid of birth, old age and death, yet still pursuing the works that lead to birth, old age and death,

For this he was moved to pity.

Because he saw them consumed by the fires of pain and sorrow, yet knowing not where to seek the still waters of Samadhi [Enlightenment],

For this he was moved to pity.

Because he saw them living in an evil time, subjected to tyrannous kinds and suffering many ills, yet heedlessly following after pleasure,

For this he was moved to pity.

Because he saw them living in a time of wars, killing and wounding on another: and knew that for the riotous hatred that had flourished in their hearts they were doomed to pay an endless retribution,

For this he was moved to pity.

Because many born at the time of his incarnation had heard him preach the Holy Law, yet could not receive it,

For this he was moved to pity.

Because some had great riches which they could not bear to give away,

For this he was moved to pity.

Because he saw the men of the world ploughing their fields, sowing the seed, trafficking, huckstering, buying and selling: and at the end winning nothing but bitterness,

For this he was moved to pity.

Buddha's Teaching

Cease to do evil; Learn to do good; Cleanse your own heart; This is the teaching of the Buddhas.

The First Sermon

Thus have I heard: once the Exalted One was dwelling near Benares, at Isipatana, in the Deer-Park.

Then the Exalted One thus spake unto the company of five monks. "Monks, these two extremes should not be followed by one who has gone forth as a wandered. What two?

"Devotion to the pleasures of sense, a low practice of villagers, a practice unworthy, unprofitable, the way of the world (on the one hand); and (on the other) devotion to selfmortification, which is painful, unworthy and unprofitable.

"By avoiding these two extremes the Tathagata [another

name for Buddha] has gained knowledge of that middle path which giveth vision, which giveth knowledge, which causeth calm, special knowledge, enlightenment, Nirvana.

"An what, monks, is that middle path which giveth vision . . . Nirvana?

"Verily it is this Ariyan eightfold way, to wit: Right view, right aim, right speech, right action, right living, right effort, right mindfulness, right concentration. This, monks, is that middle path which giveth vision, which giveth knowledge, which causeth calm, special knowledge, enlightenment, Nirvana.

"Now this, monks, is the Ariyan truth about Ill:

"Birth is Ill, decay is Ill, sickness is Ill, death is Ill: likewise sorrow and grief, woe, lamentation and despair. To be conjoined with things which we dislike: to be separated from things which we like,—that also is Ill. Not to get what one wants—that also is Ill. In a word, this body, this fivefold mass which is based on grasping—that is ill.

"Now this, monks, is the Ariyan truth about the arising of Ill:

"It is that craving that leads back to birth, along with the lure and the lust that lingers longingly now here, now there: namely, the craving for sensual pleasure, the craving to be born again, the craving for existence to end. Such, monks, is the Ariyan truth about the arising of Ill.

"And this, monks, is the Ariyan truth about the ceasing of Ill:

"Verily it is the utter passionless cessation of, the giving up, the forsaking, the release from, the absence of longing for this craving.

"Now this, monks, is the Ariyan truth about the practice that leads to the ceasing of Ill:

"Verily it is this Āriyan eightfold way, to wit: Right views, right aim, right speech, right action, right living, right effort, right mindfulness, right concentration.

"Monks, at the thought of this Ariyan truth of ill, concerning things unlearnt before, there arose in me vision, insight, understanding: there arose in me wisdom, there arose in me light.

"Monks, at the thought: This Ariyan truth about III is to be understood—concerning things unlearnt before, there arose in me vision, insight, understanding: there arose in me wisdom, there arose in me light.

"Monks, at the thought: This Ariyan truth about Ill has been understood (by me)—concerning things unlearnt before, there arose in me vision, insight, understanding: there arose in me wisdom, there arose in me light.

"Again, monks, at the thought of this Ariyan truth about the arising of Ill, concerning things unlearnt before, there arose in me vision, insight,understanding: there arose in me wisdom, there arose in me light.

"At the thought: This arising of Ill is to be put away concerning things unlearnt before . . . there arose in me light.

"At the thought: This arising of Ill has been put away—concerning things unlearnt before . . . there arose in me light.

"Again, monks, at the thought of this Ariyan truth about the ceasing of Ill, concerning things unlearnt before . . . there arose in me light.

"At the thought: This ceasing of Ill must be realized concerning things unlearnt before . . . there arose in me light.

"At the thought: This Ariyan truth about the ceasing of Ill has been realized—concerning things unlearnt before . . . there arose in me light. "Again, monks, at the thought of this Ariyan truth about the practice leading to the ceasing of Ill, concerning things unlearnt before . . . there arose in me light.

"At the thought: This Ariyan truth about the practice leading to the ceasing of Ill must be cultivatec—concerning things unlearnt before . . . there arose in me light.

"At the thought: This Ariyan truth about the practice leading to the ceasing of Ill has been cultivated—concerning things unlearnt before there arose in me vision, insight, understanding: there arose in me wisdom, there arose in me light.

"Now, monks, so long as my knowledge and insight of these thrice revolved twelvefold Ariyan truths, in their essential nature, was not quite purified—so long was I not sure that in this world there was one enlightenment with supreme enlightenment.

"But, monks, so soon as my knowledge and insight of these thrice revolved twelvefold Ariyan truths, in their essential nature, was quite purified, then, monks, was I assured what it is to be enlightened with supreme enlightenment. Now knowledge and insight have arisen in me so that I know. Sure is my heart's release. This is my last birth. There is no more becoming for me."

The Fire Sermon

All things, O monks, are on fire.

The eye, O monks, is on fire; forms are on fire; eyeconsciousness is on fire; impressions received by the eye are on fire; and whatever sensation, pleasant,unpleasant or indifferent, originates in dependence on impressions received by the eye, that also is on fire.

And with what are these on fire?

With the fire of passion, with the fire of hatred, with the fire of infaturation; with birth, old age, death, sorrow, lamentation misery, grief and despair are they on fire.

The ear is on fire; sounds are on fire . . . the nose is on fire, odors are on fire; . . . the tongue is on fire; tastes are on fire; . . . mind-consciousness is on fire; impressions received by the mind are on fire; and whatever sensation, pleasant, unpleasant or indifferent, originates in dependence on impressions received by the mind, that also is on fire.

And with what are these on fire?

With the fire of passion, with the fire of hatred, with the fire of infatuation; with birth, old age, sorrow, lamentation, misery, grief and despair are they on fire.

Perceiving this, O monks, the learned and noble disciple conceives an aversion for the eye, for forms, for eyeconsciousness, for the impressions received by the eye; and whatever senseation, pleasant, unpleasant or indifferent, originates in dependence on impressions received by the eye, for that also he conceives an aversion . . . And in conceiving this aversion, he becomes divested of passion, and by the absence of passion he becomes free, and when he is free he becomes aware that he is free; and he knows that rebirth is exhausted, that he has lived the holy life, that he has done what it behoved him to do, and that he is no more for this world.

Li Po

Selected Poems

Even during his lifetime, Li Po was recognized as one of the greatest Chinese poets, and posterity has confirmed his status. Although most of his works deal with traditional themes—the beauties of nature, the search for spiritual peace, the pleasures of wine—he brought to them a unique sense of fantasy and eloquence. About a thousand of his poems survive; the ones reproduced below are among his most popular.

Bring the Wine!

Have you never seen

the Yellow River waters descending from the sky, racing restless toward the ocean, never to return? Have you never seen

bright mirrors in high halls, the white-haired ones lamenting,

their black silk of morning by evening turned to snow? If life is to have meaning, seize every joy you can; do not let the golden cask sit idle in the moonlight! Heaven gave me talents, and meant them to be used; gold scattered by the thousand comes home to me again.

Boil the mutton, roast the ox—we will be merry,

at one bout no less that three hundred cups.

Master Ts'en!

Scholar Tan-ch'iu!

Bring the wine and no delay!

For you I'll sing a song—

be pleased to bend your ears and hear.

Bells and drums, food as rare as jade—these aren't worth prizing;

all I ask is to be drunk for ever, never to sober up!

Sages and worthies from antiquity — all gone into si-

lence; only the great drinkers have left a name behind.

The Prince of Ch'en once feasted in the Hall of Calm Delight;

wine, ten thousand coins a cask, flowed for his revelers' joy.

Why does my host tell me the money has run out?

- Buy more wine at once—my friends have cups to be refilled!
- My dapple mount,

my furs worth a thousand --

call the boy, have him take them and barter for fine wine! Together we'll wash away ten thousand years of care.

Autumn Cove

At Autumn Cove, so many white monkeys

bounding, leaping up like snowflakes in flight!

They coax and pull their young ones down from the branches

to drink and frolic with the water-borne moon.

Viewing the Waterfall at Mount Lu

Sunlight straming on Incense Stone kindles violet smoke; far off I watch the waterfall plunge to the long river, flying waters descending straight three thousand feet, till I think the Milky Way has tumbled from the ninth height of Heaven.

Seeing a Friend Off

Green hills sloping from the northern wall, white water rounding the eastern city;

once parted from this place the lone weed tumbles ten thousand miles. Drifting clouds—a traveler's thoughts; setting sun—an old friend's heart. Wave hands and let us take leave now, hsiao-hsiao our hesitant horses neighing.

Still Night Thoughts

Moonlight in front of my bed— I took it for frost on the ground! I lift my eyes to watch the mountain moon, lower them and dream of home.

		GENERAL EVENTS	LITERATURE & PHILOSOPHY
	3000		
\GE	в.с. ш Ü	1800–1600 Age of the Hebrew Patriarchs: Abraham, Isaac, Jacob	
	OR B.	1600 Israelite tribes in Egypt	
	BEFORE 1200 B.C	1280 Exodus of Israelites from Egypt under leadership of Moses	
A.	1260		
Bronze		1260 Israelites begin to penetrate land of Canaan	
	2		
B	PEF		
	1040	1040–1000 Reign of Saul, first king of Israel	
	1000 ₩ ≻	1000–961 Reign of King David	c. 1000 Formation of the Scriptures
	TH	 961 – 922 Reign of Solomon; use of iron-tipped plow and iron war chariots; height of ancient Israel's cultural power: achievements form basis of Judaic, Christian, and Islamic religions 	in written form
	OF NAR		c. 950 Book of Psalms
	AGE OF THE MONARCHY		10th-9th cent. Book of Kings
	922		
	MS	922 Civil war after death of Solomon; split of Northern Kingdom (Israel) and Southern Kingdom (Judah); classical prophetic period begins	8th-6th cent. Old Testament books
	THE	721 Northern Kingdom destroyed by Assyria	of Isaiah, Jeremiah, and Ezekiel
	AGE OF THE Two Kingdoms		
	AGE vo K		
	Tw		
	587	587 Southern Kingdom defeated; Jews driven into captivity in Babylonia	after 5th cent. Book of Job
ш	URN	539 Cyrus the Persian permits Jews to return to Jerusalem	
U	EXILE, RETURN, OCCUPATIONS	516 Dedication of Second Temple in Jerusalem	
			end of 2nd cent. Apocryphal Book of
Z		332 Conquest of Jerusalem by Alexander the Great	Judith
RON	GE OF H	2nd cent. Cult of Mithra in Rome	
	AGE		
	63		
		63 Conquest of Jerusalem by Romans under Pompey	
_	IOD	37 B.C.–A.D. 4 Reign of Herod the Great under Roman tutelage	
B.C.	ROMAN PERIOD	c. 6 B.C. Birth of Jesus	
A.D.	. NA	c. A.D. 30 Death of Jesus; beginnings of Christianity in Palestine	c. A.D. 70 "Sermon on the Mount" in Gospel of Saint
	MO	45–49 First missionary journeys of Saint Paul	Matthew, New Testament
	R	66–70 Jewish rebellions against Romans	c. A.D. 150 Justin Martyr, Apology
1	A.D.	c. 70 Titus destroys Jerusalem and razes the Temple; Jews sent into exile	7100089
	324	Dates before the 10th cent. B.C. are approximate and remain controversial	
			and the factor of the second

Chapter 6 Jerusalem and Early Christianity

MUSIC

ARCHITECTURE

ART

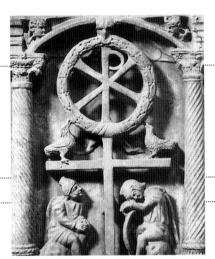

c. 961 – c. 922 Building of Temple of Solomon; city of Megiddo rebuilt by Solomon

Music often accompanied the Psalms; musical instruments in use: drums, reed instruments, lyre, harp, horns

Depiction of divinity in art prohibited in Jewish religion

734 Oxen from bronze "sea" given to King of Assyria by King Achaz

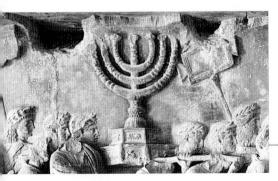

- **587** Solomon's Temple destroyed by Babylonians
- c. 536–515 Second Temple of Solomon constructed

- **19** Herod the Great begins rebuilding Third Temple of Solomon
- **A.D. 70** Herod's Temple destroyed by the armies of Titus under Emperor Vespasian
- **c.81** Arch of Titus, Rome, commemorates victory of Roman army in Jerusalem
- c. A.D. 230–240 Synagogue and House Church at Dura Europos
- c. A.D. 81 Reliefs from Arch of Titus, Rome, commemorate Roman victory in Jerusalem

CHAPTER 6

JERUSALEM AND EARLY CHRISTIANITY

Judaism and Early Christianity

ne of the interesting ironies of history is the fact that, more than three thousand years ago in the Middle East, a small tribe-turned-nation became one of the central sources for the development of Western civilization. The fact is incontestable: The marriage of the biblical tradition and Graeco-Roman culture has produced, for better or worse, the West as we know it today.

The irony is all the more telling because these ancient biblical people did not give the world great art, significant music, philosophy, or science. Their language did not have a word for *science*. Their religion discouraged the plastic arts. We have the texts of their hymns, canticles, and psalms, but we can only speculate how they were sung and how they were accompanied instrumentally. What these people did give us was a book; more precisely, a collection of many different books we now call the Bible.

Early Church Documents

These people called themselves the Children of Israel or Israelites; at a later time they became known as the Jews (from the area around Jerusalem known as Judaea). In the Bible they are called Hebrews (most often by their neighbors), the name now most commonly used to describe these biblical people.

The history of the Hebrew people is long and complex, but the stages of their growth can be outlined as follows:

• The Period of the Patriarchs. According to the Bible, the Hebrew people had their origin in Abraham, the father (patriarch) of a tribe who took his people from ancient Mesopotamia to the land of Canaan on the east coast of the Mediterranean about 2000 B.C. After settling in this land, divided into twelve tribal areas, they eventually went to Egypt at the behest of Joseph, who had risen to high office in Egypt after his enslavement there.

- The Period of the Exodus. The Egyptians eventually enslaved the Hebrews (perhaps around 1750 B.C.), but they were led out of Egypt under the leadership of Moses. This "going out" (*exodus*) is one of the central themes of the Bible; this great event also gives its name to one of the books of the Bible.
- The Period of the Conquest. The biblical books of Joshua and Judges relate the struggles of the Hebrews to conquer the land of Canaan as they fought against the native peoples of that area and the competing "Sea People" (the Philistines) who came down from the north.
- The United Monarchy. The high point of the Hebrew political power came with the consolidation of Canaan and the rise of a monarchy. There were three kings: Saul, David, and Solomon. An ambitious flurry of building during the reign of Solomon (c. 961–922 B.C.) culminated in the construction of the great temple in Jerusalem [6.1].
- Divided Kingdom and Exile. After the death of Solomon a rift over the succession resulted in the separation of the Northern Kingdom and the Southern Kingdom, the center of which was Jerusalem. Both were vulnerable to pressure from the surrounding great powers. The Northern Kingdom was destroyed by the Assyrians in the eighth century B.C. and its inhabitants (the so-called Lost Tribes of Israel) were swept away by death or exile. In 587 B.C., the Babylonians conquered the Southern Kingdom, destroyed Solomon's temple in Jerusalem, and carried the Hebrew people into an exile known to history as the Babylonian Captivity.
- The Return. The Hebrews returned from exile about 520 B.C. to rebuild their shattered temple and to resume their religious life. Their subsequent history was marked by a series of foreign (Greek, Egyptian, and Syrian) rulers, one brief period of political independence (c. 165 B.C.), and, finally, rule by Rome after the conquest of 63 B.C. In A.D. 70, after a Jewish revolt, the Romans destroyed Jerusalem

6.1 Reconstruction drawing of Solomon's Temple. The description in the Bible of this destroyed temple was an inspiration for sacred architecture well into the Middle Ages. The two bronze columns in front may have represented the columns of fire and smoke that guided the Israelites while they were in the desert.

and razed the rebuilt temple [6.2]. One small band of Jewish rebels that held off the Romans for two years at a mountain fortress called Masada was defeated in A.D. 73. Except for pockets of Jews who lived there over the centuries, not until 1948, when the state of Israel was established, would Jews hold political power in their ancestral home.

Masada

The Hebrew Bible and Its Message

The English word *bible* comes from the Greek name for the ancient city of Byblos, from which the papyrus reed used to make books was exported. As already noted, the Bible is a collection of books that took its present shape over a long period of time.

The ancient Hebrews divided the books of their Bible into three large groupings: the Law, the Prophets, and the Writings. The Law referred specifically to the first five books of the Bible, called the *Torah* (from the Hebrew word for "instruction" or "teaching"). The Prophets con-

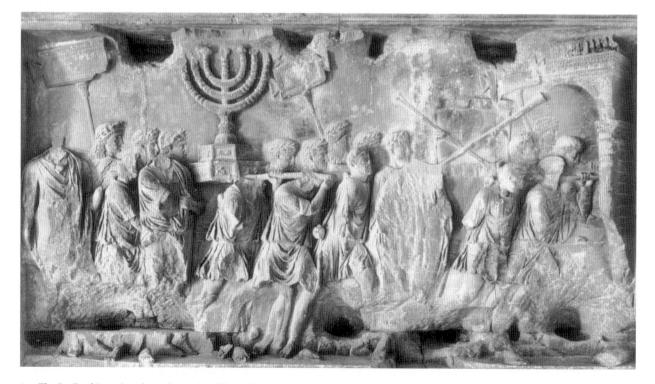

6.2 *The Spoils of Jerusalem,* from the Arch of Titus, Rome, c. A.D. 81, passageway relief. The seven-branched candelabrum (a menorah) is carried as part of the booty after the Romans sacked the city of Jerusalem.

3. Models and types. Until modern times relatively few Jews or Christians actually read the Bible on an individual basis. Literacy was rare, books expensive, and leisure at a premium. Bibles were read to people most frequently in public gatherings of worship in synagogues or churches. The one time that the New Testament reports Jesus as reading is from a copy of the prophet Isaiah kept in a synagogue (Luke 4:16ff.). The biblical stories were read over the centuries in a familial setting (as at the Jewish Passover) or in formal worship on the Sabbath. The basic point, however, is that for more than three thousand years the stories and (equally important) the persons in these stories have been etched in the Western imagination. The faith of Abraham, the guidance of Moses, the wisdom of Solomon, the sufferings of Job, and the fidelity of Ruth have become proverbial in our culture.

These events and stories from the Bible are models of instruction and illumination; they have taken on a meaning far beyond their original significance. The events described in the Book of Exodus, for example, are often invoked to justify a desire for freedom from oppression and slavery. It is not accidental that Benjamin Franklin suggested depicting the crossing of the Reed Sea (not the Red Sea as is often said) by the Children of Israel as the centerpiece of the Great Seal of the United States. Long before Franklin's day, the Pilgrims saw themselves as the new Children of Israel who had fled the oppression of Europe (read: Egypt) to find freedom in the land "flowing with milk and honey" that was America. At a later period in history, slaves in this country saw themselves as the oppressed Israelites in bondage. The desire of African Americans for freedom was couched in the language of the Bible as they sang "Go down, Moses. . . . Tell old Pharaoh: Let my people go!"

No humanities student can ignore the impact of the biblical tradition on our common culture. Our literature echoes it; our art is saturated in it; our social institutions are shaped by it. Writers in the Middle Ages said that all knowledge came from God in the form of two great books: the book of nature and the book called the Bible. We have enlarged that understanding today but, nonetheless, have absorbed much of the Hebrew Scriptures into the very texture of our culture.

The Beginnings of Christianity

The fundamental fact with which to study the life of Jesus is to remember that he was a Jew, born during the reign of Roman Emperor Augustus in the Romanoccupied land of Judaea. What we know about Him, apart from a few glancing references in pagan and Jewish literature, comes from the four Gospels (*gospel* derives from the Anglo-Saxon word meaning "good news") attributed to Matthew, Mark, Luke, and John. These Gospels began to appear more than a generation after the death of Jesus, which probably occurred in A.D. 30. The Gospels are religious documents, not biographies, but they contain historical data about Jesus as well as theological reflections about the meaning of His life and the significance of His deeds.

The Gospels

Jesus must also be understood in the light of the Jewish prophetical tradition discussed above. He preached the coming of God's kingdom, which would be a reign of justice and mercy. Israel's enemies would be overcome. Until that kingdom arrived, Jesus insisted on a life of repentance; an abandonment of earthly concerns; love of God and neighbor; compassion for the poor, downcast, and marginalized; and set forth His own life as an example. His identification with the poor and powerless antagonized his enemies—who included the leaders of His own religion and the governing authorities of the ruling Romans. Perhaps the most characteristic expression of the teachings of Jesus is to be found in His parables and in the moral code He expressed in what is variously called the Beatitudes or the Sermon on the Mount.

All of the teachings of Jesus reflect a profound grasp of the piety and wisdom of the Jewish traditions, but the Gospels make a further claim for Jesus, depicting Him as the *Christ* (a Greek translation of the Hebrew *Messiah*, "anointed one")—the Savior promised by the ancient biblical prophets who would bring about God's kingdom. His tragic death by crucifixion (a punishment so degrading that it could not be inflicted on Roman citizens) would seem to have ended the public career of Jesus. The early Christian church, however, insisted that Jesus overcame death by rising from the tomb three days after His death. This belief in the resurrection became a centerpiece of Christian faith and preaching and the basis upon which early Christianity proclaimed Jesus as the Christ.

Christianity Spreads

The slow growth of the Christian movement was given an early boost by the conversion of a Jewish zealot, Saul of Tarsus, around the year A.D. 35 near Damascus, Syria. Paul (his postconversion name) won a crucial battle in the early Christian church, insisting that non-Jewish converts to the movement would not have to adhere to all Jewish religious customs, especially male circumcision. Paul's victory was to change Christianity from a religious movement within Judaism to a religious tradition that could embrace the non-Jewish world of the Roman Empire. One dramatic example of Paul's approach to this pagan world was a public sermon he gave in the city of Athens in which he used the language of Greek culture to speak to the Athenians with the message of the Christian movement (see Acts 17:16–34).

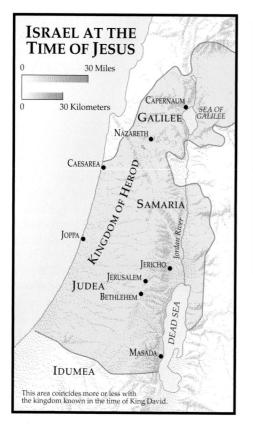

Paul was a tireless missionary. He made at least three long journeys through the cities on the northern shore of the Mediterranean (and may once have gotten as far as Spain). On his final journey he reached Rome itself, where he met his death at the hands of a Roman executioner around the year A.D. 62. In many of the cities he visited he left small communities of believers. Some of his letters (to the Romans, Galatians, Corinthians, and so on) are addressed to believers in these places and provide details of his theological and pastoral concerns.

By the end of the first century, communities of Christian believers existed in most of the cities of the vast Roman Empire. Their numbers were sufficient enough that, by A.D. 64, Emperor Nero could make Christians scapegoats for a fire that destroyed the city of Rome (probably set by the emperor's own agents). The Roman writer Tacitus provides a vivid description of the terrible tortures meted out against the Christians:

Nero charged, and viciously punished, people called Christians who were despised on account of their wicked practices. The founder of the sect, Christus, was executed by the procurator Pontius Pilate during the reign of Tiberius. The evil superstition was suppressed for a time but soon broke out afresh not only in Judea where it started but also in Rome where every filthy outrage arrives and prospers. First, those who confessed were seized and then, on their witness, a huge number was convicted, less for arson than for their hatred of the human race.

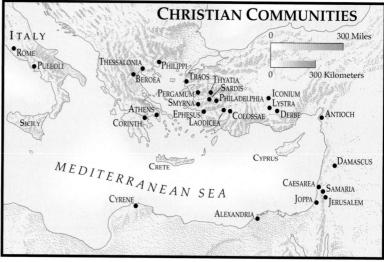

TABLE 6.1 Books of the Old and New Testaments

OLD Genesis Exodus Leviticus Numbers Deuteronomy Joshua Judges Ruth I and II Samuel I and II Kings I and II Chronicles Ezra Nehemiah Esther Iob Psalms Proverbs Ecclesiastes Song of Solomon Isaiah Ieremiah Lamentations Ezekiel Daniel Hosea Ioel Amos Obadiah Jonah Micah Nahum Habakkuk Zephaniah Haggai Zechariah Malachi

NEW The Gospels: Matthew Mark Luke John The Acts of the Apostles The Letters of Paul: Romans **I** Corinthians **II** Corinthians Galatians **Ephesians** Philippians Colossians I Thessalonians **II** Thessalonians I Timothy II Timothy Titus Philemon Hebrews The Letters of: James I Peter II Peter I John II John III John Jude The Book of Revelation (also called The Apocalypse)

CONTEMPORARY VOICES

Vibia Perpetua

Another day, while we were dining at noonday, we were summoned away to a hearing at the forum. At once, rumors swept the neighborhoods and a huge crowd assembled. We mounted the tribune. The others, when questioned, confessed. Then it was my turn. My father arrived with my infant son and pulled me down saying, "Sacrifice! Have mercy on your child!" The governor Hilarianus, who held judicial power in place of the proconsul Minucius Timianus, chimed in: "Pity your father's old age! Have mercy on your infant child! Perform the imperial rituals for the well-being of the emperor." And I answered, "I will not perform it." Hilarianus: "You are a Christian?" And I answered, "I am a Christian." And as my father still stood by trying to change my mind, Hilarianus ordered him expelled from his sight; he was struck with a rod. I wept for my father's misfortune as if I had been hit myself; I grieved for his old age.

In their death they were mocked. Some were sewn in animal skins and worried to death by dogs; others were crucified or burned so that, when daylight was over, they could serve as torches in the evening. Nero provided his own gardens for this show and made it into a circus. He mingled with the crowd dressed as a charioteer or posed in his chariot. As a result, the sufferers guilty and worthy of punishment although they were, did arouse the pity of the mob who saw their suffering resulted from the viciousness of one man and not because of some need for the common good.

[Annals XV]

Two questions arise at this point: Why were the Christians successful in spreading their religion? Why did they become the object of persecution at the hands of the Romans?

Persecution of the Christians

A number of social factors aided the growth of Christianity: There was peace in the Roman Empire; a good system of safe roads made travel easy; there was a common language in the empire (a form of common Greek called *koine*: the language of the New Testament); and Christianity was first preached in a network of Jewish centers. Scholars have also offered some religious reasons: the growing interest of pagans in monotheism; the strong Christian emphasis on salvation and freedom from sin; the Christian custom of offering mutual aid and Then the governor read out the sentence: condemned to the beasts of the arena.

Cheerfully, we returned to prison.

Since my child was an infant and accustomed to breastfeeding in prison, I sent the deacon Pomponius to my father imploring that my child be returned to me. But my father refused to give the child up. Somehow, through the will of God, the child no longer required the breast nor did my breasts become sore. I was neither tortured with grief over the child nor with pain in my breasts.

Excerpt from the narrative of Vibia Perpetua, who was martyred in Carthage in A.D. 203, when she was twenty-two years old. The last line of her narrative, written the day before her death, says simply, "If any-one wishes to write of my outcome, let him do so."

charity for its members; and its relative freedom from class distinctions. Paul wrote that in this faith there was "neither Jew nor Gentile; male nor female; slave nor free person."

This new religion met a good deal of resistance. The first martyrs died before the movement spread outside Jerusalem because of the resistance of the Jewish establishment. Very quickly, too, the Christians earned the enmity of the Romans. Even before Nero's persecution in A.D. 64, the Christians had been expelled from the city of Rome by Emperor Claudius. From those early days until the third century there were sporadic outbreaks of persecutions. In A.D. 250, under Emperor Decius, there was an empire-wide persecution, with two others coming in 257 (under Emperor Valerian) and under Emperor Diocletian in 303. Finally, in A.D. 312, Emperor Constantine issued a decree in Milan allowing Christianity toleration as a religion.

What was the basis for this long history of persecution?

The reasons are complex. Ordinarily, Rome had little interest in the religious beliefs of its subjects so long as these beliefs did not threaten public order. The Christian communities seemed secretive; they had their own network of communication in the empire; they kept away from active life in the political realm; most telling of all, they refused to pay homage to the state gods and goddesses. A common charge made against them was that they were atheists: They denied the existence of the Roman gods. Romans conceived of their society as bound together in a seamless web of *pietás*, a virtue that meant a combination of love and reverential fear. The Romans felt that one should express *pietás* to the parents of a family, the family should express that *pietás* toward the state, and the state in turn owed *pietás* to the gods. That brought everything into harmony, and the state would flourish. The Christian refusal to express *pietás* to the gods seemed to the Romans to strike at the heart of civic order. The Christians, in short, were traitors to the state.

Christian writers of the second century tried to answer these charges by insisting that the Christians wished to be good citizens and, in fact, could be. These writers (called *apologists*) wrote about the moral code of Christianity, about their beliefs and the reasons they could not worship the Roman deities. Their radical monotheism, inherited from Judaism, forbade such worship. Furthermore, they protested their roles as ready scapegoats for every ill-real and imagined-in society. The acid-tongued North African Christian writer Tertullian (c. 160-225) provided a sharp statement concerning the Christian grievance about such treatment: "If the Tiber floods its banks or the Nile doesn't flood; if the heavens stand still or the earth shakes, if there is hunger or drought, quickly the cry goes up, 'Christians to the lions!" "

One of the most important of the early Christian apologists was Justin Martyr. Born around A.D. 100 in Palestine, he converted to Christianity and taught, first, at Ephesus, and later in Rome. While in Rome he wrote two lengthy apologies to the emperors asking for toleration and attempting, at the same time, to explain the Christian religion. These early writings are extremely important since they provide a window on early Christian life and Christian attitudes toward both Roman and Jewish culture. Justin's writings did not, however, receive the audience for which he had hoped. In A.D. 165 he was scourged and beheaded in Rome under the anti-Christian laws.

Justin Martyr biography

Early Christian Art

Little significant Christian art or architecture dates from before the fourth century because of the illegal status of the Christian church and the clandestine life it was forced to lead. We do have art from the cemeteries of Rome and some other cities that were maintained by the Christian communities. These cemeteries (known as *catacombs* from the name of one of them, the *coemeterium ad catacumbas*) were the burial places of thousands of Christians. Contrary to romantic notions, these underground galleries, hewn from the soft rock known as *tufa*, were never hiding places for Christians during the times of persecution, neither were they secret places for worship. Such ideas derive not from fact but from nineteenthcentury novels. Similarly, only a minuscule number of the tombs contained the bodies of martyrs; none do today, since the martyrs were reburied inside the walls of the city of Rome in the early Middle Ages.

These underground cemeteries are important, however, because they provide us some visual evidence about early Christian beliefs and customs. This artistic material falls into the following categories.

Frescoes (Wall Paintings Done on Wet Plaster)

Frescoes are found frequently in the catacombs. Most depict biblical subjects that reflect the Christian hope of salvation and eternal life. Thus, for example, common themes like the story of Jonah or the raising of Lazarus from the dead allude to the Christian belief that everyone would be raised at the end of time. Another common motif is the communion meal of Jesus at the Last Supper as an anticipation of the heavenly banquet that awaited all believers in the next life [6.3]. These frescoes herald the beginnings of artistic themes that would continue down through the centuries. In the catacombs of Priscilla in Rome, for example, we find the first known depiction of the Virgin and Child, a subject that would in time become commonplace [6.4].

Glass and Sculpture

Although sculpture is quite rare before the fourth century, a statue of Christ as Good Shepherd [6.5], unbearded and with clearly classical borrowings, may be dated from this period. The figure repeats a common theme in the catacomb fresco art of the period. More common are the glass disks with gold paper cutouts pressed in them that are found in both Jewish and Christian catacombs as a decorative motif on individual tomb slots. After the period of Constantine, carved sarcophagi also became both common and elaborate [6.6, 6.7].

Inscriptions

Each tomb was covered by a slab of marble that was cemented in place. On those slabs would be carved the name and death date of the buried person. Quite frequently, there was also a decorative symbol such as an anchor (for hope) or a dove with an olive branch (peace). One of the most common symbols was a fish. The Greek letters that spell out the word *fish* were considered an anagram for the phrase "Jesus Christ, Son of God and Savior" so that the fish symbol became a shorthand way of making that brief confession of faith [6.8].

Symbolism of the Fish (Ichthys)

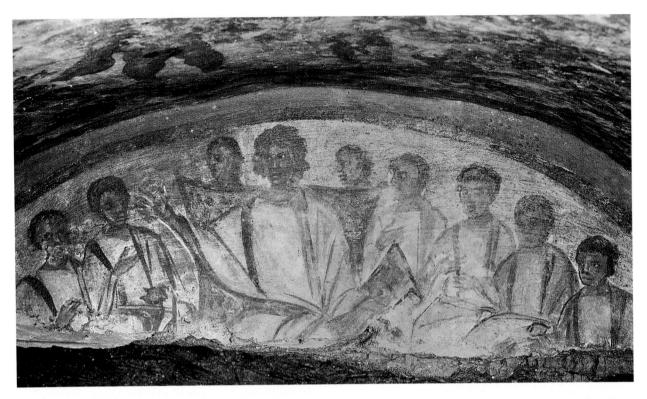

6.3 *Christ Teaching the Apostles,* Catacomb of Domitilla, Rome, c. A.D. 300. Wall painting. $1'3'' \times 4'3''$ (.38 × 1.3 m). The beardless Christ and the use of the Roman toga are characteristic. Partially destroyed; the original setting was meant to depict a eucharistic banquet.

6.4 *Virgin and Child,* Cemetery of Priscilla, c. A.D. 250. Wall painting. The figure to the left has been identified as a prophetic figure, perhaps the prophet Isaiah.

Dura-Europos

Despite the persecutions of the Christians and the hostility of the Romans to the Jews, the religions managed to coexist and, to a certain extent, to thrive in the Roman Empire. One small indication of this fact can be seen in the spectacular archaeological finds made in the 1930s at a small town in present-day Syria called Dura-Europos. This small Roman garrison town, destroyed by Persian armies in A.D. 256, was covered by desert sands for nearly seventeen hundred years. The scholars who excavated it found a street that ran roughly north and south along the city wall (they called it Wall Street) and contained a Christian house church with some intact frescoes, a temple to a Semitic god called Aphlad, a temple to the god Zeus (Roman Jupiter), a meeting place for the worshipers of the cult of Mithra, and a Jewish synagogue with more than twenty well-preserved fresco paintings of scenes from the Hebrew Scriptures [6.9].

The Dura-Europos discoveries revealed both the mingling of many religious cultures and demonstrated that the usual Jewish resistance to the visual arts was not total. Further, the evidence of a building for Christian worship

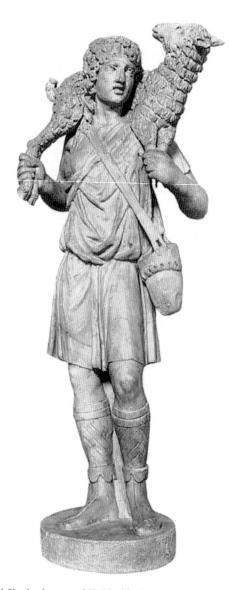

6.5 Good Shepherd, c. A.D. 300. Marble. Height 39" (99 cm). Vatican Museums, Rome. This depiction of Christ is very common in early Christian art, although sculptural examples are rather rare.

(part of a papyrus of the four Gospels harmonized into one whole was found at the site) in place sixty years before Constantine's Edict of Toleration and in use during a time when there were empire-wide persecutions of Christians is a significant discovery. Scholars see in the art of Dura-Europos the mingling of both Eastern and Roman styles that might be the source for the art that would emerge more fully in the Byzantine world. Most significantly, the finds at Dura-Europos demonstrate how complex the religious situation of the time really was and how the neat generalizations of historians do not always correspond to the complicated realities of actual life.

Constantine and Early Christian Architecture

Two of the most famous churches in Christendom are associated with the reign of Emperor Constantine (A.D. 306-337). The present Saint Peter's Basilica in the Vatican rests on the remains of a basilica built by Constantine and dedicated in A.D. 326. We do not have a fully articulated plan of that church, but its main outlines are clear. The faithful would enter into a courtyard called an atrium around which was a colonnaded arcade and from there through a vestibule into the church proper. The basilica, modeled after secular counterparts in Rome, featured a long central nave with two parallel side aisles. The nave was intersected at one end by a transept, the roof of which was pitched with wooden trusses and supported by the outer walls and the columned interiors. High up on the walls above the arches and below the roof was the so-called *clerestory* (windows that provided most of the interior illumination). This basilica-type church [6.10, 6.11] became a model from which many of the features of later church architecture evolved.

6.6 *Jonah Sarcophagus,* fourth century. Museo Pio Cristiano, the Vatican, Rome. Limestone. Besides the Jonah cycle there are other biblical scenes: at the top left, the raising of Lazarus; to the right of the sail at top, Moses striking the rock; at the far top right, a shepherd with a sheep.

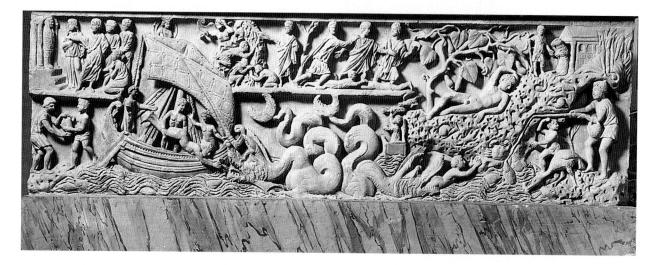

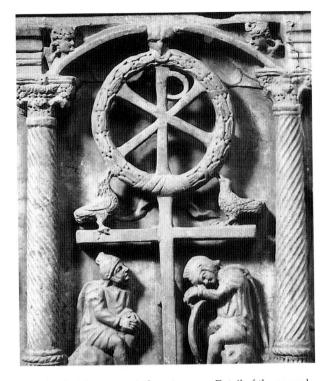

6.7 *Chi-Rho Monogram,* ninth century A.D. Detail of the sarcophagus of Saint Theodorus. Ravenna. The Vatican Museum, Rome. The first letters of Christ's name in Greek are in the center of the Roman military standard. The figure represents the Risen Christ; note the sleeping guards at the tomb under the arm of the cross.

6.9 *The Crossing of the Red Sea*, c. A.D. 245. Fresco. Dura-Europos. National Archaeological Museum, Damascus, Syria. This extraordinary scene shows Moses and Aaron with Egyptian soldiers on their right and the drowning armies on their left. This is part of a huge wall mural in a synagogue depicting scenes from the Hebrew scriptures.

6.8 *Fish and Chalice,* third century. Floor mosaic. Ostia Antica (Rome). This mosaic and other evidence led scholars to believe that a house excavated in the Roman port city of Ostia was a house church with a baptistery. The fish was a common symbol of Christ. This is one of the earliest uses of the symbol.

Old St. Peter's Basilica

The other famous church built in the Constantinian period is the Church of the Holy Sepulchre in Jerusalem [6.12]. This church was also built in the basilica style, its atrium in front of the basilica hall, but with a significant

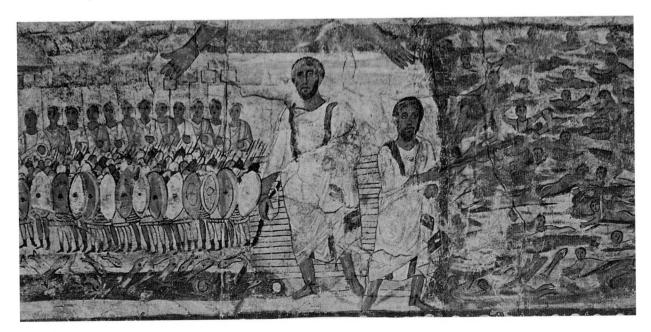

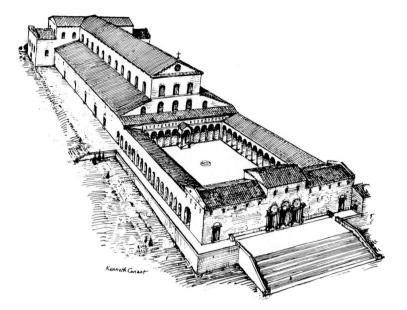

6.10 Old Saint Peter's Basilica, Rome, c. A.D. 333. Length of grand axis 835' (254.5 m), width of transept 295' (86.87 m). Reconstruction study by Kenneth J. Conant. Note the open atrium area and the basilica-style church behind it. The church was demolished in the sixteenth century when the new basilica was constructed.

addition: Behind the basilica was a domed structure that covered—it was believed—the rocky place where the body of Christ had been buried for three days. The domelike structure was utilized in Christian architecture as an adaptation of existing domed structures in pagan Rome, most notably the Pantheon and some of the vast baths.

Church of the Holy Sepulchre

Early Christian Music

If the visual arts of early Christianity turned to Graeco-Roman models for inspiration, the music of the early church drew on Jewish sources. The tradition of singing (or, rather, chanting) sacred texts at religious services

6.11 Floorplan of Old Saint Peter's Basilica.

was an ancient Jewish custom that appears to go back to Mesopotamian sources. What little we know of Jewish music, in fact, suggests that it was influenced strongly by the various peoples with whom the Jews came into contact. The lyre used by Jewish musicians was a common Mesopotamian instrument, whereas the harp for which King David was famous came to the Jews from Assyria by way of Egypt [6.13].

By early Christian times Jewish religious services consisted of a standardized series of prayers and scriptural readings organized in a fashion such as to create a cycle that fit the Jewish calendar. Many of these readings were taken over by early Christian congregations, particularly those where the number of converted Jews was high. In chanting the Psalms, the style of execution often depended on how well they were known by the congregation. Where the Jewish component of the congregation was strong the congregation would join in the chant.

6.12 Church of the Holy Sepulchre, Jerusalem, as it appeared c. A.D. 345. Reconstruction by Kenneth J. Conant. In this drawing, both the domed area, which covered the burial place of Christ, and the detached basilica in front of it can be seen. In the present church there is no separation between the domed area and the basilica.

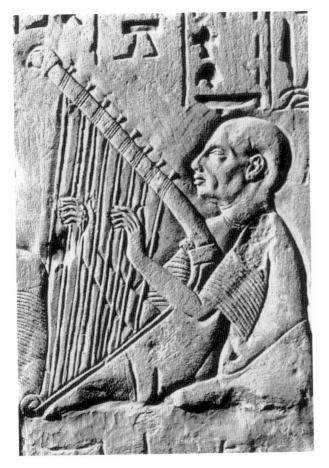

6.13 The Blind Harper of Leiden, detail from the tomb of Paatenemmheb, Saqqara, c. 1340-1330 B.C. Limestone basalt relief, height 11 1/2" (29 cm). Rijksmuseum van Oudheden, Leiden, Netherlands. It is quite possible that the lyre depicted here is similar to those mentioned in the book of Psalms.

Increasingly, however, the singing was left to trained choruses with the other congregants joining in only for the standard response of "Amen" or "Alleluia." As the music fell more into the hands of professionals, it became increasingly complex.

This professionalization proved unpopular with church authorities who feared that the choirs were concerned more with performance than with worship. In A.D. 361, a provincial council of the Christian church in Laodicea ordered that there should be only one paid performer (*cantor*) for each congregation. In Rome, the authorities discouraged poetic elaboration on the liturgical texts, a practice common among the Jews and the Christians of the East.

Part of the early Christian suspicion of music, in the West at least, was a reaction against the Greek doctrine of ethos in music, which claimed that music could have a profound effect on human behavior. That music might induce moods of passion or violence or might even be an agreeable sensation in itself was not likely to appeal to a church that required the ethos of its music to express religious truth alone. For this reason instrumental music was rejected as unsuitable for the Christian liturgy. Such instrumentation was, in the minds of many Christians, too reminiscent of pagan customs.

By the fourth century, then, the standard form of music in Christian churches was either *responsorial* singing, with a cantor intoning lines from the Psalms and the congregation responding with a simple repeated refrain, or *antiphonal* singing, with parts of the congregation (or the cantor and the congregation) alternating verses of a psalm in a simple chant tone. By the beginning of the fifth century, there is evidence of nonscriptural hymns being composed. Apart from some rare fragments, we have no illustration of music texts with notation before the ninth century.

SUMMARY

This chapter traces a very long history from the beginnings of the biblical tradition to the emergence of Christianity as a state religion in the Roman Empire, a history so complex that one hesitates to generalize about its shape and significance. Nonetheless, certain points deserve to be highlighted both because they are instructive in their own right and because of their continuing impact on the shape of Western culture.

First, the biblical tradition reflects the emergence of monotheism (a belief in one God) as a leading idea in Western culture. Judaism held the ideal of the uniqueness of God against the polytheistic cultures of Babylonia, Assyria, and Egypt. That idea carried over into Christianity and became a point of conflict with Roman culture. The Roman charge that Christians were atheists meant not that they denied the existence of God but that they rejected the Roman gods.

Second, the entire biblical tradition had a very strong ethical emphasis. The prophets never ceased to argue that the external practice of religion was worthless unless there was a "pure heart." Jesus preached essentially the same thing in his famous criticisms of those who would pray publicly but secretly, in his words, "devour the substance of widows."

This ethic was rooted in the biblical notion of *prophetism*—the belief that people could be called by God to denounce injustice in the face of hostility either from their own religious establishment or from equally hostile civil governments. Such prophetic protest, inspired by the biblical message, was always a factor in subsequent Judaism and Christianity.

Both Judaism and Christianity insisted on a personal God who was actively involved with the world of humanity to the degree that there was a *covenant* between God and people and that the world was created and sustained by God as a gift for humans. This was a powerful doctrine that flew in the face of the ancient belief in impersonal fate controlling the destiny of people or a pessimism about the goodness or reliability of the world as we have it and live in it. The biblical belief in the providence of God would have an enormous impact on later Western culture in everything from shaping its philosophy of history (that history moves in a linear fashion and has a direction to it) to an optimism about the human capacity to understand the world and make its secrets known for the benefit of people. Western culture never accepted, at least as a majority opinion, that the physical world itself was sacred or an illusion; rather it was a gift to be explored and at times exploited.

Finally, the Jewish and Christian tradition produced a work of literature: the Bible. The significance of that production can best be understood in the subsequent chapters of this book. It will soon become clear that a good deal of what the humanistic tradition of art, literature, and music produced until well into the modern period is unintelligible if not seen as an ongoing attempt to interpret that text in various artistic media according to the needs of the age.

PRONUNCIATION GUIDE

catacombs:	CAT-ah-combs	
Constantine:	CON-stan-tine	
covenant:	KUV-e-nent	
Decius:	DAY-see-us	
Diocletian:	Die-oh-KLE-shun	
Dura-Europos:	Dew-rah You-ROPE-us	
Exodus:	X-oh-dus	
Laodicea:	Lay-oh-de-SEE-ah	
Messiah:	Mess-EYE-ah	
Mithraism:	MYTH-rah-is-im	
pietá:	Pea-eh-TA	
Torah:	TOE-rah	
tufa:	TOO-fa	

EXERCISES

- 1. Hebrew religion begins in a patriarchal culture (a tribe headed by a "father") and much of its language derives from that fact. What are the common titles for God that reflect that masculine dominance? Do some feminists have a case in their criticism of the overly patriarchal nature of biblical religion?
- 2. Biblical religion insists that God has no name and cannot be depicted in art. What do you believe were the reasons behind that attitude (almost unique in the ancient world) and what were its cultural consequences?
- 3. The biblical covenant is summed up in "I will be your God; you will be my people." Can you suggest a short phrase to sum up a marriage covenant? a covenant between citizens and the state? What are the essential characteristics of a covenant?
- 4. Reread the Ten Commandments. Which of them make sense only to religious believers? Which have general applications? Could you suggest other commandments for inclusion in a modern version?
- 5. How would you characterize Jesus as a cultural type: teacher? philosopher? prophet? hero? martyr? other? Explain.

- 6. It is said that the Beatitudes are at the heart of the teaching of Jesus. Paraphrase those Beatitudes in contemporary language. Which of them sound strangest to our ears?
- 7. Do you see any lessons about religious tolerance today from the history of the persecution of the Christians in the Roman Empire?
- 8. Constantine extended the aid of the state to Christians. What are the benefits of state support for religion? the problems?
- 9. În his famous praise of the virtue of love (I Cor. 13), Paul the Apostle says that love outlives both faith and hope. What kind of love is he talking about? How does love outlive both hope and faith?

Further Reading

- Achtemeier, P. (Ed.). (1996). Rev. ed. *Harper's Bible dictionary* (Rev. ed.). San Francisco: Harper. Excellent one-volume reference work.
- Finegan, J. (1992). The archeology of the New Testament (Rev. ed.). Princeton, NJ: Princeton University Press. Excellent survey of Palestinian archeology and its relation to the Christian scriptures.
- Freedman, D. N. (Ed.). (1992). The Anchor Bible dictionary (6 vols.). Garden City, NY: Doubleday. Standard reference work.
- Frend, W. H. C. *The rise of Christianity*. Philadelphia: Fortress, 1983. Comprehensive history of early Christianity.
- Jeffrey, D. L. (Ed.). (1992). A dictionary of biblical tradition in English literature. Grand Rapids, MI: Eerdmans. Useful compendium of biblical themes in English literature.
- May, H. (Ed.). (1974). Oxford Bible atlas. New York: Oxford University Press. Invaluable for biblical geography.
- Mays, J. L. (Ed.). (1996). *Harper's Bible commentary*. San Francisco: Harper. Handy commentary on entire Bible.
- Pelikan, J. (1985). *Jesus through the centuries: His place in the history of culture.* (2nd ed.) New Haven, CT: Yale University Press. Excellent study of interpretations of Jesus in Western culture.
- Pritchard, J. B. (1969). Ancient Near Eastern texts relating to the Old Testament. Princeton, NJ: Princeton University Press. Indispensable collections of texts and images from the Near East that illuminate the study of the Bible.

Online Chapter Links

Masada: Desert Fortress Overlooking the Dead Sea at http://www.us-israel.org/jsource/Archaeology/ Masada1.html

provides a historical account with graphics and links to related information.

Photographs, maps, and biblical references are among the evidence offered at *The Location of the*

First and Second Temples in Jerusalem at http://www.templemount.org/theories.html

Internet Jewish History Sourcebook at http://www.fordham.edu.halsall/jewish/

jewishsbook/html

provides an extensive list of links to related Web sites.

The Christian Catacombs of Rome at

http://www.catacombe.roma.it/welcome.html provides a wide array of photographs and extensive information about the Catacombs of St. Callixtus, the spirituality of the catacombs, and the Christians of the persecutions.

For accounts about the formation of the biblical scriptures, consult the *Guide to Early Church Documents* at

http://www.iclnet.org/pub/resources/ christian-history.html

Return to Dura Europos at

http://www.historytoday.com/today/1197/centre/ frontline.stm

provides an account of the archaeological excavations at this ancient synagogue in Syria.

Online Chapter Resources

READING SELECTIONS

Genesis 1–2

In this section we have two quite different accounts of God as the creator and sustainer of all things. The selections from the Book of Genesis are the classic Hebrew accounts of creation; the first runs from 1:1 to 2:4a and the second to the end of the second chapter.

1 In the beginning God created the heavens and the earth. ²The earth was without form and void, and darkness was upon the face of the deep; and the Spirit of God was moving over the face of the waters.

³And God said, "Let there be light"; and there was light. ⁴And God saw that the light was good; and God separated the light from the darkness. ⁵God called the light Day, and the darkness he called Night. And there was evening and there was morning, one day.

⁶And God said, "Let there be a firmament in the midst of the waters, and let it separate the waters from the waters." ⁷And God made the firmament and separated the waters which were under the firmament from the waters which were above the firmament. And it was so. ⁸And God called the firmament Heaven. And there was evening and there was morning, a second day.

⁹And God said, "Let the waters under the heavens be gathered together into one place, and let the dry land ap-

pear." And it was so. ¹⁰God called the dry land Earth, and the waters that were gathered together he called Seas. And God saw that it was good. ¹¹And God said, "Let the earth put forth vegetation, plants yielding seed, and fruit trees bearing fruit in which is their seed, each according to its kind, upon the earth." And it was so. ¹²The earth brought forth vegetation, plants yielding seed according to their own kinds, and trees bearing fruit in which is their seed, each according to its kind. And God saw that it was good. ¹³And there was evening and there was morning, a third day.

¹⁴And God said, "Let there be lights in the firmament of the heavens to separate the day from the night; and let them be for signs and for seasons and for days and years, ¹⁵and let them be lights in the firmament of the heavens to give light upon the earth." And it was so. ¹⁶And God made the two great lights, the greater light to rule the day, and the lesser light to rule the night; he made the stars also. ¹⁷And God set them in the firmament of the heavens to give light upon the earth, ¹⁸to rule over the day and over the night, and to separate the light from the darkness. And God saw that it was good. ¹⁹And there was evening and there was morning, a fourth day.

²⁰And God said, "Let the waters bring forth swarms of living creatures, and let birds fly above the earth across the firmament of the heavens." ²¹So God created the great sea monsters and every living creature that moves, with which the waters swarm according to their kinds, and every winged bird according to its kind. And God saw that it was good. ²²And God blessed them, saying, "Be fruitful and multiply and fill the waters in the seas, and let birds multiply on the earth." ²³And there was evening and there was morning, a fifth day.

²⁴And God said, "Let the earth bring forth living creatures according to their kinds: cattle and creeping things and beasts of the earth according to their kinds." And it was so. ²⁵And God made the beasts of the earth according to their kinds and the cattle according to their kinds, and everything that creeps upon the ground according to its kind. And God saw that it was good.

²⁶Then God said, "Let us make man in our image, after our likeness; and let them have dominion over the fish of the sea, and over the birds of the air, and over the cattle, and over all the earth, and over every creeping thing that creeps upon the earth." 27So God created man in his own image, in the image of God he created him; male and female he created them. ²⁸And God blessed them, and God said to them, "Be fruitful and multiply, and fill the earth and subdue it; and have dominion over the fish of the sea and over the birds of the air and over every living thing that moves upon the earth." ²⁹And God said, "Behold, I have given you every plant yielding seed which is upon the face of all the earth, and every tree with seed in its fruit; you shall have them for food. ³⁰And to every beast of the earth, and to every bird of the air, and to everything that creeps on the earth, everything that has the breath of life, I have given every green plant for food." And it was so. 31And God saw everything that he had made, and behold, it was very good. And there was evening and there was morning, a sixth day.

2 Thus the heavens and the earth were finished, and all the 2 host of them ²And on the seventh day God finished his work which he had done, and he rested on the seventh day from all his work which he had done. ³So God blessed the seventh day and hallowed it, because on it God rested from all his work which he had done in creation.

⁴These are the generations of the heavens and the earth when they were created.

In the day that the LORD God made the earth and the heavens, ⁵when no plant of the field was yet in the earth and no herb of the field had yet sprung up, for the LORD God had not caused it to rain upon the earth, and there was no man to till the ground; ⁶but a mist went up from the earth and watered the whole face of the ground—⁷then the LORD God formed man of dust from the ground, and breathed into his nostrils the breath of life; and man became a living being. ⁸And the LORD God planted a garden in Eden, in the east; and there he put the man whom he had formed. ⁹And out of the ground the LORD God made to grow every tree that is pleasant to the sight and good for food, the tree of life also in the midst of the garden, and the tree of the knowledge of good and evil.

¹⁰A river flowed out of Eden to water the garden, and there it divided and became four rivers. ¹¹The name of the first is Pishon; it is the one which flows around the whole land of Hav'i-lah, where there is gold; ¹²and the gold of that land is good; bdellium and onyx stone are there. ¹³The name of the second river is Gihon; it is the one which flows around the whole land of Cush. ¹⁴And the name of the third river is Hid'de-kel, which flows east of Assyria. And the fourth river is the Eu-phra'tes.

¹⁵The LORD God took the man and put him in the garden of Eden to till it and keep it. ¹⁶And the LORD God commanded the man, saying, "You may freely eat of every tree of the garden; ¹⁷but of the tree of the knowledge of good and evil you shall not eat, for in the day that you eat of it you shall die."

¹⁸Then the LORD God said, "It is not good that the man should be alone; I will make him a helper fit for him." ¹⁹So out of the ground the LORD God formed every beast of the field and every bird of the air, and brought them to the man to see what he would call them; and whatever the man called every living creature, that was its name. ²⁰The man gave names to all cattle, and to the birds of the air, and to every beast of the field; but for the man there was not found a helper fit for him. ²¹So the LORD God caused a deep sleep to fall upon the man, and while he slept took one of his ribs and closed up its place with flesh; ²²and the rib which the LORD God had taken from the man he made into a woman and brought her to the man. ²³Then the man said, "This at last is bone of my bones and flesh of my flesh; she shall be called Woman, because she was taken out of Man."

²⁴Therefore a man leaves his father and his mother and cleaves to his wife, and they become one flesh. ²⁵And the man and his wife were both naked, and were not ashamed.

Job 37-40

The selections from the Book of Job constitute one of the finest poetic sections in the whole of the Bible. In answer to Job's questions about human sufferings God, speaking from a "whirlwind," catalogues the mystery of life itself. In essence, God says that the mystery of human suffering (the theme of Job) is paltry in the face of the wonders of creation. By a curious twist, God "answers" Job's questions not with an answer but by pointing to the deeper mysteries of existence itself.

 $37^{''At this also my heart trembles, and leaps out of its place.}$

- ²Hearken to the thunder of his voice and the rumbling that comes from his mouth.
- ³Under the whole heaven he lets it go, and his lightning to the corners of the earth.

- ⁴After it his voice roars; he thunders with his majestic voice and he does not restrain the lightnings when his voice is heard.
- ⁵God thunders wondrously with his voice; he does great things which we cannot comprehend.
- ⁶For to the snow he says, 'Fall on the earth'; and to the shower and the rain, 'Be strong.'
- ⁷He seals up the hand of every man, that all men may know his work.
- ⁸Then the beasts go into their lairs, and remain in their dens. ⁹From its chamber comes the whirlwind, cold from the scattering winds.
- ¹⁰By the breath of God ice is given, and the broad waters are frozen fast.
- ¹¹He loads the thick cloud with moisture; the clouds scatter his lightning.

¹²They turn round and round by his guidance, to accomplish all that he commands them on the face of the habitable world.

- ¹³Whether for correction, or for his land, or for love, he causes it to happen.
- ¹⁴"Hear this, O Job; stop and consider the wondrous works of God.
- ¹⁵Do you know how God lays his command upon them, and causes the lightning of his cloud to shine?
- ¹⁶Do you know the balancings of the clouds, the wondrous works of him who is perfect in knowledge,
- ¹⁷you whose garments are hot when the earth is still because of the south wind?
- ¹⁸Can you, like him, spread out the skies, hard as a molten mirror?
- ¹⁹Teach us what we shall say to him; we cannot draw up our case because of darkness.
- ²⁰Shall it be told him that I would speak? Did a man ever wish that he would be swallowed up?

²¹"And now men cannot look on the light when it is bright in the skies, when the wind has passed and cleared them.

²²Out of the north comes golden splendor; God is clothed with terrible majesty.

²³The Almighty—we cannot find him; he is great in power and justice, and abundant righteousness he will not violate.

²⁴Therefore men fear him; he does not regard any who are wise in their own conceit."

$38^{\rm Then \ the \ LORD \ answered \ Job \ out \ of \ the}$

- ²"Who is this that darkens counsel by words without knowledge?
- ³Gird up your loins like a man. I will question you, and you shall declare to me.

⁴"Where were you when I laid the foundation of the earth? Tell me, if you have understanding.

⁵Who determined its measurements—surely you know! Or who stretched the line upon it?

- ⁶On what were its bases sunk, or who laid its cornerstone,
- ⁷when the morning stars sang together, and all the sons of God shouted for joy?
- ⁸"Or who shut in the sea with doors, when it burst forth from the womb;
- ⁹when I made clouds its garment, and thick darkness its swaddling band,
- ¹⁰and prescribed bounds for it, and set bars and doors, ¹¹and said, 'Thus far shall you come, and no farther, and here shall your proud waves be stayed'?

¹²"Have you commanded the morning since your days began,

- and caused the dawn to know its place,
- ¹³that it might take hold of the skirts of the earth, and the wicked be shaken out of it?
- ¹⁴It is changed like clay under the seal, and it is dyed like a garment.
- ¹⁵From the wicked their light is withheld, and their uplifted arm is broken.
- ¹⁶"Have you entered into the springs of the sea, or walked in the recesses of the deep?
- ¹⁷Have the gates of death been revealed to you, or have you seen the gates of deep darkness?
- ¹⁸Have you comprehended the expanse of the earth? Declare, if you know all this.
- ¹⁹"Where is the way to the dwelling of light, and where is the place of darkness,
- ²⁰that you may take it to its territory and that you may discern the paths to its home?
- ²¹You know, for you were born then, and the number of your days is great!
- ²²"Have you entered the storehouses of the snow, or have you seen the storehouses of the hail,
- ²³which I have reserved for the time of trouble, for the day of battle and war?

²⁴What is the way to the place where the light is distributed, or where the east wind is scattered upon the earth?

²⁵"Who has cleft a channel for the torrents of rain, and a way for the thunderbolt,

²⁶to bring rain on a land where no man is, on the desert in which there is no man;

- ²⁷ to satisfy the waste and desolate land, and to make the ground put forth grass?
- ²⁸"Has the rain a father, or who has begotten the drops of dew?
- ²⁹From whose womb did the ice come forth, and who has given birth to the hoarfrost of heaven?
- ³⁰The waters become hard like stone, and the face of the deep is frozen.
- ³¹"Can you bind the chains of the Plei´ades, or loose the cords of Orion?
- ³²Can you lead forth the Maz'zaroth in their season, or can you guide the Bear with its children?
- ³³Do you know the ordinances of the heavens? Can you establish their rule on the earth?
- ³⁴"Can you lift up your voice to the clouds, that a flood of waters may cover you?
- ³⁵Can you send forth lightnings, that they may go and say to you, 'Here we are'?
- ³⁶Who has put wisdom in the clouds, or given understanding to the mists?
- ³⁷Who can number the clouds by wisdom? Or who can tilt the waterskins of the heavens,
- ³⁸when the dust runs into a mass and the clods cleave fast together?
- ³⁹"Čan you hunt the prey for the lion, or satisfy the appetite of the young lions,
- ⁴⁰when they crouch in their dens, or lie in wait in their covert?
- ⁴¹Who provides for the raven its prey, when its young ones cry to God, and wander about for lack of food?

- 39° Do you know when the mountain goats bring forth?
- Do you observe the calving of the hinds?
- ²Can you number the months that they fulfil, and do you know the time when they bring forth,
- ³when they crouch, bring forth their offspring, and are delivered of their young?
- ⁴Their young ones become strong, they grow up in the open; they go forth, and do not return to them.
- ⁵"Who has let the wild ass go free? Who has loosed the bonds of the swift ass,
- ⁶to whom I have given the steppe for his home, and the salt land for his dwelling place?
- ⁷He scorns the tumult of the city; he hears not the shouts of the driver.
- ⁸He ranges the mountains as his pasture, and he searches after every green thing.
- ⁹"Is the wild ox willing to serve you? Will he spend the night at your crib?
- ¹⁰Can you bind him in the furrow with ropes, or will he harrow the valleys after you?
- ¹¹Will you depend on him because his strength is great, and will you leave to him your labor?
- ¹²Do you have faith in him that he will return, and bring your grain to your threshing floor?
- ¹³"The wings of the ostrich wave proudly; but are they the pinions and plumage of love?
- ¹⁴For she leaves her eggs to the earth, and lets them be warmed on the ground,
- ¹⁵forgetting that a foot may crush them, and that the wild beast may trample them.
- ¹⁶She deals cruelly with her young, as if they were not hers; though her labor be in vain, yet she has no fear;
- ¹⁷because God has made her forget wisdom, and given her no share in understanding.
- ¹⁸When she rouses herself to flee, she laughs at the horse and his rider.
- ¹⁹"Do you give the horse his might? Do you clothe his neck with strength?
- ²⁰Do you make him leap like the locust? His majestic snorting is terrible.
- ²¹He paws in the valley, and exults in his strength; he goes out to meet the weapons.
- ²²He laughs at fear, and is not dismayed; he does not turn back from the sword.
- ²³Upon him rattle the quiver, the flashing spear and the javelin.
- ²⁴With fierceness and rage he swallows the ground;
- he cannot stand still at the sound of the trumpet. ²⁵When the trumpet sounds, he says 'Aha!' He smells the
- battle from afar, the thunder of the captains, and the shouting.
- ²⁶"Is it by your wisdom that the hawk soars, and spreads his wings toward the south?
- ²⁷Is it at your command that the eagle mounts up and makes the nest on high?
- ²⁸On the rock he dwells and makes his home in the fastness of the rocky crag.
- ²⁹Thence he spies out the prey; his eyes behold it afar off.
- ³⁰His young ones suck up blood; and where the slain are, there is he."

40^{And} the LORD said to Job: 2"Shall a faultfinder contend with the Almighty? He who argues with God, let him answer it."

³Then Job answered the LORD:

⁴"Behold, I am of small account; what shall I answer thee? I lay my hand on my mouth.

⁵I have spoken once, and I will not answer; twice, but I will proceed no further."

⁶Then God answered Job out of the whirlwind:

- ⁷"Gird up your loins like a man; I will question you, and you declare to me.
- ⁸Will you even put me in the wrong? Will you condemn me that you may be justified?
- ⁹Have you an arm like God, and can you thunder with a voice like his?
- ¹⁰"Deck yourself with majesty and dignity; clothe yourself with glory and splendor.
- ¹¹Pour forth the overflowings of your anger, and look on every one that is proud, and abase him.

¹²Look on every one that is proud, and bring him low; and tread down the wicked where they stand.

- ¹³Hide them all in the dust together; bind their faces in the world below.
- ¹⁴Then will I also acknowledge to you, that your own right hand can give you victory.
- ¹⁵"Behold, Be hemoth, which I made as I made you; he eats grass like an ox.
- ¹⁶Behold, his strength in his loins, and his power in the muscles of his belly.
- ¹⁷He makes his tail stiff like a cedar; the sinews of his thighs are knit together.
- ¹⁸His bones are tubes of bronze, his limbs like bars of iron.
- ¹⁹"He is the first of the works of God; let him who made him bring near his sword!
- ²⁰For the mountains yield food for him where all the wild beasts play.
- ²¹Under the lotus plants he lies, in the covert of the reeds and in the marsh.
- ²²For his shade the lotus trees cover him; the willows of the brook surround him.
- ²³Behold, if the river is turbulent he is not frightened;
- he is confident though Jordan rushes against his mouth.

²⁴Can one take him with hooks, or pierce his nose with a snare?"

Exodus 19-20

This selection from the Book of Exodus recounts the appearance of God (a theophany; a "showing forth" of God) and the giving of the Ten Commandments, which became the central core of the moral code of the Bible. When reading this passage note all the ways in which the author emphasizes the power and otherness of God in order to emphasize the awful solemnity of the events being described.

19On the third new moon after the people of Israel had gone forth out of the land of Egypt, on that day they came into the wilderness of Sinai. ²And when they set out from Reph'idim and came into the wilderness of Sinai, they encamped in the wilderness; and there Israel encamped before the mountain. ³And Moses went up to God, and the LORD called him out of the mountain, saying, "Thus you shall say to the house of Jacob, and tell the people of Israel: ⁴You 'have seen what I did to the Egyptians, and how I bore you on eagles' wings and brought you to myself. ⁵Now therefore, if you will obey my voice and keep my covenant, you shall be my own possession among all peoples; for all the earth is mine, ⁶and you shall be to me a kingdom of priests and a holy nation.' These are the words which you shall speak to the children of Israel."

⁷So Moses came and called the elders of the people, and set before them all these words which the LORD had commanded him. ⁸And all the people answered together and said, "All that the LORD has spoken we will do." And Moses reported the words of the people to the LORD. ⁹And the LORD said to Moses, "Lo, I am coming to you in a thick cloud, that the people may hear when I speak with you, and may also believe you for ever."

Then Moses told the words of the people to the LORD. ¹⁰And the LORD said to Moses, "Go to the people and consecrate them today and tomorrow, and let them wash their garments, ¹¹and be ready by the third day; for on the third day the LORD will come down upon Mount Sinai in the sight of all the people. ¹²And you shall set bounds for the people round about, saying, "Take heed that you do not go up into the mountain or touch the border of it; whoever touches the mountain shall be put to death; ¹³no hand shall touch him, but he shall be stoned or shot; whether beast or man, he shall not live.' When the trumpet sounds a long blast, they shall come up to the mountain." ¹⁴So Moses went down from the mountain to the people, and consecrated the people; and they washed their garments. ¹⁵And he said to the people, "Be ready by the third day; do not go near a woman."

¹⁶On the morning of the third day there were thunders and lightnings, and a thick cloud upon the mountain, and a very loud trumpet blast, so that all the people who were in the camp trembled. ¹⁷Then Moses brought the people out of the camp to meet God; and they took their stand at the foot of the mountain. ¹⁸And Mount Sinai was wrapped in smoke, because the LORD descended upon it in fire; and the smoke of it went up like the smoke of a kiln, and the whole mountain quaked greatly. ¹⁹And as the sound of the trumpet grew louder and louder, Moses spoke, and God answered him in thunder. 20And the LORD came down upon Mount Sinai, to the top of the mountain; and the LORD called Moses to the top of the mountain, and Moses went up. ²¹And the LORD said to Moses, "Go down and warn the people, lest they break through to the LORD to gaze and many of them perish. ²²And also let the priests who come near to the LORD consecrate themselves, lest the LORD break out upon them," ²³And Moses said to the LORD, "The people cannot come up to Mount Sinai; for thou thyself didst charge us, saying, 'Set bounds about the mountain, and consecrate it.' " ²⁴And the LORD said to him, "Go down, and come up bringing Aaron with you; but do not let the priests and the people break through to come up to the LORD, lest he break out against them." ²⁵So Moses went down to the people and told them.

 20^{And} God spoke all these words, saying, ²"I am the LORD your God, who brought you out of the land of Egypt, out of the house of bondage.

³"You shall have no other gods before me.

⁴"You shall not make yourself a graven image, or any likeness of anything that is in heaven above, or that is in the earth beneath, or that is in the water under the earth; ⁵you shall not bow down to them or serve them; for I the LORD your God am a jealous God, visiting the iniquity of the fathers upon the children to the third and the fourth generation of those who hate me, ⁶but showing steadfast love to thousands of those who love me and keep my commandments.

⁷"You shall not take the name of the LORD your God in vain; for the LORD will not hold him guiltless who takes his name in vain.

⁸"Remember the sabbath day, to keep it holy. ⁹Six days you shall labor, and do all your work; ¹⁰but the seventh day is a sabbath to the LORD your God; in it you shall not do any work, you, or your son, or your daughter, your manservant, or your maidservant, or your cattle, or the sojourner who is within your gates; ¹¹for in six days the LORD made heaven and earth, the sea, and all that is in them, and rested the seventh day; therefore the LORD blessed the sabbath day and hallowed it.

¹²"Honor your father and your mother, that your days may be long in the land which the LORD your God gives you.

¹³"You shall not kill.

¹⁴"You shall not commit adultery.

¹⁵"You shall not steal.

 $^{16\prime\prime} \rm You$ shall not bear false witness against your neighbor.

¹⁷"You shall not covet your neighbor's house; you shall not covet your neighbor's wife, or his manservant, or his maidservant, or his ox, or his ass, or anything that is your neighbor's."

¹⁸Now when all the people perceived the thunderings and the lightnings and the sound of the trumpet and the mountain smoking, the people were afraid and trembled; and they stood afar off, ¹⁹and said to Moses, "You speak to us, and we will hear; but let not God speak to us, lest we die." ²⁰And Moses said to the people, "Do not fear; for God has come to prove you, and that the fear of him may be before your eyes, that you may not sin."

²¹And the people stood afar off, while Moses drew near to the thick cloud where God was. ²²And the LORD said to Moses, "Thus you shall say to the people of Israel: 'You have seen for yourselves that I have talked with you from heaven. ²³You shall not make gods of silver to be with me, nor shall you make for yourselves gods of gold. ²⁴An altar of earth you shall make for me and sacrifice on it your burnt offerings and your peace offerings, your sheep and your oxen; in every place where I cause my name to be remembered I will come to you and bless you. ²⁵And if you make me an altar of stone, you shall not build it of hewn stones; for if you wield your tool upon it you profane it. ²⁶And you shall not go up by steps to my altar, that your nakedness be not exposed on it.'"

Amos 3-6

Amos, an eighth-century prophet, reflects many of the characteristics of classical biblical prophetism: the prophet who speaks in the name of God: the warnings against social injustice; the demand for a pure worship of God and fidelity to the biblical covenant; the judgment against neighboring people.

3 Hear this word that the LORD has spoken against you, O people of Israel, against the whole family which I brought up out of the land of Egypt:

²"You only have I known of all the families of the earth; therefore I will punish you for all your iniquities.

³"Do two walk together, unless they have made an appointment?

⁴Does a lion roar in the forest, when he has no prey? Does a young lion cry out from his den, if he has taken nothing?

⁵Does a bird fall in a snare on the earth, when there is no trap for it?

Does a snare spring up from the ground, when it has taken nothing?

⁶Is a trumpet blown in a city, and the people are not afraid? Does evil befall a city, unless the LORD has done it?

⁷Surely the LORD God does nothing, without revealing his secret to his servants the prophets.

⁸The lion has roared; who will not fear?

The LORD God has spoken; who can but prophesy?"

⁹Proclaim to the strongholds in Assyria and to the strongholds in the land of Egypt,

and say, "Assemble yourselves upon the mountains of Samar'ia,

and see the great tumults within her, and the oppressions in her midst."

¹⁰"They do not know how to do right," says the LORD,

"those who store up violence and robbery in their strongholds."

¹¹Therefore thus says the LORD God: "An adversary shall surround the land,

and bring down your defenses from you, and your strongholds shall be plundered."

¹²Thus says the LORD: "As the shepherd rescues from the mouth of the lion two legs, or a piece of an ear, so shall the people of Israel who dwell in Samar'ia be rescued, with the corner of a couch and part of a bed.

¹³"Hear, and testify against the house of Jacob," says the LORD God, the God of hosts,

¹⁴"that on the day I punish Israel for his transgressions I will punish the altars of Bethel, and the horns of the altar shall be cut off and fall to the ground.

¹⁵I will smite the winter house with the summer house; and the houses of ivory shall perish, and the great houses shall come to an end,"

says the LORD.

/ "Hear this word, you cows of Bashan,

4 who are in the mountain of Samar'ia,

who oppress the poor, who crush the needy, who say to their husbands, 'Bring, that we may drink!'

²The LORD God has sworn by his holiness that, behold, the days are coming upon you, when they shall take you away with hooks, even the last of you with fishhooks.

³And you shall go out through the breaches, every one straight before her; and you shall be cast forth into Harmon,"

says the LORD.

⁴"Come to Bethel, and transgress; to Gilgal, and multiply transgression;

bring your sacrifices every morning, your tithes every three days;

⁵offer a sacrifice of thanksgiving of that which is leavened, and proclaim freewill offerings, publish them; for so you love to do, O people of Israel!"

says the LORD God.

⁶"I gave you cleanness of teeth in all your cities, and lack of bread in all your places,

yet you did not return to me,"

says the LORD.

⁷"And I also withheld the rain from you when there were yet three months to the harvest;

I would send rain upon one city, and send no rain upon another city;

one field would be rained upon, and the field on which it did not rain withered;

⁸so two or three cities wandered to one city to drink water, and were not satisfied;

yet you did not return to me,"

says the LORD.

⁹"I smote you with blight and mildew; I laid waste your gardens and your vineyards; your fig trees and your olive trees the locust devoured;

yet you did not return to me,"

says the LORD.

¹⁰"I sent among you a pestilence after the manner of Egypt; I slew your young men with the sword;

I carried away your horses; and I made the stench of your camp go up into your nostrils;

yet you did not return to me,"

says the LORD.

¹¹"I overthrew some of you, as when God overthrew Sodom and Gomor rah,

and you were as a brand plucked out of the burning; yet you did not return to me,"

says the LORD.

¹²"Therefore thus I will do to you, O Israel; because I will do this to you, prepare to meet your God, O Israel!"

¹³For lo, he who forms the mountains, and creates the wind, and declares to man what is his thought; who makes the morning darkness, and treads on the heights of the earth the LORD, the God of hosts, is his name!

 $5^{
m Hear}$ this word which I take up over you in lamentation, $5^{
m O}$ house of Israel:

²"Fallen, no more to rise, is the virgin Israel;

forsaken on her land, with none to raise her up."

³"For thus says the LORD God: "The city that went forth a thousand shall have a hundred left,

and that which went forth a hundred shall have ten left to the house of Israel."

- ⁴For thus says the LORD to the house of Israel: "Seek me and live;
- ⁵but do not seek Bethel, and do not enter into Gilgal or cross over to Beer-sheba;
- for Gilgal shall surely go into exile, and Bethel shall come to nought."
- ⁶Seek the LORD and live, lest he break out like fire in the house of Joseph, and it devour, with none to quench it for Bethel,
- ⁷O you who turn justice to wormwood, and cast down righteousness to the earth!
- ⁸He who made the Pleiades and Orion, and turns deep darkness into the morning, and darkens the day into night,

who calls for the waters of the sea, and pours them out upon the surface of the earth,

the LORD is his name,

- ⁹who makes destruction flash forth against the strong, so that destruction comes upon the fortress.
- ¹⁰They hate him who reproves in the gate, and they abhor him who speaks the truth.
- ¹¹Therefore because you trample upon the poor and take from him exactions of wheat,
- you have built houses of hewn stone, but you shall not dwell in them;

you have planted pleasant vineyards, but you shall not drink their wine.

- ¹²For I know how many are your transgressions, and how great are your sins—
- you who afflict the righteous, who take a bribe, and turn aside the needy in the gate.

¹³Therefore he who is prudent will keep silent in such a time; for it is an evil time.

¹⁴Seek good, and not evil, that you may live;

- and so the LORD, the God of hosts, will be with you, as you have said.
- ¹⁵Hate evil, and love good, and establish justice in the gate; it may be that the LORD, the God of hosts, will be gracious to the remnant of Joseph.

¹⁶Therefore thus says the LORD, the God of hosts, the Lord:

- "In all the squares there shall be wailing; and in all the streets they shall say, 'Alas! alas!'
- They shall call the farmers to mourning and to wailing those who are skilled in lamentation,
- ¹⁷and in all vineyards there shall be wailing, for I will pass through the midst of you,"

says the LORD.

¹⁸Woe to you who desire the day of the LORD! Why would you have the day of the LORD?

- It is darkness, and not light; ¹⁹as if a man fled from a lion, and a bear met him;
- or went into the house and leaned with his hand against the wall, and a serpent bit him.
- ²⁰Is not the day of the LORD darkness, and not light, and gloom with no brightness in it?
- ²¹"I hate, I despise your feasts, and I take no delight in your solemn assemblies.
- ²²Even though you offer me your burnt offerings and cereal offerings,
- I will not accept them, and the peace offerings of your fatted beasts I will not look upon.
- ²³Take away from me the noise of your songs; to the melody of your harps I will not listen.
- ²⁴But let justice roll down like waters, and righteousness like an everflowing stream.

25 "Did you bring to me sacrifices and offerings the forty years in the wilderness, O house of Israel? ²⁶You shall take up Sakkuth your king, and Kaiwan your star-god, your images, which you made for yourselves; ²⁷therefore I will take you into exile beyond Damascus," says the LORD, whose name is the God of hosts.

C "Woe to those who are at ease in Zion,

Oand to those who feel secure on the mountain of Samar´ia.

- the notable men of the first of the nations, to whom the house of Israel come!
- ²Pass over to Calneh, and see; and thence go to Hamath the great; then go down to Gath of the Philistines.
- Are they better than these kingdoms? Or is their territory greater than your territory,
- ³O you put far away the evil day, and bring near the seat of violence?
- ⁴Woe to those who lie upon beds of ivory, and stretch themselves upon their couches,
- and eat lambs from the flock, and calves from the midst of the stall;
- ⁵who sing idle songs to the sound of the harp, and like David invent for themselves instruments of music;
- ⁶who drink wine in bowls, and anoint themselves with the finest oils, but are not grieved over the ruin of Joseph!
- ⁷Therefore they shall now be the first of those to go into exile, and the revelry of those who stretch themselves shall pass away."

⁸The LORD God has sworn by himself says the LORD, the God of hosts: "I abhor the pride of Jacob, and hate his strongholds; and I will deliver up the city and all that is in it."

⁹And if ten men remain in one house, they shall die. ¹⁰And when a man's kinsman, he who burns him, shall take him up to bring the bones out of the house, and shall say to him who is in the innermost parts of the house, "Is there still any one with you?" he shall say, "No"; and he shall say, "Hush! We must not mention the name of the LORD."

¹¹For behold, the LORD commands and the great house shall be smitten into fragments,

and the little house into bits.

Matthew 5-7

These sayings of Jesus, taken from the Gospel of Matthew, reflect the core of the teachings of Jesus. In these sayings one finds not only the Beatitudes but also a prayer that is said to reflect perfectly the essential relationship of Jesus to Abba (the familiar Aramaic word for "Father," which Jesus used to describe God). Note too the demand Jesus makes to go beyond the mere observance of law. In asking for an interior conversion beyond law, Jesus stands in the tradition of the great Jewish prophets.

Seeing the crowds, he went up on the mountain, and 5 Seeing the clowes, its second target to him.

²And he opened his mouth and taught them, saying:

³"Blessed are the poor in spirit, for theirs is the kingdom of heaven.

⁴"Blessed are those who mourn, for they shall be comforted.

⁵"Blessed are the meek, for they shall inherit the earth.

⁶"Blessed are those who hunger and thirst for righteousness, for they shall be satisfied.

⁷"Blessed are the merciful, for they shall obtain mercy.

⁸"Blessed are the pure in heart, for they shall see God.

9"Blessed are the peacemakers, for they shall be called sons of God.

¹⁰"Blessed are those who are persecuted for righteousness' sake, for theirs is the kingdom of heaven.

¹¹"Blessed are you when men revile you and persecute you and utter all kinds of evil against you falsely on my account. ¹²Rejoice and be glad, for your reward is great in heaven, for so men persecuted the prophets who were before you.

¹³"You are the salt of the earth; but if salt has lost its taste, how shall its saltness be restored? It is no longer good for anything except to be thrown out and trodden under foot by men.

¹⁴"You are the light of the world. A city set on a hill cannot be hid. 15Nor do men light a lamp and put it under a bushel, but on a stand, and it gives light to all in the house. ¹⁶Let your light so shine before men, that they may see your good works and give glory in your Father who is in heaven.

¹⁷"Think not that I have come to abolish the law and the prophets; I have come not to abolish them but to fulfil them. ¹⁸For truly, I say to you, till heaven and earth pass away, not an iota, not a dot, will pass from the law until all is accomplished. 19Whoever then relaxes one of the least of these commandments and teaches men so, shall be called least in the kingdom of heaven; but he who does them and teaches them shall be called great in the kingdom of heaven. ²⁰For I tell you, unless your righteousness exceeds that of the scribes and Pharisees, you will never enter the kingdom of heaven.

²¹"You have heard that it was said to the men of old, 'You shall not kill; and whoever kills shall be liable to judgment.' ²²But I say to you that every one who is angry with his brother shall be liable to judgment; whoever insults his brother shall be liable to the council, and whoever says, 'You fool!' shall be liable to the hell of fire.

²³So if you are offering your gift at the altar, and there remember that your brother has something against you, ²⁴leave your gift there before the altar and go; first be reconciled to your brother, and then come and offer your gift. ²⁵Make friends quickly with your accuser, while you are going with him to court, lest your accuser hand you over to the judge, and the judge to the guard, and you be put in prison; ²⁶truly, I say to you, you will never get out till you have paid the last penny.

²⁷"You have heard that it was said, 'You shall not commit adultery.' 28 But I say to you that every one who looks at a woman lustfully has already committed adultery with her in his heart. ²⁹If your right eye causes you to sin, pluck it out and throw it away; it is better that you lose one of your members than that your whole body be thrown into hell. ³⁰And if your right hand causes you to sin, cut it off and throw it away; it is better that you lose one of your members than that your whole body go into hell.

³¹"It was also said, 'Whoever divorces his wife, let him give her a certificate of divorce.' ³²But I say to you that every one who divorces his wife, except on the ground of unchastity, makes her an adulteress; and whoever marries a divorced woman commits adultery.

³³"Again you have heard that it was said to the men of old, 'You shall not swear falsely, but shall perform to the Lord what you have sworn.' ³⁴But I say to you, Do not swear at all, either by heaven, for it is the throne of God, ³⁵or by the earth, for it is his footstool, or by Jerusalem, for it is the city of the great King. ³⁶And do not swear by your head, for you cannot make one hair white or black. ³⁷Let what you say be simply 'Yes' or 'No'; anything more than this comes from evil.

³⁸"You have heard that it was said, 'An eye for an eye and a tooth for a tooth.' ³⁹But I say to you, Do not resist one who is evil. But if any one strikes you on the right cheek, turn to him the other also; 40 and if any one would sue you and take your coat, let him have your cloak as well; ⁴¹and if any one forces you to go one mile, go with him two miles. ⁴²Give to him who begs from you, and do not refuse him who would borrow from you.

⁴³"You have heard that it was said, 'You shall love your neighbor and hate your enemy.' 44But I say to you, Love your enemies and pray for those who persecute you, ⁴⁵so that you may be sons of your Father who is in heaven; for he makes his sun rise on the evil and on the good, and sends rain on the just and on the unjust. ⁴⁶For if you love those who love you, what reward have you? Do not even the tax collectors do the same? ⁴⁷And if you salute only your brethren, what more are you doing than others? Do not even the Gentiles do the same? ⁴⁸You, therefore, must be perfect, as your heavenly Father is perfect.

"Beware of practicing your piety before men in order to Obe seen by them; for then you will have no reward from your Father who is in heaven.

²"Thus, when you give alms, sound no trumpet before you, as the hypocrites do in the synagogues and in the streets, that they may be praised by men. Truly, I say to you, they have their reward. ³But when you give alms, do not let your left hand know what your right hand is doing, 4so that your alms may be in secret; and your Father who sees in secret will reward you.

5"And when you pray, you must not be like the hypocrites; for they love to stand and pray in the synagogues and at the street corners, that they may be seen by men. Truly, I say to you, they have their reward. ⁶But when you pray, go into your room and shut the door and pray to your Father who is in secret; and your Father who sees in secret will reward you.

⁷"And in praying do not heap up empty phrases as the Gentiles do; for they think that they will be heard for their many words. ⁸Do not be like them, for your Father knows what you need before you ask him. ⁹Pray then like this:

Our Father who art in heaven,

Hallowed be thy name.

¹⁰Thy kingdom come,

Thy will be done,

On earth as it is in heaven.

¹¹Give us this day our daily bread;

¹²And forgive us our debts,

As we also have forgiven our debtors; ¹³And lead us not into temptation.

But deliver us from evil.

¹⁴For if you forgive men their trespasses, your heavenly Father also will forgive you; ¹⁵but if you do not forgive men their trespasses, neither will your Father forgive your trespasses.

¹⁶"And when you fast, do not look dismal, like the hypocrites, for they disfigure their faces that their fasting may be seen by men. Truly, I say to you, they have their reward. ¹⁷But when you fast, anoint your head and wash your face, ¹⁸that your fasting may not be seen by men but by your Father who is in secret; and your Father who sees in secret will reward you.

¹⁹"Do not lay up for yourselves treasures on earth, where moth and rust consume and where thieves break in and steal, ²⁰but lay up for yourselves treasures in heaven, where neither moth nor rust consumes and where thieves do not break in and steal. ²¹For where your treasure is, there will your heart be also.

²²"The eye is the lamp of the body. So, if your eye is sound, your whole body will be full of light; ²³but if your eye is not sound, your whole body will be full of darkness. If then the light in you is darkness, how great is the darkness!

²⁴"No one can serve two masters; for either he will hate the one and love the other, or he will be devoted to the one and despise the other. You cannot serve God and mammon.

²⁵"Therefore I tell you, do not be anxious about your life, what you shall eat or what you shall drink, nor about your body, what you shall put on. Is not life more than food, and the body more than clothing? ²⁶Look at the birds of the air: they neither sow nor reap nor gather into barns, and yet your heavenly Father feeds them. Are you not of more value than they? ²⁷And which of you by being anxious can add one cubit to his span of life?

²⁸And why are you anxious about clothing? Consider the lilies of the field, how they grow; they neither toil nor spin; ²⁹yet I tell you, even Solomon in all his glory was not arrayed like one of these. ³⁰But if God so clothes the grass of the field, which today is alive and tomorrow is thrown into the oven, will he not much more clothe you, O men of little faith? ³¹Therefore do not be anxious, saying, 'What shall we eat?' or 'What shall we drink?' or 'What shall we wear?' ³²For the Gentiles seek all these things; and your heavenly Father knows that you need them all. ³³But seek first his kingdom and his righteousness, and all these things shall be yours as well.

³⁴ Therefore do not be anxious about tomorrow, for tomorrow will be anxious for itself. Let the day's own trouble be sufficient for the day.

Z"Judge not, that you be not judged. ²For with the judgment you pronounce you will be judged, and the measure you give will be the measure you get. ³Why do you see the speck that is in your brother's eye, but do not notice the log that is in your own eye? ⁴Or how can you say to your brother, 'Let me take the speck out of your eye,' when there is the log in your own eye? ⁵You hypocrite, first take the log out of your own eye, and then you will see clearly to take the speck out of your brother's eye.

⁶"Do not give dogs what is holy; and do not throw your pearls before swine, lest they trample them underfoot and turn to attack you.

⁷"Ask, and it will be given you; seek and you will find; knock, and it will be opened to you. ⁸For every one who asks receives, and he who seeks finds, and to him who knocks it will be opened. ⁹Or what man of you, if his son asks him for a loaf, will give him a stone? ¹⁰Or if he asks for a fish, will give him a serpent? ¹¹If you then, who are evil, know how to give good gifts to your children, how much more will your Father who is in heaven give good things to those who ask him? ¹²So whatever you wish that men would do to you, do so to them; for this is the law and the prophets.

¹³"Enter by the narrow gate; for the gate is wide and the way is easy, that leads to destruction, and those who enter by it are many. ¹⁴For the gate is narrow and the way is hard, that leads to life, and those who find it are few.

¹⁵"Beware of false prophets, who come to you in sheep's clothing but inwardly are ravenous wolves. ¹⁶You will know them by their fruits. Are grapes gathered from thorns, or figs from thistles? ¹⁷So, every sound tree bears good fruit, but the bad tree bears evil fruit. ¹⁸A sound tree cannot bear evil fruit, nor can a bad tree bear good fruit. ¹⁹Every tree that does not bear good fruit is cut down and thrown into the fire. ²⁰Thus you will know them by their fruits.

²¹"Not every one who says to me, 'Lord, Lord,' shall enter the kingdom of heaven, but he who does the will of my Father who is in heaven. ²²On that day many will say to me, 'Lord, Lord, did we not prophesy in your name, and cast out demons in your name, and do many mighty works in your name?' ²³And then will I declare to them, 'I never knew you; depart from me, you evildoers.'

²⁴"Every one then who hears these words of mine and does them will be like a wise man who built his house upon the rock; ²⁵and the rain fell, and the floods came, and the winds blew and beat upon that house, but it did not fall, because it had been founded on the rock. ²⁶And every one who hears these words of mine and does not do them will be like a foolish man who built his house upon the sand; ²⁷and the rain fell, and the floods came, and the winds blew and beat against that house, and it fell; and great was the fall of it."

²⁸And when Jesus finished these sayings, the crowds were astonished at his teaching, ²⁹for he taught them as one who had authority, and not as their scribes.

Acts 17:14-34

Paul's speech in Athens is a good example of Christianity's attempt to speak to the pagan world it encountered in its attempt to spread its message. The two additional passages from Paul's letters (Corinthians I and II) give us first an example of the powerful message he could articulate and a glimpse of Paul's own life as an early missionary of the infant Christian Church.

¹⁴Then the brethren immediately sent Paul off on his way to the sea, but Silas and Timothy remained there. ¹⁵Those who conducted Paul brought him as far as Athens; and receiving a command for Silas and Timothy to come to him as soon as possible, they departed.

¹⁶Now while Paul was waiting for them at Athens, his spirit was provoked within him as he saw that the city was

225

full of idols. ¹⁷So he argued in the synagogue with the Jews and the devout persons, and in the market place every day with those who chanced to be there. ¹⁸Some also of the Epicurean and Stoic philosophers met him. And some said, "What would this babbler say?" Others said, "He seems to be a preacher of foreign divinities"—because he preached Jesus and the resurrection.

¹⁹And they took hold of him, and brought him to the Areop'agus, saying, "May we know what this new teaching is which you present? ²⁰For you bring some strange things to our ears; we wish to know therefore what these things mean." ²¹Now all the Athenians and the foreigners who lived there spent their time in nothing except telling or hearing something new.

²²So Paul, standing in the middle of the Are-op'agus, said: "Men of Athens, I perceive that in every way you are very religious. ²³For as I passed along, and observed the objects of your worship, I found also an altar with this inscription, 'To an unknown god.' What therefore you worship as unknown, this I proclaim to you. ²⁴The God who made the world and everything in it, being Lord of heaven and earth, does not live in shrines made by man, ²⁵nor is he served by human hands, as though he needed anything, since he himself gives to all men life and breath and everything. ²⁶And he made from one every nation of men to live on all the face of the earth, having determined allotted periods and the boundaries of their habitation, ²⁷that they should seek God, in the hope that they might feel after him and find him. Yet he is not far from each one of us, ²⁸ for 'In him we live and move and have our being'; as even some of your poets have said, 'For we are indeed his offspring.'

²⁹Being then God's offspring, we ought not to think that the Deity is like gold, or silver, or stone, a representation by the art and imagination of man. ³⁰The times of ignorance God overlooked, but now he commands all men everywhere to repent, ³¹because he has fixed a day on which he will judge the world in righteousness by a man whom he has appointed, and of this he has given assurance to all men by raising him from the dead."

³²Now when they heard of the resurrection of the dead, some mocked; but others said, "We will hear you again about this." ³³So Paul went out from among them. ³⁴But some men joined him and believed, among them Dionys'ius the Are-op'agite and a woman named Dam'aris and others with them.

I Corinthians 13

And I will show you a still more excellent way.

13 If I speak in the tongues of men and of angels, but ²And if I have prophetic powers, and understand all mysteries and all knowledge, and if I have all faith, so as to remove mountains, but have not love, I am nothing. ³If I give away all I have, and if I deliver my body to be burned, but have not love, I gain nothing.

⁴Love is patient and kind; love is not jealous or boastful; ⁵it is not arrogant or rude. Love does not insist on its own way; it is not irritable or resentful; ⁶it does not rejoice at wrong, but rejoices in the right. ⁷Love bears all things, believes all things, hopes all things, endures all things.

⁸Love never ends; as for prophecy, it will pass away; as for tongues, they will cease; as for knowledge, it will pass away. ⁹For our knowledge is imperfect and our prophecy is imperfect; ¹⁰but when the perfect comes, the imperfect will pass away. ¹¹When I was a child, I spoke like a child, I thought like a child, I reasoned like a child; when I became a man, I gave up childish ways. ¹²For now we see in a mirror dimly, but then face to face. Now I know in part; then I shall understand fully, even as I have been fully understood. ¹³So faith, hope, love abide, these three; but the greatest of these is love.

II Corinthians 11–12

1 I wish you would bear with me in a little foolishness. Do bear with me! ²I feel a divine jealousy for you, for I betrothed you to Christ to present you as a pure bride to her one husband. ³But I am afraid that as the serpent deceived Eve by his cunning, your thoughts will be led astray from a sincere and pure devotion to Christ. ⁴For if some one comes and preaches another Jesus than the one we preached, or if you accept a different gospel from the one you accepted, you submit to it readily enough. ⁵I think that I am not in the least inferior to these superlative apostles. ⁶Even if I am unskilled in speaking, I am not in knowledge; in every way we have made this plain to you in all things.

⁷Did I commit a sin in abasing myself so that you might be exalted, because I preached God's gospel without cost to you? ⁸I robbed other churches by accepting support from them in order to serve you. ⁹And when I was with you and was in want, I did not burden any one, for my needs were supplied by the brethren who came from Macedo'nia. So I refrained and will refrain from burdening you in any way. ¹⁰As the truth of Christ is in me, this boast of mine shall not be silenced in the regions of Acha'ia. ¹¹And why? Because I do not love you? God knows I do!

¹²And what I do I will continue to do, in order to undermine the claim of those who would like to claim that in their boasted mission they work on the same terms as we do. ¹³For such men are false apostles, deceitful workmen, disguising themselves as apostles of Christ. ¹⁴And no wonder, for even Satan disguises himself as an angel of light. ¹⁵So it is not strange if his servants also disguise themselves as servants of righteousness. Their end will correspond to their deeds.

¹⁶I repeat, let no one think me foolish; but even if you do, accept me as a fool, so that I too may boast a little. ¹⁷(What I am saying I say not with the Lord's authority but as a fool, in this boastful confidence; ¹⁸since many boast of worldly things, I too will boast.) ¹⁹For you gladly bear with fools, being wise yourselves! ²⁰For you bear it if a man makes slaves of you, or preys upon you, or takes advantage of you, or puts on airs, or strikes you in the face. ²¹To my shame, I must say, we were too weak for that!

But whatever any one dares to boast of-I am speaking as a fool—I also dare to boast of that. ²²Are they Hebrews? So am I. Are they Israelites? So am I. Are they descendants of Abraham? So am I. ²³Are they servants of Christ? I am a better one—I am talking like a madman—with far greater labors, far more imprisonments, with countless beatings, and often near death. ²⁴Five times I have received at the hands of the Jews the forty lashes less one. ²⁵Three times I have been beaten with rods; once I was stoned. Three times I have been shipwrecked; a night and a day I have been adrift at sea; ²⁶on frequent journeys, in danger from rivers, danger from robbers, danger from my own people, danger from Gentiles, danger in the city, danger in the wilderness, danger at sea, danger from false brethren; ²⁷in toil and hardship, through many a sleepless night, in hunger and thirst, often without food, in cold and exposure. ²⁸And, apart from things, there is the daily pressure upon me of my anxiety for all the churches. ²⁹Who is weak, and I am not weak? Who is made to fall, and I am not indignant?

³⁰If I must boast, I will boast of the things that show my weakness. ³¹The God and Father of the Lord Jesus, he who is blessed for ever, knows that I do not lie. ³²At Damascus, the governor under King Ar´etas guarded the city of Damascus in order to seize me, ³³but I was let down in a basket through a window in the wall, and escaped his hands.

 $2^{
m I}$ must boast; there is nothing to be gained by it, but I will go on to visions and revelations of the Lord. $^{
m 2}{
m I}$ know a man in Christ who fourteen years ago was caught up to the third heaven-whether in the body or out of the body I do not know, God knows. ³And I know that this man was caught up into Paradise-whether in the body or out of the body I do not know, God knows—⁴ and he heard things that cannot be told, which man may not utter. 5On behalf of this man I will boast, but on my own behalf I will not boast, except of my weaknesses. 6 Though if I wish to boast, I shall not be a fool, for I shall be speaking the truth. But I refrain from it, so that no one may think more of me than he sees in me or hears from me. ⁷And to keep me from being too elated by the abundance of revelations, a thorn was given me in the flesh, a messenger of Satan, to harass me, to keep me from being too elated. 8Three times I besought the Lord about this, that it should leave me; 9but he said to me, "My grace is sufficient for you, for my power is made perfect in weakness." I will all the more gladly boast of my weaknesses, that the power of Christ may rest upon me. ¹⁰For the sake of Christ, then, I am content with weaknesses, insults, hardships, persecutions, and calamities; for when I am weak, then I am strong.

¹¹I have been a fool! You forced me to it, for I ought to have been commended by you. For I am not at all inferior to these superlative apostles, even though I am nothing. ¹²The signs of a true apostle were performed among you in all patience, with signs and wonders and mighty works. ¹³For in what were you less favored than the rest of the churches, except that I myself did not burden you? Forgive me this wrong!

¹⁴Here for the third time I am ready to come to you. And I will not be a burden, for I seek not what is yours but you; for children ought not to lay up for their parents, but parents for their children. ¹⁵I will most gladly spend and be spent for your souls. If I love you the more, am I to be loved less? ¹⁶But granting that I myself did not burden you, I was crafty, you say, and got the better of you by guile. ¹⁷Did I take advantage of you through any of those whom I sent to you? ¹⁸I urged Titus to go, and sent the brother with him. Did Titus take advantage of you? Did we not act in the same spirit? Did we not take the same steps?

¹⁹Have you been thinking all along that we have been defending ourselves before you? It is in the sight of God that we have been speaking in Christ, and all for your upbuilding, beloved. ²⁰For I fear that perhaps I may come and find you not what I wish, and that you may find me not what you wish; that perhaps there may be quarreling, jealousy, anger, selfishness, slander, gossip, conceit, and disorder. ²¹I fear that when I come again my God may humble me before you, and I may have to mourn over many of those who sinned before and have not repented of the impurity, immorality, and licentiousness which they have practiced.

Justin's First Apology

These selections from Justin's First Apology are interesting because they are the earliest detailed description we possess of how early Christians worshiped. Justin probably gave this description as an antidote to rumors that Christians did immoral or criminal things at their meetings for worship. The selections below give us insight both into early baptismal practice as well as an outline of what Christian worship looked like on a typical Sunday.

Chapter 61

Lest we be judged unfair in this exposition, we will not fail to explain¹ how we consecrated ourselves to God when we were regenerated through Christ. Those who are convinced and believe what we say and teach is the truth, and pledge themselves to be able to live accordingly, are taught in prayer and fasting to ask God to forgive their past sins, while we pray and fast with them. Then we lead them to a place where there is water, and they are regenerated in the same manner in which we ourselves were regenerated. In the name of God, the Father and Lord of all, and of our Savior, Jesus Christ, and of the Holy Ghost,² they then receive the washing with water. For Christ said: "Unless you be born again, you shall not enter into the kingdom of heaven."3 Now, it is clear to everyone how impossible it is for those who have been born once to enter their mothers' wombs again. Isaias the Prophet explained, as we already stated, how those who have sinned and then repented shall be freed of their sins. These are his words: "Wash yourselves, be clean, banish sin from your souls; learn to do well: judge for the fatherless and defend the widow; and then come and let us reason together," saith the Lord. "And if your sins be as scarlet, I will make them white as wool; and if they be red as crimson, I will make them white as snow. But if you will not hear me, the sword shall devour you: for the mouth of the Lord hath spoken it."⁴ And this is the reason, taught to us by the Apostles, why we baptize the way we do. We were totally unaware of our first birth, and were born of necessity from fluid seed through the mutual union of our parents, and were trained in wicked and sinful customs. In order that we do not continue as children of necessity and ignorance, but of deliberate choice and knowledge, and in order to obtain in the water the forgiveness of past sins, there is invoked over the one who wishes to be regenerated, and who is repentant of his sins, the name of God, the Father and Lord of all; he who leads the person to be baptized to the laver calls him by this name only. For, no one is permitted to utter the name of the ineffable God, and if anyone ventures to affirm that His name can be pronounced, such a person is hopelessly mad. This washing is called illumination,⁵ since they who learn these things become illuminated intellectually. Furthermore, the illuminated one is also baptized in the name of the Holy Spirit, who predicted through the Prophets everything concerning Jesus.

Chapter 62

After hearing of this baptism which the Prophet Isaiah announced, the demons prompted those who enter their temples and come to them with libations and burnt offerings to sprinkle themselves also with water; furthermore, they cause them to wash their whole persons, as they approach the place of sacrifice, before they go to the shrines where their [the demons'] statues are located. And the order given by the priests to those who enter and worship in the temples, to take off their shoes, was imitated by the demons after they learned what happened to Moses, the abovementioned Prophet. For at this time, when Moses was ordered to go down into Egypt and bring out the Israelites

- ¹ In this chapter, and again in Chapters 65, 66, and 67, Justin ignored the *Disciplina arcani* to explain some Christian practices. This was unusual at that time.
- ² The Trinitarian formula; cf. Matt. 28:19.
- ³ John 3:3. Justin did know St. John's Gospel.
- ⁴ Isa. 1:16–20.
- ⁵ *Photismós:* illumination, commonly used in ancient times as a synonym for baptism.

who were there, and while he was tending the sheep of his mother's brother in the land of Arabia, our Christ talked with him in the shape of fire from a bush. Indeed, He said: "Put off thy shoes, and draw near and hear."¹ When he had taken off his shoes, he approached the burning bush and heard that he was to go down into Egypt and bring out the people of Israel who were in that land; and he received great power from Christ who spoke to him under the form of fire, and he went down and brought out the people after he performed great and wondrous deeds. If you wish to know about these deeds you may learn them clearly from his writings.

Chapter 63

Even now, all Jews teach that the ineffable God spoke to Moses. Wherefore, the Prophetic Spirit, censuring the Jews through Isaias, the above-mentioned Prophet, said: "The ox knoweth his owner, and the ass his master's crib; but Israel hath not known Me, and My people hath not understood Me."1 Because the Jews did not know the nature of the Father and the Son, Jesus Christ likewise upbraided them, saying: "No one knows the Father except the Son; nor does anyone know the Son except the Father, and those to whom the Son will reveal Him."² Now, the Word of God is His Son, as we have already stated, and He is called Angel and Apostle; for, as Angel He announces all that we must know, and [as Apostle] He is sent forth to inform us of what has been revealed, as our Lord Himself says: "He that heareth Me, heareth Him that sent Me."3 This will be further clarified from the following words of Moses: "And the Angel of God spoke to Moses in a flame of fire out of the midst of a bush and said, 'I AM WHO I AM, the God of Abraham, the God of Isaac, and the God of Jacob, the God of your fathers; go down into Egypt, and bring forth My people.' "4 If you are curious to know what happened after this, you can find out by consulting these same Mosaic writings, for it is impossible to recount everything in this work. What has been written has been here set down to prove that Jesus Christ is the Son of God and His Apostle, being of old the Word, appearing at one time in the form of fire, at another under the guise of incorporeal beings [i.e., as an angel], but now, at the will of God, after becoming man for mankind, He bore all the torments which the demons prompted the rabid Jews to wreak upon Him. Although it is explicitly stated in the Mosaic writings: "And the Angel of God spoke to Moses in a flame of fire out of the midst of a bush and said, 'I AM WHO I AM, the God of Abraham, the God of Isaac, and the God of Jacob,' "5 the Jews assert that it was the Father and Maker of all things who spoke thus. Hence, the Prophetic Spirit reproaches them, saying: "Israel hath not known Me, and My people hath not understood Me."⁶ And again, as we have already shown, Jesus, while still in their midst, said: "No one knows the Father except the Son, nor does anyone know the Son except the Father, and those to whom the Son will reveal Him."7 The Jews, therefore, always of the opinion that the Universal Father spoke to Moses, while in fact it was the very Son of God, who is styled both Angel and Apostle, were justly reproached by both the Prophetic Spirit and by Christ Himself, since they knew neither the Father

¹ Exod. 3:5.

nor the Son. For, they who claim that the Son is the Father are reproached for knowing neither the Father nor that the Father of all has a Son, who, as the First-born Word of God, is also God. He once appeared to Moses and the other prophets in the form of fire and in the guise of an angel, but now in the time of your reign, after He became man by a virgin, as we already stated, by the design of God the Father, to effect the salvation of those believing in Him, He permitted Himself to be an object of contempt and to suffer pain, so that by dying and arising from the dead He might conquer death. But what was proclaimed to Moses from the bush: "I AM WHO I AM, the God of Abraham, and the God of Isaac, and the God of your fathers,"8 meant that those who had died were still in existence, and belonged to Christ Himself. For they were the first of all to occupy themselves in searching for God; Abraham being the father of Isaac, and Isaac the father of Jacob, as was written by Moses.

Chapter 64

From what has already been stated you can readily perceive how the demons, imitating what Moses said, instigated men to erect at the fountain-heads a statue of her who was called Kore,¹ and claimed that she was the daughter of Jupiter. For, as we stated previously, Moses said: "In the beginning God created heaven and earth. And the earth was invisible and empty, and the Spirit of God moved over the waters."² In imitation of the Spirit of God who was said to be borne over the waters, therefore, they [the demons] said that Kore was the daughter of Jupiter. They likewise viciously affirmed that Minerva was the daughter of Jupiter, not by sexual union, but, well knowing that God conceived and created the world by the Word, they state that Minerva was the first conception; which we consider most ridiculous, to present the female form as the image of conception. Their deeds likewise condemn the others who are called sons of Jupiter.

Chapter 65

After thus baptizing the one who has believed and given his assent, we escort him to the place where are assembled those whom we call brethren, to offer up sincere prayers in common for ourselves, for the baptized person, and for all other persons wherever they may be, in order that, since we have found the truth, we may be deemed fit through our actions to be esteemed as good citizens and observers of the law, and thus attain eternal salvation. At the conclusion of the prayers we greet one another with a kiss.¹ Then, bread and a chalice containing wine mixed with water² are presented to the one presiding over the brethren. He takes them and offers praise and glory to the Father of all, through the name of the Son and of the Holy Spirit, and he recites lengthy prayers of thanksgiving to God in the name of those to whom He granted such favors. At the end of these prayers and thanksgiving, all present express their approval by saying "Amen." This Hebrew word, "Amen," means "So be it." And when he who presides has celebrated the Eucharist, they whom we call deacons permit each one present

¹ Isa. 1:3.

² Matt. 11:27.

³ Luke 10:16.

⁴ Exod. 3:14–15.

⁵ Exod. 3:14–15.

⁶ Isa. 1:3.

⁷ Matt. 11:27.

⁸ Exod. 3:14–15.

¹ Cora, maiden or daughter; i.e., Proserpine.

² Gen. 1:1-3.

¹ The pagans, who misinterpreted the kiss of peace, must not have realized that it was a form of greeting confined to persons of the same sex.

² *Potérion húdatos kaì krámatos,* a chalice of wine mixed with water. It seems, however, that *kráma* is used here as a synonym for wine.

to partake of the Eucharistic bread, and wine and water; and they carry it also to the absentees.

Chapter 66

We call this food the Eucharist, of which only he can partake who has acknowledged the truth of our teachings, who has been cleansed by baptism for the remission of his sins and for his regeneration, and who regulates his life upon the principles laid down by Christ. Not as ordinary bread or as ordinary drink do we partake of them, but just as, through the word of God, our Savior Jesus Christ became Incarnate and took upon Himself flesh and blood for our salvation, so, we have been taught, the food which has been made the Eucharist by the prayer of His word,¹ and which nourishes our flesh and blood by assimilation, is both the flesh and blood of that Jesus who was made flesh. The Apostles in their memoirs, which are called Gospels, have handed down what Jesus ordered them to do; that He took bread and, after giving thanks, said: "Do this in remembrance of Me; this is My body." In like manner, He took also the chalice, gave thanks, and said: "This is My blood";² and to them only did He give it. The evil demons, in imitation of this, ordered the same thing to be performed in the Mithraic mysteries.³ For, as you know or may easily learn, bread and a cup of water, together with certain incantations, are used in their mystic initiation rites.

Chapter 67

Henceforward, we constantly remind one another of these things. The rich among us come to the aid of the poor, and we always stay together. For all the favors we enjoy we bless the Creator of all, through His Son Jesus Christ and through the Holy Spirit. On the day which is called Sunday we have a common assembly of all who live in the cities or in the outlying districts, and the memoirs of the Apostles or the writings of the Prophets are read, as long as there is time. Then, when the reader has finished, the president of the assembly verbally admonishes and invites all to imitate such examples of virtue. Then we all stand up together and offer up our prayers, and, as we said before, after we finish our prayers, bread and wine and water are presented. He who presides likewise offers up prayers and thanksgivings, to the best of his ability, and the people express their approval by saying "Amen." The Eucharistic elements are distributed and consumed by those present, and to those who are absent they are sent through the deacons. The wealthy, if they wish, contribute whatever they desire, and the collection is placed in the custody of the president. [With it] he helps the orphans and widows, those who are needy because of sickness or any other reason, and the captives and strangers in our midst; in short, he takes care of all those in need. Sunday, indeed, is the day on which we all hold our common assembly because it is the first day on which God, transforming the darkness and [prime] matter, created the world; and our Savior Jesus Christ arose from the dead on the same day. For they crucified Him on the day before that of Saturn,

² Cf. Luke 22:10; Matt. 26:26–27; Mark 14:22.

and on the day after, which is Sunday, He appeared to His Apostles and disciples, and taught them the things which we have passed on to you also for consideration.

The Passion of Perpetua and Felicity

This famous account (slightly edited) of martyrdom, compiled from the memoirs of a noblewoman named Perpetua by an unknown third-century North African Christian (possibly the great author Tertullian) recounts the death of Perpetua, her maid Felicity, and some catechumens (persons inscribed for baptism in the church) in the arena of Carthage c. A.D. 203. Fleshed out with vision narratives, it became an immensely influential work that profoundly shaped later accounts of martyrdom. It is of great significance because it is one of the few early Christian treatises that come to us from the hand of a woman before the time of Constantine. The deepest core of the account is to be seen in the fact that the mere confession "I am a Christian" was sufficient for the penalty of death to be imposed.

. . . ²There were apprehended the young catechumens, Revocatus and Felicity his fellow-servant, Saturninus and Secundulus. With them also was Vibia Perpetua, nobly born, reared in a liberal manner, wedded honorably; having a father and mother and two brothers, one of them a catechumen likewise, and a son, a child at the breast; and she herself was about twenty-two years of age. What follows here she shall tell herself; the whole order of her martyrdom as she left it written with her own hand and in her own words.

³When, saith she, we were yet with our sureties and my father was fain to vex me with his words and continually strove to hurt my faith because of his love: Father, said I, seest thou (for example's sake) this vessel lying, a pitcher or whatsoever it may be? And he said, I see it. And I said to him, Can it be called by any other name than that which it is? And he answered, No. So can I call myself nought other than that which I am, a Christian? Then my father moved with this word came upon me to tear out my eyes; but he vexed me only, and he departed vanquished, he and the arguments of the devil. Then because I was without my father for a few days I gave thanks unto the Lord; and I was comforted because of his absence. In this same space of a few days we were baptized, and the Spirit declared to me, I must pray for nothing else after that water save only endurance of the flesh. A few days after we were taken into prison, and I was much afraid because I had never known such darkness. O bitter day! There was a great heat because of the press, there was cruel handling of the soldiers. Lastly I was tormented there by care for the child. Then Tertius and Pomponius, the blessed deacons who ministered to us, obtained with money that for a few hours we should be taken forth to a better part of the prison and be refreshed. Then all of them going out from the dungeon took their pleasure; I suckled my child that was now faint with hunger. And being careful for him, I spoke to my mother and strengthened my brother and commended my son unto them. I pined because I saw they pined for my sake. Such cares I suffered for many days; and I obtained that the child should abide with me in prison; and straightway I became well, and was lightened of my labor and care for the child; and suddenly the prison was made a palace for me, so that I would sooner be there than anywhere else.

⁴Then said my brother to me: Lady my sister, thou art now in high honor, even such that thou mightest ask for a vision; and it should be shown thee whether this be a passion or else a deliverance. And I, as knowing that I conversed with the Lord, for Whose sake I had suffered such things, did

¹ Dí euchés lógou toù par' autoû: by the prayer of His word. The word lógou does not refer to the Word of God, but to the words of Christ the words of consecration: "This is My Body; this is My Blod." Indeed, Justin quotes these words of Christ to prove to the pagans why Christians believe that the bread and wine become the Body and Blood of Christ.

³ Cf. Tertullian, *De praesc. haer.* 40. The worship of the Persian sungod became popular during the reign of Hadrian (A.D. 117–138). Julian the Apostate made Mithras his god.

promise him, nothing doubting; and I said: To-morrow I will tell thee. And I asked, and this was shown me.

I beheld a ladder of bronze, marvelously great, reaching up to heaven; and it was narrow, so that not more than one might go up at one time. And in the sides of the ladder were planted all manner of things of iron. There were swords there, spears, hooks, and knives; so that if any that went up took not good heed or looked not upward, he would be torn and his flesh cling to the iron. And there was right at the ladder's foot a serpent lying, marvelously great, which lay in wait for those that would go up, and frightened them that they might not go up. Now Saturus went up first (who afterwards had of his own will given up himself for our sakes, because it was he who had edified us; and when we were taken he had not been there). And he came to the ladder's head; and he turned and said: Perpetua, I await thee; but see that serpent bite thee not. And I said: It shall not hurt me, in the name of Jesus Christ. And from beneath the ladder, as though it feared me, it softly put forth its head; and as though I trod on the first step I trod on its head. And I went up, and I saw a very great space of garden, and in the midst a man sitting, white-headed, in shepherd's clothing, tall, milking his sheep; and standing around in white were many thousands. And he raised his head and beheld me and said to me: Welcome, child. And he cried to me, and from the curd he had from the milk he gave me as it were a morsel; and I took it with joined hands and ate it up; and all that stood around said, Amen. And at the sound of that word I awoke, yet eating I know not what of sweet.

And forthwith I told my brother, and we knew it should be a passion; and we began to have no hope any longer in this world.

⁵A few days after, the report went abroad that we were to be tried. Also my father returned from the city spent with weariness; and he came up to me to cast down my faith, saying: Have pity, daughter, on my grey hairs; have pity on thy father, if I am worthy to be called father by thee; if with these hands I have brought thee unto this flower of youthand I have preferred thee before all thy brothers; give me not over to the reproach of men. Look upon thy brothers; look upon thy mother and mother's sister; look upon thy son, who will not endure to live after thee. Forbear thy resolution; destroy us not all together; for none of us will speak openly among men again if thou sufferest aught. This he said fatherwise in his love, kissing my hands and groveling at my feet; and with tears he named me, not daughter, but lady. And I was grieved for my father's case because he only would not rejoice at my passion out of all my kin; and I comforted him, saying: That shall be done at this tribunal, whatsoever God shall please; for know that we are not stablished in our own power, but in God's. And he went from me very sorrowful.

⁶Another day as we were at meat we were suddenly snatched away to be tried; and we came to the forum. Therewith a report spread abroad through the parts near to the forum, and a very great multitude gathered together. We went up to the tribunal. The others being asked, confessed. So they came to me. And my father appeared there also, with my son, and would draw me from the step, saying: Sacrifice; have mercy on the child. And Hilarianus the procurator— he that after the death of Minucius Timinian the proconsul had received in his room the right and power of the sword— Spare, said he, thy father's grey hairs; spare the infancy of the boy. Make sacrifice for the Emperors' prosperity. And I answered: I will not sacrifice. Then said Hilarianus: Art thou a Christian? And I answered: I am a Christian. And when my father stood by me yet to cast down my faith, he

was bidden by Hilarianus to be cast down and was smitten with a rod. And I sorrowed for my father's harm as though I had been smitten myself; so sorrowed I for his unhappy old age. Then Hilarianus passed sentence upon us all and condemned us to the beasts; and cheerfully we went down to the dungeon. Then because my child had been wont to take suck of me and to abide with me in the prison, straightway I sent Pomponius the deacon to my father, asking for the child. But my father would not give him. And as God willed, neither is he fain to be suckled any more, nor did I take fever; that I might not be tormented by care for the child and by the pain of my breasts.

⁷A few days after, while we were all praying, suddenly in the midst of the prayer I uttered a word and named Dinocrates; and I was amazed because he had never come into my mind save then; and I sorrowed, remembering his fate. And straightway I knew that I was worthy, and that I ought to ask for him. And I began to pray for him long, and to groan unto the Lord. Forthwith the same night, this was shown me.

I beheld Dinocrates coming forth from a dark place, where were many others also; being both hot and thirsty, his raiment foul, his color pale; and the wound on his face which he had when he died. This Dinocrates had been my brother in the flesh, seven years old, who being diseased with ulcers of the face had come to a horrible death, so that his death was abominated of all men. For him therefore I had made my prayer; and between him and me was a great gulf, so that either might not go to other. There was moreover, in the same place where Dinocrates was, a font full of water, having its edge higher than was the boy's stature; and Dinocrates stretched up as though to drink. I was sorry that the font had water in it, and yet for the height of the edge he might not drink.

And I awoke, and I knew that my brother was in travail. Yet I was confident I should ease his travail; and I prayed for him every day till we passed over into the camp prison. . . . And I made supplication for him day and night with groans and tears, that he might be given me.

 ^{8}On the day when we abode in the stocks, this was shown me.

I saw that place which I had before seen, and Dinocrates clean of body, finely clothed, in comfort; and the font I had seen before, the edge of it being drawn down to the boy's navel; and he drew water thence which flowed without ceasing. And on the edge was a golden cup full of water; and Dinocrates came up and began to drink therefrom; which cup failed not. And being satisfied he departed away from the water and began to play as children will, joyfully.

And I awoke. Then I understood that he was translated from his pains.

⁹Then a few days after, Pudens the adjutant, in whose charge the prison was, who also began to magnify us because he understood that there was much grace in us, let in many to us that both we and they in turn might be comforted. Now when the day of the games drew near, there came in my father unto me, spent with weariness, and began to pluck out his beard and throw it on the ground and to fall upon his face cursing his years and saying such words as might move all creation. I was grieved for his unhappy old age.

¹⁰The day before we fought, I saw in a vision that Pomponius the deacon had come hither to the door of the prison, and knocked hard upon it. And I went out to him and opened to him; he was clothed in a white robe ungirdled, having shoes curiously wrought. And he said to me: Perpetua, we await thee; come. And he took my hand, and we

began to go through rugged and winding places. At last with much breathing hard we came to the amphitheater, and he led me into the midst of the arena. And he said to me: Be not afraid; I am here with thee and labor together with thee. And he went away. And I saw much people watching closely. And because I knew that I was condemned to the beasts I marveled that beasts were not sent out against me. And there came out against me a certain ill-favored Egyptian with his helpers, to fight with me. Also there came to me comely young men, my helpers and aiders. And I was stripped, and I became a man. And my helpers began to rub me with oil as their custom is for a contest; and over against me I saw that Egyptian wallowing in the dust. And there came forth a man of very great stature, so that he overpassed the very top of the amphitheater, wearing a robe ungirdled, and beneath it between the two stripes over the breast a robe of purple; having also shoes curiously wrought in gold and silver; bearing a rod like a master of gladiators, and a green branch whereon were golden apples. And he besought silence and said: The Egyptian, if he shall conquer this woman, shall slay her with the sword; and if she shall conquer him, she shall receive this branch. And he went away. And we came nigh to each other, and began to buffet one another. He was fain to trip up my feet, but I with my heels smote upon his face. And I rose up into the air and began so to smite him as though I trod not the earth. But when I saw that there was yet delay, I joined my hands, setting finger against finger of them. And I caught his head, and he fell upon his face; and I trod upon his head. And the people began to shout, and my helpers began to sing. And I went up to the master of gladiators and received the branch. And he kissed me and said to me: Daughter, peace be with thee. And I began to go with glory to the gate called the Gate of Life.

And I awoke; and I understood that I should fight, not with beasts but against the devil; but I knew that mine was the victory.

Thus far have I written this, till the day before the games; but the deed of the games themselves let him write who will.

¹¹And blessed Saturus too delivered this vision which he himself wrote down.

We had suffered, saith he, and we passed out of the flesh, and we began to be carried towards the east by four angels whose hand touched us not. And we went not as though turned upwards upon our backs, but as though we went up an easy hill. And passing over the world's edge we saw a very great light; and I said to Perpetua (for she was at my side): This is that which the Lord promised us; we have received His promise. And while we were being carried by these same four angels, a great space opened before us, as it had been a pleasure garden, having rose-trees and all kinds of flowers. The height of the trees was after the manner of the cypress, and their leaves sang without ceasing. And there in the garden were four other angels, more glorious than the rest; who when they saw us gave us honor and said to the other angels: Lo, here are they, here are they: and marveled. And the four angels who bore us set us down trembling; and we passed on foot by a broad way over a plain. There we found Jocundus and Saturninus and Artaxius who in the same persecution had suffered and had been burned alive; and Quintus, a martyr also, who in prison had departed this life; and we asked of them where were the rest. The other angels said to us: Come first, go in, and salute the Lord.

¹²And we came near to a place, of which place the walls were such, they seemed built of light; and before the door of

that place stood four angels who clothed us when we went in with white raiment. And we went in, and we heard as it were one voice crying [Holy, Holy, Holy] without any end. And we saw sitting in that same place as it were a man, white-headed, having hair like snow, youthful of countenance; whose feet we saw not. And on his right hand and on his left, four elders; and behind them stood many other elders. And we went in with wonder and stood before the throne; and the four angels raised us up; and we kissed him, and with his hand he passed over our faces. And the other elders said to us: Stand ye. And we stood, and gave the kiss of peace. And the elders said to us: Go ye and play. And I said to Perpetua: Thou hast that which thou desirest. And she said to me: Yea, God be thanked; so that I that was glad in the flesh am now more glad.

¹³And we went out, and we saw before the doors, on the right Optatus the bishop, and on the left Aspasius the priest and teacher, being apart and sorrowful. And they cast themselves at our feet and said: Make peace between us, because ye went forth and left us thus. And we said to them: Art not thou our Father, and thou our priest, that ye should throw yourselves at our feet? And we were moved, and embraced them. And Perpetua began to talk with them in Greek; and we set them apart in the pleasure garden beneath a rose tree. And while we yet spoke with them, the angels said to them: Let these go and be refreshed; and whatsoever dissensions ye have between you, put them away from you each for each. And they made them to be confounded. And they said to Optatus: Correct thy people; for they come to thee as those that return from the games and wrangle concerning the parties there. And it seemed to us as though they would shut the gates. And we began to know many brothers there, martyrs also. And we were all sustained there with a savor inexpressible which satisfied us. Then in joy I awoke.

¹⁴These were the glorious visions of those martyrs themselves, the most blessed Saturus and Perpetua, which they themselves wrote down. But Secundulus by an earlier end God called from this world while he was yet in prison; not without grace, that he should escape the beasts. Yet if not his soul, his flesh at least knew the sword.

¹⁵As for Felicity, she too received this grace of the Lord. For because she was now gone eight months (being indeed with child when she was taken) she was very sorrowful as the day of the games drew near, fearing lest for this cause she should be kept back (for it is not lawful for women that are with child to be brought forth for torment) and lest she should shed her holy and innocent blood after the rest, among strangers and malefactors. Also her fellow martyrs were much afflicted lest they should leave behind them so good a friend and as it were their fellow-traveler on the road of the same hope. Wherefore with joint and united groaning they poured out their prayer to the Lord, three days before the games. Incontinently after their prayer her pains came upon her. And when by reason of the natural difficulty of the eighth month she was oppressed with her travail and made complaint, there said to her one of the servants of the keepers of the door: Thou that thus makest complaint now, what wilt thou do when thou art thrown to the beasts, which thou didst condemn when thou wouldst not sacrifice? And she answered, I myself now suffer that which I suffer, but there another shall be in me who shall suffer for me, because I am to suffer for him. So she was delivered of a daughter, whom a sister reared up to be her own daughter.

¹⁶Since therefore the Holy Spirit has suffered, and suffering has willed, that the order of the games also should be written; though we are unworthy to finish the recounting of so great glory, yet we accomplish the will of the most holy Perpetua, nay rather her sacred trust, adding one testimony more of her own steadfastness and height of spirit. When they were being more cruelly handled by the tribune because through advice of certain most despicable men he feared lest by magic charms they might be withdrawn secretly from the prisonhouse, Perpetua answered him to his face: Why dost thou not suffer us to take some comfort, seeing we are victims most noble, namely Caesar's, and on his feast day we are to fight? Or is it not thy glory that we should be taken out thither fatter of flesh? The tribune trembled and blushed, and gave order they should be more gently handled, granting that her brothers and the rest should come in and rest with them. Also the adjutant of the prison now believed. . . .

¹⁸Now dawned the day of their victory, and they went forth from the prison into the amphitheatre as it were into heaven, cheerful and bright of countenance; if they trembled at all, it was for joy, not for fear. Perpetua followed behind, glorious of presence, as a true spouse of Christ and darling of God; at whose piercing look all cast down their eyes. Felicity likewise, rejoicing that she had borne a child in safety, that she might fight with the beasts, came now from blood to blood, from the midwife to the gladiator, to wash after her travail in a second baptism. And when they had been brought to the gate and were being compelled to put on, the men the dress of the priests of Saturn, the women the dress of the priestesses of Ceres, the noble Perpetua remained of like firmness to the end, and would not. For she said: For this cause came we willingly unto this, that our liberty might not be obscured. For this cause have we devoted our lives, that we might do no such thing as this; this we agreed with you. Injustice acknowledged justice; the tribune suffered that they should be brought forth as they were, without more ado. Perpetua began to sing, as already treading on the Egyptian's head. Revocatus and Saturninus and Saturus threatened the people as they gazed. Then when they came into Hilarianus's sight, they began to say to Hilarianus, stretching forth their hands and nodding their heads: Thou judgest us, said they, and God thee. At this the people being enraged besought that they should be vexed with scourges before the line of gladiators (those namely who fought with beasts). Then truly they gave thanks because they had received somewhat of the sufferings of the Lord.

¹⁹But He Who had said Ask, and ye shall receive gave to them asking that end which each had desired. For whenever they spoke together of their desire in their martyrdom, Saturninus for his part would declare that he wished to be thrown to every kind of beast, that so indeed he might wear the more glorious crown. At the beginning of the spectacle therefore himself with Revocatus first had ado with a leopard and was afterwards torn by a bear also upon a raised bridge. Now Saturus detested nothing more than a bear, but was confident already he should die by one bite of a leopard. Therefore when he was being given to a boar, the gladiator instead who had bound him to the boar was torn asunder by the same beast and died after the days of the games; nor was Saturus more than dragged. Moreover when he had been tied on the bridge to be assaulted by a bear, the bear would not come forth from its den. So Saturus was called back unharmed a second time.

²⁰But for the women the devil had made ready a most savage cow, prepared for this purpose against all custom; for even in this beast he would mock their sex. They were stripped therefore and made to put on nets; and so they were brought forth. The people shuddered, seeing one a tender girl, the other her breasts yet dropping from her late childbearing. So they were called back and clothed in loose robes. Perpetua was first thrown, and fell upon her loins. And when she had sat upright, her robe being rent at the side, she drew it over to cover her thigh, mindful rather of modesty than of pain. Next, looking for a pin, she likewise pinned up her disheveled hair; for it was not meet that a martyr should suffer with hair disheveled, lest she should seem to grieve in her glory. So she stood up; and when she saw Felicity smitten down, she went up and gave her her hand and raised her up. And both of them stood up together and (the hardness of the people being now subdued) were called back to the Gate of Life. There Perpetua being received by one named Rusticus, then a catechumen, who stood close at her side, and as now awakening from sleep (so much was she in the Spirit and in ecstasy) began first to look about her; and then (which amazed all there), When, forsooth, quoth she, are we to be thrown to the cow? And when she heard that this had been done already, she would not believe till she perceived some marks of mauling on her body and on her dress. Thereupon she called her brother to her, and that catechumen, and spoke to them, saying: Stand fast in the faith, and love ye all one another; and be not offended because of our passion.

²¹Saturus also at another gate exhorted Pudens the soldier, saying: So then indeed, as I trusted and foretold, I have felt no assault of beasts, until now. And now believe with all thy heart. Behold, I go out thither and shall perish by one bite of the leopard. And forthwith at the end of the spectacle, the leopard being released, with one bite of his he was covered with so much blood that the people (in witness to his second baptism) cried out to him returning: Well washed, well washed. Truly it was well with him who had washed in this wise. Then said he to Pudens the soldier: Farewell; remember the faith and me; and let not these things trouble thee, but strengthen thee. And therewith he took from Pudens' finger a little ring, and dipping it in his wound gave it him back again for an heirloom, leaving him a pledge and memorial of his blood. Then as the breath left him he was cast down with the rest in the accustomed place for his throat to be cut. And when the people besought that they should be brought forward, that when the sword pierced through their bodies their eyes might be joined thereto as witnesses to the slaughter, they rose of themselves and moved whither the people willed them, first kissing one another, that they might accomplish their martyrdom with the rites of peace. The rest not moving and in silence received the sword; Saturus much earlier gave up the ghost; for he had gone up earlier also, and now he waited for Perpetua likewise. But Perpetua, that she might have some taste of pain, was pierced between the bones and shrieked out; and when the swordsman's hand wandered still (for he was a novice), herself set it upon her own neck. Perchance so great a woman could not else have been slain (being feared of the unclean spirit) had she not herself so willed it.

O most valiant and blessed martyrs! O truly called and elected unto the glory of Our Lord Jesus Christ! Which glory he that magnifies, honors and adores, ought to read these witnesses likewise, as being no less than the old, unto the Church's edification; that these new wonders also may testify that one and the same Holy Spirit works ever until now, and with Him God the Father Almighty, and His Son Jesus Christ Our Lord, to Whom is glory and power unending for ever and ever. Amen.

GENERAL EVENTS

	A.D.		
IAN ERA	64	250 Persecution of Christians under Decius	c. 67 Apostle Paul, bearer of
	PERIOD OF PERSECUTION	286 Diocletian divides Roman Empire into East and West parts ruled by himself and Maximian	Christian message throughout Mediterranean, martyred at Rome
	PERIOD ERSECUT	305 Abdication of Diocletian and Maximian; Constantius and Galerius rule as joint emperors	
ST	313	307–327 Reign of Constantine	
EARLY CHRISTIAN		313 Edict of Milan, giving Christians freedom of religion	
	D	324 Constantine convenes Council of Nicaea	c. 350 <i>Codex Sinaiticus</i> , earliest extant
		330 Constantine dedicates new capital of Roman Empire on site of Byzantium, naming it Constantinople	Greek codex of New Testament c. 374–404 Saint John Chrysostom active as writer and preacher
		337 Constantine is baptized a Christian on his deathbed	*
	395	383 Ostrogoths accept Christianity	c. 386 Saint Jerome translates Bible into Latin
	393	395 Division of Roman Empire begun by Diocletian becomes total separation	397 Augustine of Hippo, Confessions
	EMPIRE	4th–5th cent. Decline of Western Roman Empire	412–426 Augustine of Hippo, <i>The City of God</i>
		410 Visigoths sack Rome	
		455 Vandals sack Rome	
	OF EN	476 Romulus Augustulus forced to abdicate as last Western Roman emperor; Ostrogoths rule Italy	
		493–526 Theodoric the Ostrogoth reigns in Italy	
RA	Growth	527–565 Reign of Justinian as Eastern Roman emperor in Constantinople	c. 522–524 Boethius, <i>The Consolation</i> of <i>Philosophy</i> , allegorical treatise; translation of Aristotle's writings
		532 Nika revolt; civil disorders in Constantinople	524 Execution of Boethius by Theodoric the Ostrogoth
ш		c. 533 Justinian codifies Roman Law	
INE ERA	565	540 Belisarius conquers Ostrogoths in Italy for Justinian; Ravenna comes under Byzantine rule	c. 562 Procopius, History of the Wars, The Buildings, Secret History
Z	ERRITORIAL DECLINE	570 Muhammad born; dies 632	c. 620 Qur'an develops
ZAI		730–843 Iconoclastic controversy: ban on religious imagery	
Вγ	TERRIT	800 Pope Leo III crowns first Western Roman emperor (Charlemagne) at Rome since 5th cent.	
404 mar 141 mar 141 mar 144	900	988–989 Russians accept Christianity	
	SECOND GROWTH	1054 Eastern and Western Church formally split	
	1100 ·	1204 Crusaders sack Constantinople on way to Holy Land	
	FINAL	1453 Constantinople falls to Ottoman Turks, ending Byzantine Empire; Church of Hagia Sophia becomes a mosque	
	1453		

CHAPTER 7 **BYZANTIUM**

ARCHITECTURE

MUSIC

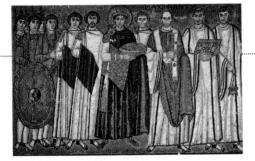

- c. 390 Obelisk of Theodosius erected in Hippodrome at Constantinople
- c. 415 Theodosius II moves gilded horses and chariot from Rome to Hippodrome

ART

c. 425 Mosaics at Mausoleum of Galla Placidia, Ravenna

- c. 450 Dome mosaic in Orthodox Baptistery, Ravenna
- 6th cent. Art tied to theological doctrine and liturgical practice of Orthodox Church
- c. 546-556 Ivory throne of Archbishop Maximian, given by Justinian for San Vitale
- c. 550 Mosaics at Sant' Apollinare Nuovo and San Vitale, Ravenna; Metamorphosis of Christ, apse mosaic from Katholikon, Monastery of Saint Catherine, Mount Sinai

- c. 324 Constantine has stadium in Constantinople enlarged to form Hippodrome
- c. 326 Holy Sepulchre, Jerusalem
- c. 333 Old Saint Peter's Basilica, Vatican
- Use of basilica plan and central plan with dome
- c. 450 Mausoleum of Galla Placidia, Neonian and Arian Baptisteries, Ravenna
- c. 493 526 Sant' Apollinare Nuovo, Ravenna
- c. 530-548 San Vitale, Ravenna
- 526 Theodoric's Tomb, Ravenna
- 527 Hagia Eirene, Constantinople, begun
- 532-537 Anthemius of Tralles and Isidore of Miletus rebuild Hagia Sophia, Constantinople, combining basilica plan and central plan with dome
- c. 533-549 Sant' Apollinare in Classe
- c. 550 Stephanos, Monastery of Saint Catherine, Mount Sinai

- after 350 Beginnings of Byzantine music, based probably on Syriac and Hebrew music
- 386 Saint Ambrose of Milan begins use of vernacular hymns in church

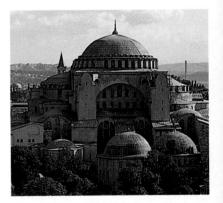

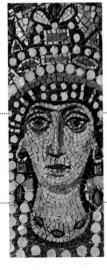

730-843 Ban on religious imagery; most earlier pictographic art destroyed

Renewal of icon tradition

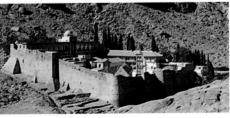

1063 Saint Mark's, Venice, begun

12th cent. Mosaics at Palermo, Sicily

c. 1410 Rublev active as painter of icons in Moscow

c. 1166 Church of the Intercession of the Virgin, near Vladimir, Russia; "onion dome" adapted from central dome

590-602 Gregorian Chant established at Rome during papacy of Gregory the Great

7th cent. Golden Age of Byzantine hymnody

IIth cent. Codification of Greek liturgy; musical modifications decline

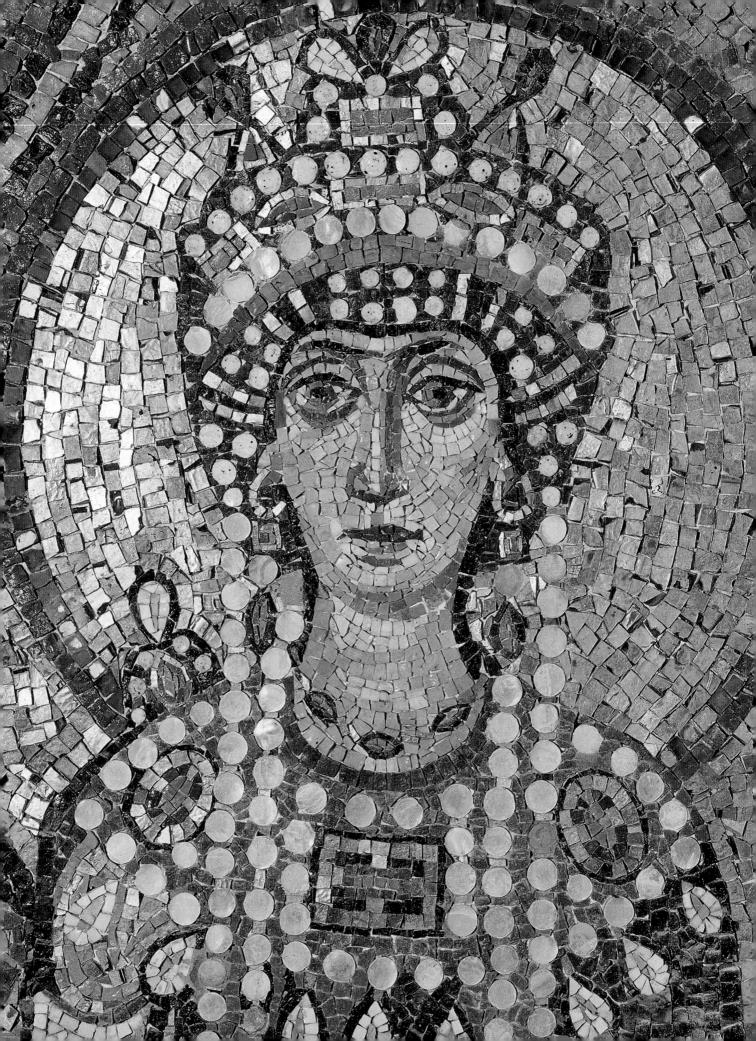

CHAPTER 7 Byzantium

THE DECLINE OF ROME

B y the early fourth century, the Roman Empire already had severe economic, political, and social problems. In 330, Emperor Constantine dedicated a Greek trading town on the Bosporus as his eastern capital, changing its name from Byzantium to Constantinople. It was to be a "new" Rome. Constantinople had some obvious advantages for a major city: It straddled the most prominent land route between Asia and Europe.

Constantinople

It had a deepwater port with natural shelter. It guarded the passage between the Mediterranean and the Black Sea. The surrounding countryside was rich in forests and water. The neighboring areas of both Europe (Thrace) and Asia (Bithynia) were rich agricultural areas that could supply the city's food needs.

Because of the tumultuous conditions in Rome, the emperors spent less time there. By the beginning of the fifth century (in A.D. 402), Emperor Honorius moved the capital of the Western empire to the northern Italian city of Ravenna on the Adriatic coast. Seventy-four years later, in A.D. 476, the last Roman emperor in the West would die there. Goths would occupy the city; they in turn were defeated by the imperial forces from Constantinople.

In the waning decades of the fourth and fifth centuries, Christianity continued to grow and expand in influence. During that period, in far different places, two writers would live who saw the decline of the West: Augustine in Roman North Africa and Boethius in the city of Ravenna. Their writings were to have an enormous impact on the culture of Europe. Each deserves consideration.

Literature and Philosophy

Augustine of Hippo

St. Augustine of Hippo

The greatest writer of the Christian Latin West, Augustine of Hippo, was a witness to the decline of Roman power. Born in 354 in North Africa (then part of the Roman provinces), Augustine received a thorough Classical education in Africa and in Rome. He was converted to Christianity in Milan and soon afterward returned to his native country, where he was named Bishop of Hippo in 390. When the Visigoths sacked Rome in 410, the pagan world was aghast and many blamed the rise of Christianity for this event. Partially as a response to this charge, Augustine wrote The City of God in an attempt to demonstrate that history had a direction willed by God and that "in the end" all would be made right as the city of man gave way to the city of God. Augustine's work, packed with reflections on scripture, philosophy, and pagan wisdom, is often cited as one of the most influential philosophies of history written in the Western world.

Indeed, it is difficult to overestimate the intellectual impact of Augustine of Hippo on the subsequent cultural history of the West. His influence within Christianity is without parallel. Until Thomas Aquinas in the thirteenth century, all Christian theologians in the West started from explicitly Augustinian premises. Even Thomas did not shake off his debt to Augustine, although he replaced Augustine's strong Platonic orientation with a more empirical Aristotelian one. Augustine emphasized the absolute majesty of God, the immutability of God's will, and the flawed state of the human condition (notions derived from Saint Paul). These tenets received a powerful reformulation in the Protestant Reformation by Martin Luther (who as a Catholic friar had lived under the rule of Saint Augustine) and by John Calvin, a profound student of Augustine's theological writings.

Augustine also made a notable impact beyond theology. The City of God, begun about 412, was an attempt to formulate a coherent and all-embracing philosophy of history, the first such attempt in the West. For Augustine, history moves on a straight line in a direction from its origin in God until it ends, again in God, at the consummation of history in the Last Judgment. Augustine rejected the older pagan notion that history repeats itself in endless cycles. His reading of the Bible convinced him that humanity had an origin, played out its story, and would terminate. The city of man would be judged and the city of God would be saved. Subsequent philosophers of history have secularized this view but, with very few exceptions (Vico, a seventeenth-century Italian philosopher, was one), have maintained the outlines of Augustine's framework to some extent. "A bright future," "an atomic wasteland of the future," and "classless society" are all statements about the end of history, all statements that echo, however dimly, the worldview of Augustine.

Augustine also invented the genre of self-reflective writing in the West. "I would know myself that I might know Thee," Augustine writes of God in the Confessions. Before Augustine's time, memoirs related a life in terms of social, political, or military affairs (as did, for example, Caesar's Gallic Wars), but Augustine's intimate selfscrutiny and inquiry into the significance of life were new in Western culture. There would be no other work like the Confessions until Petrarch, an indefatigable student of Augustine, wrote his Letter to Posterity in the mid-fourteenth century. The Renaissance writers, an extremely self-conscious generation, were devoted students of Augustine's stately Latin prose; even the great later autobiographies of our inherited culture-those of Gibbon, Mill, Newman-are literary and spiritual descendants of Augustine.

Augustine's *Confessions* is a compelling analysis of his spiritual and intellectual development from his youth until the time of his conversion to Christianity and readiness to return to his native Africa. The title must be understood in a triple sense—a confession of sin, an act of faith in God, and a confession of praise—so it is appropriate that Augustine began his book as a prayer directed to God.

Although strongly autobiographical, the *Confessions* is actually a long meditation by Augustine on the hidden grace of God as his life is shaped toward its appointed end. Augustine "confesses" to God (and the reader) how his early drive for fame as a teacher of rhetoric, his flirtation with the Manichean sect and its belief in gods of evil and good, his liaison with a woman that resulted in the birth of a son, and his restless movement from North Africa to Rome and Milan were all part of a seamless web of circumstance that made up an individual life. Interspersed in the narrative line of his early life are Augustine's reflections on the most basic philosophical and theological questions of the day, always linked to his own experience.

If the *Confessions* can be said to be the beginning of autobiography, beyond that historic importance it is classic and singular in its balance of immense learning, searching speculation, and intense self-scrutiny. It is a work concerned first of all with meaning at the deepest philosophical level, and its full power is evident only to the reader who will take the time to enter Augustine's line of argument.

Boethius

Justinian

In the twilight period in Ravenna, between the death of the last Roman emperor and the arrival of Justinian's troops, an important figure who bridged the gap between Classical paganism and Christianity lived and died. Anicius Manlius Severinus Boethius was a highly educated Roman who entered the service of the Goth king Theodoric in 522. Imprisoned for reasons that are not clear, Boethius wrote a treatise called The Consolation of Philosophy while awaiting execution. Cast as a dialogue between Lady Philosophy and the author on the philosophical and religious basis for human freedom, the work blends the spirit of the Book of Job with Roman stoicism. Attempting to console him for his sad state of disgrace and imprisonment, Lady Philosophy demands that the author avoid self-pity, that he face his troubles with serenity and hope. Insisting that a provident God overcomes all evil, Philosophy insists that blind fate has no control over humanity. She explains that human freedom exists along with an all-knowing God and that good will triumph. Although Christian themes permeate the work, there is no explicit mention of Christian doctrine. What one does sense is the recasting of Roman thought into Christian patterns. In a way, The Consolation of Philosophy is one of the last works of the late Roman period. It reflects the elegance of Roman expression, the burgeoning hope of Christianity, and the terrible sadness that must have afflicted any sensitive Roman living in this period.

The Consolation of Philosophy was one of the most widely read and influential works of the Middle Ages (Chaucer made an English translation of it from an already-existing French version). Its message of hope and faith was quoted liberally by every major medieval thinker from Thomas Aquinas to Dante Alighieri.

Boethius sets out a basic problem and provides an answer that would become normative Christian thought for subsequent centuries. In *The Consolation*, Boethius

CONTEMPORARY VOICES

Procopius of Caesarea

The whole ceiling is overlaid with pure gold . . . yet the light reflecting from the stones [of the mosaics] prevails, shining out of rivalry with the gold. There are two colonnades, one on each side, not separated in any way from the church itself. . . . They have vaulted ceilings and are decorated with gold. One of these is designated for men-worshipers and the other for women but they have nothing to distinguish them nor do they differ in any way. Their very equality serves to beautify the church and their similarity to adorn it.

Who can recount the beauty of the columns and the stones with which the church is decorated? One might imagine that he had come upon a meadow with its flowers in full bloom. For he would surely marvel at the purple of some, the green tint of others, and at those from which the white flashes, and again, at those which Nature, like some painter, varies with contrasting colors.

asks how one can reconcile human freedom with the notion of an all-knowing God. Put another way: If God knows what we do before we do it, how can we be said to be free agents who must accept responsibility for personal acts? The answer, Boethius insists through Lady Philosophy, is to look at the problem from the point of view of God, not from the human vantage point. God lives in eternity. Eternity does not mean a "long time" with a past and a future. Eternity means "no time": God lives in an eternal moment that for Him is a "now." In that sense God, does not "foresee" the future. There is no future for God. God sees everything in one simple moment that is only past, present, and future from the human point of view. Boethius says that God does not exercise praevidentia (seeing things before they happen) but providence (seeing all things in the simultaneity of their happening). Thus God, in a single eternal, ineffable moment, grasps all activity, which exists for us as a long sequence of events. More specifically, in that moment, God sees our choices, the events that follow from them, and the ultimate consequences of those choices.

The consolation of Boethius, as Lady Philosophy explains it, rests in the fact that people do act with freedom, that they are not in the hands of an indifferent fate, and that the ultimate meaning of life rests with the allseeing presence of a God, not a blind force. Lady Philosophy sums up her discussion with Boethius by offering him this "consolation." It is her assurance that his life, even while awaiting execution in a prison cell, was not the product of a blind fate or an uncaring force in the universe. And whenever anyone enters this church to pray . . . his mind is lifted up toward God and is exalted, feeling that He cannot be very far away, but must especially love to dwell in this place which He has favored. And this does not happen only to one who sees the church for the first time, but the same experience comes to him on each successive occasion, as though the sight were new each time. Of this spectacle no one ever has a surfeit, but when present in the church people rejoice in what they see, and when they depart they take enormous delight in talking about it.

Procopius of Caesarea, *The Buildings*, Book 1.1. Procopius was in the service of Emperor Justinian. His *Secret History* was a bitterly critical portrait of the emperor and the empress.

The language of Boethius, with its discussion of time, eternity, free will, and the nature of God, echoes the great philosophical tradition of Plato and Aristotle (Boethius had translated the latter's works) as well as the stoicism of Cicero and the theological reflections of Augustine. It is a fitting end to the intellectual tradition of the late Roman Empire in the West.

The Ascendancy of Byzantium

The city of Constantinople became the center of imperial life in the early fifth century and reached its highest expression of power in the early sixth century with the ascension to the throne of Justinian (527). His stated intention was to restore the empire to a state of grandeur. In this project he was aided by his wife Theodora. A former dancer and prostitute, Theodora was a toughminded and capable woman who added strength and resolve to the grandiose plans of the emperor. She was Justinian's equal, and perhaps more.

The reign of Justinian and Theodora was impressive, if profligate, by any standard. The emperor encouraged Persian monks residing in China to bring back silkworms for the introduction of the silk industry into the West. Because the silk industry of China was a fiercely guarded monopoly, the monks accomplished this rather dangerous mission by smuggling silkworm eggs out of the country in hollow tubes and, within a decade, the silk industry in the Western world rivaled that of China.

Justinian also revised and codified Roman law, a gigantic undertaking of scholarship and research. Roman law had evolved over a thousand-year period and, by Justinian's time, was a vast jumble of disorganized and often contradictory decisions, decrees, statutes, opinions, and legal codes. Under the aegis of the emperor, a legal scholar named Tribonian produced order out of this chaos. First a Code that summarized all imperial decrees from the time of Hadrian (in the second century) to the time of Justinian was published. The Code was followed by the Pandects ("digest"), which synthesized a vast quantity of legal opinion and scholarship from the past. Finally came the Institutes, a legal collection broken down into four categories by which the laws concerning persons, things, actions, and personal wrongs (in other words, criminal law) were set forth. The body of this legal revision became the basis for the law courts of the empire and, in later centuries, the basis for the use of Roman law in the West.

Justinian and Theodora were fiercely partisan Christians who took a keen interest in theology and ecclesiastical governance. Justinian's fanatical devotion prompted him to shut down the last surviving Platonic academy in the world on the grounds that its paganism was inimical to the true religion. His own personal life—despite evidences of cruelty and capriciousness—was austere and abstemious, influenced by the presence of so many monks in the city of Constantinople. His generosity to the church was great, with his largess shown most clearly in openhanded patronage of church building. Hagia Sophia, his most famous project, has become legendary for the beauty and opulence of its decoration.

Hagia Sophia

Church of Hagia Sophia: Monument and Symbol

Hagia Sophia (Greek for "Holy Wisdom") was the principal church of Constantinople. It had been destroyed twice, once by fire and—during Justinian's reign during the terrible civil disorders of the Nika revolt in 532 that devastated most of the European side of the city. Soon afterward, Justinian decided to rebuild the church using the plans of two architects: Anthemius of Tralles and Isidore of Miletus. Work began in 532 and the new edifice was solemnly dedicated five years later in the presence of Justinian and Theodora.

The Church of Hagia Sophia was a stunning architectural achievement that combined the longitudinal shape of the Roman basilica with a domed central plan. Two centuries earlier Constantine had used both the dome and basilica shapes in the Church of the Holy Sepulcher in Jerusalem, as we have seen, but he had not joined them into a unity. In still earlier domed buildings in the Roman world, such as the Pantheon and Santa Costanza, the dome rested on a circular drum. This gave the dome solidity but limited its height and expansiveness. Anthemius and Isidore solved this problem by the use of *pendentives* [7.1], triangular masonry devices that carried the weight of the dome on massive piers rather than straight down to the drum. In the Church of Hagia Sophia the central dome was abutted by two half-domes so that a person looking down at the building from above might see a nave in the form of an oval instead of a quadrangle [7.2].

The church—184 feet (55.2 m) high, 41 feet (12.3 m) higher than the Pantheon—retained a hint of the old basilica style as a result of the columned side aisles and the gallery for female worshipers in the triforium space above the arches of the aisles, but the overwhelming visual impression came from the massive dome. Since the pendentives reduced the weight of the dome, the area between drum and dome could be pierced by forty windows that made the dome seem to hang in space. Light streamed into the church from the windows and refracted off the rich mosaics and colored marbles that covered the interior [7.3].

Light, in fact, was a key theoretical element behind the entire conception of Hagia Sophia. Light is the

7.1 Dome construction:1. Pendentive; 2. Drum;3. Cupola; 4. Lantern.

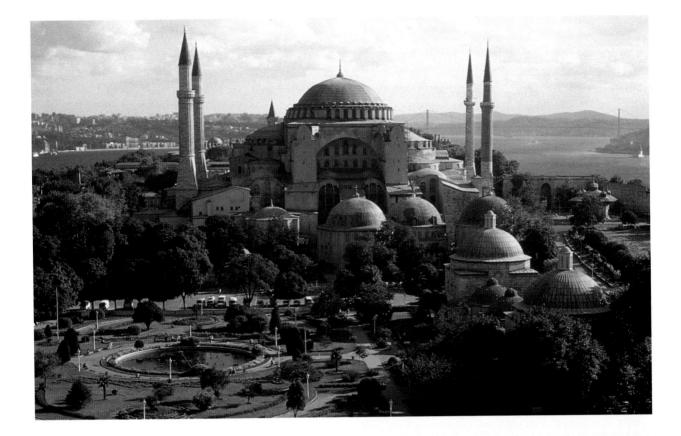

7.2 Anthemius of Tralles and Isidore of Miletus. Church of Hagia Sophia, Constantinople (Istanbul). Exterior view from the southeast. The towers, of Turkish origin, are a later addition.

symbol of divine wisdom in the philosophy of Plato and in the New Testament. A common metaphor in pagan and biblical wisdom had the sun and its rays represent the eternity of God and His illumination of mortals. The suffusion of light was an element in the Hagia Sophia that went far beyond the functional need to illuminate the interior of the church. Light refracting in the church created a spiritual ambiance analogous to that of heaven, where the faithful would be bathed in the actual light of God.

The sequence of the various parts of the worship service at Constantinople—the *liturgy*—was developed from the inspiration of Saint John Chrysostom (345–407), patriarch of the city in the century before Justinian. The official liturgy of Byzantine Christianity is still the Divine Liturgy of Saint John Chrysostom, modified and added to over the centuries. In that liturgy, the worshiping community visualized itself as standing in the forecourt of heaven when it worshiped in the church. Amid the swirling incense, the glittering light, and the stately chants of the clergy and people comes a sense of participation with the household of heaven standing before God. A fragment from the liturgy—added during the reign of Justinian's successor Justin II (565–578)—

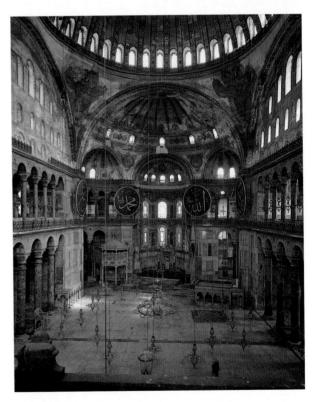

7.3 Anthemius of Tralles and Isidore of Miletus. Church of Hagia Sophia, Constantinople (Istanbul). An interior view, looking toward the apse, shows how the windows between drum and dome give an impression of floating lightness that continues down to the floor.

underscores the point dramatically. Note the characteristic cry of *Wisdom!* and the description of the congregation as mystically present in heaven:

PRIEST Wisdom! That ever being guarded by Thy power, we may give glory to Thee, Father, Son, and Holy Spirit, now and forevermore.

CONGREGATION Amen. Let us here who represent the mystic Cherubim in singing the thrice holy hymn to the life-giving Trinity now lay aside every earthly care so that we may welcome the King of the universe who comes escorted by invisible armies of angels. Alleluia. Alleluia.

Hagia Sophia was enriched by subsequent emperors, and after repairs were made to the dome (in 989), new mosaics were added to the church. After the fall of Constantinople (1453), the Turks turned the church into a mosque; the mosaics were whitewashed or plastered over since the Qur'an (also called *Koran*) prohibited the use of images. When the mosque was converted to a museum by the modern Turkish state, some of the mosaics were uncovered, so today we can get some sense of the splendor of the original interior.

Other monuments bear the mark of Justinian's creative efforts. His Church of the Holy Apostles, built on the site of an earlier church of the same name destroyed by an earthquake, did not survive the fall of the city in 1453 but did serve as a model for the Church of Saint Mark in Venice. Near the Church of Hagia Sophia is the Church of *Hagia Eirene* ("Holy Peace"), now a mosque, whose architecture also shows the combination of basilica and dome. The church, dedicated to the martyr saints Sergius and Bacchus and begun in 527, was a preliminary study for the later Hagia Sophia. In all, Justinian built more than twenty-five churches and convents in Constantinople. His program of secular architecture included an impressive water conduit system that still exists.

Ravenna

Art and Architecture

Mausoleum of Galla Placidia

Ravenna is a repository of monuments that reflect its late Roman, barbarian Gothic, and Byzantine history. The Mausoleum ("burial chapel") of Galla Placidia (who reigned as regent from 430 to 450) was built at the end of the Roman period of Ravenna's history [7.4]. Once thought to be the tomb of the empress (hence its name), it is more likely a votive chapel to Saint Lawrence origi-

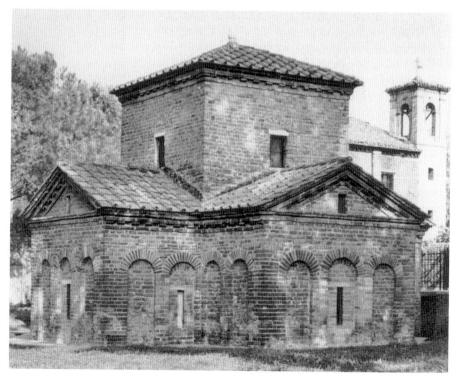

7.4 The so-called Mausoleum of Galla Placidia, Ravenna. Early fifth century. This building has sunk more than a meter (approx. 4') into the marshy soil, thus making it rather squat in appearance. nally attached to the nearby Church of the Holy Cross. The huge sarcophagi in the building are probably medieval. This small chapel in the shape of a cross, very plain on the outside, shows the architectural tendency to combine the basilica-style nave with the structure of a dome (it even uses a modified pendentive form) used later in monumental structures like Hagia Sophia.

The importance of Galla Placidia rests in the complete and breathtakingly beautiful mosaics that decorate the walls and ceiling. The north niche, just above the entrance, has a lunette (small arched space) mosaic depicting Christ as the Good Shepherd [7.5]. Clothed in royal purple and with a gold staff in his hand, the figure of Christ has a courtly, almost languid elegance that refines the more rustic depictions of the Good Shepherd theme in earlier Roman Christian art. The vaulting of both the apse (the altar end of the church) and the dome is covered with a deep blue mosaic interspersed with stylized sunbursts and stars in gold. This "Persian rug" motif symbolized the heavens, the dwelling place of God. Since the tesserae (the small cubes that make up the mosaic) are not set fully flush in the wall, the surfaces of the mosaic are irregular. These surfaces thus refract and break up the light in the chapel, especially from flickering lamps and candles. (The translucent alabaster windows now in the chapel were installed in the twentieth century.)

Opposite the lunette of the Good Shepherd is another lunette that depicts the deacon martyr of the Roman Church, Saint Lawrence, who stands next to the gridiron that was the instrument of his death. Beyond the gridiron is an open cabinet containing codices of the four gospels [7.6]. The spaces above these mosaics are filled with figures of the apostles. Between these are symbols of the search for religious understanding: deer, doves, fountains. In the arches, more spectacular and often overlooked, are the abstract interlocking designs with their brightness and *trompe l'œil* ("trick-the-eye") quality.

The two baptisteries of Ravenna represent a major religious division of the time between the Orthodox Christians, who accepted the divinity of Christ, and the Arian Christians, who did not. The Neonian Baptistery, built by Orthodox Christians in the early fifth century next to the ancient cathedral of the city, is octagonal, as were most baptisteries, because of their derivation from Roman bathhouses. The ceiling mosaic, directly over the baptismal pool, is particularly striking. The lower register of the mosaic, above the windows, shows floral designs based on common Roman decorative motifs. Just above is a circle of empty thrones interspersed with altars with biblical codices open on them [7.7]. In the band above are

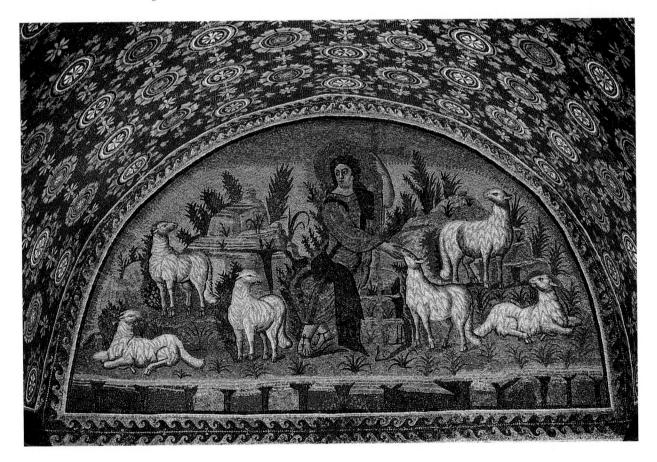

^{7.5} *Christ as the Good Shepherd.* Mosaic from the entrance wall of the Mausoleum of Galla Placidia, Ravenna, fifth century. The Persian rug motif can be seen in the vault. Note the beardless Christ dressed in a Roman toga.

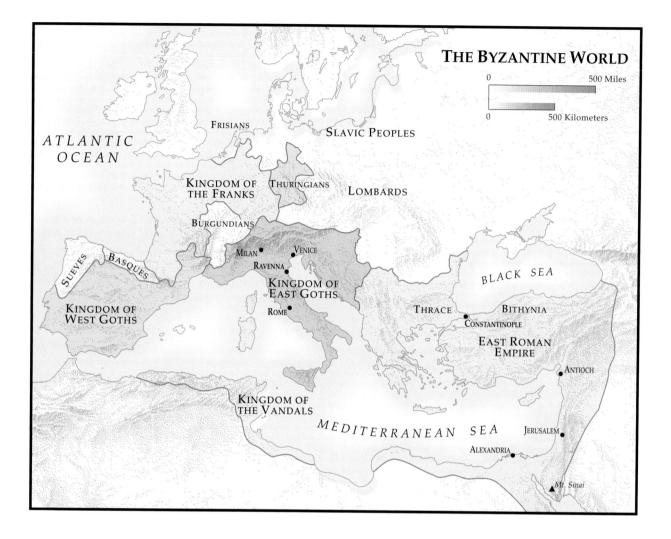

7.6 The Martyrdom of Saint Lawrence, from the Mausoleum of Galla Placidia, Ravenna, fifth century. Mosaic. The window, a modern one, is made of alabaster. Saint Lawrence, with the gridiron on which legend said he was roasted, is at the lower right.

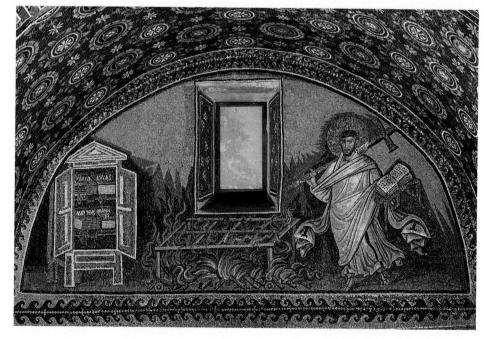

VALUES

Autocracy

The Byzantine Empire was characterized by its acceptance of the belief that the emperor was God's representative on earth who was the sole ruler of the empire and from whom all of the social and political goods for the empire flowed. This view of the political order is called *autocracy* which means, in essence, that the imperial power is unlimited and whatever power others may have (e.g., in the military or in the state bureaucracy), that power flows from the unlimited power of the emperor who has it by divine right. In this view, the emperor is both the highest civil and religious leader of the empire.

In the actual political order, emperors were overthrown or manipulated by political intrigue, but officially autocracy was accepted as the divinely ordered nature of things.

Symbolic reinforcement of the autocratic power of the emperor (visually represented in the Ravenna mosaics of Justinian and Theodora) came through a variety of symbolic means. The emperor alone dressed in the purple and gold once reserved for the semidivine pagan emperors. He lived in a palace with a rigid protocol of ceremony. When participating in the public worship of the church (the *liturgy*) he was given a special place and special recognition within that liturgy. Public insignia and other artifacts like coins recognized his authority as coming from God. It was a commonplace in the literature of the time to see the emperor as the regent of God on earth with his role compared to the sun which brings light and warmth to his subjects.

Many autocracies (from the Egyptian pharaohs to the French kings just before the Revolution) claimed such a relationship to the divine. The Byzantine Empire not only built itself on this idea but also maintained an intimate bond between the human and the divine in the person of the emperor. This concept would last almost a millennium in Constantinople and be replicated in Russia with the tsar until modern times.

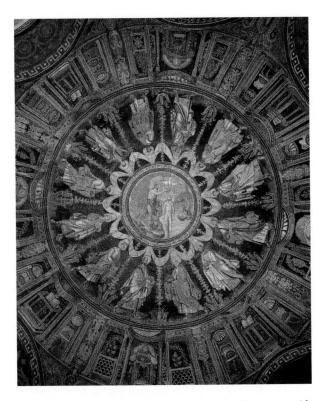

7.7 Ceiling mosaic of the Orthodox Baptistery, Ravenna, midfifth century.

the apostles, who seem to be walking in a stately procession around the circle of the dome. In the central disc is a mosaic of the baptism of Christ by John the Baptist in the river Jordan. The spirit of the river is depicted as Neptune.

The Neone Baptistery

The mosaic ensemble in the ceiling was designed to reflect the beliefs of the participants in the ceremonies below. The circling apostles reminded the candidates for baptism that the church was founded on the apostles; the convert's baptism was a promise that one day he or she would dwell with the apostles in heaven. Finally, the codices on the altars taught of the sources of their belief, whereas the empty thrones promised the new Christians a place in the heavenly Jerusalem. The art, then, was not merely decorative but, in the words of a modern Orthodox thinker, "theology in color."

The Arian Baptistery, built by the Goths toward the end of the fifth century, is far more severely decorated. Again the traditional scene of Christ's baptism is in the central disc of the ceiling mosaic. Here the figure of the river Jordan has lobsterlike claws sprouting from his head—a curiously pagan marine touch. The Twelve Apostles in the lower register are divided into two groups: one led by Peter and the other by Paul. These two groups converge at a throne bearing a jeweled cross (the crucifix with the body of Christ on the cross is very uncommon in this period) that represents in a single symbol the passion and the resurrection of Christ.

The Arian Baptistery

Theodoric, the emperor of the Goths who had executed Boethius and reigned from 493 to 526, was buried in a massive mausoleum that may still be seen on the outskirts of Ravenna [7.8]. The most famous extant monument of Theodoric's reign aside from his mausoleum is the Church of Sant' Apollinare Nuovo, originally called the Church of the Redeemer, the palace church of Theodoric. This church is constructed in the severe basilica style: a wide nave with two side aisles partitioned off from the nave by double columns of marble. The apse decorations have been destroyed, but the walls of the basilica, richly ornamented with mosaics, can be seen. The mosaics, however, are of two different dates and reflect in one building both the Roman and Byzantine styles of art. On each side of the aisles, in the spaces just above the aisle arches, are processions of male and female saints, each procession facing toward the apse and main altar [7.9]. They move to an enthroned Christ on

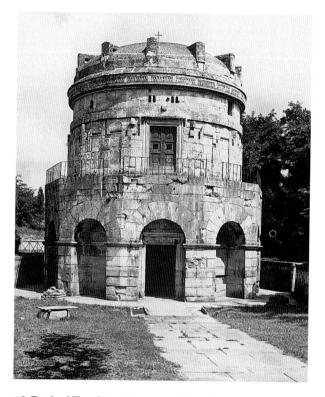

7.8 Tomb of Theodoric, Ravenna, early sixth century. The cap of the mausoleum is a huge stone that measures $36' \times 10'$ (11 \times 3 m). The great porphyry tomb inside the mausoleum was pillaged in the early Middle Ages.

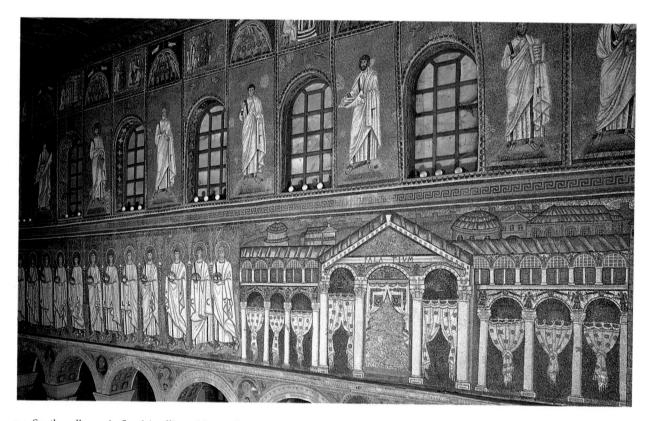

7.9 South wall mosaic, Sant' Apollinare Nuovo, Ravenna, early sixth century. The procession of male saints is in the lower register. The prophets and apostles are placed between the windows. Scenes from the Gospels are in the upper register. Detail appears in Figure 7.11.

one side and toward a Madonna and Child on the other. These mosaics were added to the church when the building passed from the Goths into Byzantine hands in the reign of Justinian. The depiction of Theodoric's palace [7.10] still in fact shows evidence of Orthodox censorship. In the arched spaces one can still see traces of halos of now-excised Arian saints (or perhaps members of Theodoric's court). On several columns of the mosaic can be seen the hands of figures that have now been replaced by decorative twisted draperies. The next register above has a line of prophetic figures. At the level of the clerestory windows are scenes from the New Testament-the miracles of Christ on one side [7.11-7.13] and scenes from his passion on the other. These mosaics are very different in style from the procession of sainted martyrs on the lower level. The Gospel sequence is more Roman in inspiration: severe and simple. Certain themes of earlier Roman Christian iconography are evident. The procession of saints, most likely erected by artists from a Constantinople studio, is much more lush, reverent, and static in tone. The Orientalizing element is especially noteworthy in the depiction of the Three Magi (with their Phrygian caps) who offer gifts to the Christ Child.

The Church of San Vitale most clearly testifies to the presence of Justinian in Ravenna [7.14]. Dedicated by Bishop Maximian in 547, it had been begun by Bishop Ec-

clesius in 526, the year Justinian came to the throne, while the Goths still ruled Ravenna. The church is octagonal, with only the barest hint of basilica length. How different it is may be seen by comparing it to Sant' Apollinare in Classe (the ancient seaport of Ravenna), built at roughly the same time [7.15]. The octagon has another octagon within it. This interior octagon, supported by columned arches and containing a second-story women's gallery, is the structural basis for the dome. The dome is supported on the octagonal walls by small vaults called *squinches* that cut across the angles of each part of the octagon.

Basilica of San Vitale

The most arresting characteristic of San Vitale, apart from its intricate and not fully understood architectural design, is its stunning program of mosaics. In the apse is a great mosaic of Christ the Pantocrator, the one who sustains all things in his hands [7.16]. Christ is portrayed as a beardless young man, clothed in royal purple. He holds in his left hand a book with seven seals (a reference to the Book of Revelation) and offers the crown of martyrdom to Saint Vitalis with his right. Flanked by the two archangels, Christ is offered a model of the church by

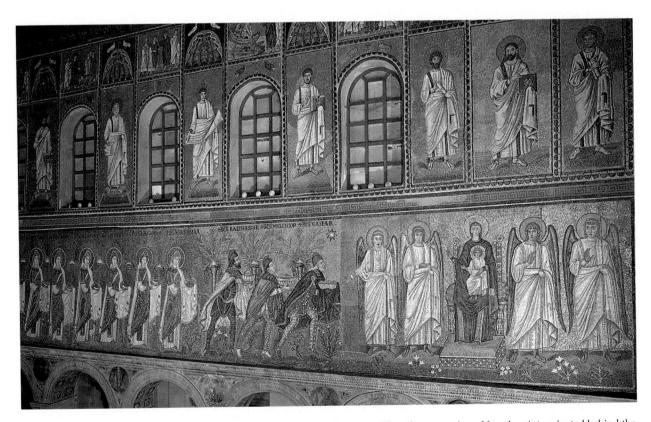

7.10 North wall mosaic, Sant' Apollinare Nuovo, Ravenna, early sixth century. Note the procession of female saints oriented behind the Three Magi, who all approach the enthroned Madonna. Details appear in Figure 7.12 and Figure 7.13.

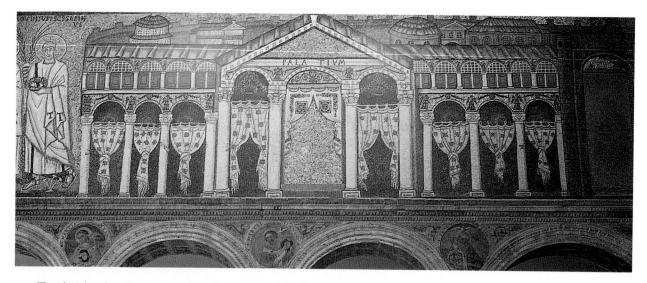

7.11 Theodoric's palace. Detail of south wall mosaic, Sant' Apollinare Nuovo, Ravenna.

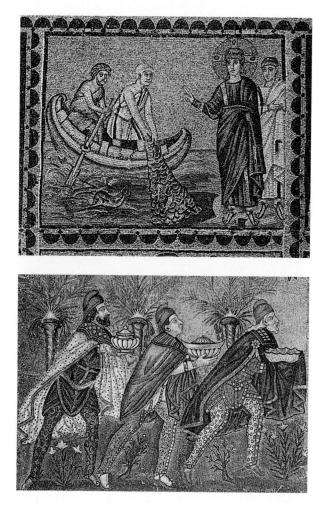

7.13 The Magi bearing gifts. Detail of north wall mosaic, Sant' Apollinare Nuovo, Ravenna. Christian legend had already named these figures Balthasar, Melchior, and Caspar, which can be seen inscribed on the mosaic. Bishop Apollinaris was a second-century apologist for Christianity who defended his faith in a treatise addressed to Emperor Marcus Aurelius.

7.12 Jesus calls the apostles Peter and Andrew. North wall upper-register mosaic, Sant' Apollinare Nuovo, Ravenna. Note the Christ figure in the royal purple toga and his beardless appearance.

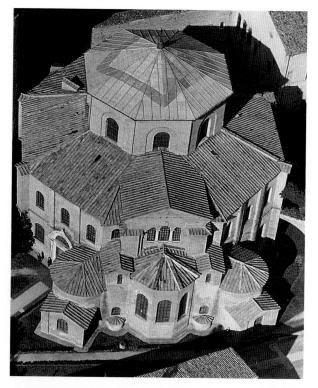

7.14 Church of San Vitale, Ravenna, c. 530–548. Aerial view. This complex building, the inspiration for Charlemagne's church at Aachen, gives little exterior evidence that it is done in the basilica style.

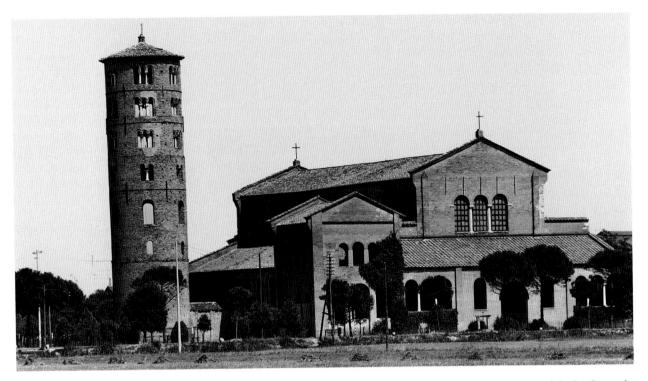

7.15 Sant' Apollinare in Classe, Ravenna, Italy, c. 533–549. The tower is a medieval addition. The clear outlines of the basilica style, with its side aisles, can be clearly seen in the photograph.

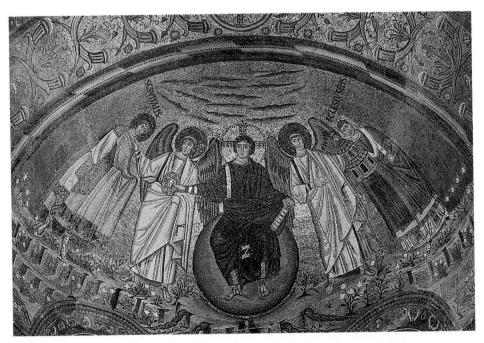

7.16 Christ enthroned, with Saint Vitalis and Bishop Ecclesius. Ceiling mosaic, San Vitale, Ravenna, c. 530. The bishop holds a model of the church at the extreme right while Christ hands the crown of martyrdom to the saint on the left.

Bishop Ecclesius, who laid its foundations. Above the figures are symbolic representations of the four rivers of paradise.

Mosaics to the left and right of the apse mosaic represent the royal couple as regents of Christ on earth. On the left wall of the sanctuary is a mosaic depicting Justinian and his attendants [7.17]. It is no mere accident or exercise of simple piety that the soldiers carry a shield with *chi* and *rho* (the first Greek letters in the name of Christ) or that there are twelve attendants or that the figure of the emperor divides clergy and laity. The emperor considered himself the regent of Christ, an attitude summed

up in the iconographic, or symbolic, program: Justinian represents Christ on earth and his power balances both church and state. The only figure identified in the mosaic is Bishop (later Archbishop) Maximian flanked by his clergy, who include a deacon with a jeweled gospel and a subdeacon with a chained incense pot.

Opposite the emperor's retinue, Empress Theodora and her attendants look across at the imperial group [7.18–7.19]. Theodora holds a chalice to complement the paten ("bread basket") held by the emperor. At the hem of Theodora's gown is a small scene of the Magi bringing gifts to the Christ Child. Scholars disagree whether the two mosaics represent the royal couple bringing the eucharistic gifts for the celebration of the liturgy or the donation of the sacred vessels for the church. It was customary for rulers to give such gifts to the more important churches of their realm. The fact that the empress seems to be leaving her palace (two male functionaries of the court are ushering her out) makes the latter interpretation the more probable one. The women at Theodora's left are striking; those to the extreme left are stereotyped, but the two closest to the empress appear more individualized, leading some art historians to suggest that they are idealized portraits of two of Theodora's closest friends: the wife and daughter of the conqueror of Ravenna, Belisarius.

The royal generosity extended not only to the building and decoration of the Church of San Vitale. An ivory throne, now preserved in the episcopal museum of Ravenna, was a gift from the emperor to Bishop Maximian, the ecclesiastical ruler of Ravenna when San Vitale was dedicated [7.20]. A close stylistic analysis of the carving on the throne has led scholars to see the work of at least four different artists on the panels, all probably from Constantinople. The front of the throne bears portraits of John the Baptist and the four evangelists, while the back has scenes from the New Testament with sides showing episodes from the Old Testament of the life of Joseph. The purely decorative elements of trailing vines and animals show the style of a different hand, probably Syrian. The bishop's throne (cathedra in Latin; a cathedral is a church where a bishop presides) bears a small monogram: "Maximian, Bishop."

The entire ensemble of San Vitale, with its pierced capitals typical of the Byzantine style, its elaborate mosaic portraits of saints and prophets, its lunette mosaics of Old Testament prefigurements of the Eucharist, and monumental mosaic scenes, is a living testimony to the rich fusion of imperial, Christian, and Middle Eastern cultural impulses. San Vitale is a microcosm of the sociopolitical vision of Byzantium fused with the religious worldview of early Christianity.

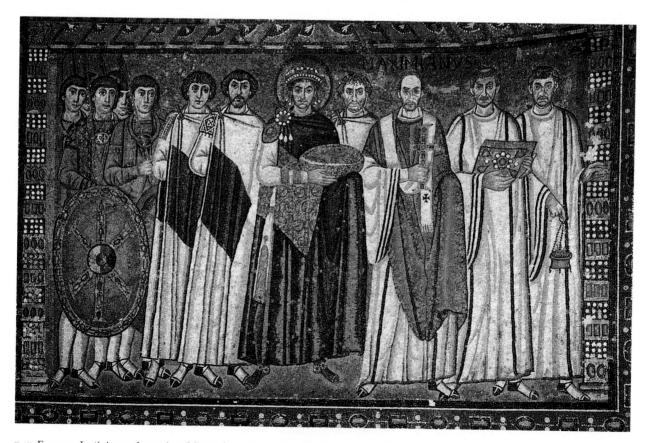

7.17 Emperor Justinian and courtiers. Mosaic from the north wall of the apse, San Vitale, c. 547. The church authorities stand at the emperor's left; the civil authorities at the right.

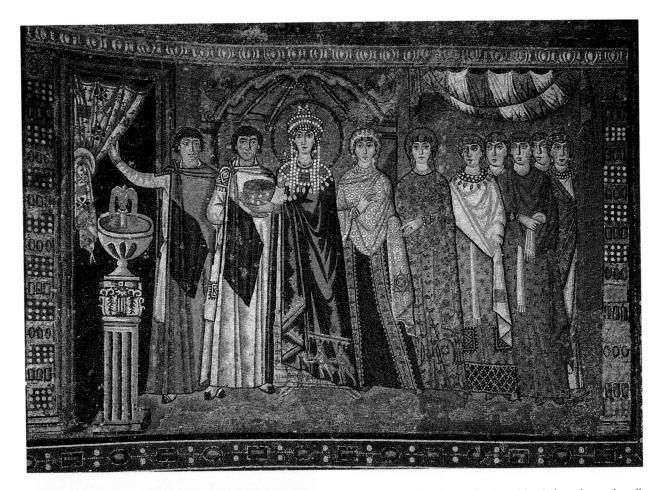

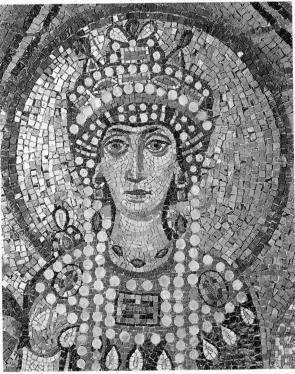

7.19 Empress Theodora. Detail of Figure 7.18, San Vitale, Ravenna, c. 547. Note the irregular placement of the tesserae in this mosaic.

7.18 Empress Theodora and retinue. Mosaic from the south wall of the apse, San Vitale, Ravenna, c. 547. Note the Three Magi on the hem of the empress' gown.

Saint Catherine's Monastery at Mount Sinai

Justinian is remembered not only in Constantinople and Ravenna but also in the Near East, where he founded a monastery that is still in use some fifteen hundred years later—a living link back to the Byzantine world.

In her *Peregrinatio*, that wonderfully tireless traveler of the fourth century, Etheria, describes a visit to the forbidding desert of the Sinai to pray at the site where God appeared to Moses in a burning bush (that, Etheria assures us, "is still alive to this day and throws out shoots") and to climb the mountain where the Law was given to Moses. She says that there was a church at the spot of the burning bush with some hermits living nearby to tend it and see to the needs of pilgrim visitors. More than a century later, Emperor Justinian built a monastery fortress at the foot of Mount Sinai and some pilgrimage chapels on the slopes of the mountain [7.21]. An Arabic inscription over one of the gates tells the story:

The pious king Justinian, of the Greek Church, in the expectation of divine assistance and in the hope of divine

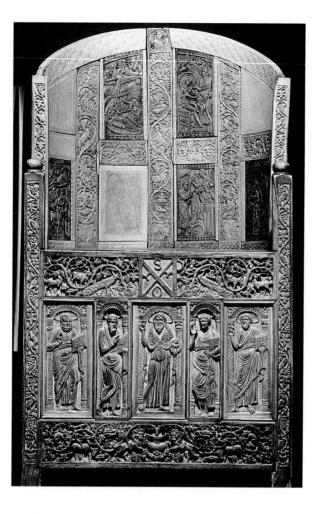

promises, built the monastery of Mount Sinai and the Church of the Colloquy [a church over the spot where Moses spoke to God in the burning bush] to his eternal memory and that of his wife, Theodora, so that all the earth and all its inhabitants should become the heritage of God; for the Lord is the best of masters. The building was finished in the thirtieth year of his reign and he gave the monastery a superior named Dukhas. This took place in the 6021st year after Adam, the 527th year [by the calendar] of the era of Christ the Savior.

Because of the number of factors—most important its extreme isolation and the very dry weather—the monastery is an immense repository of ancient Byzantine art and culture. It preserves some of Justinian's architecture and also some of the oldest icons in Christianity. The monastery is also famous as the site of the rediscovery of the earliest Greek codex of the New Testament hitherto found. Called the *Codex Sinaiticus*, it was discovered in the monastery by the German scholar Konstantin von Tischendorf in the nineteenth century. The codex, from the middle of the fourth century, was given by the monks to the Tsar of Russia. In 1933, the Soviet government sold it to the British Museum for £100,000, where it remains today, a precious document.

7.20 Bishop's *cathedra* ("throne") of Maximian, c. 546–556. Ivory panels on wood frame. Height 4'11" (1.5 m), width $1'11^{5}/_{8}$ " (.6 m). Archepiscopal Museum, Ravenna. Maximian is portrayed with his name in the Justinian mosaic (see Figure 7.17).

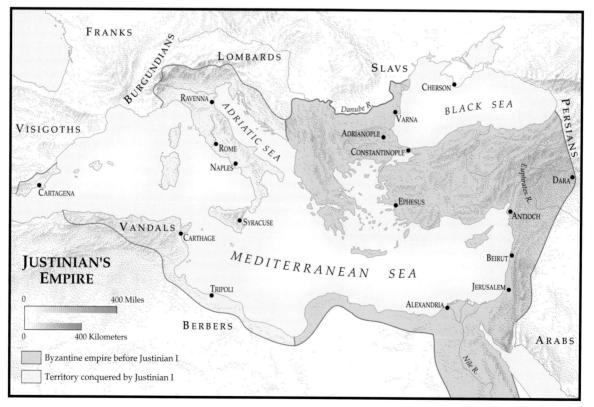

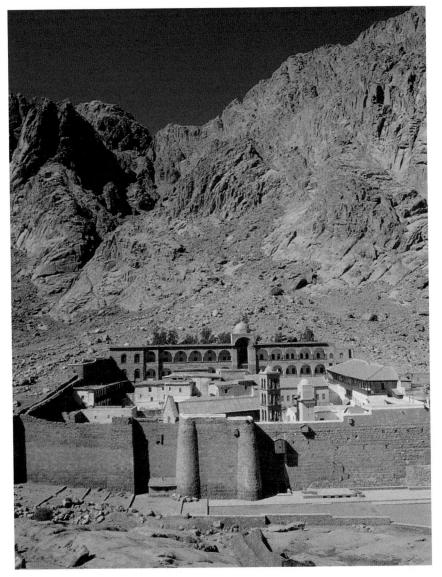

7.21 Fortress monastery of Saint Catherine in the Sinai Desert, sixth century. The church (called the *Katholikon*) from Justinian's time can be seen in the lower center of the walled enclosure, flanked by a bell tower.

The monastery is surrounded by heavy, fortified walls, the main part of which date from before Justinian's time. Within those walls are some modern buildings, including a fireproof structure that houses the monastery's library and icon collections. The monastic church, the *Katholikon*, dates from the time of Justinian, as recently discovered inscriptions carved into the wooden trusses in the ceiling of the church prove. Even the name of the architect, Stephanos, was uncovered. This church thus is unique: signed sixth-century ecclesiastical architecture.

One of the more spectacular holdings of the monastery is its vast collections of religious icons. Because of the iconoclastic controversies of the eighth and ninth centuries in the Byzantine Empire, almost no pictorial art remains from the period prior to the eighth century. Sinai survived the purges of the iconoclasts that engulfed the rest of the Byzantine world because of its extreme isolation. At Sinai, a range of icons (the Greek word *icon* means "image") that date from Justinian's time to the modern period can be seen. In a real sense, the icons of the monastery of Saint Catherine show the entire evolution of icon painting.

In the Byzantine Christian tradition, icon refers to a painting of a religious figure or a religious scene that is used in the public worship (the liturgy) of the church. Icons are not primarily decorative and they are didactic only in a secondary sense: For the Orthodox Christian faithful, the icon is a window into the world of the sacred. Just as Jesus Christ was in the flesh but imaged God in eternity, so the icon is a "thing," but it permits a glimpse into the timeless world of religious mystery. One stands before the icon and speaks through its image to the reality beyond it. This explains why the figures in an icon are usually portrayed full-front with no shadow or sense of three-dimensionality. The figures "speak" directly and frontally to the viewer against a hieratic background of gold. This iconic style becomes clear by an examination of an icon of Christ that may well have been sent to his new monastery by Justinian himself [7.22]. The icon is done using the *encaustic* method of painting (a technique common in the Roman world for funerary portraits): painting with molten wax that has been colored by pigments. Christ, looking directly at the viewer, is robed in royal purple; in his left hand he holds a jeweled codex and with his right hand he blesses the viewer.

This icon is an example from a large number found at Sinai that can be dated from before the tenth century. The entire corpus represents a continuous tradition of Byzantine art and piety. Mount Sinai is unique in its great tradition of historical continuity. Despite the rise of Islam, the harshness of the atmosphere, the vicissitudes of history, and the changing culture of the modern world, the monastery fortress at Sinai is living testimony to a style of life and a religiosity with an unbroken history to the time of Justinian's building program.

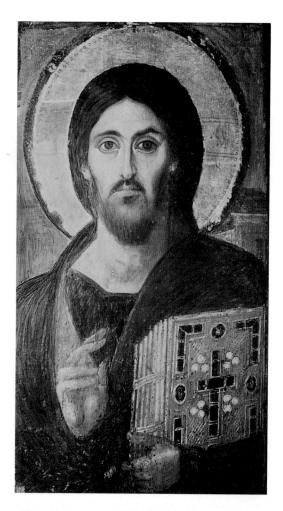

7.22 *Christ Pantocrater,* c. 500–530. Encaustic on wood panel. $32'' \times 27''$ (84×46 cm). Monastery of Saint Catherine, Mount Sinai. The book is a complex symbol of the Bible, Christ as the Word of God, and the record of human secrets that will be opened on the Last Day.

THE PERSISTENCE OF BYZANTINE CULTURE

It is simplistic to describe Byzantine art as unchanging it underwent regional, intellectual, social, and iconographic changes—but a person who visits a modern Greek or Russian Orthodox church is struck more by the similarities than by the dissimilarities with the art of early medieval Constantinople. Furthermore, the immediately recognizable Byzantine style can be found in the history of art in areas as geographically diverse as Sicily in southern Italy and the far-eastern reaches of Russia. What explains this basic persistence of style and outlook?

First of all, until it fell to the Turks in 1453, Constantinople exerted an extraordinary cultural influence over the rest of the Eastern Christian world. Russian emissaries sent to Constantinople in the late tenth century to inquire about religion brought back to Russia both favorable reports about Byzantine Christianity and a taste for the Byzantine style of religious art. It was the impact of services in Hagia Sophia that most impressed the delegates of Prince Vladimir, the first Christian ruler in Russia. Although art in Christian Russia was to develop its own regional variations, it was still closely tied to the art of Constantinople; Russian "onion-dome" churches, for example, are native adaptations of the central-dome churches of Byzantium.

Russia, in fact, accepted Christianity about one hundred fifty years after the ban on icons was lifted in Constantinople in 843. By this time the second "golden age" of Byzantine art was well under way. By the eleventh century, Byzantine artists were not only working in Russia but had also established schools of icon painting in such centers as Kiev. By the end of the century, these schools had passed into the hands of Russian monks, but their stylistic roots remained the artistic ideas of Byzantium. Even after the Mongol invasions of Russia in 1240, Russian religious art continued to have close ties to the Greek world, although less with Constantinople than with the monastic centers of Mount Athos and Salonica in Greece.

Byzantine influence was also very strong in Italy. We have already seen the influence of Justinian's court on Ravenna. Although northern Italy fell to Lombard rule in the eighth century, Byzantine influence continued in the south of Italy for the next five hundred years. During the iconoclastic controversy in the East many Greek artisans went into exile in Italy, where their work is still to be seen. Even while the Kingdom of Sicily was under Norman rule in the twelfth century, Byzantine artisans were still active, as the great mosaics of Monreale, Cefalù, and Palermo testify. In northern Italy, especially in Venice, the trade routes to the East and the effects of the Crusades permitted a strong presence of Byzantine art, as the mosaics of the Church of Saint Mark (as well as Byzantine art looted when the crusaders entered Constantinople in 1204) and the cathedral on the nearby island of Torcello attest. We shall see in later chapters the impact of this artistic presence on panel painting in Italy. Until the revolutionary changes by Cimabue and Giotto at the end of the thirteenth century, the pervasive influence of this style was so great that Italian painting up to that time is often characterized as Italo–Byzantine.

There is another reason that Byzantine aesthetics seem so changeless over the centuries. From the time of Justinian (and even more so after controversies of the eighth and ninth centuries) Byzantine art was intimately tied to the theology and liturgical practices of the Orthodox Church. The use of icons, for example, is not merely a pious practice but a deep-rooted part of the faith. Each year the Orthodox Church celebrated a feast commemorating the triumph of the Icon party called the Feast of the Triumph of Orthodoxy.

Art, then, is tied to theological doctrine and liturgical practice. Because of the innate conservatism of the theological tradition, innovation either in theology or in art was discouraged. The ideal of the artist was not to try something new but to infuse his work with a spirit of deep spirituality and unwavering reverence. This art, while extremely conservative, was never stagnant. The artists strove for fidelity to the past as their aesthetic criterion. As art historian André Grabar has noted, "Their role can be compared to that of musical performers in our day, who do not feel that their importance is diminished by the fact that they limit their talent to the interpretation of other people's work, since each interpretation contains original nuances."

This attitude of theological conservatism and aesthetic stability helps explain why, for example, the art of icon painting is considered a holy occupation in the Eastern Orthodox church. Today, when a new Orthodox church is built the congregation may commission from a monk or icon painter the necessary icons for the interior of the church. The expeditions of scholars who went to Saint Catherine's monastery to study the treasures there recall the sadness they felt at the funeral of a monk, Father Demetrios, in 1958. The last icon painter in the monastery, he marked the end of a tradition that stretched back nearly fifteen hundred years.

Travelers to Mount Athos in Greece can visit (with some difficulty) the small monastic communities (*sketes*) on the south of the peninsula, where monastic icon painters still work at their art. In our century there has been a renaissance of the appreciation of this style of painting. In Greece there has been a modern attempt to purge icon painting of Western influences (especially those of the Renaissance and the Baroque periods) in order to recover a more authentic link with the great Byzantine tradition of the past. In Russia there has been a surge of interest in the treasures of past religious art. This has resulted in careful conservation of the icons in Russia, exhibits of the art in the museums of Russia and abroad, and an intense scholarly study of this heritage as well as a revival of interest in the Orthodox Church itself.

Byzantine culture was not confined to artistic concerns. We have already seen that Justinian made an important contribution to legal studies. Constantinople also had a literary, philosophical, and theological culture. Although Justinian closed the pagan academies, later Byzantine emperors encouraged humanistic and theological studies. Even though the links between Constantinople and the West were strained over the centuries, those links did remain intact. At first a good deal of Greek learning came into the West (after having been lost in the early Middle Ages) through the agency of Arabic sources. The philosophical writings of Aristotle became available to Westerners in the late twelfth and early thirteenth centuries in the form of Latin translations or Arabic translations of the Greek: Aristotle came to the University of Paris from the Muslim centers of learning in Spain and northern Africa. Not until the fifteenth century did Greek become a widely known language in the West; in the fourteenth century Petrarch and Boccaccio had a difficult time finding anyone to teach them the language. By the fifteenth century this had changed. One factor contributing to the Renaissance love for the classics was the presence in Italy of Greek-speaking scholars from Constantinople.

The importance of this reinfusion of Greek culture can be seen easily enough by looking at the great libraries of fifteenth-century Italy. Of the nearly four thousand books in the Vatican library listed in a catalogue of 1484, a thousand were in Greek, most of which were from Constantinople. The core of the great library of Saint Mark's in Venice was Cardinal Bessarion's collection of Greek books, brought from the East when he went to the Council of Ferrara-Florence to discuss the union of the Greek and Latin churches in 1438. Bessarion brought with him, in addition to his books, a noted Platonic scholar, Genistos Plethon, who lectured on Platonic philosophy for the delighted Florentines. This event prompted Cosimo de' Medici to subsidize the collection, translation, and study of Plato's philosophy under the direction of Marsilio Ficino. Ficino's Platonic Academy, supported by Medici money, became a rallying point for the study of philosophical ideas.

The fall of Constantinople to the Turks in 1453 brought a flood of émigré Greek scholars to the West, in particular to Italy. The presence of these scholars enhanced the already considerable interest in Greek studies. Greek refugee scholars soon held chairs at the various *studia* ("schools") of the leading Italian cities. These scholars taught language, edited texts, wrote commentaries, and fostered an interest not only in Greek pagan learning but also in the literature of the Greek Fathers of the church. By the end of the fifteenth century, the famous Aldine press in Venice was publishing a whole series of Greek classics to meet the great demand for such works. This new source of learning and scholarship spread rapidly throughout Western Europe so that by the early sixteenth century the study of Greek was an ordinary but central part of both humanistic and theological education.

The cultural worldview of Justinian's Constantinople is preserved directly in the conservative traditionalism of Orthodox religious art and indirectly by Constantinople's gift of Greek learning to Europe during the Renaissance. The great social and political power of the Byzantine Empire ended in the fifteenth century although it had been in decline since the end of the twelfth century. Only the great monuments remain to remind us of a splendid and opulent culture now gone but once active and vigorous for nearly a thousand years.

SUMMARY

This chapter traces briefly the slow waning of Roman power in the West by focusing on two late Roman writers who are both Christians: Boethius, who wrote in provincial Ravenna, and Augustine, who lived in Roman North Africa.

As the wheel of fortune turned downward for Rome, Byzantium began its ascent as the center of culture. Our focus was on the great builder and patron of Byzantine culture, Emperor Justinian and his consort, Theodora. The central feature of their reign is its blending of their political power with the Christian Church so that church and state became a seamless whole. Christianity, which had been a despised and persecuted sect, now became the official religion of the state.

Byzantine Christianity had a readily recognizable look to it, a look most apparent in its art and architecture. It was an art that was otherworldly, formal, and profoundly sacred. A contemporary Orthodox theologian has said that the proper attitude of a Byzantine worshiper is *gazing*. The mosaics and icons of this tradition were meant to be seen as windows through which the devout might view the eternal mysteries of religion. No conscious attempt was made to be innovative in this art. The emphasis was always on deepening the experience of sacred mystery.

The influence of this art was far-reaching. Italo– Byzantine styles of art persisted in the West up to the beginnings of the Italian Renaissance. These same styles entered Russia at the end of the tenth century and still persist. Today, students can visit Greek or Russian churches and see these art forms alive as part of traditional Christian Orthodox worship and practice.

Because Byzantium (centered in the city of Constantinople) was Greek-speaking, the culture of ancient Greece was kept alive in that center until the middle of the fifteenth century, when the city fell to the Ottoman Turks. The removal of much of that culture to the West was a strong influence on the development of the Renaissance, as we shall see in subsequent chapters.

PRONUNCIATION GUIDE

Anthemius: Boethius: Chrysostom, John: Galla Placidia: Hagia Sophia: Honorius: Justinian: Maximian: Ravenna: Sant' Apollinare: San Vitale: Theodora: Theodoric: Tribonian: An-THEE-me-us Bow-E-thee-us CHRIS-o-stam, Jon Gala Plah-SID-e-ah Ha-GE-ah So-FEE-ah Ho-NOR-e-us Jus-TIN-e-an Max-IM-e-an Rah-VEN-ah Sahnt Ah-pole-een-ARE-eh Sahn Vee-TAHL-eh Thee-ah-DOOR-ah Thee-AH-door-ick Tree-BONE-e-an

Exercises

- 1. Augustine understood the word *confessions* to mean both an admission of sin and a statement of belief. Why is that term so useful and correct for an autobiography? Do most modern autobiographies constitute a confession in Augustine's sense of the term?
- In *The City of God* Augustine defines peace as "the tranquillity of order." What does he mean? Is that definition a good one?
- 3. The outstanding art of the Byzantine period is the mosaic. What made mosaic such a desirable art form for the period? What do you see as its limitations?
- 4. Take a long look at the Ravenna mosaics of Justinian and Theodora and their court. Taken as a whole, what political and social values show through in the composition of the scenes?
- 5. Look carefully at the various depictions of Christ found in Byzantine mosaics and icons. Which religious values are underscored in those depictions? Which values are neglected?
- 6. Define the word *icon* and be sure you understand its function in Orthodox Christianity. Is there anything comparable in contemporary art in terms of function?
- 7. Byzantine art prided itself on not changing its style but on preserving and perfecting it. Is there something to be said for continuity rather than change in artistic styles? What are the more apparent objections to such a philosophy?

Further Reading

- Beckwith, John. (1961). *The art of Constantinople*. New York: Phaidon. A reliable survey with good illustrations.
- Brown, Peter. (1967; 2nd edition, 1999). Augustine of Hippo. Berkeley: University of California Press. A brilliant biography.
- Cormack, Robin. (1986). Writing in gold: Byzantine society and its icons. New York: Oxford University Press. Good cultural study.
- Kazhdan, Alexander (Ed.). (1991). The Oxford dictionary of Byzantium (3 vols.). New York: Oxford University Press. Standard reference work.

- Mango, Cyril. (1986). *Art of the Byzantine Empire:* 312–1453. Toronto: University of Toronto Press. A survey by a noted scholar.
- Rodley, Lyn. (1994). Byzantine art and architecture: An introduction. New York: Cambridge University Press. An upto-date survey.
- Simson, Otto von. (1948). *The sacred fortress.* Chicago: University of Chicago Press. A classic work.
- Ware, Timothy. (1969). *The orthodox church*. Baltimore: Penguin. Excellent introduction to Orthodox faith and practice.

Online Chapter Links

Byzantine Studies on the Internet at

http://www.fordham.edu/halsall/byzantium/ provides an extensive list of links to related Web sites.

For introductory information about Byzantine art as well as links to sites related to representative artists, consult *Artcyclopedia* at

http://www.artcyclopedia.com/history/byzantine.html

Experience a virtual tour of the churches and monuments of Ravenna at

http://www.akros.it/comuneravenna/artefruk.htm

Online Chapter Resources

READING SELECTIONS

SAINT AUGUSTINE

Confessions

This selection from the Confessions recounts the conversion experience of Augustine with the famous "garden scene" and then the subsequent conversation that Augustine had with his mother Monica as they await a ship at the Roman port of Ostia to take them back to their native North Africa. Monica dies before their departure, which adds a sad note to the great religious conversation the two had as they looked out over the port itself.

from Воок VIII

11

This was the nature of my sickness. I was in torment, reproaching myself more bitterly than ever as I twisted and turned in my chain. I hoped that my chain might be broken once and for all, because it was only a small thing that held me now. All the same it held me. And you, O Lord, never ceased to watch over my secret heart. In your stern mercy you lashed me with the twin scourge of fear and shame in case I should give way once more and the worn and slender remnant of my chain should not be broken but gain new strength and bind me all the faster. In my heart I kept saying "Let it be now, let it be now!," and merely by saying this I was on the point of making the resolution. I was on the point of making it, but I did not succeed. Yet I did not fall back into my old state. I stood on the brink of resolution, waiting to take fresh breath. I tried again and came a little nearer to my goal, and then a little nearer still, so that I could almost reach out and grasp it. But I did not reach it. I could not reach out to it or grasp it, because I held back from the step by which I should die to death and become alive to life. My lower instincts, which had taken firm hold of me, were stronger than the higher, which were untried. And the closer I came to the moment which was to mark the great change in me, the more I shrank from it in horror. But it did not drive me back or turn me from my purpose: it merely left me hanging in suspense.

I was held back by mere trifles, the most paltry inanities, all my old attachments. They plucked at my garment of flesh and whispered, "Are you going to dismiss us? From this moment we shall never be with you again, for ever and ever. From this moment you will never again be allowed to do this thing or that, for evermore." What was it, my God, that they meant when they whispered "this thing or that"? Things so sordid and so shameful that I beg you in your mercy to keep the soul of your servant free from them! These voices, as I heard them, seemed less than half as loud as they had been before. They no longer barred my way, blatantly contradictory, but their mutterings seemed to reach me from behind, as though they were stealthily plucking at my back, trying to make me turn my head when I wanted to go forward. Yet, in my state of indecision, they kept me from tearing myself away, from shaking myself free of them and leaping across the barrier to the other side, where you were calling me. Habit was too strong for me when it asked, "Do you think you can live without these things?"

But by now the voice of habit was very faint. I had turned my eyes elsewhere, and while I stood trembling at the barrier, on the other side I could see the chaste beauty of Continence in all her serene, unsullied joy, as she modestly beckoned me to cross over and to hesitate no more. She stretched out loving hands to welcome and embrace me, holding up a host of good examples to my sight. With her were countless boys and girls, great numbers of the young and people of all ages, staid widows and women still virgins in old age. And in their midst was Continence herself, not barren but a fruitful mother of children, of joys born of you, O Lord, her Spouse. She smiled at me to give me courage, as though she were saying, "Can you not do what these men and these women do? Do you think they find the strength to do it in themselves and not in the Lord their God? It was the Lord their God who gave me to them. Why do you try to stand in your own strength and fail? Cast yourself upon God and have no fear. He will not shrink away and let you fall. Cast yourself upon him without fear, for he will welcome you and cure you of your ills." I was overcome with shame, because I was still listening to the futile mutterings of my lower self and I was still hanging in suspense. And again Continence seemed to say, "Close your ears to the unclean whispers of your body, so that it may be mortified. It tells you of things that delight you, but not such things as the law of the Lord your God has to tell."

In this way I wrangled with myself, in my own heart, about my own self. And all the while Alypius stayed at my side, silently awaiting the outcome of this agitation that was new in me.

12

I probed the hidden depths of my soul and wrung its pitiful secrets from it, and when I mustered them all before the eyes of my heart, a great storm broke within me, bringing with it a great deluge of tears. I stood up and left Alypius so that I might weep and cry to my heart's content, for it occurred to me that tears were best shed in solitude. I moved away far enough to avoid being embarrassed even by his presence. He must have realized what my feelings were, for I suppose I had said something and he had known from the sound of my voice that I was ready to burst into tears. So I stood up and left him where we had been sitting, utterly bewildered. Somehow I flung myself down beneath a fig tree and gave way to the tears which now streamed from my eyes, the sacrifice that is acceptable to you. I had much to say to you, my God, not in these very words but in this strain: Lord, will you never be content? Must we always taste your vengeance? Forget the long record of our sins. For I felt that I was still the captive of my sins, and in my misery I kept crying "How long shall I go on saying 'tomorrow, tomorrow'? Why not now? Why not make an end of my ugly sins at this moment?"

I was asking myself these questions, weeping all the while with the most bitter sorrow in my heart, when all at once I heard the sing-song voice of a child in a nearby house. Whether it was the voice of a boy or a girl I cannot say, but again and again it repeated the refrain "Take it and read, take it and read." At this I looked up, thinking hard whether there was any kind of game in which children used to chant words like these, but I could not remember ever hearing them before. I stemmed my flood of tears and stood up, telling myself that this could only be a divine command to open my book of Scripture and read the first passage on which my eyes should fall. For I had heard the story of Antony, and I remembered how he had happened to go into a church while the Gospel was being read and had taken it as a counsel addressed to himself when he heard the words Go home and sell all that belongs to you. Give it to the poor, and so the treasure you have shall be in heaven; then come back and follow me. By this divine pronouncement he had at once been converted to you.

So I hurried back to the place where Alypius was sitting, for when I stood up to move away I had put down the book containing Paul's Epistles. I seized it and opened it, and in silence I read the first passage on which my eyes fell: *Not in reveling and drunkenness, not in lust and wantonness, not in quarrels and rivalries. Rather, arm yourselves with the Lord Jesus Christ; spend no more thought on nature and nature's appetites.* I had no wish to read more and no need to do so. For in an instant, as I came to the end of the sentence, it was as though the light of confidence flooded into my heart and all the darkness of doubt was dispelled.

I marked the place with my finger or by some other sign and closed the book. My looks now were quite calm as I told Alypius what had happened to me. He too told me what he had been feeling, which of course I did not know. He asked to see what I had read. I showed it to him and he read on beyond the text which I had read. I did not know what followed, but it was this: *Find room among you for a man of over delicate conscience.* Alypius applied this to himself and told me so. This admonition was enough to give him strength, and without suffering the distress of hesitation he made his resolution and took this good purpose to himself. And it very well suited his moral character, which had long been far, far better than my own.

Then we went in and told my mother, who was overjoyed. And when we went on to describe how it had all happened, she was jubilant with triumph and glorified you, *who are powerful enough, and more than powerful enough, to carry out your purpose beyond all our hopes and dreams.* For she saw that you had granted her far more than she used to ask in her tearful prayers and plaintive lamentations. You converted me to yourself, so that I no longer desired a wife or placed any hope in this world but stood firmly upon the rule of faith, where you had shown me to her in a dream so many years before. And you turned her sadness into rejoicing, into joy far fuller than her dearest wish, far sweeter and more chaste than any she had hoped to find in children begotten of my flesh.

from BOOK IX

10

Not long before the day on which she was to leave this life-you knew which day it was to be, O Lord, though we did not-my mother and I were alone, leaning from a window which overlooked the garden in the courtyard of the house where we were staying at Ostia. We were waiting there after our long and tiring journey, away from the crowd, to refresh ourselves before our sea voyage. I believe that what I am going to tell you happened through the secret working of your providence. For we were talking alone together and our conversation was serene and joyful. We had forgotten what we had left behind and were intent on what lay before us. In the presence of Truth, which is yourself, we were wondering what the eternal life of the saints would be like, that life which no eye has seen, no ear has heard, no human heart conceived. But we laid the lips of our hearts to the heavenly stream that flows from your fountain, the source of all life which is in you, so that as far as it was in our power to do so we might be sprinkled with its waters and in some sense reach an understanding of this great mystery.

Our conversation led us to the conclusion that no bodily pleasure, however great it might be and whatever earthly light might shed luster upon it, was worthy of comparison, or even of mention, beside the happiness of the life of the saints. As the flame of love burned stronger in us and raised us higher towards the eternal God, our thoughts ranged over the whole compass of material things in their various degrees, up to the heavens themselves, from which the sun and the moon and the stars shine down upon the earth. Higher still we climbed, thinking and speaking all the while in wonder at all that you have made. At length we came to our own souls and passed beyond them to that place of everlasting plenty, where you feed Israel for ever with the food of truth. There life is that Wisdom by which all these things that we know are made, all things that ever have been and all that are yet to be. But that Wisdom is not made: it is as it has always been and as it will be for ever—or, rather, I should not say that it has been or will be, for it simply is, because eternity is not in the past or in the future. And while we spoke of the eternal Wisdom, longing for it and straining for it with all the strength of our hearts, for one fleeting instant we reached out and touched it. Then with a sigh, leaving our spiritual harvest bound to it, we returned to the sound of our own speech, in which each word has a beginning and an ending-far, far different from your Word, our Lord, who abides in himself for ever, yet never grows old and gives new life to all things.

And so our discussion went on. Suppose, we said, that the tumult of a man's flesh were to cease and all that his thoughts can conceive, of earth, of water, and of air, should no longer speak to him; suppose that the heavens and even his own soul were silent, no longer thinking of itself but passing beyond; suppose that his dreams and the visions of his imagination spoke no more and that every tongue and every sign and all that is transient grew silent—for all these things have the same message to tell, if only we can hear it, and their message is this: We did not make ourselves, but he who abides for ever made us. Suppose, we said, that after giving us this message and bidding us listen to him who made them, they fell silent and he alone should speak to us, not through them but in his own voice, so that we should hear him speaking, not by any tongue of the flesh or by an angel's voice, not in the sound of thunder or in some veiled parable, but in his own voice, the voice of the one whom we love in all these created things; suppose that we heard him himself, with none of these things between ourselves and him, just as in that brief moment my mother and I had reached out in thought and touched the eternal wisdom which abides over all things; suppose that this state were to continue and all other visions of things inferior were to be removed, so that this single vision entranced and absorbed the one who beheld it and enveloped him in inward joys in such a way that for him life was eternally the same as that instant of understanding for which we had longed so much-would not this be what we are to understand by the words Come and share the joy of your Lord? But when is it to be? Is it to be when we all rise again, but not all of us will undergo the change?

This was the purport of our talk, though we did not speak in these precise words or exactly as I have reported them. Yet you know, O Lord, that as we talked that day, the world, for all its pleasures, seemed a paltry place compared with the life that we spoke of. And then my mother said, "My son, for my part I find no further pleasure in this life. What I am still to do or why I am here in the world, I do not know, for I have no more to hope for on this earth. There was one reason, and one alone, why I wished to remain a little longer in this life, and that was to see you a Catholic Christian before I died. God has granted my wish and more besides, for I now see you as his servant, spurning such happiness as the world can give. What is left for me to do in this world?"

11

I scarcely remember what answer I gave her. It was about five days after this, or not much more, that she took to her bed with a fever. One day during her illness she had a fainting fit and lost consciousness for a short time. We hurried to her bedside, but she soon regained consciousness and looked up at my brother and me as we stood beside her. With a puzzled look she asked, "Where was I?" Then watching us closely as we stood there speechless with grief, she said, "You will bury your mother here." I said nothing, trying hard to hold back my tears, but my brother said something to the effect that he wished for her sake that she would die in her own country, not abroad. When she heard this, she looked at him anxiously and her eyes reproached him for his worldly thoughts. She turned to me and said, "See how he talks!" and then, speaking to both of us, she went on, "It does not matter where you bury my body. Do not let that worry you! All I ask of you is that, wherever you may be, you should remember me at the altar of the Lord."

Although she hardly had the strength to speak, she managed to make us understand her wishes and then fell silent, for her illness was becoming worse and she was in great pain. But I was thinking of your gifts, O God. Unseen by us you plant them like seeds in the hearts of your faithful and they grow to bear wonderful fruits. This thought filled me with joy and I thanked you for your gifts, for I had always known, and well remembered now, my mother's great anxiety to be buried beside her husband's body in the grave which she had provided and prepared for herself. Because they had lived in the greatest harmony, she had always wanted this extra happiness. She had wanted it to be said of them that, after her journey across the sea, it had been granted to her that the earthly remains of husband and wife should be joined as one and covered by the same earth. How little the human mind can understand God's purpose! I did not know when it was that your good gifts had borne their full fruit and her heart had begun to renounce this vain desire, but I was both surprised and pleased to find that it was so. And yet, when we talked at the window and she asked, "What is left for me to do in this world?" it was clear that she had no desire to die in her own country. Afterwards I also heard that one day during our stay at Ostia, when I was absent, she had talked in a motherly way to some of my friends and had spoken to them of the contempt of this life and the blessings of death. They were astonished to find such courage in a woman-it was your gift to her, O Lordand asked whether she was not frightened at the thought of leaving her body so far from her own country. "Nothing is far from God," she replied, "and I need have no fear that he will not know where to find me when he comes to raise me to life at the end of the world."

And so on the ninth day of her illness, when she was fifty-six and I was thirty-three, her pious and devoted soul was set free from the body.

SAINT AUGUSTINE *from* THE CITY OF GOD

This selection is from Augustine's massive meditation on history called The City of God. Here Augustine meditates on a perennial subject for all people: the character of peace in both its personal and social context. This great reflection on peace is all the more compelling because it was written by Augustine against the background of the Barbarian invasions of Europe and Roman North Africa as well as his own shock at the sack of the city of Rome, the occasion for his writing this book in the first place.

7. Human society divided by differences of language. The misery of war, even when just

After the city or town comes the world, which the philosophers reckon as the third level of human society. They begin with the household, proceed to the city, and then arrive at the world. Now the world, being like a confluence of waters, is obviously more full of danger than the other communities by reason of its greater size. To begin with, on this level the diversity of languages separates man from man. For if two men meet, and are forced by some compelling reason not to pass on but to stay in company, then if neither knows the other's language, it is easier for dumb animals, even of different kinds, to associate together than these men, although both are human beings. For when men cannot communicate their thoughts to each other, simply because of difference of language, all the similarity of their common human nature is of no avail to unite them in fellowship. So true is this that a man would be more cheerful with his dog for company than with a foreigner. I shall be told that the Imperial City has been at pains to impose on conquered peoples not only her yoke but her language also, as a bond of peace and fellowship, so that there should be no lack of interpreters but even a profusion of them. True; but think of the cost of this achievement! Consider the scale of those wars, with all that slaughter of human beings, all the human blood that was shed!

Those wars are now past history; and yet the misery of these evils is not yet ended. For although there has been, and still is, no lack of enemies among foreign nations, against whom wars have always been waged, and are still being waged, yet the very extent of the Empire has given rise to wars of a worse kind, namely, social and civil wars, by which mankind is more lamentably disquieted either when fighting is going on in the hope of bringing hostilities eventually to a peaceful end, or when there are fears that hostilities will break out again. If I were to try to describe, with an eloquence worthy of the subject, the many and multifarious disasters, the dour and dire necessities, I could not possibly be adequate to the theme, and there would be no end to this protracted discussion. But the wise man, they say, will wage just wars. Surely, if he remembers that he is a human being, he will rather lament the fact that he is faced with the necessity of waging just wars; for if they were not just, he would not have to engage in them, and consequently there would be no wars for a wise man. For it is the injustice of the opposing side that lays on the wise man the duty of waging wars; and this injustice is assuredly to be deplored by a human being, since it is the injustice of human beings, even though no necessity for war should arise from it. And so everyone who reflects with sorrow on such grievous evils, in all their horror and cruelty, must acknowledge the misery of them. And yet a man who experiences such evils, or even thinks about them, without heartfelt grief, is assuredly in a far more pitiable condition, if he thinks himself happy simply because he has lost all human feeling.

8. The friendship of good men can never be carefree, because of this life's dangers

If we are spared that kind of ignorance, akin to madness, which is a common affliction in the wretched condition of this life, an ignorance which leads men to believe an enemy to be a friend, or a friend an enemy, what consolation have we in this human society, so replete with mistaken notions and distressing anxieties, except the unfeigned faith and mutual affections of genuine, loyal friends? Yet the more friends we have and the more dispersed they are in different places, the further and more widely extend our fears that some evil may befall them from among all the mass of evils of this present world. For not only are we troubled and anxious because they may be afflicted by famine, war, disease, or captivity, fearing that in slavery they may suffer evils beyond our powers of imagination; there is the much more bitter fear, that their friendship be changed into treachery, malice and baseness. And when such things do happen (and the more numerous our friends, the more often they happen) and the news is brought to our ears, who, except one who has this experience, can be aware of the burning sorrow that ravages our hearts? Certainly we would rather hear that our friends were dead, although this also we could not hear without grief.

For if their life brought us the consoling delights of friendship, how could it be that their death should bring us no sadness? Anyone who forbids such sadness must forbid, if he can, all friendly conversation, must lay a ban on all friendly feeling or put a stop to it, must with a ruthless insensibility break the ties of all human relationships, or else decree that they must only be engaged upon so long as they inspire no delight in a man's soul. But if this is beyond all possibility, how can it be that a man's death should not be bitter if his life is sweet to us? For this is why the grief of a heart that has not lost human feeling is a thing like some wound or ulcer, and our friendly words of consolation are the healing application. And it does not follow that there is nothing to be healed simply because the nobler a man's spirit the quicker and easier the cure.

It is true, then, that the life of mortals is afflicted, sometimes more gently, sometimes more harshly, by the death of those most dear to us, and especially the death of those whose functions are necessary for human society; and yet we should prefer to hear, or even to witness, the death of those we love, than to become aware that they have fallen from faith or from moral conflict-that is, that they have died in their very soul. The earth is full of this vast mass of evils; that is why we find this in Scripture: "Is man's life on earth anything but temptation?" And why the Lord himself says, "Alas for the world, because of these obstacles"; and again, "Because iniquity will increase beyond measure, the love of many will grow cold." The result of this situation is that when good men die who are our friends we rejoice for them; and though their death brings us sadness, we find our surer consolation in this, that they have been spared those evils by which in this life even good men are crushed or corrupted, or at least are in danger of both these disasters.

9. The friendship of the holy angels, obscured by the deceit of demons

Our relationship with the society of the holy angels is quite another matter. Those philosophers, we observe, who insisted that the gods are our friends placed this angelic fellowship on the fourth level, as they proceeded in their scheme from the earth to the universe, intending by this method to include, in some fashion, even heaven itself. Now, with regard to the angels, we have, it is true, no manner of fear that such friends may bring us sorrow, either by their death or by their degradation. But they do not mix with us on the same familiar footing as do men-and this in itself is one of the disappointments involved in this lifeand Satan, as Scripture tells us, transforms himself at times to masquerade as an angel of light, to tempt those men who are in need of this kind of training, or men who deserve to be thus deluded. Hence God's great mercy is needed to prevent anyone from supposing that he is enjoying the friendship of good angels when in fact it is evil demons that he has as his false friends, and when he thus suffers from the enmity of those whose harmfulness is in proportion to their cunning and deceit. In fact, where is God's great mercy needed if not by men in their most pitiable state, where they are so weighed down by ignorance that they are readily deluded by the pretences of those spirits? Now those philosophers in the ungodly city alleged that the gods were their friends; but it is quite certain that they had fallen in with these malignant demons, the powers to whom that city itself is wholly subjected, and in whose company it will suffer everlasting punishment. This is made quite clear by those beings who are worshipped in that city. It is revealed unmistakably by the sacred, or rather sacrilegious, rites by which the pagans think it right to worship them, and by the filthy shows by which they think those demons must be propitiated; and it is the demons themselves who suggest, and indeed demand, the performance of such vile obscenities.

10. The reward of victory over temptation

However, not even the saints and the faithful worshippers of the one true and supreme God enjoy exemption from the deceptions of the demons and from their multifarious temptations. In fact, in this situation of weakness and in these times of evil such anxiety is even not without its use in leading them to seek, with more fervent longing, that state of serenity where peace is utterly complete and assured. For there the gifts of nature, that is, the gifts bestowed on our nature by the Creator of all natures, will be not only good but also everlasting; and this applies not only to the spirit, which is healed by the wisdom, but also to the body, which will be renewed by resurrection. There the virtues will not be engaged in conflict with any kind of vice or evil; they will be possessed of the reward of victory, the everlasting peace which no adversary can disturb. This is indeed the ultimate bliss, the end of ultimate fulfillment that knows no destructive end. Here in this world we are called blessed, it is true, when we enjoy peace, however little may be the peace-the peace of a good life-which can be enjoyed here. And yet such blessedness as this life affords proves to be utter misery when compared with that final bliss. And so, when we enjoy here, if we live rightly, such peace as can be the portion of mortal men under the conditions of mortality, virtue rightly uses the blessings of peace, and even when we do not possess that peace, virtue turns to a good use even the ills that man endures. But virtue is truly virtue when it refers all the good things of which it makes good use, all its achievements in making good use of good things and evil things, and when it refers itself also, to that end where our peace shall be so perfect and so great as to admit of neither improvement nor increase.

11. The bliss of everlasting peace, which is the fulfillment of the saints

It follows that we could say of peace, as we have said of eternal life, that it is the final fulfillment of all our goods; especially in view of what is said in a holy psalm about the City of God, the subject of this laborious discussion. These are the words: "Praise the Lord, O Jerusalem; praise your God, O Sion: for he has strengthened the bolts of your gates; he has blessed your sons within your walls; he has made your frontiers peace." Now when the bolts of her gates have been strengthened, that means that no one will any more enter or leave that City. And this implies that we must take her "frontiers" (or "ends") to stand here for the peace whose finality I am trying to establish. In fact, the name of the City itself has a mystic significance, for "Jerusalem," as I have said already, means "vision of peace."

But the word peace is freely used in application to the events of this mortal state, where there is certainly no eternal life; and so I have preferred to use the term "eternal life" instead of "peace" in describing the end of this City, where its Ultimate Good will be found. About this end the Apostle says, "But now you have been set free from sin and have become the servants of God; and so you have your profit, a profit leading to sanctification, and the end is everlasting life." On the other hand, the life of the wicked may also be taken to be eternal life by those who have no familiarity with the holy Scriptures. They may follow some of the philosophers in thinking in terms of the immortality of the soul, or they may be influenced by our Christian belief in the endless punishment of the ungodly, who obviously cannot be tortured for ever without also living for ever. Consequently, in order to make it easier for everyone to understand our meaning, we have to say that the end of this City, whereby it will possess its Supreme Good, may be called either "peace in life everlasting" or "life everlasting in peace." For peace is so great a good that even in relation to the affairs of earth and of our mortal state no word ever falls more gratefully upon the ear, nothing is desired with greater longing, in fact, nothing better can be found. So if I decide to discourse about it at somewhat greater length, I shall not, I think, impose a burden on my readers, not only because I shall be speaking of the end of the City which is the subject of this work, but also because of the delightfulness of peace, which is dear to the heart of all mankind.

12. Peace is the instinctive aim of all creatures, and is even the ultimate purpose of war

Anyone who joins me in an examination, however slight, of human affairs, and the human nature we all share, recognizes that just as there is no man who does not wish for joy, so there is no man who does not wish for peace. Indeed, even when men choose war, their only wish is for victory; which shows that their desire in fighting is for peace with glory. For what is victory but the conquest of the opposing side? And when this is achieved, there will be peace. Even wars, then, are waged with peace as their object, even when they are waged by those who are concerned to exercise their warlike prowess, either in command or in the actual fighting. Hence it is an established fact that peace is the desired end of war. For every man is in quest of peace, even in waging war, whereas no one is in quest of war when making peace. In fact, even when men wish a present state of peace to be disturbed they do so not because they hate peace, but because they desire the present peace to be exchanged for one that suits their wishes. Thus their desire is not that there should not be peace but that it should be the kind of peace they wish for. Even in the extreme case when they have separated themselves from others by sedition, they cannot achieve their aim unless they maintain some sort of semblance of peace with their confederates in conspiracy. Moreover, even robbers, to ensure greater efficiency and security in their assaults on the peace of the rest of mankind, desire to preserve peace with their associates.

Indeed, one robber may be so unequalled in strength and so wary of having anyone to share his plans that he does not trust any associate, but plots his crimes and achieves his successes by himself, carrying off his booty after overcoming and dispatching such as he can; yet even so he maintains some kind of shadow of peace, at least with those whom he cannot kill, and from whom he wishes to conceal his activities. At the same time, he is anxious, of course, to be at peace in his own home, with his wife and children and any others members of his household; without doubt he is delighted to have them obedient to his beck and call. For if this does not happen, he is indignant; he scolds and punishes; and, if need be, he employs savage measures to impose on his household a peace which, he feels, cannot exist unless all the other elements in the same domestic society are subject to one head; and this head, in his own home, is himself. Thus, if he were offered the servitude of a larger number, of a city, maybe, or a whole nation, on the condition that they should all show the same subservience he had demanded from his household, then he would no longer lurk like a brigand in his hide-out; he would raise himself on high as a king for all to see-although the same greed and malignity would persist in him.

We see, then, that all men desire to be at peace with their own people, while wishing to impose their will upon those people's lives. For even when they wage war on others, their wish is to make those opponents their own people, if they can—to subject them, and to impose on them their own conditions of peace.

Let us, however, suppose such a man as is described in the verse of epic legends, a creature so unsociable and savage that they perhaps preferred to call him a semi-human rather than a human being. Now although his kingdom was the solitude of a dreadful cavern, and although he was so unequalled in wickedness that a name was found for him derived from that quality (he was called Cacus, and kakos is the Greek word for "wicked"); although he had no wife with whom to exchange endearments, no children to play with when little or to give orders to when they were a little bigger, no friends with whom to enjoy a chat, not even his father, Vulcan (he was happier than his father only in this important respect—that he did not beget another such monster as himself); although he never gave anything to anyone, but took what he wanted from anyone he could and removed, when he could, anyone he wished to remove; despite all this, in the very solitude of his cave, the floor of which, in the poet's description

reeked ever with the blood of recent slaughter

his only desire was for a peace in which no one should disturb him, and no man's violence, or the dread of it, should trouble his repose. Above all, he desired to be at peace with his own body; and in so far as he achieved this, all was well with him. He gave the orders and his limbs obeyed. But his mortal nature rebelled against him because of its insatiable desires, and stirred up the civil strife of hunger, intending to dissociate the soul from the body and to exclude it; and then he sought with all possible haste to pacify that mortal nature, and to that end he ravished, murdered, and devoured. And thus, for all his monstrous savagery, his aim was still to ensure peace, for the preservation of his life, by these monstrous and savage methods. Accordingly, if he had been willing to maintain, in relation to others also, the peace he was so busily concerned to preserve in his own case and in himself, he would not have been called wicked, or a monster, or semi-human. Or if it was his outward appearance and his belching of murky flames that frightened away human companions, it may be that it was not lust for inflicting injury but the necessity of preserving his life that made him so savage. Perhaps, after all, he never existed or, more probably, he was not like the description given by poetic fantasy; for if Cacus had not been excessively blamed, Hercules would have received inadequate praise. And therefore the existence of such a man, or rather semi-human, is discredited, as are many similar poetical fictions.

We observe, then, that even the most savage beasts, from whom Cacus derived the wild-beast side of his nature (he was in fact also called a semi-beast), safeguard their own species by a kind of peace, by coition, by begetting and bearing young, by cherishing them and rearing them; even though most of them are not gregarious but solitary-not, that is, like sheep, deer, doves, starlings, and bees, but like lions, wolves, foxes, eagles and owls. What tigress does not gently purr over her cubs, and subdue her fierceness to caress them? What kite, however solitary as he hovers over his prey, does not find a mate, build a nest, help to hatch the eggs, rear the young birds, and, as we may say, preserve with the mother of his family a domestic society as peaceful as he can make it? How much more strongly is a human being drawn by the laws of his nature, so to speak, to enter upon a fellowship with all his fellow-men and to keep peace

with them, as far as lies in him. For even the wicked when they go to war do so to defend the peace of their own people, and desire to make all men their own people, if they can, so that all men and all things might together be subservient to one master. And how could that happen, unless they should consent to a peace of his dictation either through love or through fear? Thus pride is a perverted imitation of God. For pride hates a fellowship of equality under God, and seeks to impose its own dominion on fellow men, in place of God's rule. This means that it hates the just peace of God, and loves its own peace of injustice. And yet it cannot help loving peace of some kind or other. For no creature's perversion is so contrary to nature as to destroy the very last vestiges of its nature.

It comes to this, then; a man who has learnt to prefer right to wrong and the rightly ordered to the perverted, sees that the peace of the unjust, compared with the peace of the just, is not worthy even of the name of peace. Yet even what is perverted must of necessity be in, or derived from, or associated with-that is, in a sense, at peace with-some part of the order of things among which it has its being or of which it consists. Otherwise it would not exist at all. For instance if anyone were to hang upside-down, this position of the body and arrangement of the limbs is undoubtedly perverted, because what should be on top, according to the dictates of nature, is underneath, and what nature intends to be underneath is on top. This perverted attitude disturbs the peace of the flesh, and causes distress for that reason. For all that, the breath is at peace with its body and is busily engaged for its preservation; that is why there is something to endure the pain. And even if the breath is finally driven from the body by its distresses, still, as long as the framework of the limbs holds together, what remains retains a kind of peace among the bodily parts; hence there is still something to hang there. And in that the earthly body pulls towards the earth, and pulls against the binding rope that holds it suspended, it tends towards the position of its own peace, and by what might be called the appeal of its weight, it demands a place where it may rest. And so even when it is by now lifeless and devoid of all sensation it does not depart from the peace of its natural position, either while possessed of it or while tending toward it. Again, if treatment with embalming fluids is applied to prevent the dissolution and disintegration of the corpse in its present shape, a kind of peace still connects the parts with one another and keeps the whole mass fixed in its earthly condition, an appropriate, and therefore a peaceable state.

On the other hand, if no preservative treatment is given, and the body is left for nature to take its course, there is for a time a kind of tumult in the corpse of exhalations disagreeable and offensive to our senses (for that is what we smell in putrefaction), which lasts until the body unites with the elements of the world as, little by little, and particle by particle, it vanishes into their peace. Nevertheless, nothing is in any way removed, in this process, from the control of the laws of the supreme Creator and Ruler who directs the peace of the whole scheme of things. For although minute animals are produced in the corpse of a larger animal, those little bodies, each and all of them, by the same law of their Creator, are subservient to their little souls in the peace that preserves their lives. And even if the flesh of dead animals is devoured by other animals, in whatever direction it is taken, with whatever substances it is united, into whatever substances it is converted and transformed, it still finds itself subject to the same laws which are diffused throughout the whole of matter for the preservation of every mortal species, establishing peace by a harmony of congruous elements.

13. The peace of the universe maintained through all disturbances by a law of nature: The individual attains, by God's ordinance, to the state he has deserved by his free choice

The peace of the body, we conclude, is a tempering of the component parts in duly ordered proportion; the peace of the irrational soul is a duly ordered repose of the appetites; the peace of the rational soul is the duly ordered agreement of cognition and action. The peace of body and soul is the duly ordered life and health of a living creature; peace between mortal man and God is an ordered obedience, in faith, in subjection to an everlasting law; peace between men is an ordered agreement of mind with mind; the peace of a home is the ordered agreement among those who live together about giving and obeying orders; the peace of the Heavenly City is a perfectly ordered and perfectly harmonious fellowship in the enjoyment of God, and a mutual fellowship in God; the peace of the whole universe is the tranquility of order — and order is the arrangement of things equal and unequal in a pattern which assigns to each its proper position.

It follows that the wretched, since, in so far as they are wretched, they are obviously not in a state of peace, lack the tranquillity of order, a state in which there is no disturbance of mind. In spite of that, because their wretchedness is deserved and just, they cannot be outside the scope of order. They are not, indeed, united with the blessed; yet it is by the law of order that they are sundered from them. And when they are free from disturbance of mind, they are adjusted to their situation, with however small a degree of harmony. Thus they have amongst them some tranquillity of order, and therefore some peace. But they are still wretched just because, although they enjoy some degree of serenity and freedom from suffering, they are not in a condition where they have the right to be serene and free from pain. They are yet more wretched, however, if they are not at peace with the law by which the natural order is governed. Now when they suffer, their peace is disturbed in the part where they suffer; and yet peace still continues in the part which feels no burning pain, and where the natural frame is not broken up. Just as there is life, then, without pain, whereas there can be no pain when there is no life, so there is peace without any war, but no war without some degree of peace. This is not a consequence of war as such, but of the fact that war is waged by or within persons who are in some sense natural beingsfor they could have no kind of existence without some kind of peace as the condition of their being.

There exists, then, a nature in which there is no evil, in which, indeed, no evil can exist; but there cannot exist a nature in which there is no good. Hence not even the nature of the Devil himself is evil, in so far as it is a nature; it is perversion that makes it evil. And so the Devil did not stand firm in the truth, and yet he did not escape the judgement of the truth. He did not continue in the tranquillity of order; but that did not mean that he escaped from the power of the imposer of order. The good that God imparts, which the Devil has in his nature, does not withdraw him from God's justice by which his punishment is ordained. But God, in punishing, does not chastise the good which he created, but the evil which the Devil has committed. And God does not take away all that he gave to that nature; he takes something, and yet he leaves something, so that there may be some being left to feel pain at the deprivation.

Now this pain is in itself evidence of the good that was taken away and the good that was left. In fact, if no good has been left there could have been no grief for lost good.

For a sinner is in a worse state if he rejoices in the loss of righteousness; but a sinner who feels anguish, though he may gain no good from his anguish, is at least grieving at the loss of salvation. And since righteousness and salvation are both good, and the loss of any good calls for grief rather than for joy (assuming that there is no compensation for the loss in the shape of a higher good-for example, righteousness of character is a higher good than health of body), the unrighteous man's grief in his punishment is more appropriate than his rejoicing in sin. Hence, just as delight in the abandonment of good, when a man sins, is evidence of a bad will, so grief at the loss of good, when a man is punished, is evidence of a good nature. For when a man grieves at the loss of the peace of his nature, his grief arises from some remnants of that peace, which ensure that his nature is still on friendly terms with itself. Moreover, it is entirely right that in the last punishment the wicked and ungodly should bewail in their agonies the loss of their "natural" goods, and realize that he who divested them of these goods with perfect justice is God, whom they despised when with supreme generosity he bestowed them.

God then, created all things in supreme wisdom and ordered them in perfect justice; and in establishing the mortal race of mankind as the greatest ornament of earthly things, he has given to mankind certain good things suitable to this life. These are: temporal peace, in proportion to the short span of a mortal life-the peace that consists in bodily health and soundness, and in fellowship with one's kind; and everything necessary to safeguard or recover this peace-those things, for example, which are appropriate and accessible to our senses: light, speech, air to breathe, water to drink, and whatever is suitable for the feeding and clothing of the body, for the care of the body and the adornment of the person. And all this is granted under the most equitable condition: that every mortal who uses aright such goods, goods designed to serve the peace of mortal men, shall receive goods greater in degree and superior in kind, namely, the peace of immortality, and the glory and honor appropriate to it in a life which is eternal for the enjoyment of God and of one's neighbor in God, whereas he who wrongly uses those mortal goods shall lose them, and shall not receive the blessings of eternal life.

14. The order and law, earthly or heavenly, by which government serves the interests of human society

We see, then, that all man's use of temporal things is related to the enjoyment of earthly peace in the earthly city; whereas in the Heavenly City it is related to the enjoyment of eternal peace. Thus, if we were irrational animals, our only aim would be the adjustment of the parts of the body in due proportion, and the quieting of the appetites-only, that is, the repose of the flesh, and an adequate supply of pleasures, so that bodily peace might promote the peace of the soul. For if bodily peace is lacking, the peace of the irrational soul is also hindered, because it cannot achieve the quieting of its appetites. But the two together promote that peace which is a mutual concord between soul and body, the peace of an ordered life and of health. For living creatures show their love of bodily peace by their avoidance of pain, and by their pursuit of pleasure to satisfy the demands of their appetites they demonstrate their love of peace of soul. In just the same way, by shunning death they indicate quite clearly how great is their love of the peace in which soul and body are harmoniously united.

But because there is in man a rational soul, he subordinates to the peace of the rational soul all that part of his

nature which he shares with the beasts, so that he may engage in deliberate thought and act in accordance with this thought, so that he may thus exhibit that ordered agreement of cognition and action which we called the peace of the rational soul. For with this end in view he ought to wish to be spared the distress of pain and grief, the disturbances of desire, the dissolution of death, so that he may come to some profitable knowledge and may order his life and his moral standards in accordance with this knowledge. But he needs divine direction, which he may obey with resolution, and divine assistance that he may obey it freely, to prevent him from falling, in his enthusiasm for knowledge, a victim to some fatal error, through the weakness of the human mind. And so long as he is in this mortal body, he is a pilgrim in a foreign land, away from God; therefore he walks by faith, not by sight. That is why he views all peace, of body or of soul, or of both, in relation to that peace which exists between mortal man and immortal God, so that he may exhibit an ordered obedience in faith in subjection to the everlasting Law.

Now God, our master, teaches two chief precepts, love of God and love of neighbor; and in them man finds three objects for his love: God, himself, and his neighbor; and a man who loves God is not wrong in loving himself. It follows, therefore, that he will be concerned also that his neighbor should love God, since he is told to love his neighbor as himself; and the same is true of his concern for his wife, his children, for the members of his household, and for all other men, so far as is possible. And, for the same end, he will wish his neighbor to be concerned for him, if he happens to need that concern. For this reason he will be at peace, as far as lies in him, with all men, in that peace among men, that ordered harmony; and the basis of this order is the observance of two rules: first, to do no harm to anyone, and, secondly, to help everyone whenever possible. To begin with, therefore, a man has a responsibility for his own household-obviously, both in the order of nature and in the framework of human society, he has easier and more immediate contact with them; he can exercise his concern for them. That is why the Apostle says, "Anyone who does not take care of his own people, especially those in his own household, is worse than an unbeliever-he is a renegade." This is where domestic peace starts, the ordered harmony about giving and obeying orders among those who live in the same house. For the orders are given by those who are concerned for the interests of others; thus the husband gives orders to the wife, parents to children, masters to servants. While those who are the objects of this concern obey orders; for example, wives obey husbands, the children obey their parents, the servants their masters. But in the household of the just man who "lives on the basis of faith" and who is still on pilgrimage, far from that Heavenly City, even those who give orders are the servants of those whom they appear to command. For they do not give orders because of a lust for domination but from a dutiful concern for the interests of others, not with pride in taking precedence over others, but with compassion in taking care of others.

15. Man's natural freedom; and the slavery caused by sin

This relationship is prescribed by the order of nature, and it is in this situation that God created man. For he says, "Let him have lordship over the fish of the sea, the birds of the sky . . . and all the reptiles that crawl on the earth." He did not wish the rational being, made in his own image, to have dominion over any but irrational creatures, not man over man, but man over beasts. Hence the first just men were set

up as shepherds of flocks, rather than as kings of men, so that in this way also God might convey the message of what was required by the order of nature, and what was demanded by the deserts of sinners-for it is understood, of course, that the condition of slavery is justly imposed on the sinner. That is why we do not hear of a slave anywhere in the Scriptures until Noah, the just man, punished his son's sin with this word; and so that son deserved this name because of his misdeed, not because of his nature. The origin of the Latin word for slave, servus, is believed to be derived from the fact that those who by the laws of war could rightly be put to death by the conquerors, became servi, slaves, when they were preserved, receiving this name from their preservation. But even this enslavement could not have happened, if it were not for the deserts of sin. For even when a just war is fought it is in defense of his sin that the other side is contending; and victory, even when the victory falls to the wicked, is a humiliation visited on the conquered by divine judgement, either to correct or to punish their sins. We have a witness to this in Daniel, a man of God, who in captivity confesses to God his own sins and the sins of his people, and in devout grief testifies that they are the cause of that captivity. The first cause of slavery, then, is sin, whereby man was subjected to man in the condition of bondage; and this can only happen by the judgment of God, with whom there is no injustice, and who knows how to allot different punishments according to the deserts of the offenders.

Now, as our Lord above says, "Everyone who commits sin is sin's slave," and that is why, though many devout men are slaves to unrighteous masters, yet the masters they serve are not themselves free men; "for when a man is conquered by another he is also bound as a slave to his conqueror." And obviously it is a happier lot to be slave to a human being than to a lust; and, in fact, the most pitiless domination that devastates the hearts of men, is that exercised by this very lust for domination, to mention no others. However, in that order of peace in which men are subordinate to other men, humility is as salutary for the servants as pride is harmful to the masters. And yet by nature, in the condition in which God created man, no man is the slave either of man or of sin. But it remains true that slavery as a punishment is also ordained by that law which enjoins the preservation of the order of nature, and forbids its disturbance; in fact, if nothing had been done to contravene that law, there would have been nothing to require the discipline of slavery as a punishment. That explains also the Apostle's admonition to slaves, that they should be subject to their masters, and serve them loyally and willingly. What he means is that if they cannot be set free by their masters, they themselves may thus make their slavery, in a sense, free, by serving not with the slyness of fear, but with the fidelity of affection, until all injustice disappears and all human lordship and power is annihilated, and God is all in all.

16. Equity in the relation of master and slave

This being so, even though our righteous fathers had slaves, they so managed the peace of their households as to make a distinction between the situation of children and the condition of slaves in respect of the temporal goods of this life; and yet in the matter of the worship of God—in whom we must place our hope of everlasting goods—they were concerned, with equal affection, for all the members of their household. This is what the order of nature prescribes, so that this is the source of the name *paterfamilias*, a name that has become so generally used that even those who exercise unjust rule rejoice to be called by this title. On the other hand, those who are genuine "fathers of their household" are concerned for the welfare of all in their households in respect of the worship and service of God, as if they were all their children, longing and praying that they may come to the heavenly home, where it will not be a necessary duty to give orders to men, because it will no longer be a necessary duty to be concerned for the welfare of those who are already in the felicity of that immortal state. But until that home is reached, the fathers have an obligation to exercise the authority of masters greater than the duty of slaves to put up with their condition as servants.

However, if anyone in the household is, through his disobedience, an enemy to the domestic peace, he is reproved by a word, or by a blow, or any other kind of punishment that is just and legitimate, to the extent allowed by human society; but this is for the benefit of the offender, intended to readjust him to the domestic peace from which he had broken away. For just as it is not an act of kindness to help a man, when the effect of the help is to make him lose a greater good, so it is not a blameless act to spare a man, when by so doing you let him fall into a greater sin. Hence the duty of anyone who would be blameless includes not only doing no harm to anyone but also restraining a man from sin or punishing his sin, so that either the man who is chastised may be corrected by his experience, or others may be deterred by his example. Now a man's house ought to be the beginning, or rather a small component part of the city, and every beginning is directed to some end of its own kind, and every component part contributes to the completeness of the whole of which it forms a part. The implication is quite apparent, that domestic peace contributes to the peace of the city-that is, the ordered harmony of those who live together in a house in the matter of giving and obeying orders, contributes to the ordered harmony concerning authority and obedience obtaining among the citizens. Consequently it is fitting that the father of a household should take his rules from the law of the city, and govern his household in such a way that it fits in with the peace of the city.

17. The origin of peace between the heavenly society and the earthly city, and of discord between them

But a household of human beings whose life is not based on faith is in pursuit of an earthly peace based on the things belonging to this temporal life, and on its advantages, whereas a household of human beings whose life is based on faith looks forward to the blessings which are promised as eternal in the future, making use of earthly and temporal things like a pilgrim in a foreign land, who does not let himself be taken in by them or distracted from his course toward God, but rather treats them as supports which help him more easily to bear the burdens of "the corruptible body which weighs heavy on the soul"; they must on no account be allowed to increase the load. Thus both kinds of men and both kinds of households alike make use of the things essential for this mortal life: but each has its own very different end in making use of them. So also the earthly city, whose life is not based on faith, aims at an earthly peace, and it limits the harmonious agreement of citizens concerning the giving and obeying of orders to the establishment of a kind of compromise between human wills about the things relevant to mortal life. In contrast, the Heavenly City-or rather that part of it which is on pilgrimage in this condition of mortality, and which lives on the basis of faith-must needs make use of this peace also, until this mortal state, for which this kind of peace is essential, passes away. And therefore, it leads what we may call a life of captivity in this earthly city as in a foreign land, although it has already received the promise of redemption, and the gift of the Spirit as a kind of pledge of it; and yet it does not hesitate to obey the laws of the earthly city by which those things which are designed for the support of this mortal life are regulated; and the purpose of this obedience is that, since this mortal condition is shared by both cities, a harmony may be preserved between them in things that are relevant to this condition.

But this earthly city has had some philosophers belonging to it whose theories are rejected by the teaching inspired by God. Either led astray by their own speculation or deluded by demons, these thinkers reached the belief that there are many gods who must be won over to serve human ends, and also that they have, as it were, different departments with different responsibilities attached. Thus the body is the department of one god, the mind that of another; and within the body itself, one god is in charge of the head, another of the neck and so on with each of the separate members. Similarly, within the mind, one is responsible for natural ability, another for learning, another for anger, another for lust; and in the accessories of life there are separate gods over the departments of flocks, grain, wine, oil, forests, coinage, navigation, war and victory, marriage, birth, fertility, and so on. The Heavenly City, in contrast, knows only one God as the object of worship, and decrees, with faithful devotion, that he only is to be served with that service which the Greeks call latreia, which is due to God alone. And the result of this difference has been that the Heavenly City could not have laws of religion common with the earthly city, and in defense of her religious laws she was bound to dissent from those who thought differently and to prove a burdensome nuisance to them. Thus she had to endure their anger and hatred, and the assaults of persecution; until at length that City shattered the morale of her adversaries by the terror inspired by her numbers, and by the help she continually received from God.

While this Heavenly City, therefore, is on pilgrimage in this world, she calls out citizens from all nations and so collects a society of aliens, speaking all languages. She takes no account of any difference in customs, laws, and institutions, by which earthly peace is achieved and preserved-not that she annuls or abolishes any of those, rather, she maintains them and follows them (for whatever divergences there are among the diverse nations, those institutions have one single aim—earthly peace), provided that no hindrance is presented thereby to the religion which teaches that the one supreme and true God is to be worshipped. Thus even the Heavenly City in her pilgrimage here on earth makes use of the earthly peace and defends and seeks the compromise between human wills in respect of the provisions relevant to the mortal nature of man, so far as may be permitted without detriment to true religion and piety. In fact, that City relates the earthly peace to the heavenly peace, which is so truly peaceful that it should be regarded as the only peace deserving the name, at least in respect of the rational creation; for this peace is the perfectly ordered and completely harmonious fellowship in the enjoyment of God, and of each other in God. When we arrive at that state of peace, there will be no longer a life that ends in death, but a life that is life in sure and sober truth; there will be no animal body to "weigh down the soul" in its process of corruption; there will be a spiritual body with no cravings, a body subdued in every part to the will. This peace the Heavenly City possesses in faith while on its pilgrimage, and it lives a life of righteousness, based on this faith, having the attainment of that peace in view in every good action it performs in relation to God, and in relation to a neighbor, since the life of a city is inevitably a social life.

GENERAL EVENTS

LITERATURE & PHILOSOPHY ART

500			
300	570–632 Life of Muhammad		
	622 Muhammad flees to Mecca; this year now marks the beginning of the Muslim calendar		
600	 610–733 Spread of Islam to Arabia, Egypt, Syria, Iraq, and parts of northern Africa 638 Muslims capture Jerusalem 	Circa 530–850 Development of Kufic script	الم د ز کا ح
		<i>Qur'an</i> develops and with it the tradition of Hadith or religious commentary	
		Development of Shar´a, the Islamic legal code	
		651 Publication of <i>Qur'an</i>	
700	700 Islam spreads to all of northern Africa and to southern Spain		A A A A A A A
	732 Charles Martel holds off Muslim northern expansion at Tours		730–843 Muslim belief that God's divinity defies representation leads to a blend of intricate geometric
800	794 First paper factory established in Baghdad		design and sacred script in Muslim art and architecture
		801 Death of Rabia, Sufi saint and poet	
		833 House of Wisdom established in Baghdad, drawing scholars from all over the Muslim world, translating and preserving many Greek texts.	
		780–850 Al-Khwarizmi, inventor of algebra, develops use of zero as a number	
1000	1099 Crusading Christians capture Jerusalem	(980–1037) Avicenna, philosopher- scientist	
1100		(1126–1198) Averröes	
		(1135–1204) Maimonides, great Jewish thinker, physician, Talmudist	
1200	1258 Mongols sack Baghdad 1281 Ottoman Empire founded	1207–1273 Life of Rumi, perhaps the best-known Sufi mystic-poet	
1400	1201 Ottoman Empire Tounded		
	1453 Constantinople falls to Ottoman Turks, ending Byzantine Empire; Church of Hagia Sophia becomes a mosque		
1.845	1492 Muslims driven from Spain in the "Reconquista"		
1500	1526–1858 Mughal Reign in India		
1600			
1700			
1800			

Chapter 8 Islam

ARCHITECTURE

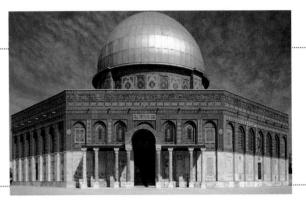

687–692 Dome of the Rock

706–715 Great Mosque of Damascus built by Al Walid

Circa 790 Great Mosque of Córdoba begun

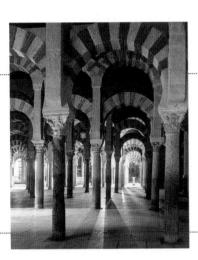

Circa 980 Al-Hakam enhances existing structure

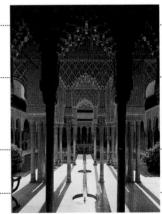

1200–1300 The Alhambra

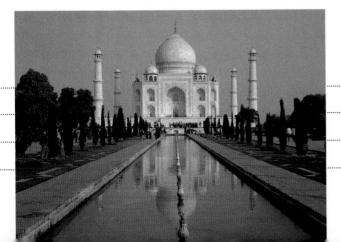

1532 Cathedral begun inside the Great Mosque of Córdoba

1632–1647 Taj Mahal

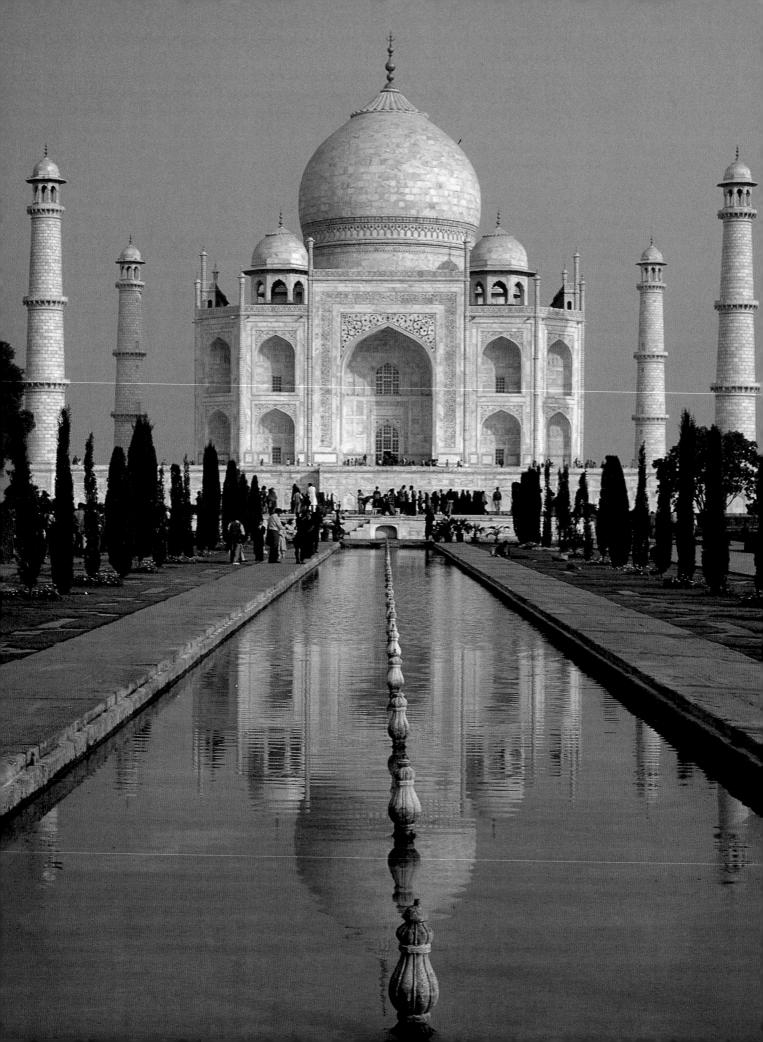

CHAPTER 8 ISLAM

MUHAMMAD AND THE BIRTH OF ISLAM

Muhammad

uhammad, the founder of Islam, was born in 570 in the Arabian city of Mecca. Orphaned as a child and reared in poverty, while still young he married a rich widow who would bear him a daughter, Fatima. Fatima would later marry the first Imam (authoritative religious leader) of the Shiites. As an ancestor of all followers of Islam, Fatima is highly venerated by all Muslims as a model of piety and purity. Muhammad's deep religious nature led him to ponder the reasons for his good fortune and he began to retreat into caves in the neighboring mountains to meditate. At about the age of forty, he began receiving revelations from God through the agency of the angel Gabriel. When he began to speak publicly about his ideas of religious reform, Muhammad soon encountered severe opposition from the citizens of Mecca who had little patience with his sermons against the city's prevalent idolatry and his insistence on the worship of one God. The antagonism was so adamant that he had to flee the city in 622, a year the Muslims now mark as the beginning of their calendar: the hegira.

In Medina, his city of refuge, Muhammad soon attracted a community of supporters. He achieved such success in this endeavor that he was able, less than ten years later, to return to Mecca and make its once pagan shrine called the Qa'aba (Arabic for "cube") the focal point of his new religion. It did not take him long to consolidate his hold over that city.

By the time Muhammad reached Mecca the rough outlines of the basis for his religion were already in place. The fundamental principle of the faith was a bedrock monotheism (the word *Islam* means "submission [to God]"). This belief was a conscious rejection of the Christian doctrine of the Trinity of persons in God. The prophet began to articulate the so-called five pillars of Islam:

Five Pillars

- 1. The recitation of the Muslim act of faith that there is one God and that Muhammad is God's messenger.
- 2. The obligation to pray five times a day in a direction that points to the Qa'aba in Mecca. Soon there was added the obligation to participate in Friday prayers as a community and hear a sermon.
- 3. To donate a portion of the surplus of one's wealth to charity.
- To fast during the holy month of Ramadan—a total abstinence of all food and drink from sunrise to sunset.
- 5. To make a pilgrimage to Mecca (called the *Haj*) at least once in a lifetime.

That latter obligation was performed by Muhammad himself around the purified and restored Qa´aba in 632, which was the same year he died in the arms of his wife. The pilgrimage to Mecca today draws millions of faithful to Mecca [8.1].

In addition to these core practices there are other characteristic practices of Islam: like Jews, Muslims do not eat pork products. Unlike Judaism and Christianity, Islam forbids the consumption of alcoholic beverages. Muslim males are circumcised. Polygamy is permitted under Islamic law but not practiced universally. The taking of interest on loans or lending for interest (usury) is forbidden by Islamic law. Over the course of time a

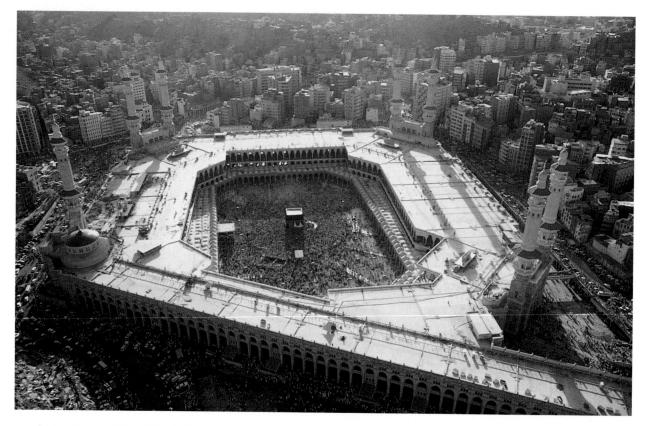

8.1 The Sanctuary at Mecca. This is the central focus of the Islamic pilgrimage in Mecca. Pious pilgrims circle the draped black stone (Qa'aba) upon which, it is believed, one can see the footprints of Abraham. The left and front of the Qa'aba is the tomb of Ishmael, from whom Muslims trace their descent.

cycle of feast days and observances developed (e.g., the birthday of the Prophet).

The very simplicity of the original Islamic teachingits emphasis on submission to the will of the one God, its insistence on daily prayer, its appeal for charity, and a demand for some asceticism in life-all help to explain the phenomenal and rapid spread of this new religion coming out of the deserts of Arabia. In less than ten years after the death of the Prophet, Islam had spread to all of Arabia, Egypt, Syria, Iraq, and parts of North Africa. A generation after the Prophet's death, the first Muslim attack (unsuccessful) on Constantinople was launched; within two generations Muslims constituted a forceful majority in the holy city of Jerusalem. By the eighth century, Islam had spread to all of North Africa (modernday Libya, Morocco, Tunisia, and Algeria) and had crossed the Mediterranean near Gibraltar to create a kingdom in Southern Spain.

The Qur'an

Evidently, many of the revelations received by the Prophet during his life at both Mecca and Medina were maintained orally, but soon after his death followers began to write down the revelations as they had received them from him. Within a generation, a serious attempt was made to collate the various oral revelations with a view of producing a uniform edition of the revelations received both at Medina and Mecca. The net result of these long editorial efforts resulted in a central sacred text of Islam called the *Qur'an* (sometimes spelled *Koran*; the word is Arabic for "recitation").

Qur´an

The *Qur'an* is roughly as long as the Christian New Testament. The book is divided into one hundred fourteen chapters (called *sûrahs*). There is an opening chapter in the form of a short prayer invoking the name of God followed by one hundred thirteen chapters arranged in terms of their length, with chapter two being the longest and the final chapter only a line or two long. Muslims have devised ways of dividing these chapters; for example, into thirty parts of near equal length so that one could complete reciting the entire book during the thirty days of the sacred month of Ramadan, which is a time of intense devotion accompanying the annual fast.

The language of the *Qur'an* is Arabic. Like all Semitic languages (e.g., Hebrew and Syriac) the text is written and read from right to left. Since Muslims believe that

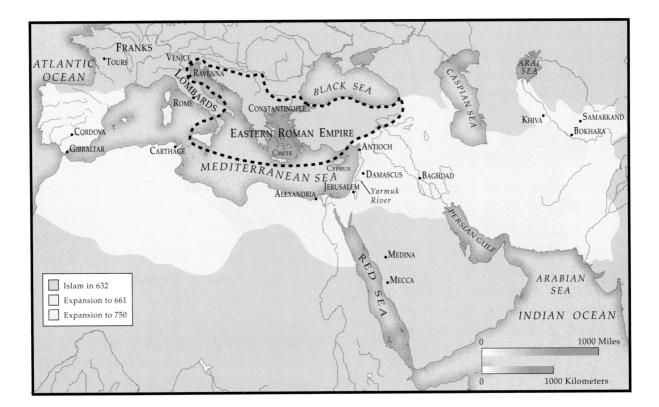

the Qur'an came as a result of divine dictation, it cannot be translated into other languages. While many vernacular versions of the Qur'an exist, they are considered to be paraphrases or glosses. The result of this conviction is that no matter where Muslims live they will hear the Qur'an recited only in Arabic. Although Arabs (contrary to popular belief) make up a relatively small proportion of the total Muslim population of the world (the largest Muslim population resides in Indonesia), the Qur'an serves as a source of unification for all Muslims. Reverence for the Qur'an, further, means that it is literally God's word to people and as such is held in the highest reverence. Committing the entire Qur'an to memory is a sign of devotion and the capacity to chant it aloud is a much-admired gift since the beauty and care of such recitation is deemed an act of religious piety in its own right. Today, public competitions of recitations of the Our'an are a regular feature on radio and television in Muslim countries. In cities having a Muslim majority it is not uncommon to find radio stations that feature a reading of the Qur'an twenty-four hours a day.

The *Qur'an* is the central text of Islam, but there is also another authoritative tradition which has shaped Islamic religion and culture. Authoritative commentators on the *Qur'an* and the explication of certain oral traditions about the Prophet and the early Islamic community constitute a body of literature called *Hadith*. From this living stream of sacred text and tradition Islamic sages and jurists have developed a complex legal code called *Shari´a* ("law"). When Muslim countries are described as adopting Islamic law for its governance, it is *Shari´a* that is being referred to. Like all legal codes *Shari´a* is both traditional and conservative yet adaptable to the needs and circumstances of time.

Hadith

Calligraphy

Calligraphy comes from two Greek words that mean "beautiful writing." It was only natural that such skills would be developed in order to render adequate honor to the written text of the *Qur'an*. The evolution of Arabic script is a long and highly complex study in its own right but certain standard forms of writing were developed. One of the most characteristic form of this writing, although it also admits of many variations, is called *Kufic* [8.2].

Kufic script

Such calligraphic skills were brought to bear not only on the text of *Qur'an* itself but also as a decorative

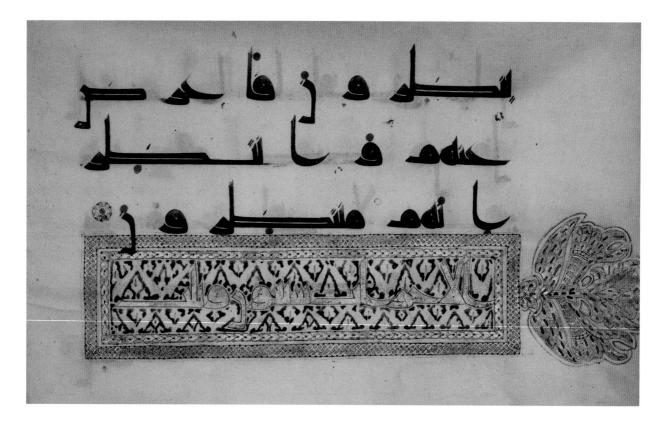

8.2 Page from the *Qur'an*, eighth century(?), $8'' \times 13''$ (21.6 × 32.5 cm). Museum of Islamic Art, Berlin. The highly stylized calligraphy is known as *Kufic* script; it is one of the earliest and most beautiful of Arabic calligraphy styles.

feature of public buildings—especially the great halls erected for assemblies of the faithful for Friday prayers and the sermons preached at the end of those prayers. These buildings are called *mosques* (from the Arabic word *masjid*, meaning "a place for ritual prostration"). Perhaps nothing is so familiar to people then pious Muslim men kneeling in prayer, touching their heads to the ground, in the great mosques of the world. This act of prostration can be "read" as a gesture touching the heart of the religion: to prostrate is to show "submission" to God (in Arabic, *Allah*).

The exterior and interior decoration of the great classical mosques are always done in an art form that emphasizes the abstract and the geometric because Muslims believe that one cannot depict divinity since Allah is beyond all imagining. It is therefore commonplace to see an intricate blend of abstract geometric designs entwined with exquisitely rendered sacred texts from the *Qur'an*. Some of the decoration found on the exterior of mosques, like that found decorating the great seventeenth-century Friday Mosque of Ishfahan in Iran uses blue tiling to set forth intricate patterns of arabesques and highly stylized bands of calligraphic renderings of lines from the *Qur'an* [8.3].

Although Islamic decoration is usually abstract it is not exclusively so. Some mosques do in fact have representational scenes in the interior. These usually depict nonhuman images of plants and flowers executed mainly in mosaic—especially when the skills of Byzantine mosaic artists were available to do such work. One does not find in such art narrative scenes since very little of the *Qur'an* has a narrative quality.

Islamic Architecture

Islam has a fifteen-hundred-year history. Its communities are found in every part of the world. In that long history it has built its buildings suitable to the circumstances in which it finds itself even though the basic needs of the mosque remain fairly constant: a large covered space for the faithful to pray especially when the community gathers for Friday prayers. Typically, the gathering area is covered with rugs; except for the steps leading up to a minbar (the "pulpit"), there is no furniture in a mosque. A niche in the wall called a michrab indicates the direction of Mecca so that the faithful at prayer are accurately oriented East. In traditional Friday mosques, there is also usually some type of fountain so that the devout may ritually cleanse their hands, feet, and mouth before prayer. Adjacent to the mosque is a tower or minaret so that the *Muezzin* may call the faithful to prayer five times a day. Visitors to Muslim countries soon become accustomed to the Muezzin's predawn call, "Wake up! Wake up! It is better to pray than to sleep. . . ."

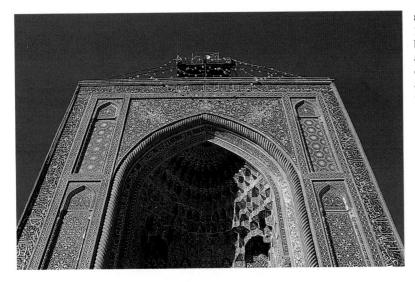

8.3 The Portal of the Ishafan Mosque (1611–1666). Notice the Islamic script that decorates both long piers of the portal (entrance) as well as the script that is on the lintel below the coffered ceiling. The interplay of calligraphy and abstract design is typical of mosque decoration in various periods.

While primarily designed to shelter the faithful at prayer, the mosque serves a larger community function in Islam. It is a community gathering center; it is a place where scholars meet to study and debate; courtroom proceedings could be held there; leisurely conversations could be held in its courtyards and people could escape the heat of the sun in its covered areas. As scholars have noted, the mosque is to Islamic countries what the Roman forum or the precincts of the medieval cathedral or the town square were to other cultures: a gathering place for the community to express itself as community.

The simple requirements for the mosque leaves much for the ingenuity and genius of the individual architect to develop. As a result, the history of Islamic architecture provides extraordinary examples of art.

The Dome of the Rock in Jerusalem is the earliest and one of the most spectacular achievements of Islamic architecture [8.4] built toward the end of the seventh century by Caliph Abd al Malik in Damascus on the Temple Mount in Jerusalem. The Temple Mount is an elevated space that was once the site of the Jewish temple destroyed by the Romans in A.D. 70. The Dome of the Rock is an octagonal building capped by a golden dome which sits upon a heavy drum supported by four immense piers and twelve columns. The interior is decorated lavishly with mosaics as was the outside of the building until, in the late Middle Ages, the mosaics were replaced by tiles. The building owes a clear debt to Roman and Byzantine architecture, but its Qur'anic verses on the inside make it clear that it was to serve an Islamic function.

Dome of the Rock

What was that function? Was its original purpose to be a mosque? a masoleum? It may well have been erected to serve as a counterpoint to the Church of the Holy Sepulcher in Jerusalem acting as a rebuff in stone to Christianity, making the artistic argument (as the Qur'an itself does) that Islam is a worthy successor both to Judaism and to Christianity. Built around a still-visible rock outcropping, it is not totally clear what the original purpose of the building was. Scholars still do not agree on the building's original purpose (some have even argued that it was built as a rival to the Qa'aba in Mecca), but all are unanimous that it is a splendid example of Islamic architecture. A ninth-century story speaks of it commemorating the spot of the night journey of the Prophet from Jerusalem to heaven, whereas other traditions speak of it as being the place where Abraham (regarded by Muslims as the first great prophet) sacrificed his son (whom the Muslims believe was Ishmael) or the place where Adam died and was buried. Apart from the tiling of the exterior in more modern times, the building stands pretty much as it did when first built two generations after Muhammad's death.

The great Mosque of Damascus, built by Abd al Malik's son, al Walid (died 715), on the site of what had been a Roman temple turned into a Byzantine church, used the massive walls surrounding the church complex as the walls of the mosque itself [8.5]. The building within the walls had its façade facing the inside of the walls (mosques tend to be inward looking). The interior prayer hall had three spaces each separated by heavy columns. Like the Dome of the Rock the interior was decorated lavishly with the lower walls paneled in marble and the upper registers decorated (by Byzantine craftsmen) with mosaics including a depiction of heaven resplendent with palaces and flowing waters [8.6]. The caliph's palace (now gone) was next to the mosque so that the ruler could pass easily from his home to the mosque.

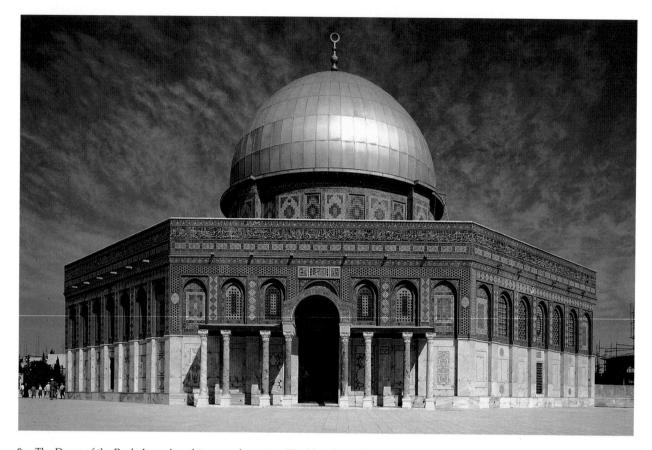

8.4 The Dome of the Rock, Jerusalem, late seventh century. The blue decoration in the upper registers are made of tile. The tile work replaces earlier mosaic work that probably was done by Byzantine craftsmen who were acknowledged experts in that art.

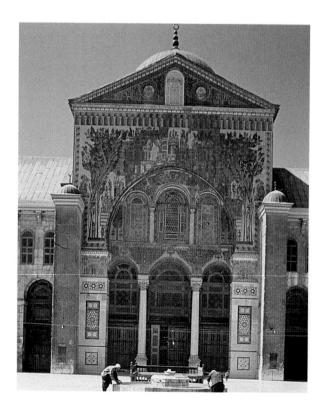

8.5 Courtyard of the Great Mosque of Damascus (c. 715). Worshippers at Friday prayers would gather in the courtyard as a spillover from the building itself. The mosque is built over a former Christian church; details of the earlier church (façade, laterals, and dome) may be detected in the architecture of the mosque itself.

Great Mosque of Damascus

One final mosque showing the relationship of Islamic architecture and Byzantine decoration is the great mosque in Córdoba (Spain). Muslims arrived in Spain in the eighth century and made Córdoba their capital. Construction began on a mosque in the late eighth century with additions both to the courtyard and the prayer hall itself executed in the ninth and tenth century. In the late tenth century, Al-Hakam, the ruler of the city, decided to enhance his mosque to make it a rival of the great mosque in Damascus. The interior of the mosque seems to be a vast tangle of columns supporting Roman arches [8.7]. To enhance the interior, Al-Hakam sent emissaries to the emperor in Constantinople with a request for

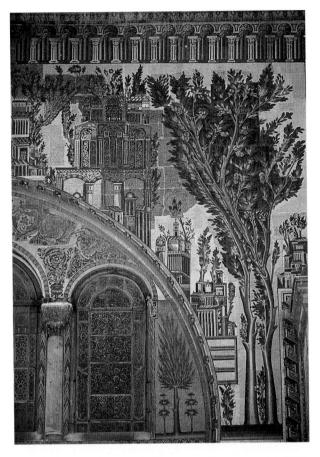

8.6 Mosaic Decoration in the Damascus Mosque, early eighth century. Even though trees and houses are easily detectable in the mosaic, the absence of any human figure is striking. This absence reflects early Islamic resistance to depicting the human figure.

workmen. Contemporary sources state that the emperor complied not only with workmen but also sent roughly seventeen tons of tesserae. The master mosaic artist, who enjoyed the hospitality of the caliph, decorated the interior of the mosque lavishly finishing his work, according to an inscription, in 965 [8.8]. The mosque managed to survive the destruction of Islamic building when the Christians drove the Muslims out of Spain in 1492—the period known as the *Reconquista*. Within the confines of the mosque, an undistinguished cathedral was begun in 1532 and much of its original interior still remains today.

One other notable Islamic building in Spain that escaped the destruction of Muslim architecture during the Reconquista was the palace complex in Granada known as the Alhambra. Its beauty was so renowned that an inscription of a poet's line on one of its exterior towers urging donations for the blind beggars of the city bears witness:

Alhambra

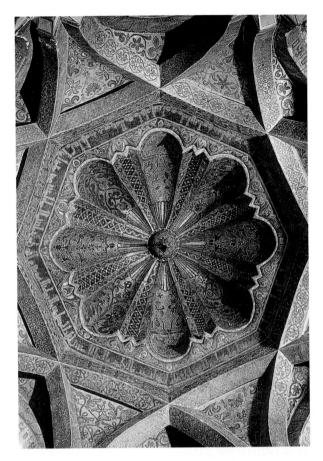

8.7 Central Dome of the Mosque of Córdoba, mid-tenth century. The decoration of the mosque, done a century after its building, is elaborate. Contemporary records show that the ruler of Córdoba imported 30,000 mosaic tessarae and workmen from Constantinople to do the work.

Give him alms, good woman, For in life there is nothing like the heartache Of being blind in Granada.

The exterior of the Alhambra, with its complex of towers and walls, provides no hint of the beauty of its interior. Built largely in the thirteenth and fourteenth centuries, the Alhambra actually consists of two adjacent palaces: the Palace of the Myrtles (so-called because of the myrtle plants in the gardens) and the Palace of the Lions [8.9]. Both palaces have central courtyards with covered walkways or porches. The Palace of the Myrtles was evidently used for public occasions; the Palace of the Lions was designed as a private home. The interiors were decorated lavishly with colored tiles and intricate woodwork. The most cunning aspect of this complex is the use of water, which runs through small interior streams springing up into fountains. The quiet murmur of the water is evident in all parts of the palaces so that one gains a sense of both interior space connected to the outside by the sound of water. The mid-fourteenth century Court of the Lions is perhaps the most representative

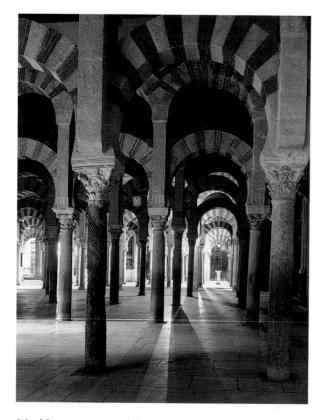

8.8 Maqsura screen of the Córdoba Mosque. The elaborate stone work columns cordoned off the space called the *maqsura*, which was the place where the ruler and his elite company would worship in the mosque.

example of the opulence within the Alhambra: slender columns; careful wooden ceiling work; molded plaster decoration; delicate tracery providing a frame for the fountain in the center held up by lions; and the water trough running to a simple circular bubbling fountain set in the tiled floor.

No discussion of Islamic architecture would be complete without reference to one of the most fabled buildings in all the world: India's Taj Mahal. From the eleventh century on, Muslim raiders arrived at the Indian subcontinent in large numbers. The high point of Muslim culture in India developed under the reign of a series of emperors known as the *Mughals*. Their long reign lasted from 1526 to 1858. India still prides itself in the many architectural, artistic, and literary works produced under these rulers.

Taj Mahal

The great Emperor Shah Jahan (died 1666) had a wife named Mumtaz Mahal (the "palace favorite") who died (1632) giving birth to their fourteenth child. Overwhelmed by grief, the emperor began a vast building complex a year later to house her body and to honor her memory. Scholars debate the complex's completion (as early as 1647; as late as 1652), but everyone agrees that it is one of the great masterpieces of world architecture and design. The building is now quite emblematic of India; it has been used in advertisements to attract tourists to the country.

Set on the banks of the river Jumna at the outskirts of the city of Agra, the central building is crowned with a great dome set on an octagonal building which houses four pavilions. The central building, which is the empress's tomb, is framed by four slender minarets [8.10]. The building, made from highly polished white marble (unlike the traditional red sandstone favored by the Mughal architects), gives the complex a shimmering quality. The exterior decorations of the building are restrained with little attempt to add any color beyond the whiteness of the polished marble.

The complex of minarets and the domed tomb are placed in a large garden setting which has reflecting pools, providing a coolness for the gardens while reflecting the whiteness of the Taj Mahal. The complex seen as a whole is inspired by the description of paradise found in the *Qur'an*. The righteous will find a paradise which is

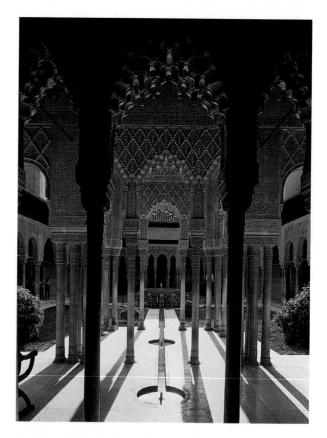

8.9 Court of the Lions in the Alhambra in Granada (c. 1391). This final great piece of Islamic architecture is characterized by the slender delicacy of its interior. Note the waterway and fountains at the level of the floor.

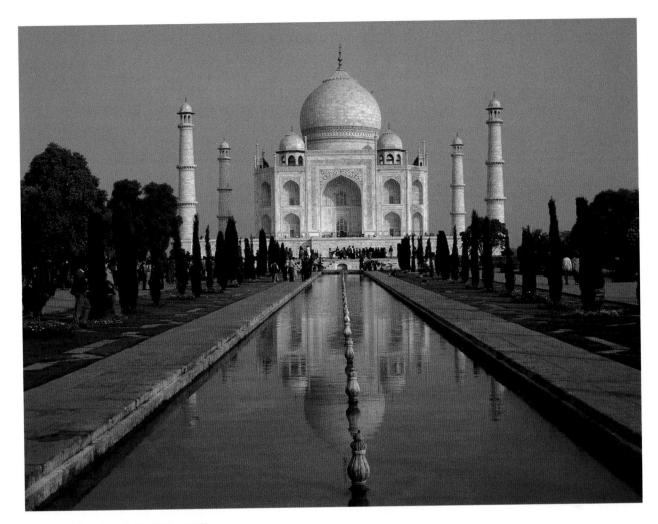

8.10 Taj Mahal, Agra, India (1631-1647).

depicted as a lush garden, abundant in water, and shimmering in the light of Allah.

Sufism

Like all of the world's religions, Islam has various traditions within it. About 85 percent of all Muslims belong to what is called the *Sunni* ("well trod") tradition. A significant minority (the majority in Iran) are members of the *Shi'a* (meaning "party" or "tradition") branch of Islam. Within those two large branches are various minor branches and traditions. From the perspective of Muslim literature, one of the most influential of these traditions is *Sufism*. The name *Sufi* most likely derives from the Arabic word for unbleached wool—the simple clothing many Sufis adopted.

Sufism is a word that describes a very ancient and highly complex movement of communities or small groups of teachers of immense religious authority called *sheyks* and their disciples that emphasized practices and disciplines that would lead a person to come to some di-

rect experience of God in this life. In other words, Sufism represents the mystical dimension of Islam. Like most mystical movements in a religious tradition, Sufism was sometimes embraced with enthusiasm by religious and civil authorities, while at other periods they and their practices were looked at with suspicion or downright hostility. In its earliest manifestations, Sufi mystics tended to live a life of retirement in poverty, preaching to people about piety and repentance.

While there are many forms of Sufism in Islamic history, it has been a significant thread in Muslim life to the present. Sufi *tariqas* ("communities") are to be found in various Muslim lands with a significant presence in North Africa and Egypt. Westerners have expressed a keen interest in Sufi practices with most large bookstores stocking translations of Sufi texts.

Two representative Sufi writers might provide us with some sense of the range of Sufi thought and expression.

The Sufi woman Saint Rabia, known as the flute player (died 801), regarded a highly developed sense of the love of God as the key to union with God. Kidnapped and sold into slavery as a child, after receiving a grant of freedom from her master she became convinced that she was one of God's chosen ones. Rabia expressed

CONTEMPORARY VOICES

Lastly, I turned to the way of the mystics. I knew that in their path there has to be both knowledge and activity and that the object of the latter is to purify the self from vices and faults of character. Knowledge was easier for me than activity so I began by reading their books . . . Then I realized that what is most distinctive of them can be attained only by personal experience, ecstasy, and change of character. I saw clearly that the mystics

were people of personal experience not of words, and that I had gone as far as possible by way of study and intellectual application, so that only personal experience and walking in the mystic way was left. . . .

Al-Ghazali (1058–1111) reflecting on his discovery of the Sufi path during his lifetime of philosophical study and research. Some see his quest for truth to be like that of the Christian writer, Saint Augustine of Hippo.

her convictions in a series of aphorisms, poems, and meditations. Her intuition about love derived from her conviction that the *Qur'an* is filled with verses speaking about the concern that Allah has for His people and the corresponding love that we should have for Allah. Like many mystics (and others concerned with the issue of love), Rabia enunciated her sayings most frequently in the form of poetry. Her focus on the love of God was highly central so she taught that when one loved God centrally in one's life, such a focus would exclude any fear of damnation as well as any hope for paradise. Love would be its own concern. "The best thing in the whole world," she once wrote, "is to possess nothing in this world or the next world except Allah."

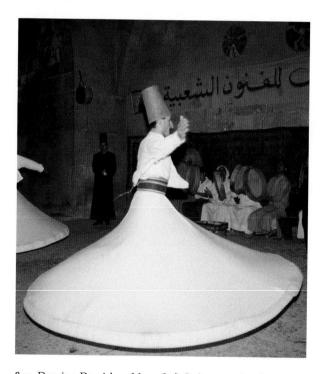

8.11 Dancing Dervishes. Many Sufi Orders practice dancing to the accompaniment of musical instruments. The practice, not universally admired by Muslims, may represent the souls of the just whirling toward paradise.

Perhaps the most famous of the Sufi mystic poets was the thirteenth-century writer known as Rumi (1207– 1273). Born in what is now Afghanistan, Rumi moved with his family to what is present-day Turkey. A prolific writer of religious verse in a form that used rhyming couplets developed by earlier Sufis, Rumi, writing in the Persian language, composed more than three thousand poems while also leaving behind seventy long discourses on mystical experience. His poetic corpus is extensive and so powerfully expressed that some have called his body of work the "Qur´an" in Persian. He was most admired for his capacity to take almost any observable ordinary thing and turn his observance of it into a poem of religious praise.

One feature of Rumi's poetry was his practice of reciting his poems while dancing in a formal but ecstatic fashion. Rumi believed that the combination of recitation and movement would focus the devotee's total attention on Allah. Rumi founded a community of these ecstatic dancers (*dervishes*), whose practitioners continue ecstatic dancing to this day [8.11].

THE CULTURE OF ISLAM AND THE WEST

One of the high points of Islamic culture in its earlier history was centered in the city of Baghdad (present-day Iraq) under the Abbasid Dynasty, which flourished in the eighth and ninth centuries. It was there that papermaking was learned from a Chinese prisoner who had learned the process in China, where papermaking had long been commonplace. Baghdad opened its first papermaking factory in 794. It would be some centuries before this process would pass to the West. Caliph Al-Mamun built a library and study center, completed in 833, which was known as the *Bait al-hikma* (the "House of Wisdom"). It was to that center that scholars flocked from all over the Muslim world.

A crucial part of the scholarly labors at the House of Wisdom was the translation of texts into Arabic. It is to this center that we owe the preservation of the works of

VALUES

Islam, considered as a culture, is a highly complex reality that contains various religious, philosophical, artistic, and theoretical currents. One thing, however, that is fundamental in Islam is its unbending teaching about the oneness of God; the Islamic statement of faith begins: "There is but One God, Allah. . . . " To grasp this belief in radical monotheism is to understand a whole variety of issues connected to Islam which have been touched on in our brief survey. The word Islam means "submission" to God. Since God is almighty his divinity is hidden from humanity; as a consequence Allah may not be depicted in artistic form. Because the revelation of Allah is final and definitive, Islam sees the reality of God beyond the revelation of the God of the Jewish Scriptures and is explicitly resistant to the trinitarian faith of Christianity. Jesus is honored as a prophet, but the idea of Jesus as divine is denied in the pages of the Qur'an. The Qur'an insists that the revelation to Muhammad brought the pure monotheism of Moses back to its original meaning. Whether God's power is such that it controls all human activity has been a subject of discussion among Islamic thinkers since the early medieval period who divide into the "free will" and "predestination" schools relative to human activity.

The fundamental monotheism of Islam also helps to explain why Islam has a tradition of missionary expansion. The omnipotent will of God is for all humanity to submit to God; if people are not aware of that fact they are not living according to the will of God. Hence, the devout are encouraged to teach people this fundamental truth.

Aristotle that were translated into Arabic by a team of Greek-speaking Christians who were in the center's employ. It is estimated that every text of Aristotle we know today (except Politics) was translated in the House of Wisdom. Additionally, these scholars translated a number of Platonic texts, the medical texts of Galen, and many treatises of the Neo-Platonic authors. When scholars (like Saint Thomas Aquinas) read Aristotle in Paris in the thirteenth century, they did so in Latin versions translated from Arabic manuscripts-the work of the scholars of Baghdad.

The greatest single scholar at the House of Wisdom was the polymath researcher Al-Khwarizmi (780-850), who made revolutionary discoveries. He led three expeditions to India and Byzantium in order to gather manuscripts and meet other scholars. As a consequence, Al-Khwarizmi had at his disposal much learning from both Indian and Byzantine (Greek) sources. He invented algebra (the word algebra derives from the title of one of his books). Medieval Europeans who knew his writings in Latin gave us another important mathematical term, which is a corruption of his name: algorithm.

Al-Khwarizmi

The most important contribution made by Al-Khwarizmi was his adaptation of Hindu notations for numbers that used nine symbols and a placeholder. This simplified numerical system replaced the clumsy Greek and Latin notational system as any person who has tried to multiply CLXII by LIV instead of 162×54 will testify. The Hindu placeholder called sunya in Sanskrit and cifra ("cipher") in Arabic came to be called zero in the West, was now regarded not merely as a placeholder, but as a number. One further advance, made in the next century by an otherwise obscure Syrian Muslim named Al-Uqlidisi, was the development of decimal fractions which then permitted, for example, the computation of a solar year at 365.242199 days.

Although these profound mathematical advances developed very rapidly in the Islamic world, their development in the West would be slow. It would take nearly one hundred fifty years before these ideas entered the Christian West via translations in those places that had the closest connection to the Muslim world, namely, Sicily (not a distant voyage from North Africa) and especially through that part of Spain which was Muslim.

Mathematics, however, was not the only area where Islamic scholarship advanced. The Egyptian scientist Al-Hazen (died 1038) did crucial work in optics and on the theory of the grinding and making of lenses. Three other scholars in the Muslim world who had had contact with Greek medicine and other sources shaped the future of medicine. Rhazes (died 932), head of the hospital in Baghdad, excelled in clinical observation, giving the world for the first time a clear description of smallpox and measles, demonstrating that they were two quite distinct diseases. It was from the observations of Rhazes that other scientists began to understand the nature of infection and the spread of infectious diseases. In the following two centuries, influential writers like Avicenna (died 1037) and Averröes (died 1198), in addition to their important work in philosophy, wrote influential treatises in medicine. The important Jewish thinker Moses Maimonides (died 1204) was trained first as a physician. He stressed the need for personal hygiene as a way of avoiding disease (a concept uncommon in his day) and had

done influential work on the nature of poisons. Maimonides was so renowned as a physician that he was called from his native Spain to serve as personal doctor to the sultan of Baghdad, Saladin. The high reputation of Jewish doctors trained in Arabic medicine was such that the popes consulted Jewish physicians who lived in the Jewish quarter across from the Vatican right through the Renaissance period.

The Islamic world in the centuries between the culture of the Abassid Dynasty in Baghdad and the flourishing culture of North Africa and Muslim Spain also gave Europe a number of goods through trade that were legendary for their quality. The swordmakers of both Damascus (Syria) and Toledo (Spain) were legendary for their quality. The woven silk of Damascus still lingers in our word *damask*. Among the earlier gifts of the Muslim world is coffee. The plants, native to tropical Africa, became a common hot beverage when Muslim traders in Ethiopia began to pulverize the beans to brew the drink. So popular was the result that in a very short time one could find in Mecca, Damascus, and even in Constantinople, an institution popular to this day: the coffeehouse.

Despite the antagonism between the Christian West and the Islamic world there was a common exchange of ideas and goods between the two worlds. The results were widespread. The West learned how to make windmills from the Muslims. Many words entered the vocabulary of the West from Arabic sources. These include agricultural words (*orange, lemon, sugar, saffron, syrup, alcohol*); words that reflected Islamic geographical researches into navigation and mapmaking (*zenith* and *nadir*) as well as now common words like *sherbet* (via Persian from the Arabic *sherbah*—"drink").

Finally, as emphasized in other chapters, Muslim scholars provided not only a great body of Greek philosophical writing but a vast commentary on it in the High Middle Ages. When Al-Ghazali (died 1111) attacked Greek philosophy in a book called *The Incoherence of the Philosophers*, he was answered by Averröes who wrote a treatise showing how Islam could be reconciled with Greek philosophy. Averröes called his book *The Incoherence of Incoherence*. A century after his death, Dante would salute Averröes in his *Divine Comedy* by calling him "He of the Great Commentary," even though Dante regarded Muhammad and Islam with fearful disdain.

SUMMARY

Muhammad always thought of the new revelation he had received from God as a new religion which could unify the whole human race under one God and bring with it amity among nations. Islam regards itself as the final perfection of God's revelation first announced to the Jews and later to the Christians. For that reason, Muhammad's religion was an unapologetic missionary faith. Within two hundred years Islam had spread from the desert world of Arabia throughout present-day Middle East and along the southern coast of the Mediterranean Sea and the Iberian peninsula of present-day Southern Spain; much of this dispersion came via military conquest.

Islam's rise coincided with a period of stagnation in what was the Christian West. The old Roman Empire was in a state of decline, having been hammered by successive waves of Barbarian invasions. The Byzantine Empire with its capital at Constantinople controlled only the city itself and its adjacent territories. It was an essentially inward looking, conservative, and noninnovative culture. Islam, by contrast, was a vigorous young religious culture and at its apex—when the Abassids ruled from its center in Baghdad and later in Damascus and Córdoba—was innovative and forward-looking.

While Islamic incursions were halted in the West in the generations before Charlemagne, and Muslims would not take possession of Constantinople until the fifteenth century, there were constant exchanges between the two cultures even though they warred against each other with ferocity (i.e., the Crusades). This hostility shows up clearly in the West. The Muslims, in Christian eyes, were simply the "Infidel" and their wickedness is a theme in *The Song of Roland*, where their beliefs and their practices were criticized and twisted into parody. The Christian holy places from these "Infidels." It should not surprise us that Dante comes to describe the walls of the city of hell as crenellated walls with domes of "fiery mosques."

The antagonism between the Christian West and the world of Islam has a long and bitter history. It is an antagonism that reflects itself today in the stereotyping of Muslims as backward, fundamentalist terrorists out to ruin the world. The irony is, of course, that we read such things on paper—an innovation that the House of Wisdom in Baghdad gave to the West in the medieval period. The real truth is that Islam is a highly complex and deeply rich culture in which religion is so central that it cannot be disentangled from political and social culture. Islam has a long tradition of learning and the arts with a worldview that attempts to explain the place of people in the social order under the watchful eye of an allpowerful God who is adored under the name of Allah.

PRONUNCIATION GUIDE

Al-Ghazali:	All Ga-zall-e
Al-Khwarizmi:	All-Kwa-riz-me
Averröes:	ah-ver-oh-es
Hadith:	Hah-dith
Hegira:	Hay-jeer-ah
Michrab:	Mick-rab
Qa´aba:	Caw-ah-bah
Qur´an:	Coor-awn
Rhazes:	Rah-zes
Sura:	Soo-rah

Taj Mahal:Taj Maw-hallTariqas:Tar-e-kas

EXERCISES

- 1. Contrast the interior space of a mosque and a Christian basilica. What similarities can be noted? differences?
- 2. Is the Muslim concept of Allah compatible with the biblical view of God? Explain why or why not.
- 3. Look at a map to see where the closest points of contact were in the eighth century between Islamic countries and the Christian West.
- 4. How does the Muslim gesture of kneeling and profoundly bowing at prayer symbolize their basic belief in God? Be attentive in future chapters to the attitude of the Christian West to the rise of Islam.

FURTHER READING

- Bloom, J., & S. Blair. (1998). *Islamic arts.* London: Phaidon. Excellent survey.
- Esposito, J. (1998). Islam: The straight path (5th ed.). New York: Oxford University Press. A standard work.
- Irwin, R. (1997). Islamic art in context: Art, architecture and the literary world. New York: Harry Abrams. Very good interdisciplinary text.
- Lewis, B. (Ed.). (1976). *The world of Islam*. London: Thames & Hudson. Authoritative work.
- Schimmel, A. (1976). *Mystical dimensions of Islam.* Chapel Hill: University of North Carolina. A standard study.

Online Chapter Links

Internet Islamic Historic Sourcebook at

http://www.fordham.edu/halsall/islam/islamsbook.html provides an extensive list of links related to Web sites.

For information about Islam, consult

www.sim.org/islam

which offers a guide to understanding Muslim religion, history, and culture.

Extensive information about the Qur'an is avail-

able at these Web sites: Holy Qur´an Resources on the Internet at

http://www.quran.org.uk/

The Noble Qur'an at

http://www.usc.edu/dept/MSA/quran/ Islamzine.com at

http://www.islamzine.com/quran/

Audio readings from the *Qur'an* are available at http://www.islaam.com/audio/quran/

Extensive information related to the hajj is available through a large number of links found at http://www.ummah.net/hajj/

Extensive information related to the hadith is available through a large number of links found at http://islam.org/Mosque/hadith.htm

To view an online collection of Islamic ceramics at Oxford University's Ashmolean Museum, visit http://www.ashmol.ox.ac.uk/ash/departments/

Among the sites providing valuable information related to the Taj Mahal are

http://www.taj-mahal.net/topEng/index.htm http://www.liveindia.com/tajmahal/index.html http://users.erols.com/zenithco/tajmahal.html http://www.angelfire.com/in/myindia/tajmahal.html

Online Chapter Resources

READING SELECTIONS

from the QUR'AN

These selections are taken from a translation by a Muslim scholar who called his work an "explanatory translation" because no human can "translate" the very words of God which were spoken in Arabic. The first and last suras of these selections are the first and last of the Qur'an itself. The others are interesting because a careful reading will reveal Islamic attitudes toward both Judaism and Christianity as well as reasons why Muslims revere Jerusalem as a holy place, and also something of their own devotional customs such as washing before prayer.

Sûrah I

THE OPENING

Revealed at Mecca

In the name of Allah, the Beneficent, the Merciful.

- 1. Praise be to Allah, Lord of the Worlds,
- 2. The Beneficent, the Merciful.
- 3. Owner of the Day of Judgment,
- 4. Thee (alone) we worship; Thee (alone) we ask for help.
- 5. Show us the straight path,
- 6. The path of those whom Thou has favored;
- 7. Not (the path) of those who earn Thine anger nor of those who go astray.

THE TABLE SPREAD

Revealed at Al-Madînah

In the name of Allah, the Beneficent, the Merciful.

 O ye who believe! Fulfill your undertakings. The beast of cattle is made lawful unto you (for food) except that which is announced unto you (herein), game being unlawful when ye are on the pilgrimage. Lo! Allah ordaineth that which pleaseth Him.

- 2. O ye who believe! Profane not Allah's monuments nor the Sacred Month nor the offerings nor the garlands, nor those repairing to the Sacred House,¹ seeking the grace and pleasure of Allah. But when ye have left the sacred territory, then go hunting (if ye will). And let not your hatred of a folk who (once) stopped your going to the Inviolable Place of Worship seduce you to transgress; but help ye one another unto righteousness and pious duty. Help not one another unto sin and transgression, but keep your duty to Allah. Lo! Allah is severe in punishment.
- 3. Forbidden unto you (for food) are carrion and blood and swine-flesh, and that which hath been dedicated unto any other than Allah, and the strangled, and the dead through beating, and the dead through falling from a height, and that which hath been killed by (the gorging of) horns, and the devoured of wild beasts, saving that which ye make lawful (by the deathstroke), and that which hath been immolated unto Idols. And (forbidden is it) that ye swear by the divining arrows. This is an abomination. This day are those who disbelieve in despair of (ever harming) your religion; so fear them not, fear Me! This day I have perfected your religion for you and completed My favor onto you, and have chosen for you as religion AL-ISLAM.² Whoso is forced by hunger, not by will, to sin: (for him) lo! Allah is Forgiving, Merciful.
- 4. They ask thee (O Muhammad) what is made lawful for them. Say: (all) good things are made lawful for you. And those beasts and birds of prey which ye have trained as hounds are trained, ye teach them that which Allah taught you; so eat of that which they catch for you and mention Allah's name upon it, and observe your duty to Allah. Lo! Allah is swift to take account.
- 5. This day are (all) good things made lawful for you. The food of those who have received the Scripture is lawful for you, and your food is lawful for them. And so are the virtuous women of the believers and the virtuous women of those who received the Scripture before you (lawful for you) when ye give them their marriage portions and live with them in honor, not in fornication, nor taking them as secret concubines. Whoso denieth the faith, his work is vain and he will be among the losers in the Hereafter.
- 6. O ye who believe! When ye rise up for prayer, wash your faces, and your hands up to the elbows, and lightly rub your heads and (wash) your feet up to the ankles. And if ye are unclean, purify yourselves. And if ye are sick or on a journey, or one of you cometh from the closet, or ye have had contact with women, and ye find not water, then go to clean, high ground and rub your faces and your hands with some of it. Allah would not place a burden on you, but He would purify you and would perfect His grace upon you, that ye may give thanks.
- 7. Remember Allah's grace upon you and His covenant by which He bound you when ye said: We hear and we obey; and keep your duty to Allah. Lo! Allah knoweth what is in the breasts (of men).

- 8. O ye who believe! Be steadfast witnesses for Allah in equity, and let not hatred of any people seduce you that ye deal not justly. Deal justly, that is nearer to your duty. Observe your duty to Allah. Lo! Allah is Informed of what ye do.
- 9. Allah hath promised who believe and do good works: Theirs will be forgiveness and immense reward.
- 10. And they who disbelieve and deny Our revelations, such are rightful owners of hell.
- 11. O ye who believe! Remember Allah's favor unto you, how a people were minded to stretch out their hands against you but He withheld their hands from you; and keep your duty to Allah. In Allah let believers put their trust.
- 12. Allah made a covenant of old with the Children of Israel and We raised among them twelve chieftains, and Allah said: Lo! I am with you. If ye establish worship and pay the poor-due, and believe in My messengers and support them, and lend unto Allah a kindly loan,³ surely I shall remit your sins, and surely I shall bring you into gardens underneath which rivers flow. Whoso among you disbelieve after this will go astray from a plain road.
- 13. And because of their breaking their covenant, We have cursed them and made hard their hearts. they change words from their context and forget a part of that whereof they were admonished. Thou wilt not cease to discover treachery from all save a few of them. But bear with them and pardon them. Lo! Allah loveth the kindly.
- 14. And with those who say: "Lo! We are Christians," We made a covenant, but they forgot a part of that whereof they were admonished. Therefore We have stirred up enmity and hatred among them till the Day of Resurrection, when Allah will inform them of their handiwork.
- 15. O People of the Scripture! Now hath Our messenger come unto you, expounding unto you much of that which ye used to hide in the Scripture, and forgiving much. Now hath come unto you light from Allah and a plain Scripture.
- 16. Whereby Allah guideth him who seeketh His good pleasure unto paths of peace. He bringeth them out of darkness unto light by His decree, and guideth them unto a straight path.
- 17. They indeed have disbelieved who say: Lo! Allah is the Messiah, son of Mary. Say: Who then can do aught against Allah, if He had willed to destroy the Messiah, son of Mary, and his mother and everyone on earth? Allah's is the sovereignty of the heavens and the earth and all that is between them. He createth what He will. And Allah is Able to do all things.
- 18. The Jews and Christians say: We are sons of Allah and His loved ones. Say: Why then doth He chastise you for your sins? Nay, ye are but mortals of His creating. He forgiveth whom He will, and chastiseth whom He will. Allah's is the Sovereignty of the heavens and the earth and all that is between them, and unto Him is the journeying.
- 19. O people of the Scripture! Now hath Our messenger come unto you to make things plain after an interval (of cessation) of the messengers, lest ye should say: There came not unto us a messenger of cheer nor any warner. Now hath a messenger of cheer and a warner come unto you. Allah is Able to do all things.

¹ I.e., the Ka bah at Mecca.

² I.e., "The Surrender" to Allah. Thus solemnly the religion which the Prophet had established received its name.

³ I.e., a loan without interest or thought of gain.

- 20. And (remember) when Moses said unto his people: O my people! Remember Allah's favor unto you, how He placed among you Prophets, and He made you kings, and gave you that (which) He gave not to any (other) of (His) creatures.
- 21. O my people! Go into the holy land which Allah hath ordained for you. Turn not in flight, for surely ye turn back as losers.
- 22. They said: O Moses! Lo! a giant people (dwell) therein, and lo! we go not in till they go forth from thence. When they go forth, then we will enter (not till then).
- 23. Then outspake two of those who feared (their Lord, men) unto whom Allah had been gracious: Enter in upon them by the gate, for if ye enter by it, lo! ye will be victorious. So put your trust (in Allah) if ye are indeed believers.
- 24. They said: O Moses! We will never enter (the land) while they are in it. So go thou and they Lord and fight! We will sit here.
- He said: My lord! I have control of none by myself and my brother, so distinguish between us and the wrongdoing folk.
- 26. (Their Lord) said: For this the land will surely be forbidden them for forth years that they will wander in the earth, bewildered. So grieve not over the wrongdoing folk.
- 27. But recite unto them with truth the tale of the two sons of Adam, how they offered each a sacrifice, and it was accepted from the one of them and it was not accepted from the other. (The one) said: I will surely kill thee. (The other) answered: Allah accepteth only from those who ward off (evil).
- 28. Even if you stretch out they hand against me to kill me, I shall not stretch out my hand against thee to kill thee, lo! I fear Allah, the Lord of the Worlds.
- 29. Lo! I would rather thou shouldst bear the punishment of the sin against me and thine own sin and become one of the owners of the Fire. That is the reward of evil-doers.
- 30. But (the others) mind imposed on him the killing of his brother, so he slew him and became one of the losers.
- 31. Then Allah sent a raven scratching up the ground, to show him how to hide his brother's naked corpse. He said: Woe unto me! Am I not able to be as this raven and so hide my brother's naked corpse? And he became repentant.
- 32. For that cause We decreed for the Children of Israel that whosoever killeth a human being for other than manslaughter or corruption on earth, it shall be as if he had killed all mankind, and whoso saveth the life of one, it shall be as if he had saved the life of all mankind. Our messengers came unto them of old with clear proofs (of Allah's sovereignty), but afterwards lo! many of them became prodigals in the earth.
- 33. The only reward of those who make war upon Allah and His messenger and strive after corruption in the land will be that they will be killed or crucified, or have their hands and feet on alternate sides cut off, or will be expelled out of the land. Such will be their degradation in the world, and in the Hereafter theirs will be an awful doom.
- 34. Save those who repent before ye overpower them. For know that Allah is forgiving, Merciful.
- 35. O ye who believe! Be mindful of your duty to Allah, and seek the way of approach unto Him, and strive in His way in order that ye may succeed.
- 36. As for those who disbelieve, lo! If all that is in the earth were theirs, and as much again therewith, to ransom

them from the doom on the Day of Resurrection, it would not be accepted from them. Theirs will be a painful doom.

- 37. They will wish to come forth from the Fire, but they will not come forth from it. Theirs will be a lasting doom.
- 38. As for the thief, both male and female, cut off their hands. It is the reward of their own deeds, an exemplary punishment from Allah. Allah is Mighty, Wise.
- 39. But whoso repenteth after his wrongdoing and amendeth, lo! Allah will relent toward him. Lo! Allah is Forgiving, Merciful.
- 40. Knowest thou not that unto Allah belongeth the Sovereignty of the heavens and the earth? He punisheth whom He will, and forgiveth whom He will. Allah is Able to do all things.
- 41. O Messenger! Let not them grieve thee who vie one with another in the race to disbelief, of such as say with their mouths: "We believe," but their hearts believe not, and of the Jews: listeners for the sake of falsehood, listeners on behalf of other folk who come not unto thee, changing words from their context and saying: If this be given unto you, receive it, but if this be not given unto you, then beware! He whom Allah doometh unto sin, thou (by thine efforts) wilt avail him naught against Allah. Those are they for whom the will of Allah is that He cleanse not their hearts. Theirs in the world will be ignominy, and in the Hereafter an awful doom.
- 42. Listeners for the sake of falsehood! Greedy for illicit gain! If then they have recourse unto thee (Muhammad) judge between them or disclaim jurisdiction. If thou disclaimest jurisdiction, then they cannot harm thee at all. But if thou judgest, judge between them with equity. Lo! Allah loveth the equitable.
- 43. How come they unto thee for judgment when they have the Torah, wherein Allah hath delivered judgment (for them)? Yet even after that they turn away. Such (folk) are not believers.
- 44. Lo! We did reveal the Torah, wherein is guidance and a light, by which the Prophets who surrendered (unto Allah) judged the Jews, and the rabbis and the priests (judged) by such of Allah's Scripture as they were bidden to observe, and thereunto were they witnesses. So fear not mankind, but fear Me. And barter not My revelations for a little gain. Whoso judgeth not by that which Allah hath revealed: such are disbelievers.
- 45. And We prescribed for them therein: The life for the life, and the eye for the eye, and the nose for the nose, and the ear for the ear, and the tooth for the tooth, and for wounds retaliation. But whoso forgoeth it (in the way of charity) it shall be explained for him. Whoso judgeth not by that which Allah hath revealed: such are wrong-doers.
- 46. And We caused Jesus, son of Mary, to follow in their footsteps, confirming that which was (revealed) before him, and We bestowed on him the Gospel wherein is guidance and a light, confirming that which was (revealed) before it in the Torah—a guidance and an admonition unto those who ward off (evil).
- 47. Let the People of the Gospel judge by that which Allah hath revealed therein. Whoso judgeth not by that which Allah hath revealed; such are evil-livers.
- 48. And unto thee have We revealed the Scripture with the truth, confirming whatever Scripture was before it, and a watcher over it. So judge between them by that which Allah hath revealed, and follow not their desires away from the truth which hath come unto thee. For

each We have appointed a divine law and a traced-out way. Had Allah willed He could have made you one community. But that He may try you by that which He hath given you (He hath made you as ye are). So vie one with another in good works. Unto Allah ye will all return, and He will then inform you of that wherein ye differ.

- 49. So judge between them by that which Allah hath revealed, and follow not their desires, but beware of them lest they seduce thee from some part of that which Allah hath revealed unto thee. And if they turn away, then know that Allah's will is to smite them for some sin of theirs. Lo! many of mankind are evil-livers.
- 50. It is a judgment of the time of (pagan) ignorance that they are seeking? Who is better than Allah for judgment to a people who have certainty (in their belief)?
- 51. O ye who believe! Take not the Jews and the Christians for friends. They are friends one to another. He among you who taketh them for friends if (one) of them. Lo! Allah guideth not wrongdoing folk.
- 52. And thou seest those in whose heart is a disease race toward them, saying: We fear lest a change of fortune befall us. And it may happen that Allah will vouchsafe (unto thee) the victory, or a commandment from His presence. Then will they repent them of their secret thoughts.
- 53. Then will the believers say (unto the people of the Scripture): Are these they who swore by Allah their most binding oaths that they were surely with you? Their works have failed, and they have become the losers.
- 54. O ye who believe! Whoso of you becometh a renegade from his religion (know that in his stead), Allah will bring a people whom He loveth and who love Him, humble toward believers, stern toward disbelievers, striving in the way of Allah, and fearing not the blame of any blamer. Such is the grace of Allah which He giveth unto whom He will. Allah is all-Embracing, all-Knowing.
- 55. Your friend can be only Allah; and His messenger and those who believe, who establish worship and pay the poor-due, and bow down (in prayer).
- 56. And whoso taketh Allah and His messenger and those who believe for friend (will know that), lo! the party of Allah, they are the victorious.
- 57. O ye who believe! Choose not for friends such as those who received the Scripture before you, and of the disbelievers, as make a jest and sport of your religion. But keep your duty to Allah if ye are true believers.
- 58. And when ye call to prayer they take it for a jest and sport. That is because they are a folk who understand not.
- 59. Say: O, People of the Scripture! Do ye blame us for aught else than that we believe in Allah and that which is revealed unto us and that which was revealed afore-time, and because most of you are evil-livers?
- 60. Shall I tell thee of a worse (case) than theirs for retribution with Allah? Worse (is the case of him) whom Allah hath cursed, him on whom His wrath hath fallen! Worse is he of whose sort Allah hath turned some to apes and swine, and who serveth idols. Such are in worse plight and further stray from the plain road.
- 61. When they come unto you (Muslims), they say: We believe; but came in unbelief and they went out the same; and Allah knoweth best what they were hiding.
- 62. And thou seest many of them vying one with another in sin and transgression and their devouring of illicit gain. Verily evil is what they do.

- 63. Why do not the rabbis and the priests forbid their evilspeaking and their devouring of illicit gain? Verily evil is their handiwork.
- 64. The Jews say: Allah's hand is fettered. Their hands are fettered and they are accursed for saying so. Nay, but both His hands are spread out wide in bounty. He bestoweth as He will. That which hath been revealed unto thee from they Lord is certain to increase the contumacy and disbelief of many of them, and We have cast among them enmity and hatred till the Day of Resurrection. As often as they light a fire for war, Allah extinguisheth it. Their effort is for corruption in the land, and Allah loveth not corrupters.
- 65. If only the People of the Scripture would believe and ward off (evil), surely We should remit their sins from them and surely We should bring them into Gardens of Delight.
- 66. If they had observed the Torah and the Gospel and that which was revealed unto them from their Lord, they would surely have been nourished from above them and from beneath their feet. Among them there are people who are moderate, but many of them are of evil conduct.
- 67. O messenger! Make known that which hath been revealed unto thee from thy Lord, for if thou do it, thou will not have conveyed His message. Allah will protect thee from mankind. Lo! Allah guideth not the disbelieving folk.
- 68. Say: O People of the Scripture! Ye have naught (of guidance) till ye observe the Torah and the Gospel and that which was revealed unto you from your Lord. That which is revealed unto thee (Muhammad) from they Lord is certain to increase the contumacy and disbelief of many of them. But grieve not for the disbelieving folk.
- 69. Lo! those who believe, and those who are Jews, and Sabaeans, and Christians—whosoever believeth in Allah and the Last Day and doeth right—then shall no fear come upon them neither shall they grieve.⁴
- 70. We made a covenant of old with the Children of Israel and We sent unto them messengers. As often as a messenger came unto them with that which their souls desired not (they became rebellious). Some (of them) they denied and some they slew.
- 71. They thought no harm would come of it, so they were willfully blind and deaf. And afterward Allah turned (in mercy) toward them. Now (even after that) are many of them willfully blind and deaf. Allah is Seer of what they do.
- 72. They surely disbelieve who say: Lo! Allah is the Messiah, son of Mary. The Messiah (himself) said: O Children of Israel, worship Allah, my Lord and your Lord. Lo! whoso ascribeth partners unto Allah, for him Allah hath forbidden Paradise. His abode is the Fire. For evildoers there will be no helpers.
- 73. They surely disbelieve who say: Lo! Allah is the third of three; when there is no God save the One God. If they desist not from so saying a painful doom will fall on those of them who disbelieve.
- 74. Will they not rather turn unto Allah and seek forgiveness of Him? For Allah is Forgiving, Merciful.
- 75. The Messiah, son of Mary, was no other than a messenger, messengers (the like of whom) had passed away before him. And his mother was a saintly woman. And they both used to eat (earthly) food. See how we make the revelations clear for them, and see how they are turned away!

⁴ Almost identical with Sûrah II, v. 62.

- 76. Say: Serve ye in place of Allah that which possesseth for you neither hurt nor use? Allah it is Who is the Hearer, the Knower.
- 77. Say: O People of the Scripture! Stress not in your religion other than the truth, and follow not the vain desires of folk who erred of old and led many astray, and erred from a plain road.
- 78. Those of the Children of Israel who went astray were cursed by the tongue of David, and of Jesus, son of Mary. That was because they rebelled and used to transgress.
- 79. They restrained not one another from the wickedness they did. Verily evil was that they used to do!
- 80. Thou seest many of them making friends with those who disbelieve. Surely ill for them is that which they themselves send on before them: that Allah will be wroth with them and in the doom they will abide.
- 81. If they believed in Allah and the Prophet and that which is revealed unto him, they would not choose them for their friends. But many of them are of evil conduct.
- 82. Thou wilt find the most vehement of mankind in hostility to those who believe (to be) the Jews and the idolaters. And thou wilt find the nearest of them in affection to those who believe (to be) those who say: Lo! We are Christians. That is because there are among them priests and monks,⁵ and because they are not proud.
- 83. When they listen to that which hath been revealed unto the messenger, thou seest their eyes overflow with tears because of their recognition of the Truth. They say: Our Lord, we believe. Inscribe us as among the witnesses.
- 84. How should we not believe in Allah and that which hath come unto us of the Truth. And (how should we not) hope that our Lord will bring us in along with righteous folk.
- 85. Allah hath rewarded them for that their saying— Gardens underneath which rivers flow, wherein they will abide forever. That is the reward of the good.
- But those who disbelieve and deny Our revelations, they are owners of hell-fire.
- 87. O ye who believe! Forbid not the good things which Allah hath made lawful for you, and transgress not. Lo! Allah loveth not transgressors.
- 88. Eat of that which Allah hath bestowed on you as food lawful and good, and keep your duty to Allah in Whom ye are believers.
- 89. Allah will not take you to task for that which is unintentional in your oaths, but He will take you to task for the oaths which ye swear in earnest. The explation thereof is the feeding of ten of the needy with the average of that wherewith ye feed your own folk, or the clothing of them, or the liberation of a slave, and for him who findeth not (the wherewithal to do so) then a three-days' fast. This is the explation of your oaths when ye have sworn; and keep your oaths. Thus Allah expoundeth unto you His revelations in order that ye may give thanks.
- 90. O ye who believe! Strong drink and games of chance and idols and divining arrows are only an infamy of Satan's handiwork. Leave it aside in order that ye may succeed.
- 91. Satan seeketh only to cast among you enmity and hatred by means of strong drink and games of chance,
- ⁵ I.e., persons entirely devoted to the service of God, as were the Muslims.

and to turn you from remembrance of Allah and from (His) worship. Will ye then have done?

- 92. Obey Allah and obey the messenger, and beware! But if ye turn away, then know that the duty of Our messenger is only plain conveyance (of the messenger).
- 93. There shall be no sin (imputed) unto those who believe and do good works for what they may have eaten (in the past). So be mindful of your duty (to Allah), and do good works; and again: be mindful of your duty, and believe; and once again: be mindful of your duty, and do right. Allah loveth the good.
- 94. O ye who believe! Allah will surely try you somewhat (in the matter) of the game which ye take with your hands and your spears, that Allah may know him who feareth Him in secret. Whoso transgresseth after this, for him there is a painful doom.
- 95. O ye who believe! Kill no wild game while ye are on the pilgrimage. Whoso of you killeth it of set purpose he shall pay its forfeit in the equivalent of that which he hath killed, of domestic animals, the judge to be two men among you know for justice, (the forfeit) to be brought as an offering to the Ka'bah; or, for expiation, he shall feed poor persons, or the equivalent thereof in fasting, that he may taste the evil consequences of his deed. Allah forgiveth whatever (of this kind) may have happened in the past, but whoso relapseth, Allah will take retribution from him. Allah is Mighty, Able to Requite (the wrong).
- 96. To hunt and to eat the fish of the sea is made lawful for you, a provision for you and for seafarers; but to hunt on land is forbidden you so long as ye are on the pilgrimage. Be mindful of your duty to Allah, unto Whom ye will be gathered.
- 97. Allah hath appointed the Ka'bah, the Sacred Month and the offerings and the garlands. That is so that ye may know that Allah knoweth whatsoever is in the heavens and whatsoever is in the earth, and that Allah is Knower of all things.
- 98. Know that Allah is severe in punishment, but that Allah (also) is Forgiving, Merciful.
- 99. The duty of the messenger is only to convey (the message). Allah knoweth what ye proclaim and what ye hide.
- 100. Say: The evil and the good are not alike even thought the plenty of the evil attract thee. So be mindful of your duty to Allah, O men of understanding, that ye may succeed.
- 101. O ye who believe! Ask not of things which, if they were made known unto you, would trouble you; but if ye ask of them when the Qur´an is being revealed, they will be made known unto you. Allah pardoneth this, for Allah is Forgiving, Clement.
- 102. A folk before you asked (for such disclosures) and then disbelieved therein.
- 103. Allah hath not appointed anything in the nature of a Bahîrah or a Sâ'bah or a Wasîlah or a Hâmi,⁶ but those who disbelieve invent a lie against Allah. Most of them have no sense.
- 104. And when it is said unto them: Come unto that which Allah hath revealed and unto the messenger, they say: Enough for us is that wherein we found our fathers. What! Even though their fathers had no knowledge whatsoever, and no guidance?
- 105. O ye who believe! Ye have charge of your own souls. He who erreth cannot injure you if ye are rightly
- ⁶ Different classes of cattle liberated in honor of idols and reverenced by the pagan Arabs.

guided. Unto Allah ye will all return; and then He will inform you of what ye used to do.

- 106. O ye who believe! Let there be witnesses between you when death draweth nigh unto one of you, at the time of bequest—two witnesses, just men among you, or two others from another tribe, in case ye are campaigning in the land and the calamity of death befall you. Ye shall empanel them both after the prayer, and, if ye doubt, they shall be made to swear by Allah (saying): We will not take a bribe, even though it were (on behalf of) a near kinsman nor will we hide the testimony of Allah, for then indeed we should be of the sinful.
- 107. But then, if it is afterwards ascertained that both of them merit (the suspicion of) sin, let two others take the place of those nearly concerned, and let them swear by Allah, (saying): Verily our testimony is truer than their testimony and we have not transgressed (the bounds of duty), for then indeed we shall be of the evil-doers.
- 108. Thus it is more likely that they will bear true witness of fear that after their oath the oath (of others) will be taken. So be mindful of your duty (to Allah) and hearken. Allah guideth not the forward folk.
- 109. In the day when Allah gathereth together the messengers, and saith: What was your response (from mankind)? they say: We have no knowledge. Lo! Thou, only Thou art the Knower of Things Hidden.
- 110. When Allah saith: O Jesus, son of Mary! Remember My favor unto thee and unto they mother; how I strengthened thee with the holy Spirit, so that thou spakest unto mankind in the cradle as in maturity; and how I taught thee the Scripture and Wisdom and the Torah and the Gospel; and how thou didst shape of clay as it were the likeness of a bird by My permission, and didst blow upon it and it was a bird by My permission, and how they didst heal him who was born blind and the leper by My permission; and how I restrained the Children of Israel from (harming) thee when thou camest unto them with clear proofs, and those of them who disbelieved exclaimed: This is naught else than mere magic.
- 111. And when I inspired the disciples, (saying): Believe in Me and in My messenger, they said: We believe. Bear witness that we have surrendered⁷ (unto Thee).
- 112. When the disciples said: O Jesus, son of Mary! Is thy Lord able to send down for us a table spread with food from heaven? He said: Observe your duty to Allah, if ye are true believers.
- 113. (They said): We wish to eat thereof, that we may satisfy our hearts and know that thou hast spoken truth to us, and that thereof we may be witnesses.
- 114. Jesus, son of Mary, said: O Allah, Lord of us! Send down for us a table spread with food from heaven; that it may be a feast for us, for the first of us and for the last of us, and a sign from Thee. Give us sustenance, for Thou art the Best of Sustainers.
- 115. Allah said: Lo! I send it down for you. And whoso disbelieveth of you afterward, him surely will I punish with a punishment wherewith I have not punished any of (My) creatures.
- 116. And when Allah saith: O Jesus, son of Mary! Didst thou say unto mankind: Take me and my mother for two gods beside Allah? he saith: Be glorified! It was not mine to utter that to which I had no right. If I

7 Or "are Muslims."

used to say it, then Thou knewest it. Thou knowest what is in my mind, and I know not what is in Thy Mind. Lo! Thou, only Thou are the Knower of Things Hidden.

- 117. I spake unto them only that which Thou commandedest of me, (saying): Worship Allah, my Lord and your Lord. I was a witness of them while I dwelt among them, and when Thou tookest me Thou wast the Watcher over them. Thou are Witness over all things.
- 118. If Thou punish them, lo! they are Thy slaves, and if Thou forgive them (lo! They are Thy slaves). Lo! Thou, only Thou are the Mighty, the Wise.
- 119. Allah saith: This is a day in which their truthfulness profiteth the truthful, for theirs are [the] Gardens underneath which rivers flow, wherein they are secure forever, Allah taking pleasure in them and they in Him. That is the great triumph.
- 120. Unto Allah belongeth the Sovereignty of the heavens and the earth and whatsoever is therein, and He is Able to do all things.

SÛRAH XVII

Banî Isrâîl, "The Children of Israel," begins and ends with references to the Israelites. V. 1 relates to the Prophet's vision, in which he was carried by night upon a heavenly steed to the Temple of Jerusalem, whence he was caught up through the seven heavens to the very presence of God. The Sûrah may be taken as belonging to the middle group of Meccan Sûrahs, except v. 81, or, according to other commentators, vv. 76–82, revealed at Al-Madînah.

THE CHILDREN OF ISRAEL

Revealed at Mecca

In the name of Allah, the Beneficent, the Merciful.

- Glorified by He Who carried His servant by night from the Inviolable Place of Worship¹ to the Far Distant Place of Worship² the neighborhood whereof We have blessed, that We might show him of Our tokens! Lo! He, only He, is the Hearer, the Seer.
- 2. We gave unto Moses the Scripture, and We appointed it a guidance for the Children of Israel, saying: Choose no guardian beside Me.
- 3. (They were) the seed of those whom We carried (in the ship) along with Noah. Lo! he was a grateful slave.
- And We decreed for the Children of Israel in the Scripture: Ye verily will work corruption in the earth twice, and ye will become great tyrants.
- 5. So when the time for the first of the two came, We roused against you slaves of Ours of great might who ravaged (your) country, and it was a threat performed.
- 6. Then We gave you once again your turn against them, and We aided you with wealth and children and made you more in soldiery,
- 7. (saying): If ye do good, ye do good for your own souls, and if ye do evil, it is for them (in like manner). So, when the time for the second (of the judgments) came (We roused against you others of Our slaves) to ravage you, and to enter the Temple even as they entered it the first time, and to lay waste all that they conquered with an utter wasting.
- It may be that your Lord will have mercy on you, but if ye repeat (the crime) We shall repeat (the punishment),

¹ Mecca.

and We have appointed hell a dungeon for the disbelievers.

- 9. Lo! this Qur'an guideth unto that which is straightest, and giveth tidings unto the believers who do good works that theirs will be a great reward.
- 10. And that those who believe not in the Hereafter, for them We have prepared a painful doom.
- 11. Man prayeth for evil as he prayeth for good; for man was ever hasty.
- 12. And We appoint the night and the day two portents. Then We make dark the portent of the night, and We make the portent of the day sight-giving, that ye may seek bounty from your Lord, and that ye may know the computation of the years, and the reckoning; and everything have We expounded with a clear expounding.
- 13. And every man's augury have We fastened to his own neck, and We shall bring forth for him on the Day of Resurrection a book which he will find open.
- 14. (And it will be said unto him): Read thy book. Thy soul sufficeth as reckoner against thee this day.
- 15. Whosoever goeth right, it is only for (the good of) his own soul that he goeth right, and whosoever erreth, erreth only to its hurt. No laden soul can bear another's load. We never punish until We have sent a messenger.
- 16. And when We would destroy a township We send commandment to its folk who live at east, and afterward they commit abomination therein, and so the Word (of doom) hath effect for it, and We annihilate it with complete annihilation.
- How many generations have We destroyed since Noah! And Allah sufficient as Knower and Beholder of the sins of His slaves.
- 18. Whoso desireth that (life) which hasteneth away, We hasten for him therein that We will for whom We please. And afterward We have appointed for him hell; he will endure the heat thereof, condemned, rejected.
- 19. And whoso desireth the Hereafter and striveth for it with the effort necessary, being a believer; for such, their effort findeth favor (with their Lord).
- 20. Each do We supply, both these and those from the bounty of they Lord. And the bounty of thy Lord can never be walled up.
- 21. See how We prefer one above another, and verily the Hereafter will be greater in degrees and greater in preferment.
- 22. Set not up with Allah any other god (O man) lest thou sit down reproved, forsaken.
- 23. Thy Lord hath decreed, that ye worship none save Him, and (that ye show) kindness to parents. If one of them or both of them attain old age with thee, say not "Fie" unto them nor repulse them, but speak unto them a gracious word.
- 24. And lower unto them the wing of submission through mercy, and say: My Lord! Have mercy on them both as they did care for me when I was little.
- 25. Your Lord is best aware of what is in your minds. If ye are righteous, then lo! He was ever Forgiving unto those who turn (unto Him).
- 26. Give the kinsman his due, and the needy, and the wayfarer, and squander not (thy wealth) in wantonness.
- Lo! the squanderers were ever brothers of the devils, and the devil was ever an ingrate to his Lord.
- 28. But if thou turn away from them, seeking mercy from Lord, for which thou hopest, then speak unto them a reasonable word.
- 29. And let not they hand be chained to thy neck nor open it with a complete opening, lest thou sit down rebuked, denuded.

- 30. Lo! thy Lord enlargeth the provision for whom He will, and straighteneth (it for whom He will). Lo, He was ever Knower, Seer of His slaves.
- 31. Slay not your children, fearing a fall to poverty, We shall provide for them and for you. Lo! the slaying of them is great sin.
- 32. And come not near unto adultery. Lo! it is an abomination and an evil way.
- 33. And slay not the life which Allah hath forbidden save with right. Whoso is slain wrongfully, We have given power unto his heir, but let him not commit excess in slaying. Lo! he will be helped.
- 34. Come not near the wealth of the orphan save with that which is better till he come to strength; and keep the covenant. Lo! of the covenant it will be asked.
- 35. Fill the measure when ye measure, and weigh with a right balance; that is meet, and better in the end.
- 36. (O man), follow not that whereof thou hast no knowledge. Lo! the hearing and the sight and the heart—of each of these it will be asked.
- 37. And walk not in the earth exultant. Lo! thou canst not rend the earth, nor canst thou stretch to the height of the hills.
- 38. The evil of all that is hateful in the sight of thy Lord.
- 39. This is (part) of that wisdom wherewith thy Lord hath inspired thee (O Muhammad). And set not up with Allah any other god, lest thou be cast into hell, reproved, abandoned.
- 40. Hath your Lord then distinguished you (O men of Mecca) by giving you sons, and hath chosen for Himself females from among the angels? Lo! verily ye speak an awful word!
- 41. We verily have displayed (Our warnings) in this Qur´an that they may take heed, but increaseth them in naught save aversion.
- 42. Say (O Muhammad, to the disbelievers): If there were other gods along with Him, as they say, then had they sought a way against the Lord of the Throne.
- 43. Glorified is He, and High Exalted above what they say!
- 44. The seven heavens and the earth and all that is therein praise Him, and there is not a thing by hymneth his praise; but ye understand not their priase. Lo! He is ever Clement, Forgiving.
- 45. And when thou recitest the Qur´an We place between thee and those who believe not in the Hereafter a hidden barrier.
- 46. And We place upon their hearts veils lest they should understand it, and in their ears a deafness; and when thou makest mention of thy Lord alone in the Qur´an, they turn their backs in aversion.
- 47. We are best aware of what they wish to her when they give ear to thee and when they take secret counsel, when the evil-doers say: Ye follow but a man bewitched.
- 48. See what similitudes they coin for thee, and thus are all astray, and cannot find a road!
- 49. And they say: When we are bones and fragments, shall we, forsooth, be raised up as a new creation?
- 50. Say: Be ye stones or iron
- 51. Or some created thing that is yet greater in your thoughts! Then they will say: Who shall bring us back (to life). Say: he who created you at the first. Then will they shake their heads at thee, and say: When will it be? Say: It will perhaps be soon.
- 52. A day when He will call you and ye will answer with His praise, and ye will think that ye have tarried but a little while.
- 53. Tell My bondmen to speak that which is kindlier. Lo!

the devil soweth discord among them. Lo! the devil is for man an open foe.

- 54. Your Lord is best aware of you. If He will, He will have mercy on you, or if He will, He will punish you. We have not sent thee (O Muhammad) ad a warden over them.
- 55. And thy Lord is best aware of all who are in the heavens and the earth. And We preferred some of the Prophets above others, and unto David We gave the Psalms.
- 56. Say: Cry unto those (saints and angels) whom ye assume (to be gods) beside Him, yet they have no power to rid you of misfortune nor to change.
- 57. Those unto whom they cry seek the way of approach to their Lord, which of them shall be the nearest; they hope for His mercy and they fear His doom. Lo! the doom of they Lord is to be shunned.
- 58. There is not a township³ but We shall destroy it ere the Day of Resurrection, or punish it with dire punishment. That is set forth in the Book (of Our decrees).
- 59. Naught hindereth Us from sending portents save that the folk of old denied them. And We gave Thamûd the she-camel—a clear portent—but they did wrong in respect of her. We send not portents save to warn.
- 60. And (it was a warning) when We told thee: Lo! thy Lord encompasseth mankind, and We appointed the vision⁴ which We showed thee as an ordeal for mankind, and (likewise) the Accursed Tree in the Qur´an.⁵ We warn them, but it increaseth them in naught save gross impiety.
- 61. And when We said unto the angels: Fall down prostrate before Adam and they fell prostrate all save Iblîs, he said: Shall I fall prostrate before that which Thou has created of clay?
- 62. He said: Seest Thou this (creature) whom Thou has honored above me, if Thou give me grace until the Day of Resurrection I verily will seize his seed, save but a few.
- 63. He said: Go, and whosoever of them followeth thee lo! hell will be your payment, ample payment.
- 64. And excite any of them who thou canst with thy voice, and urge thy horse and foot against them, and be a partner in their wealth and children, and promise them. Satan promiseth them only to deceive.
- 65. Lo! My (faithful) bondmen—over them thou hast no power, and thy Lord sufficeth as (their) guardian.
- 66. (O mankind), your Lord is He Who driveth for you the ship upon the sea that ye may seek of His bounty. Lo! He was ever Merciful toward you.
- 67. And when harm toucheth you upon the sea, all unto whom ye cry (for succor) fail save Him (alone), but when He bringeth you safe to land, ye turn away, for man was ever thankless.
- 68. Feel ye then secure that He will not cause a slope of the land to engulf you, or send a sand-storm upon you, and then ye will find that ye have no protector?
- 69. Or feel ye secure that He will not return you to that (plight) a second time, and send against you a hurricane of wind and drown you for your thanklessness, and then ye will not find therein that ye have any avenger against Us?
- 70. Verily We have honored the children of Adam. We carry them on the land and the sea, and have made provision of good things for them, and have preferred

³ Or community.

them above many of those whom We created with a marked preferment.

- 71. On the day when We shall summon all men with their record, whoso is given his book in his right hand—such will read their book and they will not be wronged a shred.
- 72. Whoso is blind here will be blind in the Hereafter, and yet further from the road.
- 73. And they indeed strove hard to beguile thee (Muhammad) away from that wherewith We have inspired thee, that thou shouldst invent other than it against Us; and then would they have accepted thee as a friend.⁶
- 74. And if We had not made thee wholly firm thou mightest almost have inclined unto them a little.
- 75. Then had We made thee taste a double (punishment of living and a double (punishment) of dying, then hadst thou found no helper against us.
- 76. And they indeed wished to scare thee from the land they might drive thee forth from thence, and then they would have stayed (there) but a little after thee.⁷
- 77. (Such was Our) method in the case of these whom We sent before thee (to mankind) and thou wilt not find for Our method aught of power to change.
- 78. Establish worship at the going down of the sun until the dark of night, and (the recital of) the Qur'an at dawn. Lo! (the recital of) the Qur'an at dawn is ever witnessed.
- And some part of the night awake for it, a largess for thee. It may be that thy Lord will raise thee to a praised estate.
- 80. And say: My Lord! Cause me to come in with a firm incoming and to go out with a firm outgoing. And give me from They presence a sustaining Power.
- 81. And say: Truth hath come and falsehood hath vanished away. Lo! falsehood is ever bound to banish.⁸
- 82. And We reveal of the Qur'an that which is a healing and a mercy for believers though it increase the evildoers in naught save ruin.
- 83. And when We make life pleasant unto man, he turneth away and is averse; and when ill toucheth him he is in despair.
- 84. Say: Each one doth according to his rule of conduct, and thy Lord is best aware of him whose way is right.
- 85. They will ask thee concerning the Spirit. Say: The Spirit is by command of my Lord, and of knowledge ye have been vouchsafed but little.
- 86. And if We willed We could withdraw that which We have revealed unto thee, then wouldst thou find no guardian for thee against Us in respect thereof.
- 87. (It is naught) save mercy from thy Lord. Lo! His kindness unto thee was ever great.⁹
- 88. Say: Verily, though mankind and the Jinn should assemble to produce the like of this Qur'an, they could not produce the like thereof though they were helpers one of another.
- 89. And verily We have displayed for mankind in this Qur´an all kinds of similitudes, but most of mankind refuse aught save disbelief.

- ⁷ If, as the Jalâleyn declare, vv. 76–82 were revealed at Al-Madînah the reference here is to the plotting of the Jews and Hypocrites.
- ⁸ These words were recited by the Prophet when he witnessed the destruction of the idols around the Ka'bah after the conquest of Mecca.
- ⁹ Vv. 85, 86, and 87 are said to have been revealed in answer to the third question, which some Jewish rabbis prompted the idolaters to ask, the first two questions being answered in the following Sûrah.

⁴ The Prophet's vision of his ascent through the seven heavens.
⁵ See Svrah XLIV, vv. 43–49.

⁶ The idolaters more than once offered to compromise with the Prophet.

- 90. And they say: We will not put faith in thee till thou cause a spring to gush forth from the earth for us;
- Or thou have a garden of date-palms and grapes, and cause rivers to gush forth therein abundantly;
- Or thou cause the heaven to fall upon us piecemeal, as thou has pretended, or bring Allah and the angels as a warrant;
- 93. Or thou have a house of gold; or thou ascend up into heaven, and even then we will put no faith in thine ascension till thou bring down for us a book that we can read. Say (O Muhammad): My Lord be glorified! Am I aught save a mortal messenger?
- 94. And naught prevented mankind from believing when the guidance came unto them save that they said: Hath Allah sent a mortal as (His) messenger?
- 95. Say: If there were in the earth angels walking secure, We had sent down for them from heaven an angel as messenger.
- 96. Say: Allah sufficeth for a witness between me and you. Lo! He is knower, Seer of His slaves.
- 97. And he whom Allah guideth, he is led aright; while, as for him whom He sendeth astray, for them thou wilt find no protecting friends beside Him, and We shall assemble them on the Day of Resurrection on their faces, blind, dumb and deaf; their habitation will be hell; whenever it abateth, We increase the flame for them.
- 98. That is their reward because they disbelieved Our revelations and said: When we are bones and fragments shall we, forsooth, be raised up as a new creation?
- 99. Have they not seen that Allah Who created the heavens and the earth is Able to create the like of them, and hath appointed for them an end whereof there is no doubt? But the wrong-doers refuse aught save disbelief.
- 100. Say (unto them): If ye possessed the treasures of the mercy of my Lord, ye would surely hold them back for fear of spending, for man was every grudging.
- 101. And verily We gave unto Moses nine tokens, clear proofs (of Allah's Sovereignty). Do but ask the Children of Israel how he came unto them, then Pharaoh said unto him: Lo! I deem thee one bewitched, O Moses.
- 102. He said: In truth thou knowest that none sent down these (portents) save the Lord of the heavens and the earth as proofs, and lo! (for my part) I deem thee lost, O Pharaoh.
- 103. And he wished to scare them from the land, but We drowned him and those with him, all together.
- 104. And We said unto the Children of Israel after him: Dwell in the land; but when the promise of the Hereafter cometh to pass we shall bring you as a crowd gathered out of various nations.¹⁰
- 105. With truth have We sent it down, and with truth hath it descended. And We have sent thee as naught else save a bearer of good tidings and a warner.
- 106. And (it is) a Qur´an that We have divided, that thou mayest recite it unto mankind at intervals, and We have revealed it by (successive) revelation.
- 107. Say: Believe therein or believe not, lo! those who were given knowledge before it, when it is read unto them, fall down prostrate on their faces, adoring,
- 108. Saying: Glory to our Lord! Verily the promise of our Lord must be fulfilled.
- 109. They fall down on their faces, weeping, and it increaseth humility in them.

- 110. Say (unto mankind): Cry unto Allah, or cry unto the Beneficent,¹¹ unto whichsoever ye cry (it is the same). His are the most beautiful names. And thou (Muhammad), be no loud voiced in they worship nor yet silent therein, but follow a way between.
- 111. And say: Praise be to Allah, Who hath not taken unto Himself a son, and Who hath no partner in the Sovereignty, nor hath He any protecting friend through dependence. And magnify Him with all magnificence.

Sûrah C

The Coursers

Revealed at Mecca

In the name of Allah, the Beneficent, the Merciful.

- 1. By the snorting coursers,
- 2. Striking sparks of fire
- 3. And scouring to the raid at dawn,
- 4. Then, therewith, their trail of dust,
- 5. Cleaving, as one the center (of the foe),¹
- 6. Lo! man is an ingrate unto his Lord
- 7. And lo! he is a witness unto that;
- 8. And lo! in the love of wealth he is violent.
- 9. Knoweth he not that, when the contents of the graves are poured forth.
- 10. And the secrets of the breasts are made known.
- 11. On that day will their Lord be perfectly informed concerning them.

SÛRAH CXII

The Unity

Revealed at Mecca

In the name of Allah, the Beneficent, the Merciful.

- 1. Say: He is Allah, the One!
- 2. Allah, the eternally Besought of all!
- 3. He begeteth not nor was begotten.
- 4. And there is none comparable unto Him.

Memories of Rabia

The following series of selections were taken down by the disciples of the early female Sufi mystic, Rabia al-Adawiyya. They are based on translations in Margaret Smith's Readings from the Mystics of Islam.

5

One day Rabi´a was seen carrying fire in one hand and water in the other and she was running with speed. They asked her what was the meaning of her action and where she was going. She replied: "I am going to light a fire in Paradise and pour water onto Hell, so that both veils¹ may completely

¹¹ The idolaters had a peculiar objection to the name *Al-Rahmân*, "The Beneficent," in the Qur´an. They said: "We do not know this Rahmân." Some of them thought that Ar-Rahmân was a man living in Yamâmah.

¹⁰ A reference to the dispersal of the Jews as a consequence of their own deeds after God had established them in the land.

¹ The meaning of the first five verses is by no means clear. The above is a probable rendering.

¹ I.e., hindrances to the true vision of God.

disappear from the pilgrims, and their purpose may be sure, and the servants of God may see Him, without any object of hope or motive of fear. What if the hope of Paradise and the fear of Hell did not exist? Not one could worship his Lord or obey Him."

6

The best thing for the servant, who desires to be near his Lord, is to possess nothing in this world or the next, save Him. I have not served God from fear of Hell, for I should be like a wretched hireling, if I did it from fear: nor from love of Paradise, for I should be a bad servant if I served for the sake of what was given, but I have served Him only for the love of Him and out of desire for Him.

The Neighbor first and then the house: is it not enough for me that I am given leave to worship him? Even if Heaven and Hell were not, does it not behoove us to obey Him? He is worthy of worship without any intermediate motive.

O my Lord, if I worship Thee from fear of Hell, burn me in Hell; and if I worship Thee from hope of Paradise, exclude me thence; but if I worship Thee for Thine own sake, then withhold not from me Thine Eternal Beauty.

7

The groaning and the yearning of the lover of God will not be satisfied until it is satisfied in the Beloved,

I have made Thee the Companion of my heart, But my body is available for those who desire its company. And my body is friendly toward its guests,

But the beloved of my heart is the Guest of my soul.

My peace is in solitude, but my Beloved is always with me. Nothing can take the place of His love and it is the test for me among mortal beings. Whenever I contemplate His Beauty, He is my *mihrāb*,² toward Him is my *qibla*³—O Healer of souls, the heart feeds upon its desire and it is the striving toward union with Thee that has healed my soul. Thou are my Joy and my Life to eternity. Thou wast the source of my life, from Thee came my ecstasy. I have separated myself from all created beings: my hope is for union with Thee, for that is the goal of my quest.

Rumi: Poems and Meditations

The prose that follows is again from Margaret Smith. The poems and meditations are from The Essential Rumi (translated by Coleman Barks and John Moyne), and reflect Rumi's deep awareness of God and illustrate his capacity to observe ordinary things and turn them into mystic reflections.

The Night Air

A man on his deathbed left instructions for dividing up his goods among his three sons.

He had devoted his entire spirit to those sons.

They stood like cypress trees around him, quiet and strong.

He told the town judge,

"Whichever of my sons is *laziest*, give him *all* the inheritance."

² A niche in the mosque, facing toward Mecca.

³ The part toward which the congregation direct their prayers.

Then he died, and the judge turned to the three,

- "Each of you must give some account of your laziness, so I can understand just *how* you are lazy."
- Mystics are experts in laziness. They rely on it, because they continuously see God working all around them.
- The harvest keeps coming in, yet they never even did the plowing!

"Come on. Say something about the ways you are lazy."

Every spoken word is a covering for the inner self. A little curtain-flick no wider than a slice of roast meat

can reveal hundreds of exploding suns.

Even if what is being said is trivial and wrong, the listener hears the source. One breeze comes from across a garden. Another from across the ash-heap.

Think how different the voices of the fox and the lion, and what they tell you!

Hearing someone is lifting the lid off the cooking pot.

You learn what's for supple. Though some people can know just by the smell, a sweet stew from a sour soup cooked with vinegar.

A man taps a clay pot before he buys it to know by the sound if it has a crack.

The eldest of the three brothers told the judge, "I can know a man by his voice, and if he won't speak, I wait three days, and then I know him intuitively."

- The second brother, "I know him when he speaks, and if he won't talk, I strike up a conversation."
- "But what if he knows the trick?" asked the judge.
- Which reminds me of the mother who tells her child, "When you're walking through the graveyard at night and you see a boogeman, run *at* it, and it will go away."

"But what," replies the child, "if the boogeyman's mother has told it to do the same thing? Boogeymen have mothers too."

The second brother had no answer.

The judge then asked the youngest brother, "What if a man cannot be made to say anything? How do you learn his hidden nature?"

- "I sit in front of him in silence, and set up a ladder made of patience, and if in his presence a language from beyond joy and beyond grief begins to pour from *my* chest,
- I know that his soul is as deep and bright as the star Canopus rising over Yemen.
- And so when I start speaking a powerful right arm of words sweeping down, I know *him* from what I say, and how I say it, because there's a window open between us, mixing the night air of our beings."

The youngest was, obviously, the laziest. He won.

Only Breath

Not Christian or Jew or Muslim, not Hindu, Buddhist, sufi, or zen. Not any religion

or cultural system. I am not from the East or the West, not out of the ocean or up

from the ground, not natural or ethereal, not composed of elements at all. I do not exist,

am not an entity in this world or the next, did not descend from Adam or Eve or any

origin story. My place is placeless, a trace of the traceless. Neither body or soul.

belong to the beloved, have seen the two worlds as one and that one call to and know,

- first, last, outer, inner, only that breath breathing human being.
- There is a way between voice and presence where information flows.

In disciplined silence it opens. With wandering talk it closes.

114

By love bitter things are made sweet: copper turns to gold. By love, the sediment becomes clear: by love torment is removed. By love the dead is made to live; by love the sovereign is made a slave. This love also is the fruit of knowledge: when did folly sit on a throne like this? — The faith of love is separated from all religion; for lovers the faith and the religion is God. O spirit, in striving and seeking, becoming like running water: O reason, at all times be ready to give up mortality for the sake of immortality. Remember God always, that self may be forgotten, so that your self my be effaced in the One to Whom you pray, without care for who is praying, or the prayer. . . .

116

Each night Thou dost set the spirits free from the net of the body! Thou dost erase the tablets of memory. The spirits escape each night from this cage, set free from control and from speech and from the tales of men. At night prisoners are unaware of the prison, at night rulers forget their power. there is no anxiety, no thought of profit or loss, no consideration of this one or that. This is the state of the gnostic,¹ even when awake. God said: "They are asleep," though they may seem to be awake. Be not afraid of this statement. He, that is, the gnostic, is asleep in regard to this world of affairs, both by day and night, like the pen which is moved by the hand of God. That one who does not see the hand, which is writing, thinks that the movement is due to the pen. A little of this state of the gnostic has been shown to us, since all creatures are subject to the sleep of the senses. Their souls have gone forth into the mysterious wastes; their spirits are at rest with their bodies. Thou callest them back into the net and bringest them all to justice and their judge. He Who created the dawn, like Isrāfīl, brings them all back from those spiritual regions into the material world. He has made the spirits to be like a horse free of its harness, this is the secret of "sleep is the brother of death."

117

We were, once, one substance, like the Sun: flawless we were and pure as water is pure. Purify yourself, therefore from the qualities of self, so that you may see your essence, perfect and pure. If you seek for a parable of the knowledge which is hidden, hear the story of the Greeks and the Chinese.

The Chinese said: "We are the better artists," and the Greeks rejoined: "We have more skill than you and more sense of beauty." So the king, in whose presence they were speaking, said to them: "I will test you in this, to see which of you is justified in your claim."

The Chinese then said: "Give us a room for ourselves and let there be a room for the Greeks." There were two rooms, with doors opposite each other; the Chinese took one room and the Greeks the other. The Chinese asked the king for a hundred different colors: the king opened his treasure-house for them to take what they would. Each morning the Chinese took from the treasure-house some of his gift of colors. But the Greeks said: "No colors or paints are needed for our work, which is only to remove the rust." They shut themselves in and polished continuously, until all was pure and clear like the sky. From many colors there is a way to freedom from color: color is like cloud, and freedom from color like the moon. Whatever radiance and light you see in the cloud, know that it comes from the stars and the moon, and the sun.

When the Chinese had finished their work, they rejoiced and began to beat drums. The king came in and looked at the pictures which were there and when he saw them he was dumbfounded. Then after that, he came to the Greeks: one of them raised the curtain that was between the rooms. The reflection of those paintings and the work the Chinese had done, fell upon those polished walls. All that the king had seen there, seemed more lovely here: the wonder of it made his eyes start from their sockets.

The Greeks are the Sufis, who dispense with study and books and learning, but they have purified their hearts, making them free from desire and greed and avarice and malice; that spotless mirror is undoubtedly the heart which receives images without number. Those who are purified have left behind them fragrance and color; each moment they see Beauty without hindrance: they have left behind the form and the externals of knowledge, they have raised the standard of certainty. Thought has gone from them and they have found light, they have found the river and then the sea of gnosis. For the Sufis, there are a hundred signs from the Empyrean and the sphere above and the empty spaces, and what are these but the very Vision of God Himself?

118

O lovers, the time has come to depart from the world; the drum is sounding in the ear of my spirit, calling us to the journey. Behold, the camel-driver has bestirred himself and set his camels in their ranks and desires us to let him start. Why are you still sleeping, O travelers? These sounds which we hear from before and behind betoken travel, for they are the camel-bells. Each moment that passes, a soul is passing out of life and starting for the Divine world. From these gleaming stars and from these blue curtains of the heavens, have come forth a wondrous people, so that marvelous things of mystery may be made known. From these revolving orbs came a heavy sleep to you: beware of this so transient life, have a care of this heavy sleep. O heart, depart toward the Beloved, O friend, go to your Friend. O watchman, keep awake, for sleep is not becoming to a watchman.

¹ Gnostic: one who has spiritual hidden understanding.

	-		
		GENERAL EVENTS	LITERATURE & PHILOSOPHY
	RISE OF 05 THE FRANKS 05	 711 Muslims invade Spain 714–741 Charles Martel, grandfather of Charlemagne, reigns as first ruler of Frankish kingdom 732 Charles Martel defeats Muslims at Battle of Poitiers 741–768 Reign of Pepin the Short, father of Charlemagne 	735 Death of Venerable Bede, author of <i>Ecclesiastical</i> <i>History of the English People</i> and other religious writings
EARLY MIDDLE AGES	CAROLINGIAN PERIOD	 768 Charlemagne ascends Frankish throne 772–778 Charlemagne's military campaigns against Muslim Emirates 778 Battle of Roncesvalles c. 790 Charlemagne settles his court at Aachen (Aix-la- Chapelle) 800 Charlemagne crowned Holy Roman emperor at Rome by Pope Leo III 814 Death of Charlemagne 910 Founding of monastery at Cluny 987–996 Reign of Hugh Capet in France ends Carolingian line of succession 	 after 780 Carolingian minuscule form of lettering developed 781 Charlemagne opens palace school, importing such scholars as Theodulf of Orléans and Alcuin of York 785 Alcuin, <i>Sacramentary</i> after 814 Carolingian monasteries adopt <i>Rule</i> of Saint Benedict of Nursia (480–547?) 821 Einhard, <i>Vita Caroli (Life of Charlemagne)</i> after 950 Hroswitha's <i>Thais</i>
EA	ROMANESQUE PERIOD	 11th cent. Pilgrimages become very popular 1066 Norman invasion of England by William the Conqueror 1096 – 1099 First Crusade; capture of Jerusalem by Christians 	 c. 1098 Song of Roland, chanson de geste inspired by Battle of Roncesvalles, written down after 300 yrs. of oral tradition 12th cent. Development of liturgical drama c. 1125 Saint Bernard of Clairvaux denounces extravagances of Romanesque decoration
GOTHIC	turner and the second	 1165 Charlemagne canonized at Cathedral of Aachen 1187 Sultan Saladin conquers Jerusalem 1202–1204 Fourth Crusade; sack of Constantinople by crusaders 1270 Eighth Crusade 1291 Fall of Acre, last Christian stronghold in Holy Land 	14th–15th cent. Play cycles performed outside the church; Everyman (15th cent.), morality play

CHAPTER 9 CHARLEMAGNE AND THE RISE OF MEDIEVAL CULTURE

ARCHITECTURE

Monastic complexes become

important centers in rural life

MUSIC

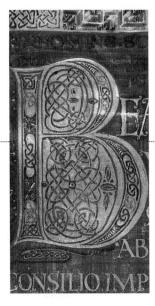

ART

- 8th–9th cent. Irish Book of Kells
- Illuminated manuscripts and carved ivories

c. 775 Centula Evangeliary and Ďagulf

prevalent

Psalter

- **c. 795** Palace and chapel of Charlemagne at Aachen
- **c. 820** Plan for Abbey of Saint Gall, the "ideal" monastery
- **c. 800** Monasteries become centers for encouragement of sacred music; theoretical study of music at Charlemagne's palace school
- **9th cent.** Use of semi-dramatic trope in liturgical music; *Quem Quaeritis* trope introduced into Easter Mass
- **c. 810** Gregorian plain chant (*cantus planus*) obligatory in Charlemagne's churches

822 Earliest documented church organ

IIth-I2th cent. Gregorian chant codified

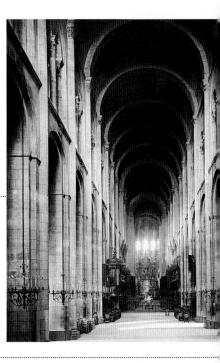

c. 1165 Reliquary of Charlemagne and candelabra commissioned for Aachen cathedral by Frederick Barbarossa for canonization of Charlemagne

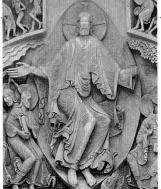

- Use of massive walls and piers, rounded arches, and minimal windows
- **c. 1071 1112** Pilgrimage church at Santiago de Compostela, Spain
- **c. 1080–1120** Church of Saint Sernin, Toulouse, pilgrimage center
- 1088–1130 Great Third Church at Cluny
- 1096–1120 Abbey Church of La Madeleine, Vézelay

early 9th cent. Crucifixion Ivory, done at palace school of Charlemagne
c. 820–840 Utrecht Psalter

800-810 Gospel Book of Charlemagne

- **1100–1125** Sculptures at Abbey Church of Saint-Pierre, Moissac
- **1120–1132** Sculptures at Abbey Church of La Madeleine, Vézelay
- **c. 1140** Portal sculptures at Priory Church, Saint-Gilles-du-Gard

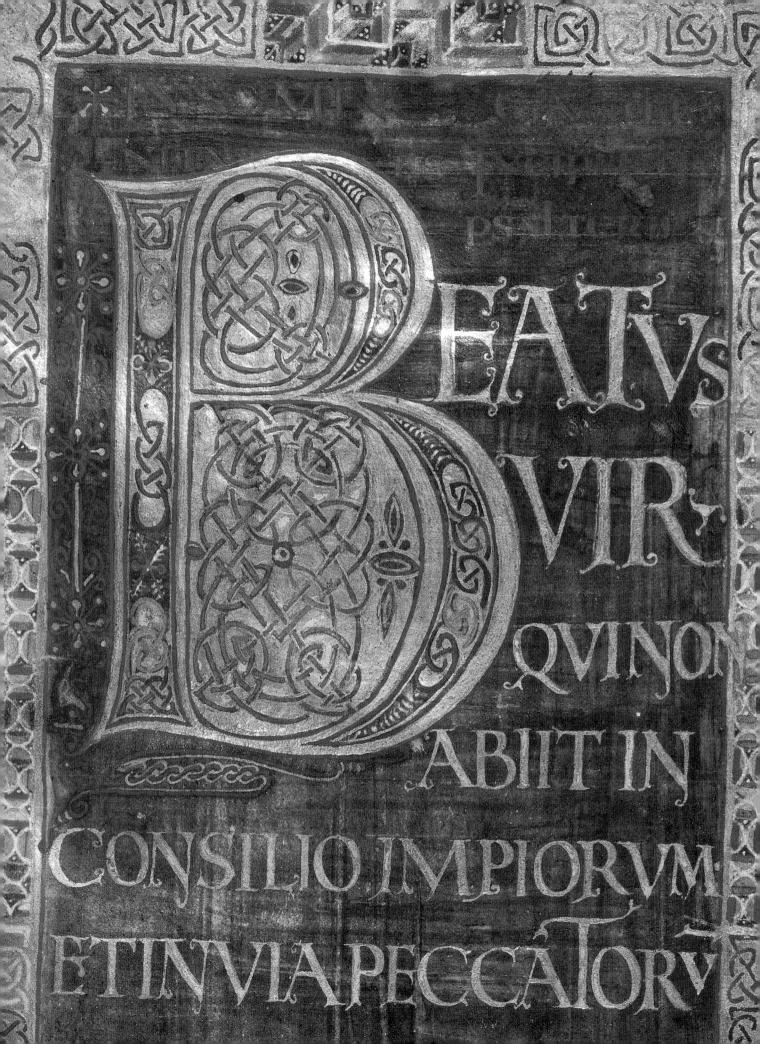

CHAPTER 9

CHARLEMAGNE AND THE RISE OF MEDIEVAL CULTURE

CHARLEMAGNE AS RULER AND DIPLOMAT

Charlemagne

harles the Great (742?–814)—known to subsequent history as Charlemagne—was crowned emperor of the Roman Empire in Saint Peter's Basilica in Rome on Christmas Day A.D. 800 by Pope Leo III, in the first imperial coronation in the West since the late sixth century. The papal coronation was rebellion in the eyes of the Byzantine court, and the emperor in Constantinople considered Charlemagne a usurper, but this act marked the revival of the Roman Empire in the West.

Charlemagne was an able administrator of lands brought under his subjugation. He modified and adapted the classic Roman administrative machinery to fit the needs of his own kingdom. Charlemagne's rule was essentially feudal-structured in a hierarchical fashion, with lesser rulers bound by acts of fealty to higher ones. Lesser rulers were generally large landowners who derived their right to own and rule their land from their tie to the emperor. Charlemagne also maintained a number of vassal dependents at his court who acted as counselors at home and as legates to execute and oversee the imperial will abroad. From his palace the emperor regularly issued legal decrees modeled on old Imperial Rome decrees [9.1]. These decrees were detailed sets of instructions that touched on a wide variety of secular and religious issues. Those that have survived give us some sense of what life was like in the very early medieval period. The legates of the emperor carried the decrees to the various regions of the empire and reported back on their acceptance and implementation. This burgeoning bureaucratic system required a class of civil servants with a reasonable level of literacy, an important factor in the cultivation of letters that was so much a part of the so-called Carolingian Renaissance.

The popular view of the early Middle Ages-often referred to as the Dark Ages—is that of a period of isolated and ignorant peoples with little contact outside the confines of their own immediate surroundings, and at times that was indeed the general condition of life. Nonetheless, it is important to note that in the late eighth and early ninth centuries Charlemagne not only ruled over an immense kingdom (all of modern-day France, Germany, the Low Countries, and Italy as far south as Calabria) but also had extensive diplomatic contact outside that kingdom. Charlemagne maintained regular, if somewhat testy, diplomatic relations with the emperor in Constantinople (at one point he tried to negotiate a marriage between himself and Byzantine Empress Irene in order to consolidate the two empires). Envoys from Constantinople were received regularly in his palace at Aachen, and Charlemagne learned Greek well enough to understand the envoys speaking their native tongue.

Charlemagne's relationship with the rulers of Islamic kingdoms is interesting. Islam had spread all along the southern Mediterranean coast in the preceding century. Arabs were in complete command of all the Middle East, North Africa, and most of the Iberian peninsula. Charlemagne's grandfather Charles Martel (Charles the Hammer) had defeated the Muslims decisively at the Battle of Poitiers in 732, thus halting an Islamic challenge from Spain to the rest of Europe. Charlemagne himself had fought the Muslims of the Córdoba caliphate on the Franco–Spanish borders; the Battle of Roncesvalles (778) was the historical basis for the later epic poem the *Song of Roland*.

Song of Roland

Despite his warlike relationship with Muslims in the West, Charlemagne had close diplomatic ties with the great Harun al-Rashid, the caliph of Baghdad. In 787, Charlemagne sent an embassy to the caliph to beg

9.1 Charlemagne's seal, ninth century. Archives Nationales, Paris. This Roman gem with the head of a philosopher or an emperor was used on official documents by Charlemagne, impressed on wax. The inscription reads *Christ protect Charles King of the Franks*.

protection for the holy places of the Christians in Muslim-held Palestine. The caliph (of *A Thousand and One Nights* fame) received and welcomed the Frankish legates and their gifts (mainly bolts of the much-prized Frisian cloth) and sent an elephant back to the emperor as a gesture of friendship. This gift arrived at Aachen and lived there for a few years before succumbing to the harsh winter climate. Charlemagne's negotiations were successful. From a pair of Palestinian monks he received the keys to the church of the Holy Sepulchre and other major Christian shrines, an important symbolic act that made the emperor the official guardian of the holiest shrines in Christendom.

Charlemagne's reign was also conspicuous for its economic developments. He stabilized the currency system of his kingdom. The silver *denier* struck at the royal mint in Frankfurt after 804 became the standard coin of the time; its presence in archaeological finds from Russia to England testifies to its widespread use and the faith traders had in it.

Trade and commerce were vigorous. Charlemagne welcomed Jewish immigrants to his kingdom to provide a merchant class for commerce. There were annual trade fairs at Saint Denis near Paris, at which English merchants could buy foodstuffs, honey, and wine from the Carolingian estates. A similar fair was held each year at Pavia, an important town of the old Lombard kingdom of northern Italy. Port cities such as Marseilles provided mercantile contracts with the Muslims of Spain and North Africa. Jewish merchants operated as middlemen in France for markets throughout the Near East. The chief of Charlemagne's mission to Harun al-Rashid's court was a Jew named Isaac who had the linguistic ability and geographic background to make the trip to Baghdad and back—with an elephant—at a time when travel

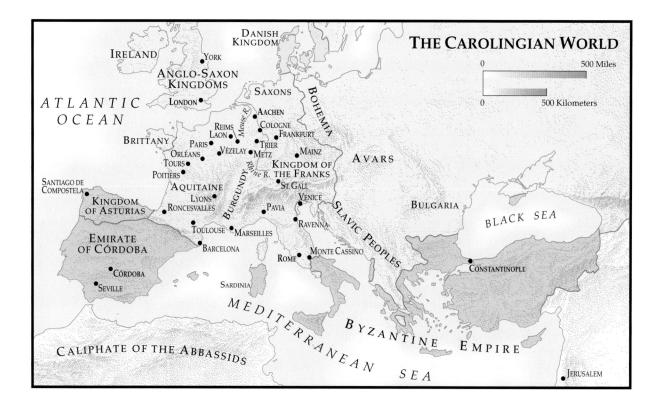

was a risky enterprise. Rivers such as the Rhine and the Moselle were utilized as important trade routes. One of the most sought-after articles from the Frankish kingdom was the iron broadsword produced at forges in and around the city of Cologne and sold to Arabs in the Middle East through Jewish merchants at the port cities. Vivid testimony to their value can be read in the repeated embargoes (imposed under penalty of death) decreed by Charlemagne against their export to the land of the Vikings, who too often put them to effective use against their Frankish manufacturers in coastal raids on North Sea towns and trading posts.

LEARNING IN THE TIME OF CHARLEMAGNE

At Aachen, Charlemagne opened his famous "palace school"—an institution that was a prime factor in initiating what has been called the Carolingian Renaissance. Literacy in Western Europe before the time of Charlemagne was rather spotty; it existed, but hardly thrived, in certain monastic centers that kept alive the old tradition of humanistic learning taken from ancient Rome. Original scholarship was rare, although monastic copyists did keep alive the tradition of literary conservation. Charlemagne himself could not write.

The scholars and teachers Charlemagne brought to Aachen provide some clues as to the various locales in which early medieval learning had survived. Peter of Pisa and Paul the Deacon (from Lombardy) came to teach grammar and rhetoric at his school since they had had contact with the surviving liberal arts curriculum in Italy. Theodulf of Orleans was a theologian and poet. He had studied in the surviving Christian kingdom of Spain and was an heir to the encyclopedic tradition of Isadore of Seville and his followers. Finally and importantly, Charlemagne brought an Anglo-Saxon, Alcuin of York, to Aachen after meeting him in Italy in 781. Alcuin had been trained in the English intellectual tradition of the Venerable Bede (died 735), the most prominent intellectual of his day, a monk who had welded together the study of humane letters and biblical scholarship. These scholar-teachers were hired by Charlemagne for several purposes.

Venerable Bede

First, Charlemagne wished to establish a system of education for the young of his kingdom. The primary purpose of these schools was to develop literacy; Alcuin of York developed a curriculum for them. He insisted that humane learning should consist of those studies which developed logic and science. It was from this distinction that later medieval pedagogues developed the two courses of studies for all schooling prior to the university: the *trivium* (grammar, rhetoric, and dialectic) and the *quadrivium* (arithmetic, geometry, music, and astronomy). These subjects remained at the heart of the school curriculum from the medieval period until modern times. (The now much-neglected "classical education" has its roots in this basic plan of learning.)

Few books were available and writing was done on slates or waxed tablets because parchment was expensive. In grammar, some of the texts of the Latin grammarian Priscian might be studied and then applied to passages from Latin prose writers. In rhetoric, the work of Cicero was studied, or Quintilian's Institutio Oratoria, if available. For dialectic, some of the work of Aristotle might be read in the Latin translation of Boethius. In arithmetic, multiplication and division were learned and perhaps there was some practice on the *abacus*, since the Latin numerals were clumsy to compute with pen and paper. Arithmetic also included some practice in chronology as students were taught to compute the variable dates of Easter. They would finish with a study of the allegorical meaning of numbers. Geometry was based on the study of Euclid. Astronomy was derived from the Roman writer Pliny, with some attention to Bede's work. Music was the theoretical study of scale, proportion, the harmony of the universe, and the "music of the spheres." Music at this period was distinguished from *cantus*, which was the practical knowledge of chants and hymns for church use. In general, all study was based largely on rote mastery of the texts.

Beyond the foundation of schools, Charlemagne needed scholars to reform existing texts and to halt their terrible corruption, especially those used in church worship. Literary revival was closely connected with liturgical revival. Part of Charlemagne's educational reform envisioned people who would read aloud and sing in church from decent, reliable texts. Literacy was conceived a necessary prerequisite for worship.

It was mainly Alcuin of York who worked at the task of revising the liturgical books. Alcuin published a book of Old and New Testament passages in Latin for public reading during Mass. He sent for books from Rome in order to publish a *sacramentary*, a book of prayers and rites for the administration of the sacraments of the church. Alcuin's sacramentary was made obligatory for the churches of the Frankish kingdom in 785. Charlemagne made the Roman chant (called *Gregorian* after Pope Gregory the Great, who was said to have initiated such chants in the end of the sixth century) obligatory in all the churches of his realm. Alcuin also attempted to correct scribal errors in the Vulgate Bible (the Latin version of Saint Jerome) by a comparative reading of manuscripts—a gigantic task he never completed.

Gregorian Chant

Beyond the practical need for literacy there was a further aim of education in this period. It was generally believed that all learning would lead to a better grasp of revealed truth—the Bible. The study of profane letters (by and large the literature of Rome) was a necessary first step toward the full study of the Bible. The study of grammar would set out the rules of writing, while dialectic would help distinguish true from false propositions. Models for such study were sought in the works of Cicero, Statius, Ovid, Lucan, and Vergil. These principles of correct writing and argumentation could then be applied to the study of the Bible in order to get closer to its truth. The pursuit of analysis, definition, and verbal clarity are the roots from which the scholastic form of philosophy would spring in the High Middle Ages. Scholasticism, which dominated European intellectual life until the eve of the Renaissance, had its first beginnings in the educational methodology established by Alcuin and his companions.

These educational enterprises were not centered exclusively at the palace school at Aachen. Under Charlemagne's direction, Alcuin developed a system of schools throughout the Frankish Empire-schools centered in both monasteries and towns. Attempts were also made to attach them to parish churches in the rural areas. The monastic school at Metz became a center for singing and liturgical study; schools at Lyons, Orleans, Mainz, Tours, and Laon had centers for teaching children rudimentary literary skills and offered some opportunity for further study in the liberal arts and the study of scripture. The establishment of these schools was accomplished by a steady stream of decrees and capitularies emanating from the Aachen palace. A circular letter, written most likely by Alcuin, called On the Cultivation of Learning, encouraged monks to study the Bible and to teach the young to do the same. A decree of 798 insisted that prelates and country clergy alike start schools for children.

This program of renewal in educational matters was an ideal set forth at a time when education was at a low ebb in Europe. Charlemagne tried to reverse that trend and in so doing encouraged real hope for an educated class in his time. His efforts were not entirely successful; many of his reforms came to naught in following generations when Europe slipped back into violence and ignorance.

Most of those who were educated were young men although there is some evidence of learning among the aristocratic women of Charlemagne's court. The only book written by a Frankish woman in his time was a sort of manual for Christian living written by Dhouda for her own son. We do, however, know that there had to be a certain level of literacy for nuns and there is also some evidence that illuminated manuscripts that have come to us were done by women in such convents.

BENEDICTINE MONASTICISM

Monasticism—from the Greek *monos* ("alone")—was an integral part of Christianity from the third century on. Monasticism came into the West from the great Eastern tradition of asceticism (self-denial) and eremitism (the solitary life). Its development in the West was very complex, and we cannot speak of any one form of monasticism as predominant before the time of Charlemagne.

Celtic monasticism in Ireland was characterized both by austere living and by a rather lively intellectual tradition. Monasticism in Italy was far more simple and rude. Some of the monasteries on the continent were lax, and Europe was full of wandering monks. No rule of life predominated in the sixth and seventh centuries. Monastic lifestyles varied not only from country to country but also from monastery to monastery.

The Rule of Saint Benedict

One strain of European monasticism derived from a rule of life written in Italy by Benedict of Nursia (480–547?) in the early sixth century. Although it borrowed from earlier monastic rules and was applied only to a small proportion of monasteries for a century after its publication, the Rule of Saint Benedict eventually became the Magna Carta of monasticism in the West. Charlemagne had Alcuin of York bring the rule to his kingdom and impose it on the monasteries of the Frankish kingdom to reform them and impose on them some sense of regular observance. In fact, the earliest copy of the Rule of Saint Benedict we possess today (a ninth-century manuscript preserved in the Swiss monastery of Saint Gall) is a copy of a copy Charlemagne had made in 814 from Saint Benedict's autographed copy then preserved at the abbey of Monte Cassino in Italy (now lost).

St. Benedict

The Rule of Saint Benedict consists of a prologue and seventy-three chapters (some only a few sentences long), which set out the ideal of monastic life. Monks (the

CONTEMPORARY VOICES

An Abbot, an Irish Scholar, and Charlemagne's Biographer

Even as the sailor, fatigued with his labors, rejoices when he sights the familiar shore toward which he has long aspired, so does the scribe rejoice who sees the long-desired end of the book which has so overcome him with weariness. The man who does not know how to write makes light of the scribes' pains, but those who have done it know how hard is this work.

A ninth-century monk-copyist describing labor in the scriptorium

I love, better than all glory, to sit in diligent study over my little book. Pangur Ben has no envy of me, for he finds a mouse in his snares while only a difficult argument falls into mine. He bumps against the wall and I against the rigors of science. . . . He rejoices when he has a mouse in his paw as I rejoice when I have understood a difficult question. . . . Each of us loves our art. He paid the greatest attention to the liberal arts. He had great respect for men who taught them, bestowing high honors on them. When he was learning the rules of grammar he received tuition from Peter the Deacon of Pisa who, by then, was an old man. For all other subjects he was taught by Alcuin, surnamed Albinus, a man of the Saxon race who came from Britain and was the most learned man anywhere to be found. Under him, the emperor spent much time and effort in studying rhetoric, dialectic, and especially astrology. He applied himself to mathematics and traced the course of the stars with great attention and care. He also tried to learn to write. With this end in view he used to keep writing tablets and notebooks under the pillows of his bed, so that he could try his hand at forming letters during his leisure moments; but, although he tried very hard, he had begun late in life and he made very little progress.

An Irish scholar and his cat

Einhard in his biography of Charlemagne

brethren) were to live a family life in community under the direction of a freely elected father (the abbot) for the purpose of being schooled in religious perfection. They were to possess nothing of their own (poverty); they were to live in one monastery and not wander (stability); their life was to be one of obedience to the abbot; and they were to remain unmarried (chastity). Their daily life was to be a balance of common prayer, work, and study. Their prayer life centered around duly appointed hours of liturgical praise of God that were to mark the intervals of the day. Called the "Divine Office," this consisted of the public recitation of psalms, hymns, and prayers with readings from the Holy Scriptures. The offices were interspersed throughout the day and were central to the monks' lives. The periods of public liturgical prayer themselves set off the times for reading, study, and the manual labor that was performed for the good of the community and its sustenance. The lifestyle of Benedictine monasticism can be summed up in its motto: "Pray and work." The rule was observed by both men and women.

The daily life of the monk was determined by sunrise and sunset (as it was for most people in those days). Here is a typical day—called the *horarium*—in an early medieval monastery. The italicized words designate the names for the liturgical hours of the day:

Horarium Monasticum

2:00 A.M. Rise

- 2:10–3:30 *Nocturns* (later called *Matins;* the longest office of the day)
- 3:30-5:00 Private reading and study
- 5:00–5:45 *Lauds* (the second office; also called "morning prayer")
- 5:45–8:15 Private reading and *Prime* (the first of the short offices of the day); at times, there was communal Mass at this time and, in some places, a light breakfast, depending on the season
- 8:15–2:30 Work punctuated by short offices of *Tierce*, *Sext*, and *None* (literally the third, sixth, and ninth hours)
- 2:30-3:15 Dinner
- 3:15-4:15 Reading and private religious exercises
- 4:15–4:45 Vespers—break—Compline (night prayers)
- 5:15-6:00 To bed for the night

This daily regimen changed on feast days (less work and more prayer) and during the summer (earlier rising, work later in the day when the sun was down a bit, more food, and so on). While the schedule now seems harsh, it would not have surprised a person of the time. Benedict would have found it absurd for people to sleep while the sun was shining and then stay up under the glare of artificial light. When we look at the horarium closely we see a day in which prayer and reading get four hours each, while there are about six hours of work. The rest of the day was devoted to personal chores, eating, and the like.

The triumph of the Benedictine monastic style of life (the early Middle Ages has been called the Benedictine centuries by some historians) is to be found in its sensible balance between the extreme asceticism of Eastern monastic practices and the unstructured life of Western monasticism before the Benedictine reforms. There was an even balance of prayer, manual labor, and intellectual life.

Women and the Monastic Life

While we tend to think of monasticism as a masculine enterprise, it should be remembered that the vowed religious life was open to both men and women. The entire early history of Christianity records a flourishing monastic life for women. In the late Roman period, groups of religious women flourished all over the Roman Empire. Saint Benedict's own sister, Scholastica (died c. 543), was head of a monastery not far from her brother's establishment at Monte Cassino. Her contemporary, Brigid of Ireland (died c. 525), was such a powerful figure in the Irish church that legends grew up about her prowess as a miracle worker and teacher. Her reputation as a saint was such that churches dedicated to her dotted Ireland, England, and places on the continent where Irish monasticism took root. In England, in the seventh century, Hilda, abbess of Whitby (614-680), not only ruled over a prominent monastery which was a center of learning (many Anglo-Saxon bishops were educated there) but she also held a famous episcopal gathering (synod) to determine church policy. Hilda also encouraged lay learning. It was she who fostered the talents of the cowherd poet Caedmon who produced vernacular poetry concerned with Christian themes.

Scholastica

Since monasticism presumed a certain degree of literacy, it was possible for women to exercise their talents in a way that was not possible within the confines of the more restricted life of the court or the family. The Benedictine tradition produced great figures like that of Hildegard of Bingen (1098–1179) who wrote treatises on prayer, philosophy, medicine, and devotion. She was also a painter, illustrator, musician, critic, and a preacher.

Among her most important works are included a vast visionary work called *Scivias* (*The Way to Knowledge*); the medical treatises *Physica* and *Causae et Curae* (*Causes and*

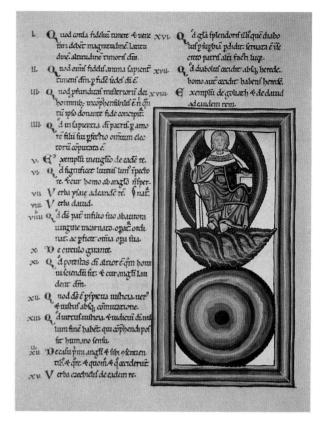

9.2 Hildegard of Bingen, The 1st Vision of Book 3 (Tafel 19) from the *Scivias*, Benediktinerinnenabtei St. Hildegard, Rüdesheim am Rhein, Germany.

Cures); as well as a song sequence called the *Symphonia* and a morality play set in music called the *Ordo Virtu-tum*; music from these latter works has been performed recently and recorded with a wonderful contemporary response. Hildegard commissioned illustrations for her *Scivias* but, alas, the originals were destroyed during the bombing of Dresden in the World War II and we now know them only in copies [9.2].

From this great tradition of monastic women we possess a number of edifying lives written by the contemporaries of these women which laud their decision to give up marriage in order to serve God. These lives of the saints were extremely popular since they served as exemplars of holy living. They were read publicly in churches (hence they were called *legends*—things read aloud) and for private devotion.

Monasticism and Gregorian Chant

The main occupation of the monk was the *Opus Dei* (work of God)—the liturgical common prayer of the monasteric horarium; life centered around the monastic

church where the monks gathered seven times a day for prayer. The centrality of the liturgy also explains why copying, correcting, and illuminating manuscripts was such an important part of monastic life. Texts were needed for religious services as well as for spiritual reading. The monks were encouraged to study the scriptures as a lifelong occupation. For monks this study was *lectio divina* (divine reading) and was central to their development as a monk. This monastic imperative encouraged the study of the Bible and such ancillary disciplines (grammar, criticism, and the like) as necessary for the study of scripture. From the seventh century on, monastic scriptoria were busily engaged in copying a wealth of material, both sacred and profane.

The monasteries were also centers for the development of sacred music. We have already seen that Charlemagne was interested in church music. His biographer Einhard tells us that the emperor "made careful reforms in the way in which the psalms were chanted and the lessons read. He was himself an expert at both of these exercises but he never read the lesson in public and he would sing only with the rest of the congregation and then in a low voice." Charlemagne's keen interest in music explains why certain monasteries of his reign notably those at Metz and Trier—became centers for church music.

Charlemagne brought monks from Rome to stabilize and reform church music in his kingdom as part of his overall plan of liturgical renovation. In the earlier period of Christianity's growth quite diverse traditions of ecclesiastical music developed in various parts of the West. Roman music represented one tradition-later called Gregorian chant after Pope Gregory the Great (540-604), who was believed to have codified the music in the late sixth century. Milan had its own musical tradition, known as Ambrosian music-in honor of Saint Ambrose, who had been a noted hymn writer, as Saint Augustine attests in the Confessions. There was a peculiar regional style of music in Spain known as Mozarabic chant, while the Franks also had their own peculiar style of chant. All of these styles derive from earlier models of music that have their roots in Hebrew, Greco-Roman, and Byzantine styles. Lack of documentation permits only an educated reconstruction of this early music and its original development.

For an example of Gregorian Chant, play "Passer invenit sibi domum" on the Listening CD.

Gregorian chant, as we know it today, was not codified until the eleventh and twelfth centuries, so it is rather difficult to reconstruct precisely the music of Charlemagne's court. It was probably a mixture of Roman and Frankish styles of singing. It was *monophonic* (one or many voices sang a single melodic line) and more often than not lacked musical accompaniment in the monastic churches. Most scholars believe that the majority of music consisted of simple chants for the recitation of the psalms at the Divine Office; more elaborate forms were used for the hymns of the office and the Mass chants. The music was simply called *cantus planus* ("plainsong or plainchant").

In its more elementary form the chant consisted of a single note for each syllable of a word. The basic symbols used to notate Gregorian chant were called *neums*. Using the Gregorian notational system with its four-line staff and the opening line of Psalm 109, *Dixit Dominus Domino Meo, sede a dextris meis* (The Lord said to my Lord: sit on my right hand), a line of syllabic chant would look like this:

<				• • •	•	•	• •	• •		•
	it Dór	ninus	Dómin	o mé-	0 :	* Séc	de a	déxtris	mé-	is

Even in the earliest form of chants, a cadence was created by emphasizing the final word of a phrase with the addition of one or two extra notes, as above. Later, more notes were added to the final words or syllables for elaboration and variation. For example:

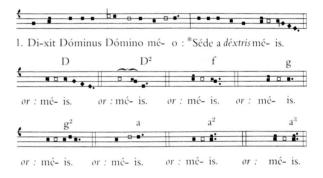

The simplicity of syllabic chant should not be regarded as useful only for the monotonous chanting of psalm verses. Very simple yet hauntingly melodic Gregorian compositions still exist that do not use elaborate cadences but rely on simple syllabic notes. A fine example is the Gregorian melody for the Lord's Prayer, reproduced here in modern notation. No rests are indicated in the musical text; the singer should simply breathe on a skipped note (it is presumed that not all would skip the same note) so that the music flows without pause. Ordinarily, these chants would be sung *a capella* (without musical accompaniment).

Certain phrases, especially words of acclamation (like *Alleluia*) or the word at the end of a line, were elaborated beyond the few notes provided in syllabic chant. This extensive elaboration of a final syllable (or any syllable) by a chain of intricate notes was called a *melisma*. An example of melismatic chant may be noted in the elaboration of the final *-ia* of the Easter *Alleluia* sung at the Easter Mass:

LITURGICAL MUSIC AND THE RISE OF DRAMA

The Liturgical Trope

One development connected with melismatic chant which evolved in the Carolingian period was the *trope*. Since books were scarce, monks memorized a great deal of liturgical chant. As an aid to memorization and to also provide some variety in the chant, words would be added to the long melismas. These words, tropes, would be verbal elaborations of the content of the text. Thus, for example, if there was a melismatic *Kyrie Eleison* (the Greek "Lord, have mercy on us" retained in the Latin Mass) with an elaboration of notes for the syllables *ri-e* of Kyrie, it became customary to add words such as *sanctus* (holy), *dominus* (lord), and the like, which were sung to the tune of the melisma. The use of tropes grew rapidly

and became standard in liturgical music until they were removed from the liturgy at the time of the Counter-Reformation in the sixteenth century.

Scholars have pointed to the introduction of tropes into liturgical music as the origin of drama in the Western world. There had of course been drama in the Classical and Byzantine worlds, but drama in Europe developed from the liturgy of the medieval church after it had largely been lost (or suppressed) in the very early Middle Ages.

A ninth-century manuscript (preserved at the monastery of Saint Gall) preserves an early trope that was added to the music of the Easter entrance hymn (the *Introit*) for Mass. It is in the form of a short dialogue and seems to have been sung by either two different singers or two choirs. It is called the *Quem Quæritis* trope from its opening lines:

The Quem Quæritis Trope

De Resurrectione	Of the Lord's Resurrec-
Domini	tion
Int[errogatio]: Quem quæritis in sepulchro, {o} Christicolæ?	Question [of the an- gels]: Whom seek ye in the sepulcher, O followers of Christ?
R[esponsio]: Jesum Nazarenum crucifixum, o cœlicolæ.	Answer [of the Marys]: Jesus of Nazareth, which was cruci- fied, O celestial ones.
[Angeli:] Non est hic;	[The angels:] He is not
surrexit, sicut,	here; he is risen,
prædixerat.	just as he foretold.
Ite, nuntiate quia	Go, announce that he is
surrexit de sepulchro.	risen from the sepulchre.

Very shortly after the introduction of this trope into the Easter Mass the short interrogation began to be acted, not at Mass but at the end of the night services preceding Easter dawn. The dialogue of the *Quem Quæritis* was not greatly enlarged but the directions for its singing were elaborated into the form of a short play. By the eleventh and twelfth centuries, the dialogue was elaborated beyond the words of the Bible and more persons were added. By the twelfth century, the stories took on greater complexity.

It was a logical step to remove these plays from the church and perform them in the public square. By the fourteenth century, sizable cycles of plays were performed in conjunction with various feast days and underwritten by the craft or merchants' guilds. Some of these cycles acted out the major stories of the Bible, from Adam to the Last Judgment. The repertory also began to include plays about the lives of the saints and allegorical plays about the combats of virtue and vice, such as the fifteenth-century work *Everyman*. These plays were a staple of public life well into the sixteenth century. William Shakespeare, for example, may well have seen such plays in his youth.

Everyman

THE MORALITY PLAY: EVERYMAN

Everyman is a fifteenth-century play that may well be a translation from a much earlier Dutch play. The subject is no longer a redoing of a biblical theme but rather the personification of abstractions representing a theme dear to the medieval heart: the struggle for the soul. The unprepared reader of Everyman will note the heavy-handed allegorizing and moralizing (complete with a "Doctor" who makes a final appearance to point up the moral of the play) with some sense of estrangement, but with a closer reading, students will also note the stark dignity of the play, the earnestness with which it is constructed, and the economy of its structure. Written in rather spare rhyming couplets, Everyman is a good example of the transitional play that forms a link between the earlier liturgical drama and the more secular drama that was to come at the end of the English medieval period.

The plot of Everyman is simplicity itself; it is quickly summarized by the messenger who opens the play. Everyman must face God in final judgment after death. None of the aids and friends of this life will support Everyman, as the speeches of the allegorical figures of Fellowship and others make clear. The strengths for Everyman come from the aiding virtues of Confession, Good Deeds, and Knowledge. The story, however, is not the central core of this play; the themes that run through the entire play are what should engage our attention. First is the common medieval notion of life itself as a pilgrimage, a notion that comes up again and again. It is embedded not only in the medieval penchant for pilgrimage but the use of that term (as one sees, for example, in Chaucer) as a metaphor. Second, the notion of the inevitability of death as the defining action of human life is omnipresent in medieval culture. Everyman has an extremely intense memento mori ("Keep death before your eyes!") motif. Finally, medieval theology places great emphasis on the will of the human being in the attainment of salvation. It is not faith (this virtue is presumed) that will save Everyman; his or her willingness to learn (Knowledge), act (Good Deeds), and convert (Confession) will make the difference between salvation and damnation.

The Messenger says that *Everyman* is "By figure a moral play." It is meant not merely to instruct on the content of religion (as does a mystery play) but to instruct for the purposes of moral conversion. The earlier mystery plays usually point out a moral at the end of the performance. The morality play uses its resources to moralize throughout the play.

The one lingering element from the liturgy in a play like *Everyman* is its pageant quality: The dramatic force of the presentation is enhanced by the solemn wearing of gowns, the stately pace of the speeches, and the seriousness of the message. The play depends less on props and place. Morality plays did not evolve directly out of liturgical drama (they may owe something to the study of earlier plays based on the classics studied in schools) but the liturgical overtones are not totally absent.

Nonliturgical Drama

At the end of the early Middle Ages we also have evidence of plays that were not dependent upon liturgical worship. Thus, a German nun-poet named Hroswitha (or Roswitha; the name is spelled variously), who lived at the aristocratic court of Gandersheim and died around the year 1000, has left us both a collection of legends written in Latin and six plays modeled on the work of the Roman dramatist Terence. What is interesting about this well-educated woman is the broad range of her learning and her mastery of classical Latin in an age that did not put a high premium on the education of females. Scholars also point out that her prose legend called *Theophilus* is the first known instance in German literature of the Faust theme—the selling of one's soul to the devil for material gain and public glory.

Hroswitha's plays were probably meant to be read aloud by a small circle of literate people, but there is some internal evidence that they may also have been acted out in some rudimentary fashion. They are heavily moralistic (typically involving a religious conversion or steadfastness in faith during a time of persecution) and very didactic. In the play The Conversion of the Harlot Thaïs, for example, the holy man Pafnutius begins with a long conversation with his disciples on a liberal education and the rules of musical proportion and harmony. Such a discussion would seem a wild digression to us today, but for her audience it would be a way not only of learning about the liberal arts but a reminder that their study inevitably leads to a consideration of God. That her plays do not have a finished dramatic quality underscores the fact that she was the *first* dramatist writing in Germany (as well as Germany's first female poet). Her model was the ancient drama of Rome as far as style was concerned, but her intention was to use that style to educate and convert. She was a direct heir of the humane learning that developed in the Carolingian and Ottonian periods.

THE LEGEND OF CHARLEMAGNE: *song of roland*

Charlemagne's kingdom did not long survive intact after the death of the emperor. By the tenth century, the Frankish kingdom was fractured and Europe reduced to a state worthy of the name "Dark Ages." Anarchy, famine, ignorance, war, and factionalism were constants in tenth-century Europe; Charlemagne's era was looked back to as a long-vanished Golden Age. By the twelfth century, Charlemagne's reputation was such that he was canonized (in Aachen on December 29, 1165) by Emperor Frederick Barbarossa. Charlemagne's cult was immensely popular throughout France—especially at the royal abbey of Saint Denis in Paris, which made many claims of earlier links with the legendary emperor.

A fifteenth-century oil painting in Aachen depicts an idealized Charlemagne as saint, wearing the crown of the Holy Roman Emperor and carrying a model of the church he had built at Aachen. Frederick Barbarossa commemorated the canonization by commissioning a great wrought-bronze candelabrum to hang in the Aachen cathedral. He also ordered a gold reliquary (now in the Louvre in Paris) to house the bones of one of his saintly predecessor's arms [9.3]; another reliquary, in the form of a portrait bust that contains fragments of Charlemagne's skull, is in the cathedral treasury at Aachen.

The memory of Charlemagne and his epoch was kept more vividly alive, however, in cycles of epic poems and in tales and memoirs developed, embroidered, and disseminated by poets and singers throughout Europe from shortly after Charlemagne's time until the late Middle Ages. These are the famous *chansons de geste* ("songs of deeds") or, as some were called, *chansons d'histoire* ("songs of history"). Of these songs, the oldest extant as well as the best and most famous—is the *Song of Roland*.

The Song of Roland was written sometime late in the eleventh century, but behind it lay some three hundred years of oral tradition and earlier poems celebrating a battle between Charlemagne's army and a Muslim force at the Spanish border. Charlemagne did indeed campaign against the emirate of Spain in 777 and 778 without conclusive result. In August 778, Charlemagne's rear guard was ambushed by the Basques while making its way through the Pyrenees after the invasion of Spain. The real extent of that battle (later placed, on not too much evidence, at the town of Roncesvalles) is unclear. Some experts maintain that it was a minor skirmish, remembered in the area in local legends later told and retold (and considerably embroidered in the process) by monks of the monasteries and sanctuaries on the pilgrimage routes to the great shrine of Saint James at Santiago de Compostela in Spain. Other historians insist that the battle was a horrendous bloodbath for the army of Charlemagne and that the tale was carried back to the

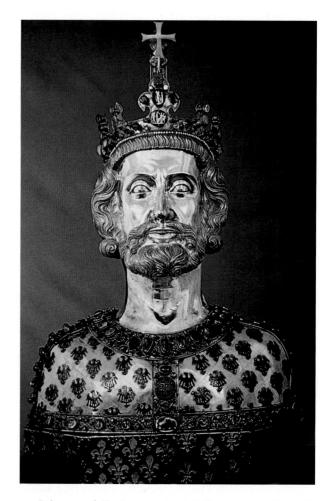

9.3 Reliquary of Charlemagne, Bust of Charlemagne after 1349; crown before 1349. Cathedral Treasury, Aachen, Germany. Reliquaries of this type are containers for some relic of the person depicted by the statue, in this case the crown of Charlemagne's skull.

Frankish cities; the legend was transformed as it was repeated by the descendants of the few survivors.

El Camino de Santiago

In any event, by the eleventh century the tale was widely known in Europe. Excerpts from the *Song of Roland* were sung to inspire the Norman army before the Battle of Hastings in 1066, and in 1096 Pope Urban II cited it in an appeal to French patriotism when he attempted to raise armies for a crusade to free the Holy Land. Medieval translations of the poem into German, Norse, and Italo–French attest to its widespread popularity outside the French-speaking area.

The *Song of Roland* is an epic poem; its unknown writer or writers had little interest in historical accuracy or geographic niceties. Its subject matter is the glory of the military campaign, the chivalric nature of the true

knight, the constant possibility of human deviousness, and the clash of good and evil. The poem, although set in the eighth century, reflects the military values and chivalric code of the eleventh century.

The story is simple: Muslims attack the retreating rear portion of Charlemagne's army (through an act of betrayal) while it is under the command of Roland, a favorite nephew of the emperor. Roland's army is defeated, but not before he sounds his ivory horn to alert the emperor to the peril. The emperor in turn raises a huge army from throughout Christendom while the Muslims also raise a great force. An epic battle follows; Charlemagne, with divine aid, is victorious.

The *Song of Roland* is some four thousand lines long; it is divided into stanzas, and each line contains ten syllables. It is impossible to reproduce the rhyme in English, since each stanza ends with an assonance, so the poem is best read in blank verse translation—although that sacrifices the recitative quality of the original.

This poem was meant to be heard, not read. It was recited by wandering minstrels—*jongleurs*—to largely illiterate audiences. This fact explains the verse style, the immediacy of the adjectives describing the characters and the situations, and the somewhat repetitive language. The still-unexplained AOI at the end of many stanzas may have something to do with the expected reaction of the *jongleur* as he uttered that particular sound to give emphasis to a stanza. (Some sense of the immediacy of the original may be gained by a reader today who declaims some of these stanzas with gestures and appropriate pauses.)

Certain details of the poem merit particular attention. A portion of the poem recounts Charlemagne's arrival on the scene and his victory over the Saracens who are beleaguering the forces commanded by Roland. Most striking is the mixture of military and religious ideals, not an uncommon motif in the medieval period. This mixture is reflected not only in the imagery and in the plot (Charlemagne's prayer keeps the sun from setting in order to allow time for victory, an echo of the biblical siege of Jericho by Joshua) but also in the bellicose Archbishop Turpin. Christian valor is contrasted with Saracen wickedness and treachery; the anti-Muslim bias of the poem is clear. The Muslim Saracens are pagans and idolaters-an odd way to describe the rigidly monotheistic followers of Islam. The Song of Roland, like much of the epic tradition from which it springs, is nevertheless devoted to the martial virtues of courage and strength, the comradeship of the battlefield, and the power of great men as well as the venality of evil ones.

The *Song of Roland* was immensely popular in its own time. It spawned a number of other compositions like the *Pseudo Turpin* and the *Song of Aspremont* in order to continue the story or elaborate portions of it. At a much later time in Italy the story was redone in the telling of the exploits of Orlando (Roland). To this day, children in Sicily visit the traditional puppet shows in which the exploits of brave Roland and his mates are acted out with great clatter and verve. Spectators at those shows witness stories that go back to the beginnings of the medieval period.

THE VISUAL ARTS

The Illuminated Book

Given Charlemagne's preoccupation with literary culture, it should not be surprising that a great deal of artistic effort was expended on the production and illumination of manuscripts. Carolingian manuscripts were made of parchment (treated animal skins, mainly from cows and sheep) since papyrus was unavailable and the process of papermaking was unknown during this period. For very fine books, the parchment was dyed purple and the letters were painted on with silver and gold pigments.

While a good deal of decoration of Carolingian manuscripts shows the influence of Irish models, the illustrations often show other influences. This is strikingly apparent in the illustrations of the *Gospel Book of Charlemagne* (800–810), where it is clear that the artists were conscious of the Roman style [9.4]. The page showing the four evangelists with their symbolic emblems is strikingly classical: The four evangelists are toga-clad like ancient Roman consuls. There is some evidence that the artists attempted some experiments in three-dimensionality. The wooded background in the receding part of the upper two illustrations tends to bring the evangelists forward and thus diminish the flatness we associate with both Byzantine and Celtic illustrations.

The Utrecht Psalter (so-called because its present home is the University of Utrecht in Holland) has been called the masterpiece of the Carolingian Renaissance. Executed at Rheims sometime around 820 to 840, it contains the whole psalter with wonderfully free and playful pen drawings around the text of the psalms. The figures are free from any hieratic stiffness; they are mobile and show a nervous energy. The illustration for Psalm 150, for example, has a scene at the bottom of the page showing various figures "praising God with horn and cymbals" [9.5]. There are two other interesting aspects of the same illustration. One is that the figures are in the act of praising Christ, who stands at the apex of the illustration with the symbols of his resurrection (the stafflike cross in his hand). Although the psalms speak of the praise of God, for the medieval Christian the "hidden" or true meaning of the scriptures was that they speak in a prefigurative way of Christ. Thus the psalmist who praises God is a "shadow" of the church that praises Christ. A second thing to note in this illustration is the bottom-center scene of an organ with two men working the bellows to supply the air.

The style of the *Utrecht Psalter* has much in common with early Christian illustration. The lavish purple and

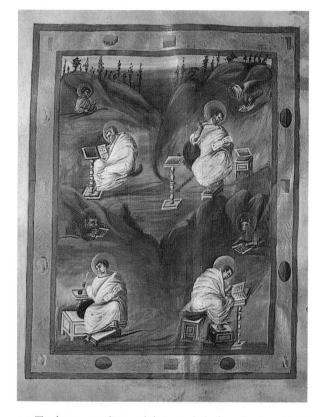

9.4 The four evangelists and their symbols, from the *Gospel Book of Charlemagne*, Palace School of Charlemagne, Aachen, early ninth century. Manuscript illustration. Cathedral Treasury, Aachen.

silver manuscripts show a conscious imitation of Byzantine taste. We have also noted the influence of Celtic illustration. Carolingian manuscript art thus had a certain international flavor, and the various styles and borrowings offer ample testimony to the cosmopolitan character of Charlemagne's culture. This universality diminished in the next century; not until the period of the so-called International Style in the fourteenth century would such a broad eclecticism again be seen in Europe.

One other art form that developed from the Carolingian love for the book is ivory carving. This technique was not unique to Charlemagne's time; it was known in the ancient world and highly valued in Byzantium. The ivories that have survived from Charlemagne's time were used for book covers. One beautiful example of the ivory carver's art is a crucifixion panel made at the palace workshop at Aachen sometime in the early ninth century [9.6]. Note the crowded scenes that surround the crucifixion event. Reading clockwise from the bottom left, one sees the Last Supper, the betraval in the garden, and, at the top, a soldier piercing Jesus' side. As a balance at the top right another soldier offers Jesus a vinegar-soaked sponge on a lance. Below that scene is one of the women at the tomb and, at the bottom, the incredulity of Thomas. Framing these scenes above are the ascension of Christ on the left and the Pentecost on the right, the two scenes separated by a stylized sun and moon. The entire ivory is framed with geometric and abstract floral designs. The composition indicates that the carver had seen some examples of early Christian carving, whereas the beardless Christ and the flow of the drapery indicate familiarity with Byzantine art.

One surviving Carolingian manuscript that allows us to see both illumination and ivorywork is the *Dagulf Psalter*, made as a gift for Pope Hadrian I, who reigned from 772 to 795. The psalms are not illustrated like the ones in the *Utrecht Psalter*; instead, the illustrator begins a tradition that will be fairly normal for future psalters: He enlarges and illuminates the initial letter of the first, fifty-first, and hundred-first psalms. The *B* of the first word of Psalm 1, *Beatus vir qui* ("Blessed is the man who"), is enlarged and decorated in the swelling style of Celtic illumination; the same patterns are echoed on the page margin [9.7].

9.5 *Psalm 150*, from the *Ultrecht Psalter*, from Hautvilliers, France, (near Reims) c. 820–840, $127/8'' \times 10''$ (33 × 26 cm). University Library, Utrecht, Netherlands. This page is typical of the quick nervous style of the unknown illustrator who did similar symbolic drawings for the entire psalter of 150 psalms.

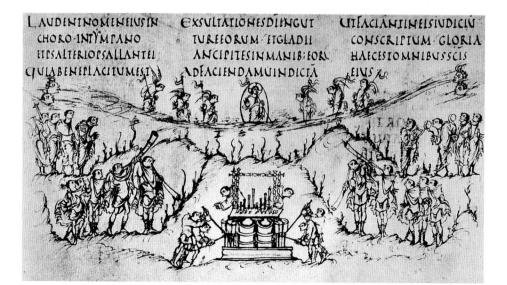

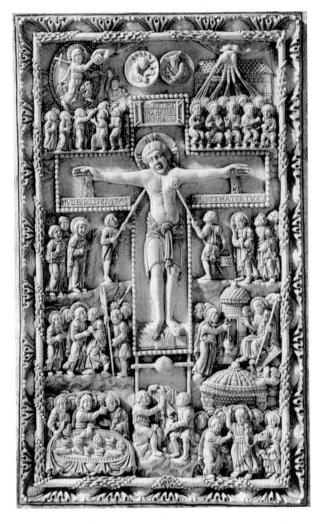

9.6 *Crucifixion.* Palace School of Charlemagne, early ninth century. Ivory $97/8'' \times 61/2''$ (25×16 cm). Cathedral Treasury of Saint Just, Narbonne. Such ivories were often used as covers for Gospel books and other liturgical works and were frequently produced as gifts for special occasions.

The ivory covers of the psalter have been preserved and are now in the Louvre [9.8]. Rather than the usual crowded scenes of most of these covers, the ivories from the *Dagulf Psalter* are composed of two scenes on each of the panels; the scenes make references to both the psalter and the papal connection. The top-left panel shows David and his court; in the scene below, David is shown singing one of his psalms to the accompaniment of his lyre. The top-right panel depicts Saint Jerome receiving a letter from Pope Damasus instructing him to correct the psalter; the scene below depicts Jerome in the act of working on the psalter while a grateful clergy looks on.

One other advance in manuscript production during the Carolingian period was in the area of fine handwriting or, as it is more technically known, calligraphy. Handwriting before the Carolingian period was cluttered, unformed, and cramped. It was very difficult to read because of its erratic flourishes and lack of symme-

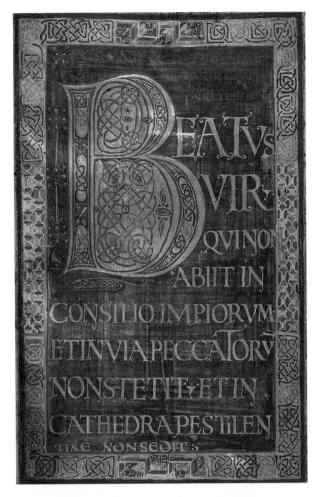

9.7 Beginning of Psalm 1 from the *Dagulf Psalter*, late eighth century. Manuscript illustration, 7 $1/2'' \times 4$ 5/8'' (19 × 12 cm). Austrian National Library. This psalter may well have been produced by a woman's hand at a convent.

try. After 780, scribes in Carolingian scriptoria began to develop a precise and rounded form of lettering that became known as the Carolingian *minuscule*, as opposed to the *majuscule* or capital letter. This form of lettering was so crisp and legible that it soon became a standard form of manuscript writing. Even in the fifteenth century, the Florentine humanists preferred the minuscule calligraphy for their manuscripts. When printing became popular in the early sixteenth century, printers soon designed type fonts to conform to Carolingian minuscule. It superseded Gothic type in popularity and is the ancestor of modern standard lettering systems.

Charlemagne's Palace at Aachen

Beyond his immediate commercial, military, and political goals, Charlemagne had an overwhelming desire to

9.8 Cover panels for the *Dagulf Psalter*, late eighth century. Ivory. $61/8'' \times 31/8''$ (17×8 cm). Louvre, Paris. Jerome correcting the psalter (lower right panel) reflects common work in the monasteries of the Carolingian period.

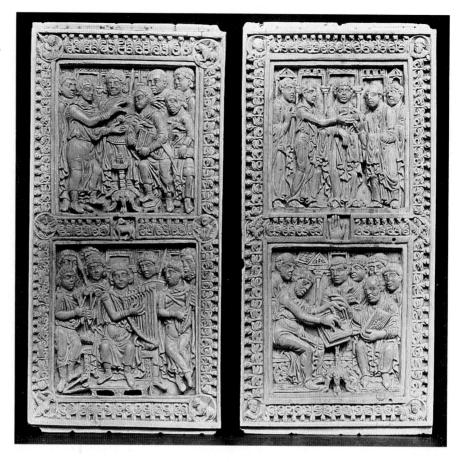

model his kingdom on that of ancient Rome. His coronation in Rome symbolized the fusion of the ancient imperial ideal with the notion of Christian destiny. It was not accidental that Charlemagne's favorite book—he had it read to him frequently at meals—was Augustine's *The City of God.* One highly visible way of making this ideal concrete was to build a capital.

At Aachen (in French it is called Aix-la-Chapelle) Charlemagne built his palace and royal chapel [9.9]. Except for the chapel (incorporated into the present cathedral), all the buildings of Charlemagne's palace have been destroyed and the Aachen city hall (itself built in the fourteenth century) covers the palace site. The palace proper was a long one-story building; its main room was the large royal hall, which measured roughly $140' \times 60'$ (42.7 × 18.3 m). So richly decorated that even the fastidious and sophisticated Byzantine legates were favorably impressed, the room had as its focal point at the western end the emperor's throne. In front of the palace was an open courtyard around which were outbuildings and apartments for the imperial retinue. Around the year 800, the courtyard held a great bronze statue of Theodoric, once king of the Ravenna Ostrogoths, that Charlemagne had brought back from Ravenna to adorn his palace.

The royal hall was joined to Charlemagne's chapel by a long wooden gallery. This royal chapel was probably

built around 795. With sixteen exterior walls, the chapel was a central-plan church based on an octagon [9.10]; its model undoubtedly was the Church of San Vitale in Ravenna, which Charlemagne had visited and admired. The octagon formed the main nave of the church, which was surrounded by cloisters; the building itself was twostoried. At the eastern end of the chapel was an altar dedicated to the Savior, with a chapel dedicated to the Virgin directly below it. The central space was crowned with an octagonal cupola, the lower part of which was pierced by windows-the main source of light in the church. The outside of the church was austere; the inside was richly ornamented with marbles brought to Aachen from Ravenna and Rome. The interior of the cupola was decorated with a rich mosaic depicting Christ and the twenty-four elders of the Apocalypse (now destroyed; the present mosaics in the chapel are modern copies) while the other planes of the interior were covered with frescoes (now also destroyed). The railing of the upper gallery was made from bronze screens that are still in place, wrought in geometrical forms.

The chapel included two objects that emphasized its royal status: the most important relic of the kingdom, Saint Martin of Tours' cape, and a throne. Charlemagne's throne was on the second floor, opposite the Savior chapel. From this vantage point, the emperor could observe the liturgical services being conducted in the

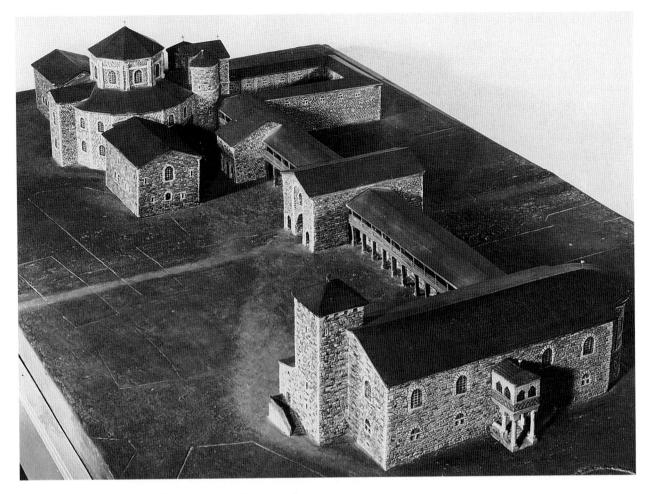

9.9 Model reconstruction of Charlemagne's palace at Aachen. Romisch-Germanisches Zentral Museum, Mainz. The royal hall with its long gallery is in the foreground. The octagonal royal chapel in the background should be compared to San Vitale in Ravenna.

Savior chapel and at the same time view the Virgin chapel with its rich collection of relics.

Charlemagne's throne, with its curved back and armrests, was mounted by six stone steps. This arrangement was obviously taken from King Solomon's throne as described in the Bible (I Kings 10: 18–19). Charlemagne was to be thought of as the "new Solomon" who, like his ancient prototype, was an ambitious builder, a sagacious lawgiver, and the symbol of national unity. That this analogy was not an idle fancy is proved by a letter to the emperor from Alcuin, Charlemagne's friend and tutor, in anticipation of his return to Aachen: "May I soon be allowed to come with palms, accompanied with children singing psalms, to meet your triumphant glory, and to see once more your beloved face in the Jerusalem of our most dear fatherland, wherein is the temple set up to God by this most wise Solomon."

9.10 Interior of the Palatine Chapel of Charlemagne, Aachen. This view, toward the east, shows the emperor's tribune in the second story. The ceiling mosaics and the lower-level inscriptions are modern.

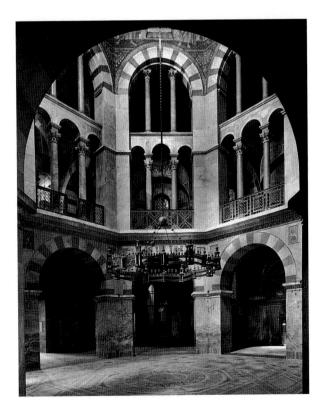

The Carolingian Monastery

In the period between Saint Benedict and Charlemagne, the Benedictine monastery underwent a complex evolution. Originally the monasteries were made up of small communities with fewer than fifteen members who led a life of prayer and work in a rather simple setting. With the decline of city, life and the disorders brought on by the repeated invasions of the Barbarians after the fifth century, the monastery became increasingly a center of life for rural populations. Monasteries not only kept learning alive and worship intact but were also called upon to serve as shelters for the traveler, rudimentary hospitals for the sick, places of refuge in time of invasion, granaries for the farmer, centers of law for both religious and civil courts, and places that could provide agricultural services such as milling and brewing.

This expansion of services, making the monastery into what has been called a "miniature civic center," inevitably changed the physical character of the monastery compound itself. By Charlemagne's time the monastery was an intricate complex of buildings suitable for the many tasks it was called upon to perform [Table 9.1]. One vivid example of the complexity of the Carolingian monastery can be gained by a study of a plan for an ideal monastery developed about 820 at the Benedictine abbey of Saint Gall in present-day Switzerland [9.11].

In the Saint Gall plan the monastic church dominated the area. Set off with its two round towers, it was a basilica-style church with numerous entrances for the use of the monks. To the south of the church was a rectangular garden space surrounded by a covered walkway (the *cloister*) from which radiated the monk's dormitory, dining hall (*refectory*), and kitchens. To the north of the church were a copying room (*scriptorium*), a separate house for the abbot, a school for youths and young novices, and a guest house. To the extreme south of the church were ranged workshops, barns, and other utilitarian outbuildings. To the east beyond the church were an infirmary and a separate house for aspirant monks (the *novitiate*), gardens, poultry houses, and the community cemetery.

The Romanesque Style

The plan of Saint Gall was never realized in stone, but the Benedictines did participate in ambitious architectural works after the Carolingian period. In the eleventh century, after a long period of desolation and warfare, Europe began to stir with new life. Pilgrimages became very popular as travel became safe. Pilgrimage routes in particular to sites in Spain, England, and Italy—crisscrossed Europe. Crusades were mounted to free the holy places of the Middle East from the Muslims so that pilgrims could journey in peace to the most desired goal of the pilgrim: Jerusalem. During this period monks built and maintained pilgrimage churches and hostels on the major routes of the pilgrims.

TABLE 9.1 The Major Parts of the Monastery		
The Monastic Church	Site of the major religious ser- vices.	
The Chapter House	Ordinary meeting room of the monastic community; the name comes from the custom of read- ing a chapter of the Rule of Saint Benedict aloud each day to the community.	
The Cloister	Technically, the enclosed part of the monastery; more commonly, the enclosed garden and walk- way in the interior of the monastery.	
The Scriptorium	Library and copying area of the monastery.	
The Refectory	Monks' dining hall.	
The Novitiate	Quarters for aspirant monks not yet vowed in the community.	
The Dormitory	Sleeping area for the monks.	
The Infirmary	For sick, retired, and elderly monks.	
The Guest House	For visitors, retreatants, and travelers.	
The Outbuildings	Buildings for the farms and crafts of the monastery. Small buildings far from the main monastery that housed farmer monks were called <i>granges</i> .	

The building style of this period (roughly from 1000 to 1200) is called *Romanesque* because the architecture was larger and more Roman-looking than the work done in the earlier medieval centuries. The two most striking characteristics of this architecture were the use of heavy stone arches and generous exterior decoration, mainly sculpture. The Romanesque style had two obvious advantages. First was that the use of heavy stone and masonry walls permitted larger and more spacious interiors. Second, the heavy walls could support stone arches (mainly the Roman barrel arch), at least in France and Spain, which in turn permitted fireproof stone and masonry roofs. Long experience had shown that basilicastyle churches, with their wooden trusses and wooden roofs, were notoriously susceptible to destruction by fire.

Romanesque architecture sprouted all over Europe, and while it showed great regional variation, its main lines are distinct. The Benedictine pilgrimage Church of Saint Sernin in Toulouse was designed to accommodate the large number of pilgrims as they made their way to the famous shrine of Santiago de Compostela in Spain. A glimpse at the floor plan [9.12] and the interior [9.13] shows clearly that the generous interior space was articulated in a manner such that large numbers of persons besides the monastic community could move freely through the building. For example, the floor plan allows

VALUES

Feudalism

The social organization of late Carolingian society was based on *feudalism*; a form of government that had its primary focus on the holding of land. Theoretically, the monarch held all land with nobles, who swore allegiance to the monarch, possessing land as a gift from the monarch. Under the nobles were persons, again pledging allegiance to their noble superiors, who held a smaller piece of land (e.g., a manor). The agricultural peasants (serfs) had the use of the land in exchange for fees and for cultivating a certain percentage for the lord above them. The clergy, also, had the legal right to certain tithes on the production of goods and services. This highly stratified system also impacted the system of warfare. Each knight (a small landholder) pledged loyalty to a higher noble who in turn pledged loyalty to the crown. Armies could be raised when, for instance, a monarch would call up the nobles pledged to him and they in turn would call up the knights who had sworn loyalty to them.

Feudal society existed only so long as a country remained rural and without large towns. Italy, with its long history of town life, never had as strong a feudal society as did the Frankish lands of what is today France and Germany. Feudalism was a highly static, hierarchical, and basically agricultural way of organizing life. It would undergo vast changes with the slow emergence of city life and the increased mobility brought on by vigorous trade and such military movements as the Crusades.

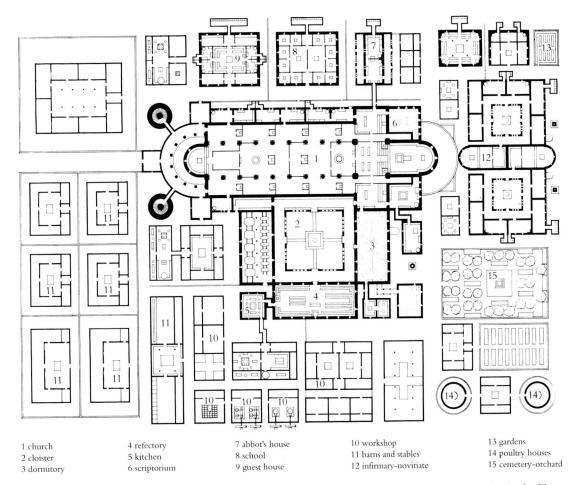

9.11 Plan for an ideal monastery, c. 820. Reconstruction by Walter Horn and Ernest Born from the manuscript in the library of the Monastery of Saint Gall in Switzerland. The original plan, 3'8'' (1.12 m) across, was drawn to scale on vellum. The monastery site would have been $480' \times 640'$ (146×195 m), and would have housed 120 monks and 170 serfs. It was a plan for future monasteries and exerted, over the centuries, considerable influence on monastery construction.

for an aisle parallel to the nave to go completely around the church. In that fashion the monastic choir, which extended out into the nave, was circumvented by the faithful—who could make a complete circle of the church without disturbing the monks.

Exterior church decoration was almost unknown in the Carolingian period, but during the Romanesque period there was a veritable explosion of exterior sculpture. The lack of interior light (precluded by the thick solid walls needed for roof vaulting) in a sense drove the artist outside. A favorite area of decoration was the *portal* or doorway, since the crowds would pass through the doors to enter the church and receive edifying instruction in the process. The artist might decorate a door jamb [9.14], a capital [9.15], or the central supporting post of a portal, the *trumeau* [9.16].

The fullest iconographic program of the Romanesque sculptor can usually be found in the half-moon-shaped space called the *tympanum* over the portal; Romanesque churches in France offer many splendid examples of this elaborated art. The sculptural program over the inner west door of the Benedictine abbey Church of Sainte

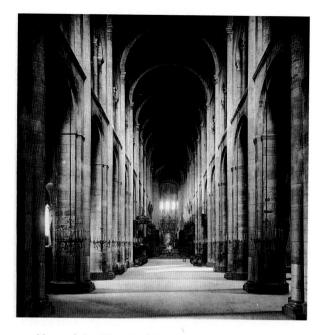

9.13 Nave of the Church of Saint Sernin, Toulouse, c. 1080–1120. The massive ceiling vaults are called *barrel* or *tunnel* vaults. The heavy stonework required heavy walls to support the weight of the vaults. The galleries, with their own vaults, also helped to support the cutstone ceiling vaults.

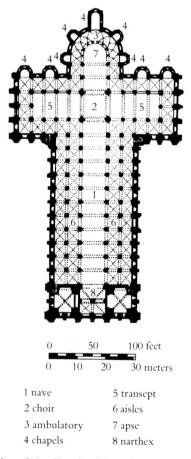

9.12 Floor plan of the Church of Saint Sernin, Toulouse. Note the ample aisles for easy passage of pilgrim groups around the entire church. The radiating chapels around the ambulatory permitted many priests to celebrate Mass simultaneously.

Madeleine at Vézelay is representative of the elaborated art in stone [9.17].

Church of St. Madeleine

The Vézelay tympanum depicts Christ, ascending into heaven, giving his church the mission to preach the gospel to the entire world. Christ, in the center almond shape called the *mandorla*, sends the power of the Holy Spirit into the apostles who cluster on either side and just below with copies of the Gospel in their hands. Below the apostles the lintel stone depicts the peoples of the world, including fanciful races known to the sculptor only through the legendary travel books and encyclopedias that circulated in Europe. The theme of the exotic peoples to be healed by the Gospel is repeated in the eight arching compartments above the central scene, which depict strange peoples, lepers, cripples, and others who need to hear the Gospel.

The outer arches, or *archivolts*, depict the signs of the zodiac and the symbolic seasons of the year, a reminder that the Gospel depicted in the central scene is to be preached "in season and out"; these symbolic medallions are interspersed with mythical and fantastic beasts. The outer archivolts are purely decorative, derived perhaps

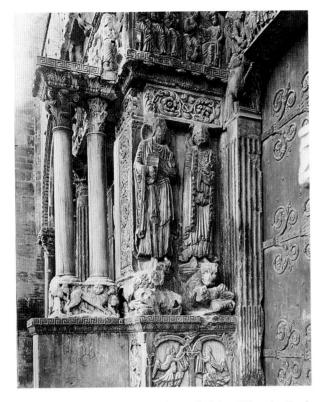

9.14 North jamb on the central portal, Saint Gilles du Gard, France, c. 1140. Notice the echoes of classical column capitals and low-relief carving on the jambs.

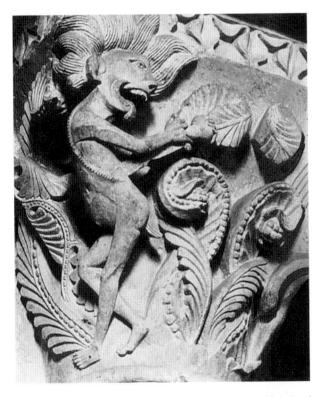

9.15 *Demon of Luxury,* nave capital sculpture, abbey Church of La Madeleine, Vézelay, c. 1130. This kind of extravagant figure would later be criticized by monastic reformers of the twelfth century.

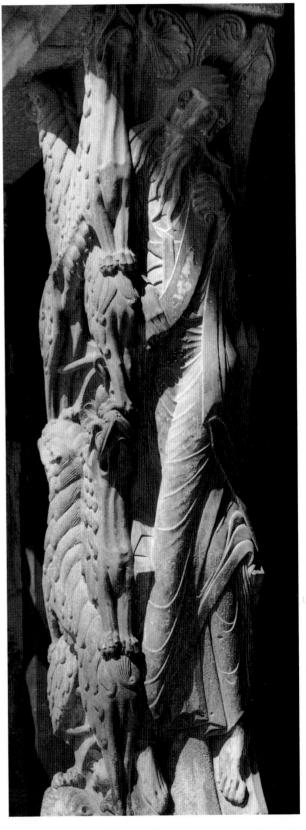

9.16 *The Prophet Jeremiah (Isaiah?)* from the trumeau of the south portal of St. Pierre, Moissac, France, early twelfth century. Lifesize. The serpentine figure of the prophet leans toward the church as he holds the scroll of his biblical book. The lions probably reflect the influence of Islamic art from Spain.

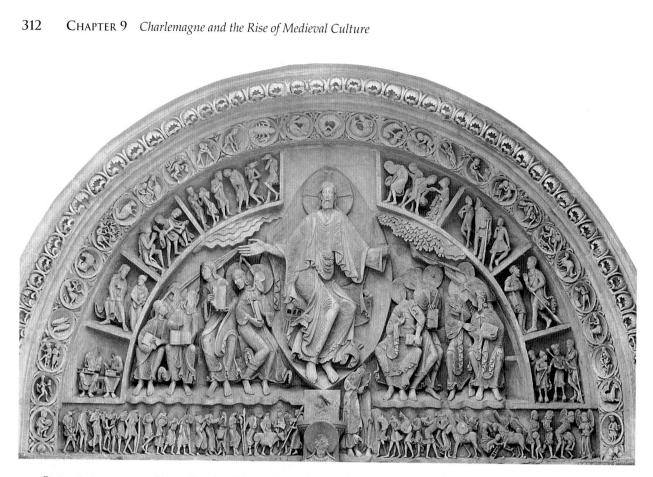

9.17 Pentecost, tympanum, abbey Church of La Madeleine, Vézelay, c. 1120-1132. The lower band of figures reflects all of the peoples of the earth called to salvation by the central figure of Christ.

from Islamic sources known to the artists through the Muslim architecture of Spain.

Romanesque style was a European phenomenon—its variant forms in Italy, Germany, and England give ample testimony-and a summing-up of much of European culture between the end of the Carolingian period and the rise of city life and the Gothic style in the late twelfth century. The roots of the Romanesque were in the Benedictine tradition of service, scholarship, and solidity. Churches like Vézelay also manifest the period's concern with travel, expansion, and the attendant knowledge that comes from such mobility. When reaction came against the more extravagant forms of Romanesque decoration it came from Bernard of Clairvaux (1090-1153), who was primarily a monastic reformer. Bernard was horrified by the fantastic nature of Romanesque sculpture since he felt so many "and so marvelous are the varieties of diverse shapes that we are more tempted to read in the marbles than in the Book and to spend our whole day wondering at these things rather than meditating on the Law of God." Even Bernard's strictures testify to the close relationship between the Benedictines and the Romanesque (especially the French Romanesque), which is another reason the period after Charlemagne and before the primacy of the city can be called simply the Benedictine Age.

SUMMARY

Our attention in this chapter shifted from Byzantium to the West and, more specifically, to the rise of the kingdom of the Franks under Charlemagne. The so-called Carolingian Renaissance rekindled the life of culture after the dark period following the fall of the last Roman emperor in the West in the late fifth century and the rise of the so-called Barbarian tribes.

Charlemagne's reign saw the standardization of monasticism, worship, music, and education in the church. Those reforms would give general shape to Western Catholicism that in some ways endured into the modern period. Equally important was Charlemagne's assumption of the title of Holy Roman Emperor. This act would establish a political office that would exist in Europe until the end of World War I in the twentieth century. It also became a cause for friction between Rome and Constantinople because the Byzantine emperors saw Charlemagne's act as an intrusion on their legitimate claim to be the successors of the old Roman Empire.

The Carolingian world was essentially rural and feudal. Society was based on a rather rigid hierarchy with the emperor at the top, the nobles and higher clergy below him, and the vast sea of peasants bound to the land at the bottom. There was little in the way of city life on any scale. The outpost of rural Europe was the miniature town known as the monastery or the stronghold of the nobles. The rise of the city and increased social mobility would eventually destroy the largely agricultural and feudal society as the High Middle Ages emerged in the eleventh century.

Finally there was Charlemagne as a mythic figure who eventually would be drawn larger than life in the *Song of Roland*. The growth of such myths always occurs because they have some deep desires behind them. In the case of Charlemagne, the desire was to describe the ideal warrior who could perform two very fundamental tasks for Europe: vanquish the Islamic powers that threatened Christian Europe and provide a model for a unified empire (the Holy Roman Empire) that would be both a perfect feudal society and one strong enough to accomplish the first task of destroying Islam. Not without reason was the *Song of Roland* a central poem for the first crusaders who turned their faces to the East.

PRONUNCIATION GUIDE

Aachen:	Ah-ken
Aix-la-Chapelle:	Aches-la-Sha-PELL
Alcuin:	AL-quin
Dagulf:	Dah-gulf
Harun al-Rashid:	Haw-RUNE all-Rah-sheed
horarium:	hoar-ARE-e-um
Hroswitha:	Haw-ros-WITH-ah or Ross-WITH-ah
psalter:	SALT-er
Quem Quæritis:	kwem QUAY-re-tus
Roland:	ROLL-on
Roncesvalles:	Ron-sa-vals
trope:	TROP
Utrecht:	YOU-trek(t)
Vézelay:	Vayz-e-LAY

EXERCISES

- 1. The "seven liberal arts" are divided into the trivium and the quadrivium. How much of the trivium lingers in primary education today? What has been added to those "trivial" subjects?
- 2. Two subjects studied in the quadrivium were music and astronomy. Those subjects were quite different from what we understand them to be today. How were they understood and how do we understand them?
- 3. One feature of the Carolingian period was the central place of monasticism. Why was monasticism exceptionally suited to a time when there was little urban life?
- 4. Many scholars have argued that monasticism is the living out of a utopian ideal. How is monasticism a "utopian" behavior and to what degree is it also a form of countercultural living?
- Why is plainchant (Gregorian chant) ideally suited for congregational singing, especially for the unaccompanied voice?
- Contrast the place of books in early medieval culture and in our own beyond the obvious issue of our better production technologies.
- 7. Drama evolved out of worship in the early medieval period just as Greek tragedy evolved out of worship in its time. Speculate on why there should be this connection between worship and drama.
- 8. Byzantine churches tended to lavish their decorative efforts on the insides of churches while Romanesque churches

tended to decorate the outsides, more especially the façades. Suggest reasons for this widely observable fact.

Further Reading

- Brault, Gerald. (1978). *The song of Roland* (2 vols.). University Park: University of Pennsylvania Press. Excellent bilingual edition with comprehensive notes.
- Bullough, Donald. (1996). *The age of Charlemagne*. New York: Putnam. Well written and lavishly illustrated.
- Dronke, Peter. (1984). *Women writers of the Middle Ages.* New York: Cambridge University Press. An authoritative study.
- McNamara, Joann. (1992). Sainted women of the Dark Ages. Durham, NC: Duke University Press. Excellent sourcebook for the period.
- Price, Lorna. (1982). *The plan of St. Gall in brief.* Berkeley: University of California. An inexpensive version of the two-volume study. Well illustrated and readable text.
- Riché, Pierre. (1978). Daily life in the age of Charlemagne. Philadelphia: University of Pennsylvania. Fascinating reading by the great Carolingian scholar of this age.

Online Chapter Links

For information about the Order of St. Benedict, visit

http://www.osb.org/gen/rule.html

The Medieval Art and Architecture Web site at http://info.pitt.edu/~medart/

provides access to a wide variety of architectural wonders in Europe—including those at St. Denis and Vézelay.

To hear Gregorian Chant, visit the Solesmes Abbey at

http://www.solesmes.com/anglais/ang_solesmes.html

For information about the pilgrimage to El Camino de Santiago visit

http://www.humnet.ucla.edu/santiago/iagohome.html which provides maps, historical accounts, and links to related sites.

A complete text of *Everyman* is available at http://www.fordham.edu/halsall/basis/everyman.html

The Romanesque style of architecture is examined at

http://www.geocities.com/Athens/Parthenon/8063/ romanesque.html

Online Chapter Resources

READING SELECTIONS

HILDEGARD OF BINGEN Selections from Causae et Curae

This passage from the Scivias begins with Hildegard's introduction to the book and, following on that the first vision. Hildegard always begins by describing her vision and then commenting on its meaning. She had so powerful a reputation that Pope Eugene actually requested a copy of her work.

DECLARATION

These Are True Visions Flowing from God

And behold! In the forty-third year of my earthly course, as I was gazing with great fear and trembling attention at a heavenly vision, I saw a great splendor in which resounded a voice from Heaven, saying to me, "O fragile human, ashes of ashes, and filth of filth! Say and write what you see and hear. But since you are timid in speaking, and simple in expounding, and untaught in writing, speak and write these things not by a human mouth, and not by the understanding of human invention, and not by the requirements of human composition, but as you see and hear them on high in the heavenly places in the wonders of God. Explain these things in such a way that the hearer, receiving the words of his instructor, may expound them in those words, according to that will, vision and instruction. Thus therefore, O human, speak these things that you see and hear. And write them not by yourself or any other human being, but by the will of Him Who knows, sees and disposes all things in the secrets of His mysteries."

And again I heard the voice from Heaven saying to me, "Speak therefore of these wonders, and, being so taught, write them and speak."

It happened that, in the eleven hundred and forty-first year of the Incarnation of the Son of God, Jesus Christ, when I was forty-two years and seven months old, Heaven was opened and a fiery light of exceeding brilliance came and permeated my whole brain, and inflamed my whole heart and my whole breast, not like a burning but like a warming flame, as the sun warms anything its rays touch. And immediately I knew the meaning of the exposition of the Scriptures, namely the Psalter, the Gospel and the other catholic volumes of both the Old and the New Testaments, though I did not have the interpretation of the words of their texts or the division of the syllables or the knowledge of cases or tenses. But I had sensed in myself wonderfully the power and mystery of secret and admirable visions from my childhood—that is, from the age of five—up to that time, as I do now. This, however, I showed to no one except a few religious persons who were living in the same manner as I; but meanwhile, until the time when God by His grace wished it to be manifested, I concealed it in quiet silence. But the visions I saw I did not perceive in dreams, or sleep, or delirium, or by the eyes of the body, or by the ears of the outer self, or in hidden places; but I received them while awake and seeing with a pure mind and the eyes and ears of the inner self, in open places, as God willed it. How this might be is hard for mortal flesh to understand.

But when I had passed out of childhood and had reached the age of full maturity mentioned above, I heard a voice from Heaven saying, "I am the Living Light, Who illuminates the darkness. The person [Hildegard] whom I have

chosen and whom I have miraculously stricken as I willed, I have placed among great wonders, beyond the measure of the ancient people who saw in Me many secrets; but I have laid her low on the earth, that she might not set herself up in arrogance of mind. The world has had in her no joy or lewdness or use in worldly things, for I have withdrawn her from impudent boldness, and she feels fear and is timid in her works. For she suffers in her inmost being and in the veins of her flesh; she is distressed in mind and sense and endures great pain of body, because no security has dwelt in her, but in all her undertakings she has judged herself guilty. For I have closed up the cracks in her heart that her mind may not exalt itself in pride or vainglory, but may feel fear and grief rather than joy and wantonness. Hence in My love she searched in her mind as to where she could find someone who would run in the path of salvation. And she found such a one and loved him [the monk Volmar of Disibodenberg], knowing that he was a faithful man, working like herself on another part of the work that leads to Me. And, holding fast to him, she worked with him in great zeal so that My hidden miracles might be revealed. And she did not seek to exalt herself above herself but with many sighs bowed to him whom she found in the ascent of humility and the intention of good will.

"O human, who receives these things meant to manifest what is hidden not in the disquiet of deception but in the purity of simplicity, write, therefore, the things you see and hear."

But I, though I saw and heard these things, refused to write for a long time through doubt and bad opinion and the diversity of human words, not the stubbornness but in the exercise of humility, until, laid low by the scourge of God, I fell upon a bed of sickness; then, compelled at last by many illnesses, and by the witness of a certain noble maiden of good conduct [the nun Richardis of Stade] and of that man whom I had secretly sought and found, as mentioned above, I set my hand to the writing. While I was doing it, I sensed, as I mentioned before, the deep profundity of scriptural exposition; and, raising myself from illness by the strength I received, I brought this work to a close—though just barely—in ten years.

These visions took place and these words were written in the days of Henry, Archbishop of Mainz, and of Conrad, King of the Romans, and of Cuno, Abbot of Disibodenberg, under Pope Eugenius.

And I spoke and wrote these things not by the invention of my heart or that of any other person, but as by the secret mysteries of God I heard and received them in the heavenly places.

And again I heard a voice from Heaven saying to me, "Cry out therefore, and write thus!"

VISION ONE

God Enthroned Shows Himself to Hildegard

I saw a great mountain the color of iron, and enthroned on it One of such great glory that it blinded my sight. On each side of him there extended a soft shadow, like a wing of wondrous breadth and length. Before him, at the foot of the mountain, stood an image full of eyes on all sides, in which, because of those eyes, I could discern no human form. In front of this image stood another, a child wearing a tunic of subdued color but white shoes, upon whose head such glory descended from the One enthroned upon that mountain that I could not look at its face. But from the One who sat enthroned upon that mountain many living sparks sprang forth, which flew very sweetly around the images. Also, I perceived in

this mountain many little windows, in which appeared human heads, some of subdued colors and some white.

And behold, He Who was enthroned upon that mountain cried out in a strong, loud voice saying, "O human, who are fragile dust of the earth and ashes of ashes! Cry out and speak of the origin of pure salvation until those people are instructed, who, though they see the inmost contents of the Scriptures, do not wish to tell them or preach them, because they are lukewarm and sluggish in serving God's justice. Unlock for them the enclosure of mysteries that they, timid as they are, conceal in a hidden and fruitless field. Burst forth into a fountain of abundance and overflow with mystical knowledge, until they who now think you contemptible because of Eve's transgression are stirred up by the flood of your irrigation. For you have received your profound insight not from humans, but from the lofty and tremendous Judge on high, where this calmness will shine strongly with glorious light among the shining ones.

"Arise therefore, cry out and tell what is shown to you by the strong power of God's help, for He Who rules every creature in might and kindness floods those who fear Him and serve Him in sweet love and humility with the glory of heavenly enlightenment and leads those who persevere in the way of justice to the joys of the Eternal Vision."

1 The strength and stability of God's eternal Kingdom

As you see, therefore, *the great mountain the color of iron* symbolizes the strength and stability of the eternal Kingdom of God, which no fluctuation of mutability can destroy; and *the One enthroned upon it of such great glory that it blinds your sight* is the One in the kingdom of beatitude Who rules the whole world with celestial divinity in the brilliance of unfading serenity, but is incomprehensible to human minds. But that *on each side of him there extends a soft shadow like a wing of won- derful breadth and length* shows that both in admonition and in punishment ineffable justice displays sweet and gentle protection and perseveres in true equity.

2 Concerning fear of the Lord

And before him at the foot of the mountain stands an image full of eyes on all sides. For the Fear of the Lord stands in God's presence with humility and gazes on the Kingdom of God, surrounded by the clarity of a good and just intention, exercising her zeal and stability among humans. And thus you can discern no human form in her on account of those eyes. For by the acute sight of her contemplation she counters all forgetfulness of God's justice, which people often feel in their mental tedium, so no inquiry by weak mortals eludes her vigilance.

3 Concerning those who are poor in spirit

And so before this image appears another image, that of a child, wearing a tunic of subdued color but white shoes. For when the Fear of the Lord leads, they who are poor in spirit follow; for the Fear of the Lord holds fast in humble devotion to the blessedness of poverty of spirit, which does not seek boasting or elation of heart, but loves simplicity and sobriety of mind, attributing its just works not to itself but to God in pale subjection, wearing, as it were, a tunic of subdued color and faithfully following the serene footsteps of the Son of God. Upon her head descends such glory from the One enthroned upon that mountain that you cannot look at her face; because He Who rules every created being imparts the power and strength of this blessedness by the great clarity of His visitation, and weak, mortal thought cannot grasp His purpose, since He Who possesses celestial riches submitted himself humbly to poverty.

4 They who fear God and love poverty of spirit are the guardians of virtues

But from the One Who is enthroned upon that mountain many living sparks go forth, which fly about those images with great sweetness. This means that many exceedingly strong virtues come forth from Almighty God, darting fire in divine glory; these ardently embrace and captivate those who truly fear God and who faithfully love poverty of spirit, surrounding them with their help and protection.

5 The aims of human acts cannot be hidden from God's knowledge

Wherefore *in this mountain you see many little windows, in which appear human heads, some of subdued color and some white.* For in the most high and profound and perspicuous knowledge of God the aims of human acts cannot be concealed or hidden. Most often they display both lukewarmness and purity, since people now slumber in guilt, weary in their hearts and in their deeds, and now awaken and keep watch in honor. Solomon bears witness to this for Me, saying:

6 Solomon on this subject

"The slothful hand has brought about poverty, but the hand of the industrious man prepares riches" [Proverbs 10:4]; which means, a person makes himself weak and poor when he will not work justice, or avoid wickedness, or pay a debt, remaining idle in the face of the wonders of the works of beatitude. But one who does strong works of salvation, running in the way of truth, obtains the upwelling fountain of glory, by which he prepares himself most precious riches on earth and in Heaven.

Therefore, whoever has knowledge in the Holy Spirit and wings of faith, let this one not ignore My admonition but taste it, embrace it and receive it in his soul.

This selection from the Causae et Curae of Hildegard of Bingen reflects what most medievals thought about human conception. Hildegard, though she is a nun, treats these matters with openness and without any of the antiwoman rhetoric common at the time. Her discussion of the "humors" was a commonplace derived from ancient Greek and Roman medicine.

WOMEN'S PHYSIOLOGY

On Intercourse

When a woman is making love with a man, a sense of heat in her brain, which brings forth with it sensual delight, communicates the taste of that delight during the act and summons forth the emission of the man's seed. And when the seed has fallen into its place, that vehement heat descending from her brain draws the seed to itself and holds it, and soon the woman's sexual organs contract and all the parts that are ready to open up during the time of menstruation now close, in the same way as a strong man can hold something enclosed in his fist.

When God created Adam, Adam experienced a sense of great love in the sleep that God instilled in him. And God gave a form to that love of the man, and so woman is the man's love. And as soon as woman was formed God gave man the power of creating, that through his love which is woman—he might procreate children. When Adam gazed at Eve, he was entirely filled with wisdom, for he saw in her the mother of the children to come. And when she gazed at Adam, it was as if she were gazing into heaven, or as the human soul strives upwards, longing for heavenly things—for her hope was fixed in him. And so there will be and must be one and the same love in man and woman, and no other.

The man's love, compared with the woman's is a heat of ardor like a fire on blazing mountains which can hardly be put out, while hers is a wood-fire that is easily quenched; but the woman's love, compared with the man's is like a sweet warmth proceeding from the sun, which brings forth fruits. . . .

But the great love that was in Adam when Eve came forth from him, and the sweetness of the sleep with which he then slept, were turned in his transgression into a contrary mode of sweetness. And so, because a man still feels this great sweetness in himself, and like a stag thirsting for the fountain, he races swiftly to the woman and she to him—she like a threshing-floor pounded by his many strokes and brought to heat when the grains are threshed inside her.

Conceiving Male and Female Children

When the man approaches the woman, releasing powerful semen and in a true cherishing love for the woman, and she too has a true love for the man in that same hour, then a male child is conceived, for so it was ordained by God. Nor can it be otherwise, because Adam was formed of clay which is a stronger material than flesh. And this male child will be prudent and virtuous. . . .

But if the woman's love is lacking in that hour . . . and if the man's semen is strong, a male child will still be born, because the man's cherishing love predominates. But that male child will be feeble and not virtuous. . . . If the man's semen is thin, and yet he cherishes the woman lovingly and she him, then a virtuous female child is procreated. . . . If the man's semen is powerful but neither the man nor the woman cherish each other lovingly, a male child is procreated . . . but he will bitter with his parents' bitterness; and if the man's semen is thin and there is no cherishing love on either side in that hour, a girl of bitter temperament is born.

The blood in every human being increases and diminishes according to the waxing and waning of the moon . . . when, as the moon waxes, the blood in human beings is increased, then both men and women are fertile for bearing fruit—for generating children—since then the man's semen is powerful and robust; and in the waning of the moon, when human blood also wanes, the man's semen is feeble and without strength, like dregs. . . . If a woman conceives a child then, whether boy or girl, it will be infirm and feeble and not virtuous.

The Temperaments of Women: *De sanguinea* (About Sanguine Women)

Some women are inclined to plumpness, and have soft and delectable flesh and slender veins, and well-constituted blood free from impurities. . . . And these have a clear and light coloring, and in love's embraces are themselves lovable; they are subtle in arts, and show self-restraint in their disposition. At menstruation they suffer only a modest loss of blood, and their womb is well developed for childbearing, so they are fertile and can take in the man's seed. Yet they do not bear many children, and if they are without hus-

bands so that they remain childless, they easily have physical pains; but if they have husbands, they are well.

De flecmatica (About Phlegmatic Women)

There are other women whose flesh does not develop as much, because they have thick veins and healthy, whitish blood (though it does contain a little impurity, which is the source of its light color). They have severe features, and are darkish in coloring; they are vigorous and practical, and have a somewhat mannish disposition. At menstruation their menstrual blood flows neither too little nor too abundantly. And because they have thick veins they are very fertile and conceive easily, for the womb and all their inner organs, too, are well developed. They attract men and make men pursue them, and so men love them well. If they want to stay away from men, they can do so without being affected by it badly, though they are slightly affected. However, if they do avoid making love with men they will become difficult and unpleasant in their behavior. But if they go with men and do not wish to avoid men's love-making, they will be unbridled and over-lascivious, according to men's report. And because they are to some extent mannish on account of the vital force (viriditas, lit. greenness) within them, a little down sometimes grows on their chin.

De colerica (About Choleric Women)

There are other women who have slender flesh but big bones, moderately sized veins and dense red blood. They are pallid in coloring, prudent and benevolent, and men show them reverence and are afraid of them. They suffer much loss of blood in menstruation; their womb is well developed and they are fertile. And men like their conduct, yet flee from them and avoid them to some extent, for they can interest men but not make men desire them. If they do get married, they are chaste, they remain loyal wives and live healthily with their husbands; and if they are unmarried, they tend to be ailing—as much because they do not know to what man they might pledge their womanly loyalty as because they lack a husband. . . .

De melancolica (About Melancholic Women)

But there are other women who have gaunt flesh and thick veins and moderately sized bones; their blood is more lead-colored than sanguine, and their coloring is as it were blended with grey and black. They are changeable and free-roaming in their thoughts, and wearisomely wasted away in affliction; they also have little power of resistance, so that at times they are worn out by melancholy. They suffer much loss of blood in menstruation, and they are sterile, because they have a weak and fragile womb. So they cannot lodge or retain or warm a man's seed, and thus they are also healthier, stronger and happier without husbands than with them-especially because, if they lie with their husbands, they will tend to feel weak afterwards. But men turn away from them and shun them because they do not speak to men affectionately, and love them only a little. If for some hour they experience sexual joy, it quickly passes in them. Yet some such women, if they unite with robust and sanguine husbands, can at times, when they reach a fair age, such as fifty, bear at least one child. . . . If their menopause comes before the just age, they will sometimes suffer gout or swellings of the legs, or will incur an insanity which their melancholy arouses, or else backache or a kidney ailment. . . . If they are not helped in their illness, so that they are not freed from it either by God's help or by medicine, they will quickly die.

EVERYMAN

Here beginneth a treatise how the high father of heaven sendeth death to summon every creature to come and give account of their lives in this world, and is in manner of a moral play.

MESSENGER I pray you all give your audience,	
And hear this matter with reverence,	
By figure [°] a moral play:	in form
The Summoning of Everyman called it is,	
That of our lives and ending shows	5
How transitory we be all day. °	always
This matter is wondrous precious,	
But the intent of it is more gracious,	
And sweet to bear away.	
The story saith: Man, in the beginning	10
Look well, and take good heed to the ending,	
Be you never so gay!	
Ye think sin in the beginning full sweet,	
Which in the end causeth the soul to weep,	
When the body lieth in clay.	15
Here shall you see how Fellowship and Jollity,	
Both Strength, Pleasure, and Beauty,	
Will fade from thee as flower in May;	
For ye shall hear how our Heaven King	
Calleth Everyman to a general reckoning:	20
Give audience, and hear what he doth say.	
[EXIT]	

[GOD SPEAKETH]

GOD I perceive, here in my majesty,	
How that all creatures be to me unkind,° Living without dread in worldly prosperity:	ungrateful
Of ghostly sight the people be so blind,	25
Drowned in sin, they know me not for	20
their God;	
In worldly riches is all their mind,	
They fear not my righteousness, the	
sharp rod.	
My law that I showed, when I for them died,	
They forget clean, and shedding of my	
blood red;	30
I hanged between two, it cannot be denied;	
To get them life I suffered to be dead;	
I healed their feet, with thorns hurt was	
my head.	
I could do no more than I did, truly;	
And now I see the people do clean for-	
sake me:	35
They use the seven deadly sins damnable,	
As pride, covetise, wrath, and lechery°	covetousness
Now in the world be made commendable;	
And thus they leave of angels the heavenly	
company.	
Every man liveth so after his own pleasure,	40
And yet of their life they be nothing sure:	
I see the more that I them forbear	
The worse they be from year to year.	1
All that liveth appaireth [°] fast;	degenerates 45
Therefore I will, in all the haste,	43
Have a reckoning of every man's person;	if
For, and° I leave the people thus alone In their life and wicked tempests,°	y tumults
Verily they will become much worse than	<i>tumuus</i>
beasts;	
For now one would by envy another up eat;	50
Charity they do all clean forget.	00
I hoped well that every man	
rioped wen diatevery main	

In my glory should make his mansion, And thereto I had them all elect; But now I see, like traitors deject,° They thank me not for the pleasure that I to° them meant Nor yet for their being that I them have lent. I proffered the people great multitude of mercy,	abject for
And few there be that asketh it heartily.° They be so cumbered with worldly riches That needs on them I must do justice, On every man living without fear. Where art thou, Death, thou mighty messenger?	earnestly 60
[ENTER DEATH]	
DEATH Almighty God, I am here at your will, Your commandment to fulfil. GOD Go thou to Everyman, And show him, in my name, A pilgrimage he must on him take, Which he in no wise may escape; And that he bring with him a sure reckoning Without delay or any tarrying.	65 70
[GOD WITHDRAWS]	
DEATH Lord, I will in the world go run overall,°	everywhere
And cruelly outsearch both great and small; Every man will I beset that liveth beastly Out of God's laws, and dreadeth not folly. He that loveth riches I will strike with my dart,	75
His sight to blind, and from heaven to depart°— Except that alms be his good friend—	separate
In hell for to dwell, world without end. Lo, yonder I see Everyman walking. Full little he thinketh on my coming; His mind is on fleshly lusts and his treasure, And great pain it shall cause him to endure Before the Lord, Heaven King.	80
[ENTER EVERYMAN]	
EVERYMAN, stand still! Whither art thou going Thus gaily? Hast thou thy Maker forget?	85
EVERYMAN Why askest thou? Wouldest thou wit?°	know
DEATH Yea, sir; I will show you: In great haste I am sent to thee From God out of his majesty. EVERYMAN What, sent to me?	90
DEATH Yea, certainly. Though thou have forget him here, He thinketh on thee in the heavenly sphere, As, ere we depart, thou shalt know. EVERYMAN What desireth God of me? DEATH That shall I show thee:	95
A reckoning he will needs have Without any longer respite. EVERYMAN To give a reckoning longer leisure	100
I crave; This blind° matter troubleth my wit.	obscure

DEATH On thee thou must take a long journey; Therefore thy book of count^o with thee thou

bring,

account

For turn again° thou cannot by no way. And look thou be sure of thy reckoning, For before God thou shalt answer, and show Thy many bad deeds, and good but a few; How thou hast spent thy life, and in what wise,	return
Before the chief Lord of paradise. Have ado that we were in that way, For, wit thou well, thou shalt make none attorney.	110
EVERYMAN Full unready I am such reckoning to give.	
I know thee not. What messenger art thou? DEATH I am Death, that no man dreadeth, For every man I rest,° and no man spareth; For it is God's commandment	115 arrest
That all to me should be obedient. EVERYMAN O Death, thou comest when I had thee least in mind!	
In thy power it lieth me to save;	120
Yet of my good° will I give thee, if thou will be kind: Yea, a thousand pound shalt thou have,	goods
And defer this matter till another day.	
DEATH Everyman, it may not be, by no way. I set not by [°] gold, silver, nor riches	care not for
Ne by pope, emperor, king, duke, ne princes;	cure not jor
For, and ^o I would receive gifts great, All the world I might get;	if
But my custom is clean contrary.	
I give thee no respite. Come hence, and not	100
tarry. EVERYMAN Alas, shall I have no longer	130
respite?	
I may say Death giveth no warning! To think on thee, it maketh my heart sick,	
For all unready is my book of reckoning.	
But twelve year and I might have abiding, My counting-book I would make so clear	135
That my reckoning I should not need to fear.	
Wherefore, Death, I pray thee, for God's	
mercy, Spare me till I be provided of remedy.	
DEATH Thee availeth not to cry, weep,	
and pray;	140
But haste thee lightly that thou were gone that journey,	
And prove thy friends if thou can;	
For, wit thou well, the tide° abideth no man, And in the world each living creature	time
For Adam's sin must die of nature.	145
EVERYMAN Death, if I should this pilgrim-	
age take, And my reckoning surely make,	
Show me, for saint charity,	
Should I not come again shortly?	
DEATH No, Everyman; and thou be once there, Thou mayst never more come here,	150
Trust me verily.	
EVERYMAN O gracious God in the high seat	
celestial. Have mercy on me in this most need!	
Shall I have no company from this vale	
terrestrial	155
Of mine acquaintance, that way me to lead? DEATH Yea, if any be so hardy	
That would go with thee and bear thee	
company.	

Hie thee that thou were gone to God's	
magnificence,	
Thy reckoning to give before his presence. What, weenest° thou thy life is given thee,	160
And thy worldly goods also?	suppose
EVERYMAN I had wend ^o so, verily.	supposed
DEATH Nay, nay; it was but lent thee;	
For as soon as thou art go,°	gone
Another a while shall have it, and then go therefro,°	<i>c</i>
Even as thou hast done.	from it
Everyman, thou art mad! Thou hast thy	
wits five,	
And here on earth will not amend thy life;	
For suddenly I do come.	170
EVERYMAN O wretched caitiff, whither shall	
I flee, That I might scape this endless sorrow?	
Now, gentle Death, spare me till tomorrow,	
That I may amend me	
With good advisement.°	reflection
DEATH Nay, thereto I will not consent,	
Nor no man will I respite;	
But to the heart suddenly I shall smite	
Without any advisement. And now out of thy sight I will me hie;	100
See thou make thee ready shortly,	180
For thou mayst say this is the day	
That no man living may scape away.	
[EXIT DEATH]	
EVERYMAN Alas, I may well weep with	
sighs deep!	
Now have I no manner of company	185
To help me in my journey, and me to keep;°	guard
And also my writing is full unready.	
How shall I do now for to excuse me?	
I would to God I had never be get!° To my soul a full great profit it had be;	been born
For now I fear pains huge and great.	190
The time passeth. Lord, help, that all wrought!	
For though I mourn it availeth nought.	
The day passeth, and is almost ago;°	gone
I wot not well what for to do.	195
To whom were I best my complaint to make?	
What and ^o I to Fellowship thereof spake,	:6
And showed him of this sudden chance?	if
For in him is all mine affiance;°	trust
We have in the world so many a day	200
Be good friends in sport and play.	
I see him yonder, certainly.	
I trust that he will bear me company;	
Therefore to him will I speak to ease my sorrow.	
Well met, good Fellowship, and good	
morrow!	205
[FELLOWSHIP SPEAKETH]	
FELLOWSHIP Everyman, good morrow, by this day!	
Sir, why lookest thou so piteously?	
If any thing be amiss, I pray thee me say,	
That I may help to remedy.	
EVERYMAN Yea, good Fellowship, yea;	210
I am in great jeopardy.	
FELLOWSHIP My true friend, show to me your mind;	
vour minu,	

T ill i f la theo to was life/e and	
I will not forsake thee to my life's end, In the way of good company.	
EVERYMAN That was well spoken, and	
lovingly.	215
FELLOWSHIP Sir, I must needs know your heaviness;°	sorrow
I have pity to see you in any distress.	
If any have you wronged, ye shall re-	
venged be, Though I on the ground be slain for thee—	
Though that I know before that I should die.	220
EVERYMAN Verily, Fellowship, gramercy.	
FELLOWSHIP Tush! by thy thanks I set not a	
straw. Show me your grief, and say no more.	
EVERYMAN If I my heart should to you break,°	open
And then you to turn your mind from me,	225
And would not me comfort when ye hear me speak,	
Then should I ten times sorrier be.	
FELLOWSHIP Sir, I say as I will do indeed.	
EVERYMAN Then be you a good friend	
at need: I have found you true herebefore.	230
FELLOWSHIP And so ye shall evermore;	
For, in faith, and thou go to hell,	
I will not forsake thee by the way.	
EVERYMAN Ye speak like a good friend; I believe you well.	
I shall deserve° it, and I may.	repay
FELLOWSHIP I speak of no deserving, by	
this day! For he that will say, and nothing do,	
Is not worthy with good company to go;	
Therefore show me the grief of your mind,	
As to your friend most loving and kind. EVERYMAN I shall show you how it is:	240
Commanded I am to go a journey,	
A long way, hard and dangerous,	
And give a strait count,° witout delay,	strict account
Before the high Judge, Adonai. Wherefore, I pray you, bear me company,	245
As ye have promised, in this journey.	
FELLOWSHIP That is matter indeed. Promise	
is duty; But and I should take such a voyage on me	
But, and I should take such a voyage on me, I know it well, it should be to my pain;	250
Also it maketh me afeard, certain.	
But let us take counsel here as well as	
we can, For your words would fear° a strong man	frighten
EVERYMAN Why, ye said if I had need	5.0
Ye would me never forsake, quick ne dead,	255
Though it were to hell, truly. FELLOWSHIP So I said, certainly,	
But such pleasures be set aside, the sooth	
to say;	
And also, if we took such a journey,	260
When should we come again? EVERYMAN Nay, never again, till the day	200
of doom.	
FELLOWSHIP In faith, then will not I come there	2!
Who hath you these tidings brought? EVERYMAN Indeed, Death was with me here.	
FELLOWSHIP Now, by God	265
that all hath bought,°	redeemed
If Death were the messenger,	
For no man that is living to-day	

I will not go that loath° journey—	loathsome
Not for the father that begat me! EVERYMAN Ye promised otherwise, pardie.° FELLOWSHIP I wot well I said so, truly;	by God
And yet if thou wilt eat, drink, and make good cheer,	
Or haunt to women the lusty company, I would not forsake you while the day is	
clear, Trust me verily. EVERYMAN Yea, thereto ye would be ready!	275
To go to mirth, solace, and play, Your mind will sooner apply,° Than to bear me company in my long	attend
journey. FELLOWSHIP Now, in good faith, I will not that way.	280
But and thou will murder, or any man kill, In that I will help thee with a good will. EVERYMAN O, that is a simple advice indeed.	
Gentle fellow, help me in my necessity! We have loved long, and now I need; And now, gentle Fellowship, remember me. FELLOWSHIP Whether ye have loved	285
me or no, By Saint John, I will not with thee go. EVERYMAN Yet, I pray thee, take the labour, and do so much for me	
To bring me forward,° for saint charity, And comfort me till I come without the town.	escort me
FELLOWSHIP Nay, and thou would give me a new gown, I will not a foot with thee go; But, and thou had tarried, I would not have left thee so.	
And as now God speed thee in thy journey, For from thee I will depart as fast as I may. EVERYMAN Whither away, Fellowship? Will thou forsake me?	295
FELLOWSHIP Yea, by my fay°! To God I	faith
betake° thee. EVERYMAN Farewell, good Fellowship; for thee my heart is sore.	commend
Adieu for ever! I shall see thee no more. FELLOWSHIP In faith, Everyman, farewell now at the ending;	300
For you I will remember that parting is mourning. [<i>EXIT</i> FELLOWSHIP]	
EVERYMAN Alack! shall we thus depart ^o	part
indeed— Ah, Lady, help!— without any more comfort?	
Lo, Fellowship forsaketh me in my most need. For help in this world whither shall I resort?	305
Fellowship herebefore with me would merry make, And now little sorrow for me doth he take.	
It is said, "In prosperity men friends may find, Which in adversity be full unkind."	310
Now whither for succour shall I flee, Sith° that Fellowship hath forsaken me? To my kinsmen I will, truly,	since
Praying them to help me in my necessity; I believe that they will do so,	315

For kind will creep where it may not go.		[EXIT KINDRED]	
I will go say,° for yonder I see them.	essay, try	EVERYMAN How should I be merry or glad?	
Where be ye now, my friends and kinsmen?		For fair promises men to me make,	370
[ENTER KINDRED AND COUSIN]		But when I have most need they me forsake.	
KINDRED Here be we now at your com-		I am deceived; that maketh me sad.	
mandment.		COUSIN Cousin Everyman, farewell now,	
Cousin, I pray you show us your intent	320	For verily I will not go with you.	
In any wise, and do not spare.		Also of mine own an unready reckoning	375
COUSIN Yea, Everyman, and to us declare		I have to account; therefore I make tarrying. Now God keep thee, for now I go.	
If ye be disposed to go anywhither;°	anywhere	Now God keep thee, for now 1 go.	
For, wit you well, we will live and die		[EXIT COUSIN]	
together. KINDRED In wealth and woe	225	EVERYMAN Ah, Jesus, is all come hereto?	
we will with you hold,°	325 aida	Lo, fair words maketh fools fain;	
For over his kin a man may be bold.	side	They promise, and nothing will do, certain.	380
EVERYMAN Gramercy, my friends and kins-		My kinsmen promised me faithfully	000
men kind.		For to abide with me steadfastly,	
Now shall I show you the grief of my mind:		And now fast away do they flee:	
I was commanded by a messenger,		Even so Fellowship promised me.	
That is a high king's chief officer;	330	What friend were best me of to provide?	385
He bade me go a pilgrimage, to my pain,		I lose my time here longer to abide.	
And I know well I shall never come again;		Yet in my mind a thing there is: All my life I have loved riches;	
Also I must give a reckoning strait, For I have a great enemy that hath me in wait,		If that my Good [°] now help me might,	Goods
Which intendeth me for to hinder.	335	He would make my heart full light.	390
KINDRED What account is that which ye must	000	I will speak to him in this distress—	
render?		Where art thou, my Goods and riches?	
That would I know.		[GOODS SPEAKS FROM A CORNER]	
EVERYMAN Of all my works I must show			
How I have lived and my days spent;		GOODS Who calleth me? Everyman? What!	
Also of ill deeds that I have used° In my time, sith life was me lent;	practiced	hast thou haste?	
And of all virtues that I have refused.		I lie here in corners, trussed and piled so high,	
Therefore, I pray you, go thither with me		And in chests I am locked so fast,	395
To help to make mine account, for saint		Also sacked in bags. Thou mayst see with	393
charity.		thine eye	
COUSIN What, to go thither? Is that the matter?	345	I cannot stir; in packs low I lie.	
Nay, Everyman, I had liefer fast bread		What would you have? Lightly [°] me say	quickly
and water		EVERYMAN Come hither, Good, in all the	
All this five year and more. EVERYMAN Alas, that ever I was bore!°	,	haste thou may,	
For now shall I never be merry,	born	For of counsel I must desire thee.	400
If that you forsake me.	350	GOODS Sir, and ye in the world have sorrow or adversity,	
KINDRED Ah, sir, what ye be a merry man!	000	That can I help you to remedy shortly.	
Take good heart to you, and make no moan.		EVERYMAN It is another disease° that	trouble
But one thing I warn you, by Saint Anne-		grieveth me;	
As for me, ye shall go alone.		In this world it is not, I tell thee so.	
EVERYMAN My Cousin, will you not		I am sent for, another way to go,	405
with me go?	355	To give a strait count general	
COUSIN No, by our Lady! I have the cramp in my toe.		Before the highest Jupiter of all;	.1
Trust not to me, for, so God me speed,		And all my life I have had joy and pleasure in Therefore, I pray thee, go with me;	thee,
I will deceive you in your most need.		For, peradventure, thou mayst before God	
KINDRED It availeth not us to tice.		Almighty	410
Ye shall have my maid with all my heart;	360	My reckoning help to clean and purify;	110
She loveth to go to feasts, there to be nice,°	wanton	For it is said ever among	
And to dance, and abroad to start:		That money maketh all right that is wrong.	
I will give her leave to help you in that		GOODS Nay, Everyman, I sing another song.	
journey, If that you and she may agree		I follow no man in such voyages;	415
If that you and she may agree. EVERYMAN Now show me the very	265	For, and I went with thee,	
effect° of your mind:	365 tenor	Thou shouldst fare much the worse for me; For because on me thou did set thy mind,	
Will you go with me, or abide behind?	101101	Thy reckoning I have made blotted ^o and	obscure
KINDRED Abide behind? Yea, that will I, and		blind,	obscure
I may!		That thine account thou cannot make truly;	420
Therefore farewell till another day.		And that hast thou for the love of me.	

 EVERYMAN That would grieve me full sore, When I should come to that fearful answer. Up, let us go thither together. GOODS Nay, not so! I am too brittle, I may not endure; I will follow no man one foot, be ye sure. EVERYMAN Alas, I have thee loved, and had great pleasure All my life-days on good and treasure. GOODS That is to thy damnation, without leasing, 	425
For my love is contrary to the love ever- lasting; But if thou had me loved moderately during,	430
As to the poor to give part of me, Then shouldst thou not in this dolour° be,	distress
Nor in this great sorrow and care. EVERYMAN Lo, now was I deceived	435
ere I was ware, $^{\circ}$	aware
And all I may write misspending of time. GOODS What, weenest thou that I am thine? EVERYMAN I had wend ^o so.	supposed
GOODS Nay, Everyman, I say no.	
As for a while I was lent thee; A season thou hast had me in prosperity.	440
My condition [°] is man's soul to kill;	nature
If I save one, a thousand I do spill.°	ruin
Weenest thou that I will follow thee?	
Nay, not from this world, verily. EVERYMAN I had wend otherwise.	445
GOODS Therefore to thy soul Good is a thief;	
For when thou art dead, this is my guise ^o —	practice
Another to deceive in this same wise	
As I have done thee, and all to his soul's reprise $^{\circ}$	450 shame
and all to his soul's reprief.°— EVERYMAN O false Good, cursed may	Shume
thou be,	
Thou traitor to God, that hast deceived me	
And caught me in thy snare! GOODS Marry, thou brought thyself in care,	
Whereof I am glad;	455
I must needs laugh, I cannot be sad.	
EVERYMAN Ah, Good, thou hast had long my	
heartly° love; I gave thee that which should be the Lord's	heartfelt
above.	
But wilt thou not go with me indeed?	
I pray thee truth to say.	460
GOODS No, so God me speed! Therefore farewell, and have good day.	
[<i>EXIT</i> GOODS]	
EVERYMAN O, to whom shall I make	
my moan For to go with me in that heavy journey?	
First Fellowship said he would	465
with me gone;°	go
His words were very pleasant and gay,	
But afterward he left me alone. Then spake I to my kinsmen, all in despair,	
And also they gave me words fair;	
They lacked no fair speaking,	470
But all forsook me in the ending. Then went I to my Goods that I loved	
Then went I to my Goods, that I loved best,	
In hope to have comfort, but there had I least; For my Goods sharply did me tell	

That he bringeth many into hell. Then of myself I was ashamed, And so I am worthy to be blamed;	475
Thus may I well myself hate. Of whom shall I now counsel take? I think that I shall never speed Till that I go to my Good Deed. But, alas, she is so weak	480
That she can neither go° nor speak; Yet will I venture° on her now. My Good Deeds, where be you?	walk gamble 485
[GOOD DEEDS SPEAKS FROM THE GROUND]	
GOOD DEEDS Here I lie, cold in the ground; Thy sins hath me sore bound, That I cannot stir.	
EVERYMAN O Good Deeds, I stand in fear! I must you pray of counsel, For help now should come right well. GOOD DEEDS Everyman, I have under-	490
standing That ye be summoned account to make Before Messias, of Jerusalem King; And you do by me, that journey with you	
will I take. EVERYMAN Therefore I come to you, my moan to make;	495
GOOD DEEDS I would full fain, but I cannot stand, verily.	
EVERYMAN Why, is there anything on you fall [°] ? GOOD DEEDS Yea, sir, I may thank you of [°] all; If ye had perfectly cheered me, Your book of count full ready had be.	befallen for
Look, the books of your works and deeds eke°!	also
Behold how they lie under the feet,	mee
To your soul's heaviness. EVERYMAN Our Lord Jesus help me! For one letter here I cannot see. GOOD DEEDS There is a blind reckoning in	505
time of distress. EVERYMAN Good Deeds, I pray you help me in this need,	
Or else I am for ever damned indeed; Therefore help me to make reckoning Before the Redeemer of all thing, That King is, and was, and ever shall. GOOD DEEDS Everyman, I am sorry of	510
your fall, And fain would I help you, and I were able. EVERYMAN Good Deeds, your counsel I pray	515
you give me. GOOD DEEDS That shall I do verily; Though that on my feet I may not go, I have a sister that shall with you also, Called Knowledge, which shall with you abide, To help you to make that dreadful reckoning.	520
[ENTER KNOWLEDGE]	
KNOWLEDGE Everyman, I will go with thee,	

and be thy guide, In thy most need to go by thy side. EVERYMAN In good condition I am now in every thing,

And am wholly content with this good thing	525
Thanked be God my creator.	
GOOD DEEDS And when she hath brought	
you there	
Where thou shalt heal thee of thy smart,°	pain
Then go you with your reckoning and your Good Deeds together,	
For to make you joyful at heart	530
Before the blessed Trinity.	000
EVERYMAN My Good Deeds, gramercy!	
I am well content, certainly,	
With your words sweet.	
KNOWLEDGE Now go we together lovingly	535
To Confession, that cleansing river.	
EVERYMAN For joy I weep; I would we were	
there!	
But, I pray you, give me cognition [°]	knowledge
Where dwelleth that holy man, Confession. KNOWLEDGE In the house of salvation:	540
We shall find him in that place,	540
That shall us comfort, by God's grace.	
That bhan as connort, by Goa's grace.	
[KNOWLEDGE TAKES EVERYMAN TO CONFESS]	[ON]
Lo, this is Confession. Kneel down and ask	
mercy,	
For he is in good conceit [°] with God	esteem
Almighty.	
EVERYMAN O glorious fountain, that all	
uncleanness doth clarify, Wash from me the spote of vice unclean	545
Wash from me the spots of vice unclean, That on me no sin may be seen.	
I come with Knowledge for my redemption,	
Redempt with heart and full contrition;	
For I am commanded a pilgrimage to take,	550
And great accounts before God to make.	
Now I pray you, Shrift,° mother of salvation	confession
Help my Good Deeds for my piteous	
exclamation.	
CONFESSION I know your sorrow well,	
Everyman.	
Because with Knowledge ye come to me,	555
I will you comfort as well as I can, And a precious jewel I will give thee,	
Called penance, voider ^o of adversity;	expeller
Therewith shall your body chastised be,	ехренет
With abstinence and perseverance in God's ser	vice. 560
Here shall you receive that scourge of me,	
Which is penance strong that ye must	
endure,	
To remember thy Saviour was scourged	
for thee	
With sharp scourges, and suffered it patiently;	
So must thou, ere thou scape that painful	
pilgrimage.	565
Knowledge, keep him in this voyage, And by that time Good Deeds will be	
with thee.	
But in any wise be siker ^o of mercy,	sure
For your time draweth fast; and ^o ye will	if
saved be,	9
Ask God mercy, and he will grant truly.	570
When with the scourge of penance man doth	
him° bind,	himself
The oil of forgiveness then shall he find.	
EVERYMAN Thanked be God for his	
gracious work!	
For now I will my penance begin;	575

This hath rejoiced and lighted° my heart Though the knots be painful and hard	lightened
within. KNOWLEDGE Everyman, look your penance that ye fulfil,	
What pain that ever it to you be; And Knowledge shall give you counsel	
at will	
How your account ye shall make clearly. EVERYMAN O eternal God, O heavenly figure, O way of righteousness, O goodly vision,	580
Which descended down in a virgin pure	
Because he would every man redeem, Which Adam forfeited by his disobedience:	585
O blessed Godhead, elect and high divine,°	divinity
Forgive my grievous offence; Here I cry thee mercy in this presence.	
O ghostly treasure, O ransomer and re-	
deemer, Of all the sward here and say lost a	
Of all the world hope and conductor, Mirror of joy, and founder of mercy,	590
Which enlumineth heaven and earth	
thereby,° Hear my clamorous complaint, though it	besides
late be;	
Receive my prayers, of thy benignity;	
Though I be a sinner most abominable, Yet let my name be written in Moses' table.	595
O Mary, pray to the Maker of all thing,	
Me for to help at my ending;	
And save me from the power of my enemy, For Death assaileth me strongly.	600
And, Lady, that I may by mean of thy prayer	
Of your Son's glory to be partner, By the means of his passion, I it crave;	
I beseech you help my soul to save.	
Knowledge, give me the scourge of penance;	605
My flesh therewith shall give acquittance; I will now begin, if God give me grace.	
KNOWLEDGE Everyman, God give you time	
and space! ^o	opportunity
Thus I bequeath you in the hands of our Saviour;	
Now may you make your reckoning sure. EVERYMAN In the name of the Holy Trinity,	610
My body sore punished shall be: Take this, body, for the sin of the flesh!	
[SCOURGES HIMSELF]	
Also° thou delightest to go gay and fresh, And in the way of damnation thou did me bring,	<i>as</i> 615
Therefore suffer now strokes and punishing.	015
Now of penance I will wade the water clear, To save me from purgatory, that sharp fire.	
[GOOD DEEDS RISES FROM THE GROUND]	
GOOD DEEDS I thank God, now I can walk and go,	
And am delivered of my sickness and woe. Therefore with Everyman I will go, and not	620
spare; His good works I will help him to declare. KNOWLEDGE Now, Everyman, be merry	
and glad! Your Good Deeds whole and sound,	625
Going upright upon the ground.	

EVERYMAN My heart is light, and shall be	
evermore; Now will I smite faster than I did before. GOOD DEEDS Everyman, pilgrim, my special	
friend, Blessed be thou without end; For thee is preparate° the eternal glory.	630 prepared
Ye have me made whole and sound, Therefore I will bide by thee in every stound.° EVERYMAN Welcome, my Good Deeds; now I	trial
hear thy voice, I weep for very sweetness of love. KNOWLEDGE Be no more sad, but ever	635
rejoice; God seeth thy living in his throne above. Put on this garment to thy behoof,° Which is wet with your tears,	advantage
Or else before God you may it miss, When ye to your journey's end come shall. EVERYMAN Gentle Knowledge, what do ye	640
it call? KNOWLEDGE It is a garment of sorrow: From pain it will you borrow;° contrition it is,	release 645
That geteth forgiveness; It pleaseth God passing° well.	arcaadinahu
GOOD DEEDS Everyman, will you wear it	exceedingly
for your heal?° EVERYMAN Now blessed be Jesu, Mary's Son, For now have I on true contrition.	salvation 650
And let us go now without tarrying; Good Deeds, have we clear our reckoning? GOOD DEEDS Yea, indeed, I have it here. EVERYMAN Then I trust we need not fear;	000
Now, friends, let us not part in twain. KNOWLEDGE Nay, Everyman, that will we not, certain.	655
GOOD DEEDS Yet must thou lead with thee Three persons of great might. EVERYMAN Who should they be?	
GOOD DEEDS Discretion and Strength they hight,° And thy Beauty may not abide behind.	660 are called
KNOWLEDGE Also ye must call to mind Your Five Wits° as for your counsellors. GOOD DEEDS You must have them ready at all hours.	senses
EVERYMAN How shall I get them hither?	665
KNOWLEDGE You must call them all together, And they will hear you incontinent.° EVERYMAN My friends, come hither and be	immediately
present, Discretion, Strength, my Five Wits, and Beauty.	
[ENTER BEAUTY, STRENGTH, DISCRETION, AND FIV	/E WITS]
BEAUTY Here at your will we be all ready. What will ye that we should do? GOOD DEEDS That ye would with every- man go,	670
And help him in his pilgrimage. Advise° you, will ye with him or not in that voyage?	consider
STRENGTH We will bring him all thither, To his help and comfort, ye may believe me.	675
DISCRETION So will we go with him all together EVERYMAN Almighty God, lofed° may thou be!	r. praised

I give thee laud that I have hither brought	
Strength, Discretion, Beauty, and Five Wits.	
Lack I nought.	680
And my Good Deeds, with Knowledge clear,	
All be in my company at my will here; I desire no more to° my business.	for
STRENGTH And I, Strength, will by you stand	501
in distress,	
Though thou would in battle fight on the	
ground.	685
FIVE WITS And though it were through the	
world round,	
We will not depart for sweet ne sour.	
BEAUTY No more will I unto° death's hour,	until
BEAUTY Whatsoever thereof befall.	
DISCRETION Everyman, advise you first of all;	690
Go with a good advisement° and	reflection
deliberation.	
We all give you virtuous monition ^o	forewarning
That all shall be well.	
EVERYMAN My friends, harken what I	
will tell:	
I pray God reward you in his heavenly	60E
sphere.	695
Now harken, all that be here,	
For I will make my testament Here before you all present:	
In alms half my good I will give with my	
hands twain	
In the way of charity, with good intent,	700
And the other half still shall remain	
In queth,° to be returned	bequest
there° it ought to be.	where
This I do in despite of the fiend of hell,	
To go quit out of his peril	
Ever after and this day.	705
KNOWLEDGE Everyman, harken what I say:	
Go to priesthood, I you advise,	
And receive of him in any wise°	without fail
The holy sacrament and ointment together.	
Then shortly see ye turn again hither;	710
We will all abide you here.	
FIVE WITS Yea, Everyman, hie you that ye	
ready were.	
There is no emperor, king, duke, ne baron,	1
That of God hath commission [°]	authority 715
As hath the least priest in the world $hain are$	715 <i>limina</i>
being;° For of the blossed secrements pure and	living
For of the blessed sacraments pure and benign	
He beareth the keys, and thereof hath	
the cure°	charge
For man's redemption—it is ever sure—	0
Which God for our soul's medicine	
Gave us out of his heart with great	720
pine.°	suffering
Here in this transitory life, for thee and me,	
The blessed sacraments seven there be:	
Baptism, confirmation, with priest-	
hood good,	
And the sacrament of God's precious flesh	
and blood,	
Marriage, the holy extreme unction, and	
penance;	725
These seven be good to have in remembrance,	
Gracious sacraments of high divinity. EVERYMAN Fain would I receive that holy body,	
and meekly to my ghostly° father I will go.	spiritual
and meeting to my grobing rather i will go.	spirinu

FIVE WITS Everyman, that is the best that ye	
can do. God will you to salvation bring, To us Holy Grintum they do togeth	730
To us Holy Scripture they do teach, And converteth man from sin heaven to reach; God hath to them more power given Than to any angel that is in heaven. With five words he may consecrate, God's body in flesh and blood to make,	735
And handleth his Maker between his hands. The priest bindeth and unbindeth all bands, Both in earth and in heaven.	740
Thou ministers° all the sacraments seven; Though we kissed thy feet, thou were worthy;	administer
Thou art surgeon that cureth sin deadly: No remedy we find under God But all only priesthood. Everyman, God gave priests that dignity, And setteth them in his stead among us to be; Thus be they above angels in degree.	745
[EVERYMAN GOES TO THE PRIEST TO RECEIVE THE LAST SACRAMENTS]	
KNOWLEDGE If priests be good, it is so, surely.But when Jesus hanged on the cross with great smart,There he gave out of his blessed heartThe same sacrament in great torment:He sold them not to us, that Lord omni-	750
potent. Therefore Saint Peter the apostle doth say That Jesu's curse hath all they	755
Which God their Saviour do buy or sell, Or they for any money do take or tell.° Sinful priests giveth the sinners exam- ple bad;	count out
Their children sitteth by other men's fires, I have heard: And some haunteth women's company With unclean life, as lusts of lechery:	760
These be with sin made blind. FIVE WITS I trust to God no such may we find; Therefore let us priesthood honour, And follow their doctrine for our souls' succour.	765
We be their sheep, and they shepherds be By whom we all be kept in surety. Peace, for yonder I see Everyman come, Which hath made true satisfaction. GOOD DEEDS Methinks it is he indeed.	770
[<i>RE-ENTER</i> EVERYMAN]	
EVERYMAN Now Jesu be your alder speed! I have received the sacrament for my re- demption,	
And then mine extreme unction: Blessed be all they that counselled me to take it! And now, friends, let us go without longer respite;	775
I thank God that ye have tarried so long. Now set each of you on this rood° your hand And shortly follow me:	CTOSS
I go before there I would be; God be our guide!	780

STRENGTH Everyman, we will not from you go Till ye have done this voyage long.	
DISCRETION I, Discretion, will bide by	
you also. KNOWLEDGE And though this pilgrimage be	
never so strong,° I will never part you fro.°	grievous from you
STRENGTH Everyman, I will be as sure by thee	j.e gen
As ever I did by Judas Maccabee.	
[EVERYMAN COMES TO HIS GRAVE]	
EVERYMAN Alas, I am so faint I may not stand;	
My limbs under me doth fold. Friends, let us not turn again to this land,	700
Not for all the world's gold;	790
For into this cave must I creep	
And turn to earth, and there to sleep.	
BEAUTY What, into this grave? Alas! EVERYMAN Yea, there shall ye consume, more	
and less.	795
BEAUTY And what, should I smother here?	
EVERYMAN Yea, by my faith, and never more appear.	
In this world live no more we shall,	
But in heaven before the highest Lord of all.	
BEAUTY I cross out all this; adieu, by Saint John!	800
I take my cap in my lap, and am gone.	000
EVERYMAN What, Beauty, whither will ye?	
BEAUTY Peace, I am deaf; I look not be- hind me,	
Not and thou wouldest give me all the gold	
in thy chest.	
[EXIT BEAUTY]	
EVERYMAN Alas, whereto may I trust?	805
Beauty goeth fast away from me; She promised with me to live and die.	
STRENGTH Everyman, I will thee also forsake	
and deny; Thy game liketh° me not at all.	pleases
EVERYMAN Why, then, ye will forsake me all?	810
Sweet Strength, tarry a little space.°	while
STRENGTH Nay, sir, by the rood of grace! I will hie me from thee fast,	
Though thou weep till thy heart to-brast.°	break
EVERYMAN Ye would ever bide by me,	
ye said. STRENGTH Yea, I have you far enough	815
conveyed.	
Ye be old enough, I understand,	
Your pilgrimage to take on hand; I repent me that I hither came.	
EVERYMAN Strength, you to displease I am	
blame;	820
Yet promise is debt, this ye well wot. STRENGTH In faith, I care not.	
Thou art but a fool to complain;	
You spend your speech and waste your	
brain. Go thrust thee into the ground!	825
[EXIT STRENGTH]	
EVERYMAN I had wend surer I should you have found.	

He that trusteth in his Strength		And stand by me, thou mother and maid,	
She him deceiveth at the length.		holy Mary.	
Both Strength and Beauty forsaketh me;	820	GOOD DEEDS Fear not; I will speak for thee.	
Yet they promised me fair and lovingly. DISCRETION Everyman, I will after Strength	830	KNOWLEDGE Here I cry God mercy. GOOD DEEDS Short our end, and minish	
be gone;		our pain;	
As for me, I will leave you alone.		Let us go and never come again.	880
EVERYMAN Why, Discretion, will ye for-		EVERYMAN Into thy hands, Lord, my soul I	
sake me?		commend;	
DISCRETION Yea, in faith, I will go from thee,		Receive it, Lord, that it be not lost.	
For when Strength goeth before	835	As thou me boughtest, so me defend,	
I follow after evermore.		And save me from the fiend's boast,	
EVERYMAN Yet, I pray thee, for the love of the Trinity,		That I may appear with that blessed host That shall be saved at the day of doom.	885
Look in my grave once piteously.		In manus tuas, of mights most	
DISCRETION Nay, so nigh will I not come;		For ever, <i>commendo spiritum meum</i> .	
Farewell, every one!	840		
		[HE SINKS INTO HIS GRAVE.]	
[EXIT DISCRETION]		KNOWLEDGE Now hath he suffered that we	
EVERYMAN O, all thing faileth, save God		all shall endure;	
alone—		The Good Deeds shall make all sure.	890
Beauty, Strength, and Discretion; For when Death bloweth his blast,		Now hath he made ending; Methinketh that I hear angels sing,	
They all run from me full fast.		And make great joy and melody	
FIVE WITS Everyman, my leave now of thee		Where Everyman's soul received shall be.	
I take;	845	ANGEL Come, excellent elect spouse, to Jesu!	895
I will follow the other, for here I thee forsake.		Hereabove thou shalt go	
EVERYMAN Alas, then may I wail and weep,		Because of thy singular virtue.	
For I took you for my best friend.		Now the soul is taken the body fro,	
FIVE WITS I will no longer thee keep;	950	Thy reckoning is crystal-clear.	000
Now farewell, and there an end.	850	Now shalt thou into the heavenly sphere, Unto the which all ye shall come	900
[EXIT FIVE WITS]		That liveth well before the day of doom.	
EVERYMAN O Jesu, help! All hath for- saken me.		[ENTER DOCTOR]	
GOOD DEEDS Nay, Everyman; I will bide		[DOCTOR] This moral men may have in mind	
with thee.		Ye hearers, take it of worth,° old and young,	value it
I will not forsake thee indeed;		And forsake Pride, for he deceiveth you in	
Thou shalt find me a good friend at need.		the end;	905
EVERYMAN Gramercy, Good Deeds! Now		And remember Beauty, Five Wits, Strength,	
may I true friends see.	855	and Discretion,	
They have forsaken me, every one;		They all at the last do every man forsake, Save his Good Deeds there° doth he take.	
I loved them better than my Good Deeds alone.		But beware, for and they be small	unless
Knowledge, will ye forsake me also?		Before God, he hath no help at all;	910
KNOWLEDGE Yea, Everyman, when ye to		None excuse may be there for every man.	
Death shall go;	860	Alas, how shall he do then?	
But not yet, for no manner of danger.		For after death amends may no man make,	
EVERYMAN Gramercy, Knowledge, with all		For then mercy and pity doth him forsake	
my heart.		If his reckoning be not clear when he doth come	015
KNOWLEDGE Nay, yet I will not from hence depart		God will say: "Ite, maledicti, in ignem eternum."	915
Till I see where ye shall become.		And he that hath his account whole and sound,	
EVERYMAN Methink, alas, that I must		High in heaven he shall be crowned;	
be gone	865	Unto which place God bring us all thither,	
To make my reckoning and my debts pay,		That we may live body and soul together.	920
For I see my time is nigh spent away.		Thereto help the Trinity!	
Take example, all ye that this do hear or see, How they that I leved best do forsake me		Amen, say ye, for saint charity.	
How they that I loved best do forsake me, Except my Good Deeds that bideth truly.	870	THUS ENDETH THIS MORAL PLAY OF EVERYMAN	
GOOD DEEDS All earthly things is but vanity:	070		
Beauty, Strength, and Discretion do man			
forsake,		Hroswitha	
Foolish friends, and kinsmen, that fair		The Conversion of the Harlot Thaïs	
spake—			
All fleeth save Good Deeds, and that am I.		This rather "aristocratic" play was written in conscious in	
EVERYMAN Have mercy on me, God most mighty	875	of the Classical Roman playwright Terence. The opening strongly didactic; the nature of music (taken from the trea	
migney	0/5	shongiy addicite, the nature of music (taken from the trea	moe De

Musica of Boethius) is discussed as part of a liberal arts education. Given the very rudimentary stage directions it is easy to imagine this play being read aloud by a circle of people (the nuns of Hroswitha's convent?) for mutual edification and instruction. We reproduce the second half of the play here.

The story of Thaïs is a very old one that Hroswitha adapts from the legends of the saints. Like many of her plays, it deals with a woman who triumphs in the life of virtue. The same story was turned into an opera titled Thaïs by Jules Massenet in 1894.

- PAFNUTIUS A certain shameless woman dwells in this land./
- DISCIPLES For all citizens a grave peril at hand./

PAFNUTIUS She shines forth in wondrous beauty, but threatens men with foul shame./

DISCIPLES How misfortunate. What is her name?/

PAFNUTIUS Thaïs.

DISCIPLES Thaïs, the whore?/

- PAFNUTIUS That is her name./
- DISCIPLES No one is unaware of her sordid fame./
- PAFNUTIUS No wonder, because she is not satisfied with leading only a few men to damnation/but is ready to ensnare all men with the allurement of her beauty and drag them along with her to eternal perdition./

DISCIPLES A doleful situation./

PAFNUTIUS And not only frivolous youths dissipate their family's few possessions on her,/ but even respected men waste their costly treasures by lavishing gifts on her./ Thus they harm themselves.

DISCIPLES We are horrified to hear./

PAFNUTIUS Crowds of lovers flock to her, wishing to be near./

DISCIPLES Damning themselves in the process.

- PAFNUTIUS These fools that come to her are blind in their hearts; they contend and quarrel and fight each other./
- DISCIPLES One vice gives birth to another./
- PAFNUTIUS Then, when the fight has started they fracture each other's faces and noses with their fists; they attack each other with their weapons and drench the threshold of the brothel with their blood gushing forth./

DISCIPLES What detestible wrong!/

- PAFNUTIUS This is the injury to our Maker which I bewail./ This is the cause of my grief and ail./
- DISCIPLES Justifiably you grieve thereof, and doubtlessly the citizens of heaven grieve with you.

PAFNUTIUS What if I visit her, disguised as a lover, to see if perchance she might be recovered from her worthless and frivolous life?

- DISCIPLES He who instilled the desire for this undertaking in you,/ may He make this worthy desire come true./
- PAFNUTIUS Stand by me with your constant prayers all the while/ so that I won't be overcome by the vicious serpent's guile./
- DISCIPLES He who overcame the prince of the dark, may He grant you triumph over the fiend.
- PAFNUTIUS Here I see some young men in the forum. First I will go to them and ask, where I may find her whom I seek./
- YOUNG MEN Hm, a stranger approaches, let's enquire what he wants.

PAFNUTIUS Young men, who are you?/

- YOUNG MEN Citizens of this town.
- PAFNUTIUS Greetings to you./
- YOUNG MEN Greetings to you whether you are from these parts or stranger./

PAFNUTIUS I just arrived. I am a stranger./

YOUNG MEN Why did you come? What do you seek?/

PAFNUTIUS Of that, I cannot speak./

YOUNG MEN Why not?

- PAFNUTIUS Because that is my secret.
- YOUNG MEN It would be better if you told us,/ because as you are not one of us, you will find it very difficult to accomplish your business without the inhabitants' advice.

PAFNUTIUS What if I told you and by telling an obstacle for myself procured?

YOUNG MEN Not from us-rest assured!/

PAFNUTIUS Then, trusting in your promise I will yield,/ and my secret no longer shield./

YOUNG MEN We will not betray our promise; we will not lay an obstacle in your way./

PAFNUTIUS Rumors reached my ear/ that a certain woman lives here/ which surpasses all in amiability,/ surpasses all in affability./

YOUNG MEN Do you know her name?/

- PAFNUTIUS I do.
- YOUNG MEN What is her name?/

PAFNUTIUS Thaïs.

- YOUNG MEN For her, we too are aflame./
- PAFNUTIUS They say she is the most beautiful woman on earth,/ greater than all in delight and mirth./
- YOUNG MEN Whoever told you that, did not tell a lie.

PAFNUTIUS It was for her sake that I decided to make this arduous journey; I came to see her today./

- YOUNG MEN There are no obstacles in your way./
- PAFNUTIUS Where does she stay?/
- YOUNG MEN In that house, quite near./
- PAFNUTIUS The one you are pointing out to me here?/
- YOUNG MEN Yes.
- PAFNUTIUS I will go there.
- YOUNG MEN If you like, we'll go along./
- PAFNUTIUS No, I'd rather go alone./
- YOUNG MEN As you wish.

PAFNUTIUS Are you inside, Thaïs, whom I'm seeking?/

THAÏS Who is the stranger speaking?/

- PAFNUTIUS One who loves you.
- THAÏS Whoever seeks me in love/ finds me returning his love./
- PAFNUTIUS Oh Thaïs, Thaïs, what an arduous journey I took to come to this place/ in order to speak with you and to behold your face./
- THAÏS I do not deny you the sight of my face nor my conversation./
- PAFNUTIUS The secret nature of our conversation/ necessitates the solitude of a secret location./
- THAÏS Look, here is a room well furnished for a pleasant stay./
- PAFNUTIUS Isn't there another room, where we can converse more privately, one that is hidden away?/
- THAÏS There is one so hidden, so secret, that no one besides me knows its inside except for God./

PAFNUTIUS What God?/

- THAÏS The true God./
- PAFNUTIUS Do you believe He knows what we do?/
- THAÏS I know that nothing is hidden from His view./

PAFNUTIUS Do you believe that He overlooks the deeds of the wicked or that He metes out justice as its due?/

THAÏS I believe that He weighs the merits of each person justly in His scale/ and that, each according to his desserts receives reward or travail./ PAFNUTIUS Oh Christ, how wondrous is the patience, of Thy great mercy! Thou seest that some sin with full cognition,/ yet Thou delay their deserved perdition./

- THAÏS Why do you tremble? Why the change of color? Why all these tears?
- PAFNUTIUS I shudder at your presumption,/ I bewail your sure perdition/ because you know all this so well,/ and yet you sent many a man's soul to Hell./ THAÏS Woe is me, wretched woman!
- PAFNUTIUS You deserve to be damned even more,/ as you offended the Divine Majesty haughtily, knowing of Him before./

THAÏS Alas, alas, what do you do? What calamity do you sketch?/ Why do you threaten me, unfortunate wretch?/

- PAFNUTIUS Punishment awaits you in Hell/ if you continue in sin to dwell./
- THAÏS Your severe reproach's dart/ pierces the inmost recesses of my heart./

PAFNUTIUS Oh, how I wish you were pierced through all your flesh with pain/ so that you wouldn't dare to give yourself to perilous lust again./

THAÏS How can there be place now for appalling lust in my heart when it is filled entirely with the bitter pangs of sorrow/and the new awareness of guilt, fear, and woe?/

PAFNUTIUS I hope that when the thorns of your vice are destroyed at the root,/ the winestock of penitence may then bring forth fruit./

THAÏS If only you believed/ and the hope conceived/ that I who am so stained,/ with thousands and thousands of sins enchained,/ could expiate my sins or could perform due penance to gain forgiveness!

PAFNUTIUS Show contempt for the world, and flee the company of your lascivious lovers' crew./

THAÏS And then, what am I to do?/

PAFNUTIUS Withdraw yourself to a secret place,/ where you may reflect upon yourself and your former ways/ and lament the enormity of your sins.

THAÏS If you have hopes that I will succeed,/ then I will begin with all due speed./

PAFNUTIUS I have no doubt that you will reap benefits.

- THAIS Give me just a short time to gather what I long saved:/ my wealth, ill-gotten and depraved./
- PAFNUTIUS Have no concern for your treasure,/ there'll be those who will use them for pleasure./
- THAÏS I was not planning on saving it for myself not giving it to friends. I don't even wish to give it to the poor because I don't think that the prize of sin is fit for good.
- PAFNUTIUS You are right. But how do you plan to dispose of your treasure and cash?/

THAÏS To feed all to the fire, until it is turned to ash./ PAFNUTIUS Why?

THAÏS So that nothing is left of what I acquired through sin,/ wronging the world's Maker therein./

PAFNUTIUS Oh how you have changed from your prior condition/ when you burned with illicit passions/ and were inflamed with greed for possessions./

THAÏS Perhaps, God willing,/ I'll be changed into a better being./

PAFNUTIUS It is not difficult for Him, Himself unchangeable, to change things according to His will./

THAÏS I will now leave and what I planned fulfill./ PAFNUTIUS Go forth in peace and return quickly.

THAÏS Come, hurry along,/ my worthless lovers' throng!/ LOVERS The voice of Thaïs calls us, let us hurry, let us go/ so that we don't offend her by being slow./

- THAÏS Be quick, come here, and don't delay,/ there is something I wish to say./
- LOVERS Oh Thaïs, Thaïs, what do you intend to do with this pile, why did you gather all these riches around the pyre yonder?/
- THAÏS Do you wonder?
- LOVERS We are much surprised./
- THAÏS You'll be soon apprised./
- LOVERS That's what we hope for.
- THAÏS Then watch me!
- LOVERS Stop it Thaïs; refrain!/ What are you doing? Are you insane?/
- THAÏS I am not insane, but savoring good health again./
- LOVERS But why this destruction of four-hundred pounds of gold,/ and of these treasures manifold?/
- THAÏS All that I extorted from you unjustly, I now wish to burn,/ so that no spark of hope is left that I will ever again return/ and give in to your lust.
- LOVERS Wait for a minute, wait,/ and the cause of your distress relate!
- THAÏS I will not stay,/ for I have nothing more to say./
- LOVERS Why do you dismiss us in obvious disgust?/ Do you accuse any one of us of breaking trust?/ Have we not always satisfied your every desire,/ and yet you reward us with hate and with ire!/
- THAÏS Go away, depart!/ Don't tear my robe apart./ It's enough that I sinned with you in the past;/ this is the end of my sinful life, it is time to part at last./
- LOVERS Whereto are you bound?/

THAÏS Where I never can be found./

LOVERS What incredible plight/ . . . that Thaïs, our only delight,/ the same Thaïs who was always eager to accumulate wealth, who always had lascivious things on her mind,/ and who abandoned herself entirely to voluptuousness of every kind,/ has now destroyed her jewels and her gold and all of a sudden scorns us,/ and wants to leave us./

THAÏS Here I come, father Pafnutius, eager to follow you.

- PAFNUTIUS You took so long to arrive here,/ that I was tortured by grave fear/ that you may have become involved once again in worldly things.
- THAÏS Do not fear; I had different things planned namely to dispose of my possessions according to my wish and to renounce my lovers publicly.
- PAFNUTIUS Since you have abandoned those/ you may now make your avowals/ to the Heavenly Bridegroom.
- THAÏS It is up to you to tell me what I ought to do. Chart my course as if drawing a circle.

PAFNUTIUS Then, come along./

THAÏS I shall follow you, I'm coming along:/ Oh, how I wish to avoid all wrong,/ and imitate your deeds!

PAFNUTIUS Here is the cloister where the noble company of holy virgins stays./ Here I want you to spend your _____days/ performing your penance.

THAÏS I will not contradict you.

PAFNUTIUS I will enter and ask the abbess, the virgins' leader, to receive you./

THAÏS In the meantime, what shall I do?

PAFNUTIUS Come with me./

THAÏS As you command, it shall be./

- PAFNUTIUS But look, the abbess approaches. I wonder who told her so promptly of our arrival./
- THAÏS Some rumor, bound by no hindrance and in speed without a rival./

PAFNUTIUS Noble abbess, Providence brings you,/ for I came to seek you./

- ABBESS Honored father Pafnutius, our most welcome guest,/ your arrival, beloved of God, is manifoldly blest./
- PAFNUTIUS May the felicity of eternal bliss/ grant you the Almighty's grace and benefice./
- ABBESS For what reason does your holiness deign to visit my humble abode?/
- PAFNUTIUS I ask for your aid; in a situation of need I took to the road./
- ABBESS Give me only a hint of what you wish me to do, and I will fulfill it forthright./ I will try to satisfy your wish with all my might.
- PAFNUTIUS I have brought you a half-dead little she-goat, recently snatched from the teeth of wolves. I hope that by your compassion its shelter will be ensured,/ and that by your care, it will be cured,/ until, having cast aside the rough pelt of a goat, she will be clothed with the soft wool of the lamb.
- ABBESS Please, explain it more./
- PAFNUTIUS She whom you see before you, led the life of a whore./
- ABBESS What a wretched life she bore!/
- PAFNUTIUS She gave herself entirely to vice./
- ABBESS At the cost of her salvation's sacrifice!/
- PAFNUTIUS But now urged by me and helped by Christ, she renounced her former frivolous way of life and seeks to embrace chastity./
- ABBESS Thanks be to the Lord for the change./
- PAFNUTIUS But because the sickness of both body and soul must be cured by the medicine of contraries, it follows that she must be sequestered from the tumult of the world,/ obscured in a small cell, so that she may contemplate her sins undisturbed./
- ABBESS That cure will work very well./
- PAFNUTIUS Then have them build such a cell./
- ABBESS It will be completed promptly./
- PAFNUTIUS Make sure it has no entry and no exit, only a tiny window through which she may receive some modest food on certain days at set hours and in small quantity./
- ABBESS I fear that the softness of her delicate disposition/ will find it difficult to suffer such harsh conditions./
- PAFNUTIUS Do not fear; such a grave offense certainly requires a strong remedy./
- ABBESS That is quite plain./
- PAFNUTIUS I am loath to delay any longer, because I fear she might be seduced by visitors again./
- ABBESS Why do you worry? Why don't you hurry/ and enclose her? Look, the cell you ordered is built./
- PAFNUTIUS Well done. Enter, Thaïs, your tiny cell, just right for deploring your sins and guilt./
- THAÏS How narrow, how dark is the room!/ For a tender woman's dwelling, how full of gloom!/
- PAFNUTIUS Why do you complain about the place?/ Why do you shudder and your steps retrace?/ It is only proper that you who for so long were wandering unrestrained/ in a solitary place should be detained./
- THAÏS A mind used to comfort and luxury,/ is rarely able to bear such austerity./
- PAFNUTIUS All the more reason to restrain it by the reins of discipline, until it desist from rebellion.
- THAÏS Whatever your fatherly concern prescribes for my reform,/ my wretched self does not refuse to perform;/ but in this dwelling there is one unsuitable thing however/ which would be difficult for my weak nature to bear./

PAFNUTIUS What is this cause of care?/

- THAÏS I am embarrassed to speak./
- PAFNUTIUS Don't be embarrassed, but speak!/
- THAÏS What could be more unsuitable/ what could be more uncomfortable,/ than that I would have to perform all necessary functions of the body in the very same room? I am sure that it will soon be uninhabitable because of the stench.
- PAFNUTIUS Fear rather the eternal tortures of Hell,/ and not the transitory inconveniences of your cell./
- THAÏS My frailty makes me afraid.
- PAFNUTIUS It is only right/ that you expiate the evil sweetness of alluring delight/ by enduring this terrible smell./
- THAÏS And so I shall./ I, filthy myself, do not refuse to dwell/ in a filthy befouled cell/ —that is my just due./ But it pains me deeply that there is no spot left dignified and pure,/ where I could invoke the name of God's majesty.
- PAFNUTIUS And how can you have such great confidence that you would presume to utter the name of the unpolluted Divinity with your polluted lips?
- THAÏS But how can I hope for grace, how can I be saved by His mercy if I am not allowed to invoke Him, against Whom alone I sinned, and to Whom alone I should offer my devotion and prayer?
- PAFNUTIUS Clearly you should pray not with words but with tears; not with your tinkling voice's melodious art/ but with the bursting of your penitent heart./
- THAÏS But if I am prohibited from praying with words, how can I ever hope for forgiveness?/
- PAFNUTIUS The more perfectly you humiliate yourself, the faster you will earn forgiveness./ Say only: Thou Who created me,/ have mercy upon me!/
- THAÏS I will need His mercy not to be overcome in this uncertain struggle.
- PAFNUTIUS Struggle manfully so that you may gloriously attain your triumph.
- THAÏS You must pray for me so that I may deserve the palm of victory./
- PAFNUTIUS No need to admonish me./
- THAÏS I hope so.
- PAFNUTIUS Now it is time that I return to my longed-for retreat and visit my dear disciples. Noble abbess,/ I commit my charge to your care and kindness,/ so that you may nourish her delicate body with a few necessities occasionally/ and nourish her soul with profitable admonitions frequently./
- ABBESS Don't worry about her, because I will look after her, and my maternal affections will never cease./
- PAFNUTIUS I will then leave.
- ABBESS Go forth in peace!/

DISCIPLES Who knocks at the door?

PAFNUTIUS Hello!/

DISCIPLES Our father's, Pafnutius' voice!

PAFNUTIUS Unlock the door!

DISCIPLES Oh father, greetings to you!/

PAFNUTIUS Greetings to you, too./

DISCIPLES We were worried about your long stay./

PAFNUTIUS It was good that I went away./

DISCIPLES What happened with Thaïs?

PAFNUTIUS Just the event for which I was praying./

DISCIPLES Where is she now staying?/

PAFNUTIUS She is bewailing her sins in a tiny cell, quite nigh./

DISCIPLES Praise be to the Trinity on High./

PAFNUTIUS And blessed be His formidable name, now and forever.

DISCIPLES Amen.

- PAFNUTIUS Behold, three years of Thaïs' penitence have passed and I don't know whether or not her penance was deemed acceptable. I will rise and go to my brother Antonius, so that through his intercession I may find out.
- ANTONIUS What unexpected pleasure, what surprising delight:/ it is my brother and co-hermit Pafnutius whom I sight!/ He is coming near./
- PAFNUTIUS I am here./
- ANTONIUS How good of you to come, brother, your arrival gives me great joy.
- PAFNUTIUS I am as delighted in seeing you as you are with my visit.
- ANTONIUS And what happy and for both of us welcome cause brings you here away from your solitary domain?/
- PAFNUTIUS I will explain./

ANTONIUS I'd like to know./

PAFNUTIUS Three years ago/ a certain whore/ by the name of Thaïs lived in this land/ who not only damned herself but dragged many a man to his miserable end./

ANTONIUS What an abominable way one's life to spend!/

- PAFNUTIUS I visited her, disguised as a lover, secretly/ and won over her lascivious mind first with kind admonitions and flattery,/ then I frightened her with harsh threats.
- ANTONIUS A proper measure,/ necessary for this whore of pleasure./
- PAFNUTIUS Finally she yielded,/ scorning the reprehensible way of life she formerly wielded/ and she chose a life of chastity consenting to be enclosed in a narrow cell./
- ANTONIUS I am delighted to hear what you tell/ so much so that my veins are bursting, and my heart beats with joy.
- PAFNUTIUS That becomes your saintliness, and while I am overjoyed by her change of heart,/ I am still disturbed by a decision on my part:/ I fear that her frailty/ can bear the long penance only with great difficulty./
- ANTONIUS Where true affection reigns,/ kind compassion never wanes./
- PAFNUTIUS Therefore I'd like to implore you that you and your disciples pray together with me until Heaven reveals to our sight or ears/ whether or not Divine Mercy has been moved to forgiveness by the penitent's tears./
- ANTONIUS We are happy to comply with your request./
- PAFNUTIUS I have no doubt that God will listen and grant your behest./

ANTONIUS Look, the Gospel's promise is fulfilled in us. PAFNUTIUS What promise?

- ANTONIUS The one that promises that communal prayer can achieve all./
- PAFNUTIUS What did befall?/
- ANTONIUS A vision was granted to my disciple, Paul./

PAFNUTIUS Call him!

- ANTONIUS Come hither, Paul, and tell Pafnutius what you saw.
- PAUL In my vision of Heaven, I saw a bed/ with white linen beautifully spread/ surrounded by four resplendent maidens who stood as if guarding the bed./ And

when I beheld the beauty of this marvelous brightness I said to myself: This glory belongs to no one more than to my father and my lord Antonius.

- ANTONIUS I am not worthy so such beautitude to soar./
- PAUL After I spoke, a Divine voice spoke: "This glory is not as you hope for Antonius, but is meant for Thais the whore."/
- PAFNUTIUS Praised be Thy sweet mercy, Oh Christ, only begotten Son of God, for Thou hast designed to deliver me from my sadness' plight./
- ANTONIUS To praise Him is meet and right./
- PAFNUTIUS I shall go and visit my prisoner.
- ANTONIUS It is proper to give her hope for forgiveness without further remiss,/ and assure her of the comfort of Heavenly bliss./
- PAFNUTIUS Thaïs, my adoptive daughter, open your window so I may see you and rejoice./
- THAÏS Who speaks? Whose is this voice?
- PAFNUTIUS It is Pafnutius, your father.
- THAÏS To what do I owe the bliss of such great joy that you deign to visit me, poor sinful soul?/
- PAFNUTIUS Even though I was absent in body for three years, yet I was constantly concerned about how you would achieve your goal./
- THAÏS I do not doubt that at all./
- PAFNUTIUS Tell me of these past three years' course,/ and how you practiced your remorse./
- THAÏS This is all I can tell:/ I have done nothing worthy of God, and that I know full well./
- PAFNUTIUS If God would consider our sins only/ no one would stand up to scrutiny./
- THAÏS But if you wish to know how I spent my time, in my conscience I enumerated my manifold sins and wickedness and gathered them as in a bundle of crime./ Then I continuously went over them in my mind,/ so that just as the nauseating smell here never left my nostrils, so the fear of Hell never departed from my heart's eyes.
- PAFNUTIUS Because you punished yourself with such compunction/ you have earned forgiveness' unction./
- THAÏS Oh, how I wish I did!
- PAFNUTIUS Give me your hand so I can lead you out.
- THAÏS Venerable Father, do not take me, stained and foul wretch, from this filth; let me remain in this place/ appropriate for my sinful ways./
- PAFNUTIUS It is time for you to lessen your fear/ and to begin to have hopeful cheer./
- THAÏS All angels sing His praise and His kindness, because He never scorns the humility of a contrite soul.
- PAFNUTIUS Remain steadfast in fearing God, and continue to love Him forever. After fifteen days you will leave your human body/ and, having completed your happy journey,/ by the favor of Heavenly grace you will reach the stars.
- THAÏS Oh, how I desire to avoid Hell's tortures, or rather how I aspire/ to suffer by some less cruel fire!/ For my merits do not suffice/ to secure me the bliss of paradise./
- PAFNUTIUS Grace is God's gift and a free award,/ and not human merit's reward;/ because if it were simply a payment for merits, it wouldn't be called grace.
- THAÏS Therefore praise Him all the company of heaven, and on earth the least little sprout or bush,/ not only all living creatures but even the waterfall's crush/ because He not only suffers men to live in sinful ways/ but rewards the penitent with the gift of grace./

- PAFNUTIUS This has been His custom from time immemorial, to have mercy on sinners rather than to slay them.
- THAÏS Do not leave, venerable father, but stand by me with consolation in my hour of death.
- PAFNUTIUS I am not leaving, / I am staying / until your soul rejoices in Heaven's gains / and I bury your earthly remains./

THAÏS Death is near./

PAFNUTIUS Then we must begin our prayer./

- THAIS Thou Who made me, Have mercy upon me/ and grant that my soul which Thou breathed into me,/ may return happily to Thee.
- PAFNUTIUS Thou Who art created by no one, Thou only art truly without material form, one God in Unity of Substance,/ Thou Who created man, unlike Thee, to consist of diverse substances;/ grant that the dissolving, diverse parts of this human being/ may happily return to the source of their original being; that the soul, divinely imparted, live on in heavenly bliss,/ and that the body, may rest in peace/ in the soft lap of earth, from which it came,/ until ashes and dirt combine again/ and breath animates the revived members; that Thaïs be resurrected exactly as she was,/ a human being, and joining the white lambs may enter eternal joys./ Thou Who alone art what Thou art, one God in the Unity of the Trinity who reigns and is glorified, world without end.

BERTILLA, ABBESS OF CHELLES

Typical of early medieval lives of the saints, this is a brief account of a seventh-century female monastic who was the first abbess of Chelles (modern Meaux in France), a Benedictine monastery that would continue in existence until the French Revolution. Attention should be paid to the emphasis on the austerity of life since, as the text itself notes, this kind of life was considered to be its own form of martyrdom. The miraculous element was typical of this kind of literature since it was widely considered that miraculous powers were a sign of God's favor. It is also worth noting the relationship between the monastery and its royal patrons. Many of the nuns would have come from the aristocracy although provisions for members of the "lower" classes to enter religious life were not lacking.

1. The brighter the religious life of holy virgins shines in merit, the more it is celebrated by word of mouth and praised in the tongues of all people. For as long as it presents an example of good behavior to others, it should move every voice to praise. Blessed Bertilla, a virgin native to the province of Soissons, sprang from parents of the highest nobility. As worthy seed gives birth to yet worthier children, she amplified the honors she received from her birth by the merits of her blessed life when Christ chose to be glorified in her and to make her glitter so that many would imitate her. From the beginnings of her earliest youth, she showed so much fervor in the faith that she willingly relinquished her parents for love of Christ, though as long as she was a child she always yielded swiftly to their desires. As soon as she reached her adolescence, the age of understanding, she desired Christ the Lord and planned, with a heart full of love, to enter His service. When questioned by the most faithful man Dado, called Ouen, as to whether she wished to serve Christ, she answered with thankful spirit that she had been devoted to Him from infancy when she had sworn to gain

Christ, the Son of God, for her spouse. But she had not dared to announce this publicly for she knew that her parents were strongly opposed and would rather impede her with their prohibitions than give her their consent. But while she was still of tender age, she astutely followed divine counsel and secretly begged help most assiduously from God that her piety might produce profits and He might ordain that she be led into a suitable consortium of holy women or one of their communities. Considering her devotion, Divine Piety Which never fails those who place their hope in It, soon sent divine grace to her aid. At last, she gained her parents' consent and her devoted brothers and sisters encouraged her to persist in holy devotion and consecrate herself as an intact virgin to God. By the Lord's inspiration, they freely gave her encouragement and soon brought her, according to her vow, to a nearby monastery of women called Jouarre. She arrived there and was commended to the Lady Abbess Theudechild, who received her with honor among the holy women.

2. Thus the noble maiden Bertilla gave many thanks to Christ, whose piety guided her from the tempest of the world to the snug harbor of the community. And from that day, in that same place, she set herself to be pleasing to God with so much humility of soul that, except for the honorable way she behaved, she took no pride in the nobility of her stock. For sprung from free people at birth, she voluntarily consented to become a slave. In the holy community, she behaved herself so admirably and praiseworthily under the norms of the holy rule, that she soon achieved senior status in holy obedience. She hastened devoutly with fervent mind to prayers and to the divine office. She behaved properly with all gravity, gentleness and temperance, winning the admiration of the holy congregation. She kept the fear of God always before her eyes, walking with a heart perfected by the purity of confession. Humble and obedient, she was always pleasant to her seniors and served her elders in every way, as the mother ordered her. She strove to do everything most faithfully with a willing spirit, trusting in the consolation of divine grace and did all that was enjoined upon her without a murmur. Thus she profited, making daily advances in her exercises. She rose steadily above herself, not simply to surpass the others in merits but to triumph in taming her own body. Who now can recollect or tell all that there was to tell of what Christ's servant Bertilla did in that time? She was foremost in the stringency of her fasting and readier in love of vigils, more laudable in assiduity of prayer, more lavish in charity, more careful in reading Holy Scripture and more remarkable in works of mercy. Despite her youth, she was an elder in her habits of obedience and so mature in the treading down of vice that, in her juvenile inexperience, she was an example of understanding to her seniors, a solace to her companions and a model of the saints' ways to her juniors. While she lived, she wished to be wholly in Christ and with Christ. Not voluptuous in her gaze nor wanton of ear, not turning her mind to pleasure, but always restraining herself with the anchor of gravity, she so worked within the monastery walls that, in many useful matters, she resembled the spiritual mother. Considering her most faithful ministry, the abbess enjoined more and heavier duties upon her than others below her. Thus, while she was trained in many holy and religious ways she behaved with pious solicitude to other sisters under the mother's direction. The care of the sick, of children and even guests was frequently entrusted to her. All of this, she performed most blessedly with a spirit of grace and equanimity, as though under divine guidance. She was chosen by the Lord for all the offices of the monastery and held the chief office second only to the mother abbess.

She discharged all with flawless obedience for the love of God. She always maintained sobriety and peace with an untroubled mind so that no provocation ever moved her spirit to scandal. And more, if she discerned any commotion or heard any sisters murmuring, for zeal of piety she strove to soothe and pacify them, to curb malicious whispers so that she might administer charity and piety by divine grace to their hearts.

3. So that the great merit in Christ's servant, Bertilla, might be shown to others, a great miracle was done through her. For once, when one of her sisters, whose spirit was troubled, spoke wrathful words to her, she called down divine judgment upon her. Although, as was seemly, the fault was mutually forgiven, Lady Bertilla continued to be fearful about the divine judgment she had summoned. Then the sister who had angered her died unexpectedly, choked by asthma. Hearing the signal, the rest of the sisters gathered for the funeral, to perform the customary pravers for the soul that had been taken from them so that the Lord might decree a warm welcome for her into His perpetual peace. Not having been told, God's servant Bertilla asked what caused the resounding chorus of psalms. One sister answered her; "Did you not know that the tones are ringing out because that sister's soul has left her body?" Hearing that, she trembled greatly because of the words they had had between them. She ran speedily, hurrying with great faith, to the place where the little body of the defunct sister lay lifeless. Entering, she immediately laid her right hand on the breast of the deceased adjuring her receding soul through Jesus Christ, the Son of God, not to leave but, before she spoke with Him, to forgive her anger against her. God permitting, at her commanding voice, the spirit which had left the body returned to the corpse and to the stupefaction of all, the revived cadaver drew breath. Looking at the servant of God, she said: "What have you done, sister? Why did you retrieve me from the way of light?" To which God's servant Bertilla said humbly: "I beg you sister to give me words of forgiveness, for once I cursed you with a troubled spirit." To which she said: "May God forgive you. I harbor no resentment in my heart against you now. Nay, rather, I hold you in fullest love. I pray that you will entreat God for me and permit me to go in peace nor cause me delay. For I am ready for the bright road and now I cannot start without your permission." And to that she said: "Go then in the peace of Christ and pray for me, sweet and lovable sister." How great was the faith in God that permitted her to recall a soul when she wished and return it when she pleased! From that miraculous deed, let us recognize how much constancy of faith God's servant had that enabled her, strengthened inwardly by the gift of celestial piety, to recall a soul indubitably gone from the body, to reanimate a cadaver. She spoke with her as she wished. And when the talk was ended, she permitted the soul to leave. Thus in the blessed Bertilla was the scripture fulfilled: "All things are possible to him that believeth" (Mark 9:23). For nothing is impossible to one who confides in God with all her heart, as this miracle makes clear.

4. Now this was in the time after the decease of Lord Clovis the King. Queen Balthild, his most noble wife, with her little son Clothar, governed the Kingdom of the Franks without reproach. All the bishops and nobles and even the commoners of the kingdom were compelled by her merits to love her with wonderful affection. For she was religious and much devoted to God and took care of paupers and churches. With great strength of soul, she governed the palace manfully. She took counsel with pontiffs and primates of the people and proposed to build a monastery of maidens at a royal villa called Chelles. For she announced that she had made up her mind that when her son, the said Lord Clothar, reached his majority and could rule for himself, she would enter that monastery under religious orders, leaving royal cares behind. And because she loved everyone with wondrous affection and everyone loved her, her counsel pleased the company and they all gave their assent to it. And, prudent and wise as she was, she ordered the monastery to be built with all haste. Foreseeing the future needs of God's handmaids, she provided the necessary substance. Then, with the convent diligently prepared, she resolved in her mind to seek a woman of worthy merits and honesty and maidenly behavior to whom she could entrust a flock of holy virgins gathered there under the rule of holy religion. Rumors of the blessed holy maid Bertilla were on many tongues and, through many tales told by the faithful, came at last to the ears of the royal lady Balthild, the most glorious and Christian Queen. She rejoiced at the news of her sanctity and took counsel on the spot and decreed that [Bertilla] should be constituted mother over the holy women whom she had gathered for the love of Christ and reverence of holy Mary in the above-named convent. This, by God's dispensation, she afterwards brought to pass. With great devotion and humility she entreated the lady abbess Theudechild to designate some servants of God from her monastery to govern her community. After long urging, she could not deny the queen's supplication and freely granted the glorious lady's petition. She ordered the Lady Bertilla with several holy maidens to proceed to the convent at Chelles, to the spiritual mother Lady Balthild with the greatest care and fitting honor. As is proper, through the great priest Genesius, the whole congregation was commended to her as spiritual mother and he presently relayed to the Lady Queen his confidence in her religion and modest manners. Accordingly, the glorious queen, Balthild, received her as a heavenly gift, with great honor and, by mandate of Lady Theudechild, imposed the burden of ruling the whole convent upon her and ordered her to be its abbess.

5. Now truly I cannot express with what prudence and utter blamelessness the venerable servant of God Bertilla prepared herself to take up the cares of governance. She was not puffed up by the honor she had assumed or the abundant wealth or the surrounding crowd of servants of both sexes. She continued to remain in herself what she had been before: humble, pious, benignant, modest, virginal and, what supercedes everything, charitable. Assiduously, with complete faith, she prayed God, Who had consoled her in all things since her infancy, to help her and give her both strength and astute counsel to govern her holy community so that it would please Him Who had deigned to call her to this dignity. With the help of divine piety, she was able, through priestly counsel, to govern the community manfully with the highest sanctity and religion and guide it wonderfully under the holy rule so that she was pleasing to God and to the holy queen in all things. For she loved each of her sons and daughters like a mother and all returned that love. So she was loved when she was angry and feared when she laughed. She fortified her daughters and others under her governance against the devil's insidiousness and used spiritual arts as precautions to lead them to good deeds. She showed herself as a shining example in every good work and provided abundantly for their physical needs. Her sober and beneficent demeanor attracted many women and even men whose hearts were faithful. As the holy woman's fame spread, even more men and women hastened to her, not only from neighboring provinces but even from across the seas, leaving parents and fatherland with love's strongest desire. And with pious affection, God's servant Bertilla received them all as a mother to her darling little ones and cared for them lovingly, instructing them with holy lessons to live justly and piously that they might be pleasing to Christ the King.

6. Now, through her continence and fullest love, blessed Bertilla was an example and model of piety to all. She carefully taught religious customs to her subjects not only through holy speech but even more through her own sanctity, so that they might love one another in charitable affection and behave purely, soberly and chastely in all things and be ever ready for offices and prayers and to take care of guests and the poor with fond concern and to love their neighbors. Through holy communion, she drew the monastic household and its near neighbors to do the penance given for their sins in confession. Thus she gained the improvement of many and gained much profit for their souls and rewards for herself. Christ's servant Bertilla had the highest devotion and diligence for the adornment of churches and altars for Christ. She ordered her priests daily to offer their sacred hosts to God for the salvation of the souls of the faithful and the right state of God's Holy Church. She was always assiduous in vigils and prayers and abstinence from food and above all it was wonderful how little she drank. And in constancy of faith, she kept her unswerving mind always on the Lord Jesus Christ. And when she carried out these and other most honest customs, her holy example was edifying to the Christianity of her brothers and sisters; meanwhile paupers and pilgrims were comforted by her munificent largesse. Through her, the Lord collected such great fruits for the salvation of souls that even from over the seas, the faithful kings of the Saxons, through trusted messengers, asked her to send some of her disciples for the learning and holy instruction they heard were wonderful in her, that they might build convents of men and nuns in their land. She did not deny these religious requests which would speed the salvation of souls. In a thankful spirit, taking counsel with her elders and heeding her brothers' exhortations, with great diligence and the protection of the saints, she sent many volumes of books to them. That the harvest of souls in that nation might increase through her and be multiplied by God's grace, she sent chosen women and devout men. And we trust that this has been fulfilled to the praise of God and Lady Bertilla.

7. Meanwhile the glorious servant of God, Queen Balthild, who had been bound to government service and the care of the affairs of the principality, felt love of Christ and devotion to religion possess her mind, even as she labored under the heavy burden. With the consent of his optimates, she abandoned care of the royal palace to her adult son Lord Clothar and enlisted as a soldier of the Lord Christ in the monastery which she had built. There, as we wrote above, she submitted herself in obedience to the abbess Lady Bertilla. Received by her and by the whole flock of holy maidens, with great veneration, as was right and proper, she determined to remain in holy religion even to her dying day. By common counsel and dual example of sanctity, [the two women] adorned the conventual buildings and offices. They shone like two of the brightest lights placed on a candlestick for the clear edification of many. By apostolic custom, through the grace of the Holy Spirit, they were one heart and one soul, and their minds were always ready to act for the good. It was wonderful what delight and charity there was between them all their days. They mutually exhorted one another, that their rewards might increase in abundance. And after Lady Balthild the Queen had completed her devotions in all ways and migrated in peace to Christ, her body was placed with honors in the grave. Then the servant of Christ, Lady Bertilla, a few of whose many deeds we here commemorate, continued to occupy her office

according to God, working in this convent while forty-six years ran their cycle. More and more, she grew in good works and progressed from strength to strength even to the day of her perfect death.

8. Blessed Bertilla would gladly have bowed her neck to gratify her great desire for martyrdom, had there been a skilled executioner ready for the task. But we believe that even though that passion was not fulfilled, yet she completed her martyrdom through mortification of her own body and blood. For when she had reached an advanced age, she drove her weary and senescent members to spiritual service. She did not follow the common custom and modify her life in old age or seek for better diet. As she had begun, she went on ever more strongly never taking enough of anything but barely sustaining her aged body, lest she might weaken from within. She indulged in a modicum of food and drink to force her weakening limbs into their nightly vigils. You yourselves have seen the many admirable deeds she performed which you will remember in full. So it is fitting that we proclaim them, though with our poor little words we could never tell you how much she loved you. And when Divine Piety had determined to reward her for so many merits, her body was stricken with a slight illness and she lay feverish on her cot. So confined to her bed of sickness, she strove to give thanks to God in psalms, hymns, and spiritual canticles admonishing those standing by to sing to God. Without being too much troubled by bodily illness, she happily scaled the heights of beatitude, with eyes raised up and holy hands stretched to heaven. The soul so dear to God was torn from the world and released in Heaven, living with Christ while the angels applauded. Then there was sorrow in the whole convent among Christ's servants. What a multitude of mourning brethren arrived immediately, their lamenting voices choked up with welling tears! It is impossible for us to tell and only those who were there in person will believe what happened. Plangent sounds reverberated, as though thunder struck the place. Nothing could be heard among the bitter sighs except everyone clamoring: "Pious nurse, noble mother! Why do you desert us and why do you leave us behind whom you have nurtured so long a time with sweet and maternal affection? Why make us derelict today, orphaned and pitiable? In your death, all of us have died too." For three days, these and similar complaints went on without intermission. On the fourth day, with fitting honors, they conducted her blessed little body, anointed with balsam, to the grave. There by the Lord's grace, for the salvation of human kind, she proved worthy to perform many miracles. Daily the prayers of the faithful are heard demanding her intercession and a variety of illnesses and infirmities are cured.

9. Therefore, for the edification of the faithful, we have been pleased to write here a few of the many deeds in the life of the servant of God, Bertilla of blessed memory. Then anyone who likes may carefully consider and imitate, as in a clear mirror, those examples of virtue, particularly humility which is the mother of virtues and the fullest loving charity, the sharpest abstinence and the prudence of astute counsel and fortitude of faith and piety of generous mercy and, the reward of integrity, holy modesty of virginity with most devout insistence on prayer and wondrous peace and fervor of holy zeal which far surpasses every beauty. Almighty God chose whatever might be pleasing from these most brilliant gems to adorn the spirit of his servant Bertilla. As He well might, He desired to conserve her, with Christ presiding, to be a participant in the rewards of the just. For this evangelical virgin of Christ could claim a hundred-fold reward and life eternal. We have no doubt that she has achieved eternal

life associated in eternal glory for her holy and splendid labors. She ran first in the race with the help of Christ and happily finished it and received the reward of the crown of eternal life in the flock of the just where she remains from everlasting to everlasting. Amen.

THE SONG OF ROLAND

The selection from the Song of Roland reproduced here recounts the death of Roland, Olivier (Lord Olivier), Archbishop Turpin, and their loyal followers and the return of Charlemagne to take up the battle against the pagans. Pay particular attention to the epic qualities of the narrative: the stark distinction between the battling forces; the bravery of the combatants in the face of death; the sacred nature of weapons and horses (indicated by their being named); and, peculiar to postclassical epic poetry, the blending of martial and biblical language. To get the full force of the poem, read some of the stanzas aloud in a declamatory fashion; this is the way they were originally meant to be "read." The phrase AOI appended to the end of many of the stanzas is of uncertain meaning. It may have been a ritual shout, but scholars do not agree.

128

Count Roland sees the slaughter of his men. He calls aside Olivier, his comrade: "Fair lord, dear comrade, in the name of God, what now? You see what good men lie here on the ground. We well may mourn sweet France the Beautiful, to be deprived of barons such as these. Oh king, my friend—if only you were here! Olivier, my brother, what can we do? By what means can we get this news to him?" "I have no notion," says Olivier, "but I'd rather die than have us vilified." AOI

129

Then Roland says: "I'll sound the oliphant, and Charles, who's moving through the pass, will hear it. I promise you the Franks will then return." Olivier says: "That would bring great shame and reprobation down on all your kin, and this disgrace would last throughout their lives! You wouldn't do a thing when I implored you, so don't act now to win my gratitude. No courage is involved in sounding it; already you have bloodied both your arms." The count replies: "I've struck some lovely blows!" AOI

130

Then Roland says: "Our fight is getting rough: I'll sound my horn—King Charles is sure to hear it." Olivier says: "That would not be knightly. You didn't deign to, comrade, when I asked you, and were the king here now, we'd be unharmed. The men out yonder shouldn't take the blame." Olivier says: "By this beard of mine, if I should see my lovely sister Alde, then *you* shall never lie in her embrace." AOI

131

Then Roland says: "You're angry with me—why?" And he replies: "Companion, you're to blame, for bravery in no sense is bravado, and prudence is worth more than recklessness. Those French are dead because of your caprice; King Charles will have our services no more. My lord would be here now, if you'd believed me, and we'd have put an end to this affray; Marsilla would be dead or taken captive. But we were doomed to see your prowess, Roland; now Charlemagne will get no help from us (there'll be no man like him until God judges) and you shall die, and France shall be disgraced. Today our loyal comradeship will end: before the evening falls we'll part in grief." AOI

132

The archbishop overhears them quarreling: he rakes his horse with spurs of beaten gold, comes over, and begins to reprimand them: "Lord Roland, you too, Lord Olivier, I beg of you, for God's sake do not quarrel! A horn blast cannot save us any more, but nonetheless it would be well to sound it; the king will come, and then he can avenge usthe men from Spain will not depart in joy. Our Frenchmen will dismount here, and on foot they'll come upon us, dead and hacked to pieces, and lift us up in coffins onto pack-mules, and weep for us in pity and in grief. They'll bury us beneath the aisles of churches, where wolves and pigs and dogs won't gnaw on us." "You've spoken very well, sire," answers Roland. AOI

133

10

20

30

Count Roland brought the horn up to his mouth: he sets it firmly, blows with all his might. The peaks are high, the horn's voice carries far; they hear it echo thirty leagues away. Charles hears it, too, and all his company: the king says then: "Our men are in a fight." And Ganelon replies contentiously: "Had someone else said that, he'd seem a liar." AOI

134

Count Roland, racked with agony and pain and great chagrin, now sounds his ivory horn: bright blood leaps in a torrent from his mouth: the temple has been ruptured in his brain. The horn he holds emits a piercing blast: Charles hears it as he crosses through the pass; Duke Naimes has heard it, too; the Franks give ear. The king announces: "I hear Roland's horn! He'd never sound it if he weren't embattled." Says Ganelon: "There isn't any battle! You're getting old, your hair is streaked and white; such speeches make you sound just like a child. You're well aware of Roland's great conceit; it's strange that God has suffered him so long. Without your orders he once captured Naples: the Saracens inside came riding out and then engaged that worthy vassal Roland, who later flushed the gory field with waterhe did all this to keep it out of sight. He'll blow that horn all day for just one hare. He's showing off today before his peersno army under heaven dares to fight him.

50

40

60

70

So keep on riding!—Why do you stop here? For Tere Majur lies far ahead of us." AOI

135

Count Roland's mouth is filling up with blood; the temple has been ruptured in his brain. In grief and pain he sounds the oliphant; Charles hears it, and his Frenchmen listen, too. The king says then, "That horn is long of wind." Duke Naimes replies, "The baron is attacking! A fight is taking place, of that I'm sure. This man who tries to stall you has betrayed them. Take up your arms, sing out your battle cry, and then go save your noble retinue: you've listened long enough to Roland's plaint!"

136

The emperor has let his horns be sounded: the French dismount, and then they arm themselves with hauberks and with casques and gilded swords. Their shields are trim, their lances long and stout, their battle pennants crimson, white, and blue. The barons of the army mount their chargers and spur them briskly, all down through the passes. There is not one who fails to tell his neighbor: "If we see Roland prior to his death, we'll stand there with him, striking mighty blows." But what's the use?—for they've delayed too long.

137

The afternoon and evening are clear: the armor coruscates against the sun, those casques and hauberks throw a dazzling glare, as do those shields, ornate with painted flowers, those spears, those battle flags of gold brocade. Impelled by rage, the emperor rides on, together with the French, chagrined and grieved. No man there fails to weep with bitterness, and they are much afraid for Roland's sake. The king has had Count Ganelon arrested, and turns him over to his household cooks. He tells Besgun, the leader of them all: "Keep watch on him, like any common thug, for he's betrayed the members of my house.' He turned him over to a hundred comrades, the best and worst together, from the kitchen. These men plucked out his beard and his moustache, and each one hit him four times with his fist; they whipped him thoroughly with sticks and clubs, and then they put a chain around his neck and chained him up exactly like a bear; in ridicule, they set him on a pack-horse. They'll guard him this way until Charles returns.

138

The hills are high and shadowy and large, the valleys deep, with swiftly running streams. The trumpets ring out to the front and rear, all racketing reply to the oliphant. The emperor rides on, impelled by rage, as do the Franks, chagrined and furious: no man among them fails to weep and mourn and pray to God that He may safeguard Roland until they all arrive upon the field. Together with him there, they'll really fight. But what's the use? They cannot be of help; they stayed too long; they can't get there in time. AOI

139

Impelled by rage, King Charles keeps riding on, his full white beard spreads out upon his byrnie. The Frankish barons all have used their spurs; not one of them but bitterly regrets that he is not beside the captain Roland, now fighting with the Saracens from Spain, and injured so, I fear his soul won't stay. But, God—the sixty in his company!

100 No king or captain his commanded better. AOI

140

110

Count Roland scans the mountains and the hills: he sees so many dead French lying there, and like a noble king he weeps for them. "My lords and barons, God be merciful, deliver all your souls to Paradise and let them lie among the blessed flowers! I've never seen more worthy knights than youyou all have served me long and faithfully, and conquered such great lands for Charles's sake! The emperor has raised you, all for naught. My land of France, how very sweet you aretoday laid waste by terrible disaster! French lords, because of me I see you dying-I can't reprieve you now, nor save your lives. May God, who never lied, come to your aid! Olivier, I won't fail you, my brother; if no one kills me, I shall die of grief. My lord companion, let's attack once more."

141

Count Roland now goes back into the field, 120 with Durendal in hand, fights gallantly: he then has cut Faldrun of Pui in two, as well as twenty-four among their best; no man will ever want revenge so badly. Just as the stag will run before the hounds, the pagans break and run away from Roland. The archbishop says: "You're doing rather well! Such gallantry a chevalier should have, if he's to carry arms and ride a horse. He must be fierce and powerful in combat-130 if not, he isn't worth four deniers should be instead a monastery monk and pray the livelong day for all our sins." "Lay on, don't spare them!" Roland says in answer, and at these words the Franks attack again. The Christians suffered very heavy losses.

142

140

150

The man who knows no captives will be taken, in such a fight puts up a stout defense: because of this, the Franks are fierce as lions. Now see Marsilla make a gallant show. He sits astride the horse he calls Gaignon; he spurs him briskly, then attacks Bevon (this man was lord of Beaune and of Dijon). He breaks his shield and smashes through his hauberk and drops him dead without a *coup de grâce*. And then he killed Ivon and Ivorie, together with Gerard of Roussillon. Count Roland isn't very far away; he tells the pagan: "May the Lord God damn you! So wrongfully you've slaughtered my companions; before we separate, you'll take a stroke, 170

160

180

190

210

and from my sword today you'll learn its name." He goes to strike him with a gallant show: the count swings down and cuts his right hand off, then takes the head of Jurfaleu the Blond (this pagan was the son of King Marsilla). The pagans raise the cry: "Help us, Mohammed! And you, our gods, give us revenge on Charles. He's sent such villains to us in this land they'd rather die than leave the battlefield." One tells another: "Let's get out of here!" And at that word a hundred thousand run. No matter who may call, they won't come back. AOI

145

The pagans, when they see the French are few, feel proud and reassured among themselves: "The emperor is wrong," one tells another. Astride a sorrel horse sits Marganice; he rakes him briskly with his golden spurs and strikes Olivier on the back, lays bare the flesh beneath the shining hauberk and shoves his lance entirely through his chest, and then he says: "You took a mortal blow! Great Charles should not have left you at the pass, he's done us wrong, he has no right to boast; through you alone, our side is well avenged."

146

Olivier feels wounded unto death, but gripping Halteclere, whose blade was polished, strikes Marganice's high-peaked golden casque; he smashes downward through fleurons and gems and splits the skull wide open to the teeth. He wrenches free and lets the dead man fall, and afterward he tells him: "Damn you, pagan! I do not say that Charles has had no loss, but neither to your wife nor any woman you've seen back where you came from shall you brag you took a denier of loot from me, or injured me or anybody else." Then afterward he calls for help to Roland. AOI

147

Olivier feels injured unto death, yet he will never have his fill of vengeance: he battles in the thick crowd like a baron, still shearing through those shafts of spears, those bucklers, and feet and wrists and shoulder-bones and ribs. Whoever saw him maiming Saracens and piling dead men one upon the other would be reminded of a worthy knight. Not wanting Charles's battle cry forgotten, he sings out in a loud, clear voice: "Monjoy!" He calls to him his friend and peer, Count Roland:

"My lord companion, come fight here by me;

today in bitter anguish we shall part." AOI

148

Count Roland contemplates Olivier: his face is gray and bloodless, wan and pale, and from his trunk bright blood is surging out and dripping down in pools upon the ground. The count says: "God, I don't know what to do. Your valor was for naught, my lord companion there'll never be another one like you. Sweet France, today you're going to be robbed of loyal men, defeated and destroyed: all this will do the emperor great harm." And at this word he faints, still on his horse. AOI

149

220

230

240

See Roland, who has fainted on his horse, and, wounded unto death, Olivier, his vision so impaired by loss of blood that, whether near or far, he cannot see enough to recognize a living man; and so, when he encounters his companion, he hits him on his jeweled golden casque and splits it wide apart from crown to nasal, but doesn't cut into his head at all. On being struck so, Roland studied him, then asked him in a soft and gentle voice: "My lord companion, did you mean to do that? It's Roland, who has been your friend so long: you gave no sign that you had challenged me." Olivier says: "Now I hear you speak. Since I can't see you, God keep you in sight! I hit you, and I beg you to forgive me." And Roland says: "I've not been hurt at all, and here before the Lord I pardon you." And with these words, they bowed to one another: in friendship such as this you see them part.

150

Olivier feels death-pangs coming on; his eyes have both rolled back into his head, and his sight and hearing are completely gone. Dismounting, he lies down upon the ground, and then confesses all his sins aloud, with both hands clasped and lifted up toward heaven. He prays that God may grant him Paradise and give His blessing to sweet France and Charles and, most of all, to his companion Roland. His heart fails; his helmet tumbles down; his body lies outstretched upon the ground. The count is dead—he could endure no more. The baron Roland weeps for him and mourns: on earth you'll never hear a sadder man.

250 **151**

Now Roland, when he sees his friend is dead and lying there face down upon the ground, quite softly starts to say farewell to him: "Your valor was for naught, my lord companion! We've been together through the days and years, and never have you wronged me, nor I you; since you are dead, it saddens me to live." And having said these words, the marquis faints upon his horse, whose name is Veillantif; but his stirrups of fine gold still hold him on: whichever way he leans, he cannot fall.

153

260

Now, Roland, grown embittered in his pain, goes slashing through the middle of the crowd; he throws down lifeless twenty men from Spain, while Gautier kills six, and Turpin five. The pagans say: "These men are infamous; don't let them get away alive, my lords: whoever fails to rush them is a traitor,

270

280

290

300

who lets them save themselves, a renegade." So once more they renew the hue and cry; from every side they go to the attack. AOI

154

Count Roland is a noble man-at-arms. Gautier of Hum a splendid chevalier, the archbishop an experienced campaigner: no one of them will ever leave the others. Engulfed within the crowd, they cut down pagans. A thousand Saracens get down on foot, and forty thousand stay upon their horses: they do not dare come closer, that I know, but they hurl at them their javelins and spears and darts and wigars, mizraks, and agers. The first barrage has killed Count Gautier; Turpin of Reims-his shield is pierced clear through, his helmet broken, injuring his head, his hauberk torn apart and stripped of mail; his body has been wounded by four spears; they kill his destrier from under him. Great sorrow comes as the archbishop falls. AOI

155

Turpin of Reims, when he sees that he's been downed by four spears driven deep into his body, the brave man leaps back quickly to his feet and looks toward Roland, then runs up to him and says this word: "By no means am I beaten; no loyal man gives up while still alive." He draws Almace, his sword of polished steel; in the crowd he strikes a thousand blows or more. Charles later on will say he spared no onehe found about four hundred, all around him, some only wounded, some who'd been run through, and others who had had their heads cut off. Thus says the geste and he who was afield, the noble Giles, for whom God brought forth wonders. At the minister of Laon he wrote the charter: whoever doesn't know that much knows little.

156

Count Roland keeps on fighting skillfully, although his body's hot and drenched with sweat: he feels great pain and torment in his head, since, when he blew his horn, his temple burst. Yet he has to know if Charles is coming back: he draws the ivory horn and sounds it feebly. The emperor pulled up so he might listen: "My lords," he says, "it's very bad for us; today my nephew Roland will be lost. From his horn blast I can tell he's barely living; whoever wants to get there must ride fast. So sound your trumpets, all this army has!" And sixty thousand of them blare so loud, the mountains ring, the valleys echo back. The pagans hear it, take it as no joke. One tells another: "Now we'll have King Charles."

157

The pagans say: "The emperor's returning; AOI just listen to the Frenchmen's trumpets blare! If Charles comes, it will be the ruin of us if Roland lives, our war will start again, and we'll have forfeited our land of Spain." About four hundred, wearing casques, assemble and launch one brutal, grim assault on Roland. This time the count has got his work cut out. AOI

158

330

Count Roland, when he sees them drawing near, becomes so strong and bold and vigilant! As long as he's alive, he'll never yield. He sits astride the horse called Veillantif and rakes him briskly with his fine gold spurs and wades into the crowd to fight them all, accompanied by Turpin, the archbishop. One tells another: "Friend, get out of here! We've heard the trumpets of the men from France; now Charles, the mighty king, is coming back."

340 **159**

Count Roland never cared much for a coward nor a swaggerer nor evil-minded man nor a knight, if he were not a worthy vassal. He called out then to Turpin, the archbishop: "My lord, you are on foot and I am mounted; for love of you I'll make my stand right here. Together we shall take the good and bad; no mortal man shall ever make me leave you. Today, in this assault, the Saracens shall learn the names Almace and Durendal." The archbishop says: "Damn him who won't fight hard! When Charles comes back here, he'll avenge us well."

160

350

360

The pagans cry out: "We were doomed at birth; a bitter day has dawned for us today! We've been bereft of all our lords and peers, the gallant Charles is coming with his host, we hear the clear-voiced trumpets of the French and the uproar of the battle cry 'Monjoy.' So great is the ferocity of Roland, no mortal man will ever vanquish him; so let us lance at him, then let him be." They hurl at him a multitude of darts, befeathered mizraks, wigars, lances, spearsthey burst and penetrated Roland's shield and ripped his hauberk, shearing off its mail, but not a one went through into his body. They wounded Veillantif in thirty places and killed him out from underneath the count. The pagans take fiight then and let him be: Count Roland is still there upon his feet. AOI

370 **161**

The pagans, galled and furious, take flight and head for Spain, as fast as they can go. Count Roland is unable to pursue them, for he has lost his charger Veillantif and now, despite himself, is left on foot. He went to give Archbishop Turpin help, unlaced his gilded helmet from his head, then pulled away his gleaming, lightweight hauberk and cut his under-tunic all to shreds and stuffed the strips into his gaping wounds. This done, he took him up against his chest and on the green grass gently laid him down. Most softly Roland made him this request: 390

400

410

420

"Oh noble lord, if you will give me leave all our companions, whom we held so dear, are dead now; we should not abandon them. I want to seek them out, identify them, and lay them out before you, side by side." The archbishop tells him: "Go and then return; this field is yours, I thank God, yours and mine."

162

Now Roland leaves and walks the field alone: he searches valleys, searches mountain slopes. He found there Gerier, his friend Gerin, and then he found Aton and Berenger, and there he found Sanson and Anseïs; he found Gerard the Old of Roussillon. The baron picked them up then, pair by pair, and brought them every one to the archbishop and placed them in a row before his knees. The archbishop cannot help himself; he weeps, then lifts his hand and makes his benediction, and says thereafter: "Lords, you had no chance; may God the Glorious bring all your souls to Paradise among the blessed flowers! My own death causes me great pain, for I shall see the mighty emperor no more."

163

Now Roland leaves, goes searching through the field: he came upon Olivier, his comrade, and holding him up tight against his chest returned as best he could to the archbishop. He laid him on a shield beside the others; the archbishop blessed him, gave him absolution. Then all at once despair and pain well up, and Roland says: "Olivier, fair comrade, you were the son of wealthy Duke Renier, who ruled the frontier valley of Runers. To break a lance-shaft or to pierce a shield, to overcome and terrify the proud, to counsel and sustain the valorous, to overcome and terrify the gluttons, no country ever had a better knight."

164

Count Roland, looking on his lifeless peers and Olivier, whom he had cared for so, is seized with tenderness, begins to weep. The color has all vanished from his face; he cannot stand, the pain is so intense; despite himself, he falls to earth unconscious. The archbishop says: "Brave lord, you've come to grief."

165

The archbishop, upon seeing Roland faint, feels sorrow such as he has never felt, extends his hand and takes the ivory horn. At Roncesvals there is a running stream; he wants to fetch some water there for Roland; with little, stumbling steps he turns away, but can't go any farther—he's too weak and has no strength, has lost far too much blood. Before a man could walk across an acre, his heart fails, and he falls upon his face. With dreadful anguish death comes over him. 166

440

Count Roland, now regaining consciousness, gets on his feet, in spite of dreadful pain, and scans the valleys, scans the mountainsides, across the green grass, out beyond his comrades. He sees the noble baron lying there the archbishop, sent by God in His own name. Confessing all his sins, with eyes upraised and both hands clasped and lifted up toward Heaven, he prays that God may grant him Paradise. Now Turpin, Charles's warrior, is dead: in mighty battles and in moving sermons he always took the lead against the pagans. May God bestow on him His holy blessing! AOI

167

450

460

470

480

Count Roland sees the archbishop on the ground: he sees the entrails bulging from his body. His brains are boiling out upon his forehead. Upon his chest, between the collarbones, he laid crosswise his beautiful white hands, lamenting him, as was his country's custom: "Oh noble vassal, well-born chevalier, I now commend you to celestial Glory. No man will ever serve Him with such zeal; no prophet since the days of the Apostles so kept the laws and drew the hearts of men. Now may your soul endure no suffering; may Heaven's gate be opened up for you!"

168

Count Roland realizes death is near: his brains begin to ooze out through his ears. He prays to God to summon all his peers, and to the angel Gabriel, himself. Eschewing blame, he takes the horn in hand and in the other Durendal, his sword, and farther than a crossbow fires a bolt, heads out across a fallow field toward Spain and climbs a rise. Beneath two lovely trees stand four enormous marble monoliths. Upon the green grass he has fallen backward and fainted, for his death is near at hand.

169

The hills are high, and very high the trees; four massive blocks are there, of gleaming marble; upon green grass Count Roland lies unconscious. And all the while a Saracen is watching: he lies among the others, feigning death; he smeared his body and his face with blood. He rises to his feet and starts to run a strong, courageous, handsome man he was; through pride he enters into mortal folly and pinning Roland's arms against his chest, he cries out: "Charles's nephew has been vanquished; I'll take this sword back to Arabia." And as he pulls, the count revives somewhat.

170

490

Now Roland feels his sword is being taken and, opening his eyes, he says to him: "I know for certain you're not one of us!" He takes the horn he didn't want to leave 500

510

530

and strikes him on his jeweled golden casque; he smashes through the steel and skull and bones, and bursting both his eyeballs from his head, he tumbles him down lifeless at his feet and says to him: "How dared you, heathen coward, lay hands on me, by fair means or by foul? Whoever hears of this will think you mad. My ivory horn is split across the bell, and the crystals and the gold are broken off."

171

Now Roland feels his vision leaving him, gets to his feet, exerting all his strength; the color has all vanished from his face. In front of him there is a dull gray stone; ten times he strikes it, bitter and dismayed: the steel edge grates, but does not break or nick. "Oh holy Mary, help me!" says the count, "Oh Durendal, good sword, you've come to grief! When I am dead, you won't be in my care. I've won with you on many battlefields and subjugated many spacious lands now ruled by Charles, whose beard is shot with gray. No man who flees another should possess you! A loyal knight has held you many years; your equal holy France will never see."

172

Roland strikes the great carnelian stone: the steel edge grides, but does not break or chip. And when he sees that he cannot destroy it, he makes this lamentation to himself: "Oh Durendal, how dazzling bright you areyou blaze with light and shimmer in the sun! King Charles was in the Vales of Moriane when God in Heaven had His angel tell him that he should give you to a captain-count: the great and noble king then girded me. With this I won Anjou and Brittany, and then I won him both Poitou and Maine. with this I won him Normandy the Proud, and then I won Provence and Aquitaine, and Lombardy, as well as all Romagna. With this I won Bavaria, all Flanders, and Burgundy, the Poliani lands, Constantinople, where they did him homagein Saxony they do what he commands. With this I won him Scotland, Ireland too, and England, which he held as his demesne. With this I've won so many lands and countries which now are held by Charles, whose beard is white. I'm full of pain and sorrow for this sword; I'd rather die than leave it to the pagans. Oh God, my Father, don't let France be shamed!"

173

Roland hammers on a dull gray stone and breaks off more of it than I can say: the sword grates, but it neither snaps nor splits, and only bounces back into the air. The count, on seeing he will never break it, laments it very softly to himself: "Oh Durendal, so beautiful and sacred, within your golden hilt are many relicsSaint Peter's tooth, some of Saint Basil's blood, some hair belonging to my lord, Saint Denis, a remnant, too, of holy Mary's dress. It isn't right that pagans should possess you; you ought to be attended on by Christians. You never should be held by one who cowers! With you I've conquered many spacious lands now held by Charles, whose beard is streaked with white:

through them the emperor is rich and strong."

174

560

550

Now Roland feels death coming over him, descending from his head down to his heart. He goes beneath a pine tree at a run and on the green grass stretches out, face down. He puts his sword and ivory horn beneath him and turns his head to face the pagan host. He did these things in order to be sure that Charles, as well as all his men, would say: "This noble count has died a conqueror." Repeatedly he goes through his confession, and for his sins he proffers God his glove. AOI

570 175

> Now Roland is aware his time is up: he lies upon a steep hill, facing Spain, and with one hand he beats upon his chest: "Oh God, against Thy power I have sinned, because of my transgressions, great and small, committed since the hour I was born until this day when I have been struck down!" He lifted up his right-hand glove to God: from Heaven angels came to him down there. AOI

₅₈₀ 176

590

600

Count Roland lay down underneath a pine, his face turned so that it would point toward Spain:

he was caught up in the memory of things of many lands he'd valiantly subdued, of sweet France, of the members of his line, of Charlemagne, his lord, who brought him up; he cannot help but weep and sigh for these. But he does not intend to slight himself; confessing all his sins, he begs God's mercy: "True Father, Who hath never told a lie, Who resurrected Lazarus from the dead, and Who protected Daniel from the lions, protect the soul in me from every peril brought on by wrongs I've done throughout my life!"

He offered up his right-hand glove to God: Saint Gabriel removed it from his hand. And with his head inclined upon his arm, hands clasped together, he has met his end. Then God sent down his angel Cherubin and Saint Michael of the Sea and of the Peril; together with Saint Gabriel they came and took the count's soul into Paradise.

177

Roland is dead, his soul with God in Heaven. The emperor arrives at Roncesvals.

650

610

620

There's not a single trace nor footpath there, nor ell, nor even foot of vacant ground, on which there's not a pagan or a Frank. "Fair nephew," Charles cries loudly, "where are you? Where's the archbishop, and Count Olivier? Where is Gerin, and his comrade Gerier? Where is Anton? and where's Count Berenger? Ivon and Ivorie, I held so dear? What's happened to the Gascon, Engelier? and Duke Sanson? and gallant Anseïs? and where is Old Gerard of Roussillon? - the twelve peers I permitted to remain?" But what's the use, when none of them reply? The king says: "God! I've cause enough to grieve that I was not here when the battle started!' He tugs upon his beard like one enraged; the eyes of all his noble knights shed tears, and twenty thousand fall down in a faint. Duke Naimes profoundly pities all of them.

178

There's not a chevalier or baron there who fails to shed embittered tears of grief; they mourn their sons, their brothers, and their nephews, together with their liege-lords and their friends; and many fall unconscious to the ground. Duke Naimes displayed this courage through all this, for he was first to tell the emperor: "Look up ahead of us, two leagues awayalong the main road you can see the dust, so many of the pagan host are there. So ride! Take vengeance for this massacre!" "Oh God!" says Charles, "already they're so far! Permit me what is mine by right and honor; they've robbed me of the flower of sweet France." The king gives orders to Geboin, Oton, Thibaud of Reims, and to the count Milon: "You guard the field—the valleys and the hills. Leave all the dead exactly as they lie, make sure no lion or other beast comes near, and let no groom or serving-man come near. Prohibit any man from coming near them till God grants our return upon this field.' In fond, soft-spoken tones these men reply: "Dear lord and rightful emperor, we'll do it!" They keep with them a thousand chevaliers. AOI

179

The emperor has had his trumpets sounded; then, with his mighty host, the brave lord rides. The men from Spain have turned their backs to them; they all ride out together in pursuit. The king, on seeing dusk begin to fall, dismounts upon the green grass in a field, prostrates himself, and prays Almighty God that He will make the sun stand still for him, hold back the night, and let the day go on. An angel he had spoken with before came instantly and gave him this command: "Ride on, Charles, for the light shall not desert you. God knows that you have lost the flower of France; you may take vengeance on the guilty race." And at these words, the emperor remounts. AOI 660 **180**

670

For Charlemagne God worked a miracle, because the sun is standing motionless. The pagans flee, the Franks pursue them hard, and overtake them at Val-Tenebrus. They fight them on the run toward Saragossa; with mighty blows they kill them as they go; they cut them off from the main roads and the lanes. The river Ebro lies in front of them, a deep, swift-running, terrifying stream; there's not a barge or boat or dromond there. The pagans call on Termagant, their god, and then leap in, but nothing will protect them. The men in armor are the heaviest, and numbers of them plummet to the bottom; the other men go floating off downstream. The best equipped thus get their fill to drink; they all are drowned in dreadful agony. The Frenchmen cry out: "You were luckless, Roland!" AOI

181

As soon as Charles sees all the pagans dead (some killed, a greater number of them drowned) and rich spoils taken off them by his knights, the noble king then climbs down to his feet, prostrates himself, and offers thanks to God. When he gets up again, the sun has set. "It's time to pitch camp," says the emperor. "It's too late to go back to Roncesvals. Our horses are fatigued and ridden down; unsaddle them and then unbridle them and turn them out to cool off in this field." The Franks reply: "Sire, you have spoken well." AOI

182

690

700

710

The emperor has picked a place to camp. The French dismount upon the open land and pull the saddles off their destriers and take the gold-trimmed bridles from their heads; then turn them out to graze the thick green grass; there's nothing else that they can do for them. The tiredest go to sleep right on the ground: that night they post no sentinels at all.

183

The emperor has lain down in a meadow. The brave lord sets his great lance at his headtonight he does not wish to be unarmedkeeps on his shiny, saffron-yellow hauberk, and his jeweled golden helmet, still laced up, and at his waist Joyeuse, which has no peer: its brilliance alters thirty times a day. We've heard a great deal spoken of the lance with which Our Lord was wounded on the cross; that lance's head is owned by Charles, thank God; he had its tip inletted in the pommel. Because of this distinction and this grace, the name "Joyeuse" was given to the sword. The Frankish lords will not forget this fact: they take from it their battle cry, "Monjoy." Because of this, no race can stand against them.

720

730

740

750

		Correct P		
		GENERAL EVENTS	LITERATURE & PHILOSOPHY	Art
	768	987 Paris made center of feudal king- dom of Hugh Capet		
MIDDLE AGES	ROMANESQUE PERIOD	 IIth cent. Capetian kings consolidate power and expand French kingdom I096–1099 First Crusade; capture of Jerusalem by Christians 	 12th cent. Golden Age of University of Paris under scholastic masters 1113 Abelard begins teaching in Paris; meets Heloise 1121 Abelard, <i>Sic et Non;</i> birth of Scholasticism 	12th cent. <i>Notre Dame de Belle Verrière,</i> stained glass window at Chartres
EAKLYN	EARLY GOTHIC PERIOD	 1141 Saint Bernard of Clairvaux leads condemnation of Abelard at Council of Sens c. 1150 Universities of Paris and Bologna founded c. 1163 Oxford University founded 1180 Philip Augustus assumes throne of France; promotes Paris as capital 	 after 1150 Recovery of lost texts by Aristotle and others via Arabic translations c. 1190 Maimonides, <i>Guide for the Perplexed</i> 	c. 1145–1170 Tympanum of right door, Royal Portal, Chartres
	1194			
TIGH MIDDLE AGES	MATURE GOTHIC PERIOD	 1202–1204 Fourth Crusade; crusaders sack Constantinople on way to Holy Land c. 1209 Cambridge University founded 1215 Magna Carta, limiting powers of king, signed in England c. 1220 Growth begins of mendicant friars: Franciscans, Dominicans 1258 Robert de Sorbon founds Paris hospice for scholars, forerunner of Sorbonne 1270 Eighth Crusade; death of Saint Louis of France c. 1271–1293 Marco Polo travels to China and India 1291 Fall of Acre, last Christian stronghold in Holy Land 1348–1367 Universities based on Paris model founded in Prague, Vi- enna, Cracow, Pecs 	 13th cent. Era of secular poems; Goliardic verse c. 1224–1226 Saint Francis of Assisi, "Canticle of Brother Sun" c. 1267–1273 Aquinas, <i>Summa Theologica</i> 1300 Dante exiled from Florence c. 1303–1321 Dante, <i>Divine Comedy</i> c. 1385–1400 Chaucer, <i>The Canterbury Tales</i> 	 c. 1200 Charlemagne window at Chartres c. 1215 Christ Blessing, trumeau, south porch, Chartres c. 1215–c. 1250 Guild windows at Chartres
	1400			

CHAPTER 10 High Middle Ages: The Search for Synthesis

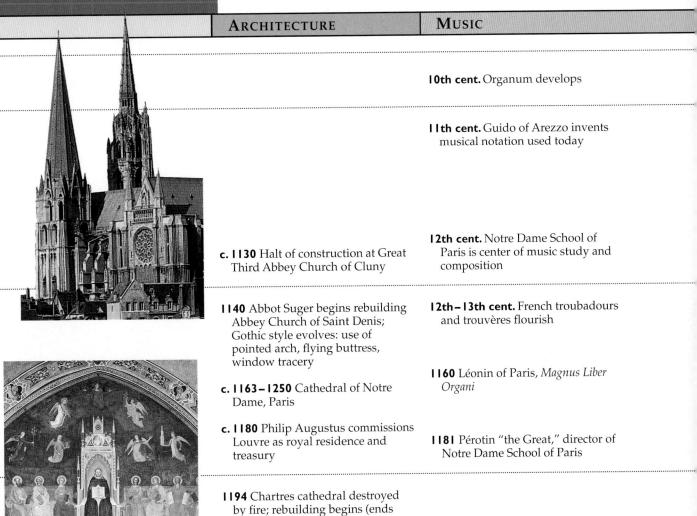

1220-1269 Cathedral of Amiens

1260)

- c. 1235 Honnecourt, notebook
- 1243-1248 Sainte Chapelle, Paris
- **1247 1568** Cathedral of Beauvais; Cathedral of Strasbourg
- **13th cent.** German minnesingers flourish
- **c. 1250** Polyphonic motets are principal form of composition

1399–1439 Spire of Strasbourg cathedral erected

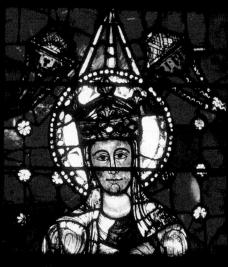

Chapter 10

HIGH MIDDLE AGES: The Search for Synthesis

THE SIGNIFICANCE OF PARIS

rom about 1150 to 1300, Paris could well claim to be the center of Western civilization. Beyond its position as a royal seat, it was a strong mercantile center. Its annual trade fair was famous. In addition, Paris gave birth to Gothic architecture, the philosophical and theological traditions known as scholasticism, and the educational community that in time became known as the university. These three creations have their own distinct history but sprang from a common intellectual impulse: the desire to articulate all knowledge in a systematic manner.

The culture of the Middle Ages derives from the twin sources of all Western high culture: (1) the humane learning inherited from the culture of Greece and Rome and (2) the accepted faith of the West, which has its origin in the worldview of the Judeo–Christian scriptures and religious worldview.

The flowering of a distinct expression of culture in and around medieval Paris was made possible by a large number of factors. There was a renewed interest in learning, fueled largely by the discovery of hitherto lost texts from the Classical world—especially the writings of Aristotle—which came to the West via the Muslim world. The often ill-fated Crusades begun in the eleventh century to recover the Holy Land and the increasing vogue for pilgrimages created a certain cosmopolitanism that in turn weakened the static feudal society. Religious reforms initiated by new religious orders like that of the Cistercians in the twelfth century and the begging friars in the thirteenth breathed new life into the church.

Beyond these more generalized currents one can also point to individuals of genius who were crucial in the humanistic renaissance of the time. The University of Paris is inextricably linked with the name of Peter Abelard just as scholasticism is associated with the name of Thomas Aquinas. The Gothic style, unlike most art movements, can be pinpointed to a specific time at a particular place and with a single individual. Gothic architecture began near Paris at the Abbey of Saint Denis in the first half of the twelfth century under the sponsorship of the head of the abbey, Abbot Suger (1080–1151).

Peter Abelard

Abbey of St. Denis

THE GOTHIC STYLE

Suger's Building Program for Saint Denis

The Benedictine Abbey of Saint Denis, over which Abbot Suger presided from 1122 until his death nearly twentynine years later, was the focal point for French patriotism. The abbey church—built in Carolingian times—housed the relics of Saint Denis, a fifth-century martyr who had evangelized the area of Paris before his martyrdom. The crypt of the church served as burial place for Frankish kings and nobles from before the reign of Charlemagne, although it lacked the tomb of Charlemagne himself. One concrete link between the Abbey of Saint Denis and Charlemagne came through a series of literary works. The fictitious Pélerinage de Charlemagne claimed that the relics of the Passion housed at the abbey had been brought there personally by Charlemagne when he returned from a pilgrimage-crusade to the Holy Land. Another work, the Pseudo-Turpin, has Charlemagne returning to the Abbey of Saint Denis after his Spanish campaign and proclaiming all France to be under the protection and tutelage of the saint. These two legends were widely believed in the Middle Ages; there is fair evidence that Suger himself accepted their authenticity. The main themes of the legends—pilgrimages, crusades, and the mythical presence of Charlemagne—created a story about the abbey that made it a major Christian shrine as well as one worthy of the royal city of Paris.

Pilgrims and visitors came to Paris to visit Saint Denis either because of the fame of the abbey's relics or because of the annual *Lendit* (the trade fair held near the precincts of the abbey). Accordingly, in 1124 Suger decided to build a new church to accommodate those who flocked to the popular pilgrimage center. This rebuilding program took the better part of fifteen years and never saw completion. Suger mentions as models two sacred buildings that by his time already had archetypal significance for Christianity. He wanted his church to be as lavish and brilliant as Hagia Sophia in Constantinople, which he knew only by reputation, and as loyal to the will of God as the Temple of Solomon as it was described in the Bible.

The first phase of Suger's project was basically a demolition and repair job; he had to tear down the more deteriorated parts of the old church and replace them. He reconstructed the western façade of the church and added two towers. In order better to handle the pilgrimage crowds and the increasingly elaborate processions called for in the medieval liturgy, the entrance was given three portals. The narthex, the part of the church one enters first (before the nave), was rebuilt and the old nave was to be extended by about 40 feet (12.2 m). In about 1140, Suger abruptly ceased work on the narthex to commence work at the opposite end-the choir, the area of the church where the monks sang the office. By his own reckoning, he spent three years and three months at this new construction. The finished choir made a revolutionary change in architecture in the West.

Suger's choir was surrounded by a double *ambulatory*, an aisle around the apse and behind the high altar. The outer ambulatory had seven radiating chapels to accommodate the increasing number of monks who were priests and thus said Mass on a daily basis. Two tall windows pierced the walls of each chapel so that there was little external masonry wall in relation to the amount of space covered by windows. The chapels were shallow enough to permit the light from the windows to fall on the inner ambulatory [10.1].

Although Suger's nave was never completed, there is some evidence that it would have had characteristics similar to that of the choir: crossed rib vaults with an abundance of stained-glass windows to permit the flooding of light into the church. We can get some idea of what that nave might have looked like by looking at churches directly inspired by Saint Denis: the cathedrals of Senlis and Noyons [10.2] (their bishops were both at the consecration of Saint Denis in 1144), begun respec-

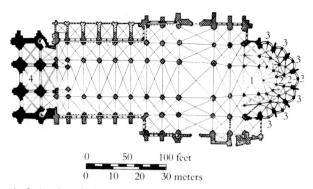

1. choir 2. ambulatory 3. radiating chapels 4. narthex

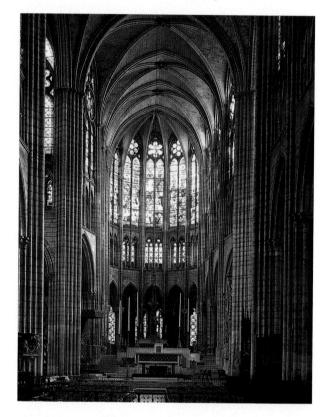

10.1 Plan of the Abbey Church of Saint Denis, built around 1140, and photograph of the ambulatory. Parts of the existing church shaded black in the plan are those rebuilt by Abbot Suger. The photograph shows how use of the ribbed vault and pointed arches gives scope for the passage of light through the lancet windows.

Abbey of St. Denis

tively in 1153 and 1157, as well as the Cathedral of Notre Dame in Paris, the first stone of which was laid in 1163. This quick emulation of the style of Saint Denis blossomed by the end of the century into a veritable explosion of cathedral building in the cities and towns radiat-

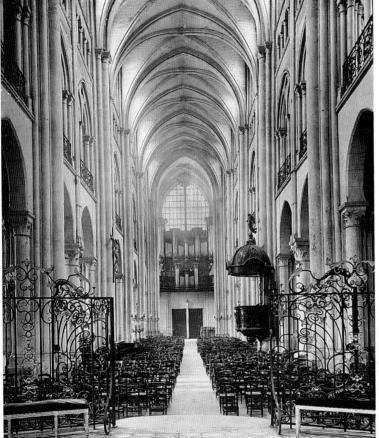

10.2 Interior of Noyons Cathedral. The nave was finished between 1285 and 1330. A fine example of the older style of Gothic architecture. The walls have four rather than the typical three levels: the nave arcade at floor level; a triforium; the clerestory with its windows. The rather thick walls of the triforium level would give way in other Gothic churches to thinner walls and more pointed arches.

ing out from Paris, the so-called Île de France. The Gothic impulse so touched other countries as well that, by the end of the thirteenth century, there were fine examples of Gothic architecture in England, Germany, and Italy.

The term Gothic merits a word of explanation. It was used first in the seventeenth century as a pejorative term meaning "barbarous" or "rude" to distinguish buildings that did not follow the Classical models of Greece and Rome, a use still current in the mid-eighteenth century. It was only as a result of the reappraisal of the medieval period in the late nineteenth century that the word lost its negative meaning.

It is tempting to say that the common characteristic of these cathedrals was the desire for verticality. We tend to identify the Gothic style with the pointed arch, pinnacles and columns, and increasingly higher walls buttressed from the outside by flying arches to accommodate the weight of a pitched roof and the sheer size of the ascending walls [10.3]. It is a truism that medieval builders seemed to engage in contests to build higher and higher almost as a matter of civic pride: Chartres (begun in 1194) reached a height of 122 feet (37.2 m); almost as a response, the builders of Amiens (begun 1220) stretched that height to 140 feet (42.7 m), while Beauvais (begun 1247) pushed verticality almost to the limit with a height

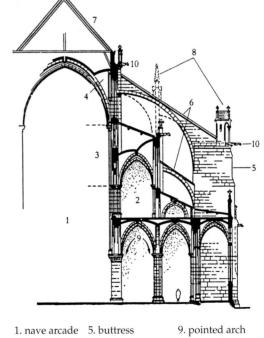

1. Inuve areau	o. Duttiebb	
2. triforium	6. flying buttress	10. gargoyle
3. clerestory	7. pitched roof	
4. vault	8. pinnacle	

10.3 Transverse half-sectional drawing of the Cathedral of Notre Dame in Paris. Height approx. 140' (42.7 m). The tiny figure at the lower right gives some sense of scale.

of 157 feet (47.9 m) from the cathedral pavement to the roof arch; indeed, Beauvais had a serious collapse of the roof when the building was barely completed.

Chartres Cathedral

That verticality typified Gothic architecture is indisputable, yet Romanesque architects only a generation before Suger had attempted the same verticality, as is evident in such churches as the proposed third abbey church of Cluny or the pilgrimage church at Santiago de Compostela in Spain. What prevented the Romanesque architect from attaining greater verticality was not lack of desire but insufficient technical means. The pointed arch was known in Romanesque architecture but not fully understood. It distributed weight more thoroughly in a downward direction and lessened the need for the massive interior piers of the typical Romanesque church. The size of the piers was further reduced by using buttresses outside the building to prop the interior piers and absorb some of the downward thrust. Furthermore, the downward thrust of the exterior buttresses themselves could be increased by the addition of heavy decorative devices such as spires.

The net result of these technical innovations was to lessen the thickness, weight, and mass of the walls of the Gothic cathedral. This reduction provided an opportunity for greater height with less bulk to absorb the weight of the vaulted roof. Such a reduction made the walls more available as framing devices for the windows

10.4 Interior of the upper chapel of La Sainte Chapelle, Paris, 1243–1248. Built to house relics of Christ's Passion, this is an exquisite example of Gothic luminosity. Restored heavily, the overall effect is nonetheless maintained of skeletal architecture used as a frame for windows.

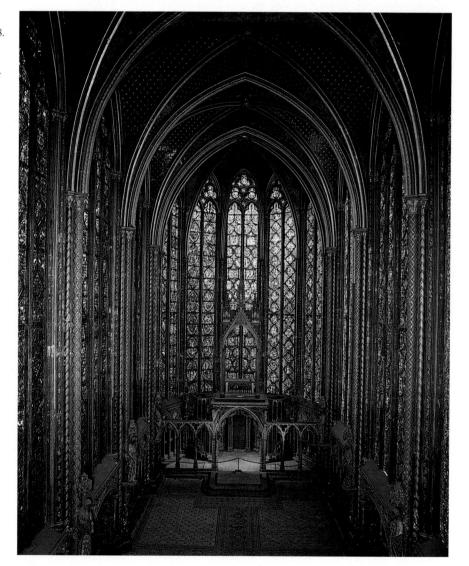

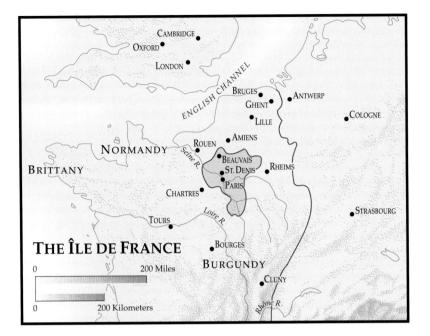

that are so characteristic of the period. It has been said, perhaps with some exaggeration, that walls in Gothic cathedrals were replaced by masonry scaffolding for windows [10.4]. In any case, the basic characteristic of Gothic architecture is not verticality but luminosity. The Gothic may be described as transparent—diaphanous architecture.

The Mysticism of Light

Abbot Suger wrote two short booklets about his stewardship of the abbey and his ideas about the building and decorating program he initiated for the abbey churchextremely important sources for our understanding of the thought that stood behind the actual work of the builder and artist. Underlying Suger's description of the abbey's art treasures and architectural improvements was a theory or (perhaps better) a theology of beauty. Suger was heavily indebted to his reading of certain mystical treatises written by Dionysius the Areopagite (whom Suger and many of his contemporaries assumed was the Saint Denis for whom the abbey was named), a fifth-century Syrian monk whose works on mystical theology were strongly influenced by Neo-Platonic philosophers as well as by Christian doctrine. In the doctrine of the Pseudo-Dionysius (as later generations have called him), every created thing partakes, however imperfectly, of the essence of God. There is an ascending hierarchy of existence that ranges from inert mineral matter to the purity of light, which is God. The Pseudo-Dionysius described all of creation under the category of light: Every created thing is a small light that illumines the mind a

bit. Ultimately, as light becomes more pure (as one ascends the hierarchy) one gets closer to pure light, which is God.

The high point of this light mysticism is expressed in the stained-glass window. Suger himself believed that when he finished his nave with its glass windows (never completed in fact) to complement his already finished choir, he would have a total structure that would make a single statement: "Bright is that which is brightly coupled with the bright, and bright is the noble edifice which is pervaded by the new light [*lux nova*]." The *lux nova* is an allusion to the biblical description of God as the God of light. Suger did not invent stained glass but he fully exploited its possibilities both by encouraging an architecture that could put it to its most advantageous employment and at the same time providing a theory to justify and enhance its use.

Stained Glass

No discussion of light and glass in this period can overlook the famous windows of the Cathedral of Chartres, a small but important commercial town south of Paris. When the cathedral was rebuilt after a disastrous fire in 1194 (which destroyed everything except the west façade of the church), the new building gave wide scope to the glazier's art.

When the walls were rebuilt, more than one hundred seventy-three windows were installed covering an area

of about two thousand square yards (1672 sq. m) of surface. It is important to note that, except for some fine details like facial contours, the glass is not painted. The glaziers produced the colors (the blues and reds of Chartres are famous and the tones were never again reproduced exactly) by adding metallic salts to molten glass. Individual pieces were fitted together like a jigsaw puzzle and fixed by leading the pieces together. Individual pieces were rarely larger than 8 feet (2.4 m) square, but 30 feet (9.2 m) sections could be bonded together safely in the leading process. The sections were set into stone frames (mullions) and reinforced in place by the use of iron retaining rods. Windows as large as 60 feet (18.3 m) high could be created in this fashion.

It would be useful at this point to compare the aesthetics of the stained-glass window to the mosaics discussed in Chapter 7. There was a strong element of light mysticism in the art of Byzantine mosaic decoration, derived from some of the same sources later utilized by Abbot Suger: Neo-Platonism and the allegorical reading of the Bible. The actual perception of light in the two art forms, however, was radically different. The mosaic refracted light off an opaque surface. The "sacred" aura of the light in a Byzantine church comes from the oddly mysterious breaking up of light as it strikes the irregular surface of the mosaic tesserae. The stained-glass window was the medium through which the light was seen directly, even if it was subtly muted into diverse colors and combinations of colors.

You can only "read" the meaning of the window by looking at it from the inside with an exterior light source—the sun—illuminating it. (*Read* is not a rhetorical verb in this context. It was a commonplace of the period to refer to the stained-glass windows as the "Bible of the Poor" since the illiterate could "read" the biblical stories in their illustrated form in the cathedral.) It was a more perfectly Platonic analogy of God's relationship to the world and its creatures. The viewer sees an object (the illustrated window) but "through it" is conscious of a distant unseen source (the sun—God) that illumines it and gives it its intelligibility.

A close examination of one window at Chartres will illustrate the complexity of this idea. The *Notre Dame de Belle Verrière* ("Our Lady of the Beautiful Window") [10.5], one of the most famous works in the cathedral, is a twelfth-century work saved from the rubble of the fire of 1194 and reinstalled in the south choir. The window, with its characteristic pointed arch frame, depicts the Virgin enthroned with the Christ Child surrounded by worshiping angels bearing candles and censers (incense vessels). Directly above her is the dove that represents the Holy Spirit and at the very top a stylized church building representing the cathedral built in her honor.

To a simple viewer, the window honored the Virgin to whom one prayed in time of need and to whom the church was dedicated. A person of some theological sophistication would further recognize the particular scene of the Virgin enthroned as the symbol of Mary as the Seat of Wisdom, a very ancient motif in religious art. The window also has a conceptual link with the exterior sculptural program. In the tympanum of the portal is an enthroned Madonna and Christ Child with two censerbearing angels. This scene is surrounded by sculptured arches, called *archivolts*, in which there are symbolic representations of the Seven Liberal Arts [10.6], which together constitute a shorthand version of the window.

The Blessed Virgin depicted as the Seat of Wisdom would be an especially attractive motif for the town of Chartres. The cathedral school was a flourishing center of literary and philosophical studies—studies that emphasized that human learning became wisdom only when it led to the source of wisdom: God. The fact that Mary was depicted here in glass would also call to mind an oft-repeated *exemplum* ("moral example") used in medieval preaching and theology: Christ was born of a virgin. He passed through her body as light passes through a window, completely intact without changing the glass. The Christ/light–Mary/glass analogy is an apt and deepened metaphor to be seen in the Belle Verrière of Chartres.

That kind of interpretation can be applied profitably to many aspects of Gothic art and architecture. Builders and theologians worked together closely while a cathedral was under construction. Church authorities felt it a primary duty not only to build a place suitable for divine worship but also to utilize every opportunity to teach and edify participating worshipers. The famous Gothic gargoyles [10.7] are a good example of this blend of functionality and didacticism. These carved beasts served the practical purpose of funneling rainwater off the roofs while, in their extended and jutting positions on the roofs and buttresses, signifying that evil flees the sacred precincts of the church. At a far more ambitious level, the whole decorative scheme of a cathedral was an attempt to tell an integrated story about the history of salvation-a story alluded to in both profane and divine learning. The modern visitor may be overwhelmed by what appears a chaotic jumble of sculptures depicting biblical scenes, allegorical figures, symbols of the labors of the month, signs of the Zodiac, representatives of pagan learning, and panoramic views of Last Judgments; for the medieval viewer the variegated scenes represented a patterned whole. The decoration of the cathedral was, as it were, the common vocabulary of sermons, folk wisdom, and school learning fleshed out in stone.

The Many Meanings of the Gothic Cathedral

Some theological and philosophical background is crucial for an appreciation of the significance of the Gothic cathedral, but it is a serious oversimplification to view the cathedral only in the light of its intellectual milieu.

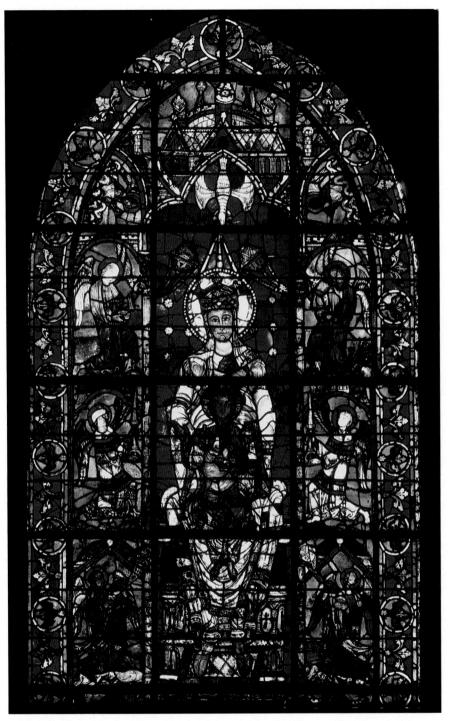

10.5 Notre Dame de Belle Verrière, Chartres Cathedral. Stained-glass window, early thirteenth century. The heavy vertical and horizontal lines are iron reinforcing rods to hold the window in place. The thinner lines are the leading. Details such as the Virgin's eyes, nose, and mouth are painted in. The red is a distinctive characteristic of the Chartres stainedglass workshops.

The cathedral was, after all, the preeminent building in the episcopal towns of the Île de France, as a view of any of the towns shows. The cathedral overwhelms the town either by crowning a hilly site, as at Laon, or rising up above the town plain, as at Amiens. The cathedrals were *town* buildings (Saint Denis, a monastic church, is a conspicuous exception) and one might well inquire into their functional place in the life of the town. It is simplistic to think that their presence in the town reflected a credulous faith on the part of the populace or the egomania of the civil and religious builders. In fact, the cathedral served vital social and economic functions in medieval society.

A modern analogy illustrates the social function of architecture and building. Many small towns in America, especially those in rural areas of the South and the Northeast, center their civic and commercial life around a town square. The courthouse symbolically emanates social control (justice); social structures (births, weddings, and deaths are registered there); power (the

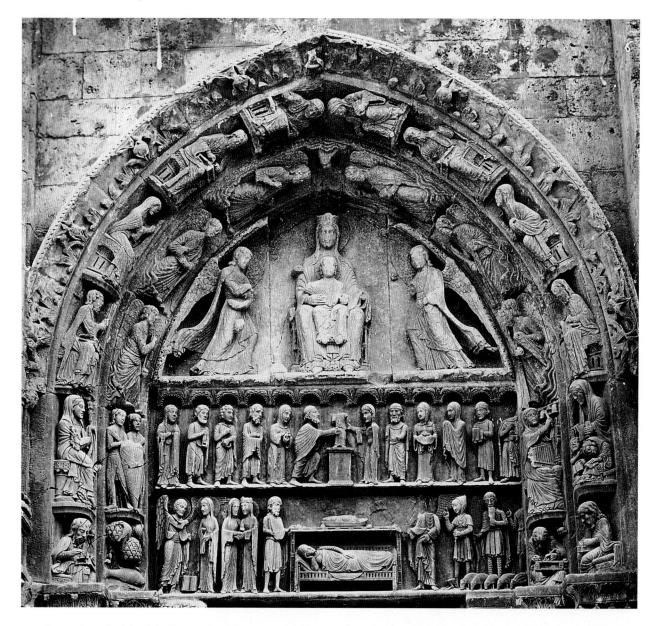

10.6 Scenes from the life of the Virgin Mary. Tympanum of the right door of the royal portal west façade, Chartres Cathedral. Done between 1145 and 1170, the central panel shows the Virgin and Child as an almost mirror image of the *Belle Verrière* (Figure 10.5). The arch has adoring angels while the outer arch (the archivolt) depicts the Seven Liberal Arts. At the lower left is Aristotle dipping his pen in ink with the female figure of Dialectic above him. Under the central figure of the Virgin are scenes from the life of Mary and the young Christ. At the lower left one can see the scene of the Annunciation.

sheriff, commissioners or aldermen, and the mayor are housed there); and—to a degree—culture, with its adjacent park and military or civic monuments to the founders and war dead. The better stores, the "uptown" churches, and the other appurtenances of respectability banks, lawyers' and physicians' offices—cluster about the square. (The urbanization and suburbanization of America has steadily destroyed this basic symmetry, replacing it with a far more diffuse city or suburban pattern where the concept of "center" is less easily identified.) The cathedral square of the typical European or Latin American town is the ancestor of the courthouse square. The difference is that the medieval cathedral exercised a degree of social control and integration more comprehensive than that of the courthouse.

The cathedral and its power were a serious force that shaped both individual and social life in the town. The individual was baptized in, made a communicant of, married in, and buried from, the cathedral. Schooling was obtained from the cathedral school and social services (hospitals, poor relief, orphanages, and so on) directed by the decisions of the cathedral staff (the *chapter*). The daily and yearly round of life was regulated by the horarium of the cathedral. People rose and ate and went to bed in rhythm with the tolling of the cathedral bell

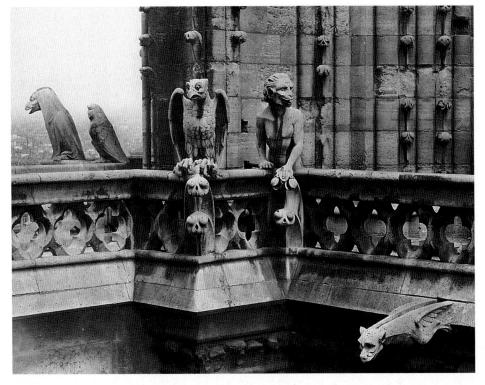

10.7 Grotesques and a gargoyle waterspout on a tower terrace of the Cathedral of Notre Dame, Paris. Many of these figures are modern representations of originals that were badly damaged during the French Revolution.

just as they worked or played in line with the feast days of the liturgical calendar of the church year. Citizens could sue and be sued in the church courts, and those same courts dispensed justice on a par with the civil courts; the scenes of the Last Judgment over the central portals of medieval cathedrals referred to more than divine justice.

Far more significant than the social interaction of town and cathedral was the economic impact of the cathedral on the town. The building of a cathedral was an extremely expensive enterprise. When the people of Chartres decided to rebuild their cathedral in 1194, the bishop pledged all of the diocesan revenues for three years (three to five million dollars!) simply to initiate the project [10.8]. It should be remembered that a town like Chartres was very small in the late twelfth century, with no more than ten to fifteen thousand residents in the town proper. Some economic historians have attempted to show that the combination of civic pride and religious enthusiasm that motivated the town to build a cathedral was economically ruinous in the long run. The majority of scholars, however, insist that it was precisely economic gain that was the significant factor in construction. This was surely the case with Chartres.

From the late ninth century, Chartres had been a major pilgrimage site. The cathedral possessed a relic of the Virgin (the tunic she wore when Jesus was born) given in 877 by Charles the Bald, the great-grandson of Charlemagne. Relics were very popular throughout the Middle Ages and this particular one was especially important to the pilgrims of the time. The relic had not been destroyed by the fire of 1194, a sure sign in the eyes of the populace that the Virgin wished the church rebuilt. Furthermore, the four great feasts of the Blessed Virgin in the liturgical year (the Purification of Mary on February 2, the Annunciation on March 25, the Assumption on August 15, and the Nativity of the Virgin on September 8) were celebrated in Chartres in conjunction with large trade fairs that drew merchants and customers from all over Europe.

These fairs were held in the shadow of the cathedral and their conduct was protected by legislation issued by the cathedral chapter. Regulations from the chapter, for example, stated that the prized textiles of the area were to be sold near the north portal while the purveyors of fuel, vegetables, fruit, and wine were to be located by the south portal. There were also sellers of images, medals, and other religious objects (forerunners of the modern souvenir) to the pilgrims who came both for the fair and for reasons of devotion. The church, then, was as much a magnet for outsiders as it was a symbol for the townspeople.

The patrons who donated the windows of Chartres Cathedral also give some indication of the economics of the place. It was only natural that some of the large windows—like a rose window—would be the gift of a royal family or that a tall, pointed *lancet* window like those in the choir would be given by the nobility or the higher clergy. A large number of the windows, however, were donated by the members of the various craft and commercial guilds in the town; their "signature frames" can be found at the bottoms of the windows. The fact

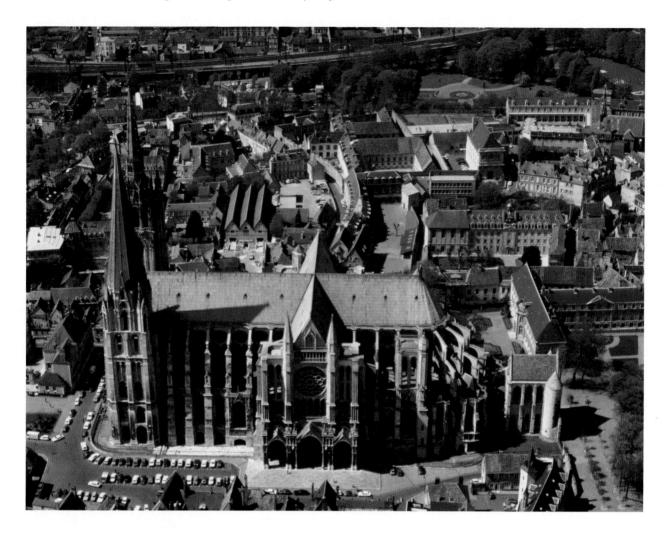

 ${\bf 10.8}$ Chartres Cathedral as rebuilt after 1194. Aerial view from the southeast.

that the five large windows in honor of the Virgin in the *chevet*, the east end of the cathedral, were donated by merchants—principally the bakers, butchers, and vintners—indicates the significant power of the guilds [10.9].

The guild, a fraternal society of craftsmen or merchants, was a cross between a modern-day union and a fraternal organization like the Elks or the Knights of Columbus. Members of the guilds put themselves under the patronage of a saint, promised to perform certain charitable works, and acted as a mutual-aid society. Many of the economic guilds appear to have developed out of earlier, more purely religious confraternities. One had to belong to a guild to work at any level beyond day labor. The guild accepted and instructed apprentices; certified master craftsmen; regulated prices, wages, working conditions; and maintained funds for the care of older members and the burial of their dead. The guilds were a crucial part of town life and would remain so well into the modern period. And, as we shall see, the university developed from the guild idea in the twelfth century.

The motivation for the building of a medieval catedral, then, came from the theological vision, religious devotion, civic pride, and socioeconomic interest. The actual construction depended on a large number of people. The cathedral chapter decided to construct a building, raised the money, and hired the master builder-architect. He in turn was responsible for hiring the various master craftsmen, designing the building, and creating the decorative scheme from ideas generated and approved by the theologians or church officials of the chapter. A great workshop was set up near the proposed site, with each master (mason, stonecutter, glazier) hiring his crew, obtaining his material, and setting up work quarters. Manual and occasional labor was recruited from the local population, but the construction crews were usually migratory groups who traveled from job to job.

The names of a number of master builders, including the builder of Chartres, have been lost, but others have survived in funerary inscriptions, commemorative plaques, and building records. Notes intended for students of buildings written by Villard de Honnecourt (about 1235), an architect from northern France, preserved in a unique copy at the Bibliothèque Nationale in

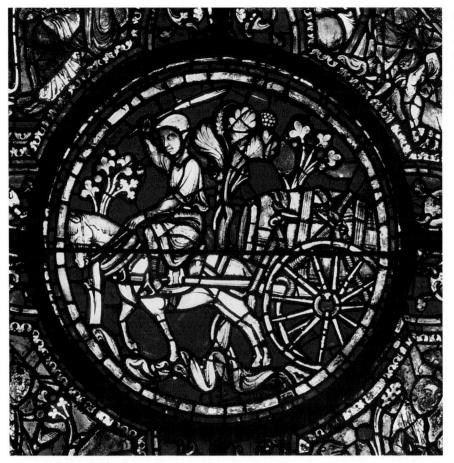

10.9 Vintner's window, glass roundel, c. 1215. Detail from the window of Saint Lubin, Cathedral, Chartres, France. This panel from a window donated by the winemakers of the area shows a wine merchant transporting vats.

Paris, provide us a rare glimpse into the skills of a medieval cathedral builder. Villard says in his book that he could teach a willing apprentice a wide range of skills ranging from carpentry and masonry to the more demanding skills of practical geometry [10.10] and plan drafting. The notebook also has random sketches and ideas jotted down for his own personal use; they include religious figures to serve as models for stonecarvers; animals and buildings that caught his eye; a perpetual motion machine (which didn't work); the first example of clockwork in the West; and a self-operating saw for cutting huge timbers for buttressing and roofing, among others. He visited Rheims and made sketches of the cathedral. He tells of traveling as far as Hungary to get work. While not as complete and wide-ranging as the Renaissance notebooks of Leonardo da Vinci (with which they have often been compared), Villard's notebook reveals a highly skilled, persistently inquisitive, and very inventive man.

A look through Villard's notebook forcefully reminds us that because our tendency is to emphasize the religious and social significance of a cathedral (as that is what first strikes us about it), we easily overlook the basic fact that a cathedral is a stunning technological achievement. A prime example of the technological virtuosity of such buildings is the elegant spire of Strasbourg Cathedral. Finished in 1439, the spire is 466 feet (142.1 m) high from pavement to tip—as high as a forty-story building. This stone structure remained the tallest in Europe until the mid-1960s, when the London Post Office Tower was completed.

The Gothic cathedral is an almost perfect artifact for the study of the humanistic enterprise since it may be approached from so many angles and at so many levels. It was first an architectural and technological achievement. Its ensemble of walls, windows, sculpture, and decoration demonstrated a peculiar way of combining human knowledge and religious faith that provides a basic aesthetic experience to the viewer. It had a fundamental economic and social significance for the community in which it was located. Finally, it was, for those who entered it in faith, a transcendental religious experience of passing from the profane to the sacred world. Henry Adams, in his wonderfully eccentric book Mont-Saint-Michel and Chartres, says that only a person coming to Chartres as a pilgrim could understand the building. The pilgrim is a central metaphor for the period whether one speaks of the actual pilgrim on the road to Santiago de Compostela or Canterbury or life itself as a pilgrimage toward God. Pilgrims to Chartres or the other cathedrals

10.10 Villard de Honnecourt. Page on "practical geometry" from his Album, c. 1275. Pen and ink. Bibliothèque Nationale, Paris. *Top row*: Measuring the diameter of a partially visible column; finding the middle of a circle; cutting the mold of an arch; arching a vault with an outer covering; making an apse with twelve windows; cutting the spring stone of an arch. *Second row*: Bringing together two stones; cutting a voussoir for a round building; cutting an oblique voussoir. *Third row*: Bridging a stream with timbers; laying out a cloister without plumb line or level; measuring the width of a river without crossing it; measuring the width of a distant window. *Bottom row*: Cutting a regular voussoir.

were pilgrims in both senses: They traveled to visit a real monument and, at the same time, hoped to find rest and salvation through the act [10.11]. It is no wonder Abbot Suger should have called Saint Denis the "Gate of Heaven": That is exactly what it was meant to be.

Music: The School of Notre Dame

It should not be surprising that in an age of artistic and architectural development such as the Gothic the austere music of the early church should also undergo change. From the time Charlemagne introduced Gregorian chant into the church life of the Frankish kingdom there had

10.11 Christ in the act of blessing, c. 1215. Figure on trumeau of main portal, Chartres Cathedral. This statue symbolically blesses all pilgrims who pass through the door, the "Gate of Heaven."

been further developments of that musical form. In the eleventh century, Guido di Arezzo had worked out a system of musical notation that provided the basis for the development of the musical notation used today. Church musicians from the tenth century on also experimented with a single melodic line of plainchant by adding parallel voices at different musical intervals above the line of chant. This first step toward polyphony, a musical term for "many voices," is called organum. Outside the church, the knightly classes also composed and performed secular music. Some of the melodies of the troubadours and trouvères have survived, giving us an idea of secular music in the twelfth and thirteenth centuries. The German minnesingers (minne means "love") of the thirteenth century used traditional church modes and melodies to create secular and sacred songs.

The school of Notre Dame in Paris was the center of systematic musical study and composition in the twelfth century. Léonin's *Magnus Liber Organi* (c. 1160) is an important source for our knowledge of music in the period of the Gothic cathedral. Léonin's book was a collection of organum compositions for use during the liturgical services throughout the church year. Léonin's work was carried on by the other great composer of the century, Pérotin, who assumed the directorship of the music school of Notre Dame sometime around 1181.

For a selection from *Magnus Liber Organi*, see the Listening CD.

In Pérotin's music, the Notre Dame organum utilized the basic melodic line of the traditional chant (the *cantus firmus*) while a second melodic line (the *duplum*), a third (*triplum*), and in some cases a fourth (*quadruplum*) voice were added above the melody. These added lines mirrored the rhythmic flow of the cantus firmus. It was soon learned, however, that pleasing and intricate compositions could be created by having the duplum and triplum move in opposition to the cantus firmus. This *counterpoint* (from *contrapunctum*, "against the note") meant, at its most basic level, that a descending series of notes in the cantus firmus would have an ascending series of notes in the melodic lines above it.

One development in the Gothic period deriving from the polyphony of organum was the motet. The *motet* usually had three voices (in some cases, four). The tenor from the Latin *tenere* ("to hold"), another term for *cantus firmus*—maintained the traditional line, usually derived from an older ecclesiastical chant. Since some of the manuscripts from the period show no words for this tenor position, it has been thought that for many motets the tenor line was the musical accompaniment. Above the tenor were two voices who sang interweaving melodies. In the early thirteenth century, these melodies were invariably in Latin and exclusively religious in content. In the late thirteenth century, it was not uncommon to sing the duplum in Latin and the triplum in French. Indeed, the two upper voices could be singing quite distinct songs: a hymn in Latin with a love lyric in French with a tenor voice (or instrument) maintaining an elaborated melody based on the melismas of Gregorian chant.

This increasingly sophisticated music, built on a monastic basis but with a new freedom of its own, is indicative of many of the intellectual currents of the period. It is a technically complex music rooted in the distant past but open to daring innovation, a blend of the traditional and the vernacular—all held together in a complicated balance of competing elements. Gothic music was an aural expression of the dynamism inherent in the medieval Gothic cathedral.

SCHOLASTICISM

The Rise of the Universities

A number of contemporary institutions have their roots in the Middle Ages. Trial by jury is one, constitutional monarchy another. By far the best-known and most widely diffused cultural institution that dates from the Middle Ages is the university. In fact, some of the most prestigious centers of European learning today stand where they were founded eight hundred years ago: Oxford and Cambridge in England; the University of Paris in France; the University of Bologna in Italy. There is also a remarkable continuity between the organization and purposes of the medieval university and our own, except that we have coeducation. The medieval student would be puzzled, to be sure, by the idea of football games, coeducation, degrees in business or agriculture, and wellmanicured campuses, were he to visit an American university. Such a student would find himself at home with the idea of a liberal arts curriculum, the degrees from the baccalaureate through the master's to the doctorate, and the high cost of textbooks. At a less serious level, he would be well acquainted with drinking parties, fraternities, and friction between town and gown (the phrase itself has a medieval ring). The literature that has come down to us from the period is full of complaints about poor housing, high rents, terrible food, and lack of jobs after graduation. Letters from the Middle Ages between students and parents have an almost uncanny contemporaneity about them except for the fact that women did not study in the medieval universities.

European universities developed in the late twelfth and early thirteenth centuries along with the emergence of city life. In the earlier medieval period, schools were most often associated with the monasteries, which were perforce situated in rural areas. As cities grew in importance, schools also developed at urban monasteries or, increasingly, under the aegis of bishops whose cathedrals were in the towns. The episcopal or cathedral school was

VALUES

Dialectics

In ancient Greece the word *dialectics* originally meant the "art of conversation." By the fifth century B.C.E., *dialectics* took on the meaning of techniques used to come to logical conclusions based on a rigorous style of reasoning. Plato singled out *dialectic* in *The Republic* as a mark of the philosopher–king, whereas Aristotle saw it containing the "path to the principles of all inquiries."

The rediscovery of *dialectic* (which was the common medieval term for "logic") coincided with the rise of the university. The study of theology and philosophy were increasingly cast into terms that could be expressed in logic modes like that of the deductive syllogism. University professors of theology, for example, had three duties: to explain the text of scripture; to preach; and to dispute"—that is, to set out Christian doctrines in some logical form. What was true of these

a direct offshoot of the increasing importance of towns and the increasing power of bishops, the spiritual leaders of town life. In Italy, where town life had been relatively strong throughout the early Middle Ages and where feudalism never took hold, there was also a tradition of schools controlled by the laity. The center of medical studies in Salerno and the law faculty of Bologna had been in secular hands since the tenth century.

A number of factors help to explain the rapid rise of formal education institutions in the twelfth century. First, the increasing complexity of urban life created a demand for an educated class who could join the ranks of administrators and bureaucrats. Urban schools were not simply interested in providing basic literacy. They were designed to produce an educated class who could give support to the socioeconomic structures of society. Those who completed the arts curriculum of a twelfth-century cathedral school (like the one at Chartres) could find ready employment in either the civil or the ecclesiastical bureaucracy as lawyers, clerks, or administrators.

There were also intellectual and cultural reasons for the rise of the universities. In the period from 1150 to 1250 came a wholesale discovery and publication of texts from the ancient world. Principal among these were lost books by Aristotle that came to the West through Muslim sources in Spain. Aristotle's writings covered a vast range of subjects ranging from meteorology and physics to logic and philosophy. Further, with a closer relationship between Christian and Arabic scholars, a large amount of scientific and mathematical material was coming into Europe [10.12]. There was also a renaissance of legal studies centered primarily at Bologna, the one intellectual center that could nearly rival Paris. Finally, there Christian scholars was also true of both contemporary Islamic and Jewish thinkers who had inherited the same tradition of Aristotle's logic. Modern scholars have pointed out that this form of dialectical reasoning, with its focus on resolving problems, had ramifications for both literature and architecture.

The greatest weakness of this emphasis was the temptation to turn the logical process into an end in itself: forgetting the search for truth in a desire to dazzle people with the sheer technique of logic. Dante would open Canto XI of the *Paradiso* with a critique of such mental pyrotechnics as he complained of those who were useless in their "reasoning" (literally: their "syllogisms") that make the wings of the mind bend "in downward flight."

was a new tool being refined by such scholars as Peter Abelard and Peter Lombard: dialectics. Theologians and philosophers began to apply the principles of logic to the study of philosophy and theology. Abelard's book *Sic et Non* (1121) combined conflicting opinions concerning theological matters with contradictory passages from the Bible and the Church Fathers and then attempted to mediate and reconcile the apparent divergences. This method was later refined and stylized into the method that was to become *scholasticism*, so-called because it was the philosophical method of the schools, the communities of scholars at the nascent universities.

Abelard's Sic et Non

The most famous and representative university to emerge in the Middle Ages was the University of Paris. The eminence of Paris rested mainly on the fame of the teachers who came there to instruct. At this state of educational development, the teacher really was the school. Students in the twelfth century flocked from all over Europe to frequent the lectures of teachers like William of Champeaux (1070–1121) and, later, his formal student and vehement critic, Peter Abelard (1079-1142). Besides these famous individual teachers Paris also had some established centers of learning that enjoyed a vast reputation. There was a school attached to the Cathedral of Notre Dame, a theological center associated with the canons of the Church of Saint Victor, and a school of arts maintained at the ancient monastery of Sainte Geneviève.

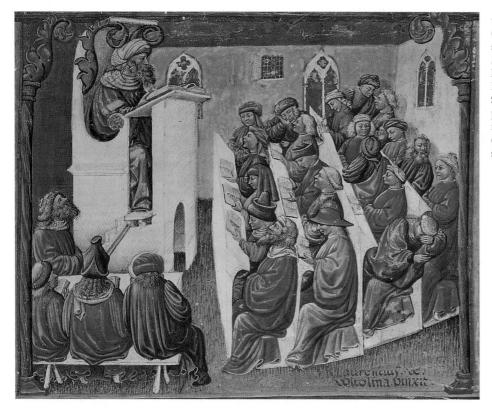

10.12 Laurencius de Voltolina (School of Bologna). A university lecture from *Lecture of Henricus de Alemania*, second half of fourteenth century. Manuscript illumination. State Museums, Berlin. The professor expounds his text from the professorial chair (*cathedra*). Note the sleeping student at the lower right.

Although it is difficult to assign precise dates, it is safe to say that the university at Paris developed in the final quarter of the twelfth and early part of the thirteenth centuries. Its development began with the *magistri* ("masters"; "teachers") of the city forming a corporation after the manner of the guilds. At this time the word *universitas* simply meant a guild or corporation. The masters formed the universitas in Paris in order to exercise some "quality control" over the teaching profession and the students entrusted to their care. At Bologna, the reverse was true. The students formed the universitas in order to hire the teachers with the best qualifications and according to the most advantageous financial terms.

The universitas soon acquired a certain status in law with a corporate right to borrow money, to sue (and be sued), and to issue official documents. As a legal body it could issue stipulations for the conduct of both masters and students. When a student completed the course of studies and passed examinations, the universitas would grant him a teaching certificate that enabled him to enter the ranks of the masters: he was a master of arts (our modern degree has its origin in that designation). After graduation, a student could go on to specialized training in law, theology, or medicine. The completion of this specialized training entitled one to be called doctor (from the Latin doctus, "learned") in his particular field. The modern notion that a professional person (doctor, lawyer, and the like) should be university-trained is an idea derived directly from medieval university usage.

Since the Carolingian period—indeed, earlier—the core of education was the arts curriculum. In the late twelfth century in Paris the arts began to be looked on as a prelude to the study of theology. This inevitably caused a degree of tension between the arts faculty and the theology masters. In 1210 this tension resulted in a split, with the masters and students of arts moving their faculty to the Left Bank of the Seine, where they settled in the area intersected by the rue du Fouarre ("Straw Street"—so named because the students sat on straw during lectures). That part of the Left Bank has traditionally been a student haunt. The name Latin Quarter reminds us of the old language that was once the only tongue used at the university.

By the end of the twelfth century, Paris was the intellectual center of Europe. Students came from all over Europe to study there. We do not have reliable statistics about their number, but an estimate of five to eight thousand students would not be far from the mark for the early thirteenth century. The students were organized into *nationes* by their place of national origin. By 1294, there were four recognized *nationes* in Paris: the French, the Picard, the Norman, and the Anglo-German. Student support came from families, pious benefactors, church stipends, or civic grants to underwrite an education. Certain generous patrons provided funds for hospices for scholars, the most famous of which was that underwritten by Robert de Sorbon in 1258 for graduate students in theology; his hospice was the forerunner of the Sorbonne in Paris.

CONTEMPORARY VOICES

A Medieval Parent and a Student

I have recently discovered that you live dissolutely and slothfully, preferring license to restraint and play to work and strumming a guitar while the others are at their studies, whence it happens that you have read but one volume of law while more industrious companions have read several. I have decided to exhort you herewith to repent utterly of your dissolute and careless ways that you may no longer be called a waster and that your shame may be turned to good repute.

[Parent to a son at the university in Orleans, fourteenth century]

We occupy a good and comely dwelling, next door but one from the schools and marketplace, so that we can go to school each day without wetting our feet. We have good companions in the house with us, well advanced in their studies, and of excellent habits—an advantage which we appreciate for, as the psalmist says "with an upright man thou wilt show thyself upright." Wherefore, lest production should cease for lack of material, we beg your paternity to send us by the bearer money for the purchase of parchment, ink, a desk, and the other things which we need, in sufficient amount that we may suffer no want on your account (God forbid!) but finish our studies and return home with honor. The bearer will also take charge of the shoes and stockings which you will send us, and any news at all.

[Scholar to his father, Orleans, fourteenth century]

By our standards, student life in the thirteenth century was harsh. Food and lodging were primitive, heating scarce, artificial lighting nonexistent, and income sporadic. The daily schedule was rigorous, made more so by the shortage of books and writing material. An "ideal" student's day, as sketched out in a late medieval pamphlet for student use, now seems rather grim:

A Student's Day at the University of Paris

	0
4:00 A.M.	Rise
5:00-6:00	Arts lectures
6:00	Mass and breakfast
8:00-10:00	Lectures
11:00-12:00	Disputations before the noon meal
1:00-3:00 р.м.	"Repetitions"-study of morning lec-
	tures with tutors
3:00-5:00	Cursory lectures (generalized lec-
	tures on special topics) or disputa-
	tions
6:00	Supper
7:00-9:00	Study and repetitions
9:00	Bed

The masters' lectures consisted of detailed commentaries on certain books the master intended to cover in a given term. Since books were expensive, emphasis was put on note taking and copying so that the student might build up his own collection of books. Examinations were oral, before a panel of masters. Students were also expected to participate in formal debates (called disputations) as part of their training.

Geoffrey Chaucer provides us an unforgettable, albeit idealized, portrait of the medieval student (the clerk or

cleric—many of the students were members of the minor clerical orders of the church) in his Prologue to the *Canterbury Tales:*

A clerk from Oxford was with us also, Who'd turned to getting knowledge, long ago. As meagre was his horse as is a rake, Nor he himself too fat, I'll undertake, But he looked hollow and went soberly. Right threadbare was his overcoat; for he Had got him yet no churchly benefice, Nor was so worldly as to gain office. For he would rather have at his bed's head Some twenty books, all bound in black and red, Of Aristotle and his philosophy Than rich robes, fiddle, or gay psaltery. Yet, and for all he was philosopher, He had but little gold within his coffer; But all that he might borrow from a friend On books and learning he would swiftly spend, And then he'd pray right busily for the souls Of those who gave him wherewithal for schools. Of study took he utmost care and heed. Not one word spoke he more than was his need; And that was said in fullest reverence And short and quick and full of high good sense. Pregnant of moral virtue was his speech; And gladly would he learn and gladly teach.

Chaucer's portrait of the lean, pious, poor, zealous student was highly idealized to create a type. We probably get a far more realistic picture of what students were actually doing and thinking about from the considerable amount of popular poetry that comes from the student culture of the medieval period. This poetry depicts a student life we are all familiar with: a poetry of wine, women, song, sharp satires at the expense of pompous professors or poor accommodations, and the occasional episodes of cruelty that most individuals are capable of only when banded into groups.

The student subculture had also invented a mythical Saint Golias, who was the patron saint of wandering scholars. Verses (called Goliardic verse) were written in honor of the "saint." The poems that have come down to us are a far cry from the sober commentaries on Aristotle's *Metaphysics* that we usually associate with the medieval scholar.

One of the more interesting collections of these medieval lyrics was discovered in a Bavarian monastery in the early nineteenth century. The songs in this collection were written in Latin, Old French, and German and seem to date from the late twelfth and thirteenth centuries. Their subject range was wide but, given the nature of such songs, predictable. There were drinking songs, laments over the loss of love or the trials of fate, hymns in honor of nature, salutes to the end of winter and the coming of spring, and cheerfully obscene songs of exuberant sexuality. The lyrics reveal a shift of emotions ranging from the happiness of love to the despair of disappointment just as the allusions range from classical learning to medieval piety. One famous song, for example, praises the beautiful powerful virgin in language that echoes the piety of the church. The last line reveals, however, that the poem salutes not Mary but generous Venus.

In 1935 and 1936, German composer Carl Orff set a number of these poems to music under the title *Carmina Burana*. His brilliant, lively blending of heavy percussion, snatches of ecclesiastical chant, strong choral voices, and vibrant rhythms have made this work a modern concert favorite. The listener gets a good sense of the vibrancy of these medieval lyrics by the use of the modern setting. Since the precise character of student music has not come down to us, Orff's new setting of these lyrics is a fine beginning for learning about the musicality of this popular poetry from the medieval university.

Did women study at the university? By and large they did not. Medieval customs sheltered women in a manner we find hard to imagine. Women were educated either privately (Heloise was tutored by her uncle in Paris when she met Abelard) or within the cloister of the convent. Furthermore, most of university life was tied to the church. The masters were clerics (except at Bologna) and most students depended on ecclesiastical benefices ("pensions") to support them. There are exceptions to this rule. There seem to have been women in universities in both Italy and Germany, but they were the exception. At Salerno, famous for its faculty of medicine, there may have been women physicians who were attached to the faculty. We do know that by the fourteenth century the university was licensing women physicians. There is also a tradition that Bologna had a woman professor of law who, according to the story, was so beautiful that she lectured from behind a screen so as not to dazzle her students! It is well to remember that the universities were very conservative and traditional institutions. It was not until this century, for example, that provisions were made for women's colleges at Oxford that enjoyed the full privileges of university life. The discrimination against women at the university level was something, for example, that moved the bitter complaints of the English novelist, Virginia Woolf, as late as the 1920s.

Francis of Assisi

St. Francis of Assisi

In Italy, at the end of the twelfth century, a young man would be born who would reshape medieval religious and cultural life. Giovanni Bernadone, born in 1181 in the Umbrian hill town of Assisi, was renamed "Francesco" ("Little Frenchman") by his merchant father. Francis grew up the son of wealthy parents as a popular, somewhat spendthrift, and undisciplined youth. He joined the volunteer militia as a youth to do battle against the neighboring city of Perugia only to be captured and put into solitary confinement until a ransom could be found.

That incident seems to have marked a turning point in his life. He dropped out of society and began to lead a life of prayer and self-denial. Eventually he came to the conclusion that the life of perfect freedom demanded a life of total poverty. He gave away all of his goods and began a life of itinerant preaching that took him as far away as the Middle East. His simple lifestyle attracted followers who wished to live in imitation of his life. By 1218, there were over three thousand "Little Brothers" (as he called them) who owed their religious allegiance to him. Francis died in 1226 when the movement he started was already a powerful religious order in the church [10.13].

If we know Francis of Assisi today, it is because of garden shop statues of him with a bird on his shoulder. That he preached to the birds is a fact [10.14], but to think of him only as a medieval Doctor Doolittle speaking to animals is to trivialize a man who altered medieval culture profoundly. First, his notion of a mendicant ("begging") brotherhood that would be mobile and capable of preaching in the newly emerging cities of Europe was a worthy substitute for the more rural, land-bound monasteries of the past. Second, Francis believed that the Gospels could be followed literally and this led him to identify closely with the humanity of Christ. It is said that in 1224, he had so meditated on the Passion of Christ that his own body bore the crucifixion marks of Christ (stigmata). This emphasis on Christ's humanity would have a powerful impact in making religious art more

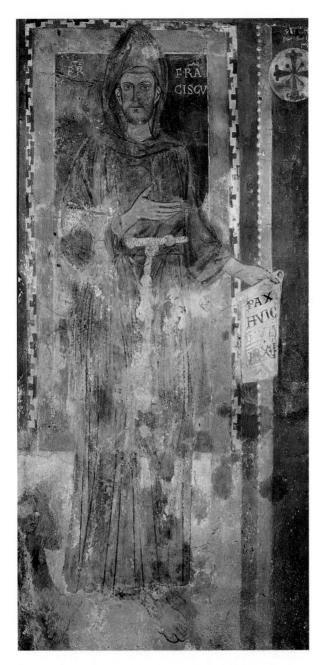

10.13 *Saint Francis of Assisi.* Fresco. Santo Specchio. This may be the earliest portrait of Saint Francis; some scholars believe that it was executed during the saint's lifetime.

realistic and vivid. Finally, Francis' attitude toward religious faith was powerfully affirmative. He praised the goodness of God's creation; he loved the created world; he preached concern for the poorest of the poor; he felt that all creation was a gift and that everything in creation praised God in its own way. Some scholars have argued that the impact of the Franciscan vision on the imagination of European culture was a remote cause of the Renaissance preoccupation with the natural world and the close observation of nature.

The early part of the thirteenth century, in fact, saw that rise of two complementary impulses that would energize late medieval culture: the intellectualism of the schools epitomized in someone like Thomas Aquinas (discussed below) and the affective and emotional religion of a Francis of Assisi. Those two impulses were best synthesized in the masterpiece that summed up high medieval culture: the *Commedia* of Dante Alighieri.

Dante

Thomas Aquinas

The Golden Age of the University of Paris was the thirteenth century, since in that period Paris could lay fair claim to being the intellectual center of the Western world. It is a mark of the international character of medieval university life that some of its most distinguished professors did not come from France: Albert the Great (a German), Alexander of Hales (English), Bonaventure and Thomas Aquinas (Italian).

Thomas Aquinas (1225?-1274) was the most famous and influential of the Parisian masters of the thirteenth century [10.15]. His intellectual influence went far beyond the lecture halls of Paris and is felt to the present. Born of noble parentage in southern Italy, Thomas Aquinas joined the Preaching Friars of Saint Dominic (the Dominicans) in 1243. From 1245 to 1248, he studied with Albert the Great at both Paris and Cologne. He was made a magister of theology in 1258 after completing his doctoral studies. During this same period (roughly 1256 to 1259) Thomas Aquinas lectured on theology in Paris. From 1259 to 1268, he was back in Italy where he lectured and wrote at Orvieto (the papal court for a time), Rome, and Naples. From 1268 to 1272, he again held a chair of theology, when he returned to Naples to teach there. He died two years later on his way to a church council at Lyons in France.

Thomas Aquinas' life ended before he was fifty, but in that span he produced a vast corpus of writings (they fill forty folio volumes) on theology, philosophy, and biblical studies. It is a mark of his mobility that his masterpiece-the Summa Theologica-was composed at Rome, Viterbo, Paris, and Naples, although it was unfinished at his death. While his writings touched on a wide variety of subjects, at root Thomas Aquinas was interested in and made a lifetime study of a very basic problem: How does one harmonize those things that are part of human learning (reason) with those supernatural truths revealed by God in the Bible and through the teaching of the church (revelation)? Aquinas' approach was to steer a middle path through two diametrically opposed opinions, both of which had avid supporters in the Middle Ages: the position of *fideism*, which held that religious faith as an absolute is indifferent to the efforts of human reason (credo quia absurdum est, "I believe because it is absurd") and rationalism, which insists that everything, rev-

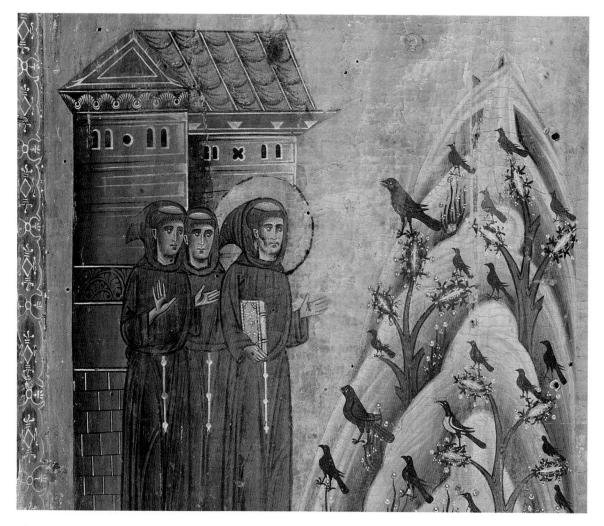

10.14 Saint Francis Preaching to the Birds. Detail of Berlingheri Altarpiece. Pescia. This detail from an altarpiece depicts incidents from the saint's life taken from early legends written about him.

elation included, must meet the test of rational human scrutiny. Aquinas wanted to demonstrate what the Gothic cathedral illustrated: that the liberal arts, the things and seasons of the world, and the mysteries revealed by God could be brought into some kind of intellectual harmony based on a single criterion of truth.

Thomas Aquinas' Summa Theologica

For Aquinas, reason finds truth when it sees evidence of truth. The mind judges something true when it has observed a sufficient number of facts to compel it to make that judgment. The mind gives assent to truth on the basis of evidence. Aquinas was convinced that there was a sufficient amount of observable evidence in the world to conclude the existence of God. He proposed five arguments in support of such a position. Still he recognized that such argumentation only yields a very limited understanding of God. Aquinas did not believe that the naked use of reason could ever discover or prove the mysteries about God revealed in the Bible: that God became a man in Jesus Christ or that there was a Trinity of persons in God. God had to tell us that. Our assent to it is not based on evidence, but on the authority of God who reveals it to us. If we could prove the mysteries of faith, there would have been no need for revelation and no need of faith.

Thus for Aquinas there is an organic relationship between reason and revelation. Philosophy perfects the human capacity to know and revelation perfects one beyond self by offering salvation and eternal life. Aquinas stated this relationship between reason and revelation at the very beginning of his great work of theology, the *Summa Theologica*.

When we read Aquinas today we get some sense of his stark and rigorous attempt to think things through. For one thing, he offers no stylistic adornment to relieve his philosophical and rational discourse. For another, he makes clear that philosophical reasoning is difficult; it is

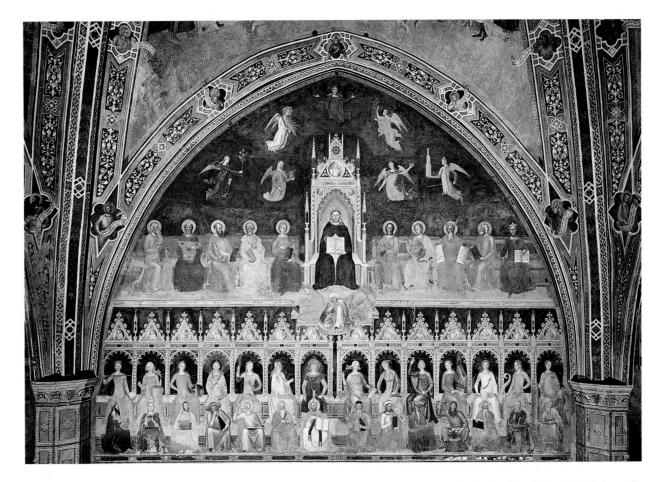

10.15 Andrea di Buonaiuto. *The Triumph of St. Thomas Aquinas,* c. 1365. Fresco. Santa Maria Novella, Florence. The saint is enthroned between figures of the Old and New Testaments with the personification of the Virtues, Sciences, and Liberal Arts below. This Florentine church had a school of studies attended by Dante Alighieri in his youth.

not a pastime for the incompetent or the intellectually lazy. Yet Aquinas was not a mere machine for logic. He had the temperament of a mystic. Some months before he died he simply put down his pen; when his secretary asked him why he had stopped writing, Aquinas simply said that in prayer and quiet he had had a vision and that what he had written "seemed as straw." Aquinas was a rare combination of intellectual and mystic.

The philosophical tradition Aquinas used in his writing was that of the Greek philosopher Aristotle. He first knew Aristotle's work in Latin translations based on Arabic texts done by Muslim scholars in the south of Spain and North Africa. Later Aquinas was able to use texts translated directly out of Greek by a Flemish friar and sometime companion, William of Moerbeke. Aquinas' use of Aristotle was certainly not a novelty in the Middle Ages. Such Arabic scholars as Avicenna (980–1036) and Averröes of Córdova (1126–1198) commented on Aristotle's philosophy and its relationship to the faith of Islam. Jewish thinkers like the famous Moses Maimonides (born in Córdova in 1135, died in Egypt in 1204) made similar attempts to bridge Greek thought and their own religious faith. Maimonides wrote his famous *Guide for the Perplexed* to demonstrate the essential compatibility of the Hebrew scriptures with the thought of Aristotle. Maimonides was determined that essentials of the biblical message not be compromised, but he likewise felt that in nonessentials there was room for human reflection. In this task of distinguishing the place of intellect and faith Maimonides anticipated the work of Thomas Aquinas by two generations.

Two other characteristics of the thought of Aquinas should be noted. First, his worldview was strongly hierarchical. Everything has its place in the universe, and that place is determined in relation to God. A rock is good because it *is* (to Aquinas existence was a gift), but an animal is more nearly perfect because it has life and thus shares more divine attributes. In turn, men and women are better still because they possess mind and will. Angels are closer yet to God because they, like God, are pure spirit.

This hierarchical worldview explains other characteristics of Aquinas' thought in particular and medieval thought in general: It is wide-ranging, it is encyclopedic, and in interrelating everything it is synthetic. Everything fits and has its place, meaning, and truth. That a person would speak on psychology, physics, politics, theology, and philosophy with equal authority would strike us as presumptuous, just as any building decorated with symbols from the classics, astrology, the Bible, and scenes from everyday life would now be considered a hodgepodge. Such was not the case in the thirteenth century, since it was assumed that everything ultimately pointed to God.

DANTE'S DIVINE COMEDY

In any discussion of the culture of the High Middle Ages two descriptive adjectives come immediately to mind: hierarchical and synthetic. It is a commonplace, for example, to compare the Gothic cathedral and the systematic treatises on philosophy and theology like the Summa Theologica of Saint Thomas Aquinas. On close inspection such comparisons may be facile, but they point to the following truths about this period that are relatively secure: Both the Gothic cathedral and the theology of Aquinas, for example, started from the tangible and sensual ("Nothing comes to the mind except through the senses" is a basic axiom for Aquinas) in order to mount in a hierarchical manner to the light that is God. Again, both writer and architect felt it possible to be universal in their desire to synthesize all human knowledge as prelude and pointer to the full revelation of God. Finally, they both constructed their edifices by the juxtaposition of tensions and syntheses.

If the Gothic cathedral and the Summa Theologica represent two masterpieces of the hierarchical and synthetic religious humanism of the Middle Ages, the Divine Comedy of Dante Alighieri (1265-1321) represents the same masterly achievement in literature. Dante [10.16] was a Florentine. He was nonetheless deeply influenced by the intellectual currents that emanated from the Paris of his time. As a comfortably fixed young man he devoted himself to a rigorous program of philosophical and theological study in order to enhance his already burgeoning literary talent. His published work gives evidence of a profound culture and a deep love for study. He wrote on the origin and development of language (De Vulgari Eloquentia), political theory (De Monarchia), and generalized knowledge (Convivio) as well as his own poetic aspirations (Vita Nuova). His masterpiece is the Divine Comedy.

Dante was exiled from Florence for political reasons in 1300. In his bitter wanderings in the north of Italy he worked on—and finally brought to conclusion—a long poem to which he gave a bitingly ironical title: *The Comedy of Dante Alighieri, A Florentine by Birth but Not in Behavior.* Dante called his poem a comedy since, as he noted, it had a happy ending and was written in the popular language of the people. The adjective *divine* was added later; some say by Boccaccio, who in the next generation lectured on the poem in Florence and wrote one of the first biographies of the great poet.

The *Divine Comedy* relates a symbolic journey that the poet begins on Good Friday, 1300, through hell, purga-

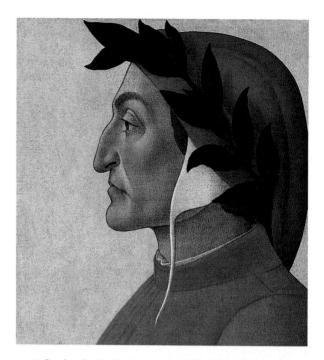

10.16 Sandro Botticelli, *Dante*, c. 1480–1485. Oil on canvas, $24^{1}/_{2}^{"} \times 18^{1}/_{2}^{"}$ (54 × 47 cm). Collection Dr. Martin Bodmer, Cologny/Geneva. Like most portraits of Dante, Botticelli's depicts him wearing the traditional laurel wreath of the poet.

tory, and heaven [Table 10.1]. In the first two parts of his journey, Dante is guided by the ancient Roman poet Vergil, whose *Aeneid* was such an inspiration to him and from which he borrowed (especially from Book VI, which tells of Aeneas' own journey to the Underworld). From the border at the top of the Mount of Purgatory to the pinnacle of heaven where Dante glimpses the "still point of light" that is God, Dante's guide is Beatrice, a young woman Dante had loved passionately if platonically in his youth [10.17].

Every significant commentator on the Comedy has noted its careful organization. The poem is made up of one hundred cantos. The first canto of the Inferno serves as an introduction to the whole poem. There are then thirty-three cantos for each of the three major sections (Inferno, Purgatorio, and Paradiso). The entire poem is written in a rhyme scheme called terza rima (aba, bcb, cdc, and so on) that is almost impossible to duplicate in English because of the shortage of rhyming words in our language. The number three and its multiples, symbols of the Trinity, occur over and over. The Inferno is divided into nine regions plus a vestibule, and the same number is found in the Purgatorio. Dante's Paradiso is constituted by the nine heavens of the Ptolemaic system plus the Empyrean, the highest heaven. This scheme mirrors the whole poem of ninety-nine cantos plus one. The sinners in the Inferno are arranged according to whether they sinned by incontinence, violence, or fraud (a division Dante derived from Aristotle's Ethics), while the yearning souls of purgatory are divided in three ways according to how they acted or failed to act in relation to love.

TABLE 10.1 The Structure of Dante's Comedy				
Hell				
The Ante	room of the Neutrals			
Circle 1:	The Virtuous Pagans (Limbo)			
Circle 2:	The Lascivious			
Circle 3:	The Gluttonous			
Circle 4:	The Greedy and the Wasteful			
Circle 5:	The Wrathful			
Circle 6:	The Heretics			
Circle 7:	The Violent against Others, Self, God/Nature/ and			
	Art			
Circle 8:	The Fraudulent (subdivided into ten classes, each of			
	which dwells in a separate ditch)			
Circle 9:	The Lake of the Treacherous against kindred, coun-			
	In an all I and a sud have fastens Catan is incomis			

try, guests, lords and benefactors. Satan is imprisoned at the center of this frozen lake.

Purgatory

Ante-Purgatory: The Excommunicated/The Lazy/The Unabsolved/Negligent Rulers The Terraces of the Mount of Purgatory

1. The Proud

- 2. The Envious
- 3. The Wrathful
- 4. The Slothful
- 5. The Avaricious
- 6. The Gluttonous
- 7. The Lascivious

The Earthly Paradise

Paradise

- 1. The Moon: The Faithful who were inconstant
- 2. Mercury: Service marred by ambition
- 3. Venus: Love marred by lust
- 4. The Sun: Wisdom; the theologians
- 5. Mars: Courage; the just warriors
- 6. Jupiter: Justice; the great rulers
- 7. Saturn: Temperance; the contemplatives and mystics
- 8. The Fixed Stars: The Church Triumphant
- 9. The Primum Mobile: The Order of Angels
- 10. The Empyrean Heavens: Angels, Saints, the Virgin, and the Holy Trinity

The saved souls in the *Paradiso* are divided into the lay folk, the active, and the contemplative. Nearest the throne of God, but reflected in the circles of heaven, are the nine categories of angels.

Dante's interest in the symbolic goes beyond his elaborate manipulation of numbers. In the *Inferno* sinners suffer punishments that have symbolic value; their sufferings both punish and instruct. The gluttonous live on heaps of garbage under driving storms of cold rain, while the flatterers are immersed in pools of sewage and the sexually perverse walk burning stretches of sand in an environment as sterile as their attempts at love. Conversely, in the *Paradiso*, the blessed dwell in the circles most symbolic of their virtue. The theologians are in the circle of the sun since they provided such enlightenment to the world, and the holy warriors dwell in the sphere of Mars.

We can better appreciate the density and complexity of Dante's symbolism by looking at a single example. Our common image of Satan is that of a sly tempter (in popular art he is often in formal dress whispering blandishments in a willing ear with just a whiff of sulphur about him) after the manner of Milton's proud, perversely tragic, heroic Satan in *Paradise Lost*. For Dante, Satan is a huge, stupid beast, frozen in a lake of ice in the pit of hell. He beats six batlike wings (a demonic leftover from his angelic existence; see Isaiah 6:1-5) in an ineffectual attempt to escape the frozen pond that is watered by the four rivers of hell. He is grotesquely three-headed (a parody of the Trinity) and his slavering mouths remorselessly chew the bodies of three infamous traitors from sacred and secular history (Judas, Cassius, and Brutus).

Why does Dante portray Satan so grotesquely? It is clear that Dante borrowed some of the picture of Satan from Byzantine mosaics with which he would have been familiar in the baptistery of Florence [10.18]. Beyond that, the whole complex of Satan is heavily weighted with symbolic significance. Satan lies in frozen darkness at a point in the universe farthest from the warmth and light of God. He is the fallen angel of light (Lucifer means "light-bearer"), now encased in a pit in the center of the earth excavated by the force of his own fall from heaven. Satan is immobile in contrast to God who is the mover of all things in the universe. He is totally inarticulate and stupid because he represents, par excellence, all of the souls of hell who have lost what Dante calls "the good of intellect." Satan, and all the souls in hell, will remain totally unfulfilled as created rational beings because they are cut off from the final source of rational understanding and fulfillment: God. Intellectual estrangement from God is for Dante, as it was for Thomas Aquinas, the essence of damnation. This estrangement is most evident in the case of Satan, who symbolizes in his very being the loss of rationality and all that derives from that fact.

Dante, following a line of thought already developed by Suger and Aquinas, conceived the human journey as a slow ascent to the purity of God by means of the created things of this world. To settle for less than God was, in essence, to fail to return to the natural source of life, God. This explains why light is such a crucial motif in the *Divine Comedy* as it had been in the theories of Abbot Suger. Neither light nor the sources of light (the sun) is ever mentioned in the *Inferno*. The overwhelming visual impression of the *Inferno* is darkness—a darkness that begins when Dante is lost in the "dark wood" of Canto I and continues until he climbs from hell and sees above his head the stars (the word *stars* ends each of the three major parts of the poem) of the Southern Hemisphere. In the ascent of the mountain of purgatory, daylight and

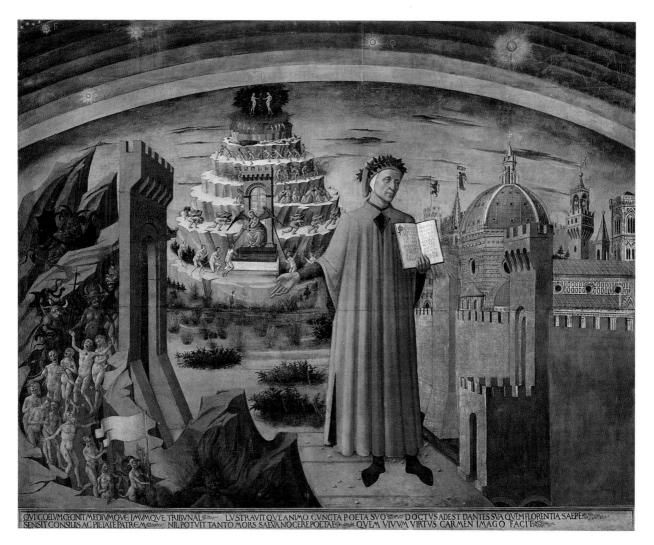

10.17 Domenico di Michelino. *Dante and His Poem*, 1465. Fresco. Florence Cathedral. Dante, with an open copy of the *Comedy*, points to Hell with his right hand. The Mount of Purgatory with its seven terraces is behind him. Florence's cathedral (with its newly finished dome) represents Paradise on the poet's left.

sunset are controlling motifs to symbolize the reception and rejection of divine light. In the *Paradiso*, the blessed are bathed in the reflected light that comes from God. At the climax of the *Paradiso*, the poet has a momentary glimpse of God as a point of light and rather obscurely understands that God, the source of all intelligibility, is the power that also moves the "sun and the other stars."

Within the broad reaches of Dante's philosophical and theological preoccupations the poet still has the concentrated power to sketch unforgettable portraits: the doomed lovers Paolo and Francesca—each of the tercets that tell their story starts with the word *amore* ("love"); the haughty political leader Farinata degli Umberti; the pitiable suicide Pier delle Vigne; or the caricatures of gluttons like Ciacco the Hog. Damned, penitent, or saved, the characters are by turns both symbols and persons. Saint Peter represents the church in the *Paradiso* but also explodes with ferociously human anger at its abuses. Brunetto Latini in the *Inferno* with "his brownbaked features" is a condemned sodomite but still anxious that posterity at least remember his literary accomplishments.

It has been said that a mastery of the Divine Comedy would be a mastery of all that was significant about the intellectual culture of the Middle Ages. It is certainly true that the poem, encyclopedic and complex as it is, would provide a primer for any reader interested in the science, political theory, philosophy, literary criticism, and theology of the thirteenth century as well as a detailed acquaintance with the burning questions of Dante's time. The very comprehensiveness of the poem has often been its major obstacle for the modern reader. Beyond that hurdle is the strangeness of the Dantean world, so at variance with our own: earth-centered, manageably small, sure of its ideas of right and wrong, orthodox in its theology, prescientific in its outlook, Aristotelian in its philosophy. For all that, Dante is not only to be read for his store of medieval lore; he is, as T. S. Eliot once wrote, the most universal of poets. He had a deeply sympathetic appreciation of human aspiration, love and hate, the destiny of humanity, and the meaning of nature and history.

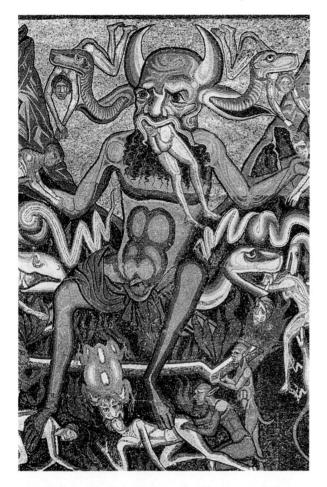

10.18 *Hell.* Detail of mosaic in vault of baptistery of Florence Cathedral, thirteenth century. As a young man Dante would have seen this mosaic, which adorned the baptistery ("My beautiful San Giovanni," he calls it in his poem) of his native city.

SUMMARY

The High Middle Ages saw the growth of a number of institutions that stood in sharp contrast to those of the Carolingian period. Foremost was the rise of the city. Urbanization brought with it a lessening of the importance of monastic life as a cultural center and the emergence of the influence of the bishop and the cathedral school. The increased need for a "knowledge class" triggered an expansion in education that would eventually lead to the university of scholars. Urbanization also warred against the old feudal values; it fostered trade and commerce; it made possible the growth of what we today call a "middle class" who stood on the social ladder between the rural peasant/city worker and the landed royalty or hereditary aristocracy.

The twelfth and thirteenth centuries were times of intense intellectual ferment and advance. New sources of knowledge came through Arabic sources either as original contributions (e.g., in medicine and science) or in the form of lost works of the Classical past (e.g., the writings of Aristotle) to fuel the work of scholars. Advances in technology as "spinoffs" from the ambitious plans of both Romanesque and Gothic architects had their impact. The increase of a money economy over a barter economy aided the growth of artistic and musical culture.

One conspicuous characteristic of medieval culture was its belief that everything knowable could be expressed in a manageable and rational whole. Whether it appeared in stone (Chartres) or technical prose (Thomas Aquinas) or in poetry (Dante), the medieval mind saw hierarchy, order, intelligibility, and, above all, God in all of observable creation. This hierarchy expressed itself in its emphasis on advancing steps of understanding. The sculptural program of Chartres, for example, is a revelation of the Old Testament figures who point us to their proper fulfillment in the New. In the theology of Aquinas we move from the plane of natural reason to a fuller truth taught by revelation. In Dante we progress from an awareness of our sinful nature to an intuition into the nature of God. In all of these cases the emphasis is on harmony and gradation and a final purpose of all knowledge, which is to become aware of God. In that sense, at least, much of medieval culture could be said to be oriented in an otherworldly manner.

PRONUNCIATION GUIDE

Abelard:	AB-eh-lard
Alighieri (Dante):	Al-e-GARY
Aquinas:	Ah-KWI-nas
Averröes:	Av-ER-row-es
Avicenna:	Av-e-CHENA
Carmina Burana:	CAR-me-nah Bur-RAN-ah
Chartres:	CHART-reh
Divina Commedia:	Dee-VEE-nah Com-EH-dee-ah
Guido di Arezzo:	GWE-dough deh Ah-RET-so
Léonin:	LEE-oh-nin
Maimonides:	My-MON-id-eze
Pérotin:	PEAR-oh-tin
Pseudo-Dionysius:	SUE-dough-Die-oh-NY-sius
Suger:	SUE-jay
Universitas:	U-nee-VER-see-tas
Villard de Honnecourt:	VEE-yar deh HO-nee-cor

EXERCISES

- 1. Is it possible to think of a building or complex of buildings serving as an organizing metaphor for a contemporary city in the way a cathedral served in the Middle Ages?
- 2. What positive and/or negative outcomes do you see deriving from the medieval cult of the Virgin?
- 3. Compare the use and role of light in the atmosphere of Hagia Sophia and the Cathedral of Chartres.
- Describe some of the technological problems medieval builders had to solve in an age with limited power sources, no tempered metals, no computers or slide rules for calculations, and so on.
- 5. The medieval university was organized around the body of scholars who made up the faculty. To what degree

does that model hold up today? What is the organizing principle of the modern college or university?

- 6. A good deal of medieval education utilized *dialectics.* What does that word mean? Where do dialectics, broadly understood, find their usefulness today?
- 7. Thomas Aquinas had no doubt that all knowledge was both interrelated and capable of being synthesized into a whole. Everything from science and philosophy to theology would fit into that synthesis. Would that view find many supporters today? If not, why not?
- 8. If you were to organize a contemporary hell for the great villains of our day, would you use Dante's classification or would you construct another schema? On what basis would it be organized?
- 9. Dante looks back to Vergil as the model for his great work of poetry. If we were to write a work today to celebrate our culture and destiny, would we feel the need to invoke a past model to do so? If so, who might it be? If not, why not?

FURTHER READING

- Adams, Henry. (1959). *Mont-Saint-Michel and Chartres*. Garden City: Doubleday. A brilliant albeit eccentric work on the culture of the Gothic world. While its scholarship has been superseded in this century, it is still an aesthetic classic.
- Bony, Jean. (1983). *French Gothic architecture of the 12th and 13th centuries.* Berkeley: University of California Press. Authoritative and lavishly illustrated.
- Cunningham, Lawrence S. (1981). *Saint Francis of Assisi.* San Francisco: Harper & Row. Readable essays on the saint and his culture with profuse illustrations.
- Ferruolo, Stephen. (1985). *The origins of the university*. Stanford, CA: Stanford University Press. A scholarly focus on the schools of Paris from 1100 to 1215.
- Gilson, Étienne. (1966). *Reason and revelation in the Middle Ages.* New York: Scribner's. A brief but excellent survey of the intellectual milieu of the period by one of the foremost authorities of our century.
- Gimpel, Jean. (1977). *The medieval machine: The Industrial Revolution of the Middle Ages.* New York: Penguin. A wonderful introduction to technology in medieval times.
- Golding, William. (1964). *The spire*. New York: Harcourt. A brilliant fictional evocation of medieval cathedral building.
- Holmes, Urban T. (1966). *Daily living in the twelfth century.* Madison: University of Wisconsin. An extremely readable account of ordinary life in medieval London and Paris drawn from documentary evidence.
- Knowles, David. (1962). *The evolution of medieval thought*. New York: Vintage. A classic study of medieval thought from Augustine to the eve of the Reformation.
- Macauley, David. (1973). *Cathedral: The story of its construction.* Boston: Houghton, Mifflin. A book for young and old readers on the construction of a cathedral, with penand-ink drawings by the author. A fascinating and lovely work that is simple but richly informative.
- McInerny, Ralph M. (1990). A first glance at St. Thomas Aquinas. Notre Dame: University of Notre Dame Press. A readable introduction to the thought of Thomas Aquinas.
- Panofsky, Erwin. (1946). *Abbot Suger*. Princeton, NJ: Princeton University Press. A translation of Suger's booklets on Saint Denis with an important introduction and full notes. Indispensable for the period.
- Singleton, Charles. (1972). The Divine Comedy of Dante Alighieri (6 vols.). Princeton, NJ: Princeton University Press. With a commentary in English by the foremost authority on Dante in America. There are separate volumes

of the poem in English with companion volumes of commentary. Excellent and indispensable.

Wilson, Christopher. (1993). *The gothic cathedral*. New York: Thames and Hudson.

Online Chapter Links

Gothic architecture is examined at

http://www.geocities.com/Athens/Parthenon/8063/ gothic.html

For introductory information about Gothic art as well as links to sites related to representative artists, consult *Artcyclopedia* at

http://www.artcyclopedia.com/history/gothic.html

The Medieval Art and Architecture Web site at http://info.pitt.edu/~medart/

provides access to a wide variety of architectural wonders in Europe—including those at St. Denis, Chartres, and Amiens.

For a virtual tour of Chartres Cathedral, visit http://info.pitt.edu/~medart/menufrance/chartres/ charmain.html

where the floor plan, glass work, and sculptures are examined in detail.

The St. Francis of Assisi Web site at

http://www.americancatholic.org/Features/Francis/ features a brief biography of the patron saint of animals and ecology and his association with blessing animals.

For information about the Franciscan Order in America, visit

http://www.pressroom.com/~franciscan/

The Digital Dante Web site

http://www.ilt.columbia.edu/projects/dante/

provides a wide range of information about the author, multiple translations of the complete text of the *Divine Comedy*, a beautiful image collection, links to related Internet sites, useful maps, and a bibliography.

For a catalog of useful links to Internet resources, consult *Medieval Music Links* at

http://classicalmus.hispeed.com/medieval.html

Karadar Classical Music at

http://www.karadar.it/Dictionary/Default.htm provides an alphabetical listing of musicians with brief biographies and a list of works (some of which are available on MIDI files).

Online Chapter Resources

READING SELECTIONS

SAINT FRANCIS OF ASSISI

Two years before he died, Francis, blind and in ill health, wrote this long poem with the hope that his brothers would sing it when on their preaching journeys. It was one of the earliest poems written in Italian. It reflects the Franciscan love for nature. The lines about peace and forgiveness as well as those about death were additions to the original poem.

The Canticle of Brother Sun

Most High, omnipotent, good Lord To you alone belong praise and glory, Honor, and blessing. No man is worthy to breathe thy name.

Be praised, my Lord, for all your creatures. In the first place for the blessed Brother Sun, who gives us the day and enlightens us through you. He is beautiful and radiant with his great splendor. Giving witness of thee, Most Omnipotent One.

Be praised, my Lord, for Sister Moon and the stars Formed by you so bright, precious, and beautiful.

Be praised, my Lord, for Brother Wind And the airy skies, so cloudy and serene; For every weather, be praised, for it is life-giving.

Be praised, my Lord, for Sister Water, So necessary yet so humble, precious, and chaste.

Be praised, my Lord, for Brother Fire, Who lights up the night. He is beautiful and carefree, robust, and fierce.

Be praised, my Lord, for our sister, Mother Earth, Who nourishes and watches us While bringing forth abundance of fruits with color And herbs.

Be praised, my Lord, for those who pardon through And bear weakness and trial. Blessed are those who endure in peace, For they will be crowned by you, Most High.

Be praised, my Lord, for our sister, Bodily Death, Whom no living man can escape. Woe to those who die in sin. Blessed are those who discover thy holy will. The second death will do them no harm.

Praise and bless my Lord. Render thanks. Serve him with great humility. Amen.

SAINT THOMAS AQUINAS *from* Summa Theologiae

These three articles from the first question of the first part of the Summa Theologiae make three points: (1) To know God one needs a revelation beyond what human reason can attain; (2) the proper

language of theology includes metaphorical language; and (3) sacred scripture has many levels of meaning. Thomas Aquinas did not consider himself a philosopher; he was a theologian, which in his day meant a commentator on the Bible.

Question I. on what sort of teaching Christian theology is and what it covers

In order to keep our efforts within definite bounds we must first investigate this holy teaching and find out what it is like and how far it goes. Here there are ten points of inquiry:

- 1. about the need for this teaching;
- 2. whether it be science;
- 3. whether it be single or several;
- 4. whether it be theoretical or practical;
- 5. how it compares with other sciences;
- 6. whether it be wisdom;
- what is its subject;
- 8. whether it sets out to prove anything;
- 9. whether it should employ metaphorical or symbolical language;
- whether its sacred writings are to be interpreted in several senses.

Article 1. is another teaching required apart from philosophical studies?

THE FIRST POINT: 1. Any other teaching beyond that of science and philosophy seems needless. For man ought not to venture into realms beyond his reason; according to *Ecclesiasticus*, *Be not curious about things far above thee*. Now the things lying within range of reason yield well enough to scientific and philosophical treatment. Additional teaching, therefore, seems superfluous.

2. Besides, we can be educated only about what is real; for nothing can be known for certain save what is true, and what is true is identical with what really is. Yet the philosophical sciences deal with all parts of reality, even with God; hence Aristotle refers to one department of philosophy as theology or the divine science. That being the case, no need arises for another kind of education to be admitted or entertained.

ON THE OTHER HAND the second epistle to Timothy says, All Scripture inspired of God is profitable to teach, to reprove, to correct, to instruct in righteousness. Divinely inspired Scripture, however, is no part of the branches of philosophy traced by reasoning. Accordingly it is expedient to have another body of sure knowledge inspired by God.

REPLY: It should be urged that human well-being called for schooling in what God has revealed, in addition to the philosophical researches pursued by human reasoning.

Above all because God destines us for an end beyond the grasp of reason; according to Isaiah, Eye hath not seen, O God, without thee what thou hast prepared for them that love thee. Now we have to recognize an end before we can stretch out and exert ourselves for it. Hence the necessity for our welfare that divine truths surpassing reason should be signified to us through divine revelation.

We also stood in need of being instructed by divine revelation even in religious matters the human reason is able to investigate. For the rational truth about God would have appeared only to few, and even so after a long time and mixed with many mistakes; whereas on knowing this depends our whole welfare, which is in God. In these circumstances, then, it was to prosper the salvation of human beings, and the more widely and less anxiously, that they were provided for by divine revelation about divine things.

These then are the grounds of holding a holy teaching which has come to us through revelation beyond the discoveries of the rational sciences.

Hence: 1. Admittedly the reason should not pry into things too high for human knowledge, nevertheless when they are revealed by God they should be welcomed by faith: indeed the passage in *Ecclesiasticus* goes on, *Many things are shown thee above the understanding of men.* And on them Christian teaching rests.

2. The diversification of the sciences is brought about by the diversity of aspects under which things can be known. Both an astronomer and a physical scientist may demonstrate the same conclusion, for instance that the earth is spherical; the first, however, works in a mathematical medium prescinding from material qualities, while for the second his medium is the observation of material bodies through the senses. Accordingly there is nothing to stop the same things from being treated by the philosophical sciences when they can be looked at in the light of natural reason and by another science when they are looked at in the light of divine revelation. Consequently the theology of holy teaching differs in kind from that theology which is ranked as a part of philosophy.

Article 9. should holy teaching employ metaphorical or symbolical language?

THE NINTH POINT: 1. It seems that holy teaching should not use metaphors. For what is proper to a lowly type of instruction appears ill-suited to this, which, as already observed, stands on the summit. Now to carry on with various similitudes and images is proper to poetry, the most modest of all teaching methods. Therefore to make use of such similitudes is ill-suited to holy teaching.

2. Moreover, this teaching seems intended to make truth clear; and there is a reward held out to those who do so: *Those who explain me shall have life everlasting*. Such symbolism, however, obscures the truth. Therefore it is not in keeping with this teaching to convey divine things under the symbolic representation of bodily things.

3. Again, the nobler the creatures the closer they approach God's likeness. If then the properties of creatures are to be read into God, then at least they should be chiefly of the more excellent not the baser sort; and this is the way frequently taken by the Scriptures.

ON THE OTHER HAND *it is declared in Hosea, I have multiplied visions and I have used similitudes by the ministry of the prophets.* To put something across under imagery is metaphorical usage. Therefore sacred doctrine avails itself of metaphors.

REPLY: Holy Scripture fittingly delivers divine and spiritual realities under bodily guises. For God provides for all things according to the kind of things they are. Now we are of the kind to reach the world of intelligence through the world of sense, since all our knowledge takes its rise from sensation. Congenially, then, holy Scripture delivers spiritual things to us beneath metaphors taken from bodily things. Dionysius agrees, *The divine rays cannot enlighten us except wrapped up in many sacred veils.*

Then also holy Scripture is intended for all of us in common without distinction of persons, as is said in the epistle to the Romans, *To the wise and the foolish I am a debtor*, and fitly puts forward spiritual things under bodily likenesses; at all events the uneducated may then lay hold of them, those, that is to say, who are not ready to take intellectual truths neat with nothing else.

Hence: 1. Poetry employs metaphors for the sake of representation, in which we are born to take delight. Holy teaching, on the other hand, adopts them for their indispensable usefulness, as just explained.

2. Dionysius teaches in the same place that the beam of divine revelation is not extinguished by the sense imagery that veils it, and its truth does not flicker out, since the minds of those given the revelation are not allowed to remain arrested with the images but are lifted up to their meaning; moreover, they are so enabled to instruct others. In fact truths expressed metaphorically in one passage of Scripture are more expressly explained elsewhere. Yet even the figurative disguising serves a purpose, both as a challenge to those eager to find out the truth and as a defense against unbelievers ready to ridicule; to these the text refers, *Give not that which is holy to the dogs*.

3. Dionysius also tells us that in the Scriptures the figures of base bodies rather than those of fine bodies more happily serve the purpose of conveying divine things to us. And this for three reasons. First, because thereby human thinking is the more exempt from error, for the expressions obviously cannot be taken in the proper sense of their words and be crudely ascribed to divine things; this might be more open to doubt were sublime figures evoked, especially for those people who can summon up nothing more splendid than physical beauty. Secondly, because understatement is more to the point with our present knowledge of God. For in this life what he is not is clearer to us than what he is; and therefore from the likenesses of things farthest removed from him we can more fairly estimate how far above our speech and thought he is. Thirdly, because thereby divine matters are more effectively screened against those unworthy of them.

Article 10. can one passage of holy Scripture bear several senses?

THE TENTH POINT: 1. It would seem that the same text of holy Scripture does not bear several senses, namely the historical or literal, the allegorical, the tropological or moral, and the anagogical. Allow a variety of readings to one passage, and you produce confusion and deception, and sap the foundations of argument; examples of the stock fallacies, not reasoned discourse, follow from the medley of meanings. Holy Scripture, however, should effectively display the truth without fallacy of any sort. One text, therefore, should not offer various meanings.

2. Besides, St. Augustine holds that *Scripture which is entitled the Old Testament has a fourfold meaning, namely according to history, to etiology, to analogy, and to allegory.* Now these four appear inconsistent with the four mentioned above; which therefore appear awkward headings for interpreting a passage of Scripture.

3. Further, there is also a parabolic sense, not included among them.

ON THE OTHER HAND, St. Gregory declares that holy Scripture transcends all other sciences by its very style of expression, in that one and the same discourse, while narrating an event, transmits a mystery as well.

REPLY: That God is the author of holy Scripture should be acknowledged, and he has the power, not only of adapting words to convey meanings (which men also can do), but also of adapting things themselves. In every branch of knowledge words have meaning, but what is special here is that the things meant by the words also themselves mean something. That first meaning whereby the words signify things belongs to the sense first-mentioned, namely the historical or literal. That meaning, however, whereby the things signified by the words in their turn also signify other things is called the spiritual sense; it is based on and presupposes the literal sense.

Now this spiritual sense is divided into three. For, as St Paul says, *The Old Law is the figure of the New*, and the New Law itself, as Dionysius says, *is the figure of the glory to come*. Then again, under the New Law the deeds wrought by our Head are signs also of what we ourselves ought to do.

Well then, the allegorical sense is brought into play when the things of the Old Law signify the things of the New Law; the moral sense when the things done in Christ and in those who prefigured him are signs of what we should carry out; and the anagogical sense when the things that lie ahead in eternal glory are signified.

Now because the literal sense is that which the author intends, and the author of holy Scripture is God who comprehends everything all at once in his understanding, it comes not amiss, as St. Augustine observes, if many meanings are present even in the literal sense of one passage of Scripture.

Hence: 1. These various readings do not set up ambiguity or any other kind of mixture of meanings, because, as we have explained, they are many, not because one term may signify many things, but because the things signified by the terms can themselves be the signs of other things. Consequently holy Scripture sets up no confusion, since all meanings are based on one, namely the literal sense. From this alone can arguments be drawn, and not, as St. Augustine remarks in his letter to Vincent the Donatist, from the things said by allegory. Nor does this undo the effect of holy Scripture, for nothing necessary for faith is contained under the spiritual sense that is not openly conveyed through the literal sense elsewhere.

2. These three, history, etiology, and analogy, are grouped under the one general heading of the literal sense. For as St. Augustine explains in the same place, you have history when any matter is straightforwardly recorded; etiology when its cause is indicated, as when our Lord pointed to men's hardness of heart as the reason why Moses allowed them to set aside their wives; analogy when the truth of one Scriptural passage is shown not to clash with the truth of another. Of the four senses enumerated in the argument, allegory stands alone for the three spiritual senses of our exposition. For instance Hugh of St. Victor included the anagogical sense under the allegorical, and enumerated just three senses, namely the historical, the allegorical, and the tropological.

3. The parabolical sense is contained in the literal sense, for words can signify something properly and something figuratively; in the last case the literal sense is not the figure of speech itself, but the object it figures. When Scripture speaks of the arm of God, the literal sense is not that he has a physical limb, but that he has what it signifies, namely the power of doing and making. This example brings out how nothing false can underlie the literal sense of Scripture.

DANTE ALIGHIERI

from the DIVINE COMEDY

These selections from the Divine Comedy include cantos from all three parts of Dante's poem: the Inferno, the Purgatorio, and the Paradiso. They represent a fair sample of Dante's sources and his highly visual imagination. In these cantos there are mythical monsters, demons, angels, saints, heroes from the Classical past, and figures from Dante's Italy. Those figures do not exist in solitude. The figure of Satan only makes sense in juxtaposition with the vision of God, the haughty pride of Farinata in contrast to the figure of Francis of Assisi.

While reading these selections keep in mind Dante's powerful use of language: a single sentence can sketch a scene; one image can set a mood; an individual can stand for a class. While the poem as a whole is immensely long, the thing that most leaps out from these pages is Dante's economy, his ability to say so much in so few words. Coupled with his near-total control of Classical and religious learning Dante makes this poem a veritable encyclopedia of medieval culture.

The translation and notes are by the late American poet John Ciardi.

Inferno

Canto I

The Dark Wood of Error

Midway in his allotted threescore years and ten, Dante comes to himself with a start and realizes that he has strayed from the True Way into the Dark Wood of Error (Worldliness). As soon as he has realized his loss, Dante lifts his eyes and sees the first light of the sunrise (the Sun is the symbol of Divine Illumination) lighting the shoulders of a little hill (the Mount of Joy). It is the Easter season, the time of resurrection, and the sun is in its equinoctial rebirth. This juxtaposition of joyous symbols fills Dante with hope and he sets out at once to climb directly up the Mount of Joy, but almost immediately his way is blocked by the Three Beasts of Worldliness: The Leopard of Malice and Fraud, The Lion of Violence and Ambition, and The She-Wolf of Incontinence. These beasts, and especially the She-Wolf, drive him back despairing into the darkness of error. But just as all seems lost, a figure appears to him. It is the shade of Vergil, Dante's symbol of Human Reason.

Vergil explains that he has been sent to lead Dante from error. There can, however, be no direct ascent past the beasts: The man who would escape them must go a longer and harder way. First he must descend through Hell (the Recognition of Sin), then he must ascend through Purgatory (the Renunciation of Sin), and only then may he reach the pinnacle of joy and come to the Light of God. Vergil offers to guide Dante, but only as far as Human Reason can go. Another guide (Beatrice, symbol of Divine Love) must take over for the final ascent, for Human Reason is selflimited. Dante submits himself joyously to Vergil's guidance and they move off.

Midway in our life's journey, I went astray from the straight road and woke to find myself alone in a dark wood. How shall I say 3 what wood that was! I never saw so drear, so rank, so arduous a wilderness! Its very memory gives a shape to fear. 6 Death could scarce be more bitter than that place! But since it came to good, I will recount all that I found revealed there by God's grace. 9 How I came to it I cannot rightly say, so drugged and loose with sleep had I become when I first wandered there from the True Way. 12 But at the far end of that valley of evil whose maze had sapped my very heart with fear

I found myself before a little hill

Reading Selections

and lifted up my eyes. Its shoulders glowed already with the sweet rays of that planet whose virtue leads men straight on every road,	18	who came to Rome after the burning of Troy. But you—why do <i>you</i> return to these distresses instead of climbing that shining Mount of Joy	75
and the shining strengthened me against the fright whose agony had wracked the lake of my heart through all the terrors of that piteous night.	21	which is the seat and first cause of man's bliss?" "And are you then that Virgil and that fountain of purest speech?" My voice grew tremulous:	78
Just as a swimmer, who with his last breath flounders ashore from perilous seas, might turn to memorize the wide water of his death—	24	"Glory and light of poets! now may that zeal and love's apprenticeship that I poured out on your heroic verses serve me well!	81
so did I turn, my soul still fugitive from death's surviving image, to stare down that pass that none had ever left alive.	27	For you are my true master and first author, the sole maker from whom I drew the breath of that sweet style whose measures have brought me honor.	84
And there I lay to rest from my heart's race till calm and breath returned to me. Then rose and pushed up that dead slope at such a pace	30	See there, immortal sage, the beast I flee. For my soul's salvation, I beg you, guard me from her, for she has struck a mortal tremor through me."	87
each footfall rose above the last. And lo! almost at the beginning of the rise I faced a spotted Leopard, all tremor and flow	33	And he replied, seeing my soul in tears: "He must go by another way who would escape this wilderness, for that mad beast that flees	90
and gaudy pelt. And it would not pass, but stood so blocking my every turn that time and again I was on the verge of turning back to the wood.	36	before you there, suffers no man to pass. She tracks down all, kills all, and knows no glut, but, feeding, she grows hungrier than she was.	93
This fell at the first widening of the dawn as the sun was climbing Aries with those stars that rode with him to light the new creation.	39	She mates with any beast, and will mate with more before the Greyhound comes to hunt her down. He will not feed on lands nor loot, but honor	96
Thus the holy hour and the sweet season of commemoration did much to arm my fear of that bright murderous beast with their good omen.	42	and love and wisdom will make straight his way. He will rise between Feltro and Feltro, and in him shall be the resurrection and new day	99
Yet not so much but what I shook with dread at sight of a great Lion that broke upon me raging with hunger, its enormous head	45	of that sad Italy for which Nisus died, and Turnus, and Euryalus, and the maid Camilla. He shall hunt her through every nation of sick pride	102
held high as if to strike a mortal terror into the very air. And down his track, a She-Wolf drove upon me, a starved horror	48	till she is driven back forever to Hell whence Envy first released her on the world. Therefore, for your own good, I think it well	105
ravening and wasted beyond all belief. She seemed a rack for avarice, gaunt and craving. Oh many the souls she has brought to endless grief!	51	you follow me and I will be your guide and lead you forth through an eternal place. There you shall see the ancient spirits tried	108
She brought such heaviness upon my spirit at sight of her savagery and desperation, I died from every hope of that high summit.	54	in endless pain, and hear their lamentation as each bemoans the second death of souls. Next you shall see upon a burning mountain	111
And like a miser—eager in acquisition but desperate in self-reproach when Fortune's wheel turns to the hour of his loss—all tears and attrition	57	souls in fire and yet content in fire, knowing that whensoever it may be they yet will mount into the blessed choir.	114
I wavered back; and still the beast pursued, forcing herself against me bit by bit till I slid back into the sunless wood.	60	To which, if it is still your wish to climb, a worthier spirit shall be sent to guide you. With her shall I leave you, for the King of Time,	117
And as I fell to my soul's ruin, a presence gathered before me on the discolored air, the figure of one who seemed hoarse from long silence.	63	who reigns on high, forbids me to come there since, living, I rebelled against his law. He rules the waters and the land and air	120
At sight of him in that friendless waste I cried: "Have pity on me, whatever thing you are, whether shade or living man." And it replied:	66	and there holds court, his city and his throne. Oh blessed are they he chooses!" And I to him: "Poet, by that God to you unknown,	123
"Not man, though man I once was, and my blood was Lombard, both my parents Mantuan. I was born, though late, <i>sub Julio,</i> and bred	69	lead me this way. Beyond this present ill and worse to dread, lead me to Peter's gate and be my guide through the sad halls of Hell."	126
in Rome under Augustus in the noon of the false and lying gods. I was a poet and sang of old Anchises' noble son	72	And he then: "Follow." And he moved ahead in silence, and I followed where he led.	

Notes

- 1. MIDWAY IN OUR LIFE'S JOURNEY: The biblical life span is three-score years and ten. The action opens in Dante's thirty-fifth year, i.e., 1300 A.D.
- THAT PLANET: The sun. Ptolemaic astronomers considered it a planet. It is also symbolic of God as He who lights man's way.
- 31. EACH FOOTFALL ROSE ABOVE THE LAST: The literal rendering would be: "So that the fixed foot was ever the lower." *Fixed* has often been translated "right" and an ingenious reasoning can support that reading, but a simpler explanation offers itself and seems more competent: Dante is saying that he climbed with such zeal and haste that every footfall carried him above the last despite the steepness of the climb. At a slow pace, on the other hand, the rear foot might be brought up only as far as the forward foot. This device of selecting a minute but exactly centered detail to convey the whole of a larger action is one of the central characteristics of Dante's style.

THE THREE BEASTS: These three beasts undoubtedly are taken from *Jeremiali* v. 6. Many additional and incidental interpretations have been advanced for them, but the central interpretation must remain as noted. They foreshadow the three divisions of Hell (incontinence, violence, and fraud) which Vergil explains at length in Canto XI, 16–111.

- 38–39. ARIES . . . THAT RODE WITH HIM TO LIGHT THE NEW CREATION: The medieval tradition had it that the sun was in Aries at the time of Creation. The significance of the astronomical and religious conjunction is an important part of Dante's intended allegory. It is just before dawn of Good Friday 1300 A.D. when he awakens in the Dark Wood. Thus, his new life begins under Aries, the sign of creation, at dawn (rebirth) and in the Easter season (resurrection). Moreover the moon is full and the sun is in the equinox, conditions that did not fall together on any Friday of 1300. Dante is obviously constructing poetically the perfect Easter as a symbol of his new awakening.
 - 69. SUB JULIO: In the reign of Julius Caesar.
 - 95. THE GREYHOUND . . . FELTRO AND FELTRO: Almost certainly refers to Can Grande della Scala (1290–1329), great Italian leader born in Verona, which lies between the towns of Feltre and Montefeltro.
- 100–101. NISUS, TURNUS, EURYALUS, CAMILLA: All were killed in the war between the Trojans and the Latins when, according to legend, Aeneas led the survivors of Troy into Italy. Nisus and Euryalus (*Aeneid* IX) were Trojan comradesin-arms who died together. Camilla (*Aeneid* XI) was the daughter of the Latin king and one of the warrior women. She was killed during a horse charge against the Trojans after displaying great gallantry. Turnus (*Aeneid* XII) was killed by Aeneas in a duel.
 - 110. THE SECOND DEATH: Damnation. "This is the second death, even the lake of fire." (*Revelation* xx, 14)
 - 118. FORBIDS ME TO COME THERE SINCE, LIVING, ETC.: Salvation is only through Christ in Dante's theology. Vergil lived and died before the establishment of Christ's teachings in Rome, and cannot therefore enter Heaven.
 - 125. PETER'S GATE: The gate of Purgatory. (See Purgatorio IX, 76 ff.) The gate is guarded by an angel with a gleaming sword. The angel is Peter's vicar (Peter, the first Pope, symbolized all Popes; i.e., Christ's vicar on earth) and is entrusted with the two great keys.

Some commentators argue that this is the gate of Paradise, but Dante mentions no gate beyond this one in his ascent to Heaven. It should be remembered, too, that those who pass the gate of Purgatory have effectively entered Heaven.

The three gates that figure in the entire journey are: the gate of Hell (Canto III, 1–11), the gate of Dis (Canto VIII, 79–113, and Canto IX, 86–87), and the gate of Purgatory, as above.

Canto III

The Vestibule of Hell

The Opportunists • The Poets pass the Gate of Hell and are immediately assailed by cries of anguish. Dante sees the first of the souls in torment. They are The Opportunists, those souls who in life were neither for good nor evil but only for themselves. Mixed with them are those outcasts who took no side in the Rebellion of the Angels. They are neither in Hell nor out of it. Eternally unclassified, they race round and round pursuing a wavering banner that runs forever before them through the dirty air; and as they run they are pursued by swarms of wasps and hornets, who sting them and produce a constant flow of blood and putrid matter which trickles down the bodies of the sinners and is feasted upon by loathsome worms and maggots who coat the ground.

The law of Dante's Hell is the law of symbolic retribution. As they sinned so are they punished. They took no sides, therefore they are given no place. As they pursued the ever-shifting illusion of their own advantage, changing their courses with every changing wind, so they pursue eternally an elusive, ever-shifting banner. As their sin was a darkness, so they move in darkness. As their own guilty conscience pursued them, so they are pursued by swarms of wasps and hornets. And as their actions were a moral filth, so they run eternally through the filth of worms and maggots which they themselves feed.

Dante recognizes several, among them Pope Celestine V, but without delaying to speak to any of these souls, the Poets move on to Acheron, the first of the rivers of Hell. Here the newly arrived souls of the damned gather and wait for monstrous Charon to ferry them over to punishment. Charon recognizes Dante as a living man and angrily refuses him passage. Vergil forces Charon to serve them, but Dante swoons with terror, and does not reawaken until he is on the other side.

I AM THE WAY INTO THE CITY OF WOE. I AM THE WAY TO A FORSAKEN PEOPLE. I AM THE WAY INTO ETERNAL SORROW.	3
SACRED JUSTICE MOVED MY ARCHITECT. I WAS RAISED HERE BY DIVINE OMNIPOTENCE, PRIMORDIAL LOVE AND ULTIMATE INTELLECT.	6
ONLY THOSE ELEMENTS TIME CANNOT WEAR Were made before me, and beyond time I stand. Abandon all hope ye who enter here.	9
These mysteries I read cut into stone above a gate. And turning I said: "Master, what is the meaning of this harsh inscription?"	12
And he then as initiate to novice: "Here must you put by all division of spirit and gather your soul against all cowardice.	15
This is the place I told you to expect. Here you shall pass among the fallen people, souls who have lost the good of intellect."	18
So saying, he put forth his hand to me, and with a gentle and encouraging smile he led me through the gate of mystery.	21
Here sighs and cries and wails coiled and recoiled on the starless air, spilling my soul to tears. A confusion of tongues and monstrous accents toiled	24
in pain and anger. Voices hoarse and shrill and sounds of blows, all intermingled, raised tumult and pandemonium that still	27

Reading Selections

whirls on the air forever dirty with it as if a whirlwind sucked at sand. And I, holding my head in horror, cried: "Sweet Spirit,	30	here and forever all hope of Paradise: I come to lead you to the other shore, into eternal dark, into fire and ice.	84
what souls are these who run through this black haze?" And he to me: "These are the nearly soulless whose lives concluded neither blame nor praise.	33	And you who are living yet, I say begone from these who are dead." But when he saw me stand against his violence he began again:	87
They are mixed here with that despicable corps of angels who were neither for God nor Satan, but only for themselves. The High Creator	36	"By other windings and by other steerage shall you cross to that other shore. Not here! Not here! A lighter craft than mine must give you passage."	90
scourged them from Heaven for its perfect beauty, and Hell will not receive them since the wicked might feel some glory over them." And I:	39	And my Guide to him: "Charon, bite back your spleen: this has been willed where what is willed must be, and is not yours to ask what it may mean."	93
"Master, what gnaws at them so hideously their lamentation stuns the very air?" "They have no hope of death," he answered me,	42	The steersman of that marsh of ruined souls, who wore a wheel of flame around each eye, stifled the rage that shook his woolly jowls.	96
"and in their blind and unattaining state their miserable lives have sunk so low that they must envy every other fate.	45	But those unmanned and naked spirits there turned pale with fear and their teeth began to chatter at sound of his crude bellow. In despair	99
No word of them survives their living season. Mercy and Justice deny them even a name. Let us not speak of them: look, and pass on." I saw a banner there upon the mist.	48	they blasphemed God, their parents, their time on earth, the race of Adam, and the day and the hour and the place and the seed the womb that gave them birth.	102
Circling and circling, it seemed to scorn all pause. So it ran on, and still behind it pressed	51	But all together they drew to that grim shore where all must come who lose the fear of God. Weeping and cursing they come for evermore,	105
a never-ending rout of souls in pain. I had not thought death had undone so many as passed before me in that mournful train.	54	and demon Charon with eyes like burning coals herds them in, and with a whistling oar flails on the stragglers to his wake of souls.	108
And some I knew among them; last of all I recognized the shadow of that soul who, in his cowardice, made the Great Denial.	57	As leaves in autumn loosen and stream down until the branch stands bare above its tatters spread on the rustling ground, so one by one	111
At once I understood for certain: these were of that retrograde and faithless crew hateful to God and to His enemies.	60	the evil seed of Adam in its Fall cast themselves, at his signal, from the shore	
These wretches never born and never dead ran naked in a swarm of wasps and hornets that goaded them the more the more they fled,	63	and streamed away like birds who hear their call. So they are gone over that shadowy water, and always before they reach the other shore	114
and made their faces stream with bloody gouts of pus and tears that dribbled to their feet to be swallowed there by loathsome worms and		a new noise stirs on this, and new throngs gather. "My son," the courteous Master said to me, "all who die in the shadow of God's wrath	117
maggots. Then looking onward I made out a throng	66	converge to this from every clime and country.	120
assembled on the beach of a wide river, whereupon I turned to him: "Master, I long	69	And all pass over eagerly, for here Divine Justice transforms and spurs them so their dread turns wish: they yearn for what they fear.	123
to know what souls these are, and what strange usage makes them as eager to cross as they seem to be in this infected light." At which the Sage:	72	No soul in Grace comes ever to this crossing; therefore if Charon rages at your presence you will understand the reason for his cursing."	126
"All this shall be made known to you when we stand on the joyless beach of Acheron." And I cast down my eyes, sensing a reprimand	75	When he had spoken, all the twilight country shook so violently, the terror of it bathes me with sweat even in memory:	129
in what he said, and so walked at his side in silence and ashamed until we came through the dead cavern to that sunless tide.	78	the tear-soaked ground gave out a sigh of wind that spewed itself in flame on a red sky, and all my shattered senses left me. Blind,	132
There, steering toward us in an ancient ferry came an old man with a white bush of hair, bellowing: "Woe to you depraved souls! Bury	81	like one whom sleep comes over in a swoon, I stumbled into darkness and went down.	

Notes

7–8. ONLY THOSE ELEMENTS TIME CANNOT WEAR: The Angels, the Empyrean, and the First Matter are the elements time cannot wear because they will last for all time. Man, however, in his mortal state, is not eternal. The Gate of Hell was therefore created before man. The theological point is worth attention. The doctrine of Original Sin is, of course, one familiar to many creeds. Here, however, it would seem that the preparation for damnation predates Original Sin. True, in one interpretation, Hell was created for the punishment of the Rebellious Angels and not for man. Had man not sinned, he would never have known Hell. But on the other hand, Dante's God was one who knew all, and knew therefore that man would indeed sin. The theological problem is an extremely delicate one.

It is significant, however, that having sinned, man lives out his days on the rind of Hell, and that damnation is forever below his feet. This central concept of man's sinfulness, and, opposed to it, the doctrine of Christ's everabounding mercy, are central to all of Dante's theology. Only as man surrenders himself to Divine Love may he hope for salvation, and salvation is open to all who will surrender themselves.

- AND BEYOND TIME I STAND: So odious is sin to God that there can be no end to its just punishment.
- 9. ABANDON ALL HOPE YE WHO ENTER HERE: This admonition is, of course, to the damned and not to those who come on Heaven-sent errands. The Harrowing of Hell provided the only exemption from this decree, and that only through the direct intercession of Christ.
- 57. WHO, IN HIS COWARDICE, MADE THE GREAT DENIAL: This is almost certainly intended to be Celestine V, who became Pope in 1294. He was a man of saintly life, but allowed himself to be convinced by a priest named Benedetto that his soul was in danger since no man could live in the world without being damned. In fear for his soul he withdrew from all worldly affairs and renounced the papacy. Benedetto promptly assumed the mantle himself and became Boniface VIII, a Pope who became for Dante a symbol of all the worst corruption of the church. Dante also blamed Boniface and his intrigues for many of the evils that befell Florence. We shall learn in Canto XIX that the fires of Hell are waiting for Boniface in the pit of the Simoniacs, and we shall be given further evidence of his corruption in Canto XXVII. Celestine's great guilt is that his cowardice (in selfish terror for his own welfare) served as the door through which so much evil entered the church.
- AN OLD MAN: Charon. He is the ferryman of dead souls across the Acheron in all Classical mythology.
- 88–90. BY OTHER WINDINGS: Charon recognizes Dante not only as a living man but as a soul in grace, and knows, therefore, that the Infernal Ferry was not intended for him. He is probably referring to the fact that souls destined for Purgatory and Heaven assemble not at his ferry point, but on the banks of the Tiber, from which they are transported by an Angel.
 - 100. THEY BLASPHEMED GOD: The souls of the damned are not permitted to repent, for repentance is a divine grace.
 - 123. THEY YEARN FOR WHAT THEY FEAR: Hell (allegorically Sin) is what the souls of the damned really wish for. Hell is their actual and deliberate choice, for divine grace is denied to none who wish for it in their hearts. The damned must, in fact, deliberately harden their hearts to God in order to become damned. Christ's grace is sufficient to save all who wish for it.
- 133-34. DANTE'S SWOON: This device (repeated at the end of Canto V) serves a double purpose. The first is technical: Dante uses it to cover a transition. We are never told how he crossed Acheron, for that would involve certain narrative matters he can better deal with when he crosses Styx in Canto VII. The second is to provide a point of departure

for a theme that is carried through the entire descent: the theme of Dante's emotional reaction to Hell. These two swoons early in the descent show him most susceptible to the grief about him. As he descends, pity leaves him, and he even goes so far as to add to the torments of one sinner. The allegory is clear: We must harden ourselves against every sympathy for sin.

CANTO V

Circle Two

The Carnal • The Poets leave Limbo [the dwelling place of the unbaptized] and enter the Second Circle. Here begin the torments of Hell proper, and here, blocking the way, sits Minos, the dread and semi-bestial judge of the damned who assigns to each soul its eternal torment. He orders the Poets back; but Vergil silences him as he earlier silenced Charon, and the Poets move on.

They find themselves on a dark ledge swept by a great whirlwind, which spins within it the souls of the Carnal, those who betrayed reason to their appetites. Their sin was to abandon themselves to the tempest of their passions: so they are swept forever in the tempest of Hell, forever denied the light of reason and of God. Vergil identifies many among them. Semiramis is there, and Dido, Cleopatra, Helen, Achilles, Paris, and Tristan. Dante sees Paolo and Francesca swept together, and in the name of love he calls to them to tell their sad story. They pause from their eternal flight to come to him, and Francesca tells their history while Paolo weeps at her side. Dante is so stricken by compassion at their tragic tale that he swoons once again.

So we went down to the second ledge alone; a smaller circle of so much greater pain the voice of the damned rose in a bestial moan.	3
There Minos sits, grinning, grotesque, and hale. He examines each lost soul as it arrives and delivers his verdict with his coiling tail.	6
That is to say, when the ill-fated soul appears before him it confesses all, and that grim sorter of the dark and foul	9
decides which place in Hell shall be its end, then wraps his twitching tail about himself one coil for each degree it must descend.	12
The soul descends and others take its place: each crowds in its turn to judgment, each confesses, each hears its doom and falls away through space.	15
"O you who come into this camp of woe," cried Minos when he saw me turn away without awaiting his judgment, "watch where you go	18
once you have entered here, and to whom you turn! Do not be misled by that wide and easy passage!" And my Guide to him: "That is not your concern;	21
it is his fate to enter every door. This has been willed where what is willed must be, and is not yours to question. Say no more."	24
Now the choir of anguish, like a wound, strikes through the tortured air. Now I have come to Hell's full lamentation, sound beyond sound.	27
I came to a place stripped bare of every light and roaring on the naked dark like seas	

wracked by a war of winds. Their hellish flight

of storm and counterstorm through time foregone, sweeps the souls of the damned before its charge. Whirling and battering it drives them on,	33	"O living creature, gracious, kind, and good, going this pilgrimage through the sick night, visiting us who stained the earth with blood,	90
and when they pass the ruined gap of Hell through which we had come, their shrieks begin anew. There they blaspheme the power of God eternal.	36	were the King of Time our friend, we would pray His peace on you who have pitied us. As long as the wind	93
And this, I learned, was the never ending flight of those who sinned in the flesh, the carnal and lusty who betrayed reason to their appetite.	39	will let us pause, ask of us what you please. The town where I was born lies by the shore where the Po descends into its ocean rest	96
As the wings of wintering starlings bear them on in their great wheeling flights, just so the blast wherries these evil souls through time foregone.	42	with its attendant streams in one long murmur. Love, which in gentlest hearts will soonest bloom seized my lover with passion for that sweet body	99
Here, there, up, down, they whirl and whirling, strain with never a hope of hope to comfort them, not of release, but even of less pain.	45	from which I was torn unshriven to my doom. Love, which permits no loved one not to love, took me so strongly with delight in him	
As cranes go over sounding their harsh cry, leaving the long streak of their flight in air, so come these spirits, wailing as they fly.	48	that we are one in Hell, as we were above. Love led us to one death. In the depths of Hell Caïna waits for him who took our lives."	102
And watching their shadows lashed by wind, I cried: "Master, what souls are these the very air lashes with its black whips from side to side?"	51	This was the piteous tale they stopped to tell. And when I had heard those world-offended lovers I bowed my head. At last the Poet spoke:	105
"The first of these whose history you would know," he answered me, "was Empress of many tongues. Mad sensuality corrupted her so	54	"What painful thoughts are these your lowered brow covers?"	108
that to hide the guilt of her debauchery she licensed all depravity alike, and lust and law were one in her decree.	57	When at length I answered, I began: "Alas! What sweetest thoughts, what green and young desire led these two lovers to this sorry pass."	111
She is Semiramis of whom the tale is told how she married Ninus and succeeded him to the throne of that wide land the Sultans hold.	60	Then turning to those spirits once again, I said: "Francesca, what you suffer here melts me to tears of pity and of pain.	114
The other is Dido; faithless to the ashes of Sichaeus, she killed herself for love. The next whom the eternal tempest lashes	63	But tell me: in the time of your sweet sighs by what appearances found love the way to lure you to his perilous paradise?"	117
is sense-drugged Cleopatra. See Helen there, from whom such ill arose. And great Achilles, who fought at last with love in the house of prayer.	66	And she: "The double grief of a lost bliss is to recall its happy hour in pain. Your Guide and Teacher knows the truth of this.	120
And Paris. And Tristan." As they whirled above he pointed out more than a thousand shades of those torn from the mortal life by love.	69	But if there is indeed a soul in Hell to ask of the beginning of our love out of his pity, I will weep and tell:	123
I stood there while my Teacher one by one named the great knights and ladies of dim time; and I was swept by pity and confusion.	72	On a day for dalliance we read the rhyme of Lancelot, how love had mastered him. We were alone with innocence and dim time.	126
At last I spoke: "Poet, I should be glad to speak a word with those two swept together so lightly on the wind and still so sad."	75	Pause after pause that high old story drew our eyes together while we blushed and paled; but it was one soft passage overthrew	129
And he to me: "Watch them. When next they pass, call to them in the name of love that drives and damns them here. In that name they will pause."	78	our caution and our hearts. For when we read how her fond smile was kissed by such a lover, he who is one with me alive and dead	132
Thus, as soon as the wind in its wild course brought them around, I called: "O wearied souls! if none forbid it, pause and speak to us."	81	breathed on my lips the tremor of his kiss. That book, and he who wrote it, was a pander. That day we read no further." As she said this,	135
As mating doves that love calls to their nest glide through the air with motionless raised wings, borne by the sweet desire that fills each breast—	84	the other spirit, who stood by her, wept so piteously, I felt my senses reel and faint away with anguish. I was swept	138
Just so those spirits turned on the torn sky from the band where Dido whirls across the air; such was the power of pity in my cry.	87	by such a swoon as death is, and I fell, as a corpse might fall, to the dead floor of Hell.	

Notes

- A SMALLER CIRCLE: The pit of Hell tapers like a funnel. The circles of ledges accordingly grow smaller as they descend.
- 4. MINOS: Like all the monsters Dante assigns to the various offices of Hell, Minos is drawn from Classical mythology. He was the son of Europa and of Zeus, who descended to her in the form of a bull. Minos became a mythological king of Crete, so famous for his wisdom and justice that after death his soul was made judge of the dead. Vergil presents him fulfilling the same office at Aeneas' descent to the underworld. Dante, however, transforms him into an irate and hideous monster with a tail. The transformation may have been suggested by the form Zeus assumed for the rape of Europa—the monster is certainly bullish enough here—but the obvious purpose of the brutalization is to present a figure symbolic of the guilty conscience of the wretches who come before it to make their confessions. Dante freely reshapes his materials to his own purposes.
- 8. IT CONFESSES ALL: Just as the souls appeared eager to cross Acheron, so they are eager to confess even while they dread. Dante is once again making the point that sinners elect their Hell by an act of their own will.
- 27. HELL'S FULL LAMENTATION: It is with the second circle that the real tortures of Hell begin.
- 34. THE RUINED GAP OF HELL: See note to Canto II, 53. At the time of the Harrowing of Hell a great earthquake shook the underworld shattering rocks and cliffs. Ruins resulting from the same shock are noted in Canto XII, 34, and Canto XXI, 112 ff. At the beginning of Canto XXIV, the Poets leave the *bolgia* of the Hypocrites by climbing the ruined slabs of a bridge that was shattered by this earthquake.

THE SINNERS OF THE SECOND CIRCLE (THE CARNAL): Here begin the punishments for the various sins of Incontinence (the sins of the She-Wolf). Punished in the second circle are those who sinned by excess of sexual passion. Since this is the most natural sin and the sin most nearly associated with love, its punishment is the lightest of all to be found in Hell proper. The Carnal are whirled and buffeted endlessly through the murky air (symbolic of the beclouding of their reason by passion) by a great gale (symbolic of their lust).

- EMPRESS OF MANY TONGUES: Semiramis, a legendary queen of Assyria who assumed full power at the death of her husband, Ninus.
- 61. DIDO: Queen and founder of Carthage. She had vowed to remain faithful to her husband, Sichaeus, but she fell in love with Aeneas. When Aeneas abandoned her she stabbed herself on a funeral pyre she had had prepared.

According to Dante's own system of punishments, she should be in the Seventh Circle (Canto XIII) with the suicides. The only clue Dante gives to the tempering of her punishment is his statement that "she killed herself for love." Dante always seems readiest to forgive in that name.

- 65. ACHILLES: He is placed among this company because of his passion of Polyxena, the daughter of Priam. For love of her, he agreed to desert the Greeks and to join the Trojans, but when he went to the temple for the wedding (according to the legend Dante has followed) he was killed by Paris.
- 74. THOSE TWO SWEPT TOGETHER: Paolo and Francesca (PAH-oe-loe: Frahn-CHAY-ska). Dante's treatment of these two lovers is certainly the tenderest and most sympathetic accorded any of the sinners in Hell, and legends immediately began to grow about this pair.

The facts are these. In 1275 Giovanni Malatesta (Djoe-VAH-nee Mahl-ah-TEH-stah) of Rimini, called Giovanni the Lame, a somewhat deformed but brave and powerful warrior, made a political marriage with Francesca, daughter of Guido da Polenta of Ravenna. Francesca came to Rimini and there an amour grew between her and Giovanni's younger brother Paolo. Despite the fact that Paolo had married in 1269 and had become the father of two daughters by 1275, his affair with Francesca continued for many years. It was sometime between 1283 and 1286 that Giovanni surprised them in Francesca's bedroom and killed both of them. Around these facts the legend has grown that Paolo was sent by Giovanni as his proxy to the marriage, that Francesca thought he was her real bridegroom and accordingly gave him her heart irrevocably at first sight. The legend obviously increases the pathos, but nothing in Dante gives it support.

- 102. THAT WE ARE ONE IN HELL, AS WE WERE ABOVE: At many points of the *Inferno* Dante makes clear the principle that the souls of the damned are locked so blindly into their own guilt that none can feel sympathy for another, or find any pleasure in the presence of another. The temptation of many readers is to interpret this line romantically: that is, the love of Paolo and Francesca survives Hell itself. The more Dantean interpretation, however, is that they add to one another's anguish (a) as mutual reminders of their sin, and (b) as insubstantial shades of the bodies for which they once felt such great passion.
- 104. CAÏNA WAITS FOR HIM: Giovanni Malatesta was still alive at the writing. His fate is already decided, however, and upon his death, his soul will fall to Caïna, the first ring of the last circle (Canto XXXII), where lie those who performed acts of treachery against their kin.
- 124–5. THE RHYME OF LANCELOT: The story exists in many forms. The details Dante makes use of are from an Old French version.
 - 126. DIM TIME: The original simply reads "We were alone, suspecting nothing." "Dim time" is rhyme-forced, but not wholly outside the legitimate implications of the original, I hope. The old courtly romance may well be thought of as happening in the dim ancient days. The apology, of course, comes after the fact: one does the possible, then argues for justification, and there probably is none.
 - 134. THAT BOOK, AND HE WHO WROTE IT, WAS A PANDER: *Galeotto*, the Italian word for "pander," is also the Italian rendering of the name of Gallehault, who in the French Romance Dante refers to here, urged Lancelot and Guinevere on to love.

CANTO X

Circle Six

The Heretics • As the Poets pass on, one of the damned hears Dante speaking, recognizes him as a Tuscan, and calls to him from one of the fiery tombs. A moment later he appears. He is Farinata degli Uberti, a great war-chief of the Tuscan Ghibellines. The majesty and power of his bearing seem to diminish Hell itself. He asks Dante's lineage and recognizes him as an enemy. They begin to talk politics, but are interrupted by another shade, who rises from the same tomb. This one is Cavalcante dei Cavalcanti, father of Guido Cavalcanti, a contemporary poet. If it is genius that leads Dante on his great journey, the shade asks, why is Guido not with him? Can Dante presume to a greater genius than Guido's? Dante replies that he comes this way only with the aid of powers Guido has not sought. His reply is a classic example of manyleveled symbolism as well as an overt criticism of a rival poet. The senior Cavalcanti mistakenly infers from Dante's reply that Guido is dead, and swoons back into the flames.

Farinata, who has not deigned to notice his fellow-sinner, continues from the exact point at which he had been interrupted. It is as if he refuses to recognize the flames in which he is shrouded. He proceeds to prophesy Dante's banishment from Florence, he defends his part in Florentine politics, and then, in answer to Dante's question, he explains how it is that the damned can foresee the future but have no knowledge of the present. He then names others who share his tomb, and Dante takes his leave with considerable respect for his great enemy, pausing only long enough to leave word for Cavalcanti that Guido is still alive.

We go by a secret path along the rim of the dark city, between the wall and the torments. My master leads me and I follow him.

"Supreme Virtue, who through this impious land wheel me at will down these dark gyres," I said, "speak to me, for I wish to understand.	6	And I to him: "Not by myself am I borne this terrible way. I am led by him who waits there, and whom perhaps your Guido held in scorn."	63
Tell me, Master, is it permitted to see the souls within these tombs? The lids are raised, and no one stands on guard." And he to me:	9	For by his words and the manner of his torment I knew his name already, and could, therefore, answer both what he asked and what he meant.	66
"All shall be sealed forever on the day these souls return here from Jehosaphat with the bodies they have given once to clay.	12	Instantly he rose to his full height: "He <i>held</i> ? What is it you say? Is he dead, then? Do his eyes no longer fill with that sweet light?"	69
In this dark corner of the morgue of wrath lie Epicurus and his followers, who make the soul share in the body's death.	15	And when he saw that I delayed a bit in answering his question, he fell backwards into the flame, and rose no more from it.	72
And here you shall be granted presently not only your spoken wish, but that other as well, which you had thought perhaps to hide from me."	18	But that majestic spirit at whose call I had first paused there, did not change expression, nor so much as turn his face to watch him fall.	75
And I: "Except to speak my thoughts in few and modest words, as I learned from your example, dear Guide, I do not hide my heart from you."	21	"And if," going on from his last words, he said, "men of my line have yet to learn that art, that burns me deeper than his flaming bed.	78
"O Tuscan, who go living through this place speaking so decorously, may it please you pause a moment on your way, for by the grace	24	But the face of her who reigns in Hell shall not be fifty times rekindled in its course before you learn what griefs attend that art.	81
of that high speech in which I hear your birth, I know you for a son of that noble city which perhaps I vexed too much in my time on earth."	27	And as you hope to find the world again, tell me: why is that populace so savage in the edicts they pronounce against my strain?"	84
These words broke without warning from inside one of the burning arks. Caught by surprise, I turned in fear and drew close to my Guide.	30	And I to him: "The havoc and the carnage that dyed the Arbia red at Montaperti have caused these angry cries in our assemblage."	87
And he: "Turn around. What are you doing? Look there: it is Farinata rising from the flames. From the waist up his shade will be made clear."	33	He sighed and shook his head. "I was not alone in that affair," he said, "nor certainly would I have joined the rest without good reason.	90
My eyes were fixed on him already. Erect, he rose above the flame, great chest, great brow; he seemed to hold all Hell in disrespect.	36	But I <i>was</i> alone at that time when every other consented to the death of Florence; I alone with open face defended her."	93
My Guide's prompt hands urged me among the dim and smoking sepulchres to that great figure, and he said to me: "Mind how you speak to him."	39	"Ah, so may your soul sometime have rest," I begged him, "solve the riddle that pursues me through this dark place and leaves my mind perplexed:	96
And when I stood alone at the foot of the tomb, the great soul stared almost contemptuously, before he asked: "Of what line do you come?"	42	you seem to see in advance all time's intent, if I have heard and understood correctly; but you seem to lack all knowledge of the present."	99
Because I wished to obey, I did not hide anything from him: whereupon as he listened, he raised his brows a little, then replied:	45	"We see asquint, like those whose twisted sight can make out only the far-off," he said, "for the King of All still grants us that much light.	102
"Bitter enemies were they to me, to my fathers, and to my party, so that twice I sent them scattering from high Italy."	48	When things draw near, or happen, we perceive nothing of them. Except what others bring us we have no news of those who are alive.	105
"If they were scattered, still from every part they formed again and returned both times," I answered, "but yours have not yet wholly learned that art."	51	So may you understand that all we know will be dead forever from that day and hour when the portal of the Future is swung to."	108
At this another shade rose gradually, visible to the chin. It had raised itself, I think, upon its knees, and it looked around me	54	Then, as if stricken by regret, I said: "Now, therefore, will you tell that fallen one who asked about his son, that he is not dead,	111
as if it expected to find through that black air that blew about me, another traveler. And weeping when it found no other there,	57	and that, if I did not reply more quickly, it was because my mind was occupied with this confusion you have solved for me."	114
turned back. "And if," it cried, "you travel through this dungeon of the blind by power of genius, where is my son? why is he not with you?"	60	And now my Guide was calling me. In haste, therefore, I begged that mighty shade to name the others who lay with him in that chest.	117

120

123

126

129

132

135

And he: "More than a thousand cram this tomb. The second Frederick is here, and the Cardinal of the Ubaldini. Of the rest let us be dumb."

And he disappeared without more said, and I turned back and made my way to the ancient Poet, pondering the words of the dark prophecy.

He moved along, and then, when we had started, he turned and said to me, "What troubles you? Why do you look so vacant and downhearted?"

And I told him. And he replied: "Well may you bear those words in mind." Then, pausing, raised a finger: "Now pay attention to what I tell you here:

when finally you stand before the ray of that Sweet Lady whose bright eye sees all, from her you will learn the turnings of your way."

So saying, he bore left, turning his back on the flaming walls, and we passed deeper yet into the city of pain, along a track

that plunged down like a scar into a sink which sickened us already with its stink.

Notes

- 11. JEHOSAPHAT: A valley outside Jerusalem. The popular belief that it would serve as the scene of the Last Judgment was based on *Joel* iii, 2, 12.
- 14. EPICURUS: The Greek philosopher. The central aim of his philosophy was to achieve happiness, which he defined as the absence of pain. For Dante this doctrine meant the denial of the Eternal life, since the whole aim of the Epicurean was temporal happiness.
- 17. NOT ONLY YOUR SPOKEN WISH, BUT THAT OTHER AS WELL: "All knowing" Vergil is frequently presented as being able to read Dante's mind. The "other wish" is almost certainly Dante's desire to speak to someone from Florence with whom he could discuss politics. Many prominent Florentines were Epicureans.
- 22. TUSCAN: Florence lies in the province of Tuscany. Italian, to an extent unknown in America, is a language of dialects, all of which are readily identifiable even when they are not well understood by the hearer. Dante's native Tuscan has become the main source of modern official Italian. Two very common sayings still current in Italy are: *Lingua toscana, lingua di Dio* ("the Tuscan tongue is the language of God") and—to express the perfection of Italian speech—*Lingua toscana in bocca romana* ("the Tuscan tongue in a Roman mouth").
- 26. THAT NOBLE CITY: Florence.
- 32-51. FARINATA: Farinata degli Uberti (deh-lyee Oob-ehr-tee) was head of the ancient noble house of the Uberti. He became leader of the Ghibellines of Florence in 1239, and played a large part in expelling the Guelphs in 1248. The Guelphs returned in 1251, but Farinata remained. His arrogant desire to rule single-handed led to difficulties, however, and he was expelled in 1258. With the aid of the Manfredi of Siena, he gathered a large force and defeated the Guelphs at Montaperti on the river Arbia in 1260. Reentering Florence in triumph, he again expelled the Guelphs, but at the Diet of Empoli, held by the victors after the battle of Montaperti, he alone rose in open counsel to resist the general sentiment that Florence should be razed. He died in Florence in 1264. In 1266, the Guelphs once more returned and crushed forever the power of the Uberti, destroying their palaces and issuing special decrees against persons of the Uberti line. In 1283, a decree of heresy was published against Farinata.

- 39. "MIND HOW YOU SPEAK TO HIM": The surface interpretation is clearly that Vergil means Dante to show proper respect to so majestic a soul. But the allegorical level is more interesting here. Vergil (as Human Reason) is urging Dante to go forward on his own. These final words then would be an admonition to Dante to guide his speech according to the highest principles.
- 52. ANOTHER SHADE: Cavalcante dei Cavalcanti was a famous Epicurean ("like lies with like"). He was the father of Guido Cavalcanti, a poet and friend of Dante. Guido was also Farinata's son-in-law.
- 61. NOT BY MYSELF: Cavalcanti assumes that the resources of human genius are all that are necessary for such a journey. (It is an assumption that well fits his character as an Epicurean.) Dante replies as a man of religion that other aid is necessary.
- 63. WHOM PERHAPS YOUR GUIDO HELD IN SCORN: This reference has not been satisfactorily explained. Vergil is a symbol on many levels—of Classicism, of Religiosity, of Human Reason. Guido might have scorned him on any of these levels, or on all of them. One interpretation might be that Dante wished to present Guido as an example of how skepticism acts as a limitation upon a man of genius. Guido's skepticism does not permit him to see beyond the temporal. He does not see that Vergil (Human Reason expressed as Poetic Wisdom) exists only to lead one to Divine Love, and therefore he cannot undertake the final journey on which Dante has embarked.
 - AND WHEN HE SAW THAT I DELAYED: Dante's delay is explained in lines 112–114.
 - 79. HER WHO REIGNS IN HELL: Hecate or Proserpine. She is also the moon goddess. The sense of this prophecy, therefore, is that Dante will be exiled within fifty full moons. Dante was banished from Florence in 1302, well within fifty months of the prophecy.
- 83. THAT POPULACE: The Florentines.
- 97–108. THE KNOWLEDGE OF THE DAMNED: Dante notes with surprise that Farinata can foresee the future, but that Cavalcanti does not know whether his son is presently dead or alive. Farinata explains by outlining a most ingenious detail of the Divine Plan: The damned can see far into the future, but nothing of what is present or of what has happened. Thus, after Judgment, when there is no longer any Future, the intellects of the damned will be void.
 - 119. THE SECOND FREDERICK: Emperor Frederick II. In Canto XIII Dante has Pier delle Vigne speak of him as one worthy of honor, but he was commonly reputed to be an Epicurean.
- 119–120. THE CARDINAL OF THE UBALDINI: In the original Dante refers to him simply as "il Cardinale." Ottaviano degli Ubaldini (born c. 1209, died 1273) became a cardinal in 1245, but his energies seem to have been directed exclusively to money and political intrigue. When he was refused an important loan by the Ghibellines, he is reported by many historians as having remarked: "I may say that if I have a soul, I have lost it in the cause of the Ghibellines, and no one of them will help me now." The words "If I have a soul" would be enough to make him guilty in Dante's eyes of the charge of heresy.
 - 131. THAT SWEET LADY: Beatrice.

CANTO XXXIII

Circle Nine: Cocytus

Compound Fraud Round Two: Antenora

The Treacherous to Country Round Three: Ptolomea

The Treacherous to Guests and Hosts• The sinner who is gnawing his companion's head looks up, wipes his bloody mouth on his victim's hair, and tells his harrowing story. He is Count Ugolino and the wretch he gnaws is Archbishop Ruggieri. Both are in Antenora for treason. In life they had once plotted together. Then Ruggieri betrayed his fellow-plotter and caused his death, by starvation, along with his four "sons." In the most pathetic and dramatic passage of the Inferno, Ugolino details how their prison was sealed and how his "sons" dropped dead before him one by one, weeping for food. His terrible tale serves only to renew his grief and hatred, and he has hardly finished it before he begins to gnaw Ruggieri again with renewed fury. In the immutable Law of Hell, the killer-by-starvation becomes the food of his victim.

The Poets leave Ugolino and enter Ptolomea, so named for the Ptolomaeus of Maccabees, who murdered his father-in-law at a banquet. Here are punished those who were Treacherous Against the Ties of Hospitality. They lie with only half their faces above the ice and their tears freeze in their eye sockets, sealing them with little crystal visors. Thus even the comfort of tears is denied them. Here Dante finds Friar Alberigo and Branca d'Oria, and discovers the terrible power of Ptolomea: So great is its sin that the souls of the guilty fall to its torments even before they die, leaving their bodies still on earth, inhabited by Demons.

The sinner raised his mouth from his grim repast and wiped it on the hair of the bloody head whose nape he had all but eaten away. At last 3 he began to speak: "You ask me to renew a grief so desperate that the very thought of speaking of it tears my heart in two. 6 But if my words may be a seed that bears the fruit of infamy for him I gnaw, I shall weep, but tell my story through my tears. 9 Who you may be, and by what powers you reach into this underworld, I cannot guess, but you seem to me a Florentine by your speech. 12 I was Count Ugolino, I must explain; this reverend grace is the Archbishop Ruggieri: now I will tell you why I gnaw his brain. 15 That I, who trusted him, had to undergo imprisonment and death through his treachery, you will know already. What you cannot know-18 that is, the lingering inhumanity of the death I suffered — you shall hear in full: then judge for yourself if he has injured me. 21 A narrow window in that coop of stone now called the Tower of Hunger for my sake (within which others yet must pace alone) 24 had shown me several waning moons already between its bars, when I slept the evil sleep in which the veil of the future parted for me. 27 This beast appeared as master of a hunt chasing the wolf and his whelps across the mountain that hides Lucca from Pisa. Out in front 30 of the starved and shrewd and avid pack he had placed Gualandi and Sismondi and Lanfranchi to point his prey. The father and sons had raced 33 a brief course only when they failed of breath and seemed to weaken; then I thought I saw

their flanks ripped open by the hounds' fierce teeth.

36

Before the dawn, the dream still in my head, I woke and heard my sons, who were there with me, cry from their troubled sleep, asking for bread.	39
You are cruelty itself if you can keep your tears back at the thought of what foreboding stirred in my heart; and if you do not weep,	42
at what are you used to weeping? — The hour when food used to be brought, drew near. They were now awake, and each was anxious from his dream's dark mood.	45
And from the base of that horrible tower I heard the sound of hammers nailing up the gates: I stared at my sons' faces without a word.	48
I did not weep: I had turned stone inside. They wept. 'What ails you, Father, you look so strange,' my little Anselm, youngest of them, cried.	51
But I did not speak a word nor shed a tear: not all that day nor all that endless night, until I saw another sun appear.	54
When a tiny ray leaked into that dark prison and I saw staring back from their four faces the terror and the wasting of my own,	57
I bit my hands in helpless grief. And they, thinking I chewed myself for hunger, rose suddenly together. I heard them say:	60
Father, it would give us much less pain if you ate us: it was you who put upon us this sorry flesh; now strip it off again.'	63
I calmed myself to spare them. Ah! hard earth, why did you not yawn open? All that day and the next we sat in silence. On the fourth,	66
Gaddo, the eldest, fell before me and cried, stretched at my feet upon that prison floor: 'Father, why don't you help me?' There he died.	69
And just as you see me, I saw them fall one by one on the fifth day and the sixth. Then, already blind, I began to crawl	72
from body to body shaking them frantically. Two days I called their names, and they were dead. Then fasting overcame my grief and me."	75
His eyes narrowed to slits when he was done, and he seized the skull again between his teeth grinding it as a mastiff grinds a bone.	78
Ah, Pisa! foulest blemish on the land where "si" sound sweet and clear, since those nearby you are slow to blast the ground on which you stand,	81
may Caprara and Gorgona drift from place and dam the flooding Arno at its mouth until it drowns the last of your foul race!	84
For if to Ugolino falls the censure for having betrayed your castles, you for your part should not have put his sons to such a torture:	87
you modern Thebes! those tender lives you split— Brigata, Uguccione, and the others	0.2

I mentioned earlier-were too young for guilt!

90

We passed on further, where the frozen mine entombs another crew in greater pain; these wraiths are not bent over, but lie supine.	93	when this one left his body to a devil, as did his nephew and second in treachery, and plumbed like lead through space to this dead level. 14;
Their very weeping closes up their eyes; and the grief that finds no outlet for its tears turns inward to increase their agonies:	96	But now reach out your hand, and let me cry." And I did not keep the promise I had made, for to be rude to him was courtesy. 150
for the first tears that they shed knot instantly in their eye-sockets, and as they freeze they form a crystal visor above the cavity.	99	Ah, men of Genoa! souls of little worth, corrupted from all custom of righteousness, why have you not been driven from the earth? 153
And despite the fact that standing in that place I had become as numb as any callus, and all sensation had faded from my face,	102	For there beside the blackest soul of all Romagna's evil plain, lies one of yours bathing his filthy soul in the eternal 156
somehow I felt a wind begin to blow, whereat I said: "Master, what stirs this wind? Is not all heat extinguished here below?"	105	glacier of Cocytus for his foul crime, while he seems yet alive in world and time!
And the Master said to me: "Soon you will be where your own eyes will see the source and cause and give you their own answer to the mystery."	108	Notes 1-90. UGOLINO AND RUGGIERI: (Oog-oh-LEE-noe: Roo-DJAIR-ee) Ugo-
And one of those locked in that icy mall cried out to us as we passed: "O souls so cruel that you are sent to the last post of all,	111	lino, Count of Donoratico and a member of the Guelph family della Gherardesca. He and his nephew, Nino de' Vis- conti, led the two Guelph factions of Pisa. In 1288, Ugolino intrigued with Archbishop Ruggieri degli Ubaldini, leader of the Ghibellines, to get rid of Visconti and to take over the
relieve me for a little from the pain of this hard veil; let my heart weep a while before the weeping freeze my eyes again."	114	command of all the Pisan Guelphs. The plan worked, but in the consequent weakening of the Guelphs, Ruggieri saw his chance and betrayed Ugolino, throwing him into prison with his sons and his grandsons. In the following year the
And I to him: "If you would have my service, tell me your name; then if I do not help you may I descend to the last rim of the ice."	117	prison was sealed up and they were left to starve to death. The law of retribution is clearly evident: in life Ruggieri sinned against Ugolino by denying him food; in Hell he himself becomes food for his victim.
"I am Friar Alberigo," he answered therefore, "the same who called for the fruits from the bad garden. Here I am given dates for figs full store."	120	18. YOU WILL KNOW ALREADY: News of Ugolino's imprisonment and death would certainly have reached Florence, what you cannot know: No living man could know what happened af- ter Ugolino and his sons were sealed in the prison and aban- danad
"What! Are you dead already?" I said to him. And he then: "How my body stands in the world I do not know. So privileged is this rim	123	 doned. 22. COOP: Dante uses the Italian word <i>muda</i>, signifying a stone tower in which falcons were kept in the dark to moult. From the time of Ugolino's death it became known as The Tower of Hungor
of Ptolomea, that often souls fall to it before dark Atropos has cut their thread. And that you may more willingly free my spirit	126	of Hunger. 25. SEVERAL WANING MOONS: Ugolino was jailed late in 1288. He was sealed in to starve early in 1289. 28. THIS BEAST: Ruggieri. 29–30. THE MOUNTAIN THAT HIDES LUCCA FROM PISA: These two cities
of this glaze of frozen tears that shrouds my face, I will tell you this: when a soul betrays as I did, it falls from flesh, and a demon takes its place,	129	 would be in view of one another were it not for Monte San Guiliano. 32. GUALANDI AND SISMONDI AND LANFRANCHI: (Gwah-LAHN- dee Lahn-FRAHN-kee) Three Pisan nobles, Ghibellines
ruling the body till its time is spent. The ruined soul rains down into this cistern. So, I believe, there is still evident	132	and friends of the Archbishop. 51–71. UGOLINO'S "SONS": Actually two of the boys were grandsons and all were considerably older than one would gather from Dante's account. Anselm, the younger grandson, was fifteen.
in the world above, all that is fair and mortal of this black shade who winters here behind me. If you have only recently crossed the portal	135	The others were really young men and were certainly old enough for guilt despite Dante's charge in line 90. 75. THEN FASTING OVERCAME MY GRIEF AND ME: That is, he died. Some interpret the line to mean that Ugolino's hunger drove
from that sweet world, you surely must have known his body: Branca D'Oria is its name, and many years have passed since he rained down."	138	him to cannibalism. Ugolino's present occupation in Hell would certainly support that interpretation but the fact is that cannibalism is the one major sin Dante does not assign a place to in Hell. So monstrous would it have seemed to him
"I think you are trying to take me in," I said, "Ser Branca D'Oria is a living man; he eats, he drinks, he fills his clothes and his bed."	141	that he must certainly have established a special punishment for it. Certainly he could hardly have relegated it to an ambi- guity. Moreover, it would be a sin of bestiality rather than of fraud, and as such it would be punished in the Seventh
"Michel Zanche had not yet reached the ditch of the Black Talons," the frozen wraith replied, "there where the sinners thicken in hot pitch,	144	 Circle. 79–80. THE LAND WHERE "SI" SOUND SWEET AND CLEAR: Italy. 82. CAPRARA AND GORGONA: These two islands near the mouth of the Arno were Pisan possessions in 1300.

- 86. BETRAYED YOUR CASTLES: In 1284, Ugolino gave up certain castles to Lucca and Florence. He was at war with Genoa at the time and it is quite likely that he ceded the castles to buy the neutrality of these two cities, for they were technically allied with Genoa. Dante, however, must certainly consider the action as treasonable, for otherwise Ugolino would be in Caïna for his treachery to Visconti.
- 88. YOU MODERN THEBES: Thebes, as a number of the foregoing notes will already have made clear, was the site of some of the most hideous crimes of antiquity.
- 91. WE PASSED ON FURTHER: Marks the passage into Ptolomea.
- 105. IS NOT ALL HEAT EXTINGUISHED: Dante believed (rather accurately, by chance) that all winds resulted from "exhalations of heat." Cocytus, however, is conceived as wholly devoid of heat, a metaphysical absolute zero. The source of the wind, as we discover in the next Canto, is Satan himself.
- 117. MAY I DESCEND TO THE LAST RIM OF THE ICE: Dante is not taking any chances; he has to go on to the last rim in any case. The sinner, however, believes him to be another damned soul and would interpret the oath quite otherwise than as Dante meant it.
- 118. FRIAR ALBERIGO: (Ahl-beh-REE-ghoe) Of the Manfredi of Faenza. He was another Jovial Friar. In 1284, his brother Manfred struck him in the course of an argument. Alberigo pretended to let it pass, but in 1285 he invited Manfred and his son to a banquet and had them murdered. The signal to the assassins were the words: "Bring in the fruit." "Friar Alberigo's bad fruit," became a proverbial saying.
- 125. ATROPOS: The Fate who cuts the thread of life.
- 137. BRANCA D'ORIA: (DAW-ree-yah) A Genoese Ghibelline. His sin is identical in kind to that of Friar Alberigo. In 1275, he invited his father-in-law, Michel Zanche, to a banquet and had him and his companions cut to pieces. He was assisted in the butchery by his nephew.

CANTO XXXIV

Circle Nine: Cocytus

Compound Fraud Round Four: Judecca

The Treacherous to Their Masters The Center

Satan • "On march the banners of the King," Vergil begins as the Poets face the last depth. He is quoting a medieval hymn, and to it he adds the distortion and perversion of all that lies about him. "On march the banners of the King—of Hell." And there before them, in an infernal parody of Godhead, they see Satan in the distance, his great wings beating like a windmill. It is their beating that is the source of the icy wind of Cocytus, the exhalation of all evil.

All about him in the ice are strewn the sinners of the last round, Judecca, named for Judas Iscariot. These are the Treacherous to Their Masters. They lie completely sealed in the ice, twisted and distorted into every conceivable posture. It is impossible to speak to them, and the Poets move on to observe Satan.

He is fixed into the ice at the center to which flow all the rivers of guilt; and as he beats his great wings as if to escape, their icy wind only freezes him more surely into the polluted ice. In a grotesque parody of the Trinity, he has three faces, each a different color, and in each mouth he clamps a sinner whom he rips eternally with his teeth. Judas Iscariot in the central mouth: Brutus and Cassius in the mouths on either side.

Having seen all, the Poets now climb through the center, grappling hand over hand down the hairy flank of Satan himself—a last supremely symbolic action—and at last, when they have passed the center of all gravity, they emerge from Hell. A long climb from the earth's center to the Mount of Purgatory awaits them, and they push on without rest, ascending along the sides of the river Lethe, until they emerge once more to see the stars of Heaven, just before dawn on Easter Sunday.

"On march the banners of the King of Hell," my Master said. "Toward us. Look straight ahead: can you make him out at the core of the frozen shell?"	3
Like a whirling windmill seen afar at twilight, or when a mist has risen from the ground— just such an engine rose upon my sight	6
stirring up such a wild and bitter wind I cowered for shelter at my Master's back, there being no other windbreak I could find.	9
I stood now where the souls of the last class (with fear my verses tell it) were covered wholly; they shone below the ice like straws in glass.	12
Some lie stretched out; others are fixed in place upright, some on their heads, some on their soles; another, like a bow, bends foot to face.	15
When we had gone so far across the ice that it pleased my Guide to show me the foul creature that once had worn the grace of Paradise,	18
he made me stop, and, stepping aside, he said: "Now see the face of Dis! This is the place where you must arm your soul against all dread."	21
Do not ask, Reader, how my blood ran cold and my voice choked up with fear. I cannot write it: this is a terror that cannot be told.	24
I did not die, and yet I lost life's breath: imagine for yourself what I became, deprived at once of both my life and death.	27
The Emperor of the Universe of Pain jutted his upper chest above the ice; and I am closer in size to the great mountain	30
the Titans make around the central pit, than they to his arms. Now, starting from this part, imagine the whole that corresponds to it!	33
If he was once as beautiful as now he is hideous, and still turned on his Maker, well may he be the source of every woe!	36
With what a sense of awe I saw his head towering above me! for it had three faces: one was in front, and it was fiery red;	39
the other two, as weirdly wonderful, merged with it from the middle of each shoulder to the point where all converged at the top of the skull;	42
the right was something between white and bile; the left was about the color one observes on those who live along the banks of the Nile.	45
Under each head two wings rose terribly, their span proportioned to so gross a bird: I never saw such sails upon the sea.	48
They were not feathers — their texture and their form were like a bat's wings — and he beat them so that three winds blew from him in one great storm:	51
it is these winds that freeze all Cocytus. He swept from his six eyes, and down three chins the tears ran mixed with bloody froth and pus.	54
In every mouth he worked a broken sinner between his rake-like teeth. Thus he kept three in eternal pain at his eternal dinner.	57

For the one in front the biting seemed to play no part at all compared to the ripping: at times the whole skin of his back was flayed away.	60	Under the midpoint of that other sky the Man who was born sinless and who lived beyond all blemish, came to suffer and die.	117
"That soul that suffers most," explained my Guide, "is Judas Iscariot, he who kicks his legs on the fiery chin and has his head inside.	63	You have your feet upon a little sphere which forms the other face of the Judecca. There it is evening when it is morning here.	120
Of the other two, who have their heads thrust forward, the one who dangles down from the black face is Brutus: note how he writhes without a word.	66	And this gross Fiend and Image of all Evil who made a stairway for us with his hide is pinched and prisoned in the ice-pack still.	123
And there, with the huge and sinewy arms, is the soul of Cassius.—But the night is coming on and we must go, for we have seen the whole."	69	On this side he plunged down from heaven's height, and the land that spread here once hid in the sea and fled North to our hemisphere for fright;	126
Then as he bade, I clasped his neck, and he, watching for a moment when the wings were opened wide, reached over dexterously	72	and it may be that moved by that same fear, the one peak that still rises on this side fled upward leaving this great cavern here."	129
and seized the shaggy coat of the king demon; then grappling matted hair and frozen crusts from one tuft to another, clambered down.	75	Down there, beginning at the further bound of Beelzebub's dim tomb, there is a space not known by sight, but only by the sound	132
When we had reached the joint where the great thigh merges into the swelling of the haunch, my Guide and Master, straining terribly,	78	of a little stream descending through the hollow it has eroded from the massive stone in its endlessly entwining lazy flow.	135
turned his head to where his feet had been and began to grip the hair as if he were climbing; so that I thought we moved toward Hell again.	81	My Guide and I crossed over and began to mount that little known and lightless road to ascend into the shining world again.	138
"Hold fast!" my Guide said, and his breath came shrill with labor and exhaustion. "There is no way but by such stairs to rise above such evil."	84	He first, I second, without thought of rest we climbed the dark until we reached the point where a round opening brought in sight the blest	141
At last he climbed out through an opening in the central rock, and he seated me on the rim; then joined me with a nimble backward spring.	87	and beauteous shining of the Heavenly cars. And we walked out once more beneath the Stars.	
I looked up, thinking to see Lucifer as I had left him, and I saw instead his legs projecting high into the air.	90	Notes	
Now let all those whose dull minds are still vexed by failure to understand what point it was I had passed through, judge if I was perplexed.	93	1. ON MARCH THE BANNERS OF THE KING: The hymn (Vexilla regis prodeunt) was written in the sixth century by Venantius Fortu- natus, Bishop of Poitiers. The original celebrates the Holy	
"Get up. Up on your feet," my Master said. "The sun already mounts to middle tierce, and a long road and hard climbing lie ahead."	96	Cross, and is part of the service for Good Friday to be sung at the moment of uncovering the cross.17. THE FOUL CREATURE: Satan.38. THREE FACES: Numerous interpretations of these three faces ex-	
It was no hall of state we had found there, but a natural animal pit hollowed from rock with a broken floor and a close and sunless air.	99	ist. What is essential to all explanation is that they be seen as perversions of the qualities of the Trinity.54. BLOODY FROTH AND PUS: The gore of the sinners he chews which is mixed with his saliva.	
"Before I tear myself from the Abyss," I said when I had risen, "O my Master, explain to me my error in all this:	102	62. JUDAS: Note how closely his punishment is patterned on that of the Simoniacs.67. HUGE AND SINEWY ARMS: The Cassius who betrayed Caesar was more generally described in terms of Shakespeare's "lean and	
where is the ice? and Lucifer—how has he been turned from top to bottom: and how can the sun have gone from night to day so suddenly?"	105	hungry look." Another Cassius is described by Cicero (<i>Catiline</i> III) as huge and sinewy. Dante probably confused the two.68. THE NIGHT IS COMING ON: It is now Saturday evening.	
And he to me: "You imagine you are still on the other side of the center where I grasped the shaggy flank of the Great Worm of Evil	108	95. MIDDLE TIERCE: In the canonical day tierce is the period from about 6 to 9 A.M. Middle tierce, therefore, is 7:30. In going through the center point, they have gone from night to day. They have moved ahead twelve hours.	
which bores through the world—you <i>were</i> while I climbed down, but when I turned myself about, you passed		 THE ONE PEAK: The Mount of Purgatory. THIS GREAT CAVERN: The natural animal pit of line 98. It is also "Beelzebub's dim tomb," line 131. A LITTLE STREAM: Lethe. In Classical mythology, the river of for- 	
the point to which all gravities are drawn. You are under the other hemisphere where you stand; the sky above us is the half opposed to that which canopies the great dry land.	111 114	getfulness, from which souls drank before being born. In Dante's symbolism it flows down from the top of Purgatory, where it washes away the memory of sin from the souls that have achieved purity. That memory it delivers to Hell, which draws all sin to itself.	
to that which canopies the great dry land.	117	aran 5 un ont to noch.	

143. STARS: As part of his total symbolism Dante ends each of the three divisions of the Commedia with this word. Every conclusion of the upward soul is toward the stars, God's shining symbols of hope and virtue. It is just before dawn of Easter Sunday that the Poets emerge—a further symbolism.

PURGATORY

CANTO I

Ante-Purgatory: the Shore of the Island

Cato of Utica • The Poets emerge from Hell just before dawn of Easter Sunday (April 10, 1300), and Dante revels in the sight of the rediscovered heavens. As he looks eagerly about at the stars, he sees nearby an old man of impressive bearing. The ancient is Cato of Utica, guardian of the shores of Purgatory. Cato challenges the Poets as fugitives from Hell, but Vergil, after first instructing Dante to kneel in reverence, explains Dante's mission and Beatrice's command. Cato then gives them instructions for proceeding.

The Poets have emerged at a point a short way up the slope of Purgatory. It is essential, therefore, that they descend to the lowest point and begin from there, an allegory of Humility. Cato, accordingly, orders Vergil to lead Dante to the shore, to wet his hands in the dew of the new morning, and to wash the stains of Hell from Dante's face and the film of Hell's vapors from Dante's eyes. Vergil is then to bind about Dante's waist one of the pliant reeds (symbolizing Humility) that grow in the soft mud of the shore.

Having so commanded, Cato disappears. Dante arises in silence and stands waiting, eager to begin. His look is all the communication that is necessary. Vergil leads him to the shore and performs all that Cato has commanded. Dante's first purification is marked by a miracle: when Vergil breaks off a reed, the stalk immediately regenerates a new reed, restoring itself exactly as it had been.

		, ,
For better waters now the little bark of my indwelling powers raises her sails, and leaves behind that sea so cruel and dark.	3	to see his final hour, though in the burning of his own madness he had drawn so near i his time was perilously short for turning.
Now shall I sing that second kingdom given the soul of man wherein to purge its guilt and so grow worthy to ascend to Heaven.	6	As I have told you, I was sent to show the way his soul must take for its salvation; and there is none but this by which I go.
Yours am I, sacred Muses! To you I pray. Here let dead poetry rise once more to life, and here let sweet Calliope rise and play	9	I have shown him the guilty people. Now I to lead him through the spirits in your keep to show him those whose suffering makes th
some far accompaniment in that high strain whose power the wretched Pierides once felt so terribly they dared not hope again.	12	By what means I have led him to this strand to see and hear you, takes too long to tell: from Heaven is the power and the command
Sweet azure of the sapphire of the east was gathering on the serene horizon its pure and perfect radiance—a feast	15	Now may his coming please you, for he goe to win his freedom; and how dear that is the man who gives his life for it best knows.
to my glad eyes, reborn to their delight, as soon as I had passed from the dead air which had oppressed my soul and dimmed my sight.	18	You know it, who in that cause found death in Utica where you put off that flesh which shall rise radiant at the Judgment Sea
The planet whose sweet influence strengthens love was making all the east laugh with her rays, veiling the Fishes, which she swam above.	21	We do not break the Laws: this man lives ye and I am of that Round not ruled by Minos, with your own Marcia, whose chaste eyes se
I turned then to my right and set my mind on the other pole, and there I saw four stars unseen by mortals since the first mankind.	24	in endless prayers to you. O blessed breast to hold her yet your own! for love of her grant us permission to pursue our quest
The heavens seemed to revel in their light. O widowed Northern Hemisphere, bereft forever of the glory of that sight!	27	across your seven kingdoms. When I go back to her side I shall bear thanks of you, if you will let me speak your name below."

Remaining Selections 505	
As I broke off my gazing, my eyes veered a little to the left, to the other pole from which, by then, the Wain had disappeared.	30
I saw, nearby, an ancient man, alone. His bearing filled me with such reverence, no father had had more from any son.	33
His beard was long and touched with strands of white, as was his hair, of which two tresses fell over his breast. Rays of the holy light	36
that fell from the four stars made his face glow with such a radiance that he looked to me as if he faced the sun. And standing so,	39
he moved his venerable plumes and said: "Who are you two who climb by the dark stream to escape the eternal prison of the dead?	42
Who led you? or what served you as a light in your dark flight from the eternal valley, which lies forever blind in darkest night?	45
Are the laws of the pit so broken? Or is new counsel published in Heaven that the damned may wander onto my rocks from the abyss of Hell?"	48
At that my Master laid his hands upon me, instructing me by word and touch and gesture to show my reverence in brow and knee,	51
then answered him: "I do not come this way of my own will or powers. A Heavenly Lady sent me to this man's aid in his dark day.	54
But since your will is to know more, my will cannot deny you; I will tell you truly why we have come and how. This man has still	57
to see his final hour, though in the burning of his own madness he had drawn so near it his time was perilously short for turning.	60
As I have told you, I was sent to show the way his soul must take for its salvation; and there is none but this by which I go.	63
I have shown him the guilty people. Now I mean to lead him through the spirits in your keeping, to show him those whose suffering makes them clean.	66
By what means I have led him to this strand to see and hear you, takes too long to tell: from Heaven is the power and the command.	69
Now may his coming please you, for he goes to win his freedom; and how dear that is the man who gives his life for it best knows.	72
You know it, who in that cause found death sweet in Utica where you put off that flesh which shall rise radiant at the Judgment Seat.	75
We do not break the Laws: this man lives yet,	

by Minos, aste eyes seem set 78 sed breast e of her ır quest 81 nen I go

84

"Marcia was so pleasing in my eyes there on the other side," he answered then "that all she asked, I did. Now that she lies	87		out. The suffering of the souls in Purgatory, on the other hand, is temporary, is a means of purification, and is eagerly embraced as an act of the soul's own will. Demons guard the
beyond the evil river, no word or prayer	87		damned to inflict punishment and to prevent escape. In Pur- gatory, the sinners are free to leave off their sufferings: noth-
of hers may move me. Such was the Decree pronounced upon us when I rose from there.	90		ing but their own desire to be made clean moves them to ac- cept their pains, and nothing more is needed. In fact, it is left
But if, as you have said, a Heavenly Dame			to the suffering soul itself (no doubt informed by Divine Illu- mination) to decide at what point it has achieved purifica-
orders your way, there is no need to flatter: you need but ask it of me in her name.	93	8.	tion and is ready to move on. DEAD POETRY: The verses that sang of Hell. Dante may equally
Go then, and lead this man, but first see to it			have meant that poetry as an art has long been surpassed by history as the medium for great subjects. Here poetry will re-
you bind a smooth green reed about his waist and clean his face of all trace of the pit.	96	7-12	turn to its Classic state. THE INVOCATION: Dante invokes all the Muses, as he did in <i>In</i> -
For it would not be right that one with eyes		, 12.	ferno, II, 7, but there the exhortation was to his own powers,
still filmed by mist should go before the angel who guards the gate: he is from Paradise.	99		to High Genius, and to Memory. Here he addresses his spe- cific exhortation to Calliope, who, as the Muse of Epic Po-
All round the wave-wracked shore-line, there below,	,,		etry, is foremost of the Nine. In <i>Paradiso</i> (I, 13) he exhorts Apollo himself to come to the aid of the poem.
reeds grow in the soft mud. Along that edge	102		Dante exhorts Calliope to fill him with the strains of the music she played in the defeat of the Pierides, the nine
no foliate nor woody plant could grow. for what lives in that buffeting must bend.	102		daughters of Pierius, King of Thessaly. They presumed to challenge the Muses to a contest of song. After their defeat
Do not come back this way: the rising sun	105		they were changed into magpies for their presumption. Ovid (<i>Metamorphoses</i> , V, 294–340 and 662–678) retells the myth in
will light an easier way you may ascend." With that he disappeared; and silently	105		detail. Note that Dante not only calls upon Calliope to fill him
I rose and moved back till I faced my Guide,			with the strains of highest song, but that he calls for that very song that overthrew the arrogant pretensions of the
my eyes upon him, waiting. He said to me: "Follow my steps and let us turn again:	108		Pierides, the strains that humbled false pride. The invocation is especially apt, therefore, as a first sounding of the theme of
along this side there is a gentle slope		17	Humility. THE DEAD AIR: Of Hell.
that leads to the low boundaries of the plain."	111		THE PLANET WHOSE SWEET INFLUENCE STRENGTHENS LOVE: Venus.
The dawn, in triumph, made the day-breeze flee before its coming, so that from afar			Here, as morning star, Venus is described as rising in Pisces, the Fishes, the zodiacal sign immediately preceding Aries. In Carte L de the Informa Detection and the the description
I recognized the trembling of the sea. We strode across that lonely plain like men	114		Canto I of the <i>Inferno</i> Dante has made it clear that the Sun is in Aries. Hence it is about to rise.
who seek the road they strayed from and who count			Allegorically, the fact that Venus represents love is, of course, indispensable to the mood of the <i>Purgatory</i> . At no
the time lost till they find it once again.	117		time in April of 1300 was Venus the morning star. Rather, it rose after the sun. Dante's description of the first dawn in
When we had reached a place along the way where the cool morning breeze shielded the dew			Canto I of the <i>Inferno</i> similarly violates the exact detail of things. But Dante is no bookkeeper of the literal. In the <i>In</i> -
against the first heat of the gathering day,	120		<i>ferno</i> he violated fact in order to compile a perfect symbol of rebirth. Here, he similarly violates the literal in order to de-
with gentle graces my Sweet Master bent and laid both outspread palms upon the grass.			scribe an ideal sunrise, and simultaneously to make the alle- gorical point that Love (Venus) leads the way and that Di-
Then I, being well aware of his intent,	123	23.	vine Illumination (the Sun) follows upon it. FOUR STARS: Modern readers are always tempted to identify
lifted my tear-stained cheeks to him, and there he made me clean, revealing my true color			these four stars as the Southern Cross, but it is almost certain that Dante did not know about that formation. In VIII, 89,
under the residues of Hell's black air. We moved on then to the deserted strand	126		Dante mentions three other stars as emphatically as he does these four and no one has been tempted to identify them on
which never yet has seen upon its waters			a starchart. Both constellations are best taken allegorically. The four stars represent the Four Cardinal Virtues: Prudence,
a man who found his way back to dry land.	129		Justice, Fortitude, and Temperance. Dante will encounter them again in the form of nymphs when he achieves the
There, as it pleased another, he girded me. Wonder of wonders! when he plucked a reed		24	Earthly Paradise.
another took its place there instantly,	132		THE FIRST MANKIND: Adam and Eve. In Dante's geography, the Garden of Eden (the earthly Paradise) was atop the Mount of
arising from the humble stalk he tore so that it grew exactly as before.			Purgatory, which was the only land in the Southern Hemi- sphere. All of what were called "the southern continents"
			were believed to lie north of the equator. When Adam and Eve were driven from the Garden, therefore, they were dri-
Notes			ven into the Northern Hemisphere, and no living soul since had been far enough south to see those stars.
 THAT SECOND KINGDOM: Purgatory. TO PURGE ITS GUILT: (See also line 66: THOSE WHOSE SUFFERING 			Ulysses and his men had come within sight of the Mount of Purgatory, but Ulysses mentioned nothing of having seen
MAKES THEM CLEAN.) There is suffering in Purgatory but no			these stars.

MAKES THEM CLEAN.) There is suffering in Purgatory but no torment. The torment of the damned is endless, produces no change in the soul that endures it, and is imposed from with-

29. THE OTHER POLE: The North pole. The Wain (Ursa Major, *i.e.*, the Big Dipper) is below the horizon.

31. ff. CATO OF UTICA: Marcus Porcius Cato the Younger, 95–46 B.C. In the name of freedom, Cato opposed the policies of both Caesar and Pompey, but because he saw Caesar as the greater evil joined forces with Pompey. After the defeat of his cause at the Battle of Thapsus, Cato killed himself with his own sword rather than lose his freedom. Vergil lauds him in the *Aeneid* as a symbol of perfect devotion to liberty, and all writers of Roman antiquity have given Cato a similar high place. Dante spends the highest praises on him both in *de Monarchia* and *li Corvivio*.

Why Cato should be so signally chosen by God as the special guardian of Purgatory has been much disputed. Despite his suicide (and certainly one could argue that he had less excuse for it than had Pier delle Vigne—see *Inferno*, XIII—for his) he was sent to Limbo as a Virtuous Pagan. From Limbo he was especially summoned to his present office. It is clear, moreover, that he will find a special triumph on Judgment Day, though he will probably not be received into Heaven.

The key to Dante's intent seems to lie in the four stars, the Four Cardinal Virtues, that shine so brightly on Cato's face when Dante first sees him. Once Cato is forgiven his suicide (and a partisan could argue that it was a positive act, a death for freedom), he may certainly be taken as a figure of Prudence, Justice, Fortitude, and Temperance. He does very well, moreover, as a symbol of the natural love of freedom; and Purgatory, it must be remembered, is the road to Ultimate Freedom. Cato may therefore be taken as representative of supreme virtue short of godliness. He has accomplished everything but the purifying total surrender of his will to God. As such he serves as an apt transitional symbol, being the highest rung on the ladder of natural virtue, but the lowest on the ladder of those godly virtues to which Purgatory is the ascent. Above all, the fact that he took Marcia (see note, line 78) back to his love, makes him an especially apt symbol of God's forgiveness in allowing the strayed soul to return to him through Purgatory.

- 53. A HEAVENLY LADY: Beatrice.
- 77. MINOS: The Judge of the Damned. The round in Hell not ruled by Minos is Limbo, the final resting place of the Virtuous Pagans, Minos (see *Inferno*, V) is stationed at the entrance to the second circle of Hell. The souls in Limbo (the first circle) have never had to pass before him to be judged.
- 78. MARCIA: The story of Marcia and of Cato is an extraordinary one. She was the daughter of the consul Philippus and became Cato's second wife, bearing his three children. In 56 B.C., in an unusual transaction approved by her father, Cato released her in order that she might marry his friend Hortensius (hence line 87: "that all she asked I did"). After the death of Hortensius, Cato took her back.

In *li Convivio*, IV, 28, Dante presents the newly widowed Marcia praying to be taken back in order that she may die the wife of Cato, and that it may be said of her that she was not cast forth from his love. Dante treats that return as an allegory of the return of the strayed soul to God (that it may die "married" to God, and that God's love for it be made manifest to all time). Vergil describes Marcia as still praying to Cato.

- 89. THE DECREE: May be taken as that law which makes an absolute separation between the damned and the saved. Cato cannot be referring here to Mark, XII, 25 ("when they shall rise from the dead, they neither marry, nor are given in marriage") for that "decree" was not pronounced upon his ascent from Limbo.
- 98. FILMED BY MIST: Of Hell.
- 100. ff. THE REED: The pliant reed clearly symbolizes humility, but other allegorical meanings suggest themselves at once. First, the Reed takes the place of the Cord that Dante took from about his waist in order to signal Geryon. The Cord had been intended to snare and defeat the Leopard with the Gaudy Pelt, a direct assault upon sin. It is now superseded by the Reed of submission to God's will. Second, the reeds are eternal and undiminishable. As such they must immedi-

ately suggest the redemption purchased by Christ's sufferings (ever-abounding grace), for the quantity of grace available to mankind through Christ's passion is, in Christian creed, also eternal and undiminishable. The importance of the fact that the reeds grow at the lowest point of the island and that the Poets must descend to them before they can begin, has already been mentioned. Curiously, the reed is never again mentioned, though it must remain around Dante's waist. See also Matthew, xxvii, 29.

119. BREEZE SHIELDED THE DEW: The dew is a natural symbol of God's grace. The morning breeze shields it in the sense that, being cool, it retards evaporation.

Even more naturally, being bathed in the dew may be taken to signify baptism. The structure of Purgatory certainly suggests a parable of the soul's stages of sacred development: the dew, baptism; the gate of Purgatory, above, first communion; Vergil's certification of Dante as lord of himself (XXVII, 143), confirmation; and Dante's swoon and awakening as extreme unction and the reception into the company of the blessed.

CANTO IX

The Gate of Purgatory

The Angel Guardian • Dawn is approaching. Dante has a dream of a golden eagle that descends from the height of Heaven and carries him up to the Sphere of Fire. He wakes to find he has been transported in his sleep, that it was Lucia (Divine Light) who bore him, laying him down beside an enormous wall, through an opening in which he and Vergil may approach the gate of purgatory.

Having explained these matters, Vergil leads Dante to the Gate and its angel guardian. The Angel is seated on the topmost of three steps that symbolize the three parts of a perfect act of confession. Dante prostrates himself at the feet of the Angel, who cuts seven p's in Dante's forehead with the point of a blazing sword. He then allows the Poets to enter. As the Gates open with a sound of thunder, the mountain resounds with a great hymn of praise.

Now pale upon the balcony of the East ancient Tithonus' concubine appeared, but lately from her lover's arms released.	3
Across her brow, their radiance like a veil, a scroll of gems was set, worked in the shape of the cold beast whose sting is in his tail.	6
And now already, where we were, the night had taken two steps upward, while the third thrust down its wings in the first stroke of flight;	9
when I, by Adam's weight of flesh defeated, was overcome by sleep, and sank to rest across the grass on which we five were seated.	12
At that new hour when the first dawn light grows and the little swallow starts her mournful cry, perhaps in memory of her former woes;	15
and when the mind, escaped from its submission to flesh and to the chains of waking thought, becomes almost prophetic in its vision;	18
in a dream I saw a soaring eagle hold the shining height of heaven, poised to strike, yet motionless on widespread wings of gold.	21
He seemed to hover where old history records that Ganymede rose from his friends,	

24

borne off to the supreme consistory.

I thought to myself: "Perhaps his habit is to strike at this one spot; perhaps he scorns to take his prey from any place but this."	27	He held a drawn sword, and the eye of day beat such a fire back from it, that each time I tried to look, I had to look away.	84
Then from his easy wheel in Heaven's spire, terrible as a lightning bolt, he struck and snatched me up high as the Sphere of Fire.	30	I heard him call: "What is your business here? Answer from where you stand. Where is your Guide? Take care you do not find your coming dear."	87
It seemed that we were swept in a great blaze, and the imaginary fire so scorched me my sleep broke and I wakened in a daze.	33	"A little while ago," my Teacher said, "A Heavenly Lady, well versed in these matters, told us 'Go there. That is the Gate ahead.'"	90
Achilles must have roused exactly thus — glancing about with unadjusted eyes, now here, now there, not knowing where he was —	36	"And may she still assist you, once inside, to your soul's good! Come forward to our three steps," the courteous keeper of the gate replied.	93
when Thetis stole him sleeping, still a boy, and fled with him from Chiron's care to Scyros, whence the Greeks later lured him off to Troy.	39	We came to the first step: white marble gleaming so polished and so smooth that in its mirror I saw my true reflection past all seeming.	96
I sat up with a start; and as sleep fled out of my face, I turned the deathly white of one whose blood is turned to ice by dread.	42	The second was stained darker than blue-black and of a rough-grained and a fire-flaked stone, its length and breadth crisscrossed by many a crack.	99
There at my side my comfort sat—alone. The sun stood two hours high, and more. I sat facing the sea. The flowering glen was gone.	45	The third and topmost was of porphyry, or so it seemed, but of a red as flaming as blood that spurts out of an artery.	102
"Don't be afraid," he said. "From here our course leads us to joy, you may be sure. Now, therefore, hold nothing back, but strive with all your force.	48	The Angel of the Lord had both feet on this final step and sat upon the sill which seemed made of some adamantine stone.	105
You are now at Purgatory. See the great encircling rampart there ahead. And see that opening—it contains the Golden Gate.	51	With great good will my Master guided me up the three steps and whispered in my ear; "Now beg him humbly that he turn the key."	108
A while back, in the dawn before the day, while still your soul was locked in sleep inside you, across the flowers that made the valley gay,	54	Devoutly prostrate at his holy feet, I begged in mercy's name to be let in, but first three times upon my breast I beat.	111
a Lady came. 'I am Lucia,' she said. 'Let me take up this sleeping man and bear him that he may wake to see his hope ahead.'	57	Seven <i>P</i> 's, the seven scars of sin, his sword point cut into my brow. He said: "Scrub off these wounds when you have passed within."	114
Sordello and the others stayed. She bent and took you up. And as the light grew full, she led, I followed, up the sweet ascent.	60	Color of ashes, of parched earth one sees deep in an excavation, were his vestments, and from beneath them he drew out two keys.	117
Here she put you down. Then with a sweep of her sweet eyes she marked that open entrance. Then she was gone; and with her went your sleep."	63	One was of gold, one silver. He applied the white one to the gate first, then the yellow, and did with them what left me satisfied.	120
As one who finds his doubt dispelled, sheds fear and feels it change into new confidence as bit by bit he sees the truth shine clear—	66	"Whenever either of these keys is put improperly in the lock and fails to turn it," the Angel said to us, "the door stays shut.	123
so did I change; and seeing my face brim with happiness, my Guide set off at once to climb the slope, and I moved after him.	69	One is more precious. The other is so wrought as to require the greater skill and genius, for it is that one which unties the knot.	126
Reader, you know to what exalted height I raised my theme. Small wonder if I now summon still greater art to what I write.	72	They are from Peter, and he bade me be more eager to let in than to keep out whoever cast himself prostrate before me."	129
As we drew near the height, we reached a place from which—inside what I had first believed to be an open breach in the rock face—	75	Then opening the sacred portals wide: "Enter. But first be warned: do not look back or you will find yourself once more outside."	132
I saw a great gate fixed in place above three steps, each its own color; and a guard who did not say a word and did not move.	78	The Tarpeian rock-face, in that fatal hour that robbed it of Metellus, and then the treasure, did not give off so loud and harsh a roar	135
Slow bit by bit, raising my lids with care, I made him out seated on the top step, his face more radiant than my eyes could bear.	81	as did the pivots of the holy gate— which were of resonant and hard-forged metal— when they turned under their enormous weight.	138

At the first thunderous roll I turned half-round,	
for it seemed to me I heard a chorus singing	
<i>Te deum laudamus</i> mixed with that sweet sound.	

I stood there and the strains that reached my ears left on my soul exactly that impression a man receives who goes to church and hears

the choir and organ ringing out their chords and now does, now does not, make out the words.

Notes

1-9. There is no wholly satisfactory explanation of this complex opening description. Dante seems to be saving that the third hour of darkness is beginning (hence, if sunset occurred at 6:00 it is now a bit after 8:00 P.M.) and that the aurora of the rising moon is appearing above the horizon. He describes the moon as the concubine of Tithonus. Tithonus, however, married the daughter of the sun, Aurora (dawn), and it was she who begged Jove to give her husband immortality while forgetting to ask perpetual youth for him. Thus Tithonus lived but grew older and older beside his ageless bride. (In one legend he was later changed into a grasshopper.) Despite his advanced years, however, he seems here to be philandering with the moon as his concubine. Dante describes the moon as rising from Tithonus' bed and standing on the balcony of the East (the horizon) with the constellation Scorpio gemmed on her forehead, that "cold [blooded] beast whose sting is in his tail" being the scorpion.

Having given Tithonus a double life, Dante now adds a mixed metaphor in which the "steps" of the night have "wings." Two of the steps (hours) have flown, and the third has just completed the first downstroke of its wings (i.e., has just begun its flight).

- 15. FORMER WOES: Tereus, the husband of Procne, raped her sister Philomela, and cut out her tongue so that she could not accuse him. Philomela managed to communicate the truth to Procne by means of her weaving. The two sisters thereupon took revenge by killing Itys, son of Procne and Tereus, and serving up his flesh to his father. Tereus, learning the truth, was about to kill the sisters when all were turned into birds. Ovid (*Metamorphoses*, VI, 424 ff.) has Tereus changed into a hoopoe, and probably (though the text leaves some doubt) Procne into a swallow and Philomela into a nightingale. Dante clearly takes the swallow to be Philomela.
- 18. PROPHETIC IN ITS VISION: It was an ancient belief that dreams that came toward dawn were prophetic.
- 19–33. DANTE'S DREAM: Each of Dante's three nights on the Mount of Purgatory ends with a dream that comes just before dawn. The present dream is relatively simple in its symbolism and, as we learn shortly after Dante's awakening, it parallels his ascent of the mountain in the arms of Lucia. The dream is told, however, with such complexities of allusion that every reference must be carefully weighed.

To summarize the symbolism in the simplest terms, the Golden Eagle may best be rendered in its attributes. It comes from highest Heaven (from God), its feathers are pure gold (Love? God's splendor?), its wings are outspread (the open arms of Divine Love?), and it appears poised to descend in an instant (as is Divine Grace). The Eagle snatches Dante up to the Sphere of Fire (the presence of God? the beginning of Purgatorial purification? both?), and both are so consumed by the fire that Dante, in his unpurified state, cannot bear it.

On another level, of course, the Eagle is Lucia (Divine Light), who has descended from Heaven, and who bears the sleeping Dante from the Flowering Valley to the beginning of the true Purgatory. Note that Lucia is an anagram for *acuila*, ("eagle").

On a third level, the dream simultaneously connects with the earlier reference to Ganymede, also snatched up by the eagle of God, but the two experiences are contrasted as much as they are compared. Ganymede was carried up by Jove's eagle, Dante by Lucia. Ganymede was out hunting in the company of his worldly associates; Dante was laboring for grace, had renounced worldliness, and was in the company of great souls who were themselves awaiting purification. Ganymede was carried to Olympus; Dante to the beginning of a purification which, though he was still too unworthy to endure it, would in time make him a perfect servant of the true God. Thus, his experience is in the same pattern as Ganymede's, but surpasses it as Faith surpasses Human Reason, and as Beatrice surpasses Vergil.

23. GANYMEDE: Son of Tros, the mythical founder of Troy, was reputedly the most beautiful of mortals, so beautiful that Jove sent an eagle (or perhaps went himself in the form of an eagle) to snatch up the boy and bring him to Heaven, where he became cupbearer to the gods. The fact that Dante himself is about to begin the ascent of Purgatory proper (and hence to Heaven) inevitably suggests an allegory of the soul in the history of Ganymede. God calls to Himself what is most beautiful in man.

The fact that Dante always thought of the Trojans as an especially chosen people is also relevant. Ganymede was the son of the founder of Troy; Troy, in Dante's Vergilian view, founded Rome. And through the Church of Rome men's souls were enabled to mount to Heaven.

- 24. CONSISTORY: Here, the council of the gods on Olympus. Dante uses the same term to describe Paradise.
- 30. SPHERE OF FIRE: The four elemental substances are earth, water, fire, and air. In Dante's cosmography, the Sphere of Fire was located above the Sphere of Air and just under the Sphere of the Moon. Hence the eagle bore him to the top of the atmosphere. The Sphere of Fire, however, may also be taken as another symbol for God.
- 34–39. ACHILLES' WAKING: It had been prophesied that Achilles would be killed at Troy. Upon the outbreak of the Trojan War, his mother, Thetis, stole him while he was sleeping, from the care of the centaur Chiron who was his tutor and fled with him to Scyros, where she hid him disguised as a girl. He was found there and lured away by Ulysses and Diomede, who burn for that sin (among others) in Malebolge. Thus Achilles, like Dante, was borne off in his sleep and awoke to find himself in a strange place.
 - 51. THAT OPENING: The Gate, as the Poets will find, is closed and guarded. Dante (here and below in line 62) can only mean "the opening in which the gate was set" and not "an open entrance." At this distance, they do not see the Gate itself but only the gap in the otherwise solid wall.
 - 55. LUCIA (LOO-TCHEE-ya): Symbolizes Divine Light, Divine Grace.
 - 77. THREE STEPS: (See also lines 94–102, below.) The entrance into Purgatory involves the ritual of the Roman Catholic confessional with the Angel serving as the confessor. The three steps are the three acts of the perfect confession: candid confession (mirroring the whole man), mournful contrition, and burning gratitude for God's mercy. The Angel Guardian, as the priestly confessor, does not move or speak as the Poets approach, because he can admit to purification only those who ask for admission.
 - 86. WHERE IS YOUR GUIDE?: It must follow from the Angel's question that souls ready to enter Purgatory are led up the mountain by another Angel. Dante and Vergil are arriving in an irregular way, as they did to the shore below, where they were asked essentially the same question by Cato. Note, too, that Vergil answers for the Poets, as he did to Cato. The allegory may be that right thinking answers for a man, at least to start with, though the actual entrance into the state of Grace requires an act of Faith and of Submission.
 - 90. TOLD US: Lucia spoke only with her eyes, and what Vergil is quoting is her look. What he is quoting is, in essence,

144

141

correct, but it does seem he could have been a bit more accurate in his first actual conversation with an Angel.

- 94–96. THE FIRST STEP: Contrition of the heart. White for purity, shining for hope, and flawless for perfection. It is not only the mirror of the soul, but it is that mirror in which the soul sees itself as it truly is and not in its outward seeming.
- 97–99. THE SECOND: Contrition of the mouth; that is, confession. The color of a bruise for the shame that envelops the soul as it confesses, rough-grained and fire-flaked for the pain the confessant must endure, and cracked for the imperfection (sin) the soul confesses.
- 100–102. THE THIRD: Satisfaction by works. Red for the ardor that leads to good works. Porphyry is, of course, a purple stone, but Dante does not say the stone was porphyry; only that it resembled it, though red in color.

"Artery" here is, of course, an anachronism, the circulation of the blood having yet to be discovered in Dante's time. Dante uses the word *vena* ("vein"), but it seems to me the anachronism will be less confusing to a modern reader than would be the idea of bright red and spurting venous blood.

- 103–105. The Angel, as noted, represents the confessor, and, more exactly, the Church Confessant. Thus the church is founded on adamant and rests its feet on Good Works.
 - 112. SEVEN P'S: *P* is for the Latin *peccatum*. Thus there is one *P* for each of the Seven Deadly Sins for which the sinners suffer on the seven ledges above: Pride, Envy, Wrath, Acedia (Sloth), Avarice (Hoarding and Prodigality), Gluttony, and Lust.

Dante has just completed the act of confession and the Angel confessor marks him to indicate that even in a shriven soul there remain traces of the seven sins which can be removed only by suffering.

- 115–117. COLOR OF ASHES, OF PARCHED EARTH: The colors of humility which befit the office of the confessor. two keys: (*Cf.* the Papal Seal, which is a crown above two crossed keys.) The keys symbolize the power of the confessor (the church, and hence the Pope) to grant or to withhold absolution. In the present context they may further be interpreted as the two parts of the confessor's office of admission: the gold key may be taken to represent his ordained authority, the silver key as the learning and reflection with which he must weigh the guilt before assigning penance and offering absolution.
 - 126. UNTIES THE KNOT: Another mixed metaphor. The soulsearched judgment of the confessor (the silver key) decides who may and who may not receive absolution, and in resolving that problem the door is opened, provided that the gold key of ordained authority has already been turned.

133–138. THE TARPEIAN ROCK-FACE: The public treasury of Rome was kept in the great scarp of Tarpeia on the Campidoglio. The tribune Metellus was its custodian when Caesar, returned to Rome after crossing the Rubicon, moved to seize the treasury. Metellus opposed him but was driven away and the great gates were opened. Lucan (*Pharsalia*, III, 154–156 and 165–168) describes the scene and the roar that echoed from the rock face as the gates were forced open.

139–141. The thunder of the opening of the Gates notifies the souls within that a new soul has entered, and they burst into the hymn "We Praise Thee, O God." (Contrast these first sounds of Purgatory with the first sounds of Hell— Inferno, III, 22–24.) Despite the thunderous roar right next to him, Dante seems to hear with his "allegorical ear" what certainly could not have registered upon his physical ear.

This seeming incongruity has long troubled me. I owe Professor MacAllister a glad thanks for what is certainly the essential clarification. The whole *Purgatorio*, he points out, is built upon the structure of a Mass. The Mass moreover is happening not on the mountain but in church with Dante devoutly following its well-known steps. I have not yet had time to digest Professor MacAllister's suggestion, but it strikes me immediately as a true insight and promises another illuminating way of reading the *Purgatorio*.

Paradise

Canto XI

The Fourth Sphere: The Sun

Doctors of the Church

The First Garland of Souls: Aquinas • Praise of St. Francis • Degeneracy of Dominicans • Aquinas reads Dante's mind and speaks to make clear several points about which Dante was in doubt. He explains that Providence sent two equal princes to guide the church: St. Dominic, the wise law-giver, being one; and St. Francis, the ardent soul, being the other. Aquinas was himself a Dominican. To demonstrate the harmony of Heaven's gift and the unity of the Dominicans and Franciscans, Aquinas proceeds to pronounce a Praise of the Life of St. Francis. His account finished, he returns to the theme of the unity of the Dominicans and Franciscans, and proceeds to illustrate it further by himself lamenting the Degeneracy of the Dominican Order.

O senseless strivings of the mortal round! how worthless is that exercise of reason that makes you beat your wings into the ground!	3
One man was giving himself to law, and one to aphorisms; one sought sinecures, and one to rule by force or sly persuasion;	6
one planned his business, one his robberies; one, tangled in the pleasure of the flesh, wore himself out, and one lounged at his ease;	9
while I, of all such vanities relieved and high in Heaven with my Beatrice, arose to glory, gloriously received.	12
— When each had danced his circuit and come back to the same point of the circle, all stood still, like votive candles glowing in a rack.	15
And I saw the splendor of the blazing ray that had already spoken to me, smile, and smiling, quicken; and I heard it say:	18
"Just as I take my shining from on high, so, as I look into the Primal Source, I see which way your thoughts have turned, and why.	21
You are uncertain, and would have me find open and level words in which to speak what I expressed too steeply for your mind	24
when I said 'leads to where all plenty is,' and 'no mortal ever rose to equal this one.' And it is well to be exact in this.	27
The Providence that governs all mankind with wisdom so profound that any creature who seeks to plumb it might as well be blind,	30
in order that the Bride seek her glad good in the Sweet Groom who, crying from on high, took her in marriage with His blessed blood,	33
sent her two Princes, one on either side that she might be secure within herself, and thereby be more faithfully His Bride.	36
One, in his love, shone like the seraphim. The other, in his wisdom, walked the earth	

bathed in the splendor of the cherubim.

39

I shall speak of only one, though to extol one or the other is to speak of both in that their works led to a single goal.	42	There as more souls began to follow him in poverty—whose wonder-working life were better sung among the seraphim—	96
Between the Tupino and the little race sprung from the hill blessed Ubaldo chose, a fertile slope spreads up the mountain's face.	45	Honorius, moved by the Eternal Breath, placed on the holy will of this chief shepherd a second crown and everflowering wreath.	99
Perugia breathes its heat and cold from there through Porta Sole, and Nocera and Gualdo behind it mourn the heavy yoke they bear.	48	Then, with a martyr's passion, he went forth and in the presence of the haughty Sultan he preached Christ and his brotherhood on earth;	102
From it, at that point where the mountainside grows least abrupt, a sun rose to the world as this one does at times from Ganges' tide.	51	but when he found none there would take Christ's pardon, rather than waste his labors, he turned back	
Therefore, let no man speaking of that place call it <i>Ascesi</i> — 'I have risen'—but rather, <i>Oriente</i> —so to speak with proper grace.	54	to pick the fruit of the Italian garden. On the crag between Tiber and Arno then, in tears of love and joy, he took Christ's final seal, the holy wounds of which he wore two years.	105
Nor was he yet far distant from his birth when the first comfort of his glorious powers began to make its warmth felt on the earth:	57	When God, whose loving will had sent him forward to work such good, was pleased to call him back to where the humble soul has its reward,	108 111
a boy yet, for that lady who, like death knocks on no door that opens to her gladly, he had to battle his own father 's wrath.	60	he, to his brothers, as to rightful heirs commended his dearest Lady and he bade them to love her faithfully for all their years.	111
With all his soul he married her before the diocesan court <i>et coram patre;</i> and day by day he grew to love her more.	63	Then from her bosom, that dear soul of grace willed its return to its own blessed kingdom; and wished its flesh no other resting place.	117
Bereft of her First Groom, she had had to stand more than eleven centuries, scorned, obscure; and, till he came, no man had asked her hand:	66	Think now what manner of man was fit to be his fellow helmsman, holding Peter's ship straight to its course across the dangerous sea.	120
none, at the news that she had stood beside the bed of Amyclas and heard, unruffled, the voice by which the world was terrified;	69	Such was our patriarch. Hence, all who rise and follow his command will fill the hold, as you can see, with fruits of paradise.	123
and none, at word of her fierce constancy, so great, that even when Mary stayed below, she climbed the Cross to share Christ's agony	72	But his flock has grown so greedy for the taste of new food that it cannot help but be far scattered as it wanders through the waste.	126
But lest I seem obscure, speaking this way, take Francis and Poverty to be those lovers. That, in plain words, is what I meant to say.	75	The more his vagabond and distant sheep wander from him, the less milk they bring back when they return to the fold. A few do keep	129
Their harmony and tender exultation gave rise in love, and awe, and tender glances to holy thoughts in blissful meditation.	78	close to the shepherd, knowing what wolf howls in the dark around them, but they are so few it would take little cloth to make their cowls.	132
The venerable Bernard, seeing them so, kicked off his shoes, and toward so great a peace ran, and running, seemed to go too slow.	81	Now, if my words have not seemed choked and blind, if you have listened to me and taken heed, and if you will recall them to your mind,	135
O wealth unknown! O plentitude untried! Egidius went unshod. Unshod, Sylvester followed the groom. For so it pleased the bride!	84	your wish will have been satisfied in part, for you will see how the good plant is broken, and what rebuke my words meant to impart	138
Thenceforth this father and this happy lord moved with his wife and with his family, already bound round by the humble cord.	87	when I referred, a while back in our talk, to 'where all plenty is' and to 'bare rock.'"	
He did not grieve because he had been born the son of Bernardone; he did not care that he went in rags, a figure of passing scorn.	90	Notes 15. RACK: Dante says "candellier," which may be taken t mean candlestick, but equally to mean the candle-rack	s
He went with regal dignity to reveal his stern intentions to Pope Innocent, from whom his order first received the seal.	93	that hold votive candles in churches. The image of th souls as twelve votive candles in a circular rack is cer tainly more apt than that of twelve candles in separat candlesticks.	ne r-

- 25–26. Lead to . . . All plenty: X, 95. No mortal ever: X, 114.
- 28–42. INTRODUCTION TO THE LIFE OF ST. FRANCIS: Compare the words of Bonaventura in introducing the life of St. Dominic, XII, 31–45.
 - 31. THE BRIDE: The Church.
 - CRYING FROM ON HIGH: Matthew, XXVII. 46, 50; Mark, XV, 34, 37; Luke, XXIII, 46; and John, XIX, 26–30; all record Christ's dying cries upon the cross.
 - 34. TWO PRINCES, ONE ON EITHER SIDE: St. Dominic and St. Francis. Dominic, on one side (line 39 equates his wisdom with the cherubic), by his wisdom and doctrinal clarity made the church secure within itself by helping to defend it against error and heresy. Francis, on the other hand (line 37 ascribes to him seraphic ardor or love), set the example that made her more faithfully the bride of Christ.
- 43–51. ASSISI AND THE BIRTH OF ST. FRANCIS: The passage, in Dante's characteristic topophiliac style, is full of local allusions, not all of which are relevant to St. Francis, but all describing the situation of Assisi, his birthplace. Perugia stands to the east of the upper Tiber. The Tiber at this point runs approximately north to south. Mount Subasio, a long and many spurred crest, runs roughly parallel to the Tiber on the west. Assisi is on the side of Subasio, and it was from Assisi that the sun of St. Francis rose to the world, as "this one" (the actual sun in which Dante and Aquinas are standing) rises from the Ganges. The upper Ganges crosses the Tropic of Cancer, the line of the summer solstice. When the sun rises from the Ganges, therefore, it is at its brightest.

THE TUPINO: Skirts Mt. Subasio on the south and flows roughly west into the Tiber. THE LITTLE RACE: The Chiascio (kyah-show) flows south along the length of Subasio and empties into the Tupino below Assisi. BLESSED UBALDO: St. Ubaldo (1084–1160), Bishop of Gubbio from 1129. He chose a hill near Gubbio as a hermitage in which to end his days, but died before he could retire there. PORTA SOLE: Perugia's west gate. It faces Mount Subasio. In summer its slopes reflect the sun's ray through Porta Sole; in winter, covered with snow, they send the cold wind. NOCERA (NAWtcheh-ra), GUALDO (GWAHL-doe): Towns on the other side of (behind) Subasio. Their heavy yoke may be their subjugation by Perugia, or Dante may have meant by it the taxes imposed by Robert of Naples and his Spanish brigands.

51-54. It is such passages that certify the failures of all translation. ASCESI, which can mean "I have risen," was a common name for Assisi in Dante's day. ORIENTE, of course, is the point at which the sun rises. Let no man, therefore, call Assisi "I have risen" (i.e., a man has risen), but let him call it, rather, the dawning east of the world (a sun has risen). 55 ff. YET FAR DISTANT: While he was still young. The phrasing

continues the figure of the new-risen sun.

Francis, born Bernardone, was the son of a relatively prosperous merchant and, early in life, assisted his father. In a skirmish between Assisi and Perugia he was taken prisoner and later released. On his return to Assisi (he was then twenty-four) he abandoned all worldly affairs and gave himself entirely to religious works.

A BOY YET: Here, as in line 55, Aquinas is overdoing it a bit: twenty-four is a bit old for being a boy yet. THAT LADY: poverty. HIS OWN FATHER'S WRATH: In 1207 (Francis was then twenty-five) he sold one of his father's horses along with a load of bread and gave the money to a church. In a rage, his father forced the church to return the money, called Francis before the Bishop of Assisi, and there demanded that he renounce his right to inherit. Francis not only agreed gladly but removed his clothes and gave them back to his father saying, "Until this hour I called you my father on earth; from this hour I can say in full truth 'our Father which art in Heaven.'"

HE MARRIED: In his "Hymn to Poverty" Francis himself celebrated his union to Poverty as a marriage. He had married her before the diocesan court of Assisi, *et coram patre* ("before the court"; i.e., in the legal presence of, his father). The marriage was solemnized by his renunciation of all possessions.

- 64-66. HER FIRST GROOM: Christ. HE: St. Francis.
 - 68. AMYCLAS: Lucan reported (see also *Convivio*, IV, 13) how the fisherman Amyclas lay at his ease on a bed of seaweed before Caesar himself, being so poor that he had nothing to fear from any man. Not even this report of the serenity Mistress Poverty could bring to a man, and not even the fact that she outdid even Mary in constancy, climbing the very cross with Christ, had moved any man to seek her in marriage.
 - 79. BERNARD: Bernard di Quintavalle, a wealthy neighbor, became the first disciple of Francis, kicking off his shoes to go barefoot in imitation of the master.
- 82–84. UNKNOWN: To men. Holy Poverty is the wealth none recognize, the plentitude none try. EGIDIUS . . . SYLVESTER: The third and fourth disciples of Francis. Peter, the second disciple, seems not to have been known to Dante. THE GROOM: Francis. THE BRIDE: Poverty.
 - 87. THE HUMBLE CORD: Now a symbol of the Franciscans but then in general use by the poor as a makeshift belt.
 - 88. GRIEVE: At his humble origins.
 - 93. HIS ORDER FIRST RECEIVED THE SEAL: IN 1210. But Innocent III thought the proposed rule of the order so harsh that he granted only provisional approval.
 - 96. AMONG THE SERAPHIM: In the Empyrean, rather than in this Fourth Heaven.
- 97–99. HONORIUS . . . SECOND CROWN: IN 1223, Pope Honorius III gave his fully solemnized approval of the Franciscan Order.
- 100–105. In 1219, St. Francis and eleven of his followers made missionary pilgrimage to Greece and Egypt. Dante, whose facts are not entirely accurate, may have meant that pilgrimage; or he may have meant Francis' projected journey to convert the Moors (1214–1215) when Francis fell ill in southern Spain and had to give up his plans.
- 106–108. In 1224, on a crag of Mount Alverna (on the summit of which the Franciscans have reared a commemorative chapel), St. Francis received the stigmata in a rapturous vision of Christ. He wore the wound two years before his death in 1226, at the age of (probably) forty-four.
- 109–117. The central reference here is to Dame Poverty. Her BOSOM: The bare ground of Poverty. NO OTHER RESTING PLACE: Than in the bare ground.
 - 119. HIS FELLOW HELMSMAN: St. Dominic. PETER'S SHIP: The Church.
- 121–132. THE DEGENERACY OF THE DOMINICANS IN DANTE'S TIME: Aquinas was a Dominican. As a master touch to symbolize the harmony of Heaven and the unity of Franciscans and Dominicans, Dante puts into the mouth of a Dominican the praise of the life of St. Francis. That praise ended, he chooses the Dominican to lament the degeneracy of the order. In XII, Dante will have the Franciscan, St. Bonaventure, praise the life of St. Dominic and lament the degeneracy of the Franciscans.
 - 122. HIS COMMAND: The rule of the Dominicans. will fill his hold: With the treasures of Paradise. Dante is carrying forward the helmsman metaphor of lines 118–120, though the ship is now commanded by a patriarch. Typically, the figure changes at once to a shepherd-and-flock metaphor.
 - 136. IN PART: In X, 95–96, in identifying himself as a Dominican, Aquinas said the Dominican rule "leads to where all plenty is" unless the lamb itself stray to "bare rock." In lines 25–26, above, he refers to these words and also to his earlier statements (X, 114) about Solomon's wisdom (that "no mortal ever rose to equal this one"). What he has now finished saying about the degeneracy of the Dominicans will satisfy part of Dante's wish (about "plenty" and "bare rock"). The other part of his wish (about "no mortal ever rose to equal this one") will be satisfied later.
 - 137. THE GOOD PLANT: Of the Dominican rule strictly observed.

45

48

51

54

Those eyes turned then to the Eternal Ray, through which, we must indeed believe, the eyes

And I, who neared the goal of all my nature,

suddenly, as it ought, grow calm with rapture.

Bernard then, smiling sweetly, gestured to me

What then I saw is more than tongue can say. One human speech is dark before the vision.

felt my soul, at the climax of its yearning,

of others do not find such ready way.

to look up, but I had already become

Little by little as my vision grew

within myself all he would have me be.

it penetrated further through the aura

of the high lamp which in Itself is true

Canto XXXIII

The Empyrean

St. Bernard • **Prayer to the Virgin** • **The Vision of God** • *St. Bernard offers a lofty* **Prayer to the Virgin**, *asking her to intercede in Dante's behalf, and in answer Dante feels his soul swell with new power and grow calm in rapture as his eyes are permitted the Direct Vision of God.*

There can be no measure of how long the vision endures. It passes, and Dante is once more mortal and fallible. Raised by God's presence, he had looked into the Mystery and had begun to understand its power and majesty. Returned to himself, there is no power in him capable of speaking the truth of what he saw. Yet the impress of the truth is stamped upon his soul, which he now knows will return to be one with God's Love.

		The ravished memory swoons and falls away.	57
"Virgin Mother, daughter of thy son; humble beyond all creatures and more exalted; predestined turning point to God's intention;	3	As one who sees in dreams and wakes to find the emotional impression of his vision still powerful while its parts fade from his mind—	60
thy merit so ennobled human nature that its divine Creator did not scorn to make Himself the creature of His creature.	6	just such am I, having lost nearly all the vision itself, while in my heart I feel the sweetness of it yet distill and fall.	63
The Love that was rekindled in Thy womb sends forth the warmth of the eternal peace within whose ray this flower has come to bloom.	9	So, in the sun, the footprints fade from snow. On the wild wind that bore the tumbling leaves the Sybil's oracles were scattered so.	66
Here, to us, thou art the noon and scope of Love revealed; and among mortal men, the living fountain of eternal hope.	12	O Light Supreme who doth Thyself withdraw so far above man's mortal understanding, lend me again some glimpse of what I saw;	69
Lady, thou art so near God's reckonings that who seeks grace and does not first seek thee would have his wish fly upward without wings.	15	make Thou my tongue so eloquent it may of all Thy glory speak a single clue to those who follow me in the world's day;	72
Not only does thy sweet benignity flow out to all who beg, but oftentimes thy charity arrives before the plea.	18	for by returning to my memory somewhat, and somewhat sounding in these verses, Thou shalt show man more of Thy victory.	75
In thee is pity, in thee munificence, in thee the tenderest heart, in thee unites all that creation knows of excellence!	21	So dazzling was the splendor of that Ray, that I must certainly have lost my senses had I, but for an instant, turned away.	78
Now comes this man who from the final pit of the universe up to this height has seen, one by one, the three lives of the spirit.	24	And so it was, as I recall, I could the better bear to look, until at last my vision made one with the Eternal Good.	81
He prays to thee in fervent supplication for grace and strength, that he may raise his eyes to the all-healing final revelation.	27	Oh grace abounding that had made me fit to fix my eyes on the eternal light until my vision was consumed in it!	84
And I, who never more desired to see the vision myself than I do that he may see It, add my own prayer, and pray that it may be	30	I saw within Its depth how It conceives all things in a single volume bound by Love, of which the universe is the scattered leaves;	87
enough to move you to dispel the trace of every mortal shadow by thy prayers and let him see revealed the Sum of Grace.	33	substance, accident, and their relation so fused that all I say could do no more than yield a glimpse of that bright revelation.	90
I pray thee further, all-persuading Queen, keep whole the natural bent of his affections and of his powers after his eyes have seen.	36	I think I saw the universal form that binds these things, for as I speak these words I feel my joy swell and my spirits warm.	93
Protect him from the stirrings of man's clay; see how Beatrice and the blessed host clasp reverent hands to join me as I pray."	39	Twenty-five centuries since Neptune saw the Argo's keel have not moved all mankind, recalling that adventure, to such awe	96
The eyes that God reveres and loves the best glowed on the speaker, making clear the joy with which true prayer is heard by the most blest.	42	as I felt in an instant. My tranced being stared fixed and motionless upon that vision, ever more fervent to see in the act of seeing.	99
		~	

Experiencing that Radiance, the spirit is so indrawn it is impossible even to think of ever turning from it.	102	d	HAT WAS REKINDLED IN THY WOMB: God. In a sense He with- trew from man when Adam and Eve sinned. In Mary He eturned and Himself became man. 35. KEEP WHOLE THE
For the good which is the will's ultimate object is all subsumed in It; and, being removed, all is defective which in It is perfect.	105	p h C	NATURAL BENT OF HIS AFFECTIONS: Bernard is asking Mary to protect Dante lest the intensity of the vision overpower his faculties. 37. PROTECT HIM FROM THE STIRRINGS OF MAN'S "LAY: Protect him from the stirrings of base human im-
Now in my recollection of the rest I have less power to speak than any infant wetting its tongue yet at its mother's breast;	108	a o [i	bulse, especially from pride, for Dante is about to receive a grace never before granted to any man and the thought of such glory might well move a mere mortal to an hybris a hubris] that would turn glory to sinfulness.
and not because that Living Radiance bore more than one semblance, for It is unchanging and is forever as it was before;	111	50. в fi s	THE EYES: Of Mary. BUT I HAD ALREADY BECOME: That is, "But I had already ixed my entire attention upon the vision of God." But if o, how could Dante have seen Bernard's smile and ges-
rather, as I grew worthier to see, the more I looked, the more unchanging semblance appeared to change with every change in me.	114	c le	ure? Eager students like to believe they catch Dante in a ontradiction here. Let them bear in mind that Dante is ooking directly at God, as do the souls of Heaven, who hereby acquire—insofar as they are able to contain it—
Within the depthless deep and clear existence of that abyss of light three circles shown— three in color, one in circumference:	117	p S	God's own knowledge. As a first stirring of that heavenly ower, therefore, Dante is sharing God's knowledge of St. Bernard. VHICH IN ITSELF IS TRUE: The light of God is the one light
the second from the first, rainbow from rainbow; the third, an exhalation of pure fire equally breathed forth by the other two.	120	v 65-66. т d	whose source is Itself. All others are a reflection of this. UMBLING LEAVES ORACLES: The Cumean Sybil (Vergil describes her in <i>Aeneid</i> , III, 441 ff.) wrote her oracles on eaves, one letter to a leaf, then sent her message scatter-
But oh how much my words miss my conception, which is itself so far from what I saw that to call it feeble would be rank deception!	123	in in ti	ng on the wind. Presumably, the truth was all contained n that strew, could one only gather all the leaves and put he letters in the right order. How can a light be so dazzling that the beholder would
O Light Eternal fixed in Itself alone, by Itself alone understood, which from Itself loves and glows, self-knowing and self-known;	126	s r s	woon if he looked away for an instant? Would it not be, ather, in looking at, not away from, the overpowering vi- ion that the viewer's senses would be overcome? So it vould be on Earth. But now Dante, with the help of all
that second aureole which shone forth in Thee, conceived as a reflection of the first— or which appeared so to my scrutiny—	129	h e c	neaven's prayers, is in the presence of God and strength- ened by all he sees. It is by being so strengthened that he an see yet more. So the passage becomes a parable of
seemed in Itself of Its own coloration to be painted with man's image. I fixed my eyes on that alone in rapturous contemplation.	132	Ē	prace. Stylistically it once more illustrates Dante's genius: Even at this height of concept, the poet can still summon and invent new perceptions, subtlety exfoliating from ubtlety.
Like a geometer wholly dedicated to squaring the circle, but who cannot find, think as he may, the principle indicated —	135	о 85-87. Т	The simultaneous metaphoric statement is, of course, hat no man can lose his good in the vision of God, but only in looking away from it. CHE IDEA HERE IS PLATONIC: The essence of all things (form) with in the mind of Cod All other things with as our
so did I study the supernal face. I yearned to know just how our image merges into that circle, and how it there finds place;	138	e 88. s e	exists in the mind of God. All other things exist as ex- impla. UBSTANCE: Matter, all that exists in itself. accident: All that exists as a phase of matter.
but mine were not the wings for such a flight. Yet, as I wished, the truth I wished for came cleaving my mind in a great flash of light.	141	109–114. In o C	HESE THINGS: Substance and accident. n the presence of God the soul grows ever more capable of perceiving God. Thus the worthy soul's experience of God is a constant expansion of awareness. God appears to
Here my powers rest from their high fantasy, but already I could feel my being turned— instinct and intellect balanced equally	144	le P	hange as He is better seen. Being perfect, He is change- ess within Himself, for any change would be away from perfection. The central metaphor of the entire <i>Comedy</i> is the image of
as in a wheel whose motion nothing jars— by the Love that moves the Sun and the other stars.		s ti	God and the final triumphant in Godding of the elected oul returning to its Maker. On the mystery of that image, he metaphoric symphony of the <i>Comedy</i> comes to rest. In the second aspect of Trinal-unity, in the circle re- lacted from the first Dante thinks he sees the image of
Notes 1–39. st. Bernard's prayer to the Virgin Mary: No reader who		n C	lected from the first, Dante thinks he sees the image of nankind woven into the very substance and coloration of God. He turns the entire attention of his soul to that mys- ery, as a geometer might seek to shut out every other
has come this far will need a lengthy gloss of Bernard's			hought and dedicate himself to squaring the circle. In <i>Il</i>

Convivio, II, 14, Dante asserted that the circle could not be

squared, but that impossibility had not yet been firmly demonstrated in Dante's time and mathematicians still worked at the problem. Note, however, that Dante as-

sumes the impossibility of squaring the circle as a weak mortal example of mortal impossibility. How much more

12-59. SI. BERNARD'S PRAFER TO THE VIGIN MART. NO Feader with has come this far will need a lengthy gloss of Bernard's prayer. It can certainly be taken as a summarizing statement of the special place of Mary in Catholic faith. For the rest, only a few turns of phrase need underlining. 3. PRE-DESTINED TURNING POINT OF GOD'S INTENTION: All-forseeing God built his whole scheme for mankind with Mary as its pivot, for through her He would become man. 7. THE LOVE impossible, he implies, to resolve the mystery of God, study as man will.

The mystery remains beyond Dante's mortal power. Yet, there in Heaven, in a moment of grace, God revealed the truth to him in a flash of light—revealed it, that is, to the God-enlarged power of Dante's emparadised soul. On Dante's return to the mortal life, the details of that revelation vanished from his mind but the force of the revelation survives in its power on Dante's feelings.

So ends the vision of the *Comedy*, and yet the vision endures, for ever since that revelation, Dante tells us, he feels his soul turning ever as one with the perfect motion of God's love.

GENERAL EVENTS

	GENERAL EVEN15	LITERATURE & I HILOSOPHY	AKI
1200			
1200			13th cent. Dependence on Byzantine models in Italian painting
	1299 Ottoman Turk dynasty founded		c. 1240–1302 Cimabue, Madonna En- throned; Crucifixion
	1300 Pope Boniface VIII proclaims first Jubilee Year ("Holy Year")	c. 1303–1321 Dante, Divine Comedy	c. 1300 New naturalism in Italian painting appears with work of Giotto
	1303 Philip the Fair of France humili- ates Pope Boniface VIII		I305 – I306 Giotto, Arena Chapel frescoes
1309			c. 1308–1311 Duccio <i>, Maestà</i> altar- piece, Siena
	1309 "Babylonian Captivity" of the papacy at Avignon begins		c. 1310 G. Pisano completes Pisa Cathedral pulpit; Giotto, <i>Madonna</i> <i>Enthroned</i>
APA	1326 Earliest known use of cannon		1333 Martini, The Annunciation
OF THE PAPACY	1337–1453 "Hundred Years' War" between France and England		1337–1339 A. Lorenzetti, <i>Allegory of Good Government</i> fresco, Siena
	1346–1378 Reign of Charles IV, Holy Roman emperor		c. 1347–1360 Prague, as residence of Charles IV, becomes major art
YTI'	1346 English defeat French at Crécy		center
VITA	1348 Bubonic plague depopulates Europe	1348–1352 Boccaccio, <i>Decameron</i> , collection of tales	c. 1350–1360 Unknown Bohemian Master, Death of the Virgin
AN C.	1356 English defeat French at Poitiers	after 1350 Petrarch compiles <i>Canzoniere</i> , collection of poems	c. 1363 Court of dukes of Burgundy at Dijon becomes important center
TNOT	1358 Revolt of lower classes (<i>Jacquerie</i>) in France	c. 1370 Saint Catherine of Siena urges end of "Babylonian Captivity"	of International Style
"BABYLONIAN CAPTIVITY"	I363–I404 Reign of Philip the Bold, duke of Burgundy	1373 Petrarch, <i>Letter to Posterity</i> , au- tobiography	
1377	1376 Popes return to Rome from Avignon		
	1377–1399 Reign of Richard II in England	c. 1377 Wycliff active in English church reform; translates Bible into English	c. 1377–1413 Wilton Diptych
ISM	1378 "Great Schism" begins	0	
r Sch	1381 Peasant riots ("Wat Tyler Rebel- lion") in England	c. 1385–1400 Chaucer, <i>The Canter-</i> <i>bury Tales,</i> collection of tales	
THE GREAT SCHISM	1399–1413 Reign of Henry IV in England	c. after 1389 Christine de Pisan, <i>The</i> <i>Book of the City of Ladies</i>	1395–1399 Broederlam, Presentation in the Temple and Flight into Egypt
ГНЕ	1413 English defeat French at Agin- court		1395–1406 Sluter, The Well of Moses
	1417 Council of Constance ends "Great Schism" with election of Pope Martin V		1413–1416 Limbourg Brothers, illus- trations for <i>Très Riches Heures du</i> <i>Duc de Berry</i>
1417			

1417

CHAPTER 11 The Fourteenth Century: A Time of Transition

ARCHITECTURE

MUSIC

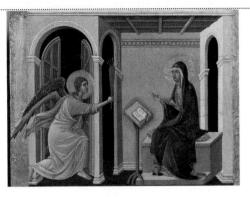

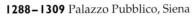

1295 Santa Croce, Florence, begun

1296 Florence Cathedral (Duomo) begun

1298 Palazzo Vecchio, Florence, begun

- **1332–1357** Gloucester Cathedral choir ("Perpendicular" style)
- c. 1345-1438 Doge's Palace, Venice

- **1325** Vitry, *Ars Nova Musicae*, treatise describing new system of musical notation
- **after 1337** Machaut, *Messe de Notre Dame*, polyphonic setting of the Ordinary of the Mass
- **c. 1350** Landini famous in Florence as performer and composer of madrigals and ballads

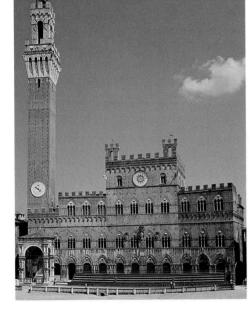

1386 Duomo of Milan begun

Shes y fery et fuirtay. L'i maintelfoie ic cloutay Se ic octory feane mille ame Le muchet qui clout decharme ille outure une pricellette Outaffes effort comte et nette Esmails east blone cocum balli l'a deux plue tende count poulling frontreliufant fonten; woulfre Lontroot finefton paevene Amepiralfesmane y mefine Lones out bien fait a deoirine Leewilk out wie conic faulone Vour faire entic atomé fiome Doulee alame out et fauoure La face blanche et confonte La bouche petite et moffette E-taumenton Vine foffette

CHAPTER 11

THE FOURTEENTH CENTURY: A TIME OF TRANSITION

CALAMITY, DECAY, AND VIOLENCE

he fourteenth century (often called the Trecento, Italian for "three hundred") is usually described by historians as the age that marks the end of the medieval period and the beginning of the Renaissance in Western Europe. If we accept this rather neat description of the period we should expect to see strong elements of the medieval sensibility as well as some stirrings of the "new birth" (Renaissance) of culture that was the hallmark of fifteenth-century European life. We must, however, be cautious about expecting the break between "medieval" and "Renaissance" to be clean and dramatic. History does not usually work with the precision employed by the historians. Neither should we expect to see cultural history moving upward in a straight line toward greater modernity or greater perfection. In fact, the fourteenth century was a period of unparalleled natural calamity, institutional decay, and cruel violence.

The Black Death

The Black Death

Midway through the century, in 1348, bubonic plague swept through Europe in a virulent epidemic that killed untold numbers of people and upset trade, culture, and daily life in ways difficult for us to imagine. It has been estimated that some cities in Italy lost as many as twothirds of their population in that year.

One prominent figure who lived through that devastation was the Italian writer Giovanni Boccaccio (1313– 1375). His great collection of stories, the *Decameron*, has a plague setting. A group of young men and women flee Florence to avoid the plague; during their ten days' sojourn in the country (*Decameron* is Greek for "ten days") they amuse each other by telling stories. Each of the ten young people tells a story on each of the ten days. The resulting one hundred stories constitute a brilliant collection of folktales, *fabliaux* ("ribald fables"), *exempla* ("moral stories"), and romances Boccaccio culled from the oral and written traditions of Europe. Because of their romantic elements, earthiness, and somewhat shocking bawdiness the *Decameron* has often been called the "Human Comedy" to contrast it with the lofty moral tone of Dante's epic work of an earlier generation.

However delightful and pleasing these stories are to read, they stand in sharp contrast to the horrific picture Boccaccio draws of the plague in his introduction to the *Decameron.* Boccaccio's account has the ring of authenticity. He had been an eyewitness to the events he describes. His vivid prose gives some small sense of what the plague must have been like for a people who possessed only the most rudimentary knowledge of medicine and no knowledge at all about the source of illness and disease.

The Great Schism

Great Schism

Nature was not the only scourge to affect the stability of Europe. The medieval Christian church, that most powerful and permanent large institution in medieval life, underwent convulsive changes in the fourteenth century—changes that were distant warning signals of the Reformation at the beginning of the sixteenth century.

A quick look at some dates indicates clearly the nature of these changes. In 1300, Pope Boniface VIII celebrated the great jubilee year at Rome that brought

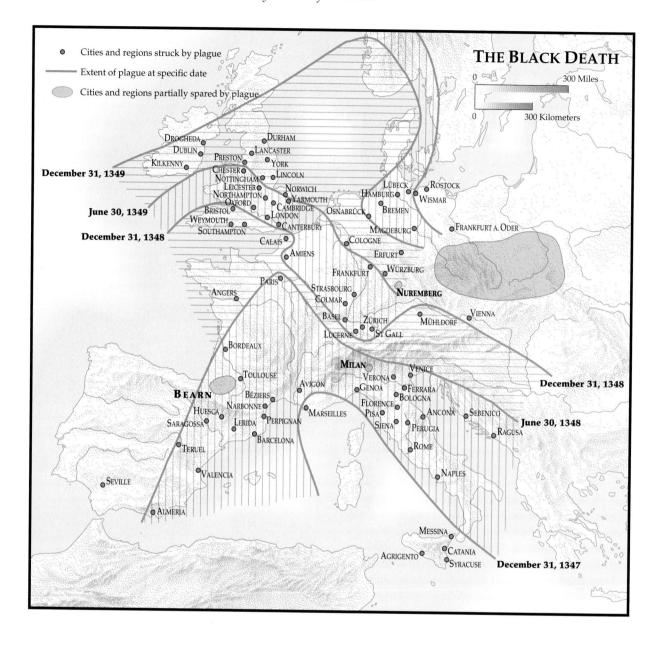

pilgrims and visitors from all over the Christian West to pay homage to the papacy and the church it represented and headed. This event was one of the final symbolic moments of papal supremacy over European life and culture. Within the next three years, Philip the Fair of France imprisoned and abused the same pope at the papal palace of Anagni. The pope died as a result of his humiliating encounters with royal power; even Dante's implacable hatred of Boniface could not restrain his outrage at the humiliation of the office of the pope. By 1309, the papacy, under severe pressure from the French, had been removed to Avignon in Southern France, where it was to remain for nearly seventy years. In 1378, the papacy was further weakened by the Great Schism, which saw European Christianity divided into hostile camps, each of

whom pledged allegiance to a rival claimant to the papacy. Not until 1417 was this breach in church unity healed; a church council had to depose three papal pretenders to accomplish the reunification of the church.

The general disarray of the church in this period spawned ever more insistent demands for church reforms. Popular literature (as both Boccaccio and, in England, Geoffrey Chaucer, clearly demonstrate) unmercifully satirized the decadence of the church. Great saints like the mystic Catherine of Siena (1347–1380) wrote impassioned letters to the popes at Avignon in their "Babylonian Captivity" demanding that they return to Rome free from the political ties of the French monarchy. In England, John Wyclif's cries against the immorality of the higher clergy and the corruption of the church fueled

VALUES

Natural Disaster and Human Response

All of the chapters in this book single out a particular value expressed in the culture of the period under discussion. In this chapter, however, we raise another kind of issue affecting human values: How do people respond to catastrophic events in their lives? One historian has called the Plague Years of 1347–1351 the "greatest natural disaster ever to have struck Europe." Although firm figures are hard to come by, it is safely assumed that Europe lost 30 percent of its population in that period, with mortality rates in some areas as high as 60 percent.

Boccaccio, in the *Decameron*, said that the Florentines responded either with an orgy of entertainment, on the presumption that on the morrow they might all be dead; or by turning to religion for solace; while many, like the ten young people of the *Decameron*, fled to what they thought would be an area of safety.

We have abundant documentation to show that other (not surprising) reactions were common. One was to find a scapegoat upon whom blame for the plague could be laid. The most conspicuous fourteenth-century scapegoat was the Jewish population, who became the object of expulsion orders, riots, and massacres by unruly mobs with the compliance of the authorities.

Another common reaction was the outbreak of religious mania. During the plague years, itinerant bands of men and women marched through villages and towns, scourging themselves, crying out for penance, and describing the plague as God's judgment. These *flagellants* (as they were called) came mainly from the lay ranks who were infected with a hysteria over a catastrophe they could not understand.

With the slow passing of the plague, its long-range effects began to take hold: famine caused by the shortage of manpower in agriculture, and the breakdown of social authority which, within a generation, would result in the uprisings of the lower classes in places as different as Florence, France, and England.

The most poignant of the Plague Chronicles was one written by an Irish friar in 1349 who says that he left some unused parchment attached to his story in case anyone "of Adam's race" would survive to continue his story. Another hand wrote in that blank space: "Here it seems that the author died."

indignation at all levels. The famous Peasant Revolt of 1381 was greatly aided by the activism of people aroused by the ideas of Wyclif and his followers.

The 1381 revolt in England was only the last in a series of lower-class revolutions that occurred in the fourteenth century. The frequency and magnitude of these revolts (like that of the French peasants beginning in 1356) highlight the profound dissatisfactions with the church and the nobility in the period. It is not accidental that the story of Robin Hood, with its theme of violence toward the wealthy and care for the poor, began in the fourteenth century.

The Hundred Years' War

The terrible violence of the fourteenth century was caused not only by the alienation of the peasants but also by the Hundred Years' War between France and England. While the famous battles of the period—Poitiers, Crécy, Agincourt—now seem romantic and distant, it is undeniable that they brought unrelieved misery to France for long periods. Between battles, roaming bands of mercenaries pillaged the landscape to make up for their lack of pay. The various battles were terrible in themselves. One example must suffice. According to Jean Froissart's *Chronicles*, the English King Edward III sent a group of his men to examine the battlefield after the Battle of Crécy (1346), in which the English longbowmen slaughtered the more traditionally armed French and mercenary armies: "They passed the whole day upon the field and made a careful report of all they saw. According to their report it appeared that eighty banners, the bodies of eleven princes, twelve hundred knights, and thirty thousand common men were found dead on the field." It is no wonder that Barbara Tuchman's splendid history of life in fourteenth-century France, *A Distant Mirror* (1978), should have been subtitled "The Calamitous Fourteenth Century."

Hundred Years' War

LITERATURE IN ITALY, ENGLAND, AND FRANCE

Amid the natural and institutional disasters of the fourteenth century there were signs of intense human creativity in all the arts, especially in literature. In Italy, Dante's literary eminence was secure at the time of his death (1321) and the reputation of Italian letters was further enhanced by two other outstanding Tuscan writers: the poet Francesco Petrarch and Giovanni Boccaccio, famed for the *Decameron*. In England, one of the greatest authors in the history of English letters was active: Geoffrey Chaucer. His life spanned the second half of the fourteenth century; he died, almost symbolically, in 1400.

Petrarch

Petrarch

It is appropriate to begin a discussion of fourteenthcentury culture with Petrarch. His life spanned the better part of the century (1304–1374) and in that life we can see the conflict between the medieval and early Renaissance ideals being played out.

Petrarch (Petrarca in Italian) was born in Arezzo, a small town in Tuscany, south of Florence. As a young man, in obedience to parental wishes, he studied law for a year in France and for three years at the law faculty in Bologna. He abandoned his legal studies immediately after the death of his father to pursue a literary career. To support himself he accepted some minor church offices but was never ordained to the priesthood.

Petrarch made his home at Avignon (and later at a much more isolated spot near that papal city, Vaucluse), but for the greater part of his life he wandered from place to place. He could never settle down; his restlessness prevented him from accepting lucrative positions that would have made him a permanent resident of any one place. He received invitations to serve as secretary to various popes in Avignon and, through the intercession of his close friend Boccaccio, was offered a professorship in Florence. He accepted none of these positions.

Petrarch was insatiably curious. He fed his love for the ancient classics by searching out and copying ancient manuscripts that had remained hidden and unread in the various monasteries of Europe. It is said that at his death he had one of the finest private libraries in Europe. He wrote volumes of poetry and prose, carried on a vast correspondence, advised the rulers of the age, took a keen interest in horticulture, and kept a wide circle of literary and artistic friends. We know that at his death he possessed pictures by both Simone Martini and Giotto, two of the most influential artists of the time. In 1348, Petrarch was crowned poet laureate of Rome, the first artist so honored since the ancient days of Rome.

One true mark of the Renaissance sensibility was a keen interest in the self and an increased thirst for personal glory and fame. Petrarch surely is a fourteenth-

century harbinger of that spirit. Dante's Divine Comedy is totally oriented to the next life; the apex of Dante's vision is that of the soul rapt in the vision of God in eternity. Petrarch, profoundly religious, never denied that such a vision was the ultimate goal of life. At the same time, his work exhibits a tension between that goal and his thirst for earthly success and fame. In his famous prose work Secretum (My Secret), written in 1343, the artist imagines himself in conversation with Saint Augustine. In a dialogue extraordinary for its sense of self-confession and self-scrutiny, Petrarch discusses his moral and intellectual failings, his besetting sins, and his tendency to fall into fits of depression. He agrees with his great hero Augustine that he should be less concerned with his intellectual labors and the fame that derives from them and more with salvation and the spiritual perfection of his life. However, Petrarch's argument has a note of ambivalence: "I will be true to myself as far as it is possible. I will pull myself together and collect my scattered wits, and make a great endeavor to possess my soul in patience. But even while we speak, a crowd of important affairs, though only of this world, is waiting for my attention."

The inspiration for the Secretum was Augustine's Confessions, a book Petrarch loved so much that he carried it with him everywhere. It may well have been the model for Petrarch's Letter to Posterity, one of the few examples of autobiography we possess after the time of Augustine. That Petrarch would have written an autobiography is testimony to his strong interest in himself as a person. The Letter was probably composed in 1373, a year before his death. Petrarch reviews his life up until 1351, where the text breaks off abruptly. The unfinished work is clear testimony to Petrarch's thirst for learning, fame, and selfawareness. At the same time, it is noteworthy for omitting any mention of the Black Death of 1348, which carried off the woman he loved. The letter is an important primary document of the sensibility of the fourteenthcentury "proto-Renaissance."

Petrarch regarded as his most important works the Latin writings over which he labored with devotion and in conscious imitation of his most admired classical masters: Ovid, Cicero, and Vergil. Today, however, only a literary specialist or an antiquarian is likely to read his long epic poem in Latin called Africa (written in imitation of Vergil's Aeneid), or his prose work in praise of the past masters of the world (De Viris Illustris), or his meditations on the benefits of the contemplative life (De Vita Solitaria). What has assured the literary reputation of Petrarch is his incomparable vernacular poetry, which he considered somewhat trifling but collected carefully into his Canzoniere (Songbook). The Canzoniere contains more than three hundred sonnets and forty-nine canzoni ("songs") written in Italian during the span of his adult career.

The subject of a great deal of Petrarch's poetry is his love for Laura, a woman with whom he fell immediately in love in 1327 after seeing her at church in Avignon. Laura died in the plague of 1348. The poems in her honor are divided into those written during her lifetime and those mourning her untimely death. Petrarch poured out his love for Laura in over three hundred sonnets (fourteen-line poems) he typically broke into an octave and a sestet. Although they were never actually lovers (Petrarch says in the Secretum that this was due more to her honor than to his; Laura was a married woman), his Laura was no mere literary abstraction. She was a flesh-and-blood woman whom Petrarch genuinely loved. One of the characteristics of his poetry, in fact, is the palpable reality of Laura as a person; she never becomes (as Beatrice does for Dante) a symbol without earthly reality.

The interest in Petrarch's sonnets did not end with his death. Petrarchism, by which is meant the Petrarchan form of the sonnet and particularly the poet's attitude to his subject matter-praise of a woman as the perfection of human beauty and the object of the highest expression of love-was introduced into other parts of Europe before the century was over. In England, Petrarch's sonnets were first imitated in form and subject by Sir Thomas Wyatt in the early sixteenth century. Although the Elizabethan poets eventually developed their own English form of the sonnet, the English Renaissance tradition of poetry owes a particularly large debt to Petrarch, as the poetry of Sir Philip Sidney (1554-1586), Edmund Spenser (1552-1599), and William Shakespeare (1564-1616) shows. Their sonnet sequences follow the example of Petrarch in linking together a series of sonnets in such a way as to indicate a development in the relationship of the poet to his love.

Petrarch's Sonnet 15

Backwards at every weary step and slow These limbs I turn which with great pain I bear; Then take I comfort from the fragrant air That breathes from thee, and sighing onward go. But when I think how joy is turned to woe, Remembering my short life and whence I fare, I stay my feet for anguish and despair, And cast my tearful eyes on earth below. At times amid the storm of misery This doubt assails me: how frail limbs and poor Can severed from their spirit hope to live. Then answers Love: Hast thou no memory How I to lovers this great guerdon give, Free from all human bondage to endure? (*John Addington Symonds, trans.*)

Chaucer

Chaucer

10

While it is possible to see the beginning of the Renaissance spirit in Petrarch and other Italian writers of the fourteenth century, the greatest English writer of the century, Geoffrey Chaucer (1340–1400), still reflects the culture of his immediate past. The new spirit of individualism discernible in Petrarch is missing in Chaucer. He is still very much a medieval man. Only in the later part of the fifteenth century, largely under the influence of Italian models, can we speak of the Renaissance in England. This underscores the valuable lesson about history that movements do not necessarily happen immediately and everywhere.

Scholars have been able to reconstruct Chaucer's life with only partial success. We know that his family had been fairly prosperous wine merchants and vintners and that he entered royal service early in his life, eventually becoming a squire to King Edward III. After 1373, he undertook various diplomatic tasks for the king, including at least two trips to Italy to negotiate commercial contracts. During these Italian journeys Chaucer came into contact with the writings of Dante, Petrarch, and Boccaccio. There has been some speculation that he actually met Petrarch, but the evidence is tenuous. Toward the end of his life Chaucer served as the customs agent for the port of London on the river Thames. He was thus never a leisured "man of letters"; his writing had to be done amid the hectic round of public affairs that engaged his attention as a highly placed civil servant.

Like many other successful writers of the late medieval period, Chaucer could claim a widespread acquaintance with the learning and culture of his time. This was still an age when it was possible to read most of the available books. Chaucer spoke and wrote French fluently, and his poems show the influence of many French allegories and "dream visions." That he also knew Italian literature is clear from his borrowings from Dante and Petrarch and from his use of stories and tales in Boccaccio's Decameron (although it is not clear that he knew that work directly). Chaucer also had a deep knowledge of Latin literature, both classical and ecclesiastical. Furthermore, his literary output was not limited to the composition of original works of poetry. He made a translation from Latin (with an eye on an earlier French version) of Boethius' Consolation of Philosophy as well as a translation from French of the thirteenth-century allegorical erotic fantasy Romance of the Rose. He also composed a short treatise on the astrolabe and its relationship to the study of astronomy and astrology (two disciplines not clearly distinguished at that time).

The impressive range of Chaucer's learning pales in comparison to his most memorable and noteworthy talents: his profound feeling for the role of the English language as a vehicle for literature; his efforts to extend the range of the language (the richness of Chaucer's vocabulary was not exceeded until Shakespeare); and his incomparable skill in the art of human observation. Chaucer's characters are so finely realized that they have become standard types in English literature: his pardoner is an unforgettable villain, his knight the essence of courtesy, his wife of Bath a paradigm of rollicking bawdiness.

These characters, and others, are from Chaucer's masterpiece, *The Canterbury Tales*, begun sometime after 1385. To unify this vast work, a collection of miscellaneous tales, Chaucer used a typical literary device: a narrative frame, in this case a journey during which people tell each other tales. As noted, Boccaccio had used a similar device in the *Decameron*.

Canterbury Tales

Chaucer's plan was to have a group of thirty pilgrims travel from London to the shrine of Saint Thomas à Becket at Canterbury and back. After a general introduction, each pilgrim would tell two tales on the way and two on the return trip in order to pass the long hours of travel more pleasantly. Between tales they might engage in perfunctory conversation or prologues of their own to cement the tales further into a unified whole.

Chaucer never finished this ambitious project; he died before half of it was complete. The version we possess has a General Prologue in which the narrator, Geoffrey Chaucer, describes the individual pilgrims, his meeting with them at the Tabard Inn in London, and the start of the journey. Only twenty-three of the thirty pilgrims tell their tales (none tells two tales) and the group has not yet reached Canterbury. There is even some internal evidence that the material we possess was not meant for publication in its present form.

Although *The Canterbury Tales* is only a draft of what was intended to be Chaucer's masterwork, it is of incomparable literary and social value. A close reading of the General Prologue, for instance—with its representative, although limited, cross section of medieval society (no person lower in rank than a plowman or higher in rank than a knight appears)—affords an effortless entry into the complex world of late medieval England. With quick, deft strokes Chaucer not only creates verbal portraits of people who at the same time seem both typical and uniquely real but also introduces us to a world of slowly dying knightly values; a world filled with such contrasts as clerical foibles, the desire for knowledge, the ribald taste of the lower social classes, and an appetite for philosophical conversation.

After the General Prologue, the various members of the pilgrim company begin to introduce themselves and proceed to tell their tales. Between the tales they engage in small talk or indulge in lengthy prologues of their own. In the tales that he completed, we see that Chaucer drew on the vast treasury of literature—both written and oral—that was the common patrimony of medieval culture. The Knight's Tale is a courtly romance; the miller and reeve tell stories that spring from the ribald *fabliaux* tradition of the time; the pardoner tells an *exemplum* such as any medieval preacher might employ; the prioress draws from the legends of the saints; the nun's priest uses an animal fable, while the parson characteristically enough provides a somewhat tedious example of a medieval prose sermon.

At places, as in the prologue to the tale of the Wife of Bath, we get from Chaucer a long meditation on some of the problems of the age. The Wife of Bath introduces her tale, for instance, with a discourse explaining why the persistent tradition against women (misogyny) is unjust and contrary to authentic Christian theology. She also makes a passionate plea for seeing sexual relations as a good given by God. This may strike us as unnecessary but in an age that prized the unmarried state (e.g., for monks, nuns, priests, etc.) it was a necessary corrective.

Christine de Pisan

Christine de Pisan

Christine de Pisan (1365–1428?) is an extraordinary figure in late medieval literature if for no other reason than her pioneering role as one of Europe's first women professional writers to make her living with the power of her pen.

Born in Venice, Christine accompanied her father Thomas de Pizzano to the French court of Charles V when still a small child. Thomas was the king's physician, astrologer, and close adviser. He evidently gave his daughter a thorough education: She was able to write in both Italian and French and probably knew Latin well enough to read it. At fifteen she married Eugene of Castel, a young nobleman from Picardy. That same year (1380) the king died and the family fell on hard times with the loss of royal patronage. Five years later her father and her husband were both dead, leaving Christine the sole support of her mother, niece, and three young

CONTEMPORARY VOICES

John Ball

Good people: things cannot go right in England and never will, until goods are held in common and there are no more villeins ["peasants"] and gentle-folk. . . . In what way are those whom we call lords greater masters than ourselves? How have they deserved it? If we all spring from a common mother and father, Adam and Eve, how can they claim or prove that they are lords more than us except by making us produce and grow the wealth which they spend?

They are clad in velvet and camlet lined with squirrel and ermine, while we go dressed in coarse cloth.

They have the wines, the spices, and the good bread; we have the rye, the husks, and the straw and we drink water.

They have shelters and ease in their fine manors and we have hardship and toil, the winds and the rains in the fields. And from us must come, from our labor, the things which keep them in luxury.

We are called serfs and beaten if we are slow in service to them, yet we have no sovereign lord we can complain to; none to hear us and do us justice.

Let us go to the king—he is young—and show him how we are oppressed and tell him how we want things changed or else we will change them ourselves. If we go in good earnest and all together, very many people who are called serfs and are held in subjection will follow us to get their freedom.

When the king hears us he will remedy the evil, willingly or otherwise!

[Sermon of the priest John Ball, a leader in the English Peasant Revolt of 1381, recorded in *The Chronicles* of Froissart.]

children. To maintain this large family, Christine hit on an almost unheard of solution for a woman of the time: She turned to writing and the patronage such writing could bring to earn a living.

Between 1399 and 1415, Christine composed fifteen books, which, as one of her translators has noted, is a staggering record in an age that had neither typewriters nor word processors. In 1399, she entered a famous literary debate about the *Romance of the Rose*. The *Romance*, a long and rather tedious poem, had been written in the preceding century and was immensely popular (Chaucer did an incomplete English translation of it). In 1275, Jean de Meung had written an addition to it that was violently critical of women. Christine attacked this misogynistic addition in a treatise called *A Letter to the God of Love*. In 1404, she wrote her final word on this debate in a long work titled *The Book of the City of Ladies*.

Christine de Pisan's The Book of the City of Ladies

The Book of the City of Ladies is indebted in its structure to Augustine's *The City of God*, and for its sources, a Latin treatise by Boccaccio titled *De Claris Mulieribus*. Through use of stories of famous women (*clarae mulieres*), Christine demonstrates that they possessed virtues precisely opposite to those vices imputed to women by Jean de Meung.

The following year (1405) Christine wrote *The Treasure* of the City of Ladies, a book of etiquette and advice to help

women survive in society. What is extraordinarily interesting about this book (one of the few available in English translation) is its final section, in which Christine pens advice for every class of women—from young brides and wives of shopkeepers to prostitutes and peasant women.

Around 1418, Christine retired to a convent in which her daughter was a nun, where she continued to write. Besides a treatise on arms and chivalry and a lament about the horrors of civil war, she also composed prayers and seven allegorical psalms. Of more enduring interest was *The Book of Peace*, a handbook of instruction for the Dauphin who was to become Charles VII and a short hymn in honor of the great Joan of Arc. Whether Christine lived to see the bitter end of Joan is uncertain, but her hymn is one of the few extant works written while Joan was alive.

Immensely popular in her own time (the Duc de Berry owned copies of every book she wrote), her reputation waned in the course of time, to be revived only in the last decade or so as scholars have tried to do justice to the forgotten heroines of our common history.

Art in Italy

Giorgio Vasari's *Lives of the Artists* (1550), the earliest account of the rebirth of Italian art in the Renaissance, treats first of all the great Florentine painter Giotto da Bondone (1266 or 1267–1337). In his *Life of Giotto* Vasari pays tribute to Giotto's work and also gives him credit for setting painting once again on the right path, from which it had strayed.

Vasari's Lives of the Artists

Later generations have accepted Vasari's assessment and have seen Giotto as a revolutionary figure not for the fourteenth century alone but for the entire history of European art, marking a major break with the art of the Middle Ages. Like all revolutionary figures, Giotto was more intimately linked with his past than his contemporaries and immediate successors realized, and to understand the magnitude of his achievements we must first see something of their context.

The Italo-Byzantine Background

Throughout the later Middle Ages art in Italy showed little of the richness and inventiveness of the great centers of northern Europe. Not only in France, where the University of Paris formed the intellectual capital of the Western world, but also in England and Germany, construction of the great Gothic cathedrals provided opportunities for artists to refine and develop their techniques. Sculptured decorations like *The Death of the Virgin* from Strasbourg Cathedral [11.1] are stylistically far more advanced than contemporary work in Italy. One of the reasons for this is that northern Gothic artists were beginning to return for inspiration not to their immediate predecessors but to Classical art, with its realistic portrayal of the body and drapery. In Italy, however, artists were still rooted in the Byzantine tradition. Italian churches were generally decorated not with lifelike sculptural groups like the one from Strasbourg, but with solemn and stylized frescoes and mosaics, a style called Italo-Byzantine.

There are notable exceptions to the generally conservative character of Italian art in the thirteenth century. Nicola Pisano (1220/1225-1284?) and his son Giovanni (1245/1250-1314) have been described as the creators of modern sculpture. Nicola's first major work was a marble pulpit for the baptistery in Pisa completed in 1260, clearly influenced by the Roman sarcophagi the sculptor could see around him in Pisa. By crowding in his figures and filling the scene with lively detail Nicola recaptured much of the vitality and realism of late Roman art while retaining the expressive qualities of Gothic sculpture. The work of his son Giovanni was less influenced by Classical models than by his contemporaries in northern Europe—so much so that some scholars believe he must have spent some time in France. In his pulpit for the cathedral at Pisa, finished in 1310, the figures are more elegant and less crowded than those of his father, and show an intensity of feeling typical of northern late Gothic art [11.2, 11.3]. Both of these great sculptors foreshadowed major characteristics in the art of the Renaissance, Nicola by his emphasis on Classical models and Giovanni by the naturalism and emotionalism of his figures and by his use of space.

11.1 The Death of the Virgin, tympanum of the south transept portal, Strasbourg Cathedral, c. 1220. The expressive faces and elaborate drapery shows the influence of Classical sculpture.

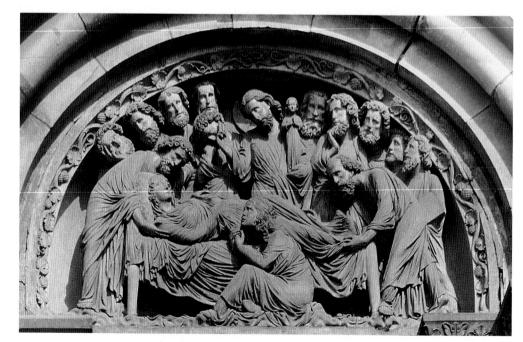

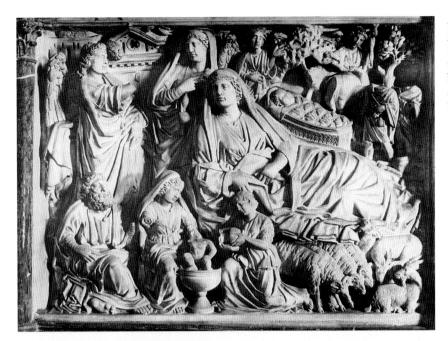

11.2 Nicola Pisano, *Annunciation and Nativity*, detail of pulpit, Baptistery, Pisa, 1259–1260. Marble. By crowding his figures together Nicola was able to combine the scene of the Nativity with the Annunciation and the shepherds in the fields.

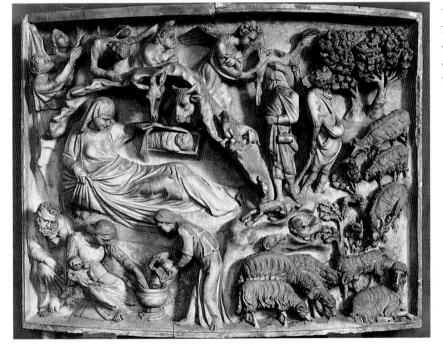

11.3 Giovanni Pisano, *Nativity and Annunciation to the Shepherds*, 1302–1310. Detail of pulpit. Marble. Cathedral, Pisa. The slender figures and sense of space create an effect very different from that of the work of the artist's father.

Nicola Pisano

While some Italian sculptors were responding to influences from outside, painting in Italy remained firmly grounded in the Byzantine tradition. Byzantine art was originally derived from Classical art. Although its static and solemn characteristics seem a long way away from Greek or Roman styles, Byzantine painters and mosaicists inherited the late Hellenistic and Roman artists' ability to give their figures a three-dimensional quality and to represent foreshortening. With these techniques available to him, Giotto was better able to break away from the stereotypical forms of Italo-Byzantine art and bring to painting the same naturalism and emotional power that appear in Giovanni Pisano's sculptures.

Giotto's predecessor as the leading painter in Florence, and perhaps also his teacher, was Cimabue (1240?-1302?). Not enough of his work has survived for us to have a clear impression of how much Giotto owed to Cimabue's influence, but the crucifix Cimabue painted for the Church of San Domenico in Arezzo shows a remarkable realism and sophistication in the depiction of Christ's body [11.4]. Cimabue shows a genuine if incomplete understanding of the anatomy of the figure and, more important, uses it to enhance the emotional impact of his painting by emphasizing the sense of strain and weight. At the same time the draped loincloth is not merely painted as a decorative design but as naturalistically soft folds through which the limbs beneath are visible. If in other works, like the immense Santa Trinità Madonna [11.5], Cimabue is more directly in the Italo-Byzantine tradition, here at least he seems directly to prefigure the impact of Giotto's art.

Cimabue

The works of Cimabue's contemporary Duccio di Buoninsegna (1255/60–1318/19) are more directly Byzantine in inspiration, but here too the new spirit of

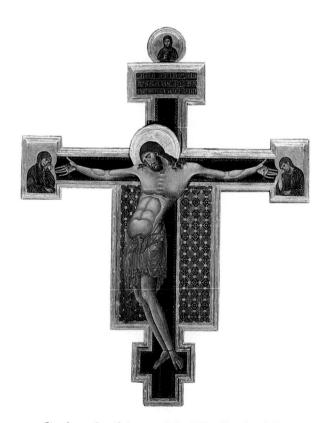

11.4 Cimabue. *Crucifixion*, c. 1240–1302. Church of San Domenico, Arezzo.

the times can be felt [Table 11.1]. His greatest achievement was the huge Maestà, painted between 1308 and 1311, for the high altar of Siena Cathedral in his native city. The majestic Madonna who gives the work its name faced the congregation [11.6], while both the front and back of the altarpiece were covered with small compartments filled with scenes from the lives of Christ and the Virgin. The episodes themselves are familiar from earlier painters, but the range of emotional expression is new and astonishing, as Duccio reveals to us not only the physical appearance of each of his subjects but their emotional states as well. In a number of the scenes the action takes place within an architectural setting that conveys a greater sense of space than we find in any earlier paintings, including those from the ancient world [11.7].

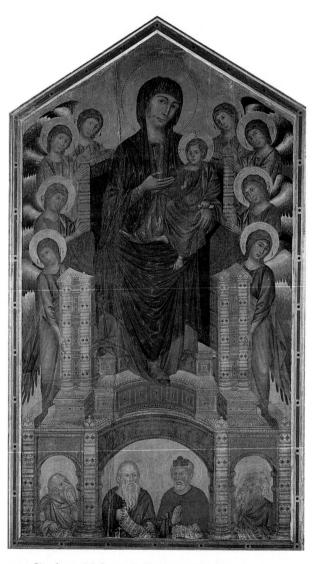

11.5 Cimabue. *Madonna Enthroned*, 1270–1285. Tempera on panel, $12'6'' \times 7'4''$ (3.81 × 2.24 m). Galleria degli Uffizi, Florence. Although much of the detail is Byzantine in inspiration, the scale of this painting has no Byzantine counterpart.

TABLE 11.1 *Siena in the Age of Duccio* (1255/1260–1318/1319)

Population	20,000
Political Institutions	Council of the Nine, rotating Con- sistory (Magistracy)
Economy	Banking, wool manufacture, jew- elry, and goldwork
Cultural Life	Painting (Duccio, Martini); Sculp- ture (della Quercia); <i>Laudi</i> , or sa- cred songs (Bianco da Siena); Theology (Saint Catherine)
Principal Buildings	Cathedral, Palazzo Pubblico (Town Hall)
Divine Protectress	The Virgin Mary, Queen of Siena

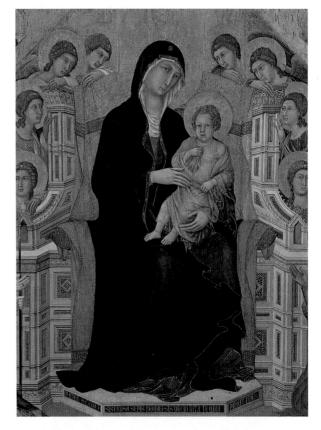

11.6 Duccio. *Madonna Enthroned*. Detail of front panel of *Maestà* Altar, c. 1308–1311. Tempera on panel. Height $6'10^{1}/_{2}''$ (2.1 m). Cathedral Museum, Siena. Note the greater gentleness of the faces and the softer, flowing robe of the Virgin here than in Cimabue's painting (Figure 11.5).

Giotto's Break with the Past

Great as Duccio's contribution was to the development of painting, it was achieved without any decisive break with the tradition in which he worked. Even if we can now see the roots of some of Giotto's achievements in the works of Cimabue, the boldness of his vision, and the certainty with which he communicates it to us, represent one of the supreme achievements of Western art.

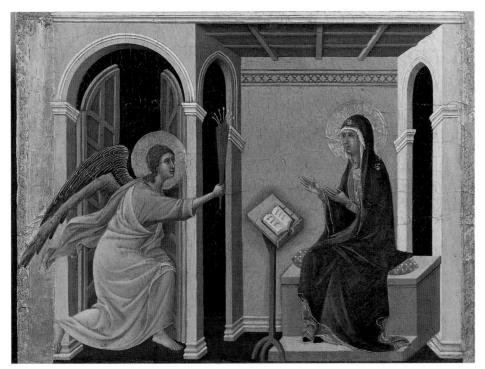

11.7 Duccio. *The Annunciation* of the Death of the Virgin, c. 1308–1311. Tempera on panel. From the Maestà Altar. Cathedral Museum, Siena. One of the episodes from the Maestà altarpiece, this scene demonstrates Duccio's ability to create a convincing architectural space around his figures.

Giotto's preeminent characteristic was his realism. The Byzantine style had aimed for a rich, glowing surface, with elaborate linear designs. Now for the first time figures were painted with a sense of depth, their volume represented by a careful use of light and dark, so that they took on the same strength and presence as works of sculpture. Instead of being confronted with an image, spectators saw the living and breathing figures before them. In his great altarpiece, Madonna Enthroned, painted in 1310, Giotto brings us into the presence of the Virgin herself [11.8]. We see the majestic solidity of her form, an impression enhanced by the realistic throne on which she sits. This is achieved not only by the three-dimensional modeling of the figures but also by the sense of space that surrounds the Virgin and child and separates them from the worshiping angels.

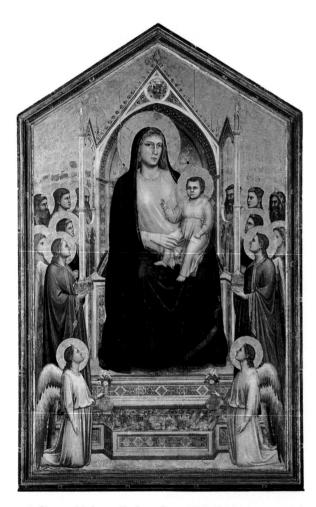

11.8 Giotto. *Madonna Enthroned*, c. 1310. Tempera on wood, $10'8'' \times 6'8''$ (3.25 × 2.03 m). Galleria degli Uffizi, Florence. Although contemporary with Duccio's Madonna from the *Maestà* altarpiece, Giotto's painting has a much greater sense of weight and volume.

But Giotto's greatness lay not so much in his ability to create realistic images-to "imitate Nature," as his contemporaries called it-as in using these images for dramatic effect. Rather than confining himself to single subjects in individual panel paintings, like that of the Madonna enthroned, he preferred to work on a more complex and monumental scale. His chief claim to fame is the great cycle of frescoes that fills the walls of the Arena Chapel in Padua. In these panels illustrating the lives of the Virgin and of Christ, Giotto used the new naturalistic style he had developed to express an almost inexhaustible range of emotions and dramatic situations. In the scene depicting the meeting of Joachim and Anna, the parents of the Virgin, the couple's deep affection is communicated to us with simplicity and humanity [11.9]. The quiet restraint of this episode is in strong contrast to the cosmic drama of the lamentation over the dead body of Christ [11.10]. Angels wheel overhead, screaming in grief, while below Mary supports her dead son and stares fiercely into his face. Around her are the other mourners, each a fully characterized individual. If the disciple John is the most passionate in the expression of his sorrow, as he flings his arms out, no less moving are the silent hunched figures in the foreground.

The Franciscans also engaged the talents of Giotto to pay honor to their patron, Francis of Assisi. While there is no scholarly consensus that Giotto painted the great cycle on the life of Francis once attributed to him in the upper basilica at Assisi (most scholars now attribute those works to an unknown artist called the "Master of the St. Francis Cycle"), there is no doubt that in the second decade of the fourteenth century he did the fresco cycle in the Bardi Chapel in the Church of Santa Croce in Florence.

Giotto

Giotto interpreted the deeds of Francis based on the life of the saint written by Saint Bonaventure (died 1274) who had been a contemporary of Thomas Aquinas. The narratives are not as simple as they first seem. The scene depicting Francis renouncing all of his earthly goods [11.11] shows a dramatic confrontation set before the palace of the local bishop. On the left is Pietro Bernadone holding the clothes of the saint who had stripped himself nude as a sign of renunciation. To the viewer's right is Bishop Guido, covering the nakedness of the saint with his episcopal cape (symbolizing his entry into the life of the church) while Francis assumes an attitude of prayer. Bonaventure's *Life* says that on that occasion Francis said, "Once I was called the son of Pietro Bernadone; now I say 'Our Father, who art in heaven'." Giotto frames

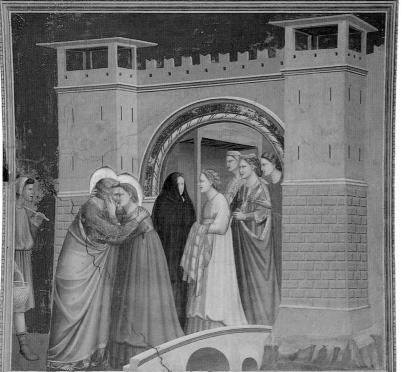

11.9 Giotto. *The Meeting of Joachim and Anna,* c. 1305. Fresco. Arena Chapel, Padua.

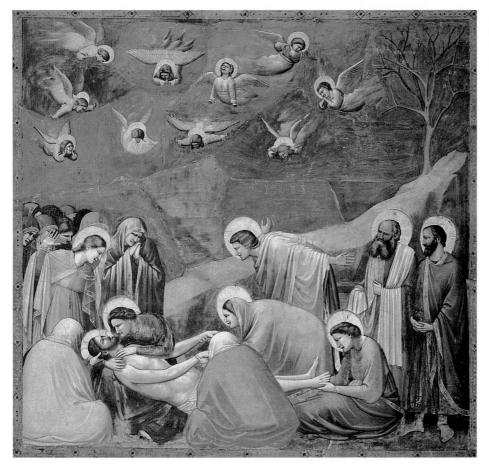

11.10 Giotto. The Lamentationover the Dead Christ, 1305.Fresco, $7'7'' \times 7'9''$ (2.31 \times 2.36 m). Arena Chapel,Padua, Italy.

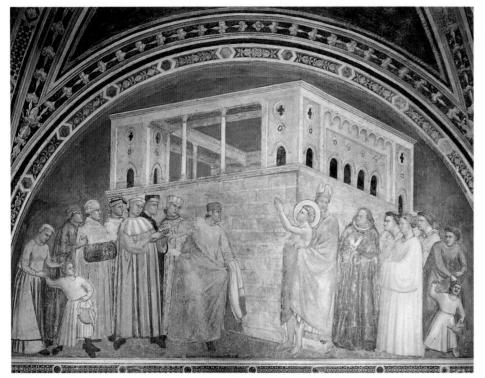

11.11 Giotto. *Saint Francis Renounces His Worldly Goods.* Santa Croce, Bardi Chapel in Florence, Scala.

this dramatic scene with children placed at opposite ends of the line of figures, reacting to the confrontation of father and son.

Painting in Siena

Giotto's appeal was direct and immediate, and at Florence his pupils and followers continued to work under his influence for most of the remainder of the fourteenth century, content to explore the implications of the master's ideas rather than devise new styles. As a result, the scene of the most interesting new developments in the generation after Giotto was Siena, where Duccio's influence (although considerable) was much less overpowering. Among Duccio's pupils was Simone Martini (c. 1285-1344), a close friend of Petrarch, who worked for a time at Naples for the French king Robert of Anjou and spent the last years of his life at the papal court of Avignon. In Martini's work we find the first signs of the last great development of Gothic art, the so-called International Style. The elegant courts of France and the French kingdoms of Italy had developed a taste for magnificent colors, fashionable costumes, and rich designs. Although Martini's Sienese background preserved him from the more extreme effects, his Annunciation has an insubstantial grace and sophistication that are in strong contrast to the solid realism of Giotto [11.12]. The resplendent robe and mantle of the angel Gabriel and the deep-blue dress of the Virgin, edged in gold, produce an impression of great splendor, while their willowy figures approach the ideal of courtly elegance.

If Simone Martini was willing to sacrifice naturalism to surface brilliance, two of his contemporaries in Siena were more interested in applying Giotto's discoveries to their own work. Pietro Lorenzetti was born around 1280, his brother Ambrogio around 1285; both probably died in 1348, the year of the Black Death. The younger brother's best-known work is a huge fresco that decorates an entire wall in Siena's city hall, the Palazzo Pubblico; it was painted between 1338 and 1339 and illustrates the effects of good government on the city of Siena and the surrounding countryside [11.13]. The streets and buildings, filled with scenes of daily life, are painted with elaborate perspective. Richly dressed merchants with their wives, craftsmen at work, and graceful girls who dance in the street preserve for us a vivid picture of a lifestyle that was to be abruptly ended by the Black Death. The scenes in the country, on the other hand, show a world that survives even today in rural Tuscany: peasants at work on farms and in orchards and vineyards [11.14].

ART IN NORTHERN EUROPE

By the middle of the fourteenth century the gulf between artists in Italy and those north of the Alps had been

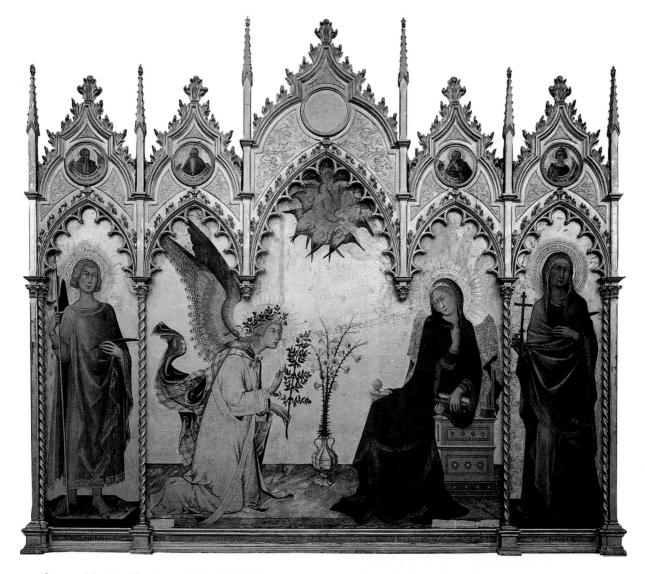

11.12 Simone Martini. *The Annunciation*, 1333. Tempera on wood, approx. $10'1'' \times 8'81'_2''$ (3.05×2.54 m). (Frame reconstructed in the nineteenth century.) Galleria degli Uffizi, Florence. The courtly elegance of the figures is in strong contrast to the massive realism of Giotto's Madonna (Figure 11.8).

reduced considerably. Painters like Simone Martini who carried the latest developments in Sienese art to France, were in turn influenced by styles they found there, and subsequently brought them back to Italy. The growing tendency toward a unity of artistic language throughout Western Europe was further increased by political developments. When, for example, in 1347 the city of Prague became the residence of Emperor Charles IV, it became a major art center rivaling even Paris in importance. Around 1360, an unknown Bohemian master working there painted a panel showing the death of the Virgin that combines the rich colors and careful architecture of Sienese painting with the strong emotional impact of

northern Gothic art [11.15]. By the end of the century it was no longer possible to identify an artist's origins from the work. The Wilton Diptych was painted in England sometime after 1377 [11.16]. One of the two panels shows the young King Richard II accompanied by his patron saints, while on the other the Virgin and child appear before the praying king, accompanied by eleven angels. They probably commemorate Richard's coronation in 1377, since he was eleven years old at the time. The wonderfully delicate yet rich colors and the careful use of shading have no parallel in English art of the period. The artist seems to have been familiar with the work of painters like Duccio and Simone Martini, but the elegance of the paintings and technique are neither simply Italian nor French. The painter of the Wilton Diptych was working in a style that can only be called International.

One of the first great centers of the International Style was the court of the Duke of Burgundy at Dijon, where sculptors like the Dutchman Claus Sluter and painters like the Flemish Melchior Broederlam served Duke

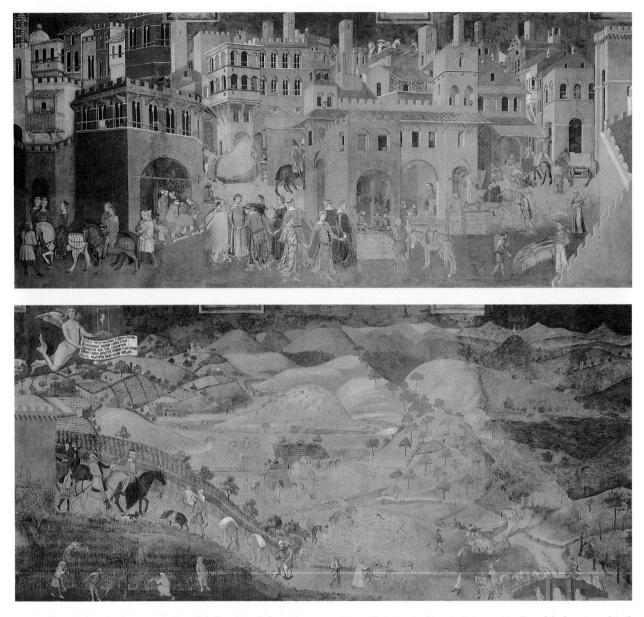

11.13 Top: Ambrogio Lorenzetti. *Peaceful City*. Detail from the fresco *Allegory of Good Government: The Effects of Good Government in the City and the Country*, 1337–1339. Sala della Pace, Palazzo Pubblico, Siena. Note the skillful use of perspective.

Philip the Bold, who ruled there from 1364 to 1404, and his brother John, Duc de Berry. Sluter (active about 1380–1406) was commissioned to provide sculpture for a monastery, the Chartreuse de Champmol, founded near Dijon by Duke Philip. His most impressive work there is the so-called *Well of Moses*, designed for the monastery's cloister [11.17]. Not really a well at all, it consists of an elaborate base surrounded by statues of Moses and five other Old Testament prophets on which originally stood a crucifixion, now missing. At first glance, the style of the figures is reminiscent of earlier Gothic statues, like those at Strasbourg; but a more careful look shows a host of

11.14 Bottom: Ambrogio Lorenzetti. Peaceful Country, detail from the fresco Allegory of Good Government: The Effects of Good Government in the City and the Country, 1337–1339. Sala della Pace, Palazzo Pubblico, Siena.

carefully depicted details. In the figure of Moses the textures of the heavy drapery, the soft beard, and the wrinkled face are differentiated skillfully, and the expression has the vividness of a portrait. Equally realistic is the sense of weight and mass of the body beneath the drapery.

Sluter's Well of Moses

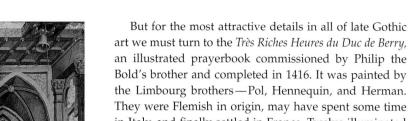

Bold's brother and completed in 1416. It was painted by the Limbourg brothers-Pol, Hennequin, and Herman. They were Flemish in origin, may have spent some time in Italy, and finally settled in France. Twelve illuminated pages are included in the book; these illustrate the twelve months of the year. These paintings are filled with an almost inexhaustible range of details that combine to depict the changing seasons of the year with poetry and humanity. On the page representing February the farmworkers warming themselves inside the cottage, and the sheep huddling together outside, attract our attention immediately, but the whole scene is filled with marvelously painted details, from the steamy breath of the girl on the far right, stumbling back through the snow toward a warm fireside, to the snow-laden roofs of the frozen village in the far distance [11.18]. In May we move

11.15 Unknown Bohemian Master, second quarter, fourteenth century. *Death of the Virgin.* Tempera on panel, $39^{3}/_{8}^{"} \times 28"$ (100 × 70 cm). Museum of Fine Arts, Boston (William Francis Warden Fund; Seth K. Sweetser Fund, The Henry C. and Martha B. Angell Collection, Juliana Cheney Edwards Collection, Gift of Martin Brimmer, and Gift of the Reverend and Mrs. Frederick Frottingham, by exchange).

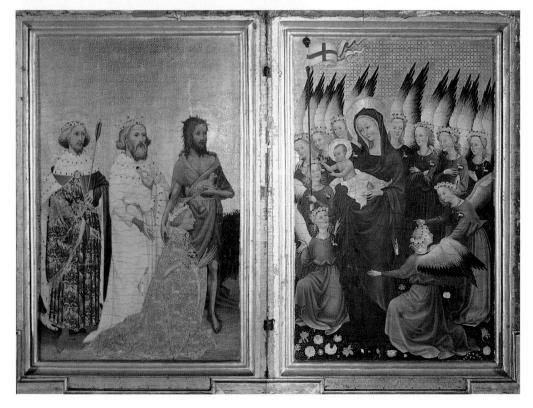

11.16 French School. *Richard II Presented to the Virgin and Child by His Patron Saints (Wilton Diptych)*, c. 1395. Oak panels, each $18'' \times 11^{1/2''}$ (46 × 29 cm). National Gallery, London (reproduced by courtesy of the Trustees).

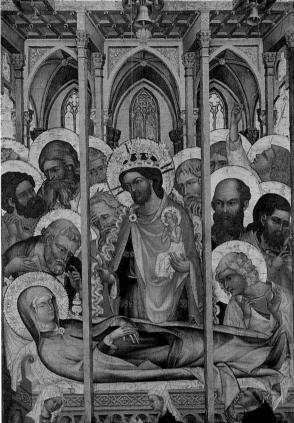

11.17 Claus Sluter. *The Well of Moses*, 1395–1406. Marble. Height of figures about 6' (1.83 m). Chartreuse de Champmol, Dijon. The horns represent rays of light (a usage based on a Bible mistranslation).

from the world of peasants to that of the aristocracy as a gorgeously dressed procession of lords and ladies rides out in the midst of the fresh greenery of springtime with the roof and turrets of a great castle in the background [11.19]. The sense of idleness and the delightful conceits of chivalry seem to evoke the world of Chaucer, while stylistically the sense of perspective and elegance of the figures is still another reminder of the influence of Sienese art.

Limbourg Brothers

LATE GOTHIC ARCHITECTURE

As in the case of painting and sculpture, the generally unified style of northern Gothic architecture never really crossed the Alps into Italy. Although some of the most important Italian buildings of the fourteenth century are generally labeled Gothic, their style is very different from that of their northern counterparts. Two of the century's greatest churches illustrate this, both begun in Florence at the end of the thirteenth century—Santa Croce around 1295 and the cathedral (better known by the Italian word for cathedral, *duomo*) in 1296. Neither has buttresses and in both most of the wall surface is solid rather than pierced with the typical Gothic windows. The duomo's most outstanding feature does not even date to the fourteenth century: Its magnificent dome was built by the great early Renaissance architect Filippo Brunelleschi between 1420 and 1436 [11.20].

More self-consciously Gothic is the duomo in Milan, begun in 1386, which perhaps makes one feel relieved that Italian architects in general avoided the chief features of northern Gothic style. The immensely elaborate façade, bristling with spires, and the crowded piers of the sides seem to be stuck on rather than integrated into the design. The presence of Classical elements in the dec-

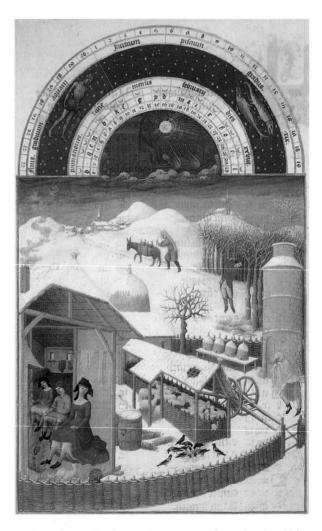

11.18 Limbourg Brothers. February page from the *Très Riches Heures du Duc de Berry*, 1416. Manuscript illumination, approx. $81/_2'' \times 53/_8''$ (22 × 14 cm). Musée Condé, Chantilly, France. The chart above the painting represents the signs of the zodiac for the month of February.

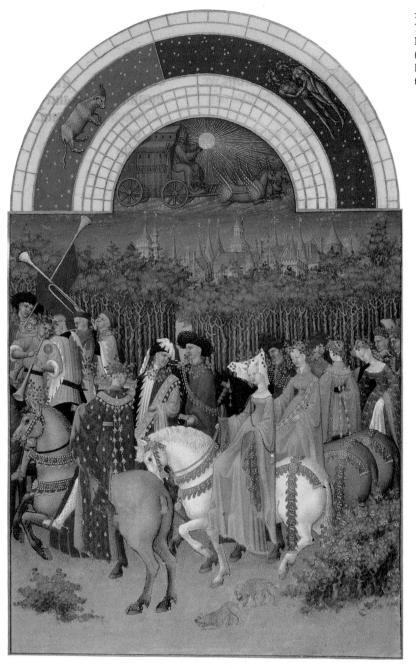

11.19 Limbourg Brothers. May page from the *Très Riches Heures du Duc de Berry*, 1413–1416. Manuscript illumination, approx. $8^{1}/_{2}^{"} \times 5^{3}/_{8}^{"}$ (22 × 14 cm). Musée Condé, Chantilly, France. The hunters blow their horns, but the courtiers are more interested in the ladies.

orations is a reminder that by the time the Milan Duomo was completed the Renaissance had dawned [11.21].

Far more attractive are the secular public buildings of the age. The town halls of Florence and Siena, the Palazzo Vecchio (begun 1298) and the Palazzo Pubblico (begun 1288), convey the sense of strong government and civic pride that characterized life in these cities during the Trecento [11.22]. The towers served the double purpose of providing a lookout over the city and surrounding countryside while they expressed the determination of the city rulers to resist attack. The most beautiful of all government centers is probably the Doge's Palace in Venice, a city where more than anywhere else Gothic architecture took on an almost magical quality of lightness and delicacy. The Doge's Palace (begun about 1345) is composed of a heavy upper story that seems to float on two arcades, the lower a short and sturdy colonnade and the upper composed of tall, slender columns. The effect is enhanced by the way in which the entire building seems suspended in space between sky and sea [11.23].

Doge's Palace, Venice

11.20 Florence Cathedral, Italy, 1296–1436 (view from the south).

11.21 Duomo, Milan. Begun 1386. The Classical moldings over the windows and doorways of the façade area are a reminder that the duomo was not completed until the Renaissance.

For a final look at late Gothic architecture at its most typical we must turn to England, where the style of this period is generally known as Perpendicular. The choir of Gloucester Cathedral, built between 1332 and 1357, illustrates the reason for the label [11.24]. The vertical line is emphasized, and our eyes are carried up to the roof, where a complex web of ribs decorate the vault. Unlike the ribs in earlier buildings, these serve no structural purpose but have become purely decorative. Their delicacy seems an apt reflection in stone of the graceful precision of the *Wilton Diptych* and the *Très Riches Heures*.

Gloucester Cathedral

MUSIC: ARS NOVA

While Giotto was laying the foundations for a new naturalistic style of painting, and writers like Petrarch and Chaucer were breathing fresh life into literary forms,

11.22 Palazzo Pubblico, Siena, Italy, 1288–1309. The slits around the base of the gallery at the top of the tower were used for firing through on attackers below.

11.23 Doge's Palace, Venice, 1345–1438. Unlike the heavily fortified Palazzo Pubblico at Siena, this palace of the rulers of Venice, with its light, open arches, reflects the stability and security of the Venetian Republic. composers in France and Italy were changing the style of music. To some extent this was the result of social changes. Musicians had begun to break away from their traditional role as servants of the church and to establish themselves as independent creative figures; most of the music that survives from the fourteenth century is secular. Much of it was written for singers and instrumentalists to perform at home for their own pleasure [11.25], or for the entertainment of aristocratic audiences like those depicted in the *Très Riches Heures*. The texts composers set to music were increasingly varied: ballads, love songs, even descriptions of contemporary events, in contrast to the religious settings of the preceding century.

As the number of persons who enjoyed listening to music and performing it began to grow, so did the range of musical expression. The term generally used to describe the sophisticated musical style of the fourteenth century is *ars nova*, derived from the title of a treatise written by the French composer Philippe de Vitry (1291–1361) around 1325. The work was written in Latin and called *Ars Nova Musicae* (*The New Art of Music*). Although it is really concerned with only one aspect of composition and describes a new system of rhythmic notation, ars nova has taken on a wider use and is applied to the new musical style that began to develop in France in the early fourteenth century and soon spread to Italy.

Its chief characteristic is a much greater richness and complexity of sound than before. This was partly achieved by the use of richer harmonies; thirds and sixths were increasingly employed and the austere

11.24 Choir, Gloucester Cathedral, 1332–1357. The strong vertical lines show why the style of such buildings is called Perpendicular.

sounds of parallel fifths, unisons, and octaves were generally avoided. Elaborate rhythmic devices were also introduced, including the method of construction called *isorhythm* (from the Greek word *isos*, which means "equal"). Isorhythm consisted of allotting to one of the voices in a polyphonic composition a repeated single melody. The voice was also assigned a repeating rhythmical pattern. Since the rhythmical pattern was of a different length from the melody, different notes would be stressed on each repetition. The purpose of this device was twofold: It created a richness and variety of texture, and imparted an element of unity to the piece.

The most famous French composer of this period was Guillaume de Machaut (1304?–1377), whose career spanned the worlds of traditional music and of the *Ars Nova*. He was trained as a priest and took holy orders, but much of his time was spent traveling throughout Europe in the service of the kings of Bohemia, Navarre, and France. Toward the end of his life he retired to Rheims, where he spent his last years as a canon. His most famous composition, and the most famous piece of music from the fourteenth century, is the *Messe de Notre Dame*. A four-part setting of the Ordinary of the Mass, it is remarkable chiefly for the way in which Machaut gives

11.25 A knight playing and singing to a lady, manuscript illumination of *Romance of the Rose*. Flemish, $14'' \times 10''$ (36 × 25 cm). British Library, London. The romantic interlude is enhanced by the idyllic surroundings: a walled garden with a fountain playing.

unity to the five sections that make up the work by creating a similarity of mood and even using a single musical motif that recurs throughout:

Guillaume de Machaut

Machaut's *Messe de Notre Dame* is the first great example of the entire Ordinary of the Mass set to polyphonic music by a single composer. The Ordinary of the Mass refers to those parts of the Roman Catholic liturgy that do not change from day to day in contrast to the Propers (the readings from the Gospel or Epistles), which do change daily. The parts of the Ordinary are:

- The *Kyrie Eleison:* the repeated Greek phrases that mean "Lord have mercy on us!" and "Christ have mercy on us!"
- 2. The *Gloria*: a hymn of praise sung at all masses except funerals and masses during Lent and Advent.
- 3. The *Credo:* the Profession of Faith sung after the Gospel.
- 4. The *Sanctus* and *Benedictus:* a short hymn based on the angelic praise found in Isaiah 6, sung at the beginning of the eucharistic prayer.
- 5. The *Agnus Dei*: the prayer that begins "Lamb of God," sung before Communion.

For a selection from *Messe de Notre Dame*, see the Listening CD.

Machaut's *Messe de Notre Dame*, then, stands at the head of a long tradition of musical composition in which composers use the Ordinary of the Mass to express in their own cultural idiom the timeless words of the liturgy. Machaut's Mass, in that sense, is the ancestor of the Renaissance compositions of Palestrina in the sixteenth century, the Baroque masses of Johann Sebastian Bach in the eighteenth century, and the frenetically eclectic modern *Mass* of Leonard Bernstein.

Machaut also contributed to another great musical tradition, that of secular song. With the increasing use of polyphony, composers began to turn their attention to the old troubadour songs and write new settings that combined several different voices. Machaut's polyphonic secular songs took a number of forms. His *ballades* were written for two or three voices, the top voice carrying the melody while the others provided the accompaniment. These lower voices were probably sometimes played on instruments rather than sung. As in the ballades of earlier times the poems consisted of three stanzas, each of seven or eight lines, the last one or two lines being identical in all the stanzas to provide a refrain.

Many of these secular songs, both by Machaut and by other composers, deal with amorous topics, and are often addressed to the singer's beloved. The themes are predictable—the sorrow of parting, as in Machaut's *Au départir de vous*, reproaches for infidelity, protestations of love, and so on—but the freshness of the melodies and Machaut's constant inventiveness prevent them from seeming artificial.

The other important composer of the fourteenth century was the Italian Francesco Landini (1325–1397), who lived and worked in Florence. Blinded in his youth by smallpox, he was famous in his day as a virtuoso performer on the organ, lute, and flute. Among his surviving works are a number of *madrigals*, a form of word setting involving two or three verses set to the same music and separated by a refrain set to different music. In addition, he wrote a large number of *ballate* ("ballads") including many for solo voice and two accompanying instruments. The vocal lines are often elaborate, and Landini makes use of rich, sonorous harmonies. But in the case of these and other works of the period, there is no specification of the instruments intended, or, indeed, of the general performance style Landini would have expected [11.26]. We know from contemporary accounts that in some cases performers would have changed the written notes by sharpening or flattening them, following the convention of the day. This practice of making sounds other than those on the page was called musica ficta ("fictitious music"), but no systematic description of the rules followed has been handed down to us. As a result, modern editors and performers often have only their own historical research and instincts to guide them. Although the Ars Nova of the fourteenth century marks a major development in the history of music, our knowledge of it is far from complete.

The fourteenth century was a time of stark contrast between the horrors of natural and social disasters and the flowering of artistic and cultural movements that were the harbingers of the fifteenth-century Renaissance in Italy.

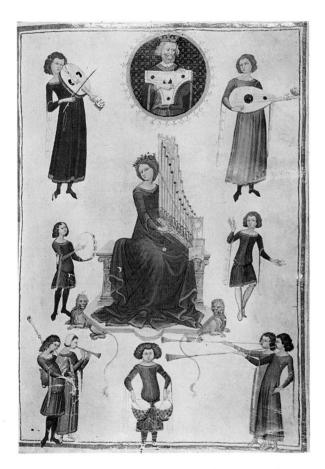

11.26 Music and musicians. Manuscript illumination illustrating a treatise, *De Musica*, fourteenth century. Biblioteca Nazionale, Naples. Some of the instruments of the time are shown. The goddess Music is at the center, playing a small organ. Grouped around her are musicians with stringed instruments, percussion, and wind instruments. The inset shows David, founder of church music, plucking a psaltery.

Chaucer, as noted, died in 1400, the year that may be taken as the close of the medieval period. By that time, some of the prime figures of the Italian Renaissance—Donatello, Fra Angelico, and Ghiberti—were already in their teens. The great outburst of cultural activity that was to mark Florence in the fifteenth century was near, even though it would not make a definite impact on England until the end of the century. The calamitous fourteenth century was a costly seedbed for rebirth and human renewal.

SUMMARY

The Transition from Medieval Culture to the Renaissance The fourteenth century marks the painful transition from the medieval period to the world of the Renaissance. Its beginning saw the construction of several major buildings in Italy, including Florence's duomo and Siena's Palazzo Pubblico, seat of city government. Music flourished throughout the century, especially in France, where Machaut was the leading composer of his day. In the years shortly after 1300, the new naturalistic style of Giotto revolutionized the art of painting, whereas the works of the Pisano family proved equally important for the history of sculpture. Yet the age was fraught with disaster and racked by war: the Hundred Years' War between France and England (1337-1453) was barely under way when in 1348 Europe was devastated by bubonic plague-the Black Death. Among the works of literature to reflect the effects of the terrible plague is Boccaccio's Decameron.

The Papacy in Avignon: Petrarch As the century began, the church appeared to be at the height of its influence. In 1300, Pope Boniface VIII proclaimed the first holy year, and pilgrims flocked to Rome. Yet within a few years the French had forced the transfer of the papacy to Avignon in Southern France. Among those who accompanied the papal court was the poet Petrarch, many of whose sonnets deal with his love for Laura, killed by the Black Death. The Babylonian Captivity lasted from 1309 to 1376, and the pope's return to Rome was embittered by the Great Schism, which saw the Western powers locked in a struggle to impose rival claimants.

The International Style One of the artistic consequences of the papal move from Rome was that Italian styles were carried north of the Alps. The resulting blend of Italian and Northern elements is called the International Style, which quickly spread throughout Europe; two of its main centers were at Prague and at Dijon. The more cosmopolitan spirit of the age is also illustrated by the career of the greatest English writer of the time, Chaucer, who traveled to Italy and to France and may have actually met Petrarch.

Social Protests In an age of such foment the pressure for reform intensified. In England, John Wyclif's charges

of church corruption heightened dissatisfaction among the lower classes, leading to the peasant riots of 1381. Similar popular protests against both the church and the aristocracy occurred in France in 1356, while in 1378 the poor woolen workers of Florence revolted against the city authorities. These manifestations of general discontent brought no immediate radical changes in government, but they did prepare the way for the social mobility of the Renaissance.

The Hundred Years' War The greatest struggle of the century, the Hundred Years' War, was supposedly fought over the right of succession to the French throne. In fact, its underlying cause was the commercial rivalry between France and England and the attempts of both countries to gain control of the wool-manufacturing region of Flanders. The war's early stages were marked by a series of English victories, culminating in the Battle of Poitiers (1356). By 1380, the French had reversed the tide, and the last years of the century saw inconclusive skirmishes, with both sides resigned to a stalemate.

Thus, a century in which political, economic, and religious strife and revolutionary artistic developments were accompanied by the disaster of plague produced deep changes in the fabric of European society and made possible the renewal of the Renaissance.

Pronunciation Guide

Arezzo: a-RET-so Avignon: AV-een-yon **Boccaccio: Bo-KACH-owe** Chaucer: CHAW-ser Cimabue: Chim-a-BOO-av Crécy: CRAY-see Duccio: DO-chee-owe duomo: DWO-mo Froissart: FRWAS-are Giotto: IOT-toe Guillaume Machaut: Ghee-OHM Mash-OWE Lorenzetti: Lo-ren-ZETT-i Maestà: Ma-ey-STAH Palazzo Vecchio: Pa-LAT-so VEK-ee-owe Petrarch: PET-rark **Pisano:** Pee-ZAN-owe **Poitiers:** PWAH-tee-av Santa Croce: SAN-ta CROW-chay schism: SISM Trecento: Tray-CHEN-toe Vasari: Vaz-ARE-ee

EXERCISES

1. Compare the literary achievements of Boccaccio and Petrarch. What light do they throw on the history of their times?

- 2. How does Chaucer characterize the participants in *The Canterbury Tales*? Select two and describe their chief features.
- 3. Describe Giotto's contribution to the history of painting and compare him to his predecessors.
- 4. What are the principal characteristics of Northern European art in the fourteenth century? How does it differ from Italian art?
- 5. How did musical styles change in the fourteenth century? Discuss the contribution of Guillaume Machaut.

Further Reading

- Allmand, C. T. (1988). The Hundred Years' War: England and France at war c. 1300-c. 1450. New York: Cambridge University Press. A concise introduction to the major conflict of the fourteenth century.
- Bynum, C. W. (1987). *Holy feast and holy fast: The religious significance of food to medieval women.* Berkeley: University of California Press. An engrossing study of medieval links between food and spirituality in women's lives.
- Duby, G. (Ed.). (1988). A history of private Life, volume II: Revelations of the medieval world. Cambridge, MA: Harvard University Press. Essays on various aspects of life in medieval times, showing the developing concepts of privacy and the individual.
- Gottfried, R. S. (1983). *The Black Death: Natural and human disaster in medieval Europe.* New York: Free Press. An important cultural study of the plague and its impact on late medieval culture.
- Howard, D. (1977). *The idea of* Canterbury Tales. Berkeley: University of California Press. An important study of the structure of Chaucer's greatest work.
- Kane, G. (1984). *Chaucer*. New York: Oxford University Press. A brief, well-written study; part of the "Past Masters" series.
- Martindale, A. (1966). *The complete paintings of Giotto*. New York: Abrams. After a brief introduction, the book offers a fully illustrated catalogue of Giotto's paintings with some excellent detail photographs.
- Meiss, M. (1964). *Painting in Florence and Siena after the Black Death.* New York: Harper & Row. A brilliant work of scholarship that treats "The arts, religion and society in the mid-Fourteenth Century."
- Pope-Hennessy, J. (1972). *Italian Gothic sculpture*. London: Phaidon. An excellent illustrated survey. The comprehensive bibliography is especially valuable.
- Stubblebine, J. (Ed.). (1969). The Arena Chapel frescoes. New York: Norton. An illustrated collection of essays on Giotto's frescoes.
- Tuchman, B. (1978). A distant mirror: The calamitous fourteenth century. New York: Knopf. A brilliant work by one of our best popular writers on history. The book focuses almost exclusively on France and as a result lacks some balance. A joy to read and very revealing nevertheless.
- White, J. (1966). Art and architecture in Italy 1250–1400. Baltimore, MD: Pelican. A useful single-volume survey, comprehensive yet detailed. Highly recommended.
- Wilkins, E. H. (1961). *Life of Petrarch*. Chicago: University of Chicago Press. An exemplary biography valuable for its discussion of Italy in the fourteenth century and Petrarch's relationship with such figures as Boccaccio, Giotto, Simone Martini, and Chaucer.

Online Chapter Links

The Decameron Web at

http://www.brown.edu/Departments/Italian_Studies/ dweb/dweb.shtml

provides valuable information about Boccacio's *Decameron*, the author, a beautiful image collection, historical background, links to related Internet sites, useful maps, and a bibliography.

The Canterbury Tales Project at

http://www.cta.dmu.ac.uk/projects/ctp/ provides a summary of textual research and links to related sites.

Women Writers of the Middle Ages at

http://www.millersv.edu/~english/homepage/duncan/ medfem/medfem.html

offers an extensive list of links to valuable Web sites—art, literature, domestic life, warfare, law, politics, music, and philosophy.

An extensive Giotto biography and links to numerous related sites, including many of his bestknown works of art, are found at http://www.christusrex.org/wwwl/francis/

Many of Giotto's best known and most beautiful frescoes are available at

http://www.kfki.hu/~arthp/html/g/giotto/padova/ index.html (the Arena Chapel, Padua) http://www.kfki.hu/~arthp/html/g/giotto/s_croce/bardi/

index.html (the Bardi Chapel, Florence)

Beautiful graphics and informative text related to the Limbourg Brothers and *Les Très Riches Heures du Duc de Berry* are available at

http://christusrex.org/www2/berry/index.html

For introductory information about Gothic art as well as links to sites related to representative artists, consult *Artcyclopedia*

http://www.artcyclopedia.com/history/gothic.html

For a catalog of useful links to Internet resources, consult *Medieval Music Links*

http://classicalmus.hispeed.com/medieval.html

Karadar Classical Music at

http://www.karadar.it/Dictionary/Default.htm provides an alphabetical listing of musicians with brief biographies and a list of works (some of which are available on MIDI files).

Online Chapter Resources

Reading Selections

GIOVANNI BOCCACCIO from the Decameron

Preface to the Ladies

This selection is the prologue to the hundred tales that make up the Decameron. It reflects not only the experience of the writer who lived through the terrible plague year of 1348 but also his reflections on the effects of this terrible plague on both the minds of the population and the structures of society. Boccaccio senses the tendency of some to "let go" in the face of death by seizing whatever pleasures are available while others turn to God for mercy and relief from the scourge of sickness. Furthermore, he details how the very whisper of plague destroyed public order and familial bonds. In our own century the French writer Albert Camus would use a plague setting as a symbol of the Nazi occupation of France to depict the reactions of people faced with extreme social conditions—conditions that call forth both cowardice and heroism and much in between.

How many times, most gracious ladies, have I considered in my innermost thoughts how full of pity you all are by nature. As often as I have thought this, I recognized that this present work will have in your judgment a depressing and unpleasant beginning. For it bears in its initial pages a disheartening remembrance of the past mortal pestilence, which was irksome and painful to all who saw it or otherwise knew it. But I do not wish that this should frighten you from going further, as if your reading will continuously carry you through sighs and tears. Let this horrid beginning be to you not otherwise than a rugged and steep mountain to travelers, next to which lies a lovely and delightful plain. The plain is all the more pleasing to them, in proportion to the great difficulties of climbing and descending. For just as sorrow dims our extreme happiness, so miseries are ended by supervening joy. To this brief unpleasantness (I say brief since it is contained in few words) there shall at once follow sweetness and delight. I have promised it to you in advance; for it might not have been expected from such a beginning, if it hadn't been told you. In truth, if I could have in honesty led you where I want by a way other than a path as rough as this, I would willingly have done so. But without this recollection I could not have shown you the reason why the things took place, of which you soon will be reading. Thus even, strained, as if by necessity, I brought myself to write of them.

I say, then, that it was the year of the bountiful Incarnation of the Son of God, 1348. The mortal pestilence then arrived in the excellent city of Florence, which surpasses every other Italian city in nobility. Whether through the operations of the heavenly bodies, or sent upon us mortals through our wicked deeds by the just wrath of God for our correction, the plague had begun some years before in Eastern countries. It carried off uncounted numbers of inhabitants, and kept moving without cease from place to place. It spread in piteous fashion towards the West. No wisdom of human foresight worked against it. The city had been cleaned of much filth by officials delegated to the task. Sick persons were forbidden entrance, and many laws were passed for the safeguarding of health. Devout persons made to God not just modest supplications and not just once, but many, both in ordered processions and in other ways. Almost at the beginning of the spring of that year, the plague horribly began to reveal, in astounding fashion, its painful effects.

It did not work as it had in the East, where anyone who bled from the nose had a manifest sign of inevitable death. But in its early stages both men, and women too, acquired certain swellings either in the groin or under the armpits. Some of these swellings reached the size of a common apple, and others were as big as an egg, some more and some less. The common people called them plague-boils. From these two parts of the body, the deadly swellings began in a short time to appear and to reach indifferently every part of the body. Then, the appearance of the disease began to change into black or livid blotches, which showed up in many on the arms or thighs and in every other part of the body. On some they were large and few, on others small and numerous. And just as the swellings had been at first and still were an infallible indication of approaching death, so also were these blotches to whomever they touched. In the cure of these illnesses, neither the advice of a doctor nor the power of any medicine appeared to help and to do any good. Perhaps the nature of the malady did not allow it; perhaps the ignorance of the physicians (of whom, besides those trained, the number had grown very large both of women and of men who were completely without medical instruction) did not know whence it arose, and consequently did not take required action against it. Not only did very few recover, but almost everyone died within the third day from the appearance of these symptoms, some sooner and some later, and most without any fever or other complication. This plague was of greater virulence, because by contact with those sick from it, it infected the healthy, not otherwise than fire does, when it is brought very close to dry or oily material.

The evil was still greater than this. Not only conversation and contact with the sick carried the illness to the healthy and was cause of their common death. But even to handle the clothing or other things touched or used by the sick seemed to carry with it that same disease for those who came into contact with them. You will be amazed to hear what I now must tell you. If the eyes of many, including my own, had not seen it, I would hardly dare to believe it, much less to write it, even if I had heard it from a person worthy of faith. I say that the character of the pestilence we describe was of such virulence in spreading from one person to another, that not only did it go from man to man, but many times it also apparently did the following, which is even more remarkable. If an animal outside the human species contacted the belongings of a man sick or dead of this illness, it not only caught the disease, but within a brief time was killed by it. My own eyes, as I said a little while ago, saw one day (and other times besides) this occurrence. The rags of a poor man dead from this disease had been thrown in a public street. Two pigs came to them and they, in their accustomed manner, first rooted among them with their snouts, and then seized them with their teeth and tossed them about with their jaws. A short hour later, after some staggering, as if the poison was taking effect, both of them fell dead to earth upon the rags which they had unhappily dragged.

Such events and many others similar to them or even worse conjured up in those who remained healthy diverse fears and imaginings. Almost all were inclined to a very cruel purpose, that is, to shun and to flee the sick and their belongings. By so behaving, each believed that he would gain safety for himself. Some persons advised that a moderate manner of living, and the avoidance of all excesses, greatly strengthened resistance to this danger. Seeking out companions, such persons lived apart from other men. They closed and locked themselves in those houses where no sick person was found. To live better, they consumed in modest quantities the most delicate foods and the best wines, and avoided all sexual activity. They did not let themselves speak to anyone, nor did they wish to hear any news from the outside, concerning death or the sick. They lived amid music and those pleasures which they were able to obtain.

Others were of a contrary opinion. They affirmed that heavy drinking and enjoyment, making the rounds with singing and good cheer, the satisfaction of the appetite with everything one could and the laughing and joking which derived from this, were the most effective medicine for this great evil. As they recommended, so they put into practice, according to their ability. Night and day, they went now to that tavern and now to another, drinking without moderation or measure. They did even more in the houses of others; they had only to discern there things which were to their liking or pleasure. This they could easily do, since everyone, as if he was destined to live no more, had abandoned all care of his possessions and of himself. Thus, most houses had become open to all, and strangers used them as they happened upon them, as their proper owner might have done. With this inhuman intent, they continuously avoided the sick with all their power.

In this great affliction and misery of our city, the revered authority of both divine and human laws was left to fall and decay by those who administered and executed them. They too, just as other men, were all either dead or sick or so destitute of their families, that they were unable to fulfill any office. As a result everyone could do just as he pleased.

Many others held a middle course between the two mentioned above. Not restraining themselves in their diet as much as the first group, nor letting themselves go in drinking and other excesses as the second, they satisfied their appetites sufficiently. They did not go into seclusion but went about carrying flowers, fragrant herbs and various spices which they often held to their noses, believing it good to comfort the brain with such odors since the air was heavy with the stench of dead bodies, illness and pungent medicines. Others had harsher but perhaps safer ideas. They said that against plagues no medicine was better than or even equal to simple flight. Moved by this reasoning and giving heed to nothing but themselves, many men and women abandoned their own city, their houses and homes, their relatives and belongings in search of their own country places or those of others. Just as if the wrath of God, in order to punish the iniquity of men with the plague, could not pursue them, but would only oppress those within city walls! They were apparently convinced that no one should remain in the city, and that its last hour had struck.

Although these people of various opinions did not all die, neither did they all live. In fact many in each group and in every place became ill, but having given example to those who were still well, they in turn were abandoned and left to perish.

We have said enough of these facts: that one townsman shuns another; that almost no one cares for his neighbor; that relatives rarely or never exchange visits, and never do they get too close. The calamity had instilled such terror in the hearts of men and women that brother abandoned brother, uncle nephew, brother sister, and often wives left their husbands. Even more extraordinary, unbelievable even, fathers and mothers shunned their children, neither visiting them nor helping them, as though they were not their very own.

Consequently, for the enormous number of men and women who became ill, there was no aid except the charity of friends, who were few indeed, or the avarice of servants attracted by huge and exorbitant stipends. Even so, there weren't many servants, and those few men and women were of unrefined capabilities, doing little more than to hand the sick the articles they requested and to mark their death. Serving in such a capacity, many perished along with their earnings. From this abandonment of the sick by neighbors, relatives and friends and from the scarcity of servants arose an almost unheard-of custom. Once she became ill, no woman, however attractive, lovely or well-born, minded having as her servant a man, young or old. To him without any shame she exhibited any part of her body as sickness required, as if to another woman. This explains why those who were cured were less modest than formerly. A further consequence is that many died for want of help who might still be living. The fact that the ill could not avail themselves of services as well as the virulence of the plague account for the multitude who died in the city by day and by night. It was dreadful to hear tell of it, and likewise to see it. Out of necessity, therefore, there were born among the survivors customs contrary to the old ways of the townspeople.

It used to be the custom, as it is today, for the female relative and neighbors of the dead man to gather together with those close to him in order to mourn. Outside the house of the dead man his friends, neighbors and many others would assemble. Then, according to the status of the deceased, a priest would come with the funeral pomp of candles and chants, while the dead man was borne on the shoulders of his peers to the church chosen before death. As the ferocity of the plague increased, such customs ceased either totally or in part, and new ones took their place. Instead of dying amidst a crowd of women, many left this life without a single witness. Indeed, few were conceded the mournful wails and bitter tears of loved ones. Instead, quips and merrymaking were common and even normally compassionate women had learned well such habits for the sake of their health. Few bodies had more than ten or twelve neighbors to accompany them to church, and even those were not upright citizens, but a species of vulture sprung from the lowly who called themselves "grave-diggers," and sold their services. They shouldered the bier and with hurried steps went not to the church designated by the deceased, but more often than not to the nearest church. Ahead were four or six clerics with little light or sometimes none, who with the help of the grave-diggers placed the dead in the nearest open grave without straining themselves with too long or solemn a service.

Much more wretched was the condition of the poor people and even perhaps of the middle class in large part. Because of hope or poverty, these people were confined to their houses. Thus keeping to their quarters, thousands fell ill daily and died without aid or help of any kind, almost without exception. Many perished on the public streets by day or by night, and many more ended their days at home, where the stench of their rotting bodies first notified their neighbors of their death. With these and others dying all about, the city was full of corpses. Now a general procedure was followed more out of fear of contagion than because of pity felt for the dead. Alone or with the help of whatever bearers they could find, they dragged the corpses from their houses and piled them in front so, particularly in the morning, anyone abroad could see countless bodies. Biers were sent for and when they were lacking, ordinary planks carried the bodies. It was not an isolated bier which carried two or three together. This happened not just once, but many biers could be counted which held in fact a wife and husband, two or three brothers, or father and son. Countless times, it happened that two priests going forth with a cross to bury someone were joined by three or four biers carried behind by bearers, so that whereas the priests thought they had one corpse to bury, they found themselves with six, eight or even more. Nor were these dead honored with tears, candles or mourners. It had come to such a pass that men who died were shown no more concern than dead goats today.

All of this clearly demonstrated that although the natural course of events with its small and occasional stings had failed to impress the wise to bear such trials with patience, the very magnitude of this now had forced even the simple people to become indifferent to them. Every hour of every day there was such a rush to carry the huge number of corpses that there was not enough blessed burial ground, especially with the usual custom of giving each body its own place. So when the ground was filled, they made huge trenches in every churchyard, in which they stacked hundreds of bodies in layers like goods stowed in the hold of a ship, covering them with a bit of earth until the bodies reached the very top.

And so I won't go on searching out every detail of our city's miseries, but while such hard times prevailed, the surrounding countryside was spared nothing. There, in the scattered villages (not to speak of the castles which were like miniature cities) and across the fields, the wretched and impoverished peasants and their families died without any medical aid or help from servants, not like men but like beasts, on the roads, on their farms, and about the houses by day and by night. For this reason, just like the townspeople, they became lax in their ways and neglected their chores as if they expected death that very day. They became positively ingenious, not in producing future yields of crops and beasts, but in ways of consuming what they already possessed. Thus, the oxen, the asses, sheep, goats, pigs and fowl and even the dogs so faithful to man, were driven from the houses, and roamed through the fields where the abandoned wheat grew uncut and unharvested. Almost as if they were rational, many animals having eaten well by day returned filled at night to their houses without any shepherding.

To leave the countryside and to return to the city, what more could be said? Such was heaven's cruelty (and perhaps also man's) that between March and the following July, the raging plague and the absence of help given the sick by the fearful healthy ones took from this life more than one hundred thousand human beings within the walls of Florence. Who would have thought before this deadly calamity that the city had held so many inhabitants? Oh, how many great palaces, how many lovely houses, how many rich mansions once filled with families of lords and ladies remained empty even to the lowliest servant! Alas! How many memorable families, how many ample heritages, how many famous fortunes remained without a lawful heir! What number of brave and beautiful ladies, lively youths, whom not only others, but Galen, Hippocrates, and Aesculapius themselves would have pronounced in the best of health, breakfasted in the morning with their relatives, companions and friends, only to dine that very night with their ancestors in the other world!

GEOFFREY CHAUCER

from The Canterbury Tales

Two extensive selections from The Canterbury Tales appear here. The General Prologue, reprinted in its entirety, should be read both for the sheer poetry of Chaucer's characterizations and for its careful descriptions of the various individuals in medieval society who make up the pilgrimage groups. Pay particular attention to the economy with which Chaucer sketches a personality. One way to do that is to ask what particulars the author notices to give us an image of a person. For example, what physical characteristics of the Pardoner make us say, almost instinctively, that here is a person about whom the author holds very negative feelings?

The Prologue of the Wife of Bath's Tale is interesting for its lengthy discussion about the place of women in medieval society. The Wife of Bath mounts a sustained argument against male chauvinism and the misogyny that pervaded medieval life.

General Prologue

Here begins the Book of the Tales of Canterbury When the sweet showers of April have pierced The drought of March, and pierced it to the root, And every vein is bathed in that moisture Whose quickening force will engender the flower: And when the west wind too with its sweet breath Has given life in every wood and field To tender shoots, and when the stripling sun Has run his half-course in Aries, the Ram, And when small birds are making melodies, That sleep all the night long with open eyes, (Nature so prompts them, and encourages); Then people long to go on pilgrimages, And palmers to take ship for foreign shores, And distant shrines, famous in different lands; And most especially, from all the shires Of England, to Canterbury they come, The holy blessed martyr there to seek, Who gave his help to them when they were sick.

It happened at this season, that one day In Southwark at the Tabard where I stayed Ready to set out on my pilgrimage To Canterbury, and pay devout homage, There came at nightfall to the hostelry Some nine-and-twenty in a company, Folk of all kinds, met in accidental Companionship, for they were pilgrims all; It was to Canterbury that they rode. The bedrooms and the stables were good-sized, The comforts offered us were of the best. And by the time the sun had gone to rest I'd talked with everyone, and soon became One of their company, and promised them To rise at dawn next day to take the road For the journey I am telling you about.

But, before I go further with this tale, And while I can, it seems reasonable That I should let you have a full description Of each of them, their sort and condition, At any rate as they appeared to me; Tell who they were, their status and profession, What they looked like, what kind of clothes they dressed in;

And with a knight, then, I shall first begin. There was a knight, a reputable man,

Who from the moment that he first began Campaigning, had cherished the profession 20

30

Of arms: he also prized trustworthiness, Liberality, fame, and courteousness. In the king's service he'd fought valiantly, And traveled far; no man as far as he In Christian and in heathen lands as well, And ever honored for his ability. He was at Alexandria when it fell, Often he took the highest place at table Over the other foreign knights in Prussia; He'd raided in Lithuania and Russia, No Christian of his rank fought there more often. Also he'd been in Granada, at the siege Of Algeciras; forayed in Benmarin; At Ayas and Adalia he had been When they were taken; and with the great hosts Freebooting on the Mediterranean coasts; Fought fifteen mortal combats; thrice as champion In tournaments, he at Tramassene Fought for our faith, and each time killed his man. This worthy knight had also, for a time, Taken service in Palatia for the Bey, Against another heathen in Turkey; And almost beyond price was his prestige. Though eminent, he was prudent and sage, And in his bearing mild as any maid. He'd never been foul-spoken in his life To any kind of man; he was indeed The very pattern of a noble knight. But as for his appearance and outfit, He had good horses, yet was far from smart. He wore a tunic made of coarse thick stuff, Marked by his chainmail, all begrimed with rust, Having just returned from an expedition, And on his pilgrimage of thanksgiving.

With him there was his son, a young squire, A lively knight-apprentice, and a lover, With hair as curly as if newly waved; I took him to be twenty years of age. In stature he was of an average length, Wonderfully athletic, and of great strength. He'd taken part in cavalry forays In Flanders, in Artois, and Picardy, With credit, though no more than a novice, Hoping to stand well in his lady's eyes. His clothes were all embroidered like a field Full of the freshest flowers, white and red. He sang, or played the flute, the livelong day, And he was fresher than the month of May. Short was his gown, with sleeves cut long and wide. He'd a good seat on horseback, and could ride, Make music too, and songs to go with it; Could joust and dance, and also draw and write. So burningly he loved, that come nightfall He'd sleep no more than any nightingale. Polite, modest, willing to serve, and able, He carved before his father at their table.

The knight had just one servant, a yeoman, For so he wished to ride, on this occasion. The man was clad in coat and hood of green. He carried under his belt, handily, For he looked to his gear in yeoman fashion, A sheaf of peacock arrows, sharp and shining, Not liable to fall short from poor feathering; And in his hand he bore a mighty bow. He had a cropped head, and his face was brown; Of woodcraft he knew all there was to know. 50

60

70

80

90

100

110

He wore a fancy leather guard, a bracer, And by his side a sword and a rough buckler, And on the other side a fancy dagger, Well-mounted, sharper than the point of spear, And on his breast a medal: St Christopher, The woodman's patron saint, in polished silver. He bore a horn slung from a cord of green, And my guess is, he was a forester.

There was also a nun, a prioress, Whose smile was unaffected and demure; Her greatest oath was just, 'By St Eloi!' And she was known as Madame Eglantine. She sang the divine service prettily, And through the nose, becomingly intoned; And she spoke French well and elegantly As she'd been taught it at Stratford-at-Bow, For French of Paris was to her unknown. Good table manners she had learnt as well: She never let a crumb from her mouth fall; She never soiled her fingers, dipping deep Into the sauce: when lifting to her lips Some morsel, she was careful not to spill So much as one small drop upon her breast. Her greatest pleasure was in etiquette. She used to wipe her upper lip so clean, No print of grease inside her cup was seen, Not the least speck, when she had drunk from it. Most daintily she'd reach for what she ate. No question, she possessed the greatest charm, Her demeanor was so pleasant, and so warm; Though at pains to ape the manners of the court, And be dignified, in order to be thought A person well deserving of esteem. But, speaking of her sensibility, She was so full of charity and pity That if she saw a mouse caught in a trap, And it was dead or bleeding, she would weep. She kept some little dogs, and these she fed On roast meat, or on milk and fine white bread. But how she'd weep if one of them were dead, Or if somebody took a stick to it! She was all sensitivity and tender heart. Her veil was pleated most becomingly; Her nose well-shaped; eyes blue-grey, of great beauty; And her mouth tender, very small, and red. And there's no doubt she had a fine forehead, Almost a span in breadth, I'd swear it was, For certainly she was not undersized. Her cloak, I noticed, was most elegant. A coral rosary with gauds of green She carried on her arm; and from it hung A brooch of shining gold; inscribed thereon Was, first of all, a crowned 'A,' And under, Amor vincit omnia. With her were three priests, and another nun, Who was her chaplain and companion.

There was a monk; a nonpareil was he, Who rode, as steward of his monastery, The country round; a lover of good sport, A manly man, and fit to be an abbot. He'd plenty of good horses in his stable, And when he went out riding, you could hear His bridle jingle in the wind, as clear And loud as the monastery chapel-bell. Inasmuch as he was keeper of the cell, The rule of St Maurus or St Benedict 120

130

140

160

150

180

190

200

210

220

Being out of date, and also somewhat strict, This monk I speak of let old precepts slide, And took the modern practice as his guide. He didn't give so much as a plucked hen For the maxim, 'Hunters are not pious men,' Or 'A monk who's heedless of his regimen Is much the same as a fish out of water,' In other words, a monk out of his cloister. But that's a text he thought not worth an oyster; And I remarked his opinion was sound. What use to study, why go round the bend With poring over some book in a cloister, Or drudging with his hands, to toil and labor As Augustine bids? How shall the world go on? You can go keep your labor, Augustine! So he rode hard-no question about that-Kept greyhounds swifter than a bird in flight. Hard riding, and the hunting of the hare, Were what he loved, and opened his purse for. I noticed that his sleeves were edged and trimmed With squirrel fur, the finest in the land. For fastening his hood beneath his chin, He wore an elaborate golden pin, Twined with a love-knot at the larger end. His head was bald and glistening like glass As if anointed; and likewise his face. A fine fat patrician, in prime condition, His bright and restless eyes danced in his head, And sparkled like the fire beneath a pot; Boots of soft leather, horse in perfect trim: No question but he was a fine prelate! Not pale and wan like some tormented spirit. A fat roast swan was what he loved the best. His saddle-horse was brown as any berry.

There was a begging friar, a genial merry Limiter, and a most imposing person. In all of the four Orders there was none So versed in small talk and in flattery: And many was the marriage in a hurry He'd had to improvise and even pay for. He was a noble pillar of his Order, And was well in and intimate with every Well-to-do freeman farmer of his area, And with the well-off women in the town; For he was qualified to hear confession, And absolve graver sins than a curate, Or so he said; he was a licentiate. How sweetly he would hear confession! How pleasant was his absolution! He was an easy man in giving shrift, When sure of getting a substantial gift: For, as he used to say, generous giving To a poor Order is a sign you're shriven; For if you gave, then he could vouch for it That you were conscience-stricken and contrite; For many are so hardened in their hearts They cannot weep, though burning with remorse. Therefore, instead of weeping and prayers, They should give money to the needy friars. The pockets of his hood were stuffed with knives And pins to give away to pretty wives. He had a pleasant singing voice, for sure, Could sing and play the fiddle beautifully; He took the biscuit as a ballad-singer, And though his neck was whiter than a lily, Yet he was brawny as a prize-fighter. He knew the taverns well in every town,

And all the barmaids and the innkeepers, Better than lepers or the street-beggars; It wouldn't do, for one in his position, One of his ability and distinction, To hold acquaintance with diseased lepers. It isn't seemly, and it gets you nowhere, To have any dealings with that sort of trash, Stick to provision-merchants and the rich! And anywhere where profit might arise He'd crawl with courteous offers of service. You'd nowhere find an abler man than he, Or a better beggar in his friary; He paid a yearly fee for his district, No brother friar trespassed on his beat. A widow might not even own a shoe, But so pleasant was his In principio He'd win her farthing in the end, then go. He made his biggest profits on the side. He'd frolic like a puppy. He'd give aid As arbitrator upon settling-days, For there he was not like some cloisterer With threadbare cape, like any poor scholar, But like a Master of Arts, or the Pope! Of the best double-worsted was his cloak,

And bulging like a bell that's newly cast. He lisped a little, from affectation, To make his English sweet upon his tongue; And when he harped, as closing to a song, His eyes would twinkle in his head just like The stars upon a sharp and frosty night. This worthy limiter was called Hubert.

A merchant was there, on a high-saddled horse: He'd a forked beard, a many-colored dress, And on his head a Flanders beaver hat, Boots with expensive clasps, and buckled neatly. He gave out his opinions pompously, Kept talking of the profits that he'd made, How, at all costs, the sea should be policed From Middleburg in Holland to Harwich. At money-changing he was an expert; He dealt in French gold florins on the quiet. This worthy citizen could use his head: No one could tell whether he was in debt, So impressive and dignified his bearing As he went about his loans and bargaining. He was a really estimable man. But the fact is I never learnt his name. There was a scholar from Oxford as well, Not yet an MA, reading Logic still; The horse he rode was leaner than a rake, And he himself, believe me, none too fat, But hollow-cheeked, and grave and serious.

230 Threadbare indeed was his short overcoat: A man too unworldly for lay office, Yet he'd not got himself a benefice. For he'd much rather have at his bedside A library, bound in black calf or red, Of Aristotle and his philosophy, Than rich apparel, fiddle, or fine psaltery. And though he was a man of science, yet He had but little gold in his strongbox; But upon books and learning he would spend All he was able to obtain from friends; 240 He'd pray assiduously for their souls, Who gave him wherewith to attend the schools. Learning was all he cared for or would heed. He never spoke a word more than was need,

250

260

270

290

300

And that was said in form and decorum, And brief and terse, and full of deepest meaning. Moral virtue was reflected in his speech, And gladly would he learn, and gladly teach.

There was a wise and wary sergeant-at-law, A well-known figure in the portico Where lawyers meet; one of great excellence, Judicious, worthy of reverence, Or so he seemed, his sayings were so wise. He'd often acted as Judge of Assize By the king's letters patent, authorized To hear all cases. And his great renown And skill had won him many a fee, or gown Given in lieu of money. There was none To touch him as a property-buyer; all He bought was fee-simple, without entail; You'd never find a flaw in the conveyance. And nowhere would you find a busier man; And yet he seemed much busier than he was. From yearbooks he could quote, chapter and verse, Each case and judgement since William the First. And he knew how to draw up and compose A deed; you couldn't fault a thing he wrote; And he'd reel all the statutes off by rote. He was dressed simply, in a colored coat, Girt by a silk belt with thin metal bands. I have no more to tell of his appearance.

A franklin—that's country gentleman And freeman landowner-was his companion. White was his beard, as white as any daisy; Sanguine his temperament; his face ruddy. He loved his morning draught of sops-in-wine, Since living well was ever his custom, For he was Epicurus' own true son And held with him that sensuality Is where the only happiness is found. And he kept open house so lavishly He was St Julian to the country round, The patron saint of hospitality. His bread and ale were always of the best, Like his wine-cellar, which was unsurpassed. Cooked food was never lacking in his house, Both meat and fish, and that so plenteous That in his home it snowed with food and drink, And all the delicacies you could think. According to the season of the year, He changed the dishes that were served at dinner. He'd plenty of fat partridges in coop, And keep his fishpond full of pike and carp. His cook would catch it if his sauces weren't Piquant and sharp, and all his equipment To hand. And all day in his hall there stood The great fixed table, with the places laid. When the justices met, he'd take the chair; He often served as MP for the shire. A dagger, and a small purse made of silk, Hung at his girdle, white as morning milk. He'd been sheriff, and county auditor: A model squireen, no man worthier. A haberdasher and a carpenter,

A naberdasher and a carpenter, A weaver, dyer, tapestry-maker — And they were in the uniform livery Of a dignified and rich fraternity, A parish-guild: their gear all trim and fresh, Knives silver-mounted, none of your cheap brass; Their belts and purses neatly stitched as well, All finely finished to the last detail. Each of them looked indeed like a burgess, And fit to sit on any guildhall dais. Each was, in knowledge and ability, Eligible to be an alderman; For they'd income enough and property. What's more, their wives would certainly agree, Or otherwise they'd surely be to blame— It's very pleasant to be called 'Madam' And to take precedence at church processions, And have one's mantle carried like a queen's.

320

330

340

350

360

370

They had a cook with them for the occasion, To boil the chickens up with marrowbones, Tart powdered flavouring, spiced with galingale. No better judge than he of London ale. And he could roast, and seethe, and boil, and fry, Make a thick soup, and bake a proper pie; But to my mind it was the greatest shame He'd got an open sore upon his shin; For he made chicken-pudding with the best.

A sea-captain, whose home was in the west, Was there—a Dartmouth man, for all I know. He rode a cob as well as he knew how, And was dressed in a knee-length woolen gown. From a lanyard round his neck, a dagger hung Under his arm. Summer had tanned him brown. As rough a diamond as you'd hope to find, He'd tapped and lifted many a stoup of wine From Bordeaux, when the merchant wasn't looking. He hadn't time for scruples or fine feeling, For if he fought, and got the upper hand, He'd send his captives home by sea, not land. But as for seamanship, and calculation Of moon, tides, currents, all hazards at sea, For harbor-lore, and skill in navigation, From Hull to Carthage there was none to touch him. He was shrewd adventurer, tough and hardy. By many a tempest had his beard been shaken. And he knew all the harbors that there were Between the Baltic and Cape Finisterre, And each inlet of Britanny and Spain. The ship he sailed was called 'The Magdalen.'

With us there was a doctor, a physician; Nowhere in all the world was one to match him Where medicine was concerned, or surgery; Being well grounded in astrology He'd watch his patient with the utmost care Until he'd found a favorable hour, By means of astrology, to give treatment. Skilled to pick out the astrologic moment For charms and talismans to aid the patient, He knew the cause of every malady, If it were 'hot' or 'cold' or 'moist' or 'dry,' And where it came from, and from which humor. He was a really fine practitioner. Knowing the cause, and having found its root, He'd soon give the sick man an antidote. Ever at hand he had apothecaries To send him syrups, drugs, and remedies, For each put money in the other's pocket-Theirs was no newly founded partnership. Well-read was he in Aesculapius, In Dioscorides, and in Rufus, Ancient Hippocrates, Hali, and Galen, Avicenna, Rhazes, and Serapion, Averroës, Damascenus, Constantine, Bernard, and Gilbertus, and Gaddesden. In his own diet he was temperate,

380

390

400

410

420

430

For it was nothing if not moderate, Though most nutritious and digestible. He didn't do much reading in the Bible. He was dressed all in Persian blue and scarlet Lined with taffeta and fine sarsenet, And yet was very chary of expense. He put by all he earned from pestilence; In medicine gold is the best cordial. So it was gold that he loved best of all.

There was a business woman, from near Bath, But, more's the pity, she was a bit deaf; So skilled a clothmaker, that she outdistanced Even the weavers of Ypres and Ghent. In the whole parish there was not a woman Who dared precede her at the almsgiving, And if there did, so furious was she, That she was put out of all charity. Her headkerchiefs were of the finest weave, Ten pounds and more they weighed, I do believe, Those that she wore on Sundays on her head. Her stockings were of finest scarlet red, Very tightly laced; shoes pliable and new. Bold was her face, and handsome; florid too. She had been respectable all her life, And five times married, that's to say in church, Not counting other loves she'd had in youth, Of whom, just now, there is no need to speak. And she had thrice been to Jerusalem; Had wandered over many a foreign stream; And she had been at Rome, and at Boulogne, St James of Compostella, and Cologne; She knew all about wandering—and straying: For she was gap-toothed, if you take my meaning. Comfortably on an ambling horse she sat, Well-wimpled, wearing on her head a hat That might have been a shield in size and shape; A riding-skirt round her enormous hips, Also a pair of sharp spurs on her feet. In company, how she could laugh and joke! No doubt she knew of all the cures for love, For at that game she was a past mistress.

And there was a good man, a religious. He was the needy priest of a village, But rich enough in saintly thought and work. And educated, too, for he could read; Would truly preach the word of Jesus Christ, Devoutly teach the folk in his parish. Kind was he, wonderfully diligent; And in adversity most patient, As many a time had been put to the test. For unpaid tithes he'd not excommunicate, For he would rather give, you may be sure, From his own pocket to the parish poor; Few were his needs, so frugally he lived. Wide was his parish, with houses far asunder, But he would not neglect, come rain or thunder, Come sickness or adversity, to call On the furthest of his parish, great or small; Going on foot, and in his hand a staff. This was the good example that he set: He practiced first what later he would teach. Out of the gospel he took that precept; And what's more, he would cite this saying too: 'If gold can rust, then what will iron do?' For if a priest be rotten, whom we trust, No wonder if a layman comes to rust.

It's shame to see (let every priest take note) A shitten shepherd and a cleanly sheep. It's the plain duty of a priest to give Example to his sheep; how they should live. He never let his benefice for hire And left his sheep to flounder in the mire While he ran off to London, to St Paul's To seek come chantry and sing mass for souls, Or to be kept as chaplain by a guild; But stayed at home, and took care of his fold, So that no wolf might do it injury. He was a shepherd, not a mercenary.

450

460

470

480

490

500

510

And although he was saintly and virtuous, He wasn't haughty or contemptuous To sinners, speaking to them with disdain, But in his teaching tactful and humane. To draw up folk to heaven by goodness And good example, was his sole business. But if a person turned out obstinate, Whoever he was, of high or low estate, He'd earn a stinging rebuke then and there. You'll never find a better priest, I'll swear. He never looked for pomp or deference, Nor affected an over-nice conscience, But taught the gospel of Christ and His twelve Apostles; but first followed it himself.

With him there was his brother, a ploughman, Who'd fetched and carried many a load of dung; A good and faithful laborer was he, Living in peace and perfect charity. God he loved best, and that with all his heart, At all times, good and bad, no matter what; And next he loved his neighbor as himself. He'd thresh, and ditch, and also dig and delve, And for Christ's love would do as much again If he could manage it, for all poor men, And ask no hire. He paid his tithes in full, On what he earned and on his goods as well. He wore a smock, and rode upon a mare. There was a reeve as well, also a miller,

A pardon-seller and a summoner, A manciple, and myself—there were no more. The miller was a burly fellow—brawn And muscle, big of bones as well as strong, As was well seen-he always won the ram At wrestling-matches up and down the land. He was barrel-chested, rugged and thickset, And would heave off its hinges any door Or break it, running at it with his head. His beard was red as any fox or sow, And wide at that, as though it were a spade. And on his nose, right on its tip, he had A wart, upon which stood a tuft of hairs Red as the bristles are in a sow's ears. Black were his nostrils; black and squat and wide. He bore a sword and buckler by his side. His big mouth was as big as a furnace. A loudmouth and a teller of blue stories

A loudmouth was as big as a furnace. A loudmouth and a teller of blue stories (Most of them vicious or scurrilous), Well versed in stealing corn and trebling dues, He had a golden thumb—by God he had! A white coat he had on, and a blue hood. He played the bagpipes well, and blew a tune, And to its music brought us out of town.

A worthy manciple of the Middle Temple Was there; he might have served as an example 530

520

540

560

550

To all provision-buyers for his thrift In making purchase, whether on credit Or for cash down: he kept an eye on prices, So always got in first and did good business. Now isn't it an instance of God's grace, Such an unlettered man should so outpace The wisdom of a pack of learned men? He'd more than thirty masters over him, All of them proficient experts in law, More than a dozen of them with the power To manage rents and land for any peer So that—unless the man were off his head— He could live honorably, free of debt, Or sparingly, if that were his desire; And able to look after a whole shire In whatever emergency might befall; And yet this manciple could hoodwink them all.

There was a reeve, a thin and bilious man; His beard he shaved as close as a man can; Around his ears he kept his hair cropped short, Just like a priest's, docked in front and on top. His legs were very long, and very lean, And like a stick; no calf was to be seen. His granary and bins were ably kept; There was no auditor could trip him up. He could foretell, by noting drought and rain, The likely harvest from his seed and grain. His master's cattle, dairy, cows, and sheep, His pigs and horses, poultry and livestock, Were wholly under this reeve's governance. And, as was laid down in his covenant, Of these he'd always rendered an account Ever since his master reached his twentieth year. No man could ever catch him in arrears. He was up to every fiddle, every dodge Of every herdsman, bailiff, or farm-lad. All of them feared him as they feared the plague. His dwelling was well placed upon a heath, Set with green trees that overshadowed it. At business he was better than his lord: He'd got his nest well-feathered, on the side, For he was cunning enough to get round His lord by lending him what was his own, And so earn thanks, besides a coat and hood. As a young man he'd learned a useful trade As a skilled artisan, a carpenter. The reeve rode on a sturdy farmer's cob That was called Scot: it was a dapple grey. He had on a long blue-grey overcoat, And carried by his side a rusty sword. A Norfolk man was he of whom I tell, From near a place that they call Bawdeswell. Tucked round him like a friar's was his coat: He always rode the hindmost of our troop.

A summoner was among us at the inn, Whose face was fire-red, like the cherubim; All covered with carbuncles; his eyes narrow; He was as hot and randy as a sparrow. He'd scabbed black eyebrows, and a scraggy beard, No wonder if the children were afraid! There was no mercury, white lead, or sulphur, No borax, no ceruse, no cream of tartar, Nor any other salves that cleanse and burn, Could help with the white pustules on his skin, Or with the knobbed carbuncles on his cheeks. He'd a great love of garlic, onions, leeks, 580

590

600

610

620

630

640

C C
Also for drinking strong wing, red as blood
Also for drinking strong wine, red as blood, When he would roar and gabble as if mad.
And once he had got really drunk on wine,
Then he would speak no language but Latin.
He'd picked up a few tags, some two or three,
Which he'd learned from some edict or decree—
No wonder, for he heard them every day.
Also, as everybody knows, a jay
Can call our 'Wat' as well as the Pope can.
But if you tried him further with a question,
You'd find his well of learning had run dry;
<i>Questio quid juris'</i> was all he'd ever say.
A most engaging rascal, and a kind,
As good a fellow as you'd hope to find:
For he'd allow — given a quart of wine —
A scallywag to keep his concubine
A twelvemonth, and excuse him altogether.
He'd dip his wick, too, very much sub rosa.
And if he found some fellow with a woman,
He'd tell him not to fear excommunication
If he were caught, or the archdeacon's curse,
Unless the fellow's soul was in his purse,
For it's his purse must pay the penalty.
'Your purse is the archdeacon's Hell,' said he.
Take it from me, the man lied in his teeth:
Let sinners fear, for that curse is damnation,
Just as their souls are saved by absolution.
Let them beware, too, of a 'Significavit.'
Under his thumb, to deal with as he pleased,
Were the young people of his diocese;
He was their sole adviser and confidant.
Upon his head he sported a garland
As big as any hung outside a pub,
And, for a shield, he'd a round loaf of bread.
With him there was a peerless pardon-seller
Of Charing Cross, his friend and his confrère,
Who'd come straight from the Vatican in Rome. Loudly he sang, 'Come to me, love, come hither!'
The summoner sang the bass, a loud refrain;
No trumpet ever made one half the din.
This pardon-seller's hair was yellow as wax,
And sleekly hanging, like a hank of flax.
In meager clusters hung what hair he had;
Over his shoulders a few strands were spread,
But they lay thin, in rat's tails, one by one.
As for a hood, for comfort he wore none,
For it was stowed away in his knapsack.
Save for a cap, he rode with a head all bare,
Hair loose; he thought it was the <i>dernier cri</i> .
He had big bulging eyes, just like a hare.
He'd sewn a veronica on his cap.
His knapsack lay before him, on his lap,
Chockful of pardons, all come hot from Rome.
His voice was like a goat's, plaintive and thin.
He had no beard, nor was he like to have;
Smooth was his face, as if he had just shaved.
I took him for a gelding or a mare.
As for his trade, from Berwick down to Ware
You'd not find such another pardon-seller.
For in his bag he had a pillowcase
Which had been, so he said, Our Lady's veil;
He said he had a snippet of the sail
St Peter had, that time he walked upon
The sea, and Jesus Christ caught hold of him.

And he'd a brass cross, set with pebble-stones,

And a glass reliquary of pigs' bones.

670

650

660

680

690

But with these relics, when he came upon Some poor up-country priest or backwoods parson, In just one day he'd pick up far more money Than any parish priest was like to see In two whole months. With double-talk and tricks He made the people and the priest his dupes. But to speak truth and do the fellow justice, In church he made a splendid ecclesiastic. He'd read a lesson; or saint's history, But best of all he sang the offertory: For, knowing well that when that hymn was sung, He'd have to preach and polish smooth his tongue To raise — as only he knew how — the wind, The louder and the merrier he would sing.

And now I've told you truly and concisely The rank, and dress, and number of us all, And why we gathered in a company In Southwark, at that noble hostelry Known as the Tabard, that's hard by the Bell. But now the time has come for me to tell What passed among us, what was said and done The night of our arrival at the inn; And afterwards I'll tell you how we journeyed, And all the remainder of our pilgrimage. But first I beg you, not to put it down To my ill-breeding if my speech be plain When telling what they looked like, what they said, Or if I use the exact words they used. For, as you all must know as well as I, To tell a tale told by another man You must repeat as nearly as you can Each word, if that's the task you've undertaken, However coarse or broad his language is; Or, in the telling, you'll have to distort it Or make things up, or find new words for it. You can't hold back, even if he's your brother: Whatever word is used, you must use also. Christ Himself spoke out plain in Holy Writ, And well you know there's nothing wrong with that. Plato, as those who read him know, has said, 'The word must be related to the deed.' Also I beg you to forgive it me If I overlooked all standing and degree As regards the order in which people come Here in this tally, as I set them down: My wits are none too bright, as you can see.

Our host gave each and all a warm welcome, And set us down to supper there and then. The eatables he served were of the best; Strong was the wine; we matched it with our thirst. A handsome man our host, handsome indeed, And a fit master of ceremonies. He was a big man with protruding eyes -You'll find no better burgess in Cheapside-Racy in talk, well-schooled and shrewd was he; Also a proper man in every way. And moreover he was a right good sort, And after supper he began to joke, And, when we had all paid our reckonings, He spoke of pleasure, among other things: 'Truly,' said he, 'ladies and gentlemen, Here you are all most heartily welcome. Upon my word—I'm telling you no lie— All year I've seen no jollier company At one time in this inn, than I have now. I'd make some fun for you, if I knew how.

710

720

730

740

750

760

770

'You're off to Canterbury—so Godspeed! The blessed martyr give you your reward! And I'll be bound, that while you're on your way, You'll be telling tales, and making holiday: It makes no sense, and really it's no fun To ride along the road dumb as a stone. And therefore I'll devise a game for you, To give you pleasure, as I said I'd do. And if with one accord you all consent To abide by my decision and judgement, And if you'll do exactly as I say, Tomorrow, when you're riding on your way, Then, by my father's soul—for he is dead— If you don't find it fun, why, here's my head!

And, as it happens, I have just now thought

Of something that will please you, at no cost.

We were not long in making up our minds. It seemed not worth deliberating, so We gave our consent without more ado, Told him to give us what commands he wished. 'Ladies and gentlemen,' began our host, 'Do yourselves a good turn, and hear me out: But please don't turn your noses up at it. I'll put it in a nutshell: here's the nub: It's that you each, to shorten the long journey, Shall tell two tales en route to Canterbury, And, coming homeward, tell another two, Stories of things that happened long ago. Whoever best acquits himself, and tells The most amusing and instructive tale, Shall have a dinner, paid for by us all, Here in this inn, and under this roof-tree, When we come back again from Canterbury.

Now not another word! Hold up your hands!'

To make it the more fun, I'll gladly ride With you at my own cost, and be your guide. And anyone who disputes what I say Must pay all our expenses on the way! And if this plan appeals to all of you, Tell me at once, and with no more ado, And I'll make my arrangements here and now.'

To this we all agreed, and gladly swore To keep our promises; and furthermore We asked him if he would consent to do As he had said, and come and be our leader, And judge our tales, and act as arbiter, Set up our dinner too, at a fixed price; And we'd obey whatever he might decide In everything. And so, with one consent, We bound ourselves to bow to his judgement. And thereupon wine was at once brought in. We drank; and not long after, everyone Went off to bed, and that without delay.

Next morning our host rose at break of day: He was our cockcrow; so we all awoke. He gathered us together in a flock, And we rode, at little more than walking-pace Till we had reached St Thomas' watering-place, Where our host began reining in his horse. 'Ladies and gentlemen, attention please!' Said he. 'All of you know what we agreed, And I'm reminding you. If evensong And matins are in harmony—that's to say, If you are still of the same mind today— Let's see who'll tell the first tale, and begin. And whosoever balks at my decision 780

790

800

810

820

Must pay for all we spend upon the way, Or may I never touch a drop again! And now let's draw lots before going on. The one who draws the short straw must begin. Sir Knight, my lord and master,' said our host, 'Now let's draw lots, for such is my request. Come near,' said he, 'my lady Prioress, And, Mister Scholar, lay by bashfulness, Stop dreaming! Hands to drawing, everyone!' To cut the story short, the draw began, And, whether it was luck, or chance, or fate, The truth is this: the lot fell to the knight, Much to the content of the company. Now, as was only right and proper, he Must tell his tale, according to the bargain Which, as you know, he'd made. What more to say? And when the good man saw it must be so, Being sensible, and accustomed to obey And keep a promise he had freely given, He said, 'Well, since I must begin the game, Then welcome to the short straw, in God's name! Now let's ride on, and listen to what I say.'

And at these words we rode off on our way, And he at once began, with cheerful face, His tale. The way he told it was like this:

The Prologue of the Wife of Bath's Tale

'Experience—and no matter what they say In books—is good enough authority For me to speak of trouble in marriage. For ever since I was twelve years of age, Thanks be to God, I've had no less than five Husbands at church door—if one may believe I could be wed so often legally! And each a man of standing, in his way. Certainly it was told me, not long since, That, seeing Christ had never more than once Gone to a wedding (Cana, in Galilee) He taught me by that very precedent That I ought not be married more than once. What's more, I was to bear in mind also Those bitter words that Jesus, God and Man, Spoke in reproof to the Samaritan Beside a well—"Thou hast had," said He, "Five husbands, and he whom now thou hast Is not thy husband." He said that, of course, But what He meant by it I cannot say. All I ask is, why wasn't the fifth man The lawful spouse of the Samaritan? How many lawful husbands could she have? All my born days, I've never heard as yet Of any given number or limit, However folk surmise or interpret. All I know for sure is, God has plainly Bidden us to increase and multiply-A noble text, and one I understand! And, as I'm well aware, He said my husband Must leave father and mother, cleave to me. But, as to number, did He specify? He named no figure, neither two nor eight-Why should folk talk of it as a disgrace?

'And what about that wise King Solomon: I take it that he had more wives than one! Now would to God that I might lawfully Be solaced half as many times as he!

What a God-given gift that Solomon Had for his wives! For there's no living man Who has the like; Lord knows how many about That noble king enjoyed on the first night With each of them! His was a happy life! Blessed be God that I have married five! Here's to the sixth, whenever he turns up. I won't stay chaste for ever, that's a fact. For when my husband leaves this mortal life Some Christian man shall wed me soon enough. For then, says the Apostle Paul, I'm free To wed, in God's name, where it pleases me. He says that to be married is no sin, Better it is to marry than to burn. What do I care if people execrate The bigamy of villainous Lamech? I know that Abraham was a holy man, And Jacob too, so far as I can tell; And they had more than two wives, both of them, And many another holy man as well. Now can you tell me where, in any age, Almighty God explicitly forbade All marrying and giving in marriage? Answer me that! And will you please tell me Where was it He ordained virginity? No fear, you know as well as I do, that The Apostle, where he speaks of maidenhood, Says he has got no firm precept for it. You may advise a woman not to wed, But by no means is advice a command. To our own private judgement he left it; Had virginity been the Lord's command, Marriage would at the same time be condemned. And surely, if no seed were ever sown, From what, then, could virginity be grown? Paul did not dare command, at any rate, A thing for which the Lord gave no edict. There's a prize set up for virginity: Let's see who'll make the running, win who may! 'This teaching's not for all men to receive, Just those to whom it pleases God to give The strength to follow it. All I know is, That the Apostle was himself a virgin; But none the less, though he wished everyone -Or so he wrote and said—were such as he, That's only to advise virginity.

20

10

850

860

30

Better than marrying out of frailty. I call it frailty, unless he and she Mean to live all their lives in chastity. 'I grant all this; I've no hard feelings if Maidenhood be set above remarriage. Purity in body and in heart May please some—as for me, I make no boast. For, as you know, no master of a household Has all of his utensils made of gold; Some are of wood, and yet they are of use. The Lord calls folk to Him in many ways,

I have his leave, by way of concession,

A second marriage can incur no blame.

Though it were good for a man not to touch

For who'd bring fire and tow too close together?

A woman-meaning in his bed or couch,

I think you'll understand the metaphor!

Well, by and large, he thought virginity

To be a wife; and so it is no shame,

My husband dying, if I wed again;

40

50

60

70

80

90

And each has his peculiar gift from God, Some this, some that, even as He thinks good.

'Virginity is a great excellence,

And so is dedicated continence, But Christ, of perfection the spring and well, Did not bid everyone to go and sell All that he had, and give it to the poor, And thus to follow in His tracks; be sure He spoke to those who would live perfectly; And, sirs, if you don't mind, that's not for me. I mean to give the best years of my life To the acts and satisfactions of a wife.

'And tell me also, what was the intention In creating organs of generation, When man was made in so perfect a fashion? They were not made for nothing, you can bet! Twist it how you like and argue up and down That they were only made for the emission Of urine; that our little differences Are there to distinguish between the sexes, And for no other reason-who said no? Experience teaches that it is not so. But not to vex the scholars, I'll say this: That they were fashioned for both purposes, That's to say, for a necessary function As much as for enjoyment in procreation Wherein we do not displease God in heaven. Why else is it set down in books, that men Are bound to pay their wives what's due to them? And with whatever else would he make payment If he didn't use his little instrument? It follows, therefore, they must have been given Both to pass urine, and for procreation.

'But I'm not saying everyone who's got The kind of tackle I am talking of Is bound to go and use it sexually. For then who'd bother about chastity? Christ was a virgin, though formed like a man, Like many another saint since time began, And yet they lived in perfect chastity. I've no objection to virginity. Let them be loaves of purest sifted wheat, And us wives called mere barley-bread, and yet As St Mark tells us, when our Saviour fed The multitude, it was with barley-bread. I'm not particular: I'll continue In the condition God has called us to. In married life I mean to use my gadget As generously as my Maker gave it. If I be grudging, the Lord punish me! My husband's going to have it night and day, At any time he likes to pay his dues. I shan't be difficult! I shan't refuse! I say again, a husband I must have, Who shall be both my debtor and my slave, And he shall have, so long as I'm his wife, His "trouble in the flesh." For during life I've "power of his body" and not he. That's just what the Apostle Paul told me; He told our husbands they must love us too. Now I approve entirely of this view—'

Up leapt the pardoner — 'Now then, madam, I swear to you by God and by St John, You make a splendid preacher on this theme. I was about to wed a wife—but then Why should my body pay a price so dear? I'll not wed this nor any other year!'

'You wait!' said she. 'My tale has not begun. It is a different cask that you'll drink from Before I've done; a bitterer brew than ale. And when I've finished telling you my tale Of tribulation in matrimony

— And I'm a lifelong expert; that's to say That I myself have been both scourge and whip-You can decide then if you want to sip Out of the barrel that I mean to broach. But you had best take care if you approach Too near-for I've a dozen object-lessons And more, that I intend to tell. "The man Who won't be warned by others, he shall be Himself a warning to all other men." These are the very words that Ptolemy Writes in his Almagest: you'll find it there.'

'Let me beg you, madam,' said the pardoner, 'If you don't mind, go on as you began, And tell your tale to us and spare no man, And teach all us young fellows your technique.'

'Gladly,' said she, 'if that's what you would like; But let no one in this company, I beg, If I should speak what comes into my head, Take anything that I may say amiss; All that I'm trying to do is amuse.

'And now, sir, now, I will begin my tale.

The three good ones were very rich and old;

To the terms of our covenant and contract-

How cruelly I made them sweat at night!

And I can tell you it meant nothing to me.

They'd given me their land and property;

To win their love, or treat them with respect.

Since I'd got them in the hollow of my hand,

What point was there in taking pains to please,

And they'd made over to me all their land,

They all loved me so much that, heavens above!

I'd no more need to be assiduous

I set no store whatever by their love. A wily woman's always out to win

A lover—that is, if she hasn't one.

Bless me! you'll all know what I mean by that!

It makes me laugh to think, so help me Christ,

Three were good husbands, two of them were bad.

May I never touch a drop of wine or ale

If this be not the truth! Of those I had,

But barely able, all the same, to hold

130

110

120

140

150

160

170

Except for my advantage, or my ease? Believe you me, I set them so to work That many a night I made them sing, "Alack!" No flitch of bacon for them, anyhow, Like some have won in Essex at Dunmow. I governed them so well in my own way, And kept them happy, so they'd always buy Fairings to bring home to me from the fair. When I was nice to them, how glad they were! For God knows how I'd nag and give them hell! 'Now listen how I managed things so well,

You wives that have the wit to understand! Here's how to talk and keep the upper hand: For no man's half as barefaced as a woman When it comes to chicanery and gammon. It's not for knowing wives that I say this, But for those times when things have gone amiss. For any astute wife, who knows what's what, Can make her husband think that black is white, With her own maid as witness in support. But listen to the kind of thing I'd say:

180

190

200

210

220

That's what you say, old barrelful of lies!

Our apprentice with curly golden hair

"And about Jankin you've the wrong idea,

But, damn you, tell me this—God send you sorrow!— Why do you hide the strongbox keys from me?

Who makes himself my escort everywhere-

I wouldn't have him if you died tomorrow!

It's mine as much as yours—our property!

You'll never be, no matter how you scold,

Make her look like an idiot and a fool?

Master of both my body and my gold,

No, by St James! For you'll have to forgo

I sometimes think you want to lock me in

I shan't believe the tales they tell in malice,

I know you for a faithful wife, Dame Alice."

We love no man who watches carefully

Our coming and going; we want liberty.

Who set down in his book, the Almagest

A curse how well-off other people are?

This proverb: "Of all men he is the wisest

From which proverb you are to understand

Don't worry, you old dotard—it's all right,

What bigger miser than he who'll not let

Another light a candle at his lantern

With dresses and expensive jewelry,

As thus: 'In chaste and modest apparel

'And not with braided hair and jewelry,

You women must adorn yourselves,' said he,

Such as pearls and gold; and not in costly dress.'

It only puts at risk our chastity;

Who doesn't care who has the world in hand."

That if you have enough, why should you care

You'll have cunt enough and plenty, every night.

He won't have any the less light, I'm thinking!

If you've enough, what's there to grumble at?

"And you say if we make ourselves look smart

And then, confound you, you must quote this text, And back yourself up with the words of Paul,

That astrologer, Mister Ptolemy,

"Blessed above all other men is he,

That strongbox of yours, when you should be saying

"Dear wife, go where you like, go and have fun,

One or the other, take or leave it! Now, What use is all your snooping and your spying?

What! I'm the mistress of the house, and you'll

"So this is how things are, old Mister Dotard? Why does the woman next door look so gay? She can go where she likes, and all respect her, -I sit at home, I've nothing fit to wear! Why are you always over at her house? She's pretty, is she? So you're amorous! What did I catch you whispering to the maid? Mister Old Lecher, drop it, for God's sake! And if I've an acquaintance or a friend, You rage and carry on just like a fiend If I pay him some harmless little visit! And then you come back home pissed as a newt, And preach at me, confound you, from your bench! What a great shame-just think of the expense-To marry a poor woman, so you tell me. And if she's rich, and comes of a good family, It's hell, you say, to put up with her pride, And her black moods and fancies. Then, you swine, Should she be beautiful, you change your line, And say that every rakehell wants to have her, That in no time she's bound to lose her honor, Because it is assailed on every side.

"You say that some folk want us for our riches, Some for our looks, and others for our figures, Or for our sex appeal, or our good breeding; Some want a girl who dances, or can sing, Else it's our slender hands and arms they want. So the devil takes the lot, by your account! None can defend a castle wall, you say. For long if it's attacked day after day.

"And if she's plain, why then you say that she's Setting her cap at every man she sees: She'll jump upon him, fawning like a spaniel, Till someone buys what she has got to sell. Never a goose upon the lake so grey But it will find its gander, so you say. Says you, it's hard to manage or control A thing no man would keep of his own will. That's how you talk, pig, when you go to bed, Saying that no sane man need ever wed, Nor any man who hopes to go to heaven. Wretch, may your withered wrinkled neck be broken In two by thunderblast and fiery lightning!

"And then, you say, a leaky roof, and smoke, And nagging wives, are the three things that make A man flee from his home. Oh, for God's sake! What ails an old man to go on like that?

"Then you go on to claim we women hide Our failings till the knot is safely tied, And then we show them — A villainous saying, A scoundrel's proverb, if I ever heard one!

"You say that oxen, asses, horses, hounds, Can be tried out and proved at different times, And so can basins, washbowls, stools, and spoons, And household goods like that, before you buy; Pots, clothes and dresses too; but who can try A wife out till he's wed? Old dotard! Pig! And then, says you, we show the faults we've hid.

'You also claim that it enrages me If you forget to compliment my beauty, If you're not always gazing on my face, Paying me compliments in every place, If on my birthday you don't throw a party, Buy a new dress, and make a fuss of me; Or if you are ungracious to my nurse, Or to my chambermaid, or even worse, Rude to my father's kinsfolk and his cronies,— 240

250

260

270

280

290

300

But of your text, and your red-letter rubric, I'll be taking no more notice than a gnat! "And you said this: that I was like a cat,

For you have only got to singe its skin, And then the cat will never go from home; But if its coat is looking sleek and gay, She won't stop in the house, not half a day, But off she goes the first thing in the morning, To show her coat off and go caterwauling. That's to say, if I'm all dressed up, Mister Brute, I'll run out in my rags to show them off!

"Mister Old Fool, what good is it to spy? If you begged Argus with his hundred eyes To be my bodyguard-what better choice?-There's little he would see unless I let him, For if it killed me, yet I'd somehow fool him!

"And you have also said, there are three things, Three things there are that trouble the whole earth, And there's no man alive can stand the fourth-Sweet Mister Brute, Jesus cut short your life! You keep on preaching that an odious wife Is to be counted one of these misfortunes.

310

320

330

340

350

360

Really, are there no other comparisons That you can make, and without dragging in A poor innocent wife as one of them?

"Then you compare a woman's love to Hell, To barren lands where rain will never fall. And you go on to say, it's like Greek fire, The more it burns, the fiercer its desire To burn up everything that can be burned. And just as grubs and worms eat up a tree, Just so a woman will destroy her husband; All who are chained to wives know this, you say."

'Ladies and gentlemen, just as you've heard I'd browbeat them; they really thought they'd said All these things to be in their drunkenness. All lies—but I'd get Jankin to stand witness And bear me out, and my young niece also. O Lord! the pain I gave them, and the woe, And they, heaven knows, guite innocent of course. For I could bite and whinny like a horse. I'd scold them even when I was at fault, For otherwise I'd often have been dished. Who comes first to the mill, is first to grind; I'd get in first, till they'd be glad to find A quick excuse for things they'd never done In their whole lives; and so our war was won. I'd pick on them for wenching; never mind They were so ill that they could barely stand!

'And yet it tickled him to the heart, because He thought it showed how fond of him I was. I swore that all my walking out at night Was to spy out the women that he tapped; Under that cover, how much fun I had! To us at birth such mother-wit is given; As long as they live God has granted women Three things by nature: lies, and tears, and spinning. There's one thing I can boast of: in the end I'd gain, in every way, the upper hand By force or fraud, or by some stratagem Like everlasting natter, endless grumbling. Bed in particular was their misfortune; That's when I'd scold, and see they got no fun. I wouldn't stop a moment in the bed If I felt my husband's arm over my side, No, not until his ransom had been paid, And then I'd let him do the thing he liked. What I say is, everything has its price; You cannot lure a hawk with empty hand. If I wanted something, I'd endure his lust. And even feign an appetite for it; Though I can't say I ever liked old meat-And that's what made me nag them all the time. Even though the Pope were sitting next to them I'd not spare them at table or at board, But paid them back, I tell you, word for word. I swear upon my oath, so help me God, I owe them not a word, all's been paid back. I set my wits to work till they gave up; They had to, for they knew it would be best, Or else we never would have been at rest. For even if he looked fierce as a lion, Yet he would fail to get his satisfaction.

'Then I would turn and say, "Come, dearest, come! How meek you look, like Wilkin, dear old lamb! Come to me, sweetheart, let me kiss your cheek! You ought to be all patient and meek, And have ever such a scrupulous conscience— Or so you preach of Job and his patience!

Always be patient; practice what you preach, For if you don't, we've got a thing to teach, Which is: it's good to have one's wife in peace! One of us has got to knuckle under, And since man is more rational a creature Than woman is, it's you who must forbear. But what's the matter now? Why moan and groan? You want my quim just for yourself alone? 380 Why, it's all yours—there now, go take it all! By Peter, but I swear you love it well! For if I wished to sell my pretty puss, I'd go about as sweet as any rose; But no, I'll keep it just for you to taste. Lord knows you're in the wrong; and that's the truth!" 'All arguments we had were of that kind. Now I will speak about my fourth husband. 'My fourth husband was a libertine; 390 That is to say, he kept a concubine; And I was young, and passionate, and gay, Stubborn and strong, and merry as a magpie. How I would dance to the harp's tunable Music, and sing like any nightingale, When I had downed a draught of mellow wine! Metellius, the dirty dog, that swine Who with a club beat his own wife to death Because she drank—if I had been his wife, Even he would not have daunted me from drink! 400 And after taking wine I'm bound to think On Venus-sure as cold induces hail, A greedy mouth points to a greedy tail. A woman full of wine has no defense, All lechers know this from experience. 'But, Lord Christ! when it all comes back to me, And I recall my youth and gaiety, It warms the very cockles of my heart. And to this day it does my spirit good To think that in my time I've had my fling. But age, alas, that cankers everything, 410 Has stripped me of my beauty and spirit. Let it go then! Goodbye, and devil take it! The flour's all gone; there is no more to say. Now I must sell the bran as best I may; But all the same I mean to have my fun. And now I'll tell about my fourth husband. 'I tell you that it rankled in my heart That in another he should take delight. But he was paid for it in full, by God! From that same wood I made for him a rod -420 Now with my body, and not like a slut, But certainly I carried on with folk Until I made him stew in his own juice, With fury, and with purest jealousy. By God! on earth I was his purgatory, For which I hope his soul's in Paradise. God knows he often had to sit and whine When his shoe pinched him cruelest! And then How bitterly, and in how many ways, I wrung his withers, there is none can guess 430 Or know, save only he and God in heaven! He died when I came from Jerusalem, And now lies buried under the rood beam, Although his tomb is not as gorgeous As is the sepulcher of Darius That Apelles sculpted so skillfully; For to have buried him expensively Would have been waste. So goodbye, and God rest him! He's in his grave now, shut up in his coffin.

440

450

460

470

480

490

'Of my fifth husband I have this to tell -I pray God keep and save his soul from hell!-And yet he was to me the worst of all: I feel it on my ribs, on each and all, And always will until my dving day! But in our bed he was so free and gay And moreover knew so well how to coax And cajole when he wanted my belle chose, That, though he'd beaten me on every bone, How quickly he could win my love again! I think that I loved him the best, for he Was ever chary of his love for me. We women have, I'm telling you no lies, In this respect the oddest of fancies; If there's a thing we can't get easily, That's what we're bound to clamor for all day: Forbid a thing, and that's what we desire; Press hard upon us, and we run away. We are not forward to display our ware: For a great crowd at market makes things dear; Who values stuff bought at too cheap a price? And every woman knows this, if she's wise.

'My fifth husband - may God bless his soul! Whom I took on for love, and not for gold, Was at one time a scholar at Oxford, But had left college, and come home to board With my best friend, then living in our town: God keep her soul! her name was Alison. She knew me and the secrets of my heart As I live, better than the parish priest: She was my confidant; I told her all-For had my husband pissed against a wall, Or done a thing that might have cost his life-To her, and also to my dearest niece, And to another lady friend as well, I'd have betrayed his secrets, one and all. And so I did time and again, dear God! It often made his face go red and hot For very shame; he'd kick himself, that he Had placed so great a confidence in me.

'And it so happened that one day in Lent (For I was ever calling on my friend, As I was always fond of having fun, Strolling about from house to house in spring, In March, April, and May, to hear the gossip) Jankin the scholar, and my friend Dame Alice, And I myself, went out into the meadows. My husband was in London all that Lent, So I was free to follow my own bent, To see and to be seen by the gay crowd. How could I know to whom, and in what place. My favors were destined to be bestowed? At feast-eves and processions, there I was; At pilgrimages; I attended sermons, And these miracle-plays; I went to weddings, Dressed in my best, my long bright scarlet gowns. No grub, no moth or insect had a chance To nibble at them, and I'll tell you why: It was because I wore them constantly.

'Now I'll tell you what happened to me then. We strolled about the fields, as I was saying, And got on so well together, he and I, That I began to think ahead, and tell him That if I were a widow we could marry. For certainly—I speak without conceit— Till now I've never been without foresight In marriage matters; other things as well. I'd say a mouse's life's not worth a leek Who has but one hole to run to for cover, For if that fails the mouse, then it's all over!

510

520

530

540

550

560

570

'I let him think that he'd got me bewitched. It was my mother taught me that device. I also said I dreamed of him at night, That he'd come to kill me, lying on my back, And that the entire bed was drenched in blood. And yet I hoped that he would bring me luck— In dreams blood stands for gold, so I was taught. All lies—for I dreamed nothing of the sort. I was in this, as in most other things, As usual following my mother's teachings.

'But now, sirs, let me see—what was I saying? Aha! Bless me, I've found the thread again.

'When my fourth husband was laid on his bier I wept for him—what a sad face I wore!— As all wives must, because it's customary; With my kerchief I covered up my face. But, since I was provided with a mate, I wept but little, that I guarantee!

To church they bore my husband in the morning Followed by the neighbors, all in mourning, And one among them was the scholar Jankin. So help me God, when I saw him go past, Oh what a fine clean pair of legs and feet Thought I—and so to him I lost my heart. He was, I think, some twenty winters old, And I was forty, if the truth be told. But then I always had an itch for it! I was gap-toothed; but it became me well; I wore St. Venus' birthmark and her seal. So help me God, but I was a gay one, Pretty and fortunate; joyous and young; And truly, as my husbands always told me, I had the best what-have-you that might be. Certainly I am wholly Venerian In feeling; and in courage, Martian. Venus gave to me lust, lecherousness; And Mars gave me my sturdy hardiness. Taurus was my birth-sign, with Mars therein. Alas, alas, that ever love was sin! And so I always followed my own bent, Shaped as it was by my stars' influence, That made me so that I could not begrudge My chamber of Venus to a likely lad. I've still the mark of Mars upon my face, And also in another secret place. For, sure as God above is my salvation, I never ever loved in moderation, But always followed my own appetite, Whether for short or tall, or black or white; I didn't care, so long as he pleased me, If he were poor, or what his rank might be.

'There's little more to say: by the month's ending, This handsome scholar Jankin, gay and dashing, Had married me with all due ceremony. To him I gave all land and property, Everything that I had inherited. But, later, I was very sorry for it— He wouldn't let me do a thing I wanted! My God, he once gave my ear such a box Because I tore a page out of his book, That from the blow my ear became quite deaf. I was untamable as a lioness; My tongue unstoppable and garrulous; And walk I would, as I had done before, 580

590

600

610

620

630

From house to house, no matter how he swore I shouldn't; and for this he'd lecture me, And tell old tales from Roman history; How one Simplicius Gallus left his wife, Left her for the remainder of his life, Only because one day he saw her looking Out of the door with no head-covering.

'He said another Roman, Whatsisname Because his wife went to a summer-game Without his knowledge, went and left her too. And then he'd get his Bible out to look In Ecclesiasticus for that text Which with absolute stringency forbids A man to let his wife go gad about; Then, never fear, here's the next thing he'd quote: "Whoever builds his house out of willows, And rides a blind horse over the furrows, And lets his wife trot after saints' altars, Truly deserves to be hung on the gallows." But all for nothing; I cared not a bean For all his proverbs, nor for his old rhyme; And neither would I be reproved by him. I hate a man who tells me of my vices And God knows so do more of us than I. This made him absolutely furious: I'd not give in to him, in any case.

'Now, by St Thomas, I'll tell you the truth About why I ripped a page out of his book, For which he hit me so that I went deaf.

'He had a book he loved to read, that he Read night and morning for his own delight; Valerius and Theophrastus, he called it, Over which book he'd chuckle heartily. And there was a learned man who lived in Rome. A cardinal who was called St. Jerome, Who wrote a book attacking Jovinian; And there were also books by Tertullian, Chrysippus, Trotula, and Heloise, Who was an abbess not far from Paris, Also the parables of Solomon, Ovid's Art of Love, and many another one, All bound together in the same volume. And night and morning it was his custom, Whenever he had leisure and freedom From any other worldly occupation, To read in it concerning wicked women: He knew more lives and legends about them Than there are of good women in the Bible. Make no mistake, it is impossible That any scholar should speak good of women, Unless they're saints in the hagiologies; Not any other kind of woman, no! Who drew the picture of the lion? Who? My God, had women written histories Like cloistered scholars in oratories, They'd have set down more of men's wickedness Than all the sons of Adam could redress. For women are the children of Venus, And scholars those of Mercury; the two Are at cross purposes in all they do; Mercury loves wisdom, knowledge, science, And Venus, revelry and extravagance. Because of their contrary disposition The one sinks when the other's in ascension; And so, you see, Mercury's powerless When Venus is ascendant in Pisces, And Venus sinks where Mercury is raised.

That's why no woman ever has been praised By any scholar. When they're old, about As much use making love as an old boot, Then in their dotage they sit down and write: Women can't keep the marriage vows they make!

'But to the point—why I got beaten up, As I was telling you, just for a book: One night Jankin—that's my lord and master— Read in his book as he sat by the fire, Of Eva first, who through her wickedness Brought the whole human race to wretchedness, For which Jesus Himself was crucified, He Who redeemed us all with His heart's blood. Look, here's a text wherein we plainly find That woman was the ruin of mankind.

650

660

670

680

690

700

'He read to me how Samson lost his hair: He slept; his mistress cut it with her shears, Through which betrayal he lost both his eyes. 'And then he read to me, if I'm no liar,

Of Hercules and his Dejaneira. And how she made him set himself on fire. 'He left out nothing of the grief and woe That the twice-married Socrates went through; How Xantippe poured piss upon his head, And the poor man sat stock-still as if dead; He wiped his head, not daring to complain:

"Before the thunder stops, down comes the rain!" 'And out of bloody-mindedness he'd relish The tale of Pasiphaë, Queen of Crete-Fie! say no more—it's gruesome to relate Her abominable likings and her lust! 'Of the lechery of Clytemnestra, How she betrayed her husband to his death, These things he used to read with great relish. 'He also told me how it came about That at Thebes Amphiarus lost his life: My husband had a tale about his wife Eriphile, who for a golden brooch Had covertly discovered to the Greeks Where they might find her husband's hiding-place, Who thus, at Thebes, met a wretched fate. 'He told of Livia and Lucilia, Who caused their husbands, both of them, to die; One out of love, the other out of loathing. Hers, Livia poisoned late one evening. Because she hated him; ruttish Lucilia

On the contrary, loved her husband so, That she mixed for him, so that he should think Only of her, an aphrodisiac drink So strong that before morning he was dead. Thus husbands always have the worst of it! 'Then he told me how one Latumius Once lamented to his friend Arrius That there was a tree growing in his garden

That there was a tree growing in his garden On which, he said, his three wives, out of dudgeon, Had hanged themselves. "Dear friend," said Arrius, "Give me a cutting from this marvelous tree, And I shall go and plant it in my garden."

'Concerning wives of later days, he read How some had killed their husbands in their bed, And let their lovers have them while the corpse Lay all night on its back upon the floor. And others, while their husbands slept, have driven Nails through their brainpans, and so murdered them. Yet others have put poison in their drink. He spoke more evil than the heart can think. On top of that, he knew of more proverbs 710

720

740

730

750

760

Than there is grass and herbage upon earth. "Better to live with a lion or dragon," Said he, "than take up with a scolding woman. Better to live high in an attic roof Than with a brawling woman in the house: They are so wicked and contrarious That what their husbands love, they always hate." He also said, "A woman casts off shame When she casts off her smock," and he'd go on: "A pretty woman, if she isn't chaste, Is like a gold ring stuck in a sow's nose." Now who could imagine, or could suppose, The grief and torment in my heart, the pain?

'When I realized he'd never make an end But read away in that damned book all night, All of a sudden I got up and tore Three pages out of it as he was reading, And hit him with my fist upon the cheek So that he tumbled back into our fire, And up he jumped just like a raging lion. And punched me with his fist upon the head Till I fell to the floor and lay for dead. And when he saw how motionless I lay, He took alarm, and would have run away, Had I not burst at last out of my swoon. "You've murdered me, you dirty thief!" I said, "You've gone and murdered me, just for my land! But I'll kiss you once more, before I'm dead!"

'He came close to me and kneeled gently down, And said, "My dearest sweetheart Alison, So help me God, I'll not hit you again. You yourself are to blame for what I've done. Forgive it me this once, for mercy's sake." But once again I hit him on the cheek: "You robber, take that on account!" I said. "I can't speak any more; I'll soon be dead." After no end of grief and pain, at last We made it up between the two of us: He gave the reins to me, and to my hand Not only management of house and land, But of his tongue, and also of his fist-And then and there I made him burn his book! And when I'd got myself the upper hand And in this way obtained complete command, And he had said, "My own true faithful wife, Do as you please from now on, all your life: Guard your honor and look after my estate." -From that day on we had no more debate. So help me God, to him I was as kind As any wife from here to the world's end, And true as well—and so was he to me. I pray to God Who reigns in majesty, For His dear mercy's sake, to bless his soul. Now if you'll listen, I will tell my tale.'

CHRISTINE DE PISAN from The Book of the City of Ladies

This work (its title is a play on Augustine's City of God) is an elaborate allegory describing a city with women's accomplishments. It is an argument against the antifeminist writers of the day who condemned women as the snare of Satan and inferior to men. This selection deals with some notable women: Sappho, the goddess Minerva, and notable educated women of the Middle Ages.

30. Here She Speaks of Sappho, that Most Subtle Woman, Poet, and Philosopher

"The wise Sappho, who was from the city of Mytilene, was no less learned than Proba. This Sappho had a beautiful body and face and was agreeable and pleasant in appear-780 ance, conduct, and speech. But the charm of her profound understanding surpassed all the other charms with which she was endowed, for she was expert and learned in several arts and sciences, and she was not only well-educated in the works and writings composed by others but also discovered many new things herself and wrote many books and poems. Concerning her, Boccaccio has offered these fair words couched in the sweetness of poetic language: 'Sappho, possessed of sharp wit and burning desire for constant study in the midst of bestial and ignorant men, frequented the heights of Mount Parnassus, that is, of perfect study. Thanks to her fortunate boldness and daring, she kept company with the Muses, that is, the arts and sciences, without being turned away. She entered the forest of laurel trees filled with may boughs, greenery, and different colored flowers, soft fragrances and various aromatic spices, where Grammar, Logic, noble Rhetoric, Geometry, and Arithmetic live and take their leisure. She went on her way until she came to the deep grotto of Apollo, god of learning, and found the brook and conduit of the fountain of Castalia, and took up the 800 plectrum and quill of the harp and played sweet melodies, with the nymphs all the while leading the dance, that is, following the rules of harmony and musical accord.' From what Boccaccio says about her, it should be inferred that the profundity of both her understanding and of her learned books can only be known and understood by men of great perception and learning, according to the testimony of the ancients. Her writings and poems have survived to this day, most remarkably constructed and composed, and they serve as illumination and models of consummate poetic craft and 810 composition to those who have come afterward. She invented different genres of lyric and poetry, short narratives, tearful laments and strange lamentations about love and other emotions, and these were so well made and so well ordered that they were named 'Sapphic' after her. Horace recounts, concerning her poems, that when Plato, the great philosopher who was Aristotle's teacher, died, a book of Sappho's poems was found under his pillow.

"In brief this lady was so outstanding in learning that in the city where she resided a statue of bronze in her image was dedicated in her name and erected in a prominent place so that she would be honored by all and be remembered forever. This lady was placed and counted among the greatest and most famous poets, and, according to Boccaccio, the honors of the diadems and crowns of kings and the miters of bishops are not any greater, nor are the crowns of laurel and victor's palm.

34. Here She Speaks of Minerva, Who Invented Many Sciences and the Technique of Making Armor from Iron and Steel

"Minerva, just as you have written elsewhere, was a maiden of Greece and surnamed Pallas. This maiden was of such excellence of mind that the foolish people of that time, because they did not know who her parents were and saw her doing things which had never been done before, said she was a goddess descended from Heaven; for the less they knew about her ancestry, the more marvelous her great knowledge seemed to them, when compared to that of the women of her time. She had a subtle mind, of profound understanding, not only in one subject but also generally, in

790

every subject. Through her ingenuity she invented a shorthand Greek script in which a long written narrative could be transcribed with far fewer letters, and which is still used by the Greeks today, a fine invention whose discovery demanded great subtlety. She invented numbers and a means of quickly counting and adding sums. Her mind was so enlightened with general knowledge that she devised various skills and designs which had never before been discovered. She developed the entire technique of gathering wool and making cloth and was the first who ever thought to shear sheep of their wool and then to pick, comb, and card it with iron spindles and finally to spin it with a distaff, and then she invented the tools needed to make the cloth and also the method by which the wool should finally be woven.

"Similarly she initiated the custom of extracting oil from different fruits of the earth, also from olives, and of squeezing and pressing juice from other fruits. At the same time she discovered how to make wagons and carts to transport things easily from one place to another.

"This lady, in a similar manner, did even more, and it seems all the more remarkable because it is far removed from a woman's nature to conceive of such things; for she invented the art and technique of making harnesses and armor from iron and steel, which knights and armed soldiers employ in battle and with which they cover their bodies, and which she first gave to the Athenians whom she taught how to deploy an army and battalions and how to fight in organized ranks.

"Similarly she was the first to invent flutes and fifes, trumpets and wind instruments. With her considerable force of mind, this lady remained a virgin her entire life. Because of her outstanding chastity, the poets claimed in their fictions that Vulcan, the god of fire, wrestled with her for a long time and that finally she won and overcame him, which is to say that she overcame the ardor and lusts of the flesh which so strongly assail the young. The Athenians held this maiden in such high reverence that they worshiped her as a goddess and called her the goddess of arms and chivalry because she was the first to devise their use, and they also called her the goddess of knowledge because of her learnedness.

"After her death they erected a temple in Athens dedicated to her, and there they placed a statue of her, portraying a maiden, as a representation of wisdom and chivalry. This statue had terrible and cruel eyes because chivalry has been instituted to carry out rigorous justice; they also signified that one seldom knows toward what end the meditation of the wise man tends. She wore a helmet on her head which signified that a knight must have strength, endurance, and constant courage in the deeds of arms, and further signified that the counsels of the wise are concealed, secret, and hidden. She was dressed in a coat of mail which stood for the power of the estate of chivalry and also taught that the wise man is always armed against the whims of Fortune, whether good or bad. She held some kind of spear or very long lance, which meant that the knight must be the rod of justice and also signified that the wise man casts his spears from great distances. A buckler or shield of crystal hung at her neck, which meant that the knight must always be alert and oversee everywhere the defense of his country and people and further signified that things are open and evident to the wise man. She had portrayed in the middle of this shield the head of a serpent called Gorgon, which teaches that the knight must always be wary and watchful over his enemies like the serpent, and furthermore, that the wise man is aware of all the malice which can hurt him. Next to this image they also placed a bird that flies by night, named the owl, as if to watch over her, which signified that the knight must be ready by night as well as by day for civil defense, when necessary, and also that the wise man should take care at all times to do what is profitable and fitting for him. For a long time this lady was held in such high regard and her great fame spread so far that in many places temples were founded to praise her. Even long afterward, when the Romans were at the height of their power, they included her image among their gods."

36. Against those Men Who Claim It Is Not Good for Women to be Educated

Following these remarks, I, Christine, spoke, "My lady, I realize that women have accomplished many good things and that even if evil women have done evil, it seems to me, nevertheless, that the benefits accrued and still accruing because of good women—particularly the wise and literary ones and those educated in the natural sciences whom I mentioned above—outweigh the evil. Therefore, I am amazed by the opinion of some men who claim that they do not want their daughters, wives, or kinswomen to be educated because their mores would be ruined as a result."

She responded, "Here you can clearly see that not all opinions of men are based on reason and that these men are wrong. For it must not be presumed that mores necessarily grow worse from knowing the moral sciences, which teach the virtues, indeed, there is not the slightest doubt that moral education amends and ennobles them. How could anyone think or believe that whoever follows good teaching or doctrine is the worse for it? Such an opinion cannot be expressed or maintained. I do not mean that it would be good for a man or a woman to study the art of divination or those fields of learning which are forbidden—for the holy Church did not remove them from common use without good reason—but it should not be believed that women are the worse for knowing what is good.

"Quintus Hortensius, a great rhetorician and consumately skilled orator in Rome, did not share this opinion. He had a daughter, named Hortensia, whom he greatly loved for the subtlety of her wit. He had her learn letters and study the science of rhetoric, which she mastered so thoroughly that she resembled her father Hortensius not only in wit and lively memory but also in her excellent delivery and order of speech-in fact, he surpassed her in nothing. As for the subject discussed above, concerning the good which comes about through women, the benefits realized by this woman and her learning were, among others, exceptionally remarkable. That is, during the time when Rome was governed by three men, this Hortensia began to support the cause of women and to undertake what no man dared to undertake. There was a question whether certain taxes should be levied on women and on their jewelry during a needy period in Rome. This woman's eloquence was so compelling that she was listened to, no less readily than her father would have been, and she won her case.

"Similarly, to speak of more recent times, without searching for examples in ancient history, Giovanni Andrea, a solemn law professor in Bologna not quite sixty years ago, was not of the opinion that it was bad for women to be educated. He had a fair and good daughter, named Novella, who was educated in the law to such an advanced degree that when he was occupied by some task and not at leisure to present his lectures to his students, he would send Novella, his daughter, in his place to lecture to the students from his chair. And to prevent her beauty from distracting the concentration of her audience, she had a little curtain drawn in front of her. In this manner she could on occasion supplement and lighten her father's occupation. He loved her so much that, to commemorate her name, he wrote a book of remarkable lectures on the law which he titled *Novella super Decretalium*, after his daughter's name.

"Thus, not all men (and especially the wisest) share the opinion that it is bad for women to be educated. But it is very true that many foolish men have claimed this because it displeased them that women knew more than they did. Your father, who was a great scientist and philosopher, did not believe that women were worth less by knowing science; rather, as you know, he took great pleasure from seeing your inclination to learning. The feminine opinion of your mother, however, who wished to keep you busy with spinning and silly girlishness, following the common custom of women, was the major obstacle to your being more involved in the sciences. But just as the proverb already mentioned above says, 'No one can take away what Nature has given,' your mother could not hinder in you the feeling for the sciences which you, through natural inclination, had nevertheless gathered together in little droplets. I am sure that, on account of these things, you do not think you are worth less but rather that you consider it a great treasure for yourself; and you doubtless have reason to."

And I, Christine, replied to all of this, "Indeed, my lady, what you say is as true as the Lord's Prayer."

GLOSSARY

- Terms italicized within the definitions are themselves defined within the Glossary.
- a capella Music sung without instrumental accompaniment.

abacus (1) The slab that forms the upper part of a *capital*. (2) A computing device using movable counters.

- **academy** Derived from Akademeia, the name of the garden where Plato taught his students; the term came to be applied to official (generally conservative) teaching establishments.
- **accompaniment** The musical background to a melody.
- **acoustics** The science of the nature and character of sound.

acropolis Literally, the high point of a Greek city, frequently serving as refuge in time of war. The best known is the Acropolis of Athens.

acrylic A clear plastic used to make paints and as a casting material in sculpture.

adagio Italian for "slow"; used as an instruction to musical performers.

adobe Sun-dried mud brick.

aesthetic Describes the pleasure derived from a work of art, as opposed to any practical or informative value it might have. In philosophy, aesthetics is the study of the nature of art and its relation to human experience.

agora In ancient Greek cities, the open marketplace, often used for public meetings.

aisle In church *architecture*, the long open spaces parallel to the *nave*.

aleatory music Music made in a random way after the composer sets out the elements of the musical piece.

allegory A dramatic or artistic device in which the superficial sense is accompanied by a deeper or more profound meaning.

allegro Italian for "merry" or "lively"; a musical direction.

altar In ancient religion, a table at which offerings were made or victims sacrificed. In Christian churches, a raised structure at which the sacrament of the Eucharist is consecrated, forming the center of the ritual.

- **altarpiece** A painted or sculptured *panel* placed above and behind an altar to inspire religious devotion.
- **alto** The lowest range of the female voice, also called contralto.
- **ambulatory** Covered walkway around the *apse* of a church.
- amphora Greek wine jar.
- **anthropomorphism** The endowing of nonhuman objects or forces with human characteristics.

antiphony Music in which two or more *voices* alternate with one another.

apse Eastern end of a church, generally semicircular, in which the *altar* is housed.

architecture The art and science of designing and constructing buildings for human use.

- architrave The lowest division of an *entablature*.
- **archivault** The molding that frames an arch.
- **aria** Song for a solo voice in an *opera*, an *oratorio*, or a *cantata*.
- Ars Nova Latin for "the New Art." Describes the more complex new music of the fourteenth century, marked by richer harmonies and elaborate rhythmic devices.

assemblage The making of a sculpture or other three-dimensional art piece from a variety of materials. Compare *collage*, *montage*.

- atelier A workshop.
- **atonality** The absence of a *key* or tonal center in a musical composition.

atrium An open court in a Roman house or in front of a church.

augmentation In music, the process of slowing down a melody or musical phrase by increasing (generally doubling) the length of its notes.

aulos Greek wind instrument, similar to an oboe but consisting of two pipes.

autocracy Political rule by one person of unlimited power.

avant-garde French for advanceguard. Term used to describe artists using innovative or experimental techniques.

axis An imaginary line around which

the elements of a painting, sculpture or building are organized; the direction and focus of these elements establishes the axis.

ballad A narrative poem or song with simple stanzas and a refrain which is usually repeated at the end of each stanza.

- **ballet** A dance performance, often involving a narrative or plot sequence, usually accompanied by music.
- **band** A musical performance group made up of *woodwind*, *brass*, and *percussion*, but no *strings*.
- **baritone** The male singing voice of medium register, between *bass* and *tenor*.
- **barrel vault** A semicircular *vault* unbroken by ribs or groins.
- **basilica** Originally a large hall used in Roman times for public meetings, law courts, etc.; later applied to a

specific type of early Christian church.

bas-relief Low relief; see relief.

bass The lowest range of the male voice.

- **beat** The unit for measuring time and *meter* in music.
- **Berber** Muslim peoples of North Africa.
- **binary form** A two-part musical form in which the second part is different from the first, and both parts are usually repeated.
- **bitonality** A musical technique involving the simultaneous performance of two melodies in different *tonalities*.
- **black figure** A technique used in Greek vase painting which involved painting figures in black paint in silhouette and incising details with a sharp point. It was used throughout the Archaic period. Compare *red figure*.
- **blank verse** Unrhymed verse often used in English *epic* and dramatic poetry. Its meter is *iambic pentameter*. Compare *heroic couplet*.
- **blue note** A flattened third or seventh note in a *chord*, characteristic of jazz and blues.

- **brass instruments** The French horn, trumpet, trombone, and tuba, all of which have metal mouthpieces and bodies.
- **Bronze Age** The period during which bronze (an alloy of copper and tin) was the chief material for tools and weapons. It began in Europe around 3000 B.C. and ended around 1000 B.C. with the introduction of iron.
- **Buddha** Literally "The Enlightened One." Title of Siddartha Gautama.
- burin Steel tool used to make copper *engravings*.
- **buttress** An exterior architectural support.
- **cadenza** In music, a free or improvised passage, usually inserted toward the end of a *movement* or *aria*, intended to display the performer's technical skill.
- **caliph** An Arabic term for leader or ruler.
- **calligraphy** The art of penmanship and lettering—literally "beautiful writing."
- **campanile** In Italy the bell tower of a church, often standing next to but separate from the church building.
- **canon** From the Greek meaning a "rule" or "standard." In *architecture* it is a standard of proportion. In literature it is the authentic list of an author's works. In music it is the melodic line sung by overlapping voices in strict *imitation*. In religious terms it represents the authentic books in the Bible or the authoritative prayer of the Eucharist in the Mass or the authoritative law of the church promulgated by ecclesiastical authority.
- **cantata** Italian for a piece of music that is sung rather than played; an instrumental piece is known as a *sonata*.
- **cantus firmus** Latin for "fixed song," a system of structuring a *polyphonic* composition around a preselected melody by adding new melodies above and/or below. The technique was used by medieval and Renaissance composers.
- **canzoniere** The Italian word for a songbook.
- **capital** The head, or crowning part, of a column, taking the weight of the *entablature*.

- **capitulary** A collection of rules or regulations sent out by a legislative body.
- cartoon (1) A full-scale preparatory drawing for a picture, generally a large one such as a wall painting.(2) A humorous drawing.
- **caryatid** A sculptured female figure taking the place of a column.
- **cast** A molded replica made by a process whereby plaster, wax, clay, or metal is poured in liquid form into a mold. When the material has hardened the mold is removed, leaving a replica of the original from which the mold was taken.
- **catharsis** Literally, "purgation." Technical term used by Aristotle to describe the emotional effect of a tragic drama upon the spectator.
- **cathedra** The bishop's throne. From that word comes the word cathedral, i.e., a church where a bishop officiates.
- **cella** Inner shrine of a Greek or Roman temple.
- **ceramics** Objects made of baked clay, such as vases and other forms of pottery, tiles, and small sculptures.
- chamber music Music written for small groups.
- **chancel** The part of a church that is east of the *nave* and includes *choir* and *sanctuary*.
- **chant** A single line of melody in free rhythm and unaccompanied. The term is most frequently used for liturgical music such as Gregorian or Ambrosian chant.
- **chapel** A small space within a church or a secular building such as a palace or castle, containing an *altar* consecrated for ritual use.
- **chevet** The eastern (*altar*) end of a church.
- chiaroscuro In painting, the use of strong contrasts between light and dark.
- choir The part of a church *chancel* between *nave* and *sanctuary* where the monks sing the Office; a group of singers.
- chorale A simple hymn tune sung either in unison or harmonized.
- **chord** Any combination of three or more notes sounded together.
- **chorus** In ancient Greek drama, a group of performers who comment collectively on the main action. The term came to be used, like *choir*, for a group of singers.

- cithara An elaborate seven-string *lyre* used in Greek and Roman music.
- **classical** Generally applied to the civilizations of Greece and Rome; more specifically to Greek art and culture in the fifth and fourth centuries B.C. Later imitations of classical styles are called neoclassical. Classical is also often used as a broad definition of excellence: a "classic" can date to any period.
- clavecin French for "harpsichord."
- clef French for "key." In written music the term denotes the sign placed at the beginning of the *staff* to indicate the range of notes it contains.
- **clerestory** A row of windows in a wall above an adjoining roof.
- cloister The enclosed garden of a monastery, surrounded by a covered walkway; by extension the monastery itself. Also, a covered walkway alone.
- **coda** Italian for "tail." Final section of a musical *movement* in sonata form, summing up the previous material.
- codex A manuscript volume.
- **coffer** In *architecture*, a recessed panel in a ceiling.
- **collage** A composition produced by pasting together disparate objects such as train tickets, newspaper clippings, or textiles. Compare *assemblage, montage*.
- colonnade A row of columns.
- **comedy** An amusing and lighthearted play or narrative intended to provoke laughter on the part of the spectator; or a work with a happy ending.
- **composer** The writer of a piece of music.
- composition Generally, the arrangement or organization of the elements that make up a work of art. More specifically, a piece of music.
- **concerto** A piece of music for one or more solo instruments and *orchestra*, usually with three contrasting *movements*.
- **concerto grosso** A piece of music similar to a *concerto* but designed to display the *orchestra* as a whole.
- **concetto** Italian for "concept." In Renaissance and Baroque art, the idea that undergirds an artistic ensemble.
- **consul** One of two Roman officials elected annually to serve as the highest state magistrates in the Republic.

contralto See alto.

- **contrapposto** In sculpture, placing a human figure so that one part (e.g., the shoulder) is turned in a direction opposite to another part (e.g., the hip and leg).
- **cori spezzati** Italian for "split choirs." The use of two or more choirs for a musical performance.
- **Corinthian** An order of *architecture* that was popular in Rome, marked by elaborately decorated *capitals* bearing acanthus leaves. Compare *Doric, Ionic.*
- **cornice** The upper part of an *entablature*.
- **counterpoint** Two or more distinct melodic lines sung or played simultaneously in a single unified composition.
- **crescendo** In music, a gradual increase in volume.
- **cruciform** Arranged or shaped like a cross.

crypt A *vaulted* chamber, completely or partially underground, which usually contains a *chapel*. It is found in a church under the *choir*.

cult A system of religious belief and its followers.

cuneiform A system of writing, common in the ancient Near East, using characters made up of wedge shapes. Compare *hieroglyphics*.

da capo Italian for "from the beginning." In a musical performance, return to and repetition of the beginning section.

daguerreotype Early system of photography in which the image is produced on a silver-coated plate.

decrescendo In music, a gradual decrease in volume.

design The overall conception or scheme of a work of art. In the visual arts, the organization of a work's *composition* based on the arrangement of lines or contrast between light and dark.

development Central section of a *sonata-form* movement, in which the themes of the exposition are developed.

dialectics A logical process of arriving at the truth by putting in juxtaposition contrary propositions; a term often used in medieval philosophy and theology, and also in the writings of Hegel and Marx.

diatonic The seven notes of a major or minor *scale*, corresponding to the piano's white *keys* in an *octave*.

diminuendo In music, a gradual decrease in volume.

- Daiymo A Japanese war lord.
- **diminution** The speeding up of a musical phrase by decreasing (usually halving) the length of the notes.
- **dithyramb** Choral hymn to the Greek god Dionysus, often wild and violent in character. Later, any violent song, speech, or writing. Compare *paean*.
- dome A hemispherical vault.

dominant The fifth note of a *diatonic scale*.

Doric One of the Greek orders of *ar-chitecture*, simple and austere in style. Compare *Corinthian*, *Ionic*.

dramatis personae Latin for characters in a play.

dynamics In music, the various levels of loudness and softness of sound, together with their increase and decrease.

echinus The lower part of the *capital*. elevation In *architecture*, a drawing of the side of a building which does not show perspective.

- encaustic A painting technique using molten wax colored by pigments.
- engraving (1) The art of producing a depressed design on a wood or metal block by cutting it in with a tool. (2) The impression or image made from such a wood or metal block by ink that fills the design. Compare *burin, etching, woodcut*.

entablature The part of a Greek or Roman temple above the columns, normally consisting of *architrave*, *frieze*, and *cornice*.

entasis The characteristic swelling of a Greek column at a point about a third above its base.

epic A long narrative poem celebrating the exploits of a heroic character.

Epicurean A follower of the Greek philosopher Epicurus, who held that pleasure was the chief aim in life.

epithet Adjective used to describe the special characteristics of a person or object.

essay A short literary composition, usually in prose, dealing with a specific topic. etching (1) The art of producing a depressed design on a metal plate by cutting lines through a wax coating and then applying corrosive acid that removes the metal under the lines.

(2) The impression or image made from such a plate by ink that fills the design. Compare *engraving*, *woodcut*.

- ethos Greek word meaning "character." In general, that which distinguishes a particular work of art and gives it character. More specifically, a term used by the Greeks to describe the moral and ethical character that they ascribed to music.
- evangelist One of the authors of the four *Gospels* in the Bible: Matthew, Mark, Luke, and John.
- exposition In music, the statement of the themes or musical ideas in the first section of a *sonata-form move-ment*.

façade The front of a building.

- **ferroconcrete** A modern building material consisting of concrete and steel reinforcing rods or mesh.
- **finale** In music, the final section of a large instrumental composition or of the act of an *opera*.
- flagellants Persons who whip themselves out of religious devotion.
- **flat** A symbol (,) used in music to signify that the note it precedes should be lowered by one halfstep.
- **flute** Architectural term for the vertical grooves on Greek (and later) columns generally.
- **foot** In poetry, the unit for measuring *meter*.
- **foreshortening** The artistic technique whereby a sense of depth and three-dimensionality is obtained by the use of receding lines.
- **form** The arrangement of the general structure of a work of art.
- forte Italian for "loud."
- **fresco** A painting technique that employs the use of pigments on wet plaster.
- friar A member of one of the religious orders of begging brothers founded in the Middle Ages.
- frieze The middle section of an *entablature*. A band of painted or carved decoration, often found running

around the outside of a Greek or Roman temple.

- **fugue** A *polyphonic* composition, generally for two to four voices (vocal or instrumental), in which the same themes are passed from voice to voice and combined in *counterpoint*.
- **gallery** A long, narrow room or corridor, such as the spaces above the *aisles* of a church.
- **genre** A type or category of art. In the visual arts, the depiction of scenes from everyday life.
- Gesamtkunstwerk German for "complete work of art." The term, coined by Wagner, refers to an artistic ensemble in which elements from literature, music, art, and the dance are combined into a single artistic totality.
- **glaze** In oil painting a transparent layer of paint laid over a dried painted canvas. In *ceramics* a thin coating of clay fused to the piece by firing in a kiln.
- **gospels** The four biblical accounts of the life of Jesus, ascribed to Matthew, Mark, Luke, and John. Compare *evangelist*.
- **gouache** An opaque watercolor medium.
- graphic Description and demonstration by visual means.
- **Greek cross** A cross with arms of equal length.
- **Gregorian chant** *Monophonic* religious music usually sung without accompaniment. Called *plainsong*. Compare *melisma*, *neum*, *trope*.
- **ground** A coating applied to a surface to prepare it for painting.
- **guilloche** A decorative band made up of interlocking lines of design.
- hadith Islamic law/traditions outside of the Qu'ran.

haj The Islamic pilgrimage to Mecca. **Haiku** Short three-lined Japanese

- poem made up of five, seven, and five syllables.
- hamartia Literally Greek for "missing the mark," "failure," or "error." Term used by Aristotle to describe the character flaw that would cause the tragic end of an otherwise noble hero.
- **happening** In art, a multimedia event performed with audience participa-

tion so as to create a single artistic expression.

- **harmony** The *chords* or vertical structure of a piece of music; the relationships existing between simultaneously sounding notes and chord progressions.
- **hedonism** The philosophical theory that material pleasure is the principal good in life.
- hegira Muhammad's flight from Mecca to Medina; marks the beginning of the Islamic religion.
- heroic couplet The *meter* generally employed in *epic* poetry, consisting of pairs of rhyming *iambic pentameter* lines. Compare *blank verse*.
- **hierarchy** A system of ordering people or things which places them in higher and lower ranks.
- hieroglyphics A system of writing in which the characters consist of realistic or stylized pictures of actual objects, animals, or human beings (whole or part). The Egyptian hieroglyphic script is the best known, but by no means the only one. Compare *cuneiform.*
- high relief See relief.
- hippodrome A race course for horses and chariots. Compare *spina*.
- **homophony** Music in which a single melody is supported by a harmonious accompaniment. Compare *monophonic*.
- hubris The Greek word for "insolence" or "excessive pride."
- humanist In the Renaissance, someone trained in the humane letters of the ancient classics and employed to use those skills. More generally, one who studies the humanities as opposed to the sciences.
- **hymn** A religious song intended to give praise and adoration.
- iambic pentameter Describes the *meter* of poetry written in lines consisting of five groups (pentameter) of two syllables each, the second syllable stressed more than the first (iambic *foot*).
- icon Greek word for "image." Panel paintings used in the Orthodox church as representations of divine realities.
- **iconography** The set of symbols and allusions that gives meaning to a complex work of art.

- ideal The depiction of people, objects, and scenes according to an idealized, preconceived model.
- **idol** An image of a deity that serves as the object of worship.
- image The representation of a human or nonhuman subject, or of an event.
- **imitation** In music, the restatement of a melodic idea in different voice parts of a *contrapuntal* composition.
- **impasto** Paint laid on in thick textures.
- **improvisation** In musical performance, the spontaneous invention of music for voice or instrument.
- **incising** Cutting into a surface with a sharp instrument.
- **intercolumniation** The horizontal distance between the central points of adjacent columns in a Greek or Roman temple.
- interval Musical term for the difference in pitch between two musical notes.
- **Ionic** One of the Greek orders of *architecture*, elaborate and graceful in style. Compare *Doric*, *Corinthian*.
- **Iron Age** The period beginning in Europe around 1000 B.C. during which iron was the chief material used for tools and weapons.
- **isorhythmic** *Polyphonic* music in which the various sections are unified by repeated rhythmic patterns, but the melodies are varied.
- italic The type face *like this* designed during the Renaissance that was based on a form of handwriting often used in manuscript copying.
- **jamb** Upright piece of a window or a door frame, often decorated in medieval churches.
- **jazz** Form of American music first developed in the Black community in the early twentieth century, consisting of improvisation on a melodic theme.
- **jongleur** In French, a wandering minstrel. A professional musician, actor, or mime who went from place to place, offering entertainment.

Kabuki A kind of Japanese drama based on real life characters.key (1) The tonal center around which a composer bases a musical

work. (2) The mechanism by which a keyboard instrument (piano, organ, etc.) or wind instrument (clarinet, bassoon, etc.) is made to sound.

keystone Central stone of an arch.

kore Type of standing female statue produced in Greece in the Archaic period.

kouros Type of standing male statue, generally nude, produced in Greece in the Archaic period.

lancet A pointed window frame of a medieval Gothic cathedral.

landscape In the visual arts, the depiction of scenery in nature.

Latin cross A cross with the vertical arm longer than the horizontal arm.

legato Italian for "tied." In music, the performance of notes in a smooth line. The opposite, with notes detached, is called *staccato*.

Leitmotif German for "leading motif." A system devised by Wagner whereby a melodic idea represents a character, an object, or an idea.

lekythos Small Greek vase for oil or perfume, often used during funeral ceremonies.

libretto Italian for "little book." In music, the text or words of an *opera, oratorio*, or other musical work involving text.

lied German for "song."

line engraving A type of *engraving* in which the image is made by scored lines of varying width.

lintel The piece that spans two upright posts.

lithography A method of producing a print from a slab of stone on which an image has been drawn with a grease crayon or waxy liquid.

- **liturgy** The rites used in public and official religious worship.
- **loggia** A gallery open on one or more sides, often with arches.
- low relief See relief.
- **lunette** Semicircular space in wall for window or decoration.
- **lyre** Small stringed instrument used in Greek and Roman music. Compare *cithara*.

lyric (1) Words or verses written to be set to music. (2) Description of a work of art that is poetic, personal, even ecstatic in spirit.

Madonna Italian for "My Lady." Used for the Virgin Mary.

madrigal *Polyphonic* song for three or more voices, with verses set to the same music and a refrain set to different music.

mandorla Almond-shaped light area surrounding a sacred personage in a work of art.

Mass The most sacred rite of the Catholic *liturgy*.

matroneum Gallery for women in churches, especially churches in the Byzantine tradition.

mausoleum Burial chapel or shrine.

meander Decorative pattern in the form of a maze, commonly found in Greek geometric art.

melisma In *Gregorian chant*, an intricate chain of notes sung on one syllable. Compare *trope*.

meter A systematically arranged and measured rhythm in poetry or music.

metopes Square slabs often decorated with sculpture which alternated with *triglyphs* to form the *frieze* of a *Doric* temple.

michrab A recessed space or wall design in a mosque to indicate direction of Mecca for Islamic worshippers.

Minbar A pulpit in an Islamic mosque.

- **minnesingers** German medieval musicians of the aristocratic class who composed songs of love and chivalry. Compare *troubadors*.
- **minuet** A French seventeenth-century dance, the form of which was eventually incorporated into the *sonata* and *symphony* as the third *movement*.

mobile A sculpture so constructed that its parts move either by mechanical or natural means.

mode (1) In ancient and medieval music an arrangement of notes forming a scale which, by the character of intervals, determines the nature of the composition. Compare *tetrachord*. (2) In modern music one of the two classes, major or minor, into which musical scales are divided.

modulation In music, movement from one *key* to another.

monastery A place where monks live in communal style for spiritual purposes.

- **monochrome** A single color, or variations on a single color.
- **monody** A *monophonic* vocal piece of music.
- **monophonic** From the Greek meaning "one voice." Describes music consisting of a single melodic line. Compare *polyphonic*.
- **montage** (1) In the cinema, the art of conveying an idea and/or mood by the rapid juxtaposition of different images and camera angles. (2) In art, the kind of work made from pictures or parts of pictures already produced and now forming a new composition. Compare *assemblage*, *collage*.
- **mosaic** Floor or wall decoration consisting of small pieces of stone, ceramic, shell, or glass set into plaster or cement.

mosque Islamic house of worship.

motet (1) Musical composition, developed in the 13th century, in which words (French "mots") were added to fragments of *Gregorian chant*. (2) sixteenth-century composition: four- or five-voiced sacred work, generally based on a Latin text.

movement In music, an individual section of a *symphony, concerto,* or other extended composition.

- **mullions** The lines dividing windows into separate units.
- **mural** Wall painting or mosaics attached to a wall.
- **myth** Story or legend whose origin is unknown; myths often help to explain a cultural tradition or cast light on a historical event.
- **narthex** The porch or vestibule of a church.
- natural In music, the sign (‡) which cancels any previously indicated *sharp* (‡) or *flat* (,).
- **nave** From the Latin meaning "ship." The central space of a church.
- Neanderthal Early stage in the development of the human species, lasting from before 100,000 B.C. to around 35,000 B.C.
- **Negritude** A literary movement in twentieth century Black Africa based on African culture.
- Neolithic Last part of the Stone Age, when agricultural skills had been developed but stone was still the principal material for tools and weapons. It began in the Near East

around 8000 B.C. and in Europe around 6000 B.C.

- **neum** The basic symbol used in the notation of *Gregorian chant*.
- **niche** A hollow recess or indentation in a wall to hold a statue or other object.
- **notation** The system of writing out music in symbols that can be reproduced in performance.
- **obelisk** A rectangular shaft of stone that tapers to a pyramidal point.
- **Obi** Title of ruler of the medieval African kingdom of Benin (modern Nigeria).
- **octave** The *interval* from one note to the next with the same pitch; e.g., from C to the C above or below.
- **oculus** A circular eye-like window or opening.
- **ode** A lyric poem, usually exalted and emotional in character.
- **oil painting** Painting in a medium made up of powdered colors bound together with oil, generally linseed.
- **opera** Theatrical performance involving a drama, the text of which is sung to the accompaniment of an orchestra.
- opus Latin for "work." Used for chronological lists of composers' works.
- **Opus Dei** Latin for "work of God." Used to describe the choral offices of monks, which are sung during the hours of the day.
- **oral composition** The composition and transmission of works of literature by word of mouth, as in the case of the Homeric epics.
- oratorio An extended musical *composition* for solo singers, *chorus*, and *orchestra* on a religious subject. Unlike *opera*, the oratorio is not staged.
- **orchestra** (1) In Greek theaters, the circular space in front of the stage in which the *chorus* moves. (2) A group of instrumentalists who come together to perform musical *compositions*.
- order (1) In *classical architecture* a specific form of column and *entabla-ture*; see *Doric, Ionic,* and *Corinthian.*(2) More generally, the arrangement imposed on the various elements in a work of art.
- **organum** An early form of *polyphonic* music in which one or more

melody lines were sung along with the song line of plainsong. Compare *Gregorian chant*.

- orientalizing Term used to describe Greek art of the seventh century B.C. that was influenced by Eastern artistic styles.
- **overture** An instrumental *composition* played as an introduction to a *ballet*, *opera*, or *oratorio*.
- **paean** A Greek hymn to Apollo and other gods, either praying for help or giving thanks for help already received. Later generally applied to any song of praise or triumph. Compare *dithyramb*.
- **Paleolithic** The Old Stone Age, during which human beings appeared and manufactured tools for the first time. It began around two and a half million years ago.
- **palette** (1) The tray on which a painter mixes colors. (2) The range and combination of colors typical of a particular painter.
- panel A rigid, flat support, generally square or rectangular, for a painting; the most common material is wood.
- **pantheon** The collected gods. By extension, a temple to them. In modern usage a public building containing the tombs or memorials of famous people.
- **pantocrator** From the Greek meaning "one who rules or dominates all." Used for those figures of God and/or Christ found in the *apses* of Byzantine churches.
- **parable** A story told to point up a philosophical or religious truth.
- **parallelism** A literary device, common in the psalms, of either repeating or imaging one line of poetry with another that uses different words but expresses the same thought.
- **pastel** A drawing made by rubbing colored chalks on paper.
- **pathos** That aspect of a work of art that evokes sympathy or pity.
- **pediment** The triangular space formed by the roof *cornices* on a Greek or Roman temple.
- **pendentives** Triangular architectural devices used to support a dome of a structure; the dome may rest directly on the pendentives. Compare *squinches*.

- **percussion instruments** Musical instruments that are struck or shaken to produce a sound, e.g., drums, tambourine, cymbals.
- **peripatetic** Greek for "walking around." Specifically applied to followers of the philosopher Aristotle.
- **peristyle** An arcade (usually of columns) around the outside of a building. The term is often used of temple *architecture*.
- **perspective** A technique in the visual arts for producing on a flat or shallow surface the effect of three dimensions and deep space.
- piano Italian for "soft."
- **piazza** Italian term for a large, open public square.
- **pietà** An image of the Virgin with the dead Christ.
- **pietra serena** Italian for "serene stone." A characteristic building stone often used in Italy.
- pilaster In architecture a pillar in relief.
- **Pillow book** Japanese literary work in the form of a daily diary.
- **pitch** In music the relative highness or lowness of a note as established by the frequency of vibrations occurring per second within it.
- **pizzicato** Italian for "plucked." An instruction to performers on *string* instruments to pluck instead of bow their strings.
- plainsong See Gregorian chant.
- **plan** An architectural drawing showing in two dimensions the arrangement of space in a building.
- **podium** A base, platform, or pedestal for a building, statue, or monument.
- **polis** The Greek word for "city," used to designate the independent citystates of ancient Greece.
- polychrome Several colors. Compare *monochrome*.
- **polyphonic** From the Greek meaning "many voices." Describes a musical composition built from the simultaneous interweaving of different melodic lines into a single whole. Compare *monophonic*.
- **portal** A door, usually of a church or cathedral.
- **portico** A porch with a roof supported by columns.
- prelude In music, a short piece that precedes a large-scale *composition*.pre-socratic Collective term for all
- Greek philosophers before the time of Socrates.

presto Italian for "fast."

- **program music** Instrumental compositions that imitate sound effects, describe events, or narrate a dramatic sequence of events.
- prophet From the Greek meaning "one who speaks for another." In the Hebrew and Christian tradition it is one who speaks with the authority of God. In a secondary meaning, it is one who speaks about the future with authority.
- **proportion** The relation of one part to another, and each part to the whole, in respect of size, whether of height, width, length, or depth.
- **prosody** The art of setting words to music.
- **prototype** An original model or form on which later works are based.
- **psalter** Another name for the Book of Psalms from the Bible.
- **Qur'an** The sacred scriptures of Islam.
- **Rajput** Medieval Indian ruler generally of central Asian descent.
- **realism** A nineteenth-century style in the visual arts in which people, objects, and events were depicted in a manner that aimed to be true to life. In film, the style of Neorealism developed in the post–World War II period according to similar principles.
- **recapitulation** The third section of a *sonata-form* movement in which the ideas set out in the *exposition* are repeated.
- **recitative** A style of musical declamation that is halfway between singing and ordinary speech.
- red figure A technique used in Greek vase painting which involved painting red figures on a black background and adding details with a brush. Compare *black figure*.
- **register** In music, the range of notes within the capacity of a human voice or an instrument.
- **relief** Sculptural technique whereby figures are carved out of a block of stone, part of which is left to form a background. Depending on the degree to which the figures project, the relief is described as either high or low.

- reliquary A small casket or shrine in which sacred relics are kept.
- requiem A Mass for the dead.
- revelation Divine self-disclosure to humans.
- **rondo** A musical form in which one main theme recurs in alternation with various other themes. The form was often used in the last *movement* of a *sonata* or *symphony*.
- Samurai A Japanese warrior. Sangha A Buddhist monastery or the
- Buddhist monastic life in general. sanctuary In religion, a sacred place. The part of a church where the altar is placed.
- sarcophagus From the Greek meaning "flesh eater." A stone (usually limestone) coffin.
- satire An amusing exposure of folly and vice, which aims to produce moral reform.
- Satyagraha Nonviolence; a sociopolitical strategy devised by Mohandas Gandhi.
- satyr Greek mythological figure usually shown with an animal's ears and tail.
- scale (1) In music, a succession of notes arranged in ascending or descending order. (2) More generally, the relative or proportional size of an object or image.
- scherzo Italian for "joke." A lighthearted and fast-moving piece of music.
- **score** The written form of a piece of music in which all the parts are shown.
- scriptorium That room in a medieval monastery in which manuscripts were copied and illuminated.
- **section** An architectural drawing showing the side of a building.
- **secular** Not sacred; relating to the worldly.
- **sequence** In music, the repetition of a melodic phrase at different *pitches*.
- **serenade** A type of instrumental *composition* originally performed in the eighteenth century as background music for public occasions.
- serial music A type of twentiethcentury musical *composition* in which various components (notes, rhythms, dynamics, etc.) are organized into a fixed series.
- sharp In music, a sign (#) which raises the note it precedes by one halfstep.

- **silhouette** The definition of a form by its outline.
- **skolion** Greek drinking song, generally sung at banquets.
- **soliloquy** A speech delivered by an actor either while alone on stage or unheard by the other characters, generally so constructed as to indicate the inner feelings of a character.
- **sonata** An extended instrumental *composition,* generally in three or four *movements*.
- **sonata form** A structural form for instrumental music that employs *exposition, development,* and *recapitulation* as its major divisions.
- sonnet A fourteen-line poem, either eight lines (octave) and six lines (sextet) or three quatrains of four lines and an ending couplet. Often attributed to Petrarch, the form keeping the basic fourteen lines was modified by such poets as Spenser, Shakespeare, and Milton.
- **soprano** The highest *register* of the female voice.
- spandrel A triangular space above a window in a *barrel vault* ceiling, or the space between two arches in an arcade.
- **spina** A monument at the center of a stadium or *hippodrome*, usually in the form of a triangular *obelisk*.
- **squinches** Either columns or *lintels* used in corners of a room to carry the weight of a superimposed mass. Their use resembles that of *pendentives*.
- staccato See legato.
- **staff** The five horizontal lines, with four spaces between, on which musical notation is written.
- **stele** Upright stone slab decorated with relief carvings, frequently used as a grave marker.
- still life A painting of objects such as fruit, flowers, dishes, etc., arranged to form a pleasing composition.
- **stoa** A roofed *colonnade*, generally found in ancient Greek open markets, to provide space for shops and shelter.
- stoic School of Greek philosophy, later popular at Rome, which taught that the universe is governed by Reason and that Virtue is the only good in life.
- stretcher A wooden or metal frame on which a painter's canvas is stretched.

- **string quartet** A performing group consisting of two violins, viola, and cello; a *composition* in *sonata form* written for such a group.
- string instruments The violin, viola, violoncello (or cello), and double bass. All of these have strings that produce sound when stroked with a bow or plucked.
- Stupa A sacred tower in Buddhism. stylobate The upper step on which the columns of a Greek temple stand.
- **suite** In music, a collection of various *movements* performed as a whole, sometimes with a linkage in *key* or theme between the movements.
- **summa** The summation of a body of learning, particularly in the fields of philosophy and theology.
- **sura** A chapter division in the *Qur'an*, the scripture of Islam.
- syllogism A form of argumentation in which a conclusion is drawn from a major premise by the use of a minor premise: All men are mortal/Socrates is a man/ Therefore Socrates is mortal.
- **symmetry** An arrangement in which various elements are so arranged as to parallel one another on either side of an *axis*.
- symphonic poem A one-movement orchestral work meant to illustrate a nonmusical object like a poem, painting, or view of nature. Also called a tone poem.
- **symphony** An extended orchestral *composition,* generally in three or four movements, in *sonata form*.
- **syncopation** In music, the accentuation of a beat that is normally weak or unaccented.
- synthesizer An electronic instrument for the production and control of sound that can be used for the making of music.
- tabernacle A container for a sacred object; a receptacle on the altar of a Catholic church to contain the Eucharist.
- tambour The drum that supports the cupola of a church.
- **tempera** A painting technique using coloring mixed with egg yolk, glue, or casein.
- **tempo** In music, the speed at which the notes are performed.

- **tenor** The highest range of the male voice. In medieval *organum*, it is the voice that holds the melody of the *plainsong*.
- **ternary form** A musical form composed of three separate sections, with the second in contrast to the first and third, and the third a modified repeat of the first.
- terra cotta Italian meaning "baked earth." Baked clay used for *ceramics*. Also sometimes refers to the reddish-brown color of baked clay.
- **tesserae** The small pieces of colored stone used for the creation of a *mosaic*.
- **tetrachord** Musical term for a series of four notes. Two tetrachords formed a *mode*.
- **theme** In music, a short melody or a self-contained musical phrase.
- tholos Term in Greek *architecture* for a round building.
- **timbre** The particular quality of sound produced by a voice or instrument.
- **toccata** In music, a *virtuoso composition* for a keyboard instrument characterized by a free style with long, technically difficult passages.
- toga Flowing woolen garment worn by Roman citizens.
- **tonality** In music, the organization of all tones and chords of a piece in relation to the first tone of a *key*.
- **tonic** The first and principal note of a *key*, serving as a point of departure and return.
- **tragedy** A serious drama in which the principal character is often brought to disaster by his/her *hamartia*, or tragic flaw.
- **transept** In a cruciform church, the entire part set at right angles to the *nave*.
- treble In music, the higher voices, whose music is written on a *staff* marked by a treble *clef*.
- **triglyphs** Rectangular slabs divided by two vertical grooves into three vertical bands; these alternated with *metopes* to form the *frieze* of a *Doric* temple.
- triptych A painting consisting of three panels. A painting with two panels is called a diptych; one with several panels is a polyptych.
- trompe l'oeil From the French meaning "to fool the eye." A painting technique by which the viewer

seems to see real subjects or objects instead of their artistic representation.

- **trope** In *Gregorian chant*, words added to a long *melisma*.
- troubadors Aristocratic southern French musicians of the Middle Ages who composed *secular* songs with themes of love and chivalry; called trouvères in northern France. Compare *minnesingers*.
- **trumeau** A supporting pillar for a church *portal*, common in medieval churches.
- **twelve-tone technique** A *serial* method of *composition* devised by Schönberg in the early twentieth century. Works in this style are based on a tone row consisting of an arbitrary arrangement of the twelve notes of the *octave*.
- **tympanum** The space, usually decorated, above a *portal*, between a *lintel* and an *arch*.
- **unison** The sound that occurs when two or more voices or instruments simultaneously produce the same note or melody at the same *pitch*.
- value (1) In music, the length of a note. (2) In painting, the property of a color that makes it seem light or dark.
- vanishing point In perspective, the point at which receding lines seem to converge and vanish.
- vault A roof composed of arches of masonry or cement construction.
- **virginal** A stringed keyboard instrument, sometimes called a spinet, which was a predecessor of the harpsichord.
- virtuoso A person who exhibits great technical ability, especially in music. As an adjective, it describes a musical performance that exhibits, or a music composition that demands, great technical ability.
- vivace Italian for "lively" or "vivacious."
- **volutes** Spirals that form an *Ionic capital.*
- **votive** An offering made to a deity either in support of a request or in gratitude for the fulfillment of an earlier prayer.
- **voussoirs** Wedge-shaped blocks in an arch.

waltz A dance in triple rhythm.

woodcut (1) A wood block with a raised design produced by gouging out unwanted areas. (2) The impression or image made from such a block by inking the raised surfaces. Compare *engraving*, *etching*, *lithograph*.

woodwind instruments The flute, oboe, English horn, clarinet, bass clarinet, bassoon, contrabassoon, and saxophone. All of these are pipes perforated by holes in their sides which produce musical sound when the columns of air within them are vibrated by blowing on a mouthpiece.

ziggurat An Assyrian or Babylonian stepped pyramid.

INDEX

Page numbers in italics indicate photo illustrations.

Α

A cappella chant, 299 Aachen, 246, 293-296, 302, 305-312, 307, 309-312 Abacus, 48, 49, 295 Abbasid Dynasty, 276 Abbey of Saint Denis, 302, 343-347, 344-346, 349, 354 Abelard, Peter, 343, 356 Sic et Non, 356 Abraham (Hebrew patriarch), 203, 207, 268, 271 Abu Simbel, Temple at, 16, 20 Academy, of Plato, 80, 238 Achilles, 38-39, 41, 49, 51, 56 Acropolis, 44, 46, 72, 72-73, 78, 84-87,86,87 Actium, Battle of, 137 Acts, Book of, 207, 224-225 Adams, Henry, 353 Mont-Saint-Michel and Chartres, 353 Adoptive emperors of Rome, 137 Aegean culture in the Bronze Age, 18-27 Cycladic art, 20-21, 21 influence of, 18-19 Minoan culture, 19, 21–22, 23-26, 24, 175 Mycenaean culture, 19, 24-27, 27, 35 timeline, 1 Aegisthus, 76, 76 Aeneas, 140, 141, 141 Aeneid (Vergil), 138-140, 158-167, 363, 400 Aeschylus, 74, 75, 76-77, 83 Agamemnon, 76, 76 The Eumenides, 75, 76 The Libation Bearers, 76 Oresteia trilogy, 76-77 Suppliants, 75 Aesthetics in philosophy, 52 Afghanistan, 178 Africa (Petrarch), 400 African Americans, slavery and Biblical symbolism, 207 Afterlife. See also Religion ancient Egyptian religion, 10-12, 13, 14 Dante's Divine Comedy, 278, 356, 363-365, 365, 370-393,400 from Epic of Gilgamesh, 30 Agamemnon, 25, 38, 49, 51, 76, 76 Agamemnon (Aeschylus), 76, 76 Age of Colonization, Greece, 35, 41-42 Agesander, 96 Agincourt, Battle of, 398 Agni, 191-194

Agnus Dei in Ordinary of the Mass, 419 Agra, 274, 275 Agricultural words, 278 Aias, 56 Aix-la-Chapelle. See Aachen Ajax, 56 Akhenaton, Nefertiti and Three of Their Children, 14-15, 17 Akhenaton, pharaoh of Egypt, 14-15, 17 Akkad, 8 Akkadians, 6, 8-9 Al-Ghazali, 278 The Incoherence of the Philosophers, 278 Al-Hakam, 272-273 Al-Hazen, 277 Al-Khwarizmi, 277 Al Malik, Abd, 271 Al-Mamun, 276 Al-Rashid, Harun, 293, 294 Al-Uqlidisi, 277 Al Walid, Abd, 271 Albert the Great, 360 Alcaeus, 52, 128 Alcuin of York, 295, 296, 297, 307 On the Cultivation of Learning, 296 Aldine press, 253 Alemanni, 152 Alexander of Hales, 360 Alexander Severus, emperor of Rome, 137 Alexander the Great, 10, 17–18, 71, 79, 80, 92, 93, 95 Alexandria, 93, 138 Alexandria, Temple of the Muses at, 93 Algebra, 182 Algorithm, 277 Alhambra, 273-275, 274 Alighieri, Dante. See Dante Alighieri Allahah, 270, 277 The Allegory of the Cave (Plato), 117-118, 356 Altamira cave paintings, 4 Altar of Peace, 141-142, 141 - 142Altar to Zeus, 95, 96, 97 Amarna art, ancient Egypt, 15, 17 Ambrose, Saint, 299 Ambrosian music, 299 Ambulatory, 344, 344 Amenhotep IV, pharaoh of Egypt, 14 America, Imperial Rome's influence on, 139 Amiens Cathedral, 345-346,

346

Amos, Book of, 221-223 Amphion, 49 Ananke, 39 Anavysos Kouros, 44, 45 Anaxagoras of Clazomenae, 52 Anchise, 140 Ancient civilizations Aegean culture in the Bronze Age, 5, 18-27, 20-27, 35 Minoan culture, 19, 21-22, 23-26, 24, 175 Mycenaean culture, 19, 24-27, 27, 35 China (See China and Chinese culture) Egypt (See Egypt and Egyptian culture) Greece (See Greece) India (See India and Indian culture) map, 5 Mesopotamia, 6-10 Akkadian culture, 6, 8-9 Assyrians, 6, 9, 11, 27, 203 Babylonian culture, 6, 9, 11, 203 Cvcladic art, 20-21, 21 Sumer, 6–8 Neolithic period, 3–5, 18 Paleolithic period, 3, 4, 27 readings, 29-31 Rome (See Rome) timeline, 1-2 Andrew, Apostle, 246 Annals (Ennius), 133 Annunciation and Nativity (Pisano, N.), 404, 405 The Annunciation (Martini), 410, 411 The Annunciation of the Death of the Virgin (Duccio), 407 Anoninius Pius, emperor of Rome, 137 Anthemius of Tralles, 238, 239 Antigone, 77 Antigone (Sophocles), 14, 75, 77 Antioch, 93, 94, 138 Antiphonal singing, 215 Antonines emperors of Rome, 137 Antony, Mark, 137 Anubis, 13 Aphlad, 211 Aphrodite, 36, 37, 91, 135 Aphrodite at Cyrene (Venus Anadyomene) (Praxiteles), 91,91 Apollo Delos as sacred to, 72 in Laocoön Group, 97, 135 in literature, 36–37, 76 in music, 49, 51

Roman equivalency, 135

sculpture of, Temple of Zeus, 83.86 Temple of, 48, 77, 144 Apollo of Veii, 130, 130 Apologists, Christian, 210 Apology (Plato), 79, 112-114 Avology (Xenophon), 79 Apostles of Jesus, 243-244 Apoxyomenos (The Scraper) (Lysippus), 92 Apse, 241 Aqueducts, 150, 150 Aquinas, Saint Thomas Aristotle's influence on, 80-81, 277, 365 Augustine's influence on, 235-236 Boethius' influence on, 236 estrangement from God, 364 scholasticism, 343, 360-363, 362 Summa Theologica, 360, 361, 363, 368-370 Ara Pacis, 141-142, 141-142 Arabic language, 6, 268-269, 276-277 Arabic numerals, 182, 277 Arch, 147, 147-149, 148, 150 Arch of Constantine, 154 Arch of Titus, 147, 204 Archaeology Dura-Europos, 211-212, 213 Etruscans, 129 Minoan culture and Knossos excavation, 16, 21-23, 23 - 27Mycenae and Schliemann's excavations, 21, 24-27, 27 Pompeii, 16, 143-144, 143-147, 146 Troy, 25, 26 Tutankhamen's tomb, 15–16, 19 Archaic smile, 45, 45 Architecture ancient civilizations Aegean, 16, 23, 24, 24–25, 26.35 Bronze Age, 5 Egypt, 10-13, 15, 20, 47 - 48Indian, 179 Mesopotamia, 8-9, 10 Byzantium ascendancy of, 238-240, 239, 249-252, 251 Ravenna, 240-252, 240-252 Charlemagne and Medieval culture, 246, 295-296, 302, 305-312, 307-312 Christian period, early, 212-214, 214

Greece Classical, 83-88, 89, 91-92, 92 early period, 46-48, 49, 83, 85 Hellenistic, 93-97, 95, 96 Pergamum, 95, 95 Islam, 270-275 Middle Ages and Fourteenth century Gothic style, 343-355, 344-346, 349-354, 357, 414-416, 416-419 light, mysticism of, 347-348, 349, 350, 351 Romanesque style, 308, 310, 310, 311, 312, 346 Rome Etruscan, 147-148 Imperial, 143-145, 146, 147, 147-150, 148, 149, 150, 238 late, 152, 153, 153-154, 154 Republican, 136, 136-137 Architrave, 48, 49 Archivolts, 310, 312, 348 Arena Chapel, Padua, 408 Ares, 36, 37, 135 Arezzo, Guido de, 355 Argos, 76, 79, 82 Ariadne, 21 Arian Baptistery, 241, 243-244 Arian Christians, 241, 243-244 Arian Saints, 245 Aristion, Stele of, 45, 47 Aristophanes, 78-79 The Birds, 78 Lysistrata, 78 Aristotle Aquinas, influence on, 80-81, 235, 277, 362, 365 Boethius' translation of, 237 Charlemagne, influence on, 295 on dialectics, 355 Lyceum founding, 80 music and, 49, 50, 51, 81 paradoxes discussed by, 53 as Plato's pupil, 80 on polis, 74 recovery of, 343, 356 significance of, 71, 80, 81 on tragedy, 77-78, 80 translations of, 237, 253, 277, 295 works Ethics, 363 Metaphysics, 80, 359 The Nichomachean Ethics, 118-121 Physics, 80 Poetics, 77-78, 80 Politics, 121-123 Rhetoric, 80 Ars Nova, 416-419, 418, 419 Ars Nova Musicae (The New Art of Music) (Vitry), 417

Art. See also Architecture; Painting; Pottery and ceramics; Sculpture; specific artists and artworks ancient periods and cultures Aegean cultures, 18-26, 20-22, 21, 23-27 China, 185, 186-188, 189 Egypt, 7, 10-18, 12, 15-20, 43 Indian Buddhism and Hinduism, 179-181, 180-182 Mesopotamia, 6-10, 7-11 Neolithic period, 3, 4-5 Paleolithic period, 3, 4, 4, 27 Byzantium, 240-252, 240-252, 253 (See also Mosaics) Christian period, early, 210-211, 211, 212, 213 Greece Archaic period, 43-44 Classical period, 82-90, 89 early period, 37, 39-46, 40-42, 515 Hellenistic period, 93-97, 95,96 Islam, 40, 269-270, 276, 277-278 Middle Ages and Fourteenth century Charlemagne and Medieval culture, 303-305, 304-305, 304-306, 305, 306 illuminated books, 296, 298, 303-305, 305, 306, 357, 419 Italy, 403-410, 404-410 Northern Europe, 410-414, 413-415 stained-glass windows, 344, 347-348, 349 Rome Etruscan, 129, 129-130 Imperial, 145, 146, 153-154, 154 Republican, 131, 136, 136-137 Artabanus, 54 Artemis, 22, 27, 37, 51, 135 Artemis, Temple of, 92 Aryans of Indus Valley, 175-179 Aryballos, Corinthian vase, 42 Asceticism, 177, 178 Ashoka, Emperor of India, 178-179, 180 Asia. See China and Chinese culture; India and Indian culture Assisi, Saint Francis of, 359-360, 360, 361, 368, 370, 408, 410 Asso, 138 Assurbanipal, king of Assyrians, 9, 11

Assurnasirpal II, king of Assyrians, 9 Assyrian Empire, 6, 9, 11, 27, 203 Astronomy, 295 Athena Acropolis, honored on, 72, 84,86-87,88 in literature, 36, 37, 76 in music, 49 Roman equivalency, 135 Temple of (See Parthenon) Athena Slaying the Giant, 96, 97 Athenodorus, 96 Athens Acropolis in, 44, 46, 72, 72-73, 78, 84-87, 86, 87 art, 42-43 Christianity, Paul's sermon on, 207 Classical Ideal in, 71-74 drama in, 74-79 Golden Age of, 73, 141 Heroic Age, 35 as Mycenaean city, 25, 35 Peloponnesian War, 71-74, 78-79, 80, 84, 85 Pericles' leadership of, 73, 73-74,84-85 Persians, defeat of, 53 Plato in, 80 Socrates in, 79-80 Atman, 177 Atomic Theory, 53 Atomism, 53 Aton, 14 Aton-Ra, 12, 13 Atrium, 212, 214 Atropos, 39 Attalids, 94 Attalus I, king of Pergamum, 95 Attic Red Figured Calyx Krater, 76 Attica, 35 Attick Black-figure crater, Corinthian vase, 42, 43 Atticus, 133-134 Au départir de vous (Machaut), 419 Augustine of Hippo, Saint, 235-236,400 The City of God, 235-236, 257-263, 306, 403, 437 Confessions, 236, 255-257, 299,400 Augustus, emperor of Rome, 136, 137, 137-143, 139, 142, 167 Augustus of Prima Porta, 141, 150 Aulos, 50, 50, 81 Autocracy, 243 Avatar, 180, 181 Averröes of Córdova, 277, 278, 362 The Incoherence of Incoherence, 278

Avicenna, 277, 362 Avignon, 397, 400-401

B B. C. E. (before the common era), 175 Babylonian Captivity of Hebrews, 203 Babylonian culture, 6, 9, 11, 203 Bacchae (Euripides), 78 Bacchus, 135 Bach, Johann Sebastian, 419 Baghavad-Gita, 180, 181 Baghdad, 276-278 Bait al-hikma (House of Wisdom), 276-277 Ball, John, 403 Ballades, 419 Baptisteries of Ravenna, 241, 242-243, 243 Barbarossa, Frederick, emperor, 302 Barks, Coleman, 288 The Essential Rumi, 288 Baroque period and Hellenistic Greece, 94 Barrel vault, 148, 148, 308, 310 Basilica, Saint Peter's, 212, 214, 293 Basilica of Constantine, 147, 152, 153 Basilica style, 147, 152, 153, 212, 214, 238, 271 Basques, 302 Battle(s) Actium, 137 Agincourt, 398 Chaeronea, 79 Crécy, 399 Hastings, 302 Marathon, 53, 76 Pharsalus, 133 Poitiers, 293, 399 Roncesvalles, 293, 302 Beatitudes, 207 Beatrice, 363 Beauvais Cathedral, 345-346, 346 Bede, Venerable, 295 Before the common era (B. C. E.), 175 Belisarius, 248 Benares, 178 Benedict of Nursia, Saint, 296 Benedictine monasticism, 296–298, 308, 310. See also Abbey of Saint Denis Benedictus in Ordinary of the Mass, 419 Benefices, 359 Bernadone, Giovanni, 359. See also Francis of Assisi Bernard of Clairvaux, 312 Berry, Duc de, 403, 411, 414 Bertilla, Abbess of Chelles, 330-333

Bes, 12 Bessarion, Cardinal, 253 Bhakti, 177 Bible. See also Christianity; Religion Biblical traditions and the West, 203 book list of Old and New Testament, 208 ethics in, 206 Greek codex of New Testament, 250 as Hebrew history, 203-204 message of the Hebrew Bible, 204 - 207monotheism in, 205-206 readings, 217-228 revelation in, 206 stories as models and types, 207 stories in stained glass, 348, 349 study of, during Charlemagne's rule, 295-296 translations, 295 Bibliothèque Nationale, Paris, 352-353 The Birds (Aristophanes), 78 Bishop Ecclesius, 245, 247, 247 Bishop Maximian, 245, 248, 248, 250 Bishop of Hippo. See Augustine of Hippo, Saint Bishop's throne, 248, 250 Bithynia, 235 Black Death, 397, 398, 410 Black-figure style, 46, 48 Blacks, 10, 207 The Blind Harper of Leiden, 214, 215 Boccaccio, Giovanni, 253, 363, 389, 399, 400 De Claris Mulieribus, 403 Decameron, 397, 399, 401, 402, 422 - 424Bodhisattvas, 180, 181, 182 Boeotia, 35, 51 Boethius, Anicius Manlius Severinus, 235, 236-237, 295 The Consolation of Philosophy, 236-237,401 Bonaventure, Saint, 360, 408, 410 Boniface VIII, Pope, 397 The Book of Peace (de Pisan), 403 The Book of the City of Ladies (de Pisan), 403, 437-439 Book of the Dead, 12 Books. See also Bible; specific titles and authors education in Charlemagne's time, 295

illuminated, 296, 298, 303–305, 305, 306, 357, 418, 419

Born, Ernest, 309 Bosporus, 235 Botticelli, Sandro, 363 Dante, 363 Boulé, 72 Brahman, 177, 178 Brigid of Ireland, 298 Brihad-Aranyaka Upanishad, 193-196 Britain. See England British Museum, 87, 88, 89 Broederlam, Melchior, 411 Bronze Age, 5, 18-27, 35 Brunelleschi, Filippo, 414 Bubonic plague, 73-74, 397, 398, 410 Bucolics (Vergil), 138 Buddha, 177-178, 196-198 Buddhism art, 179–180, 182 Buddha's life, 177–178 in China, 187 Hellenistic Greece and, 93 in India, 178-181 reading, 180, 182, 197-198 The Buildings (Procopius of Caesarea), 237 Bull, figure of, 175 Minotaur, 21, 22, 51 Buonaiuto, Andrea di, 362 The Triumph of Saint Thomas Aquinas, 362 Burgundy, Duke of, 411 Burial rituals and funeral practices Byzantine, 244, 244-245 Chinese, 186, 186 Christian, early, 210 Egyptian, 12, 12-13 Etruscan, 129, 130, 131 Greek, 14, 82, 84 Mesopotamian, 14 Neanderthal people, 14 tomb(s) Hunting and Fishing at Tarquinia, 130, 131 Theodoric, 244, 244-245 Tutankhamen's tomb, 15-16, 19 Butes, 88 Buttresses, 345, 346, 346 Byblos, 204 Byzantium, 235-255 Al-Khwarizmi in, 277 art, 240-253, 240-525 (See also Mosaics) ascendancy, 237-240 Charlemagne's coronation as rebellion to, 293 Constantine, emperor of, 139 Fourteenth century art, Italo-Byzantine influence in, 253, 404-406, 404-407 Hagia Sophia, Church of, 238-240, 239, 252 Islam, influence on, 271, 272

literature, 235–237, 255–263 maps, 242, 250 persistence of Byzantine culture, 252–254 Ravenna, 240–252 Rome, decline of, 235–237 Saint Catherine's Monastery at Mount Sinai, 249–252, 251, 252, 253 timeline, 232–233

С

Caedmon, 298 Caesar, Julius. See Julius Caesar Caesar Augustus, emperor of Rome, 136, 137, 137-143, 139, 142, 167 Calendar, Julian, 127 Calf-Bearer, 44, 45 Caligula, emperor of Rome, 137, 138 Calligraphy, 187, 189, 269-270, 305 Calvin, John, 235 Cambridge University, 355 Canaan, 203 Canon of the Bible, 205 The Canon (Polykleitos), 82 Canova, 147 The Canterbury Tales (Chaucer), 358, 401-402, 424-437 Cantor, 215 Cantus, 295 Cantus firmus, 355 Cantus planus, 299 Canzoni, 400 Canzoniere (Songbook) (Petrarch), 400-401 Cape, Saint Martin of Tours', 306 Capital (architecture), 48, 49 Capitoline hills, Rome, 131 Capitoline She-Wolf, 129 Carmina Burana (Orff), 359 Carolingian Empire, map of, 294. See also Charlemagne and Medieval culture Carolingian monastery, 308, 309 Carolingian Renaissance, 293, 303 Carter, Howard, 15, 19 Carthage, 132, 140, 209, 228 Caryatids, 88, 89 Caste system, India, 176 Catacombs, 210 Catechumens, 228 Catharsis, 80 Cathedra, 248, 250 Cathedral(s). See also Church(es) at Amiens, 345-346 at Beauvais, 345-346 cathedral defined, 248 Charlemagne's at Aachen, 246, 302 at Chartres, 345-348, 349, 350, 351-353, 352, 353

in early Christian period, 212-214, 214, 238-240, 239 at Florence, 414, 416 at Gloucester, 416, 418 Gothic architecture high middle ages, 343-355, 344, 345, 346, 349-354 late middle ages, 414-416, 416, 417 Hagia Sophia, Church of, 238-240, 239, 252 Holy Sepulchre, Church of the, 213-214, 214, 238, 271, 294 illuminated books, 296, 298, 303-305, 305, 306, 357, 418, 419 light, mysticism of, 347-348, 349, 350, 351 at Milan, 415, 416 at Notre Dame, 344-345, 345, 351.356 at Novons, 344, 345 Ravenna, 235, 236, 240-252, 240 - 252at Senlis, 344, 345 stained-glass windows, 344, 347-348, 349 at Strasbourg, 404, 404 town center, cathedral as, 347-354 Catherine, Saint, Monastery at Mount Sinai, 249-252, 251, 252, 253 Catherine of Siena, Saint, 398 Catholic church. See also Christianity; Saint(s) Aristotalian philosophy and, 80 - 81canonical Books of the Bible, 205 Charlemagne, canonization of, 302, 302-303 Great Schism, 289-399 Vatican, 212, 214, 253, 293 Cattle, as Arvan currency, 176 Catullus, 128-129, 133, 157 Causae et Curae (Causes and Cures) (Hildegard of Bingen), 298, 314-316 Cave paintings, Paleolithic period, 4, 4 Cecrops, king of Athens, 88 Cefalù, 252 Ceiling mosaic in Orthodox Baptistery, 243 Cemetery at Ur, Royal, 14 Cemetery of Vergina, Royal, 90, 90 Ceramics. See Pottery and ceramics Ceres, 135 Cerveteri, 129 Cevlon, 179 Chaeronea, Battle of, 79 Champs Elysées, arch on, 148 Chandra Gupta I, 180-181

Chandra Gupta II, 180-181, 182 Chansons de geste, 302 Chansons d'histoire, 302 Chanting and religious observance, 214, 295, 298-300, 355 Chapel of Charlemagne, 306-307, 307 Chapter, 350 Charity in Islam, 268 Charlemagne and Medieval culture, 291-339. See also Middle Ages architecture, 246, 295-296, 302, 305-312, 307-312 art, 303-305, 304-306 Charlemagne idealization and canonization of, 302, 302-303 rule of, 293–296, 297, 302 drama, 301-302 education, 295-296, 297 literature, 295-296, 301, 302-303 map, 294 monasticism, 296-300 music, 298-301 Saint Denis Abbey, 343-344 sculpture, 310, 311-312 timeline, 290-291 Charles IV, Emperor, 411 Charles the Bald, 351 Charles the Great, 293. See also Charlemagne Charles V, king of France, 402 Charles VII, king of France, 402 Chartres Cathedral, 345-348, 349, 350, 351-353, 352, 353 Chaucer, Geoffrey, 236-237, 398, 400, 401-402, 420 The Canterbury Tales, 358, 401-402, 424-437 Chefren, pharaoh of Egypt, 13, 13, 15, 16 Chelles, Bertilla, Abbess of, 330-333 Chensu, 13 Cheops, pharaoh of Egypt, 13 Chevet, 352 Chi, 247, 248 Chi-Rho Monogram, 210, 213 Children of Israel, 203, 207 Ch'in Dynasty, 185-186 China and Chinese culture art, 185, 186-188, 189 Confucianism, 184, 185 **Dynasties** Ch'in, 185-186 Chou, 183-184, 185, 186, 187, 187 Han, 185, 186 T'ang, 185, 186 Golden Age of, 186 map, 183 Silk industry, 237 Taoism, 184-185

timeline, 172-173 unification of China, 184-188 Choir, 344, 344 Chorus in Greek drama, 75 Chou Dynasty, 183-184, 185, 186, 187, 187 Chou Fang, 188 Christ, defined, 207 Christ as Good Shepherd, 210, 212 Christ as the Good Shepherd mosaic, 241, 241 Christ Pantocrater, 252, 252 Christ Teaching the Apostles, 210, 211 Christ the Pantocrater, 245, 247, 247, 252, 252 Christianity. See also Bible; Monasteries; specific Saints **Byzantium** architecture, 238-252, 239 - 252ascendancy of, 237-240 literature, 235-237, 255 - 263painted icons, 252, 252 - 253philosophy, 235-237 Roman decline, 235-237 early architecture, 212-214, 214 art, 210-211, 211, 212, 213 beginnings of, 207-212 Dura-Europos archeological site, 211-212, 213 Judaism and, 203-215 map, 208 music, 214-215 persecutions of Christians, 208-210 readings, 204-210, 217-231 renewed covenant, 205 Roman Empire, official religion of, 127, 135, 154 spread of, 207-210 timeline, 200-201 Middle Ages architecture, Gothic style, 343-355, 344-346, 349-354, 357, 414-416, 416 - 419Great Schism, 397-399 impact on, 343 Reconquista in Spain, 273 Orthodox Christians icons, 251, 252, 253 Neonian Baptistry, 241, 242, 243 Theodoric's palace, 245 pilgrimages, 272, 302, 308, 351, 353-354 Christine de Pisan, 402-403 The Book of Peace, 403 The Book of the City of Ladies, 403, 437-439 A Letter to the God of Love, 403

The Treasure of the City of Ladies, 403 Chronicles (Froissart), 399, 403 Chrysippus, 82 Chrysostom, Saint John, 239 Church(es). See also Cathedral(s); Catholic church; Mosque(s); Temple(s) Colloquy, Church of the, 250 Greek Orthodox Church, 252, 253 Hagia Sophia, Church of, 238-240, 239, 252 Holy Sepulchre, Church of the, 213-214, 214, 238, 271, 294 light in Byzantine structures, 238-239, 239 Saint Catherine's Monastery at Mount Sinai, 249-252, 251, 252, 253 Saint Denis Abbey, 302, 343-347, 344, 345, 346, 349, 354 Saint Peter's Basilica, 212, 214, 293 San Domenico, 406, 406 San Vitale, 245, 246-249, 247, 248.306 Sant' Apollinare Nuovo, 244-245, 244-247 social significance of, 348-354 Cicero, Marcus Tullius Aristotle, influence by, 80 bust of. 136 Charlemagne, influence on, 295, 296 Julius Caesar and, 133-134. 136, 136, 137 Montaigne, influence on, 400 Petrarch, influence on, 237 Cifra, 277 Cimabue, 253, 406, 406, 407 Crucifixion, 406, 406 Madonna Enthroned, 406, 406 Cistercians, 343 Cithara, 50, 50 The City of God (Augustine), 235-236, 257-263, 306, 403, 437 City-states China, 183 civic pride in, 74 Greece, 10, 35, 41-42, 72-73, 74,78-79 Italy, 74 Mesopotamia, 10 Civilization, characteristics of, 3 De Claris Mulieribus (Boccaccio), 403 Class. See Social class Classe, 245, 247 The Classic of the Way and Its Power (Tao te ching) (Laotzu), 184

Classical Greece. See Greece, Classical and Hellenistic Classical Ideal, Greco-Roman, 71-74, 154 Classics of Songs, 186 Claudius, emperor of Rome, 137, 142, 209 Cleopatra, queen of Egypt, 137, 140 Clerestory, 212 Cloisters, 306, 308, 309, 359 Clotho, 39 Cluny Abbey, 346 Clytemnestra, 76, 76 Cnidus, 91 Codex Sinaiticus, 250 Coffeehouse, 278 Coleridge, Samuel Taylor, 80 Colloquy, Church of the, 250 Cologne, 295 Colonization, Age of, and Greece, 35, 41-42 Colosseum, Rome, 147 Columns corinthian order, 48, 149, 149 doric order, 46-48, 49, 83, 85, 85 ionic order, 46-48, 49, 85, 86, 87-88,89 Minoan vs. Egyptian and Greek, 22 Comedy, 78-79, 133 Commentaries (Julius Caesar), 133 Commerce. See Trade and commerce Commodus, emperor of Rome, 137 Compline, 297 Composers. See Music; specific composers and compositions Conceptual art, ancient Egypt, 14 Confessions (Augustine), 236, 255-257, 299, 400 Confucianism, 184, 185 Confucius, 184, 184, 185, 186 Conquest, period in Hebrew history, 203 The Consolation of Philosophy (Boethius), 236-237, 401 Constantine, Arch of, 154 Constantine, emperor of Rome capital moved from Rome, 139, 151 Christian toleration decree. 209 early Christian Period, 212-214, 214, 235, 238 as last principal Roman emperor, 137 marble head of, 152 Receiving Homage from the Senate, 154 Roman architecture, 153 Constantinople capital moved to, 151, 235

Charlemagne's rule, 293–294 D Hagia Sophia, Church of, 238-240, 239 influence of, 252-254 Justinian's rule, 237–238 Mosque of Córdoba, materials for, 272, 273 Muslim attack on, 268 Turk conquest of, 252, 254 Contemporary voices Ashoka's Rock Edict, 178 of Ball, John, 403 in Charlemagne's time, 297 Homer's world, daily life in, 41 Kerdo the Cobbler on, 94 Medieval parent and student, 358 Middle Ages, scholarship in, 297 Procopius of Caesarea, 178 Rome, Imperial, dinner party in, 94 Sufi path, Al Ghazzali on, 278 Vibia Perpetua, 178 The Conversion of the Harlot Thaïs (Hroswitha), 301, 325-330 Convivio (Dante), 363 Córdoba, 272, 293 Córdoba, Mosque of, 272, 273, 274 Corinth, 42-43, 48, 72, 79 Corinthian order, 48, 149, 149 Corinthians, Paul's letters to, 208, 225-226 Cornice, 48, 49 Corpus Iuris Civilis, 135 Cosmeterium ad catacumbas, 210 Cotton cultivation, 175 Counterpoint, 355 Court of the Lions, Alhambra, 273-274, 274 Covenant, 205 Crécy, Battle of, 399 Credo in Ordinary of the Mass, 419 Creon, king of Thebes, 14, 77 Crete, 19, 20, 25 Crito and Timarista, Stele of, 85 Crito (Plato), 79 The Crossing of the Red Sea, 211, 213 Crucifixion (Cimabue), 406, 406 Crucifixion ivory carving, 304, 305 Crusades, 252, 308, 343, 344 Cuneiform system of writing, 6, 7,19 Cush, 10, 27 Cybele, 154 Cyclades islands, 20-21 Cycladic art, 20-21, 21 Cyprus, 26

Cyrus the Great, 10

Delos, 72

Da Vinci, Leonardo, 81 Dagulf Psalter, 304-305, 305, 306 Dalton, John, 53 Damascus, 207, 271, 272 Damascus, Mosque of, 271, 272 Dance, in early Greece, 49-51, 51 Dante Alighieri vs. Boccaccio, 397 Boethius, quoting of, 236 on dialectics, 356 in Fourteenth century, 400 on Great Schism, 398 on Leonardo da Vinci, 81 on Vergil, 138 works Convivio, 363 The Divine Comedy, 278, 356, 363-365, 365, 370-393 De Monarchia, 363 Vita Nuova, 363 De Vulgari Eloquentia, 363 Dante and His Poem (Michelino), 365 Dante (Botticelli), 363 Darius, king of Persia, 53 Dark Ages, 293, 302. See also Middle Ages David, king of Hebrews, 203 David (artist), 147 De Claris Mulieribus (Boccaccio), 403 De Meun, Jean, 403 De Monarchia (Dante), 363 De Musica, 419 De Pizzano, Thomas, 402 De Rerum Natura (On the Nature of Things) (Lucretius), 134 De Viris Illustris (Petrarch), 400 De Vita Solitaria (Petrarch), 400 De Vulgari Eloquentia (Dante), 363 Death of the Virgin, 404, 404, 413, 415 Decameron (Boccaccio), 397, 399, 401, 402, 422-424 Decimals, 182, 277 Decius, emperor of Rome, 137, 209 Deities. See also God, monotheistic Babylonian, 9 Christian denial of, 209-210 Egyptian, 10–12, 14 Greek, 27, 36-39, 40, 49, 51, 76-79,135 Hindu, 40, 177, 179-180 Indian / Aryan, 191-194 Minoan, 24, 26 Mother Goddess, 4, 5, 6, 20, 21, 22, 27 Roman, 134-136, 135, 154, 209 - 210Sumerian, 8 Delian League, 72, 73, 85

Delphi, 41, 49, 77, 91 Demeter, 27, 37, 135 Demetrios, Father, 253 Demon of Luxury, 311 Demosthenes, 79 Denier, 294 Dervishes, dancing, 276 Descriptive style of art, ancient Egypt, 14 Desire (Pothos) (Scopas), 91, 91 Destiny, 39 Devotion, in Hinduism, 177 Dhouda, 296 Dialectics, 355 Diana, 135 Dido, queen of Carthage, 140 Dijon, 411 Dilogues of Plato, 79 Diocletian, emperor of Rome, 137, 153, 209 Dionysius II, king of Sicily, 80 Dionysius the Areopagite, 347 Dionysus, 21, 36, 37, 51, 74-75, 135 Dipylon Amphora, 40, 41, 41 Discobolos (Discus Thrower) (Myron), 82, 82 A Distant Mirror (Tuchman), 399 Dithyramb, 51 Divided Kingdom, period in Hebrew history, 203 The Divine Comedy (Dante), 278, 356, 363-365, 365, 370-393,400 Divine Liturgy of John Chrysostom, 239 Divine Office, 297, 299 Divorce, 9, 18 Doctor, as academic title, 357 Doge's Palace, Venice, 415, 417 Dome, architectural, 148, 148-149, 238, 238 Dome of the Rock, Jerusalem, 271, 272 Dominic, Saint, 360 Dominicans, 360 Domitian, emperor of Rome, 137, 151 Don Quixote (Strauss), 51 Dorian mode of music, 50, 81 Doric order, 46-48, 49, 83, 85, 85 Doryphoros (Spearbearer) (Polykleitos), 82, 84 Dragon, Chinese bronze, 187, 187 Drama. See also Literature; specific plays and playwrights Charlemagne and Medieval culture, 301-302 comedy in, 78-79, 133 Florence, classical revival in, 75 Greece, 53, 74-79 Middle Ages, 301 tragedy, 74-78, 80, 133

Dualists, 53 Duccio di Buoninsegna, 406, 410 The Annunciation of the Death of the Virgin, 407 Madonna Enthroned, 406, 407 Maestà, 406, 407 Duomo (Florence), 414, 416 Duomo (Milan), 414-415, 416 Duplum, 355 Dura-Europos, 211-212, 213 Dusyanta, 182

E

Ecclesia, 72 Ecclesius, Bishop, 245, 247, 247 Echinus, 48 Eclogues (Vergil), 138 Edict of Diocletian, 153 Education. See also Universities Aristotle's Lyceum, 80 Bait al-hikma (House of Wisdom), 276-277 cathedrals and, 350-351 in Charlemagne's time, 295-296, 297 Greek studies, 253-254 Middle Ages, impact on, 343 Plato's Academy, 80 scholasticism, 355-363 social class, 296 studia in Italy, 253 of women, 301, 359, 402-403 Edward III, king of England, 399,401 Egypt and Egyptian culture, 10 - 18Alexander's conquest of, 17 - 18ancient Egypt, 10-18 art, 7, 10-18, 12, 15-20, 43 Buddhist missionaries in, 179 Cleopatra, queen of, 137, 140 Hebrew exodus, 203, 206 hieroglyphics, 7 influence of, 27 love, marriage, and divorce in ancient, 18 vs. Mesopotamia, 5 New Kingdom, 10, 14-18 Old and Middle Kingdoms, 12 - 14overview of ancient, 5, 10 Ptolemies kingdom in, 93 religion and deities, 10–12, 14 timeline, 1 Eightfold Noble Path of Buddhism, 178 Einhard, 297, 299 Electra, 76 Elephant ceremonial vessel, 184 Elgin, Lord, 87 Elgin Marbles, 87, 88, 89 Eliot, T. S., 138, 365 Emotion, love, 18, 133 Empedocles of Acragas, 52

456 INDEX

Emperors of Rome, 137, 151 Empire, values of, 139 Encaustic method of painting, 252, 252 Encheiridion (Epictetus), 134 England Hundred Years' War, 399 late Gothic architecture in, 416, 418 literature of Chaucer in, 401-402, 424-437 Peasant Revolt, 399, 403 Enkidu, 6 Enlightened One (Buddha), 177 Ennius, 133 Annals, 133 Entablature, 48, 49 Entasis, 85 Ephesus, 48, 92 Epic of Gilgamesh, 6-8, 30-31 Epictetus, 134-135 Encheiridion, 134 Handbook, 134 Epicureanism, 53, 134, 135, 154 Epicurus, 134 Epistemology in philosophy, 52 Erechtheum temple, 84, 87-88, Erechtheus, king of Athens, 88 The Essential Rumi (Barks and Moyne), 288 Etheria, 249-250 Peregrinatio, 249-250 Ethics, in Bible, 205, 206 Ethics (Aristotle), 363 Ethos, 50, 81, 215 Etruscans, 129-130, 147-148 Euclid, 295 Eumenes II, king of Pergamum, 95 Eumenides, 76 The Eumenides (Aeschylus), 75, 76 Euphrates River, 5, 5, 6 Euphronios Vase, 46, 48 Euripides, 74, 75, 78 Bacchae, 78 Helen, 78 Iphigenia in Taurus, 78 The Suppliant Women, 78 Evans, Arthur, 21-23, 23-27 Everyman (morality play), 301, 317-325 Evolution, human, 3 Exekias, 46, 48 Exemplum, 348, 397, 402 Exile, period in Hebrew history, 203-204 Exodos, period in Hebrew history, 203 Exodus, Book of, 207, 220-221

F

Fabliaux, 397, 402 Fairs. *See* Trade and commerce *Fasting Buddha*, 180, 182

Fate, 39, 77-78 Fatima, daughter of Muhammad's, 267 Female head from Uruk, 6, 8 Fertile Crescent, 7. See also Mesopotamia Feudalism, 293, 309 Ficino, Marsilio, 253 Fideism, 360 Fifth Century B. C., Greek sculpture and vase painting, 82-90, 82-90. See also Greece, Classical and Hellenistic First Apology (Justin Martyr), 226-228 Fish and Chalice, 213 Fish as Christian symbol, 210, 213 Five Classics, 186 Flagellants, 399 Flavian emperors of Rome, 137 Flood, in Epic of Gilgamesh, 7, 30 Florence, 74, 363, 415. See also Italy Florence, Cathedral of, 365, 414, 416 Fortuna, 39 Forum, Roman, 131, 132 Four Noble Truths of Buddhism, 179 Fourfold Noble Path of Buddhism, 178 Fourteenth century. See Middle Ages, Fourteenth century Fourth Century B. C., visual arts in, 90-92, 90-92. See also Greece, Classical and Hellenistic Fourth interval in music, 81 France. See also Paris cave paintings, Paleolithic period, 4, 4 Hundred Years' War, 399 Île-de-France, 345, 347, 348, 349 literature of Christine de Pisan in, 402-403, 437-439 music, 416-419, 418, 419 Francis of Assisi, Saint, 359-360, 360, 361, 368, 370, 408, 410 Franciscans, 359-360, 408 François Vase, 42 Frankish kingdom, 295, 296, 299, 302. See also Charlemagne and Medieval culture Franklin, Benjamin, 207 Frederick Barbarossa, emperor of Roman Empire, 302 Frescoes, 146, 210, 211, 211, 213 Freud, Sigmund, 77 Frieze, 48, 49, 85, 86, 87, 141, 180

Froissart, Jean, 399, 403 *Chronicles*, 399, 403 Funeral practices. *See* Burial rituals and funeral practices The Furies, 76

G

Gabriel, Angel, 267 Gaius, 141 Gaius Caligula, emperor of Rome, 137, 138 Galatians, Paul's letters to, 208 Galen, 277 Galla Placidia, regent of Ravenna, 240, 240-241, 241, 242 Gandersheim, 301 Gandhara, Buddhist sculpture at, 93 Gandharan, 93 Ganges River Valley, 180 Gargoyles, 348, 351 Gaul, 95, 132 Gautama, Siddhartha, 177-178 Genesis, Book of, 7, 205-306, 217-218 Geometric art, Greek pottery, 39-40, 40, 41, 42 Geometric period, 40 Georgics (Vergil), 138-139 Geranos, 51 Germany Hroswitha's dramas, 301 minnesingers in, 355 Peasant Revolt, 399, 403 Gesamtkunstwerk, 75 Al-Ghazali, 278 The Incoherence of the Philosophers, 278 Gilgamesh, ruler of Sumeria, 6-8,30-31 Giotto da Bondone, 253, 400, 403 - 410The Lamentation over the Dead Christ, 408, 409 Madonna Enthroned, 408, 408 The Meeting of Joachim and Anna, 408, 409 Saint Francis Renounces His Worldly Goods, 408, 410, 410 Giza, pyramids at, 13, 15 Gladiatorial contests, 127, 128 Glass art in early Christian period, 210 stained-glass windows, 344, 347-348, 349 Gloria in Ordinary of the Mass, 419 Gloucester Cathedral, 416, 418 God, monotheistic Aquinas on, 361-362 Aristotle on, 80-81 Augustine of Hippo on, 235 - 236

Boethius on, 236-237 Dante's view on, 363-365 in Hebrew Bible, 205-207 in Islam, 267, 268, 269 light, mysticism of, 347-348, 349, 350, 351 Gods and Goddesses. See also Deities Greece, 27, 36-39, 40, 49, 51, 76-79,135 Rome, 134-136, 135, 154, 209-210 Goethe, Johann Wolfgang von, 147 Golden Ages of Athens, 73, 141 of Augustus, New, 141 of China, 186 of Greece, 71, 84 of Latin Literature, 142 of Rome, 137 Goliadic verse, 359 Golias, Saint, 359 Good Shepherd, 210, 212 Gospel Book of Charlemagne, 303, 304 Gospels, 207, 212, 223-224, 245. See also Bible Gothic, as a term, 345 Gothic style, architecture high middle ages, 343–355, 344-346, 349-354 late middle ages, 414-416, 416, 417 Goths, 152, 235, 236, 243-244, 306 Government and political theory autocracy, 243 Confucius, 184 democracy, 72, 130-131 gothic cathedral and, 348-352 Greek tyrants, 44, 79 of Plato, 80, 117-118 Roman, 135 Grabar, André, 252 Graeco-Roman culture and the West, 203 Granada, 273-274, 274 Grave Stele of Crito and Timarista, 85 Great Panathenaic Festival, 86, 88 Great Schism, 397-399 Great Wall of China, 185, 185 - 186Greece. See also Athens Classical and Hellenistic, 71 - 99architecture, 83-88, 89, 91-92, 92, 93-97, 95, 96 art, 93-94, 96 city-states of, 72-73, 78-79 Classical Ideal, 71-74 drama, 53, 74-79

INDEX 457

Hebrew conquest, 203 Knossos, 20-21 literature, 99-123 map, 36, 93 music, 81, 127 Mycenaean culture, 19, 24-27, 27, 35 painting, 46, 48, 82, 84, 90 Peloponnesian War, 71-74, 78-80, 82, 84, 85 Persian Wars, 72-73, 79 philosophy, 79-81 poetry, 51-52, 64, 78 Roman conquest of, 132, 133 sculpture, 82, 82-85, 90-92, 90-92 sphinx as motif, 13, 15 Thirty Tyrants rule in, 80 timeline, 68-69 cultural influence of Buddhist missionaries in, 179 Byzantine influences on, 253 - 254impact on Middle Ages, 343 language, 253, 293 scholarship, 253-254 early period, 35-55 Aegean culture in the Bronze Age, 18-27 Age of Colonization, 35, 41 - 42architecture, 46-48, 49 art, 37, 39-46, 40-42, 515 city-states of, 10, 35, 36, 41 - 42defeat of Persians by, 27, 44 Heroic Age, 35-39 Iron Age, 26, 27, 35 literature, 37-39, 51-54, 56-67 map, 36 music and dance, 49–51, 51 Olympic Games, 41 painting, 46, 48 philosophy, 52-53 poetry, 51-52 religion and deities, 27, 36-39, 49, 51 sculpture, 43-46, 43-47 Gods and Goddesses, 27, 36-39, 40, 49, 51, 76-79, 135 Golden Age of, 71, 84 Greek literature in translation (Herondas, Howe, and Harrer), 94 Greek Orthodox Church, 252, 253 Gregorian chant, 295, 298–300, 355 Gregory the Great, Pope, 295,

299

Gudea, 9, 9 Guide for the Perplexed (Maimonides), 362 Guido di Arezzo, 355 Guilds, trade, 352–353 Gupta Empire, 180–183 Gutians, 8

н

Hadith, 269 Hadrian, emperor of Rome, 136, 137, 149, 238 Hagia Sophia, Church of, 238-240, 239, 252 Haj, 267 Al-Hakam, 272-273 Hamartia, 78 Hammurabi, king of Babylonia, 9, 10, 11 Hammurabi, Stele of, 7, 9, 11 Han Dynasty, 185, 186, 187, 187, 188, 189 Handbook (Epictetus), 134 Handwriting. See Writing Haphaistos, 88 Hapi, 13 Harappa, 175 Harmony, 53, 81 Harp, 214, 215 Harrer, Gustave Adolphus, 94 Hastings, Battle of, 302 Hathor, 13 Al-Hazen, 277 Hebrew, 6 Hebrews, history of, 203-204. See also Judaism Hector, 38, 56 Hegira, 267 Heisenberg, Werner, 53 Helen (Euripides), 78 Hell, in Dante's Divine Comedy, 363-365, 366, 370-383 Hellenistic Greece. See Greece, Classical and Hellenistic Heloise and Abelard, 359 Hemlock, Socrates' poison, 79 Henotheism, 205 Hephaestus, 37, 135 Hera, 27, 36, 37, 48, 49, 135 Hera, Temple of, 48, 49 Heraclitus of Ephesus, 53, 64 - 65Hermes, 37, 49, 135 Hermes with Infant Dionysus (Praxiteles), 90, 90 Herodotus, 53-54, 65-67 History of the Persian Wars, 53, 65 - 67Heroic Age in early Greece, 35-39 Herondas, 94 Hesiod, 51, 52 Theogony, 51 Works and Days, 51 Hierarchical, Middle Ages as, 363

Hieroglyphics, 7, 22 High Middle Ages. See Middle Ages, High period of High relief, 44 Hilda, abbess of Whitby, 298 Hildegard of Bingen, 298, 298, 314-316 Causae et Curae (Causes and Cures), 298, 314-316 Ordo Virtutum, 298 Physica, 298 Scivias, 298, 298, 314-316 Symphonia, 298 Hinayana, 187 Hinduism art, 179-180 gods, 40 literature, 176-177 number notation, 277 origins, 177, 181 Hippo, Augustine of. See Augustine of Hippo, Saint Historians, 53-54, 73 History of Ancient Art (Winckelmann), 147 History of Egypt (Manetho), 10 History of the Peloponnesian War (Thucydides), 73 History of the Persian Wars (Herodotus), 53, 65-67 Hittites, 6 Holy Sepulchre, church of, Jerusalem, 213-214, 214, 238, 271, 294 Homer identity of, and stories, 37-39,79 vs. rational philosophy, 52 Trojan War, 25 works Iliad, 25, 35, 37-39, 41, 49, 56-64, 139 Odyssey, 21, 25, 35, 37-39, 139 Honorius, emperor of Rome, 235 Horace, 138, 142, 167 odes of, 167-168 Horarium Monasticum, 297 - 298Horn, Walter, 309 Horses, Aryan civilization, 176 Hortensian Law, 132 Horus, 12, 13 House of the Silver Wedding, Pompeii, 146 House of Wisdom (Bait alhikma), 276-277 Howe, George, 94 Hroswitha, 301, 325-326 The Conversion of the Harlot Thaïs, 301, 325-330 Theophilus, 301 Hubris, 54, 72

Human form in Greek art, 40 Humphries, Christian, 196 The Wisdom of Buddha, 196-198 Hundred Years' War, 399 Huns, 152, 182 Hymns. See Vocal music Icons, 251, 253 Île-de-France, 344, 347, 348, 349 Iliad (Homer), 25, 35, 37-39, 41, 49, 56-64, 139 Ilium, 25 Illuminated manuscripts, 296, 298, 303-305, 305, 306, 357, 418, 419 Imam, 267 Imhotep, 13, 47 Imperial fora, Rome, 149, 149 - 150Imperial Rome. See Rome, Imperial The Incoherence of Incoherence (Averröes of Córdova), 278 The Incoherence of the Philosophers (Al-Ghazali), 278 India and Indian culture art, 179-180, 180-182 Aryans, 175-179 Ashoka's reign, 178–179 Greek influences on, 92 Gupta Empire, 180-183 Indus Valley civilization, 175-176 Al-Khwarizmi in, 277 literature, 176-177, 181-182, 191-199 Taj Mahal, 274, 275 timeline, 172-173 Indus River Valley, 18-19, 175-176, 180 Inferno, in Dante's Divine Comedy, 363-365, 366, 370-383 Ingres, Jean Auguste Dominique, 147 Inscriptions, early Christian art, 210, 213 Institutes, Justinian's, 238 Institutio Oratoria (Quintilian), 295 International Style of art, 410, 411 Interval, fourth, in music, 81 Introit, 300 Ionic order, 46-48, 49, 85, 86, 87-88.89 Iphigenia, 76 Iphigenia in Taurus (Euripides), 78 Iran, 8 Ireland, 296

Irene, empress of Byzantium, 293 Iron Age, 26, 27, 35 Isaac, Charlemagne's envoy to Al-Rashid, 294 Isadore of Seville, 295 Ishafan Mosque, 271 Ishmael, 271 Isidore of Miletus, 238, 239 Isis, 12, 154 Islam and Muslims Aquinas' use of scholarship, 362 architecture, 270-275 art, 40, 269-270, 276, 277 - 278birth of, 267-269 Charlemagne and, 293-294, Crusades against, 252, 308, 343, 344 culture of, 276-278 dialectics and, 355 Hagia Sophia, conversion of, 240India, rulers of, 183 literature, 277, 279-289, 293, 294 map, 269 medicine and science of, 277-278 Muslim Spain, 272, 293 pilgrimages, 267 Qur'an, 240, 268-270, 270, 271, 275-278 revelation and, 206 in Song of Roland, 303 Sufism, 275-276 timeline, 264-265 Isorhythm, 418 Israel, 203-204, 207, 208. See also Jerusalem Israelites, 203 Istanbul. See Constantinople Italo-Byzantine art, 404, 405 Italy. See also under Rome architecture, late Gothic, 414-416, 416, 417 art in Fourteenth century, 253, 400, 403-410, 404-410 Byzantine influence in, 252-253 Etruscan period, 129 Greek colonization of, 41-42 literature of Petrarch, 236, 253, 400-401, 410 monasticism in, 296 music in Fourteenth century, 416-419, 418, 419 Renaissance city-states of, 74 Roman control of, 132 Venice, 74, 253, 415-416, 417 Ius Civile of Rome, 135 Ivory carving, 304-305, 305, Juno, 135 306 Jupiter, 135, 211

Jade, carved, 187 Jahan, Shah, 274 James, Shine of Saint, 302 Jerome, Saint, 295 Jerusalem Christian martyrs, 209 Church of the Holy Sepulchre, 213-214, 214, 238, 271, 294 Hebrew history, 203-204 Islam, 268, 271-272, 272 Jesus, 207 pilgrimages to, 308 timeline, 200-201 Jesus, 207, 210, 210, 243. See also Christianity Jesus calls the apostles Peter and Andrew, 246 Jewelry, 22, 24, 42 Jews. See Judaism Joan of Arc, 403 Job, 207 Job, Book of, 218-220, 236 John, Duc de Berry, 412 John, Gospel of, 207 John Chrysostom, Saint, 239 John the Baptist, 243, 248, 250 Jonah Sarcophagus, 210, 212 Jongleurs, 303 Jordan river, 243 Joseph, Hebrew patriarch, 203, 248 Joshua, Book of, 203 Judaism Black Death and, 399 Christianity, early, and, 203-215 dialectics and, 355 early history of, 6, 203 Hebrew Bible, 204-207 history of Hebrews, 203-204 immigration, Charlemagne's welcome of, 294-295 Middle Ages, impact on, 343 music, 214-215 scholars during Middle Ages, 278 Judges, Book of, 203 Julio-Claudian emperors of Rome, 137 Julius Caesar architecture of, 136-137 assassination of, 131-132, 133, 137 calendar by, 127 as dictator of Rome, 132, 133-134, 135 law and, 135 siege of Alexandria by, 93 works Commentaries, 133 Ius Civile, 135 Julius Caesar (Shakespeare), 133 Jumna River, India, 274

Jupiter of the Capitoline, Temple of, 139 Jurisprudence. See Legal issues Justin II, emperor of Byzantium, 239-240 Justin Martyr, 210, 226-228 Justinian, emperor of **Byzantium** ascendancy of, 237-238 churches built by, 240 Corpus Iuris Civilis, 135 Hagia Sophia, Church of, 238 as icon of Christ, 252, 252 map, 250 Ravenna, 236, 245, 247, 248 represented as Christ, 247-248, 248 Saint Catherine's Monastery at Mount Sinai, 249-252, 251, 252, 253 Justinian's Code, 135, 136, 238, 253 Juvenal, 151, 168-169 Satires, 151, 168-169 Third Satire, 168-169

K

Ka'ba, 268 Kalidosa, 181–182 Sakuntala, 182 Kao-tsu, 186 Karma, 177 Karnak, Temple at, 16 Kassites, 9 Katholikon, 251, 251 Kerdo the Cobbler, 94 Al-Khwarizmi, 277 King, Martin Luther, Ir., 206 King's Peace, Greece, 79 Knossos excavation and Minoan culture, 16, 21-23, 23 - 27Koine, 209 Koran. See Qur'an Kore (korai), 43, 43, 44, 46 Kouros (kouroi), 43, 44, 44, 45 Krishna, 180, 181 Krishna and the Maiden in a Garden, 180, 181 Kritios Boy, 45-46, 47, 86 Kufic calligraphy, 269, 270 Kyrie Eleison in Ordinary of the Mass, 419

L

La Sainte Chapelle, 346 Labyrinth, 20, 51 Lachesis, 39 Laconia, 35 Lady of Warka, 6, 8 Lady Philosophy by Boethius, 236-237 Laertes, 39 Lagash, 9 The Lamentation over the Dead Christ (Giotto), 408, 409 Lancet window, 351

Landini, Francesco, 419 Lao-tzu, 184 Tao te ching, 184 Laocoön Group, 96, 97 Laodicea, 215 Laon, 296, 349 Lapith and Centaur, 83, 86, 87 Lascaux cave paintings, 4, 4 Last Supper motif, 210, 211 Late Gothic architecture, 414-416, 416, 417 Late period, ancient Egypt, 10, 17 - 18Late Stone Age, 3-5 Latin language, 129, 175-176, 253 Latin Quarter, Paris, 357 Latins, 129 Lauds, 297 Laurencius de Voltolina, 357 Law. See Legal issues The Law Code of Hammurabi, 9, 10, 11 Law of the Twelve Tables, 135 Lawrence, Saint, 240, 241, 242 League of Corinth, 79 Learning. See Education Lectio divina, 299 Lecture of Henricus de Alemania, 357 Left Bank of the Seine, University of Paris, 356 Legal issues Athen's democratic form of government, 72 Charlemagne's legal decrees, 293 Greece, Solon in, 44 Hammurabi's code, 9, 10, 11 in Hebrew Bible, 204-205 Hortensian Law, 132 Islamic Shari'a, 269 Ius Civile, 135 Justinian's Code, 135, 136, 238, 253 Law of the Twelve Tables, 135 Rome, Republican, 134-136, 238, 253 Socrates, trial of, 79-80 Ten Commandments, 205 university establishment, 356 vendetta, primitive law of, 76 Legends, 298 Lendit, 344 Lenses and optics, 277 Leo III, Pope, 293 Leonardo da Vinci, 81 Léonin, 355 Magnus Liber Organi, 355 Lesbia, 132 Lesbos, 50, 51 Letter to Posterity (Petrarch), 236,400 A Letter to the God of Love (de Pisan), 403 Leucippus, 53

Leuctra, 79 Li Po, 187, 198-199 The Libation Bearers (Aeschylus), 76 Libraries, 93, 253, 352-353 Life of Giotto (Vasari), 403-404 Light churches of Byzantium, 238-239, 239 mysticism of, 347-348, 349, 350.351 symbolism of, 239 Lighthouse of Alexandria, 93, 94,95 Limbourg Brothers, 413, 414, 415 Très Riches Heures du Duc de Berry, 413, 414, 415, 416 Lion capital, 179, 180 Literacy. See Education Literature. See also Drama; Poetry; specific authors; specific literary works ancient periods and cultures China, 184, 186-187, 198-199 Egyptian library at Alexandria, 93 Indian/Arvan, 176–177, 181-182, 191-199 Mesopotamia, 6-8 Sumer, 6, 29-31 Byzantium, 235-237, 255-263 Christianity, early, 204-210, 217-231, 235-237 Greece, 37-39, 51-54, 56-67, 94,99-123 Hinduism, 176-177 Islam, 277, 279–289, 293, 294 Middle Ages Charlemagne and Medieval culture, 295-296, 301, 302-303, 314-339 in Fourteenth century, 399-403, 422-439 High period, 359-365, 366, 368-393 Rome Imperial, 138-140, 142, 150-151 Republican, 133-134, 157 - 171The Little Clay Cart (Sudraka), 182 Liturgical trope, 300-301 Liturgy in Byzantine empire, 239-240, 243, 251 during Charlemagne's rule, 295, 298-299 Lives of the Artists (Vasari), 403 Livia, empress of Rome, 139 Livy, 142 Logic in philosophy, 52 Lombard, Peter, 356

Lombard, Peter, 3 Lombards, 252 Lorenzetti, Ambrogio, 410, 412 Peaceful City, 410, 412 Peaceful Country, 410, 412 Lorenzetti, Pietro, 410 Lost Tribes of Israel, 203 Love, 18, 133 Low relief, 44 Lower Egypt, 10 Loyang, 189 Lucan, 296 Lucifer, 364 Lucretius, 134 De Rerum Natura (On the Nature of Things), 134 Luke, Gospel of, 207 Lunette, 241 Lung-men Caves, 187, 189 Luther, Martin, 235 Lux nova, 347 Luxor, Temple at, 16 Lyceum, 80 Lvdia, 129 Lydian mode of music, 50, 81 Lyons, 296 Lyre, 49, 50, 214 Lyric poetry, 51-52, 64, 78, 128, 133, 157 Lysippus, 90, 91, 91, 92 Apoxyomenos, 92 Lysistrata (Aristophanes), 78

м

Macedon, 74, 79, 80 Macedonian Empire, 71, 79, 92-93,94 Machaut, Guillaume de, 418 - 420Au départir de vous, 419 Messe de Notre Dame, 418-419 Madonna Enthroned (Cimabue), 406, 406 Madonna Enthroned (Duccio), 406, 407 Madonna Enthroned (Giotto), 408,408 Madrigals, 419 Maecenas, 167 Maestà (Duccio), 406, 407 Magi, 245, 246, 248 Magi Bearing Gifts, 245, 246 Magister, 360 Magistri, 357 Magnus Liber Organi (Léonin), 355 Mahabharata, 176, 180, 181 Mahal, Muntaz, 274 Mahayana, 187 Maimonides, Moses, 277-278, 362 Guide for the Perplexed, 362 Mainz, 296 Majuscule, 305 Al-Malik, Abd, 271 Mallia, 22, 24 Al-Mamun, 276 Mandorla, 310, 312 Manetho, 10

Maps Ancient World, 5 Black Death, 398 Buddhism, spread of, 179 Byzantium, 242, 250 Carolingian Empire, 294 Charlemagne and Medieval culture, 294 China, ancient, 183 Christian communities, early, 208 Greece, 36, 93 Île-de-France, 347 Indian / Aryan civilization, 179 Islamic world, 269 Israel at time of Jesus, 208 Justinian's Empire, 250 Roman world, 128 Marathon, Battle of, 53, 76 Marcus Aurelius Antoninus, emperor of Rome, 134-135, 137, 168-171 The Meditations, 135, 169-171 Marius, 132 Mark, Gospel of, 207 Mark, Saint, 252, 253 Maro, Publius Vergilius. See Vergil Marriage, in Egypt, 18 Mars, 135 Martel, Charles "Charles the Hammer," 293 Martini, Simone, 400, 410-411, 411, 412 The Annunciation, 410, 411 The Martyrdom of Saint Lawrence, 241, 242 Martyrs, Christian, 208-209 Masada, 204 Masjid, 270 Materialists, 52 Mathematics in Charlemagne's time, 295 decimals, 182, 277 Gupta Indian, 182 Islamic influence, 277-278 Polykleitos' system, 82 Pythagoras and, 53 Matins, 297 Matthew, Gospel of, 207, 223-224 Mausoleum of Galla Placidia, 240, 240-241, 241, 242 Maximian, Bishop, 245, 248, 248, 250 Meander pattern, 40 Mecca, 267, 268, 268 Mechanics, Gupta Indian, 182 Medea, 78 Medes, 9 Medici, Cosimo de', 139, 253 Medicine, 182, 277-278 Medieval culture. See Charlemagne and Medieval culture

History of Egypt, 10

Medina, 268, 269 The Meditations (Marcus Aurelius Antoninus), 135, 169 - 171Medusa, 46, 47 The Meeting of Joachim and Anna (Giotto), 408, 409 Melisma, 300, 355 Memento mori motif, 301 Memorabilia (Xenophon of Colophon), 79 Menandros, ruler of Greece, 93 Mendicant brotherhood, 359 Menorah, 204 Merchant class, 294-295 Mercury, 135 Mesopotamia, 6-10 Abraham from, 203 Akkadia culture, 8-9 Assyrian culture, 6, 10, 11, 27, 203 Babylonian culture, 6, 9, 11, 203 burial rituals, 14 vs. Egypt, 5 influence of, 27 Sumerian culture, 6-8 timeline, 1 Messe de Notre Dame (Machaut), 418-419 Messiah, 206, 207 Metaphysics (Aristotle), 80, 359 Metaphysics in philosophy, 52 Metopes, 48, 49, 83, 87 Metz, 296, 299 Meun, Jean de, 403 Michelino, Domenico di, 365 Michrab, 270 Middle Ages early Medieval period, 293-313 architecture, 246, 295–296, 302, 305-312, 307-312 Aristotle's influence on, 80 - 81art, 296, 298, 303-305, 305, 306, 357, 418, 419 Charlemagne and, 293-296, 297, 302-303 drama, 301 Islam, 272, 277-278, 293 literature, 295-296, 301, 302-303, 314-339 liturgical trope, 300-301 medicine and science, 277 - 278monasteries, Benedictine and Carolingian, 296-298, 308, 309 music, 295, 298-300, 355 Roman influence on, 133, 138 Romanesque style during, 308, 310, 310, 311, 312 scholasticism, 277-278 sculpture, 310, 311-312 timeline, 290-291

Fourteenth century, 395-439 architecture, Gothic style, 414-416, 416-419 art, 403-416, 404-410, 416, 417 Black Death, 397, 399, 410 Dante's Divine Comedy, 278, 356, 363-365, 365, 370-393 Francis of Assisi, 359-360, 360, 361, 368, 370 Great Schism in, 397-399 Hundred Years' War, 39 literature, 399-403, 422 - 439music, 416-419, 418, 419 painting in Siena, 410, 411, 412, 413 Paris during, 343 Petrarch in, 236, 253, 400-401,410 timeline, 394-395 High period of, 343-367 Aquinas during, 360-363, 362 architecture, 343-355, 344-346, 349-354, 357, 419 art, 344, 347-348, 349 literature, 359-365, 366, 368-393 music at the school of Notre Dame, 354-355 painting, 360, 361, 362, 363, 365 scholasticism, 296, 343, 355-363 sculpture, 348, 350, 351, 354 timeline, 340-341 universities during, 355-359, 357 Middle Kingdom, ancient Egypt, 10, 13-14 Middle Way of Buddhism, 178 Milan, 74, 235, 415, 416 Milan, Cathedral (duomo) of, 415.416 Milton, John, 138, 364 Paradise Lost, 364 Minarets, 270-271, 274 Minerva, 135 Minnesingers, 355 Minoan culture, 19, 21-22, 23-26, 24, 175 Minos, king of Knossos, 20 Minotaur, 20, 22, 51 Minuscule, 305 Misogyny, 402, 403 Mithra, 154, 211 Mixolydian mode of music, 81 Mohenjo-daro, 175, 176 Moirai, 39 De Monarchia (Dante), 363 Monarchy. See specific monarchs Monarchy, United, in Hebrew history, 203, 206

Monasteries Benedictine, 296-298, 308, 310 Bertilla, Abbess of Chelles, 330-333 Buddhist, 178-179, 180, 187 Carolingian monastery, 308, 309 Dominicans, 360 education and, 355-356 Franciscan, 359-360, 408 Gregorian chant and, 295, 298-300, 355 major parts of, 308 monasticism defined, 296 monks in Constantinople, 238 Mount Sinai, 248-249 Russian, 252 Saint Catherine's Monastery at Mount Sinai, 249-252, 251, 252, 253 Saint Denis Abbey, 343-345, 344, 345 Saint Gall Monastery, 308, 309 Sainte Geneviève, 356 women and monastic life, 296, 297, 298 Mongols, 252 Monophonic singing, 299 Monotheism, 205-206, 209, 267. See also God, monotheistic Monreal, 252 Mont-Saint-Michel and Chartres (Adams), 353 Monte Cassino monastery, Italy, 296, 298 Morality play, 301 Everyman, 301, 317-325 Mortality and (cultural) values, 14 Mosaics. See also Architecture; Art **Byzantine** in early Christian period, 213 Hagia Sophia, 238, 239 influence of, 252 at Ravenna, 241, 241-249, 243-245, 246-247 Rome, 128 San Vitale church, 245, 246, 247, 247, 248, 249 Islamic, 271, 272, 273 Italo-Byzantine, 404, 405 Middle Ages, 366 vs. stained-glass windows, 348 Moses, 203, 206, 207, 248, 249, 277 Mosque(s) Córdoba, 272, 273, 274 Damascus, 271, 272

Hagia Sophia as, 240

Ishafan, 271

Islamic architecture and, 270-272, 271-274 Motets, 355 Mother Goddess, 4, 5, 6, 20, 21, 22.27 Mount Athos, 252, 253 Mount Sinai, 248 Saint Catherine's Monastery at, 249-252, 251, 252, 253 Mount Vesuvius, eruption of, 143 - 145Movne, John The Essential Rumi, 288 Mozarabic chant, 299 Muezzin, 270 Mughals, 274 Muhammad, 206, 267, 277, 278 Mummification in ancient Egypt, 13 The Murder of Agamemnon by Aegisthus, 76 Muses at Alexandria, Temple of the, 93 Museum at Alexandria, 93 Music. See also Vocal music: specific composers and compositions Christian and Jewish, early, 214 - 215Greece, 49-51, 51, 53, 81, 127, 215 Middle Ages Charlemagne and Medieval culture, 295, 298 - 301in Fourteenth Century, 416-419, 418, 419 High period of, 354-355. 359 of Rome, 127 Music harmony, 53, 81 Musica ficta, 419 Muslims. See Islam and Muslims My Secret (Secretum) (Petrarch), 400 - 401Mycale, 53 Mycenae, 16, 19, 24-27, 27, 35 Mycerinus, pharaoh of Egypt, 13 Myron, 82, 82 Discus Thrower, 82, 82 Mysteries, Villa of the, 145, 146 Mysticism of light, 347-348, 349, 350, 351

N

Nabi, 206 Nalanda, 182 Naram-Sin, Stele of, 8, 9 Narthex, 344, 344 Nationes, University of Paris, 357 Nativity and Annunciation to the Shepherds (G. Pisano), 405

Natural History (Pliny the Elder), 143 Nave, 212 Naxos, 21 Neanderthal people, 4, 14 Near Eastern art, Greek influence on, 42 Nefertiti, queen of Egypt, 10, 17 Neo-Platonism, 348 Neolithic period, 3-5, 18 Neonian Baptistry, 241, 242, 243 Neptune, 135 Neptune, Temple of, 49 Nero, emperor of Rome, 127, 134, 137, 138, 208-209 Nerva, emperor of Rome, 137 Neums, 299 New Golden Age of Augustus, 141 New Kingdom, ancient Egypt, 16 - 18New Testament, Bible, 205, 207, 208, 239, 250 New York, Washington Square, arch on, 148 The Nichomachean Ethics (Aristotle), 118-121 Nile River, 5, 5, 10, 13 Nîmes, 150, 151 Nimrud, 9 Nineveh, 8, 9, 11 Nirvana, 178 Noah, 6 Nobatae, 10 Nocturns, 297 Normans, 252, 302 Northern European art, 410-414, 413, 414, 415 Notre Dame Cathedral, 344-345, 345, 351, 356 Notre Dame de Belle Verrière, 348, 349 Notre Dame school of music, 354 - 355Novitiate, 308, 309 Noyons Cathedral, 344, 345 Nubians, 10 Numerical systems, 277

0

Octave, 53, 81 Octavian, emperor of Rome, 137. See also Augustus, emperor of Rome Octavius, 137 Oculus, dome, 149 Odysseus, 38, 39 Odyssey (Homer), 21, 25, 35, 37-39, 139 Oedipus, 13, 78 Oedipus the King (Sophocles), 75, 77-78, 99-112 Old Kingdom, ancient Egypt, 10, 12 - 14Old Saint Peter's Basilica, 212, 214, 293

Old Stone Age, 3 Old Testament, Bible, 205, 206, 208 Olympia, 41, 43, 83, 85, 85, 86, 91 Olympic Games, 41 Olympus, 50 On the Cultivation of Learning (Alcuin of York), 296 On the Nature of Things (De Rerum Natura) (Lucretius), 134 Opera, invention of, 75. See also Vocal music Oplontis, 147 Optics, 277 Opus Dei, 298 Ordinary of the Mass, 418-419 Ordo Virtutum (Hildegard of Bingen), 298 Oresteia trilogy (Aeschylus), 76-77 Orestes, 76 Orff, Carl, 359 Carmina Burana, 359 Organum, 355 Orientalizing, 42 Orlando. See Song of Roland Orleans, 296 Orpheus, 49 Orthodox Christians icons, 251, 252, 253 Neonian Baptistry, 241, 242, 243 Theodoric's palace, 245 Osiris, 12, 12, 13, 74 Ostia, 150, 151 Outcasts, Aryan caste, 176 Ovid, 142, 296, 400 Oxford University, 355, 359

P

Padua, 408 Paean, 51 Paestum, 48 Pafnutius, 301 Paganism, 236, 253 Painting. See also Art ancient periods and cultures Aegean cultures, 23, 24, 25 in caves, 4, 4Egypt, 6 Byzantium, encaustic, 252, 252 Christian, early, 210-211, 211, 213 Greece Archaic period, 43-44, 46, 48 early period, 50 Hellenistic, 82, 84 Middle Ages Fourteenth Century, 403-414, 406-415 High period of, 360, 361, 362, 363, 365

Pavia, 294

illuminated manuscripts, 296, 298, 303-305, 305, 306, 357, 418, 419 Rome, 130, 131, 133, 139, 145, 146 Pakistan, 175, 178 Palace(s) Alhambra, 273, 274, 274 Assyrian, 9, 11 Charlemagne's at Aachen, 295-296, 305-312, 307, 309, 310, 311, 312 Diocletian, 153, 153 Doge's Palace, Venice, 415-416, 417 of the Lions, Alhambra, 273, 274, 274 Minoan, 22, 23, 24, 24, 26, 27 Mycenaean, 26-27, 27 of the Myrtles, Alhambra, 273 Theodoric's palace, 245, 246 Palatine Hill, Rome, 131, 147 Palazzo Pubblico, Siena, 410, 412, 415, 417 Palazzo Vecchio, 415 Paleolithic period, 3, 4, 27 Palermo, 252 Palestine, 294 Palestrina, 136, 137 Pan-Hellenic League, 85 Pandects, Justinian's, 238 Pantheon, 148, 149, 238 Pantocrater, Christ the, 245, 247, 247 Paper making, 277, 303 Paradise Lost (Milton), 364 Paradise (Paradiso) in Dante's Divine Comedy, 356, 363-365, 388-393 Parcae, 39 Parchment, 303 Paris Champs Elysées, arch on, 148 in High Middle Ages, 343, 357 University of, 343, 355, 356, 357-358,404 Parmenides of Elea, 53, 65 Parthenon, 72, 72, 73, 84-87, 86, 87, 141 Parthians, 141 Pasiphae, 21 The Passion of Perpetua and Felicity, 228-231 Paten, 248, 248 Pater Patriae, 139 Patriarchs, period in Hebrew history, 203 Patricians, 131, 132 Patroclus, 38, 39, 56, 60 Paul, Apostle, 243 Paul, early Christian zealot, 207-208 Paul the Deacon, 295

Peace, Altar of, 141-142, 141 - 142Peaceful City (Lorenzetti, A.), 410, 412 Peaceful Country (Lorenzetti, A.), 410, 412 Peasant Revolt, Germany, 399, 403 Pediment, 48, 49 Pélerinage de Charlemagne, 343 Peloponnesian War, 71-74, 78-80, 82, 84, 85 Peloponnesus, 24 Pendentives, 238 Penelope, 39 Peplos Kore, 44, 46 Peregrinatio (Etheria), 249-250 Pergamum, 93, 94-95, 95, 97, 137 Pericles, ruler of Athens, 73, 73-74, 77, 84-85 Period of Warring States, 183 Peripatetic, 80 Pérotin, 355 Perpendicular architecture, 416, 418 Persepolis, 179 Persian Empire Alexander the Great, 79 Assyria and, 9-10, 27 Egypt and, 10, 17-18, 27 Greece and, 27, 42, 44, 139 influence on India, 179 Persian Wars, 71, 72-73, 79, 83 Rome and, 153 Peter, Apostle, 243, 246 Peter of Pisa, 295 Peter the Deacon, 295, 297 Petrarch, Francesco, 253, 400-401,410 Africa, 400 Canzoniere (Songbook), 400 - 401De Viris Illustris, 400 De Vita Solitaria, 400 Letter to Posterity, 236, 400 Secretum (My Secret), 400-401 Petronius, 135 The Satyricon, 135 Phaedo (Plato), 79, 114-117 Phaedra, 78 Phaistos, 22 Pharaohs of ancient Egypt, 12, 13-18, 17, 27 Pharsalus, Battle of, 133 Phidias, 85 Philip of Macedon, 74, 79, 80 Philip the Bold, Duke, 411-412 Philistines, 203 Philosophy. See also specific philosophers and works Biblical influence on, 205-206 China, 184-185, 186 Christianity, early, 235-237, 241

defined, 52 Greece, 51, 52-53, 79-81, 134 Middle Ages, 356-363 Rome, 134-136 Phoenicians, 6, 42, 132 Phrygians, 50, 81, 154 Physica (Hildegard of Bingen), 298 Physics (Aristotle), 80 Pictographs, cuneiform, 6, 7, 19 Pietas, 209-210 Pilgrimages Christian, 272, 302, 308, 351, 353-354 Islamic, 267 Pisano, Giovanni, 404-405, 405 Nativity and Annunciation to the Shepherds, 405 Pisano, Nicola, 404, 405 Annunciation and Nativity, 404, 405 Pisistratus, 44 De Pizzano, Thomas, 402 Plague, 73-74, 397, 398, 410 Plataea, 53 Plato Academy of, 80, 238 The Allegory of the Cave, 117-118,356 Arabic translations, 277 Augustine of Hippo, influence on, 235 Boethius and, 237 dialectics, 355 ideal society and political theory of, 80 on light, 239 music, 50, 51, 81 paradoxes discussed by, 53 significance of, 52, 71 Socrates and, 79-80 on the soul, 90 study of, 253 Theory of Forms, 80 Three Fates and, 39 works Apology, 79, 112–114 Crito, 79 Phaedo, 79, 114-117 The Republic, 117-118, 356 Plautus, 133 Plebeians, 131, 132 Plethon, Genistos, 253 Pliny the Elder, 143, 295 Natural History, 143 Pliny the Younger, 143-145 Pluto Seizing Persephone, 90, 90 Poetics (Aristotle), 77-78, 80 Poetry. See also Literature; specific poets Chinese, 186-187 Fourteenth century, 400-401 Goliadic verse, 359 Indian, 176-177, 181 Islamic, 276, 288-289

lyric, 51-52, 64, 78, 128, 133, 157 of Middle Ages, 302-303, 358-359, 363-365 Roman, 133, 138-140, 157 - 169Poitiers, Battle of, 293, 399 Polis, Greek, 35, 41-42, 74 Political philosophy, 52 Political theory. See Government and political theory The Politics (Aristotle), 121-123 Polydrus of Rhodes, 96 Polykleitos, 82, 84 The Canon, 82 Doryphoros, 82, 84 Polynices, 77 Polyphony, 355, 418 Polytheism, 205 Pompeii, 16, 143-144, 143-147, 146 Pompey, senator of Rome, 132, 133 Pont du Gard, Nîmes, 150, 151 Pope(s) Boniface VIII, 397 Gregory the Great, 295, 299 Leo III, 293 Urban II, 302 Porch of the Maidens, 88, 89 Portal, 310 Portonaccio Temple, 130 Portrait busts, 136, 136-137 Portrait of Confucius, 184 Poseidon, 37, 87, 88, 135 Pothos (Desire) (Scopas), 91, 91 Pottery and ceramics Aegean culture, 20, 21, 22 China, 186, 187, 188 Greece classical, 76, 82, 84 early, 39-40, 40-42, 42-43, 46, 48, 51 India, 175 invention of, 5 vase painting, 46, 48, 82, 84 Praeneste, 137 Prague, 411 Praxiteles, 90-91 Aphrodite of Cyrene, 91, 91 Hermes with Infant Dionysus, 90,90 Prayer in Islam, 267, 268, 270-271 monastic life, 296-298 Opus Dei, 298 Preaching Friars of Saint Dominic, 360 Predynastic Egypt, 10 Prehistory, timeline of, 1 Presocratics, 52-53, 64-65 Priene, 91 Priests ancient Egypt, 12, 13 Christian (See Catholic

church)

Sumer, 6 Prime, horarium monasticum. 297 Priscian, 295 Priscilla catacombs, 210, 211 Procopius of Caesarea, 237 The Buildings, 237 Secret History, 237 Propertius, 142 The Prophet Jeremiah, 311 The Prophets, Hebrew Bible, 204-205, 206 Propylaea, Parthenon, 87, 89 Protagoras, 53 Protestantism, 235, 397-399 Protogeometric period, 40 Providence, 237 Psalms, 214, 215 Psalters, 303-305, 305, 306 Psammetichos I, pharaoh of Egypt, 43 Pseudo-Dionysius, doctrine of, 347 Pseudo-Turpin, 303, 343 Ptah, 13 Ptolemies, kingdom of, 92, 93 Ptolemy, king, 93 Publius Vergilius Maro. See Vergil Puja, 177 Punic Wars, 132 Purgation of the soul, 80 Purgatory, in Dante's Divine Comedy, 363-365, 383-388 Purgatory (Purgatorio) in Dante's Divine Comedy, 363-365, 383-388 Pyramids, Egyptian, 12-13, 15, 17 Pyrenees, 302 Pythagoras of Samos, 52-53, 81 Pythagoreanism, 52 Pythian Games, 51 Qá aba, Mecca, 267

Indian caste, 176, 182-184

Readings

Quadrivium, 295 Quadruplum, 355 Quem Quæritis trope, 300 The Questions of King Milinda, 93 Quintilian, 295 Institutio Oratoria, 295 Qur'an, 240, 268-269, 270, 275-277, 279-288

R

Rabia, Saint, 275, 287-289 Ramadan, 267 Ramapithecus, 3 Ramayana, 176 Ramses II, pharaoh of Egypt, 16,20 Al-Rashid, Harun, 293, 294 Rationalism, 360 Ravenna, 235, 236, 240-252, 240 - 252

ancient civilization, 29-31 Byzantium, 255-263 early Christianity, 217-231 Fourteenth century, 422-439 Greece, 56-67, 99-123 India, 191-199 Islam, 279-289 Middle Ages, 314-339, 368-393, 422-439 Rome, 157-171 Reason, Aquinas' view on, 361 Reconquista, 273 Red-figure style, 46, 48 Refectory, 308, 309 Reformation, 235, 397-399 Reheims, 418 Relics, 343, 351 Relief carving. See Sculpture Religion. See also Buddhism; Christianity; Deities; God, monotheistic; Islam and Muslims; Judaism; specific theologians afterlife ancient Egyptian religion, 10 - 12, 13, 14in Dante's Divine Comedy, 278, 356, 363-365, 365, 370-393,400 from Epic of Gilgamesh, 30 ancient periods and cultures Aegean culture, 8–9, 24 China, 184-185 Egypt, 11-15 India/Aryan, 175-177 Sumer, 6 Black Death, 398-399 Greece, 35-39, 52, 53, 72 Hinduism, 177, 179-180 light, mysticism of, 347-348, 349, 350, 351 prayer, 267, 268, 270-271, 296-298 of Rome, 134-135 Taoism, 184–185 Reliquary of Charlemagne, 302 Remus, 129, 141 Renaissance appreciation of classics, 253 city-states of Italy, 74 Imperial Rome's influence on, 139 writers devotion to Augustine, 236 The Republic (Plato), 117-118, 356 Republican Rome. See Rome, Republican De Rerum Natura (On the Nature of Things) (Lucretius), 134 Responsorial singing, 215 Return from exile, period in Hebrew history, 203-204 Revelation, 206 Revelation, Book of, 245 Rhazes, 277

Rhetoric (Aristotle), 80 Rho, 210, 213, 247, 248 Rhodes, 26, 91 Riace Bronzes, 82, 83 Richard II, king of England, 411 Richard II Presented to the Virgin and Child by His Patron Saints (Wilton Diptych), 411, 413 The Rig Veda, 177-178, 191-194 Robert of Anjou, king of France, 410 Robin Hood, 399 Rock Edict XII, 178 Roland, Song of, 293, 302-303, 333-339 Roman Catholic Church. See Catholic church Roman chant, 295 Romance of the Rose, 401, 403 Romanesque style, 308, 310, 310, 311, 312, 346 Romanization, 135 Rome cultural importance of, 127-129,343 Etruscans, 129-130 Gods and Goddesses, 134-136, 135, 154, 209-210 Imperial, 137-171 architecture, 143-145. 146-154, 147-150. 153-154, 238 art, 145, 146, 153-154, 154 Charlemagne as ruler of, 293, 294 Christianity in, 207, 208 - 210decline of, 129, 151-154, 182, 235-237 dinner party in, 135 emperors of, 137, 151 Hebrews, conquest of, 203 - 204length of period, 129 literature, 138-140, 142, 150 - 151model of, 147 as multiethnic, 139 as object of satire, 150-151 Paul's letters to, 208 sculpture, 140-143, 141, 142 urban life in, 150 values of, 139 map, 128 Republican, 130-137, 154 - 171architecture, 136, 136-137 art, 136-137 conquest of Greece by, 71 historic periods of, 129 law of, 134-136, 238, 253 literature, 133-134, 157-171 overview, 130-133 philosophy, 134-136 timeline, 124-125

Sidney, Sir Philip, 401

Romulus, *129*, 141 Romulus Augustulus, 151 Roncesvalles, Battle of, 293, 302 Rose window, 351 Roswitha. *See* Hroswitha Royal Cemetery at Ur, 14 Royal Cemetery of Vergina, 90, 90 Royal Grave Circle, Troy, 25, 26 Rule of Saint Benedict, 296–298 Rumi, 288–289 Russia, 243, 250, 252, 253, 254 Russian Orthodox church, 252

S

Sacadas of Argos, 51 Sacramentary, 295 Saint Catherine's Monastery at Mount Sinai, 249-252, 251, 252.253 Saint Denis Abbey, 302, 343-347, 344, 345, 346, 349, 354 Saint Francis Preaching to the Birds, 361 Saint Francis Renounces His Worldly Goods (Giotto), 408, 410, 410 Saint Gall monastery, Switzerland, 296, 300, 308, 309 Saint James, Shine of, 302 Saint Mark's Church, Venice, 252, 253 Saint Peter's Basilica, 212, 214, 293 Saint Sernin Church, 308, 310, 310 Saint Victor, church of, 356 Sainte Geneviève Monastery, 356 Sainte Madeleine, church of, 310, 311, 312 Saint(s) Ambrose, 299 Aquinas, Thomas (See Aquinas, Saint Thomas) Augustine (See Augustine of Hippo, Saint) Benedict of Nursia, 296 Bonaventure, 360, 408, 410 Catherine of Siena, 398 Charlemagne, 302 Dominic, 360 Francis of Assisi, 359-360, 360, 361, 368, 370, 408, 410 Golias, 359 Jerome, 295 John Chrysostom, 239 Lawrence, 240, 241, 242 Mark, 252, 253 Martin of Tours, 306 Rabia, 275, 287-289 Victor, 356 Vitalis, 245, 247 Sakuntala (Kalidosa), 182 Saladin, 278

Salerno, 356 Salonica, 252 Samos, 48 San Domenico, Church of, 406, 406 San Vitale, Church of, 245, 246-249, 247, 248, 306 Sanctuary of Fortuna Primigenia, 136, 137 Sanctus in Ordinary of the Mass, 419 Sanghas, 179 Sanskrit, 175-176, 177, 181, 277 Sant' Apollinare Nuovo church, 244, 244-245, 245, 246, 247 Santa Costanza, 238 Santa Croce, 414 Santiago de Compostela shrine, 302, 308, 346 Sappho, 51-52, 64, 128 Sargon, king of Akkadians, 8, 8 Sarnath, 177 Satan, 37, 364, 366 Satire, Rome as object of, 150-151 Satires (Juvenal), 151, 168-169 Satyr play, 74-75 The Satyricon (Petronius), 135 Saul, king of Hebrews, 203 Saul of Tarsus, 207 Scene of Hunting and Threshing, 187, 188 Schliemann, Heinrich, 21, 24-27,27 Scholastica, sister of Saint Benedict, 298 Scholasticism, 296, 343, 355-363 Science. See also Mathematics astronomy, 295 Gupta Indian, 181, 182 Islamic, 277-278 medicine, 182, 277-278 no Hebrew word for, 203 Scivias (The Way to Knowledge) (Hildegard of Bingen), 298, 298, 314-316 Scopas, 90, 91, 91 Pothos, 91, 91 The Scraper (Apoxyomenos) (Lysippus), 92 Scriptorium, 308, 309 Sculpture. See also Art ancient periods and cultures Aegean, 23, 24, 24-25, 26 Assyria, 9, 11 China, 183, 184, 187, 187, 189 Egypt, 14-15, 16, 17, 17, 20 India, 175, 176, 179, 180 Mesopotamia, 6-10, 8-10 Neolithic and Paleolithic, 4,5 Buddhist, 93 Christian period, early, 204, 210, 212, 213

Greece Archaic period, 43-45, 43 - 46Classical, 82, 82-85, 90-92, 90 - 92early period, 37, 43-46, 43 - 47Helenistic, 95, 95-96, 97 Middle Ages Charlemagne and Medieval culture, 310, 311-312 Fourteenth Century Italy, 404-405, 404-405, 411-412, 414 High period of, 348, 350, 351, 354 Rome Etruscan, 129-130, 129-131 Imperial, 136, 136-137, 140-143, 141, 142, 154, 154, 204 Republican, 133 Seal of Charlemagne, 294 Seal stones, 22, 175 Secret History (Procopius of Caesarea), 237 Secretum (My Secret) (Petrarch), 400 - 401Seker, 13 Seleucids, kingdom of, 92, 93, 93 Selinus, 44, 46 Semitic period, Mesopotamia, 6 Senate Republican Rome, 131, 132 United States, 139 Seneca, 134 Senlis Cathedral, 344, 345 Septimius Severus, emperor of Rome, 137 Septuagint version of Bible, 205 Sermon on the Mount, 207 Sesostris III, pharaoh of Egypt, 14,17 Set. 13 Sethos, 12 Seven Wonders of the World, 93 Sexual union and Hinduism, 179 Shah Jahan, 274 Shakespeare, William, 401, 402 Julius Caesar, 133 Shamash, 9, 11 Shang Dynasty, 183 Shem, 6 Sheyks, 275 Shi'a tradition, Islam, 275 Shih Huang-ti, 185-186 Shiites, 267 Shiva, 40 Shrine of Saint James, Spain, 302 Sic et Non (Abelard), 356 Sicily, 41, 74, 80, 129, 252 Siddhartha Gautama, 177-178

Siena, 74, 406, 407, 410, 411, 412, 413 Siena, Saint Catherine of, 398 Silk industry, 237, 278 Sinai, Mount, Saint Catherine's Monastery at, 249-252, 251, 252, 253 Singing. See Vocal music Sketes, 252 Slavery, 13, 22, 207 Sluter, Claus, 412, 414 Smile, archaic, Greek sculpture, 45.45 Smith, Margaret, 288 Snake Goddess, 22, 26 Social class during Charlemagne's rule, 294-295, 296 Christianity, early, 209 Indian/Aryan, 176, 182-183 Rome, 131, 138 Social War, Roman, 132 Socrates, 52, 79-80 Solar year calculation, 277 Solomon, king of Hebrews, 203, 207 Solomon, Temple of, 203, 204, 205 Solon, 44 Song of Aspremont, 303 Song of Roland, 293, 302-303, 333-339 Songs. See Vocal music Sonnets. See Poetry Sophists, 79 Sophocles, 74, 77 Antigone, 14, 75, 77 Oedipus the King, 75, 77-78, 99-112 Sorbon, Robert de, 357 Sorbonne, 357 Spain, 272, 293, 302, 310 Sparta, 35, 53, 72-73, 78-79 Spearbearer (Doryphoros) (Polykleitos), 82, 84 Spenser, Edmund, 401 Sphinx, 13, 15 Spirituality. See Religion Split, 153, 153 The Spoils of Jerusalem, 204 Sports and game Chinese, 187, 188 Etruscan, 130 Olympic Games, 41 Pythian Games, 51 Spring Fresco, 25 Squinches, 245 Sri Lanka, 179 Stained-glass windows, 344, 347-348, 349 Statius, 296 Statues. See Sculpture Stele, 7, 8, 8, 9, 9, 11, 45, 47, 85 Stele of Aristion, 45, 47 Stele of Crito and Timarista, 85 Stele of Hammurabi, 7, 9, 11

Stele of Naram-Sin, 8, 9 Stephanos (architect), 251 Stevenson, Robert Louis, 44 Stigmata, 359 Stoicism, 134-135, 154, 236, 237 Stone Age, 3-5 Strasbourg Cathedral, 404, 404 Strauss, Richard, 51 Don Quixote, 51 Till Eulenspiegel, 51 Studia, 253 Stupas, 179 Sudraka, 182 The Little Clay Cart, 182 Suetonius, 143 Sufi tradition in Islam, 275-276 Suger, Abbot, 343-345, 344, 347, 354, 364 The Suicide of Ajax (Exekias), 46, 48 Sulla, 132, 136, 137 Sumer, 6-8 Summa Theologica (Aquinas), 360, 361, 363, 368-370 Sunni tradition, Islam, 275 Sunya, Hindu number notations, 277 The Suppliant Women (Euripides), 78 Suppliants (Aeschylus), 75 Sûrah, Qur'an, 268, 279-289 Swift, Jonathan, 151 Swordmaking, 278, 295 Sybaris, 41 Symphonia (Hildegard of Bingen), 298 Symposium (Xenophon), 79 Synthesis, 363. See also Middle Ages, High period of Syracuse, 41, 80 Syria, 6, 92, 93, 179, 203, 207, 211

T

Tablature in music, 81 Tacitus, 143-144, 208-209 Taj Mahal, 274, 275 Tammuz, 6 T'ang Court Ladies Playing Board Game, 187, 188 T'ang Dynasty, 185, 186, 187, 189 Tao, 184 Tao te ching (Lao-tzu), 184 Taoism, 184-185, 187 Tariqas, 275 Tarquinia, 129, 130, 131 Tel el-Amarna, 14, 15 Telemachus, 39 Temple Mount, Jerusalem, 271 Temple(s). See also Architecture Abu Simbel, 16, 20 Apollo, 48, 77, 144 Ara Pacis, 141-142, 141-142 Artemis, 92 Athena (See Parthenon) Dura-Europos, 211-212, 213

Egyptian, 16, 19, 20 Etruscan, 130 Greek, 46-48, 49, 83, 85, 85, 86, 92, 92, 148 Hera, 48, 49 Jerusalem, 203, 204, 204 Jupiter of the Capitoline, 139 of the Muses at Alexandria, 93 Neptune, 49 Parthenon, 72, 72, 73, 84-87, 86,87 Portonaccio, 130 Roman, 133, 141-142, 148 Solomon, 203, 204, 205 Sumerian, 6 of Zeus, 83, 85, 86 Ten Commandments, 205 Tenor, 355 Terence, 133, 301 Terpander, 50 Tertullian, 210 Terza rims, 363 Tesserae, 241 Testament, 205 Tetrachord, 81 Thales of Miletus, 52 Theater. See Drama Thebes, 13, 14, 19, 25, 35, 72, 79 Themis, 39 Theodora, empress of Byzantium, 237-238, 248, 249, 250 Theodoric, king of Goths, 236, 244, 244-245, 306 Theodoric's palace, 245, 246 Theodulf of Orleans, 295 Theogony (Hesiod), 51 Theology. See Religion; specific theologians Theophany, 220 Theophilus (Hrosvitha), 301 Theory of Forms, 80 Thera, 22 Thermopylae, 53 Theseus, ruler of Athens, 21, 51, 78 Third Satire (Juvenal), 168-169 Tholos, 92, 92 Thomas Aquinas. See Aquinas, Saint Thomas Thoth, 12, 12, 13 A Thousand and One Nights, 294 Thrace, 235 Three Fates, 39 Three Goddesses, 87, 88 Thrones Bishop Maximian, 248, 250 of Charlemagne, 306-307 from Tutankhamen's tomb, 19 Thucydides, 73 History of the Peloponnesian War, 73 Tiber River, 129 Tiberius, emperor of Rome, 137, 142

Tigris River, 5, 5, 6 Till Eulenspiegel (Strauss), 51 Timelines ancient civilizations, 1-2 Byzantium, 232-233 China and India, 172–173 Christianity, early, and Jerusalem, 200-201 Greece classical and Hellenistic, 68 - 69early, 32-33 Islam, 264-265 Middle Ages Charlemagne and Medieval culture, 290-291 Fourteenth century, 394 - 395High period, 340-341 Rome, 124-125 Tischendorf, Konstantin von, 250 Titus, Arch of, 147, 204 Titus, emperor of Rome, 137 Toga, 130 Toledo Tomb(s). See also Burial rituals and funeral practices Hunting and Fishing at Tarquinia, 130, 131 Theodoric, 244, 244-245 Tutankhamen's tomb, 15–16, 19 Torah, 204 Torcello, 253 Torso of a Man, 175, 176 Tours, 296 Tower of Winds at Athens, 94 Town center, cathedral as, 347-354 Trade and commerce Byzantine routes, 252 cathedral as town center, 347-354 Charlemagne and, 294-295 Etruscan, 129-130 fairs (lendit), 334, 351, 362 in Greece, 41-42, 44 Guilds and, 352-353 Indian / Arvan, 175 Islamic, 278 Tragedy, 74-78, 80, 133 Tragic flaw, of Aristotle, 80 Trajan, emperor of Rome, 137 Transept, 212 The Treasure of the City of Ladies (de Pisan), 403, 437-439 Trecento, 397, 415 Très Riches Heures du Duc de Berry (Limbourg Brothers), 413, 414-415, 416 Tribonian, 238 Tribunes, 131 Trier, 299 Triforium, 238 Triglyphs, 48, 49, 83 Trilogy, Greek tragedy, 75

Triplum, 355 The Triumph of Saint Thomas Aquinas (Buonaiuto), 362 Trivium, 295 Trojan War, 25, 38-39, 56, 76 Trompe l'oeil, 241 Trope, 300 Troubadours, 355 Trouvères, 355 Troy, 25-26, 26, 76, 97, 140 Trumeau, 310, 311 Tsar of Russia, 243, 250 Tuba, 127 Tuchman, Barbara, 399 A Distant Mirror, 399 Tufa, 210 Tunnel vault, 148, 148, 308, 310 Turks, conquest of Constantinople, 240, 252, 253 Tuscany, 129 Tutankhamen, pharaoh of Egypt, 15-16, 19, 27 Twelve Apostles of Jesus, 243 - 244Twelve Tribes of Israel, 203 Tyche, 39 Tympanum, 310, 312 Tyrants, Greek rulers as, 44, 79

U

Ulpian, 136 Ultrecht Psalter, 303-304, 304 Unification of China, 184-188 United Monarchy, Hebrew, 203 United States (U.S.), Imperial Rome's influence on, 139 Universitas, 357 Universities Bologna, 355, 356, 359 Cambridge, 355 Oxford, 355, 359 Paris, 343, 355, 356, 357-358, 404 rise of, during Middle Ages, 355-359, 357 Upanishads, 177, 193-196 Upper Egypt, 10 Al-Uqlidisi, 277 Ur, 8, 10 Ur, Royal Cemetery at, 14 Urban II, Pope, 302 Urbino, 74 Uruk, 6, 8 Usury in Islam, 267 Utnapishtim, 7

V

Valerian, emperor of Rome, 209 Values autocracy, 243 Black Death, 399 civic pride in city-states, 74 destiny, 39 dialectics, 356 empire, of Rome, 139 feudalism, 309

Islamic values, 277 love, marriage, and divorce in Egypt, 18 mortality, 14 natural disaster and human response, 399 revelation, 206 Varaha, 180, 181 Varanasi, 178 Vasari, Giorgio, 403-404 Life of Giotto, 403-404 Lives of the Artists, 403 Vases, Greek painting of, 46, 48, 82, 84. See also Pottery Vatican library, 253 Saint Peter's Basilica, 212, 214, 293 Vedas, 177-178, 181 Vendetta, primitive law of, 76 Venice, 74, 253, 415-416, 417 Venus, 135, 141 Venus Anadyomene (Aphrodite at Cyrene) (Praxiteles), 91, 91 Venus of Willendorf, 4, 5 Vergil Augustus, emperor of Rome, and, 138-140 in Dante's Divine Comedy, 363 Golden Age of Latin literature, 142 Petrarch and, 400 scholasticism, 296 works Aeneid, 138-140, 158-167, 363,400 Bucolics, 138 Eclogues, 138 Georgics, 138-139 Vergina, Royal Cemetery of, 90, 90

Verona, 74 Vespasian, emperor of Rome, 137 Vespers, 297 Vesuvius, eruption of, 143-145 Vézelay, 310, 311, 312 Vibia Perpetua, 209 Vico, Giambattista, 3 Victor, Saint, 356 Victoria, queen of England, 139 Victorian Age, 139 Victory Stele of Naram-Sin, 8, 9 Vikings, 295 Villa of the Mysteries, 145, 146 Villard de Honnecourt, 352-353, 354 Vintner's window, 353 Virgil. See Vergil Virgin and Child, 210, 211 De Viris Illustris (Petrarch), 400 Vishnu, 180, 181 Visigoths, 235 Visual arts. See Art Vita Nuova (Dante), 363 De Vita Solitaria (Petrarch), 400 Vitalis, Saint, 245, 247 Vitry, Philippe de, 417 Ars Nova Musicae (The New Art of Music), 417 Vladimir, prince of Russia, 252 Vocal music. See also Music antiphonal singing, 215 chanting and religious observance, 214, 295, 298-300, 355 choir, 344, 344 early Greece, 50 monophonic singing, 299 opera, invention of, 75 polyphony, 355, 418

Volterra, 130, *131*, 136 Volutes, 48, 49 Vulcan, 135 *De Vulgari Eloquentia* (Dante), 363 Vulgate Bible, 295

W

Wagner, Richard, 75 Al Walid, Abd, 271 Warrior Seated at His Tomb, 82, 84 Washington Square, NY, arch on, 148 Wasp Pendant, 22, 24 The Way to Knowledge (Scivias) (Hildegard of Bingen), 298, 298, 314-316 The Well of Moses (Sluter), 411-412, 414 The West, 203 White Huns, 182-183 William of Champeaux, 356 William of Moerbeke, 362 Wilton Diptych, 411, 413, 416 Winckelmann, Johann, 147 History of Ancient Art, 147 The Wisdom of Buddha (Humphries), 196-198 Women. See also specific women education of, 301, 359, 402 - 403Greek sculpture of, 91 monastic life, 296, 297, 298 Mother Goddess, 4, 5, 6, 20, 21, 22, 27 Woolf, Virginia, 359 Words from Islamic culture, 278 Works and Days (Hesiod), 51 Writing

calligraphy, 187, 189, 269–270, 305 in Charlemagne's time, 295 cuneiform, 6, 7, 19 illuminated manuscripts, 296, 298, 303–305, 305, 306, 357, 418, 419 Indian / Aryan, 175–176 invention of, 6 Islamic, 268–270 The Writings, Hebrew Bible, 204–205 Wyatt, Sir Thomas, 401

X–Z

Wyclif, John, 398

Xenophanes of Colophon, 52 Memorabilia, 79 Xenophon, 79 Apology, 79 Memorabilia, 79 Symposium, 79 Xerxes, king of Persia, 53, 54, 65,72 Zakro, 22 Zeno, 53 Zero, 182, 277 Zeus Altar to, 95, 96, 97 destiny, 39 Dura-Eurpoas ruins, 211 Greek and Roman deities, 135 impact of, 27 in literature, 36, 37, 37, 54, 76 Temple of, 83, 85, 86 Ziggurats, 8, 18 Zoser, 135 Zoser, pharaoh of Egypt, 13

Chapter 1—Photo 1.1: Colorphoto Hans Hinz, Allscheil/Basel, pp. 2, 4; Photo 1.2: Naturhistorisches Museum, Vienna, p. 5; Photo 1.3: Hirmer Fotoarchiv, Munich, p. 7; Photo 1.4: Hirmer Fotoarchiv, Munich, p. 8 (L); Photo 1.5: Scala/Art Resource, New York, p. 8 (R); Photo 1.6: Saskia Ltd. Cultural Documentation, p. 9; Photo 1.7: © Dean Conger/CORBIS, p. 10 (Top); Photo 1.8: The Metropolitan Museum of Art, New York, Harris Brisbane Dick Fund, 1959. (59.2) Photograph copyright © 1982 Metropolitan Museum of Art, p. 10 (Bot); Photo 1.9: © Réunion des Musées Nationaux, Paris, p. 11 (Top); Photo 1.10: Courtesy of the Trustees of the British Museum, London, p. 11 (Bot); Photo 1.11: Hirmer Fotoarchiv, Munich, p. 12; Photo 1.12: Robert Harding Picture Library, London, p. 15; Photo 1.13: Hirmer Fotoarchiv, Munich, p. 16; Photo 1.14: Hirmer Fotoarchiv, Munich, p. 17 (L); Photo 1.15: © Ägyptishes Museum, Staatliche Museen, Bildarchiv Preussischer Kulturbesitz, Berlin, p. 17 (UR); Photo 1.16: C Margarete Büsing/ Bildarchiv Preussischer Kulturbesitz, Berlin, p. 17 (LR); Photo 1.17: Katherine Young, NYC/AP/Wide World Photos, p. 19 (Top); Photo 1.18: © Charles & Josette Lenars/CORBIS, p. 19 (Bot); Photo 1.19: John P. Stevens, Ancient Art and Architecture Collection, London, p. 20; Photo 1.20: Erich Lessing/Art Resource, New York, p. 21 (L); Photo 1.21: Courtesy of the Trustees of the British Museum, London, p. 21 (R); Photo 1.22: © Gail Mooney/CORBIS, p. 23; Photo 1.24: Robert Harding Picture Library, London, p. 24 (Top); Photo 1.25: Ancient Art and Architecture Collection, Harrow-on-the-Hill, England, p. 24 (Bot); Photo 1.26: Hirmer Fotoarchiv, Munich, p. 25; Photo 1.27: Leonard Von Matt, p. 26 (L); Photo 1.28: Hirmer Fotoarchiv, Munich, p. 26 (R); Photo 1.29: Alton S. Tobey, Larchmont, NY, p. 27

Chapter 2—Photo 2.1: Nimatallah/ Art Resource, New York, p. 37; Photo 2.2: Deutsches Archaeologisches Institut, Athens, p. 40; Photo 2.3: Copyright © Colorphoto Hans Hinz, Allschwil/Basel, p. 41; Photo 2.4: Berlin-Staatliches Museen zu Preussischer Kulturbesitz Antikensammiung/BPK, p. 42 (Top); Photo 2.5: Scala/Art Resource, New York, p. 42 (Bot); Photo 2.6: Deutsches Archaeologisches Institut, Athens, p. 43;

Photo 2.7: Metropolitan Museum of Art, New York, Fletcher Fund, 1932 (32.11.1). Photo copyright © 1993 The Metropolitan Museum of Art, p. 44; Photo 2.8: Saskia Ltd. Cultural Documentation, p. 45 (L); Photo 2.9: Nimatallah/Art Resource, NY, pp. 34, 45 (R); Photo 2.10: Studio Kontos, p. 46 (L); Photo 2.11: Alinari/Art Resource, New York, p. 46 (R); Photo 2.12: Ancient Art and Architecture Collection, Harrow-on-the-Hill, England, p. 47 (L); Photo 2.13: Nimatallah/Art Resource, NY, p. 47 (R); Photo 2.14: Photo from Laboratories Photographique, Devos, p. 48 (Top); Photo 2.15: Metropolitan Museum of Art, bequest of Joseph H. Durkee, gift of Darlus Ogden Mills and gift of C. Ruxton Love, by exchange, 1972. (1972.11.10). Copyright © 1999 by the Metropolitan Museum of Art, p. 48 (Bot); Photo 2.16: © Tony Gervis/F.R.P.S./Robert Harding Picture Library, p. 49; Photo 2.18: Metropolitan Museum of Art, New York (Fletcher Fund, 1956). Copyright © 1989 by the Metropolitan Museum of Art, p. 50 (L); Photo 2.19: Hirmer Fotoarchiv, Munich, p. 50 (R); Photo 2.20: Deutsches Archaologisches Institut, Athens, p. 51

Chapter 3—Photo 3.1: © Paul Warhol Photography, pp. 70, 72; Photo 3.2: Photo Vatican Museums, p. 73; Photo 3.3: Rhoda Sidney, PhotoEdit, Long Beach, CA, p. 75; Photo 3.4: William Francis Warden Fund. Courtesy of the Museum of Fine Arts, Boston, p. 76; Photo 3.5: Eric Lessing/PhotoEdit, Long Beach, CA, p. 77; Photo 3.6: Alinari/Art Resource, New York, p. 82; Photo 3.7: Scala/Art Resource, New York, p. 83; Photo 3.8: Scala/Art Resource, New York, p. 84 (L); Photo 3.9: Hirmer Fotoarchiv, Munich, p. 84 (R); Photo 3.10: Hirmer Fotoarchiv, Munich, p. 85; Photo 3.12: Scala/Art Resource, New York, p. 86 (Top); Photo 3.13: Royal Ontario Museum, Toronto, p. 86 (Bot); Photo 3.14: William Katz/ Photo Researchers, Inc., p. 87; Photo 3.15: Hirmer Fotoarchiv, Munich, p. 88 (Top); Photo 3.16: Reproduced by courtesy of the Trustees of the British Museum, London. Hirmer Fotoarchiv, Munich, p. 88 (Bot); Photo 3.17: Reproduced by courtesy of the Trustees of the British Museum, London. Hirmer Fotoarchiv, Munich, p. 89 (UL); Photo 3.18: Scala/Art Resource, New York, p. 89 (Bot); Photo 3.19: D. Photo 5.4: C Micheal Holford, p. 181

Lada/H. Armstrong Roberts, p. 89 (R); Photo 3.20: Courtesy of the Hellenic Ministry of Culture, p. 90 (L); Photo 3.21: Scala/Art Resource, New York, p. 90 (R); Photo 3.22: Alinari/Art Resource, New York, p. 91 (L); Photo 3.23: Barbara Malter, Capitoline Museums, Rome, p. 91 (R); Photo 3.24: Vatican Museums, Rome, p. 92 (L); Photo 3.25: M. Thonig/H. Armstrong Roberts, p. 92 (R); Photo 3.26: Hirmer Fotoarchiv, Munich, p. 95 (UL); Photo 3.28: Staatliche Musseen zu Berlin-Preussischer Kulturbesitz Antikensannlung, Berlin, p. 95 (Bot); Photo 3.29: Eric Lessing/Art Resource, p. 96 (Top); Photo 3.30: Scala/Art Resource, New York, p. 96 (Bot)

Chapter 4-Photo 4.2: photo Henri Stierlin, p. 129; Photo 4.3: Ĉanali Photobank, Italy, p. 130; Photo 4.4: Hirmer Fotorarchiv, Munich, p. 131 (Top); Photo 4.5: Alinari/Art Resource, New York, p. 131 (Bot); Photo 4.6: 1994 Richard T. Nowitz/Photo Researchers, Inc., p. 132; Photo 4.7: Alinari/Art Resource, New York, p. 136; Photo 4.9: Scala/Art Resource, New York, p. 139; Photo 4.10: Alinari/Art Resource, New York, p. 141; Photo 4.11: Scala/Art Resource, New York, p. 142 (Top); Photo 4.12: Scala/Art Resource, New York, p. 142 (Bot); Photo 4.13: Superstock, p. 143; Photo 4.14A: Superstock, p. 144 (UL); Photo 4.14B: Leonard Van Matt/Photo Researchers, Inc., p. 144 (UR); Photo 4.15: Alinari/Art Resource, New York, p. 144 (Bot); Photo 4.16: Scala/Art Resource, New York, 146 (Top); Photo 4.17: pp. 126, Scala/Art Resource, New York, p. 146 (Bot); Photo 4.18: Scala/Art Resource, New York, p. 147 (Top); Photo 4.19: Alinari/Art Resource, New York, p. 147 (Bot); Photo 4.21: Alinari/Art Resource, New York, p. 148; Photo 4.24: © M. Thonig/H. Armstrong Roberts, p. 150; Photo 4.25: Fototeca Unione, p. 151; Photo 4.26: Scala/Art Resource, New York, p. 152 (Top); Photo 4.27: Scala/Art Resource, New York, p. 152 (Bot); Photo 4.28: Alinari/Art Resource, New York, p. 153; Photo 4.29: Alinari/Art Resource, New York, p. 154

Chapter 5—Photo 5.1: Borromeo/Art Resource, New York, p. 176; Photo 5.2: Archeological Survey of India, Janpath, New Delhi, p. 180 (L); Photo 5.3: © Adam Wolfitt/CORBIS, p. 180 (R);

(Top); Photo 5.5: © B. D. Rupani/Dinodia, p. 181 (Bot); Photo 5.6: Courtesy of the Freer Gallery of Art, Smithsonian Institution, Washington, DC. Accession #F1949.9, p. 182 (Top); Photo 5.7: Scala/Art Resource, NY, p. 182 (Bot); Photo 5.8: Courtesy of the Freer Gallery of Art, Smithsonian Institution, Washington, DC. Accession #F1936.6, p. 184 (Top); Photo 5.9: © Mary Evans Picture Library, p. 184 (Bot); Photo 5.10: © Superstock, p. 185; Photo 5.11: © Superstock, p. 186; Photo 5.12: Réunion des Musées Nationaux/Art Resource, NY, p. 187 (Bot); Photo 5.13: © Peoples Republic of China/Lauros-Giraudon, Paris/Superstock, p. 187 (Top); Photo 5.14: Richard Rudolph Collection, Los Angeles, p. 188 (Top); Photo 5.15: Courtesy of the Freer Gallery of Art, Smithsonian Institution, Washington, DC. Accession #F1939.37, pp. 174, 188 (Bot); Photo 5.16: © Werner Foreman/COR-BIS, p. 189 (Top)

Chapter 6—Photo 6.2: Alinari/Art Resource, New York, p. 204 (Bot); Photo 6.3: Andre Held, Ecublens, Switzerland, p. 211 (Top); Photo 6.4: Scala/Art Resource, New York, p. 211 (Bot); Photo 6.5: Scala/Art Resource, New York, p. 212 (Top); Photo 6.6: Alinari/Art Resource, New York, p. 1875, Roma, Sarcofago Cristiano-Museo Laterano, p. 212 (Bot); Photo 6.7: Alinari/Art Resource, New York, p. 213 (UL); Photo 6.8: Robert Harding Picture Library, London, p. 213 (UR); Photo 6.9: Zev Radovan, Jerusalem, p. 213 (Bot); Photo 6.13: Rijksmuseum van Oudheden, Leiden, Netherlands, p. 215

Chapter 7—Photo 7.2 Alan Oddie/ PhotoEdit, Long Beach, CA, p. 239 (Top); Photo 7.3: Zefa/H. Armstrong Roberts, p. 239 (Bot); Photo 7.4: Hirmer Fotoarchiv, Munich, p. 240; Photo 7.5: Scala/Art Resource, New York, p. 241; Photo 7.6: Scala/Art Resource, New York, p. 242; Photo 7.7: Scala/Art Resource, New York, p. 243; Photo 7.8: Alinari/Art Resource, New York, p. 244 (Top); Photo 7.9: Estate of Leonard von Matt, Stansstad, Switzerland, p. 244 (Bot); Photo 7.10: Estate of Leonard von Matt, Stansstad, Switzerland, p. 245; Photo 7.11: Ancient Art and Architecture Collection, Harrowon-the-Hill, England, p. 246 (Top); Photo 7.12: Scala/Art Resource, New York, p. 246 (Mid); Photo 7.13: Scala/Art Resource, New York p. 246 (LL); Photo 7.14: Fotocielo, Rome, p. 246 (LR); Photo 7.15: Hirmer Fotoarchiv, Munich, p. 247 (Top); Photo 7.16: Scala/Art Resource, New York, p. 247 (Bot); Photo 7.17: Canali Photobank, Italy, p. 248; Photo 7.18: Canali Photobank, Italy, p. 249 (Top); Photo 7.19: Estate of Leonard von Matt, Stansstad, Switzerland, pp. 234, 248 (Bot); Photo 7.20: Hirmer Fotoarchiv, Munich, p. 250; Photo 7.21: 1991 Laura Zito/Photo Researchers, Inc., p. 251; Photo 7.22: Ancient Art and Architecture Collection, Harrow-on-the-Hill, England, p. 252

Chapter 8-Photo 8.1 Mehmet Biber/ Photo Researchers, Inc., p. 268; Photo 8.2: Bildarchiv Preussischer Kulturbesitz, Berlin, p. 270; Photo 8.3: © Christopher Rennie/Robert Harding Picture Library, p. 271; Photo 8.4: Yoram Lehmann, Jerusalem, p. 272 (Top); Photo 8.5: © Ronald Sheridan/Ancient Art & Architecture, p. 272 (Bot); Photo 8.6: © Ronald Sheridan/Ancient Art & Architecture, p. 273 (L); Photo 8.7: © Ronald Sheridan/Ancient Art & Architecture, p. 273 (R); Photo 8.8: © M. Thonig/H. Armstrong Roberts, p. 274 (Top); Photo 8.9: Institut Anatler d'Art Hispanic, p. 274 (Bot); Photo 8.10: © Ronald Sheridan/Ancient Art & Architecture, pp. 266, 275; Photo 8.11: © K.M. Westermann/CORBIS, p. 276

Chapter 9-Photo 9.1: Archives Nationales de France, p. 294; Photo 9.2: Tafel 19, Scivias, courtesy of Sr. Scholastica, Abtei St., p. 298; Photo 9.3: D.Y./Art Resource, New York, p. 302; Photo 9.4: © Ann Munchow, Dom-Kapitel-Aachen, p. 304 (Top); Photo 9.5: Rare Books and Manuscript Division, New York Public Library, p. 304 (Bot); Photo 9.7: Austrian National Library (Österreichische Nationalbibliothek), Vienna, pp. 292, 305 (R); Photo 9.8: Giraudon/Art Resource, New York, p. 306; Photo 9.9: Romisch-Germanisches Zentral Museum, Mainz, p. 307 (Top); Photo 9.10: Dr. Harold Busch, p. 307 (Bot); Photo 9.13: Bildarchiv Foto Marburg/Art Resource, New York, p. 310; Photo 9.14: Marburg/Art Resource, p. 311 (UL); Photo 9.15: Archives Photographiques, Paris/SPADEM, p. 311 (LL); Photo 9.16: Emeric Feher © CNMHS/SPA-DEM, p. 311 (R); Photo 9.17: J. E. Bulloz Editions, Paris, p. 312

Chapter 10—Photo 10.1b: Scala/Art Resource, New York, p. 344; Photo 10.2: © ND—Viollet, p. 345; Photo 10.4: Sonia Halliday and Laura Lushington, Weston Turville, England, p. 346; Photo 10.5: Giraudon/Art Resource, New York, pp. 342, 349; Photo 10.6: Giraudon/Art Resource, New York, p. 350; Photo 10.7: Alinari/Art Resource, p. 351; Photo 10.8: © Marc Garanger/CORBIS, p. 352; Photo 10.9: Giraudon/Art Resource, New York, p. 353; Photo 10.10: Bibliotheque Nationale, Paris, p. 354 (L); Photo 10.11: Getty Research Institute, Research Library, Wim Swaan Photograph Collection, 96.P.21, p. 354 (R); Photo 10.12: Bildarchiv Preussischer Kulturbesitz, Berlin, p. 357; Photo 10.13: Scala/Art Resource, New York, p. 360; Photo 10.14: Scala/Art Resource, New York, p. 361; Photo 10.15: Scala/Art Resource, New York, p. 362; Photo 10.16: Colorphoto Hans Hinz, Artothek, p. 363; Photo 10.17: Scala/Art Resource, New York, p. 365; Photo 10.18: Scala/Art Resource, New York, p. 366

Chapter 11-Photo 11.1: Archives Photographiques, Paris/SPADEM, p. 404; Photo 11.2: Alinari/Art Resource, New York, p. 405 (Top); Photo 11.3: Alinari/Art Resource, New York, p. 405 (Bot); Photo 11.4: Scala/Art Resource, New York, p. 406 (L); Photo 11.5: Scala/Art Resource, NY, p. 406 (R); Photo 11.6: Alinari/Art Resource, New York, p. 406 (Top); Photo 11.7: Scala/Art Resource, New York, p. 406 (Bot); Photo 11.8: Studio Pizzi/Summerfield, p. 408; Photo 11.9: Alinari/ Art Resource, New York, p. 409 (Top); Photo 11.10: Scala/Art Resource, New York, p. 409 (Bot); Photo 11.11: Scala/ Art Resource, New York, p. 410; Photo 11.12: Canali Photobank, Italy, p. 411; Photo 11.13: Scala/Art Resource, New York, p. 412 (Top); Photo 11.14: Scala/Art Resource, New York, p. 412 (Bot); Photo 11.15: William Francis Warden Fund; Seth K. Sweetser Fund, The Henry C. and Martha B. Angell Collection, Juliana Cheney Edwards Collection, Gift of Martin Brimmer, and Gift of Reverend and Mrs. Frederick Frottingham, by exchange. Courtesy of the Museum of Fine Arts, Boston, p. 413 (Top); Photo 11.16: Eric Lessing/Art Resource/Reproducedby courtesy of the Trustees of the National Gallery, London, p. 413 (Bot); Photo 11.17: Giraudon, Paris, p. 414 (Top); Photo 11.18: Giraudon/Art Resource, New York, p. 414 (Bot); Photo 11.19: Giraudon, p. 415; Photo 11.20: Scala/Art Resource, New York, p. 416 (Top); Photo 11.21: R. Krubner/H. Armstrong Roberts, p. 416 (Bot); Photo 11.22: Scala/Art Resource, New York, p. 417 (Top); Photo 11.23: G. Barone/ Superstock, Inc., p. 417 (Bot); Photo 11.24: Woodmansterne, London, p. 418 (L); Photo 11.25: Courtesy of the Trustees of the British Library, London, pp. 396, 418 (R); Photo 11.26: Scala/Art Resource, New York, p. 419

CHAPTER 1—page 9: From the LAW CODE OF HAMMURABI. Copyright University of Chicago Press. Reprinted by permission; page 18: From LIFE UNDER THE PHARAOHS by Leonard Cottrell, pp. 84, 94. Copyright © 1960 by Leonard Cottrell. Reprinted by permission of Henry Holt and Company, LLC; page 18: From TEM-PLES, TOMBS AND HIEROGLYPH-ICS by Barbara Mertz, 1964. Copyright © 1964, 1978 by Barbara Mertz. All rights reserved; pages 30-31: From THE EPIC OF GILGAMESH, trans. N. K. Sanders, 1960, 1964. Copyright by N. K. Sanders, 1966, 1964. Published by Penguin Books, Ltd.

CHAPTER 2—page 41: From BOOK XVII of THE ÎLIĂD by Homer, translated by E. V. Rieu. Published by Penguin Books, Ltd.; pages 56-64: Excerpt from THE ILIAD by Homer, translated by Richard Lattimore, copyright 1951 from Books XVIII, XXIII, XV, XXIV. Copyright 1951 University of Chicago Press. Reprinted by permission; pages 64-65: Excerpt from SAPPHO AND THE GREEK LYRIC POETS, translated by Willis Barnstone, copyright © 1962, 1967, 1988 by Willis Barnstone. Used by permission of Schocken Books, a division of Random House, Inc.; pages 64-65: Excerpt from THE CLASSICS IN TRANSLATION, VOLUME I, edited by Paul L. MacKendrick and Herbert M. Howe, copyright 1952. Reprinted by permission of The University of Wisconsin Press; pages 64–65: Excerpt from THE CLASSICS IN TRANSLA-TION, VOLUME I, edited by Paul L. MacKendrick and Herbert M. Howe, copyright 1952. Reprinted by permission of The University of Wisconsin Press; pages 65-67: Excerpt from Book VIII of THE HISTORIES by Herodotus, translated by Aubrey de Selincourt. Copyright 1954 by the Estate of Aubrey de Selincourt. Published by Penguin Books, Ltd.

CHAPTER 3—page 94: "Kerdo the Cobbler" by Herondas from GREEK LIT-ERATURE IN TRANSLATION, translated by George Howe and Gustave Adolphus Harrer (New York: Harper, 1924). Reprinted by permission of Marcella Harrer; pages 99–112: Albert Cook, translation of "Oedipus Rex" in *Oedipus Rex: A Mirror for Greek Drama*, Wadsworth Pub. Co., 1963: Re-issued

Waveland Press, 1982. Copyright © 1982 Albert Cook. Reprinted by permission; pages 112-114: Excerpt from THE CLASSICS IN TRANSLATION, VOLUME I, edited by Paul L. Mac-Kendrick and Herbert M. Howe, copyright 1952. Reprinted by permission of The University of Wisconsin Press; pages 114-117: "Phaedo" by Plato from THE GREAT DIALOGUES OF PLATO, translated by W. H. D. Rouse. Copyright © 1956 and renewed 1984 by J. C. G. Rouse. Used by permission of Dutton Signet, a division of Penguin Putnam Inc.; pages 117-118: Allegory of the Cave" by Plato from THE GREAT DIALOGUES OF PLATO, translated by W. H. D. Rouse. Copyright © 1956 and renewed 1984 by J. C. G. Rouse. Used by permission of Dutton Signet, a division of Penguin Putnam Inc.

CHAPTER 4—page 134: "Letter by Cicero" translated by John Reich. page 135: From THE SATYRICON by Petronius, translation formerly attributed to Oscar Wilde. Privately printed; page 157: Poems V, LXXXVII, LXXV, LVIII from THE LYRIC GENIUS OF CATALLUS by Catullus, translated by Eric Alfred Havelock, 1939; pages 158-167: From Book I, Book IV, Book VI of "The Georgics of Vergil" translated by C. Day Lewis. Copyright 1953 by C. Day Lewis. Reprinted by permission of Sterling Lord Literistic, Inc.; pages 167–168: From THE ODES OF HORACE by Horace, translated by James Michie. Translation copyright © 1965 by James Michie. Used by permission of Viking Penguin, a division Penguin Putnam Inc.; pages of 168-169: From THIRD SATIRE by Juvenal in THE SATIRES OF JUVE-NAL, translated by Rolfe Humphries, © 1958 Indiana University Press. Reprinted by permission; pages 169-171: Reprinted with the permission of Scribner, a division of Simon & Schuster from Book II in MARCUS AURELIUS: MEDITATIONS, translated by G. M. A. Grube. Copyright © 1963 by The Bobbs-Merrill Company, Inc.

CHAPTER 5—pages 191–193: From RIG VEDA, translated by Wendy Doniger O'Flaherty, © 1987. Published by Penguin Books, Ltd.; pages 193–196: From THE UPANISHADS, translated by Juan Mascaro, © 1965.

Published by Penguin Books, Ltd.; **pages 196–198:** From THE WISDOM OF BUDDHISM, translated by Christmas Humphries, © 1960; **pages 198–199:** From THE COLUMBIA BOOK OF CHINESE POETRY: From Early Times to the Thirteenth Century, translated and edited by Burton Watson, pp. 207–210, 212, © 1984 Columbia University Press. Reprinted by permission.

CHAPTER 6—pages 217-226: From Genesis, Exodus, Job, Amos, Matthew, Acts, I Corinthians, and II Corinthians of Revised Standard Version Bible, copyright 1946, 1952, © 1972 by the Division of Christian Education of the National Council, Churches of Christ in the U.S.A.; pages 226-228: From "The First Apology" by Justin Martyr from WRITINGS OF SAINT JUSTIN MARTYR, translated by Thomas Falls. Copyright © Catholic University Press of America. Reprinted by permission; pages 228-231: From THE PASSIONS OF SAINTS PERPETUA AND FELIC-ITY, translated by W. H. Shewring (London: Steed and Ward, 1931).

CHAPTER 7—page 237: Reprinted by permission of the publishers and the Trustees of the Loeb Classical Library from PROCOPIUS: VOLUME I, Loeb Classical Library Volume L048, translated by H.B. Dewing, Cambridge, MA: Harvard University Press, 1914. The Loeb Classical Library® is a registered trademark of the President and Fellows of Harvard College; pages 255-257: From Book VIII and Book IX of SAINT AUGUSTINE: CONFES-SIONS by Saint Augustine, translated by R. S. Pine-Coffin, © 1961 by R. S. Pine-Coffin. Published by Penguin Books, Ltd.; pages 257-263: From Book XIX of CITY OF GOD by Saint Augustine, translated by Henry Bettenson, © 1972 by Henry Bettenson. Published by Penguin Books, Ltd.

CHAPTER 8—pages 279–287: From "The Opening," "The Table Spread," "The Children of Israel," "The Coursers," "The Unity" from THE MEAN-ING OF THE GLORIOUS KORAN, translated by Mohammed Marmaduke Pickthall, 1930, George Allen & Unwin, an imprint of HarperCollins Publishers, Ltd., 1930; pages 287– 288: From READINGS FROM THE MYSTICS OF ISLAM, translated by Margaret Smith, 1950; pages 288-289: Excerpt from ESSENTIAL RUMI, translated by Coleman Barks and John Moyne. © 1995 Coleman Barks. Reprinted by permission.

CHAPTER 9-page 300: "Quem Quæritis" trope from SAINT GAIL MANU-SCRIPTS in CHIEF PRE-SHAKE-SPEAREAN DRAMAS by John Quincey Adams, editor, 1924; pages 314-315: From HILDEGARD OF BIN-GEN by Mother Columbia Hart and Jane Bishop, © 1990 by the Abbey of Regina: Laudis Benedictine Congregation Regina Laudis of the Strict Observance, Inc. Used with permission of Paulist Press, www.paulistpress.com; pages 315-316: "Causae et Curae" from WOMEN WRITERS OF THE MIDDLE AGES: A Critical Study of Texts from Perpetua to Marguerite. . . by Peter Dronke. Copyright © Cambridge University Press. Reprinted by permission; pages 317-325: "Everyman" from EVERYMAN AND ME-DIEVAL MIRACLE PLAYS, edited by A. C. Crowley, 1952, © Everyman Publishers, Gloucester Mansions, 140A Shaftesbury Ave., London, UK C2H THE INFERNO, Cantos XI, XXXIII

8HD; pages 325-330: THE CONVER-SION OF THE HARLOT THAIS by Hrosvitha von Gandersheim from THE PLAYS OF HROSTVIT VON GANDERSHEIM, translated by Katharina Wilson. Reprinted by permission of the author; pages 330–333: From "Saint Bertilla, Abbess of Chelles" in SAINTED WOMEN OF THE DARK AGES, edited and translated by Jo Ann McNamara and John E. Harlborg. © 1992, Duke University Press. Reprinted by permission. All rights reserved; pages 333-339: From SONG OF ROLAND translated by Robert Harrison. Copyright © 1970 by Robert Harrison. Used by permission of Dutton Signet, a division of Penguin Putnam Inc.

CHAPTER 10-page 358: From "General Prologue" of THE CANTERBURY TALES by Geoffrey Chaucer, translated by David Wright. Copyright © 1985 by David Wright. Reprinted by permission of PFD on behalf of the Estate of David Wright; pages 370-393: Cantos I, IX from THE PURGATORIO, Cantos I, III, V, X, XXXIII, XXXIV from

from THE PARADISO in THE DI-VINE COMEDY by Dante Alighiere, translated by John Ciardi. Copyright 1954, © 1957, 1959, 1960, 1961, 1965, 1967, 1970 by the Ciardi Family Publishing Trust. Used by permission of W. W. Norton & Co.

CHAPTER 11-pages 422-424: "Preface to the Ladies" from DECAM-ERON by Bocaccio in MEDIEVAL CULTURÉ AND SOCIETY by David Herlihy. Copyright © 1968 by David Herlihy. Reprinted by permission of HarperCollins Publishers, Inc.; pages 424-437: From "General Prologue" and "The Wife of Bath's Tale" of THE CANTERBURY TALES by Geoffrey Chaucer, translated by David Wright. Copyright © 1985 by David Wright. Reprinted by permission of PFD on behalf of the Estate of David Wright; pages 437-439: Selections from THE BOOK OF THE CITY OF LADIES by Christine de Pizan are translated by Earl Jeffrey Richards. Copyright © 1982, 1998 by Persea Books, Inc. Reprinted by permission of Persea Books, Inc. (New York).